THE OXFORD HANDBOOK OF

MENTAL HEALTH AND CONTEMPORARY WESTERN AESTHETICS

OXFORD HANDBOOKS IN PHILOSOPHY AND PSYCHIATRY

SERIES EDITORS: K.W.M. FULFORD, LISA BORTOLOTTI, MATTHEW R. BROOME, KATHERINE MORRIS, JOHN Z. SADLER, AND GIOVANNI STANGHELLINI

Volumes in the Series:

THE OXFORD HANDBOOK OF PHILOSOPHY AND PSYCHIATRY
Edited by K.W.M. Fulford, Martin Davies, Richard Gipps, George Graham, John Sadler, Giovanni Stanghellini, and Tim Thornton

THE OXFORD HANDBOOK OF PSYCHIATRIC ETHICS
Edited by John Z. Sadler, Werdie (C.W.) Van Staden, and K.W.M. Fulford

THE OXFORD HANDBOOK OF PHILOSOPHY AND PSYCHOANALYSIS
Edited by Richard Gipps and Michael Lacewing

THE OXFORD HANDBOOK OF PHENOMENOLOGICAL PSYCHOPATHOLOGY
Edited by Giovanni Stanghellini, Matthew R. Broome, Anthony Vincent Fernandez, Paolo Fusar-Poli, Andrea Raballo, and René Rosfort

OXFORD HANDBOOK OF PSYCHOTHERAPY ETHICS
Edited by Manuel Trachsel, Jens Gaab, Nikola Biller-Andorno, John Sadler, and Serife Tekin

OXFORD HANDBOOK OF MENTAL HEALTH AND CONTEMPORARY WESTERN AESTHETICS
Edited by Martin Poltrum, Michael Musalek, Kate Galvin, and Yuriko Saito

THE OXFORD HANDBOOK OF

MENTAL HEALTH AND CONTEMPORARY WESTERN AESTHETICS

Edited by
MARTIN POLTRUM, MICHAEL MUSALEK, KATHLEEN GALVIN,
and
YURIKO SAITO

Editorial advisor
HELENA FOX

OXFORD
UNIVERSITY PRESS

Great Clarendon Street, Oxford, OX2 6DP,
United Kingdom

Oxford University Press is a department of the University of Oxford.
It furthers the University's objective of excellence in research, scholarship,
and education by publishing worldwide. Oxford is a registered trade mark of
Oxford University Press in the UK and in certain other countries

© Oxford University Press 2025

The moral rights of the authors have been asserted

All rights reserved. No part of this publication may be reproduced, stored in
a retrieval system, or transmitted, in any form or by any means, without the
prior permission in writing of Oxford University Press, or as expressly permitted
by law, by licence or under terms agreed with the appropriate reprographics
rights organization. Enquiries concerning reproduction outside the scope of the
above should be sent to the Rights Department, Oxford University Press, at the
address above

You must not circulate this work in any other form
and you must impose this same condition on any acquirer

Published in the United States of America by Oxford University Press
198 Madison Avenue, New York, NY 10016, United States of America

British Library Cataloguing in Publication Data
Data available

Library of Congress Control Number: 2024939889

ISBN 978–0–19–286692–9

DOI: 10.1093/oxfordhb/9780192866929.001.0001

Printed in the UK by
Bell & Bain Ltd., Glasgow

Oxford University Press makes no representation, express or implied, that the
drug dosages in this book are correct. Readers must therefore always check
the product information and clinical procedures with the most up-to-date
published product information and data sheets provided by the manufacturers
and the most recent codes of conduct and safety regulations. The authors
and the publishers do not accept responsibility or legal liability for any errors in the
text or for the misuse or misapplication of material in this work. Except where
otherwise stated, drug dosages and recommendations are for the non-pregnant
adult who is not breast-feeding

The manufacturer's authorised representative in the EU for product safety is
Oxford University Press España S.A. of el Parque Empresarial San Fernando
de Henares, Avenida de Castilla, 2 – 28830 Madrid (www.oup.es/en).

Contents

Acknowledgements — xi
List of Contributors — xiii

SECTION I: INTRODUCTION

1. Why Aesthetics Matters in Mental Health — 3
 MARTIN POLTRUM, YURIKO SAITO, MICHAEL MUSALEK, KATHLEEN GALVIN, AND HELENA FOX

2. The Participatory Turn in Museum Curation as a Model for Person-Centred Clinical Care — 7
 K. W. M. FULFORD AND ANNA BERGQVIST

3. Positive Psychiatry and Mental Health — 28
 MERYAM SCHOULER-OCAK

SECTION II: HISTORICAL BACKGROUND AND BASIC IDEAS

Introduction: Historical Background and Basic Ideas — 45
 MARTIN POLTRUM

4. Platonic Proportions: Beauty, Harmony, and the Good Life — 48
 ANGELA HOBBS

5. Nietzsche's Healing Art of Transfiguration — 68
 PAUL VAN TONGEREN

6. John Dewey's Aesthetic Theory and Mental Health — 84
 THOMAS LEDDY

7. The Place of Health in Foucault's Aesthetics of Existence — 96
 ROBERT L. WICKS

8. Frankfurt School Aesthetics: The Aesthetic Dialectics of
 Mental Health　　　　　　　　　　　　　　　　　　　　　　111
 JOHAN FREDERIK HARTLE

9. Aesthetic Engagement as a Pathway to Mental Health
 and Well-Being　　　　　　　　　　　　　　　　　　　　　　130
 EUGENE HUGHES AND ARNOLD BERLEANT

SECTION III: ENVIRONMENTAL AESTHETICS AND WELL-BEING

Introduction: Environmental Aesthetics and Well-Being　　　　　149
 YURIKO SAITO

10. Everyday Aesthetics and the Good Life　　　　　　　　　　　152
 YURIKO SAITO

11. Sensible Well-Being: Environmental Aesthetics and Multi-sensory
 Perception　　　　　　　　　　　　　　　　　　　　　　　　168
 MĂDĂLINA DIACONU

12. On the Well-Being of Aesthetic Beings　　　　　　　　　　　186
 SHERRI IRVIN

13. On Enjoying What There Is: The Aesthetics of Presence　　　203
 ARTO HAAPALA

14. Gardening and the Power of Engagement with Nature for Mental
 Well-Being　　　　　　　　　　　　　　　　　　　　　　　　213
 ISIS BROOK

15. Aesthetic Choice in the Age of Ecological Awareness　　　　231
 SANNA LEHTINEN

16. Everyday Aesthetics and Resilience　　　　　　　　　　　　247
 SALEM AL QUDWA

17. Everyday Aesthetics, Happiness, and Depression　　　　　　264
 IAN JAMES KIDD

SECTION IV: SOCIAL AESTHETICS AND MENTAL HEALTH

Introduction: Social Aesthetics and Mental Health 289
 MICHAEL MUSALEK

18. Imaginary World-Making in Adaptation and Therapy 294
 SÉBASTIEN ARVISET

19. Spatial and Narrative Atmospheres: Social Aesthetic Perspectives 308
 GUENDA BERNEGGER

20. Applied Social Aesthetics in Clinical Practice: The Will to Beauty and Its Impact on Mental Health 326
 MICHAEL MUSALEK AND OLIVER SCHEIBENBOGEN

21. Inquiry on Hospitality, Compassion, and 'Antlitz' by Emmanuel Levinas 344
 LAZARE BENAROYO

22. Philosophical Aesthetics in Psychiatric Practice and Education 362
 MICHAEL LANEY AND JOHN Z. SADLER

23. Unleashing Therapeutic Gain by Deploying Social Aesthetic Values in Co-Producing Healthcare Decisions 380
 WERDIE VAN STADEN

24. Images of Care: 'To the Things Themselves!' 401
 GIOVANNI STANGHELLINI AND GEORGE IKKOS

SECTION V: LITERATURE, STORYTELLING, MOVIES, AND MENTAL ILLNESS

Introduction: Literature, Storytelling, Movies, and Mental Illness 419
 MARTIN POLTRUM

25. Mental Illness in Literature between Phenomenology and Symbolism 422
 DIETRICH V. ENGELHARDT

26. Bibliotherapy or the Healing Power of Reading in the Context of Cultural History: Basics—Development—Dimensions—Perspectives 440
 DIETRICH V. ENGELHARDT

27. An Aesthetics of Relating and Its (Therapeutic) Potentials: A Transcultural Perspective on Literature, Storytelling, and the Power of the (Spoken) Word 463
 KATHARINA FÜRHOLZER AND JULIA PRÖLL

28. 'Everyone Has a Story': Aesthetic Experiences of Storytelling in *The Strangers Project* 489
 ERZSÉBET STRAUSZ

29. 'Film is Psychosis': Filmmakers with Lived Experience 507
 SAL ANDERSON AND DOLLY SEN

30. Cinema Therapy—The Film as a Medicine. From the Silent Film Era to the Present Day 529
 MARTIN POLTRUM

31. Connoisseurs of the Soul, Psycho Villains: Psychotherapists, Psychologists, and Psychiatrists in Feature Films and Series 555
 MARTIN POLTRUM

32. Mental Disorders in Feature Films—Addiction, Suicide, Delusion, Psychosis, and Schizophrenia 578
 MARTIN POLTRUM

33. Imaging Children's Realities in Films: Visual Anthropological Approaches and Representations of Emotions in Childhood 598
 ALISON L. KAHN

SECTION VI: PSYCHOPATHOLOGY, ART, AND CREATIVITY

Introduction: Psychopathology, Art, and Creativity 617
 KATHLEEN GALVIN

34. Social-Aesthetic Strategies for a Change of Heart 620
 SHELLEY SACKS

35. Bodily Aesthetics: Challenging Damaging Imaginaries of the Body 647
KATHLEEN LENNON

36. Art and Trauma: An Aesthetic Journey 661
TANIA L. ABRAMSON AND PAUL R. ABRAMSON

37. The Psychology of Art-Viewing: Insights from Interpretative Phenomenological Analysis 683
RACHEL A. STARR AND JONATHAN A. SMITH

38. Psychoanalysis as an Art of Meeting the Other: Now Moments, Moving Along, and the Possibility of Change 706
TIMO STORCK AND RAINER M. HOLM-HADULLA

39. The Aesthetics of Dementia 717
JULIAN C. HUGHES

40. Supporting a Motivated Creative Practice via Collaboration, Dialogue, and Making: Workshop to Aid Creative Well-Being 733
CHRISTINA READING AND JESS MORIARTY

41. Aesthetic Experience and Aesthetic Deprivation in Hospitals 749
HILARY MOSS

SECTION VII: AESTHETIC EXPERIENCE IN THE CLINIC: PERSPECTIVES AND REFLECTIONS FROM PRACTICE

Introduction: Aesthetic Experience in the Clinic: Perspectives from Practice 771
HELENA FOX

42. Aesthetics for Everyday Quality: Enriching Health-Care Improvement Debates 776
ALAN CRIBB AND GRAHAM PULLIN

43. Developing Clinician Insight into Practice Through the Aesthetic Lens 797
LOUISE YOUNIE

44. Aesthetic Experience in the Everyday Clinical Work of Healthcare Practitioners: A Practice-Based Description 817
HELENA FOX

45. Gardens and Human Flourishing 840
 SUE STUART-SMITH

46. The Moving Pieces Approach: Poetic Space, Embodied Creativity, Polarity, and Performance as Aspects of Aesthetic Experience 862
 CHARLIE BLOWERS

47. Aesthetics and the Clinical Encounter: Perfect Moment and Privileged Moments 888
 FEMI OYEBODE

48. An Exploration of the Aesthetic Moment in the Clinical Encounter Using Free Musical Improvisation as a Model 905
 ANDREW WEST

49. Creative Arts, Aesthetic Experience, and the Therapeutic Connection in Eating Disorders 924
 JACINTA TAN, CAROLYN NAHMAN, KIRAN CHITALE, AND STEPHEN ANDERSON

50. Theological Aesthetics and Clinical Care 959
 ARIEL DEMPSEY

Index 983

Acknowledgements

Our *Oxford Handbook of Mental Health and Contemporary Western Aesthetics* has many fathers and mothers to whom we owe our gratitude. One very special obstetrician, without whom our project would never have been realized, must be explicitly acknowledged here. We are specially indebted to Bill Fulford, the mastermind of the international movement of philosophy and psychiatry. Bill Fulford not only prepared the ground on which this project could flourish by establishing the Collaborating Centre for Values-based Practice in Health and Social Care at St Catherine's College in Oxford which hosts the Aesthetics in Mental Health Network (AiMH), to which the majority of the editors of our handbook belong, but also continuously acted as a good, wise, and experienced obstetrician during the entire process so that our publication could finally see the light of day. Dear Bill, we express our sincere gratitude and our full appreciation for all this!

On 30 November 2018, parts of the editorial team met another supporter who also deserves great thanks, Senior Commissioning Editor Martin Baum, at the magnificent headquarters of Oxford University Press. Thank you, Martin, for accompanying our project and for the freedom you granted us in terms of content and your practical wisdom that enabled us to take a stand on critical voices!

Senior Project Editor Jade Dixon was a constant help and support in practical questions of detail. A special thanks, dear Jade!

Last but definitely not least, we would like to thank our sixty-two authors, who worked diligently on their contributions across four continents and thus made our project possible in the first place. Dear authors, many sincere thanks for your great dedication and wonderful contributions!

Contributors

Dr Paul R. Abramson, Department of Psychology, University of California, Los Angeles, USA

Tania L. Abramson, MFA Visual Artist, Faculty, Honors Program, University of California, Los Angeles; Department of Feminist Studies, University of California, Santa Barbara, USA

Sal Anderson, Filmmaker and Independent Scholar, London, UK

Dr Stephen Anderson, Consultant Psychiatrist, Adult Eating Disorder Service, NHS Greater Glasgow and Clyde, UK

Sébastien Arviset, PhD, Managing Editor, Philosophy, Psychiatry & Psychology, John Hopkins University Press, USA

Professor Emeritus Lazare Benaroyo, MD, PhD, Interdisciplinary Ethics Research Center, University of Lausanne, Switzerland

Dr Anna Bergqvist, PhD, Reader in Philosophy, Manchester Metropolitan University, UK

Dr Arnold Berleant, Emeritus Professor of Philosophy, Long Island University, USA

Dr Guenda Bernegger, University of Applied Sciences and Arts of Southern Switzerland, Switzerland

Charlie Blowers, Founder and Artistic Director of Moving Pieces Collective; Arts and Body-Oriented Psychotherapist; Practice-based Researcher in Collaboration with the Department of Dance and Psychology, Roehampton University, London, UK

Dr Isis Brook, Visiting Research Fellow, Bath Spa University, UK

Dr Kiran Chitale, MRCPsych, Consultant Child and Adolescent Psychiatrist, Ellern Mede Eating Disorders Outpatient Service, London, UK

Professor Alan Cribb, Centre for Public Policy Research, King's College London, UK

Dr Mădălina Diaconu, Associate Professor, University of Vienna, Austria

Dr Ariel Dempsey, MD, DPhil candidate, Science and Religion, Healthcare and Humanities Fellow, Faculty of Theology and Religion, Wycliffe Hall, University of Oxford, UK

Professor Emeritus Dietrich v. Engelhardt, University of Lübeck, Germany

Dr Helena Fox, MRCPsych, PhD, Consultant Psychiatrist, Independent Sector, London; Arts-based Research, School of Arts, Oxford Brookes University, Oxford, UK

Professor K. W. M. Fulford, Fellow of St Catherine's College, Member of the Philosophy Faculty, and Founder Director of the Centre for Values-based Practice in Health and Social Care, University of Oxford, UK

Dr Katharina Fürholzer, University of Rostock, Germany

Professor Kathleen Galvin, School of Sport and Health Science, University of Brighton, UK

Professor Arto Haapala, University of Helsinki, Finland

Dr Johan Frederik Hartle, Academy of Fine Arts Vienna, Austria

Professor Angela Hobbs, Department of Philosophy, University of Sheffield, UK

Professor Rainer M. Holm-Hadulla, University of Heidelberg, Germany

Dr Eugene Hughes, University of the Arts, Philadelphia, USA

Professor Julian C. Hughes, Bristol Medical School, University of Bristol, UK

Professor George Ikkos, Consultant Psychiatrist in Liaison Psychiatry, Royal National Orthopaedic Hospital, Middlesex, UK

Professor Sherri Irvin, University of Oklahoma, USA

Dr Alison L. Kahn, Stanford University Overseas Program, Oxford, UK

Dr Ian James Kidd, University of Nottingham, UK

Professor Michael Laney, University of the Southwestern Medical Center, Dallas, Texas, USA

Professor Emeritus Thomas Leddy, San José State University, USA

Dr Sanna Lehtinen, Research Fellow, Aalto University, Finland

Professor Emerita Kathleen Lennon, Department of Philosophy, University of Hull, UK

Dr Jess Moriarty, School of Humanities and Social Science, University of Brighton, UK

Professor Hilary Moss, Health Research Institute, University of Limerick, Ireland

Professor Michael Musalek, Institute of Social Aesthetics and Mental Health, Sigmund Freud University, Vienna, Austria

Dr Carolyn Nahman, MRCPsych, PhD, Consultant Child and Adolescent Psychiatrist, Oxford

Professor Femi Oyebode, Honorary Professor of Psychiatry, Institute of Clinical and Experimental Sciences, School of Medicine, University of Birmingham, UK

Professor Martin Poltrum, Faculty of Psychotherapy Science, Sigmund Freud University, Vienna, Austria

Associate Professor Julia Pröll, Institute for Romance Studies, University of Innsbruck, Austria

Professor Graham Pullin, Duncan and Jordanstone College of Art and Design, University of Dundee, Dundee, UK

Dr Salem Al Qudwa, 2020–2022 Practitioner Fellow in Conflict and Peace, Harvard Divinity School, USA

Dr Christina Reading, Independent Researcher

Professor Emerita Shelley Sacks, Social Sculpture Research Unit, Oxford Brooks University, UK; Interdisciplinary Artist and Author, Social Sculpture Lab, Germany

Professor John Z. Sadler, University of the Southwestern Medical Center, Dallas, Texas, USA

Professor Emerita Yuriko Saito, Rhode Island School of Design, USA

Dr Oliver Scheibenbogen, Institute of Social Aesthetics and Mental Health, Sigmund Freud University, Vienna, Austria

Professor Meryam Schouler-Ocak, Psychiatric University Clinic of the Charité, Berlin, Germany

Dolly Sen, Filmmaker, London, UK

Professor Jonathan A. Smith, Birkbeck College, Department of Psychology, University of London, UK

Professor Werdie van Staden, Centre for Ethics and Philosophy of Health Sciences, University of Pretoria, South Africa

Professor Giovanni Stanghellini, Department of Health Sciences, University of Florence, Italy

Dr Rachel A. Starr, Birkbeck College, Department of Psychology, University of London, UK

Professor Timo Storck, Psychologische Hochschule Berlin, Germany

Dr Erzsébet Strausz, Department of International Relations, Central European University, Austria

Dr Sue Stuart-Smith, PhD, Consultant Medical Psychotherapist, Doc Health Service, British Medical Association, London, UK

Dr Jacinta Tan, Consultant Child and Adolescent Psychiatrist (retired); DPhil, University of Oxford Sociology; FRCPsych, UK

Professor Emeritus Paul van Tongeren, Radboud University, Nijmegen, Netherlands

Dr Andrew West, Consultant Psychiatrist (retired); Coach and Mentor NHS England; MRCPsych, UK

Professor Robert L. Wicks, School of Humanities at the University of Auckland, New Zealand

Professor Louise Younie, General Practitioner and Clinical Professor of Medical Education, Institute for Health Sciences Education, Faculty of Medicine & Dentistry, Queen Mary University of London, UK

SECTION I
INTRODUCTION

CHAPTER 1

WHY AESTHETICS MATTERS IN MENTAL HEALTH

MARTIN POLTRUM, YURIKO SAITO, MICHAEL MUSALEK, KATHLEEN GALVIN, AND HELENA FOX

HUMAN flourishing depends upon the mental health of individuals. Throughout history, various cultural traditions have established and practised diverse strategies to maintain their community members' mental health, treat their mental illness, and enhance their well-being. They range from spiritual disciplines, religious rituals, and philosophical training, to communal activities, educational instructions, and community support. It is noteworthy that aesthetic objects and activities are frequently integrated into these strategies. They include visual arts, music, dance, story-telling, theatre, and occasions and events made special by certain food, drinks, decorations, clothes, and fragrance.

This long-held and widely practised integration of aesthetics into promotion of mental health testifies to the power of the aesthetic to affect the well-being of humans and their communities. The world's major philosophies and religious traditions have recognized this power of the aesthetic. For example, Plato's proposed censorship of the arts in his utopian Republic indicates his acknowledgement of, and a respect for, the power of the arts to mould citizens' psyche and character. Confucianism also utilizes arts and rituals to promote moral virtues. Finally, Buddhism teaches the cultivation of mindful practice for human flourishing by developing an alternative relationship with present-moment experience such as suffering and distress.

Today, the most dominant method of treating mental illness in the West is psychotherapy, psychology, and psychiatry, methodologies and practices established and developed in Europe since the nineteenth century. In addition, mindfulness-based practice combines principles from ancient Buddhism with Western psychology in programmes used for the amelioration of many physical and mental conditions as well as for enhancing flourishing in life in the general public. Here, attentional training would also embrace aesthetic experience if it constitutes part of current moment experience. One of the recent developments in these practices is the increased recognition

of the efficacy of aesthetic strategies and their active incorporation in the treatment of patients suffering from mental illness. This handbook addresses the role aesthetics plays in psychotherapy and psychiatry both as theories and practices.

Among the various aesthetic strategies employed by psychotherapy and psychiatry, the role played by arts has been most prominent. Ever since the birth of art and poetry, its purpose has been to inspire, stir, and move people, sometimes even to shake or shock them. Which varied roles art has played and will continue to play in this process depends primarily on the favoured aesthetic discourse, the respective aesthetic position and what is intended to be achieved through aesthetic experience. The occidental tradition of philosophy, just as with non-Western traditions of thought, is overabundant with discourses on aesthetics, and historical and contemporary art clearly shows, to borrow Theodor W. Adorno's expression, that everything that art and aesthetics was and is no longer fits into any concept. If a psychologist, psychotherapist, psychiatrist, caregiver, social worker … or aesthetic theorist raises the question about the significance of the aesthetic experience in the context of therapy and mental health, then they are forced to make a selection. From the sea of aesthetic phenomena, it is necessary to choose and thematize those phenomena that are capable of arousing people's spirits, that are soothing, that convey experiences of purpose, that offer consolation, that give courage and hope that everything will be good again, and that emphasize that life is worth living. It is clear, and the art of the avant-garde and neo-avant-garde shows this sufficiently, that there are also times, situations, and historical constellations in which art does and must do exactly the opposite, namely shock, disturb, stir, shake up, and offer resistance.

Western Aesthetics and Mental Health

The *Oxford Handbook of Mental Health and Contemporary Western Aesthetics* presented here, which is primarily interested in the aesthetic positions and discourses that can be made fruitful for the field of therapy and mental health, is by necessity highly selective. That is, we give a subordinate or minor role to the view that art should shock and disturb, the aesthetics of the terrible and ugly, and the creation of negative emotions, such as pain, suffering, and horror, through various aesthetic practices. It is because we must not forget that psychotherapy and psychiatry are devoted to caring for the mental health of people who have often experienced much suffering, anxiety, terror, cruelty, trauma, homelessness, and alienation in their lives. Therefore, our book focuses on those positions that hold that art not only enhances the well-being of the art recipient, but also that contact with the aesthetic can become a life-changing experience.

The realization that aesthetic experiences have a benefit and positive effects on life has always led psychotherapists and psychiatrists to give their treatment programmes an aesthetic-therapeutic touch. This ranges from the book as a therapeutic tool

(bibliotherapy) to cinema therapy, which was already considered in the silent movie era, from art therapy to the idea of understanding psychotherapy as applied aesthetics and, more recently, the emergence of the discourse on the art of living, to mention just a few. These strategies illustrate that aesthetic experience provides an invaluable benefit and service for mental health.

In addition to the above-mentioned focus, a further thematic perimeter of our project is the fact that our *Oxford Handbook of Mental Health and Contemporary Western Aesthetics*, as the name suggests, has a primarily Western focus, at least as far as the discussion of philosophical positions on aesthetics is concerned. This specification is not only justified by the fact that the notion of mental health was explicitly articulated in the Western intellectual and medical tradition but also by our conviction that this tradition of thought could play a pioneering role, as far as the propagation of aesthetics for therapy is concerned. After all, the role aesthetics plays in protecting mental health and enhancing human flourishing transcends spatio-temporal borders. Thus, ideally, our handbook would initiate further book projects which, due to our foundation work, would be able to include other traditions of aesthetic theory in therapeutic considerations. If we succeeded in this, we would be proud!

Aesthetic Experience

In recent years, the term *aesthetic experience* has become a guiding concept in the aesthetics discourse. Initially, the shift of traditional focus on art and beauty to aesthetic experience occurred to accommodate newer objects of aesthetic appreciation such as avant-garde art, popular arts, and nature. However, there is also an increasing recognition that it is no longer the work or the object itself that gives rise to an aesthetic experience but rather the mode of our engagement with it. As a result, there is a growing agreement that aesthetic experiences are possible not just from objects that are already aesthetically charged, but also from anything at all, even including the most nondescript and unspectacular object, as well as any everyday event. Accordingly, therapeutic practice can also give rise to an aesthetic experience for both the patient and the therapist alike, one that at the same time has healing power.

Section Outlines

The *Oxford Handbook of Mental Health and Contemporary Western Aesthetics* is divided into seven sections and systematically brings together and develops the links, reciprocities, and multifarious interrelationships between the aesthetic experience and mental health, which until now have been discussed in isolation from one another. With fifty original articles written by major practitioners and theorists from the

mental health and aesthetics discourses, the book makes available the collective knowledge and worldwide activities practised in our field to a wide audience and contributes to sustainable and effective work with patients. Taking into account the fundamental discourse and most promising debates, we have structured the handbook as follows: (I) Introduction (Responsibility: Michael Muselek), (II) Historical Background and Basic Ideas (Responsibility: Martin Poltrum), (III) Environmental Aesthetics and Well-Being (Responsibility: Yuriko Saito), (IV) Social Aesthetics and Mental Health (Responsibility: Michael Musalek), (V) Literature, Storytelling, Movies, and Mental Illness (Responsibility: Martin Poltrum), (VI) Psychopathology, Art, and Creativity (Responsibility: Kathleen Galvin), and (VII) Aesthetic Experience in the Clinic: Perspectives and Reflections from Practice (Responsibility: Helena Fox).

We hope that our handbook will contribute to the scientific reception of the topic and wish you a pleasant and inspiring read!

Martin Poltrum (Vienna, AUT), Yuriko Saito (Providence, USA), Michael Musalek (Vienna, AUT), Kathleen Galvin (Brighton, UK), and Helena Fox (Oxford, UK)

CHAPTER 2

THE PARTICIPATORY TURN IN MUSEUM CURATION AS A MODEL FOR PERSON-CENTRED CLINICAL CARE

K. W. M. FULFORD AND ANNA BERGQVIST

Introduction

AESTHETICS has until recently been something of a Cinderella discipline in health care. While the medical humanities have led the way in integrating the arts into aspects of modern medicine (such as education; see Hilton & Slotnick, 2005); and while 'narrative medicine' might be considered a received clinical practice (Charon, 2006, 2017; Greenhalgh & Hurwitz, 1999), aesthetics has remained largely marginalized from the mainstream. This is perhaps understandable given the twentieth-century dominance of medical science and technology reflected notably in evidence-based approaches to clinical care. Aesthetics, with its emphasis on taste and human sensibility, might be considered to sit somewhat uncomfortably beside the rigorously objective empiricism on which the many successes of twentieth-century medicine were built. Yet towards the end of the twentieth century, it became increasingly clear that empiricism, although necessary, was not sufficient as a basis for delivering clinical care that served the patient. The first indication of this was the development of mid-twentieth-century medical ethics with its promotion of patient autonomy. But this too proved insufficient: patients found themselves, as the British social scientist, Priscilla Alderson, argued at the time, doubly disenfranchised. Yes, she agreed, patients had indeed been disenfranchised by the professionalism of medical science; and the focus of medical ethics on patient autonomy could in principle help to remedy this. But in practice, medical ethics, instead of empowering patients, was disenfranchising them anew by the increasingly professionalized form that it was taking (Alderson, 1990, 1994).

It was against this background that in the early years of the twenty-first century, concepts like person-centred care,[1] co-production, and shared decision-making made their appearance in medicine and related areas of clinical practice. These concepts were each concerned in different ways with restoring the patient to centre stage in health care. Importantly, though, and in contrast to earlier autonomy-driven models of medical ethics, the 'patient' in these new person-centred concepts, denoted a *particular individual person* in narrative terms. In earlier models, scientific and ethical, the 'patient' was conceived as an abstract and generalized person standing in opposition to the equally abstract and generalized person of the 'clinician'. In the new person-centred models, by contrast, the patient is a particular *individual person* engaging with a particular individual clinician (or individual team members) in a particular health-care interaction. This essentially relational concept expresses a working partnership between patient and clinician in a shared model of clinical decision-making. (We return to shared clinical decision-making below.)

The central role of particular individuals in health care is what motivated the appearance, also in the early twenty-first century, of a new resource for tackling contested values, called values-based practice (Fulford, 2004; Fulford et al., 2012). A key challenge of person-centred health care (to the extent that as just outlined this is concerned with particular individuals) is the diversity of our individual values. This diversity is central to how we differentiate ourselves as unique individuals one from another (Bergqvist, 2018a, 2018b, 2020, 2022, 2023). Yet for precisely this reason, just *because* our values are highly individual, they may often come into conflict. Hence the need for a resource, the resource of values-based practice, required for tackling these conflicts. Values-based practice, as we describe further below, works in partnership with evidence-based practice in 'linking science with people'.[2]

We return to values-based practice and its role in person-centred care in the first section of the chapter. As we describe there, although drawing on an increasingly wide range of philosophical and other resources, values-based practice has to date followed the precedents of scientific medicine and autonomy-driven medical ethics, in largely neglecting aesthetics. There are important exceptions (noted below). But these are indeed just that, exceptions, not the rule. This is of note given that, as indicated above, the key shift in thinking over this period has been from a generalized and abstract concept of 'the patient' to a focus on particular individuals, that is to say, particular individuals with all their correspondingly individual values, including, perhaps centrally including, aesthetic values. Thus, while it was perhaps understandable that earlier autonomy-driven models of medical ethics should have followed medical science in neglecting aesthetics as a discipline, there was no corresponding justification for the relative neglect of aesthetics in values-based practice.

At first glance it might seem that models derived from museum studies are too remote from the contingencies of the health-care front line to illuminate clinical concepts. Yet, as we show, the participatory turn reflects a trend within curation towards emphasizing the visitor's role in the co-creation of meaning, a trend that directly parallels, and thereby potentially informs, the contemporary move in health care towards person-centred care. We explore the learning from the participatory turn for person-centred

care in the third section of the chapter. To anticipate, traditional views of curatorship, in which professionals assume responsibility for determining the meaning of the objects in their displays, parallel traditional clinician-led views of health-care decision-making; while, by contrast, participatory models of curation parallel shared decision-making and other aspects of the partnership working that underpins person-centred clinical care. Such parallels, we argue, drawing on recent work (theoretical and practical) in museum studies, make the participatory turn in curation a heuristically powerful model for person-centred care.

Person-Centred Care, Shared Decision-Making, and Individual Values

'Person-centred care', like many other terms of art in wide use in contemporary health care, has come to be used in different contexts with often widely divergent meanings (Fulford, 2020). In this chapter we use person-centred care to mean health care that is concerned centrally with the *values of*—with what *matters or is important to*—the particular individuals concerned in a given health-care situation. We do not have space to defend this values-focused use of 'person-centred care' in detail. Nor indeed do we make any hegemonious claim for it. It is perhaps sufficient that given the irreducible role of values in defining individual identity (as intimated in our introduction), person-centred care is necessarily concerned with the values (in the above sense) of the particular individual persons concerned (Allott et al., 2002). This, we may suppose, is why it is this values-focused aspect of person-centred care that is reflected in recent legal and professional guidance on shared clinical decision-making (described immediately below). At all events, it is the contested values necessarily arising from the diversity of individual values, that motivated the development of values-based practice. We will look briefly at shared clinical decision-making and then at values-based practice, before turning to the particular challenges of contested values arising in mental health care and the emerging philosophical resources for tackling them.

Shared Clinical Decision-Making and Person-Centred Care

Shared decision-making of the kind with which we are concerned in this chapter, means decision-making, based on evidence and values, that is shared between the individual clinician (or clinical team members) and the individual patient involved in the particular health situation in question.

Once again, there will be variation among authors in the details. But one indication of the significance of shared decision-making so defined is its increasing incorporation

into medical law. In the United Kingdom (UK), for example, it was the basis of a recent Supreme Court decision on duty of care, the *Montgomery judgement* (Montgomery v Lanarkshire Health Board, 2015). Set out in an extended ruling running to some thirty-seven pages, and incorporating precedents from international human rights law,[3] *Montgomery* makes shared decision-making between clinician and patient based on evidence and values, the test of duty of care in determining treatment for all areas of clinical care (Herring et al., 2017). Adding weight to its authority, *Montgomery* relies on a model of consent that in turn reflects professional guidance from the General Medical Council (GMC).[4] Other regulatory bodies have issued similar guidance including, notably, the National Institute for Health and Care Excellence (NICE),[5] the body responsible for setting evidence-based guidelines for the UK health service.

Values-Based Practice and Shared Decision-Making

Shared decision-making of this kind may be challenging in both its evidence base and its values base. Evidence-based practice provides a process that supports clinical decision-making where the *evidence* in question is contested (because complex and/or conflicting). Values-based practice provides a process that supports clinical decision-making where the *values* in question are contested (because complex and/or conflicting). The processes provided by the two disciplines, although complementary, are of course different. Evidence-based practice relies on statistical and computational methods such as meta-analyses of high-quality research data. Values-based practice relies on a range of more practical process elements that build on learnable clinical skills.[6] But the principle, of relying on process rather than prescribing outcomes, is the same. The result is that values-based practice has the role in clinical decision-making of, as one of us has put it elsewhere, 'linking science with people' (Fulford et al., 2012, 1).

The differences between evidence-based practice and values-based practice in their respective process elements, reflect their differences of origin. Evidence-based practice is essentially *empirical* in origin,[7] whereas values-based practice by contrast is *philosophical* in origin. Values-based practice is derived from work in ordinary language analytic philosophy, by J. L. Austin, R. M. Hare, and others of the mid-twentieth century 'Oxford School', on the logic (the meanings and implications) of value terms (Fulford, 1989; Fulford & van Staden, 2013). In being philosophical in origin, values-based practice is perhaps closer to ethics rather than to evidence-based practice. Both are indeed in this respect part of a larger 'tool kit' of resources for working with values in health care: other 'tools' in the 'tool kit' include for example health economics (Williams, 1995) and decision analysis (Dowie et al., 2002). Values-based practice, however, and consistently with the focus on individual values in shared decision-making, is distinctive among these tools in focusing on the individual and in providing a resource for tackling the contested values arising from differences of individual values.

Values-based practice is currently being developed across a range of contemporary health-care disciplines. These include front-line evidence-based services such as surgery

(Handa et al., 2016), paramedic emergency care (Eaton & Paige, 2019), and imaging and radiotherapy (Fulford et al., 2018). Mental health, too, has been the focus of extensive values-based initiatives. It was indeed in mental health that values-based approaches were first developed, essentially as a philosophy-into-practice off-shoot of philosophy and psychiatry (Fulford, 1990). These initiatives were supported, inter alia, by non-governmental organizations (NGOs), including the Sainsbury Centre for Mental Health and Turning Point (both in London), and by the UK government's Department of Health. Early values-based programmes developed over this period included the first training manual (Woodbridge & Fulford, 2004) and resources for specialist areas including mental health assessment (National Institute for Mental Health in England (NIMHE) and the Care Services Improvement Partnership 2008 (Fulford et al., 2015a) and compulsory or involuntary psychiatric treatment (Care Services Improvement Partnership (CSIP)) and the National Institute for Mental Health in England (NIMHE 2008; see Fulford et al., 2015b). Yet despite these early initiatives, implementation in mental health has proven to be more challenging than in bodily health. Understanding just why this should have been so is important for our understanding of the potential role of aesthetics in mental health. Again, we will not have space to explore this point in detail. But the bottom line, a bottom line that derives directly from the origins of values-based practice in ordinary language philosophy of values (Fulford, 1989; Fulford & Van Staden, 2013), is that the challenges of implementation in mental health are a direct reflection of the *more contested nature of the values* operative in mental health compared with bodily health.

Person-Centred Care in Mental Health

Cleary there is a great deal that could be said about the similarities and differences between bodily health and mental health. We note here just two points, one negative, the other positive. The negative point is that the challenges of implementation of values-based approaches in mental health have little or nothing to do with any supposed deficiency in the sciences underpinning the field. True, the areas in which values-based approaches have in recent years developed most strongly (like surgery, paramedic emergency medicine, and radiography, as noted above) are all firmly evidence-based. True, also, values-based practice becomes more and not less important with every advance in medical science and technology—this is because such advances open up new choices that in turn open up clinical decision-making to an ever-wider range of individual values (this is the basis of the 'science-driven' principle of values-based practice (see Fulford et al., 2012, chapter 12). True, finally, the evidence base may be more straightforward in bodily health. In many areas of bodily health, we have a widely agreed corpus of evidence-based knowledge on which to base clinical decisions. Whereas, by contrast, in mental health, an agreed corpus of evidence is often lacking. Yet, all that being said, it is not the evidence-base of clinical decision-making in mental health that makes it a more challenging area of person-centred care, but its values-base.

The more challenging values-base of decision-making in mental health is because the operative values are both more complex and more conflicting than their counterparts in bodily medicine. Consider anorexia nervosa, for example, a potentially life-threatening condition characterized by extreme self-starvation and weight loss. In anorexia, everyone, including the patient, may well recognize the fact that if he or she[8] continues along their anorexic path of self-starvation, they will die. To this extent the evidence-base for clinical decision-making is straight-forward (we note that there are widely divergent views about the management of anorexia). The difference is rather in how this outcome is *evaluated*: in a word, the patient, broadly speaking, evaluates it as a *good thing*; while everyone else evaluates it as a *bad thing*.[9] So, in this way, the values of the patient and others are in conflict.

But there is more. For whereas in most areas of bodily medicine, even where values diverge, the values in question are readily understandable, this is far from the case with many areas of mental health. Consider anorexia again. Few other than perhaps their peers, could claim to understand why starvation (and risk of death) are more important to the person concerned than breaking their fast and gaining weight. It is important to be aware that such 'anorexic' values, although in this respect obscure, are not entirely idiosyncratic. There are whole websites devoted to the positive promotion of anorexic values.[10] A moment's perusal of such websites, though, will reinforce our point about the relative obscurity of the operative values. This is true for anorexia. It is true in other areas of mental health: in alcohol and addictive disorders, for example, in obsessional and personality disorders, and, perhaps most radically of all, in delusional disorders (see Fulford, 1989, chapter 10).

Values in mental health, then, are more complex and conflicting than their counterparts in bodily medicine, and they are also more obscure. Small wonder, therefore, that implementing values-based practice, and with it, shared decision-making, has proven to be more challenging in mental health than in bodily medicine. This is where additional philosophical resources for values-based practice, over and above those offered by its foundation in ordinary language philosophy, have started to come into play.

New Philosophical Resources for Values-Based Practice in Mental Health

First in line among new philosophical resources for values-based practice was phenomenology. From a growing range of contributors,[11] resources of particular relevance to anorexia have been the focus of work by the Italian philosopher and psychiatrist, Giovanni Stanghellini. Stanghellini has developed detailed insights into the values of people with anorexia and other feeding and eating disorders (FEDs) based on the mid-twentieth-century French phenomenologist, Jean Paul Sartre's, three-way phenomenology of the body (Stanghellini, 2019). Stanghellini's work has included the development

of empirical resources for phenomenological research in FEDs (Stanghellini et al., 2012); and a phenomenologically informed values-based diagnostic assessment interview for general use in mental health (Stanghellini & Mancini, 2017).

Similarly, extensive work in phenomenology and values has been developed by the Brazilian phenomenologist and psychiatrist, Guilherme Messas, focusing on alcohol and addictive disorders. Messas' work encompasses the values challenges arising not only in clinical care but also in health policy and management (Messas & Fulford, 2021; Messas & Soares, 2021). Yet other emergent philosophical resources address public health models. These include 'Batho Pele', a form of values-based practice derived from African philosophy, developed by the South African philosopher and psychiatrist, Werdie Van Staden. Batho Pele, again, has applications in both policy (Ujewe & Van Staden, 2021) and clinical contexts (Van Staden, 2021). Analytic philosophy, too, has generated new resources: for example, work by one of us on the relationality of values and other key topics (see Bergqvist, 2018a, 2018b, 2019, 2020, 2022, 2023).

Yet despite this growing range of new resources, aesthetics, as we noted earlier, has to date been largely absent even from values-based practice. There are important exceptions. For example, theoretical work by one of the editors of this book, Michael Musalek (2017a, 2017b), showed the value of aesthetics as a resource for managing addictive disorders.[12] Musalek has also been directly involved with spear-heading recent initiatives aimed at incorporating aesthetics into values-based practice. With colleagues Martin Poltrum (in Vienna) and Helena Fox (in the UK), he led on the establishment of a network for Aesthetics in Mental Health (the AiMH network) within the Oxford Collaborating Centre for Values-based Practice. Yet it continues to be the case that, notwithstanding the impressive work of the AiMH network and others, and notwithstanding the expansion of philosophical resources supporting the field, even within values-based practice, aesthetics remains on the margins of mainstream medicine. This brings us to the role of the participatory turn as a model for person-centred care.

The Participatory Turn in Curating

Everyone is familiar with museum institutions and many will have visited one or more art galleries or encountered other examples of public art. Characteristic of such venues is the aim of establishing specific contexts, sometimes called 'framings', which distinguish them from viewing the world unmediated or face-to-face (Bergqvist, 2016). They are in this sense literally 'exhibitions', collections of objects curated to exhibit a story or narrative. Engagement with such narratives has in the past sometimes been characterized as a cognitively unmediated process in sensory items. The participatory turn, by contrast, starts from a recognition of the extent to which traditional curation has (usually unwittingly) expressed the perspective of the curator in question: and it involves seeking in one way or another to incorporate and focus on visitor or audience participation.

Like 'person-centred care', 'shared decision-making', and other terms of art in health care, the notion of a 'participatory turn' in curating has been subject to varying interpretations. By definition, the participatory turn represents a turn towards visitor participation and audience engagement. But the extent and nature of the turn in question, and how this is interpreted and understood, varies widely. Here is one example.

The Silent University

Describing itself as a 'knowledge exchange platform', and working in partnership with museums and art galleries, Ahmet Öğüt's *The Silent University* is led by and for refugees and asylum seekers to activate the 'silenced knowledge' of migrant populations in different locations. As its website describes, the aim of *The Silent University* is

> … to challenge the idea of silence as a passive state, and explore its powerful potential through performance, writing, and group reflection… (and thereby) … attempt to make apparent … the loss of skills and knowledge experienced through the silencing process of people seeking asylum.[13]

The Silent University was launched originally in London with support from the arts-oriented NGO, the Delfina Foundation,[14] and in collaboration with The Showroom[15] and London South Bank's Tate Modern art gallery.[16] It has subsequently been extended to a number of European countries, notably including Sweden, at Stockholm's Tensta Konsthall museum (Lind, 2021). Some of these venues were natural partners. The Tensta Konsthall museum for example was founded by the artist and social worker, Gregor Wroblewski, in 1998, when Stockholm was the European Cultural Capital; and it is now one of a group of venues that focus on engaging their local communities. *The Silent University*, furthermore, came to Tensta under the Directorship of Maria Lind who has written widely of participatory models (Lind, 2019, 2020, 2021); we return to Lind's work on 'curating in the expanded field' below. In contrast, London's Tate Modern, one of the original hosts of *The Silent University*, although curatorially highly inventive, has a more traditional/art gallery ethos.

In adapting to different venues, *The Silent University* has sought to achieve its aims in a range of different ways. At Tate Modern, for example, it took the form of a year-long residency facilitated by Ahmet Öğüt in 2012, comprising a series of weekly workshops in collaboration with lectures with a variety of asylum, migrant, and refugee experiences. At Tensta museum, by contrast, *The Silent University* was set up as an arts café in a segregated area of the city of Stockholm where people without legal papers could practise their language skills as part of building an educational platform. The guiding aim common to all *The Silent University's* activities is to give voice through, as they put it (in the quoted passage from their website above) '… performance, writing, and group reflection', to the lived experience of those who, though professionally or academically trained in their countries of origin, found themselves unable to use their qualifications

in their host country due to factors relating to their migration status. Working together, the participants developed course topics connected to their qualifications. In this way, the 'artwork' takes dialogue and untapped potential as its point of departure for knowledge-exchange and critical reflection on what it means to be a migrant.

Curating in the Expanded Field

Our choice of *The Silent University* as an example of the participatory turn might seem to be off message for our argument. Surely, it might be said, as a community engagement project, *The Silent University* has more to tell us about, well, community engagement, than about museum curation. There are, after all, more overtly 'aesthetic-object-oriented' examples of the curatorial turn.[17] There are, similarly, several straightforwardly community engagement projects that have been successfully perused, with aims compatible with those of *The Silent University*, in, among other venues, community centres.[18] There is, however, a different way of understanding our example that points to a contrary conclusion, namely, that although indeed an example of community engagement, *The Silent University* shows the extent to which the participatory turn itself involves an expansion of the scope of aesthetics.

We take this expanded-scope interpretation from the work of Maria Lind, who, as we noted above, was Director of the Tensta Museum when it hosted *The Silent University*. Under her leadership, Tensta became one of a group of museums that actively pursue programmes of community engagement. These programmes were, she said, 'curating in the expanded field'. As Lind herself has put it, curating

> ... is a craft that can be involved in much more than making exhibitions—beyond the walls of an institution as well as beyond what are traditionally called programming and education. This is 'curating in the expanded field.' The curatorial is understood as a multidimensional role that includes critique, editing, education, fundraising, etc., ...
> (https://cimam.org/news-archive/situating-the-curatorial/)
> [last accessed 30 September 2024]

Interpreted in this way, then, as 'curating in the expanded field', *The Silent University*, just in being a community engagement project, is an appropriate example of the participatory turn. Not only that, but as we will see in the next section, *The Silent University* is of particular significance for person-centred care in mental health.

The Participatory Turn and Person-Centred Care

Although superficially very different, the clinical encounter parallels museums, art galleries and the like, in framing our experiences within specific contexts. There are

also several more specific parallels between them. Much, indeed, about the participatory turn is resonant of shared decision-making in person-centred care: its emphasis on open-endedness, on process, and on multiple authorship, for example. *The Silent University* is illustrative of all these and other parallels. In the rest of this section, we focus on two such parallels: partnership working and dialogue, and attention to strengths, respectively.

Partnership Working and Dialogue

Partnership working and dialogue are written all over *The Silent University*, from its opening self-description (not as seeking to *deliver* knowledge but rather as a 'knowledge *exchange* platform'), through its collaborative mode of engagement ('working together …'), to its choice of funders and venues. In all its instantiations, *The Silent University* has involved partnership working, mediated by dialogue, carried out on an equal basis between, on the one hand, Ögüt and his colleagues and, on the other hand, the migrants concerned in the activity in question. Partnership working and dialogue are integral similarly to the shared decision-making underpinning person-centred care. In particular, the *Montgomery* judgement (outlined above) makes explicit the importance of dialogue between clinician and patient in coming to a shared decision—the words 'dialogue' and 'discussion' are used at several points in the ruling.[19] A further parallel is that both depend upon what one of us has called elsewhere a 'no priority view' (Bergqvist, 2016, 2020), an equality of voice within which, in contrast to autonomy-driven medical ethics, neither view, neither the view of the curator nor that of the visitor, neither that of the clinician nor of the patient, has priority over the other.

There is, however, also an important anti-parallel between the participatory turn and person-centred care, namely in their respective ease of implementation. Thus, while the participatory turn has been widely and enthusiastically taken up among curators, shared decision-making, despite person-centred care being embraced in principle by clinicians, has often struggled to make an impact. In the UK, for example, notwithstanding the *Montgomery* ruling having been in force since 2015, and notwithstanding the GMC guidance that it mirrored having been operative for many years before that, clinical decision-making remains largely clinician-led, and in many situations largely doctor-led.[20] This raises the question as to why the participatory turn has succeeded in curating where shared decision-making has failed in the clinical domain (relatively speaking).

It is in answering this question that the range of exegetical literature in museum studies, noted above, comes into play. We do not have space to discuss this literature as a whole. Its potential, however, as a resource for deeper understanding of shared decision-making, and hence for readier implementation of person-centred care, is evident from the work of the North American philosopher of public art, Hilde Hein. Hein's (2006) work is distinctive in the extent to which she draws our attention to the agentic aspects of the participatory turn as reflected in the co-creative nature of its entailed aesthetic judgements. The relevance of this for person-centred care comes through clearly in her

account of the 'aesthetic object'. Thus, on Hein's (2006) account, objects in museum collections inspire new experiences through an open-ended dialogue. In this dialogue, the unified narratives of which the collections in question are part, are fluid and collaborative, drawing on the museum, the curators, and the visitors. Hein derives this co-creative understanding of curation from her concept of public art. This in turn is derived from her account of the role of public artists as integrally involving the responses of the public as active agents rather than as merely passive recipients of the objects themselves. She writes:

> *Today's public artists incline to replace answers with questions. They seek to advance debate and discussion. Their art is left open-ended and invites participation. Its orientation is toward process and change rather than material stability. Since its borders are indefinite, so is its authorship.*
>
> (Hein, 2006, 76)

Hein argues that all of these characteristics, and more, are to be found in new public art that can come to serve as a paradigm for the new (participatory) museum. The new museum's focus on affecting certain experiences in the visitor is typically presented as a challenge to the traditional model of the museum as public educator by virtue of its (alleged) capacity to illustrate established ideas and to demonstrate truths through displaying objects in its collections (Neufeld, 2008). Thus, just as the perspective of the patient is given greater prominence in person-values-centred care, so, in Hein's (2006) paradigm, is the perspective of the museum visitor given greater prominence in museum curation. This, in turn, carries with it a corresponding redefinition of the professional's role. Again, the parallel is very direct. In person-centred care, the role of the professional (whether a clinician or other health-care professional) ceases to be that of a mere conveyor of expertise and is redefined along the lines of being a partner in decision making. These two features of the model then come together in the move noted above towards *shared roles and partnership working* between user (visitor/patient) and professional (curator/health professional).

This aspect of the participatory turn takes us to the heart of its significance for person-centred care. First and foremost, it is inclusive. While acknowledging the shift to the user (visitor) perspective and redefinition of the professional's (curator's) role, the shift in both instances is not simply a shift from one dominant perspective to another but a shift to partnership in which neither voice has priority over the other. This 'no priority' view as we have indicated is central to the shared decision-making underpinning person-centred care.[21] The contrast between the no-priority view and the autonomy-driven medical ethics of the late twentieth century, noted in the introduction to this chapter, is worth emphasizing. Thus, the 'no priority' view stands over and against the familiar polarized subject/object dichotomies in integrating art and science, that, among other consequences, lie behind ethics of this kind.

One of the limitations of autonomy-driven medical ethics, as we indicated, was that it came to be read as substituting the traditional priority of the professional perspective for

that of the patient. Concerns about making autonomy a 'top value' were expressed at the time, for example by the theologian and philosopher, Alastair Campbell (1994). He was, we believe, right to be concerned. Patients may have felt, to repeat Patricia Alderson's powerful image of the patient from our introduction, doubly disenfranchised by the move to patient autonomy (in that it relied for its effectiveness on a professionalized medical ethics asserting patient autonomy on behalf of patients). But professionals felt disenfranchised too. This had unintended consequences. Instead of balancing contested values in clinical decision-making, autonomy-driven medical ethics became all too often a tick-box exercise with professionals 'following the rules' mechanically rather than engaging substantively with patient autonomy, and indeed other relevant values, in delivering best care. To repeat, the founders of medical ethics were among those warning of just these consequences[22]; and there were movements within ethics itself to counter them.[23] But the overall impact on health-care decision-making of simply substituting the priority of 'patient autonomy' for that of 'clinician beneficence', was that instead of tackling contested values head on, the contested values in question were either driven underground or simply ignored.

If all this is right, it brings with it clear implications of Hein's (2006) account for contemporary moves towards shared decision-making within person-centred care. First, as to practical implications, Hein's (2006) interpretation of the participatory turn shows the need for a 'no priority' view as an essential framework for shared clinical decision-making. Absent this, and it would not be surprising if clinicians, feeling disenfranchised by shared decision-making, as they had earlier felt disenfranchised by autonomy-driven medical ethics, resisted shared decision-making; or, at best, responded with the mechanical 'tick box' approach noted above, an approach aimed at satisfying GMC/Montgomery requirements, rather than at serving the ends of person-centred care. Several UK medical Royal Colleges, for example, responded to *Montgomery* either by ignoring it or by issuing guidelines to the effect that nothing much had changed beyond including all relevant risks.[24] This, they implied, would 'tick the *Montgomery* box'. Yet not only is this contrary to the dialogue and conversation required by *Montgomery*; it is expressly prohibited by the judgement.[25]

Second, among the theoretical implications of Hein's (2006) account for person-centred care, is a reframing of the nature of shared clinical decision-making itself. Given the power of evidence-based medicine, it is perhaps unsurprising that clinicians should assume shared decision-making to be, as clinician-led decision-making had so successfully been, a matter exclusively of science-based evidence. One form that this model of clinical decision-making has taken is what might be called 'outsourcing' clinical decision-making to the merely mechanical application of evidence-based guidelines. Hein's (2006) agentic account of the participatory turn suggests, to the contrary, that shared clinical decision-making, like the participatory turn, requires an agentic framework if it is to be applied successfully in practice. Combining this with the practical implication of Hein's (2006) and Bergqvist's (2016) 'no priority' account, the agency of patient and clinician alike is thus restored in the shared model of clinical decision-making underpinning person-centred care.

Attention to Strengths

The focus in the participatory turn on strengths, as well as on needs and difficulties, is a further feature of the participatory turn relevant to person-centred care. As in health care, it is perhaps natural that the focus in the participatory turn should be on presenting problems, such as the silencing of migrant voices in *The Silent University*. Yet even in that project the focus on strengths comes through clearly in the way that it takes as its point of departure for knowledge-exchange, the 'untapped potential' of its migrant participants (all of whom are professionally or academically qualified in their countries of origin). Attending to strengths as well as needs and difficulties is important across the board in health care[26] but especially so in mental health. This is because in mental health, attention to strengths is a key driver of recovery. This is defined in mental health as recovering a good quality of life as determined by the values of (by what matters or is important to) the individual concerned (Allott et al., 2002). The importance of strengths in this regard was reflected for example in the UK government programme on values-based mental health assessment noted earlier. The *3 Keys* programme, as it was called (National Institute for Mental Health in England (NIMHE) and the Care Services Improvement Partnership, 2008[27]), identified three shared 'keys' to good practice in mental health assessment, i.e., three things that were identified in a wide ranging consultation as being important alike by health professionals of all kinds and by service users (patients and carers). The third of these keys was defined in the subsequently published Good Practice Guidance, as 'a person-centred focus that builds on the *strengths, resiliencies and aspirations* of the individual service user as well as identifying his or her needs and challenges' (National Institute for Mental Health in England (NIMHE) and the Care Services Improvement Partnership, 2008, 6); and the guidance included a number of real-life case examples of best recovery practice reflecting this aspect of mental health care.[28]

Just as, therefore, *The Silent University* builds on the strengths of its participants as an intervention, so, in mental health, recovery builds on the strengths, resiliencies, and aspirations of the service users concerned. We find though an even more significant parallel here when we consider *The Silent University*, as we considered it above, as an example of Maria Lind's concept of 'curating in the expanded field' (Lind, 2019, 2020, 2021).

Recovery in the Expanded Field

Where Maria Lind's 'curating in the expanded field' took curation outside its normal range of operation, recovery takes mental health practice outside its normal therapeutic range. This was evident in the case studies published with the *3 Keys* good practice guidance. These showed that for many of those concerned, what mattered to them, what mattered for their quality of life, was not symptom reduction as such, but, say, housing, or employment, or finding a friendship group. In Lind's terms, then, we might say that recovery in person-centred mental health care, in so far as it builds on the strengths,

resiliencies, and aspirations of the person concerned, is 'recovery in the expanded field' (Lind, 2019, 2020, 2021).

There is perhaps more than merely a parallel here. Lind's interpretation is consistent with work in such areas as 'connective aesthetics' (Gablik, 1992) and 'social sculpture' (Sacks & Zumdick, 2013), indicating the power of aesthetics to broaden empathic understanding. As such, aesthetics, as Helena Fox has shown, could prove crucial to expanding the empathic engagement of health-care professionals, shifting us, as she has memorably put it, 'from anaesthetic to aesthetic'. This is important not least for mental health in providing additional resources for understanding and engaging with the more obscure values commonly involved (as in anorexia, in our example above). On a wider front, it has importance also for health-care training. Although emphasized in most models of person-centred care (Fulford, 2020), and widely included as a curriculum element, empathy has proven challenging as a training objective.[29] At the very least then, incorporating Lind's expanded field understanding of aesthetics into mental health training could help to remedy this. We return to the wider implications of incorporating aesthetics into health care in our conclusions.

Conclusion

In this chapter we have argued that several features of the participatory turn in curation make it a powerful model for deepening our understanding of contemporary person-centred clinical care. Drawing by way of example on Ahmet Öğüt's *The Silent University*, we noted the importance of partnership working and dialogue. These features, interpreted within the agentic account of the participatory turn developed by Hilde Hein, point to the importance of a similarly agentic approach to the shared decision-making underpinning person-centred care. Such an approach would recognize and build on the decisional agency of patient and clinician alike in coming to a shared decision, rather than the clinician seeking, as we put it, to 'outsource' decision-making to the mechanical application of generic guidelines, however comprehensively drawn. We then turned to a second feature of the participatory turn, attention to strengths, with particular relevance for person-centred care in mental health. Illuminated further by Maria Lind's concept of 'curating in the expanded field', recovery in mental health might, we said, be helpfully characterized as 'recovery in the expanded field'.

Clearly, there is more that could be said about the implications of the participatory turn for person-centred care. For a start there is a wealth of further philosophical exegesis. We have focused here on the agentic implications of Hilde Hein's work as a philosopher specifically of public art. But there are many other relevant philosophies. One of us, for example, working in analytic moral philosophy, has explored a range of relevant concepts, including, the relationality of values (Bergqvist, 2019), evaluative perception (Bergqvist, 2018b), the 'no priority' view (Bergqvist, 2016) and narrative understanding (Bergqvist, 2020). A particularly novel approach is the psychiatrist and

philosopher, Gerrit Glas' exploration of the normative implications for person-centred care of the neo-Calvinist philosophy of Herman Dooyeweerd (Glas, 2019). Then again, there are many other practical examples on which we might have drawn. Of particular relevance for mental health is the participatory turn as exemplified in heritage site management. A comparative study, for example, of two heritage sites, respectively in the UK and the United States (US),[30] showed, inter alia, the potential positive impact on visitor well-being of a historically multifaceted and diverse approach to interpretation and how this could improve specific facets of well-being such as visitor autonomy, racialized trauma, personal connections and belonging to a place, visitor inclusion and respect. The findings of this study reinforce the role of aesthetics in supporting positive practice in mental health (as reflected in our conclusions about 'recovery in the extended field'). Combined with a values-based analysis of racial inequalities in mental health (Fulford et al., 2020), the study also points to a further role for aesthetics in preventing bad practice.[31]

We opened this chapter with an image of aesthetics sitting, as we put it, 'somewhat uncomfortably' beside the rigorous empiricism on which the many successes of twentieth-century medical science had been built. Our conclusions point to a contrary image. As a role model, the participatory turn shows the importance of aesthetics as sitting not only in full comfort besides, but as an essential partner to, medical science, in delivering the shared clinical decision-making by which twenty-first-century person-centred clinical care is underpinned. One way of expressing this would be to say that in this regard aesthetics is integral to the role of values-based practice, characterized in the first section of the chapter, as 'linking science with people'. Another and perhaps more challenging way of expressing it would be to say that in this regard aesthetics is no less essential to clinical decision-making than science. So understood, then, clinical decision-making (at least of the shared kind that is integral to contemporary person-centred clinical care) is a matter equally of aesthetics as it is of science. Again, we do not have space to explore this idea in detail. But if it is right, it makes it even more surprising that aesthetics has to date been largely absent from health care: absent from its science, absent from its ethics, and, most surprisingly of all, absent from values-based practice. Our aim has been to show that with the model of the participatory turn before us, aesthetics need be absent from health care no more.

Acknowledgements

We are grateful to several colleagues and to the editors of this book for their helpful comments on earlier drafts of this chapter.

Notes

1. This term is sometimes rendered as 'patient-centred care'. We use the term 'person-centred care' in this chapter for two reasons. First, to the extent that it denotes the patient,

'person-centred care' emphasizes that 'the patient' is a person, that is a unique individual with (*inter alia*) unique individual values, including aesthetic values. Second, 'person-centred care' signals that clinicians and other team members are also persons whose values, although not central, are nonetheless material to health-care decision-making. Person-centred care, so understood, is of course different from, though also entirely compatible with, the medical scientific concept of 'personalized medicine'.

2. As the guiding idea behind values-based practice, this phrase served as the subtitle to Fulford, Peile, and Carroll's (2012) *Essential Values-based Practice*.
3. See, for example, paragraph 80 of *Montgomery* (Montgomery v Lanarkshire Health Board, 2015).
4. The GMC is the medical regulator for the UK as a whole. The guidance on consent at the time of Montgomery was actually subtitled '*Patients and doctors making decisions together*' (General Medical Council, 2008).
5. NICE, the National Institute for Health and Care Excellence, includes the following statement in the preface to all of its guidelines: '… When exercising their judgement, professionals and practitioners are expected to take this guideline fully into account, alongside the individual needs, preferences and values of their patients or the people using their service.' See, for example, National Institute for Health and Care Excellence (2015/2017).
6. Further information on values-based practice, including full text downloads of training materials, an extensive reading guide, and dedicated library resource, is given on site of the Collaborating Centre for Values-based practice at St Catherine's College.
7. Its early development in its present form derived in large part from epidemiology; see, for example, Sackett et al. (2000).
8. Anorexia is more common in women than in men.
9. In practice, the values in play, although indeed polarized, are a good deal more complex than we have presented them here; see Tan, Hope, and Stewart (2003).
10. See, for example, https://en.wikipedia.org/wiki/Pro-ana [last accessed 30 September 2024].
11. Our apologies to the many colleagues that we have not had space to mention, who have made and are continuing to make important contributions to the expanding field of phenomenology-informed values-based practice.
12. Musalek carried out this work as Director of the Anton-Prosch Clinic in Vienna, the largest clinic for addiction disorders in Europe.
13. See https://thesilentuniversity.org
14. Based in the heart of London, the Delfina Foundation is an independent, non-profit foundation dedicated to facilitating artistic exchange and developing creative practice through residencies, partnerships, and public programming; see delfinafoundation.com.
15. Part of East London's thriving artistic community, The Showroom describes itself as ' … commissioning and producing art and discourse; providing an engaging, collaborative programme that challenges what art can be and do for a wide range of audiences, including art professionals and our local community.' (See theshowroom.org)
16. See Tate.org.uk.
17. For example, Natascha Sadr Haghighian's installation *Fuel to the Fire* at Tensta Konsthall in 2016—see www.tenstakonsthall.se/uploads/177-2_EN_NATASCHA_161027.pdf.
18. Witness for example the Wandsworth Community Engagement Network (WCEN): the https://wcen.co.uk.

19. The ruling uses the word 'dialogue' at paragraph 90, for example, and 'discussion' at paragraphs 93 and 110.
20. There is a whole website devoted to encouraging doctors and other health professionals to find out from their patients what really matters to them as unique individuals. The site includes resources and several case studies. The message is that everyone wins when you ask, 'What matters to you?'. See www.whatmatterstoyou.scot [last accessed 30 September 2024].
21. As we have also indicated, it is the co-creative nature of shared decision-making that brings with it the challenge of contested values; for more on this, see Bergqvist (2020, 2022).
22. Besides Alastair Campbell, we would note for example, early editions of the foundational *Principles of Bio Medical Ethics*, by philosopher, Tom Beauchamp, and theologian, James Childress, in which they formulated ethical reasoning explicitly as balancing its eponymous four principles, two of which were clinician beneficence and patient autonomy (see, e.g., Beauchamp & Childress' third edition, 1989).
23. The practice skills programme in Oxford (see Hope, Fulford, & Yates, 1996), for example, and various forms of 'practical ethics' (e.g., Hébert, 2009; Foddy et al., 2013).
24. For example, even though the case was one of caesarean section, The Royal College of Obstetricians and Gynaecologists in the UK put out a statement saying that it had not felt it necessary to update its guidance on consent—their guidance on caesarean section provides a helpfully detailed list of what risks should be disclosed but is largely silent on the main elements emphasized in the judgement (such as the importance of dialogue)—they remain largely silent on Montgomery (although referring to General Medical Council Guidance and mentioning 'benefits' and 'meaningful discussion') in subsequently published (August 2022) guidance on Planned Caesarean Birth—see https://www.rcog.org.uk/media/33cnfvso/planned-caesarean-birth-consent-advice-no-14.pdf.
25. See, in particular, the conclusion of paragraph 90 of *Montgomery* '… The doctor's duty is not therefore fulfilled by bombarding the patient with technical information which she cannot reasonably be expected to grasp, let alone by routinely demanding her signature on a consent form.'
26. For an example, see the account of managing hypertension, in Fulford, Peile, and Carroll (2012, chapter 10).
27. A copy of the full report is available at https://valuesbasedpractice.org/more-about-vbp/full-text-downloads/
28. In identifying the importance of strengths for recovery, the 3 *Keys* programme was in line with other work on recovery practice; see, e.g., Slade et al. (2014).
29. Narrative medicine has been advocated as a possible remedy (Greenhalgh & Hurwitz, 1999). Improved empathic understanding is also supported by open-ended dialogue of the kind required by the Montgomery ruling as noted above (see also Bergqvist, 2020, 2022).
30. Chatsworth House (UK) and the Biltmore Estate (US).
31. The values-based analysis in question was a study of race equality in mental health coproduced by us in partnership with UK-based activists and writer, Colin King. Combined with this study, work on the participatory turn in heritage site management carries implications for reducing the risks of psychiatric abuse, i.e., of psychiatry being used not for therapeutic purposes but as a means of social or political control.

References

Alderson, P. (1990). *Choosing for children: Parents' consent to surgery.* Oxford University Press.

Alderson, P. (1994). *Children's consent to surgery.* Open University Press.

Allott, P., Loganathan, L., & Fulford, K. W. M. (2002). Discovering hope for recovery. *Canadian Journal of Community Mental Health 21* (2), 13–33. Special Issue *Innovation in Community Mental Health: International Perspectives.*

Beauchamp, T. L., & Childress, J. F. (1989). *Principles of biomedical ethics*, third edition. Oxford University Press.

Bergqvist, A. (2016). Framing effects in museum narratives: Objectivity in interpretation revisited. *Royal Institute of Philosophy Supplement 79*, 295–318.

Bergqvist, A. (2018a). Moral perception and relational self-cultivation: Reassessing attunement as a virtue. In S. Werkhoven & M. Dennis (Eds.), *Ethics and self-cultivation: Historical and contemporary perspectives* (pp. 197–221). Routledge.

Bergqvist, A. (2018b). Moral perception, thick concepts and perspectivalism. In A. Bergqvist & R. Cowan (Eds.), *Evaluative perception* (pp. 258–281). Oxford University Press.

Bergqvist, A. (2019). Companions in love: Attunement in the condition of moral realism. In R. Rowland & C. Cowie (Eds.), *Companions in guilt arguments in metaethics* (pp. 197–221). Routledge.

Bergqvist, A. (2020). Narrative understanding, value, and diagnosis: A particularist account of clinical formulations and shared decision-making in mental health. *Philosophy, Psychiatry & Psychology 27* (2), 149–167.

Bergqvist, A. (2022). Psychiatric ethics. In S. Caprioglio Panizza & M. Hopwood (Eds.), *Murdoch in mind* (pp. 479–492). Routledge.

Campbell, A. V. (1994). Dependence: The foundational value in medical ethics. In K. W. M. Fulford, G. Gillett, & J. Soskice (Eds.), *Medicine and moral reasoning* (pp. 184–192). Cambridge University Press.

Care Services Improvement Partnership (CSIP) and the National Institute for Mental Health in England (NIMHE) (2008). *Workbook to Support Implementation of the Mental Health Act 1983 as Amended by the Mental Health Act 2007.*

Charon, R. (2006). *Narrative medicine: Honouring the stories of illness.* Oxford University Press.

Charon, R. (2017). *Principles and practice of narrative medicine.* Oxford University Press.

Dowie, J., Pell, I., Clarke, A., Kennedy, A., & Bhavnani, V. (2002). Development and preliminary evaluation of a clinical guidance programme for the decision about prophylactic oophorectomy for women undergoing a hysterectomy. *Quality and Safety in Health Care 11*, 32–39.

Eaton, G., & Paige, M. (2019). Values: What are they worth? *Paramedicine 42*, 18–19.

Foddy, B., Kahane G., & Savulescu, J. (2013). Practical neuropsychiatric ethics. In K. W. M. Fulford, M. Davies, R. Gipps, G. Graham, J. Sadler, G. Stanghellini, & T. Thornton (Eds.), *The Oxford handbook of philosophy and psychiatry* (pp. 1185–1201). Oxford University Press.

Fulford, K. W. M. (1989) [reprinted 1995 and 1999]. *Moral theory and medical practice.* Cambridge University Press.

Fulford, K. W. M. (1990). Philosophy and medicine: The Oxford connection. *British Journal of Psychiatry 157*, 111–115.

Fulford, K. W. M. (2004). Ten principles of values-based medicine. In J. Radden (Ed.), *The philosophy of psychiatry: A companion* (pp. 205–234). Oxford University Press.

Fulford, K. W. M. (2020). Groundwork for a metaphysic of person-centred care: A contribution from ordinary language philosophy. *European Journal for Person Centered Healthcare 8* (1), 58–69.

Fulford, K. W. M., Dewey, S., & King, M. (2015b). Values-based involuntary seclusion and treatment: Value pluralism and the UK's Mental Health Act 2007. In J. Z. Sadler, W. van Staden, & K. W. M. Fulford (Eds.), *The Oxford handbook of psychiatric ethics* (pp. 839–860). Oxford University Press.

Fulford, K. W. M., Duhig, L., Hankin, J., Hicks, J., & Keeble, J. (2015a). Values-based assessment in mental health: The 3 keys to a shared approach between service users and service providers. In J. Z. Sadler, W. van Staden, & K. W. M. Fulford (Eds.), *The Oxford handbook of psychiatric ethics* (pp. 1069–1090). Oxford University Press.

Fulford, K. W. M., King, C., & Bergqvist, A. (2020). Hall of mirrors: Toward an open society of mental health stakeholders in safeguarding against psychiatric abuse. *Eidos: A Journal for Philosophy of Culture 2*, 23–38.

Fulford, K. W. M., Newton-Hughes, A., Strudwick, R., & Handa, A. (2018). Values-based practice for imaging and therapy professionals: An introduction. *Imaging and Oncology*, 26–33. https://www.sor.org/learning-advice/professional-body-guidance-and-publications/documents-and-publications/imaging-and-oncology/imaging-oncology-2018-(4-1mb)

Fulford, K. W. M., Peile, E., & Carroll, H. (2012). *Essential values-based practice: Clinical stories linking science with people.* Cambridge University Press.

Fulford, K. W. M., & van Staden, W. (2013). Values-based practice: Topsy-turvy take home messages from ordinary language philosophy (and a few next steps). In K. W. M. Fulford, M. Davies, R. Gipps, G. Graham, J. Sadler, G. Stanghellini, & T. Thornton (Eds.), *The Oxford handbook of philosophy and psychiatry* (pp. 385–412). Oxford University Press.

Gablik, S. (1992). Connective aesthetics. *American Art 6* (2), 2–7.

General Medical Council. (2008). *Consent: Patients and doctors making decisions together.* The General Medical Council.

Glas, G. (2019). *Person-centred care in psychiatry: S-relational, contextual and normative perspectives.* Routledge.

Greenhalgh, T., & Hurwitz, B. (1999). Why study narrative? *British Medical Journal 318* (7175), 48–50.

Handa, I. A., Fulford-Smith, L., Barber, Z. E., Dobbs, T. D., Fulford, K. W. M., & Peile, E. (2016). The importance of seeing things from someone else's point of view. *BMJ Careers*; also published in hard copy as 'Learning to Talk about Values' at: http://careers.bmj.com/careers/advice/The_importance_of_seeing_things_from_someone_else's_point_of_view [last accessed 19 May 2023].

Hébert, P. (2009). *Doing right: A practical guide to ethics for medical trainees and physicians*, second edition. Oxford University Press.

Hein, H. (2006). *Public art: Thinking museums differently.* Rowman and Littlefield.

Herring, J., Fulford, K. W. M., Dunn, D., & Handa, A. (2017). Elbow room for best practice? Montgomery, patients' values, and balanced decision-making in person-centred care. *Medical Law Review 25* (4), 582–603.

Hilton, S. R., & Slotnick, H. B. (2005). Proto-professionalism: How professionalisation occurs across the continuum of medical education. *Medical Education 39* (1), 58–65.

Hope, T., Fulford, K. W. M., & Yates, A. (1996). *The Oxford practice skills course: Ethics, law and communication skills in health care education.* Oxford University Press.

Lind, M. (2019). *Seven years: The Rematerilization of art from 2011 to 2017.* Sternberg Press.

Lind, M. (2020). *Selected Maria Lind writing*. Sternberg Press.

Lind, M. (2021). *Tensta museum: Reports from New Sweden*. Sternberg Press.

Messas, G., & Fulford, K. W. M. (2021). A values-based phenomenology for substance use disorder: A new approach for clinical decision-making. *[Uma fenomenologia baseada em valores nos transtornos por uso de substâncias: uma nova abordagem para a tomada de decisão clínica]*. Estudos de Psicologia (Campinas) 38, 1–11. https://doi.org/10.1590/1982-0275202138 e200102

Messas, G., & Soares, M. J. (2021). Alcohol use disorder in a culture that normalizes the consumption of alcoholic beverages: The conflicts for decision-making. In D. Stoyanov, G. Stanghellini, W. van Staden, M. T. Wong, & K. W. M. Fulford (Eds.), *International perspectives in values-based mental health practice: Case studies and commentaries* (pp. 163–170). Springer Nature.

Montgomery v Lanarkshire Health Board (judgement delivered 11 March, 2015): available at: www.supremecourt.uk/cases/uksc-2013-0136.html [last accessed 30 September 2024].

Musalek, M. (2017a). *Der Wille zum Schönen I. Als alles bestimmende Naturkraft*. Berlin.

Musalek, M. (2017b). *Der Wille zum Schönen II. Als Kulturgeschehen auf dem Weg zur Kosmopoesie*. Berlin.

National Institute for Health and Care Excellence (2015/2017). *Suspected cancer: Recognition and referral: NICE guideline NG12*. Department of Health. Published June 2015. Last updated July 2017.

National Institute for Mental Health in England (NIMHE) and the Care Services Improvement Partnership (2008). *3 Keys to a Shared Approach in Mental Health Assessment*. Department of Health.

Neufeld, J. (2008). Review of Hilde Hein, public art: Thinking museums differently'. *Journal of Aesthetics and Art Criticism* 66 (1), 102–105.

Sackett, D. L., Straus, S. E., Scott Richardson, W., Rosenberg, W., & Haynes, R. B. (2000). *Evidence-based medicine: How to practice and teach EBM*, second edition. Churchill Livingstone.

Sacks, S., & Zumdick, W. (2013). *ATLAS of the poetic continent: Pathways to ecological citizenship*. Temple Lodge.

Slade, M., Amering, M., Farkas, M., Hamilton, B., O'Hagan, M., Panther, G., Perkins, R., Shepherd, G., Tse, S., and Whitley, R. (2014). Uses and abuses of recovery: Implementing recovery-oriented practices in mental health systems. *World Psychiatry* 13, 12–20.

Stanghellini, G. (2019). The PHD Method for psychotherapy: Integrating phenomenology, hermeneutics, and psychodynamics. *Psychopathology* 52 (2), 75–84.

Stanghellini, G., Castellini, G., Brogna, P., Faravelli, C., & Ricca, V. (2012). Identity and Eating Disorders (IDEA): A questionnaire evaluating identity and embodiment in eating disorder patients. *Psychopathology* 45 (3), 147–158.

Stanghellini, G., & Mancini, M. (2017). *The therapeutic interview in mental health - a values-based and person-centered approach*. Cambridge University Press.

Tan, J. O. A., Hope, T., & Stewart, A. (2003). Anorexia nervosa and personal identity: The accounts of patients and their parents. *International Journal of Law and Psychiatry* 26, 533–548.

Ujewe, S., & Van Staden, W. (2021). Policy-making indabas to prevent 'not listening': An added recommendation from the Life Esidimeni tragedy. In D. Stoyanov, G. Stanghellini, W. van Staden, M. T. Wong, & K. W. M. Fulford (Eds.), *International perspectives in values-based mental health practice: Case studies and commentaries* (pp. 257–262). Springer Nature.

Van Staden, W. (2021). 'Thinking too much': A clash of legitimate values in clinical practice calls for an indaba guided by African values-based practice. In D. Stoyanov, G. Stanghellini, W. van Staden, M. T. Wong, & K. W. M. Fulford (Eds.), *International perspectives in values-based mental health practice: Case studies and commentaries* (pp. 179–187). Springer Nature.

Williams, A. (1995). Economics, QALYs and medical ethics: A health economists perspective. *Health Care Analysis 3* (3), 221–226.

Woodbridge, K., & Fulford, K. W. M. (2004). *Whose values? A workbook for values-based practice in mental health care.* The Sainsbury Centre for Mental Health.

CHAPTER 3

POSITIVE PSYCHIATRY AND MENTAL HEALTH

MERYAM SCHOULER-OCAK

Introduction

TRADITIONALLY, psychiatry deals with the diagnosis, prevention, and treatment of mental disorders, which include various maladaptation's related to mood, behaviour, cognition, and perception (Wikipedia). Psychiatric practice and research focus on understanding the causes of mental illnesses, developing and using safe and effective treatments, as well as reducing associated suffering and disability (Jeste, 2018). According to the World Health Organization, health is defined as not an absence of disease or infirmity, but a state of complete physical, mental, and social well-being (WHO Constitution, 1948). As a growing body of research indicates, factors like resilience, optimism, and social engagement are associated with objectively measured better health outcomes including greater longevity as well as subjective well-being (Rasmussen et al., 2009). Vaillant (2012) describes seven concepts of positive mental health: effective functioning, strength of character, maturity, positive emotional balance, socio-emotional intelligence, life satisfaction (true happiness), and resilience. Vaillant's study of positive mental health requires safeguards. He underlines that mental health must be broadly defined in terms that are culturally sensitive and inclusive (Vaillant, 2012). Furthermore, empirically and longitudinally validated criteria for mental health are required. Vaillant (2012) also emphasizes that mental health is one of the most important values of humanity and that efforts to achieve positive mental health, while respecting individual autonomy, should be made at all costs.

Positive Psychiatry—What Is It?

Jeste et al. (2015) used the definition that positive psychiatry represents science and practice which focus to understand and promote well-being using assessment and

interventions with the aim to improve behavioural and mental wellness. The main factor of positive psychiatry is that it brings together positive mental health outcomes and positive psychosocial characteristics like resilience and social support. The key point is to improve well-being, which can be optimized through an increase in positive psychosocial characteristics such as resilience and social support. Positive psychiatry is part of the medicine, which promotes health and well-being through interventions based on psychosocial/behavioural and biological factors (Timmerby et al., 2016). Positive psychiatry is an approach analogous to psychodynamic or biological psychiatry and transcultural psychiatry. It's definition includes no limitation to specific disorders (mental illnesses). In traditional psychiatry the treatment goal is symptom relief and relapse prevention whereas in positive psychiatry the focus is upon recovery, increased well-being, as well as posttraumatic growth and successful aging. Furthermore, the main treatment approaches in traditional psychiatry utilize medications and generally, short-term psychotherapies for symptom relief and relapse prevention. Jeste et al. (2015) underlined that the focus on prevention is also different. While in traditional psychiatry it is mostly ignored, in positive psychiatry it is very important across the whole lifespan.

Furthermore, positive psychiatry supports a shift towards a new paradigm of promoting prevention in general and mental health. The focus is more on the clinical practice of well-being, personal growth, and the reduction of perceived stress. Its main concept is based on certain psychobiological traits, mainly resilience, optimism, and coping strategies, and additionally, environmental factors, such as social support and access to medical and psychological care (Jeste et al., 2015). Patients' personal skills and social environment play an important role in their individual functioning. The family environment can be protective or be a risk factor, depending on family dynamics. For example, in those suffering from a mood disorder, worse psychosocial functioning was associated with higher rates of conflict. Obviously, family environment dynamics might have an impact on individual functioning, and this might have important implications for early intervention programmes, in which not only patients but also their caregivers should be addressed (Verdolini & Vieta, 2021).

History of Positive Psychiatry

William James, a physician and psychologist, developed the concept of a new approach to study and apply psychological principles underlying the success of the so-called 'mind-cure'. This was in 1906. His concept referred to the purported healing powers of positive emotions and beliefs (Pawelski, 2003). This concept was ignored for many years, until Seligman and colleagues in the late 1990s focused on positive psychology. Seligman defined this as 'a reoriented science that emphasizes the understanding and building of the most positive qualities of an individual: optimism, courage, work ethic, future-mindedness, interpersonal skills, capacity for pleasure and insight, and social responsibility (Seligman, 1999). Since then, positive psychology developed to a global movement and the International Positive Psychology Association was founded. Positive

psychology and positive psychiatry partially overlap in their concepts and goals but both have their unique training background and skills.

Meanwhile, a formal section on Positive Psychiatry in the World Psychiatric Association and a Caucus on Positive Psychiatry in the American Psychiatric Association have been established. More and more symposia have been realized in national and international conferences. Moreover, publications on positive psychiatry are increasing (e.g., Jeste & Palmer, 2015; Summers & Jeste, 2018).

Positive Psychiatry Interventions

Jeste and Palmer (2015) highlighted that studies of interventions aiming to promote health and well-being in individual patients with mental illnesses have demonstrated promising findings. Intervention in patients with schizophrenia involved exercises to pursue a meaningful goal, reflection on their own strengths, daily savouring of positive experiences, and brief mindfulness meditation; this intervention was able to improve well-being, hope, self-esteem, and levels of psychopathology after treatment and at a follow-up after three months(Meyer et al., 2012). Granholm et al. (2013) used a manualized intervention for schizophrenia, focusing on cognitive behavioral social skills training (CBSST), with the aim to challenge thoughts and misinterpretations of experiences as well as to keep track of personally meaningful goals. Interestingly, the authors found that this intervention could improve cognitive insight, objectivity in reappraisal of psychotic symptoms, self-esteem, and life satisfaction. Moreover, it could reduce amotivation, anxiety, and depression. Other studies focused on interventions in which resilience, stress reduction, and compassion in people with or without mental illnesses were the targets (Creswell et al., 2012; Adler et al., 2015). Kelly and Carter (2015) used a randomized controlled trial (RCT) in patients with binge eating disorder, in which a three-week self-compassion training and food planning intervention could significantly improve self-compassion and eating disorder pathology in comparison to controls. Daniels et al. (2015) used structured questionnaires in older veterans with PTSD to conduct a life review therapy, which could increase self-assessed wisdom significantly and reduce depressive symptoms. More research on positive psychiatry is needed as there are only a few studies on this so far.

Positive Organizational Behaviour and Psychological Capital

Over the past twenty years, a new paradigmatic perspective of human and organizational behaviour has developed, represented by the fields of Positive Psychology and

positive organizational behaviour, which is defined as 'the study and application of positively oriented employee strengths and psychological skills that can be measured and contribute to improved performance in the workplace' (Luthans, 2002, p. 698).

For the positive organizational behaviour, three specific criteria were discussed. These were (1) theory—and research-based and validly measurable, (2) related to performance improvement, and (3) state-oriented and thus open to learning, development, change and management (Luthans, 2002). Positive organizational behaviour includes positive constructs which are science-based and state-oriented and can thus be developed through brief, targeted, evidence-based, and scientifically validated training interventions.

Psychological capital consists of the four well-known constructs of: (1) Hope, (2) Efficacy, (3) Resilience, and (4) Optimism (Luthans, 2002; Broad & Luthans, 2020).

Hope

Hope has a long theoretical and empirical history in psychology and, as an important component, largely fulfils the inclusion criteria for a psychological capital. Hope is primarily based on the theoretical and scientific work of Snyder et al. (1991). According to Snyder et al. (1991), hope is defined as a positive motivational state based on an interactively derived sense of successful (1) agency (goal-directed energy) and (2) ways (planning to achieve goals). Individuals who have hope tend to be good at setting goals, identifying multiple paths or 'steps' on their goal path. They have the ability to reset their goals when they encounter obstacles and adversity. Individuals with high levels of hope are also resourceful; they look to others for support and ideas to find additional paths to their goal, while optimizing their resources by using their strengths along the way (Broad & Luthans, 2020).

Personal Mastery and Coping Self-Efficacy

According to Spencer and Patrick (2009), personal mastery is defined as the degree to which a person believes in and controls forces and events that affect that person's life, as well as personal expectations of being able to achieve desired outcomes. It is an important protective factor against the negative effects of stress and illness (Mausbach et al., 2007). The related term self-efficacy coping refers to the assessed ability to respond to challenging, demanding, or threatening situations or events by using specific coping strategies (Benight & Harper, 2002).

Self-efficacy refers to one's confidence and belief based upon Bandura's (1977) considerable theory and research. Self-efficacy means having the inner conviction that one person can cope well with difficult or challenging situations—and that this person can do so out of his/her own strength. According to Stangl (2022), self-efficacy is the concept of general self-efficacy with the expectation that one asks about the personal assessment of

one's own competencies to cope with difficulties and barriers in daily life. This conviction regarding one's own abilities determines how people feel, think, motivate themselves and act in a concrete situation; it therefore influences perception and performance in the most diverse ways. Thus, self-efficacy refers to the conviction that one is capable of learning something or performing a certain task, for example. Studies show that people who believe in their own strength are more persistent in accomplishing tasks, and develop a lower risk of anxiety disorders (Stangl, 2022). Stajkovic and Luthans (1998) demonstrated in a meta-analysis a strong relationship between efficacy and performance, and provided clear guidelines on how it can be developed. They found that individuals with high self-efficacy have a general belief in their ability to achieve their goals and that they draw on domain-specific experiences when faced with unique, complex challenges.

Resilience

Resilience is the ability to recover from or adapt successfully to illness, stress, or other adverse events as well as to facilitate coping strategies such as positive reappraisal of adverse events. It is defined as the ability to bounce back from adversity or even dramatic positive change (Masten, 2001). Moreover, it is goal-directed problem-focused coping and development of positive meaning (Eglit et al., 2018). Furthermore, resilience refers to the ability to cope with whatever life throws at you. Some people are knocked down by challenges, but they return as a stronger person more steadfast than before. Coutu (2002) describes people with resilience as having an unwavering acceptance of reality, a deep conviction, often supported by strongly held values, that life is meaningful, and an uncanny ability to improvise and adapt to significant change. Resilience includes having a good support system, maintaining positive relationships, having a good self-image and having a positive attitude. Moreover, it is very important to have the capacity to make realistic plans.

The resources of resilience can also be classified according to the biopsychosocial model: *biological* (physical exercise, understanding the body, relaxation, treatment of medical illnesses), *psychological* (positive emotions and humour, acceptance, cognitive flexibility, empowering self-esteem, active coping), *social* (social relatedness, reconnecting the family, creating and enhancing social support) (Dantzer et al., 2018; Eglit et al., 2018). Building resilience is essential to achieving flexibility and adaptability. People with high resilience can deal with emotional stress following adversity and therefore bounce back more quickly when they encounter obstacles. This ability to bounce back increases the type of goals individuals set for themselves (hope), as well as overall confidence. Individuals with high resilience also have more confidence in their ability to deal with challenges, adversity, and stressors.

Optimism

Optimism is a view of life in which the world or a thing is seen from the best side. The term generally designates a cheerful, confident, and life-affirming basic attitude

as well as a confident attitude determined by positive expectations in the face of something regarding the future. Furthermore, optimism denotes a philosophical view that the world is the best of all possible worlds, in which everything is good and reasonable or will develop for the better (https://de.wikipedia.org/wiki/Optimismus). According to Seligman (2002), optimists interpret bad events as only temporary, while pessimists interpret bad events as permanent. These attributions touch on two crucial dimensions of optimism: permanence and pervasiveness. Optimists tend to make permanent attributions, while pessimists tend to make temporary attributions. Carver and Scheier (1999) reported that optimism has been consistently associated with better psychological adjustment and self-reported physical health in response to diverse life transitions including entering college, pregnancy, cardiac surgery, and caregiving. However, in different studies the outcomes were less clear regarding the role of optimism as a resilience factor in the face of stressful events (Segerstrom, 2005). Segerstrom (2005) and Cohen et al. (2012) found that studies of optimism as a potential buffer to the effects of stressors on immune function showed mixed outcomes. The existing literature is insufficient in either number of studies or consistency in results to establish optimism as a buffer to the effects of stressors on immunity and physical disease outcomes (Segerstrom, 2005).

Moreover, optimism affects how people perceive stress and, perhaps more importantly for psychiatry, how they cope with stress. Optimism also determines how people solve problems when faced with complexity, adversity, and obstacles. Optimists tend to adopt a coping approach that is most adaptive and least dysfunctional in many life situations. Furthermore, this optimistic coping strategy affects the level of hope, demonstrating the interactive, synergistic nature of the psychological capacity (Broad & Luthans, 2020).

Measures of Positive Psychiatry Outcomes

Well-Being

Leamy et al. (2011) describe well-being as a central component in positive psychiatry and emphasize the experience of meaning and self-actualization, rather than positive emotions and joy actualization. In the process of personal recovery, core features are the promotion of well-being and support in building hope as well as optimism. Positive psychiatry and personal recovery focus on positive attributes and strengths, which is very different to the pessimistic concepts of mental illnesses. In the case of schizophrenia, longitudinal clinical and epidemiology studies challenged the widely adopted notion that persons with mental illnesses could not get better (Thomas et al., 2018; Harrison et al., 2001; Harding & Hall, 1997). Stories of recovery in persons with life experience of mental illness were shared and brought attention to an alternative

to the dementia praecox 'story'. Moreover, through qualitative research, subjectivity and a broad range of experiences could be explored, rather than focusing narrowly on symptoms. As a consequence of these reports, the notion of clinical recovery changed. The focus shifted and 'symptom reduction' was now not the only desirable outcome (Leamy et al., 2011; Bejerholm & Roe, 2018). These developments were important to enrich and understand personal recovery. Thus, recognition grew that traditional mental health services seldom provided hope or supported personal goals, and mostly promoted dependence and fostered stigma (Bellack & Drapalski, 2012). Along with these publications, the vision of personal recovery was improved.

Huppert (2009) defined well-being as the combination of feeling good and functioning well, alongside the experience of positive emotions such as happiness and contentment. Additionally, the definition included the development of one's potential, having some control over one's life, having a sense of purpose, and experiencing positive relationships.

Flourishing

Flourishing is defined as the ability for a person to grow as a human being through good times and through life struggles (Huppert & So, 2011). It is also defined as a descriptor and measure of positive mental health and overall life well-being. According to Van der Weele (2017), flourishing involves the following five broad domains: (1) happiness and life satisfaction; (2) health, both mental and physical; (3) meaning and purpose; (4) character and virtue; and (5) close social relationships.

Low Level of Perceived Stress

Perceived stress plays an important role in reduction of well-being and is a risk factor for mental disorders. It refers to the extent to which an individual perceives that current demands or challenges exceed his/her ability to cope with them. There is evidence that an individual's perception of stress is a stronger predictor of health-related outcomes than the objective demands of a situation (Cohen et al., 1983). Results of a study done by Dhingra and Dhingra (2020) indicate that high levels of perceived stress lead to a feeling of low psychological well-being. Additionally, if subjective happiness is low, psychological well-being was found to be low among health care workers during COVID-19. The perception of stress affecting health may impact health outcomes differently than the amount or the severity of stress. Whereas appraisals of personal risk often lead to the initiation of coping mechanisms, a heightened perception of risk has been associated with increased psychological distress (Schwartz et al., 1995) and may be related to other adverse health outcomes.

Successful Psychosocial Aging

Older adults want to improve the subjective psychosocial aspects of aging, which include adapting to losses and limitations as well as maintaining social contacts and fostering self-growth etc. (Montross et al., 2006). Older adults would like to see themselves as aging successfully despite having chronic physical illnesses and disability. According to Montross et al. (2006), studies of the reliability and validity of subjective ratings of successful aging are needed.

Post-Traumatic Growth

Traumatic life events are stressful events that can lead to the development of post-traumatic stress disorder (PTSD) or post-traumatic growth. Positive change in an individual's perception of self involves increased self-efficacy, self-esteem, confidence in oneself, and an overall sense that one is a good person. Specifically, individuals may accept that an adverse event has occurred and view their subsequent response as an opportunity to readjust their priorities, reevaluate people in their lives, and improve their life circumstances (Harmon & Venta, 2021).

Social Engagement and Social Support

Social engagement refers to the quality and quantity of one's social network. Key aspects include the frequency of social contacts, the intimacy or closeness experienced in these contacts, and the enjoyment of social interactions.

Social support involves the extent to which other people are available for emotional and physical support. Social support includes the resources provided to a person by their social network. It comes in a variety of forms, including instrumental (e.g., provision of transport or money), informational (e.g., advice or guidance), and emotional (e.g., expressions of empathy and reassurance) support, which can come from a variety of sources such as friends, family, and work colleagues (Cohen, 2004). Meta-analytic results show that social support is negatively associated with symptoms of several mental disorders, including depression (Santini et al., 2015) and PTSD (Brewin et al., 2000). In addition, researchers have shown that perceived social support, i.e., the subjective feeling of being supported by others, is more strongly associated with positive mental health outcomes than received (i.e., actual) social support (Thoits, 2011). In both cross-sectional and longitudinal studies, higher levels of social support are associated with better mental health outcomes, suggesting that high levels of social support are a potential protective factor for mental health (Prati & Pietrantoni, 2010). Research showing that perceived social support is an important protective factor in maintaining

mental health highlights the potential role of social support as a target for mental health interventions among at-risk groups (Vig et al., 2020).

Spirituality and Religiosity

Spirituality can be described as the way in which a person's beliefs, attitudes, and behaviours reflect an orientation towards transcendent themes such as belief in a higher power, the meaning of life, and the level of consciousness (Eglit et al., 2018). Religiosity refers to a person's participation in organized religious practices and is thus a social phenomenon rather than the more internalized construct of spirituality. Studies show that religion and spirituality can promote mental health through positive religious coping, community and support, and positive beliefs (Weber & Pargament, 2014). Research also reports that religion and spirituality can harm mental health through negative religious coping, misunderstanding and miscommunication, and negative beliefs. Tools to assess patients' spiritual needs have been explored and incorporating spiritual issues into treatment has shown promise (Weber & Pargament, 2014).

Positive Environmental Factors and Family Dynamics

According to Eglit et al. (2018), positive environmental factors also promote health and well-being. They underline that the most important factors are family dynamics and social support. Family dynamics refer to the nature of interpersonal relationships between family members, including mutual expectations and individual cognitions, emotions, and behaviours. Considerable literature on the impact of family dynamics and support on symptom severity, treatment response, and possibility of recovery for a number of neuropsychiatric and physical disorders has been published (Repetti et al., 2002). High-risk families are characterized by conflict and aggression, and cold, unsupportive, and neglectful relationships. These family characteristics create vulnerabilities and/or interact with genetically determined vulnerabilities in the offspring that lead to disruptions in psychosocial functioning (especially emotion processing and social competence), disruptions in stress-responsive biological regulatory systems, and poor health behaviours, especially substance abuse. This integrated biological behavioural profile leads to increased risk of mental disorders, severe chronic diseases, and early mortality (Repetti et al., 2002).

The family environment, the first environment with which the individual comes into contact, can therefore act as a protective or a risk factor, depending on family dynamics. Verdolini et al. (2021) reported that two years after a first psychotic episode, poorer psychosocial functioning in psychotic patients was found to be associated with a lower proportion of active-recreational and achievement-oriented family environments.

Moreover, the authors found a higher proportion of moral-religious emphasis and control in the family. Worse functioning was associated with higher rates of conflict in the family. Similarly, poorer psychosocial functioning in patients with affective disorders was associated with higher rates of conflict. This could have important implications for early intervention programmes that should involve not only patients but also their caregivers (Verdolini et al., 2021).

Positive Psychiatry and Mental or Physical Illness

Several recent studies have shown that the presence of positive psychosocial factors and outcomes has been underestimated in people with severe mental illness. People with bipolar disorder have been found to have relatively high levels of resilience, spirituality, and empathy (Galvez et al., 2011). People with first-episode psychosis have been found to have feelings of happiness and life satisfaction comparable to people without psychiatric illness (Agid et al., 2012). There are studies in which patients with chronic schizophrenia have been found to have a wide range of happiness and life satisfaction (Fervaha et al., 2016). The authors highlighted that higher levels of happiness and life satisfaction in people with schizophrenia were associated with greater optimism and personal coping, and lower levels of perceived stress, depression, and amotivation (Fervaha et al., 2016). Edmonds et al. (2018) found that these positive traits were also associated with healthier levels of biomarkers of inflammation and insulin resistance.

Regarding physical illness, Rasmussen et al. (2009) reported that higher levels of optimism are associated with better outcomes in cardiovascular health, cancer, pregnancy, pain, and longevity, in part due to better immune function, as well as greater engagement in physical activity and healthier dietary patterns (Giltay et al., 2007). Everson-Rose and Lewis (2005) pointed out that social engagement is associated with lower risk of cardiovascular disease, healthier biomarkers of immune function and inflammation. According to Holt-Lunstad et al. (2010) social engagement results in longer life expectancy. Furthermore, Uchino (2006) reported that higher levels of social support are associated with lower prevalence and severity of depression, anxiety, substance use disorders, and hypertension, as well as cardiovascular disease and higher life expectancy. Thus, positive psychosocial factors can improve the well-being and health of people with mental or physical illness and can be useful intervention targets. Clearly, these factors are much more significant than previously assumed. Therefore, they should be taken into account much more in interventions.

Training in Positive Psychiatry

According to Jeste et al. (2015), to uphold the principles of positive psychiatry, it is essential that they should be explicitly taught and exemplified at every stage of medical training and education. Psychiatrists must be encouraged to recognize that their required knowledge base extends far beyond the realm of mental illness to encompass the entire spectrum of health, including mental health. Such a view implies, for example, that understanding depression is incomplete without additional knowledge about happiness. Another example is that knowledge about trauma and abuse in children is incomplete without also knowing the elements of positive and growth-promoting parenting. Therefore, positive psychiatry must be an integral part of every trainee's didactic and clinical learning experiences. In addition to initiatives such as new didactic courses, intensive efforts must be made to incorporate these principles into existing educational trainings and reinforce them during intervision and supervision (Rettew et al., 2014). Written treatment plans in assessment and progress reports should teach trainees to include aspects of positive psychiatry, which could be a separate category to be dealt with (Jeste et al., 2015).

Conclusion

Positive psychiatry expands the scope of traditional psychiatry by focusing on promoting the positive psychosocial attributes of individuals to foster their recovery, e.g., well-being and growth. These positive factors have historically received too little attention in people with mental illness or at risk of such illness. Positive psychiatry is a promising area to improve the current understanding of mental health and well-being and to use it therapeutically. Key to such progress and application in clinical practice is the development of psychometrically robust measures of positive psychosocial factors and outcomes (Eglit et al., 2018). Interventions based on positive psychiatry concepts should be improved and made available to different target groups at all levels of prevention. Positive psychiatry can open new avenues for treatment strategies that go beyond the traditional psychiatric approach (Jeste et al., 2015). When applied to the general population, these interventions can promote good mental health and avoid or reduce 'medicalization'. In addition, for those at higher risk of developing a psychiatric disorder, the onset of illness can be prevented or mitigated. Finally, patients in both the early and late stages of disease can benefit from these interventions, as they can reduce disabling symptoms, improve psychosocial functioning, and make patients feel in control of their own lives, thereby avoiding stigma, increasing awareness, and improving quality of life (Verdolini & Vieta, 2021). According to the authors, it is indeed time to bring positive psychiatry and precision psychiatry together. Jeste et al. (2015) highlighted that

positive psychological characteristics such as resilience, optimism, and social engagement have been reported to be associated with better health outcomes. The authors also reported that they are rarely addressed in psychiatric practice, training, journals, or other publications. Furthermore, the authors underlined the special significance of the assessment of positive psychological characteristics. The use of interventions to enhance positive psychological characteristics in patients with mental or physical illnesses should become part of routine clinical practice, education, and research (Jeste et al., 2015).

References

Adler, A. B., Williams, J., McGurk, D., Moss, A., & Bliese, P. D. (2015). Resilience training with soldiers during basic combat training: Randomisation by platoon. *Applied Psychology: Health and Well Being 7* (1), 85–107.

Agid, O., McDonald, K., Siu, C., Tsoutsoulas, C., Wass, C., Zipursky, R. B., Foussias, G., & Remington, G. (2012). Happiness in first-episode schizophrenia. *Schizophrenia Research 141* (1), 98–103.

Bandura, A. (1977). Self-efficacy: Toward a unifying theory of behavioral change. *Psychological Review 84*, 191–215.

Bejerholm, U., & Roe, D. (2018). Personal recovery within positive psychiatry. *Nordic Journal of Psychiatry 72* (6), 420–430.

Bellack, A., & Drapalski, A. (2012). Issues and developments on the consumer recovery construct. *World Psychiatry 11*, 156–160.

Benight, C. C., & Harper, M. L. (2002). Coping self-efficacy perceptions as a mediator between acute stress response and long-term distress following natural disasters. *Journal of Traumatic Stress 15* (3), 177–186.

Brewin, C. R., Andrews, B., & Valentine, J. D. (2000). Meta-analysis of risk factors for posttraumatic stress disorder in trauma-exposed adults. *Journal of Consulting and Clinical Psychology 68*, 748–766.

Broad, J. D., & Luthans, F. (2020). Positive resources for psychiatry in the fourth industrial revolution: Building patient and family focused psychological capital (PsyCap). *International Review of Psychiatry 32* (7–8), 542–554.

Carver, C. S., & Scheier, M. F. (1999). Stress, coping, and self-regulatory processes. In L. A. Pervin & O. P. John (Eds.), *Handbook of personality* (pp. 553–575). Guilford Press.

Cohen, S. (2004). Social relationships and health. *American Psychologist 59*, 676–684.

Cohen, S., Janicki-Deverts, D., Crittenden, C. N., & Sneed, R. S. (2012). Personality and human immunity. In S. C. Segerstrom (Ed.), *The Oxford Handbook of psychoneuroimmunology* (pp. 146–169). Oxford University Press.

Cohen, S., Kamarck, T., & Mermelstein, R. (1983). A global measure of perceived stress. *Journal of Health and Social Behavior 24* (4), 385–396.

Coutu, D. L. (2002). How resilience works. *Harvard Business Review 80* (5), 46–55.

Creswell, J. D., Irwin, M. R., Burklund, L. J., Lieberman, M. D., Arevalo, J. M., Ma, J., Breen, E. C., & Cole, S. W. (2012). Mindfulness-based stress reduction training reduces loneliness and pro-inflammatory gene expression in older adults: A small randomized controlled trial. *Brain, Behavior, and Immunity 26* (7), 1095–1101.

Daniels, L. R., Boehnlein, J., & McCallion, P. (2015). Aging, depression, and wisdom: A pilot study of life-review intervention and PTSD treatment with two groups of Vietnam veterans. *Journal of Gerontological Social Work* 58 (4), 420–436.

Dantzer, R., Cohen, S., Russo, S., & Dinan, T. G. (2018). Resilience and immunity. *Brain, Behavior, and Immunity* 74, 28–42.

Dhingra, V., & Dhingra, M. (2020). Effect of perceived stress on psychological well-being of health care workers during COVID 19: Mediating role of subjective happiness. *European Journal of Molecular & Clinical Medicine* 7 (2), 3683–3701.

Edmonds, E. C., Martin, A. S., Palmer, B. W., Eyler L. T., Rana, B. K., & Jeste, D. V. (2018). Positive mental health in schizophrenia and healthy comparison groups: Relationships with overall health and biomarkers. *Aging & Mental Health* 22 (3), 354–362.

Eglit, G. M. L., Palmer, B. W., & Jeste, D. V. (2018). Overview of measurement-based positive psychiatry. *Nordic Journal of Psychiatry* 72 (6), 396–403.

Everson-Rose, S. A., & Lewis, T. T. (2005). Psychosocial factors and cardiovascular diseases. *Annual Reviews of Public Health* 26, 469–500.

Fervaha, G., Agid, O., Takeuchi, H., Foussias, G., & Remington, G. (2016). Life satisfaction and happiness among young adults with schizophrenia. *Psychiatry Research* 242, 174–179.

Galvez, J. F., Thommi, S., & Ghaemi, S. N. (2011). Positive aspects of mental illness: A review in bipolar disorder. *Journal of Affective Disorders* 128 (3), 185–190.

Giltay, E. J., Geleijnse, J. M., Zitman, F. G., Buijsse, B., & Kromhout, D. (2007). Lifestyle and dietary correlates of dispositional optimism in men: The Zutphen Elderly study. *Journal of Adult Development* 63 (5), 483–490.

Granholm, E., Holden, J., Link, P. C., McQuaid, J. R., & Jeste, D. V. (2013). Randomized controlled trial of cognitive behavioral social skills training for older consumers with schizophrenia: Defeatist performance attitudes and functional outcome. *The American Journal of Geriatric Psychiatry* 21 (3), 251–262.

Harrison, G., Hopper, K., Craig, T., Laska, E., Siegel, C., Wanderling, J., Dube, K. C., Ganev, K., Giel, R., an der Heiden W., Holmberg, S. K., Janca, A., Lee, P. W., León, C. A., Malhotra, S., Marsella, A. J., Nakane, Y., Sartorius, N., Shen, Y., ...Wiersma, D. (2001). Recovery from psychotic illness: A 15- and 25-year international follow-up study. *British Journal of Psychiatry* 178, 506–517.

Harding, C., & Hall, G. (1997). Long-term outcome studies of schizophrenia: Do females continue to display better outcomes as expected? *International Review of Psychiatry* 9, 409–418.

Harmon, J., & Venta, A. (2021). Adolescent posttraumatic growth: A review. *Child Psychiatry & Human Development* 52, 596–608.

Holt-Lunstad, J., Smith, T. B., & Layton, J. B. (2010). Social relationships and mortality risk: A meta-analytic review. *PLoS Medicine* 7 (7), e1000316.

Huppert, F. A. (2009). Psychological well-being: Evidence regarding its causes and consequences. *Applied Psychology: Health and Well-Being* 1 (2), 137–164.

Huppert, F. A., & So, T. T. C. (2011). Flourishing across Europe: Application of a new conceptual framework for defining well-being. *Social Indicators Research* 110 (3), 837–861.

Jeste, D. V. (2018). Positive psychiatry comes of age. *International Psychogeriatrics* 30 (12), 1735–1738.

Jeste, D. V., & Palmer, B. W. (2015). *Positive psychiatry: A clinical handbook*. American Psychiatric Publishing.

Jeste, D. V., Palmer, B. W., Rettew, D. C., & Boardman, S. (2015). Positive psychiatry: Its time has come. *Journal of Clinical Psychiatry* 76 (6), 675–683.

Kelly, A. C., & Carter, J. C. (2015). Self-compassion training for binge eating disorder: A pilot randomized controlled trial. *Psychology and Psychotherapy 88* (3), 285–303.

Leamy, M., Bird, V., Le Boutillier, C., Williams, J., Slade, M. (2011). Conceptual framework for personal recovery in mental health: Systematic review and narrative synthesis. *British Journal of Psychiatry 199* (6), 445–452.

Luthans, F. (2002). The need for and meaning of positive organizational behavior. *Journal of Organizational Behavior 23* (6), 695–706.

Masten, A. S. (2001). Ordinary magic: Resilience processes in development. *The American Psychologist 56* (3), 227–239.

Mausbach, B. T., Patterson, T. L., Von Känel, R., Mills, P. J., Dimsdale, J. E., Ancoli-Israel, S., Grant, I. (2007). The attenuating effect of personal mastery on the relations between stress and Alzheimer caregiver health: A five-year longitudinal analysis. *Aging and Mental Health 11* (6), 637–644.

Meyer, P. S., Johnson, D. P., Parks, A., Iwanski, C., & Penn, D. L. (2012). Positive living: A pilot study of group positive psychotherapy for people with schizophrenia. *The Journal of Positive Psychology 7* (3), 239–248.

Montross, L. P., Depp, C., Daly, J., Reichstadt, J., Golshan, S., Moore, D., Sitzer, D., Jeste, D. V. (2006). Correlates of self-rated successful aging among community-dwelling older adults. *The American Journal of Geriatric Psychiatry 14* (1), 43–51.

Pawelski, J. O. (2003). William James, positive psychology, and healthy-mindedness. *The Journal of Speculative Philosophy 17* (1), 53–67.

Prati, G., & Pietrantoni, L. (2010). The relation of perceived and received social support to mental health among first responders: A meta-analytic review. *Journal of Community Psychology 38*, 403–417.

Rasmussen, H. N., Scheier, M. F., & Greenhouse, J. B. (2009). Optimism and physical health: A meta-analytic review. *Annals of Behavioral Medicine 37* (3), 239–256.

Repetti, R. L., Taylor, S. E., & Seeman, T. E. (2002). Risky families: Family social environments and the mental and physical health of offspring. *Psychological Bulletin 128*, 330–366.

Rettew, D. C., Althoff, R. R., & Hudziak, J. J. (2014). Happy kids: Teaching trainees about emotional-behavioral wellness, not just illness. Paper presented at the 43rd Annual Conference of the American Association of Directors in Psychiatric Residency Training, Tucson, Arizona.

Santini, Z. I., Koyanagi, A., Tyrovolas, S., Mason, C., & Haro, J. M. (2015). The association between social relationships and depression: A systematic review. *Journal of Affective Disorders 175*, 53–65.

Schwartz, M. D., Lerman, C., Miller, S. M., Daly, M., & Masny, A. (1995). Coping disposition, perceived risk, and psychological distress among women at increased risk for ovarian cancer. *Health Psychology 14* (3), 232–235.

Segerstrom, S. C. (2005). Optimism and immunity: Do positive thoughts always lead to positive effects? *Brain, Behavior, and Immunity 19*, 195–200.

Seligman, M. E. P. (1999). The president's address. *American Psychologist 54*, 559–562.

Seligman, M. E. P. (2002). Positive psychology, positive prevention, and positive therapy. In C. R. Snyder & S. J. Lopez (Eds.), *Handbook of positive psychology* (pp. 3–9). Oxford University Press.

Snyder, C. R., Harris, C., Anderson, J. R., Holleran, S. A., Irving, L. M., Sigmon, S. T., Yoshinobu, L., Gibb, J., Langelle, C., & Harney, P. (1991). The will and the ways: Development and validation of an individual-differences measure of hope. *Journal of Personality and Social Psychology 60* (4), 570–585.

Spencer, S. M., & Patrick, J. H. (2009). Social support and personal mastery as protective resources during emerging adulthood. *Journal of Adult Development 16* (4), 191–198.

Stajkovic, A., & Luthans, F. (1998). Self-efficacy and work-related performance: A meta-analysis. *Psychological Bulletin 12* (2), 240–261.

Stangl, W. (2022). Self-efficacy - Online Encyclopedia of Psychology & Education. https://lexikon.stangl.eu/1535/selbstwirksamkeit-selbstwirksamkeitserwartung_access_28112022

Summers, R., & Jeste, D. V. (Eds). (2018). *Positive psychiatry: A casebook.* American Psychiatric Publishing.

Thoits, P. A. (2011). Mechanisms linking social ties and support to physical and mental health. *Journal of Health and Social Behavior 52,* 145–161.

Thomas, E., Despeaux, K., Drapalski, A., Amy L. Drapalski A. L., & Bennett, M. (2018). Person-oriented recovery of individuals with serious mental illnesses: A review and meta-analysis of longitudinal findings. *Psychiatric Services 69,* 259–267.

Timmerby, N., Austin, S., & Bech, P. (2016). Positiv psykiatri [Positive psychiatry]. *Ugeskr Laeger 8 178* (6), V09150759.

Uchino, B. N. (2006). Social support and health: a review of physiological processes potentially underlying links to disease outcomes. *Journal of Behavioral Medicine 29* (4), 377–387.

Vaillant, G. E. (2012). Positive mental health: Is there a cross-cultural definition? *World Psychiatry 11* (2), 93–99.

Van der Weele, T. J. (2017). On the promotion of human flourishing. *Proceedings of the National Academy of Sciences 114* (31), 8148–8156.

Verdolini, N., Amoretti, S., Mezquida, G., Cuesta, M. J., Pina-Camacho, L., García-Rizo, C., Lobo, A., González-Pinto, A., Merchán-Naranjo, J., Corripio, I., Salagre. E., Baeza, I., Bergé, D., Garriga, M., Bioque, M., Vallespir, C., Serra, M., Vieta, E., & Bernardo, M. (2021). The effect of family environment and psychiatric family history on psychosocial functioning in first-episode psychosis at baseline and after 2 years. *European Neuropsychopharmacology 49,* 54–68.

Verdolini, N., & Vieta, E. (2021). Resilience, prevention and positive psychiatry. *Acta Psychiatrica Scandinavica 143* (4), 281–283.

Vig, K. D., Mason, J. E., Carleton, R. N., Asmundson, G. J. G., Anderson, G. S., & Groll, D. (2020). Mental health and social support among public safety personnel. *Occupational Medicine 9 70* (6), 427–433.

Weber, S. R., & Pargament, K. I. (2014). The role of religion and spirituality in mental health. *Current Opinion in Psychiatry 27* (5), 358–363.

Wikipedia: https://en.wikipedia.org/wiki/Psychiatry

WHO Constitution 1948. https://www.who.int/about/governance/constitution#:~:text=Constitution%20of%20the%20World%20Health%20Organization.%20The%20Constitution%20was%20adopted

World Health Organization: Definition of Health. https://www.who.int/about/governance/constitution_download 16072023

SECTION II

HISTORICAL BACKGROUND AND BASIC IDEAS

INTRODUCTION
Historical Background and Basic Ideas

MARTIN POLTRUM

In the section 'Historical Background and Basic Ideas', six articles introduce selected perspectives and ideas on aesthetics. The chapters on Plato, Friedrich Nietzsche, John Dewey, Michel Foucault, the philosophers of the Frankfurt School, and the reflections on aesthetic engagement as a pathway to mental health and well-being only represent aspects of what could have been addressed in this section. Instead of an introduction to the individual articles, a few very personal gleanings from the reading on the topic of aesthetics as therapeutics will be presented here, and two scenes from the film *American Beauty* (1999) will be discussed. The latter inspired the author of these lines so much for some time that they were repeatedly shown at several international conferences as part of lectures on beauty as a therapeutic agent.[1] These scenes summarize well why the experience of beauty is curative. *American Beauty* (1999) is a film that, among other things, deals with the inspiring effect of aesthetic experience. Especially in the famous 'plastic bag scene' in the middle of the film, in which a young man (Ricky Fitts) shows his girlfriend (Jane Burnham) the most beautiful thing he has ever filmed: a plastic sack dancing in the wind. That floating bag is so important to Ricky because he arrives at a significant realization thanks to this experience.

Ricky Fitts: 'You want to see the most beautiful thing I've ever filmed? It was one of those days where it's a minute away from snowing and there was this electricity in the air. You can almost hear it. Right? And this bag was just dancing with me, like a little kid begging me to play with it for minutes. That's the day I realized that there was this entire life behind things and this incredibly benevolent force that wanted me to know that there was no reason to be afraid, ever. (…) Sometimes there's so much beauty in the world.'[2]

This short scene shows three things. First, that the experience of beauty cannot solely be ignited by high-quality aesthetic objects; second, that even objects as insignificant as a plastic bag dancing in the wind can reveal beauty; and third, what the experience of beauty offers us to contemplate. For Ricky Fitts, it is the experience that there is life behind all things and a benevolent force that wants him to know that there is no reason to be fearful. Beauty to him is an anxiolytic and an experience that conveys a certainty of being and induces basic trust.

One of the most beautiful documents of Western philosophy, which Franz Rosenzweig[3] found in the Prussian Royal Library in Berlin (today: Alte Bibliothek Berlin) in 1913 when he was working on Hegel, and which is now archived in the Biblioteka Jagiellonska in Krakow (Poland), *The Oldest Systematic Programme of German Idealism*, speaks of beauty in a similarly dignified and honouring way like Ricky Fitts. In this text, we read that it is beauty which ultimately unites all ideas. Since this double-page manuscript does not fit Hegel's aesthetics in the least, although it was probably penned by him, there has been much speculation as to who the actual author of these lines is (see Jamme & Schneider, 1984; Hammermeister, 2002, 76). Written by Hegel's hand, its content is in accordance with Schelling's late philosophy and its pathos is similar to Hölderlin's Hymns, it may even be a co-production of the three roommates and classmates from the Tübinger Stift. It says:

> *An Ethics.* … Finally the idea which unites all, the idea of *beauty*, the word taken in the higher platonic sense. I am convinced that the highest act of reason, which, in that it comprises all ideas, is an aesthetic act, and that *truth* and *goodness* are united like sisters *only in beauty*—The philosopher must possess just as much aesthetic power as the poet. The people without aesthetic sense are our philosophers of the letter. The philosophy of the spirit is an aesthetic philosophy. One cannot be clever in anything, one cannot even reason cleverly in history—without aesthetic sense. It should now be revealed here what those people who do not understand ideas are actually lacking—and candidly enough admit that everything is obscure to them as soon as one goes beyond charts and indices.
>
> Poetry thereby obtains a higher dignity; it becomes again in the end what it was in the beginning—*teacher of (history) the human race* because there is no longer any philosophy, and history; poetic art alone will outlive all the rest of the sciences and arts.[4]

Why the experience of beauty is so important and what this experience prompts us to contemplate can be found again, varied and modified, in the final scene of *American Beauty* (1999). Lester Burnham, played by Kevin Spacey, who dies at the end of the film, reports:

> Lester: 'I had always heard your entire life flashes in front of your eyes the second before you die. First of all, that one second isn't a second at all. It stretches on forever, like an ocean of time. For me, it was lying on my back at a Boy Scout camp, watching falling stars. And yellow leaves from the maple trees that lined our street. Or my grandmother's hands and the way her skin seemed like paper. And the first time I saw my cousin Tony's brand-new Firebird. And Janie … and Janie … and Carolyn. I guess I could be pretty pissed off about what happened to me, but it's hard to stay mad when there's so much beauty in the world. Sometimes I feel like I'm seeing it all at once and it's too much. My heart fills up like a balloon that's about to burst. And then I remember to relax and stop trying to hold on to it. And then it flows through me like rain, and I can't feel anything but gratitude for every single moment of my … life.'[5]

The fact that the moment of dying can include the experience of beauty as well as the experience of gratitude seems to lie in the nature of finiteness and in the nature of beauty. In the experience of beauty, we are made to face the things that appear in such a way that the realization shines through: things themselves are inherently beautiful. They are not beautiful because they appear beautiful to us humans and because we render them beautiful by beholding them, but because they themselves are beautiful. We respond to this

experience with wonder and gratitude. In the experience of beauty, the being of things becomes illuminated, it becomes clear that things have a being and that life exists within things. The fact that this experience is most intense when the being of things begins to fade away lies in the nature of being and nothingness. Through the disappearance and passing, through the parting and deprivation of a thing, one may only become aware of the actual significance, the value and the treasure that something holds. The gratitude conveyed by the experience of beauty, which leaves us grateful for the fact that we exist and that we have experienced beauty and for the fact that we experience life and our life as a precious asset and gift, differs from ordinary gratitude directed at someone through its namelessness and its ontological revealing function. (…) In the form of nameless gratitude, the ability to be is revealed as a given. (Pöltner, 2008, 254) It is ultimately this experience that whispers to us what seems indispensable for mental health: 'You must change your life' (Rilke, 1908).

Notes

[1]. For example (selection): Martin Poltrum (2018) Aesthetic Theory: Opinions and Doctrines of the Great Philosophers, Advanced Studies Conference: Aesthetic Moments in Everyday Clinical Practice. Inspiration and Innovation for Connected Humane Care, St Catherine's College, University of Oxford, 31 October 2018 / Martin Poltrum (2017) Ethics and Aesthetics—Philosophical Perspectives, Core-Symposium Ethics and Aesthetics in Psychiatry—Tasks and Goals, European Congress of Psychiatry, European Psychiatric Association, Florence, 1–4 April 2017 / Martin Poltrum (2013) Ars psychiatrica—the therapeutic power of beauty, Symposium: Social Aesthetics—World Psychiatric Association International Congress, Austria Center Wien, 27–30 October 2013 / Martin Poltrum (2011) Felix Aestheticus—Das Schöne als Pharmakon, Symposium: Ars Psychiatrica—Ästhetische Aspekte der Psychiatrie, Jahrestagung der Deutschen Gesellschaft für Psychiatrie, Psychotherapie, Psychosomatik und Nervenheilkunde, Berlin, 25 November 2011.
2. See www.script-o-rama.com/movie_scripts/a/american-beauty-script-transcript-spacey.html [last accessed 6 October 2024].
3. See https://plato.stanford.edu/entries/rosenzweig/#OldSysProGerIde [last accessed 19 March 2024].
4. See https://control-society.livejournal.com/10718.html [last accessed 6 October 2024] translated by Diana I. Behler; https://en.wikipedia.org/wiki/The_Oldest_Systematic_Program_of_German_Idealism#:~:text=%22The%20Oldest%20Systematic%20Program%20of,Behler [last accessed 6 October 2024]; https://archive.org/details/oldest-systematic-program-2021-ferrer/page/n21/mode/2up [last accessed 6 October 2024].
5. See www.script-o-rama.com/movie_scripts/a/american-beauty-script-transcript-spacey.html

References

Filmography

Hammermeister, K. (2002). *The German aesthetic tradition*. Cambridge University Press.
Jamme, C., & Schneider. H. (Eds.). (1984). *Mythologie der Vernunft. Hegels ältestes Systemprogramm des deutschen Idealismus*. Suhrkamp Verlag.
"Mendes (1999)" reference here after "Jamme & Schneider 1984".
Pöltner, G. (2008). *Philosophische Ästhetik*. Kohlhammer Verlag.
Rilke, R. M. (1908). *Archaic torso of Apollo*. https://poets.org/poem/archaic-torso-apollo [last accessed 6 October 2024].

CHAPTER 4

PLATONIC PROPORTIONS

Beauty, Harmony, and the Good Life

ANGELA HOBBS

INTRODUCTION: AN INITIAL PUZZLE

'We must look for artists and craftsmen capable of perceiving the real nature of what is beautiful (*kalon*), and then our young men living as it were in a healthy climate, will benefit because all the works they see and hear influence them for good, like the healthy breezes from wholesome places...' (Plato *Republic* 401c–d).[1]

Many people who have not read Plato simply associate him with censorship of the arts, and it is perfectly true that in the ideally just state outlined by the character of Socrates in the *Republic*, the arts are indeed to be heavily censored: in Book X, for instance, the only poetry that is allowed is a grim-sounding diet of hymns to the gods and paeans to good men (607a). Given this, those who have not read Plato might then initially be surprised to read the above passage from Book III and learn of the absolutely central role that beauty and aesthetic experience play throughout his work. When considering this apparent tension, we need to start by considering three points. Firstly, the very call for artistic censorship in the ideally just state *itself* reveals how powerfully Plato thinks art affects our emotions and our moral and intellectual development. Secondly, his dialogues are themselves magnificent works of art: Plato is a great artist as well as a great philosopher. And thirdly, a key component of his artistry is the skilful deployment of irony, and there is no more salient example of this than the fact that the dialogue that has been known since Roman times as the *Republic*, or *Res Publica*, would be *banned* in the ideally just state that it purports to describe: it does not meet its own censorship criteria.[2] Plato cannot have been unaware of this supreme irony. We must beware of assuming that Plato the off-stage author simply agrees uncritically with all the views he puts into the mouth of the main interlocutor in each dialogue (usually Socrates).

So let us leave to one side any image we may have unjustly acquired of Plato the arid censor, and focus instead on Plato the lover of beauty and advocate of both actual

and metaphorical harmony,[3] and explore and examine their fundamental place in his account of individual and communal flourishing and a good life.

Psychic Harmony and a Flourishing Life

Let us start with one of the most important passages of the *Republic*, the account in Book IV of the truly just person. For such a person justice (*dikaiosunē*) is not simply a matter of external actions, but an internal harmony (*harmonia*) of the *psychē* or soul.[4] This harmony arises when the three faculties that comprise the human *psychē*—reason, a spirited element (*to thumoeides*) and the appetites—are all performing their proper functions. It is the task of reason to seek and love truth and to rule for the good of the soul as a whole; the spirited element loves and seeks honour and success and its task is to carry out the orders of reason; the appetites desire physical satisfaction and the money that may be needed to acquire them, and their task is to obey. Psychic harmony, in other words, only occurs when all three elements agree that reason should rule. Such a man will not allow the three elements of his *psychē* to interfere with each other's functions, but

> By keeping all three in tune, like the notes on a scale (high, middle and low, and any others that may exist), he will truly set his house to rights, attain self-mastery and order and achieve good terms with himself. By binding all these elements together he will genuinely become one instead of many, self-controlled and harmonious (443d3–e2).[5]

The notion of psychic harmony, and the grace and beauty of soul and life that flow from it, is utterly foundational to the moral and political programme of the entire dialogue. Self-control (*sōphrosunē*) is also defined at 430e3–4 as a 'kind of concord and harmony', while at 413e and 423e Socrates says that the aim of the primary education system is to produce men who are rhythmic, harmonious, and measured.[6] The consequences of such internal harmony are highlighted at 588a, where the just person is said to be greatly superior to the unjust person in terms of 'grace and beauty of life', while in 591d we are told that the just person attunes the harmony of their body to the harmony of their *psychē*, since they are the 'true *mousikos*', the person truly living in accord with the Muses.

We will be returning to these key passages later, but three seminal points need to be noted immediately. Firstly, the notion that psychic harmony and a harmonious life can be viewed as both aesthetically *and morally* beautiful: we will be examining shortly how this is a natural viewpoint in Greek thought when we discuss the full meaning of the *kalon*, the usual term for 'beautiful'. Secondly, this outer and, especially, inner beauty are also portrayed as *beneficial* to the agent: the beautiful psychic harmony that comprises justice also comprises the *flourishing*, or *eudaimonia*, of the agent. *Eudaimonia* is a more

objective concept than subjective 'happiness', involving the actualization of our various faculties—rational, imaginative, affective, and physical (literally, it means living under the protection of a good *daimōn*, a good guardian spirit). Indeed, in 444d–e we find the first known reference in western thought to the concept of mental health:

> It seems, then, that excellence (*aretē*) is a kind of mental health (*hygieia ... psychēs*) or beauty or fitness, and defect a kind of illness or deformity or weakness.

Finally, as we saw in 443e, this mental health manifests itself in being 'one instead of many', a *whole* person, living a *whole* life, whereas mental illness and disorder involves a fracturing and fragmentation of the self. It also leads naturally to the view that a person and their life can be seen and assessed in terms of narrative shape, of life models and role models, which in turn deepen the very close links in Plato between ethics and aesthetics—links which lie at the very heart of his thought and which we shall be exploring further.

It is clear, therefore, that Plato's treatment of harmony involves issues of the most profound importance to our individual and communal wellbeing. In what follows I want to address four fundamental questions:

(a) What exactly does Plato *mean* by 'harmony', *harmonia*, and its cognates?
(b) How does he reach this notion of psychic harmony *in theory*?
(c) How does he think individuals, and individual societies, can achieve it *in practice*?
(d) Is it *true* that Plato's conception of psychic harmony would in fact lead to a good life? What are the dangers inherent in his conception and could there be a Platonic response to them?

The Concept of *Harmonia*

The original meaning of *harmonia* is a 'joining' or 'fitting-together', and its expert practitioners are carpenters. But it swiftly takes on two specific musical senses, and it is these senses which are very much to the fore in Plato. Before examining them, we need to clarify immediately that in ancient Greek musical theory *harmonia* does *not* mean what we mean by complex musical harmony. Its original musical sense refers to the building blocks of melody: a tuning or fitting-together of notes, a pattern of pitches and intervals—in other words, a scale. As we will see, the Pythagoreans analysed the mathematical ratios of these patterns in ways which deeply influenced Plato.

This Pythagorean approach to *harmonia* is based on *quantitative* analysis. But there was also a *qualitative* approach pioneered by a mysterious fifth century BCE Athenian sophist called Damon, a friend and adviser to Pericles and a friend of Socrates, which takes us to the second of the two musical senses of *harmonia*. Damon argued that there

were special types of scale—special patterns of tuning—which were associated with particular characteristics and emotional effects and named (probably by Damon himself) after particular ethnic groups, such as the Dorian, Phrygian, Lydian, and Ionian. When used in this second sense, *harmoniai* are usually translated 'modes' and probably achieve their effects by also being associated with particular rhythms and melodies.[7]

Whichever of these two musical senses Plato has uppermost in mind in any particular passage, the same basic point holds: when he is talking of the human psyche being in a state of internal harmony he is talking about it being in tune—indeed, precisely as the phrase 'like the notes on a scale' in 443d above suggests. Later we will see how he extends the musical metaphor even beyond the psyche to the cosmos itself.

Aesthetic Beauty and Moral Nobility: Understanding the *Kalon*

What of our second question? What is the theoretical underpinning of Plato's notion of psychic harmony in both quantitative and qualitative senses? To get a grasp of this, we first need to take note of the key Greek term *kalon*, which we met in the opening quote exhorting us to seek out artists and craftsmen who can appreciate its true nature. '*Kalon*' embraces both outward aesthetic beauty and inner moral beauty, moral nobility: as *Republic* 402a makes clear, it exerts a strong power of attraction even before reason has fully developed, and it merits admiration and praise. As we shall see, it is what allows Plato to depict correct ethical choice as at least partly a matter of possessing good taste. The psychology that underlies this is something we shall be exploring in our discussion of the philosopher-artist; our immediate task is to understand what it is that fundamentally connects outer and inner beauty in Plato. The answer again lies in mathematics—the mathematical ratios and proportions that, for him, underpin musical and all other forms of harmony also connect the sensible and non-sensible instances of the *kalon*. In addition, as we shall also explore in detail later, it is the notion of proportional balance that connects the *kalon* to the good and beneficial (the *agathon*), including in its manifestations of mental and physical health. This mathematical underpinning helps explain why what is truly *kalon* is always an *objective* matter for Plato: he acknowledges wide subjective differences of perception and opinion concerning what counts as beautiful but, for him, some of these subjective views are quite simply mistaken. Indeed, as we shall see, ultimately what is to count as an instantiation of true beauty will depend on the absolute Form of Beauty itself.

On Not Neglecting Geometry

Plato had long been fascinated by mathematics and in 387 BCE, after many years of travelling around the Mediterranean after his beloved friend and mentor Socrates

had been put to death by the Athenian democracy in 399, he visited the Pythagorean communities in Magna Graecia in southern Italy in order to learn from their mathematical and astronomical studies. He seems to have been particularly intrigued by the Pythagorean findings that music could be mathematically notated in terms of the numerical ratios governing intervals in scales and melodies, such as the ratios between different lengths of string on the lyre. The lengths of two sections of a string giving notes an octave apart are in the ratio 2:1; 3:2 gives a fifth and 4:3 a fourth. Hippasus of Metapontum (c. 500–450 BCE) is thought to have discovered the relation between musical chords and whole number ratios,[8] but it seems to have been Philolaus of Croton (c. 470–390 BCE) who did most to develop the study of musical theory. In his system there are three basic principles: the unlimited, limiters and their 'fitting-together', *harmonia*, which combines limiters and the unlimited in an attractive way according to number. The clearest example of this, he believes, is the musical scale: the unlimited continuum of sound is limited by a sequence of pitches to form a scale, and these pitches are established by mathematical ratios which produce *harmonia*. The science of harmonics takes account of the ratios of intervals in scalar systems corresponding to notes, as Plato makes clear at *Philebus* 17a–e, a passage which owes much to Pythagorean teaching in general and probably Philolaus in particular.[9]

Philolaus also seems to have thought that the cosmos as a whole was governed by these mathematical principles and ratios, and that in consequence the cosmos is a true *harmonia* (and that that is why it is called a *kosmos*—the term suggesting beauty as well as order, as 'cosmetic' indicates). It may also have been Philolaus who first proposed the idea that the movement of each celestial body—sun, moon, planets—emitted a sound, and that the movements of the planets revolving around the earth produce a series of coherently related pitches, the proportional relations between them creating the exquisite 'music of the spheres'.[10]

Philolaus had died three years before Plato's arrival in 387, and the leading Pythagorean was now Archytas of Tarentum, a former pupil of Philolaus who became one of Plato's close friends. Archytas also worked extensively on the mathematics that govern musical theory, and is the first person on record to talk of 'geometrical proportion' (fragment. 2);[11] he may therefore have been influential in formulating the distinction between 'geometrical equality' and 'arithmetical equality' that we shall shortly find playing such a central role in Plato's *Gorgias*. And as he was also a practising politician—he was elected the democratic leader of Tarentum seven years in succession—he may well have begun the application of harmonic theory to the social sphere that Plato develops in the *Gorgias*, *Republic* and elsewhere.

All these findings and speculations made a very deep impression on Plato. He probably wrote the *Gorgias* soon after his return to Athens in 387, and Pythagorean influences are markedly in evidence in its latter stages. In 503e–504a, Socrates says that if you look at the work of any artist or craftsman—whether painter, builder, or shipwright—you will see how

> each of them arranges everything according to a certain order, and makes one part to suit and fit (or 'harmonise' *harmottein*) with another, until he has combined the whole into a regular and ordered production.[12]

Nor does this simply apply to inanimate artefacts: the task of the physical trainer and doctor, too, is to bring order (*kosmos*) and arrangement into the body (504a). And, crucially, the *psychē* also requires arrangement (*taxis*) and order (*kosmos*) if it is to be good (*chrēstos* 504b). Proper arrangement and order in the body we call strength and health, and in the *psychē* we call them lawfulness, justice, and temperance—in short, virtue and excellence (*aretē* 504e).[13]

Three things immediately strike us. Firstly, as we have seen, the terms *kosmos* and *harmottein* have aesthetic as well as purely pragmatic connotations: the order achieved through the correct assemblage of parts into wholes is beautiful and (in its general sense) harmonious. Secondly, in a living body, it is also healthy and good. Thirdly, and most important of all, the analogy between the well-ordered body and the well-ordered and virtuous *psychē* suggests that the orderly *psychē*, too, will be in a state of health (and at 507d–e Socrates also says that the person whose soul is in a virtuous state will flourish and be blessed). Although the *Gorgias* does not yet contain a sophisticated psychological theory to underpin such a claim, Plato is already feeling his way towards the theory of mental health which he will articulate most clearly a few years later in the tripartite psychology of the *Republic*.

The culmination of these beliefs comes in *Gorgias* 508a–b, where Socrates is trying to convince his intemperate interlocutor, Callicles, to abandon his dissolute ways. He adduces the testimony of certain 'wise men'—almost certainly the Pythagoreans[14]— who say that

> heaven and earth and gods and men are held together by communion and friendship, by orderliness (*kosmiotēs*), temperance and justice; and that is the reason, my friend, why they call the whole of this world by the name of order (*kosmos*), not of disorder or dissoluteness. Now you … do not give proper attention to this … but have failed to observe the great power of geometrical equality amongst both gods and men: you hold that grabbing more than your fair share is what one ought to practise, because you neglect geometry.[15]

When, in the post-*Gorgias Republic*, Socrates outlines the higher education system for those Guardians selected to be trained as future Philosopher-Rulers, he does indeed not neglect geometry: the trainee philosophers are to study, in order, arithmetic, plane geometry, solid geometry, astronomy, and harmonics before finally being introduced to dialectic (521c–531c). Done correctly, the study of the unit is amongst those studies that are able to 'lead the mind on and turn it to the vision of reality' (524e–525a). Harmonics is said to be the counterpart of astronomy, in that our ears are made to perceive the movements of harmony. Socrates here praises the Pythagoreans for apprehending the numerical relationships in audible concord, but also says that they have not gone far enough in their study of harmonics: we need to understand more fully which numerical relations are concordant, which not, and why (531c).

There is a story from later antiquity that over the entrance to the Academy that Plato set up in Athens there was a sign that read 'Let no-one enter here who has not studied geometry'. Whether the tale is true or not—and I very much hope that it is—it certainly

reflects the heart of Plato's thought. This cosmos is beautiful, harmonious, and good precisely because it is ordered on mathematical principles, on the ratios and proportions that underpin all the mathematical sciences, including geometry.

Microcosm and Macrocosm

The essential orderliness of the world and the importance of mirroring it in the individual *psychē* is also a prominent theme in the *Timaeus*. At 36a the character of Timaeus—a mathematician and astronomer from Locris in southern Italy[16]—details the mathematical ratios that play a key role in the generation of the cosmos (happily we do not need to concern ourselves with their highly intricate nature here); and at 87c he emphasizes the need to reflect these proportions in the human soul:

> All the good and beneficial (*agathon*) is beautiful and fine (*kalon*) and the *kalon* is not disproportionate. So every living creature that is to be thus [*agathon* in body and mind] must also be of due proportion.[17]

At *Timaeus* 90 c–d when discussing the health of the *psychē* he continues:

> There is only one way to look after anything and that is to give it its proper nourishment and motions. And the motions that are akin to the divine in us are the thoughts and revolutions of the universe (lit: 'the whole'). We should each therefore attend to these motions and by learning thoroughly about the harmonies (*harmoniai*) and revolutions of the universe repair the damage done to the circuits in our head in connection with our coming into being, and so restore our understanding, in accordance with our original nature, to its likeness with the object of understanding. When that is done we shall have achieved the goal set us by the gods, the life that is best for the present time and all time to come.[18]

There is, however, one major development between the *Gorgias* and the *Timaeus*, and this development also applies to the *Republic* (in the *Timaeus* Socrates claims that on the previous day they had been discussing the establishment of an ideal state, and the topics he mentions match those of *Republic* Books 2–5). Between writing the *Gorgias* and the *Republic* and *Timaeus*, Plato has come to the conclusion that the ultimate realities in the cosmos—the only things stable enough to be truly objects of knowledge and not simply of belief—are what he terms Forms: eternal, unchanging, perfect paradigms of goodness, beauty, justice, and indeed all animate and inanimate objects. Forms cannot be directly apprehended by our sense organs, but only understood by our intellect. In the realm of the Forms,

everything is in order and according to reason (*Republic* 500c);
and it is to this realm that the philosopher looks for guidance and which
is the model which he imitates and to which he assimilates himself as far as
he can (500c).[19]

Crucially, it appears that this rational order again depends on proportion: Forms are individually proportionate and so too is the realm they inhabit. It is this key fact that leads to Socrates at *Republic* 486d highlighting one of the most important qualities required in the true philosopher:

> But furthermore we would say that a tasteless and graceless nature inevitably leads to disproportion.
> Absolutely.
> And is truth akin to proportion or disproportion?
> To proportion.
> So, in addition to all the other qualities, let us also seek a mind endowed with proportion and grace, whose nature will allow it to be led to the Form of each reality.

Once again, proportion is viewed as morally fine, aesthetically pleasing, and wholesome and beneficial. Given that at this point in the *Republic*, Socrates is arguing specifically for philosopher-rulers, the benefits will accrue not just to the individual philosopher, but to society as a whole. We shall be returning to this point, but first I want to suggest that the metaphysical underpinning of the connections Plato makes between the morally fine, beauty, and health may not simply be the general proportionality of the Forms and their realm; I wish to suggest that the Form of Beauty is at the very least extremely closely connected to the Form of the Good, and may even be identical to it in reference if not in sense. As I discuss this possibility in detail elsewhere, I will only briefly mention some of the evidence here.[20] At *Republic* 517c Socrates says that the Form of the Good (*to agathon*) is the inferred cause of all fine and beautiful (*kala*) things; yet at *Republic* 475–479 he had said that *kala* things are *kala* through participation in the Form of Beauty (*to kalon*). Socrates, in short, appears to be treating the two forms interchangeably. Three more key texts are *Republic* 505d11–e1 and *Symposium* 210e4–6 and 211c2: in the *Republic*, it is the Form of the Good which is said to be 'that which every soul pursues and for the sake of which everything is done', while in the *Symposium* passages it is the Form of *Beauty* which is 'that for the sake of which all previous labours were undertaken', and which is the 'final goal' (*telos*), 'that for the sake of which' the lover 'always strives'. For a discussion of the implications of this apparent identity in reference, and an explanation of how the two Forms still differ in sense, see Hobbs 2000, 222–227; all we need emphasize here is the fact that Plato believes his theory of psychic harmony and a beautiful life has a transcendent basis.

The Shape of a Life

Let us now return to *Republic* 443–444 and 591, as we are now in a position to understand the thinking that underpins the need to attune the three psychic faculties, and further to attune *psychē* to body: it is only thus that we can live the harmonious life of the true *mousikos* (*Republic* 591d).[21] We are also in a much better position to appreciate the brief suggestion there that Plato's approach to ethics

> leads naturally to the view that a person and their life can be seen and assessed in terms of narrative shape, of life models and role models, which in turn deepen the very close links in Plato between ethics and aesthetics.[22]

For Plato (and it would seem also for the historical Socrates), the fundamental ethical questions are 'how should life be lived?' and 'what sort of person should I be?' (*Gorgias* 500c; *Republic* 352d). It is an agent-centred approach, at least capable of taking on board the complexities of the lived human experience. It is because it considers the *whole person*, living a *whole* life, that it invites us to consider the structure, shape, and narrative of a well-lived life (or for that matter a badly lived one). It presents us with a story and perceives a life as capable of aesthetic as well as ethical evaluation. In Plato's last work, the *Laws*, the main character (in this dialogue the mysteriously named Athenian Stranger, not Socrates)[23] says at 803a–b:

> Just as a shipwright at the commencement of his building outlines the shape of his vessel by laying down her keel, so I appear to myself to be doing just the same—trying to frame, that is, the shapes of lives according to the ways of their *psychai*, and thus literally laying down their keels, by considering by what means and by what ways[24] of living we shall best navigate our barque of life through this voyage of existence.[25]

A life, no less than a ship, can be viewed in terms of the proper relations between its parts, and between parts and the whole, and such considerations once more depend on notions of proportion and harmony: 'structure, after all, can impart not only intelligibility but grace.'[26]

Philosopher-Artists: Shaping Society

We saw above how it is the ruler's task to model him- or herself on the proportionate Forms and their realm. But having formed themselves, they then need to rule. And both

Socrates in the *Republic* and the Athenian Stranger in the *Laws* conceive of this task in terms of the *shaping* of both whole societies and the citizens within them on proportionate, harmonious lines. These rulers are to be philosopher-artists, sculpting society in the image of both individual Forms and the realm they inhabit. The passage in *Republic* 500c quoted above continues:

> Then if the philosopher is compelled to try to introduce [the standards] he has seen there into the habits of the people in both their private and public lives, and mould not only himself [but them too], will he lack the skill to produce self-discipline and justice and all the other demotic virtues?[27]
> Certainly not.
> And if the public discover that we are telling the truth about philosophers, will they still be angry with them and disbelieve us when we say that no state can flourish unless the artists drawing it use a divine pattern?
> If they do make the discovery, they will stop being angry. But what sort of drawing do you mean?
> The first thing our artists must do ... —and it's not easy—is to wipe the slate of human society and human habits clean. For our philosophic artists differ at once from all others in being unwilling to start work on an individual or a city, or draw out laws, until they are given, or have made themselves, a clean canvas.
> They are quite right.
> After that the first step will be to sketch in the outline of the social system.
> Yes, and then?
> Our artist will, I suppose, as he works, look frequently in both directions, that is at justice and beauty and self-discipline and the like in their true nature, and again at the copy of them he is trying to make in human beings, mixing and blending traits to give the colour of manhood...
> ... He will sometimes delete and draw again, of course, but will go on until he has made human nature as acceptable to God as possible.
> It should be a very beautiful picture.

We shall be returning to the disturbing implications of this passage. For now we should note that the verb here translated 'mould' (*plattein*) is normally used of a sculptor shaping clay or wax, and that the same verb was used earlier in the *Republic* at 377b, where Socrates emphasizes that it is important to start moulding children when they are very young and their natures are still soft and malleable.

In later dialogues the business of ruling is likened to other arts and crafts. In the *Statesman* (*Politicus*) 308–311 the task of the ideal ruler is to 'weave' together naturally courageous characters (the warp) with naturally restrained and modest characters (the woof) into a beautiful citizen body, partly through an education which aims at instilling shared beliefs and values, and partly through intermarriage.[28] And in Plato's last work, the *Laws*, the philosophic lawmakers claim at 817b that it is they, rather than the dramatists and poets, who in framing the constitution write the most beautiful and best tragedies. All these comparisons—to painting, sculpting, weaving, and

writing—reinforce the notion that the material of a character and a life needs to be carefully and skilfully shaped.

Education in Beauty

The malleability of children's natures emphasized at *Republic* 377b is claimed by Socrates to make them not just impressionable but also naturally mimetic, and thus particularly susceptible to cultural influences. In this, Plato seems to have been influenced by the sophist Protagoras. In the dialogue named after him, the character of Protagoras says in his Great Speech that children are made to learn the works of 'good poets' by heart, since they contain,

> Many admonitions, but also many descriptions and praises and encomia of good men in times past, so that the boy may, through envy, imitate them and long to become such as they. (*Protagoras* 326a)[29]

In (suitable) literary texts children will find appropriate role models. But this is by no means the only way that cultural influences are absorbed. Protagoras goes on to claim (326b) that music teachers

> Insist on familiarizing the children's *psychai* with the rhythms and modes, so that they may become more gentle, and by gaining in rhythmic and harmonic grace may become effective in both speech and action. For the whole of a human life requires the graces of rhythm and harmony.[30]

Plato develops this basic position of Protagoras in the *Republic*, and applies it not only to musicians, poets, and other writers, but to all craftsmen. Our opening quote concerning the importance of artists and craftsmen perceiving the real nature of what is beautiful, the *kalon*, comes from a key summary of early education for the Guardian children (400c–403c). The passage makes it clear that artistic and aesthetic influences can be absorbed and emulated both through formal education in literature and music (collectively called *mousikē*), and also informally through immersion in the human-made and natural environment. This is because, as the character of Socrates puts it, true, objective, outer beauty arises from true, objective, inner moral beauty—a moral beauty which is the internalization of reason, of *logos*. It is such a central passage to our enquiry that it is worth citing at some length; in the lead up to our opening quote Socrates declares that

> Good literature, therefore, and good music, beauty of form and good rhythm all depend on goodness of character…

The graphic arts are full of the same qualities and so are the related crafts, weaving and embroidery, architecture and the manufacture of furniture of all kinds; and the same is true of living things, animals and plants. For in all of them we find beauty and ugliness. And ugliness of form and bad rhythm and disharmony are akin to poor quality expression and character, and their opposites are akin to and represent good character and discipline.

... It is not only to the poets therefore that we must issue orders requiring them to portray good character in their poems or not to write at all; we must issue similar orders to all our artists and craftsmen, and prevent them portraying bad character, ill-discipline, meanness or ugliness in pictures of living things, in sculpture, architecture, or any work of art... We shall thus prevent our Guardians being brought up among representations of what is evil, and so day by day and little by little, by grazing widely as it were in an unhealthy pasture, insensibly doing themselves a cumulative psychological damage that is very serious.

Yet if artists and craftsmen who do truly understand the nature of beauty can be found, and the children in consequence benefit from such works as if breathing in 'healthy breezes from wholesome places', then they will without realizing it be led from earliest childhood into 'close sympathy and conformity with beauty and reason' (401d). This, says Socrates, is why this stage of education is so vital:

For rhythm and harmony penetrate deeply into the psyche and take a most powerful hold on it, and, if education is good, bring and impart grace and beauty; if it is bad, the reverse. And moreover the proper training we propose will make [the child] quick to perceive the shortcomings of works of art or nature, whose ugliness he will rightly dislike; anything beautiful he will welcome gladly, will make it his own and so grow in true goodness of character; anything ugly he will properly condemn and dislike, *even when he is still young and cannot understand the reason for so doing* [italics mine], while when reason comes he will recognize and welcome it as a familiar friend because of his upbringing.

A key question to which we shall be returning is whether artistic beauty is able to penetrate into the psyche of an adult whose character has not been well formed when young. For now, let us note again the intimate connection between beauty (both sensible and moral) and the good and beneficial in this crucial passage. Socrates is claiming both (a) that immersion in sensible beauty will help to inculcate moral beauty in the child and that this is to the benefit of the child's psychological well-being, and also (b) that a child who can appreciate sensible beauty, and convert it into inner moral beauty, will naturally welcome the development of reason and the understanding it offers of *why* both outer and inner beauty is beneficial to our psychological health. Both claims together lead us to the conclusion of *Republic* 445c that there is just one form of moral excellence (*aretē*). I submit that it is the internalization of proportional beauty.

The Tripartite *Psychē*: The Role of the *Thumoeides*

So how is this pre-rational penetration of the *psychē* by beauty to be achieved? To appreciate this, we need to consider the middle 'part' of the tripartite *psychē* detailed in the *Republic*, the spirited element or *thumoeides*. Although the innate reasoning capabilities of young children are not yet fully realized—it appears that they do not really develop until the child is about ten—the *thumoeides* is vigorously active from birth, and because it desires honour and success, it is instinctively inclined towards those characters, actions, and works of art which are already honoured and praised in the surrounding society. It has a natural sensitivity to those things, people, and actions which its society calls *kala*, fine and beautiful, and if this sensitivity is guided towards true *kala*, then the *thumoeides* will indeed be able to perform its proper function of being the ally of the reasoning element (the *logistikon*).[31] Although 410b–412a makes it clear that education in the arts is ultimately aimed at training the *logistikon*, while physical training (*gymnastikē*) is mainly aimed at the *thumoeides*, a properly guided *thumoeides* can nevertheless do much to pave the way for the proper development of reason.

411b–412a is central to our discussion in that it vividly describes the power of aural and visual stimuli to penetrate deep into the *psychē*, and the consequent need to achieve the correct balance between *mousikē* and *gymnastikē* in early education. Too much *mousikē*, or *mousikē* in the wrong harmonic mode, slackens and eventually destroys the 'sinews of the *psychē*', leaving the young person weak and cowardly. Excessive physical training, on the other hand, makes those same psychic sinews too taut and brittle: it is vital that both the *logistikon* and the *thumoeides* are tuned to the right pitch. The educator who can do this, who can correctly tune the *psychē*, is thus able to produce music of far more significance to the state than any artist.

The Training of Eros

As both inner and outer beauty naturally attract us and inspire love and desire, the educational programme outlined by Socrates in the *Republic* is conceived in essence as the proper guidance of our capacity to love: at 403a, for example, in a discussion of sex, Socrates says that to love rightly is to love what is 'orderly and beautiful', but it is immediately (403c) made clear that this does not simply refer to sexual desire, but that teaching us to love both whom and what are truly beautiful should be the ultimate object of all education. To understand this better we need to appreciate three central points about Plato's philosophy of eros, erotic love. Firstly, eros entails desire (*epithumia*),[32] so what

is claimed of eros is claimed of desire too. Secondly, in Plato all three faculties of the *psychē* have their *own* desires (and loves); this is one of the key differences between his psychology and many modern conceptions of the relation between reason and desire, such as that of Hume.[33] Thirdly, these desires are not viewed as emanating from separate sources, but are conceived as a single stream of erotic energy which can be directed onto different objects, and the training of this erotic energy is utterly central to the wellbeing of both individual and community. The hydraulic imagery is explicit in *Republic* 485d, where our desires are likened to a stream which can be diverted in different directions (what should never be done, Socrates makes clear, is simply to block it, because then it will simply burst forth uncontrollably). This channelling and rechannelling of eros is powerfully depicted in *Symposium* 210–212, where the (almost certainly fictional) priestess Diotima recounts the lover's ascent up the 'ladder of love', their erotic attraction being directed towards ever more abstract objects of beauty, until finally they dwell in communion with the perfect, eternal, non-sensible Form of Beauty itself.[34]

Tellingly for our present discussion, in the *Symposium* it is not only artists and philosophers who think that eros comes under their provenance, but doctors too. The doctor Eryximachus gives a speech (186–188) in which he claims that a proper understanding of eros between different elements in the body leads to their correct proportions and the resulting healthy harmony (he makes an explicit comparison between medicine and music); furthermore, the expertise of the seer also involves an understanding of the proper erotic relations between humans and gods, and this understanding in its turn leads to friendship between the two.

Afterlives

Plato's view that both outer and inner beauty is an objective matter of correct and harmonious proportions fundamental to our psychological health has been hugely influential in western culture, though it undeniably also raises some uncomfortable challenges. It was an approach taken up with devotion by the Neoplatonists—see, for example, Plotinus *Enneads* 1.6 and 1.3.2—and largely through them it fed into the thinking of Christian writers such as the seventh century John of Climacus, whose *Ladder of Divine Ascent* seems to be influenced in part by the ladder of love in Plato's *Symposium*, in addition to the explicit analogy the author draws with Jacob's Ladder.[35] We also find the image of the celestial ladder of love and beauty in Gregory of Nyssa, St. Augustine, Pseudo-Dionysius the Areopagite, Boethius, and St. Bonaventure.[36] In the fifteenth century, the Florentine priest, philosopher, and (covert) magician Ficino draws deeply on Plato's conception of beauty in his commentary on Plato's *Symposium*, the *de Amore*.[37]

Nor do Plato's writings on beauty and harmony solely feed into spiritual traditions and practices; it is highly likely that they also profoundly influenced architecture and art in practical ways. The Roman architect and military engineer Vitruvius (first century BCE) advises in Book I.i of his *de Architectura* that the architect should be

knowledgeable about philosophy and music as well as geometry and optics, and in his introduction to Book VII, where he is presenting his learned credentials, he lists Plato as amongst the very best and most gifted philosophers. It is eminently plausible to believe that Plato's writings on beauty, harmony, and proportion helped shape Vitruvius' own deep commitment to proportion, which he discusses not only in relation to architecture but also to the human body: he holds it to be a 'truth of nature' that nature's designs are based on laws of proportion and symmetry. In I.i.3 he gives detailed specifications for a perfectly proportioned human body—specifications which Leonardo da Vinci took as the basis for his celebrated drawing *Vitruvian Man*.

For modern interest in the Platonic link between harmony and mental health we need to turn to Freud. Freud had a profound admiration for Plato and considerable—albeit apparently fragmentary—knowledge of some of his works, particularly the *Symposium* and parts of the *Republic* and *Phaedrus*.[38] Such respect strikes me as particularly illuminating in that Freud's thinking developed in part from extensive clinical practice—a resource which Plato clearly did not have at his disposal. Although Freud does not explicitly say that his tripartition of ego, superego, and id is influenced by Plato's tripartition of reason, the *thumoeides*, and the appetites, the connections between the two tripartitions suggest that there is at least a case to be made for subliminal influence;[39] we may particularly note the central importance in both thinkers of the notion of a healthy psyche being harmonious and integrated, as opposed to the discordant fragmentation of a psyche in ill health. Freud does explicitly remark on the similarities between his concept of the libido and Plato's conception of eros as a stream of erotic energy which can be guided onto different objects.[40] In fact there are significant differences between Platonic rechannelling and Freudian sublimation,[41] but the salient point here is that in both Plato and Freud blocking/repression is regarded as highly dangerous: if the object of desire is either unattainable or inadvisable, then the recommended course is to divert erotic attention onto healthier objects.

Beauty, Harmony, and the Bad Life?

There is no question, then, that Plato's views on beauty, harmony, and mental health have been highly influential. But what of the challenges that they raise? Clearly Plato's conception of beauty as grounded in objective mathematical truths—and indeed ultimately grounded in the Form of Beauty itself—will not be attractive to all those who conceive of beauty as entirely subjective, existing solely in the senses and mind of the perceiver. Disquiet, too, might be felt about the way Plato repeatedly privileges aesthetic experiences that take place *at a distance* from the perceived object, such as sight and hearing and smell—Plato always appears to be uncomfortable at the thought of the immediate physical contact required by touch and taste.[42] Some issues raised are even more disturbing. For Plato, true beauty is not simply a matter of objective perfection, but, as the ladder of love in the *Symposium* makes clear, that perfection is *homogeneous*:

all instances of beauty in this phenomenal world are simply tokens of a type, and there is little room for individual artistic expression and experimentation.[43] Admittedly, in the considerably less than perfectly beautiful world which Plato admits we currently inhabit, there is a need for disruptors such as Socrates (and indeed Plato himself), but it does appear as if a Platonically beautiful heaven, if ever attained, might be rather dull.

Furthermore, despite the rich and positive potential of identifying inner beauty and harmony with mental health, it is also an identification which contains very serious dangers. If moral goodness is to be identified with psychic harmony and health, and moral badness with psychic disharmony and illness, then this opens the door to psychiatric and political abuse. It opens the door to pernicious claims that, for example, political dissidents are not only morally bad but also mentally disordered, and in need of state 'treatment' through drugs or even lobotomies in the kind of secretive and out-of-the-way 'sanatoria' that existed in the Soviet Union under Brezhnev.[44] Is there any way of retaining the riches while avoiding such evils? I think there might be, through an account of psychological health which emphasizes the importance of autonomy, and an account of moral goodness which is not defined by any particular political or medical regime, but these are issues too large for the scope of our present enquiry. But before concluding, there is a further, utterly fundamental challenge to Plato's account of beauty, moral goodness, and psychic harmony which I wish to address.

The reason this challenge is so fundamental is that it does not involve the contingency of a warped political or medical regime abusing definitions of moral goodness and health. It is a challenge to the heart of Plato's claims that immersion in aesthetic beauty will help to form inner beauty, goodness, and psychological health, and it arises from the well-attested fact that many very wicked people, who committed the most terrible atrocities, took pleasure in the arts: Hitler and Goebbels, for example, both loved Wagner, and there is no reason to think that this was simply because of the ideology associated (both rightly and wrongly) with Wagner; there is no reason to think that they did not take real pleasure in listening to his music. Goebbels apparently also loved Schubert, with whom there are no such ideological associations. Yet clearly these aesthetic experiences did not make them into good people, or people we would point to as examples of fine mental health. Is there any possible Platonic response to such a grave charge?

Conclusion: The Tripartite *Psychē* Revisited

Again, I believe there is, though here too a detailed exploration is beyond the scope of this enquiry. The easy—and possibly lazy—answer would be to say that they were not sufficiently immersed in true beauty from early enough in childhood; another easy—and I think also lazy—response would be to say that Plato would not allow the music of

Wagner and Schubert to be genuinely beautiful. But this will not do: Plato might well have had a number of objections to Wagner's operas, based on the censorship criteria outlined by the character of Socrates in the *Republic*, but it is harder to think that he would have objected to every composition by Schubert. And in any case it would surely not be hard to find artistic examples allowed by Plato to count as beautiful which have been enjoyed by morally bad people. If there is to be a more satisfying Platonic response to the challenge, I think it will lie in the tripartite psychology of the *Republic*, and the crucial passages we have been examining from 400–403 and 411–412: how *deeply* is the music—or whatever art form—penetrating into the *psychē*? Is the sound simply being enjoyed at a superficial level by the appetitive element, or is it also penetrating and shaping the spirited and reasoning elements, the *thumoeides* and *logistikon*? In the case of Hitler and Goebbels, I submit, Plato could say that at these deeper levels the music has simply failed to penetrate their *psychai*.

And, if so, I think Plato would have a point. If, for example, a Nazi engineering the Final Solution claimed that they took pleasure in listening to Beethoven's *Ode to Joy*, but still did not feel moved to alter their views or behaviour in any way, then I think we can justly say that at some deeper level the Nazi has simply failed to appreciate, absorb, and internalize the full beauty of the music, and its powerful message. Plato's views on beauty, harmony, goodness, and psychological health may indeed raise serious challenges for us to ponder—and they are certainly not fashionable—but I submit that they are of profound and lasting interest and importance, and it would be to our advantage to give them equally serious consideration.

Notes

1. Unless otherwise stated, the translations of the *Republic* (R.) are adapted by me from Plato *Republic*, 2007, translated by Lee.
2. Cicero appears to have been the first to give it the title of *Res Publica*; in Greek it was known as *Politeia*. One of the many ways in which the dialogue flouts the censorship rules it contains is in its inclusion of morally flawed characters, such as the sophist Thrasymachus in Book I.
3. This key and complex term will be discussed further in this chapter.
4. *Dikaiosunē* is broader in scope than 'justice', and can sometimes be closer to 'right conduct' in general. Note how in 444d below, Socrates concludes this discussion of *dikaiosunē* with a statement about *aretē*, 'excellence' or 'virtue' in general.
5. 'Harmonious' translates *hērmosmenon*: literally 'having been fitted harmoniously together'.
6. The term for 'measured', *metrioi*, can also mean proportionate. While Socrates talks of males in this passage, it is clear from later in the *Republic* (e.g., 454d–e; 540c) that selected girls from the two Guardian classes are also to receive the same training, and with the same aim.
7. *Republic* 398d–399e (on which more below) discusses Damon and his work on the different modes and their effects: the Dorian mode, for example, both represents and fosters courage and self-control, while the Ionian represents and fosters voluptuousness and the Mixolydian and Extreme Lydian are associated with dirges and laments.

8. According to a scholium on Plato *Phaedo*, 2010, 108d.
9. Plato *Philebus*, 1983. For Philolaus, see Barker (1989, 63 n.34)—though also see Barker's caveats (n.41).
10. In his *Natural History* II.xviii.xx, Pliny the Elder attributes the theory to Pythagoras himself; but Pythagoras is a mysterious figure of quasi-mythical status, and many of the later teachings of the Pythagoreans were indiscriminately attributed to him. This cosmic harmony was later termed *musica universalis* and elaborated in particular by Johannes Kepler (1571–1630), who held that this 'music' was inaudible to the ear, but could be heard by the soul. However, on 29 June 2023 it was announced in the press that astronomers had detected a rumbling 'cosmic bass note' of gravitational waves. See, e.g., https://bit.ly/3rcdzTr.
11. See Dodds (1959, 338).
12. Plato *Gorgias* (1925, 457).
13. In 506e Socrates will say that the excellence of *everything* is a matter of regular and orderly arrangement. In *Phaedo* 85e–86d Simmias, who had studied with the Pythagorean Philolaus, discusses the conception of the *psychē* as an incorporeal *harmonia* which arises from the correct attunement and functioning of the parts of the corporeal body.
14. Dodds (1959, 337–338).
15. Translation revised by Hobbs from that of Lamb (1925, 471).
16. Later tradition held him to be a Pythagorean, and that would certainly accord with some of the views attributed to him in the dialogue. It is not known whether or not he was a fictional or historical character.
17. Plato *Timaeus*, 1977.
18. Translation revised by Hobbs from that of Lee (3rd edition 1977), revised by Johansen (2008).
19. As we have seen, Plato makes it absolutely clear at *Republic* 540c (see also *Timaeus* 18c) that there are to be female as well as male philosophers, and indeed Philosopher-Queens as well as Philosopher-Kings.
20. See Hobbs (2000, 221–227).
21. Page 49
22. Page 50.
23. Often thought to be a cover for Plato himself; an alternative suggestion is the Athenian lawgiver Solon.
24. 'Ways' translates *tropous* (accusative plural); a *tropos* can also mean a mode, style, in music.
25. Plato, *Laws*, 1926. Translation revised by Hobbs from that of Bury (1926, vol. 2, 53).
26. Hobbs (2000, 67).
27. Translation by Hobbs. 'Demotic' virtues here refer to the virtues as they are exemplified by ordinary citizens, based on true beliefs, rather than in their highest 'philosophic' instantiation (when they are based directly on full knowledge of the Forms).
28. Plato, *Statesman* (*Politicus*), 1925.
29. Plato, *Protagoras*, 1924. Translation revised by Hobbs from that of Lamb (1924, 143).
30. Translation revised by Hobbs from that of Lamb (1924, 145).
31. The *thumoeides* is said to be the natural ally of the *logistikon* at 440b. For the relation between the two see also Hobbs (2000, 11–12; 16–17; 30–31; 229–230).
32. For eros entailing desire (*epithumia*), see *Symposium* 200a.
33. Hume (1985, 462) 'Reason is, and ought only to be, the slave of the passions' (*A Treatise of Human Nature* III.iii.3).

34. Plato, *Symposium*, 1925.
35. See Nygren (1953, 594).
36. Lesher (2006, 329).
37. See Hobbs (2019, 243–258, especially 250–251). The *de Amore* is in fact only in part a commentary on (certain passages of) the *Symposium*—it is a rich alchemical brew of many different sources on eros—but it is nevertheless infused throughout with Plato's views on beauty, and the connection between beauty, goodness, and well-being.
38. See Price (1990, 247–270), Santas (1988), and Hobbs (2000, 46–49).
39. See Price (1990, 258–270, Hobbs (2000, 46–49).
40. *Pelican Freud Library* (*PFL*) (1991, vii.43); (1991, xii.119); (1993, xv.269). For Freudian sublimation as a reworking of Platonic rechannelling, see *PFL* (1990, xiv.470). See Price (1990, 248 and 250–258).
41. In Freud, eros works away from its original state, whereas in the *Symposium* eros is returning to it. Furthermore, Freud sometimes appears to be sexualizing all love, whereas in the account of the ladder of love in the *Symposium* the priestess Diotima seems to be de-sexualizing even originally sexual love. In Plato, moreover, there is no clear concept of the unconscious. Nevertheless, the emphasis in both Plato and Freud on the essential fluidity of desire and the importance of channelling and re-channelling it rather than simply thwarting it is highly significant.
42. In *Philebus* 51a–e, for example, Socrates claims that the pleasures arising from sights, sounds, and odours are pure, unmixed with the pain of lack, while at *Timaeus* 47a–d sight is praised for helping us see the divine heavens, and hearing for giving us access to harmony.
43. As we have seen, Socrates in the *Republic* advocates strict censorship of what he regards as flawed existing artworks; however, once new works of art are created on philosophically 'correct' foundations in the ideally just state, he is equally keen that there should then be no innovation in artistic style: any change from perfection could only result in deterioration (see *Republic* 424b–c). In the *Laws* 656c–657b, the Athenian Stranger expresses admiration for the unvarying (and morally fine) artistic practices to be found in Egypt.
44. For an incisive analysis of such dangers, see Kenny (1973, 1–27).

References

Barker, A. (1989). *Greek musical writings II: Harmonic and acoustic theory*. Cambridge University Press.

Bury, R. G. (translator). (1926). Plato: *Laws*. Vol. 2. Harvard University Press.

Dodds, E. R. (1959). *Plato Gorgias: A revised text with introduction and commentary*. Oxford University Press.

Hobbs, A. (2000). *Plato and the hero*. Cambridge University Press.

Hobbs, A. (2019). The erotic magus: Ficino's *de Amore* as a guide to Plato's *Symposium*. In J. F. Finamore & T. Nejeschleba (Eds.), *Platonism and its legacy* (pp. 243–258). The Prometheus Trust in Association with the International Society for Neoplatonic Studies.

Hume, D. (1985). E. Mossner (Ed.). *A treatise of human nature* (o.d. 1739–40). Penguin.

Johansen, T. (2008). Revised translation of D. Lee (translator) Plato: *Timaeus* (3rd edition, 1977). Penguin.

Kenny, A. (1973). Mental health in Plato's *Republic*. In A. Kenny (Ed.), *The anatomy of the soul* (pp. 1–27). Oxford University Press.
Lamb, W. R. M. (translator). (1925). Plato: *Lysis, Symposium, Gorgias* (Loeb Classical Library). Harvard University Press.
Lee, D. (translator). (1977). Plato: *Timaeus and Critias*. Penguin.
Lee, D. (translator). (1987). Plato: *Republic* (with an introduction by Melissa Lane 2007). Penguin.
Lesher, J. H. (2006). Some notable afterimages of Plato's *Symposium*. In J. H. Lesher, D. Nails, & F. Sheffield (Eds.), *Plato's* Symposium: *Issues in interpretation and reception* (pp. 313–340). Center for Hellenic Studies, Trustees for Harvard University.
Nygren, A. (1953). *Agape and Eros* (translated by P. S. Watson). University of Pennsylvania Press.
Pelican Freud Library (general editor A. Richards) Vol. vii (1991). *On sexuality*. Penguin.
Pelican Freud Library Vol. xii. (1991). *Civilization, society and religion*. Penguin.
Pelican Freud Library Vol. xiv. (1990). *Art and literature*. Penguin.
Pelican Freud Library Vol. xv. (1993). *Historical and expository works in psychoanalysis*. Penguin.
Plato. (1924). *Protagoras* (translated by W. R. M. Lamb in Loeb Classical Library *Laches, Protagoras, Meno, Euthydemus*). Harvard University Press.
Plato. (1925). *Gorgias* (translated by W. R. M. Lamb in Loeb Classical Library *Lysis, Symposium, Gorgias*). Harvard University Press.
Plato. (1925). *Statesman* (*Politicus*) (translated by H. N. Fowler in Loeb Classical Library *Politicus, Philebus*). Harvard University Press.
Plato. (1925). *Symposium* (trans. W. R. M. Lamb in Loeb Classical Library *Lysis, Symposium, Gorgias*). Harvard University Press.
Plato. (1926). *Laws* (translated by R. G. Bury in Loeb Classical Library). Harvard University Press.
Plato. (1977). *Timaeus* (translated by D. Lee, revised T. Johansen 2008). Penguin.
Plato. (1982). *Philebus* (translated by R. Waterfield). Penguin.
Plato. (2007). *Republic* (translated by D. Lee, with an introduction by M. Lane). Penguin.
Plato. (2010). *Phaedo* (translated by C. J. Rowe in *The Last Days of Socrates* (*Euthyphro, Apology, Crito, Phaedo*). Penguin.
Price, A. W. (1990). Plato and Freud. In C. Gill (Ed.), *The person and the human mind: Issues in ancient and modern philosophy* (pp. 247–270). Oxford University Press.
Santas, G. (1988). *Plato and Freud: Two theories of love*. Oxford University Press.

CHAPTER 5

NIETZSCHE'S HEALING ART OF TRANSFIGURATION

PAUL VAN TONGEREN

Introduction

There is ample reason to contribute a paper on Nietzsche to a volume that deals with the dual domains of (mental) health and aesthetics. Health, for Nietzsche, is always a combination both of mental and physical health, and of personal and cultural health. His writings continuously thematize and reflect on health: it is the primary purpose of his work as a philosopher. The arts, particularly literature, theatre, and music, are among the most important aspects of his thought. I will present 'transfiguration' as a central node in Nietzsche's thought, connecting the arts and health, after briefly outlining the role of these themes in his work.

The Philosopher as a Physician

During his life, Friedrich Nietzsche was a man in poor health. His ailments and infirmities only too frequently made it impossible for him to read and write, forcing him to retire early from his professorship in Basel. His failing health made him into his own physician: not only did he continuously seek those places with the most favourable climatic conditions, but he was also constantly experimenting with dietary regimes, painkillers, and other medicines. He is even reported to have used his doctorate to pretend to be a medical doctor to obtain medication with self-written prescriptions at pharmacies. However, what is more pertinent to us is that Nietzsche says his philosophy is born from and moulded by his suffering (GS, preface 3).

Nietzsche's medical history is undoubtedly one of the explanations for the widespread use of medical terminology in his oeuvre. But even before illness took over his life, his

texts already contained examples of the connection between philosophy and medicine. As early as 1873, he drafted a plan for a book entitled *The Philosopher as a Physician of Culture*' (KSA 7 23[15]), and throughout his writing, he both implicitly and explicitly compares the philosopher with a physician or a doctor. Sometimes this doctor is a psychologist, sometimes a physiologist. In 1886 he writes of a 'philosophical physician':

> I am still waiting for a philosophical physician in the exceptional sense of that word—one who has to pursue the problem of the total health of a people, time, race or of humanity—to muster the courage to push my suspicion to its limits and to risk the proposition: what was at stake in all philosophising hitherto was not at all 'truth' but something else—let us say, health, future, growth, power, life.
>
> (GS, preface 2)

Nietzsche persistently presents his analyses in terms of illness and health: the connection between philosophy and medicine remains a common thread throughout his oeuvre. Nietzsche may have derived this connection from Greek antiquity, with which he was intimately familiar due to his training and work in classical philology. From the pre-Socratic thinkers until Aristotle and onward, philosophy is often related to medical practice. Many of the ancient thinkers were doctors, and medical vocabulary often served as a paradigm for philosophical thinking. Virtue ethics, an important part of ancient Greek philosophy, aims at the flourishing of man and society, and Hellenistic philosophy has rightly been defined as 'a therapy of desire' (Nussbaum, 1994).

When Nietzsche asserts that philosophy should be a medicine for culture, this points to at least two important characteristics of his philosophy: its object is culture, and its way of dealing with culture is a medical one. I will elaborate on the first in the next section and discuss the second first.

The human being is a site in which nature becomes culture. This transitionary state makes humans both the most interesting and the sickliest part of nature. For Nietzsche, being interesting and being sick, or sickly, go hand in hand (cf. GM I, 6 and III, 13). The human being is interesting because of what makes it susceptible to illness, too—being an 'as yet undetermined animal.' Nietzsche is specifically interested in the medical condition of the human being. He is inquiring into its mental and physical condition, its strength and weakness, its suffering and flourishing. The subject of Nietzsche's thinking is this sick culture-producing product of culture. Sickness defines the human being in its transition from nature to culture. Of course, this transition may happen in different ways: but nobody should think that they are not affected by it to some degree. Furthermore, not only those whom Nietzsche criticizes are sick: he considers himself a philosopher precisely because he learned from his own sickness! He is 'physician and patient in one' (HAH II, preface 5). We will see more about this when we go a little deeper into the methodological meaning of Nietzsche's affinity with medical practice.

This dual role, present in Nietzsche's medical vocabulary, relates to Nietzsche's philosophical practice. It helps clarify his relation to his thought, or more precisely, to his way of approaching phenomena. This approach, much like medical practice, has three

aspects: diagnosis, prognosis, and therapy. The most important part—and undoubtedly the part of Nietzsche's 'medical' philosophy that receives most of his attention—is *diagnosis*. Our word 'diagnosis' finds its roots in a combination of the Greek *dia*, meaning 'through,' and *gignooskein*, meaning 'to learn to know.' When engaged in the act of diagnosis, we learn to know what is the case by looking beyond the surface, by looking behind what one sees initially. Nietzsche reads phenomena as if they were symptoms of something behind or underneath them: his philosophy is *symptomatology*. Whoever seeks to interpret symptoms, or phenomena as symptoms refuses to take them at face value or for what they present themselves to be. A doctor takes their patient's complaints as symptoms or signs that may indicate what really is the matter. This symptomatological approach is also characteristic of Nietzsche's critique of other thinkers. He does not address them and their ideas in dialogue, as one person discussing with another, but instead treats them as patients, their ideas as symptoms. 'Indeed, as a physician one might ask: "How could the most beautiful growth of antiquity, Plato, contract such a disease?"' (BGE, preface). What the philosopher sees when they look at human beings or products of culture as symptoms is comparable to what a physician sees: a certain condition of life and a certain type of life. A medical doctor knows as little as anyone about what life 'really' is. But what they do know is whether this particular life is healthy or not. When Nietzsche gives his diagnosis of human culture (its philosophies, works of art, moralities, religions), he evaluates it in terms of its strength or health:

> Every art, every philosophy may be viewed as a remedy and an aid in the service of growing and struggling life; they always presuppose suffering and sufferers. But there are two kinds of sufferers: ... I now avail myself of this main distinction: I ask in every instance, 'is it hunger or superabundance that has here become creative?'
> (GS 370)

This evaluation of life in terms of strength and weakness presents us with another important characteristic of Nietzsche's thinking: as a physician of culture, he is more interested in what produces a healthy life than in what life really is. Or maybe we should say that as a physician, he knows that life *is* a striving for health, growth, and self-enhancement, or as Nietzsche calls it, self-overcoming (see ThSZ II, Tarantulas). And because they know what life is, the physician of culture is interested in how to make it even healthier.

Evaluating health allows us to consider the other aspects of Nietzsche's medical thought, the prognostic and therapeutic aspects. *Prognosis* means knowing what will happen, not through prophetic inspiration but rather by an understanding of the present symptoms and what their possible and probable developments will be. In his *therapy*, he prescribes all kinds of salutary measures, medications, diets, and practices. Besides some more specific prescriptions, he primarily offers therapy through the presentation of the ideal of great health (GS 382) and through anticipatory descriptions of the characteristics of those who realize this ideal (BGE chapter IX).

From a therapist's perspective, Nietzsche does not consider all people to be his patients: 'To the incurable, one should not try to be a physician—thus Zarathustra teaches' (ThSZ III, Tablets 17). Of all the figures Nietzsche stages, Zarathustra has the most therapeutic and educational characteristics. The subtitle of the Zarathustra books proclaims it to be 'A book for all and none.' This expression reminds us of the fact that a *selection* will be made between those who can and those who cannot be healed, although it will be a most peculiar selection: all may try, none will succeed. The explanation of this lies in two related aspects of Nietzsche's thinking. First, he does not select his audience before addressing it—all may try—but he is selective in the way he addresses it. Nietzsche uses all kinds of stylistic techniques to bring about this selection: to challenge the reader not only to read the text but to unravel it, complete it, interpret it, apply it. Only in doing so will the reader see if he or she can meet these requirements. One of the criteria will be whether one does or does not understand that

> there is no health as such, and all attempts to define a thing that way have been wretched failures. Even the determination of what is healthy for your *body* depends on your goal, your horizon, your energies, your impulses, your errors, and above all on the ideals and phantasms of your soul.... [T]he more we abjure the dogma of the 'equality of men,' the more must the concept of a *normal* health, along with a normal diet and the normal course of an illness, be abandoned by medical men. Only then would the time have come to reflect on the health and illness of the *soul,* and to find the peculiar virtue of each man in the health of his soul.
>
> (GS 120)

This passage shows a further aspect of Nietzsche's thinking too, relevant to our purposes here: *there is more than one health*. Nietzsche's therapy at least partly consists of making clear that one has to find, even create, one's own personal health to become healthy. Zarathustra says—ironically alluding to what Jesus said, as recorded in the gospel of John (14:6)—'*the* way—that does not exist' (ThSZ III, Spirit of Gravity 2). And at the end of the first part Nietzsche presents Zarathustra sending away his disciples:

> You are my believers—but what matter all believers? You had not yet sought yourselves: and you found me. Thus do all believers; therefore all faith amounts to so little.
> Now I bid you lose me and find yourselves; and only when you have all denied me will I return to you.
>
> (ThSZ I, Gift-Giving Virtue 3)

There is a last aspect to what I am calling Nietzsche's medical philosophy. If all culture is a symptom of a certain condition of life, then all philosophy, including Nietzsche's own, is a symptom too. Nietzsche is keenly aware of this *self-referential* effect of his thinking. When he describes the development and expression of ideas about itself, life is always either flourishing or degrading. When he calls life 'a means to knowledge' (GS 324), this knowledge is always knowledge that has come from a certain type and condition of life. But life may learn from its own illnesses and use them as a means to

greater health. Such is the case with Nietzsche: forced to be his own doctor, Nietzsche became a physician of culture too. This process also has an inverse parallel: as a critic of the illnesses of culture, he was able to achieve greater health for himself. To discover the sickly life present in philosophical ideas, moral practices, or religious beliefs—all characterized by a tendency to elevate themselves *above* life—is to liberate oneself and gain access to a healthier kind of life and philosophizing. The sickly life will turn out to be the life that denies itself in its ideas about another life. Nietzsche's medical praxis is not only the diagnostics of this pathology but equally the therapeutic practice of attuning his thinking to life. I will return to this in the penultimate section of this paper.

Our Ultimate Gratitude to Art

The other feature implied in Nietzsche's use of medical terminology defines the subject matter of Nietzsche's philosophy. Today we are accustomed to dividing philosophy into different kinds of specialities. We hardly ever do philosophy as such: we do epistemology or ethics or metaphysics or logic and so forth. Although many great thinkers from the past were not as rigid in their delineation as we are today, they still wrote separate works on one or more of these branches of philosophy. One of the difficulties of reading Nietzsche is that each of his books addresses the whole of philosophy. Many scholars have been tempted to reconstruct Nietzsche's epistemology, philosophy of nature, ethics, social philosophy, anthropology, etc. But this becomes misleading, as soon as one forgets that, properly speaking, there is only one subject matter of philosophy for Nietzsche: culture. More precisely, and as we saw in the previous section, his subject is the human being as a product and a producer of culture.

In culture, as humans produce it and as it produces humans, Nietzsche distinguishes different *domains*. Here, some of the well-known disciplines or branches of philosophy return. Nietzsche generally distinguishes four domains of culture: knowledge (philosophy, scholarship, science, and also ordinary consciousness), morality and politics (on the different levels of everyday practice, doctrinal and theoretical discussion, and justification), religion (not only explicitly religious belief but also the many implicit ways in which this belief pervades our culture, even when we no longer consider ourselves religious), and art (music, the visual arts, the rhetorical art of writing and speaking, and foremost the artist as a type of being). In this paper, the focus is on the last domain: art. One might be tempted to compare Nietzsche's division of culture (and of the human being) into knowledge, morality and religion, with Kant's famous suggestion that the three questions of philosophy—What can I know?, What should I do?, What am I allowed to hope for?—are summarized in the question: what is the human being? Still, one should not forget about the differences. First, Kant does not mention 'art' explicitly, although it receives a manner of treatment in his third Critique, *The Critique of Judgement*. And still more important to us: Kant holds that the human being is the emancipated subject that wakes up from its dogmatic dreams and starts to think by itself. In its autonomy, it finds the moral principle through which it can and should have

respect for itself as a rational being. By means of its critical capacity, it leaves space for a rational belief and an appreciation of beauty. Nietzsche, on the contrary, studies these domains from the perspective of the human being that is an 'as yet undetermined animal,' and therefore as an interesting part of nature, though prone to getting sick. The cultural products of knowledge, morality, and religion—even art, to some extent—are studied as symptoms of the ways in which the human being has dealt with its sickness. To some extent, and mainly in his early aphoristic writings, Nietzsche takes art as part of this sickness, but as his own work develops, it increasingly refers to the way in which it may be cured and overcome too.

In almost all of Nietzsche's writings, these four domains of culture are the main targets of his critical analyses, albeit in different and changing ways. In some of Nietzsche's aphoristic books these domains even seem to form the basis of the organization of the text and can sometimes be recognized clearly in the chapter titles—specifically in *Human, All Too Human* and *Beyond Good and Evil*. Among these four domains, art plays a special role. As he starts publishing philosophical texts, it is always one of the most important and most explicit themes. And though it may seem to disappear from view in later works, when it no longer is treated as a separate subject, a closer look shows us that it has, instead, received a different status. Nietzsche's thematization of the different areas of culture is always part of his job as a physician of culture. As we said, diagnoses are most prominent at the start, but the prognosis increasingly gains attention. Art, and especially works of art and artists, were initially scrutinized under the diagnostic analysis of the disease. But his thinking on art expands and opens up, making art available as a creative gaze and way of life and a perspective for recovery. Art holds out the promise of recovery for the domains of religion, morality too, but it most forcefully speaks to philosophy, or, as we shall see hereafter: to the philosopher.

This does not mean that later works contain no criticism of art or artworks, or that art is never a symptom of nihilism. Nietzsche distinguishes between an art that is 'the consequence of the insufficiency of the real' and what he calls 'an expression of *gratitude for the happiness enjoyed*' (KSA 12, 119 2[114]). The first is the negation of existence, the second shows 'the essence' of art: '*Affirmation, blessing, deification of existence . . .* ' (KSA 13, 241 14[47]). In the latter we might recognize what the young Nietzsche wrote about tragedy—let us take a closer look at this therapeutic role art has in Nietzsche's first book, *The Birth of Tragedy* (BT). There, we will encounter the important concept of transfiguration, which returns in the second edition of *The Gay Science*.

Only as an Aesthetic Phenomenon Is Existence and the World Eternally Justified

Of the almost 300 hits 'artwork' gives in the *Kritische Studienausgabe* (KSA), some 80 per cent of the references are in the earliest texts that precede the aphoristic works: more

than half of these are in the *Birth of Tragedy* and the writings and notes directly related to it. This gives at least one good reason to draw attention to these texts first.

Almost without exception, the work of art Nietzsche discusses in these early writings is Greek tragedy. When we read these texts in the framework of our search for the healing power of art, two things stand out in Nietzsche's interpretation. Firstly, as he writes in *Das Griechische Musikdrama* (GMD)—which he did not publish—that tragedy is not about what is done or made as much as it is about what is suffered: 'in Greek drama the accent is on suffering, not on action' (KSA 1, 528). Secondly, Nietzsche takes an unusual position in his considerations. The descriptions are not from the producer's point of view, neither that of the author nor that of the actor. These are 'imitators' or themselves products of the two actual 'artistic energies', 'the Apollinian and its opposite, the Dionysian' (BT 2). 'Only insofar as the genius in the act of artistic creation coalesces with this primordial artist of the world, does he know anything of the eternal essence of art [...] for in this state he is [...] at once subject and object, at once poet, actor and spectator' (BT 5). According to Nietzsche, a work of art is not just a product of the artist. Rather, man *becomes* an artist by allowing himself to be (co)determined in the creation of the work of art by the ingenious-artistic powers.

This is why *The Birth of Tragedy* is directed primarily at the spectator—the real, or the ideal spectator, as portrayed in the chorus (cf. BT 7). Nietzsche combines a traditional position, 'that tragedy arose from the tragic chorus', with 'the idea of A.W. Schlegel, who advises us to regard the chorus somehow [...] as the "ideal spectator"' (BT 7). When he also criticizes this last position (in the seventh chapter of *The Birth of Tragedy*) it is only to avoid that we think of contemporary theatre-goers when we talk about the spectator, and not without reaffirming the criticized thesis at the end of the chapter. In Nietzsche's 'artist metaphysics' the artist is primarily a spectator—and a listener. I will return to this difference between watching and listening and its importance for the physicality and the healing power of the aesthetic experience in the final section.

The chorus' ideal spectator brings the real spectator into a state of 'Dionysian excitement' (BT 8), so to speak, thereby showing how to view the drama. At least that corresponds to what happens in the tragedies of Aeschylus and Sophocles. Nietzsche holds that tragedy starts dying by Euripides' doing: his tragedies no longer employ drama to elevate the spectator to the ideal, but instead bring the contemporary spectator onto the stage, lowering the ideal to contemporary everyday life (cf. BT 11). The choir teaches its audience how to look at things properly: to not just passively watch, but to be touched and excited by this looking. This is not a passive watching, but being touched and excited in a way that evokes creativity. Nietzsche says that we 'must understand Greek tragedy as the Dionysian chorus which ever anew discharges itself in an Apollinian world of images' (BT 8). The spectators in the tragedy become both manufacturer and manufactured, creator and creation. They are manufactured in the sense that, being intoxicated, they become 'a creation of the artist Dionysus' (KSA 1, 555); at the same time, they become creative manufacturers because, theatrically dreaming, they produce this dream while knowing or otherwise suspecting that it is just a dream.

For Nietzsche, the chorus is the place where a perspective that has 'looked boldly right into the terrible destructiveness of so-called world history as well as the cruelty of

nature' is turned 'into notions […] with which one can live' (BT 7). In a language that he will later criticize, Nietzsche calls the chorus the instance of a 'metaphysical comfort': 'that life is at the bottom of things, despite all the changes of appearances, indestructibly powerful and pleasurable, this comfort appears in incarnate clarity in the chorus of satyrs' (BT 7).

This way of looking, then, is a 'transfiguring' one: it shows the terrors of fate, the absurdity of existence, and the 'necessity of the sacrilege' (BT 9) as something that can nevertheless be affirmed. The spectator sees his life (with its accompanying absurd suffering and foolish sacrilege) in a transfiguring light. In this way, the tragic work of art made the Greek transformation of 'the dreadful or absurd nature of being human' possible: it enabled them 'to see existence as it is in a transfiguring mirror' (KSA 1, 560).

In his 'Attempt at Self-Criticism', added to the new edition of *The Birth of Tragedy* as a preface in 1886, Nietzsche criticized his first work as romantic idealism. But the original text of 1872 does not present the tragic work of art as an ideal world, in whose name the real world is denied. The justification of existence 'as an *aesthetic phenomenon*' (BT 5) does not negate reality: it does not reduce it to a mere appearance on behalf of 'the true world'. On the contrary: Nietzsche speaks of the 'demotion of appearance to the level of mere appearance' (BT 4). Tragedy shows the absurdity of fate precisely in the tragic heroes—even the gods are subject to fate! It is this absurdity of fate that is shown as appearance: 'The terrible or the absurd is uplifting because it is only apparently terrible or absurd' (KSA 1, 570). This 'only' should, however, not be misunderstood: it is not opposed to a true world.

For Nietzsche, this making visible of the appearance of appearance also portrays a fundamental difference between tragedy and myth on the one hand and religion's claim to 'some alleged historical reality' (BT 10) on the other. Tragedy and myth recognize the appearance of their images, while religion assumes a true world. Religious theodicies explain outrage and evil by attributing the meaning of a higher order to them—but in doing so, Nietzsche holds that it misjudges the reality of evil. Myth, on the other hand, recognizes evil absurdity by elevating them to a mythical figure and thereby showing it as appearance—even a beautiful appearance.

Using 'appearance' in this way may be misleading, not least in light of how the term functions in Schopenhauer's metaphysics. Nietzsche's 'appearances', however, should not be understood metaphysically, but aesthetically; not as opposed to truth, but as referring to another (namely beautiful) mode of appearance. The tragic work of art enables the affirmation of the absurd existence by teaching the human being to view it in a certain way: as a sculpture allows us to see stone and statue at the same time, so tragedy shows us the absurdity of existence in a beautiful form—and does so without forgetting or denying the absurdity. It is akin to 'when one is dreaming and at the same time senses that this is a dream. So the servant of Dionysus must be intoxicated and at the same time lie in wait behind him as an observer' (KSA 1, 555).

Nietzsche also engages Heraclitus' thoughts on becoming and passing away, remarking that '[o]nly the aesthetic person views the world in this way, the one who has learned from the artist and the creation of the work of art how the conflict of multitudes

can carry law and justice in itself, how the artist is contemplative about and working in the work of art, how necessity and play, conflict and harmony must be paired to create the work of art' (KSA 1, 831). Tragedy taught the tragic Greeks a second, and substantially different way to look at reality, providing a view that could show the beauty of reality without denying its absurdity. For the Greek, 'existence and the world [could be] eternally justified', that is: 'as an *aesthetic phenomenon*' (BT 5).

Transfiguration

In the fourth section of *The Birth of Tragedy*, Nietzsche introduces the term 'transfiguration' when he describes and interprets Rafael's famous last painting—Rafael, who as 'one of these immortal "naïve" ones' was equated with another 'naive artist': Homer. In his last and unfinished picture, the *Transfigurazione del Signore*, the painter gives a visual representation of what Nietzsche holds to be essential to tragedy: the 'necessary interdependence' of Apollo and Dionysus, linked in a way that makes affirmation possible. In order to recall Rafael's painting and Nietzsche's interpretation, I cite the relevant passage:

> In his *Transfiguration*, the lower half of the picture, with the possessed boy, the despairing bearers, the bewildered, terrified disciples, shows us the reflection of suffering, primal and eternal, the sole ground of the world: the 'mere appearance' here is the reflection of eternal contradiction, the father of things. From this mere appearance arises, like ambrosial vapor, a new visionary world of mere appearances, invisible to those wrapped in the first appearance […]. Here we have presented, in the most sublime artistic symbolism, that Apollinian world of beauty and its substratum, the terrible wisdom of Silenus; and intuitively we comprehend their necessary interdependence.
>
> (BT 4)

The difference with the (no longer naïve) art of tragedy is that tragedy connects the separated parts even if they are 'necessarily interdependent', whereas the separation remains a feature of the painting. There is no separation of the 'Apollinian world of beauty' on the one hand and the Dionysian 'primal and eternal suffering' on the other: the Dionysian world of pain and absurdity itself is presented as a beautiful appearance in the figure of the divine hero. Let's investigate how Nietzsche reaches this interpretation.

In the previous section, I showed the importance of the spectator in Nietzsche's description of tragedy and indicated that the conjoining of Apollo and Dionysus takes place by means of the spectator. In a sense, the spectator becomes the artist, and the artist shows themselves as a spectator.

Rafael's painting now shows a similar figure. It depicts a complicated story from the gospel (cf. Mark 9, Matthew 17, and Luke 9): Jesus selects three of his disciples to

accompany him to the top of the mountain, where he will appear transfigured and glorified. Meanwhile, the other disciples are desperate: they are harassed by miserable people who beg, in vain, for them to heal a possessed boy. Depictions of this gospel narrative have consistently shown the stark contrast between the glorious situation on Mount Tabor and the horrific situation in the valley below. This often caused these paintings to appear disjointed, falling apart in two disparate parts.

Rafael elevates this contrast into mutual dependency, and does so in three ways. First, he shows that at least one of the apostles who remained below points to the chosen ones and seems almost to touch them. Second, he portrays the chosen apostles as being so blinded by the transfigured Lord that they have to avert their eyes, thus seeing less of the glorified Lord and more of the misery in the valley. Third, and most importantly, two figures are added to the biblical narrative—an unusual move on Rafael's behalf—placed in the painting's centre field, between the other two scenes. These two figures seem to observe both the valley and the mountain scene without difficulty. One of the onlookers has his hands raised in prayer, the other stretches out his hands in devotion, and together these spectators solidify the unification of the painting's disparate elements. Where the figures in the lower world do not perceive the transfiguration and are caught up in their misery; and the chosen apostles on the mountain are so struck by the vision that, (as Peter suggests) they want to raise tents and stay there forever—Rafael shows us the connection between both worlds. Jesus is no longer the only one transfigured, while his chosen disciples look on: the spectator's vision of the misery of ordinary life is transfigured into bliss at the same time. And this transfiguration not only takes place within the picture, in the painted spectators, but it is external to the painting too, that is: it takes place in the spectator who views the painting and experiences a sense of reconciliation.

In the *Twilight of the Idols*, in a text about the psychology of the artist that includes several aphorisms ('Skirmishes of an untimely man', 8–10), Nietzsche writes about this procedure, shortly before he again cites Rafael as an example: 'This *having to* transform into perfection is—art' (TI, Skirmishes. 9). Similarly, in the preface to *The Gay Science* he writes: 'This art of transfiguration *is* philosophy.' In this latter text, he is pointing to his own path through illness and recovery and to how he necessarily kept 'transposing his states every time into the most spiritual form and distance' (GS preface 3).

Physician and Patient in One

'The most peculiar product of a philosopher is his life, it is his work of art and as such it is directed towards both the one who created it and the other people' (KSA 7, 804 34[37]). Whether this is true or not in general, the best way to learn about Nietzsche's medical philosophy is to look at his own history of illness and recovery, which he reports in one of his autobiographies. I am not referring to *Ecce Homo* but instead to the autobiography that we find in the prefaces Nietzsche wrote around 1886. I will briefly introduce these prefaces.

After having finished his *Thus Spoke Zarathustra*, Nietzsche considered it his most important work. In this book, the experience of the eternal return is most fully expressed and to some extent even 'realized'. This idea of the eternal return was, according to Nietzsche, the highest thought humankind ever could reach. After having completed this book in 1885, Nietzsche looked back at his development up to that point. He felt the need to gather his life as a story of which this book was the plot, with the newly reached insights as this story's pinnacle. For this reason, though he also wanted to move to another publisher and wanted to prepare new editions of his previous books, he reread his own works and wrote new prefaces for almost all of them. We find these new prefaces in *The Birth of Tragedy*; *Human, All Too Human*, volumes I and II; *Daybreak*; and *The Gay Science*.

These prefaces should not only be read in connection with the works they preface but also in relation to each other; they are intimately bound together as an intellectual autobiography. In these texts, Nietzsche describes his development as one of illness and cure. The preface to the first volume of *Human, All Too Human* presents this history as the development of the so-called free spirit. The preface to the second volume of *Human, All Too Human* repeats the story, but now as Nietzsche's own development. It describes how Nietzsche became a 'physician and patient in one' (HAH II, preface 5). He learned to be a philosopher for himself (KSA 7, 715 29[213]) and expresses the presumption that this experience was not just a personal one (HAH II, preface 6). The preface to *The Gay Science*, finally, looks back on the development from the point of view of one who has acquired health, and confirms that it was the precondition for the philosophical task to which Nietzsche feels he was called and prepared.

The illness seems to consist of discomfort about life. Nietzsche himself started his intellectual life as a romantic who despised his age and took refuge in a world, located beyond the confines of the earthly domain (BT preface). But his discovery of the unreality of this other world only served to aggravate his discomfort and thereby his illness, as did the unmasking of the imagined heroes of and guides to this other world. Nietzsche became disappointed in the persons he initially thought could save culture: Arthur Schopenhauer and Richard Wagner. This disappointment taught him to be suspicious of every ideal. And this suspicion, itself initially a manifestation of the illness (that is, the conviction that nothing is truly worthwhile or reliable), is also the turning point after which the recovery starts. By becoming suspicious of everything, one discovers the capacity to leave all bonds and commitments behind. What is experienced as a loss on the side of illness becomes liberation on the side of the cure. But this is only the beginning of the process of recovery. The deliberate self-liberation from all bonds leads to a solitude which, in turn, forms a new threat to health. One has to learn not only to liberate oneself from all ideals but also from the ideal of complete freedom; not only to free oneself from all deceptive beliefs, ideas, and ideals but also to use them as possible interpretations; not only to unmask all lies but also to lie and wear masks oneself. This is the acknowledgement of perspectivism, the realization that one's perspective determines all knowledge. It is the final condition for attaining full health.

It is not, then, unexpected when we find Nietzsche's description of his task, the task of renewing a tragic philosophy, in this philosophical autobiography in the new prefaces:

after all, this is where he is describing his personal and philosophical development. His philosophy experiments with his personal life, which simultaneously reaches far beyond the private–personal. It is at once personal *and* general because it does not *talk about* what one should do to make one's life a work of art, but it *presents* how life becomes a work of art. Philosophy becomes art, or what is essential to art: what Nietzsche calls 'transfiguration'. It is in this sense that art is no longer just one of the cultural domains alongside religion, morality, and philosophy, but also presents (or is expected to show in the near future) the semblance of a sane, non-pessimistic, non-nihilistic philosophy (and, perhaps, even such morality and religion).

To be therapeutic, philosophy has to be art, has to do in its own way what art does in its essence:

> [T]he essential thing about art remains its perfection of existence, its creation of perfection and fullness / art is essentially *affirmation, blessing, deification of existence* ... [...] There is no such thing as pessimistic art [...]. Art affirms. Job affirms'
> (KSA 13, 241 14[47])

That Nietzsche cites Job, the main character of a religious-moral story from the Old Testament, as an example of art confirms what I wrote before, namely that there can also be a creative morality and religion.

As we have seen through our investigation of tragedy, art achieves the fulfilment of existence not by veiling the horrible or relativizing it from the safety of an ideal point of view (the horrible would then, after all, be confined to the here and now, but not be able to reach beyond it), but by allowing another, second look, in which it appears as beautiful. Nietzsche recognizes this possibility even in allegedly pessimistic writers: 'There is no pessimistic art. Art affirms. Job affirms. But Zola? But de Goncourt?—the things they show are ugly: but *that* they show them is out of lust for the ugly ...' (KSA 13, 241 14[47]).

This art consists in seeing the ugly as beautiful, not by denying it, but by first becoming a spectator, learning to enjoy it as a spectacle, and thus becoming a beautifying artist. The Greeks were able to do this. 'They knew how to *live*. What is required for that is to stop courageously at the surface, the fold, the skin, to adore appearance' (GS, preface 4).

A philosophy that conceives of these Greeks as its model will not seek a true world beyond or beneath this surface, no meaning behind suffering, no justifying function of evil. On the contrary, it will accept suffering and evil as material and experiment for the knower. Only those who understand this art and, in this sense, know how to see the ugly as beautiful can avoid that ugliness makes us 'bad and gloomy' (GS 290).

At the beginning of the fourth book of *The Gay Science*, Nietzsche formulates his project 'for the new year':

> I want to learn more and more, to see as beautiful what is necessary in things; then I shall be one of those who make things beautiful. Amor fati: let that be my love henceforth! (GS 276).

This citation does not bear witness to a private, personal project only, but to a philosophical programme too: the programme of a philosophical art of living. This programme, of which the end says that 'some day I wish to be only a Yes-sayer', seems to clash with what Nietzsche wrote in *Ecce Homo*, speaking of 1885. There, we read that '[t]he task for the years that followed now was indicated as clearly as possible. After the Yes-saying part of my task had been solved, the turn had come for the No-saying, *No-doing* part' (EH, Beyond 1). But this apparent clash dissipates on closer inspection: Art's yes-saying consists, among other things, in attacking and eliminating the metaphysical (i.e., romantic, pessimistic, idealistic) denial of the reality of suffering, evil, and ugliness. It is not blind for suffering and ugliness, nor does it deny them: it transforms it—it is an art of transfiguration.

From an 'Art Before Witnesses' to 'the Music of Forgetting'

This healing art of transfiguration experiences an important development in another text from the same period: the fifth book of *The Gay Science*, which was also added to the new 1886 edition of this book, just like the preface from which we retrieved the term 'transfiguration'. As I argue more extensively elsewhere (Van Tongeren, 2016), the second half of this fifth book, clearly more 'personal' than the rest, presents the search for health as the question of how we can live under the unavoidable conditions of nihilism.

Once more, we find Nietzsche engaged in a critique of ideals, performing analyses in which his 'eye grew ever sharper for that most difficult and captious form of *backward inference*, […] from the ideal to those who *need it*' (GS 370). But he feels that this also applies to himself. Although he has sworn off 'all ideals that might lead one to feel at home even in this fragile, broken time of transition' because 'we do not believe that they will *last*' (GS 377), this brings him to the difficult situation of a homeless person. In GS 372, he even asks himself why 'we' are not rather idealists, and he suspects an illness to be the reason. In GS 375, he speaks of the dangers of the 'disappointed idealist'. Part of the danger resides in not seeing how this homeless existence is itself driven by ideals. In GS 377, while distancing himself from the ideal of humanity (or the 'love of humanity'), he doubts the very ideal of 'truth' and ultimately openly admits that he, too, is guided by a 'faith'. He shouts at those on a similar journey to his: 'and when you have embarked on the sea, you emigrants, you, too, are compelled to this by—a *faith*!'

The climax of this confrontation with the ideal can be found in the last aphorism before the epilogue: GS 382, entitled 'The great health'—in which the word 'ideal' occurs eight times. It is here that Nietzsche sketches the outlines of his own ideal. It is the ideal of one whose soul 'craves to have experienced the whole range of values and desiderata to date, and to have sailed around all the coasts of this ideal "Mediterranean"', the ideal

of the one who knows by experience how all 'conquerors and discoverers of the ideal […] of the old style' feel. His ideal is the ideal of the 'great health', or 'the ideal of a human, superhuman well-being and benevolence'. However much it may be called 'another ideal', and perhaps even appear to be a 'parody' of previous ideals, it cannot avoid being an ideal once more.

We also find art and artists featuring explicitly and prominently in this second half of the fifth book. The words 'art', 'artist', 'artificial' etc., are used up to four times more often in the second half. More importantly, music doesn't appear at all in the first half, while it is mentioned no less than twenty-eight times in the second half.

Here, art appears differently from how it appeared in the earlier works, and in ways comparable to how the broader domain of culture still appears: in most cases, art is no longer a patient to be diagnosed (although we do still come across that notion in some sections), but now offers a perspective of recovery. We find this illustrated when he asserts 'that we are virtuosos in contempt': 'refined contempt is our taste and privilege, our art' (GS 379). At the end of that text, he writes that 'we' love art which 'is the artist's escape from man, or the artist's mockery of man, or the artist's mockery of himself …'. Nietzsche seems to refer to an art in which the artist mocks himself or forgets himself; he is pointing to an art of forgetting. In this second half of the fifth book of *The Gay Science*, I presume that Nietzsche is looking for recovery from his own (and thus also culture's) illness by means of art, especially through the art of music. I want to suggest that it is music that allows for a further step in the development of Nietzsche's healing art of transfiguration.

Looking back at what Nietzsche wrote about transfiguration in *The Birth of Tragedy*, we might have been surprised to see that this early Nietzsche, who was already so fiercely interested in music, nevertheless interpreted tragedy, which he presented as born from music, using such a strong visual framework, i.e., as a spectator-art and as a drama.

The visual arts can transfigure reality; they do so through representation. They help us to see reality as beautiful. This artistic way of (re)presenting the reality of suffering and ugliness as beautiful remains bound to what Nietzsche describes as 'the whole pose of "man *against* the world"' or 'the sublime presumption of the little word "and"' in the expression 'man and world' (all citations from GS 346, where Nietzsche explains that even the critic of nihilism might still be caught in what he criticizes). But the philosophical physician of culture who has discovered that he has to be his own physician is after a more radical transfiguration. And while he took the concept of 'transfiguration' from the visual arts and applied it first to theatre, he finally seems to acknowledge that music enables us to transform and transfigure life.

It is in GS 367 that we read:

> I do not know of any more profound difference in the whole orientation of an artist than this, whether he looks at his work in progress (at 'himself') from the point of view of the witness, or whether he 'has forgotten the world', which is the essential feature of all monological art; it is based *on forgetting*, it is the music of forgetting.

Rafael's picture makes it clear that transfiguration in visual arts is still an 'art before witnesses': the transfiguration takes place in the two (supplemented) eyewitnesses. Of course, in GS 367, Nietzsche suggests that the two types of art he differentiates (monological art and art before witnesses) are present in all areas of art, that is, concerning 'all thought, written, poetry, painting, compositions, even buildings and sculptures'. Furthermore, this 'art before witnesses' is linked to the stage-actor, whom Nietzsche regularly criticizes in the fifth book. But could this also be an instance in which Nietzsche is trying to distance himself from visual art? In this text, he not only transitions from art before witnesses to monological art but also 'from the *view* of the witness' to a '*music* of forgetting' (my emphases). Not only is the spectator forgotten in the latter, but the distance between the actor and the spectator is also overcome.

Music and dance transfigure us more directly than visual art ever could. In the following aphorism, immediately after the 'music of forgetting', Nietzsche writes:

> What is it that my whole body really expects of music? I believe, its own *ease*: as if all animal functions should be quickened by easy, bold, exuberant, self-assured rhythms; as if iron, leaden life should be gilded by good golden and tender harmonies. My melancholy wants to rest in the hiding places and abysses of *perfection*: that is why I need music. What is the drama to me!
>
> (GS 368)

Conclusion

In a philosophy that music reflects as the art of transfiguration, life is no longer *viewed as* beautiful, no longer interpreted, construed, but *experienced*, felt with the sensuality of the 'music of life' (GS 372) in which the subject is forgotten and leaves all idealism behind. And might this not also be a fruitful background against which to read Nietzsche's oft-cited words that '[w]ithout music, life would be an error' (TI, maxims, 33)?

References

Nietzsche, F. (BGE). (1966). *Beyond good and evil*. Translated from German by W. Kaufmann. Random House, Inc.

Nietzsche, F. (BT). (1967). *The birth of tragedy* and *the case of Wagner*. Translated from the German by W. Kaufmann. Random House, Inc.

Nietzsche, F. (EH). (1989). *Ecco homo*. Translated from German by W. Kaufmann. Vintage Books.

Nietzsche, F. (GM). (1989). *On the genealogy of morals*. Translated from German by W. Kaufmann and R.J. Hollingdale. Vintage Books.

Nietzsche, F. (GS). (1974). *The gay science*. Translated from German by W. Kaufmann. Random House, Inc.

Nietzsche, F. (HAH). (1986). *Human, all too human*. Translated from German by R. J. Hollingdale. Cambridge University Press.

Nietzsche, F. (KSA). (1980). *Sämtliche Werke*. Kritische Studienausgabe in 15 Bänden. DTV/W. de Gruyter (all quotations from KSA in my translation, P. v. Tongeren).

Nietzsche, F. (ThSZ). (1982). *Thus Spoke Zarathustra*. In *The portable Nietzsche*. Translated from the German and edited by W. Kaufmann, 103–439. Viking Penguin Inc.

Nietzsche, F. (TI). (1982). *Twilight of the Idols*. In *The portable Nietzsche*. Translated from the German and edited by W. Kaufmann, 463–563. Viking Penguin Inc.

Nussbaum, M. C. (1994). *The therapy of desire. Theory and practice in Hellenistic ethics*. Princeton University Press.

Van Tongeren, P. (2016). Die "Musik des Vergessens" und das "Ideal eines menschlich-übermenschlichen Wohlseins und Wohlwollens". Über Nihilismus, Transfiguration und Lebenskunst bei Nietzsche. *Nietzsche-Studien 45*, 143–157.

CHAPTER 6

JOHN DEWEY'S AESTHETIC THEORY AND MENTAL HEALTH

THOMAS LEDDY

INTRODUCTION

'MENTAL health' does not appear in the index of Dewey's *Art as Experience* (Dewey, 1989) (nor have I ever seen it in the index of a reference work on Dewey), and yet Dewey had a long-standing interest in psychology before writing on aesthetics. (See Hildebrand, 2023, Chapter 2 Psychology.) Also, his deep commitment to education and democracy entailed a concern to promote human flourishing, or happiness, which, in turn, is thought by many to be the goal of mental health (for example, Anonymous 2019). Moreover, his theory of aesthetics is not narrowly concerned with 'high art' experiences but is directed to experience in general, including everyday non-art experience. In this regard, he has had enormous influence on the emerging field of Everyday Aesthetics (Leddy, 2012; Saito, 2021). Dewey's idea of 'an experience', as developed in *Art as Experience,* can be seen as an ideal of experience. What he also called 'integral experience' involves consummation, which is closely related to flourishing. So one could say that, for Dewey, not only art but aesthetic experience overall is conducive to mental health.

In philosophy, moral theory is usually given the task of dealing with human flourishing. But Dewey considers the influence of moral theory as insignificant in comparison to that of the arts on life (Dewey, *Art as Experience* [henceforth AE], 348). He further observes that even politics and economics cannot secure a rich and abundant life without the flourishing of the arts. If we take the arts to be the tip of the iceberg of aesthetics, which also includes the aesthetics of nature, design, human form, animal form, conversation, and a multitude of other things, then it is even more true that positive aesthetic experience provides a basis for human flourishing and hence mental health. One

should also bear in mind that 'mental health' not only refers to the efforts we take to deal with the major mental diseases of suicide, depression, psychosis, schizophrenia, bipolar disorder, and dementia, but also to deal with more universal forms of mental disturbance or discomfort such as mild depression, melancholy, mourning, anxiety, various phobias, hysteria, and compulsive disorder. Dewey's philosophy can say little about the first group, although pragmatists are generally sympathetic to scientific approaches to such problems. His main relevance is to the second.

Although the literature on Dewey, aesthetics, and mental health is not extensive, there has been some fruitful work amongst those who combine Dewey's theory of art and his theory of education, and this is relevant to the extent that education has as its goal the flourishing of its students. This will be discussed in the sections on education and, more narrowly, art education, following. Similarly, the literature on art therapy often refers to Dewey. Drachnik, for instance, sees both Freud and Dewey as 'the main catalysts of the child study movement', which he associates with art therapy (Drachnik, 1976). More recent writers (de Botton & Armstrong, 2013; Samaritter, 2018) have also mentioned Dewey in connection with the ideas of art therapy. However Ruitenberg (2016), who opposes a 'life-hack' approach to art, 'where the practical utility of "repurposed" works offers redemption for purported uselessness', (Ruitenberg, 2016, 101) argues that de Botton and Armstrong's theory and practice take us away from the aesthetic experience itself.

In this chapter I will consider not only Dewey's actual theory but the developments of his followers, as many of these have extended his ideas in a way that can be helpful for the theory of mental health.

Dewey and Freud

Although Dewey hardly ever referred to Freud, or Freud to Dewey, they were near contemporaries and were deeply influenced by many of the same historical figures, especially Darwin. Both were prolific writers who covered a wide range of topics. Both were rationalists and naturalists critical of traditional religion. Both were concerned with the betterment of humankind achieved equally through science and the humanities. Freud's direction was more to the individual, Dewey's more to the social (Levitt, 1960, 174).

In his rather old (but nearly unique) book comparing the two thinkers, Morton Levitt found similarities in their dynamic psychological systems, as well as in their views on instinct, transference, symbolism, and sublimation (Levitt, 1960, 142). (See also, Feuer 1960.) He concluded that their understanding of the nature of man was complementary rather than opposing (Levitt, 1960, 173). However, Karier (1963), in response, believed that the differences were greater than the similarities, seeing Freud as an authoritarian rebel and a pessimist in contrast to Dewey as a democratic revolutionary and optimist. In a more recent study, Seckinger and Nel observe that Dewey thought that Freud and his followers reified the concept of the subconscious mind, and that this led to a series

of false dualisms, such as between the life and death instincts (Seckinger & Nel, 1993, 4). They also note Dewey's belief that human nature was much more flexible than allowed by the Freudian notion of instinct: his 'modern man is a pragmatic and sociable optimist [while] Freud's man or woman, in contrast, knows there is a severe psychic price to pay for uprooting the human being from his or her traditional patterns of family and community life' (Seckinger & Nel, 1993, 3) Similarly, Hohr (2010) observes that, whereas Dewey is optimistic about cognition, Freud is more concerned with destructive impulses of the emotions. And yet Dewey seemed aware of the psychic price of civilization insofar as he was critical of contemporary society and was praiseful of the primitive societies who followed traditional patterns of behaviour, suggesting a utopia in which a return to happiness, much like one find's in Marx's theory of alienation resolved in revolution, would be possible. Also, as we shall see in our discussion of art as expression, Dewey, like Freud, gives a significant role to unconscious processes.

A Freud–Dewey 'dialogue' continues. For instance Brendel (2006) argues for an application of pragmatism, including Dewey, to psychiatry. Unfortunately he does not discuss aesthetics. Colapietro (2006), finding many similarities between pragmatism and Freudian psychology, argues that '[f]or pragmatism no less than for psychoanalysis, human experience and action are not explicable solely in reference to conscious, voluntary agency' (Colapietro, 2006, 197). As he puts it, 'like psychoanalysis, pragma be seen as a protracted attempt to come to more honest terms with the actual co. of human existence, including the finite character of the human mind' (Colapietro, 2006, 197). He adds that pragmatism shares with Freud 'a refusal to equate mind with consciousness' (Colapietro, 2006, 200). Casey Haskins, a Dewey scholar, observes, in connection with a mention of Freud, that Dewey's is 'a vision of Art as a place to go when life gets to be too much or when it is not enough, a place where our historically persistent need to imaginatively create, recreate, and criticize experience as we know it is allowed, as Kant almost said, free play' (Haskins, 1992, 242).

Laura McMahon ties mental health and Dewey in this way: 'If the self is what it is only in a systemic relationship with its environment or world, then how should we understand the nature of healthy and unhealthy behaviours on the part of the individual? The answer … should be sought in identifying self-environment equilibria that promote… the intrinsic tendency toward growth and development on the part of the living being' (McMahon, 2018, 613). McMahon is worth quoting at length here even though she seems only aware of Dewey's early writings in educational theory. The framework she describes can, in itself, justify the writing of this chapter.

As she says, 'we should understand healthy human existence in terms of the manner in which this open-ended power of plasticity is promoted by the systematic interaction between self and environment. A healthy self-environment system enables the individual to be open to his or her own self-transformation through further growth. This growth enables the constitution of a rich, expansive environment, which in turn calls forth the further development of powers on the part of the individual. Healthy human existence is characterized by an increased capacity on the part of the individual to recover in the face of shocks to the environmental system, not by "bouncing back" to one's

former equilibrium but by adapting to new circumstances through the accommodation of new norms and, with these, the establishment of a new equilibrium with the environment.' (McMahon, 2018, 614). Dewey would only add from the standpoint of art as experience that this healthy capacity to achieve new accommodations and equilibriums can be enhanced both by creative making and appreciation in the arts.

Educational Theory

Before turning to discussion of Dewey's aesthetics we should briefly address his educational theory in relation to mental health. In 1900, Dewey delivered a paper to a group of psychologists on the issue of the relation of mental health to the arts and arts education. In it, he asked, 'But is there anything with which the teacher has concern that is not included in the ideal of physical and mental health? Does health define to us anything less than the teacher's whole end and aim?' (Dewey, 1900, 116). His answer was that: 'A wrong method of teaching reading, wrong I mean in the full educational and ethical sense, is also a case of pathological use of the psychophysical mechanism.' He further argued that, '[a] method is ethically defective that, while giving the child a glibness in the mechanical facility of reading, leaves him at the mercy of suggestion and chance environment to decide whether he reads the "yellow journal", the trashy novel, or the literature which inspires and makes more valid his whole life.' He then asked 'Is it any less certain that this failure on the ethical side is repeated in some lack of adequate growth and connection in the psychical and physiological factors involved?' (Dewey, 1900, 116). In short, he believed that wrong education leads to aesthetically bad consequences, whereas right education is conducive to mental health and development. Moreover, from others of his writings on education we find that Dewey saw practice in the arts as an important part of schooling. The very idea of 'learning by doing', so associated with Dewey's educational theory, encourages the incorporation of art making into the progressive classroom.

Art Education

Closely related to educational theory is art education theory. Many consider Dewey the leading theorist and promoter of art education (English & Doddington, 2019; Goldblatt, 2006; Nakamura, 2009). In *Democracy in Education* (Dewey 1980) Dewey includes 'aesthetic taste', which he understands as the capacity to appreciate artistic excellence, as one of the goals of education. For the sake of this chapter, I associate happiness with mental health (Anonymous, 2019). For Dewey, the goal of happiness can only be found through finding one's proper calling: 'To find out what one is fitted to do and to secure an opportunity to do it is the key to happiness. Nothing is more tragic than failure to discover

one's true business in life, or to find that one has drifted or been forced by circumstance into an uncongenial calling. A right occupation means simply that the aptitudes of a person are in adequate play, working with the minimum of friction and the maximum of satisfaction' (*Democracy and Education*, 360) Later, Dewey wrote, 'The moments when the creature is both most alive and most composed and concentrated are those of fullest intercourse with the environment, in which sensuous material and relations are most completely arranged' (AE, 109). As Nakamura observes, 'When emotion is transformed into a sense of meaning, the quality of the emotion is enhanced as appreciation of value. This enhancement leads to a refinement of personality' (Nakamura, 2009, 431).

Recently we have been hearing about the success of programmes in Iceland to get teens off drugs. One of the methodologies has been to encourage young people to participate in the arts. Here, personal and social well-being comes into play in a Deweyan manner (Young, 2017).

Toward a Better-Ordered Society

As mentioned earlier, Dewey's aesthetics have a utopian side, one that would entail greater human flourishing and mental health (Freeman-Moir, 2011). He writes that 'In a better-ordered society than that in which we live, an infinitely greater happiness than is now the case would attend all modes of production' (AE, 87). A better-ordered society would be one not dominated by capitalism. He further argues that, although there is a lot of organization in our world today, this organization is not conducive to a growing experience that leads us to fulfilment. This goal can be assisted by art, particularly art as enjoyed by the community (AE, 87). He goes so far as to argue that art is an extension of rites and ceremonies, and that all three contribute to uniting men through shared celebration (AE, 275): Art 'renders men aware of their union with one another in origin and destiny' (AE, 275). In sum, art is conducive to a collective life in a better-ordered society, and hence conducive to mental health.

Aesthetic Experience: An Experience and Expression

The most relevant material on mental health in Dewey's aesthetic theory is contained in his notion of 'an experience', as developed in *Art as Experience*. While discussing experience generally, Dewey has an ideal, which he calls '*an* experience' or, as mentioned earlier, 'integral experience'. '*An* experience' has a beginning, middle, and end. It is an organic whole. Its end is not just an ending but a consummation. A famous example of 'an experience' he gives is a meal in a fine restaurant which sums up all that a meal

can be. However any experience that has a unity and a pervasive quality, for instance solving a problem with one's car, can count as an integral experience. Dewey contrasts 'an experience' to 'inchoate experience', which is disorganized in the sense of not having any organic unity. An example would be working on an assembly line, since there is no consummation in such an experience. He implies that an important goal in life is to have *more* integral experiences and *fewer* inchoate experiences. Art gives us integral experiences, and this is much of its value. He also believed that art is instrumental not in serving narrow purposes but in helping us to achieve serenity of mind and a 'refreshed attitude' about ordinary experience (AE, 144).

Expression

Dewey saw art as expression. Insofar as self-expression is conducive to the mental health of the artist, art can be seen as conducive to mental health. As he puts it, 'Many a person is unhappy, tortured within, because he has at command no art of expressive action' (AE, 71). Moreover, as with Freud on dreams and hysteria, Dewey understands the creative process as emerging dynamically from the unconscious, saying that '[m]aterials undergoing combustion because of intimate contacts and mutually exercised resistances constitute inspiration.' Elaborating on this, he says that, on 'the side of the self, elements that issue from prior experience are stirred into action in fresh desires, impulses, and images. These proceed from the subconscious... fused in the fire of internal commotion. They do not seem to come from the self, because they issue from a self not consciously known' (AE, 71). Moreover, the initial inspiration is confused, and needs to 'find objective fuel on which to feed' (AE, 71). Freud similarly discusses a dynamic relation between early childhood memories and events from the preceding day in the process of making dreams (Freud, 1935).

Previously, I had mentioned Dewey's anti-dualism and the idea that erasure of dualist assumptions is required for human flourishing, and hence mental health. A dualist approach sees inspiration as distinct from expression. But, for Dewey, the two are dynamically related: 'The act of expression is not something which supervenes upon an inspiration already complete. It is the carrying forward to completion of an inspiration by means of the objective material of perception and imagery' (AE, 72). Freud would similarly say that the dream work is the carrying forward of an unconscious wish by means of a complex mechanism involving perception and imagery in the dream illusion. Freud himself has a theory of art in which imaginative creation is a continuation of, and substitute for, the play of childhood, the work of art being a kind of day-dream in which the artist softens the egoistic, and initially repulsive, character of the wishes and phantasies presented by way of purely formal pleasure (Freud, 1908).

Unfortunately, Freud does not here provide a role for the arts in promoting mental health. For Freud, it is not the dream itself, or the recounting of it, that contributes to mental health, but its interpretation by the trained psychoanalyst in conjunction with

the patient, along with the cathartic moment of transference. The patient is cured when he or she understands the original trauma that gave rise to aberrant behaviour. Dreams are not the same as hysteria, but both originate in similar impulses. One could say, however, that the work of dream analysis is a continuation of something that commenced with the dreamwork, with mental health as its ideal result.

Dewey writes that, 'there must be something in the present to evoke the happiness [experienced by children in dancing and singing].' He adds, '[b]ut the act is expressive only as there is in it a unison of something stored from past experience, something therefore generalized, with present conditions' (AE, 78). He observes that the marriage of past values and present incidents happens easily for … young children, but less so for mature persons, since here we have obstructions to overcome and wounds to heal. Therefore 'the achievement of complete unison is rare; but when it occurs it is so on a deeper level and with a fuller content of meaning' (AE, 78). This implies the therapeutic power of art. Dewey also notes that when this is successful, the 'final expression may issue with the spontaneity of the cadenced speech or rhythmic movement of happy childhood' (AE, 78).

Everyday Awareness

It is possible, however, to overemphasize the importance of integral experience in Dewey's thinking about life-development and improvement. Whereas 'an experience' refers to an experience which is quite special and unusual (although as I have mentioned, it can include anything integral), Dewey also seems concerned, much in the style of William Morris, with everyday life, for example setting the table for dinner, or telling jokes, and the ways in which such experience can be improved.

It may perhaps be better to understand the Deweyan idea as one of avoiding the 'anesthetic'. The anesthetic state could be seen as one in which there is no mental health. It is described as a state in which '[t]here are beginnings and cessations, but no genuine initiations and concludings. One thing replaces another, but does not absorb it and carry it on. There is experience, but so slack and discursive that it is not *an* experience' (AE, 47).

Stroud, Shusterman, Johnson, Duran, and the Art of Living

Two contemporary pragmatist philosophers, Scott Stroud and Richard Shusterman, derive their thinking mainly from Dewey's *Art as Experience* and focus on the notion of 'the artful life'. As Stroud puts it, (2011, 73) 'Aesthetic experience is a way that experience

can be, and Dewey marks it off as the highpoint of experience. ... aesthetic experience can encompass most of life, and ... life becomes the "supreme art" that one is to master' (73). He quotes Dewey: 'Living itself is the supreme art; it requires fineness of thought; skill and thoroughness of workmanship; susceptible response and delicate adjustment to a situation apart from reflective analysis; instinctive perception of the proper harmonies of act and act, of man and man' (Dewey, *Outlines of a Critical Theory of Ethics* 2008, 316). (See also Shusterman, 2018.) Mark Johnson similarly argues that the environment enters into the shape of our thought 'via the aesthetics of our bodily senses ... sculpting our most abstract reasoning out of our embodied interactions with the world' (Johnson, 2007, 154). (See also Granger, 2006.)

Jane Duran takes a feminist angle to Dewey which provides similar insights (Duran, 2001, 285). Duran observes that for Dewey 'the artist takes the mundane experience of everyday living and shapes it to include something more' and that 'what distinguishes the artist's vision is not some mystical experience that cannot be articulated' but something based on the five senses. She observes that feminists not rooted in Continental thought have taken a remarkably Dewey-like approach to human flourishing. Feminists, she argues, also share with Dewey and with the social sciences an emphasis on context that is sadly lacking in much analytic aesthetics.

Anti-Dualism and Continuity

It could be argued, from a Deweyan perspective, that mental health requires a non-dualist stance towards the relation of mind and body (also taken by those feminists mentioned previously). As noted earlier, whereas Freud was concerned with the internal life of the individual, Dewey was more focused on the social. But, for both thinkers, these were deeply related. I have already mentioned the utopian component of Dewey's thinking. Dewey does not address the issue of dualism explicitly in *Art as Experience* until the last chapter 'Art and Civilization'. But, much like Marx, Dewey believed that the problem was one of 'social arrangements' which is just another word for class hierarchy, which, for Marx, leads to alienation.

Positive Psychology

Similarities may also be found between Dewey's aesthetics and the theories of Positive Psychology. M. Csikszentmihalyi, a leading theorist of this movement, defines 'flow' as 'a state in which people are so involved in an activity that nothing else seems to matter; the experience is so enjoyable that people will continue to do it even at great cost, for the sheer sake of doing it' (Csikszentmihalyi, 1990, 4). (See also Csikszentmihalyi & Nakamura 2011 and Seligman & Csikszentmihalyi, 2000.) This seems similar to Dewey's

idea of '*an* experience' (Goldblatt, 2006). Dewey himself describes '*an* experience' in terms of flow when he says that, '[i]n such experiences, every successive part flows freely, without seam and without unfilled blanks, into what ensues' (AE, 43). Art, in particular, 'quickens us from the slackness of routine and enables us to forget ourselves by finding ourselves in the delight of experiencing the world about us in varied qualities and forms' (AE, 110).

Rathunde (2001) argues that Dewey, along with James earlier, and Maslow later, 'initiated an "experiential turn" toward human subjectivity that was (and is) essential to explore questions about what makes life fulfilling or meaningful' (Rathunde, 2001, 139), thus setting the stage for positive psychology. Csikszentmihalyi and Csikszentmihalyi confirm this, claiming that James and Dewey taught us that 'psychology should deal first and foremost with lived experience and only secondarily with more "objective" phenomena like behaviours, traits, and physical or mental abilities' (Csikszentmihalyi & Csikszentmihalyi, 2006, 141).

Christine Doddington

One recent article that addresses the issue of the relation between Dewey's views on aesthetics and mental health, by Christine Doddington, combines the very ideas we are concerned with here: flourishing, education, aesthetic experience, and meaning (Doddington, 2021). She also usefully brings into the discussion such contemporary pragmatists as Shusterman, Johnson, and Garrison. Doddington opposes the neo-liberal view of education as focused on high-performing individuals who contribute to economic viability. Hers is a pragmatist and democracy-centred theory of what education can be. She draws not only on Dewey but also on Shusterman, particularly his idea of somaesthetics (a term he coined) which stresses the centrality of the body to aesthetic sensibility. Shusterman, as we have seen, is a leading contemporary advocate of a pragmatist aesthetics. Mental health is, as I argued above, another word for human flourishing; human flourishing is promoted by right education, and right education focuses on aesthetic sensibility with recognition of embodiment. As Doddington puts it, 'To be able to grow, or to flourish, centers on living well with, in particular, the ability and desire to engage wholeheartedly with meaningful experiences that occur. Flourishing means being able to appreciate, desire and consciously pursue embodied activity that generates meaning' (Doddington, 2021, np). She argues for 'a humane, embodied and sense-enhanced life that strives for meaning, attachments and affiliations' (Doddington, 2021, np), and sees this as having implications for education. She advocates for sense-based activities that give therapeutic experiences, which she considers particularly relevant during the COVID-19 pandemic. Following Dewey and Shusterman, and also drawing on pragmatist Jim Garrison, she stresses reinstatement of the body as intrinsic to the mind and mind to the body (see Garrison & Neiman, 2003). In education, many of these experiences are communal. As she puts it, 'Dewey explains that with senses fully

engaged and an attitude that is open to the new or unfamiliar, balanced with a growing capacity for activity, imagination, and refection, an individual is primed for educative experience. Dewey develops the sense in which this constitutes aesthetic experience by identifying how the qualities of aesthetic experience include a vitality and immediacy as the individual struggles to find meaning and how this form of experience rounds itself towards a sense of completion or consummation' (Garrison & Neiman, 2003).

Following Dewey again, she observes that some 'educationalists have developed practices of highlighting the value of embodied aesthetic experience as a way to encourage imagination and a sense of belonging' (Garrison & Neiman, 2003) which, of course, would be conducive to mental health.

Conclusion

Although Dewey did not directly address the issue of mental health and aesthetics, his background in psychology and education allowed him to work out a theory of human development and flourishing which provided a vision of ideal human nature. This ideal was similar to Freud's in some respects, but different in others. The two thinkers were both naturalists, and yet Dewey focused more on the social, Freud on the personal. However, Dewey could not abide by Freudian discussions of instinct that, for him and his followers, suggested residual dualism. Even prior to *Art as Experience*, Dewey stressed the importance of art education in schools, and this could be seen as relevant to the issue of the child's mental health. Most importantly, with the concept of 'an experience' developed in *Art as Experience*, as well as his notion of self-expression in the creative process, Dewey gives a picture of mental health and the arts that is similar in some respects to the contemporary school of Positive Psychology.

References

Anonymous. (May 28, 2019). How mental stability affects happiness. AMFM Mental Health Treatment Center: Orange County Drug Rehab Center. https://amfmtreatment.com/how-mental-stability-affects-happiness/ [last accessed 30 September 2024].

Brendel, D. (2006). *Healing psychiatry: Bridging the science/humanism divide*. MIT Press.

Colapietro, V. (2006). Pragmatismo e Psicanálise – C. S. Peirce como uma Figura Mediadora Vincent [Pragmatism and psychoanalysis – C. S. Peirce as a mediating figure]. *Cognitio 7*(2), 189–205.

Csikszentmihalyi, M. (1990). *Flow: The psychology of optimal experience*. HarperCollins.

Csikszentmihalyi, M., & Csikszentmihalyi, I. (Eds.). (2006). *A life worth living: Contributions to positive psychology*. Oxford University Press.

Csikszentmihalyi, M., & Nakamura, J. (2011). Positive psychology: Where did it come from, where is it going? In K. M. Sheldon, T. B. Kashdan, & M. F. Steger (Eds.), *Designing positive psychology: Taking stock and moving forward* (pp. 3–8). Oxford University Press.

De Botton, A., & Armstrong, J. (2013). *Art as therapy*. Phaidon Press.

Dewey, J. (AE). (1989). Art as experience. In J. A. Boydston (Ed.), *The later works, 1925–1953. Volume 10, 1934*. Southern Illinois University Press.

Dewey, J. (1900). Psychology and social practice. *Psychological Review 7*, 105–124.

Dewey, J. (1980). Democracy and education. In J. A. Boydston (Ed.), *John Dewey: The middle works, 1899–1924*, vol. 9. Southern Illinois University Press.

Dewey, J. (2008). Outlines of a critical theory of ethics. In Jo Ann Boydson (Ed.), *Early works of John Dewey Volume 3, 1882–1898: Essays and outlines of a critical theory of ethics, 1889-1892* (pp. 239–388). University of Illinois Press.

Doddington, C. (2021). Flourishing with shared vitality: Education based on aesthetic experience, with performance for meaning. *Studies in Philosophy and Education 40*, 261–274.

Drachnik, C. (1976) A historical relationship between art therapy and art education and the possibilities for future integration. *Art Education 29*(7), 16–19.

Duran, J. (2001). A holistically Deweyan feminism. *Metaphilosophy 32*(3), 279–292.

English, A., & Doddington, C. (2019). Dewey, aesthetic experience, and education for humanity. In S. Fesmire (Ed.), *The Oxford Handbook of Dewey* (pp. 411–441). Oxford University Press.

Feuer, L. (1960). The standpoints of Dewey and Freud: A contrast and analysis. *Journal of Individual Psychology 16*(2), 119.

Freeman-Moir, J. (2011). Crafting experience: William Morris, John Dewey, and Utopia. *Utopian Studies 22*(2), 202.

Freud, S. (1935). *The interpretation of dreams*. Translated by J. Strachey. Basic Books Inc.

Freud, S. (1994, 1908). The relation of the poet to daydreaming. In S. Ross (Ed.), *Art and its significance* (pp. 500–506), 3rd edition. State University of New York Press.

Garrison, J., & Neiman, A. (2003). Pragmatism and education. In N. Blake, P. Smeyers, R. Smith, & P. Standish (Eds.), *The Blackwell guide to the philosophy of education*. Blackwell.

Goldblatt, P. (2006). How John Dewey's theories underpin art and art education. *Education and Culture 22*(1), 17–34.

Granger, D. (2006). *John Dewey, Robert Pirsig, and the art of living: Revisioning aesthetic education*. Palgrave-Macmillan.

Haskins, C. (1992). Dewey's 'Art as Experience': The tension between aesthetics and aestheticism. *Transactions of the Charles S. Peirce Society 28*(2), 217–259.

Hildebrand, D. (Fall, 2023). John Dewey. *The Stanford encyclopedia of philosophy*. Edited by Edward N. Zalta & Uri Nodelman. https://plato.stanford.edu/archives/fall2023/entries/dewey/ [last accessed June 29, 2023].

Hohr, H. (2010). Aesthetic emotion: An ambiguous concept in John Dewey's aesthetics. *Ethics and Education 5*(3), 247–261.

Johnson, M. (2007). *The meaning of the body: Aesthetics of human understanding*. University of Chicago Press.

Karier, C. (1963). The rebel and the revolutionary: Sigmund Freud and John Dewey. *Teacher's College Record 64*, 605–613.

Leddy, T. (2012). *The extraordinary in the ordinary: The aesthetics of everyday life*. Broadview Press.

Levitt, M. (1960). *Freud and Dewey: On the nature of man*. Philosophical Library.

McMahon, L. (2018). (Un)Healthy systems: Merleau-Ponty, Dewey, and the dynamic equilibrium between self and environment. *The Journal of Speculative Philosophy 32*(4), 607–627.

Nakamura, K. (2009). The significance of Dewey's aesthetics in art education in the age of globalization. *Educational Theory 59*(4), 427–440.

Rathunde, K. (2001). Toward a psychology of optimal human functioning: What Positive Psychology can learn from the 'experiential turns' of James, Dewey, and Maslow. *The Journal of Humanistic Psychology* 41(1), 135–153.

Ruitenberg, C. (2016). Against a 'life hack' approach to art education. *Canadian Review of Art Education 43*, 98–102.

Saito, Y. (2021). Aesthetics of the everyday. *The Stanford encyclopedia of philosophy* (Spring 2021 edition). Edited by Edward N. Zalta. https://plato.stanford.edu/archives/spr2021/entries/aesthetics-of-everyday [last accessed 30 September 2024].

Samaritter, R. (2018). The aesthetic turn in mental health: Reflections on an explorative study into practices in the arts therapies. *Behavioral Sciences (2076-328X) 8*(4), 41.

Seckinger, D., & Nel, J. (1993). Dewey and Freud. Paper submitted for the Annual Meeting of the Northern Rocky Mountain Educational Research Association, September to October, 1993, Jackson, Wyoming. https://files.eric.ed.gov/fulltext/ED379181.pdf [last accessed 30 September 2024].

Seligman, M., & Csikszentmihalyi, M. (2000). Positive Psychology. *American Psychologist* 55(1), 5–14.

Shusterman, R. (2018) Multiculturalism and the art of living. In R. Shusterman. *Performing live: Aesthetic alternatives for the ends of art* (pp. 182–200). Cornell University Press.

Stroud, S. (2011). *John Dewey and the artful life pragmatism, aesthetics, and morality*. Penn State University Press.

Young, E. (2017). How Iceland got teens to say no to drugs. *The Atlantic*. http://www.theatlantic.com/health/archive/2017/01/teens-drugs-iceland/513668/ [last accessed 30 September 2024].

CHAPTER 7

THE PLACE OF HEALTH IN FOUCAULT'S AESTHETICS OF EXISTENCE

ROBERT L. WICKS

INTRODUCTION

IN an April 1984 interview given two months before he died, Michel Foucault looked forward to when an aesthetics of existence would once again govern people's lives. His studies revealed how the foundation of moral experience during Antiquity resided in an aesthetics of existence based upon—and this can be expressed in a variety of ways—a person's sense of freedom as self-determination, self-control, self-direction, self-governance, self-management, self-mastery, self-domination, self-formation, self-regulation, self-regimentation, self-administration, or self-discipline. He noted that this more artistic, self-styling approach to morality gave way during the Christian period to a universalistic, systematized, codified understanding based abstractly, rigidly, and impersonally upon sets of rules or principles, often extensive and detailed. Most significantly, he observed that during his own lifetime, the Christian conception of morality had eroded sufficiently to allow the re-emergence of this ancient idea of living more freely in accord with an aesthetics of existence:

> This elaboration of one's own life as a personal work of art, even if it obeyed certain collective canons, was at the centre, it seems to me, of moral experience, of the will to morality in Antiquity, whereas in Christianity, with the religion of the text, the idea of the will of God, the principle of obedience, morality took on increasingly the form of a code of rules (only certain ascetic practices were more bound up with the exercise of personal liberty). From Antiquity to Christianity, we pass from a morality that was essentially the search for a personal ethics to a morality as obedience to a

system of rules. And if I was interested in Antiquity it was because, for a whole series of reasons, the idea of a morality as obedience to a code of rules is now disappearing, has already disappeared. And to this absence of morality corresponds, must correspond, the search for an aesthetics of existence.

(Foucault, 1988a, 49)

Some historical context should be given to Foucault's observation that morality construed as obedience to a code of rules was disappearing. His main books appeared in the sixties, seventies, and eighties, beginning with *Madness and Civilization* in 1961 and concluding with the last two volumes of *The History of Sexuality* in 1984. The concept of an aesthetics of existence issued mainly from his later work on sexuality, noticeably in the books and seminars of the 1980s. He published *Madness and Civilization* when he was thirty-five years old, which is to say that he grew up in France during the late 1940s and 1950s—a period that contrasted significantly with the more liberating 1960s and the decades immediately following. When World War II broke out in September 1939, Foucault was a month shy of his thirteenth birthday.

With respect to the themes that interested Foucault—madness, the medical establishment, prisons, social surveillance, knowledge, power, discipline, varieties and discourses of control, the nature of historical change, freedom, and sexuality— the 1950s atmosphere is encapsulated succinctly in the respective prologue and epilogue statements of two recent movies whose stories take place during those times, *The Three Christs* (also entitled *State of Mind*) (2017) and *The Imitation Game* (2014). The former presents the story of an American psychiatrist's obstacle-ridden effort to develop a more humane, less violent treatment for paranoid schizophrenia, the prologue of which mentions that in mental institutions of the 1950s, typical treatments for schizophrenia were prefrontal lobotomy, insulin-induced coma, electroshock therapy, anti-psychotic drugs, and minimal psychotherapy.[1] Foucault was sadly familiar with such methods through his work in a psychiatric hospital in the 1950s—an experience that contributed to his motivation to write *Madness and Civilization—A History of Insanity in the Age of Reason*.[2] *The Imitation Game* tells the tragic story of Alan Turing (1912–1954)—the father of contemporary artificial intelligence and computer science whose codebreaking abilities helped immeasurably to secure an Allied victory during World War II. Despite Turing's astounding social contribution, he was persecuted for his homosexuality to the point of suicide. The movie's epilogue notes that between 1885 and 1967, approximately 49,000 homosexual men were convicted of gross indecency under British law (i.e., in a span of eighty-two years, an average of eleven people per week). Having grown up in a social context of this kind, Foucault could appreciate how the 1960s initiated a liberating change and the perception that morality was undergoing a transformation through women's liberation, gay liberation, and the civil rights movement.

Neoclassicism and the Aesthetics of Existence

At first sight, Foucault's call for an aesthetics of existence appears uniquely to be the expression of a defiantly open-minded French thinker who revealed how historically contingent and hence revisable, our social values happen to be. We often remember him participating in political protests with Jean-Paul Sartre, or his dynamic debate on Dutch television with Noam Chomsky in 1971. Not sufficiently recognized, however, is how Foucault's views on the aesthetics of existence were not particularly new, at least insofar as he was reiterating and advocating a theme common to some leading nineteenth century thinkers who dedicated themselves to rendering their societies healthier and less alienated. Although they expressed this in an assortment of ways, they all admired the ancient Greek culture as a paradigm of health, the spirit of which they hoped somehow to bring back to life. Foucault's notion of an aesthetics of existence can be situated within this neoclassical tradition.

Not unlike Foucault's observation that Christian values were diminishing during his lifetime to open up a new era, known then popularly as the 'age of Aquarius', Hegel felt similarly at the beginning of the nineteenth century that he was in the midst of a 'widespread upheaval in various forms of culture', writing in the Preface to his *Phenomenology of Spirit* (1807) that 'it is not difficult to see that ours is a birth-time and period of transition to a new era' (Hegel, 1977, 6). As we can appreciate in hindsight, Hegel was witnessing the transition from the 'age of enlightenment' to the 'age of progress' where the latter involved a more intense, existential awareness of time, a pervading upshot of which was a more salient appreciation of developmental historical sequencing and cultural growth, not to mention a more firmly grounded sense of the physical world as the primary, if not the only, world.

The results were manifold. Biological realities became explicitly thematized, triggering a heightened awareness of raw instinct as a bodily governing force, and more broadly, a more pronounced philosophical attention to the world's non-rational characteristics, as we see respectively in Freud's conception of the id and Schopenhauer's metaphysics of will. Religious, otherworldly realities such as heaven and God began to lose their hold on people's minds, generating a crisis in Christianity and personal meaning, accompanied by a corresponding amplification of existential awareness with respect to the sense of one's finitude amidst the overall contingency of things. The devaluation of traditional values and a crisis of personal meaning—the debilitating threat of nihilism in reaction to the 'death of God'—emerged as fundamental problems.

Coincident with and contributing to these changes in orientation towards the world was the development of industry, with its impact upon the human psyche in terms of an

increased division of labour, dehumanization, objectification, economic exploitation, impoverishment for the working classes, and the vast accumulation of wealth in the hands of industrialists. With the general perception that Europe consequently had become unwell, self-appointed cultural physicians came to the rescue. Their characteristic solution, as noted, was nostalgically to recall the ancient Greeks with a view towards reintroducing their ideas into nineteenth-century society.[3]

At the vanguard of reshaping the late eighteenth and nineteenth century attitudes towards ancient Greek culture was the art historian and archaeologist Johann Joachim Winckelmann (1717–1768). His influential 1755 work 'Thoughts on the Imitation of Greek Works in Painting and Sculpture' (*Gedanken über die Nachahmung der griechischen Werke in der Malerei und Bildhauerkunst*) celebrated fifth-century Greece, popularly known as the 'golden age', explaining its greatness in terms of an artistic, beauty-oriented, rationally tempered cultural awareness. This was attended by an ideal of emotional self-control:

> The last and most eminent characteristic of the Greek masterpieces is a noble simplicity and tranquil grandeur (*eine edle Einfalt, und eine stille Grösse*) in gesture and expression. As the bottom of the sea remains still beneath a foaming surface, in Greek figures a great soul lies tranquil beneath the strife of the passions.
>
> (Winckelmann, 1972, 72)

As the title of his study suggests, Winckelmann was convinced that the key to greatness was to 'imitate' the Greeks, for he described them most enthusiastically as having achieved the perfect fusion of rationality, with its attention to proportion and balance, with sensuosity, with its attendant visceral appeal. He accordingly presented Greek culture as having had a prevailing artistic awareness that was disposed to embody the ideal of perfect beauty in all walks of life. As one can imagine, Winkelmann's characterization of the Greek culture was itself a product of his own idealization, as is evident in his estimation of their physical health:

> Those diseases which are destructive of beauty were moreover unknown to the Greeks. There is not the least hint of smallpox in the writings of their physicians; and Homer, whose portraits are always so truly drawn, mentions not one pitted face. Venereal plagues and their daughter the English malady [i.e., nervous disorders] had not yet names.
>
> (Winckelmann, 1972, 63)

Winckelmann's image of the Greeks entered the psyche of the later eighteenth and nineteenth century, much like an older man's memory of his youth as a stronger, more athletic, physically attractive, energetic, forward-looking individual carries the power to motivate a return to a healthy diet, exercise, and enthusiastic planning for the upcoming years. Through such imagery—and we can bear in mind Hegel's reference to ancient Greek culture as the adolescence of humanity, full of freshness and vitality[4]—one

remembers the past therapeutically in a positive, if one-sided and quasi-mythological manner.

This image of the healthy Greeks continued well into the nineteenth century in writers such as Schiller, Hegel, and Nietzsche. We see its influence as well in their predecessor Kant, who defined ideal beauty in *The Critique of the Power of Judgment* (1790) (§17) as the amalgamation of morality with sensuosity, essentially as Winckelmann prescribed. In view of their logical independence, though, it is worth questioning the proposed linkage between morality and aesthetics, for neither does a beautiful physical appearance imply a good moral character, nor does a lifestyle constructed as a work of art imply that the lifestyle is substantially moral. Morality and aesthetics are nonetheless compatible and amalgamable, and these authors were appreciating the possibility and benefits of joining them. Kant's ideal of beauty is that to be *most* beautiful, a person's beautiful physical body should expressively reveal goodness of heart, purity, strength, and peace (Kant, 1914, §17). One can imagine a population of people shaped like walking Greek statues, all of whose characters are morally pure.

In the same spirit, but less idealistically, Schiller describes a beautiful 'soul' as one wherein...

> ... sensuousness and reason, duty and inclination are in harmony, and grace is their expression as appearance. Only in the service of a beautiful soul can nature possess freedom and at the same time preserve its form, since freedom vanishes under the control of a strict disposition and form under the anarchy of sensuousness. A beautiful soul spreads an irresistible grace over a physique lacking in architectonic beauty and often one even sees it triumph over natural shortcomings. All movements that emanate from it become light and gentle, and yet lively. The eye shines bright and clear, and sentiment gleams in it.
>
> (Schiller, 2005, 153)

In contrast to the Kantian and Winckelmannian formalistic, technical conceptions of beauty, Schiller's description of a beautiful soul shifts our focus away from statuesque appearances towards the behavioural expression of the quality of a person's subjectivity, bringing us a step closer to the tenor of Foucault's aesthetics of existence. We are no longer referring to people who are physically attractive in their structural or what Schiller calls their 'architectonic' beauty, but to those whose attractiveness is based on how they carry themselves gracefully, and for Foucault, how they beautifully organize their lives and temperament. Nietzsche, who advocates developing one's character into 'a work of art'—providing thereby the characteristic phrasing of Foucault's aesthetics of existence—presents his own idealized healthy type in the figure of Zarathustra, described in *Thus Spoke Zarathustra* (1883–1885) (Prologue, §2) as a person who 'walks like a dancer' to echo Schiller's idea of grace as expressive of a beautiful soul.

The differences between Schiller and Winckelmann notwithstanding, Schiller affirmed the superiority of Greek culture, writing the following in his *Letters on the Aesthetic Education of Man* (1794):

> The Greeks have put us to shame not only by their simplicity, which is foreign to our age; they are at the same time our rivals, nay, frequently our models, in those very points of superiority from which we seek comfort when regretting the unnatural character of our manners. We see that remarkable people united at one fulness of form and fulness of substance, both philosophizing and creating, both tender and energetic, uniting a youthful fancy to the virility of reason in a glorious humanity.
>
> (Schiller, 1902, 17)

Hegel's understanding of historical change was more acute than Schiller's, but he was of the same mind. He acknowledged the Greeks' outstanding amalgamation of spirituality and physicality while comprehending with greater hermeneutical sensitivity that there can be no return to the past:

> … the perfection of art reached its peak here precisely because the spiritual was completely drawn through its external appearance; in this beautiful unification it idealized the natural and made it into an adequate embodiment of spirit's own substantial individuality. Therefore classical [i.e., Greek] art became a conceptually adequate representation of the Ideal, the consummation of the realm of beauty. Nothing can be or become more beautiful.
>
> (Hegel, 1975, 517)

> However all this may be, it is certainly the case that art no longer affords that satisfaction of spiritual needs which earlier ages and nations sought in it, and found in it alone, a satisfaction that, at least on the part of religion, was most intimately linked with art. The beautiful days of Greek art, like the golden age of the later Middle Ages, are gone.
>
> (Hegel, 1975, 10)

Despite Hegel's widespread influence, hermeneutical sensitivities did not always prevail after his death in 1831. In his early writings of the 1870s, Nietzsche passionately adopted the project of resurrecting the Greek spirit in the modern industrial age, hoping to inaugurate a new 'tragic culture' by promoting Kant's and Schopenhauer's philosophies in conjunction with the music of Bach, Beethoven, and especially Wagner. His 1872 book *The Birth of Tragedy* could easily have been entitled *The Rebirth of Tragedy*, given his intentions. He saw essentially the same problem in his own culture that Schiller perceived, but instead of describing it in reference to industrialization and the increasing division of labour, he maintained that for centuries, technological reason or 'science' had been gradually overshadowing instinct and sapping people's vitality, and had finally debilitated the culture as a whole.

As a professor of classical philology, Nietzsche interpreted the ancient Greek performances of tragic dramas as exhibitions of their supreme cultural health in the face of having apprehended the utter meaninglessness of existence—a feeling Camus later expressed poignantly with the reminder that 'from the point of view of Sirius, Goethe's works in ten thousand years will be dust and his name forgotten' (Camus, 1955, 58). The Greek tragic performances ended with the terrifying demise of the heroes,

but the powerful chorus of satyrs and music that spiritually supported the stage upon which the individuals' downfall took place—a support with which the audience primarily identified—stimulated a therapeutic immersion into and resurgence of the eternal energies of 'life itself'. According to Nietzsche, by identifying with these perpetually creative energies that enliven all living things, the audience experienced a 'metaphysical comfort' that allayed all concerns about hopelessness and meaninglessness. In his own time, Nietzsche believed that Wagner's music had an especially enlivening, hopelessness-dissipating power that reawakened this rejuvenating feeling of life.

In his later writings of the 1880s, having come to identify health more directly with strength and growth, and correspondingly, illness with weakness and degeneration, Nietzsche lost his sympathy for comforting, pain-relieving outlooks. He was convinced that the more pain one could positively tolerate, the more one could face reality, and the healthier one's condition would be. In place of advocating the individuality-dissolving immersion into life energies that he described in *The Birth of Tragedy*, he defined the healthiest attitude as one wherein a person retained his or her sense of individuality while being able to summon the mental strength to accept and embrace life's sufferings—all without the aid of anaesthetic beliefs, and powerful enough to say 'yes' to the details of existence, horrors and heartbreaks in their full impact included.

In accord with this conception of health-as-strength, as much as he respected Aristotle's ideal of the 'great-souled' man who exuded social power, respect, and outstanding magnanimity, Nietzsche did not subscribe to Aristotle's prescription that we should live with an eye towards moderation, keeping our behaviour in balance to avoid both excess and deficiency. An Aristotelian, for example, would aim to be courageous as the intermediate position between the extremes of rashness and cowardice. Contrasting with this temperate attitude, Nietzsche presented a more daredevil-like, superhuman ideal of supreme health residing at the pinnacle of power and strength, beyond the bounds of traditional morality and the capacities of virtually everyone, all of whom were relegated to the level of being human-all-too-human:

> *The great health* ... the ideal of a spirit that plays naively, i.e. not deliberately but from overflowing abundance and power, with everything that was hitherto called holy, good, untouchable, divine; a spirit which has gone so far that the highest thing which the common people quite understandably accepts as its measure of value would signify for it danger, decay, debasement, or at any rate recreation, blindness, temporary self-oblivion: the ideal of a human, superhuman well-being and benevolence that will often enough appear *inhuman* ...
>
> <div align="right">(Nietzsche, 1974, 346–347)</div>

When speaking to presently existing individuals who he deemed capable of self-development, and as Foucault described in his aesthetics of existence, Nietzsche advised that it would be optimal to shape one's character as if creating a work of art. In *The Gay Science* (§290), he encouraged that one should 'give style' to one's character with an aim towards organic unity and integration under a single principle. Recalling classical ideas

almost word-for-word, he prescribed that through long practice and daily work, strengths and weaknesses could be made explicit and worked into a pleasing presentation by either removing, reinterpreting, or transforming what is weak and unsightly into a more inspiring appearance. More than 1,500 years earlier, Plotinus (c. 205–270) said the same, revealing the classical roots of the proposition that we should shape our lives into works of art:

> Withdraw within yourself and examine yourself. If you do not yet therein discover beauty, do as the artist, who cuts off, polishes, purifies until he has adorned his statue with all the marks of beauty. Remove from your soul, therefore, all that is superfluous, straighten out all that is crooked, purify and illuminate what is obscure, and do not cease perfecting your statue until the divine resplendence of virtue shines forth upon your sight… But if you try to fix on it an eye soiled by vice, an eye that is impure, or weak, so brilliant an object, that eye will see nothing, not even if it were shown a sight easy to grasp. The organ of vision will first have to be rendered analogous and similar to the object it is to contemplate. Never would the eye have seen the sun unless first it had assumed its form; likewise, the soul could never see beauty, unless she herself first became beautiful.
>
> (Plotinus, 1952, 25)

Beauty, Health, and the Aesthetics of Existence

Given the above background from Plotinus, Winckelmann, Kant, Schiller, Hegel, and Nietzsche, how should we understand the place of health in Foucault's aesthetics of existence? We have at this point the ideas of freedom as self-determination, the prescription to live in moderation, to make one's life into a work of art, and to make one's life as beautiful as possible. Here are some quotes from Foucault to this effect:

> I am referring to what might be called the 'arts of existence'. What I mean by the phrase are those institutional and voluntary actions by which men not only set themselves rules of conduct, but also seek to transform themselves, to change themselves in their singular being, and to make their life into an *oeuvre* that carries certain aesthetic values and meets certain stylistic criteria.
>
> (Foucault, 1990, 10–11)

> … it was more suited to the areas I was dealing with and the documents at my disposal to conceive of this morality in the very form in which contemporaries had reflected upon it, i.e., in the form of an *art of existence* or, rather, a *technique of life*. It was a question of knowing how to govern one's own life in order to give it the most beautiful possible form (in the eyes of others, of oneself, and of the future generations for which one might serve as an example). That is *what* I tried to reconstitute: the formation and development of a practice of self whose aim was to constitute oneself as the worker of the beauty of one's own life.
>
> (Kritzman, 1988, 259)

> Moderation, understood as aspect of dominion over self, was on an equal footing with justice, courage, or prudence; that is, it was a virtue that qualified a man to exercise his mastery over others. The most kindly man was king of himself (*basilikos, basileuōn heautou*).
>
> <div align="right">(Foucault, 1990, 81)</div>

The essential and attractive feature of an aesthetics of existence is the freedom it provides. This contrasts with living more mechanically in accordance with a rigid, codified morality as a set of detailed rules and regulations. In its style of freedom, it compares to a jazz improvisation on a simple melody in contrast to a determinate classical musical score, the performance of which requires an exact adherence. An aesthetics of existence recognizes a society's broadly defined moral rules, but these rules are conceived as akin to a simple, revisable melody in view of which the individual can freely develop a lifestyle creatively and artistically.[5] An aesthetics of existence promotes self-determination, self-discipline, self-regulation, and the other closely related qualities mentioned at the outset.

As attractive as an aesthetics of existence may be when defined in terms of freedom, by itself freedom furnishes only the thought of being creative in one's lifestyle. It gives little else to go by with respect to considerations of health and how the lifestyle might substantially look. Understanding the aesthetics of existence exclusively in terms of freedom can misleadingly suggest that a person has in principle no lifestyle constraints and is disposed to approach life anarchistically and narcissistically.[6]

To appreciate how this would be a misunderstanding, one need only consider the further qualities of an aesthetics of existence that Foucault highlights, namely, beauty, and implied by it, moderation. It is not merely that one approaches one's life as if it were a work of art of any kind whatsoever, since works of art can be variously sublime, repulsive, imaginative, traditional, predictable, comic, and so on; one approaches one's life as if it were, or could be, a *beautiful* work of art. Beauty is the keynote insofar as it prescribes substantially how the lifestyle ought to be structured and provides a way to understand the connection between an aesthetics of existence, morality, and a person's health.

Beauty is difficult to define precisely, but basic structural features include pleasing proportion, balance, and organic unity that work together to convey a measure of calm and peacefulness. As an expressive property, a hint of love or loveliness is often recognized, as in Edmund Burke's eighteenth-century aesthetics (Burke, 1764, Part III, Section I). Some theorists, such as Kant, further understand beauty to be a 'symbol' of morality (Kant, 1914, §59). The idea of an aesthetics of existence, then, is to stylize one's life uniquely and as beautifully as possible in view of a loosely defined moral code, analogous to how a jazz musician plays a smooth and peaceful reinterpretation of a simple and familiar melody.

The main features of beauty also imply a conception of health. These include moderation and balance in taste and emotion, an integrated and regular rhythm of behaviour, a reasonable variation in one's activities, and underlying and informing the totality, a single, overriding vision of oneself and guiding purpose. This conception of health is more temperately Aristotelian than powerfully Nietzschean, where the latter involves pushing oneself to the utter extreme and becoming a friend to the most intense suffering.

Although not surprising due to its classical sources and inspiration, it is noteworthy to discern the temperate Aristotelian quality of Foucault's aesthetics of existence, for the affinities between Foucault and Nietzsche are otherwise strong. For example, an important aspect of an aesthetics of existence reiterates one of Nietzsche's observations about the conditions for self-development, namely, the ability to look down upon oneself:

> [Nietzsche] Every enhancement of the type 'man' has so far been the work of an aristocratic society—and it will be so again and again—a society that believes in the long ladder of an order of rank and differences in value between man and man, and that needs slavery in some sense or other. With that *pathos of distance* which grows out of the ingrained difference between strata—when the ruling class constantly looks afar and looks down upon subjects and instruments and just as constantly practices obedience and command, keeping down and keeping at a distance—that other, more mysterious pathos could not have grown up either—the craving for an ever new widening of distances within the soul itself, the development of ever higher, rarer, more remote, further-stretching more comprehensive states—in brief, simply the enhancement of the type 'man', the continual 'self-overcoming of man', to use a moral formula in a supra-moral sense.
>
> (Nietzsche, 1966, 201)

> [Foucault] In other words, to form oneself as a virtuous and moderate subject in the use he makes of pleasures, the individual has to construct a relationship with the self that is of the 'dominance-submission', 'command-obedience', 'mastery-docility', type (and not, as will be the case in Christian spirituality, a relationship of the 'elucidation-renunciation', 'decipherment-purification' type). This is what could be called the 'heautocratic' structure of the subject in the ethical practice of the pleasures.
>
> (Foucault, 1990, 70)

> [Foucault] Opposite the tyrant, there was the positive image of the leader who was capable of exercising a strict control over himself in the authority he exercised over others. His self-rule moderated his rule over others.
>
> (Foucault, 1990, 81)

Nietzsche's idea of looking down on oneself has its own distinctive quality. It entails an unforgiving self-objectification and effort to transcend one's self-conception to become a new person, profoundly stronger and healthier than before. I reflect upon who I am now as if I were looking down at another person, discern weaknesses and strengths therein, try to overcome those weaknesses for the sake of undergoing a metamorphosis so remarkable, that I become virtually a new person as a result. The change involves discarding one's former self, denying a return to what one was, and repudiating any form of degeneration. In this severe approach to self-growth and self-improvement, health is about going higher and higher, avoiding degeneration and increased weakness.

Here, the 'dominance–submission' or 'master–servant' structure is expressed with a sharp opposition between subject (i.e., master) and object (i.e., servant). In the objectification of oneself for the purpose of self-transcendence, there is an aspect of self-disgust and self-repulsion as one looks down upon oneself as a deficient being that stands in need of a strengthening metamorphosis to become healthier. One can call this the 'dissociative' and 'deprecative' way of 'looking down' on oneself.

Foucault's aesthetics of existence operates with a dominance–submission model as well, but it is characterized by a more friendly, less oppositional, integrative attitude towards oneself. Unlike the Nietzschean model which has a self-deprecating quality, the aesthetics of existence is marked by an attitude of 'care' for oneself. This sense of self-respect combines with a positive approach to self-knowledge used constructively to modify one's attitude and self-management. Through self-control, the goal is to form oneself as an ethical subject, as, following Plato's image, a charioteer controls a pair of unruly horses to keep them in line to pull in the same direction. Among related analogies, Foucault includes that of a doctor who cares for a patient:

> … forming oneself as a subject in control of his conduct; that is, the possibility of making oneself like the doctor treating a sickness, a pilot steering between the rocks, or the statesman governing the city – a skillful and prudent guide of himself, one who has a sense of the right time and the right measure.
>
> (Foucault, 1990, 138–139)

The optimal result is a person who freely and creatively uses self-knowledge to reshape and integrate his or her personality with moderation, rationality, and a sense of beauty, all with a view towards moral behaviour. Although the subject–object distinction underlies the association between self-control and the dominance–submission model, the 'object' of dominance retains a strong identification with the 'subject' that is actuating the self-control. The outcome is someone who feels less alienated, more integrated, and more at-home with himself or herself. The person is healthy in the sense of being well-integrated.

This contrast between Nietzsche's and Foucault's conceptions of health—a Nietzschean one that involves self-alienation, self-distancing and radical transformation of one's former self for the sake of growth and avoiding degeneration versus a Foucaultian one that involves integration and the moderate reshaping of the self for the sake of moral balance and beauty—are models wherein the very opposition between subject and object assumes contrasting forms. The Nietzschean model maximizes it whereas the Foucaultian model minimizes it. The Nietzschean model involves looking down on oneself and regarding the object (one's self) as an alien being to be cast-off and transcended; Foucault's aesthetics of existence involves looking down on oneself and regarding the object (one's self) as fundamentally a 'subject' that one cares for. In the latter, the subject–object relationship approaches a subject–subject relationship.

A logical disposition would aim to accept one model and reject the other in an 'either-or' fashion. It would be more appropriate, however, to realize how the structure

of self-consciousness inheres in both models. This structure is paradoxical insofar as I say as a subject that some object is nonetheless 'me', namely, a subject. A subject stands opposed to an object while it simultaneously identifies itself with the object. Insofar as we intensify the opposition between subject and object, the Nietzschean model stands out; insofar as we intensify the identity between subject and object, the aesthetics of existence model stands out. They express two sides of the self-consciousness coin, for in the act and structure of self-consciousness there is an inherent fusion of an 'I–It' (subject–object) and an 'I–Thou' (subject–subject) relationship. Since the two aspects are inseparable in this regard, the contrasting Nietzschean and aesthetics of existence models of health should be understood as complementary rather than exclusionary.

Conclusion

Since the ancients lived in a world that had not yet been industrialized, computerized, or globalized, their experience of an aesthetics of existence took place within a simpler social context. Even during Foucault's own time, the advance of globalization and computerization was less clearly discernable than it is now, leading him to believe that the world was patterned more as an array of disconnected, relatively discontinuous parts on the model of a heterotopia. Under this assumption he wrote the following, describing globalization as an outdated and unrealistic myth from the Christian past:

> The idea which had been predominant throughout the Middle Ages was that all the kingdoms on the earth would be one day united in one last empire just before the Christ's return to earth. From the beginning of the seventeenth century, this familiar idea is nothing more than a dream, which was also one of the main features of political thought, or of historical-political thought, during the Middle Ages. This project of reconstituting the Roman Empire vanishes forever. Politics has now to deal with an irreducible multiplicity of states struggling and competing in a limited history.
> (Foucault, 1988b, 152)

Twenty-first-century society is gradually looking less like an irreducible multiplicity of states and more like a globalized unity managed by a set of multinational corporations, institutions, and staggeringly wealthy individuals, i.e., by a global technocratic control system. Electronic surveillance on multiple dimensions is intensifying in the financial sector, in the workplace, on roadways, within businesses, and across the Internet, often resembling the panoptic institutional prison that Foucault described well in *Discipline and Punish—The Birth of the Prison* (1975). It appears that the more globalized the world becomes, the less objective, real-world, spatio-temporally grounded freedom people will be able to experience.

The flip side is that the Internet is simultaneously promoting the experience of what one might call subjective or 'monadic' freedom, where individuals, although under

computer surveillance, can gratify many of their desires in a personalized virtual world, immediately and potentially without limit. A lifestyle characterized predominantly by immediate gratification, though, disposes a person, perhaps dangerously and unhealthily, to a more infantile psychological condition and general life attitude. The combined result is a subjective condition where a person feels imaginatively free and satisfied within a virtual world while living objectively within a social and political context that overbearingly controls what the person can do. The situation points to what has been portrayed, albeit more extremely, in movies such as *The Matrix* (1999) and *Ready Player One* (2018).

These considerations awaken a message of caution about all therapeutically oriented projects that aim to transpose past ideas into the present for the sake of restoring health or improving the human condition. The context into which the past ideas are to be imported may have features that either distort or undermine the project, as in present-day transformations of the concept of freedom. The aesthetics of existence as practised in Antiquity involved a lifestyle that embodied more personal freedom than what the later Christian world offered, and advocating its contemporary institutional reintroduction for the sake of restoring some freedom in people's lives makes moral sense. The counteracting forces, however, are powerful: the geopolitical context appears to be growing globalistically in a direction that is gradually imposing significant restrictions on objectively expressed freedom, accompanied by a strong cultural drift for individuals to compromise their ordinary conception of freedom towards a more subjectively centred, monadic, one—a conception to be realized in a relatively unrealistic, fictional manner within a virtual, imagination-centred, computer-generated, three-dimensional space. If the upshot is to infantilize the individual psychology of individuals while simultaneously distracting them from developing their political awareness by eroding their sense of objective reality, the dangers are obvious, and reveal the difficulty of finding effective ways to improve people's health such as reinstituting an aesthetics of existence, as Foucault had hoped.

Notes

1. Such treatments, not only for schizophrenia, but for a range of mental conditions, either temporary or relatively permanent, were institutionally entrenched to the point of acceptance by almost everyone, including some of the most prominent families in the United States at the time. For example, the United States Ambassador to the United Kingdom (1938–1940) Joseph P. Kennedy, authorized the lobotomy of his daughter Rosemary in 1941; the President of the United States (1960–1963) John F. Kennedy, authorized electroshock treatments for his wife Jacqueline in 1956.
2. Joel Whitebook describes Foucault's experience: 'Without going into much detail, Foucault refers to the "malaise" and the "great personal discomfort" that resulted from his experience of working at Sainte-Anne [psychiatric hospital]. The situation appears to have centered on Roger, a patient of Foucault's, who was subjected to the ultimate act of therapeutic despair, namely, a prefrontal lobotomy, when he did not respond to treatment by other, less drastic

means. [David] Macey is no doubt correct when he says that "given Foucault's own depressive tendencies," the encounter with Roger "must have had a considerable impact." Not only does it seem to have derailed Foucault's plans to become a psychiatrist, but it also seems to have left him with an "indelible image of suffering"' (Whitebook, 2005, 317).

3. Foucault adopted a balanced view about recollecting the past nostalgia alone that adds perspective to his interest in reviving the idea of an aesthetics of existence during his own time: 'All of this beauty of old times is an effect of and not a reason for nostalgia. I know very well that it is our own invention. But it's quite good to have this kind of nostalgia, just as it's good to have a good relationship with your own childhood if you have children. It's a good thing to have nostalgia toward some periods on the condition that it's a way to have a thoughtful and positive relation to your own present. But if nostalgia is a reason to be aggressive and uncomprehending toward the present, it has to be excluded' (Martin, 1988, 12).

4. Hegel writes: 'Among the Greeks we feel ourselves immediately at home … At an earlier stage I compared the Greek world with the period of adolescence … [in the sense] that youth does not yet present the activity of work, does not yet exert itself for a definite intelligent aim—but rather exhibits a concrete freshness of the soul's life … Greece presents to us the cheerful aspect of youthful freshness, of Spiritual vitality' (Hegel, 1899, 223).

5. Foucault writes: 'By "morality" one means a set of values and rules of action that are recommended to individuals through the intermediary of various prescriptive agencies such as the family (in one of its roles), educational institutions, churches, and so forth' (Foucault, 1990, 25).

6. Criticisms of Foucault's aesthetics of existence tend to be along these lines. It has its defenders as well. Jane Bennett (Bennett, 1996) surveys such criticisms, arguing in particular against Terry Eagleton's objections. Marli Huijer does not substantially address such criticisms, but she points out that a concept such as friendship, for example, inherently carries along with it a moral awareness that is independent of codified ethical systems (Huijer, 1999). Cristian Iftode describes the ethical dimension of Foucault's aesthetics of existence, but only goes as far as to say that moral reflection takes place substantially within a community and that aesthetic values are themselves communal (Iftode, 2015).

References

Bennett, J. (1996). How is it, then, that we still remain barbarians?: Foucault, Schiller, and the aestheticization of ethics. *Political Theory* 24 (4), 653–672.

Burke, E. (1764). *A philosophical inquiry into the origin of our ideas of the sublime and the beautiful, fourth edition*. R. & J. Dodsley.

Camus, A. (1955). *The myth of Sisyphus and other essays*. Translated by J. O'Brien. Vintage Books.

Foucault, M. (1988a). *Michel Foucault – politics, philosophy, culture – interviews and other writings, 1977–1984*. Translated by A. Sheridan et al. Routledge, Chapman & Hall, Inc.

Foucault, M. (1988b). The political technology of individuals. In H. Martin, H. Gutman, & P. Hutton (Eds.), *Technologies of the self – a seminar with Michel Foucault*, pp. 145–162. The University of Massachusetts Press.

Foucault, M. (1990). *The use of pleasure – the history of sexuality, Volume 2*. Translated by R. Hurley. Vintage Books.

Hegel, G. W. F. (1899). *The philosophy of history*. Translated by J. Sibree. The Colonial Press.

Hegel, G. W. F. (1975). *Aesthetics – lecture on fine art, Vol I*. Translated by T. M. Knox. Oxford University Press.

Hegel, G. W. F. (1977). *Phenomenology of spirit*. Translated by A. V. Miller. Oxford University Press.

Huijer, M. (1999). The aesthetics of existence in the work of Michel Foucault. *Philosophy & Social Criticism 25* (2), 61–85.

Iftode, C. (2015). The ethical meaning of Foucault's aesthetics of existence. *Cultura. International Journal of Philosophy of Culture and Axiology 12* (2), 145–162.

Kant, I. (1914). *Critique of judgement*. Macmillan and Co.

Kritzman, L. D. (Ed.). (1988). *Michel Foucault – politics, philosophy, culture – interviews and other writings 1977–1984*. Routledge.

Martin, R. (1988). Truth, power, self: An interview with Michel Foucault, October 25, 1982. In L. H. Martin, H. Gutman, & P. Hutton (Eds.), *Technologies of the self – a seminar with Michel Foucault*, 9–15. The University of Massachusetts Press.

Nietzsche, F. (1966). *Beyond good and evil*. Translated by W. Kaufmann. Random House.

Nietzsche, F. (1974). *The gay science*. Translated by W. Kaufmann. Vintage Books.

Plotinus. (1952). 'Beauty', *Ennead I*, Book VI, chapter 9. In R. M. Hutchins (Ed.), translated by S. McKinna & B. S. Page, *Great books of the Western world, Vol. 17*, 21–25. Encyclopedia Britannica.

Schiller, F. (1902). Letters on the aesthetical education of man. In N. Haskell Dole *(Ed.)*, *Aesthetical and philosophical essays*, *Vol. 1*, pp. 3–110. Francis A. Niccolls & Company.

Schiller, F. (2005). On grace and dignity. In J. V. Curran & C. Fricker (Eds.), *Schiller's 'On Grace and Dignity' in its cultural context – essays and a new translation*, pp. 123–170. Camden House.

Whitebook, J. (2005). Foucault's struggle with psychoanalysis. In G. Gutting (Ed.), *The Cambridge companion to Foucault*, second edition, pp. 312–347. Cambridge University Press.

Winckelmann, J. (1972). On the imitation of the painting and sculpture of the Greeks. In D. Irwin (Ed.), *Winckelmann – writings on art*, pp. 61–85. Phaidon.

CHAPTER 8

FRANKFURT SCHOOL AESTHETICS

The Aesthetic Dialectics of Mental Health

JOHAN FREDERIK HARTLE

Introduction: Obstinacy or Pathology

In the many thousand fragments and short stories of Alexander Kluge (in books, films, and television material) one can find many extreme biographical constellations of abandonment, rape, war, of betrayal and tragic desire, but also of the incalculable moments of the everyday, many of which one would see as hampering conditions of mental health. Some of these micro-narratives appear as model cases for socio-historical constellations of our time, some of them as extreme psychological examples of specific historical epochs, or as illustrations of the infinite possibilities of history and its contingency. Alexander Kluge writes with astonishment over the many possible turns of history, over unexpected developments of individual lives, and the course of history in general, to undermine the solidity of the given, of monolithic understandings of reality: 'It must be possible to present reality as the historical fiction that it is' (Kluge, 2012, 178).

In their historiography of human desires and passions Oskar Negt and Alexander Kluge approach the emotional life of the historical individuals as a 'raw material' (see Negt & Kluge, 2014; see also Jameson, 2009, 110) of history and politics. From the many different ways in which individuals react to extreme situations, politics emerges as the patterns in the organization of the emotional life of the collective. Here, the endless labour of storytelling comes in as the historiography of 'obstinacy' (see Negt & Kluge, 2014) of un-predicted and non-conformist behaviour, the liberating effect of contingency is omnipresent.[1] The fact that all these stories remain short fragments, often appear unfinished, as 'work-in-progress' (see Elsaesser, 2012, 23) and that his oeuvre gives a mosaic-like or even kaleidoscopic image of history and society, is not a coincidence (see also Jameson, 2009, 116). The task of art, according to Kluge, is: 'producing

the capacity of differentiation at any price' (Kluge, 2012, 193). His own miniatures thus never constitute a closed narrative that would present itself as an objective entity to the readers or viewers, leaving her in a position of contemplative passivity. Rather, it requires spontaneity to make sense of these fragments (see Rancière, 2009).

With this impulse to open up perspectives of different versions of life, Kluge's work can be seen as therapeutic in a very wide sense: It blows open the closed space of objectified social relations, within which spaces of action become invisible. This gain in space is not the least significant contribution of art to the psychological mobility of social actors that art and literature can make. Kluge presents an example of the aesthetic theories of the Frankfurt School which could be seen as one extreme pole on the scale of possibilities. In other theoretical models, the reference to specific social pathologies, and the attempt to directly react on damage to mental health is more explicit. The main interest of Frankfurt School critical theory (and this holds for all of its disparate members of the inner and outer circles) is a critical analysis and theoretical understanding of socio-structural conditions and only subsequently their effects on the individuals' lives, driven by the critique of conformism and political authoritarianism.

At the other pole of possibilities, the implicit psychological account of Frankfurt School aesthetics addresses the critical reflection and confrontation of 'social pathologies' and the ways in which social structures and resulting dominant personality types hamper the well-being and flourishing of a free society as pre-condition for the well-being of individuals. Even such an account is somewhat in conflict with direct approaches to normative conceptions of individual 'health'. If mental health, however, is understood in broad terms (as by the WHO) as a 'state of mental well-being that enables people to cope with the stresses of life, realize their abilities, learn well and work well, and contribute to their community' and if one focuses specifically on 'unfavourable social, economic, geopolitical and environmental circumstances' (WHO, 2022) the approach of the Frankfurt school resonates with contemporary scientific debates on mental health and its respective terminology.

Adorno's *Minima Moralia* of 1951 suggests these detours to the question of mental health in at least two ways. Its most famous sentence, the concluding sentence from Aphorism 18 ('Asylum for the Homeless'): 'Wrong life cannot be lived rightly' (Adorno, 2005, 39), although primarily meant in ethical terms, seems to leave little space for positive conceptions of mental health but rather documents the variety of obstacles and pitfalls for more adequate forms of self.

The book presents itself as a collection of 'reflections on damaged life'. It is, therefore, the complete opposite of advice literature yet implying an indirect reference to an undamaged live, which, with some extra investment one could construct as mental health. In this way, Adorno's approach to social and cultural criticism categorically avoids direct positive conceptions and suggests a clearly anti-normative understanding of critical theory. Critical theory does not hold the key to the truth, health, or anything alike, but 'can only', as he writes in the *Authoritarian Personality* 'remove some of the barriers in the way of its pursuit' (Adorno, 2003a, 163). For the key thinkers of the Frankfurt School, the experience of exile was a very specific barrier on the way to a good life. Much

of the *Minima Moralia* reflects this historical experience and presents the process of writing (much like psychoanalysis) as an attempt to process and cope. The fragmentary, sometimes associative and half-exaggerating tone (see Düttmann, 2004) of Adorno's aphorisms reflects this strategy.

The relationship between aesthetics and positive conceptions of health, mental stability, well-being, or the like, is hardly less complex than the one between Frankfurt School critical theory and mental health in general. In their various aesthetics, art is not understood in an anthropological sense as a contribution to human, bodily, psychological well-being, or harmony. Adorno puts this quite clearly: 'dissonance' is regarded as 'the seal of everything modern' (Adorno, 1978, 15). And modernity is the whole scope and framework of Frankfurt School aesthetics.

Aesthetics, in Frankfurt School critical theory, is generally conceived as a social practice with historical significance rather than a practice contributing to individual well-being. Against this background, the focus is on the disruptive, dissonant, shocking, provocative, and transgressive forms of art. Stabilizing, comforting understandings of art that might support immediate conceptions of well-being or mental health or help compensate for the experience of socially determined suffering, are generally suspected as ideology. To understand the relationship between mental health and aesthetics in the Frankfurt context, one therefore has to construct a more indirect relationship between the two and focus on the wider range of social conditions for mental health, including questions of (political) self-determination and the possibility to partake in the construction of a livable future.

In the following, I will approach the history of various aesthetic conceptions of Frankfurt School aesthetics in four further steps.

- The reconstruction of the Frankfurt School aesthetic approaches to mental health begin with a maverick's position that constitutes a highly influential reference for further media theoretical debates: In the mid-thirties Walter Benjamin developed an understanding of modern mass media that contains a psychological understanding of the release of social psychological tensions inherent to the modernist development of urban life and technology that are to be turned through media art which then gains the function of collective psychotherapy.
- The early analyses of authoritarianism (specifically by Erich Fromm in collaboration with Max Horkheimer and Herbert Marcuse) started in the early 1930s and are further developed in 1950 by Theodor W. Adorno (in collaboration with psychologists Else Frenkel-Brunswik, Daniel Levinson, and Nevitt Sanford), identify fascist authoritarianism with a social psychological pathology. Since the Frankfurt discourse on aesthetics is deeply rooted in the assessment of the socio-political situation, they also pave the way for further discussions of the psychological implications of the aesthetic and the respective capacity to allow for ambivalence and ambiguity. This argument is present especially in Adorno's writings on the sociology of music and the analysis of various types of listeners.

- Opposed to authoritarian forms of compulsion and repression, the idea that modern art can have a liberating effect is nowhere as clearly articulated as in Herbert Marcuse's writings of the 1950s and 1960s. Psychoanalytical arguments are the very foundation of Marcuse's reflections. Art and the aesthetic are generally understood as non-repressive forms of sublimation, giving shape to widely repressed libidinal impulses. In the arguably most advanced aesthetic conception of the Frankfurt School, Theodor W. Adorno's *Aesthetic Theory*, posthumously published in 1970, contains reflections on all of these arguments. His theory of aesthetic experience attributes a historical truth function to the genuine work of art, and also sees potential to realize pre-conscious somatic impulses that are otherwise repressed in social communication.
- Clearly, all of this leaves questions about the timely relevance of such models unanswered, which will be considered in the conclusion.

Media Technology and the Historical Modes of Perception

The literary critic, philosopher, and essayist Walter Benjamin probably was the most independent thinker in the wider context of the Frankfurt School, with close ties to the inner circle of the Frankfurt School (a close friendship with Theodor Adorno specifically) yet with a large number of different references (from Jewish Mysticism to French Symbolism) that went somewhat beyond the systematic ambitions of the Frankfurt Institute for Social Research. Benjamin's key interests, however, strongly converged with the theoretical ambitions of the Frankfurt School's inner circle (at that time Horkheimer, Adorno, Fromm, Marcuse, & Pollock). His approach to aesthetics addresses the historical condition of social experience in light of the failure of the bourgeois capitalist era, trying to adjust art and the aesthetic to the new historical challenges by politicizing it.

Benjamin's aesthetics is conceptualized as a fundamentally historical understanding of *aesthesis* (perception, experience). According to Benjamin, the shape of a historical situation with all of its ideological layers becomes concrete in the structure of experience, which he regards as both materially and practically constituted. Adorno critically described this approach, in his correspondence with Benjamin, as an 'anthropological materialism', for which the 'human body represents the measure of all concreteness' (Adorno & Benjamin, 2004, 146).

Following this major interest, material culture is analysed as an objectified cast of such historical subjectivity. This historical diagnosis defines one of the key references of Walter Benjamin's media aesthetic. It builds on a specific appropriation of the work of Alois Riegl and Franz Wickhoff. Specifically in his *Late Roman Art Industry*, Alois Riegl (1985) suggested that historical artefacts (such as late roman reliefs) can be interpreted

as documents and indications of a change in people's perceptual apparatus. Benjamin thus addresses the extended body of a social collective as a symptom and signature of its historical situation. In his later writings (around the late 1930s and his *Arcades Project*), Benjamin speaks very explicitly of the 'collective body' and thus of a collective psyche that is to be subjected to the therapeutic practice of art and media. He writes:

> Just as the entire mode of existence of human collectives changes over long historical periods, so too does their mode of perception. The way in which human perception is organized—the medium in which it occurs is conditioned not only by nature but by history.
>
> (Benjamin, 2008, 23)

Material culture (cities, architecture, but also machinery and technical media) are historically specific forms of organizing the human body and its sensuous apparatus (see also Hartle, 2018, 1010). One might, because of this strongly somatic focus, expect that therapeutic positions on individual suffering play a central role in his aesthetic theory. In fact, Benjamin generally analyses and reconstructs historical layers of experience (like mimetic experience, storytelling, auratic experience, phantasmagoria) both curiously and neutrally and, more often than not, without making strong judgements. This changes with his media theoretical writings of the 1930s. In these writings Benjamin hopes to develop an aesthetic theory and art theoretical theses that are 'completely useless for the purposes of fascism' and have an explicitly political and strategic purpose (Benjamin, 2008, 20).

Benjamin writes these theses not only in light of the advent of European fascism (in Italy, Germany, and Spain) but also of the blatant disproportion between technological progress and political reaction (such as fascist authoritarianism). This was one of the big challenges the Frankfurt School was addressing in the mid-1930s, the question of a so-called 'cultural lag'. As Max Horkheimer formulates in 1936:

> 'Cultural lag' means that at the present time social life depends on material factors and that change occurs more quickly in areas immediately related to the economy than in other cultural spheres.
>
> (Horkheimer, 2002, 65; see also Fromm, 1936, 21 f.)

Key reference for Walter Benjamin's discussion of this issue is Georg Simmel's text on the 'Metropolis and Mental Life', which describes the accelerating impulses, and the increasing level of abstraction (in the monetary representation of goods, in the means of communication) of modern forms of life.

Simmel 'examines', as he writes, 'the body of culture with reference to the soul' (Simmel, 2005, 11), or differently put, how the historical individuals adapt mentally and culturally to the challenges of ever-changing objective culture. 'The deepest problems of modern life', he writes

flow from the attempt of the individual to maintain the independence and individuality of his existence against the sovereign powers of society, against the weight of the historical heritage and the external culture and technique of life.

(2005, 11)

Modern, metropolitan life, is, Simmel holds, specifically characterized by the 'intensification of emotional life due to the swift and continuous shift of internal and external stimuli' (2005, 12), which is in 'deep contrast with the slower, more habitual, more smoothly flowing sensory-mental phase of the small-town and rural existence' (2005, 13). Such challenges, if unprocessed, may have dramatic cultural impacts: 'through the rapidity and the contradictoriness of their shifts', they 'force the nerves to make such violent responses, tear them about so brutally that they exhaust their last reserves of strength' (2005, 14).

The major cultural shifts that Georg Simmel had diagnosed, find their attentive analyst in Walter Benjamin. Or, more strongly put, Walter Benjamin takes on the cultural political (if not therapeutic) challenge that it implies. In his most famous essay, 'The Artwork in the Age of its technological Reproducibility', Benjamin discusses the appropriateness of specific forms of experience regarding the specific challenges of the historical situation. Modern media (and film specifically), are discussed as the place where such conflicts are being played out. For Benjamin, this is first and foremost modern film. He writes:

> The function of film is to train human beings in the apperceptions and reactions needed to deal with a vast apparatus whose role in their lives is expanding almost daily. Dealing with apparatus also teaches them that technology will release them from their enslavement to the powers of the apparatus only when humanity's whole constitution has adapted itself to the new productive forces.
>
> (Benjamin, 2008, 26)

For Benjamin, film opens up a 'vast and unsuspected field of action' (2008, 37) by stretching time and space (with slow motion, by zooming in, etc.) and allowing for the analytical confrontation with the problem of accelerated (industrial, metropolitan) life. The film camera is thus presented as a means to process the psychological effects of modernity.

> This is where the camera comes into play, with all its resources for swooping and rising, disrupting and isolating, stretching or compressing a sequence, enlarging or reducing an object. It is through the camera that we first discover the optical unconscious, just as we discover the instinctual unconscious through psychoanalysis.
>
> (Benjamin, 2008, 37)

The analogies with psychoanalysis are explicit: With the camera, another unconscious and dreamlike sphere move into the spotlight. The 'optical unconscious' identifies the

unprocessed layers of perception that need to be processed and appropriated. When Benjamin appropriates psychoanalysis for the critical discussion of modern urban life and technology, he suggests that 'these two types of unconscious are intimately linked' (2008, 37).

According to Benjamin, modern (media) art, then, is a therapeutic confrontation with the technological overload that articulates itself as fragmentation, acceleration, and spatial compression. This process is analytically demonstrated in film, in which the 'optically unconscious' is made habituated, in order to catch up with the 'cultural lag' of the modernization processes. The chairs in the auditorium of the cinema thus appear as a collective couch.

In this quasi-analytical process, the role of the analyst (if one follows this analogy), is far from passive. Active confrontation is the therapeutic means through which the optical unconscious is appropriated. The aesthetic (or, even: strategic) importance of shock has to be seen in this light. Shock experience, the experience of speed and proximity, repeats the overwhelming experience of unprocessed technological modernity and triggers 'a therapeutic release of unconscious energies' (Benjamin, 2008, 38; see Hartle, 2018, 1012 f.).

Film thus lays bare the collective nature of perception and of unprocessed unconscious energies. What previously appeared to be an individual quirk and could only be dealt with individually now appears as a collective situation whose collective character is fully exposed: 'Thanks to the camera, therefore, the individual perceptions of the psychotic or the dreamer can be appropriated by collective perception' (Benjamin, 2008, 38).

Benjamin mobilizes art against the technological slumber to prevent the worst: The mass psychotic alternative, according to Benjamin, is a political disaster. If the 'cultural lag' is not overcome, if, differently put, the experiential overload with the challenges of modernity is not met, over-identification with the aggressor will be the likely consequence. According to Benjamin, the fascist aesthetic of sublimity (as in Futurism) expresses such collective delusion. Filippo Tommaso Marinetti's enthusiasm for the destructive energy of modern war machinery, is the most plausible example. Ernst Jünger's German version of futurism with its glorification of industrial warfare, is another one of Benjamin's references.

Benjamin's Artwork-essay thus suggests that at the bottom of unprocessed modernity there is an explosive load of aggression, which continuously threatens to be discharged in war.

Benjamin's media aesthetics merges psychological arguments with a general cultural-political approach. His real opponent is fascist subjectivity, which is described with pathologizing vocabulary ('psychosis'). One may discuss to which extent such a psychological characterization of fascism could still be plausible and of contemporary relevance. Some layers of the psychological argument, however, are obviously timely. The 'cultural lag', and the violent implications of unprocessed technological development, at least, persist today. In Chinese high-tech factories, newly recruited workers of rural origins often have trouble coping with their new environment, as the massive rate of suicides suggests (Merchant, 2017).

Authoritarianism and Experience

While Benjamin was writing his Artwork essay, the inner circle of the Frankfurt Institute for Social Research discussed the logic and structure of fascist (or: authoritarian) subjectivity and the crisis of experience in different terms. The *Studies in Authority and Family* (by Horkheimer, Fromm, Marcuse, et al.) from 1936 constituted a whole field of research that remained relevant for at least another decade and a half. Together with *The Studies on the Authoritarian Character* (by Adorno, Frenkel-Brunswik, Levinson, & Sanford) of 1950, the original considerations of 1936 have become classics of social and political psychology. Both studies are trying to reconstruct the advent and persistence of fascism as the socially most regressive development of advanced western societies. They are both driven by the conviction

> that no politico-social trend imposes a graver threat to our traditional values and institutions than does fascism, and that knowledge of the personality forces that favor its acceptance may ultimately prove useful in combating it.
> (Adorno, 2003a, 149)

Without this anti-fascist impulse, none of the theoretical efforts of the Frankfurt School, from social psychology to aesthetics, can be fully comprehended. In light of the recent rise of authoritarian politics (as with Trump, Erdogan, Orban, Bolsonaro, Modi, and others), this also underlines the timeliness of a Frankfurt School approach (Benjamin, 2008, 37), even if the methodological approaches and political consequences have to be adjusted.

Both studies mentioned above attempt quite generally to outline the ways in which social domination sustains itself by ways of identification of the oppressed with the oppressors, how 'the response to authority is not only coerced behavior' but 'must be intensified through an emotional connection' (Fromm, 1936, 11; see Horkheimer, 2002, 54, 56). This pointedly characterizes the historical situation of Marxism in the interbellum years after the failure of a revolutionary transformation of capitalism (Jacoby, 1981) and the authoritarian development in Western Fascist countries (but also, successively in Soviet Russia). In 1950, Adorno phrases this question as follows: How was it possible that workers, specifically, identified with capitalism more strongly than with its revolutionary transformation? How could a worker be driven 'not only not to consider his material interests [for instance through union organization, JH], but even to go against them' (Adorno, 2003a, 159)? Why would subordinate classes have chosen for authoritarian regimes that destroy their organizations and maximize economic exploitation and political repression? Searching for answers, the Frankfurt School psychoanalytically reconstructed the identification with the aggressor.

One can hardly overestimate the importance of such analyses of authoritarianism for the self-understanding of the Frankfurt School. By working against fascism as the radically negative example, the analyses of authoritarian behaviour and character also

attempted to study the conditions of critical theory's own possibility. These analyses were at the same time indirect and reflexive attempts at a socio-theoretical foundation of critical theory, or, in the words of Alex Demirovic, non-conformism (Demirovic, 1999; Gordon, 2022, 25). Horkheimer, Fromm, and Marcuse attempt to reconstruct the social origins of the decline of liberal capitalism from within. Society was interpreted as a form of organization within which collective histories and structurally shared forms of experience and thus a shared libidinal structure constitute a body of desires that help maintain social order. This poses the question of how libidinal energies contribute to the coherence of society and help maintain complex forms of social oppression.

The 1936 study focuses on family. After the failure of liberal capitalism, authoritarianism was seen as the problem of the time, with the changing role of the family as its origin. The *Study* of 1936 was driven by the observation that authority had become pathological and

> the ground for a blind and slavish submission which originates subjectively in psychic inertia and inability to make one's own decisions and which contributes objectively to the continuation of constraining and unworthy conditions of life.
> (Horkheimer, 2002, 71)

The *Studies in Authority and Family* analyse the relationship between the traditional bourgeois family and authoritarianism, primarily by the analysis of the 'suppression or repression of drives' (Fromm, 1936, 36). Fromm sees the family as 'the psychological agency of society' (1936, 18). In this constellation the internalization of the superego through the overidentification with the father is seen as the primary source of libidinal repression. The higher the grade of fear, uncertainty, and libidinal repression, the weaker the potential for the development of a strong ego-function, capable of mediating between conflicting demands of social integration and libidinal desire. The identification with the father introduces the general identification with a strong 'external social force' (1936, 15). Social authority, authoritarianism specifically, was thus seen as an extended effect of the super-ego, and the 'perpetuation and renewal of the adult's superego is always based on the internalization of external force' (1936, 16). According to the Freudian understanding of the *Studies*, the function of the super-ego is in a constant process of regulation and balancing with the ego function. Fromm writes:

> As long as the ego is still weak, it requires a certain degree of freedom from fear in order to develop. The more the weak ego is threatened by fear, the more inhibited its development: alternately, the stronger the ego, the less effective the fear
> (Fromm, 1936, 31)

For the rise of fear, there are historical reasons. The structure of the family and the role of the father, such was the analysis of Max Horkheimer specifically, was seen to be in decline due to the weakening of economic freedom and stability. In times of economic crisis and successive monopolization, the overidentification with repressive institutions took over the protective (yet repressive) role of the *pater familias*. The historical

instability of the father figure due to the crisis-laden economic situation of the 1920s thus was seen to lead to new forms of authoritarianism, particularly amongst those social classes who were (or, like the petit bourgeoisie, considered themselves as) the most vulnerable. 'The level of fear among the lower classes is naturally greater than among those who wield the instruments of social power' (Fromm, 1936, 31; see Horkheimer, 2002, 110).

The *Studies* suggest that massive economic instability (and thus the weakening of the role of the petit-bourgeois and proletarian father) correlates negatively with the development of a strong self and the capacity to critically mediate within the oedipal structure of libidinal repression. The newly emerged dominant social character is authoritarian sado-masochism—the identification with libidinal repression and its major representatives. 'Pleasure in submission to authority' (Fromm, 1936, 37) is characterized as the authoritarian-masochistic character, which, according to Fromm plays 'a colossal social role' (47). Such sado-masochism includes aggression toward those who rank low and who appear weak and vulnerable (1936, 43 f.), it is 'sadistically cruel and potentially violent towards the weak and masochistically self-subordinating vis-à-vis the dominant social order' (Gandesha, 2018, 7).

Of course, the main strategies to counter such authoritarian developments are not primarily aesthetic, or even cultural political. As much as the so-called cultural Marxism of the Frankfurt School was a form of Marxism, it was never primarily cultural.[2] The leading argument is socio-political and economic and aims at the development of a strong democratic culture (that includes the prevention of economic instability for the weakest). Fromm writes:

> Ultimately, overcoming sadomasochism is only conceivable in a society where people can systematically, rationally and actively regulate their lives, and in which, rather than the fortitude of endurance and obedience, the courage to be happy and contemplate fate is the supreme virtue.
>
> (Fromm, 1936, 46 f.)

The struggle against authoritarianism thus meant overcoming unnecessary fear through social stability and economic regulation (1936, 48) and it meant overcoming the ideology of absolute necessity. For this, social theory (and not artistic interventions) and progressive politics were the most obvious means:

> once theoretical understanding breaks down the seemingly unconditional economic necessity, once authority in the bourgeois sense collapses, the new authority, too, loses its strongest ideological basis.
>
> (Horkheimer, 2002, 90)

A common understanding of the social-historical conditions had, however, been central in all Neo-Marxist aesthetic theories, too. This is the effect of realism and the historical claim to truth. Georg Lukács and Bertolt Brecht have discussed this widely, defining a

framework also for Frankfurt School approaches. More often than not, aesthetic experience was seen as a second-order experience that re-embedded experience in its social and historical conditions and that gained its truth function from the reflection of and critical stance towards the dominant social conditions. More will have to be said about this later—but not without saying more about a second strand in the Frankfurt School approaches to authoritarianism.

Fourteen years after the *Studies*, a second major analysis on Authoritarianism would be published. This second study presents itself not so much as a psychoanalytically backed theory of dominant tendencies on character development, but rather as an empirically backed character typology (based on questionnaires and extensive qualitative interviews). The key category in the study on *The Authoritarian Personality* is the so-called F-Scale, the fascism-scale, that measures the degree to which individuals are perceptive to fascism. The F-Scale corresponds with other scales as well, such as anti-Semitism and economic conservatism. Quite generally, in the arrangement of the experiment 'high scorers' tend to avoid ambiguity and show a strong need for ordered situations.

> High scorers show more rigidity and avoidance of ambiguity. The inability, on the part of high scorers, to face 'ambivalence',— which is emotional ambiguity— has been discussed previously […]. A rigid, and in most instances, conventionalized set of rules seems thus to determine the conception the typical high scorer has of his own and other people's behaviour […]. The interviews of low-scoring subjects show their readiness to think over matters and to come to a solution through their own thinking as well as their unwillingness to take over traditional and fixed concepts and ideals without scrutiny.
>
> (Frenkel-Brunswik, 2019, 463)

The general lack of reflexive capacities and the repression of ambiguities and uncontrolled, spontaneous impulses characterizes the subject that appears as rather susceptible to fascism.

In a recent reading of the study, Peter Gordon emphasized how the study introduces authoritarianism as 'a broader failure of critical imagination' (Gordon, 2022, 20), as the high-scorer rejects all reconcilement with social and cultural diversity and all perspectives of utopian change. Eventually, so Gordon argues, the authoritarian personality is characterized by its obedience to the 'authority of the given' (2022, 23), the idea of a well-established and monolithic social order.

These most explicitly psychological approaches found in the Frankfurt School do not easily relate to conceptions of mental health or illness, respectively. The pathology (if one wants to call it that) eventually manifests itself on the level of society rather than in forms of individual suffering (being 'authoritarian' will not necessarily and maybe not normally subjectively be perceived as unfavourable). Fromm, in the 1936 *Studies*, carefully distinguishes the sado-masochistic character as a general character type from

the pathological extreme of a sado-masochist (Fromm, 1936, 46). However, the social effects of such psychological dispositions are quite clearly presented as utterly destructive and detrimental. They are destructive, if not for the authoritarian individual itself, then clearly for society.

The relationship of such studies to aesthetic theorizing is far from obvious but not too far-fetched either. Authoritarianism is generally presented not only as a societal defect, but also as a crisis of experience, both as a crisis of imagining beyond the 'authority of the given' and a crisis of authentically experiencing alterity. Authoritarianism with its binary thinking and hatred of ambiguity represents the very antithesis of the capacity for the experience or confrontation with the other. Against this background, it can hardly be overestimated that ambiguity, diversity, and social imagination will constantly re-appear in the structural descriptions of aesthetic experience found in the Frankfurt School tradition.

In empirical sociological studies, a relationship between authoritarianism and the capacity for aesthetic experience appears as well. Although Adorno has not explicitly related the types of social character that he presented in *The Authoritarian Personality* to the other typology that he has, as a social researcher, become (in)famous for: the 'Types of Musical Conduct' in his *Introduction to the Sociology of Music*. The typology has rightly been criticized for its elitist and overly traditional understanding of music (including the contempt for jazz and pop music). Its strongly judgemental arrangement certainly lost much of its plausibility. Theodor W. Adorno presents a sevenfold typology of the experience of music, from the 'expert' (capable of analysing the formal structure and the inherent meaning of complex compositions (Adorno, 1976, 4)) to the 'indifferent, the unmusical, and the anti-musical' (Adorno, 1976, 17). These patterns of musical behaviour also describe the degree to which social individuals do or do not have the capacity to react spontaneously with aesthetic material. Adorno speculates that 'brutal authority' 'caused the defects in this type' [the unmusical] (Adorno, 1976, 17). In this sense, the scale of the capacity to authentically experience music (in its construction, complexity, and meaningfulness) echoes the degree of studies in authoritarianism without mentioning them. At least by identifying the complete lack of musical understanding with the scars of authoritarian upbringing, this relationship is being made explicit. The typology thus suggests a subcutaneous relationship between the critical analysis of the authoritarian disposition and aesthetics. Inversely, one could say that structures of 'hardened subjectivity' can be 'softened' by aesthetic experience, that they can be, at least gradually, made capable of ambivalence and empathy. The 'good listener' (second on the scale of the capacities to musical reception) can claim some measure of success here.

As mentioned previously, the studies in authoritarianism are hardly ever directly related to aesthetic theory. It is beyond doubt, however, that the structure of the authoritarian personality seems incompatible with the capacity of modern aesthetic experience. Although not always explicit, this basic insight remains fundamental for the further aesthetic theorizing of the Frankfurt School.

Aesthetic Liberation, Resistance to the Cliché, and the Dialectics of Happiness

The capacity to experience ambivalent and complex aesthetic material converges with social qualities that the various analyses on authoritarianism have emphasized in their societal and political importance. This introduces a somewhat psychological approach to aesthetics. Much of this remains present in the most advanced and sophisticated aesthetic theory of the Frankfurt School, in Herbert Marcuse's various aesthetic essays (as in *Eros and Civilization*, *Art and Liberation*, and *Counterrevolution and Revolt*) and in Theodor W. Adorno's *Aesthetic Theory* (and the various essays that surround it).

Both Adorno and Marcuse see the aesthetic in light of superordinate social structures that tend to be repressive: the permanent threat of late bourgeois societies to fall back into authoritarianism (through the repression of libido and the over-identification with social hierarchy and its institutions). The aesthetic, then, mediates between the merely rational logic of construction and the layers of content on the one hand, and the mimetic, i.e., the impulse and purely material character of the work, on the other hand. Aesthetic practice thus re-introduces somatic layers of man's impulsive nature and undermines the likely return of authoritarianism.

Specifically, Marcuse develops a model of aesthetic liberation that interprets aesthetic practices as means to new forms of subjectivity, as means of liberation, and a non-repressive mediation between social organization and libidinal impulses. Marcuse's approach suggests that pathologies of authoritarian subjectivity are (in part) to be corrected or supplemented by aesthetic practice by releasing repressed libidinal impulses. This is where he locates the sources of aesthetic happiness:

> The affirmative character of art [...] is in the commitment of art to Eros, the deep affirmation of the Life Instincts in their fight against instinctual and social oppression.
> (Marcuse, 1978, 11 f.)

Ever since his 1937 essay 'On the Affirmative Character of Culture', Marcuse confronts the implicit promises to happiness (articulated by the classical aesthetic tradition) with social reality. The major problem of classical aesthetics, in Marcuse's eyes, is, then, that classical aesthetics is too good to be true. In good Hegelian fashion, he locates the problem on the side of reality:

> Like imagination, which is its constitutive mental faculty, the realm of aesthetics is essentially "unrealistic": it has retained its freedom from the reality principle at the price of being ineffective in the reality.
> (Marcuse, 1966, 172)

Such is his idealizing outlook on the aesthetic, when he speaks of a humane 'goal of praxis, namely the reconstruction of society and nature under the principle of increasing the human potential for happiness' (Marcuse, 1978, 56).

Marcuse's aesthetics is derived from the aesthetic tradition (Kant/Schiller) on the one hand, and (Freudian) psychoanalysis on the other. The specific connection between Schiller and Freud, between aesthetic education and the possibility of a pleasure principle becoming real, is the merging of aesthetic education with a culture of Eros. This, he writes, 'is indeed the idea behind the Aesthetic Education. It aims at basing morality on a sensuous ground' (Marcuse, 1966, 190).

In his critique of a successively mechanical relationship to libido that is simplified and instrumentalized by commercialized culture (Marcuse speaks of 'institutionalized de-sublimation' or 'repressive de-sublimation'), he emphasizes the idea of a non-repressive form of sublimation, in which a culturally shaped form of libido, Eros, takes over:

> Libido transcends beyond the immediate erotogenic zones—a process of non-repressive sublimation. In contrast, a mechanized environment seems to block such self-transcendence of libido.
>
> (Marcuse, 1964, 77)

While Marcuse quite directly identifies art and the aesthetic as a force of liberation and happiness, Adorno offers a more realistic—but also more grim—account of aesthetics that resists the clichés of comforting art and aesthetics. To Adorno, art and aesthetics are not so much means and vehicles of happiness but rather (because they have a realist responsibility and a 'truth content') fully contaminated with history and society and, therefore also expressions of the social impossibility of individual happiness.

There have been attempts to interpret Adorno as an affirmative thinker of a fulfilled life, fulfilled experience, and happy contemplation and to aesthetics as its medium (see Seel, 2004, especially p. 39 f.). Generally, however, Adorno is quite clear: 'Art', he writes, 'is the ever broken promise of happiness' (Adorno, 1978, 136). As is generally the case in his philosophy, fulfilled life is kept in the negative, and aesthetics is not presented as an easy way out. Most importantly, aesthetic practice is not so much a means of locus of happiness but a specific way of processing the situation of happiness in society: 'For the sake of happiness, happiness is renounced. It is thus that desire survives in art' (1978, 13). Behind this structural argument that confronts art's realism with its inherent promises of enjoyment, there is a sociological and a historical argument. The sociological argument is implied in his critique of Culture Industry, the commercialized production of easy entertainment. To Adorno, easy and popular enjoyment, cultural goods produced for the market, are a form of betrayal. They falsely suggest the accessibility of happiness and pleasure in a world that structurally undermines its very possibility. As long as a world within which a life beyond scarcity and beyond the compulsion to work for the major part of the population remains impossible. Such cultural goods thus betray the aesthetic idea of real happiness.

Along these lines, Adorno identifies a fundamental rupture in the history of aesthetic enjoyment: 'After The Magic Flute', Adorno famously argues regarding the history of music, 'it was never again possible to force serious and light music together' (Adorno, 1991, 32).

The rejection of light aesthetics is also a rejection of conformism. Adorno 'valued the idiosyncratic as a marker of resistance to conformism' (Jay, 2022, 136), and kept emphasizing modern art's resistance to direct communication.

> That works renounce communication is a necessary yet by no means sufficient condition of their unideological essence. The central criterion is the force of expression, through the tension of which artworks become eloquent with wordless gesture.
> (Adorno, 1978, 237)

Aesthetic autonomy, in Adorno, is radically understood as a rejection of any utilitarian value—be it for market ends or political propaganda. The rejection of communication, also a rejection to play along in authoritarian mass societies (see Gandesha, 2022), however, is yet something else: In his 1941 essay on 'Art and Mass Culture', Max Horkheimer states that: 'Today art is no longer communicative' (Horkheimer, 1941, 294). Such rejection of communication was, however, not just seen as a gesture of resistance against 'so-called entertainment and the world of "cultural goods"' (Horkheimer, 1941, 295). 'The work of art,' he argued, 'is the only adequate objectification of the individual's deserted state and despair' (Horkheimer, 1941, 295). Georg Lukács had argued in his theory of reification (Lukács, 1971), that the structure of social interaction following the logics of individual commodity exchange was both antagonistic and atomistic. He claimed that such a form of late-bourgeois individualism determined the 'total outer and inner life of society' (Lukács, 1971, 84). The decline of communication was thus also seen as a necessary effect of antagonistic market societies. Art was seen as its mimicry.

Already this general negative reference to authoritarianism, to social atomism, and to instrumental rationality (of marketability, propagandistic use, etc.) identifies the anti-fascist construction of Adorno's aesthetics. Its inner logic is fundamentally political, even though its politics is indirect and contained within a strong sense of ambiguity and autonomy. The historical experience of fascism is present in at least one more respect. Generally, Adorno's thinking has been characterized as philosophy 'after Auschwitz'. For his aesthetics, this holds as well.

Adorno's socio-historical understanding of the relevance of art implies the constant and fundamental questioning of the possibility of art. For him, it does not go without saying that art can exist and maintain its task to keep up the promise of a fulfilled life and to reflect the historico-political situation at the same time. The name Auschwitz thus not only signifies a civilizational rupture but also a fundamental question concerning the possibility of art. When dealing with the civilizational rupture of Nazi mass killings, artistic expression (the main example being poetry) finds itself between the necessity to express the horror and the inadequacy of any artistic means to do so. 'To write poetry after

Auschwitz is barbaric' Adorno writes in 1949 (Adorno, 2003b, 163)—and differentiated in 1965 as follows:

> Perennial suffering has as much right to expression as a tortured man has to scream; hence it may have been wrong to say that after Auschwitz you could no longer write poems.
>
> (Adorno, 1973, 362)

As an expression of its time, art is processing the historical guilt of a failed civilization as well. In such a way, Adorno also discusses the question of how to deal with (collective) trauma in a world that keeps reproducing it. Trauma is present on any page in Adorno's aesthetics and explains the impossibility of art to play along and deliver harmonious comfort. Art, again, is not regarded as a solution to individual trauma, but as a field of discourse for the possibility of a better culture. In light of the worst forms of historical terror, the adequacy of its means is no longer obvious. It cannot simply play along and contains, comprises, and communicates the reasons for its own incapacity to be social and communicative. After collective trauma, art's reference to human well-being thus becomes even more indirect. How can one remain sane at all in a world of utter insanity?

Conclusion: Mental Health and Capitalism

Some years ago, the paleo-conservative American journal *The Chronicles* published a comment which scandalized the reference to a book by Adorno and others (*The Authoritarian Personality*) not only because of the Jewish money that financed it, but also because: 'The Adorno study found all Americans disagreeing with the Frankfurt School mentally ill' (de Toledano, 1999, 4). Although a rather grotesque detail from current political culture, the fear of political opponents of being pathologized carries a kernel of truth. Also in more serious contexts the plausibility of the terminology of 'social pathologies' has been criticized. Martin Jay suggested that such pathologizing implies a 'tacit dehumanization of the targets of such critiques' (2022, 140). Against the backdrop of Michel Foucault's critical history of the classificatory systems we find in the human sciences (including criminology, psychiatry, medical discourse), Jay finds it rather 'difficult to restore full faith in the innocence of categories of pathology transferred from physical conditions to mental states' (Jay, 2022, 132). And he asks further: 'Does "health" correspond to an assumed standard of normality (or normalcy) and "illness" to deviance from that norm?' (Jay, 2022, 132). This intervention is all the more plausible, if one sees critical theory as a means to restore and strengthen subjective forces of non-conformism and to rewrite, in the words of Negt and Kluge, the history of obstinacy.

The socio-theoretical focus on societal obstacles to happiness and to a flourishing democratic culture has not lost any plausibility. In light of more contemporary studies on neoliberal capitalism and its effects on mental health, much of the classical Frankfurt School arguments have been reconstructed in a slightly different form. Alain Ehrenberg, in *The Weariness of the Self* (2009), has argued that extended entrepreneurial responsibility for individual well-being and economic flourishing has led to a structural growth of depression in post-Fordist societies.

In countless analyses of contemporary (popular) culture, Mark Fisher (2009, 2016) has discussed the contemporary impossibility of thinking beyond capitalism, or even: of emphatically thinking of a future. In light of the general political passivity to confront climate catastrophe, these arguments have only gained importance. If depression, however, appears as a symptom of decreased political imagination (as Fisher suggests), then the unthinkability of a world beyond the catastrophic destiny inscribed into the historical logic of capitalism is not only a problem to democratic culture but also mentally unbearably. (Neoliberal) capitalism is causing its mental effects (Zeira, 2021).

Capitalism, of course, is a problem too big for aesthetics to solve, yet too important a context for aesthetics to ignore. In this light, the contribution Frankfurt School's aesthetics to debates on mental health is its insistence on the fact that another world is always possible—even though art and aesthetics can do little more than allude to its possibility. Quite concretely, the Frankfurt School's general aesthetic approach presents various attempts to counter overarching and overburdening forms of social objectivity with coping strategies, resources of reflexive distance, practising the handling of ambiguous layers of (bodily and social) experience. The essential insight that emerges from the aesthetic tradition of the Frankfurt School vis-à-vis the discourse on mental health is the understanding of art as an effect and reflection of social structure and as a cultivation of the 'biosphere of imagination' (Kluge, 2004, 102 f., my translation).

As for mental health, self-care, and individual well-being under given societal conditions, such positions remain ambivalent. All that the early Frankfurt School holds against self-preservation, against the atomistic struggle for individual convenience, holds against the post-Fordist strategies of self-optimization and probably some of the discourse on mental health as well: It leaves the rationality of the overarching structure of society untouched. According to the Frankfurt paradigm, art and aesthetics therefore do not provide capacities for individual well-being rather than strategies of resistance and moving beyond societal constraints: It might be true that cows give more milk when they are exposed to the music of Beethoven (SWR, 2019, Spiegel), but if anything, Frankfurt School aesthetics articulates protest against the compulsion to exploit human beings like dairy cows.

Notes

1. As Thomas Elsaesser writes: 'Translating literally as "self-sense", the Eigensinn of the title can mean anything from obstinacy and persistence to resistance and self-determination' (Elsaesser, 2012, 25).

2. In this sense the right-wing populist term 'Cultural Marxism' misses the point of the Frankfurt School.

References

Adorno, Th. W. (1973) *Negative dialectics*. London: Routledge.
Adorno, Th. W. (1976) *Introduction to the sociology of music*. New York: Seabury Press.
Adorno, Th. W. (1978) *Aesthetic theory*. London and New York: Continuum.
Adorno, Th. W. (1991) 'On the Fetish Character of Music and the Regression of Listening'. In Jay M. Bernstein (ed.), *Th. W. Adorno, the culture industry* (pp. 29–60). London: Routledge.
Adorno, Th. W. (2003a) 'Studies in the Authoritarian Personality'. In Theodor W. Adorno, *Gesammelte Schriften in 20* Bänden, vol. 9 (pp. 143–509). Berlin: Suhrkamp.
Adorno, Th. W. (2003b) 'Cultural Criticism and Society'. In Rolf Tiedemann (ed.), *Can one live after Auschwitz? A philosophical reader* (pp. 146–162). Stanford: Stanford University Press.
Adorno, Th. W. (2005) *Minima Moralia. Reflections from damaged life*. London: Verso.
Adorno, Th. W., & Benjamin, W. (2004) *The complete correspondence, 1928–1940*. Cambridge, MA: Harvard University Press.
Benjamin, W. (2008) *The artwork in the age of its technological reproducibility*. Cambridge, MA: Belknap.
Demirovic, A. (1999) *Der nonkonformistische Intellektuelle. Die Entwicklung der Kritischen Theorie zur Frankfurter Schule*. Frankfurt: Suhrkamp.
Düttmann, A. (2004) *Philosophie der Übertreibung*. Frankfurt: Suhrkamp.
Ehrenberg, A (2009) *The weariness of the self. Diagnosing the history of depression in the contemporary age*. Montreal: McGill-Queen's University Press.
Elsaesser, Th. (2012) 'The Stubborn Persistence of Alexander Kluge'. In Tara Forrest (ed.), *Alexander Kluge. Raw materials for the imagination* (pp. 22–29). Amsterdam: Amsterdam University Press.
Fisher, M. (2009) *Capitalist realism: Is there no alternative?* Winchester: Zero Books.
Fisher, M. (2016) *Ghosts of my life: Writings on depression, hauntology and lost futures*. Winchester: Zero Books.
Frenkel-Brunswik, E. (2019) 'Dynamic and Cognitive Personality Organization as Seen Through the Interviews'. In Adorno and others, *The authoritarian personality* (pp. 442–467). London: Verso.
Fromm, E. (1936) 'Studies on Authority and the Family. Sociopsychological Dimensions'. *Fromm Forum 24 / 2020* (Special Issue), 8–58.
Gandesha, S. (2018) 'Identifying with the Aggressor: From the Authoritarian to Neoliberal Personality'. *Constellations 2018*, 1–18. https://doi.org/10.1111/1467-8675.12338
Gandesha, S. (2022) 'How do People Become a Mass'. *Polity 54*, 84–106.
Gordon, P. (2022) 'Realism and Utopia in the Authoritarian Personality'. *Polity 54* (1), 8–28.
Hartle, J. (2018) 'Aesthetics and Its Critique: The Frankfurt Aesthetic Paradigm'. In Beverley Best, Werner Bonefeld, & Chris O'Kane (eds.), *The SAGE Handbook of Frankfurt School critical theory* (pp. 1006–1023). Thousand Oaks, CA: SAGE.
Horkheimer, M. (1941) 'Art and Mass Culture'. *Zeitschrift für Sozialforschung 9-2/1940*, 290–304.
Horkheimer, M. (2002) 'Authority and the Family'. In Max Horkheimer (Ed.), *Critical theory. Selected essays* (pp. 47–128). New York: Continuum.

Jacoby, R. (1981) *Dialectic of defeat: Contours of Western Marxism*. Cambridge: Cambridge University Press.

Jameson, F. (2009) 'Marx and Montage'. *New Left Review* 58, 109–117.

Jay, M. (2022) 'The Authoritarian Personality and the Problematic Pathologization of Politics'. *Polity* 54(1), 124–145.

Kluge, A. (2004) *Chronik der Gefühle. Basisgeschichten*, Frankfurt: Suhrkamp.

Kluge, A. (2012) 'The Sharpest Ideology: That Reality Appeals to its Realistic Character'. In Tara Forrest (ed.), *Alexander Kluge. Raw materials for the imagination* (pp. 191–196). Amsterdam: Amsterdam University Press.

Lukács, G. (1971) *History and class consciousness: Studies in Marxist dialectics*. Cambridge, MA: MIT Press.

Marcuse, H. (1964) *One-dimensional man. Studies in the ideology of advanced industrial society*. Boston: Beacon Press.

Marcuse, H. (1966) *Eros and civilization. A philosophical inquiry into Freud*. Boston: Beacon Press.

Marcuse, H. (1978) *The aesthetic dimension: Toward a critique of Marxist aesthetics*. Boston: Beacon Press.

Merchant, B. (2017) 'Life and Death in Apple's Forbidden City'. *Guardian,* 18 June 2017. Available at: https://www.theguardian.com/technology/2017/jun/18/foxconn-life-death-forbidden-city-longhua-suicide-apple-iphone-brian-merchant-one-device-extract [last accessed 30 September 2024].

Negt, O. & Kluge, A. (2014) *History and obstinacy*. New York: Zone Books.

Rancière, J. (2009) *The emancipated spectator*. London: Verso.

Riegl, A. (1985) *Late Roman art industry*. Roma: Giorgio Bretschneider.

Seel, M. (2004) *Adornos Philosophie der Kontemplation*. Frankfurt: Suhrkamp.

Simmel, G. (2005) 'Metropolis and Mental Life'. Available at: https://www.blackwellpublishing.com/content/bpl_images/content_store/sample_chapter/0631225137/bridge.pdf. [last accessed 30 September 2024].

SWR. (2019) 'Geben Kühe mehr Milch, wenn sie Musik hören?'. Available at: https://www.swr.de/wissen/1000-antworten/umwelt-und-natur/geben-kuehe-mehr-milch-wenn-sie-musik-hoeren-100.html [last accessed 30 September 2024].

de Toledano, R. (1999) 'On Mental Illness and the Frankfurt School'. *Chronicles 4*.

WHO. (2022) 'Mental Health. Key Facts'. Available at: https://www.who.int/news-room/fact-sheets/detail/mental-health-strengthening-our-response [last accessed 30 September 2024].

Zeira, A. (2021) 'Mental Health Challenges Related to Neoliberal Capitalism in the United States'. *Community Mental Health Journal* 58, 205–212. https://doi.org/10.1007/s10597-021-00840-7

CHAPTER 9

AESTHETIC ENGAGEMENT AS A PATHWAY TO MENTAL HEALTH AND WELL-BEING

EUGENE HUGHES AND ARNOLD BERLEANT

INTRODUCTION

HIDDEN away on the second floor of an old warehouse in the SoHo district of downtown Manhattan, is a room filled with 360 square metres of dirt. Named *The New York Earth Room*, it takes up a space that would otherwise be a high-end apartment in this prime New York real estate and has done so since it was first installed in October 1977 by one of the pioneers of the American land art movement, Walter De Maria (Aldrich et al., 2017). The giant mass of dark organic matter, 179 cubic metres to be exact, stretches 56 centimetres high across the white space, right up the sides of the loft's walls and windows. Raked and watered meticulously every week, the same soil is kept as close as possible to how it first appeared almost forty-five years ago.

When you walk up the stairs or take the lift to the second floor, on arriving at *The New York Earth Room*, you are first greeted by a silence in stark contrast to the noise of the busy shopping streets of SoHo below. A musty smell of moist air, albeit subtle, envelops you. Then you turn and see this still monolithic mass of dark earth laid out before you. The soil may be still, but on some sensory level, you realize *The New York Earth Room* is alive. Unlike most art galleries, this one has only one work, and Bill Dilworth, who has been curating and caring for *The New York Earth Room* for the past thirty years, has commented that many people walk right past the work or ask, 'Is that it?' This is precisely the conundrum the installation presents: What is 'it'? Is it the earth? Is it the juxtaposing of biotic and abiotic factors? Is it the stillness? Is it the silence? Is it the smell? Is it the unique atmosphere created by the combination of parts? Is it the fact that, with every breath you inhale, some particles of this organic matter enter your body, and with every exhalation the earth reciprocates?

The New York Earth Room is an immersive experience. There is no explanatory audio file heard on headsets and photography is not allowed, so you cannot distract or distance yourself from the experience. As a result, you begin to realize that you are a part of this out-of-the-ordinary environment. The words 'viewer' or 'observer' are inadequate because integral to the experience is your participation within it. Any contemplative separation between viewer and art object fades away in a setting where the space is as alive as elements within it. When you are in *The New York Earth Room*, you become another biotic component of this still yet nonetheless very alive environment. At a physiological level, you are an active participant, whether you choose to notice or not. Walter De Maria's brilliance is to bring our consciousness to this reciprocity through the theatre of his work. The artist is the master facilitator of this out-of-the-ordinary encounter.

The experience of *The New York Earth Room* works on the possibility of a continuity rather than a delineation and separation between entities. The space between is as alive and dynamic as entities that move within this continuum. Physical factors and bodily sensations are as alive as the empathy and imagination the experience evokes. When self-experience takes on aesthetic qualities of this nature, there is a felt fusion between the physical self and psychological self. One's sense of self is no longer located in opposition to the other. This aesthetic engagement provides the conditions to experience an embodied sense of self that expands beyond the usual spatial boundaries of 'me' and 'not me'. Once the visitor to *The New York Earth Room* steps back out of this space into the hustle and bustle of New York City street life, their usual ways of perceiving the world surrounding them more than likely return. Familiar perceptual states return but one's capacity to attune with environments in the way experienced in *The New York Earth Room* remains.

What Is Aesthetic Engagement?

Modernism's iconoclasm paved the way for a succession of radical movements in art throughout the twentieth century, which led to artists in the 1960s and 1970s wondering if concepts and behaviour were more interesting than objects. From there, new and innovative art practices grew. Not only did artists incorporate new materials and techniques, but they also began to extend into the formerly untouched space of the observer and invite active involvement. For some artists, participation became an essential component to the fulfilment of the art experience, not only in the visual arts but in theatre and other art forms. The traditional separation between subject and art object and the honoured tradition of contemplative appreciation was deliberately breached.

Artists such as Walter De Maria and Nancy Holt in the United States and Richard Long and Hamish Fulton in the United Kingdom challenged prevailing attitudes towards the use of physical space. Feeling restricted by the space inside St Martin's School of Art in London, on the 2 February 1967, two students, Hamish Fulton and Richard Long, organized a group walk with some of their fellow students (Lodermeyer & Abramovic,

2009). They met on the corner of a street near St Martin's and tied each other together with one piece of rope before setting off. It took the students fifteen minutes to walk a distance that would usually take three minutes, walking very slowly, until they came back round to the front of the school. This event was the genesis of Fulton and Long's life art practice as walking artists. Such innovative practices freed art from the flat surface and frame of the painting and the separation of the observer from the object.

This is the context in which traditional aesthetics was put into a quandary. Unlike a painting or a sculpture, the physical space cannot be considered a neutral and objective medium. It is both shaped by and inseparable from the perceiver. For well over two centuries Kant's central theory of disinterestedness, coupled with the subsequent theory of distancing attitude held by theorists, had formed the backbone of traditional ways of characterizing aesthetic experience. This disinterestedness and distancing became the prerequisites for the aesthetic appreciation of both art and nature. Without these contemplative techniques, how could one begin to experience a sense of awe at the chasm between the vastness of the universe and the finiteness of the self? But in the immersive art that emerged in the 1960s and 1970s, this approach seemed inappropriate and irrelevant. Once the observer discovered they were inside the so-called art object, all notions of separation needed to be re-evaluated. Appreciating the perceptual processes involved within this participation, be it an overt physical action or the more subtle shifting of attention made it difficult to accept the inherent duality within traditional accounts of the aesthetic. The assumptive stance of separation and opposition disappeared in appreciation of the reciprocity and continuity of experience.

Aesthetic engagement was born out of the need for an alternative to the traditional model of aesthetic appreciation that was inhibiting our apprehension of the new type of art that was emerging (Berleant, 1995). Developed over the past forty years, aesthetic engagement replaces the cognition-centred contemplative model of the aesthetic with a phenomenological appreciation of the direct experience of the self's participatory involvement in a situation, be it a work of art, a performance, an architectural or environmental location, or a social situation (Berleant, 2010). The delineation between entities is inconsequential within a continuum of experience in which they act upon each other, overlap, and merge. The leading feature of the encounter is the perceptual participation involved rather than the delineation of the subject from the object.

While the concept of aesthetic engagement is well suited to the artistic innovations of the twentieth century, it also reinvigorates our experience of art from earlier periods. The work of old masters can take on new qualities when appreciated through the lens of perceptual participation. Moreover, by applying this approach to the appreciation of environments, physical space is no longer neutral (Berleant, 2012). The aesthetic appreciation of the landscape is not experienced through removed observation but through dynamic perceptual participation. This exchange between perceiver and environment, once acknowledged, allows the perceiver to dissolve into it. Within this dynamic, the environment is not wholly dependent as an aesthetic object on the perception of the person. It also imposes itself in significant ways on the perceiver, engaging in a relationship of mutual influence. Whether visiting *The New York Earth Room*, trekking through

a remote forest on a bright winter day after a night of snowfall, or in sitting in deep conversation with an old friend whom you have not seen for many years, aesthetic engagement provides a way of appreciating the sense of intimacy and reciprocity that can occur.

Aesthetic engagement is not the first alternative to contemplative models of aesthetic appreciation to be proposed. Most notably, John Dewey and Maurice Merleau-Ponty developed active, phenomenological models of aesthetic experience (Dewey, 2005; Merleau-Ponty, 2012). Similarly, psychologists such as Kurt Lewin, who introduced field theory (Lewin & Lewin, 1997), and James J. Gibson, who developed the concept of affordances offered by environments (Gibson, 2014), describe the interdependent relationships between perceiver and environments. Aesthetic engagement differs from these other active models in its consideration of reciprocity—the ways environmental factors impose themselves on the perceiver, and the perceiver energizes the environment. This perspective moves one from being a disinterested observer to an active participant, where the engagement with the environment is a whole-body experience. Space is not visually observed in opposition to the viewer as a composition of flat surfaces or a collection of objects but an enveloping atmosphere one is immersed within.

Although much of human perception operates at an automatic and unconscious level, aesthetic engagement is a conscious act. Experiencing oneself as an active participant of the living environment versus a distant and removed observer requires intentionality. It takes conscious effort. This shift in perspective of the self-experience occurs when we intentionally draw our attention to our multi-sensory perceptual involvement. This creates a fundamentally different experience of self from that in the construct of a subject–object relationship. For example, by shifting awareness to their multi-sensory response, the visitor to *The Earth Room* becomes aware of their active participation within this environment. By bringing the multi-sensory reciprocity between perceiver and environment to the foreground of our awareness, there is far more to the experience than just what we see. Not only does the environment come alive; so too does our experience of self. Through an aesthetic engagement, our sense of the environment and our sense of self become two sides of the same coin. In this way, aesthetic engagement provides a way to experience and explore a sense of self that is deeply connected with the world around it.

Perceptual Participation

Aesthetic engagement differs from traditional models by returning aesthetics (from Greek *aisthetikos* 'of or for perception by the senses') to its etymological origins by stressing the primacy of sense perception. As an idea derived from how the self engages with one's environment, aesthetic engagement recognizes perception as the mutual activity of all the sense modalities. This somatosensory participation is where aesthetic engagement is fundamentally different from aesthetic models based on an underlying duality of subject and object, which privilege vision. By rejecting the distance between

observer and object and any notion of objectification, aesthetic engagement positions multisensory perceptual participation as central to the experience. The quintessential characteristic of aesthetic engagement is the conscious focusing of our attention toward our multisensory perceptual participation. This departure from traditional aesthetics calls into question our traditional understanding of perception. Historically, perception has been viewed as a siloed function of input and interpretation of the (five) sensory modalities, ranked and treated as operating independently of each other.

Before the art happenings of the 1960s, pre-postmodernism, it was not uncommon for art critics to propose that art degenerates the closer it moves towards theatre (Fried, 1988; Greenberg, 2000). Such sentiment seeks to underline the importance of the observation of the object, consequently, the superiority of visual perception. The term *visual arts* itself excludes the other senses. It suggests we can, or even should, ignore the other senses when engaging with a painting or a sculpture. The prioritization of visual perception is not exclusive to the arts. Studies show that over 70 per cent of scientific research on perception and perceptual memory has focused on vision over all the other senses (Hutmacher, 2019). We must question if vision is much more important than the others. Is this prioritization physiologically accurate or are there other factors involved in this reasoning? Researchers have begun to ask this very question, and their findings point to a significant cultural component in our ranking of the senses. By studying the history of the hierarchy of the senses in Western culture and comparing this to non-Western cultures, researchers conclude that there is no universal hierarchy. There may well be solid neurological reasoning for the dominance of vision in perception, but there is also a strong cultural dimension for why we rely on sight so heavily (Howes, 2021). The neurological model and the cultural model are not opposed. Both hold partial truths. The point is that the scientific neglect of the other senses is in large part due to this cultural bias.

Embracing All the Senses

The idea that our understanding of the senses has been at the mercy of cultural beliefs sparks much interest among contemporary scholars. Sensory studies are emerging across disciplines as diverse as anthropology, architecture, artificial intelligence, design, history, philosophy, and psychology. In anthropology, for instance, historically the bias in observing other cultures has led to inappropriate text and textual interpretations of foreign societies. The anthropologist Paul Stoller proposes an ethnography that embraces the sensory epistemologies of the cultures being studied rather than one that imposes the ethnographer's (Stoller, 1989). In doing so, we can gain a more embodied understanding of these societies and what they have to teach us about the human experience. A sensory ethnography is particularly meaningful, for example, in understanding cultures that value taste and smell more highly, in certain aspects of their lives, than sight or sound.

This surge of academic interest in the senses has not escaped the cognitive sciences. There are three strands of development worth mentioning concerning aesthetic engagement. First is that previously side-lined sense modalities are getting more attention. The more attention they get, the more important and complex they become. Recent developments in our understanding of our sense of smell illustrate this well. The Nobel Prize-winning work of researchers from Columbia University brought the scientific community's attention to the sophistication of the olfactory system by discovering that a relatively small cluster of 400 receptors in the nasal passage is capable of discriminating millions, if not billions, of smells (Buck & Axel, 1991). This discovery is striking as scientific communities historically dismissed smells and odours as notoriously tricky for humans to identify and describe. Kant famously claimed smell was not only the most ungrateful but the most dispensable of all the senses (Kant, 2003). The apparatus may be there, but do we need it as much as our ancestors did in this sanitized modern world? Studies show that regardless of whether we are conscious of it or not, our sense of smell significantly influences how we behave toward each other.

The second strand of emerging research focuses on understanding how different sensory modalities work together as an integrated sensorium. Whereas perception is historically believed to involve single sense modalities operating independently, recent studies suggest that perception relies primarily on multi-modal and cross-modal activity. This multisensory activity is not confined to the famous five. Visual, auditory, olfactory, and gustatory systems, with receptors located on or near the orifices of the body, interact with sensory systems responsible for touch, pain, pressure, temperature, movement, balance, and vibration, which have receptors located throughout the body (Fitzpatrick & McCloskey, 1994). This multisensory integration is critical to how we perceive the world around us. Rather than a siloed system that takes in and interprets external stimuli individually, sensory systems work together to make sense of, adapt, and respond to environmental stimuli. An everyday example of this is the simple act of turning the lights off. This change in the environment will stimulate the sensorium to shift its constellation to engage with the stimuli available. When vision is impaired, haptic, proprioceptive, and vestibular sensory systems automatically and unconsciously work together to adapt to these new environmental conditions (Batson, 2009; Redding, 2010).

The third strand of research explores the role imagination plays in multi-sensory integration. Researchers have begun to unpack the complex relationship between what we imagine and what we perceive in the external environment. For example, studies show that what we imagine hearing (auditory mental imagery) can affect our perception of what we are seeing. Similarly, visual mental imagery can affect our auditory perception (Berger, 2016; Berger & Ehrsson, 2013). Although we have just begun to scratch the surface of the complicated relationship between imagination and sensation, it is clear that mental imagery plays a far more significant role in perception than previously thought. When these strands of research are brought together, our empirical understanding of perception radically evolves from the isolated input and interpretation of external stimuli to the multisensory, cross-modal integration of real and imagined sensory stimuli.

Contemporary studies of perception present a fascinating intersection between aesthetic theory and the cognitive sciences. Recent developments in our empirical understanding of perceptual processes have helped substantiate and elucidate the idea of aesthetic engagement. The two concur in holding that the individual is intimately involved in a dynamic process of perceptual participation within the environment. Beyond categorizations of mind and body, this evolved understanding of perceptual processes suggests a space where the physical self and the psychological self merge. The need to delineate between sensation and cognition, between what we feel and what we think, becomes somewhat secondary to what is actually happening in the perceiver's environmental experience.

The concept of aesthetic engagement brings our attention to the appreciation of our immersion and involvement within any given environment or scenario. It invites you to consciously participate not only with the arts but with the rest of life, both human and other-than-human. By orienting our attention toward our multi-sensory perception, we become aware of a continuum of experience where the in-between is as real as either end. Where sensation ends and cognition begins becomes both impossible to delineate and irrelevant. Physical sensations are treated with the same curiosity and interest as emotions and ideas. In our capacity to consciously shift our attention, our experience of life, and self, moves from an anaesthetic to an aesthetic engagement.

A Sense of Self

In essence, aesthetic engagement opens up the possibility of an experience of self that is not based on boundaries and containment that define us, but instead on communion and expansion. It is an experience of self that possesses porous boundaries. Aesthetic engagement enriches our sense of environment as it simultaneously enriches our sense of self. Where a Kantian aesthetics invites the observer to reflect with awe on the chasm between the infinity of the universe and the finiteness of the self, aesthetic engagement draws one into experiencing the sensation of intimacy involved in being part of the whole environment (Hughes, 2022). As such, aesthetic engagement challenges the conventional psychological boundary of 'me' and 'not me.' To experience self in this way is to experience an embodied sense of self rather than to reflect on an abstracted construct of self.

In St. Augustine's fourth-century autobiographical text *Confessions*, the outer physical world served only to deceive and distract him from searching for the true self, which he positioned as intimately interior and separate. As scholars point out, this inner world was an invention (Ostenfeld, 1982), a brilliant metaphorical device to articulate his understanding of the less tangible aspects of human experience. Almost seventeen centuries later, St. Augustine's interiority of the self still lives on in popular psychology and psychotherapy. His grand metaphor is often used in a more literal sense to refer to psychological processes. For example, Betterup, a high-profile US-based mental health

organization patronized by Prince Harry, the Duke of Sussex, launched in 2022 an 'Inner Work' campaign to promote 'self-care'.[1] The use of these terms illustrates how the notion of an inner world is so engrained in Western thinking that it is readily used and broadly understood.

As the depth-psychologist James Hillman pointed out, the enduring question for all psychology is not 'who am I?' but 'where am I?' (Roszak et al., 1995, 5). When delineations between self and environment, sensation and cognition, subject and object are dissolved, the internalized self-representation is replaced by an embodied sense of self. The embodied experience of a sense of one's own existence is prioritized over the somewhat ethereal and elusive hunt for some abstracted concept of self that resides in an imaginary space inside. We experience self through the ever-changing and emerging sensations that occur within the physiology of a body moving with its environment. This phenomenological attitude has influenced cognitive scientists interested in the self in the past three decades, and researchers have started exploring the age-old quest for the self from this embodiment approach (Fuchs, 2018; Fuchs & De Jaegher, 2009; Niedenthal et al., 2005; Varela et al., 2016).

Drawing upon the past few decades of empirical research, a recent study from a group of researchers in Japan statistically extracted three factors that constitute an embodied sense of self (Asai et al., 2016). Cross-referenced against the work of leading neuroscientists, the team verified three structural components to an embodied sense of self: a sense of ownership, a sense of agency, and a sense of narrative. Ownership refers to one's ability to feel one's body and its actions as one's own (e.g., 'This is my hand that is moving.'). Agency refers to the ability to experience oneself as the agent of these actions (e.g., 'I am the one moving my hand.'). Narrative refers to the ability to experience oneself as continuous over time, which also enables a sense of uniqueness to develop (e.g., 'These are my hands that used to love playing piano but not any more').

A sense of ownership and agency make up what cognitive scientists refer to as the minimal or core self, which starts to develop in the first few months of an infant's life. A sense of narrative relies upon this minimal self and begins to develop as a temporal dimension within the first eighteen months of life. The process does not stop. The minimal and narrative self evolves over the lifespan of the individual. In this way, a sense of self is not an entity or structure but an ever-evolving process of possibilities, extensions, and transitions. Any simple action that involves the body moving through space and time creates the opportunity to experience this embodied sense of self.

Before proposing an embodied sense of self is necessarily a better or more healthy sense of self, there is a qualitative dimension to take into consideration. An embodied sense of self may not be sufficient to experience psychological well-being. It is possible for an individual to feel an embodied sense of self and experience distress or discomfort. There must be some other overall quality or qualitative aspects to the experience. We cannot ignore the near widespread agreement among psychologists, psychiatrists, and cognitive scientists on the positive correlation between an overall cohesive sense of self and psychological health (Asai et al., 2016; Gleason, 2005; Zahn et al., 2008). The cohesive sense of self provides the individual with the inner resourcefulness

necessary to withstand life's blows and develop their capacity for what Heinz Kohut referred to as joyful, creative living. Conversely, the fragile self is the basis for most psychopathologies. Heinz Kohut was so convinced of the importance of a sense of cohesiveness that he prophesized the greatest psychological challenge facing modern society is the fragmenting self (Kohut 2009).

The notion of cohesiveness raises an interesting tension between the concept of aesthetic engagement and what is widely considered to constitute a psychologically healthy sense of self. Is the porous, fluid nature of aesthetic engagement threatening to an overall sense of cohesion in some way? Or conversely, can aesthetic engagement help cultivate a healthy sense of self? As a conscious process of active perceptual participation, aesthetic engagement facilitates the opportunity to experience an embodied sense of self. But how does the aesthetic quality of the experience translate into psychological well-being?

Aesthetic engagement strives for communion rather than cohesion, where the psyche encounters an extraordinary sense of intimacy with the environment it inhabits. Aesthetic engagement holds the self within this experience in a space and time that allow a fusion between the physical and the psychological. This self experience is markedly different from the sense of individual cohesion we strive for and value in our everyday social environments. It presents an experience of self that is not constrained by the need to navigate between what is 'me' and what is 'not me', what is revealed and what must be hidden, what is cohesive and what is fragile, what is bounded and what is porous. Within an aesthetic engagement the individuation of entities is replaced with a continuum of experience.

The Totality of Nature

This continuum of experience may seem a somewhat threatening proposition to the subjective–objective mindset that underpins many mainstream Western philosophical and psychological beliefs. The poet and activist Paula Gunn Allen helps illustrate a way of being different from Western culture's separate self in her summary of North American First Nations peoples' perception:

> We are the land; that is the fundamental idea embedded in Native American life. The land is not really the place (separate from ourselves) where we act out the drama of our isolated destinies. It is not a means of survival, a setting for our affairs. It is rather a part of our being, dynamic, significant, real. It is our self. It is not a matter of being close to nature. The Earth is, in a very real sense, the same as our self (or selves).
> (Hobson, 1979, 191–193)

This apprehension of nature, which absorbs humans into the rest of nature, interprets everything as part of a single, continuous whole. Whether we consider nature to be the whole of material reality, independent of humans, or whether we believe nature to

encompass the whole universe and everything within it, including humans and human activities, bears significant theoretical and practical consequences. The impact of separating humans from the rest of nature started to emerge in the nineteenth-century with environmentalists, such as the Scottish American John Muir. He viewed nature as God's temple and argued specific environments must be separated and protected from humankind to remain pristine and pure (Muir, 1980). His work heavily influenced the early environmental movement and led to the establishment of the National Park System in the United States (Runte, 1990). The great Yosemite National Park is a product of this system. Unlike Muir, the peoples who lived on that land for over four thousand years before him had no need to ringfence and protect it because they felt they were part of it.

It is easy to assume that Muir and his contemporaries' Garden-of-Eden-like fantasy of purity that protects and separates certain kinds of nature from humans has no influence on policy today. Still, it remains entrenched within the common narrative and frequently shows up in mainstream research, public policy, and across many disciplines. For example, the British Government's 2020 protection of green space policy classifies spaces as natural and unnatural, as if the materials we use to construct environments come from some other than natural sources.[2] Of course, it is hard to argue against the need to protect special places from human intervention but the question we have to ask ourselves is 'Why?'. The flip side of this need to protect is our endless desire to manipulate and dominate environments founded on a belief that we are in some way separate. The problem with such a blunt distinction is that it ignores the true complexity of environments and how they work. For example, it implies that the non-human biotic and abiotic factors we find in all types of environments, such as air, temperature, and microorganisms, do not count as natural.

The categorization of nature as separate not only influences current government policy on environmental planning, but it also holds significant consequences for psychological research and practices. For instance, in the last four decades, a substantive body of empirical research has emerged on the psychological benefits of exposure to green spaces. In general, studies report findings that suggest green spaces have physical, mental health, and well-being benefits including increased attention, working memory performance, reduction of ADHD symptoms, and general relief of stress and anxiety symptoms. Typically, studies measure changes in cognitive performance and affect based on periods of exposure within a range of a few minutes to an hour (Schutte et al., 2021).

Because humans may inherently feel natural environments are good for us, it is easy to accept the claim that so-called green space is better for our mental health and well-being than other types of spaces. Several researchers suggest such claims are empirically insubstantial as the evidence is not sufficient to make concrete links between exposure to green spaces and physical health, mental health, and well-being, as it is difficult to establish the causal relationship (Schutte et al., 2021, 65). Environmental neuroscience studies have shown that similar cognitive effects to the outcomes suggested in green space studies can be experienced when using pictures, videos, or sounds in a laboratory

setting. Some longitudinal studies even suggest that, unlike rural environments, the multi-sensory intensity of urban environments has a 'train the brain' effect that can reduce cognitive aging (Cassarino et al., 2016). In terms of psychological health, studies such as these go some way to challenge the grossly simplified assumption that being in so-called green space is in some way better for you than other environments.

Environments, and our human involvement within them, are far more complex than this duality allows. Although the tendency of environmental psychology since the beginning of the 1990s has been to position the human subject within a particular type of place that is categorized as natural or otherwise and to measure the effects, inherent within this approach is a subjective–objective worldview. To date, vision is the perceptual process that gets the most research attention, followed in rapidly descending order by other single sense modalities. From a phenomenological point of view, the objectification of environments denies the human organism's involvement. It moves farther away from up-close and immediate experience. The objectification of environments and the narrowing of humans' perceptual participation within them ignores the reciprocity within the dynamic and therefore misses out on essential qualities and textures of the human experience. It is this qualitative dimension, this aliveness, that we can call the aesthetic.

Psychology is essentially anthropocentric, so the idea that everything is nature, including humans and their activities, has its challenges. How does one reconcile the notion of mutual reciprocity between the human mind and the mindless? When it comes to studying the human mind, how can you not treat space as anything other than a separate, neutral, and objective medium? Everything other-than-human is positioned as the backdrop to intrapersonal and interpersonal dynamics within an anthropocentric worldview. When it comes to psychological well-being, nothing can stand up to the intimate bonds between humans that we widely accept as the basis for a psychologically healthy and fulfilling life. As John Bowlby wrote in his highly influential three-volume tome, *Attachment and Loss*:

> Intimate attachments to other human beings are the hub around which a person's life revolves, not only when he is an infant or a toddler or a schoolchild but throughout his adolescence and his years of maturity as well, and on into old age. From these intimate attachments, a person draws his strength and enjoyment of life and, through what he contributes, he gives strength and enjoyment to others. These are matters about which current science and traditional wisdom are at one.
> (Bowlby, 1980, 442)

Bowlby, amongst others, inspired decades of clinical research into early infant relationships and the role of affectionate bonds throughout life. The pervasive belief that humans are intrinsically relational beings has focused much psychological research, theory, and practice towards intrapersonal and interpersonal realms. Some scholars have even commented that more has been written in the psychology literature on the fear and psychopathology of being alone than any potential psychological value of the

experience. But what if, by focusing on the fish, we've neglected the pond? Questioning psychology's anthropocentric focus represents an existential threat: Where does psychology go if we dislodge the centrality of the mind? But as voices in the emerging field of embodied cognition describe it, saying consciousness is just in the brain is like saying flight is just in the wings of the bird (Høffding, 2019, 492). The emphasis on the human-relational, intrapersonal, and interpersonal may have sidelined the physiological reality of the interchange between perceiver and environment and the psychological role this plays in self-experience.

It is not surprising that cognitive scientists question if human consciousness is so separate from the physical environments we inhabit. Most of the other sciences accept the totality of nature, including humans and their activities. Relativity physics, for example, works on the basis that all matter and space are fused into one single dynamical reality (Capek, 1991). Similarly, appreciating humans as part of the cycle of life has led contemporary environmental biologists to research and innovate ways for human presence to be favourable to ecologically sustainable and biodiverse environments (Simberloff, 2014). But the human superiority complex is closely wedded to the concept of mind, and only once we truly accept and appreciate nature as a totality, and ourselves as interdependent parts, can we own and shape our human influence accordingly. Given the extent of environmental damage we cause to the planet, this remains one of the most important and challenging concepts modern humans can grasp.

The hypothesis that cognition is embodied and embedded within the environment is heavily influenced by phenomenological thinkers such as Husserl, Merleau-Ponty, and others who treated environments as the natural processes people participate within. The environment is experienced; it is lived (Berleant, 1995). No differentiation is made between natural and artificial environments, cultural realms, and physical realms. Space is both shaped by and inseparable from the human body. The physical space demands a somatosensory involvement, which reacts and responds. The concept of aesthetic engagement is similarly derived from this phenomenological stance that everything, including humans and their activities, is alive within the experience. It expands upon this idea by exploring the quality and the texture of the experience. The significance of an aesthetic engagement with environments is that it breaks our appreciation free from the confines of the art gallery, beyond its well-designed building and pristinely landscaped gardens, to encompass the ways we engage with the grey sky on a rainy day, the smells from the landfill sites we try to ignore, the atmospheric changes in a room as the sunlight turns to dusk. The world you inhabit ceases to be a composition of objects and surfaces you interact with. Our appreciation lies not in separating or denying certain parts of our world to favour others but in embracing all as having equal claims to be taken seriously (Berleant, 1995). The whole of the world, and how we choose to engage within it, has allurement and aesthetic possibility.

One of the challenges researchers of aesthetic experience face is that, historically, perceptual studies have been heavily biased toward visual perception (Hutmacher, 2019). In a recent podcast, the director of the Penn Center for Neuroaesthetics at the University of Pennsylvania, Professor Anjan Chatterjee, commented that their challenge is how to

bring the field into the lab, or better still, the lab into the field.[3] This is one of the reasons why a phenomenological approach to research is particularly useful when studying multi-sensory experiences. A recent study on how being alone in nature affects a sense of self concluded that under certain conditions, people do experience heightened perceptual effects (Hughes, 2022). Based on in-depth interviews with a selection of twenty well-regarded land artists, wilderness guides, and nature-based therapists from around the world, the study explored their lived experiences of spending long periods alone in environments with low-to-no human presence. Free from human distractions, over a period of time people reported experiencing a heightened physiological and psychological sense of attunement with the stimuli within their perceptual range.

One of the respondents, the British artist Julie Brook, is no stranger to seeking solitude with nature. Her fascination with the edges of landscapes has lured her to work in some of the more isolated places on the planet: from the rugged Atlantic shorelines in the Scottish Hebrides, to the stark black stone valleys of the Libyan Sahara and to the remote Kunene region in Northwest Namibia. In 1991, Julie came across a natural cliff arch whilst walking early one morning on a trip on the remote island of Jura in the Inner Hebrides. As soon as Julie saw the cliff arch's position overlooking the craggy shoreline, she knew that she wanted to come back and work there. Over the course of three years, Julie returned for periods of months on end, setting up a makeshift home inside the cliff arch where she lived in solitude. As her relationship with the place deepened, she spent increasingly more time on the island, ultimately spending a full year on her own there in 1993. Describing her encounters with new environments, Brook's words help to illustrate the heightened perceptual state that respondents in the study recalled experiencing:

> When I go to a new environment, I bring who I am and what I've done before. But gradually, the environment starts having its own influence on me. It can take a bit of time to let go, but when I'm open enough to experience the land, I can start to really listen. Listening is a better word to use than looking. Listening describes in a more holistic way how I'm physically engaged as well as visually. And when I'm listening in this way, I sense this alignment of my imagination, my emotion, and my physical body. You can't contrive that experience. But when it comes, it's very, very strong. It's like a door opens.
>
> <div align="right">Julie Brook, Artist (Hughes, 2022)</div>

Brook describes a self-experience that is grounded in the multi-sensory reciprocity between perceiver and the stimuli within their perceptual field, and the heightened sensory awareness of both real and imagined stimuli. The findings from this study exhibit the three core components of an embodied sense of self: a sense of ownership, agency, and narrative. Further, they suggest an embodied sense of self that expands beyond the usual spatial boundaries of self experience. Perceptual participation creates the sense of the environment reaching out to draw one in and an experience of the self as a living part of this process. This study goes some way to show empirically that experiences of this kind can take on an aesthetic dimension and, as such, become a form of self-portrait

beyond the autobiographical self because they evoke not only an embodied but also an aesthetic sense of self (Hughes, 2022).

Aesthetic experience is an elusive term, but it can generally be defined as a special state that is qualitatively different from the everyday (Marković, 2012). This study suggests that the quality of this experience is dependent upon perceptual participation. In contrast, the objectification of environments limits awareness of full perceptual participation and, in doing so, denies the overall quality of the experience. The employment of an aesthetics of engagement draws our consciousness to the human body's participation within the perceptual field, and to the living organism within a living environment of continuous forces, in which there is reciprocal action of an organism on an environment and an environment on the organism. Every movement and transition, be it overt or subtle, evokes a sense of ownership, a sense of agency, and a sense of narrative. What differentiates an aesthetic engagement from the everyday is that it draws our awareness to the perceptual participation within environments and how this participation both energizes the environment and enriches our sense of self beyond that of being separate and singular. Within our awareness of physiological reciprocity, there is an appreciation of the beautiful in the sensation of intimacy.

Conclusion

The central issue aesthetic engagement addresses is not the difference between art and non-art but between the aesthetic and the anaesthetic. Its theoretical value extends beyond the arts and artistic endeavours to encompass an aesthetic appreciation of ordinary life, activities, and everyday environments we inhabit. In its ability to provide a framework for appreciating environments, and, furthermore, describing a type of self-experience that enriches the feeling of aliveness, aesthetic engagement has proved particularly useful. In aesthetic engagement, we find the type of self-experience that enriches the embodied feeling of aliveness. You can gaze at a beautiful painting and intellectually know it must be a wonderful sight. Still, the sensation is half-lived if you cannot feel it to be part of a multi-sensory autobiographical experience. Aesthetic engagement offers the self the opportunities to be within the world, especially the other-than-human world, in a way that enriches an embodied experience of aliveness.

Aesthetic engagement is less concerned with meaning making, and more with the quality and the texture of the up-close and immediate experience of being alive. It is a conscious act that illuminates the experience of appreciation both of the event and the self. One's perception of environment and one's embodied sense of self are two sides of the same event. The quality of self-experience depends on the perceptual quality of engagement with environment. This perceptual participation determines the quality of the self-experience. It is far too simplistic to assume that observation, or sensorially limited exposure to an environment, will yield the same texture and quality of self-experience as an aesthetic engagement. It is the quality of engagement that affects our overall sense

of self. This qualitative dimension to one's overall sense of self is best described as an aesthetic sense of self, in the true epistemological roots of the term, as sense perception. An aesthetic sense of self is an embodied experience that is enriched through the awareness and appreciation of the perceptual participation involved. Almost seventeen centuries ago, St. Augustine directed our attention to an inner world, toward an introspective consciousness. Aesthetic engagement invites us to direct our attention to our perceptual participation, and in doing so to experience an out-of-the-ordinary sense of communion with this more-than-human world.

On entering *The New York Earth Room*, the visitor has a choice. One can choose to maintain an observational distance and ponder the significance of the artwork. Alternatively, one can consciously tune into the multi-sensorial interaction of a body in a physical space. This requires the visitor to give as much credence to physical sensations as any mental imagery that comes to the foreground of their awareness. As you allow the delineation between sensation and cognition to melt away, so too does any perceived boundary between self and space. In this process of attunement between the self and environment lies the possibility of experiencing an unusual sensation of intimacy. On leaving *The Earth Room* and stepping back onto the busy New York streets, one also has a choice. The ability to aesthetically engage with the world around us does not stop at the door of the art gallery. It exists in the way we choose to engage with the whole of life. This does not mean one will choose to engage with the world in this way all the time. But it is available at those moments in life we choose not to focus on the delineation between the 'me' and the 'not me', between being human and the rest of nature.

Notes

1. Available at: www.betterup.com/inner-work-day?hsCtaTracking=a33cf1f6-92ea-47ec-a37e-b27ee513cf49%7Cdba0e1db-ff0e-4b86-9e28-6f4bfea3da90 [last accessed 4 October 2024].
2. Available at: https://assets.publishing.service.gov.uk/government/uploads/system/uploads/attachment_data/file/904439/Improving_access_to_greenspace_2020_review.pdf [last accessed 4 October 2024].
3. Available at: https://incoherence.buzzsprout.com/1874863/9518498 [last accessed 4 October 2024].

References

Aldrich, R., Dunning, J., Faivovich, G., Goldberg, N., Winters, T., Atkins, K., Kivland, K., & Dia Art Foundation (Eds). (2017). *Artists on Walter De Maria*. Artists on Artists Lecture Series. Dia Art Foundation.

Asai, T., Kanayama, N., Imaizumi, S., Koyama, S., & Kaganoi, S. (2016). Development of Embodied Sense of Self Scale (ESSS): Exploring everyday experiences induced by anomalous self-representation. *Frontiers in Psychology 7*. https://doi.org/10.3389/fpsyg.2016.01005.

Batson, G. (2009). Update on proprioception: Considerations for dance education. *Journal of Dance Medicine & Science 13* (2), 35–41.

Berger, C. C. (2016). *Where imagination meets sensation: Mental imagery, perception and multisensory integration*. Thesis, Karolinska Institutet.

Berger, C. C., & Ehrsson, H. H. (2013). Mental imagery changes multisensory perception. *Current Biology 23* (14), 1367–1372. https://doi.org/10.1016/j.cub.2013.06.012.

Berleant, A. (1995). *Aesthetics of environment*. Temple University Press.

Berleant, A. (2010). *Sensibility and sense: The aesthetic transformation of the human world*. St Andrews Studies in Philosophy and Public Affairs, v. 6. Exeter, UK. Imprint Academic.

Berleant, A. (2012). *Aesthetics beyond the arts: New and recent essays*. Ashgate.

Bowlby, J. (1980). *Attachment and loss. 3: Loss, sadness and depression*. The International Psycho-Analytical Library 109. Hogarth Press.

Buck, L., & Axel, R. (1991). A novel multigene family may encode odorant receptors: A molecular basis for odor recognition. *Cell 65* (1), 175–187. https://doi.org/10.1016/0092-8674(91)90418-X.

Capek, M. (1991). *The new aspects of time: Its continuity and novelties*. Boston Studies in the Philosophy and History of Science. Springer.

Cassarino, M., O'Sullivan, V., Kenny, R. A., & Setti, A. (2016). Environment and cognitive aging: A cross-sectional study of place of residence and cognitive performance in the Irish Longitudinal Study on Aging. *Neuropsychology 30* (5), 543–557. https://doi.org/10.1037/neu0000253.

Dewey, J. (2005). *Art as experience*. Perigee.

Fitzpatrick, R., & McCloskey, D. I. (1994). Proprioceptive, visual and vestibular thresholds for the perception of sway during standing in humans. *The Journal of Physiology 478* (1), 173–186. https://doi.org/10.1113/jphysiol.1994.sp020240.

Fried, M. (1988). *Absorption and theatricality: Painting and beholder in the age of Diderot*. University of Chicago Press.

Fuchs, T. (2018). *Ecology of the brain: The phenomenology and biology of the embodied mind*. First edition. Oxford University Press.

Fuchs, T., & De Jaegher, H. (2009). Enactive intersubjectivity: Participatory sense-making and mutual incorporation. *Phenomenology and the Cognitive Sciences 8* (4), 465–486. https://doi.org/10.1007/s11097-009-9136-4.

Gibson, J. J. (2014). *The ecological approach to visual perception*. Psychology Press and Routledge Classic Edition.

Gleason, D. K. (2005). The self cohesion scale: A measure of the Kohutian concept of self cohesion. Available from: https://core.ac.uk/reader/268793240 [last accessed 4 October 2024].

Greenberg, C. (2000). *Homemade esthetics: Observations on art and taste*. Oxford University Press.

Hobson, G. (Ed). (1979). *The remembered Earth: An anthology of contemporary native American literature*. Red Earth Press.

Høffding, S. (2019). Review of Dan Hutto and Erik Myin, *Evolving Enactivism* (2017, MIT Press); Shaun Gallagher, *Enactivist Interventions* (2017, Oxford University Press); Ezequiel Di Paolo, Thomas Buhrmann, & Xabier E. Barandiaran, *Sensorimotor Life* (2017, Oxford University Press). *Philosophy 94* (3), 492–499. https://doi.org/10.1017/S0031819119000044.

Howes, D. (Ed). (2021). *Empire of the senses: The sensual culture reader*. Routledge. https://doi.org/10.4324/9781003230700.

Hughes, E. (2022). *Attunement: The psychology of being alone with nature*. Ph.D. Dissertation. University of the Arts, Philadelphia.

Hutmacher, F. (2019). Why is there so much more research on vision than on any other sensory modality? *Frontiers in Psychology 10*, 2246. https://doi.org/10.3389/fpsyg.2019.02246.

Kant, Immanuel. (2003). *Critique of pure reason*. Translated by Marcus Weigelt. Penguin Classics.

Kohut, H. (2009). *The analysis of the self: A systematic approach to the psychoanalytic treatment of narcissistic personality disorders*. University of Chicago Press.

Lewin, K., & Lewin, K. (1997). *Resolving social conflicts: Field theory in social science*. American Psychological Association.

Lodermeyer, P., & Abramovic, M. (Eds). (2009). *Personal structures: Time, space, existence*. DuMont.

Marković, S. (2012). Components of aesthetic experience: Aesthetic fascination, aesthetic appraisal, and aesthetic emotion. *I-Perception 3* (1), 1–17. https://doi.org/10.1068/i0450aap.

Merleau-Ponty, M. (2012). *Phenomenology of perception*. Translated by D. A. Landes. Routledge.

Muir, J. (1980). *Wilderness essays*. Gibbs-Smith.

Niedenthal, P. M., Barsalou, L. W., Winkielman, P., Krauth-Gruber, S., & Ric, F. (2005). Embodiment in attitudes, social perception, and emotion. *Personality and Social Psychology Review 9* (3), 184–211. https://doi.org/10.1207/s15327957pspr0903_1.

Ostenfeld, E. N. (1982). *Forms, matter and mind: Three strands in Plato's metaphysics*. Springer Netherlands. Available from: http://public.ebookcentral.proquest.com/choice/publicfullrecord.aspx?p=3107431 [last accessed 4 October 2024].

Redding, E. (2010). Considerations for dance educators. *Journal of Dance Medicine & Science 14* (2), 43–44.

Roszak, T., Gomes, M. E., & Kanner A. D. (Eds.). (1995). *Ecopsychology—restoring the Earth, healing the mind*. Sierra Club Books.

Runte, A. (1990). *Yosemite: The embattled wilderness*. University of Nebraska Press.

Schutte, A. R., Torquati, J. C., & Stevens, J. R. (Eds.). (2021). *Nature and psychology: Biological, cognitive, developmental, and social pathways to well-being*. Nebraska Symposium on Motivation 67. Springer. https://doi.org/10.1007/978-3-030-69020-5.

Simberloff, D. (2014). The 'balance of nature'—Evolution of a Panchreston. *PLOS Biology 12* (10), e1001963. https://doi.org/10.1371/journal.pbio.1001963.

Stoller, P. (1989). *The taste of ethnographic things: The senses in anthropology*. University of Pennsylvania Press.

Varela, F. J., Thompson, E., & Rosch, E. (2016). *The embodied mind: Cognitive science and human experience*. Revised edition. MIT Press.

Zahn, R., Talazko, J., & Ebert, D. (2008). Loss of the sense of self-ownership for perceptions of objects in a case of right inferior temporal, parieto-occipital and precentral hypometabolism. *Psychopathology 41* (6), 397–402. https://doi.org/10.1159/000158228.

SECTION III
ENVIRONMENTAL AESTHETICS AND WELL-BEING

INTRODUCTION
Environmental Aesthetics and Well-Being

YURIKO SAITO

This section comprised of eight chapters addresses the role environmental aesthetics plays in promoting human well-being. In popular parlance, the term, environmental aesthetics, may immediately be associated with nature aesthetics. In fact, this subdiscipline of Western aesthetics discourse first emerged during the latter half of the twentieth century by addressing our aesthetic experience of nature, a topic that had been largely neglected since the eighteenth century. However, its reach soon expanded to include cultivated nature, such as agricultural lands and parks, and built environments and the objects within, leading to the understanding of environment as the world at large, natural or artefactual. The notion of environment further broadened to include our social environment consisting of human behaviour, interactions with others, and atmospheres created thereby. This wide scope of aesthetics is today often referred to as everyday aesthetics, the most recent outgrowth of environmental aesthetics, which was specifically proposed and developed to liberate aesthetics from the art-centric approach that dominated the twentieth century Western aesthetics.

Everyday aesthetics calls attention to the aesthetic potentials of objects, phenomena, and activities that we experience in our daily lives. Mostly concerned with practical interests, our management of everyday life renders those aesthetic potentials rather invisible. Even when they become visible, since most of these items are not specifically meant to induce an aesthetic experience, their aesthetic value is considered to be not comparable to that of works of art. At the same time, the psychological, social, existential, political, and environmental (understood as referring to sustainability) roles their aesthetic experience plays in our lives is significant. The chapters in this section explore such contributions everyday aesthetic experiences make in promoting human well-being and flourishing, as well as helping to construct a humane and sustainable society.

Particularly important in this regard is that everyday aesthetics aims to recover the authentic mode of living in this world. By challenging Western philosophy's

general neglect of our bodily existence involving all sensory engagements, in particular those involving what is more bodily oriented, namely taste, touch, smell, proprioception, and kinesthetic sensations. Everyday aesthetics makes us aware of our bodily attunement to the world, which in turn illuminates our interdependency with the world around us. Ranging from developing a full and rich experience of engaging with the world to deriving a quiet and humble satisfaction from the familiar aspects of our daily lives, everyday aesthetics suggests many ways of improving the quality of life without incurring those psychological, physical, financial, or environmental trappings often associated with pursuing happiness in today's consumerist and materialist society.

Such mindful living requires practice. Conventional Western aesthetics discourse characterises aesthetic experience as something that we undergo when we adopt a right, namely disinterested, attitude. The characterisation is thus rather passive by emphasising *withholding* the usual mode of experiencing the world and *disconnecting* us from the life concerns. Mostly lost in this characterisation is the agency we can exercise in facilitating aesthetic experience, whether conceptually or literally through performing some action. It reminds us that we are empowered to determine the character of our experiences and ultimately the quality of life.

Some aspects of our lives are within our control, and we can change our environments and lives to suit our needs and desires. We decide how to present ourselves to the world with clothing, hair styling, facial make-up, perfumery, and the general comportment with which we carry ourselves, while we try to create a comfortable, stable, clean, safe, and pleasing domestic environment through performing regular house chores and yard work, while changing interior and outdoor decorations from time to time. We relate to others in a caring, friendly, and respectful manner, or in an indifferent, or sometimes even hostile, manner, not only through the content of our conversation with others and actions regarding them but also by aesthetic manifestations: tone of voice, facial expression, and body movement.

However, other aspects of our lives are beyond our control. Plants in a garden grow in a way that we cannot totally control, material existence including our bodies is subject to the natural ageing process, and, for some people, lives and environments are quite precarious due to poverty, political and military conflict, and natural disasters. Even in these cases, we can practise aesthetic agency, on the one hand by discovering or creating as much aesthetic potential as possible in the small crevices of environment and life, thereby fortifying the power of resilience. On the other hand, we can also exercise our agency by actively shifting our focus from self to the world and transforming submission to what we cannot control from a source of disappointment to acceptance or even contentment.

While thus being useful in promoting a good life for oneself, everyday aesthetics also reminds us that we should not conceive of it as a self-enclosed practice. Ever mindful of the authentic mode of human existence, which is always relational, whether in terms of the relationship with the material world, nature, or other humans,

everyday aesthetics helps us attend to the inseparability of our own well-being and that of the others and the world. In particular, we develop an awareness that we are not only an aesthetic agent but also an aesthetic object judged by others, sometimes subjected to injustice and degradation, reminding us of the power of the aesthetic in determining the character of a society, for better or worse. Whether regarding the quality of societal life and human interactions within or environmental sustainability of our life on this earth, promotion of our well-being takes place in this web of interdependence, mutual penetration, and entanglement. As such, living a good life is not a solitary venture but is supported by and in turn supports others' similar efforts.

The essays in this section collectively argue that environmental aesthetics is instrumental in promoting one's well-being by encouraging more mindful and engaged living in this world. At the same time, they also remind us that developing one's sense of being at home in the world should not come at the expense of others' well-being, ethical considerations, and the sustainability of the world.

Chapter 10

Everyday Aesthetics and the Good Life

Yuriko Saito

Introduction

Everyday aesthetics has emerged as a subdiscipline of Western aesthetics discourse during the early part of the twenty-first century. However, the ideas associated with everyday aesthetics today were percolating before then without using the specific term. Unlike many non-Western aesthetics, Western aesthetics discourse, particularly in its Anglo-American formulation, was almost exclusively focused on the philosophy of art in the twentieth century. This is a deviation from the original nature of aesthetics, a study of sense perception and sensibility regardless of the objects of experience. The re-opening of the sphere of aesthetic inquiry started during the latter half of the twentieth century with nature aesthetics, followed by environmental aesthetics that soon included built environment, and finally the aesthetics of popular arts. Everyday aesthetics continues this trajectory by addressing various objects and aspects of people's everyday lives that have not been adequately captured by art-centric aesthetics.

Everyday aesthetics thus started as a corrective measure against the monopoly of art as the focus of aesthetic inquiry, but it soon became a more proactive enquiry into the nature of aesthetics in general. This is in part due to the expanded scope of what is considered art today, including participatory art, socially engaged art, street art, video games, culinary arts, and perfumery, to list only a few. However, the significance of these newer forms of art and the broadened scope of aesthetics does not lie merely in diversifying the items in the purview of aesthetics discourse. More fundamentally, everyday aesthetics challenges the long-held model of aesthetics that has guided the inquiry since the birth of modern Western aesthetics in the eighteenth century. According to this model, a typical aesthetic experience is directed toward a certain object from a disinterested spectator's point of view, leading to an impartial judgement of its aesthetic value which is intersubjective.

Everyday aesthetics instead questions whether the following factors, often associated with objects and activities from our daily life, disqualify them from the aesthetic arena:

the lack of an established frame for an object of aesthetic experience; general absence of knowledge regarding the authorship and accompanying intention behind objects of daily use; the constant changes that everyday objects go through due to their own aging process and wear and tear from use; the inclusion of so-called lower senses and the entire bodily participation in the aesthetic experience; intimate relationship with practical considerations in managing everyday life; and predominantly first-person accounts of performing actions without referring to any objects or resulting in judgements. By exploring the aesthetic credentials of experiences that are inseparable from our management of daily life, everyday aesthetics helps us recognize how aesthetics affects the quality of life and the state of the world. Contrary to the rather unfortunate popular characterization of aesthetics as a dispensable fluff and superficial amenities, everyday aesthetics illuminates the invaluable role aesthetics plays in the constitution of the good life and good society. This chapter explores different ways in which leading an aesthetically grounded and informed life contributes to the good life (for a more detailed overview of everyday aesthetics, see Saito, 2019).

Appreciation of Hidden Gems

One of the consequences of art-centric aesthetics has been to create an impression that only those objects made by artists and experienced in an artworld context, such as a gallery or a concert hall, are aesthetically valuable. Because many of these objects are created specifically to induce an aesthetic experience, their power to affect us aesthetically appears to be greater than those objects that are not created for the same purpose. Furthermore, experiencing them in a context isolated from daily affairs is conducive to focusing on their aesthetic value. For example, a landscape painting with a frame and a unified composition within presents an aesthetic whole readily amenable for aesthetic appreciation. A drama depicted in a novel with a beginning, middle, and end and a finely wrought plot development creates a satisfying narrative that is much more aesthetically appreciable than the unstructured dramas experienced in our daily lives. In general, a slice of life without artistic intent or context is regarded as lacking in aesthetic appeal.

At the same time, however, art aesthetics helps shed light on the hidden gems in our daily life experiences by sharpening our perceptual acuity and sensibility. What may be normally experienced as ordinary and nondescript can appear extraordinary with a sense of aura (Leddy, 2012). Nature writers often give an account of this kind of experience in their work. Marcel Proust's well-known account of the smell of madeleines illuminates the potency of rich memories evoked by a mundane cake, while Annie Dillard's description of seeing a peach 'unpeached' points to truly 'seeing' an object unencumbered by various associations and knowledge. We may also learn to see our everyday environment with an eye of a photographer, such as Henri Cartier-Bresson and Aaron Siskind, so that ordinary street scenes come alive with both subtle and rich aesthetic significance. Finally, many examples of so-called land art or environmental art help us to experience various landscapes and celestial phenomena with a framework

around it, such as an opening in an *in-situ* construction, which assists us in focusing on things like a landscape, the sky, and weather conditions (Beardsley, 1989).

The potential for art-assisted aesthetic experiences in the humdrum of daily lives is fully utilized by the strategy of so-called 'artification' or 'creative industry'. Often employed by businesses, industries, and organizations, artification aims to enliven organizational life and professional work, which tend to be governed strictly by practical and economic considerations. Through studying and creating art, the artifying practice helps people in the workplace cultivate perceptual acuity and aesthetic sensibility. Examples include: medical professionals sharpening their diagnostic skills through learning photography; industry employees learning to think creatively and imaginatively outside the box through studying various arts; businesspeople becoming more attuned to the workplace social dynamics by participating in theatre performances; and educators gaining more confidence in taking risks through developing an appreciation for improvisational arts like jazz. While the ultimate goal is to increase accuracy, productivity, and efficiency, the immediate goal is to enhance creativity and imagination, as well as rendering the workplace experience fulfilling (Linstead & Höpfl, 2000; Darsø 2004; Naukkarinen & Saito, 2012).

It is not only the ordinary and nondescript that can provide a rich positive aesthetic experience. The aspects of our environment that may be regarded negatively for being decrepit, shabby, imperfect, messy, and disorderly can also be experienced positively for offering a different kind of aesthetic stimulation and satisfaction. Supported by the historical precedents such as the eighteenth century British picturesque and the Japanese of *wabi* aesthetics, which originated in the sixteenth century to accompany the tea ceremony, the emerging field of imperfectionist aesthetics calls attention to how that which is normally regarded aesthetically deficient can be a rich source of aesthetic experience. Again, art can be instrumental in aiding such appreciation, ranging from jazz performances and intentional 'mistakes' in literary writings and movie-makings to recent art projects that feature broken objects and their repair (Kelly et al., 2021; Cheney, 2023).

Such ubiquity of aesthetic gems thus excavated often with the aid of art implies that the positive aesthetic experiences are not limited to specific objects, occasions, or those who are versed in today's artworld. While requiring a sharpened sensibility, one's aesthetic life can be enriched without invoking specific knowledge, affiliation, or possession. The possibility of an aesthetically rich life is available to everyone, even to those whose lives are challenged by life circumstances, such as poverty, war, and natural disasters. As Salem al Qudwa eloquently illustrates, even in the midst of crumbled structures torn asunder by a political conflict, pockets of aesthetic gems can provide a desperately needed respite and dignity, feeding the power of resilience (Al Qudwa, 2017; Al Qudowa, this volume). The coastal residents affected by the 2011 tsunami in Japan also found comfort and strength in the cherry blossoms that bloomed soon after the disaster destroyed everything, as poignantly documented in the 2011 film, *Tsunami and the Cherry Blossoms*, directed by Lucy Walker.

Even without such debilitating traumas which make the experience of pockets of aesthetic gems both poignant and powerful, we can derive quiet pleasure from our

daily routine which affords us a sense of stability, comfort, and hominess (Haapala, 2005; Haapala, this volume). We can lead a satisfying life without any cost incurred by purchasing various goods or travelling to exotic places. Furthermore, we can avoid various trappings and environmental harms associated with excessive consumption and jet-setting lifestyles. There is a practical wisdom in cultivating everyday aesthetic sensibility so that we can be content with the status quo by savouring aesthetic riches that can be found in every corner of our everyday life (Irvin, 2008a; Irvin, 2008b).

At the same time, it is important to note that this strategy of everyday aesthetics should not be regarded as justifying various social ills that cause negative aesthetics in people's lives. In general, positive aesthetic values associated with objects lead to support for their continued existence, often seen in an argument for the preservation of threatened landscapes, creatures, and historic structures. However, deriving positive aesthetic experience from the signs of misery, poverty, discrimination, or injustice should not imply endorsing their existence. In particular, spectator's gaze on their surface qualities which can lead to so-called ruin porn, poverty tourism, and aestheticization of poverty is morally problematic because the primary concern should be addressing the social ills and injustices that are manifested aesthetically. In fact, what may be called imperfectionist aesthetics of the British picturesque and Japanese *wabi* aesthetics was later criticized for this very reason (Saito, 2021).

This point applies not only to the experiences of spectators as outsiders but also to those of the ones affected by various trauma. On the one hand, particularly if the calamities they are experiencing are beyond their control, such as natural disasters or wars, the aestheticization strategy may offer a prudential wisdom for dealing with misery and suffering. At the same time, if the negative factors in their lives are something they can work on changing, such as by engaging in an activism to improve their living conditions, the possible positive aesthetic experiences in their impoverished lives should not hinder such efforts. As Katya Mandoki and Arnold Berleant argue, negative aesthetics in our lives should not be swept under the rug by the aesthetically motivated eagerness to turn a blind eye to those negativities in our lives and to transform them into positive aesthetics (Mandoki, 2007; Berleant 2010, chapter 9). Thus, while deriving a positive aesthetic experience from various aspects of our lives is a potent strategy for dealing with challenging factors in our lives, practical wisdom, moral sensibility, and a sense of justice need to weigh in to determine the appropriateness of aesthetic appreciation so as to avoid the problems of indiscriminate aestheticization.

In Tune with the Whole Body

One of the long-standing legacies of the Western philosophical tradition is its emphasis on the intellectual over the sensible and the emotive. The latter was regarded with scepticism because it was considered to often lead one away from reality and truth. This hierarchy is reflected within the senses themselves. Vision and hearing are considered

higher senses because of their likeness to the cognitive. The content of their experience can be quantified and measured, such as in the Golden section and the mathematical measurement of a musical sound. In contrast, smell, taste, and touch are considered to be lower senses because they are not amenable to measurable quantification, hence not objectifiable, while too closely associated with the bodily functions that we humans share with non-human animals. Similarly, any bodily experiences such as proprioception and kinaesthesia are regarded too personal and subjective to be worthy of philosophical reflections. Paradigmatic art in the Western tradition, dominated by visual arts, music, and literary arts, reinforces this hierarchical framework and it is only recently that the artworld expanded to include olfactory arts, culinary arts, and installations that require the viewers' bodily engagement, such as crawling or lying flat on the back.

Everyday aesthetics challenges this hierarchy of the senses and the neglect of body in the conventional art-centric aesthetics. It reminds us that our daily life consists of a series of synesthetic experiences and, although we sometimes have a mono-modal experience isolated from others as if we were a spectator dissociated from lived experience. A large swathe of our life integrates various senses, the cognitive, the emotive, and the sensible, as well as bodily engagement with the world. Cultivating this awareness helps us become in tune with our whole being situated in this world. We are not a disembodied monad with little direct relationship with others, whether humans, nature, or the artefactual world. Their existence around us and our interactions with them define our mode of living and help us manage our everyday life.

In tandem with including the heretofore neglected aspects of our everyday lived experience in the aesthetic arena, everyday aesthetics calls attention to another avenue of gaining aesthetic experience: as an active agent engaged in actions. When managing everyday living, we sometimes observe, listen, and think, and the conventional object-directed and spectator-oriented aesthetics can comfortably accommodate these modes of experience. However, more often than not, we engage in some kind of physical action, whether walking, cleaning, cooking, eating, talking, gardening, or sewing. Although all these acts require active participation of aesthetic sensibility by being attentive, discriminatory, and imaginative, they do not easily fit into the usual aesthetic model. Spectators of somebody else's physical movements and recipients of the end product of such physical movements are expected to be able to make an aesthetic judgement on the performance of an athlete, the appearance of a garden, or the taste of a food, and engage in disputes when disagreements occur. However, within such a framework, physical acts themselves experienced from within create a problem because they don't have an object which enables judgement-making that is intersubjective (Dowling, 2010). Hence, food aesthetics has typically focused on the taste of food without considering the act of eating or cooking, and sports aesthetics generally refers to the spectator's experience and judgement of the performance of a skater or a gymnast. In short, activities described with a verb, such as garden*ing*, cook*ing*, eat*ing*, runn*ing*, and repair*ing* experienced from the first-person perspective, have not garnered enough attention in aesthetics discourse, in contrast to an object or a phenomenon characterized with a noun, such as a garden, a cooked food, a performance, and a repaired object.

This relative neglect of the experience of an active agent poses several challenges for aesthetics. First, although spectators can go through a vicarious experience while watching a dazzling movement of a skater, for example, it is still a third-person imaginative exercise. What about the actual kinaesthetic sensation felt when actually skating? Recent development of somaesthetics calls attention to the aesthetic dimension of doing things and performing activities from the performer's own perspective (Shusterman, 2012; Shusterman, 2013). Attending to these aspects of our lives is important in helping us to be grounded in this world as an embodied existence intricately and incessantly conversing and collaborating with the world. Such attentiveness recuperates the authentic mode of being in this world.

Second, emphasizing the spectator-mode of aesthetics tends to encourage us to be disengaged from the affairs of daily life. The long-accepted characterization of the aesthetic has been disinterestedness. This attitude as a defining characteristic of the aesthetic experience was first suggested by Shaftesbury at the beginning of the eighteenth century, although he did not use this particular term. It was Immanuel Kant who codified this notion with the specific term. His well-known formulation characterizes disinterestedness as facilitating an experience of 'the mere representation of the object ... however indifferent I may be as regards the existence of the object of this representation' (Kant, 1974, 39), because 'every interest spoils the judgment of taste and takes from its impartiality' (Kant, 1974, 58). By being indifferent to the existence of the object we experience, its aesthetic dimension is divorced from other life concerns, in particular the practical and the moral, which dominate daily affairs.

On the one hand, disinterestedness helps encourage open-mindedness so that we experience the object for what it is, without imposing our moral or practical judgement. On the other hand, the notion of disinterestedness alienates the aesthetic from other concerns which guide the management of life in general (Berleant, 2004, chapter 3). Objects in our daily life exist enmeshed in the web of relations with other material objects, as well as social relations due to uses, memories, associations, expectations, and hopes. When it comes to various activities we undertake in daily life, we engage in many of them for practical purposes. If we apply disinterestedness to doing things, only when we abstract from our activities the practical considerations can we have an aesthetic experience. However, it is difficult, if not impossible, to perform such a surgery to clearly separate everyday activities from the goals they are supposed to achieve: making a dinner, cleaning clothes and rooms, talking with my friend to help her think through a personal problem, and so on. Nor is it desirable to do so, even if it were possible, because it isolates various activities from our lived experience that occurs only in the context of the entangled web of goals, expectations, and relationships. The aesthetic dimensions of cooking, cleaning, and having a conversation are guided by the purpose of such activities. That is, the desired outcome of a meal determines the way in which we cook: cutting vegetables, seasoning them, arranging them on a plate, and so on. Cleaning a house aims not only to ensure sanitary conditions, cleanliness, and orderliness but sometimes to maximize functionality and efficiency, some other times to provide comfort and hominess, yet other times to welcome a guest. These varied aims guide

how to arrange furniture and decorative items, at times intentionally leaving messiness untouched (Lee, 2010). The particular circumstance of conversing with my friend may encourage me to play the role of a sympathetic listener or take a more active role in leading the course of exchanges. The goal-directedness is an integral part of the aesthetic dimension of performing these activities, again, reminding us that our everyday aesthetic experiences are holistic and various considerations are fully integrated. Aesthetic experiences promoted by everyday aesthetics thus encourage us to be thoroughly engaged with the world, instead of isolating us in a state of pure contemplation, which the disinterested attitude tends to encourage.

These considerations suggest another reason why it is important not to neglect this active dimension of everyday aesthetic experience. Our everyday actions shape our environment, both material and social, for ourselves and others. We are thus empowered to be world-makers and aesthetics plays a significant role in this project. As such, they contribute to defining the quality of life not only for ourselves but for those concerned.

Exercising Active Agency

The disadvantage of the spectator-oriented aesthetics is that it tends to give an impression that we are a passive recipient of the world around us, being affected by the aesthetic values of various objects and situations. In addition, the object-centred aesthetics discourse tends to place the primary task of an aesthetic experience on the object with its aesthetic value. As mentioned in the last section, the notion of disinterestedness also tends to emphasize the passivity of the experiencing agent whose task is to refrain from bringing in life concerns. Instead, everyday aesthetics follows the views shared by John Dewey and Arnold Berleant that the aesthetic experience requires active engagement with the world around us through attentive perception and imagination, which leads to a collaborative give and take, what Dewey calls 'undergoing' and 'doing' (Dewey, 1958, chapter 3; Berleant, 1991).

With its inclusion of the aesthetics of actions, everyday aesthetics illuminates the active role we as experiencing agents play in creating and directing our aesthetic life. Through the aesthetics of actions, we can determine the quality of life for ourselves and others, as well as the state of the world. For example, we sometimes interact with other people in an indifferent, inconsiderate, rude, inhumane, or hostile way, while other times in a warm, caring, considerate, thoughtful, humane, or gentle manner. These characterizations are based upon the way in which we carry out an action: the tone of voice, facial expression, posture, and body movement. What is often dismissed as superficial concerns with etiquette or manners actually carries a substantial weight of conveying one's attitude toward others, even when the 'same' task gets accomplished. I can drive my neighbour to a doctor or help her carry a heavy load gently and cheerfully or grudgingly with a rough manner and a big sigh, slamming a door and creating a loud untoward noise. In the latter scenario, the value of what gets accomplished, that is

getting her to the doctor or lightening her load, becomes compromised, or even nullified (Saito, 2022, chapter 3; Saito, 2017, 174–185; Sherman, 2005; Naukkarinen, 2014; Stohr, 2012; Holdforth, 2009; Buss, 1999). The aesthetics involved in these human-to-human interactions, termed social aesthetics by Arnold Berleant as a subfield of environmental aesthetics (Berleant, 2005, chapter 14; Berleant, 2017; Berleant, 2023), reminds us that we are all proactive agents who can exercise agency to determine the character of those interactions. One can practice acting gently and thoughtfully to contribute to humane and caring relationships, and such a practise requires not only the moral sensitivity but also aesthetic sensibility, a point emphasized by Eastern spiritual traditions such as Buddhism and Confucianism (Gier, 2001; Mullis, 2007; Mullis, 2017; Kidd, this volume).

The aesthetic expression of my attitude toward others is not limited to my direct interactions with them. I can show my thoughtfulness and care for others through making, handling, and arranging of objects and environments. Perhaps the best illustration is cooking for others. The care that goes into cooking, arranging food on the plate, and serving is a care expressed to the recipient of the meal. Similar considerations are involved in preparing a room for a guest to stay, or a house and yard for the family and neighbours. Laundering, ironing, folding, and putting away the laundered items can be done as an act of love for the family (Rautio, 2009).

We should note that a successful social interaction requires both parties to the relationship exercising utmost aesthetic sensibility. That is, the 'recipients' of my caring and thoughtful attitude must acknowledge and reciprocate in some way (provided they are in a position to do so); otherwise, my effort ends up being a one-way street and the experience will not be satisfying. The 'recipient' of my kindness needs to attend to the subtle gesture and tone of voice with which I carry out my help toward her, the delightful arrangement of food on a plate with meticulous attention to detail, or the freshly laundered and carefully folded shirts with crisp texture neatly arranged in a drawer (Saito, 2022, chapter 2 and chapter 4).

As mentioned in the Introduction, when these phenomena are folded into our daily life, we tend to take them for granted, rendering them invisible. Being blind to these aesthetic manifestations of care impoverishes our life by taking them for granted and noticing only when they are absent or, worse, when we become aware of the aesthetic expression of indifference or hostility. In contrast, acknowledging these manifestations as expression of care by others, whether a family member, a friend, or a neighbour, enriches our life and helps highlight the fact that we are an interdependent existence supported by other people's care for us. It warms our heart to know that our existence and experience are taken seriously and attended to by others who express their care for us, sometimes explicitly through direct actions but other times quietly and indirectly through objects. Such grateful acknowledgement and appreciation require aesthetic sensibility and its cultivation promotes civility and provides a foundation for a fulfilling life. At the same time, practising care for others through aesthetic means in the spirit of 'pay it forward' brings satisfaction, particularly when others express their gratefulness aesthetically.

Although it may strike the Western audience as an exotic practice, the Japanese tea ceremony, established as an art form in the sixteenth century and practised today not

only by professionals but also by laypeople, offers a model for an aesthetic practice of cultivating moral virtues as a guide to social interactions. Despite various rules stipulating body movements, preparation of tea, snacks, utensils, the tea hut, and the garden, the most important point is 'vigilant consideration of others' (Surak, 2013, 52), according to one commentator, and 'silent aesthetic communion … through artistry of motion and gesture' (Ikegami, 2005, 227), according to another. Through making and serving tea and drinking it, the tea ceremony helps cultivate a model of social interaction drenched with care, consideration, and thoughtfulness, which are conveyed aesthetically. While the specifics involved in the Japanese tea ceremony may be culture-specific, the foundation of a civil discourse that this art practice aims at is universally shared and is indispensable for human flourishing. Everyday aesthetics reminds us that we are empowered to exercise agency in enhancing both our own well-being and that of others.

Working *with* the World

Another long-held legacy of Western philosophical tradition is that the material world is outside of the moral sphere because of its presumed inferior ontological status. Material objects lack sentience, let alone free will, while humans are sentient and can exercise agency themselves. As such, artefacts are considered morally relevant only if our actions on or with them affect the human world. Otherwise, there is no moral constraint on their use. Environmental ethics has addressed the disastrous consequences of this anthropocentric way of regarding nature as something we humans can use freely. One well-known strategy is to enfranchise natural objects and environments, sometimes eco-systems and nature as a whole, into the moral arena, by according them rights. When it comes to the artefactual world, however, anthropocentric thinking still prevails, primarily because it is created by humans to serve human needs (Hoły-Łuczaj, 2019). Except for works of art, historically significant structures and objects, and those things from our lives that function much like them, such as family heirlooms and mementos from special occasions and trips, we simply use the objects around us without much thought. Their existence does not register on our consciousness radar that is calibrated to capture standout objects or those which malfunction and assert their status as 'present-at-hand' in the Heideggerian sense. Or, when they function as a vehicle for expression of care, as discussed in the last section, our appreciation is directed toward the care given to us by other humans.

However, everyday aesthetics questions this anthropocentric attitude toward the artefactual world by exploring the aesthetic dimension of our interactions with it. Our everyday life is supported by these objects' existence and service to us, despite the fact we make and operate them. Recognizing our indebtedness to them leads to our grateful appreciation of their faithful companionship and our lives together. But in order for them to serve us, we need to take care of them beyond not breaking them. The proactive care and maintenance of the artefactual world occupies a substantial portion of our daily life:

cleaning, dusting, washing, drying, polishing, painting, repairing, in short, most of the daily house chores (Saito, 2022, chapter 4).

House chores are usually regarded as drudgery, something we would rather avoid and delegate to others or machines like robots (Lippard, 2016). Alternatively, we hope for technological advancement, such as self-cleaning and -repairing materials, to lessen the burden of some of these chores. Particularly given the fact that these chores have traditionally been relegated to those who are exploited to perform them, such as the women in a household or servants from marginalized and oppressed segments of a society, we need to be careful not to unduly romanticize or glorify these tasks.

At the same time, however, we should also be mindful of the loss incurred by minimizing our dealings with the material world, because having to care for these objects empowers us to create small pockets of control in our environment on the one hand, but, perhaps more importantly, encourages us to develop humility. That is, we can achieve the desired outcome, such as a clean kitchen, stain-free shirt, and a tasty meal, only by adjusting our action according to the materials and objects we are dealing with. The specific nature of the object and its condition dictates what tool to use, how to use it, and how to handle the material. This required flexibility and nimbleness often become routine-like and we normally do not give much thought, such as when choosing a particular knife for chopping vegetables or a method for removing a stain. However, when we stop and analyse what is involved in such a task, we realize that we are essentially submitting ourselves to the dictate of the material world. A particular stain calls for applying a specific stain remover in a certain way, sometimes vigorously rubbing while other times leaving it untouched for some time. There is a seamless back and forth between body engagement, observation, judgement, and the desired outcome. We constantly adjust the work according to how the object is responding to our activity and what method best achieves the desired outcome. We have to carefully listen to the object's dictates and negotiate with it. Despite general guidelines, there is no one-size-fits-all way of dealing with each situation and we have to improvise. It is instructive to hear the first-person accounts of those who engage in these acts, as most often they refer to the need to 'listen to', 'respond to', 'work with', and 'cooperate with' the object. This mode of doing things requires both an ethical relationship based upon respect and collaboration and an aesthetic engagement.

Losing such experiences may liberate us from cumbersome, and sometimes backbreaking, tasks. But at the same time, it deprives us of a chance to work *with* the world. The authentic mode of living in this world has to involve working collaboratively with the world, even if the experience is sometimes exhausting or frustrating. We need to experience the feeling of traction, sometimes friction, with the world around us because, being an embodied existence, we are always living *with* the world. As long as it is not a case of exploitation, engaging in house chores affords such an opportunity and it is doubtful whether being totally liberated from taking care of our material environment will lead to a good life (Mattern, 2020).

Aesthetics plays a significant role in promoting a life which honours our mode of being in the world: interdependence and collaboration with everything around us. Particularly in today's consumerist society, the human relationship with the artefactual

world has become compromised because we are systematically encouraged to participate in a culture of disposability. Any signs of wear and tear, damage, and outdated style of an object are considered aesthetic defects and nudge us toward throwing it away and replacing it with a newer object. We are discouraged from living *with* the objects and sharing our life with them. We thus tend to lose an opportunity to develop a relationship with them as our companions who deserve our appreciation and care. For example, consider a tea cup or a coffee mug we use daily. We handle it carefully and gently, not just because we don't want to break it, but because we savour its faithful service to us which helps us be grounded in our daily routine. It shows wear, discoloration, and stains from repeated use, a sign of sharing its life with us. We are humbled by their quiet presence that sustains our daily life and we are moved to reciprocate with careful handling of them. Our life is enriched by this grateful acknowledgement of the artefactual world's faithful presence, which reminds us of the authentic mode of living in this world that is made possible by interdependence, instead of independence or autonomy (Yanagi, 2018, 29–57).

Perhaps the care act regarding the artefactual world most pregnant with aesthetic implications is repair, a practice consumerism systematically discourages. However, the practice of repair is gaining more attention and popularity recently as a counter measure to the various environmental, social, and psychological harms associated with excessive production and disposal of 'stuff'. In addition to technical consideration, repair involves various aesthetic decisions, the most prominent of which is whether or not to make the signs of repair inconspicuous. Traditionally favoured is invisible repair to restore the object as close to its pre-damaged state as possible. Repair activists, in contrast, tend to prefer visible repair because it highlights the history of the object and its repair (Berger & Irvin, 2023; Sekules, 2020; RISD Museum, 2018). With either invisible or visible repair, however, various object- and damage-specific aesthetic decisions have to be made, and the act of repair requires modulated bodily movements in cutting, sewing, applying glue, hammering, and so on, which also has its own aesthetic dimensions in responding to the material's dictate (Spelman, 2002; Rodabaugh, 2018). If today's increasingly technologically mediated human-to-human interactions alienate us from socially engaged relationships, the ethos of consumerist society exacerbates the general disengagement from the material world. Aesthetic engagement reconnects us to the material world and recovers an authentic mode of living and working with the world.

SHAPING OUR LIVES AND THE WORLD

All these examples from social interactions and dealings with the artefactual world show how everyday aesthetics is instrumental in promoting our agency in shaping life and the world around us. It reminds us that aesthetics can help us become an artist of our lives. Friedrich Nietzsche, for one, advocates creating an aesthetic whole out of our lives. This requires courage and will power to say 'yes' to what happens to us, even when some

of these things are difficult for us to accept. Affirming all events and occurrences that happen to us justifies their presence as necessary parts of our life. He draws an analogy to dissonant chords in a piece of classical music which may sound unpleasant if heard in isolation but indispensable in the overall harmonic flow of the piece (Nietzsche, 1968b, 141). In short, 'it is only as an *aesthetic phenomenon* that existence and the world are eternally justified' (Nietzsche, 1968b, 52) and 'existence and the world seem justified only as an *aesthetic phenomenon*' (Nietzsche, 1968b, 141, emphasis added).

It is not only by accepting what happens to me that leads to creating a work of art out of my life, Nietzsche continues. According to him, '*creature* and *creator* are united' (Nietzsche, 1968a, 344) in a human being. I sculpt myself by affirming the integrity of the whole consisting of various parts by saying 'yes' to what constitutes the 'I'. Again, this takes courage because there are inevitably weaknesses in my character (Nietzsche, 1974, 232; Nietzsche, 2009, *passim*). This does not mean that I do not have to work on improving myself. Rather, it requires accepting who I am, with warts and all, and maintaining integrity while working on improving some parts. I am not a bundle of various qualities but instead an integrated being with different parts merging into each other to constitute a singular identity. I am given a raw material with which to work, and he criticizes those who lament and resent the weaknesses in their character by accusing them of imposing an 'ugly sight' on others (Nietzsche, 1974, 233). Thus, Nietzsche encourages creating one's self and life by aesthetic strategies with an emphasis on the unity and integrity, as well as respect for its singularity. Of course, moral concerns play a large role in self-creation and one's attitude toward life's contingencies. However, considering the whole project as an aesthetic endeavour makes it a welcome experience that stimulates creativity and imagination, rather than an arduous task motivated solely by a sense of duty or a moral discipline.

It is noteworthy that the Japanese art of *kintsugi* (repair by gold) is often used as a metaphor for healing a fractured soul. Broken pieces are put back together to restore the original shape, but the visible repair by gold retains the history of damage and repair. It creates an aesthetically appealing new appearance of 'the same' entity (Saito, 2022, 162–164; Kemske, 2021, 136–153). A poignant *kintsugi* project that not only puts broken pottery pieces back together but also serves as a potent vehicle of promoting healing and resilience is the *Repairing Earthquake Project* led by a Japanese artist, Nishiko, practising in the Netherlands. In response to the devastation left by the 2011 earthquake in Japan, she documented its aftermath through eyewitness accounts and photographed various objects. In addition, she collected fragments and debris from this catastrophe, put them back together by *kintsugi* repair, placed each repaired item in a box specifically created for it, and either returned it to the owner, if found, or entrusted it with a foster family for safekeeping. The entire project was recorded in photographs, videos, installations, performances, publications, and blogs. The broken pieces symbolize the scars left by this natural disaster and the act of repair a process of healing (Repairing Earthquake Project, 2019; also see *Nishiko*).

Finally, let us consider Socrates' well-known statement at his trial in the ancient Athenian court that the unexamined life is not worth living. Life well-lived requires that we reflect upon and examine life. Considering this advice in tandem with the nature of

philosophy as wondering at the obvious, I suggest that a good life is inseparable from questioning various assumptions, including aesthetic concerns, that guide our daily activities and decisions. When examining our everyday life, we are rather surprised to discover that many of our decisions and activities are guided by aesthetic considerations. We tend to think that most of our daily decisions and actions are guided by practical considerations, but they are often motivated, enhanced, complemented, or sometimes even overridden, by aesthetic interests. Among them are our purchasing decisions regarding clothes, automobiles, furniture, and even houses. In addition to their functionality and cost, aesthetic concerns are a significant part of, or sometimes the decisive factor in, our decision-making. Aesthetics even directs the consumer preference for perfectly formed fresh produce, leading farmers and supermarkets to discard 'deformed' produce, such as two legged carrots, cucumbers with prominent curves, peppers with a lump, and fruits with holes made by worms, thereby creating a large volume of waste and methane gas emitted during their rotting process. Consumer products' care and maintenance are also often dictated by aesthetic desiderata. How else can we explain the obsession with wrinkle- and stain-free, pristine white shirts, which requires environmentally harmful chemicals in the detergents and softeners? The functionality of automobiles and various hi-tech gadgets are rarely compromised by dents, scratches, or rust, but these 'defects' on their appearance nudge us to replace them with new ones (of course if we can afford to do so). Expanding the scope further, some of the decisions and policies that affect environments are guided by people's aesthetic preferences. Examples include the protection of natural landscapes, creatures, plants, and other natural objects motivated by their perceived aesthetic values, in contrast to indifference, neglect, and downright destruction of those parts that do not have immediate aesthetic appeal. Furthermore, public objections to wind turbines, outdoor laundry hanging, and urban community gardens cite their presumed eyesore-like appearance. At the same time, the aesthetic ideal of a velvety smooth green lawn supports the practice of its cultivation and maintenance, despite the well-documented environmental harm this causes (Saito, 2007, 58–69; Saito, 2017, 141–149).

Finally, our judgements of other people's appearance and demeanour affect employment decisions, legal deliberations, and formation of social groups. The consequences of this so-called 'lookism' are profound, leading to unjust judgements and treatments of those whose bodies do not conform to the societal aesthetic norm of normality and beauty, exacerbating racism, ablism, and ageism. In addition, those whose appearance and demeanour do not conform to societal and cultural norms of 'respectability', often constituted by the dominant and powerful segment of a society, are subject to moral censure, intensifying homophobia, classism, and cultural discrimination. Sometimes these judgements inflict harm through people's own effort to force their body to conform to what is regarded as the societal ideal, such as whitening the skin, extreme dieting, chemically enhanced body building, tanning, cosmetic surgery, and the like. Furthermore, the oppressed people's effort to conform to the societal expectation of 'respectable' demeanour may alienate themselves from their own culture and deprive them their identity (Postrel, 2003; Rhode, 2010; Siebers, 2013; Irvin, 2016; Widdows, 2018).

Conclusion

The various examples assembled in this chapter illustrate that people's aesthetic preferences and tastes literally shape the world around us, including ourselves. On the one hand, it reinforces one of the themes of this chapter that everyday aesthetics empowers us to exercise our agency in shaping the world and ourselves. At the same time, it reminds us of the vital importance of examining various aesthetic assumptions that guide our preferences and judgements regarding the world around us because they can lead to serious consequences. With empowerment comes responsibility. Everyday aesthetics emphasizes the importance of questioning various aesthetic assumptions governing our lives and society, developing what may be called aesthetic literacy and vigilance by being cognizant of the consequences of those assumptions, directing our power toward creating a just, humane, and sustainable world, and promoting a life sustained and enriched by aesthetic relationships we form with others, whether people, nature, or artefactual world. Everyday aesthetics helps us to improve the quality of life by aesthetic enrichment, develop a firm footing of living in this world with others, and cultivate aesthetic literacy to ensure that aesthetics' world-making power leads to a good life and humane world.

References

Al Qudwa, S. (2017). Aesthetic value of minimalist architecture in Gaza. *Contemporary Aesthetics 15*. Available from: https://digitalcommons.risd.edu/liberalarts_contempaesthetics/vol15/iss1/14/ [last accessed 4 October 2024].

Beardsley, J. (1989). *Earthworks and beyond: Contemporary art in the landscape*. Abbeville Press.

Berger, M., & Irvin, K. (Eds.). (2023). *Repair: Sustainable design futures*. Routledge.

Berleant, A. (1991). *Art and engagement*. Temple University Press.

Berleant, A. (2004). *Re-thinking aesthetics: Rogue essays on aesthetics and the arts*. Ashgate.

Berleant, A. (2005). *Aesthetics and environment: Variations on a theme*. Ashgate.

Berleant, A. (2010). *Sensibility and sense: The aesthetic transformation of the human world*. Imprint Academic.

Berleant, A. (2017). Objects into persons: The way to social aesthetics. *The Slovak Journal of Aesthetics 6*(2), 9–18.

Berleant A. (2023). *The social aesthetics of human environments: Critical themes*. Bloomsbury.

Buss, S. (1999). Appearing respectful: The moral significance of manners. *Ethics 109*(4), 795–826.

Cheney, P. (Ed.). (2023). *Imperfectionist aesthetics in art and everyday life*. Routledge.

Darsø, L. (2004). *Artful creation: Learning-tales of arts-in-business*. Samfundslitteratur.

Dewey, J. (1958). *Art as experience*. Capricorn Press.

Dowling, C. (2010). The aesthetics of daily life. *British Journal of Aesthetics 50*(3), 225–242.

Gier, N. F. (2001). The dancing *Ru*: A Confucian aesthetics of virtue. *Philosophy East & West 51*(2), 280–305.

Haapala, A. (2005). On the aesthetics of the everyday: Familiarity, strangeness, and the meaning of place. In A. Light & J. M. Smith (Eds.), *The aesthetics of everyday life* (pp. 39–55). Columbia University Press.

Holdforth, L. (2009). *Why manners matter: What Confucius, Jefferson, and Jackie O knew and you should too*. Plume.

Hoły-Łuczaj, M. (2019). Artifacts and the limitations of moral considerability. *Environmental Ethics 41*(1), 69–87.

Ikegami, E. (2005). *Bonds of civility: Aesthetic networks and the political origins of Japanese culture*. Cambridge University Press.

Irvin, S. (2008a). Scratching an itch. *The Journal of Aesthetics and Art Criticism 66*(1), 25–35.

Irvin, S. (2008b). The pervasiveness of the aesthetic in ordinary experience. *British Journal of Aesthetics 48*(1), 29–44.

Irvin, S. (Ed.). (2016). *Body aesthetics*. Oxford University Press.

Kant, I. (1974). *Critique of judgment*. Translated by J. H. Bernard. Hafner Press.

Kelly, C., Kemper, J., & Rutten, E. (Eds.). (2021). *Imperfection: Studies in mistakes, flaws, and failures*. Bloomsbury. Available from: www.bloomsburycollections.com/book/imperfections-studies-in-mistakes-flaws-and-failures/ch1-the-aesthetics-of-imperfection-in-every day-life [last accessed 4 October 2024].

Kemske, B. (2021). *Kintsugi: The poetic mind*. Herbert Press.

Leddy, T. (2012). *The extraordinary in the ordinary: The aesthetics of everyday life*. Broadview Press.

Lee, J. (2010). Home life: Cultivating a domestic aesthetic. *Contemporary Aesthetics 8*. Available from: https://digitalcommons.risd.edu/liberalarts_contempaesthetics/vol8/iss1/15/ [last accessed 4 October 2024].

Linstead, S., & Höpfl, H. (Eds.). (2000). *The aesthetics of organization*. SAGE Publications.

Lippard, L. R. (2016). Never done: Women's work by Mierle Laderman Ukeles. In P. C. Phillips (Ed.), *Mierle Laderman Ukeles: Maintenance art* (pp. 14–20). Queens Museum.

Mandoki, K. (2007). *Everyday aesthetics: Prosaics, the play of culture and social identities*. Ashgate.

Mattern, S. (2020). Maintenance and care. *Places Journal*. November 2018. Available from: https://placesjournal.org/article/maintenance-and-care/ [last accessed 4 October 2024].

Mullis, E. (2007). The ethics of Confucian artistry. *The Journal of Aesthetics and Art Criticism 65*(1), 99–107.

Mullis, E. (2017). Thinking through an embodied Confucian aesthetics of persons. In K. M. Higgins, S. Maira, & S. Sikka (Eds.), *Artistic visions and the promise of beauty* (pp. 139–149). Springer International Publishing.

Naukkarinen, O. (2014). Everyday aesthetic practices, ethics and tact. *Aisthesis 7*(1), 23–44.

Naukkarinen, O., & Saito, Y. (Eds.). (2012). *Artification*. Contemporary aesthetics. Special Volume 4.

Nietzsche, F. (1968a). *Beyond good and evil*. In W. Kaufmann (editor and translator), *Basic writings of Nietzsche* (pp. 191–435). The Modern Library.

Nietzsche, F. (1968b). *The birth of tragedy*. In W. Kaufmann (Ed. and Trans.), *Basic writings of Nietzsche* (pp. 17–144). The Modern Library.

Nietzsche, F. (1974). *The gay science*. Translated by W. Kaufmann. Vintage Books.

Nietzsche, F. (2009). *Thus spoke Zarathustra: A book for everyone and nobody*. Translated by Graham Parkes. Oxford University Press.

Postrel, V. (2003). *The substance of style: How the rise of aesthetic value is remaking commerce, culture, and consciousness*. HarperCollins Publishers.

Rautio, P. (2009). On hanging laundry: The place of beauty in managing everyday life. *Contemporary Aesthetics 7*.

Repairing Earthquake Project. (2019). Den Haag: Stroom Den Haag.

Rhode, D. L. (2010). *The beauty bias: The injustice of appearance in life and law*. Oxford University Press.

RISD Museum. (2018). *Manual: A journal about art and its making* 11 'Repair'. Rhode Island School of Design Museum.

Rodabaugh, K. (2018). *Mending matters*. Abrams.

Saito, Y. (2007). *Everyday aesthetics*. Oxford University Press.

Saito, Y. (2017). *Aesthetics of the familiar: Everyday life and world-making*. Oxford University Press.

Saito, Y. (2019). Aesthetics of the everyday. In *Stanford Encyclopedia of Philosophy*. Available from: http://plato.stanford.edu/entries/aesthetics-of-everyday/ [last accessed 4 October 2024].

Saito, Y. (2021). Aesthetics of imperfection in everyday life. In C. Kelly, J. Kemper, & E. Rutten (Eds.), *Imperfection: Studies in mistakes, flaws, and failures* (pp. 23–49). Bloomsbury. Available from: www.bloomsburycollections.com/book/imperfections-studies-in-mistakes-flaws-and-failures/ch1-the-aesthetics-of-imperfection-in-everyday-life [last accessed 4 October 2024].

Saito, Y. (2022). *Aesthetics of care: Practice in everyday life*. Bloomsbury.

Sekules, K. (2020). *Mend! A refashioning manual and manifesto*. Penguin Books.

Sherman, N. (2005). Of manners and morals. *British Journal of Educational Studies* 53(3), 272–289.

Shusterman, R. (2012). *Thinking through the body: Essays in Somaesthetics*. Cambridge University Press.

Shusterman, R. (2013). 'Everyday aesthetics of embodiment'. In R. Bhatt (Ed.), *Rethinking aesthetics: The role of body in design* (pp. 13–35). Routledge.

Siebers, T. (2013). *Disability aesthetics*. The University of Michigan Press.

Spelman, E. (2002). *Repair: The impulse to restore in a fragile world*. Beacon Press.

Stohr, K. (2012). *On manners*. Routledge.

Surak, K. (2013). *Making tea, making Japan: Cultural nationalism in practice*. Stanford University Press.

Widdows, H. (2018). *Perfect me: Beauty as an ethical ideal*. Princeton University Press.

Yanagi, S. (2018). *The beauty of everyday things*. Translated by M. Brase. Penguin Classics.

CHAPTER 11

SENSIBLE WELL-BEING

Environmental Aesthetics and Multi-sensory Perception

MĂDĂLINA DIACONU

Introduction

The scope of aesthetics was extended during the last few decades to natural environments, new and traditional devalued artistic forms, and a wide range of artefacts and practices that have always enjoyed an undisputable aesthetic status in non-Western cultures. Quite often such experiences are multi-sensory and include senses that in the Western world were banned from aesthetics and were taboo subjects. The enlargement of aesthetics was supported by its reinterpretation as aisthetics or the theory of sensory perception (from αἴσθησις, sensation). This chapter explores the crucial role of touch, smell, and taste for mental health and well-being in general. The first section unveils the general reasons for the marginalization or even exclusion of these senses from aesthetics, and their nocuous consequences. Based on the understanding of the subject as bodily and immersed into environments, the second part emphasizes the impact of tactile, olfactory, and gustatory experiences on the relation to one's own self, on interpersonal and social relationships, and on the feeling of being at home in the world. Selected examples for each of the three aforementioned 'secondary senses' (Diaconu, 2006) demonstrate that well-being transcends merely sensual pleasure, is imbued with ethical values, and contributes to identity-making. Finally, the last part analyses the different nuances of well-being, such as the pre-reflexive confidence in one's own body, comfort, pleasure, happiness, and existential fulfilment.

The Intellectualist Coalition

For a long time, aesthetics has privileged interpretation and judgement over experience and existence. Whether we date the beginning of aesthetics back to Greek Antiquity

or to the eighteenth century Enlightenment, the philosophy of art and beauty was rooted in Western metaphysics and was indebted to anthropological, epistemological, ontological, and moral approaches that altogether produced what can be called the phallogocentric or intellectualist coalition.

Platonic body–mind dualism was inherited, passing through Neoplatonism, by Christian theology and was perpetuated in early modernity by Descartes and the mechanistic *Weltbild*. The living body was considered fragile, and its joys were disdained as ephemeral and superficial. The corruptibility of the flesh was twofold: the body was condemned to putridity, and its temptations endangered the salvation of the soul. The anonymity of the flesh—that Merleau-Ponty converted later into the positive premise for our belonging to the world—was believed to compromise the person as sign of kinship with God and equated to the relapse into pre-spiritual materiality.

The history of sensibility in the Middle Ages is usually described as the strive to overcome immanence by means of ascetic repression, control, and disciplining of the senses (from ἄσκησις, exercise). This stereotype needs revision through a careful differentiation between Western and Eastern Christian spirituality, between patristics, Aristotelian scholastics, the rehabilitation of the inner senses by the mystics, and the puritanism of the Protestant world. The terminology, liturgy, and the mystical experience are particularly relevant here. In the Pauline epistles σάρξ (*caro*, flesh) was mostly associated with passivity and hetero-normativity, but σῶμα (*corpus*, body) was considered the 'temple' of the Holy Spirit (1 Cor 6:19); the human body was at the same time the locus of perdition and of praising God, for example, by receiving the eucharist. As a result, the body was not bad in itself, but a site for construction (Scornaienchi, 2008), and sensory experience was judged according to its context and effects: the pious pleasures of liturgy were contrasted with the pleasures of the 'world' (Harvey, 2006).

In its polemics against Gnosticism, the patristic theology emphasized that the historical Incarnation had redeemed materiality and corporality. This paved the way for approving the sensuous experience under two conditions: to think in symbols and never pursue sensory pleasure for itself. Because symbols partake in both the immanent and the transcendent, symbolical artefacts and practices were conceived as anagogical, purifying tools that prepared believers for the encounter with the holy. Ascesis and liturgy were complementary. However, the development of the Catholic liturgy since the Middle Ages privileged the visual (e.g., the adoration of the ostensory) and after the Second Vatican Council it restricted the incensation, coming closer to the sensory 'minimalism' of the Protestant religious service. In the wake of the sensory turn, phenomenologists rediscovered the synaesthetic dimension of liturgical practices: 'We experience liturgy as we see, hear, smell, taste, and touch. Liturgy is fully incarnate, corporeal, and sensory experience' (Gschwandtner, 2019, 111).

The devotional, 'mystical' literature—understood as a specific Western phenomenon that emerged in the late Middle Ages and Reformation and moved away from institutionalized traditions toward inward experiences of faith (Louth, 2007)—not only challenged the authority of male priesthood, but provided also proto-phenomenological, first-person accounts of experience, that focused on the 'inner senses' and inversed the hierarchy of the senses. Taste, touch, and smell were most exalted (Manoussakis, 2007,

144), probably because of their intimacy, pre-reflexive immediacy, and strong emotional impact. In the counterculture of mysticism, meta-physical experiences went hand in hand with the transfiguration of sensibility.

The hierarchy of the senses that still prevails in the Western world is inherited from Antiquity. Aristotle placed the distal senses sight and hearing on top, followed by smell and the proximal senses taste and touch (Aristotle, 1993, Book III, chapter 1). The oculocentric Greek–Roman culture and the Jewish preference for hearing coalesced in the Christian synthesis. Theology supported the primacy of sight and hearing, claiming that the Providence endowed humans with double organs for those senses that lead to God. In Renaissance and Baroque, the competition among senses became a favourite subject in literature and opera (Jütte, 2005). In philosophy, both rationalists and empiricists agreed that the epistemic value of sight and hearing is superior to the 'lower senses': touch (including temperature and pain), smell, and taste. For Descartes, not even physical pain was reliable, because amputated limbs can still be a source of pain (Descartes, 1912, 293). John Locke, by contrast, rehabilitated perception as the beginning and last source of all knowledge. Nevertheless, he distinguished between primary and secondary qualities: primary qualities cannot be separated from things, which convey objectivity to their knowledge; secondary qualities, like smells and tastes, have a fundament in the object, yet come into being only insofar as they are perceived (Locke, 1975). Kant did not only overcome the alternative between rationalism and empiricism, but in his 'Apology for Sensibility' he also rejected one by one the objections that the senses confuse, control the understanding instead of being its 'handmaid', and deceive (Kant, 1996, §§ 8–11, pp. 28–32). Kant divided the senses into the vital (e.g., temperature) and organic (the five classical senses), explicitly excluding any others. He separated the 'objective' or 'mechanical' senses of sight, hearing, and touch from the 'subjective' or 'chemical' senses of taste and olfaction; the first group informs us about an object, the second tells us more about the way the object *affects* the subject. This explains why the *Critique of Judgment* despises smells as merely (dis)agreeable; they are unworthy of aesthetic consideration because we cannot expect any intersubjective agreement about their quality. The number of the senses varied between four and seventeen, until mid-nineteenth century physiology imposed the idea of an open system of the senses.

This intellectual context helps to better understand the dominant 'discrimination' against touch, smell, and taste in aesthetics and the disgust at their 'facile' structure (Osborne, 1977). Typical in this respect is Hegel, who, on one hand, defended art against its trivialization as superficial entertainment and, on the other, elevated art to a self-expression of the Absolute and reduced its sensuous experience to the 'theoretical senses' of sight and hearing. Touch, smell, and taste cannot generate art; their objects are ephemeral and consumable, and their qualities, merely sensible and agreeable (Hegel, 1975, 38–39). This verdict remained undisputed until the rehabilitation of the *aisthetic* origin of aesthetics at the end of the twentieth century. Sociological explanations for the exclusion of the proximal senses from aesthetics, related to the delimitation of the rising bourgeoisie from the hedonism of aristocracy, also deserve to be taken into consideration (Bourdieu, 1984; Shusterman, 2021).

As a result, social and ethno-cultural stereotypes emerged that associated the 'lower' pleasures of touch, smell, and taste with the inferior specimens of humanity. The Other of the white, Western-European, Northern (protestant), middle-class male subject comprised women, children, and the poor working class. The late nineteenth century added to them the genetically 'degenerated' aristocracy, socially 'deviant' and mentally 'insane' people. Not only did these groups have to be educated to control and repress their needs, but the internal ethnic Other (e.g., the Jews) and the 'primitives' from other continents did as well. The 'process of civilization' that in Western Europe had increasingly forbidden touching and smelling in public (Elias, 1997) was exported in the colonial age to other continents. The Western pattern of sensibility was regarded as universal and imposed with various means, from formal education to unwritten codes of everyday aesthetics (etiquette, personal hygiene), to other cultures. Deviations from this normative model—as when other cultures displayed a higher degree of perceptual discrimination for touch or smell—gave off their underdevelopment and 'Orientalism', both Western constructs that emerged in the nineteenth century.

The intellectualist coalition had far-reaching consequences on aesthetic theory and everyday aesthetic practices. The scope of philosophical aesthetics was restricted to art and excluded the multi-sensory experience of nature. The realm of art itself left out a whole range of practices that had a long history or were reinvented in the nineteenth century (perfumery, aromatherapy, *haute cuisine*, industrial design)—*nota bene*, all practices that contribute to well-being. Even after physiological and evolutionary aesthetics attempted to rehabilitate the multi-sensory experience that is embedded in life processes (Grant, 1877; Guyau, 1904), and psychological aesthetics began to explore synaesthesia, beauty remained dissociated from well-being. Landscapes were appreciated according to pictural criteria as picturesque, sublime, symbolic, or atmospheric, and architecture focused on facades, vistas, and perspectives, ignoring the temperature and echo of spaces, or the smell of materials. Multi-sensory environmental perception—the rule in daily life—was simplified to the juxtaposition of distinct experiences. The flaneur, a symbol of the epoch, was watching the spectacle of the street without *living* there or interacting with the passers-by. The aesthetics of spectatorship was extended to theatres, concert halls, and cinemas. In the eighteenth century there was light in the audience area and spectators could consume refreshments; one century later, the show *in* the audience was stopped and, like the readers of literature, the spectators found themselves *alone* with the performance, passively seated at a secure physical distance from the passions on stage. Any behaviour other than bodiless worship in the temples of art betrayed the lower class and the philistine art *consumer*. Bodies and sociability were remembered only in the dinners that took place after and outside artistic institutions; conviviality was distinct from artistic connoisseurship, the 'art of conversation' from art criticism. The community-building function of art and its impact on life itself were rediscovered only in the twentieth century.

Divide et impera was the imperative of Western modernity: analytical sciences, a politics of fragmentation and the quarantining of the aesthetic were aimed at mastering nature (including one's own animality). Psychology discussed the subject's faculties

separately. 'Holy' art was separated from prosaic life, and a series of spatiotemporal framings guaranteed the middle class and elites a controlled satisfaction of their physiological and emotional needs. Architecture and urbanism zoned buildings and districts according to their function (and accompanying body, food, or industrial smells). Everything that was 'tainted' with non-aesthetic interests was either excluded from aesthetics or interpreted in a distorted way. The Kantian difference between the allegedly purely aesthetic *pulchritudo vaga* and *pulchritudo adherens* influenced the curricula at art academies and introduced a hierarchy between academic arts, applied arts, and crafts. Pottery and textile art, which were traditionally practised by women, continue to be assigned a lower status at art academies, and perfumery still fights for its recognition as art. In the aesthetic evaluation of the *cuisine*, from the monumental *pieces montées* of the nineteenth century to the tricks of food photography, the visual display came first. The rise of design theory and popular culture in the last century shattered the primacy of the 'higher' senses, yet often with the result of co-opting designers in the intellectualist coalition and reducing practical objects to lifestyle-icons, as if chairs were meant to be looked at and not sat on.

The ideal subject remained a disembodied mind that was able to examine, understand, survey, and supervise (both derived from *super*: over and *videre*: to see) the external and inner life. The consequences of this intellectualism and voluntarism on well-being have already made the object of solid analyses of the Western disciplinary society (Foucault, 1995). Well-feeling fell outside of the scope of philosophy and aesthetics. Not even experience-led phenomenology completely succeeded in rehabilitating touch, smell, and taste in aesthetics despite extensive analyses of tactility, smell, pain, and animal perception. The condescension of the proximal senses, that are closely related to somatic functions and animality, is still strong in philosophy.

Likewise, aesthetics operated within a narrow concept of art and work of art. Multi- and intermodal experiences were reduced to audio-visual perception and imagination. Contact with art was confined to spatiotemporal enclaves within life and privileged understanding (of the producers' intentions and unconscious, of Being or society); this was expected to lead to judgements of taste in which aesthetic emotion counted only as a side-effect of appreciation. The authentic aesthetic experience was not meant to please, but to wake and shake, illuminate and emancipate. The phallogocentric paradigm—evident from Hegel to Gadamer and Adorno—operated within a vicious circle: it ignored what it disdained (asemantic objects that were denied complexity and resisted description, along with experiences that were suspected of lacking aesthetic disinterestedness), but it was precisely this repression that obstructed conceptual work and self-cultivation, that impeded the development of a fine-grained terminology, and affected the sensitivity and skills related to the 'secondary senses'. The sensualist counter-tradition remained a minority, and the same goes for eudemonistic ethics and a process ontology that would have made it easier to appreciate transitoriness. Individual contemplation was opposed both to consumption and to the performative, physical engagement with the object. Since the extension of aesthetics and partially resorting to phenomenological arguments, philosophers started to claim the integration of a holistic

sensitivity in aesthetics (Berleant, 2010) and to outline an aesthetics of touch, smell, and taste (Diaconu, 2005; Shiner, 2020).

The Exertion of All Senses as Prerequisite of Wellness

Phenomenology showed that the plurality of senses involves an irreducible diversity of experiences; the senses build specific 'worlds' and 'gates' to reality (Diaconu, 2013). Even when they target the same object, their correlates in consciousness do not coincide: the warmth of fire is distinct from its crackling or vacillating light. At the same time, senses are interconnected and communicate in form of intermodal qualities (warm/cold, high/low, wide/narrow, etc.), and experiences of a sense evoke other senses, as when we see the roughness of a surface or recognize a rose by inhaling its fragrance. This unity in diversity enables people with acquired sensory impairments to activate representations of the lost sense. However, making up for losses is only a special case of wellness. In general, the entanglement of the senses is used for practical purposes; the coordination of eye and hand when handling objects is simply taken for granted. From an aesthetic perspective, the diversity of senses conveys richness to experience. Sensory deficits and sensory repression impoverish life and affect wellness because the subject of perception is neither the organ of sense, nor the brain, but the corporeal self. Senses are functions of living bodies that exist only *as relations* to themselves, to others, to the world, and even to the holy. This shifts the attention from the ego-actant to the responsive and impressionable 'me'-subject (Waldenfels, 2000; Wiesing, 2009; Hasse, 2014): to resonate with the Other becomes more important than to master it or keep it at a distance. In particular, touch, smell, and taste can create proximity and intimacy both in a physical and emotional respect or, on the contrary, traumatize. Their contribution to well-being and the art of living reaches from the satisfaction of needs to an autotelic, 'disinterested' enjoyment.

Sensory Reflexivity and Self-Acceptance

Looking in the mirror is only one mechanism of identity-making; the primary self is, according to Didier Anzieu (2018), the Skin-ego. Its functions develop by leaning on the tasks of the skin: it maintains the psyche, interiorizing the mother who holds her baby; it contains the inner organs and the organs of sense, covering the entire body; it is a protective shield against stimuli; it individuates the self and distinguishes it from other bodies; it has an intersensorial function, by housing different sense organs in its cavities; its erogenous zones support sexual excitation; it is subject to sensorimotor stimulation from outside; finally, it provides a surface for imprints like blushing, scars, eczema, and symbolic wounds (Anzieu, 2018, 105–114). Most of these functions involve the other: the

caring parent, the blaming observer, the admirer. The other's acceptance is essential for self-acceptance. Phenomenology analysed sensory reflexivity in the example of the two hands of the same body that touch each other, yet only with respect to their ambiguous active and passive roles, without any reference to pleasure (Merleau-Ponty, 2012).

The formation of subjectivity involves a 'dialectics of Me and I' (Böhme, 2012, 17), the interplay between accepting the body that has been given to me and making myself through cultural practices. The natural 'olfactory self' (Diaconu, 2021) depends on gender and age, nourishing habits and physical activity, health condition and medicines. Being mostly related to sexual and excretory functions, the issue of body odours was addressed only in medicine. Contemporary artists broke with this taboo: they distillate their body odours and exhibit them in perfume bottles, and find inspiration in subjects who reject their body odours. For most people, feeling a whiff of their own smell is agreeable or reassuring; disorders of the olfactory self-acceptance indicate mental problems (Tellenbach, 1968). In olfactory reference syndrome people falsely believe in the emitting of offensive smells and misinterpret people's behaviour toward them. They develop a compulsive need to control their body smell, avoid physical activities that make them sweat, fear other people's presence and end in isolation, depression, and even by committing suicide (Philips & Menard, 2011). This morbid exacerbation of the need to control one's own body odour made artists design smell suits that promise control over both smell input and output or pills that transform the malodourous perspiration into fragrance from within. The use of scented cosmetic products and fragrances is more common; regarding its motivations, self-directed well-feeling prevails over the wish to please and impress others, in particular for women (Jellinek, 1994, 214–226). In addition to this, teenagers' preferences often reflect identificatory models and are influenced by advertising testimonials. Feeling well passes through feeling like admired celebrities; selves are unstable results of making processes. The Proust syndrome deserves special mention: situations in which a smell suddenly revives a past world convey temporal depth to the self and produce an intense happiness.

Bodily self-acceptance, meaning to feel well in one's own body, has become a major problem of young people in Western (and Westernized) countries, and is usually understood as having difficulties with one's own *figure*, which is a concept of visual origin. However, the body shape is the result of a combination between genetics, health conditions, and diet. Physiological ailments, including food allergies and intolerances, affect well-being in a different way than the mental disorders of bulimia nervosa or anorexia, in which mostly young women from middle- and upper-class backgrounds reject their 'curves' and develop a compulsive need to control their weight, appetite, and food preferences. Another major disease of civilization, obesity, recalls the description of the present as the age of an industrial oral society (Anders, 1980), of excessive, uncritical consumption.

Celebrating Togetherness: Conviviality

Feeling well is inconceivable without others. The reversibility of touch means that one cannot touch without being touched; the promise of pleasure is indissociable from

vulnerability. As a matter of fact, touch is only the generic term for various situations: it can be therapeutic and relax or relieve; it can develop a healing power and bring solace, express affection and love, but also force sexual intercourse and produce traumas. Touch generates pleasure as well as pain, emotional comfort or discomfort; this is the reason why so many professions—physicians and nurses, masseurs and hair stylists, dancers and sportsmen, police as well as security forces—need to be taught *how* to touch the other in the right way. The different qualities and manners of touch can be developed into styles, from making love to playing music. Language itself gives evidence for the broad semantic field of touch: something can touch physically, as well as emotionally and even intellectually, as when during a conversation someone remarks '*touché*', meaning 'you made a good point'.

Individuals need attachment and words never have the emotional intensity of a kiss, caress, or embrace. From the earliest age, physical contact is crucial for psychological development; suckling is also a form of tactile, aural, and olfactory communication, and the firmness with which the baby is carried can influence the later feeling of stability in life. Special situations, such as the COVID-19 pandemic, with its lockdowns, home office, distant learning and social distancing, have increased the awareness of the importance of proximity for well-being. Sensory deprivation affects the *joie de vivre*: anosmia can lead to depression, while discomfort when being touched in general can be a symptom of autism.

Let us explore the aesthetic dimension of touch through the examples of proxemics, care, and eroticism. First, proxemics investigates the use of space in interpersonal communication and the cultural variation in the perception of nearness (Hall, 1966). The intimate space, the social and consultative spaces, and the public space are associated with specific activities, categories of people (intimate and closest friends, colleagues and acquaintances, 'strangers'), and types of communication. The trespassing of hidden borders, as when someone comes too close, is felt as a violation of privacy, but the opposite situation, in which artificially imposed distances are interpreted as unfriendliness or reveal inequality, is uncomfortable as well. The proxemic behaviour has consequences not only for business communication, but also for architecture and interior design (e.g., arranging the tables and seats in a restaurant or hotel lobby) and even cinema (long shots of the camera correspond to the public proxemic, while close-ups create intimacy with the character).

Secondly, Yuriko Saito detected three structural similarities between the aesthetic experience and care in the view of feminist care ethics: respect and appreciation for the other in its singularity; an appropriate response to the other's specific needs in specific situations; and acknowledging the experience as intrinsically valuable (Saito, 2020). Physical care activities predominantly involve tactile, olfactory, and gustatory experiences, such as grooming, cooking, washing, and cleaning the other or in the other's service. However, if they are practised in the aforementioned 'aesthetic' manner, they naturally include 'disinterested' gestures of affection.

The third example, the erotic caress, 'transcends the sensible' and its intention is not to unveil, but to explore; touch expresses love and feeds desire (Lévinas, 2001, 288).

Above all tenderness transforms the body from a 'being' among others into flesh and a locus of liberty. While Emmanuel Lévinas prefers the moral approach to the phenomenology of eros, Richard Shusterman acknowledges its aesthetic dimension. His somaesthetics describes lived experience with the final aim to improve our bodily condition; a healthy sexuality is indispensable in this respect. Shusterman's *Ars erotica* (2021) sets forth Foucault in criticizing the philosophers' suspicion about sexuality. Analyses of pre-modern erotic treatises pursue, on one hand, to unravel the roots of the heterosexual norm and of the objectification of women, and on the other, to rehabilitate *ars erotica* and spread this 'know-how' of premodern elites in the modern democratic societies. Erotic pleasure was considered an end in itself; the erotic 'performance' was carefully composed, and the manner of gestures and movements counted as much as the sexual act itself. Moreover, *ars erotica* incorporated poetry and music, perfumery, gastronomy, fashion, and body care. Its success depends not only on physical health, vital strength, and a good relationship with one's own body, but also on the 'arts' of self-presentation and conversation; therefore, it reveals the continuity between nature and culture. According to Shusterman, it can even build character, since it requires empathy and tactfulness in relation to the partner.

The association between female seduction and perfumery is a strong stereotype in modern Western literature. Historical and anthropological research also disclosed the olfactory basis of racial and social discrimination (Reinarz, 2014; Classen et al., 1994). The anxiety provoked by the 'stench' of foreigners and outsiders has been mentioned since Roman Antiquity and has biological roots. Nonhuman animal species use biological scent-marks to circumscribe their territories; familiar smells inspire trust, unknown odours alert, and the bird literally removes the 'invader' from its nest. The German concept of *Nestgeruch* refers to the atmosphere that makes up a community; individuals are accepted or excluded from it prior to any arguments. Smell in this broad meaning is the sense of 'pre-judice' (Tellenbach, 1968, 25). Until the nineteenth century, odours were supposed to herald diseases that, in turn, required other smells and fumigations to heal them (Le Guérer, 2002). Physicians were instructed to diagnose physical and even mental illness (e.g., schizophrenia) by their nose; body odours were considered undeceiving symptoms. Uncanny contemporary art installations allude to this fear of smells in relation either to disease and death or to sexual pheromones that make one lose self-control. In Teresa Margolles' *Vaporización* (2002), an empty gallery space was filled with the steam of the water used to wash corpses; the information about the origin of the vapours—meant as an allusion to the high rate of criminality in Ciudad de México—was disquieting to visitors, as if death were contagious. In contrast, Carsten Höller's and François Roche's *Hypothèse de grue* (2013) was a white metallic smoke machine whose shape vaguely recalled a dragon; the caption in the exhibition *Belle Haleine* (Museum Tinguely, Basel, 2015) said that its fog was containing neurostimulants, which sufficed to alert the visitors.

The community-making power of senses is most obvious in the case of taste; eating and drinking are eminently social activities. People who feast together are called in

French *convives*; conviviality has started to be praised lately as a political virtue. Plato and Petronius narrated about the symposia in which fellow diners and drinkers share common interests; the consumption of beverages and delicacies is until today the pretext for a social and intellectual event. Scientific symposia and congresses combine the exchange of opinions with formal dinners and informal come-together-events. Meals are opportunities that gather the small and large family every day or for feasts ('holy days'); a Christian tradition says that no one eats alone but at least in the company of an angel. From feeding the poor in the Middle Ages to contemporary charity dinners and art performances such as *Permanent Breakfast*, collective meals create social cohesion and counteract urban anonymity and loneliness. Daniel Spoerri's *Tableaux-pièges* celebrated friendship by fixing the remainders of meals on tables.

Social aesthetics includes etiquette rules and inequality: at the Court, no one started to eat before the emperor; in traditional families, to cut and distribute the meat was the privilege of the male head of family. Sitting at the same table does not exclude inequality in the guests' placement or in serving gender- and age-'appropriate' dishes and beverages. The menus, cutlery and vessels, the food display and the table arrangement reflect wealth and social status (conspicuous consumption), moral values (veganism), or ecological commitment (local and seasonal food). Since the opening of the first public restaurants in Paris after the French Revolution, various eating cultures and types of conviviality have emerged, such as gentlemen's clubs, cafés and tea-houses, wine bars, and night clubs.

Living in the World: Co-Naturality

Modern philosophy and aesthetics were centred on the experience of works, which means objects. New developments—site-specific, often multi-sensory, and interactive art installations, the spatial turn, and the return of synaesthesia studies—made it necessary to rethink perception. The corporeal and situated subject does not primarily grasp isolated or juxtaposed objects, but perception being a function of life, it experiences first and foremost environments, within which it distinguishes things and qualities. As a result, new categories, such as surface, depth and consistency, material texture and chemical composition, have gained in importance.

The enjoyment of looking at art can be partly traced back to intersensory analogies. Haptic qualities in painting, sculpture, and cinema evoke a close engagement with texture and surface details simply by watching them (Riegl, 2004; Berenson, 1948; Barker, 2009). The traces on the canvas enable one to reconstruct the artist's gestures, their intensity and emotional quality, while the vanishing point perspective invites an imaginary immersion into a landscape painting. Inclusive art and art education represent a special field, in which spectators are explicitly asked to touch works. In architecture and design, the haptic qualities of materials both serve practical concerns and are enjoyable. Although the design theory focused on user experience was for a long time dominated

by the visual, a wide range of objects—from beds and cups to touchscreens—are expected primarily to be comfortable, manoeuvrable, and agreeable to touch.

Whereas hands actively grasp, hold, and explore the object, the skin is exposed all over to touch and draws (dis)pleasure from being touched. The feeling of passive touch has seldom been discussed (Husserl, 1973), yet it is essential to the experience of wearing clothes. These bodily wrappings are our next tactile interfaces and a kind of second skin, just like dwellings build our third skin. The form of clothes—felt as tight or loose—influences gestures and movements and marks the distinction between work-related and leisure time, between activities, and personal styles. Their texture produces a wide range of haptic impressions which we usually reduce to a scale between soft and rough. Art history usually investigates the visual patterns of luxury garments, while for the wearers' well-being the technical properties of fabrics are mainly responsible. Textile engineering belongs to the most innovative domains of haptic design and its technology was extended from the military industry, sports, and technical equipment to all segments of the population that carry out outdoor activities. Functional clothing promises comfort and protection from the natural elements due to its adaptability: it retains or releases body heat, enables free movement, is resistant to wear and has a pleasant touch, is wind- and water-resistant or even wind- and waterproof, etc. The new categories that emerged in this field, such as membrane (materials that regulate the exchange of water and energy), layering system, insulation, breathability and air permeability, moisture management, etc., demonstrate that the contact between the two surfaces of fabric and epidermis involves a transaction between two environments. While the intellectualist alliance conveys profoundness to meaning, the 'new' depth is fleshly: the body temperature is higher in the brain and chest than on its periphery and in its limbs. Additional qualities of fabrics, such as wrinkle recovery, drapability, gloss, fabric tear strength, and pilling resistance, address the tactile eye.

In architecture, usability and liveability transcend visual haptics and other intermodal experiences. Buildings are not three-dimensional images that additionally and accidentally can be entered and crossed, but environments to live in. The variation of surface materials (for example, in a park) can be dictated by practical reasons, but be perceptually rewarding for walkers, joggers, and toddlers as well. Conversely, built environments can make one sick. Dystoposthesia or environmental sensitivity is the name of an obscure physical illness that makes people suffer in some places; one of its causes is the odour of materials (Fletcher, 2005). The strong effect of smells on well-being is a core subject in olfactory design; its activities range from the strategic placement of nice-smelling shops in leisure centres and underground stations to product design and advertisement, the odorization of hotels and other transit spaces, as well as landscape architecture (Henshaw et al., 2018). Long before the fresh air cures inspired the rise of the modern outdoor culture and the architecture of sanatoriums, Byzantine emperors had built hospitals near to gardens (*Geoponika*, 2011). Health institutions face the dilemma that pungent smells awaken associations with pain and suffering, while the sterile 'whiff of nothing' is suspected of concealing negative experiences (Stenslund, 2015). From reducing air pollution and the fresh smell of cleaning products that makes

'visible' the humble (mostly women's) daily chores to the complex scent compositions of perfumes lies a broad spectrum of olfactory practices that produce well-being.

The recent atmospheric turn has propelled the olfactory studies, too. Topophilia, understood as the comforting feeling of belonging to a place, has not only visual, but also olfactory clues. Vegetal smells evoke positive associations in all cultures; therefore, landscape architecture can use them not only to enforce emplacement and identity but also as emotionally gratifying. Artists and scholars in urban studies developed new research methods: they distillate the smells of multicultural neighbourhoods, ask residents about their perception of the smells of a city, map urban smellscapes, and organize smell walks. Brian Goeltzenleuchter, for example, produces 'counter-monuments', olfactory public artworks that, despite their fleetingness and event-like character, inscribe themselves in the collective memory (Goeltzenleuchter, 2021). While Western culture has traditionally praised durability and rejected the possibility of olfactory and culinary art because of their ephemerality, sustainability requires in our age precisely *not* to leave ineffaceable material traces. Short-sighted individualism and wellness mentality endanger communal long-term well-being.

Being with others includes non-human species. The touch of a light breeze on a hot day or warming in the sun at the end of the winter, bathing and swimming—all of these pleasures result from being immersed in the natural elements and humans share them with non-human animals. Such joys have been despised for centuries as trivial and 'animalic' by the intellectualist alliance before the everyday aesthetics as 'aesthetics of the familiar' (Saito, 2017) rehabilitated them. When we pay attention to ordinariness, it can reveal a profound existential dimension; 'bathing' in the sun, water, or smell symbolizes an embeddedness in the environment of the 'Earthbound', to speak with Bruno Latour (2017). Enjoyment itself would not be possible without the primary co-naturality, 'complicity' or 'kinship' between the subject and the world, that inspired in Mikel Dufrenne the notion of affective *a priori* for the aesthetic experience (Dufrenne, 1973, 461–462). The subject is a fold of nature and in nature (Merleau-Ponty, 1968), whereby nature is neither an environment that externally surrounds the body, nor a medium of immersion. Instead, subject and world are like communicating vessels: the body is permeated by warmth and inhales the air.

Another example for our co-naturality with the world is food intake. Digestion is the process that appropriates the world by converting it into fleshly substance: the outer environment is transformed into species-specific inner environment. However, food and beverage have to be edible and drinkable, which depends both on their quality and on our physiological functions as well as dysfunctions. The sight of refreshments at the end of a tiresome journey can be considered in itself an aesthetic pleasure (Guyau, 1904). Moreover, the smell of food makes an appetite and anticipates its flavour or provokes disgust; the spontaneous verdictive response of the sense of taste was one of the reasons for it having been taken as a model for the faculty of aesthetic judgement. Since time immemorial cooking and eating have meant much more than to appease hunger and produce satiety. *Ars culinaria* engages several senses, from the harmonious combination of the five basic tastes to acoustic and tactile sensations that accompany chewing, and

the visual display of the edible. Further aesthetic aspects regard the styles of different cuisines, the mythological names of dishes in the nineteenth century, and the literary-visual quality of menus. Infinitesimal differences are essential to gourmets and connoisseurs, which makes from consuming certain beverages and delicacies a school of perception and self-cultivation.

The Many Shades of Well-Being

The ambivalence in the way sensibility relates us to the world reflects our being more than nature: as bodies we depend on our physical and social environments, but as *human* bodies our life surpasses biological survival and well-being. Martin Heidegger's equation of existential authenticity with becoming aware of our thrownness in the world and being-toward-death was rightly criticized; the child's primary *Grundstimmung* is trust or the feeling of being at home in the world (Bachelard, 1994; Tellenbach, 1968). The proximal senses discussed here confirm it: our first, pre-natal environment is the maternal body; once born, the infant rejects neither the nourishing breast nor the arms that carry her. Without this pre-reflexive trust both in the intimate relationships and in the physical environment—we do not start by questioning the air we breathe, the water we drink or the solidity of the ground—no one could survive. If we learn later to be critical about their *quality* and develop environmental concerns, this is precisely because we realize the human's situatedness and facticity. At this elementary level, well-being means simply to live. Biological life—of humans as well as of other living beings—is as such intrinsically valuable; being is a good thing to be preserved. From this perspective, well-being appears as a positive state of functioning and normality, as the result of a process of exchanges and transactions with the environment and as this process itself. Being well implies that nothing extraordinary happens and one's own body is a reliable partner that remains silent.

Trust comes first, pleasure follows. The founder of the intellectualist coalition, Plato, mistrusted the sensory pleasure that is derived from the satisfaction of needs, remarking that it does not have an existence in itself, but emerges simultaneously with the recession of displeasure and pain (Plato, 1975, 31b–c, p. 24). Such well-being can be called secondary or reactive, since it involves relief and liberation from need. In contrast with the bodily silence in the stage of ordinariness, this time the body claims its rights. The amount of attention our fellow-body requires varies with our health condition; the more fragile our health is, the stronger are the self-imposed restrictions and the narrower the basis of well-being. The state of an acceptable health condition turns out to be the result of an incessant self-defensive combat against illness. A special form of well-being is intensively experienced in recovery and healing processes. However, in general wellness implies at this level the need to preserve life by being friendly to the body and paying attention to its signals.

A third form of well-feeling is closely linked to tactility in everyday life: comfort. Well-being means to feel well in our own skin, primarily in one's own body (self-acceptance),

but also in the extended skins created by culture and history: clothes, dwelling, city, country, and environment at large. Living bodies feel well only if the exchanges with all these physical and social environments function in a satisfactory way. Regarding sensory comfort, the emphasis of historic philosophical hedonism on pleasure may have been strategically wrong: pleasures can be merely temporary and to take pleasure-seeking as an ideal of life can put too much pressure on the subject and pave the way for moralists like Augustine to reject the concupiscence of the senses. Comfort is more moderate and remains in the middle zone between displeasure and pleasure; therefore, similar to the state of the silent body, it often remains unnoticed. Comfort can be mechanical (e.g., furniture), thermic (garments), or chemical (breathing in a non-toxic environment, ingesting healthy food). The fact that comfort is less demanding than pleasure represents an advantage in our world of sensory overkill, luring advertisement, and compelling consumption. When we think of shoes, comfortable ones are not the new ones, but the old ones, having already adapted to the foot form up to the point of becoming body extensions; in other words, objects of personal use that became 'familiar' from a tactile perspective are comfortable. Moreover, comfort is more democratic than pleasure: everyone has the right to it on a daily basis. Pleasure was blamed for weakening stamina and emasculating the character; in contrast, it suffices to look at the etymology of 'comfort' (from Latin *com-* and *fortis*) to expect strengthening and support from it—in a material as well as emotional and intellectual respect. Comfort is not only sought from a warm bath, but also from the possibility of communicating with the psychotherapist or the judge in one's mother tongue; moreover, affectionate gestures and words can afford mental comfort, solace, and consolation. The transition from comfort to pleasure is smooth: 'comfortable' was used as a synonym of 'pleasant, agreeable' and 'cheering, cheerful', and it is still described as 'a state of tranquil enjoyment' ('Comfortable'). To be comfortable means at the same time to need and be able to be comforted; a philosophy of comfort acknowledges the subject's vulnerability, yet its message is optimistic and includes the comforting Other. This twofold aspect of comfort—moderately agreeable and depending on the other's assistance—integrates the previous shades of well-being: trust and confidence, familiarity, and the alleviation of pain. At the same time, it opens up to pleasure and emphasizes the positive value of togetherness, understood as emotional nearness and intimacy.

The *pro* and *contra* discourses on pleasure are as old as philosophy itself. As the first section showed, the intellectualist alliance disapproved of merely sensory satisfaction, which determined Kant to distinguish between the gratifying agreeable and the disinterested liking of the beautiful (Kant, 1987). An interesting attempt to mediate between them was undertaken by Moritz Geiger. On one hand, he rejected the plain separation of art from life, given that all experiences obey the same psychological laws, but on the other hand, he differentiated between superficial effects, isolated occurrences of pleasure in common activities, and the depth effects of art. Surface effects (also called amusement, entertainment, delight, or enjoyment) are caused by sentimental songs, shows, or the consumption of delicacies. Art can be misused for the sake of narcissistic satisfaction, but real art can and should produce happiness, in which case pleasure is neither autotelic (like in the surface effects), nor incidental. Intense artistic emotions are only the

symptom and corollary of achieving the goal, which is understanding. As for happiness, this implies 'a total state of the self as a whole, […] arising from a state of serenity or one of exaltation' and a 'bliss' that 'includes the conditions of pleasure but which is not itself pleasure' (Geiger, 1986, 50). Happiness involves the person, conceived as the deeper level of the self, and surpasses somatic reactions to stimuli. Most importantly, Geiger neither considered pleasure in itself as reprehensible, nor criticized surface effects 'as inferior in themselves, but only as non-artistic or extra-artistic' (1986, 53). Therefore, the extension of the scope of aesthetics beyond art also prepares the integration of pleasure. A new conception of the subject, paired with a restructured system of moral values, enables the rehabilitation of sensory well-being without falling back into crude hedonism.

Happiness, once the central value in the eudemonistic ethics, tends to be replaced at present by the concepts of resonance (Rosa, 2016), life fulfilment, and the quality of life. This reconceptualization de-subjectifies happiness and allows for linking wellness with environmental perception, because the quality of life depends on two factors: fulfilling the human potential and monitoring the quality of external environments. First, if the subject is incarnate, the realization of its potential cannot exclude sensory well-being; sensory deprivation is not only emotionally frustrating but also produces impoverished forms of life and can cause health problems in the long run. Second, 'healthful living and working conditions safeguard human physical well-being' (Berleant, 2012, 113) and implicitly mental well-being. Although human fulfilment is, according to Arnold Berleant, irreducible to psychophysiological health, it is still conditioned by the liveability of physical (natural and built) and social environments. As living beings whose freedom means both the temporary *liberation from* needs and the positive *liberty to* engage with the world, humans are capable of transforming their inescapable being-in-the-world and being-with-others into existentially fulfilling togetherness and resonance that generate intense happiness. Only then do they live a humane life.

Conclusion

The tradition of mind–body dualism, a rationalistic epistemology and a religion that placed real life in transcendence after the end of history shaped altogether a history of Western philosophy and civilization that mostly condemned sensory pleasure. The disdain for the senses in general and for the 'lower' senses of touch, smell, and taste in particular had as consequences puritanism and a morality of duty, the repression of emotions and the obsession with self-control, the lower status of the professions that cared for sensory well-being, prohibitions regarding behaviour in public space and the topics of scientific discourse, as well as the terminological underdevelopment for the qualities of touch, smell, and taste. The intellectualist or phallogocentric alliance in science, philosophy, and theology banished entire sets of cultural practices into the realm of privacy and femininity and impoverished the field of art in its quest for aesthetic disinterestedness and purely aesthetic values.

A new anthropology of the incarnate living being and the enlargement of aesthetics beyond art throw new light on the relevance of tactility, olfaction, and taste for life. Well-being has developed from an emotional state derived from perception into the quality of a threefold environmental relation of the subject: to the own body, to society, and to the physical world. Accepting the body is a prerequisite for well-being and for a harmonious relation to others. Conviviality transcends practical communication and involves the pleasures of engaging physically with each other. Finally, being in the world does not necessarily have to be experienced as thrownness and alienation but can generate deep feelings of resonating or being one with the world as well. Physical, emotional, and existential well-being do not coincide, yet are entangled and coalescent. The understanding of the subject as bodily and of its identity as relational shifts the focus on the 'art' of shaping these relations and the aforementioned environments through various forms of aesthetic engagement. For this purpose it is necessary to distinguish between several kinds of well-being: the silence of the body (simply living, survival), physical and mental health (including processes of healing, regeneration, and resilience), comfort, and pleasure. Only on this basis can happiness and a fulfilled life be achieved. The solution is not to master bodies, society, and nature, but regulate their exchanges, not to replace ascetical self-discipline with uncritical consumption, but integrate all corporeal functions into a holistic self that is concerned with self-cultivation with the help, but not at the expense of the external, social, and physical environments in which it is immersed.

References

Anders, G. (1980). *Die Antiquiertheit des Menschen*, Bd. 2. *Über die Zerstörung des Lebens im Zeitalter der dritten industriellen Revolution*. C. H. Beck.

Anzieu, D. (2018). *The skin-ego*. Translated by Naomi Segal. Routledge.

Aristotle (1993). *De Anima*. Books II and III (with passages from Book I). Translated with introduction and notes by D. W. Hamlyn. Clarendon Press.

Bachelard, G. (1994). *The poetics of space*. Translated by M. Jolas. With a new Foreword by J. R. Stilgoe. Beacon Press.

Barker, J. M. (2009). *The tactile eye. Touch and the cinematic experience*. University of California Press.

Berenson, B. (1948). *Aesthetics and history*. Doubleday & Company.

Berleant, A. (2010). *Sensibility and sense. The aesthetic transformation of the human world*. Imprint Academic.

Berleant, A. (2012). *Aesthetics beyond the arts*. Ashgate.

Böhme, G. (2012). *Ich-Selbst. Über die Formation des Subjekts*. Fink.

Bourdieu, P. (1984). *Distinction. A social critique of the judgment of taste*. Translated by R. Nice. Harvard University Press.

Classen, C., Howes, D., & Synnott, A. (1994). *Aroma. The cultural history of smell*. Routledge.

'Comfortable'. Available from: www.etymonline.com/word/comfortable [last accessed 27 April 2023].

Descartes, R. (1912). *The philosophical works of Descartes*, Vol. I. Translated by E. S. Haldane & G. R. T. Ross. Cambridge University Press.

Diaconu, M. (2005). *Tasten, Riechen, Schmecken. Eine Ästhetik der anästhesierten Sinne.* Königshausen & Neumann.

Diaconu, M. (2006). Reflections on an aesthetics of touch, smell and taste. *Contemporary Aesthetics 4*. Available from: https://digitalcommons.risd.edu/liberalarts_contempaesthetics/vol4/iss1/8/ [last accessed 27 April 2023].

Diaconu, M. (2013). *Phänomenologie der Sinne.* Reclam.

Diaconu, M. (2021). Being and making the olfactory self: Lessons from contemporary artistic practices. In N. Di Stefano & M. Teresa Russo (Eds.), *Olfaction: An interdisciplinary perspective from philosophy to life sciences* (pp. 55–73). Springer.

Dufrenne, M. (1973). *The phenomenology of aesthetic experience.* Translated by E. S. Casey et al. Northwestern University Press.

Elias, N. (1997). *Über den Prozess der Zivilisation. Soziogenetische und psychogenetische Untersuchungen. Erster Band. Wandlungen des Verhaltens in den weltlichen Oberschichten des Abendlandes.* Suhrkamp.

Fletcher, C. (2005). Dystoposthesia: Emplacing environmental sensitivities'. In D. Howes (Ed.), *Empire of the senses: The sensual culture reader* (pp. 380–396). Berg.

Foucault, M. (1995). *Discipline and punish. The birth of the prison.* Translated by A. Sheridan. Vintage Books.

Geiger, M. (1986). *The significance of art. A phenomenological approach to aesthetics.* Edited and translated by K. Berger. Center for Advanced Research in Phenomenology & University Press of America.

Geoponika. Farm work. (2011). Translated by A. Dalby. Prospect Books.

Goeltzenleuchter, B. (2021). The olfactory counter-monument. Active smelling and the politics of wonder in the contemporary museum. In G. A. Lynn & D. Riley Parr (Eds.), *Olfactory art and the political in an age of resistance* (pp. 182–194). Routledge.

Grant, A. (1877). *Physiological aesthetics.* Henry S. King & Co.

Gschwandtner, C. M. (2019). *Welcoming finitude. Toward a phenomenology of orthodox liturgy.* Fordham University Press.

Guyau, M. (1904). *Les problèmes de l'esthétique contemporaine.* Félix Alcan.

Hall, E. T. (1966). *The hidden dimension.* Doubleday.

Harvey, S. A. (2006). *Scenting salvation. Ancient Christianity and the olfactory imagination.* University of California Press.

Hasse, J. (2014). *Was Räume mit uns machen – und wir mit ihnen. Kritische Phänomenologie des Raumes.* Alber.

Hegel, G. W. W. (1975). *Aesthetics. Lectures on fine art*, Vol. 1. Translated by T. M. Knox. Clarendon Press.

Henshaw, V., McLean, K., Medway, D., Perkins, C., & Warnaby, G. (2018). *Designing with smells. Practices, techniques and challenges.* Routledge.

Husserl, E. (1973). *Zur Phänomenologie der Intersubjektivität. Texte aus dem Nachlaß. Zweiter Teil: 1921–1928.* Husserliana XIV.2. Nijhoff.

Jellinek, P. (1994). *Die psychologischen Grundlagen der Parfümerie.* Edited by J. S. Jellinek. Hüthig.

Jütte, R. (2005). *A history of the senses. From antiquity to cyberspace.* Translated by J. Lynn. Polity Press.

Kant, I. (1987). *Critique of judgment. Including the first introduction.* Translated, with an Introduction, by W. S. Pluhar. With a Foreword by M. J. Gregor. Hackett Publishing Company.

Kant, I. (1996). *Anthropology from a pragmatic point of view*. Translated by V. L. Dowdell. Revised and edited by H. H. Rudnick. With an Introduction by Frederick P. Van De Pitte. Southern Illinois University Press.

Latour, B. (2017). *Facing Gaia. Eight lectures on the new climatic regime*. Translated by C. Porter. Polity.

Le Guérer, A. (2002). *Les Pouvoirs de l'odeur*. Odile Jacob.

Lévinas, E. (2001). *Totalité et Infini. Essai sur l'extériorité*. Kluwer Academic.

Locke, J. (1975). *An essay concerning human understanding*. Edited with a Foreword by P. H. Nidditch. Oxford University Press.

Louth, A. (2007). *The origins of the Christian mystical tradition. From Plato to Denys*. Oxford University Press.

Manoussakis, J. P. (2007). *God after metaphysics. A theological aesthetic*. Indiana University Press.

Merleau-Ponty, M. (1968). *The visible and the invisible. Followed by working notes*. Edited by C. Lefort. Translated by A. Lingis. Northern University Press.

Merleau-Ponty, M. (2012). *Phenomenology of perception*. Translated by D. A. Landes. Routledge.

Osborne, H. (1977). Odours and appreciations. *The British Journal of Aesthetics* 17(1), 37–48.

Philips, K. A., & Menard, W. (2011). Olfactory reference syndrome: Demographic and clinical features of imagined body odor. *General Hospital Psychiatry* 33, 398–406.

Plato. 1975. *Philebus*. Translated with notes and commentary by J. C. B. Gosling. Clarendon.

Reinarz, J. (2014). *Past scents: Historical perspectives on smell*. University of Illinois Press.

Riegl, A. (2004). *Historical grammar of the visual arts*. Zone Books.

Rosa, H. (2016). *Resonanz. Eine Soziologie der Weltbeziehung*. Suhrkamp.

Saito, Y. (2020). Aesthetics of care. In Z. Somhegyi & M. Ryynänen (Eds.), *Aesthetics of dialogue. Applying philosophy of art in a global world* (pp. 187–202). Peter Lang.

Saito, Y. (2017). *Aesthetics of the familiar: Everyday life and world-making*. Oxford University Press.

Scornaienchi, L. (2008). *Sarx und Soma bei Paulus. Der Mensch zwischen Destruktivität und Konstruktivität*. Vandenhoeck & Ruprecht.

Shiner, L. E. (2020). *Art scents: Exploring the aesthetics of smell and the olfactory arts*. Oxford University Press.

Shusterman, R. (2021). *Ars erotica. Sex and Somaesthetics in the classical arts of love*. Cambridge University Press.

Stenslund, A. (2015). A whiff of nothing: Presence of absent smells – Hospital. *The Senses and Society* 10(3), 341–360.

Tellenbach, H. (1968). *Geschmack und Atmosphäre. Medien menschlichen Elementarkontaktes*. Otto Müller.

Waldenfels, B. (2000). *Das leibliche Selbst. Vorlesungen zur Phänomenologie des Leibes*. Suhrkamp.

Wiesing, L. (2009). *Das Mich der Wahrnehmung. Eine Autopsie*. Suhrkamp.

CHAPTER 12

ON THE WELL-BEING OF AESTHETIC BEINGS

SHERRI IRVIN

Introduction

As aesthetic beings, we are receptive to and engaged with the sensuous phenomena of life while also knowing that we are targets of others' awareness: we are both aesthetic agents and aesthetic objects. Our psychological health, our standing within our communities, and our overall well-being can be profoundly affected by our aesthetic surroundings and by whether and how we receive aesthetic recognition from others. Being aware of and responsive to how others aesthetically experience us shapes our sense of self and our ability to function in a world with others who are also both agents and objects. Likewise, how we respond aesthetically to others shapes their sense of self and ability to function as, and in a world of, aesthetic beings. Our aesthetic interactions constitute a multitude of feedback loops in which we project our aesthetic values to and on the world and its objects and in which we too are subject to the projections of others. When our embodied selves and our cultural products are valued, and when we have rich opportunities for aesthetic experience and for the exercise of aesthetic agency, the aesthetic can foster and sustain well-being and help to make our lives worthwhile. But when we are subjected to aesthetic blight, restriction of our aesthetic agency, and aesthetic devaluing of our embodied selves and our communities' cultural products, the aesthetic can do great harm.

In this essay we will explore the notions of aesthetic objects and aesthetic agents, their relations with each other, and the unique affordances of persons' status as simultaneously aesthetic objects and aesthetic agents. We will explore the prospects for bodily aesthetic experience to promote well-being and, at the end, consider how the aesthetic might play a role in establishing forms of mutual vulnerability and recognition to combat oppressive social hierarchies.

Aesthetic Objects

To be an aesthetic object is to be an object of experience. We may have aesthetic experiences of enjoying or taking an interest in the form of an object—a sculpture, a house, a canyon—or in the unfolding of an event, as when the wind continually rearranges the configuration of leaves and branches seen through a window. Aesthetic experience often focuses on the sensory qualities of a thing, but examples from literature, mathematics, and conceptual art recommend the view that ideas and concepts, too, can be objects of aesthetic experience (Dutilh Novaes, 2019; Schellekens, 2007). Aesthetic objects enliven our experience by imparting colour, flavour, and texture, whether literal or metaphorical. An aesthetic object may be in the foreground or the background of our experience: the environment that surrounds us both contains aesthetic objects and is itself an aesthetic object, even if it does not stand out to us at every moment (Carlson, 1979). The aesthetic thus plays a crucial and comprehensive role in shaping how we experience our lives and is a key contributor to well-being (Irvin, 2008b).

An aesthetic object is a potential target of appreciation that identifies the object's aesthetic properties and assigns it aesthetic value. Appreciation, in this context, does not imply enjoyment or positive assessment: aesthetic appreciation may involve detecting the ugliness of something, finding it unpleasant, and judging it to have negative aesthetic value. Aesthetic appreciation may focus primarily on perceptual or structural features or may also involve knowledge of features such as the object's functions (Parsons & Carlson, 2008). When it eventuates in aesthetic judgement that makes a claim to intersubjective validity, aesthetic appreciation typically involves comparison of the object to others in a relevant category (Walton, 1970). Responses to aesthetic objects often carry positive or negative affective valence, even if subtle. But aesthetic appreciation can take the form of exploring an object's aesthetic features without aiming to issue a judgement and while suspending confidence in one's experience of their valence (Irvin, 2017).

There are community practices of aesthetic appreciation and community norms for what counts as aesthetically valuable. For this reason, communities often converge in their judgements that certain objects are highly valuable while others are aesthetically blighted. As in many domains, community members with more social and political power and capital have outsized influence on norms of aesthetic appreciation and valuing. Where communities are arranged hierarchically, aesthetically valued objects tend to be those associated with dominant or empowered cultures and identities. The objects valued by disempowered communities are sometimes disvalued as kitsch or acknowledged as merely agreeable or pleasant rather than truly beautiful, to use the Kantian distinction (Kant, 1790/1987). Where an aesthetic object deviates from cultural norms, if it is associated with an empowered person or community it is more likely to be acknowledged as a creative innovation, whereas if it is associated with a disempowered person or community it is more likely to be dismissed as aesthetically inferior and explained as the product of inadequate resources or unsound aesthetic judgement.[1]

More broadly, the value of an aesthetic object is not merely its value as a perceptual object considered in isolation. In our everyday lives, aesthetic objects are positioned and perceived in relation to other things and to aesthetic agents and users, and the value we recognize in them may be deeply influenced by context. Which sensory appearances are most relevant to aesthetic assessment may depend on what the object is most used for: aesthetic assessment of a casserole served for family dinner may be tied more to olfactory and gustatory than to visual properties, while aesthetic assessment of a knife may be tied to tactile properties and effectiveness at performing its function. Aesthetic assessment of a garden plant may be connected to how it fits into a broader environment and contributes to an overall effect.

Assessments of aesthetic value shape how an aesthetic object receives uptake within the community. Objects judged to have higher aesthetic value are esteemed, collected, displayed, and protected. People are drawn to these objects and wish to engage with them and spend time in their presence. Objects judged to have less aesthetic value are not esteemed and are often targeted for revision, removal, or at least concealment. Empowered communities tend to have greater ability to enforce the modification or removal of objects they aesthetically devalue; communities with less economic and political power are more likely to be stuck with aesthetically blighted objects in their environments, and the presence of such objects may serve as a constant reminder that the social and political standing of one's community is compromised.

As we will explore below, aesthetic objects may be not merely appreciated but shaped by aesthetic agents. An aesthetic object may be created by an aesthetic agent, or modified or recontextualized in a way that alters its aesthetic value. When agents make aesthetic judgements about objects that they have rights over (or, sometimes, even in the absence of such rights), they may take action that brings an object or environment into line with their aesthetic assessment, producing what they take to be greater aesthetic value.

These observations have multifaceted implications for well-being. First, our well-being is affected by the aesthetic value of the objects in our environment. Access to aesthetically interesting and valuable objects and environments may greatly enhance quality of life. Being surrounded by aesthetically disvalued objects, on the other hand, is unpleasant and has adverse consequences for both mental and physical health. Moreover, insofar as a community's relegation to an aesthetically blighted environment signals disempowered social status, it may be one of the mechanisms for the adverse effects of racism and other forms of social marginalization on well-being (Garvin et al., 2013).

Second, as we will explore in greater detail below, we ourselves, by virtue of our physical and behavioural presence in the world, are aesthetic objects continually targeted for aesthetic assessment by others. Whether others value our bodies aesthetically affects our access to a wide variety of goods: social and romantic relationships, employment, health care, fair treatment in the criminal justice system, as well as general kindness and respect for our human dignity (Irvin, 2017). Bodies that are aesthetically valued, and the people whose bodies they are, tend to be prized and protected; those whose bodies are aesthetically disvalued are also socially marginalized and excluded, subject to abuse,

and sometimes violently attacked (Frazier, 2023a; Siebers, 2010). Our status as aesthetic objects, then, has pervasive effects on our well-being across many domains.

Aesthetic Agents

To be an aesthetic agent is to be capable of experiencing aesthetic objects and taking various sorts of actions in relation to them. Aesthetic agency encompasses at least three kinds of engagement with aesthetic objects: engagement that constitutes the agent's own aesthetic experiences, engagement that affects the existence or nature of the aesthetic object, and engagement that shapes the aesthetic experiences and values of other aesthetic agents. Let us consider these in turn.

As an aesthetic agent, I am capable of aesthetically experiencing and responding to aesthetic objects, whether in art or in everyday life. I may have an experience of bliss in response to a great work of opera, an experience of disgust in relation to a scene in a horror film, or an experience of pleasure and comfort when settling on the couch in a cozily furnished domestic interior. My experiences of these objects are complex, with cognitive, emotional, and somatic components: the opera's clever interplay of score and libretto may engage my intellect; the horror movie may cause my body to tense and shudder; and settling on the couch may ease my stress and inculcate a sense of calm. To the extent that I have the time and resources to do so, I am likely to select aesthetic objects to produce the kinds of experiences I desire in a given moment. I watch a horror movie when I welcome and feel prepared to handle the intense somatic and emotional responses I know will ensue; I seek out the couch when I long for gentleness and ease, perhaps to temper the effects of the horror movie. As John Dewey notes, our choices to seek out particular aesthetic stimuli are on a continuum with the behaviours of animals, who monitor their internal states and seek inputs that will rectify any unease and produce a more satisfying state of being (Dewey, 1934/1980). I can also choose to attend to the qualities of an object that are more satisfying while ignoring those I find less appealing or interesting (Irvin, 2008a).

My experience of aesthetic objects may involve judging their quality: I may judge objects to be of high quality if they consistently produce satisfying experiences in me, or I may be influenced by cultural factors to assign high value to aesthetic objects that satisfy communal norms regardless of whether I enjoy them. Where my preferences diverge from communal norms, I may feel ambivalent about the aesthetic objects that give me pleasure, adding a tinge of guilt or shame to experiences I otherwise enjoy. For those who belong to a disempowered cultural group whose aesthetic products are disvalued, this disvaluing may play an important role in stigmatizing the group and leaving its members feeling a persistent unease, since their very enjoyment of their own cultural products is treated as a sign of inferior judgement.

Not surprisingly, the effect that aesthetic objects have on my own and others' experience may lead me to take actions that affect those objects' nature or very existence. I may

choose to create new aesthetic objects, to modify or rearrange existing objects to create new aesthetic effects, and to preserve the aesthetic objects I value while allowing others to deteriorate. My choices in this domain have both aesthetic and ethical significance, since they may profoundly affect the experiences of others. The kinds of representations that are available affect what we are able to imagine and to what extent we can empathize with or understand others' cognitive and emotional states (Nussbaum, 1990). They also affect how we cognize members of a group, particularly when that group is socially disempowered: representations can reinforce stereotypes and reductive tropes about a group or open up new ways of seeing and valuing its members (Collins, 2000; Eaton, 2016; Frazier, 2023b; Siebers, 2010; Taylor, 2016).

Even without taking actions that affect the existence or nature of aesthetic objects, I can shape the experiences of others through my choices about which representations to distribute or share and by engaging in critical discourse. If I commend an aesthetic object to others, this may cause them to engage with, value, and preserve it. We often give special attention to aesthetic objects that we know to be valued by our community or by people with whom we have relationships of trust and care. Through discourse, I can shape others' encounter with an aesthetic object, drawing their attention to features they might otherwise have overlooked or highlighting relationships to other artworks or allusions to non-art content. I might thereby cause them to have a more satisfying aesthetic encounter and to value the object more highly, or by drawing attention to negative features I might diminish their enjoyment of and care for the object.

In addition to shaping each other's experiences of particular objects, aesthetic agents shape each other's aesthetic tastes and tendencies. The cultural norms associated with aesthetic appreciation are taught: children learn what is pretty and what is ugly and learn to cultivate pleasure in the experience of pretty things and displeasure in the experience of ugly things.[2] We engage in forms of discipline designed to incentivize the production and maintenance of aesthetically valuable objects and the elimination or concealment of aesthetically disvalued objects. Whoever is judged responsible for an aesthetically disvalued object may receive criticism, penalties, harassment, and threats designed to induce negative affect and motivate action to remove the (purported) aesthetic stain on others' experience. Legal and quasi-legal structures enforce these norms: local statutes and homeowners' association rules maintain aesthetic standards related to landscaping, laundry, and home renovations, while employment rules and dress codes maintain aesthetic standards related to clothing and hairstyles. A sense that one is in compliance with community aesthetic norms regarding one's person, one's domestic environment, and one's possessions may produce well-being, while a sense of being out of compliance may produce shame and distress in addition to whatever discipline one is subjected to. Discipline regarding the aesthetic qualities of bodies is particularly acute. The mere public presence of people deemed unsightly, often due to disability or poverty, has been criminalized in some contexts.[3] As Tobin Siebers notes, when a person's body is disvalued they may be subject to 'aesthetic disqualification': 'a symbolic process [that] removes individuals from the ranks of quality human beings, putting them at risk of unequal treatment, bodily harm, and death' (Siebers, 2010, 23).

Aesthetic agents have the capacity to engage collectively in social aesthetic projects which may be either oppressive or liberatory. When an empowered group disvalues the aesthetic products of a disenfranchised group, they may undermine or drive underground the group's ability to produce and enjoy their own cultural products, and thereby to sustain and celebrate their collective identity. But aesthetic agents may also resist oppression through aesthetic mechanisms. Members of disempowered groups may express dissent or assert political belonging or ownership through aesthetic interventions like street art or the destruction of sculptural monuments, and members of empowered groups may engage in allyship (Fried, 2019). Generally speaking, collective aesthetic projects can either reinforce or resist broader social and aesthetic norms. This will be explored further below.

Aesthetic Objects and Well-Being

As aesthetic agents, we are susceptible to both subtle and intense effects of aesthetic objects on the quality of our experience and thus on our well-being. We may experience exquisite pleasures from beautiful or sublime objects, or everyday pleasures and a sense of comfort from tasty food, interesting clothing, or a warm cup of coffee in a mug that perfectly fits our hand. The aesthetic features of our environment, such as quality of light, textures, or the sound of wind or running water, may affect the tenor of our experience and improve or diminish our well-being in ways we do not consciously notice. Empirical research supports the idea that the aesthetic qualities of our environment have a significant impact on our well-being (Sternberg, 2009). The results related to nature and green space are particularly robust: people who spend at least two hours per week in natural environments experience gains in physical and mental well-being including reduced stress and anxiety, improvement of immune functioning and mood, and reduced risk of aggression and attention deficit disorder (White et al., 2019). People who live in rural, suburban, or urban areas rated as more scenic report better levels of health, controlling for socioeconomic factors (Seresinhe et al., 2015).[4] A simple view of green space through a window has been found to reduce both the length of hospital stay and the need for pain medication, and green space in one's neighbourhood is linked to life expectancy (Kuo, 2015; Ulrich, 1984).[5] Spending time in nature also appears to have cognitive benefits by virtue of shifting how we pay attention to our surroundings or enhancing our working memory (Bratman et al., 2015; Kaplan & Kaplan, 1989). Some health-care providers have even taken to 'prescribing' time spent in nature as part of medical care (Robbins, 2020).

Aesthetic objects trigger emotional and somatic responses, sometimes through learned cultural associations. At times, this may happen even when our direct attention to the aesthetic object is limited or absent (Berridge & Winkielman, 2003). Music, for instance, can make us feel cheerful, create a somber mood, or cause us to feel anxious or on edge, capacities often drawn upon by filmmakers (Cohen, 2010). Music can

also trigger distinctively pleasurable emotional states of 'being moved' and 'aesthetic awe' (Konečni, 2008). Research demonstrates that we manifest physiological signs of emotion, such as facial muscle activation and skin conductance, when we listen to music, and that different forms of music have different effects: music usually described as 'happy', compared to music described as 'sad', activates both self-reported happiness and physiological signs associated with happiness (Lundqvist et al., 2009). Some of the emotional and aesthetic effects of aesthetic objects are mediated by somatic response: when we see dancers in motion or regard a sculpture of a human form, we may experience subthreshold muscular activation that simulates what we see, leading us to attribute aesthetic qualities to the object (Freedberg & Gallese, 2007; Montero, 2006).

Aesthetic objects may be used to form a sense of intimacy and cohesiveness among a group of people, such that being exposed to those objects creates a sense of belonging, community, and home (Nguyen & Strohl, 2019). When aesthetic objects that are culturally specific to us are included and even celebrated in different or broader cultural contexts, this conveys respect for the worth and humanity of our community and for us as members of that community. Due to cultural associations, the same object may signal belonging, comfort, and home to one person while standing out as surprising and unique to another.

While they are sometimes a source of belonging and comfort, in other situations aesthetic objects can induce moderately or intensely negative experiences. Katya Mandoki refers to 'aesthetic abuse' (2007, 42) and 'aesthetic poisoning' (2007, 38), while Arnold Berleant (2010, 155) notes that aesthetic objects may be 'unsatisfying, painful, perverse, or even destructive'. For these reasons, Yuriko Saito (2017), even in advocating that we recognize positive aesthetic value in imperfection in many cases, urges us to maintain our negative evaluation of imperfections that cause or indicate the suffering of disempowered groups of people. Notoriously, negative aesthetic experiences can be used to punish: hard surfaces, loud noises, bright lights, rough textures, and untasty food are staples of carceral spaces such as prisons and death camps. As Mandoki (2007, 38) notes, 'Cruelty is not only a moral category but an aesthetic one: it always targets sensibility.'

How aesthetic objects affect us depends on many aspects of background and context. The same aesthetic stimuli that may be sought out and enjoyed in some contexts are used to enact punitive social control, as when classical music is used as an anti-loitering tactic or when the United States Central Intelligence Agency used music to torture detainees at Guantánamo Bay (McKinney, 2014). The ability to control our experience and exercise agency may play a crucial role in whether exposure to an aesthetic object is experienced as desirable, neutral, or painful, especially when the object impinges strongly on our senses.

Because we are aesthetic agents, we have the capacity to make choices that moderate the effects of aesthetic objects on our well-being. We may be able to enhance the aesthetic quality of an environment or leave an unpleasant one; and we may be able to change what we focus on, or even cultivate different tastes, so as to have more positive aesthetic experiences of an aesthetic object or environment (Eaton, 2016; Irvin,

2017; Lintott & Irvin, 2016). Our ability to exercise these choices depends on sufficient resources including money, time, energy, and social power. Socially or economically disempowered people are more likely to have aesthetically blighted objects in their environments and may have less control over whether and when they experience particular aesthetic stimuli, resulting in adverse effects on well-being. Shifts in focus or modifications in taste may not be viable or desirable ways of coping with aesthetic blight: people experiencing aesthetic blight due to socioeconomic disempowerment are more likely to experience stress-related cognitive demands that would make it difficult for them to shift how they respond to aesthetically devalued objects, even if such a shift were possible (Mani et al., 2013). Moreover, it is a societal responsibility to alleviate blight that affects disempowered communities, not the responsibility of these communities to dampen its effects on them.

What It Means to Be Both Aesthetic Agent and Aesthetic Object

As aesthetic agents, we are affected by aesthetic objects and have the capacity to make aesthetic choices that contribute positively to our well-being. But our status as simultaneously aesthetic agents and aesthetic objects has its own affordances and challenges related to well-being. First, I am an aesthetic object for myself: I can aesthetically assess and appreciate my own appearance and embodiment. This relationship has the potential to produce deeply pleasurable and satisfying experiences, since bodies are aesthetically rich and complex objects with fascinating formal structures, movement potential, and functionality (Irvin, 2017). But our ability to appreciate the positive affordances of our own bodies is complicated—and sometimes thoroughly undermined—by social processes. Because public aesthetic norms for how bodies should look, move, and be adorned, and public practices of disciplining people to comply with these norms, are so pervasive, the aesthetic lens through which we see our own bodies is typically profoundly influenced by community standards and practices. Some of us—especially women, people of colour, and fat, disabled, queer, or gender non-conforming people—are more likely to be socially identified with or reduced to our bodies, and are disproportionately subjected to aesthetic discipline related to our bodily appearances (see, e.g., Bartky, 1990; Frazier, 2023a; Hobson, 2018; Kozak, 2021; Siebers, 2010). The compound effects of occupying more than one of these identities are complex and make one even more susceptible to adverse consequences for well-being. Even those not occupying disempowered social identities may experience a strong identification of themselves and their value with their bodily appearance. For these reasons, we are likely to be acutely aware of how other aesthetic agents are viewing us as aesthetic objects. For members of disempowered groups especially, it may be impossible to form a bodily self-conception that is independent of disciplinary gazes targeted at the body. Frantz Fanon's (1967)

Black Skin, White Masks, in particular the chapter 'The Fact of Blackness', is an essential study of the transformative experience of realizing one is a racialized aesthetic object in the eyes of others. As Sachi Sekimoto and Christopher Brown (2020, 2) succinctly put it, 'race functions as a visual economy of difference in which visible phenotypes are coded into hierarchical social relations'.

The regime of aesthetic discipline around bodily appearance, especially for socially disempowered groups, can generate constant hypervigilance related both to our bodily appearance itself and to signs that someone else has noticed our appearance and is preparing to discipline us for it. We may experience a perpetual undercurrent of anticipatory shame, guilt, and dread, since our bodies always have the potential to go awry: advertising and media keep us constantly on alert for ways that our skin, hair, weight, and other bodily features might manifest sudden unruliness. And since bodily aesthetic value is defined partly in terms of youth, especially for women and femmes, the body's aesthetic deterioration is relentless. Even compliments on appearance may be double-edged, especially in contexts where our achievements should be central: they help to maintain the scheme of aesthetic discipline by reinforcing the idea that our appearance as aesthetic objects for others is the most important thing about us.

This situation produces, as Bartky describes it, 'an estrangement from [one's] bodily being: On the one hand, she *is* it and is scarcely allowed to be anything else; on the other hand, she must exist perpetually at a distance from her physical self, fixed at this distance in a permanent posture of disapproval' (1990, 40). Such estrangement may obtain for people of any gender who manifest one or more socially disempowered identities. The 'pervasive feeling of bodily deficiency' produced by aesthetic discipline (1990, 81) often yields to 'a pervasive sense of personal inadequacy' (1990, 85) extending beyond the bodily realm, especially given the tendency to reduce socially disempowered people to their bodies. Undermining human worth is a central consequence of oppressive aesthetic disciplinary schemes: as noted earlier, 'aesthetic disqualification', as Siebers (2010) describes it, makes people eligible for forms of adverse treatment including violence. Because people subjected to ubiquitous forms of bodily aesthetic discipline often internalize the relevant aesthetic standards and participate openly in practices that reinforce them, the harms of constant aesthetic self-surveillance are concealed or, if acknowledged, blamed on those on whom they are inflicted: it is their own fault for choosing to prioritize the supposedly trivial matter of bodily appearance (Bartky, 1990).

In addition to undermining the pleasure one might take in one's own embodiment and positioning people for disqualification, aesthetic disciplinary schemes that target disempowered groups play a powerful role in distorting the lens through which one is seen both by oneself and by others (Collins, 2000; Hobson, 2018; Taylor, 2016). George Yancy (2008) describes this, in contexts of anti-Blackness, as the 'confiscation' of the Black body by the white gaze. But these distortions are not totalizing: and recognition of the gap between how one is culturally represented and how one understands oneself can be the foundation for resistance (hooks, 1992). Our status as aesthetic agents rather than mere objects creates the potential for practices that push back against aesthetic inferiorization, distortion, and disqualification.

Some calls for resistance take the form of admonitions to develop bodily self-love even in the face of oppressive social forces. But bearing in mind Bartky's (1990, 55) cautionary note about the 'failure of a politics of personal transformation', aesthetic agents may also engage in collective and coalitional forms of resistance. bell hooks (1992) discusses the development of the 'oppositional gaze' as a collective project of Black women, noting that 'Even in the worst circumstances of domination, the ability to manipulate one's gaze in the face of structures of domination that would contain it, opens up the possibility of agency' (1992, 116). hooks argues that once such agency is claimed, interrogating and deconstructing oppressive images can be an aesthetic pleasure for Black women (1992, 126). Rosemarie Garland-Thomson (2009), too, argues for the importance of the gaze as a form of resistance: both looking and being looked at are central elements of human experience, and people who attract the stares of others due to their unusual embodiment can exercise agency through their gazes and other choices about how to respond. She describes the photographic project of Kevin Connolly, who was born without legs and navigates on a skateboard: he has taken thousands of pictures all over the world of people staring at him, a project that re-establishes his role as aesthetic agent against the reduction to object status that is threatened by the pervasive stares of others (Garland-Thomson, 2009, 89ff).

The creation of new cultural products that better represent disempowered social groups can make a great contribution to individual and collective well-being, both by facilitating more positive self-conceptions for individuals and by reshaping cultural perceptions and treatment. Janell Hobson (2018) discusses the crucial need for Black women to gain control of the means of cultural production and distribution so that they can create and circulate aesthetic products that push back against distorted and truncated representations that remain culturally prevalent. She notes the success of Carrie Mae Weems, Kara Walker, and Beyoncé in exposing and correcting cultural distortions targeting Black women (cf. Davidson's 2016 discussion of Walker). Cheryl Frazier (2023b) argues for the importance of better practices of representing fatness to eliminate the reductive and harmful tropes that reinforce stereotypes and mistreatment. Anna Malinowska (2018) reflects on the many pitfalls that must be avoided in representing disability, especially in contexts of sexuality: narratives of pity and of triumphant overcoming are both harmful, as are those that, in an attempt to restore a sense of normalcy, erase the distinctive embodiment, experiences, and needs of disabled people. Even those not involved in the creation of new cultural products can engage in individual or collective projects that enhance well-being by consuming representations that upend harmful tropes and expanding our ability to appreciate and enjoy non-normative bodily appearance (Eaton, 2016; Irvin, 2017; Lintott & Irvin, 2016).

Creativity in embodied self-presentation is another way for communities to engage their agency in resisting harmful aesthetic norms and practices. Queer communities often develop and celebrate forms of aesthetic appearance and expression that subvert mainstream expectations.[6] Shirley Anne Tate discusses Black women creatively appropriating white fashions—and, in a continuous loop, remixing white appropriations of Black fashions—to create a 'Black beauty cut-and-mix' that asserts their belonging in

the realm of beauty from which they have historically been excluded (2009, 32). Frazier (2023a) argues that beauty labour, when performed with an at least nascent awareness of harmful norms and intention to resist them, is a way for fat people to reclaim aesthetic space and resist practices that treat them as unworthy of being seen.

Aesthetic Agency and Bodily Experience

As we have discussed, our embodiment makes us an aesthetic object both for ourselves and for other aesthetic agents: we evaluate each other's bodies aesthetically in ways that may be either affirming or harmful, especially given the entanglement of aesthetic practices with social hierarchies. But our embodiment also contributes to a second sense in which we are simultaneously aesthetic agents and aesthetic objects: we have access to our own felt bodily experience, which may be a rich wellspring of aesthetic encounters. Because bodily experience can be explored in private, away from disciplinary gazes, attending to such experience is a way of connecting with one's own body (and occasionally the bodies of others) that is less subject to, though not exempt from, the mechanisms of social hierarchy.

Barbara Montero (2006) argues that proprioceptive experiences can be aesthetic: one can feel the grace of one's own movements, and through forms of neurophysiological mirroring that are triggered by seeing someone else move, one can even have proprioceptive aesthetic experiences of the movements of others. This raises the prospect of aesthetic agency that enhances well-being through movement that is intended only to be felt: one can move with the intention of producing aesthetically satisfying bodily experiences for oneself, regardless of how the movement looks. Moreover, those who experience pain, or disability that impedes control over their movement, need not be condemned to negative bodily aesthetic experiences: attending directly to our bodily experience and suspending judgement can sometimes shift its valence or open our awareness to positive aesthetic qualities associated with its complex and ever-changing structure (Irvin, 2008a).

Madeline Martin-Seaver (2019) argues that aesthetic attention to one's bodily experience, as felt from the inside, can support resistance to oppressive objectification. An aesthetics of the body that relies principally on visual appearances, which is the kind of bodily aesthetics that we are socially encouraged to adopt and that is most theorized, leaves us vulnerable to the forces of aesthetic discipline described earlier. Attending more to what it feels like to exist and move in the world as an embodied being allows us to cultivate aesthetic satisfactions that do not rely on external standards and conventions and a sense of aesthetic agency that resists the reduction to objecthood.

Attention to the tactile, rather than merely visual, qualities of bodies may be another strategy for aesthetic well-being. Because discourse about what we 'should' feel in tactile

or haptic encounters is less developed than discourse about norms for visual appearance, bodies that tend to be aesthetically disqualified based on their visual features may nonetheless be sources of great aesthetic pleasure when other senses are deployed. Tactile experience of the textures and contours of a body, one's own or someone else's—as when giving a massage or having a sexual encounter—may allow one to have free-flowing aesthetic experiences of exploration, enjoyment, and surprise that are less tied to normative expectations about what bodies should be like.

The aesthetics of the tactile and proprioceptive realm has received far less theoretical attention than the aesthetics of the visual and auditory; touch is often treated, along with smell and taste, as a 'lower sense' that can give rise only to crude pleasures. While the aesthetics of taste and smell have received sophisticated critical defenses (Korsmeyer, 1999 and Shiner, 2020, respectively), experiences of touch continue to be dismissed as mere pleasures or displeasures that are too simplistic to rise to the level of the aesthetic. However, recent discussions of the aesthetics of touch by Tom Roberts (2022) and of the neuroscience of touch as deployed in aesthetic contexts by neuroscientists Alberto Gallace and Charles Spence (Etzi et al., 2014; Gallace & Spence, 2014a; Gallace & Spence, 2014b; Spence & Gallace, 2020), as well as Rachel Zuckert's (2009, 2019) examination of the role of touch in Johann Gottfried Herder's eighteenth-century aesthetics of sculpture, suggest that the tactile may be ripe for broader recognition as a realm of aesthetic experience.

Regardless of whether we count it aesthetic or not, touch plays a tremendous role in well-being (Gallace & Spence, 2010). Constructing satisfying tactile and haptic experiences for ourselves is a form of aesthetic agency that deploys our body, the most readily available aesthetic object. While any physical activity can be pursued with attention to the aesthetic affordances of bodily experience, the construction of satisfying tactile experiences is particularly central to the realm of sexuality. Here as in other domains, oppressive social norms intrude on aesthetic agency: normative sexuality is expected to prioritize penetrative heterosexual activity culminating in a male orgasm, and alternative sexualities explored by queer and disabled people, as well as others who choose to ignore this narrow script, are dismissed as deviant or treated with objectifying fascination. People of colour of all genders, and women who choose to pursue sexual agency, have often been subject to social control that targets them as sexually pathological. The pervasive stigma surrounding sexual exploration may explain why 'philosophers tend to insistently exclude [sexuality] from aesthetic experience' (Shusterman, 2006, 218).

The sexual and sensual realms offer rich opportunities to explore the complexities of bodily experience, and aesthetic agency that deploys the body as a source of sensual pleasure and cultivates awareness of the nuances of experience has great promise in contributing to well-being. To fully realize this potential, we will need to unlearn societal messages that the sensory affordances of our bodies are beneath serious attention and that we are bad or wrong for exploring them. We may also need to orient our sexual exploration less toward specific acts and outcomes and more toward immersive attention to sensory experience.

Aesthetics, Well-Being, and Mutual Vulnerability

The aesthetic realm has rich promise for physical and psychological well-being. We can engage in aesthetic agency to seek out and create aesthetic objects, environments, and experiences that enhance quality of life for ourselves and others. But forces of political hierarchy and social control disrupt aesthetic well-being in a variety of ways: by inhibiting the exercise of aesthetic agency by disempowered people, subjecting them to higher levels of aesthetic blight, and devaluing their cultural products; by channelling agency in ways that limit the prospects for aesthetic enjoyment; and by undermining the ability to recognize the positive aesthetic affordances of one's own and others' bodies. To enhance well-being, aesthetic agency must be deployed not only in pursuit of certain kinds of aesthetic objects and experiences, but also in collective projects of reconstructing both aesthetic norms and the practices of appreciation that underpin and sustain them.

Because the aesthetic implicates cognitive, emotional, and somatic responses, aesthetic reconstruction and revision is deep and important work to promote well-being. Monique Roelofs (2014, 52) notes that the aesthetic has 'a prominent role in enabling survival, sustenance, community, meaning, critique, pleasure and creativity in the face of racial, gender, and economic oppression', even as it has been instrumental in constituting that oppression. Mariana Ortega (2016, n.p.) remarks, elaborating on Roelofs' point, that 'the aesthetic is intertwined with various modes of living informed by a vast web of relationships of being-in-the-world that ultimately make our life and our world livable, enjoyable, and pleasurable or miserable, painful, and deadly'.

Due to our dual status as aesthetic agents and aesthetic objects, we have a profound mutual vulnerability: we have the capacity to exercise care by aesthetically treasuring each other and the capacity to harm or destroy through aesthetic disqualification. Because of the formative role that the gaze of others plays in one's own sense of self, it can fairly be said that we co-constitute each other's selfhood through aesthetic engagement. Nicholas Whittaker argues, in this regard, that the very conceptual division between agent (or subject) and object is harmful and promulgates anti-Blackness and other forms of oppression. Whittaker describes, after artist and philosopher Adrian Piper, 'the catalytic aesthetic', which 'creates or depends on a sense of the self's basic being as intertwined with that of … the "object" of perception so as to be relevantly indistinct' (2021, 458). We should, Whittaker suggests, cultivate a recognition that our 'ownmost being' is deeply interpenetrated with the being of others, not separable. Elsewhere, Whittaker calls into question the view that there is a right to be left alone and aesthetically unaffected: 'This is a logic that insists on the necessity and desirability *of*

policing the sensuous being of others: their sound, their smell, their flesh' (2022, n.p.; emphasis in original).

Whittaker's suggestion recalls George Yancy's proposal for an aesthetic project of 'un-suturing': rather than keeping our selves tightly knit and impenetrable, shoring up our independence, distinctness, and agency against others whom we construe as aesthetic objects and (as in the case of anti-Blackness) potentially as threats, we must un-suture ourselves to acknowledge and welcome our mutual vulnerability, recognition, and responsibility for care. 'As an aesthetic gesture/site,' Yancy says, 'un-suturing is a form of exposure, an opening, a corporeal style and a dispositional sensibility that troubles the insularity of whiteness, that troubles and overwhelms the senses, revealing our somatic porosity and instigating instability, that sense of being thrown off balance, off center, and exposing different (and counter-hegemonic) ways of being attuned to our intercorporeal existence, our mutual touching' (2016, 259).

Far from a trivial or decorative matter to be addressed once more 'basic' needs are met, the aesthetic gets to the heart of what we experience and how we engage with one another. Attending to the aesthetic in our design of institutions, the built environment, and social relationships, and providing opportunities for the development and exercise of aesthetic agency, are strategies with great promise to enhance well-being.

Acknowledgements

I am grateful to Sheila Lintott for discussion and collaboration that significantly shaped my approach to this topic, and to Yuriko Saito for careful editing and helpful suggestions.

Notes

1. In *The Cultural Promise of the Aesthetic* (2014), Monique Roelofs offers a detailed study of the way in which the aesthetic constitutes and reinforces sociopolitical hierarchies including those of race, gender, and class.
2. This is not to deny that we are naturally disposed to find some kinds of stimuli pleasant and others unpleasant: babies, for instance, manifest more attention to some visual arrays than others. But cultural aesthetic norms extend far beyond our natural response tendencies and may even recommend their modification or suppression, as when we learn to take pleasure in the bitterness of coffee, the astringency of whisky, or the dissonance in a passage of music.
3. In her survey of so-called ugly laws, Susan Schweik (2009) notes that laws prohibiting the public presence of unsightly bodies were enforced up to the 1970s in the United States.
4. As Seresinhe et al. (2015) note, self-reported health is a meaningful measure, since it is strongly inversely correlated with subsequent mortality.
5. See Hamilton (2016) for a discussion of results complicating Ulrich's (1984) analysis.
6. Jack Halberstam has explored queer and trans aesthetics in a series of works, most recently *Wild Things: The Disorder of Desire* (2020).

References

Bartky, S. (1990). *Femininity and domination: Studies in the phenomenology of oppression*. Routledge.
Berleant, A. (2010). *Sensibility and sense: The aesthetic transformation of the human world*. Imprint Academic.
Berridge, K., & Winkielman, P. (2003). What is an unconscious emotion? (The case for unconscious 'liking'). *Cognition and Emotion 17*(2), 181–211.
Bratman, G. N., Daily, G. C., Levy, B. J., & Gross, J. J. (2015). The benefits of nature experience: Improved affect and cognition. *Landscape and Urban Planning 138*, 41–50.
Carlson, A. (1979). Appreciation and the natural environment. *Journal of Aesthetics and Art Criticism 37*(3), 267–275.
Cohen, A. J. (2010). Music as a source of emotion in film. In P. N. Juslin & J. A. Sloboda (Eds.), *Handbook of music and emotion: Theory, research, applications* (pp. 879–908). Oxford University Press.
Collins, P. H. (2000). *Black feminist thought: Knowledge, consciousness, and the politics of empowerment*, second edition. Routledge.
Davidson, M. d. G. (2016). Black silhouettes on white walls: Kara Walker's magic lantern. In S. Irvin (Ed.), *Body aesthetics* (pp. 15–36). Oxford University Press.
Dewey, J. (1980). *Art as experience*. Perigee. Originally published in 1934.
Dutilh Novaes, C. (2019). The beauty (?) of mathematical proofs. In A. Aberdein & M. Inglis (Eds.), *Advances in experimental philosophy of logic and mathematics* (pp. 63–94). Bloomsbury.
Eaton, A. W. (2016). Taste in bodies and fat oppression. In S. Irvin (Ed.), *Body aesthetics* (37–59). Oxford University Press.
Etzi, R., Spence, C., & Gallace, A. (2014). Textures that we like to touch: An experimental study of aesthetic preferences for tactile stimuli. *Consciousness and Cognition 29*, 178–188.
Fanon, F. (1967). *Black skin, White masks*, translated by Charles Lam Markmann. Grove Press. Originally published in French as *Peau noire, masques blancs*, 1952, Paris, Éditions du Seuil.
Frazier, C. (2023a). Beauty labor as a tool to resist anti-fatness. *Hypatia 38*(2), 231–250. https://doi.org/10.1017/hyp.2023.22.
Frazier, C. (2023b). Imperfection as a vehicle for fat visibility in popular media. In P. Cheyne (Ed.), *Imperfectionist aesthetics in art and everyday life* (pp. 284–295). Routledge.
Freedberg, D., & Gallese, V. (2007). Motion, emotion and empathy in esthetic experience. *Trends in Cognitive Sciences 11*(5), 197–203.
Fried, J. (2019). Ally aesthetics. *The Journal of Aesthetics and Art Criticism 77*(4), 447–459.
Gallace, A., & Spence, C. (2010). The science of interpersonal touch: An overview. *Neuroscience & Biobehavioral Reviews 34*(2), 246–259.
Gallace, A., & Spence, C. (2014a). *In touch with the future: The sense of touch from cognitive neuroscience to virtual reality*. Oxford University Press.
Gallace, A., & Spence, C. (2014b). The neglected power of touch: What the cognitive neurosciences can tell us about the importance of touch in artistic communication. In P. Dent (Ed.), *Sculpture and touch* (pp. 107–124). Ashgate.
Garland-Thomson, R. (2009). *Staring: How we look*. Oxford University Press.
Garvin, E., Branas, C., Keddem, S., Sellman, J., & Cannuscio, C. (2013). More than just an eyesore: Local insights and solutions on vacant land and urban health. *Journal of Urban Health 90*(3), 412–426.

Halberstam, J. (2020). *Wild things: The disorder of desire*. Duke University Press.
Hamilton, D. K. (2016). Too sick for the window and the view? *HERD: Health Environments Research & Design Journal* 9(2), 156–160.
Hobson, J. (2018). *Venus in the dark: Blackness and beauty in popular culture*, second edition. Routledge.
hooks, bell. (1992). *Black looks: Race and representation*. South End Press.
Irvin, S. (2008a). Scratching an itch. *Journal of Aesthetics and Art Criticism* 66(1), 25–35.
Irvin, S. (2008b). The pervasiveness of the aesthetic in ordinary experience. *The British Journal of Aesthetics* 48(1), 29–44.
Irvin, S. (2017). Resisting body oppression: An aesthetic approach. *Feminist Philosophy Quarterly* 3(4), Article 3, 1–25.
Kant, I. (1987). *Critique of judgment*, translated by Werner Pluhar. Hackett. Originally published as *Kritik der Urteilskraft* in 1790.
Kaplan, R., & Kaplan, S. (1989). *The experience of nature: A psychological perspective*. Cambridge University Press.
Konečni, V. J. (2008). Does music induce emotion? A theoretical and methodological analysis. *Psychology of Aesthetics, Creativity, and the Arts* 2(2), 115–129.
Korsmeyer, C. (1999). *Making sense of taste: Food and philosophy*. Cornell University Press.
Kozak, A. (2021). 'What i wanted to wear': The battle for self-expression amid transphobic street violence'. In K. Carter & J. Brunton (Eds.), *TransNarratives: Scholarly and creative works on transgender experience* (pp. 223–234). Women's Press.
Kuo, M. (2015). How might contact with nature promote human health? Promising mechanisms and a possible central pathway. *Frontiers in Psychology* 6, Article 1093, 1–8.
Lintott, S., & Irvin, S. (2016). Sex objects and sexy subjects: A feminist reclamation of sexiness. In S. Irvin (Ed.), *Body aesthetics* (pp. 299–317). Oxford University Press.
Lundqvist, L.-O., Carlsson, F., Hilmersson, P., & Juslin, P. N. (2009). Emotional responses to music: Experience, expression, and physiology. *Psychology of Music* 37(1), 61–90.
Malinowska, A. (2018). Lost in representation: Disabled sex and the aesthetics of the 'norm'. *Sexualities* 21(3), 364–378.
Mandoki, K. (2007). *Everyday aesthetics: Prosaics, the play of culture and social identities*. Ashgate.
Mani, A., Mullainathan, S., Shafir, E., & Zhao, J. (2013). Poverty impedes cognitive function. *Science* 341(6149), 976–980.
Martin-Seaver, M. (2019). First-personal body aesthetics as affirmations of subjectivity. *Contemporary Aesthetics* 17(1), Article 12. Available from: https://digitalcommons.risd.edu/liberalarts_contempaesthetics/vol17/iss1/12/ [last accessed 11 May 2023].
McKinney, K. (2014). How the CIA used music to 'break' detainees. *Vox*, 11 December 2014. Available from: www.vox.com/2014/12/11/7375961/cia-torture-music [last accessed 11 May 2023].
Montero, B. (2006). Proprioception as an aesthetic sense. *The Journal of Aesthetics and Art Criticism* 64(2), 231–242.
Nguyen, C. T., & Strohl, M. (2019). Cultural appropriation and the intimacy of groups. *Philosophical Studies* 176(4), 981–1002.
Nussbaum, M. C. (1990). *Love's knowledge: Essays on philosophy and literature*. Oxford University Press.
Ortega, M. (2016). The difference that art makes. *Contemporary Aesthetics* 14(1), Article 20. Available from: https://digitalcommons.risd.edu/liberalarts_contempaesthetics/vol14/iss1/20/ [last accessed 11 May 2023].

Parsons, G., & Carlson, A. (2008). *Functional beauty*. Oxford University Press.
Robbins, J. (2020). Ecopsychology: How immersion in nature benefits your health. *Yale Environment 360*, January 9. Available from: https://e360.yale.edu/features/ecopsychology-how-immersion-in-nature-benefits-your-health [last accessed 11 May 2023].
Roberts, T. (2022). Feeling fit for function: Haptic touch and aesthetic experience. *The British Journal of Aesthetics* 62(1), 49–61.
Roelofs, M. (2014). *The cultural promise of the aesthetic*. Bloomsbury.
Saito, Y. (2017). The role of imperfection in everyday aesthetics. *Contemporary Aesthetics* 15(1). Available from: https://digitalcommons.risd.edu/liberalarts_contempaesthetics/vol15/iss1/15/ [last accessed 11 May 2023].
Schellekens, E. (2007). The aesthetic value of ideas. In P. Goldie & E. Schellekens (Eds.), *Philosophy and conceptual art* (pp. 71–91). Oxford University Press.
Schweik, S. M. (2009). *The ugly laws: Disability in public*. New York University Press.
Sekimoto, S. & Brown, C. (2020). *Race and the senses: The felt politics of racial embodiment*. Routledge.
Seresinhe, C. I., Preis, T., & Moat, H. S. (2015). Quantifying the impact of scenic environments on health. *Scientific Reports* 5(1), 1–9.
Shiner, L. (2020). *Art scents: Exploring the aesthetics of smell and the olfactory arts*. Oxford University Press.
Shusterman, R. (2006). Aesthetic experience: From analysis to eros. *The Journal of Aesthetics and Art Criticism* 64(2), 217–229.
Siebers, T. (2010). *Disability aesthetics*. University of Michigan Press.
Spence, C., & Gallace, A. (2020). Making sense of touch. In H. Chatterjee (Ed.), *Touch in museums: Policy and practice in object handling* (pp. 21–40). Routledge.
Sternberg, E. M. (2009). *Healing spaces: The science of place and well-being*. Harvard University Press.
Tate, S. A. (2009). *Black beauty: Aesthetics, stylization, politics*. Ashgate.
Taylor, P. C. (2016). *Black is beautiful: A philosophy of black aesthetics*. Wiley Blackwell.
Ulrich, R. S. (1984). View through a window may influence recovery from surgery. *Science* 224(4647), 420–421.
Walton, K. L. (1970). Categories of art. *The Philosophical Review* 79(3), 334–367.
White, M. P., Alcock, I., Grellier, J., Wheeler, B. W., Hartig, T., Warber, S. L., Bone, A., Depledge, M. H., & Fleming, L. E. (2019). Spending at least 120 minutes a week in nature is associated with good health and wellbeing. *Scientific Reports* 9(1), 1–11.
Whittaker, N. (2021). Blackening aesthetic experience. *The Journal of Aesthetics and Art Criticism* 79(4), 452–464.
Whittaker, N. (2022). The right to be alone. *The Philosophers' Magazine*. 7 February 2022. Available from: www.philosophersmag.com/essays/267-the-right-to-be-alone [last accessed 11 May 2023].
Yancy, G. (2008). *Black bodies, White gazes: The continuing significance of race*. Rowman & Littlefield.
Yancy, G. (2016). White embodied gazing, the Black body as disgust, and the aesthetics of un-suturing. In S. Irvin (Ed.), *Body aesthetics* (pp. 243–260). Oxford University Press.
Zuckert, R. (2009). Sculpture and touch: Herder's aesthetics of sculpture. *The Journal of Aesthetics and Art Criticism* 67(3), 285–299.
Zuckert, R. (2019). *Herder's naturalist aesthetics*. Cambridge University Press.

CHAPTER 13

ON ENJOYING WHAT THERE IS

The Aesthetics of Presence

ARTO HAAPALA

Introduction

There is an element of mindfulness in the traditional conception of aesthetic contemplation. The contemplative attitude requires concentration on the particulars of the object or event in question and a bracketing of disturbing factors from the outside. It is not too farfetched to regard this kind of attitude as a mindful one. What is important in most theories of the aesthetic attitude and aesthetic contemplation is that the object must be somehow distinctive, worthy of our attention. A mindful attitude is easier to adopt when the object is a special one, almost like demanding our attention. This is the reason why works of art, monumental architectural structures, and spectacular natural sites have gained so much aesthetic attention. Taking into account the history of art, the different practices in which works of art are put into display—museums, galleries, theatre building, concert halls—and the strong emphasis in philosophical aesthetics on art, it is easy for us to concentrate on the extraordinary. We expect to be entertained by something that by its very nature and by the context in which it is put into display requires our attention. It is only in the past twenty years that aesthetics of the everyday has become more prominent in philosophical aesthetics. However, even in everyday aesthetics, the emphasis has quite often been on the extraordinary rather than on the ordinary.

There is no reason to deny the relevance and importance of the noteworthy in our daily lives and in everyday aesthetics. However, I want to draw attention to the very everydayness itself, to the ordinary in its ordinariness. Is there any aesthetic potential in the habits and routines of our everyday life? Can we operate with the standard notion of the aesthetic when looking for the aesthetic aspects of the everydayness itself? Should

we perhaps stretch the notion of the aesthetic in order to accommodate possible aesthetic features of the everyday into the sphere of philosophical aesthetics? Or alternatively, should we simply accept that there are several concepts of the aesthetic which are all relevant from a philosophical point of view? What is aesthetically interesting in art is different from what is aesthetically interesting in our daily routines. Finally, what is the significance of everyday aesthetic experiences for our well-being?

To get a grip of everyday aesthetics, we need to understand what constitutes the everyday. For this, I will use some of Martin Heidegger's ideas of human existence, starting from the concept of 'being-in-the-world' (Heidegger, 1962, 91–95). Our taking care of different matters and the structures of our being-in-the-world create stability and order, 'reliability' (Heidegger, 1971, 34; German original: *Verlässlichkeit*) in Heidegger's terms, and this is at the core of the everyday itself. The experience of stability, something being familiar and trustworthy has an aesthetic dimension to it. This is what I understand to be the aesthetic aspect of the everyday itself, and it goes hand in hand with the concept of presence. We experience our everyday environment here and now, and most of the time we exist in the structures of the everyday. Rather than looking for something new and exciting, we should—and we can—pay attention to what there is at hand in the present moment. Becoming aware of the aesthetic potential of the everyday, appreciating the quiet pleasure of the ordinary is, in the end, indispensable in leading a good life.

This is significant from the ecological point of view, too. If we are capable of developing our aesthetic understanding, and respective sensitivity, to include the everyday per se, the potential to contribute towards more sustainable environments increases as our needs or desires for aesthetic satisfaction can be fulfilled without travelling to exotic places or acquiring new aesthetically pleasing things. This does not imply that everything new and exciting should be abandoned—we humans clearly have an urge for the exotic, we are curious creatures—but the everyday and the aesthetics of presence offer another pathway to aesthetically satisfying experiences.

Ontology of the Everyday

I will first delineate briefly the existential foundations of everyday aesthetics. This is important not only because all conceptions of aesthetic properties and values rely on some ontological theory—often simply assumed rather than explicitly stated—but also because an account of the existential structures explains the aesthetic nature of our everyday existence. Although Heidegger's existential phenomenology developed in *Being and Time* is a standard reference by now and widely known and discussed, it is still useful to pick up some key concepts from it, in order to get a better understanding of the everyday. Here, I will operate with three notions: being-in-the-world *(In-der-Welt-Sein)*, taking care *(Sorge)*, and reliability (Heidegger, 1962, 149–163). In the spirit of pragmatism, my purpose here is to use these notions for exploring the ontology of the everyday, rather than offering an interpretation and analysis of Heidegger's thoughts.

As humans we are always in a world. 'World' understood in the Heideggerian sense is not a collection of objects, i.e., by listing all the things around you, you have not characterized your world. The world is the meaning-giving context which makes human existence possible: we see trees as trees, houses as houses, moving objects as cars and bicycles; in short, there is a meaningful setting with various matters and events, thanks to the world. The 'in' in 'being-in-the-world' is not primarily a spatial 'in', although most of the time our existence is tied to some spatial configuration. At the moment, I am in a university building, at my office; my body can be located into a particular spatial location. But more importantly, I am sitting at my desk, surrounded by books, working with my computer, i.e., I am in a meaningful world, more particularly, in my Lebenswelt, which is partly constituted by the university environment.

Our language makes it difficult to talk about the world without spatial connotations, and it is most often the case that one's world is integrated into some space. What is crucial, however, is that our experienced environment is not an abstract space but a meaningful and value-laden place, our world, which we to some extent always share with our fellow-humans and with other living creatures.

My world is both shared and private. Being-in-the-world is being with other humans and being alongside different kinds of things. I share the university world with my colleagues and my students. And again, not only do we share the same physical space but the cultural entity called the 'University of Helsinki', which involves numerous conventions, practices, roles, and the like. At the same time, my world has features that nobody else's world has. Due to my particular life history, the specific existential career that I have carved during my life, my Lebenswelt has characteristics that belong only to it. For example, I may have a special relationship, a nostalgic one, to this University building due to the fact that I used to visit it often during my studies. The warm feelings that this building raises in me define the way I see it. This does not mean that I would live in a solipsistic world—you and me, we both enter the same cultural entity when visiting the building, even though the ways we see and experience it will differ in some respects.

The Problem of Care

When living in the world we always take care of things. Sometimes our concerns are very conscious, and we might be stressed with the duties ahead and our capabilities of being able to carry them out. Often the lack of time makes us worry about things—do I have time to do this and that? 'Care' and 'taking care', in the sense I am using these expressions here, do not necessarily involve explicitly conscious activity. During the time we are awake, we are constantly taking care of all kinds of matters. Our everyday lives consist of taking care; in Heideggerian terms, care is one of the existentials defining our existence (Heidegger, 1962, 235–241). Depending on our particular situation, the matters we take care of vary considerably, but from an existential point of view, it is not relevant to try to make any kind of mapping or listing of the numerous activities different people

are involved in. This is a research area for social scientists. From the existential point of view, the very fact that our existence consists of taking care is crucial.

Yuriko Saito gives a prominent role to the notion of care but her account is very different from mine. As far as I can see, Saito's considerations are on a different level. This is the Heideggerian distinction between the ontic and the ontological. There is no evaluation involved in this distinction; neither is more important than the other, even though the ontological is the basis for the ontic. At the same time, the ontological level requires ontic manifestations in order to be there. Saito writes about the aesthetics of care as follows:

> It is my contention that 'care' offers a site where the ethical and the aesthetic are integrated and deeply entrenched in the management of our daily life. It defines the way in which we relate to the other, whether other humans, nonhuman nature, or the artifactual world, situate ourselves in the world, and cultivate a virtuous way of living and, in short, a good life. The care relationship determines the ethical and aesthetic mode of being in the world.
>
> (Saito, 2021, 2)

'Care' and 'taking care' are, indeed, ethical and aesthetic notions in Saito's account. I agree that we should be considerate to our fellow-humans, and we should respect other living creatures, as well as different cultural achievements. We should live in harmony with our environment. Not to respect or not to act in a considerate way towards our fellow-humans, cultural products, and natural environment is wrong, both morally and in many legal systems also juridically. Intuitively it is easy to understand that there is an aesthetic dimension in many caring activities—as Saito puts it, 'both require attention to the particularity of the other, open-minded responsiveness, and imaginative engagement' (Saito, 2021, 5).

However, in my usage, from an ontological point of view, also a farmer using pesticides in his farming activities, a business-woman driving to a meeting in her fancy car with heavy fuel consumption, and a university professor flying all over the world to give talks, are all taking care of matters relevant in their lives. Their activities may be ecologically unsustainable, and perhaps even, by some moral standards, immoral, but from their point of view, they are involved in activities important in their worlds. 'Care' in this sense is ethically and ecologically neutral, but aesthetically laden. The business-woman feels safe and secure in her car, she takes comfort in the familiar setting, and the driving experience is smooth and without disturbances. The university professor is very much looking forward to meeting colleagues and exchanging ideas, as he has done numerous times before. Being at a conference is a congenial experience for him.

Reliability

On most occasions, we take care of things and matters we are familiar with. Familiarity and together with it, safety, constitute our everyday—at least it is something we,

most of the time, aim at. Undeniably, total stability, an environment without any changes, would easily be a cause of boredom, but familiarity of some kind is a necessity for human existence. Constant, unpredictable changes, say, in our own home environment, would soon result in an impossible situation—how difficult would it be, if we would not find the things we need, and how stressful in the long run, if the visual scenery would change constantly? To this stability I refer with the expression 'reliability'.

Heidegger introduces the notion of *Verlässlichkeit* in his essay on the origin of works of art when describing and analysing a painting by van Gogh, representing a pair of old shoes, which Heidegger claims to be those of a peasant woman. The shoes function as they should, in Heidegger's account, in the peasant woman's world because she can rely on them. Heidegger then generalizes this by saying that the 'equipmental being of equipment is reliability' (Heidegger, 1971, 34).

This is true not only of different kinds of tools or pieces of equipment, but of our world in general. Our world and our being-in-the-world rest on reliability. We take this reliability for granted, so much so that we do not normally pay any attention to it. We assume that things stay as they are—at least most of the time. We assume that there are no surprises at home when we come back from a business trip—'Nice to be back home!' This feeling captures the aesthetic character of everydayness—it is always there but we notice it when it has been missing. It is nice to be back in old routines, it is nice to not notice any changes—it is nice to be back in normalcy.

Another way to notice the importance of normalcy is when radical changes occur. Heidegger's analysis of tools not functioning as they should is illuminating (Heidegger, 1962, 97–102). Let us draw the Heideggerian way of thinking closer to our skins. Here is a case we have all experienced: the problem with new shoes. They were fine when we tried them on in the shop, but now, when actually wearing them, they feel uncomfortable. Even if the shoes would not cause physical pain, as they sometimes do, the very fact that they remind us of their existence is something we do not want. Pieces of equipment, such as shoes, should function so that they do not remind us of their existence; they should remain unnoticed. Being noticed is disturbing, while being unnoticed brings a quiet pleasure. In Heideggerian spirit we can say that tools themselves disappear in their usefulness. The main thing is that they function in the expected way; their smooth functioning creates stability and order.

Aesthetics of the Familiar

When we encounter significant works of art and great natural sites, the aesthetic potential is remarkable. The experience can be overwhelming, something we might remember for the rest of our lives. Most often, however, aesthetic experiences stay with us only for the time of the experience and are then soon forgotten. It was a great movie, a great concert, a brilliant exhibition, but now I enter back into my normal routines—nice to be back home.

Even in significant aesthetic experiences, repetition—and in this sense coming back to the familiar—plays a role. I just want to listen to the *Sonata Pathétique* all over again. I know what is coming, and this knowledge, and the fact that my expectations are fulfilled, is very satisfying. This is coming back to the familiar. No doubt, I do enjoy the musical composition and the brilliance of different performers and the differences in their performances, but on top of all this is the recognition that I know all this, this is my musical home; here I feel safe.

In the design-context, this experience has been explored by the Danish design theorist Kristine H. Harper. Her starting point is very similar to what I have discussed so far, as she writes about the 'pleasure of the familiar' and the 'pleasure of the unfamiliar'. Although the conclusions she draws as to what counts as aesthetically pleasing in these two categories differ from mine, the design examples she gives are illuminating. In successful design, both the familiar and the unfamiliar should be present:

> Objects that produce the Pleasure of the Familiar are characterized by accommodating recipient expectations regarding idiom, materials, color combinations, and functionality. But the object should still contain an element, however small, of renewal, variation, or aesthetic stimulation in order not to appear inconsequential or too anonymous. Such an element could be in the form of intricately patterned lining, which appears out of place at first glance, but which is nevertheless pleasing to the eye, as it corresponds to Itten's scheme of color contrasts and thus complements the color of the blouse. The aesthetic element of surprise could also be in the guise of appliqués of a slightly untraditional material, which nevertheless support both form and function. The beautiful aesthetic experience, which fills the recipient with pleasure, is not an anonymous experience, but rather an experience of 'coming home.'
>
> (Harper, 2018, 71)

The experience of comforting familiarity, that of 'coming home' or of 'being at home', is the long neglected everyday aesthetic experience. It arises from the very existential structures of our being, and because it is so close to us, it often goes unnoticed. We can, however, pay attention to it, and reflect on the experience. Most often we notice it in a roundabout way when our routines and familiar surroundings undergo changes. But we should not forget or neglect what there is in our present situation. For most of us, this is the mode in which we live most of our lives. This is the potential of the aesthetics of presence.

When it comes to design objects, including clothing, Harper's point that the familiar and the unfamiliar should be in a dialogue with each other, so that the object in question raises our interest, is relevant. Complete familiarity can lead to indifference, and the object sinks immediately into oblivion. This is something that designers and especially artists try to avoid. A designer's skill is applied to finding the balance between the familiar and the unfamiliar: to please our desire for stability and at the same time our urge for the new. In comparison, artists can take the unfamiliar to the extreme without having to worry about the practicalities of everyday life.

However, an aesthetics of the familiar is a more frequent occurrence than that of the unfamiliar in our everyday life. Human existence always returns to the familiar; even the strangest circumstances and surroundings—like those caused by a war—will eventually become familiar. We can adapt ourselves to hostile and to some degree even to dangerous environments. Clearly, if the circumstances pose a permanent threat to one's life or health, there is not much pleasure to be taken from them, and the talk about the aesthetics of the familiar in the positive sense becomes superfluent. A sine non qua for the aesthetic characteristics of the familiar to occur and to remain is that at least some of the basic human needs are fulfilled. If I am in constant pain, in fear, suffering from hunger, I cannot enjoy the familiarity of the circumstances. This obviously applies to the aesthetics of the unfamiliar, too—if I am physically or mentally seriously deprived in whatever way, it is very difficult, if not impossible, to enjoy great art or notice the minute changes in a design object.

However, an indication of the human need and desire for familiarity and safety is the fact that even in the most difficult conditions—such as a war—people tend to find pockets of safety and relative comfort. A metro station can become a temporary home for many during an airstrike. Humans are adaptable, but there are limits, varying to some degree from person to person, which cannot be surpassed without the possibilities of aesthetic satisfaction being lost.

Ethical and Ecological Considerations

Let me now address the ethical and ecological issues I referred to above. Saito's notion of care has clear ethical connotations, or rather the ethical and the aesthetic are intimately tied together: 'my focus is on how care is an aesthetic and ethical practice that we ourselves can engage in, which contributes to a good life' (Saito, 2022, 21). I already pointed out that my notion of care does not imply anything as to what kind of 'caring activities' are ethically good. A thief's concerns and care are about how to get hold of other people's properties; in their particular Lebenswelt, care is directed so that it causes harm to other people. By most ethical, legal, and social norms this is clearly wrong. However, one of the advantages of my notion of care is that it is not committed to any particular ethical system. It is another discussion to argue what is ethically good or bad. Independently of different ethical views, humans are creatures who always take care of something, whatever it may be, religious beliefs, scientific concerns, or sports activities. In a world of an individual human being, care and routines that come with it create comfort.

By taking care, we create familiarity around ourselves. We take the surroundings, so to speak, into our own sphere, parts of our Lebenswelt. At this moment, I am watching a building from my office at the university. I do not quite know what kinds of functions the building serves, probably an office building of some kind, but its visual appearance has become a part of my everyday environment. It is not a particularly noteworthy

building; I would not stop on my way back home to admire its aesthetic features. But I find it relaxing that it is still there, that my eyes spot it as expected as I enter the room. I enjoy the presence, the simple fact that things have not undergone any changes.

In a sense, this is a humble attitude towards the environment; I am not expecting to be entertained by anything new. This might also be described as a conservative attitude; we value stability. Without any political connotations, we can say that humans are conservative by nature. As I pointed out above, there is no denying that we want to take breaks from our routines every now and then: we go to places we have not been before, we go to movies, to a concert, to the theatre to break the everyday routines—to cut the monotony, one might say. But in the end, what these breaks from familiarity show is that the basis of our existence lies in the stability and reliability of the familiar.

The aesthetics of the familiar does not exclude other aesthetic pleasures in the sense that we are or should be satisfied all the time with what we have seen and experienced before. There are also often ethical considerations that have to be taken into account that outweigh the existing conditions. There are many reasons and grounds for making changes—social, human health and well-being, economic, ecological, and aesthetic. A historic building might be aesthetically significant, but if it is structurally dangerous and beyond repair, aesthetic values do not weigh enough to justify its continued existence, even though the building might be a familiar sight for many people. We all know that from time to time we want to make changes to our homes—paint walls, buy a new couch, a new graphic print, etc. These are the small changes that attract our attention for some time. Their newness is refreshing and brings satisfaction and joy.

Conclusion

If we become more aware of the simple pleasures of the familiar, and perhaps even consciously resist the temptations of consumerism, the ecological advantages are obvious. An aesthetics of the familiar cannot and should not replace the aesthetics of the unfamiliar completely. It is rather a question of balancing the two anew—more emphasis on familiarity, less on unfamiliarity. A similar kind of balancing act must often be taken when considering ethical, ecological, and aesthetic values. There are clear cases in which ethical and ecological values overrule an aesthetic one, be they familiar or unfamiliar, but this is not always the case. For example, city parks most often require heavy maintenance—cutting the lawn, using fertilizes, planting flowers that would not grow naturally in the park—but even though this is ecologically unsustainable, the aesthetic pleasures that the park provides justify its existence. It would be wrong—on aesthetic and perhaps also on social grounds—to demolish it on ecological grounds.

Even though we humans are, at least to some extent, forward-looking creatures, making plans for the future, the present conditions offer great potential for an aesthetically satisfying existence. When we become more conscious and learn to value the present states of affairs—provided that the present does not constitute a threat to our

well-being—the variety of aesthetic choices increases, and even small changes in the current conditions can be significant from the point of view of the aesthetic of the unfamiliar. In fact, I do think that many people already lead their lives in this way. Then it is the question of understanding the aesthetic significance of the everyday both in the familiar mode as well as in the unfamiliar, and becoming more aware of it. This is the key to developing our mental well-being—one should not forget or ignore the aesthetic satisfaction that our everyday provides. This is the aesthetics of presence.

Finally, let me point out something that has been implicit in this essay, and to which I referred to at the beginning. How many concepts of the aesthetic do we actually need? Is there an essence of the aesthetic? As I see the matter, an aesthetic of the familiar operates on a different register compared to the aesthetic of the noteworthy or strange or unfamiliar. It would be a mistake to expect anything spectacular when encountering something familiar; this is not what the aesthetics of the familiar is about. This co-presence is a potential richness of human lives: we can enjoy both the familiar and the unfamiliar. For the sake of clarity, it is useful to make a distinction between the two; they might not be fundamentally different but they clearly have a distinctive character. In this sense, there is no essence in the aesthetic (Haapala, 2019).

What is the point, then, to call the pleasures of the familiar 'aesthetic'? I think this is a pragmatic issue to be decided by the usefulness of the parlance—why should we not use the term in these cases? Works of art are very diverse and varied, and most philosophers have given up the effort of defining art. The field of art has expanded and is expanding. The same goes for aesthetic phenomena more generally. The usage has already gained ground, and the potential practical advantages are great—as I have tried to show above. Humble pleasures can thus have huge potential for human well-being and mental health, as well as in the environment at large.

Acknowledgments

I would like to thank Yuriko Saito for her insightful comments on an earlier version of this chapter.

References

Haapala, A. (2019). The varieties of aesthetic experiences and urban greenery: Mapping a territory. In A. Haapala, B. Frydryczak, & M. Salwa (Eds.), *Moving from landscapes to cityscapes and back. Theoretical and applied approaches to human environments*. Seria 'Krajobrazy' / Series 'Landscapes', Tom / Vol. 9. Lódz.

Harper, K. H. (2018). *Aesthetic sustainability. Product design and sustainable usage*. Routledge.

Heidegger, M. (1962/1927). *Being and time*, translated by John Macquarrie and Edward Robinson. Blackwell.

Heidegger, M. (1971). The origin of the work of art. In A. Hofstadter (editor and translator), *Poetry, language, thought* (pp. 15–86). Harper & Row.

Saito, Y. (2022). *Aesthetics of care: Practice in everyday life*. Bloomsbury Academic.

Further reading

Bergmann, S., & Clingerman, F. (Eds.). (2018). *Arts, religion, and the environment: Exploring nature's texture*. Brill Rodopi.

Boe, S., Faber, H. C., & Strandhagen, B. (Eds). (2014). *Raw: Architectural engagements with nature*. Ashgate.

Forsey, J. (2013). *The aesthetics of design*. Oxford University Press.

Leddy, T. (2012). *The extraordinary in the ordinary: The aesthetics of everyday life*. Broadview Press.

Light, A., & Smith, J. M. (Eds.). (2005). *The aesthetics of everyday life*. Columbia University Press.

Szécsényi, E. (Ed.). (2020). *Aesthetics, nature and religion: Ronald W. Hepburn and his legacy*. Aberdeen University Press.

Saito, Y. (2007). *Everyday aesthetics*. Oxford University Press.

Saito, Y. (2021). Aesthetics of the everyday. In E. N. Zalta (Ed.), *The Stanford Encyclopedia of Philosophy* (Spring 2021 edition). Available at: https://plato.stanford.edu/archives/spr2021/entries/aesthetics-of-everyday/ [last accessed 4 October 2024].

CHAPTER 14

GARDENING AND THE POWER OF ENGAGEMENT WITH NATURE FOR MENTAL WELL-BEING

ISIS BROOK

Introduction

The evidence of health and general well-being benefits of time spent with plants is now well established (Leavell et al., 2019; Hall & Knuth, 2019a, b). Since the work on faster recovery time in hospital when patients had a view of a tree (Ulrich, 1984) there is now a huge number of studies examining something that, to many, seems obviously to be the case. Time in nature, amongst plants, activities like gardening and so on are good for you. The proof of this has taken many forms over the intervening years. In the scientific literature there are many very cleverly designed experiments to measure the health benefits, with controls for variables such as income and education. These look at a range of health conditions and they show us the circumstances in which people benefit, what kind of people benefit the most, how much nature exposure is required, and what additional benefits also accrue: such as greater sociability, safer neighbourhoods, and so on. In this chapter I will give an overview of the evidence and then discuss potential explanations of why contact with nature seems involved not just in healing when health problems arise but also as necessary for everyone. I will then focus in more depth on what is involved in gardening processes and why such contact seems to be especially helpful for those with mental health issues. This section will include the aesthetic qualities and responses involved in various aspects of gardening, such as: soil, engaged activity, the social dimension, metaphor, beauty through all the senses, and the de-centering idea of unselfing. Together these aspects shed light on what is happening in the human–plant–garden relationship and why that can be beneficial.

Evidence of Mental Health Benefits

I want to give a brief overview of the health benefits. Many studies focus on single aspects such as cardiovascular health or stress reduction, but they also play into one another because, whilst a study may look at one thing, the effect on a person has a more holistic impact. Thus, even studies that focus on a physical problem will encounter well-being gains that are more general and promote better mental health. The studies might look at walking in natural environments, natural elements such as a tree seen from a window or a pot plant on a desk, pictures of landscapes or individual plants, or even just thinking about nature. There are also many studies of gardening as an activity and reviews of the efficacy of horticultural therapy as a medical intervention and therapeutic horticulture as a support resource for social prescribing.

The benefits for physical health that have been evidenced in scientific studies include: improved rehabilitation, lower cardiovascular disease risk and blood pressure, improved autonomic nervous system and parasympathetic activity, decreased diabetes, better sleep patterns, enhanced immunity, healthier birthweight, decreased ocular discomfort, decrease in allergies, improved pain control, obesity reduction, de mortality (Hall & Knuth, 2019b). With these studies of physical health the be measured and explained by physiological markers, such as: heart rate, insulin, glucose, proinflammatory cytokines, various hormones, or c-reactive protein, and rarely by self-reporting or interviews.

Benefits to mental health are similarly well documented and those covered by scientific studies include: reduced stress and anxiety, attention deficit recovery including reduction in ADD/ADHD, and attention restoration, decreased depression, improved self-esteem, mitigation of PTSD, enhanced memory retention, reduced effects of dementia, increased creativity, pro-sociality and greater empathy, enhanced productivity and attention. With mental health benefits there are sometimes elements of self-reporting, interviews or questionnaires, but again biological markers are also used. For example, the type of biological markers used for measuring reduction in stress and anxiety include: heart rate, skin conductance recovery, concentrates of cortisol, changes in nerve activity, EEG brainwave amplitude and frequency, EEG plus eye tracking, cerebral oxygenation levels, salivary amylase levels, cytokines in blood samples, near infrared spectroscopy, and functional magnetic resonance imaging (Hall & Knuth, 2019a).

Minimal Nature Required

Two things stood out to me in all this material. The first was how little exposure to nature, particularly to plants, it took for measurable benefits. Experiments, for ease of

control, often involve images of plants or landscapes or nature videos as opposed to immersion in nature or even, with the use of fMRIs, just imagining a plant (Vedder et al., 2015). Even where there is immersion it can be for as little as five minutes (Piff et al., 2015; Richardson et al., 2021). There is growing evidence on the benefits of forest bathing (Williams, 2018, 71), where time in a forest is guided by prompts to focus on the five senses. With forest bathing a little longer is spent amongst trees, but the wealth of evidence for the benefit of nature is not based on, for example, hikes in national parks and wild camping. As profound as the experiences from deep immersion in nature are, what is striking is that real and lasting health benefits accrue from so little.

One study is called 'Moments not minutes: the nature–wellbeing relationship' to describe the finding that it is not the time spent but whether an encounter of some kind takes place. Such an encounter might just be smelling a flower, but it has to do with noticing something in nature. This noticing is more likely to happen when one is engaged in simple activities. As the study says:

> When examining the factors that explained variance in wellbeing and illbeing using multiple linear regressions, only nature connectedness and engaging in simple nature activities emerged as significant; the association with time in nature was not significant, nor were indirect contact with nature or knowledge/study of nature.
>
> (Richardson et al., 2021, 23)

I suspect that there is something happening when we properly encounter an aspect of nature, such as a plant. In my experience, occasions when we wake up to their plant nature and see them as active beings, rather than passive background, can be moments of connection. This can be very striking when we find them having done something unexpected. Botanically it might be all perfectly explicable, such as germinating and pushing up through the soil or grasping hold of an adjacent rake handle rather than the cane supports provided. In that moment when we encounter them freshly doing something particularly active, or not what we planned, it is like a real encounter and it shifts our mind-set; it opens us to the world in a fresh way.

The other thing that struck me when diving into all this literature was the careful design of experiments and collecting of impressive evidence but the near absence of discussion about why. The physical pathway to e.g., lowering blood pressure or mitigating stress hormones is explained, but there is rarely an explanation of *why* nature has this impact.

Potential Explanations

Reference to potential explanations, when it is made, is most often to the work of Rachel and Stephen Kaplan. Their explanation was called attention restoration theory and

proposed that mental fatigue was relieved by taking a break in or looking at nature. This is because trees or natural landscapes have the right amount of detail to interest but not overwhelm us (Kaplan & Kaplan, 1989). We can engage in effortless attention, what they called 'soft fascination', which is restorative of our cognitive functions, and is not provided by built environments that can be too busy or too bland. Recent refinements of this have questioned the type of nature involved, with favoured natural landscapes being particularly restorative (Besson, 2020).

In the influential work of Roger Ulrich, using EEG monitoring, the focus shifts from attention restoration to a theory of stress reduction (Ulrich et al., 1991). However, the major thrust of work in this area was focused on demonstrating *that* there really is this connection between health and nature or urban green space (what the Kaplans had called 'nearby nature'), and not as much on *why* there is this connection. Currently there is a lot of funding going into work on the health benefits of nature because the impact on health has been demonstrated and could bring substantial savings to healthcare budgets (Leavell et al., 2019, 300). The impact on productivity and employee retention has also been demonstrated. If something works then the question of why it works becomes less important, but no less fascinating.

When deeper explanations of *why* do surface in the scientific studies, the suggestion offered points to an evolutionary picture of humans having dwelt in natural environments for millennia before the development of urban environments and the kind of spaces we inhabit today. Our bodies and, especially, our brains have evolved for a very different context than the one that—in evolutionary terms—suddenly surrounds us. This explanation suggests that there is a fittingness, a sense of coming home, that we subliminally experience in response to nature. Our bodies, minds, and souls resonate with this in a way that they cannot in the office or shopping mall. This fits with explanations of our cross cultural aesthetic landscape preferences such as the 'savannah hypothesis' (Orians, 1986) or 'prospect refuge theory' (Appleton, 1990), both of which point to an inbuilt preference for what sustained our primeval ancestors.

The other, related, concept that is sometimes mentioned in these studies is biophilia. Originally coined by Erich Fromm, this term was developed and popularized by the biologist Edward O. Wilson in the 1980s. Biophilia, as he describes it, is: 'an innately emotional affiliation of human beings to other living organisms' (Wilson, 1993, 31). Experiencing biophilia gives us both a feeling of pleasure and it stimulates motivations such as exploration. Biophilia is innate but then gets culturally reinforced through myths and storytelling.

Nature Deficit

Linking the 'recovery through nature' phenomenon to the deep connections of our ancestral past and biophilia does suggest that we should not only be using time

in nature to ameliorate health problems, but also to define what is necessary for everyone to support well-being in general and prevent, what has been termed, 'nature deficit disorder' (Louv, 2005, 35; Brook, 2010b). Taking a more salutogenic approach to health would mean that green spaces, allotments, community gardens, domestic gardens, and so on are part of a necessary access to nearby nature for everyone as a means of preventing illness occurring. We have known for a long time that nearby nature is a way of buffering everyone from the stresses of urban living (De Vries et al., 2003).

Well-being from this perspective goes beyond not getting ill, and it encompasses the opportunity to have a good life. If we imagine everyone has some kind of baseline of health that they are constitutionally capable of, then the claim would be that they would experience greater health in an environment with lots of natural elements such as street trees than one with minimal natural elements, and in an environment devoid of nature they would fall below their normal baseline (Baxter & Pelletier, 2019).

Access to green spaces does seem to be implicated in a range of psycho/social benefits where people just seem nicer in these kinds of environments. We could look to an explanation such as the Kaplans' Reasonable Person Model, which suggests that we all have the capacity to be reasonable and pleasant, but can become unreasonable and unpleasant. As the Kaplans point out: 'The reasonable person model posits that the difference is often in the environment, and specifically, that people are more reasonable when the environment supports their basic informational needs' (Kaplan & Kaplan, 2005, 273).

There have been many studies demonstrating neighbourhood improvement through the introduction of shared green space. A study that helps to bring out the complexity of the situation, and one that does seem to endorse the basic idea of the reasonable person model, is by Kuo and Sullivan on domestic violence (Kuo & Sullivan, 2001). The study involved tapping into a housing allocation that was happening in Chicago. In this random allocation tenants were moved into two different housing schemes, both of which had some accommodation that looked out on green spaces and some that was entirely devoid of any green spaces or nature. The four groups (scheme 1 with nature, scheme 1 without nature, scheme 2 with nature, scheme 2 without nature) were later interviewed regarding the strategies they used to solve conflicts with their partners. The findings showed a very significant difference between the two greener areas and the two barren areas on measures of psychological aggression, mild violence, and severe violence. As Sullivan later reports: 'These findings provide evidence that treeless, barren neighbourhood settings have a considerable cost in terms of human behaviour and functioning' (Sullivan, 2005, 245).

Thus, when thinking about mental health and green space, it is not just of concern to those with designated physical or mental health problems or what are termed 'vulnerable populations'. To some extent, without access to nature, we are all vulnerable.

And so to Gardening

One of the main sites of interaction between people and plants is the garden. As Charles Lewis says:

> Our participation through physical and mental investment draws us into a deeper level of experience, creating a closer person–plant relationship than occurs as passive observers. The most intimate person–plant relationship occurs in gardening, where we physically participate in maintaining green nature.
>
> (Lewis, 1996, 49)

The term garden covers many types of green space including publicly managed land smaller than (or small ornamental sections within) a park. However, it is community gardens, allotments, institutional gardens such as in care homes, hospitals, and prisons, that are the site of much of the work on mental health benefits. There is less research with private residential gardens. This is not a reflection on their efficacy but rather it is just harder to design and control such projects (Chalmin-Pui et al., 2021). That said, the value of these private garden spaces for supporting mental health became very evident during the COVID-19 pandemic with its attendant lockdowns (Theodouro et al., 2021; Marsh et al., 2021).

Garden spaces of all kinds are the sites most used in both horticultural therapy and therapeutic horticulture. The distinction between these two disciplines is that horticulture therapy is defined as where a therapist is using plants for predefined clinical goals (often taking place with patients of a hospital or care home garden) and therapeutic horticulture is a more general term for improving well-being through horticultural activities (Clatworthy et al., 2013). Clients of the latter are more likely to be living in the community and might be prescribed time in their own garden or a community garden/allotment where there is some assistance and social management of a gardening project. Prison gardens are another site for more general therapeutic horticulture, but will not be discussed specifically in this chapter.

Despite this distinction, however, there is a wealth of evidence supporting the benefits of both approaches (Soga et al., 2017) and I will be drawing from studies based on both types in what follows. To address what is happening when people engage with plants, I will also draw on my own experience as a gardener and the wider literature in phenomenology and aesthetics. In looking at this literature and interrogating my own experience, certain components of the garden and certain aspects crop up repeatedly. I will use these to organize the material that ensues under the following headings: soil, meaningful active engagement, social dimension, metaphor, beauty, and unselfing.

Soil

Connecting with soil seems important. This friable medium that can be worked and shaped takes us into a different space. It is, literally, grounding. The sensory experience

of having 'one's hand in the earth' feels good (Leavell et al., 2019, 301) and helpfully activates the sense of touch (Smith-Carrier et al., 2019, 6). There is a strong aesthetic dimension to feeling the soil, as it takes us into the ground, even if it is just compost from a bag. The shift from seeing soil as dirt—something to be avoided or even as defiling—to experiencing it as nurturing and valuable is an important part of this descent into the materiality of the world. This connection to earth, to something fundamental as Merleau-Ponty suggests, calls us to the Earth as the ground of our experience (Merleau-Ponty, 1968, 259; Brook, 2005, 357). It is interesting that the root of the word human is shared with the word humus (soil), and of course 'humility'. Perhaps the freedom to feel soil and connect with it brings a connection to one's own physicality as a nurturing home. Something seen as bad is now seen as good and participants can return to a childhood pleasure in feeling and playing with soil. Could this facilitate a new awareness of transformation being possible?

This sense of soil as a transforming medium is most evident in composting. The value of seeing kitchen 'waste' transformed into a valuable resource that helps to grow more food is another chance to experience, at some level, the possibility of redemption.

A strong sensory experience also comes through smell with the pungency of healthy soil or leaf mould returning us to childhood or just imparting an intriguing earthiness. The evocative smell is identified chemically as *geosmin* and is created by the bacteria genus *Streptomyces,* which is even used in some perfumes (Chater, 2015). The common soil microbes *mycobacterium vaccae* have also been shown to activate serotonin-releasing neurons in the brain and lift the mood (Ramirez-Andreotta et al., 2019, 9). This is possibly part of the reason people engaged in therapeutic horticulture love to dig (Leavell et al., 2019, 7), even when the person managing a project might be trying to organize a plot, for good horticultural reasons, on 'no dig' principles. As one permaculture inspired coordinator of a community garden said, 'I always leave one bed traditionally managed because they do love to dig' (personal communication, 2019). This active engagement leads to the next aspect of gardening which differentiates it from simply time in nature.

Meaningful Active Engagement

Activity in and of itself is valuable for physical health and psychological well-being, but this is enhanced by the sense of doing something purposeful. Gardening tasks are seen as building self-worth (de Seixas et al., 2017, 88; Smith-Carrier et al., 2019, 11; Elings, 2006). Allotment projects where produce is grown and then sold or eaten allows participants to feel pride in their ability to make a positive contribution; they see themselves in a new light. Something as simple as seeds that one has planted, germinating and growing, means that something in the world has changed. The world is better and, for example, a person with depression struggling to see anything good in themselves can see that their activity has actually brought about positive change. As one study summarizes it, 'The contribution of physical, mental and emotional energy to the process of gardening gives

the human–nature relationship a sense of purpose and by extension can bring a broader sense of purpose to one's life' (Bell-Williams et al., 2021, 7).

The activity of gardening, whether guided or not, also opens the way for increased confidence and self-esteem through developing practical skills. Horticultural knowledge from books or gardening programmes is partnered with hands-on practice that grows the embodied tacit knowledge of how to carry out tasks. The fact that we get delayed feedback from the garden as to the success or not helps to build skills in the helpful context of having the weather or pests to partly blame if something doesn't work well.

The physical activity of gardening, whether strenuous, such as turning a compost heap, or dexterous, such as pricking out seedlings, connects us to the world and engages us in a multisensory aesthetic experience that delivers fresh sensations on each occasion. This might be warming sunlight or cold wind, sweet or pungent smells, rough textured seeds or the reassuring smoothness of a well-worn trowel handle, delicate bird song or the thwomp of a spade turning wet soil, new cobwebs sparkling with frost or the deep magenta of an opening peony. The world of the garden embraces us and enlivens our senses and awakens us to nature. We tune into this aesthetic smorgasbord of sensations particularly strongly, I think, because we are involved in the making or care of the garden. Unlike visiting a public garden—no matter how beautiful—working in a garden seems to draw its gardener out of themselves and into noticing what needs attention or what is doing better than expected and what the next task will be. We are carried on a stream of meaningful engagement in the ever-changing environment, encouraged by a sense of (unburdensome) responsibility. The question of 'what next?' is often answered by the garden, freeing the gardener from a confusing open-ended matrix of possibilities, but with enough space to express creativity.

Social Dimension

Strong evidence for the effectiveness of gardening in improving mental health is often attributed to its customary pairing with a social dimension, such as in community gardens or groups of patients working together in a therapy setting (Alaimo et al., 2016; Sempik et al., 2013). Humans are social beings and the isolation and alienation that is often experienced in poor mental health makes matters worse. Well-being for everyone is tied to the individual being embedded in a network of positive relationships (Malberg Dyg et al., 2019) and those relationships become hard to maintain with poor mental health or conditions such as dementia (Smith-Carrier et al., 2019). In interviews with participants who had been prescribed community gardening, the value they find in social interaction and sharing tasks with others comes through. As one participant says:

> When I first started coming I couldn't speak to anyone, and as time went on, I started to talk to a few people and then you're just embraced in this family… There is a sense of community, and yeah, a sense of belonging.
>
> (Quoted in Stevens, 2018, 269)

This is a typical response and the words that come up in these studies are things like: camaraderie, connection, learning together, making friends, and we are a team. There is a growing confidence that comes from having a role and even beginning to help others with gardening tasks; this comes across in many reports. Participants seem to transition from being patients, to useful helpers, to guiding others new to the garden, and planning future developments. The distinction between those managing or guiding a project and the mental health clients/volunteers is often blurred and there is a sense that everyone is just working together (Sempik et al., 2005; Stevens, 2018).

In reviewing the literature on community gardens as therapeutic horticulture, it is often hard to determine which aspect is doing the heavy lifting in terms of psychological improvement: the garden or the social dimension? Perhaps that is a misguided question because although the social element is often cited by participants, the garden context seems to make a non-threatening accepting social interaction possible (Spano et al., 2020; Smith-Carrier et al., 2019; Malberg Dyg et al., 2019; Stevens, 2018; Leavell et al., 2019). There is something about gardens and gardening that, in most contexts, is wholly welcoming and affords the kind of activities that can be carried out alone, or alongside others, or with others. This variety offers a helpful freedom for participants to move between these levels of interaction as suits their mood on the day or over a period of participation.

Another approach to that question, of whether it is the social interaction or the garden that is doing the therapeutic work, is to question the distinction itself. In growing and tending plants, the groundwork for interacting with other humans is laid. The plants appear to participants as responsive but not judgemental. As one study notes:

> Example statements included: 'the plants accept me as I am', 'I have always suffered low self-esteem, in the garden I don't have to measure up'.
>
> (Scott et al., 2014, 15)

And as Elings says: 'Plants are non-judgemental, non-threatening, and non-discriminating' (Elings, 2006, 52). Charles Lewis captures this well when he questions why working with plants is effective in a way not provided by some other craft activity.

> Plants and people share the rhythm of life. They both evolve and change, respond to nurture and climate, and live and die. This biological link allows a patient to make an emotional investment in a plant; however, it is a safe, non-threatening investment. The commitment is one-way. Should the patient choose to withdraw, there will be no recriminations. In severely damaged patients, such a relationship can signify the first willingness to reach out to another living being.
>
> (Lewis, 1996, 104)

In gardening and responding to plants we quickly learn that mistakes can be made, but they can be rectified and the garden will still flourish (Sempik et al., 2005, 70). In our relationship with plants, they feel forgiving in, for example, their ability to revive from neglect with just a bit of care or to push up new shoots even when all the visible leaves

have been damaged by frost. Mistakes made in gardening feel like being guided rather than chastised. The garden space invites relaxation, or at least freedom from anxiety, and this, along with seeing the value of observing and listening (tuning in to what is needed) is the very set of skills that help with positive social interactions. It seems that establishing a relationship with plants models what then becomes possible with other people.

Metaphor

The transition from relating with plants to relating with people introduces a further aspect of the gardening context: it is rich in metaphor. Much of our language in general, including for health and for psychological processes, utilizes words related to plants and gardening tasks (Brook, 2010a, 19). Words such as: growing, flourishing, wilting, tending, pruning, weeding, germinating, seeding, budding, fruiting, branching, new shoots, rooting, digging, reaping, and dormancy, all seep out into areas beyond the plant/garden context and capture aspects of human activity or states of being. Our language seems purposely built to facilitate a translation of plant activity to more general human reflection on life in general. Thus, the helpful connections that participants make between their plants flourishing and how they are feeling (Hall & Knuth, 2019a, 34) is reinforced because thought/reflection uses these words that can speak both of the plant and the person. As an early paper in this area expressed it:

> Issues of germination and birth, of nurturance and caretaking, of unexpected reversal, traumas, loss are just a few of the powerful existential dramas that can be played out in parallel fashion in both human and plant worlds. Horticultural therapy often provides the patient with an opportunity for a microcosmic re-enactment in the world of plants of the kinds of struggles he or she is experiencing in everyday life.
>
> (Stamm & Barber, 1978, 12)

In horticultural therapy, tasks can be suggested that in some way speak to a participant's issues, and the metaphor inherent in this forms a bridge to being able to address the issue (Neuberger, 1990). Even negative aspects, such as death and decay, in gardening come in manageable forms that allow what Clatworthy et al. call, 'benign contact' with those issues, making them easier to address (Clatworthy et al., 2013, 216). We can weed out unhelpful thoughts, plant seeds of hope, branch out into a new activity, dig deep to get to the root of a problem, nourish our soil to find new strength and harvest the benefits.

The plant to human metaphor is often expressed when participants run together the cycles of nature and their own lives. The seasons of the garden relate easily to life stages and aging is seen as just part of nature. Something that resonates particularly with participants in horticultural therapy is a sense of hope that new growth brings

(Smith-Carrier et al., 2019). Expressions about the weather and moods combine; a cloudy day can be seen as just a passing thing and tomorrow will be brighter, or the snow covering the soil can be seen as protecting what will emerge in the spring. Nature, and particularly plant life, gives a sense of vitality and renewal that seems to refresh and enliven us. It also demonstrates the resilience that participants want to cultivate in themselves.

When trying to get at what is happening when a human is responding to a plant, there does seem to be a kind of mirroring that is taking place. What I mean by mirroring is some kind of expression or recognition of a quality of a plant that touches us. This is a difficult thought to raise because it could so easily spill over into an obscuring anthropomorphizing (Ryan, 2020, 104), where we attribute to a plant a human trait because of some appearance or action. However, there do seem to be occasions where engaging with plants, whether through their beauty or vulnerability, opens us up to a recognition of something in ourselves. The curled fronds of a fern speak to us of closeness, of love even. We connect to the plant *as if* there is some fellow feeling. The resemblance, the mirror, has brought us up sharply to recall closeness, being nurtured, a seedling pushing up through the soil can fill us with hope or adventure, and a towering redwood suggests soaring. Mirroring can be emotionally negative as well, such as encountering a plant wilting through lack of moisture or eaten away and seeing in this a personal problem or regret. However, in my experience of this mirroring phenomenon, negative feelings are less common than, for example, the impact of a humorous or touching similarity. That similarity might be to foolhardiness, persistence, opportunistic cheekiness, and so on, and it just lightens the day through making an imaginative connection.

Perhaps, as in mirroring other people, our mirror neurons (Rizzolatti, 2009) take on the feel of the form that a plant is making and it resonates with us such that we feel as we would if we were making that gesture. Mirroring the form of the plant recalls to us somatically that, for example, caring or soaring exists and we get a taste of what that would feel like.

Beauty

Participants in therapy situations or those just reporting finding relaxation or solace in their gardens speak of the beauty of nature, particularly, flowers. The classical beauty of flowers seems to shape the light and space around them and shift the mood of the day. They give pause to our gardening activity as we drink in their colour and form or perfume.

The role of beauty is clear in an interesting study, which focused on the impact on stress levels through the intervention of providing planted containers for the tiny paved front areas of houses in a socially deprived neighbourhood. Here gardening as activity was minimal as the planted containers were put in place by the researchers, but the

impact on participants was impressive. One of the responses is used in the title of the paper 'It made me feel brighter in myself' (Chalmin-Pui et al., 2021). The intervention did help with managing stress (as measured by saliva cortisol patterns), but it is striking to see how little beauty is needed to shift moods or give a sense of pride and motivate people to improve their conditions. As the researchers report:

> All residents reported that they feel more cheerful and lifted their emotions when viewing them. They talked about better moods upon leaving/returning to the house. Though experienced by all, qualitative assessment of emotional intensity during interviews suggested that this was most acutely appreciated by people struggling with poor mental health.

And they go on to anonymously quote a participant:

> 'It's lovely. It really cheers me up […] I love nature, and I see so little of it. So every time I get out of the house, I get a little wave of pride. It gives me a lift, a little swing in my step. Every time'.
>
> Female, 51 (Chalmin-Pui et al., 2021, 7)

With the aspect of beauty it is easy to be drawn straight to the visual aesthetic—the thing that strikes us immediately—but the other senses are also quietly enriched in the garden.

Aesthetics (as the root term aesthesis suggests) involves all the senses and in the aesthetics of the everyday the less obvious sources of rich aesthetic experience are recognized as important resources in our experiential life (Saito, 2020). The garden is a place that invites a full immersion into sensory experience. The feel of the soil was mentioned above, but the various textures of leaves, from furry to glossily smooth, invite touch, as does the comforting feel of handling well-worn tools. The feel in the hand of a simple tool that extends one's ability to dig or prune or rake fallen leaves is satisfying and empowering. There is a fittingness between tool and hand, and between tool in action and task that brings pleasure.

Working in the garden—as opposed to just viewing it—has the health benefit of physical exercise, but digging deeper into the kinaesthetic experience, we can relish the calming nature and particular pleasure of repeated purposeful movement. We can even relish the satisfying sensation of tired muscles after doing such work. Garden tasks have variety as well, from heavy digging to the delicate motor control needed for handling seedlings. Here we need a delicacy of touch as we tuck the intricate roots of these tiny plants into a fine soil. Such tasks move us into the fine motor movements that make up this skilled and caring work.

The perfume of flowers and the volatile oils in herb leaves can be experienced intimately as we breathe in these fragrances while moving around the garden. Such smells invite us to pause and take in more of what is happening in nature. Beyond the obviously beautiful smells we can also develop an appreciation of the pungency of leaf mould or well-made compost. The role of smell in reminiscence is well recognized and garden

smells have been found to trigger 'the recall of pleasant memories' (Smith-Carrier et al., 2019, 12).

Something that is often valued in gardens is the absence of sound, such as traffic noise (Stevens, 2018, 7). However, what starts as an absence soon becomes an awareness of the presence of other sounds: birdsong, insects, water, the scrape of a hoe, the sound of a garden fork striking a rock under the soil. Once noticed, these sounds become louder and more informative. We tune in to them and they become distinguishable, but also woven into the garden experience. In a study of the way gardens became a refuge, an oasis, for many during the COVID-19 lockdowns, participants describe how they had become more attentive to nature and as one put it 'the birds felt louder' (Marsh et al., 2021, 4). This study also noted a shift in attitudes to the garden. Its role as sanctuary in troubling times prompted a newly found or intensified gratitude. There was also a greater relaxation about maintenance, preferring a more contemplative approach. As the researchers put it: 'some gardeners in our study felt they had been re/acquainted with life's "essence", or with that which was felt to be of fundamental importance, during COVID-19' (Marsh et al., 2021, 4).

Unselfing

The way gardens and working in gardens can shift a mood is readily experienced and this is often reported in terms of taking one out of oneself. Everyday concerns drop away through absorption in nature and the task at hand. As we saw above, the focus on other senses that the garden context invokes is a way to stop self-critical or depressing thoughts, even to stop the intrusive voices that figure in some mental illness (Sempik et al., 2005, 87). This aspect of moving away from self-absorbed thoughts into activity is aided by the plants themselves and goes beyond momentary distraction. Participants (and gardeners in general) report a shift in their attitude or outlook on life. It includes, for example, the growing awareness that with plants you can't dictate your own desires and you need to listen and respond to what the plant needs (Brook, 2010a, 22). As one participant said:

> You can't force things. The best thing you can do is deeply understand what things are going to do naturally, because everything is going to act in its own best interest whether it's a plant a person or a cat. (Quoted in Ramirez-Andreotta et al., 2019, 4)

Charles Lewis captures this sentiment well when he says: 'Gardening teaches us that we cannot always have our own way and yet allows us to feel good about that reality' (Lewis, 1996, 8). To garden is to be involved in positive mental states or habits of mind such as trust, hope, care, and even reverence. We are not in control and yet we collaborate with nature to bring something about; some change for the better (Cooper, 2006, 95).

There is in gardening an easy entrance to a deeper sense of reality—the world outside of oneself is made clearer. This might be through the need for care, as we notice a plant needing water or through more classically aesthetic experiences such as beauty. Iris Murdoch speaks of this impact of beauty as an 'unselfing', where our usual consciousness, wrapped up in our self, drops away and there is only the beauty: in her example, a hovering kestrel (Murdoch, 2001, 82). In the garden, beauty and wonder can create this movement from self to world. For Murdoch, this shift is where the reality of the world breaks through. This decentering allows us to make a connection and even dissolve the notion of connection as a joining of two separate things. We step beyond the illusion of our habitual dualistic mindset. To give a personal example, I am reminded of one day in the heat of the Greek summer, where I encountered the climbing plant Morning Glory (*Ipomoea purpurea*) covered in papery thin flowers of a delicate but iridescent blue. The shimmering blue offered the vivid beauty of the sky but nestled in a dark refreshing nest of green. It was hard to look away, and for a space in time there was just the plant and a receiving of its beauty. Beauty breaks open the shell of self, there is no 'I' responding to something, it just is, and whatever 'I' means is swept up as part of what is. Strong experiences of unselfing are often connected to the aesthetic experience of awe: usually associated with natural phenomena of great size or power, but, as illustrated by the Morning Glory example, this is not always the case.

In aesthetics, beauty is often aligned with pleasure and the sublime with awe. Both can bring a certain decentering of the self, but a sense of awe is usually considered even more powerful in stripping away the ego and enhancing a sense of connection to something greater. Experience of the sublime is often triggered by vastness and can have an edge of fear. Nature is full of opportunities for awe, from the vastness of a starry sky, the thunder of a huge waterfall or towering peaks. For plant-generated awe, we usually think of large or ancient trees. With awe comes a recognition of one's smallness, one's insignificance in the face of reality and with that the diminishment of the problems that had previously seemed overwhelming (Piff et al., 2015, 884). Awe experiences are also strongly correlated with openness, prosociality and generosity (Piff et al., 2015; Zhang et al., 2013) which takes us back again to the way social connection, as a positive aspect of mental health, can be tied to access to nature.

A Speculative Conclusion

Though anchored in the literature on therapeutic horticulture, the preceding explorations of gardening have also drawn from philosophical thinking and experiential work on the nature of gardening and particularly our relationship to plants. I have explored some of those instances where something of plant nature breaks through our ordinary consciousness, because this might shed some light on why plants have the effects that the well-being literature shows they have on anyone, in even the most unpromising situations, and with very little exposure. Something that runs through these occasions (of digging,

of stopping to listen, of finding that seeds have sprouted, or experiencing beauty, and of finding a mirror of our potential selves in a plant) is the way nature can bring a sense of connection. Moreover, as the unselfing idea suggests, the connection is not between me as subject and an 'other' but more like a consubstantiality: a sharing of the fabric of being, the flesh of the world as Merleau-Ponty expresses it (Merleau-Ponty, 1968, 139; Brook, 2005). The dissolving of an individual ego that is part of these encounters, particularly beauty, seems a necessary part of encountering that being. The plant realm, particularly as experienced through gardening, strikes me as an easy portal to be able to experience the fabric of the world as a shifting process and not a world of discrete objects in space. The occasions of surprise encounter give us a taste of this; our dualistic preconceptions are unseated and we are led to a different style of encounter. The meeting, or rather absorption into being, that the plant realm can trigger feels like something very old, some older cultural connection shaped from a very real primeval consubstantiality. This sense, however minimally glimpsed, that provides a freeing sensation dislodges us from other cares and worries and places us in a new and healthier relationship to the world, one that is stronger, more resilient, and closer to reality.

References

Alaimo, K., Beavers, A. W., Crawford, C., Snyder, E. H., & Litt, J. S. (2016). Amplifying health through community gardens: A framework for advancing multicomponent, behaviourally based neighbourhood interventions. *Current Environmental Health Reports 3*, 302–312. https://doi.org/10.1007/s40572-016-0105-0.

Appleton, J. (1990). *The symbolism of habitat*. University of Washington Press.

Baxter, D., & Pelletier, L. (2019). Is nature relatedness a basic human psychological need? A critical examination of the extant literature. *Canadian Psychology/Psychologie canadienne 60*(1), 21–34.

Bell-Williams, R., Irvine, K. N., Reeves, A., & Warberd, S. (2021). Digging deeper: Gardening as a way to develop non-human relationships through connection with Nature. *European Journal of Ecopsychology 7*, 1–18.

Besson, A. M. (2020). Aesthetics and affordances in a favourite place: On the interactional use of environments for restoration. *Environmental Values 29*(5), 557.

Brook, I. (2005). Can Merleau-Ponty's notion of 'flesh' inform or even transform environmental thinking. *Environmental Values 14*(3), 353–362.

Brook, I. (2010a). The virtues of gardening. In D. O'Brien (Ed.), *Gardening and philosophy* (pp.13–25). Wiley.

Brook, I. (2010b). The importance of nature, green spaces, and gardens in human wellbeing. *Ethics, Place and Environment 13*(3), 295–312.

Chalmin-Pui, L. S., Roe, J., Griffiths, A., Smyth, N., Heaton, T., Clayden, A., & Cameron, R. (2021). 'It made me feel brighter in myself' - The health and well-being impacts of a residential front garden horticultural intervention. *Landscape and Urban Planning 205*. https://doi.org/10.1016/j.landurbplan.2020.103958.

Chater, K. F. (2015). The smell of the soil'. *Microbiology Today*. May 2015. Available at: https://microbiologysociety.org/publication/past-issues/soil/article/the-smell-of-the-soil.html [last accessed 11 May 2023].

Clatworthy, J., Hinds, J., & Camic, P. (2013). Gardening as a mental health intervention: A review. *Mental Health Review Journal 18*(4), 214–225.

Cooper, D. E. (2006). *A philosophy of gardens*. Oxford University Press.

De Seixas, M., Williamson, D., Barker, G., & Vickerstaff, R. (2017). Horticultural therapy in a psychiatric in-patient setting. *British Journal of Psychiatry International 14*(4), 87–89.

De Vries, S., Verheij, R. A., Groenewegen, P. P., & Spreeuwenberg, P. (2003). Natural environments? An explanatory analysis of the relationship between greenspace and health. *Environment and Planning 35*(10), 1717–1731.

Elings, M. (2006). People–plant interaction. In J. Hassink & M. van Dijk (Eds.), *Farming for health* (pp. 43–55). Springer.

Hall, C., & Knuth, M. (2019a). An update of the literature supporting the well-being benefits of plants: A review of the emotional and mental health benefits of plants. *Journal of Environmental Horticulture 37*(1), 30–38.

Hall, C., & Knuth, M. (2019b). An update of the literature supporting the well-being benefits of plants: Part 2 physiological health benefits. *Journal of Environmental Horticulture 37*(2), 63–73.

Kaplan, R., & Kaplan, S. (1989). *The experience of nature: A psychological perspective*. Cambridge University Press.

Kaplan, R., & Kaplan, S. (2005). Preference, restoration, and meaningful action in the context of nearby nature. In P. F. Bartlett (Ed.), *Urban place: Reconnecting with the natural world* (pp. 271–298). MIT Press.

Kuo, F. E., & Sullivan, W. (2001). Aggression and violence in the inner city: Impacts of environment and mental fatigue. *Environment and Behaviour 33*(4), 543–571.

Leavell, M. A., Leiferman, J. A., Gascon, M., Braddick, F., Gonzalez, J. C., & Litt, J. S. (2019). Nature-based social prescribing in urban settings to improve social connectedness and mental well-being: A review. *Current Environmental Health Reports 6*(4), 297–308.

Lewis, C. (1996). *Green nature human nature: The meaning of plants in our lives*. University of Illinois Press.

Louv, R. (2005). *Last child in the woods: Saving our children from nature deficit disorder*. Algonquin Books.

Malberg Dyg, P. M., Christensen, S., & Peterson, C. J. (2019). Community gardens and wellbeing amongst vulnerable populations: A thematic review. *Health Promotion International 35*(4), 790–803. https://doi.org/10.1093/heapro/daz067.

Marsh, P. O., Dieckmann, L., Egerer, M., Lin, B., Ossola, A., & Kingley, J. (2021). Where birds felt louder: The garden as a refuge during COVID-19. *Wellbeing Space and Society 2*, 302–312. https://doi.org/10.1016/j.wss.2021.100055.

Merleau-Ponty, M. (1968). *The visible and the invisible*. Claude Lefort (editor), Alphonso Lingus (translator). Northwestern University Press.

Murdoch, I. (2001). *The sovereignty of the good*. Routledge.

Neuberger, K. (1990). Horticultural therapy in a psychiatric hospital: Picking the fruit. In D. Relf (Ed.), *The role of horticulture in human well-being and social development* (pp. 185–188). Timber Press.

Orians, G. (1986). An ecological and evolutionary approach to landscape aesthetics. In E. Penning-Roswell & D. Lowenthal (Eds.), *Landscape meaning and values* (pp. 3–25). Allen and Unwin.

Piff, P., Dietze, P., Feinberg, M., Stancato, D. M., & Keltner, D. (2015). Awe, the small self, and prosocial behaviour. *Journal of Personality and Social Psychology 108*(6), 883–899.

Ramirez-Andreotta, D., Tapper, A., Clough, D., Carrera, J. S., & Sandhaus, S. (2019). Understanding the intrinsic and extrinsic motivations associated with community gardening to improve environmental public health prevention and intervention. *International Journal of Environmental Research and Public Health 16*(3). https://doi.org/10.3390/ijerph16030494.

Richardson, M., Passmore, H-A., Lumber, R., Thomas, R., & Hunt, A. (2021). Moments, not minutes: The nature-wellbeing relationship. *International Journal of Wellbeing 11*(1), 8–33.

Rizzolatti, G., Fabbri-Destro, M., & Cattaneo, L. (2009). Mirror neurons and their clinical relevance. *Nature Clinical Practice Neurology 5*(1), 24–35. https://doi.org/10.1038/ncpneuro0990.

Ryan, J. C. (2020). Writing the lives of plants: Phytography and the botanical imagination. *Auto/biography Studies 35*(1), 97–122.

Saito, Y. (2020). *Aesthetics of the familiar: Everyday life and worldmaking*. Oxford University Press.

Scott, T. L., Masser, B. M., & Pachana, N. A. (2014). Exploring the health and wellbeing benefits of gardening for older adults. *Aging & Society 35*(10), 2176–2200. https://doi.org/10.1017/S0144686X14000865.

Smith-Carrier, T. A., Béres, L., Johnson, K., Blake, C., & Howard, J. (2019). Digging into the experiences of therapeutic gardening for people with dementia: An interpretative phenomenological analysis. *Dementia 20*(1). https://doi.org/10.1177/1471301219869121.

Sempik, J., Aldridge, J., & Becker, S. (2005). *Health, well-being and social inclusion*. The Policy Press.

Sempik, J., Rickhuss, K., & Beeston, A. (2013). The effects of social and therapeutic horticulture on aspects of social behaviour. *British Journal of Occupational Therapy 77*(6), 313–319.

Soga, M., Gaston, K., & Yamura, Y. (2017). Gardening is beneficial for health: A meta-analysis. *Preventative Medicine Reports 5*, 92–99.

Spano, G., D'Este, M., Giannico, V., Carrus, G., Elia, M., Lafortezza, R., Panno, A., & Sanesi, G. (2020). Are community gardening and horticultural interventions beneficial for psychosocial well-being? A meta-analysis. *International Journal of Environmental Research and Public Health 17*, 3584. https://doi.org/10.3390/ijerph17103584.

Stamm, I., & Barber, A. (1978). The nature of change in horticultural therapy. Presented at the National Council for Therapy and Rehabilitation through Horticulture, Topeka, Kansas, September 1978 (quoted in Lewis, 2006).

Stevens, P. (2018). A hypnosis framing of therapeutic horticulture for mental health rehabilitation. *The Humanistic Psychologist 46*(3), 258–273. https://doi.org/10.1037/hum0000093.

Sullivan, W. (2005). Forest, savannah, city: Evolutionary landscapes and human functioning. In P. F. Bartlett (Ed.), *Urban place: Reconnecting with the natural world* (pp. 237–252). MIT Press.

Theodouro, A., Panno, A., Carrus, G., Carbone, G. A., Massullo, C., & Imperatori, C. (2021). Stay home, stay safe, stay green: The role of gardening activities on mental health during the Covid-19 home confinement. *Urban Forestry and Urban Greening 61*. https://doi.org/10.1016/j.ufug.2021.127091.

Ulrich, R. S. (1984). View through a window may influence recovery from surgery. *Science 224*, 420–421. https://doi.org/10.1126/science.6143402.

Ulrich, R. S., Simons, R. F., Losito, B. D., Fiorito, E., Miles, M. A., & Zelson, M. (1991). Stress recovery during exposure to natural environments. *Journal of Environmental Psychology 11*(1), 201–230.

Vedder, A., Smigielski, E., Gutyrchik, Y., Bao, Y., Bautzik, J., Pöppel, E., Zaytsera, Y., & Russell, E. (2015). Neurofunctional correlates of environmental cognition: An fMRI study with images from episodic memory. *Plos One 10*(4). https://doi.org/10.1371/journal.pone.0122470.

Williams, F. (2018). *The nature fix: Why nature makes us happier, healthier, and more creative.* W.W. Norton Company.

Wilson, E. O. (1993). Biophilia and the conservation ethic. In S. Kellert & E. O. Wilson (Eds.), *The biophilia hypothesis* (pp. 31–40). Shearwater Books.

Zhang, J. W., Piff, P. K., Iyer, R., Koleva, S., & Keltner, D. (2013). An occasion for unselfing: Beautiful nature leads to prosociality. *Journal of Environmental Psychology 37*, 61–72.

CHAPTER 15

AESTHETIC CHOICE IN THE AGE OF ECOLOGICAL AWARENESS

SANNA LEHTINEN

Introduction

It has become especially clear in recent years that grave ecological concerns are increasingly present in areas of life where they have previously been considered largely absent. Following the twenty-sixth UN Climate Change Conference in November 2021 and a recent report of the Intergovernmental Panel on Climate Change (IPCC) published in February 2022, the message is clear and alarming: human-generated climate change has proceeded so far that the window for mitigation activity will close soon and the focus should already be diverted to adaptation. As the report formulates, the 'impacts, adaptation, and vulnerability' are being discussed and negotiated now and even more in the future and this will inevitably require a shift in mindset focused on halting global warming altogether. The language is clear even to the broader audience: the scientific discourse on climate change has turned from proving the existence of the phenomenon to solving how the consequences of an inescapable change can be alleviated or at least mitigated. This is a significant turn and marks the beginning of an era of painful choices between two or more options of which none are necessarily ideal.

The connections between aesthetics and global climate crisis (GCC), as a grave example of the broader set of environmental crises, have been studied recently in more specialized strands of philosophical and applied aesthetics. Environmental aesthetics in particular has approached GCC as an overarching phenomenon that is causing significant changes in the aesthetic perception and values of different types of environments (Brady, 2014, 2022; Auer, 2019; Nomikos, 2018). Natural environments in particular have received attention, although the deeply entrenched human influence is also taken into consideration as the idiosyncrasies of hybrid environments become even clearer with

the changing conditions (Di Paola & Ciccarelli, 2022). The negative impacts of GCC are often difficult to fully assess, especially when intangible cultural heritage and values are at stake. Anthropogenic environmental change affects people and cultures both in direct and indirect ways, for example when people need to relocate from areas when their livelihoods disappear due to changing climate. In the context of the UN climate work, the concept of non-economic loss and damage (NELD) is useful for assessing the destruction of cultural values at large and also aesthetic values in particular as part of what gets lost (Light, 2018).

In addition to clear consequences to environmental aesthetic perception, in the area of everyday aesthetics, as well, ecological and climate awareness has been proven to cause serious re-evaluation of many longstanding aesthetic values and preferences, such as ideas about beauty, the sublime, and the differences in perceiving perfection or imperfection (Saito, 2017). Everyday aesthetics is in fact a crucial area for expressions of climate awareness as it is directly linked to consumer culture and behaviour but also to mass production which not only directs individual choices but in addition amplifies them into large volumes that have traceable impacts on ecosystems of different scale. What is termed here 'ecological awareness' refers to the omnipresent realization that actions have indirect consequences much beyond the perceivable and direct effects. Mitigation of risks and evaluation and anticipation of damage are applied as main strategies when managing the consequences of a large-scale phenomenon such as the GCC. Scenarios rising from various forms of risk thinking are present as the first reaction to imminently looming change which is beyond human control. In this discourse, it is difficult to situate the sphere of human judgements, preferences, and choices as it seems all too subjective, impulsive to anticipate, and insignificant for the bigger picture.

There are still areas which need further discussion when trying to understand how GCC and negative human-inflicted environmental change more broadly are linked to aesthetics. First of all, the discussion is prevalently human-centred, but concerns and questions requiring a multispecies approach in aesthetics will also be exceedingly relevant in the future. That is, we must ask how we relate to other species. What can we know of the preferences of other species? To what extent do these preferences have an aesthetic component in them? Animal studies are increasingly proving that there exists complex cognition in animal species that have previously been considered to function based on instincts. The ongoing paradigm shift in the humanities towards a vibrant posthuman landscape portrays these scientific developments and departs from the assumption that the human species would be the indisputable centre of attention and action on our planet. Aesthetics as a markedly human-focused field has various ways in which to take into account these transitions which essentially make understanding the aesthetic dimension of the particularly human existence even more interesting and relevant. Human aesthetics is a way of discussing relevant questions but it also definitely affects other living species. The focus of this chapter is on consumerism at large, but the idea is to show also how it is part of a larger human-oriented network of climate-change-enabling activity.

Linked to the broad introduction to the current theme of environmental change and aesthetics, the main research questions of this chapter are (1) how do we make aesthetic choices in complex contemporary everyday situations? And (2) how is the necessity of making these aesthetic choices affecting the mental well-being of an individual? These questions of course spread broadly and cannot be conclusively answered by the sole perspective of philosophical aesthetics. However, as I intend to show, some critical insight can be gained if aesthetic preferences are treated as based on aesthetic values that are interlinked with the strong ethical consciousness that is explicit in the form of heightened environmental awareness.

Aesthetics in Support of Cultures of Excess

Advancing sustainable lifestyles has been one strand of strategies among the means to combat grave and interconnected environmental and ecological problems such as GCC and biodiversity loss. There are, however, increasingly doubts about the limits to the usefulness of this approach that directly addresses lifestyles and the choices within the reach of an individual person (Böhme et al., 2022). Simply grasping the phenomenon can seem an insurmountable task: we are deranged in our inability to act in the current moment, perplexed and unable to see the consequences that inaction will bring as well (Ghosh, 2016). Yet we are continuously required to make decisions based on knowledge that we do not have yet and information that we do not have access to.

Aesthetic values behind choices are also culturally conditioned and, as such, reflect the overall ethos of the economic system and what is portrayed as favourable consumer behaviour. In the following sections, I distinguish and briefly introduce three significantly *aesthetic* phenomena that are behind some of the self-perpetuating and vicious cycles of aesthetic choices in favour of unecological (over)consumption.

Fascination with the New

It is easy to recognize the curiosity and excitement that encountering new things and people in favourable circumstances arouses in ourselves. The freshness of new impressions and simply drawing our attention by previously unknown perceptual cues can at least momentarily fill us with a tingling aesthetic excitement. Whether the ability to experience this type of fascination towards the new is an innate property of the human species is out of the reach of this chapter. However, it is clearly a shared and very common phenomenon that drives human activity in many instances. By acknowledging this, I would wish to open space for discussion which would take value of the new

into consideration particularly linked to everyday aesthetic choices and the cultural connotations behind them.

A famous description of this important facet of the human experience linked to the sphere of the everyday comes from the poet, literary critic, and philosopher Samuel Taylor Coleridge's description of the life and literary endeavours of the English Romantic poet William Wordsworth in his *Biographia Literaria* (1817). According to Coleridge,

> Mr. Wordsworth […] was to propose to himself as his object, to give the charm of novelty to things of every day, and to excite a feeling analogous to the supernatural, by awakening the mind's attention from the lethargy of custom, and directing it to the loveliness and the wonders of the world before us; an inexhaustible treasure, but for which in consequence of the film of familiarity and selfish solicitude we have eyes, yet see not, ears that hear not, and hearts that neither feel nor understand.
>
> (Coleridge, 2004 [1817], chapter XIV)

The passage describes the titillating sensation of fascination towards the new, in which the aesthetic attention is drawn by previously unknown and strange elements instead or in addition of the known and familiar aspects of everyday life.[1]

Showing how the aesthetic dimension is present both in the sense of the familiar and the new underlines the overall presence and role of aesthetic experiences in everyday life. The field of psychology has developed further since the hierarchy of needs was introduced by Abraham Maslow in 1943. The famous and also much criticized hierarchy can, however, be at least tentatively used to describe the role of aesthetic values in human internal life and motivation. In common talk, aesthetics is often considered to be a sort of 'cherry on top' value, something that you focus on and can afford to pay attention to when everything else has been taken care of and sorted out: functional, economic, ecological, as well as social values thus gain precedence. Looking closer to recent developments in the fields such as everyday or evolutionary aesthetics, however, it becomes clear that the role of aesthetic interest and appreciation plays much more fundamental role in the internal and intersubjective lives and well-being of humans and are thus present in most stages of human needs, from the more primordial to the most complex ones.

The Diderot Effect

The Diderot effect is a term coined to explain an interesting cultural and social phenomenon of how people's purchases do not directly follow from the functional or practical features of the item in question but are also based on their overall aesthetic appeal and, in particular, their relational aesthetic qualities: how they appear as related to the appearance and aesthetic value of other things. As such, the process describes 'a coercive force' that affects the consumption pattern of an individual (McCracken, 1988, 118). The name and first description of the phenomenon comes from the philosopher of the

Enlightenment era Denis Diderot, who in his 'Regrets on Parting with My Old Dressing Gown' (1772) describes a transformation which a new item, a gift from a friend, sets in motion in his perception of his other worldly possessions (Diderot, 2016 [1772]): the beautiful new gown makes everything else in Diderot's home look dowdy, unappealing, and 'not quite up to standard' (McCracken, 1988, 119).

While the Diderot effect has been studied from behavioural perspectives to develop marketing practices, it also has value for philosophical aesthetics. It refers to the situation when something new makes everything else in its close vicinity (e.g., the context of the home environment) seem of lesser or negative aesthetic value, worn-out, and pushes the consumer to purchase yet again new products that better complement the overall aesthetic character of the newest purchased thing. The phenomenon should be of significant interest to aesthetic theory and practice, especially with the ecological emphasis that is studied both in environmental as well as everyday aesthetics. The Diderot effect manages to explicate a side of human behaviour which is highly influential in the contemporary culture of spiralling consumption and directly linked to fascination with the new.

The Diderot effect is used also in a suspicious way to *nudge* people towards purchasing things they do not actually need. Nudge and nudging have been introduced as concepts in the field of behavioural economics to describe how people are influenced to make desired choices and it can also be used to explicate purposeful change in aesthetic values to some extent (Lehtinen, 2021). Both the Diderot effect and especially the concept of the nudge underline the fact that aesthetic choices can be manipulated and their link to other values thus obscured. In Diderot's original account, the feeling of regret is central: acquiring new items in a rush does not lead to satisfaction but the old items are missed for their cosy familiarity (Scott, 2016). Mental well-being is thus at stake also with this account of a particular consumer habit. The Diderot effect discourages people from waiting to purchase a new product only as an older one needs to be either replaced or upgraded. The contemporary consumerist culture relies on the idea that new items replace existing ones in the cycles of consuming far before the older ones have ceased to function. Within the current system of production, this creates an unsustainable situation.

Planned Obsolescence

Planned obsolescence is a term used to describe how human-made products are designed in advance to have a limited lifespan, after which they become unusable and need to be replaced. Lifecycles of products are manipulated in order to create a need for new products. It is because once a part or a component would need to be changed, repair is not possible with the product in question. Instead, they become fully unusable and this habituates the user/consumer to a faster cycle of upgrading many of the everyday tools and technologies which often fall into this category. This is a serious problem for the usability of products but also has significant aesthetic repercussions. However, the

concept of planned obsolescence is of a different category in relation to aesthetic values than fascination with the new or the Diderot effect. It describes an artificial perpetuation of the consumerist cycle of styles and validates the urge to attain completely new.

In contrast, it is possible to facilitate gradual maintenance and take care of the material goods in the world around us. Increasing adaptability and facilitating repair through modularity, for example, are valid methods for adding flexibility and temporal longevity into designed products. This strategy also offers an emotionally and aesthetically important insight into the processes of valuing something for the sake of both its ecological and aesthetic qualities. If the consumer goods do not need to be replaced as often, but only changing parts of them would be enough for maintenance, one might afford to become more attached to the design object in question. As various circular economy models make clear, the methods for circulating materials should not lead to increasing the pace of the consumerist cycle, either. This goal requires a reconsidered and fine-tuned aesthetic awareness of what speaks to us aesthetically in the first place and secondly, whether the phenomenon in question is ecologically sound. The right-to-repair movement, for example, focuses attention towards maintainability and has gained traction and needed transnational regulation in recent years. Although shortening and manipulation of lifecycles in general is a matter of design and business strategy, it shows how aesthetic value is intertwined with other values and often trends are created by these unnecessary updates. Aesthetics leaning on repair solutions thus makes care and maintenance visible and a moves away from trend-based aesthetics to facilitate value deliberation and decision-making is indeed possible.

The phenomena described earlier in this chapter are not to be understood only as consumerist aesthetic phenomena, but also culturally significant drivers for and signals of what is ultimately valued. What the phenomena of fascination of the new, the Diderot effect, and planned obsolescence describe is how aesthetic judgements and ensuing choices do not take place in a vacuum. The relationality of aesthetic values to temporally preceding values as well as to simultaneously existing aesthetic values is difficult to grasp with the concepts that have traditionally been at the focus of aesthetic theory, such as beauty, sublimity, and the like, because they are generally non-relational values and often carry strong associations with disinterestedness. However, when aesthetic values are related to future aesthetic values and to other types of values, such as functional, moral, and political, even if something familiar is not prone to provide the full-spectrum of appreciation and excitement that something fresh and new can optimally provide, it offers a rich aesthetic experience.

The aim so far has been to point out that aesthetically informed choices are relational to other choices to a significant degree and that this has to be taken into consideration when estimating the overall toll for an individual's mental well-being. Aesthetically informed choices are preceded by an accumulation of previous choices and influenced by the changing context. It is clear that this is true in the realm of everyday choices, and not only when making art- or culture-related choices. The account of the consumerist aesthetic phenomena consists both of deeply ingrained subjective, internalized patterns of behaviour as well as particular features of the capitalist system of production. These

need to be discussed together in order to grasp the full picture of why certain things seem more lucrative than others and what is the role of aesthetic value in these consumption choices.

As a summary, these three aforementioned factors converge today to promote rampant consumerism that not only leads to environmental problems but also compromises human well-being. That is, we are never satisfied because we are caught in a perpetual cycle of buying more and more things, newer things, and we are deprived of an opportunity of developing and nurturing a long-lasting relationship with the things we have. This all has significant impact on the quality of one's life. It is of crucial importance to recognize that the environmental problems consumerism creates are not only a problem for the environment but a problem for our sense of well-being and quality of life. These negative effects of consumerism help in pointing out why our aesthetic scope should be broadened (Saito, 2018). This should also be one important driver for motivating large-scale changes in the system of production.

Broadening the Scope of Aesthetic Evaluation

Shared cultural norms and customs are strongly linked to what is considered aesthetically appealing in each epoch of time. Patterns of behaviour around beauty and aesthetic appreciation are part of a socially formed culture, with long-rooted traditions often supporting the ways of doing and appreciating. Breaking away from these patterns is not easy or even possible for an individual, whose sphere of action and perception is defined by the very culture in which they operate. What there is to be perceived and experienced in the first place is produced by a long continuation of cultural processes. The ongoing paradigm shift from human-centred, production-oriented perspective to a more dispersed, ecology-driven worldview requires challenging the underlying conceptions and the role of aesthetic values in the process.

I will describe next some of the less studied phenomena and factors that affect aesthetic choices and are heavily linked to other values such as functional, economic, political, and ecological values besides aesthetic ones in the everyday decision-making processes. The given concepts do not necessarily function on the same register, but I claim that they are equally valuable to be taken into consideration in the increasingly complex evaluation processes into which contemporary life, especially in Western, consumerism-oriented societies, puts individuals.

Aesthetic Choice

Aesthetic choice has been already used in this chapter but will now be discussed in more depth. As a concept, it has been surprisingly little discussed in relation to everyday

aesthetics. Kevin Melchionne opens the discussion about the concept by linking it to cultural products and their consumption, although promisingly taking cues from contemporary choice theories (Melchionne, 2017). According to Melchionne, aesthetic choice signifies a 'capacity to direct attention to favourable aesthetic opportunities' (Melchionne, 2017, 283). Aesthetic choices entail complex value deliberations, especially in the context of everyday life. For example, an increasing amount of knowledge is required of the origins of materials, modes of production, and the overall sustainability of the whole item of issue at hand. This makes us not only choose between one or more options but seriously reconsider the need to make the choice at all. To a significant degree, eco-aware aesthetic choices can be associated with wealthy, consumerism-oriented societies. This context, however, does not allow taking the full extent of aesthetic choices into consideration.

According to Melchionne, aesthetic choices are the basis for a satisfying, 'fulfilling aesthetic life' (Melchionne, 2017, 287). He nonetheless describes them as having 'low stakes and relaxed deliberation' (2017, 285). This greatly undermines the underlying value dimension, especially when the aesthetic choices are made in the context of the everyday realm. Bridging aesthetic value with the ethical implications makes these seemingly low stake situations of choice striking representatives of the injustices of the world. By making an aesthetic (or aesthetically informed) choice in the context of the everyday, the subject not only follows one's preferences by either conforming or rewriting them but also shows significant agency by engaging in actively construing the sphere of one's life. Encouraging ethically grounded aesthetic choice is not meant as a stick approach but instead a more positive approach by empowering us consumers to exercise agency in fashioning our life that is ethically grounded. So, considering the environmental ramifications of our purchasing decisions is not a kind of punishment and deprivation but rather a positive empowerment, which should and could promote our mental well-being in a sustainable way. The opportunities are dependent on the overall circumstances and aesthetic choices linked to consumption are thus more prominent (and significant) in affluent and overconsuming societies.

Aesthetic Disillusionment

The phenomenon of *aesthetic disillusionment* describes a phenomenon in which aesthetic appreciation is changed with new knowledge about the object of appreciation. It acknowledges the moment when knowledge about the phenomenon starts to change our perception of it, and how the change takes place in the viewer, not in the object (Foster, 1992).[2] This sort of dampening of the experience is a pervasive part of the contemporary experience, in which most practices that were previously considered harmful have become intolerable because of their ecological unsustainability. The ongoing reevaluation of material practices, such as architectural design, is a good example of this 'shift in appreciative perception' (Foster, 1992, 205; Foster refers to John Dewey). For example, once we gain more knowledge of the unsustainability of concrete as a material,

we look at new concrete buildings with the awareness of this new insight and it starts eroding their aesthetic value for us.

Interestingly, aesthetic disillusionment is linked with the idea of the aesthetic footprint presented next. The idea of an aesthetic footprint points further towards taking into consideration the multiple, often conflicting, sets of information that punctuate our aesthetic experience and appreciation: aesthetic choices have far broader consequences than what has been traditionally taken into consideration within the scope of aesthetic theory. The awareness of the aesthetic footprint reflects back to aesthetic values and starts changing them.

Aesthetic Footprint

One further step in eroding the exceedingly problematic and directly harmful human–nature dichotomy, posthumanism in philosophical and ecological thought has questioned the status of the uniquely human subjective experience. This opens up the perspective to other species and even environmental phenomena as having full agencies of their own.[3] Philosopher Ossi Naukkarinen presents aesthetic footprint as a concept that is still tied to aesthetics as a particularly human mode of appreciative perception, yet describes well the fact that human choices have aesthetic consequences far beyond the perceived sphere of influence (Naukkarinen, 2011).

Aesthetic choices have environmental and aesthetic repercussions that reach beyond the geographical or temporal boundaries of the places in which the decisions are made. The aesthetic footprint described in this way entails both the positive as well as the negative aesthetic impacts of the aesthetic deed or choice. As an example of a negative aesthetic footprint, one can refer to the drastic change in landscapes with an increase in ecologically produced cotton which still impacts extensive areas of land for cultivation. A positive aesthetic footprint can refer to a piece of public art, which, despite a possible energy-consuming process of creation, is available to large numbers of urban dwellers and brings within their reach at least the possibility of aesthetically driven joy and positive experience. In more recent literature, the concept of the handprint has been proposed to describe the positive impacts in comparison with the negative impacts described by the footprint. The linguistics behind this choice of words is interesting as a foot takes place upon Earth, physically stomping things and destroying environments beyond recognition. The handprint, on the other hand, implies a more caring agency, a softer form of touch in reaching out to the world. Without going deeper into the different interpretation possibilities of the footprint metaphor here, it is important to recognize that in the developments of contemporary aesthetic thought the concept has served to broaden what is considered to be the breadth of the aesthetic impacts of any human activity. These types of considerations have so far been missing from aesthetic literature, which has focused on temporally more narrow notions such as judgement (especially since Kant) and experience (especially since Dewey).

To summarize, the aforementioned phenomena are central in the sphere of everyday aesthetics and found at the very core of everyday decision-making. Although behavioural explanations of aesthetics come predominantly from biology-originating fields such as evolutionary aesthetics, they have potential to bridge two notions of aesthetics: philosophical and value-oriented, and psycho-biological and behaviour-focused. To think that aesthetic choices always imply negotiating between different values has interesting, possibly even transformative, implications for aesthetics.

In this context, the opportunities provided by *transcultural* understanding of aesthetic values has proven important in challenging and stretching the fixated ideas of the Western cultural ethos, related to beauty, sublimity, and so on, that have dominated philosophical aesthetics. Japanese aesthetics, in particular, is already well-known globally for its emphasis on valuing signs of ageing and use in artefacts. According to this line of thinking, the aesthetic value of imperfection derives precisely from the time-relatedness of artefacts that can be perceived and felt in their use (Saito, 1997). The understanding of perfection and imperfection in the context of Japanese aesthetics could have broader relevance for our contemporary understanding of how expectations fluctuate and how they can be redirected according to ecological ramifications. Instead of putting emphasis on the specifically Western notions of beauty which often imply perfection, even more could be learned from non-Western and indigenous cultures and their different conceptualizations of the aesthetic dimension of human activity. Not only accepting but aesthetically appreciating imperfection and aging effect can help us accept our own imperfection and aging process, contributing to a well-adjusted life in our bodies and in this world.

Coping Strategies in the Face of Aesthetic Choices

Significant mental friction and dire confusion can take place in situations of decision making and value processing. When actively trying to make an informed decision, one oscillates between different types of values and tries to make sense of their often conflicting push and pull, pros and cons. Within the scope of everyday decision-making, the tension arrives, on the one hand, from aesthetically prevalent and, on the other hand, ethically and ecologically directed possibilities. What might appear first as the most appealing choice might show in a completely different light when ecological consequences are fully taken into consideration. This is a process that has already been described to some extent in philosophical and applied aesthetics, especially in the fields of environmental and everyday aesthetics (Saito, 2007; Naukkarinen, 2011) The birth of these fields in the very last years of the twentieth century itself is linked to the growing awareness and consciousness or the ecologically damaging nature of human activity.

There is some recent work which describes changes in aesthetics as a response to contemporary crises. Michael Dango's *Crisis Style: The Aesthetics of Repair* (2022), for example, acknowledges that aesthetic coping mechanisms play an important role in the extensive attempts to correct wrongs and redirect humanity to more sustainable paths. He distinguishes four different aesthetic strategies which reflect times of crises. The first two strategies are detoxing and filtering, linked to 'obsessive' attempt to curate the scope of choice to the bare essentials. The next two strategies are bingeing and ghosting, which refer to 'manic' attempts to repair recognition in the sense of manifesting attention (Dango, 2022, 41–42). The mere fact that Dango uses psychologically strongly determined vocabulary testifies to the need to make some sense of the increasing complexity of the aesthetic sphere, in which likes or dislikes are simply not enough anymore to found solid decisions and choices, let alone to repair the wrongs of the past. Dango also criticizes the idea that decisions are made with clear intentions and reminds us that the implicit imperative 'to act rationally and with self-awareness in this sense has become particularly problematic in our times when crises seem to follow one after the other' (Dango, 2022, 19).

The focus of this chapter is to make visible and bring attention to the mindsets that enable or hinder aesthetic deliberation in the first place. Assuming that mental friction exists in the push and pull of ecological and aesthetic values, the aim is to describe what reactions this situation leads to. Work such as Dango's can then be seen as a further elaboration of these reactions, taking the aesthetic realm into consideration. It also has to be acknowledged that the whole scope of value modalities, hierarchies, and decision-making has not been studied by the traditionally prevalent aesthetic perspective. Besides the aforementioned work on *aesthetic choice* by Melchionne in art and cultural consumption, how aesthetic choice is constitutive in everyday situations has gained less direct attention so far. Next, I will describe three ways to relate to the exceedingly complex landscape of everyday aesthetic decision-making. The formulations have been made with the intention to emphasize the role of mental load and friction. Also, these mindsets or stances describe a range of climate-awareness from passive to more active and engaged. Through a simplified presentation of some of the main strategies of dealing with mental friction created by ecological awareness, the aim is to point out the already existing modes of behaviour: ecological awareness generates responses, emotions, and paths to either act or to abstain from acting.

Nihilism

One solution in situations of conflicting values would be to resort to a certain form of nihilism. The complexity and overall difficulty of the ecological situation and the difficulty of changing the modes of production as well as the aesthetic norms affecting us provide enough causes for a strong counter reaction (Gertz, 2019). Aesthetically, nihilism becomes visible in the lack of care either for the conditions or the context of the sphere of the human aesthetics. The disappointment and neglect of ecological values might

present also in a form of conservative, backwards-leaning appreciation of more traditional forms of aesthetic culture such as the so-called high arts. The tension between current ecological problems and the traditionalist, even elitist values, could be a source of resourceful tactics (e.g., when vernacular tradition provides ecological alternatives for production) but with the nihilist perspective, this is not actively sought out or even acknowledged.

Nihilism provides a mindset of closing oneself off from the ecological news and moral imperatives and puts forward scepticism about values and the possibility of making morally valid choices. In this sense, nihilism denies that the aesthetic dimension of human life could have any worthwhile connection to other human values and focuses only on the surface aesthetic values, if even those. Looking further into the manners in which nihilism gets manifested in relation to aesthetics is an interesting area of study, the links of which to ecological concerns are clear.

Ecoanxiety

Another direction is here described through a pervasive form of ecoanxiety as the distress that one suffers from at the time of increased awareness of environmental conflicts and crises (Pihkala, 2020). Anxiety can stifle and paralyze in the moments of decision-making or can start creating aversion towards any choices that might be aesthetically lucrative in less stressful situations. This can lead to withdrawal from moments of decision-making and discomfort in the face of decisions which have only bad and worse consequences. Anxiety is a normal reaction to mental friction caused by the resistance to accepting that the whole framework for everyday decision-making has changed and that the new context does not offer simple solutions, either. The particularly ecological form and cause for anxiety recognizes the interdependency of human values and the condition of the life-sustaining processes on the Earth but also acknowledges the deep injustice and even absurdity of having to make choices in the unbalanced and aggravated ecological situation.

'The crisis of meaning' has 'aesthetic roots' and so far, as it turns into a form of ecoanxiety, can be at least alleviated by further reflection for example through the arts (Clingerman, 2018, 186). Art gives a space for reflection and introspection. It can provide strategies for cultural change, and, in some instances, it can even provide solace to support mental well-being. In comparison to nihilism as a direction, the sensitivity to frictions in values remains here, although the capacity to decide is significantly slowed or even fully hindered. This being the case, whether anxiety and further alleviating reflection turn into action and better choices remains uncertain.

Care

Central approaches in care ethics have been recently applied to the sphere of human aesthetic interests and values (Saito, 2020, 2022; Lehtinen, 2020). Particularly the

perspectives originating from feminist ethics to caring, maintaining, and sustaining life and material processes direct attention to practices and attitudes that enable an active engagement with the changes in the physical world. The mere general idea, that actions and choices are context-dependent and relational, has significant implications for aesthetic theory. This fits the larger scheme of complex sustainability issues, in which choices have to be reflected also through their long-term and indirect consequences to the environment. The notion of care underlines the dispersion of attention and acknowledges that choices are always made in complex networks of interdependencies. Although care is necessarily care towards something, the power relations are less central than in the traditional approaches to aesthetics in which judgement is central. Judgement implies always an ethos of assessment and comparison and this entails using power over that which is being aesthetically judged. Care allows for more nuanced positive aesthetic judgements, implies patience, and does not depend on a whim. Care implies that the one who cares also tries to flex their understanding towards the particular kind of aesthetic values that the object of attention and care stands for. The point of view of care aesthetics is thus more amenable to possible idiosyncrasies and attentive to nuances in the aesthetic realm.

Attitude of care towards the aesthetic dimensions of human decision-making are thus presented here as the third value modality. From an individual's point of view, this means, for example, recognizing the links between the aesthetic appearance and the ecological significance of objects. This implies a type of ecologically attuned 'aesthetic sensibility' that adjusts according to new knowledge or other changes in the context of the experience (Korpelainen, 2021). It has to be mentioned, that on the broader societal level, such as in the processes of political decision-making or governance, the care ethical perspective is still largely missing: the Western tradition of ethics has had a distinctive focus on obligations and responsibilities (Saito, 2020).

The three aforementioned ways, or coping mechanisms, of dealing with the growing pressures between ecological and aesthetic concerns and values are by no means exhaustive: the distinct mental friction can be conceptualized in other ways as well. In the context of this chapter, they have been conceptualized with the goal of offering tools for analysing different types of real-world situations. Further analysis of the commercially driven consumption culture could benefit from this type of analysis.

From the perspective of aesthetic appreciation, the coping mechanisms can be understood to derive from experiencing at times significant friction between values which are difficult to reconcile. As a manageable middle way, one must try to adopt an approach combining compromise and control in order to manage the friction in values. If beauty, and aesthetic pleasure in general, can be described as a sort of 'object of longing' (Sartwell, 2004), some type of active input is implied in relation to either reaching out to the object or abstaining from doing so. If the longing does not become fulfilled through aesthetic choices in consumption (as it would not become even without ecological awareness), then some other type of active stance is required. The three described directions can be understood as different types of coping mechanisms, or more reflexive strategies, as a response to the increasing complexity of what to long for and why.

We are not participating only in an 'imaginative failure' (Ghosh, 2016) but also a failure in the value deliberation processes facilitated by the loss of sensible directions. 'Staying with the trouble' as Donna Haraway (2016) evocatively suggests is possible through an engaged, empathetic relationship with the eroding matter and organisms which need to be shielded by our daily choices. These choices, no matter how insignificant they might seem, either reinforce or oppose the existing valuescapes. The attitude and worldview of care, for example, implies that long-term effects of choices are taken into consideration, thus placing first the processual nature of any form of human aesthetic meaning-making and value process.

Conclusions

The perspectives presented in this chapter highlight some links between everyday aesthetics and climate awareness. The focus has been on everyday aesthetic decision-making and change in aesthetic values. How aesthetic choices reflect the friction in values is a relatively new area for research, so the aim has been to preliminarily bring forth concepts that would be valuable for further discussion. In the scope of this contribution, it has been possible to show tentatively how aesthetic choices are linked to broadly ethical and, more precisely, ecological considerations. The idea has been to show also how ecological concerns form a distinct set of questions that need to be addressed separately from the overarching ethical framework; as with GCC and biodiversity loss, the scale of ongoing and potential damage is taking place on a planetary scale.

It has been in the scope of this chapter to show how ecologically aware attitudes can and do have an effect on aesthetic or aesthetically affected choices. There is enough reason to believe that this is an increasingly shared experience and a predisposition of the current and future generations of humans. It remains to be seen what types of new coping strategies can be distinguished in the future as new knowledge is gained.

One of the main arguments of the chapter has been that climate awareness often culminates in moments of everyday decision-making and aesthetic choices between two or more options. These situations put a serious strain on mental well-being as the awareness of the negative ecological consequences of the necessary choices is continuously increasing. It has become clear that mere positive thinking and promise of hope does not protect humans from the hard decisions. The broader underlying question is: what is the role of human aesthetic appreciation and preferences in facing grave global environmental complexities, and to what extent does aesthetics even matter? This chapter has been based on the strong conviction that aesthetics not only matters on the subjective level of well-being but that it also plays a crucial role in solving some of the inevitable tensions between awareness of the ecological crises and the necessity of making choices on a daily basis.

Notes

1. For an account based on Martin Heidegger's philosophy on this distinction between familiarity and strangeness, see Haapala (2005).
2. Cheryl Foster bases her account on Immanuel Kant's famous passage about listening to birdsong which is revealed to be performed by a boy instead of a bird.
3. Exemplified by the *Embassy of the North Sea* project that aims to give direct political representation to the sea and all its species and representatives, inspired by the philosophy of Bruno Latour. See www.embassyofthenorthsea.com [last accessed 4 October 2024].

References

Auer, M. (2019). Environmental aesthetics in the age of climate change. *Sustainability 11* (18), 1–12.

Böhme, J., Walsh, Z., & Wamsler, C. (2022). Sustainable lifestyles: Towards a relational approach. *Sustainability Science 17*, 2063–2076. https://doi.org/10.1007/s11625-022-01117-y.

Brady, E. (2014). Aesthetic value, ethics and climate change. *Environmental Values 23* (5), 551–570.

Brady, E. (2022). Global climate change and aesthetics. *Environmental Values 31* (1), 27–46.

Clingerman, F. J. (2018). Conclusion: The aesthetic roots of environmental amnesia: The work of art and the imagination of place. In S. Bergmann & F. J. Clingerman (Eds.), *Arts, religion, and the environment: Exploring nature's texture* (pp. 186–212). Brill.

Coleridge, S. T. (2004 [1817]). *Biographia Literaria*. Available from: www.gutenberg.org/files/6081/6081-h/6081-h.htm [last accessed 4 October 2024].

Dango, M. (2022). *Crisis style: The aesthetics of repair*. Stanford University Press.

Diderot, D. (2016 [1772]). Regrets on parting with my old dressing gown. Translated by K. Tunstall and K. Scott. *Oxford Art Journal 39* (2), 175–184.

Di Paola, M., & Ciccarelli, S. (2022). The disorienting aesthetics of mashed-up anthropocene environments. *Environmental Values 31* (1), 85–106.

Foster, C. (1992). Aesthetic disillusionment: Environment, ethics, art. *Environmental Values 1* (3), 205–215.

Gertz, N. (2019). *Nihilism*. MIT Press.

Ghosh, A. (2016). *The great derangement: Climate change and the unthinkable*. University of Chicago Press.

Haapala, A. (2005). On the aesthetics of the everyday familiarity, strangeness, and the meaning of place. In A. Light & J. Smith (Eds.), *The aesthetics of everyday life* (pp. 39–55). Columbia University Press.

Haraway, D. (2016). *Staying with the trouble: Making kin in the Chthulucene*. Duke University Press.

Korpelainen, N.-H. (2021). Cultivating aesthetic sensibility for sustainability. *ESPES. The Slovak Journal of Aesthetics 10* (2), 165–182.

Lehtinen, S. (2020). Buildings as objects of care in the urban environment. In Z. Somhegyi & M. Ryynänen (Eds.), *Aesthetics in dialogue: Applying philosophy of art in a global world* (pp. 223–236). Peter Lang.

Lehtinen, S. (2021). Aesthetic sustainability. In R. Toivanen & P. Krieg (Eds.), *Situating sustainability: A handbook of contexts and concepts* (pp. 255–268). Helsinki University Press. https://doi.org/10.33134/HUP-14.

Light, A. (2018). Aesthetic integrity, climate loss, and damage. International Association of Aesthetics Interim Conference: 'Margins, Futures, and Tasks of Aesthetics', Aalto University, Espoo, Finland (6 July 2018, environmental aesthetics keynote).

Maslow, A. (1943). A theory of human motivation. *Psychological Review* 50 (4), 370–396.

McCracken, G. (1988). *Culture and consumption: New approaches to the symbolic character of consumer goods and activities*. Indiana University Press.

Melchionne, K. (2017). Aesthetic choice. *British Journal of Aesthetics* 57 (3), 283–298.

Naukkarinen, O. (2011). Aesthetic footprint. *Aesthetic Pathways* 2 (1), 89–111.

Nomikos, A. (2018). Place matters. *The Journal of Aesthetics and Art Criticism* 76 (4), 453–462.

Pihkala, P. (2020). Anxiety and the ecological crisis: An analysis of eco-anxiety and climate anxiety. *Sustainability* 12 (19), 7836.

Saito, Y. (1997). The Japanese aesthetics of imperfection and insufficiency. *The Journal of Aesthetics and Art Criticism* 55 (4), 377–385.

Saito, Y. (2007). *Everyday aesthetics*. Oxford University Press.

Saito, Y. (2017). The role of imperfection in everyday life. *Contemporary Aesthetics* 15, article 15.

Saito, Y. (2018). Consumer aesthetics and environmental ethics: Problems and possibilities. *The Journal of Aesthetics and Art Criticism* 76 (4), 429–439.

Saito, Y. (2020). Aesthetics of care. In Z. Somhegyi & M. Ryynänen (Eds.), *Aesthetics in dialogue: Applying philosophy of art in a global world* (pp. 187–201). Peter Lang.

Saito, Y. (2022). *Aesthetics of care: Practice in everyday life*. Bloomsbury.

Sartwell, C. (2004). *Six names of beauty*. Routledge.

Scott, K. (2016). The philosopher's room: Diderot's regrets on parting with my old dressing gown. *Oxford Art Journal* 39 (2), 185–216. https://doi.org/10.1093/oxartj/kcw014.

CHAPTER 16

EVERYDAY AESTHETICS AND RESILIENCE

SALEM AL QUDWA

The Concept of the 'Everyday'

Henri Lefebvre (1971, 1991), who consecrated the concept of everyday life and its rhythms, attempted to provide a Marxist critique of contemporary mass culture such as he saw it in the 1930s, set against a backdrop of historical transformation. He helped overcome the dichotomous and hierarchical thinking while focusing entirely on disclosure of the social life. According to Lefebvre, everyday life is dependent on certain universals such as 'sustenance, clothing, furnishing, homes, neighbourhoods, environment ...' (Lefebvre, 1971, 21). Lefebvre referred to this level of functionality as the 'the totality of the real', and suggested that it is there that the social dimension of life acquires meaning (Lefebvre, 1991, 97). However, Lefebvre's contribution to the understanding of the everyday is twofold. On the one hand, the everyday 'comprises seemingly unimportant activities'. On the other, it is 'a set of functions which connect and join together systems that might appear to be distinct' (Lefebvre, 1971, cited in Upton, 2002, 707). The inference is complex and one that relates to how the everyday may be perceived by all that is absent, instead of what is present, or taken for granted.

Everyday habits and social activities constitute a routine according to which we renew our existence everyday, and this led Lefebvre to speak about the concept of the 'rhythm of lived spaces' as a principle through which the everyday becomes possible. He states that: 'What we live are rhythms—rhythms experienced subjectively. Which means that, here at least, "lived" and "conceived" are close: the laws of nature and the laws governing our bodies tend to overlap with each other—as perhaps too with the laws of so-called social reality' (Lefebvre, 1991, 206). The rhythms of *lived* spaces that specify the life of a community or of a society are notoriously complex and actively produce the life of that community or society. These rhythms result in the routine and habits of the everyday, and Lefebvre intended to uncover how such routine and habits produce life

itself through the diversity of various practices. It was in order to study such rhythms that Lefebvre proposed that we use the concept of dialectics, aiming to describe the process through which the practice of everyday life unfolds (Middleton, 2016, 414–415).

Michel de Certeau, who is credited for developing these theories into his own interpretation of the everyday, stressed the relevance of everyday practices and the tactics that ordinary people, or 'obscure heroes', deploy for the assurance of their existence (de Certeau, 1998, 3). As de Certeau showed, the everyday refers to a myriad of activities that lack the lustre of the productions of an artist or of those of an expert. Instead, the ordinary men and women of the everyday appear 'passive' and subjected to a wealth of already-made ideas and objects that fill up their life. They are, in other words, 'consumers' of the processes of making and regulation that they have little influence over (de Certeau, 1998, 251). They are neither architects, nor urban planners, yet their life is the subject of both these professions. De Certeau's argument was that, despite their perceived passivity, most people are deeply concerned with an 'art of making' that gives meaning to the everyday (de Certeau, 1998, 216; Saito, 2017).

This chapter draws from these thinkers' views in an attempt to show how the everyday can be the source of another aesthetic for the built environment—one not limited to traditional categories of the beautiful or the sublime. The intention is to convey an understanding that 'the aesthetics of the ordinary' is integral to an understanding of what constitutes the everyday in an unstable environment.

Aesthetics of the Ordinary

The notion of seeing beauty in the ordinary and functionality in beauty is one that is core to my understanding as a practising architect (Figure 16.1). House designs, even in their most modest form as interim shelters, need to assert the significance of a collective humanity and a right to adequate housing. In an attempt to make sense of 'place-making' (Casey, 1997), it is important to consider how cultural and spiritual meanings have advanced 'everyday making' as the space where the aesthetic dimension accommodates a certain quality of life and determines the social and political aspect of our world, for better or worse. How this then impacts on the way people live or are forced to live is one that I consider fundamental to my argument for a house design prototype that will take those that live there into account.

In this vein, my experience as an emergency architect and shelter manager for the Gaza Strip exposed me to the importance of humanitarian design in dealing with vulnerable and poor communities traumatized by conflict. This work has made me increasingly aware of the connection between aesthetics and dignity and the importance of beauty and design for even the most deprived families. It has also taught me that the simplest and most minimal interventions can provide both beauty and dignity under the right circumstances. In her works, Yuriko Saito (2007, 2017) consistently points out how seemingly trivial everyday aesthetic experiences can have profound significance in

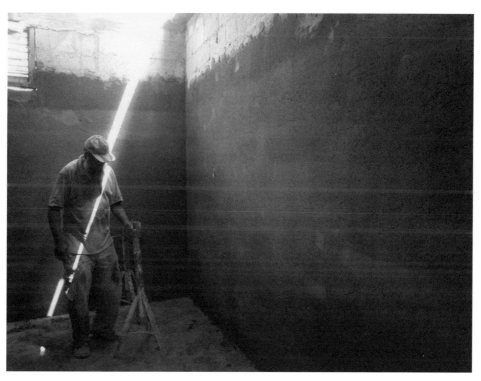

FIGURE 16.1 A local builder bathing in natural light.

Source: Salem Al Qudwa, Al Shouka, 2011.

people's lives in a manner that is perhaps not sufficiently acknowledged by either ourselves or other aestheticians. Given limited resources globally, the aim is to direct and facilitate a cumulative and collective enterprise of constant better world-making. Such a change in the content of the 'aesthetic experience' is motivated by the fact that, while traditional art works are often understood only by audiences who are familiar with the art world, an everyday sense of the beautiful is accessible to all, given the ubiquity of the everyday (Saito, 2017, 26). In addition, Saito includes a feminist dimension in her research when she addresses the domestic domain, such as cooking, cleaning, 'doing laundry' and 'laundry hanging' (Saito, 2017, 121), as more than simply functional spaces in ways that have been neglected (Figure 16.2).

I also attempt to understand this 'recognition of the universal in the specific' within the context of domestic life representative of many households in the Gaza Strip. In particular, how dough prepared by Palestinian women is an integral part of the rituals of the everyday, and more specifically how the confines of a room are equivalent to a week's supply of flat bread rounds; bread which is 'the symbol of the hardships of life and work' (de Certeau, 1998, 86). In this accommodation, the task essential to daily life has an aesthetic sensitivity and an emphasis of gendered space. In addition to place as a site of normal daily activities, women from the same extended family and their neighbours

FIGURE 16.2 A week's supply of flat bread rounds prepared in a room used for the purpose during the day and for the children's sleeping quarters at night.

Source: Salem Al Qudwa, Beit Lahia, 2007.

often gather in the semi-open space of the house (usually in the living rooms with proper natural lighting) to prepare the bread which is then baked in a shared mud or metal oven located on the ground floor of one of the houses. I shall explore these points for the purposes of meaning and design motif.

As highlighted elsewhere (Mushtaha & Noguchi, 2006), and based on my field observation, the living area and/or the guest reception room play an important part in the household arrangements: where necessary these spaces are turned into sleeping areas at night by arranging mattresses on the floor. In response to this specific situation and to the multiple needs of low-income extended families, the need of spaces for accommodation in Gaza can explain how homes are shaped and appropriated over time. Lefebvre's concept of the appropriation of space is the closest approximation for such understanding of dwellings in relation to family members modifying homes on various scales and making them their own.

Thomas Leddy (2012) stresses the close relationship between everyday aesthetics and the aesthetics of art and points out the relevance of this relationship to the objects and environments we encounter in daily life. According to Saito (2017), such a theory will also highlight a different way in which we think about design. This allows us to observe

the architectural object as a work of art (Bader, 2015) which is less likely to be considered of greater value but to the detriment of the ordinary, the familiar, and/or the useful. In my capacity as an architect with an interest in accommodating the aesthetic in a design based on functionality with limited materials, I constantly look for signs of artistic sensibility in objects of everyday life, or 'everyday objects that are not always depicted in architectural drawings' (Tayob, 2018, 211). One I noted while writing up this chapter was a shop in the historic city centre of Oxford displaying enduring household tools and practical items. These reproduce universal archetypes of everyday 'vernacular' objects that have been made in a similar way with similar materials for a long time and would be instantly recognizable in most parts of the world. It is clear that the domestic has been addressed in new ways, particularly the ones that underline the aesthetic.

Everyday Objects and Their Aesthetic Origin

The German artist Joseph Beuys (1921–1986) argued that everybody can practise their own particular kind of art, thereby contributing to renewed ways of social organization, which he understood to be summarized by the concept of social sculpture (Jordan, 2013). Beuys raised the question: what might distinguish a conceptual masterpiece from a bit of urban debris? Can the block of stone in which a sculpture originated generate an aesthetic experience in the same way in which the actual sculpture does? In this sense, it should be pointed out that any work of art might be considered to presuppose an emplacement, in that it is concerned not just with an object, the actual artefact, but also with a space and a place. From a more sociological point of view, for a work of art to be received as such, it is necessary that it describes a space and that it engages meaningfully with the very world that produces it, foregrounding certain aspects of that world.

It is the sociological relevance of the work of art that led Joseph Beuys to develop the theory of social sculpture in the 1970s, supporting his idea that most aspects of everyday life could be approached creatively. The concept of 'social sculpture'—the vestiges of the everyday transformed—reunited Joseph Beuys' idealistic ideas of a utopian society with his aesthetic practice (Jordan, 2013). He took this further in his attempt to reduce the divide between the artist and the rest of society. He believed that life is a social sculpture that everyone is called to and can help shape (Packer, 2003). The realm of art and that of ordinary experience were made to communicate and to interrogate each other, something that may happen in a process of decoding the message of a work of art. And while the work of art is generally presented as abstracted from the world and from life, as Remko Scha points out,

> When dealing with the products of human artists, these conditions for the aesthetic experience are usually not fulfilled. The artist does have practical aspirations, and

often the work betrays this all too clearly. In many cases, the artwork does embody an explicit idea, and a dedicated observer may in fact reverse-engineer the work and reconstruct the idea.

(Scha, 1998, 105)

Art constantly invites one to actively interpret it as well as the world that one brings into contact with the world of art, as his/her own background. In turn, artists often use everyday objects to create masterpieces, and in so doing they assert not just their own message, but also the power of universal human creativity, teaching everybody that everybody can be an artist and that in becoming artists, people can empower themselves to carry the message of their work of art further into the social, economic, or political spheres. In de Certeau's view, art can be an art of making and doing things, thus becoming a principle of organization, which is present in the idea of sculpture, in the idea of design, and by extension, in the idea of moulding and transforming a neighbourhood and a society. Such a principle of creative organization suggests the ability of the individual or a 'household' to join others and to participate in the 'collective' agency, through which one can hope to effect change in the world (de Certeau, 1998, 163; Mistry, 2004).

The capacity of an art of making to mobilize creative energies is also found in the collage representing the dirty or tired hands of everyday people, self-builders and craftsmen who fashion out of common materials works of art or installations. All of these people are also brought together by means of an attempt at another work of art, which is at the same time a documentary, namely the collage in Figure 16.3.

For example, the creation of 'fragile pieces' in situ—an installation in an urban or rural setting, part of a naturescape or demolition site—fit within the realm of the everyday, as daily rituals may be repeated, but are never quite the same (Figure 16.4). Photography and audio-video recordings play a crucial role in providing a lasting record of such works, displaying their presence and marking the moment; or even capturing the memories for the everyday, when the work is at its most alive. The connections are layered, embedded in the fabric of the chosen material and how the artist and/or the

FIGURE 16.3 Hands of self-builders and makers of daily objects.

Source: Salem Al Qudwa, 2016.

FIGURE 16.4 Salvaged damaged breeze blocks after destruction from a totally damaged building in the Gaza Strip.

Source: Salem Al Qudwa, 2015.

self-builder choose to rearrange these within their surroundings. For this research, the significance of such process into the 'architecture of the everyday' in the Gaza Strip has a duality between the need for survival, to build a shelter, and aesthetic preferences. The use of similar tools for memorization is an attempt to show in the preparation for the house design prototype the multi-layered connections. These include a relationship between the individual household members—male and female, young and old—and their engagement with me as an architect during the participatory design sessions. Added to this are the choice of available materials, the political situation and the climatic conditions. Put all these layers together and the objective remains an examination of the potential for building homes that encourage ownership through the involvement in the processes of conceptualization and building from all family members. Consistent with Lefebvre's concept of 'producing an appropriated space', this is also essential for housing rehabilitation in high-density areas while involving incremental development processes with the focus on small-scale increments of one room or a kitchen and a bathroom (Ward et al., 2011).

This chapter proposes that the benefits of an everyday aesthetic sensibility are apparent in situations of conflict, and, if acknowledged for their transformative capacity, they could be of relevance to those societies which are affected by on-going economic, social, and mental crises. The qualities of resilience and resourcefulness in the Gaza Strip is such an example (Saito, 2017, 19). The urban texture has been affected by successive attacks from the Israeli military force, and reconstruction is made more difficult by the lack of materials, lack of a clear planning framework for reconstruction, as

well as the economic and political blockade that applies to the Gaza Strip. Given these circumstances, people's everyday life and environment are precarious, and for this reason they may consider it futile to plan for a better future. However, even in these conditions there is an attempt at organization and transforming what is available, albeit damaged and worn, into a new structure with its own aesthetic (Figure 16.5). As Saito states,

> Given that the political situation unfortunately cannot be resolved by individual effort, everyday aesthetic experience can help its residents retain a sense of humanity, dignity, and resilience. In such a case, everyday aesthetics' contribution to their lives can be considerable.
>
> (Saito, 2017, 19)

In this vein, it would be presumptuous to think that a focus on a well-considered architectural design would provide sufficient resilience in the face of on-going conflict with Israel. Hence, the research undertaken in this chapter promotes a self-build approach for low-income extended families which enables them to have some control on their future. The self-build houses can be supported or enhanced by institutional players which can denote a sense of identity, pride, and permanence to their inhabitants. This supports a notion that the 'new vernacular' in Gaza is heavily influenced by the concept of 'permanence' as 'resistance' to the 'occupation' and the on-going conflict that is experienced on a day-to-day basis. While the field of research and expertise in relief and development for housing the displaced rarely mentions the 'everyday', the main contribution to knowledge of this research is to consider the value of the everyday, its unique power, and its aesthetic appreciation by the inhabitants in the context of living in conflict zones with economic instability. When 'resourcefulness' and not 'hopelessness' is mentioned as a reference to the way people repair, reconstruct and rebuild their

FIGURE 16.5 Simple behaviours to improve the appearance of ceilings and walls within the physical environment of self-built houses, by having ornaments added to them in Al Shouka (left) and Beit Lahia (right), the Gaza Strip.

Source: Salem Al Qudwa, 2011.

damaged houses in the Gaza Strip, it is not the intention to encourage ordinary people to appreciate the negative aesthetic qualities of what they already have.

Quite the opposite, and in the responses to the situation imposed against any economic prosperity in Gaza (Roy, 2016), this research highlights the relevance of the everyday aesthetics discourse as well as simple and minimal buildings in the Gaza Strip. The challenge then becomes how to provide an impetus for improvement of the living environment in the sense of physical identity, stability, and getting better functional yet healthy, comfortable, and protected homes for the inhabitants. On the other hand, there is limited evidence regarding a published discussion on the aesthetic considerations to support the architecture of the everyday as more than simply a functional application (Kowaltowski, 1998; Al Qudwa, 2017). For the purpose of filling in the lacunae, I attempt to develop the notion of the aesthetics of the everyday in terms of its theoretical framework.

Architecture of the Everyday

Lefebvre (1991) points out that any definition of architecture requires a prior consideration of the concept of space and place-making. Moreover, Lefebvre's concern with the spatial nature of social life resonated with a long-established claim that an awareness of how space is produced should be the defining element of a modern architecture and with the belief that everyday life has the potential to mount a critique of modernity. It should be pointed out here that, often, architectural discourse sets out an explicit goal to make sense of modernity and outline what a modern architecture might be (Upton, 2002). This chapter focuses on the production of space with a view to better understanding the everyday routines of domestic life, such as the necessary requirements to establish a domestic space for low-income extended families and how these impact on the wider urban and rural environments that have been central to the selection criteria for the house design prototype. The constraints that the wider environment places on a domestic space not only determines its functionality in providing accommodation, but also ensures privacy and the preservation of life (Rapoport, 1969), that is, the lives of various categories of individuals that make up a family.

Buildings are complex systems and, often, the process of inhabiting an architectural environment presupposed aspects that cannot be determined at the design and construction phase, with users actively reshaping the relationships that best suit the inhabited space for them. It is therefore important to consider the uses that architectural space are put to and this requires an awareness of subject–object relationships that architects can only influence to a limited degree. In this sense, Victor Buchli refers to the 'social logic of space', which is surrounded by boundaries of architectural durable walls, and to 'how changes within something like the arrangement of rooms could provide evidence of a cultural unconscious' (Buchli, 2013, 54–55). The trends that such a cultural unconsciousness describes point to necessity and can be summarized as follows: land is becoming scarcer; population grows rapidly; and there is a steady migration

from rural to urban areas in search of work. In this vein, the impact of social tension or a sense of belonging in relation to the built environment and place-making may have enduring consequences for the whole family. For example, the wife of one household in Gaza left her home and children, returning to her parents' household, when her unemployed husband could not complete the extended family house and provide his wife with an appropriate independent living area. '*The building materials were expensive, but I had the financial help of others, so I built four walls between the columns on the top of the ground floor with a small kitchen. I hope that the new added room will encourage my wife to return to take care of our six children. My mother is taking care of them right now.*' Drawing on evidence based on cultural norms and local needs, Amos Rapoport (1969) has argued that the constraints imposed by the wider environment on domestic space not only determine its functionality in providing accommodation, but also the degree to which it ensures privacy and the preservation of life. During constraints and ongoing conflict such as in the Gaza Strip, Rapoport's (1969) and Lefebvre's (1991) discussions in the wake of the post-war shortage of accommodation become relevant. Accordingly, to inhabit homes in Gaza is to appropriate domestic spaces while falling in between the Israeli constraining powers and the sociocultural forces of appropriation.

Kerry Mistry (2004), for instance, suggests in her design research the notion of domestic space as separate from its wider environment and which can be redefined as a 'collective urban environment'. The intention is to examine 'the spatial and architectural implications of a departure from traditional forms of domesticity and the family ideal'. The establishment of a collective urban environment is one that could be considered as more appropriate for communities like those in the Gaza Strip, where there is a lack of infrastructure and very little stability. From this point of view, house design prototypes would need to take into account that the boundaries between individual homes and the immediate neighbourhoods are blurred as inter-generational families live in communities and share many of the domestic activities on a daily basis (Figure 16.6).

Arguments on how to design for a communal as well as an individual use of architectural space to accommodate the everyday are not new. Gaston Bachelard (1969), for instance, speaks about how we seem to inhabit shells and refers to the house as a soul-endowed organism, with cleaning the house being a kind of polishing of that soul. The building's inner life and the characteristics of occupancy enable an architectural understanding of performance-related concerns during the building operation or the 'use phase', and this aspect is increasingly brought to bear upon the design decision-making process. In this sense, and in direct connection with 'the everyday', architect Kate Macintosh explains what architecture means to her: 'Architecture must offer both shelter and protection at the most basic level but it must also free people, liberate them both psychologically and emotionally to achieve their own objectives, their own realisation. And unless it can do that as well as shelter, it is not architecture' (Macintosh, 2010).

In line with the household dynamic and the process of change in rural houses (Rapoport, 1969; Buchli, 2013; Hourigan, 2015), the use of photography in conveying the architectural features of buildings can be helpful as much as misleading. The use of photography provides a certain architectural understanding of a building that is informed

FIGURE 16.6 A collective of rural and marginalized environments: a depart from traditional forms of space configuration using affordable building materials to design with a view to accommodating inter-generational families.

Source: Salem Al Qudwa, Gaza, 2011.

by the photographer's choice of position in relation to the building while taking the photograph, and the context when the viewer contemplates the image of the building. Yeoryia Manolopoulou noted that capturing the unnoticed beauty of such 'architectural moments' is about the 'simplicity of chance in the form of coincidence and simultaneity' (Manolopoulou, 2013, 63).

The wish to see an aesthetic that may say more about a viewer's perception of what they observe than the conditions being photographed is one that the architect Christopher Day would argue may not relate to the building in its architectural form. The only feature the building shares with the photograph refers to the extent to which it constitutes an aesthetic experience and thus invites certain emotions. According to Day, 'Photographs focus our attention but let us ignore context. Architecture, however, is the frame in which we live. We don't just look at architecture; we live in it' (Day, 2004, 1).

In agreement with Day's view, I am mindful to consider photography as a tool for record keeping—to show the potential for a collective urban environment with its own everyday aesthetic appearance. In addition, photography also proved a reliable medium for communicating and sharing information with the participants at the time of working with marginalized communities in need. I could engage further with the participants by encouraging them to comment on the photographs, drawings, and collages, with the aim of making small but positive changes to their houses and surroundings (Figure 16.7).

I carefully edited these photos so the aesthetic aspects have as much impact as possible for Western eyes. In general, some of my Gaza photos might remind the audience of the passage in Adolph Loos' *Ornament Is Crime*, where he describes with regret the sadness of the shoemaker who is asked to make simple shoes devoid of ornament. I

FIGURE 16.7 The house door as a place of reverie and withdrawal, connecting the inside with the outside. The door to marginalized households is a fine line between the outer spaces and confined interiors, both of which have repeated movement.

Source: Salem Al Qudwa, 2016.

think when one is poor it may be harder to accept simple unadorned design. For a rich person, buried in possessions, voluntary minimalism represents a kind of freedom, but for the poor for whom it is involuntary, perhaps something quite different.

Everyday and the Self-build

Deborah Berke and Steven Harris (1997) used the term 'Architecture of the Everyday' in order to connote a rejection of architecture as a consumer product or a fashion accessory, implying that the 'everyday' rather stands for the restoration of a sense of nobility and dignity to small-scale buildings for clients of modest means. In this context it may be different from 'vernacular architecture', that is, traditional architecture built with limited means and without professional assistance as described by Rapoport (1969). As Paul Oliver (1997, 2003) has argued, vernacular architecture 'will be necessary in the future in order to ensure sustainability in both cultural and economic terms beyond the short term' (Oliver, 2003, 13–14). Thus, the relevance of 'vernacular architecture' to the 'everyday' lies in its being an expanding field of knowledge, because it contains 'significant' or important examples of everyday buildings produced by people without 'formal' architectural training (Crysler, 2003, 7). The essential meaning of vernacular architecture—narrowly conceived as 'the architecture of a particular people, place or region'—has been replaced by a 'neo-traditional' configuration (Steele, 2005). This tendency in the literature is highlighted by Neasa Hourigan, who concludes that 'this type of (vernacular) building is one that does not remain static and is often characterized by its ability to adapt and transform itself to new usages… and linked to the social, economic and environmental history of a given region or nation' (Hourigan, 2015, 22).

On the other hand, Berke and Harris state that characteristics of an architecture of the everyday include: (1) Architecture that supports authorship, denies celebrity, and embraces invisibility in physical and tectonic terms; and (2) Architecture that draws strength from its simplicity, use of common materials, and its relationship to other fields of study (Berke & Harris, 1997, 8). These characteristics are in line with Deborah Fausch (2014) and her perception towards architecture being 'ordinary'. In the same vein, Manolopoulou defines modernist architectural discourse indeterminacy in buildings in terms of its flexibility, stating that 'a flexible building should allow change' (Manolopoulou, 2013, 69). The works of Steven Moore (1997) and Besim Hakim (2007) specifically refer to their manifesto as 'everyday' (re)generative processes in architecture and urbanism, highlighting that this change may be done by democratic means, by engaging citizens (extended families) in decision making about such (building) technologies and communication among community members to improve the places where they live. Such 'regenerative architecture' needs to be instrumental in the construction and implementation of future technologies that support the routines and customary practices of everyday life. This emphasis on the process of place-making and the changes effected by users' needs, family practices, and natural growth over

periods of time is advanced in tandem with the concept of self-building of houses and neighbourhoods and the physical identity of houses (Turner, 1976). In this sense, design criteria are often severely constrained by immediate necessity, by limited availability of resources, and by the need to attend to the lowest possible cost. Families try still to prioritize the social and financial investment in their houses so they may last for a lifetime, and for this reason, they are keen to participate actively in the rehabilitation and/or building of their homes. From this context, perception towards local needs, cultural norms, and common construction materials present a strong case for buildings that comply with an expected image. Influenced by the concept of 'permanence', building materials were selected as part of everyday resilience, noting the significance of a stable core structure for possible social growth and horizontal extension.

Since formal aspects of architecture are shown to have limited application in relation to the self-building process, Doris Kowaltowski (1998) discusses the complexity of aesthetic considerations in the context of self-built houses under economic constraints. Such considerations are showing that 'the perceived "beauty" is mainly linked to socializing aspects and diversity in house appearance while the perceived "ugliness" is linked to a lack of urban infrastructure and lack of maintenance' (Monzeglio, 1990, cited in Kowaltowski, 1998, 300). This, of course, is in keeping with the relation between tradition and innovation, such as was outlined by Hourigan:

> The vernacular may be shaped over time by the utilitarian requirements of its occupants and indeed all functioning cultures concomitantly synthesize both tradition and innovation in everyday life as a necessary component of development.
>
> (Hourigan, 2015, 22)

As Howard Davis writes that 'healthy architecture has traditionally developed through common, culturally embedded knowledge of building, along with the political and economic ability to put that knowledge to use' (Davis, 2005), I endorse the original meaning of 'participation' rather than using it as 'a facade of good intentions' (White, 1996). With a view to improving the living conditions and mental health for low-income extended families, the main interest lies in the connection of theories regarding place-making and spatial awareness (Rapoport, 1969; Lefebvre, 1991; Casey, 1997) with the everyday practical needs of inhabitants and how these may be accommodated (Berke & Harris, 1997; Buchli, 2013; Hourigan, 2015).

Conclusion

The transformative nature of the 'ordinary' is highly significant to an understanding of the importance of the 'architecture of the everyday'. This chapter highlights this aspect with specific regard to the design of a house prototype that would accommodate extended families in need in the Gaza Strip. While reviewing the theoretical resources

of a 'vernacular' architecture, this chapter has also shown that finding a solution to the habitation issues such as those of Gaza presupposed the dynamic nature of the vernacular, with a view to accommodating a daily life domestic perspective. The latter focuses on providing an improved environment that has an impact both socially and physically, and that can also accommodate current social and political challenges. The identification of architectural possibilities has highlighted the need for a consideration of the 'aesthetic of the ordinary' and the 'art of making' in the design and implementation process of a house prototype. A crucial reason for these considerations is that families' domestic place-making processes and realities in Gaza seem to highlight the importance of 'architecture of the everyday' (Berke & Harris, 1997) which can become a 'new vernacular' but also can enhance resilience and strengthen identity. Furthermore, there are gaps in knowledge in Gaza as this is an under-researched area. In researching architectural design, it was found that Palestinian academic engagement with the topic of 'architecture of the everyday' is very limited, with fewer than five publications written by Palestinian researchers in the past two decades.

In such an environment of protracted conflict, subjective definitions and understandings of 'home' are affected by the glaring contradiction between 'home' as an ideal, and 'home' as lived experience—a contradiction that demands further research. This is mainly due to the restricted living conditions and lack of available choice for upgrading or rebuilding houses in the Gaza Strip. In this research the terms 'home' as a physical and social setting, and 'place-making' as a process, are central to the contribution it makes to the academic discourse. They are used to describe inhabited indoor spaces, and the ways and processes in which low-income Palestinian extended families have built, used, and appropriated their ordinary houses in the Gaza Strip. Applying a place-focused approach (Rapoport, 1969; Lefebvre, 1991; Casey, 1997), it is these inhabitable physical and social settings that can be seen and mapped: the variety of a family's everyday activities with place, collective lived experiences, and agency that result while dealing with everyday challenges in times of on-going conflict (Kowaltowski, 1998; Buchli, 2013; Hourigan, 2015).

The challenge then becomes how to provide an impetus for improvement of the living environment in the sense of physical identity, stability, and getting better functional yet healthy, comfortable, and protected homes for the inhabitants. This chapter highlights the relevance of everyday aesthetics discourse through home-making/architectural agency and the promotion of one's mental health and resilience, particularly in a dire living condition such as the Gaza Strip. These main problems are all arguments to take into account for providing healthy spatial and physical interventions and to overcome the current conditions. In tackling the housing needs of vulnerable inhabitants in the Gaza Strip, for example, one often needs to make use of alternatives in order to deal with material scarcity or lack of land availability. The goals of architectural practice can be realized by approaching the everyday reality of existence in ways that provide low-cost, affordable, and energy-efficient housing in the Gaza Strip as elsewhere. What emerges can be used in contexts that are similar to the one in the Gaza Strip, Palestine, and to address human displacement and active large-scale post-conflict reconstruction of the

built environment in places such as Syria, Iraq, Yemen, and Libya. The purpose of this is to improve the quality of life of residents and improve resilience of families in need.

References

Al Qudwa, S. (2017). Aesthetic value of minimalist architecture in Gaza. *Contemporary Aesthetics* 15(1). Available online at: https://digitalcommons.risd.edu/liberalarts_contempaesthetics/vol15/iss1/14/ [last accessed 4 October 2024].

Bachelard, G. (1969). *The poetics of space*. Translated by Maria Jolas. Beacon Press.

Bader, A. P. (2015). A model for everyday experience of the built environment: The embodied perception of architecture. *Journal of Architecture* 20(2), 244–267. https://doi.org/10.1080/13602365.2015.1026835.

Berke, D., & Harris, S. (Eds.). (1997). *Architecture of the everyday*. Princeton Architectural Press.

Buchli, V. (2013). *An anthropology of architecture*. Bloomsbury Academic.

Casey, E. S. (1997). *The fate of place: A philosophical history*. University of California Press.

Crysler, C. G. (2003). *Writing spaces: Discourses of architecture, urbanism and the built environment, 1960–2000*. Routledge.

Davis, H. (2005). Architectural education and vernacular architecture. In L. Asquith & M. Vellinga (Eds.), *Vernacular architecture in the 21st century: Theory education and practice* (pp. 231–244). Intermediate Technology Publications.

Day, C. (2004). *Places of the soul: Architecture and environmental design as a healing art*, 2nd edn. Architectural Press.

De Certeau, M., Giard, L., & Mayol, P. (1998). *Practice of everyday life: Volume 2: Living and cooking*. Edited by L. Giard and translated by T. J. Tomasik. University of Minnesota Press.

Fausch, D. (2014). *Can architecture be ordinary?* Available at: www.mascontext.com/issues/23-ordinary-fall-14/can-architecture-be-ordinary/ [last accessed 4 October 2024].

Hakim, B. S. (2007). Generative processes for revitalizing historic towns or heritage districts. *Urban Design International* 12(2–3), 87–99.

Hourigan, N. (2015). Confronting classifications - When and what is vernacular architecture?' *Civil Engineering and Architecture* 3(1), 22–30. https://doi.org/10.13189/cea.2015.030104.

Jordan, C. (2013). The evolution of social sculpture in the United States: Joseph Beuys and the work of Suzanne Lacy and Rick Lowe. *Public Art Dialogue* 3(2), 144–167. https://doi.org/10.1080/21502552.2013.818430.

Kowaltowski, D. (1998). Aesthetics and self-built houses: An analysis of a Brazilian setting. *Habitat International* 22(3), 299–312. https://doi.org/S0197-3975(98)00005-8.

Leddy, T. (2012). *The extraordinary in the ordinary: The aesthetics of everyday life*. Broadview Press.

Lefebvre, H. (1971). *Everyday life in the modern world*. Translated by Sacha Rahlnovitch. Harper and Row.

Lefebvre, H. (1991). *The production of space*. Translated by Donald Nicholson-Smith. Wiley-Blackwell Publishing.

Macintosh, K. (2010). *Kate Macintosh explains what architecture means to her*. Available at: www.utopialondon.com/wiki/kate-macintosh [last accessed 15 June 2023].

Manolopoulou, Y. (2013). *Architectures of chance (design research in architecture)*. Ashgate Publishing.

Middleton, S. (2016). Henri Lefebvre on education: Critique and pedagogy. *Policy Futures in Education* 15(4), 410–426.

Mistry, K. (2004). *Collective domesticity*. Available at: www.kerriemistry.com/2012/04/collective-domesticity-urban-housing.html [last accessed 4 October 2024].

Monzeglio, E. (1990). Uma Avaliação E Perspectiva de Habitante da Periferia de Sao Paulo: O Pó´s-Uso Segundoo Desenho. In *Sinopse, niversidade de Sa J Paulo, Faculdade de Arquitetura erbanismo*, No. 13, Sao Paulo, pp. 26–42.

Moore, S. (1997). Value and regenerative economy in architecture. In the *85th ACSA Annual Meeting Proceedings, Architecture: Material and Imagined* (pp. 544–550). Available at: www.acsa-arch.org/chapter/value-and-regenerative-economy-in-architecture/ [last accessed 4 October 2024].

Mushtaha, E., & Noguchi, T. (2006). Evaluation and development of housing design: Analytical study on detached houses' plan of Gaza City. *Journal of Architecture and Planning (Transactions of AIJ)* 71(605), 23–30.

Oliver, P. (1997). *Encyclopedia of vernacular architecture of the world*. Cambridge University Press.

Oliver, P. (2003). *Dwellings, the vernacular houses worldwide*. Phaidon.

Packer, R. (2003). *Notes for discussion based on the reading of the Joseph Beuys essays*. Available at: www.zakros.com/jhu/apmSu03/notes_beuys.html [last accessed 4 October 2024].

Rapoport, A. (1969). *House form and culture*. Prentice-Hall.

Roy, S. (2016). *The Gaza Strip: The political economy of de-development*, 3rd edn. Institute for Palestine Studies.

Saito, Y. (2007). *Everyday aesthetics*. Oxford University Press.

Saito, Y. (2017). *Aesthetics of the familiar: Everyday life and world-making*. Oxford University Press.

Scha, R. (1998). *Art, chance and algorithm: Towards an architecture of chance*. Available at: www.remkoscha.nl/wiederhaE.html [last accessed 15 June 2023].

Steele, J. (2005). *The architecture of Rasem Badran: Narratives on people and place*. Thames and Hudson.

Tayob, H. (2018). Subaltern architectures: Can drawing 'tell' a different story?. *Architecture and Culture* 6(1), 203–222. https://doi.org/10.1080/20507828.2017.1417071.

Turner, J. (1976). *Housing by people, towards autonomy in building environments*. Marion Boyars.

Ward, P., et al. (2011). Self-help housing policies for second generation inheritance and succession of 'the house that mum & dad built'. *Habitat International* 35, 467–485. https://doi.org/10.1016/j.habitatint.2010.12.005.

White, S. (1996). Depoliticising development: The uses and abuses of participation. *Development in Practice* 6(1), 6–15. https://doi.org/10.1080/0961452961000157564.

Upton, D. (2002). Architecture in everyday life. *New Literary History* 33(4), 707–723. https://doi.org/10.1353/nlh.2002.0046.

CHAPTER 17

EVERYDAY AESTHETICS, HAPPINESS, AND DEPRESSION

IAN JAMES KIDD

Preliminaries

This chapter will introduce everyday aesthetics and conceptions of happiness, explore their interconnections, and indicate some ways they might relate to depression. Each topic is large and complex and can be connected to the others in a variety of ways, some obvious and others not. Some connections are well-served by the literature, such as the idea that certain kinds of aesthetic experience can contribute to our happiness, while others tend to be rather neglected. Moreover, each topic admits of cross-cultural variation. What is these days called 'the aesthetics of the everyday' is credited to East Asian traditions, especially those of Japan (Saito, 2007; Yuedi & Carter, 2014). Subsequent work has identified allied themes in the Western philosophical tradition, however, as well as from garden designers, cosmetologists, craftspeople, potters, gastronomes, and others professionally concerned with aesthetically significant aspects of life (Leddy 2012; Light & Smith, 2005).

We find similar complexities in the term 'depression', which includes a variety of predicaments with different aetiologies, symptoms, prognoses, and treatment pathways. Mental health conditions are also phenomenologically diverse, subject to competing theoretical descriptions, and in many cases acquire cultural and moral meanings. Since any general discussion of mental health would collapse into banality, I focus on the variety of predicaments which typically receive diagnoses of major depression. Using work in phenomenological psychopathology, I argue that experiences of depression involve changes in the ability to experience kinds of significant possibilities. The experiential world of the person diagnosed with depression is therefore structurally different: possibilities and kinds of significance we more ordinarily take-for-granted

are no longer available—something communicated in the familiar rhetoric of the world seeming 'strange', 'different' in a way that is hard to describe, but often characterized as 'dark', 'cold', and in other ways diminished. This conception of depression has important implications for aesthetic experience and happiness, for each of these presuppose our ability to experience kinds of significant possibilities (the experience of something as beautiful, interesting, pleasing, satisfying, and so on). If so, then aesthetic experience and the attainment of happiness presupposes something necessarily lost in the experience of depression.

Everyday Aesthetics

'Everyday aesthetics' is a recent development in academic philosophical aesthetics, albeit well-established within East Asian cultural traditions and, perhaps, implicit in the everyday life of many people innocent of aesthetic theory. Most advocates of everyday aesthetics devote time to explaining its neglect within the history of Western philosophical aesthetics, at least since the emergence of 'aesthetics' as a distinct discipline in the eighteenth century. Gradually, the scope of aesthetics shrank to the fine arts, essentially making aesthetics the philosophy of art. Fortunately, expansions of aesthetic attention during the twentieth century led to a reconsideration of the occluded possibilities. A decisive expansion was environmental aesthetics, initially focused on natural environments but later including the built environment. Over time, environmental and everyday aesthetics became allied and often conjoined: much of our everyday aesthetic life includes appreciation of the natural environment, of weather, plants, animals, forests, and so on (on this alliance, see Saito, 2007, chapter 2, and Carlson, 2020). Much of the contemporary interest owes to the work of Yuriko Saito, especially her book, *Everyday Aesthetics*, which identifies two main culprits for its neglect: *art-centred aesthetics* and *special experience-based aesthetics*, like those fixated on rare, spectacular experiences, especially of the sublime (Saito, 2007, Part I).

Art-Centred Aesthetics

Art-centred aesthetics is animated by the idea of art as 'the quintessential model for an aesthetic object', a stance either explicitly defended, as by Hegel, or implicitly adopted as a taken-for-granted focus (Saito, 2007, 13). A turning point was John Dewey's book *Art and Experience* of 1934, which celebrated aesthetic activities that enhanced 'the processes of everyday life', while challenging 'the museum conception of art', which fixated on art works, displayable in museums or galleries (Dewey, 1934). Dewey challenged the 'fallacy' that 'art and the aesthetic must *necessarily* be something separate

from ordinary everyday modes of experience and activity' (Leddy & Puolakka, 2021, §2.2). Aestheticians should challenge a confinement of the aesthetic to art, and the attitude that art appreciation alone counts as 'serious' (Hepburn, 2001).

Everyday aesthetics does not deny the significance of the arts. Many of its champions voice their own appreciation of many arts and, moreover, many take inspiration from the important East Asian concept of a Way (Chinese *dào*, Japanese *dō*). Ways include what in the West would be classed as crafts, the fine and martial arts, and kinds of aesthetic practice usually regarded as hobbies, such as cosmetics and the presentation of food. In the Chinese and Japanese philosophical traditions, Ways are embodied, aesthetically charged, morally infused practices, acting as forms of 'bio-spiritual cultivation' (Kirkland, 2004, 33). It is attention to these Ways that helps challenge what Saito calls the 'narrowing' effects of art-centred aesthetics, uncritical adoption of which limits our sense of the 'reach' and the significance of the aesthetic (Saito, 2007, 13–14ff). In practice, one could inherit and endorse narrow conceptions of the following:

(1) aesthetic activities
(2) aesthetic objects
(3) aesthetic qualities
(4) aesthetic appreciation—as, say, disinterested, spectatorial, episodic, something we do 'at' special performances under special conditions, while setting aside practical and other interests.

Everyday aestheticians challenge (a) a narrow focus on these activities, objects, qualities, and modes of appreciation and (b) secondary or derogatory status given to a wider range of alternative aesthetic activities—cosmetics, perfumery, sports, cooking. Most also challenge the paradigmatic status assigned to the fine arts. In issuing these challenges, everyday aesthetics also resists the culturally and historically narrow scope of art-centred aesthetics. A common complaint is that 'what has been regarded as mainstream aesthetics is based upon art and its experience turns out to be specific to, and circumscribed by, the practice primarily of the last two centuries in the West' (Saito, 2007, 12—cf. Higgins, 2017).

One important argument for an inclusion of the everyday into aesthetics concerns the fact that many everyday-aesthetic activities, objects, and qualities are 'inescapable' (Papanek, 1995, 175). Food, home décor, signage, packaging, and self-presentation, to name but a few, are ubiquitous: they are available to (almost) everyone and depend on aesthetic abilities and sensibilities almost everyone has (Tanizaki, 2001). If so, everyday aesthetics both reflects and embodies what Saito calls 'aesthetic egalitarianism' (Saito, 1999; cf. Light & Smith, 2005, chapters 8 to 11). Crispin Sartwell, too, endorses the attempt to liberate aesthetic experiences from 'extraordinary moments and extraordinary places', the ideal being 'immersion in the world' (Sartwell, 1995, xi).

Everyday aesthetics therefore acts as a critique of the forms of 'narrowing' characteristic of the forms of art-centred aesthetics that dominated philosophical aesthetics.

There is also the positive aspiration: to establish—or restore—a more expansive sense of our aesthetic experience and activity. In doing so, everyday aesthetics expands our sense of the *roles* that aesthetic concerns and activities play in everyday life. Food, for instance, can be a source of pleasure, a display of skills, a demonstration of love, a means of sustaining familial bonds, an exercise of religious discipline, and so on. Successfully fulfilling these aims often depends on the aesthetics of the preparation, presentation, and consumption of the food. Moreover, an aesthetics of the everyday can reveal connections between putatively distinct spheres of value, like 'aesthetic' and 'moral' (a distinction that is not integral to East Asian traditions in which an aesthetics of the everyday is dominant). A good example is the ideal of *care*—for our bodies and those of others, the activities and objects of everyday life, and domestic, social, and natural environments. Saito argues that 'the care relationship' is related to 'our moral life' and 'how we conduct ourselves in the world' (Saito, 2022, 132). Once caregiving actions, such as washing and tidying, are carefully appreciated, one sees how aesthetic-moral values are 'deeply entrenched in the management of our daily life' and integral to 'the ethical and aesthetic mode of being in the world' (Saito, 2022, 2).

Some Examples of Everyday Aesthetics

Everyday aesthetics challenges various entrenched convictions of philosophical aesthetics. Importantly, though, its champions insist that its main claims about the scope of aesthetic experience and activity are quite consistent with the everyday experience and life of most people. An optimistic conviction of most everyday aestheticians is that most of us enjoy a far richer aesthetic life than is recognized by art-centred theories.

Consider, then, some of the typical examples of the richly textured aesthetic character of everyday life—a combination of *activities* and *objects*, including places and creatures:

- animals
- architecture
- clothing
- cosmetics
- doodling
- flower arranging
- food
- gardens
- home décor
- knitting
- listening to birdsong
- manners and etiquette
- packaging
- singing

- table setting
- the weather

This list includes many kinds of things: arts and crafts, environmental features, aspects of self-stylization, interpersonal social performances—some universal, others culturally or historically specific—some are human practices, others natural phenomena, while others, like gardening, depend on intimate cooperation between the cultural and the natural (see Cooper, 2006). Crucially, they are not confined to those 'environments that we "visit" and ... images that we behold' (Saito, 2007, 51).

Consider, now, some typical examples of the *aesthetic qualities* invoked in everyday aesthetics, both 'positive' and 'negative':

- apt
- correct
- cute
- dilapidated
- disgusting
- dowdy
- elegant
- gnarled
- grimy
- immaculate
- inviting
- mellow
- ornate
- ostentatious
- pristineness
- ramshackle
- spotless
- squalid

Such aesthetic qualities are complex; they are integral to our evaluative practices, and in some cases relate to wider concerns about hygiene, moral character, self-respect, even religious and political identity (cf. Leddy, 1995, 2012; Saito, 2007, chapters 4 and 5). The aesthetics of character, conduct, and self-presentation are good examples of the interfusion of the aesthetic and the moral (Sherman, 2005). We can also include kinds of *sensation*. Materials, such as surfaces or textiles, could be harsh, rough, smooth, squidgy, 'soft like satin', or 'icky'. Many combine visual and tactile qualities, sometimes aural qualities, too. Multimodal qualities, like squelchiness, might involve many different qualities (Irvin, 2008; Leddy, 1995). Such qualities are integral to our experiences of artefacts: a comfy chair, soft cotton jumper, the hum of a washing machine. We can also include less specific kinds of aesthetic description. If a person is praised as 'well-put-together', one is describing their bodily appearance, odour, comportment, and sartorial choices (cf. Novitz, 1992).

East Asian Aesthetics of the Everyday

East Asian traditions of China and Japan are 'home' to the most carefully articulated, best-developed examples of everyday aesthetics. One can also find similar themes in Buddhism, which later became integral to the development of the Japanese Zen tradition. Consider some examples:

Indian Buddhism

The Buddha praises 'wholesome' (*kusala*) actions, behaviours, and mental states, those which enhance one's bodily, mental, and moral condition (see *Majjhima Nikaya* 46–47). Wholesomeness is achieved by following the disciplined ways of acting defined by the Eightfold Path and, for monks and nuns, the *Vinaya Pitaka*, the regulations for monastic life. Buddhist monastic practice aspires to transform one into a wholesome character, incorporating kinds of aesthetically pleasing appearance and comportment. Beauty for a monk, explains the Buddha, consists in their perfect habits, right conduct, and restraint (*Digha Nikāya* 26). Beautiful comportment manifests those virtues constitutive of wholesomeness and, ultimately, conductive to enlightenment. Its features include a 'charisma' or 'energy', 'radiating outwards', which the Buddha nicely compared to the scent of a flower or perfume (*Dhammapada* 55–56—cf. McGhee, 2000, 183). This extends to monastic appearance, clothing, interpersonal conduct, and micro-behaviours such as how one eats, talks, begs alms, chants, and meditates (Cooper, 2017; Kidd, 2017; Mrozick, 2007). By manifesting this wholesome comportment, monks can 'go forth beautifully' and 'attract the people's hearts' to the holy life (Samuels, 2010, 78–79).

Confucianism

Central to the moral teachings of Confucius is 'ritual' (*lĭ*), a rich concept encompassing not only formal and religious practices, but the whole range of everyday actions and behaviours. The scope of ritual includes ways of greeting guests, caring for the elderly, conversing with friends, and any personal and public comportment. Indeed, an enthusiastic disciple is advised not to walk, talk, or speak 'unless it is in accordance with the rituals' (*Analects* 12.1). Ritual conduct involves disciplined physical performance of morally virtuous actions—humble gestures, say, or respectful countenance, and these behaviours are conceived as 'somaesthetic expressions of … moral dispositions' (Mullis, 2017, 144). Confucius, who acts as a model and theoretician of ritual, emphasizes that ritual conduct is 'beautiful' and 'harmonious', comparable to dance and music (Fu & Wang, 2015; Zehou, 2010, chapter 1). Like dance, consummate ritual conduct is a smooth and graceful means of conducting oneself in constant

responsiveness to people, who are expected to reciprocate in turn (Gier, 2001; Ha Poong, 2006). Like music, ritual conduct should be spontaneous and authentic, not mechanical repetition, and involves 'training in a certain ethico-aesthetic character' (Kim-Chong, 1998, 70).

Zen Buddhism

Japanese tradition features various 'ways' (*dō*), such as *chadō* (the Way of tea) and *jūdō* (the gentle Way). Ways are practices of self-cultivation; they cultivate and express virtuous dispositions and sensibilities, enhancing our physical and moral health and lending beauty to our actions. Ways include everyday practices usually performed in everyday environments—such as cooking or caring for a garden—and this reflects the Zen emphasis on *practice* as a means to enlightenment, rather than doctrine (cf. James, 2004, 98). For D. T. Suzuki, what influenced Japanese tradition was 'the atmosphere emanating from Zen', not its doctrines, like 'emptiness' (Suzuki, 1973, 362). Everyday activities—sweeping the floor, grinding rice, folding one's sleeping mattress—can each express humility, naturalness, and spontaneity (Parkes & Loughnane, 2018). Moreover, Zen appreciation of nature, too, focuses on simple, undramatic things. Dōgen found that the grass swaying in the wind or the croaking of a frog can 'expound the profound dharma' (Dōgen, 1995, 146). 'Nothing special', a Zen motto, emphasizes the possibility of enlightenment in the most ordinary of experiences: 'the moon and the flowers will guide you', says the poet Ryōkan, not the grandiose achievements of 'the fleeting world' (Ryōkan, 2001, 23).

Shinto

Shinto, often called Japan's indigenous religion, shares an appreciation of the moral and aesthetic significance of everyday experiences and practices (Carter, 2008). 'Religion' may be misleading, prompting one influential scholar to characterize it as an 'existential spirituality' (Kasulis, 2004, 44 and 69). Central to Shinto are *kami*, supernatural beings who inhabit objects, natural forces, and landscapes, and are worshipped at household and public shrines (*kamidana* and *jinja*, respectively). Shinto practices are aestheticized, like the *kagura* dances and everyday-aesthetic practices, especially those concerned with purity (*harae*). To make environments proper dwellings for *kami*, enormous moral and aesthetic attention is put on 'order, cleanliness, brightness' and 'impeccability' (Pilgrim, 1993, 10). This is a rich aesthetic of simplicity and orderliness which easily lends itself to an aesthetics of the everyday: 'the natural expresses itself through the simplicity of materials and artist. If simplicity is valued, the natural will be able to express itself most directly through the hands of the cook, the potter, or the chopstick maker' (Kasulis, 2004, 44).

From Aesthetics to Happiness

Indian and Zen Buddhism, Confucianism, and Shinto are diverse traditions with substantial differences in their moral and aesthetic convictions. I offer them as examples of traditions in which kinds of aesthetics of the everyday are well-developed. Moreover, they illustrate how aesthetic experience and practice relate to the theme of happiness:

1. Human lives should be aesthetically rich, incorporating, appreciating, and engaging with many different kinds of aesthetic objects, each experienced in terms of many different aesthetic qualities.
2. The domain of the aesthetic is continuous with the moral, spiritual, and existential domains; indeed, their interrelations are so deep that even a notional separation of them into distinct value-spheres is deeply distorting ('wholesomeness', 'excellence' for Confucius, and Shinto 'purity' are all 'ethical-aesthetic' concepts—cf. Saito, 2007, 205f).
3. Aesthetic experience and activity is integral to all aspects of human life, from modes of personal comportment to experience of natural places and creatures, to how we relate to and care for other people, to our performance of social roles and duties, and our participation in our cultural and spiritual communities.

For these general reasons, everyday aesthetics and happiness clearly relate to one another, although the details need spelling out. For Thomas Leddy, 'happiness is a function, to a large extent, of [the] pervasiveness of distinctively aesthetic pleasure' (Leddy, 2014, 32). Similarly, for Arnold Berleant, appreciation of 'the prosaic landscapes of home, work, local travel, and recreation is an important measure of the quality of our lives' (Berleant, 1997, 16).

Happiness

The term 'happiness' is versatile, studied by psychologists and philosophers, and the theme of an industry of popular 'self-help', therapeutic literature. In everyday language, the term is used to refer to pleasant feelings and emotions, bliss, good mood, high spirits, or the quality of one's life, or at least large sections of it (cf. David et al., 2014). It is related to religion and spirituality, social and cultural conditions, and interpersonal relationships, as well as to popular concepts, such as resilience, well-being, and flourishing. An academic discipline, 'positive psychology', explores the psychology of happiness and other positive states, with an eye to developing effective interventions.

There are two main accounts of happiness, each internally diverse, which are usually called *hedonic* accounts, that define happiness in terms of enjoyable feelings, like

pleasure, and *life-satisfaction* accounts, which use richer, morally charged concepts, like flourishing and well-being (cf. David et al., 2014, sections II and III). However, each admits considerable variety, depending on their biological, psychological, emotional, social and philosophical or religious commitments. Philosophically, most accounts endorse some sort of life-satisfaction account, such as Aristotelian *eudaimonia*, whose compass is 'one's life-as-a-whole' (Annas, 1993). Life-satisfaction accounts emphasize the many features a life ought to have to count as happy or flourishing: stable patterns of emotion, a diversity of interpersonal relationships, initiating and completing meaningful projects, and value-infused practices and habits. Of course, such account should also emphasize various facts of life—that, for instance, most lives will involve periods of sadness and happiness, or the fact that many events in life are too evaluatively complex to be described in such simple terms as 'happy' or 'sad'. Happiness, flourishing, well-being and other positive concepts and ideals are intermingled, conceptually and existentially, with their negative counterparts (see Kagan, 2014; Woodard, 2023).

The Phenomenology of Happiness

I offer a more general account of happiness, compatible with hedonist and life-satisfaction accounts, which emphasizes the ways that forms of happiness depend on a more basic way of experiencing the world. In a famous passage, Ludwig Wittgenstein remarked, 'the world of the happy man is a different one from that of the unhappy man', the world of a happy man 'must, so to speak, wax and wane' (Wittgenstein, 1974, §6.43). Without pretending to know Wittgenstein's meaning, I take his remark to refer to a phenomenology of happiness. When one is happy, one might enjoy specific experiences, activities, and relationships, but these will presuppose some background sense of the world, of its mood or character. Such world-experiences can be hard to describe, for they are the backdrops to the experiences which more usually occupy our concern.

To develop the idea, consider a recent account of the phenomenology of happiness, offered by the philosopher David E. Cooper (Cooper, 2013). In happiness, one's world—the world of everyday perception, understanding, and engagement—is experienced as being at once *expansive* and *energetic*. The world feels expansive—open, filled with possibilities, and a space of opportunities, receptive to aspiration and hope. Moreover, the world also seems charged with energy—a place of dynamic, change, and buoyancy, encouraging a sense that one's projects will be energized, sustained, and helped to completion. Experienced in these ways, the world is experienced aesthetically, as beautiful, and many aestheticians testify to intimate connections between beauty, energy, and expansiveness. Elaine Scarry describes beauty as a 'locus of aspiration', one that 'quickens' and makes life 'more vivid' and 'worth living' (Scarry, 2001, 24–25). A Greek tradition, including Plato and Plotinus, connected the Beautiful with the Good and understood experiences of beauty in terms of a love or longing for a goodness which human beings, with effort, could take up into their lives. Alexander Nehemas wrote a book on

beauty, titled *Only a Promise of Happiness*, inspired by Stendhal's aphorism. Beauty is 'the promise of happiness', since finding someone beautiful includes 'a desire to continue interacting with them', in increasingly rich ways, driven by 'a sense that our life will be more worthwhile if [he or she] is part of it' (Nehamas, 2007, 53, 73, 75). Such claims are common in the philosophy of beauty, intimating deep connections between the beauty and the good life. Beauty and happiness disclose the world as a place of enticing and desirable possibilities—for aesthetic appreciation, interpersonal connection, and a satisfying life. In Cooper's account, then, happiness fundamentally involves ways of experiencing and responding to the world:

> The world of the happy person becomes more open, turning itself into an arena of possibilities for initiatives, projects, enjoyments and fresh commitments. To become open in this way, the world of the happy person must, so to speak, be a vista, something visible and surveyable: the possibilities that it enables, or indeed *is*, must be lit up like a clearing in a forest. Otherwise it cannot be experienced as the theatre of opportunities and initiatives that it needs to be in order to be open and expansive. It must be a world, too, that quickens, that gives out an impression of energy and animation: a place that is not fixed and static, but one where there is movement and vigour.
>
> (Cooper, 2013, 39)

Happiness, then, does not consist of fleeting, brief, episodic experience of pleasure. It is a way of experiencing the world as an expansive, energized space of positive possibilities, the receptive arena for a person to create a meaningful, satisfying life. The world of the happy person is one that affords a secure, nourishing environment for the confident attainment of happiness. Put in these terms, a phenomenological account resonates with everyday discourse about happiness:

A. Appraisal of the quality of one's life is inseparable from a background sense of the world. If the world feels harsh and hostile, a Schopenhauerian realm of suffering, it cannot be experienced as a theatre of happiness.
B. Happiness should have a sense of *ubiquity*. Brief moments of happiness cannot in practice suffice to make a life happy. One needs different forms and sources of happiness which pervade most or all of one's experiences and activities. A world can be elaborately textured with many experiences of happiness, many of them modest, subtle, and idiosyncratic. As one historian puts it, the 'idea of happiness ... points us to an all-inclusive assessment of a person's condition' (White, 2006, vii).
C. Happiness has a futural dimension: a person cannot be happy if all their happiness is behind them in past experiences and achievements, without any anticipation and prospect of more to come. Happiness projects into a sense that one's life is progressing, that things are going well, and that projects will come to fruition. Here, the future is experienced as a beckoning space of enticing possibilities—perhaps a sense that the world guarantees us future happiness. For Freud, people

'strive after happiness; they want to become *happy* and to remain so' (Freud, 2005, 25).

Happiness, then, should not be confined to brief, episodic instances of pleasure or positive emotion. It involves a broader experience of the world as an expansive and energetic space of enticing possibilities which one can explore and actualize in different ways. Experiencing the world as a rich and unfolding space of positive possibilities provides the background for more specific forms and experiences of happiness, of the sort central to the hedonist and life-satisfaction accounts.

Happiness and Everyday Aesthetics

How does this conception of happiness relate to everyday aesthetics? We should expect substantive connections, if, as Saito declares, one 'part of the goal of everyday aesthetics is to illuminate the ordinarily neglected, but gem-like, aesthetic potentials hidden behind the trivial, mundane, and commonplace façade' of everyday life (Saito, 2007, 50). I discuss three connections: *enrichment* of experience, *aesthetization* of negative aspects of life, and the enhancement of our *aesthetic agency*:

Happiness and Everyday Aesthetics (1): Enrichment of Experience

Cultivating appreciative sensitivity to the 'gem-like' aesthetic potential of our everyday life, sensations, environments, and activities could enrich our experiential and aesthetic world. If 'aesthetic experience' is confined to art or experiences of the sublime, then few, if any of us would regularly have *aesthetic* experiences; however, if a more expansive conception of the aesthetic is adopted, our prospects improve. Many lives, if not all, can be filled with a subtle pulse of beautiful, attractive, pleasing experiences, even if some of us do seem to live, intentionally or not, in an 'aesthetic vacuum' (Scruton, 2011, 50). The attractions of everyday aesthetics include its encouraging conviction that there is far more aesthetic richness in our lives than we typically recognize and appreciate. If we fail to see this, then our lives possess a richness we do not perceive or appreciate, whether due to distraction, inattentiveness, or an internalization of attitudes or theoretical convictions that narrow our aesthetic outlook and imagination (Cooper, 2010; Danto, 2014). In 1900, the Japanese novelist Natsume Sōseki, visiting England, was laughed at for inviting someone to a 'snow-viewing' (in Hume, 1995, 40). Other enrichment strategies are available, including 'aesthetic exploration', appreciation of how aesthetic prejudices sustain social oppression, an edifying exercise of virtues, or kinds of aesthetic appreciation of animals (cf. Cooper, 2010; Irvin, 2017; Greaves, 2019).

Aesthetic enhancement of experience can take many forms, partly shaped by material, cultural, and personal constraints. Our aesthetic opportunities depend, for instance, upon the materials, artefacts, natural spaces, environmental conditions, and humanized places immediately available (contrast central New York, the Argentinean *pampas*, and Svalbard). Japanese aesthetics, for instance, is shaped by its religious, cultural, and environmental history, lending that tradition a diversity concealed by the current fixation on *wabi-sabi*, the tea ceremony, and *shakuhachi* music (Saito, 2009). Zen influence on music, literature, and garden design have emphasized certain tastes and sensibilities—such as appreciation of indistinctness, transience, and impermanence (Cooper, 2017; Suzuki, 1973; Yanagi, 1989). Other influences, however, may point in other directions. Motoori Norinaga rejected the Buddhist-infected taste for *wabi* and *sabi*—weathered stones, frayed scrolls, faded fabric—that 'exemplify the conditions of decay, imperfection ... insufficiency' (Saito, 2007, 187). Norinaga preferred a Shinto-inspired aesthetic, of immaculateness, cleanliness and purity, celebrating, not 'decay', but 'order, clarity' and 'brightness' (Pilgrim, 1993, 10; cf. de Bary, 2010, 409–421). So, the specific objects and qualities that enter our enriched experience will depend on our wider aesthetic influences.

In speaking of 'enrichment', we should distinguish three claims. First, cultivating an everyday-aesthetic sensibility adds new kinds of appreciable aesthetic experience, ones not previously a feature of our experience. Second, that sensibility enhances the status of certain aesthetic experiences, 'promoting' them, as it were, to the status of the genuinely aesthetic. Third, an everyday-aesthetic sensibility can deepen our understanding of the depth or meaningfulness of our everyday-aesthetic experiences. Perhaps one starts to see aesthetic opportunities woven into one's daily life, or to appreciate the seriousness of sorts of aesthetic practice one previously regarded as trivial. In these cases, there is enrichment.

HAPPINESS AND EVERYDAY AESTHETICS (2): AESTHETIZATION OF NEGATIVE ASPECTS OF THE WORLD

Everyday experience includes negative aspects of the world: suffering, death, illness, the physical and mental decrepitude integral to ageing, devastated people and places, and wider processes of deterioration, which affects bodies and minds as much as artefacts, buildings, and environments. These include aesthetic features: the blemished, decayed, chipped, cracked, crumpled, eroded, faded, mouldering, ruined, which cultural geographers suggest is a cross-culturally stable dislike (Saito, 2007, 174, n.53). However, there are exceptions, including the *Ruinenlust*—the appreciation of ruins, inspired by German Romanticism—and the *wabi-sabi* aesthetic in Japan, and other philosophical and cultural movements that aimed to aestheticize aspects of the world

usually condemned. 'Pleasure in ruins' might not come naturally, but can be taught if one develops appropriate conceptions of their significance (see Cooper, 2012a; Dekkers, 2000).

Similar claims are made about the aesthetization of ageing, a major theme of Japanese aesthetics, where it is connected to a sense of inevitable loss, impermanence, and evanescence. Frailty is integral to worldly existence. In Buddhist terms, human life is suffused with *dukkha*—'suffering' or 'dis-ease', including inevitable separation from what is desired (youth, health, people and things we love) and inevitable subjection to what is not desired (senescence, illness, grief). Human life, indeed, is suffused with actual and inevitable loss (cf. Carel, 2021). Saito calls these 'existential conditions', and argues, interestingly, the existential strategy of aestheticization as a way to cope with them. Aesthetic appreciation of aged things can involve different things: we may come to find things beautiful in new ways, inflect painful transience with a sense of pleasing preciousness, come to experience aged things as manifestations of humility and other virtues, and see aged things as indicators of deep truths about the world (Saito, 2007, 184–204, which includes criticisms of such claims).

Happiness and Everyday Aesthetics (3): Enhancement of Our Aesthetic Agency

A virtue of an aesthetics of the everyday is that it can enhance our sense of the scope of aesthetic agency. By 'aesthetic agency', I refer to the variety of bodily, practical, creative, imaginative abilities that enable us to engage in practices that change the aesthetic character of aspects of the world. Aesthetic agency includes applying makeup, decorating a room, dancing, drawing, painting, playing musical instruments, and sculpting. Some of this is individual, some is shared, and some is collective. Aesthetic agency aims at different things. It can be aimed at creating *objects*, like paintings, or mean initiating or participating in *processes*, like a dance or singing in a choir (cf. Nguyen, 2020, chapter 7). It can involve a range of specific tools and materials, such as paints and brushes, or simply our own bodily capacities. Aesthetic agency can involve changing the appearance of things (painting) or the composition of things (adding spices to a soup) or, perhaps, removing and destroying things ('tearing down' ugly wallpaper). In many cases, agency also includes acts of appraisal, such as connoisseurship and spectatorship, involving aesthetic commentary ('The French horn came in too late!', 'What graceful movement!') Saito describes kinds of everyday aesthetic agency:

> [M]ost of us attend to our personal appearance almost daily: choosing what to wear and what sort of haircut to get, cleaning and ironing clothes, and deciding whether or not to dye our hair or try some kind of 'aesthetic rejuvenation' treatment or body decoration [...] choosing the paint colour for the house, planting flowers in the yard,

cleaning and tidying rooms … replacing shabby-looking drapes, and reupholstering a threadbare couch.

(Saito, 2007, 46–47)

Everyday aesthetics encourages an expansive sense of aesthetic agency, and this can enhance a person's life. It can sustain a sense of activity, self-assertion, and abilities to creatively shape one's body and environment, which could contribute to our happiness, at least in cases where one's aesthetic efforts are met with approval. Praise, compliments, and nods of appreciation can be sources of pleasure, feelings of social connection, and a sense of belonging within a receptive community. Of course, exercising aesthetic agency can create problems, too, including the snobbish reactions of others and risking appearing or acting in ways liable to elicit negative reactions (Irvin, 2017; Kieran, 2010). For this reason, the connection of happiness to everyday aesthetic agency is complicated, contingent on many factors. In some cases of psychiatric illness, however, one might suffer a diminished ability to experience forms of happiness and aesthetic experience.

Happiness, Aesthetics, and Depression

Depression, as a psychiatric category, covers a range of different kinds of predicament, which share a range of common phenomenological features. These include altered experiences of one's body, other people, time, and the social world, as well as feelings of grief, hopelessness, despair, guilt, and diminutions of one's sense of agency and the sense of belonging to a shared world. Describing the first-person experience of these predicaments is the task of phenomenological psychopathology, which applies the resources of existential phenomenology to psychiatric illnesses, including depression. In this section, I describe the influential account of the phenomenology of depression by Matthew Ratcliffe in his book *Experiences of Depression* and other papers (Ratcliffe, 2015). I explore its mostly negative implications for my earlier accounts of everyday aesthetics and happiness.

Depression and Aesthetic Experience

Experiences of depression are often described in terms of the *world* seeming strange, altered, or different somehow, often in a sense that is hard to describe. Here is a typical example:

It was October, and one of the unforgettable features of this stage of my disorder was the way in which my own farmhouse, my beloved home for thirty years, took on for

me at that point when my spirits regularly sank to their nadir an almost palpable quality of ominousness. The fading evening light […] had none of its familiar autumnal loveliness, but ensnared me with a suffocating gloom. I wondered how this friendly place, teeming with such memories […] could almost perceptibly seem so hostile and frightening.

(Styron, 1990, 45)

Some common descriptions invoke a range of visual and tactile metaphors: the world seems 'cold', 'dark', one feels 'immersed', 'trapped', as if in an over-heated room, or a 'closed, concentrated world, airless', in 'a kind of spiritual winter, frozen, sterile, unmoving' (Ratcliffe, 2015, 65). Such language testifies to a wide-ranging aesthetic impoverishment; the world now lacks colour, vitality, movement, energy, and is no longer experienced as an experiential environment describable in terms of comfort, openness, or space (see Ratcliffe, 2015, 111f for indicative testimonies). A common feature of such accounts are reports of a stubborn sense of the inadequacy of language to properly convey the altered experience of the world. This may be a combination of (a) disruptions to a person's descriptive abilities, (b) general limitations in our shared descriptive and linguistic resources, and (c) the radically different experiential character of the world itself, especially the loss of a background sense of reality which our descriptive
and resources more ordinarily presuppose:

> You know that you have lost life itself. You've lost a habitable earth. You've lost the invitation to live that the universe extends to us at every moment. You've lost something that people don't even know is. That's why it's so hard to explain.
>
> (quoted by Hornstein, 2009, 213)

> Such feelings are not easy to describe: our vocabulary—when it comes to talking about these things—is surprisingly limited. The exact quality of perception requires the resources of poetry to express. […] I awoke into a different world. It was as though all had changed while I slept: that I awoke not into normal consciousness but into a nightmare.
>
> (quoted by Rowe, 1978, 268–269)

Such changes in the aesthetic character of the world are diverse. Aesthetic concepts are still deployed, albeit typically the negative ones—the world seems dark, cold, drained of light and life. The changes can take place slowly. The nature writer, Richard Mabey, noted a sudden loss of pleasure in the beauty of birds, which had once meant so much to him, during the early stages of a period of depression (Mabey, 2005). The changes often become total. For the phenomenologist Karl Jaspers, 'perception is unaltered in itself but there is some change which envelops everything with a subtle, pervasive and strangely uncertain light' (Jaspers, 1963, 98). Fiona Shaw spoke of her world becoming a 'bleak shadowland' (Shaw, 1997, 25). William James, too, emphasizes the change in world-experience—the world seems 'remote, strange, sinister, uncanny. Its colour is

gone' (James, 1906, 151, 243). Positive aesthetic experiences tend to recede, sometimes even to the point that the possibility of their returning seems gone, consistent with the loss of various kinds of hope: one loses a sense that 'things are fluid, that they unfold and change, that new kinds of moment are eventually possible, that the future will arrive' (Lott, 1996, 246–247).

Such descriptions indicate that experiences of depression can involve both (a) the loss or diminishment of aesthetic experience and (b) wider-ranging changes that seem to invite description using a vocabulary of aesthetic impoverishment ('dark', for instance, is used visually, psychologically, and philosophically to describe nights, moods, or outlooks). The aesthetic diminishment can also take many different forms. In the case of beauty, one might be able to ascribe but not notice it, or notice it but not be moved by it, or be moved by it but not feel happy because of it, and so on (Scrutton, 2018, 107).

These aesthetic changes also involve other typical aspects of experiences of depression. A loss of hope, for instance, is often described as involving a sense of one's future seeming *dark* and *empty* (see Ratcliffe, 2015, chapter 4). Moreover, different aspects of depression can affect aesthetic experience in different ways. Scrutton notes that 'a sense of alienation from the interpersonal and, by extension, the aesthetic world, as distinct from an inability to appreciate beauty *per se*, is characteristic of depression' (Scrutton, 2018, 105). One can lose one's capacity for aesthetic appreciation, of beauty at least, while retaining a sense of being connected to the aesthetic world; by contrast, one can become alienated from the aesthetic world altogether.

Depression and Happiness

Experiences of depression also affect one's experiences of, and capacity for, the variety of positive emotions and moods gathered under the term 'happiness', which can also include joy, elation, and delight. Such forms of happiness are often experienced as newly absent from the world one now inhabits:

> When I am not depressed my feelings/emotions are totally different, because I can think clearly. I can see a future for myself. I can feel happiness. I can see the joys in life. I can socialize. I can be loving and friendly. When I am depressed, I am unable to think clearly. I feel sorrow, anger, frustration, sadness, lonely, worthless, despair and mainly I feel like my life is not worth living and I would rather be dead!
> (quoted in Ratcliffe, 2015, 113)

These altered experiences of happiness are often entangled with altered interpersonal experience; after all, we are often happy in relation to people, whether because we are happy *for* someone (a colleague is promoted) or happy *because* of someone (a friend spontaneously buys you a lovely gift) or happy *with* someone (a couple holding

their first-born baby for the first time). Altered interpersonal experience will therefore involve disruptions to the kinds of experience of happiness a person can access or anticipate:

> I become paranoid. People don't like me, I'm a burden, they become patronizing because they know I can't cope. When they care, it's because they have to—and their happiness always seems to be in spite of me, never because of me, and I know I get in their way. Those I don't see often feel like they're from a different life and they're moving quicker than me. They're effort. They're intense.
>
> (quoted in Ratcliffe, 2015, 225)

In many cases, the loss of happiness takes a more profound form: loss of the possibility of happiness. Sometimes, we are not happy because there is, contingently, nothing and no one that might elicit it, even if one continues to anticipate happiness at some future point. In many experiences of depression, however, one ceases to anticipate happiness. Andrew Solomon writes in his memoir, *The Noonday Demon*, that 'the first thing that goes is happiness. You cannot gain pleasure from anything [...] soon other emotions follow happiness into oblivion' (Solomon, 2001, 19). Ratcliffe explains this 'oblivion' as a loss of the *possibility* of happiness:

> It is kinds of emotion that fall into 'oblivion' rather than their instances. It is not that the person stops feeling happy about *p, q,* and *r*. She gradually loses the sense that anything in the world could offer happiness; she ceases to experience its possibility. What Solomon describes is both an inability to anticipate feeling happy and an inability to actually feel happy.
>
> (Ratcliffe, 2015, 55–56)

In his book, Ratcliffe argues that experiences of depression involve a more fundamental loss of access to kinds of significant possibility. Our experience ordinarily incorporates a diverse range of possibilities, ones implicit in our everyday experience and engagement with the world. These include perceptual possibilities, practical possibilities, and various interpersonal possibilities, all of them interrelated in dynamic, mutually coherent ways, constituting our experiential world (Ratcliffe, 2015, chapters 1 and 2). Such possibilities are experienced as significant in many different ways—as, for instance, boring, dangerous, exciting, interesting, irrelevant, relevant, strange, unusual, useful, useless. Such kinds of significance are shaped by our values, commitments, interests, goals, and habits (an inheritance from existentialist philosophy; see Cooper, 2012b, §§2.3–2.4). Human life is an ongoing process whereby we experience and respond to these unfolding systems of possibility—actualizing those salient to our life-projects and trying to resist those which would be destructive of them. 'Our access to kinds of possibility', explains Ratcliffe, 'is itself integral to our experience', without which one would not inhabit a habitable world (Ratcliffe, 2015, 51).

Loss and Impoverishment

Experiences of depression, on this account, involve loss of access to kinds of significant practical and interpersonal possibility. Things no longer 'light up' as enticing, so our practices and activities seem meaningless; social roles and commitments cease being significant and intelligible; other people are no longer experienced in terms of possible meaningful interaction, communion, or connection. As kinds of possibilities are drained from one's world, there is a sense of diminishment, absence, and loss. In a very severe case, however, the awareness of there having been a loss is, itself, lost (see Ratcliffe, 2015, 110ff). In some cases, a person's experiential world undergoes a change involving the temporary restoration of a sense of possibility. 'Renee', the titular patient of *Autobiography of a Schizophrenic Girl*, offers a vivid account:

> [W]hen we were outside I realized that my perception of things had completely changed. Instead of infinite space, unreal, where everything was cut off, naked and isolated, I saw Reality, marvellous Reality, for the first time. The people whom we encountered were no longer automatons, phantoms, revolving around, gesticulating without meaning; they were men and women with their own individual characteristics, their own individuality. It was the same with things. They were useful things, having sense, capable of giving pleasure. Here was an automobile to take me to the hospital, cushions I could rest on. [...] for the first time I dared to handle the chairs, to change the arrangement of the furniture. What an unknown joy, to have an influence on things; to do with them what I liked and especially to have the pleasure of wanting the change
>
> (Sechehaye, 1970, 105–106)

In Ratcliffe's terms, 'Renee' (a pseudonym) experiences temporary restoration of her ability to experience kinds of significant practical and interpersonal possibilities. 'Things' became *useful objects*, artefacts like chairs and automobiles. Other people were 'men and women', individuals offering possibilities for meaningful interaction. Moreover, this restoration was aesthetically charged and one of happiness—one of 'joy', 'pleasure', and 'marvellous'.

If the experience of depression involves a diminished ability to experience kinds of significant possibility, how does this relate to everyday aesthetics and happiness? To start with, everyday aesthetics presupposes our ability to experience the world, or aspects of it, in a rich variety of aesthetically charged ways. If aesthetic possibilities are unavailable, then there can be no everyday aesthetic experience—or, perhaps, there can be only negative aesthetic possibilities. Everyday aesthetic appreciation and agency presupposes that one can experience a range of experiential and practical possibilities. One spots things, admires them, picks them up, handles them, and finds things beautiful, neat, and satisfying. If these forms of appreciation and agency are unavailable, there can be no aesthetic enrichment.

A second connection concerns the bodily phenomenology of depression as it can relate to everyday aesthetic experience and happiness. Recall that everyday aesthetics, in many cases, involves the appreciation and aestheticization of one's own body—its motion, textures, sounds, smells, and appearance. Think of the Confucian rituals, which strive for spontaneity, harmony, and propriety in one's posture, gait, tone of voice, and facial appearance. However, this positive self-experience is undermined by typical kinds of changes to bodily phenomenology in depression. Depression testimonies consistently mention fatigue, pain, sluggishness, tiredness, an intense sense of difficulty with even relatively small tasks. Others mention extremely negative experience of one's body as fat, useless, or ugly (cf. Ratcliffe, 2015, 76–77). In such cases, the everyday aesthetic aspiration to aestheticize the appearance and comportment of one's body will seem to be either practically or phenomenologically difficult, if not impossible. Moreover, it may be impossible for someone to experience their bodily comportment in positive ways, as their bodily phenomenology becomes dominated by estrangement (see Fuchs, 2013).

A third connection concerns the diminution of the interpersonal world which is integral to experiences of depression. Scrutton notes that aesthetic experiences are often interpersonal, too: we admire things together, show things to one another, share our opinions and so on ('Ooh, that's pretty!', 'That cravat goes lovely with that shirt!'). This includes many everyday-aesthetic experiences and practices (think of food, style, and cosmetics and the experience of public places, parks, homes, and workplaces). Any diminishment of our interpersonal world, then, can entail diminishment of our aesthetic possibilities. Diminishment, though, does not exhaust the effects of depression on the phenomenology of aesthetic experience, as Scrutton notes:

> Experiences of beauty in depression ... often induce feelings of loneliness, sadness, fear and so on, because they draw attention to the depressed person's alienation from the interpersonal world. Consequently, people with depression may appreciate beauty in the sense of perceiving and being moved by it, but feel sadness, numbness, or fear rather than joy or wonder because of it.
>
> (Scrutton, 2018, 107–108)

The possibility of happiness, too, presupposes our ability to experience other people and feel various kinds of connection to, or belonging in, a shared social world. However, the interpersonal possibilities and sense of belonging this requires are eroded in depression, hence the talk of the social world as 'shadowland', populated by 'automatons', pervaded by an inchoate sense of threat, distrust, and hostility (see Ratcliffe, 2015, chapter 8). If one's world is bereft of enticing interpersonal possibilities, then the kinds of connections and relationships with others that could sustain kinds of happiness become impossible and even inconceivable. Moreover, many kinds of happiness and pleasure depend on the initiation, continuation, or completion of our projects—going on a long hike, painting a portrait, studying for a degree. If those projects cease to be intelligible or meaningful, then one is locked out of the happiness they could have afforded.

Conclusion

In many cases, experiences of depression will involve the loss or diminishment of the experiential possibilities presupposed by everyday aesthetics and conceptions of happiness. If depression involves a loss of access to kinds of significant possibility, this includes the possibilities for aesthetic appreciation and agency, interpersonal connection and social intercourse, and for an expansive sense of one's life as a space of enticing possibilities which, if realized, would offer contentment and pleasure. It is unclear what therapeutical implications follow this account (cf. Ratcliffe, 2015, chapter 10 and Scrutton, 2018). However, three things should be clear. First, aesthetic experience and agency are much richer than theories focused on art and special experiences indicate; revealing this fact is a main virtue of the aesthetics of the everyday. Second, happiness involves not only aesthetic activities and enjoyments, but also a certain way of experiencing the world. Third, aesthetic experience and happiness depend on our capacity to experience various kinds of possibility—a capacity arguably diminished, or even lost, in experiences of depression. This suggests that that loss of positive aesthetic and existential possibilities is integral to most if not all experiences of depression.

Acknowledgements

I am grateful to Yuriko Saito for the invitation to contribute, and for her patience and her comments on an earlier draft.

References

References to the *Analects* are in the standard book-chapter format, and I mainly use the translations by D. C. Lau and Edward Slingerland. References to Buddhist *suttas* are to the *Majjhima Nikaya* (translated by Bhikkhu Nanamoli and Bhikkhu Bodhi), the *Digha Nikaya* (translated by Maurice Walshe), and the *Dhammapada* (translated by Valerie Roebuck).

Annas, J. (1993). *The morality of happiness*. Oxford University Press.
Berleant, A. (1997). *Living in the landscape: Toward and aesthetics of environment*. The University Press of Kansas.
Carel, H. (2021). 'Creatures of a day': Contingency, mortality, and human limits. *Royal Institute of Philosophy Supplement 90*, 193–214.
Carlson, A. (2020). Environmental aesthetics. In E. N. Zalta (Ed.), *The Stanford Encyclopedia of Philosophy*. Available from: https://plato.stanford.edu/entries/environmental-aesthetics/.
Carter, R. E. (2008). *The Japanese arts and self-cultivation*. State University of New York Press.
Chong, K.-C. (1998). The aesthetic moral personality: *Li, Yi, Wen,* and *Chih* in the *Analects*. *Monumenta Serica 46*(1), 69–90.
Cooper, D. E. (2006). *A philosophy of gardens*. Oxford University Press.

Cooper, D. E. (2010). Edification and the experience of beauty. In W. Keping (Ed.), *International yearbook of aesthetics: Diversity and universality in aesthetics* (pp. 62–80). Institute for Transcultural Studies), Beijing.

Cooper, D. E. (2012a). Should ruins be preserved? In G. Scarre & R. Coningham (Eds.), *Appropriating the past: Philosophical perspectives on the practice of archaeology* (pp. 222–236). Cambridge University Press.

Cooper, D. E. (2012b). Existentialism as a philosophical movement. In S. Crowell (Ed.), *The Cambridge companion to existentialism* (pp. 27–49). Cambridge University Press.

Cooper, D. E. (2013). *Sunlight on the sea: Reflecting on reflections*. Kindle edition.

Cooper, D. E. (2017). Buddhism, beauty, and virtue. In K. Higgins, S. Maira, & S. Sikka (Eds.), *Artistic visions and the promise of beauty* (pp. 123–138). Springer.

Danto, A. (2014). Kalliphobia in contemporary art. *Art Journal* 63(2), 24–35.

David, S., Boniwell, I., & Ayers, A. C. (2014). *The Oxford handbook of happiness*. Oxford University Press.

De Bary, W. T. (2010). *Sources of Japanese tradition: 1600 to 1868*, second edition, volume 2 (abridged). Columbia University Press.

Dekkers, M. (2000). *The way of all flesh: A celebration of decay*, translated by S. Marx-Macdonald. Harvill.

Dewey, J. (1934). *Art and experience*. Touchstone.

Dōgen. (1995). *Moon in a dewdrop: Writings of Zen Master Dōgen*, edited by K. Tanahashi. North Point Press.

Freud, S. (2005). *Civilization and its discontents*, edited by J. Strachey. Norton, Gibbard, Allan.

Fu, X., & Wang, Y. (2015). Confucius on the relationship of beauty and goodness. *The Journal of Aesthetic Education* 49(1), 68–81.

Fuchs, T. (2013). Depression, intercorporeality, and interaffectivity. *Journal of Consciousness Studies* 20(7–8), 219–238.

Gier, N. (2001). The dancing *Ru*: A Confucian aesthetics of virtue. *Philosophy East and West* 51(2), 280–305.

Greaves, T. (2019). Movement, wildness, and animal aesthetics. *Environmental Values* 28(4), 449–470.

Ha Poong, K. (2006). Confucius's aesthetic concept of noble man: Beyond moralism. *Asian Philosophy* 16(2), 111–121.

Hepburn, R. (2001). *The reach of the aesthetic: Collected essays on art and nature*. Ashgate.

Higgins, K. (2017). Global aesthetics—What can we do?' *Journal of Aesthetics and Art Criticism* 75(4), 339–349.

Hornstein, G. A. (2009). *Agnes's Jacket: A psychologist's search for the meanings of madness*. Rodale.

Hume, N. G. (1995). *Japanese aesthetics and culture: A reader*. State University of New York Press.

Irvin, S. (2008). The pervasiveness of the aesthetic in ordinary experience. *British Journal of Aesthetics* 48(1), 29–44.

Irvin, S. (2017). Resisting body oppression: An aesthetic approach. *Feminist Philosophy Quarterly* 3(4), 1–26.

James, S. P. (2004). *Zen Buddhism and environmental ethics*. Ashgate.

James, W. (1906). *The varieties of religious experience: A study in human nature*. Pennsylvania State University Press.

Jaspers, K. (1963). *General psychopathology*, translated by J. Hoenig & M. W. Hamilton. University of Chicago Press.

Kagan, S. (2014). An introduction to ill-being. In M. Timmons (Ed.), *Oxford studies in normative ethics*, volume 4 (pp. 261–288). Oxford University Press.

Kasulis, T. P. (2004). *Shinto: The way home*. University of Hawai'i Press.

Kidd, I. J. (2017). Beautiful *Bodhisattvas*: The aesthetics of religious exemplarity. *Contemporary Buddhism* 18(2), 331–345.

Kieran, M. (2010). The vice of snobbery: Aesthetic knowledge, justification and virtue in art appreciation. *Philosophical Quarterly* 60, 243–263.

Kirkland, R. (2004). *Taoism: The enduring tradition*. Routledge.

Leddy, T. (1995). Everyday surface aesthetic qualities: 'neat', 'messy', 'clean', 'dirty'. *Journal of Aesthetics and Art Criticism* 53(3), 259–268.

Leddy, T. (2012). *The extraordinary in the ordinary: The aesthetics of everyday life*. Broadview Press.

Leddy, T. (2014). Everyday aesthetics and happiness. In L. Yuedi & C. L. Carter (Eds.), *Aesthetics of everyday life: East and west* (pp. 26–47). Cambridge Scholar's Press.

Leddy, T., & Puolakka, K. (2021). Dewey's aesthetics. In E. N. Zalta (Ed.), *The Stanford Encyclopedia of Philosophy*. Available from: https://plato.stanford.edu/entries/dewey-aesthetics/.

Light, A., & Smith, J. M. (Eds.). (2005). *The aesthetics of everyday life*. Columbia University Press.

Lott, T. (1996). *The scent of dried roses*. Viking.

Mabey, R. (2005). *Nature cure*. Chatto & Windus.

McGhee, M. (2000). *Transformations of mind: Philosophy as spiritual practice*. Cambridge University Press.

Mrozick, S. (2007). *Virtuous bodies: The physical dimensions of morality in Buddhist ethics*. Oxford University Press.

Mullis, E. (2017). Thinking through an embodied Confucian aesthetics of persons. In K. Higgins, S. Maira, & S. Sikka (Eds.), *Artistic visions and the promise of beauty* (pp. 139–149). Sophia Studies in Cross-cultural Philosophy of Traditions and Cultures 16. Springer.

Nehemas, A. (2007). *Only a promise of happiness: The place of beauty in a world of art*. Princeton University Press.

Nguyen, T. (2020). *Games: Agency as art*. Oxford University Press.

Novitz, D. (1992). *The boundaries of art: A philosophical inquiry into the place of art in everyday life*. Temple University Press.

Papanek, V. (1995). *The green imperative: Natural design for the real world*. Thames and Hudson.

Parkes, G., & Loughnane, A. (2018). Japanese aesthetics. In E. N. Zalta (Ed.), *Stanford encyclopedia of philosophy*. Available from: https://plato.stanford.edu/entries/japanese-aesthetics/.

Pilgrim, R. B. (1993). *Buddhism and the arts of Japan*. Anima.

Ratcliffe, M. (2015). *Experiences of depression: A study in phenomenology*. Oxford University Press.

Rowe, D. (1978). *The experience of depression*. John Wiley.

Ryōkan. (2001). *One robe, one bowl: The Zen poetry of Ryōkan*, edited and translated by J. Stevens. Weatherill.

Saito, Y. (1999). Japanese aesthetics. In M. Kelly (Ed.), *Encyclopedia of aesthetics*, volume 2 (pp. 545–547). Oxford University Press.

Saito, Y. (2007). *Everyday aesthetics*. Oxford University Press.

Saito, Y. (2009). Japanese aesthetics. In S. Davies (Ed.), *A companion to aesthetics* (pp. 384–387). Wiley-Blackwell.

Saito, Y. (2022). *The aesthetics of care: Practice in everyday life*. Bloomsbury.

Samuels, J. (2010). *Attracting the heart: Social relations and the aesthetics of emotion in Sri Lankan monastic culture*. University of Hawai'i Press.

Sartwell, C. (1995). *The art of living: Aesthetics of the ordinary in world spiritual traditions*. State University of New York Press.

Scarry, E. (2001). *On beauty and being just*. Duckworth.

Scruton, R. (2011). *Beauty: A very short introduction*. Oxford University Press.

Scrutton, A. P. (2018). Depression and aesthetic experience: Can people with depression appreciate beauty? *Discipline Filosofiche 28*(2), 105–122.

Sechehaye, M. (1970). *Autobiography of a schizophrenic girl*. Signet.

Shaw, F. (1997). *Out of me: The story of postnatal breakdown*. Penguin.

Sherman, N. (2005). Of manners and morals. *British Journal of Educational Studies 53*(3), 272–289.

Solomon, A. (2001). *The noonday demon: An atlas of depression*. Simon & Schuster.

Styron, W. (1990). *Darkness visible*. Vintage Books.

Suzuki, D. T. (1973). *Zen and Japanese culture*. Princeton University Press.

Tanizaki, J. (2001). *In praise of shadows*. Vintage.

White, N. (2006). *A brief history of happiness*. Blackwell.

Wittgenstein, L. (1974). *Tractatus Logico-Philosophicus*, translated by D. F. Pears & B. G. McGuinness. Routledge.

Woodard, C. (2023). The value and significance of ill-being. *Midwest Studies in Philosophy 46*, 1–23.

Yanagi, S. (1989). *The unknown craftsman: A Japanese insight into beauty*. Kodansha International.

Yuedi, L., & Carter, C. L. (2014). *Aesthetics of everyday life: East and west*. Cambridge Scholar's Press.

Zehou, L. (2010). *The Chinese aesthetic tradition*. University of Hawai'i Press.

SECTION IV
SOCIAL AESTHETICS AND MENTAL HEALTH

INTRODUCTION
Social Aesthetics and Mental Health

MICHAEL MUSALEK

When considering aesthetics, we can distinguish between individual aesthetics and social aesthetics, just as we do in the field of ethics. Individual ethics are defined as a type of ethics in which certain individual values serve as the basis for developing ethical-moral ideas, considerations, and maxims. In contrast, the focus of interest in social ethics is upon community values. Human rights and obligations are considered and determined solely in terms of their relevance for the community. Moral and ethical convictions take shape and are only relevant within the community (Ulfig, 1999). By analogy, social aesthetics, in contrast to individual aesthetics, can be understood as an aesthetic which focuses on community values. Community values take precedence over individual values. The possibilities and impossibilities for human sensual perception and experiences are considered and determined primarily in terms of their significance for the community. Aesthetic forms of experience and convictions take shape and have their relevance above all in togetherness with fellow human beings.

As individual forms of aesthetic experience always constitute social relationships and the aesthetic experience of social relationships, i.e., are inseparably linked with encounters and relationships, not to say are one with them, every aesthetic is actually also a form of social aesthetic, so that social aesthetics become fundamental aesthetics. Conceived in a narrow sense, social aesthetics is understood as the science of sensual perceptions and forms of experience (aisthesis) of encounters and relationships *between* and *with* other humans—in an even narrower definition, as the science of human encounters and relationships that we as human beings experience as beautiful and successful. In a broader interpretation, however, social aesthetics is the science of all sensually experienced encounters and relationships, not only those between and with people, but also those with objects, situations, and events in general.

This broad view of social aesthetics also captures the original meaning of what Arnold Berleant (2005), who introduced the term social aesthetics into philosophical

parlance, understood when in his article entitled 'Ideas for a Social Aesthetics' he wrote that 'Social aesthetics is, …, an aesthetic of the situation.… Like every aesthetic order, social aesthetics is contextual. It is also highly perceptual, for intense perceptual awareness is the foundation of aesthetics.' For Arnold Berleant, an intense sensual encounter with a particular event, with a specific object, or a special situation is not a one-way relationship but is always a two-way relationship, making it a social-aesthetic event. It is not just the individual who encounters the object, the object also encounters the individual (Berleant, 1992, 2017).

At any rate, it is the human being with his or her sensual experience who is at the centre of the event, once as the one who encounters a Something and at the same time also as the one who is encountered by the Object. Seen in this way, social aesthetics is always also a form of anthropology. In social aesthetics, the human being is understood as a social and communal being with a capacity for sensual experience. From the very beginning of our lives we are dependent upon others. We are born as unfinished beings. It is only with the help and support of others that we can develop and flourish. Throughout our lives, we need other people to help us cope with the challenges life throws at us, especially in old age, when age-related diseases or deficits occur that need to be compensated for with the help of others. We are not genuine individual beings who first must painstakingly learn to live our lives in community with others. On the contrary: we are genuinely communal beings, who only over the course of our lives—and generally with significant difficulties—also now and then have to learn to cope on our own with the demands of this life and to master the challenges life throws at us.

Moreover, human beings are also genuinely artistic and cultural beings. We are not only capable of discerning our world as such, but we are also able to shape and form it ourselves within given frameworks. From the dawn of humanity, man has created wonderful works of art to adorn the sites that are sacred to him; the wall paintings in the Lascaux Cave being an impressive example. Aesthetic sensibility and aesthetic creation were and are inextricably linked. It is impossible to imagine a human being outside of culture (Bodicce, 2019) and this culture is always a shared culture, a jointly created and communicated culture —thus social aesthetics with its central question: 'How do we humans create and shape our culture?' also becomes the central cultural science. New creations or remakes can only ever take place in certain given frameworks or constellations of conditions, among which the atmospheres in which such creative processes are cast must be accorded special significance. Experiencing them sensually is not only a social aesthetic event par excellence, atmospheres can, in negative cases, hinder and prevent human creative and formative processes; however, they can also in a very special way enable, support, and catalyse them and in doing so make the possible possible (Bernegger, 2015).

The three main areas of social aesthetics research are thus: (1) touching, (2) hospitality, and (3) atmospheres. The term *touching* is associated first and foremost with tactile contact. Physical touching does indeed play an important role in human encounters and relationships, be it in the form of a welcoming handshake or a familiar

slap on the back through to more intimate forms of physical touch such as kissing or more complex sexual acts. From the day we are born, physical touching is central to our lives. It is of paramount importance for personality development but also for our living together as human beings and hence for our ability to create and lead flourishing lives. The immediate effect of touching depends not only on how we are touched, but also on the time and place, and above all on the situational, social, and cultural contexts in which touching takes place—in some situations it can be pleasant, calming, and reassuring, and in others unpleasant, unsettling, or disturbing. In any case, physical touch is inextricably linked to mental touch—physical touch has the power to move us emotionally as a whole being!

However, we can be touched emotionally without being touched physically. We experience such mental touching when we are touched by a wonderful conversation, a loving glance, or smile. We can also be touched mentally in an exceptional way by glorious paintings, sculptures, or pieces of music, to say nothing of situations and events that touch our hearts. But we can also experience emotional touching and being touched in the transcendental realm. We refer to spiritual touching in situations when religious convictions, heavenly experiences, transcendental ideas, ideologies or fantasies deeply move us on an emotional level (Palmquist, 2016). All these forms of touching are constitutive for the way we live our lives—they are, as it were, the lifeblood of human existence.

When touching and being touched, sensuously, mentally, spiritually, and possibly transcendentally, we are living: 'Tango, tangor ergo sum'—I touch and become touched, therefore I am', emphasizes the famous German philosopher of life, Wilhelm Schmid (2019), in his book on the power of touching. Touching opens up new possibilities for and in encounters and relationships, strengthens trust in ourselves and in others. However, it also opens doors to a direct experience of beauty and thus strengthens and reinforces the power and vitality we need to cope with the challenges of life—and last but not least, it also empowers us to a significant degree to actively practice humanity and solidarity in social coexistence with others.

The basis for this social coexistence is reflected in the concept of **hospitality**. We all have a fundamental longing to become part of this world. To achieve this great goal, we must learn to become both the host and the guest of our fellow human beings in this world. When we refer to hospitality in this context, then not as something reduced to kindness in welcoming strangers, but as something profoundly aesthetic as suggested by Jacques Derrida (1997) and Emanuel Levinas (1979), which is characterized by a stepping back from oneself (him or her Self) in order to make room in oneself (him or her Self) for the other (the Others). Hospitality, as a special mode of encounter, thus becomes the life-determining moment of our social coexistence. We experience it when as the host we meet another human being, when we welcome the other, the one who is still a stranger to us. But we also experience it when we enter the as-yet-unknown world of the other as a guest. Without the other, without the others, without the one who is still a stranger, without the ones who are still strangers, there is no life.

To develop and grow as human beings, we need the other, the others. But it is up to us to cultivate hospitality in our encounters with others and thus to make our life and social coexistence a flourishing one in beauty (Musalek, 2011).

All interpersonal encounters and relationships arise and exist in certain atmospheres. By atmospheres, we mean something indeterminate, something difficult to say, but which we can experience quite directly. Atmospheres are, as Walter Benjamin (1974) put it, 'a strange tissue of space and time: the unique apparition of a distance, however near it may be.' Atmospheres move us emotionally and therefore also significantly influence our actions, even if we are not consciously aware of such atmospheres and are therefore unaware of their influence. They are thus also motors that give direction to our encounters and relationships. The success or failure of our encounters and relationships often depends on atmospheres, which can enable and facilitate them, but also hamper them and make them impossible—and as such they form a key focus of social aesthetic research.

A socially aesthetic life is inextricably linked with a healthy life (Musalek, 2013). As the World Health Organization defines mental health as not merely the absence of mental illness, but above all as a state of mental well-being and the latter can be achieved when an individual is able to live a largely autonomous and joyful life, the social aesthetic maxim—'Live your life so that it is beautiful for you, but also beautiful for others!'—is of central importance in living and shaping a mentally healthy life. The main areas of interest in social aesthetic mental health research are thus not only the exploration of social aesthetic coordinates and vectors in the treatment and prevention of illness, but above all involve addressing social aesthetic life goals and the possibilities of a social aesthetic way of life—with cosmopoetry in the real meaning of the word (Musalek, 2017). The following chapters will present and discuss key focus areas of social aesthetic mental health research, the results of such research, and the knowledge that is gained from it.

References

Benjamin, W. (1974). Das Kunstwerk im Zeitalter seiner technischen Reproduzierbarkeit. In: *Walter Benjamin - Gesammelte Schriften*, Bd 1. Suhrkamp.

Berleant, A. (1992). *The aesthetics of environment*. Temple University Press.

Berleant, A. (2005). Ideas for a social aesthetics. In A. Light and J. M. Smith (Eds.), *The aesthetics of everyday life*. Columbia University Press.

Berleant, A. (2017). Honorary keynote lecture on 'social aesthetics. Advanced Studies Conference: Hospitality and Mental Health organized by the Institute for Social Aesthetics and Mental Health, Sigmund-Freud-University Vienna and the Aesthetics in Mental Health Network of the Collaborating Centre for Values-based Practice, St. Catherine's College, University of Oxford, at the Sigmund Fred University Vienna, Austria, 19–20 May, 2017.

Bernegger, G. (2015). Das Mögliche möglich machen. Der Therapeut als Seiltänzer. In M. Poltrum and U. Heuner (Eds.), *Ästhetik als Therapie. Therapie als ästhetische Erfahrung*. Parodos Verlag.

Bodicce, R. (2019). *History looks forward: Interdisciplinarity and critical emotion research. Emotion Review 12*(3), open access, available here: https://journals.sagepub.com/doi/10.1177/1754073920930786.

Derrida, J. (1997). *De l'hospitalité*. Calmann-Lévy.

Levinas, E. (1979). *Totality and infinity: An essay on exteriority*. Duquesne University Press.

Musalek, M. (2011) Medizin und Gastfreundschaft. In: M. Musalek and M. Poltrum (Eds.), *Ars Medica. Zu einer neuen Ästhetik in der Medizin*. Parodos.

Musalek, M. (2013). Health, well-being and beauty in medicine. *Topoi 32*, 171–178.

Musalek, M. (2017). *Der Wille zum Schönen II – Als Kulturgeschehen auf dem Weg zur Kosmopoesie*. Parodos.

Palmquist, S. (2016). The transcendental priority of touch: Friendship as a foundation for a philosophy of touch. *Arete Philosophy Journal 1*, 104–118.

Schmid, W. (2019). *Von der Kraft der Berührung*. Insel Verlag.

Ulfig, A. (1999). *Lexikon der Philosophischen Begriffe*. Fourier.

CHAPTER 18

IMAGINARY WORLD-MAKING IN ADAPTATION AND THERAPY

SÉBASTIEN ARVISET

INTRODUCTION

RE-AUTHORING (RA) is one of the crucial tools of narrative therapy (NT), its goal being for patients, together with their therapists as co-authors, to produce new narratives allowing them to distance themselves from past predicaments, the model for these narratives being, as acknowledged by Bruner (1991), literary.

This being the case, I will first explore what an author and co-authors are. Secondly, I will determine what the main characteristics of a narrative are. This will help bring into focus some of the problems that narrative RA entails, since what patients are expected to produce, far from being personal, is in fact determined by a very precise and formalized literary paradigm.

In the third part of this chapter, while highlighting some of NT's other problematic areas, I will argue that it can still be useful as a preliminary step in the therapeutic process, preparing patients for the authoring-forth of world-making (WM), in order to adapt to, and build, their future, while switching from a narrow artistic paradigm to a holistic aesthetic one.

AUTHOR AND CO-AUTHORS

According to Carey and Russell (2003):

> Re-authoring conversations take place between a therapist and the person(s) who have come to see them and involve the identification and co-creation of alternative

storylines of identity. The practice of re-authoring is based on the assumption that no one story can possibly encapsulate the totality of a person's experience, there will always be inconsistencies and contradictions. There will always be other storylines that can be created from the events of our lives. As such, our identities are not single-storied—no one story can sum us up. We are multi-storied. Re-authoring conversations involve the co-authoring of storylines that will assist in addressing whatever predicaments have brought someone into counselling. (2003, 2)

Re-authoring implies that something has already been authored, but is it the case? In that sense, the first question to ask is whether these narratives which NT proposes to re-author are not in fact authored during the NT process itself. To take a quite apposite literary example since, as we will see, the narratives that NT promotes are modelled on literary narratives, *Portnoy's Complaint* is itself the first narrative that a patient, Portnoy, produces for the benefit of his analyst. The whole novel but the last sentence is actually an authoring process encompassing various if not all of the narrator's past predicaments, which constitutes an overarching narrative, summing up, in one convenient, coherent, and logical narrative a series of life experiences. Then comes the novel's conclusion, its very last sentence, the only instance when the therapist intervenes, and the moment when readers realize that the whole novel is in fact the narrator's address to his therapist during sessions, and, as well, the start of the re-authoring process when the analyst, after hearing Portnoy conclude his life story, simply tells him: 'So. Now vee may perhaps to begin. Yes?' (Roth, 1969, 309).

What *Portnoy's Complaint* shows is that the re-authoring process first implies the authoring of a narrative that, together with their therapists, patients will re-author. But one may wonder whether, before it was authored for the benefit of therapy, this narrative even existed. I will come back to this question in the second part of this essay. For now, it is important to understand what an author and co-authors are.

As Livingston notes: 'Behind the question of authorship lies the interest we take in knowing who, on a specific occasion, has been proximally responsible for the intentional production of a given utterance' (Livingston, 2005, 68). Livingston then defines the author as follows: 'an agent who intentionally makes an utterance, where the making of an utterance is an action, an intended function of which is expression or communication' (Livingston, 2005, 69).

Then, for patients and therapists to be co-authors, a joint action, such as that described above, would be necessary, an action which would require the satisfaction of a certain number of conditions, for example the knowledge of each participant in the action intended by the other participants, their mutual supervision. Each participant should also commit to supporting each other, coordinate their ancillary plans, and even present throughout this joint action a collective intention to carry out this action. To be a co-author, moreover, requires collectively producing a single utterance. Thus, for there to be collaborative authoring, the following elements must be present:

(1) A_1 intends to contribute to the making of utterances U as an expression of A_1's attitudes.

(2) A_1 intends to realize (1) by acting on, and in accordance with sub-plans that mesh with those of the other contributors, including sub-plans relative to the manner in which the utterance is to be produced and to the utterance's expressive contents.
(3) A_2 intends to contribute to the making of utterance U as an expression of A_1's attitudes.
(4) A_2 intends to realize (3) by acting on, and in accordance with subplans that mesh with those of the other contributors, including sub-plans relative to the manner in which the utterance is to be produced and to the utterance's expressive contents.
(5) $A_1, ..., A_n$ mutually believe that they have the attitude (1)–(4) (Livingston, 2005, 84–85).

According to Wayne C. Booth, the author of a narrative can be analysed in the following way. First, we have the flesh and blood author (a), who produces the narrative; then the implied author (b) and, last, the narrator (c):

(a) 'the inferable voice of the flesh-and-blood person for whom this [tale] is only one concentrated moment selected from the infinite complexities of the "real" life.
(b) that of the implied author, who knows that the [tale] is in one sense an artificial construct but who takes responsibility for it, for whatever values or norms it implies, and for the suggestion that "in responding to me you respond to a real person."
(c) that of the immediate [...] narrator, who takes the whole tale straight and expects the [reader] to do the same' (Booth, 1983, 428–431).

As Booth underlines in the case of literary narratives, both the flesh-and-blood author and the implied author are aware that what they are producing is an artificial construct. A narrative does not have to be fictional to be artificial, of course. Memoirs and autobiographies are as artificial, and often as fictional, as novels. Yet, this artificiality does not seem to be taken into account with RA. The artificial nature of the re-authored narratives may be implicit since the entire RA process aims at proving that other viewpoints can be adopted on past events. Still, it is as if patients were expected to strictly assume the role of narrator, as if any exteriority to the new narrative was negated.

Moreover, in spite of what NT claims, one may wonder to what extent RA is really collaborative. First, the rules of production are the therapist's. Patients may be invited to appropriate them, but it still remains the fact that the authoring process is, at first at least, controlled by therapists. In that sense, it is difficult to understand RA as a real collaborative effort. Patients may be experts of themselves, therapists are NT experts, and what patients will engage in is RA, which is an important part of NT. So in a very real sense, the narratives that will be produced are the therapists', who are to their patients what Pygmalion was to the statue he sculpted and that Aphrodite then brought to life (Ovid 8AD/1966, 260–261). Similarly, therapists are supposed to bring patients to a

new, liveable, life. Still, these narratives can probably be seen as collaborative in the sense that both patients and therapists share the same intention, that of producing new narratives that will help patients distance themselves from the ones that were holding them back.

Then, once RA starts, patients, together with their therapists, are supposed to analyse this primary narrative, and recreate parts of it through new interpretations of past events. These new interpretations are meant to bring new meanings to patients, but also to help them take control of their pasts: this by creating these new meanings, which amounts to their authoring their pasts *themselves*, whereas in their primary narrative, other people, the sources of their trauma, were controlling the authoring process. Thus, more than just a simple RA process, what is at stake is the taking-over of the authoring function. The problem, of course, is that this takeover is focused on the past, at a time when patients were traumatized; yet the taking-over of the authoring function cannot change that past. As Hutto and Gallagher explain (2017, 160):

> Narrative therapy subscribes to a constructivist framework that promotes the view that social realities are something that we can create and construct for ourselves, even if not radically. In this NT is directly inspired by the interpretive turn made prominent by French postmodernists. In adhering to a post-structuralist framework NT opposes the sort of exclusive scientific realism associated with grand narratives about science.

And indeed, as Bruner puts it (1991, 69):

> Today, the tide has turned completely. We have come to reject the view that a 'life' is anything in itself and to believe that it is all in the constructing, in the text, or the text making. If you read contemporary writers on autobiography, like William Spengemann or Janet Varner Gunn, you will find them thoroughgoing constructionists. Their concerns are with literary-historical invention, with form, with the depiction of reality. Like me, they are concerned with the literary forces that shape autobiography. Is an autobiography, say, a *Bildungsroman*, premissed on the accretion of wisdom from experience, as a British empiricist might put it? As if, so to speak, one gradually transforms the primary qualities of direct experience into the secondary qualities of higher knowledge.

But there are limits to constructivism that NT does not seem to acknowledge. For instance, one may wonder to what extent one can be the sole author of one's life. In many ways, our lives are determined, and predetermined. We do not choose our parents, the time and place when and where we are born, etc. These cannot be re-authored. In that sense, what can really be re-authored might be rather limited (one is reminded of saint Polycarp of Smyrna who, according to Flaubert (Adam, 1972), used to cry to God: 'O Lord, why did you bring me to life in such times?' In spite of everything, Polycarp had no other choice than to make do with the time period he was dealt with …). In that

sense, because of these determinisms, parts of our lives are out of our control, cannot be re-authored.

Nevertheless, constructivism may be acceptable as long as it is applied to the future. And this is exactly what authoring-forth and WM can provide to patients: a way to enable them to construct their future and the rest of their lives. In such an outlook, past predicaments are past events, out of one's control, and of no interest whatsoever anymore. What is important is not what happened yesterday, or the fact that one was born there and then. What is at stake is what will happen today, what I will be able to make out of tomorrow. Although NT considers that only the exploitation of old life-material can be productive, what patients may actually need the most is to be taught how to explore, how to find new paths, new territories where they can grow and lead fulfilling lives. In fact, with NT, imaginative constructs are bound to reiterate the past. WM, authoring-forth, on the contrary, can bring patients to adapt to a reality that, until then, has defeated them. Although patients may need to come to terms with their past, what they will then need is a way to live their future, to adapt to new events and realities. In that sense, WM is essential, and channelled through an authoring-forth of the Self, can help patients to adapt to the world, to changes, and to live the rest of their lives in a more fulfilling way.

Moreover, the current popularity of WM should make its therapeutic use even easier. As Dubourg and Baumard explain (2022, 1):

> Imaginary worlds are extremely successful. The most popular fictions produced in the last decades contain such fictional worlds. They can be found in all fictional media, from novels (e.g., *Lord of the Rings*, *Harry Potter*) to films (e.g., *Star Wars*, *Avatar*), video games (e.g., *The Legend of Zelda*, *Final Fantasy*), graphic novels (e.g., *One piece*, *Naruto*) and TV series (e.g., *Star Trek*, *Game of Thrones*), and they date as far back as ancient literature (e.g., the Cyclops Islands in *The Odyssey*, 850 BCE). Why such a success? Why so much attention devoted to nonexistent worlds? … [I]maginary worlds co-opt our preferences for exploration, which have evolved in humans and non-human animals alike, to propel individuals toward new environments and new sources of reward. Humans … find imaginary worlds very attractive for the very same reasons, and under the same circumstances, as they are lured by unfamiliar environments in real life.

I will expand on WM in the third part of this chapter. For now, after having examined some of the problems relating to the authoring and RA processes, it may be interesting to have a better look at what these processes produce, i.e., narratives.

Narratives

As we have seen, according to Carey and Russell (2003, 2), RA involves the co-authoring of narratives that will assist in addressing whatever predicaments have brought patients

into counselling. There are four characteristics that go into the development of a story-line. A story-line is comprised of:

(i) events
(ii) in a sequence
(iii) across time
(iv) organized according to a plot or theme.

Narratologists, for their part, define narrative as, in its most basic form, the representation of an event, or a series of events, the event being of prime importance since without it, although there can be other types of texts, there is no narrative (Porter Abbott, 2008, 13). And action, or the taking place of an event, implies a timeline.

In his *Dictionary of Narratology*, Gerald Prince explicates this definition:

> [A narrative is] [t]he recounting... of one or more real or fictitious EVENTS communicated by one, two, or several (more or less overt) NARRATORS to one, or two, or several (more or less overt) NARRATEES...
>
> (Porter Abbott, 2008, 14–15)

It is also important to stress that it is a representation, a way of conveying a series of events (Porter Abbott, 2008, 15). That is to say that there is nothing neutral in a narrative, and that narratives do not give access to bare facts, but produce the effects the author is looking for. Similarly, Prince's definition stresses the importance of the narrator. What one has access to when reading or being told a story has nothing to do with the real world. The narrative is in itself a world (diegesis). What is true and false within that world is not necessarily so in the real one. The narrator is intradiegetic, the implied author straddles along the fence of real world and diegesis, while the flesh-and-blood person who authored this narrative is extradiegetic.

Of course, this applies to the narratives that are being re-authored as well. That is to say that, although the first narrative that a patient produces may differ from the real world, the re-authored one will as well, while also differing from the primary narrative. One may wonder how these distinct worlds, the real and narrative worlds, are meant to be brought together, how one can act on the other without doing away with the narrator, which would imply that these narratives are conflated with the real world when they are actually three distinct worlds, one that is real, the other two artificial, if not wholly fictional.

This underlines the fact that, among the characteristics of a narrative listed by NT practitioners, 'author' or 'narrator' is missing, as well as 'intention' and 'subject matter', characteristics that are all central to a narrative. The time component is there, but more so in order to situate events than to explicate the context of production (Levinson, 2007) of the narrative.

Yet, once a narrative is produced, it can be considered from the perspective of its context of production, e.g., produced while in therapy. Its author or co-authors are patients

and therapists. What they intended in these narratives is to help patients distance themselves from one or many past events. The subject matter is these events. But to go back to *Portnoy's Complaint,* the context of production is not the same whether we are thinking of Portnoy, the narrator, or Roth, the flesh-and-blood author. Portnoy authors his narrative during his sessions with his analyst with the intention of understanding his life, his relationship with his mother, women, etc., while Roth authored it with the intention of creating a novel about a character named Portnoy who tells his life story to an analyst. In this case, the distinction is obvious. The problem is that, strictly therapeutic narratives are as artificial as *Portnoy's Complaint* is. What distinguishes them the most is their intention (Levinson, 1992, 232): one is literary, the other therapeutic. But this intention must be stated in order for the distinction to be made. Otherwise, why could not one consider that *Portnoy's Complaint* is a very long therapeutic narrative written by a patient for his analyst? Vice versa, a patient that has some literary talent can easily turn their therapeutic narratives into a work of literature. The only thing that changes is the intention.

The frontier between the types of narratives is extremely thin, and will appear even thinner if we now consider the question of plots. Plots are, par excellence, literary topoi. So much so that literary specialists consider their number to be limited. For instance, according to Booker, there are seven basic plots while in his analysis of folktales, Propp, for his part, underlines thirty-one functions that determine plots (Propp, 1968, 25):

(1) Overcoming the monster: in which the hero must defeat an evil foe. (Booker, 2004, 21)
(2) Rags to riches: where the hero goes from being poor to rich and vice versa in a formative narrative. (Booker, 2004, 51)
(3) The quest: the acquisition of a treasure or the discovery of a new territory. (Booker, 2004, 69)
(4) Voyage and return: formative travel. (Booker, 2004, 87)
(5) Comedy. (Booker, 2004, 107)
(6) Tragedy. (Booker, 2004, 153)
(7) Rebirth. (Booker, 2004, 193).

Most of these plot characteristics can typically be found in therapeutic narratives. Likewise, still according to Propp, characters will appear under seven types (hero, villain, etc.) (Propp, 1968, 81), most of them to be found in therapeutic narratives as well.

These plots or subplots, together with the characters they entail, can be found in all narratives, therapeutic narratives included, the primary narrative as well as the reauthored one. That is to say that, in many ways, there is very little freedom for patients to express anything remotely personal through the means of a narrative, since they will inevitably end up using one of these types, that are not theirs, but the culture's to which they belong. In that sense, claiming that patients are experts of themselves and that, as such, are best placed to express what troubles them through a narrative is not quite convincing.

As Hutto and Gallagher put it (2017, 160):

> Narrative therapy justifiably rejects the idea that there is one and only one true story to be told about ourselves and the world—especially when, to this basic claim, it is added that such a story must be told, in the end, in the vocabulary of the hard sciences—preferably, if possible, only in the language of physics. Following in Foucault's foot steps, NT practitioners treat this claim as part and parcel of 'the "grand abstractions" of reductionist science ... [abstractions that have] dehumanized and objectified people.'

But in fact, while NT rejects the vocabulary of the hard sciences, its use of the literary one does not offer more freedom to its patients.

Finally, as *Portnoy's Complaint* illustrates, although NT does not aim at producing one main narrative, it may inevitably be what happens. One may wonder to what extent patients can avoid organizing the totality of their life experiences within one organized, overarching narrative. There are multiple narratives in *Portnoy's Complaint*, but they are all organized according to the narrator's conception of himself. Even if RA ends up modifying only a few of these narratives, the whole will be transformed into a new metanarrative of oneself.

Moreover, one may also wonder to what extent such a metanarrative is not exposed to the same fate as philosophy of history's metanarratives, a fate that Lyotard explained in his 1979 *La condition postmoderne*. According to him, these metanarratives have become obsolete because they could not do justice to a fragmented world anymore. What is valid relative to philosophy of history may be valid in the case of philosophy of *personal* history as well. And indeed, can the Self really be considered as some hard core that can be the subject of such metanarratives? Moreover, one must not forget that philosophies of history often are teleological: they aim to show that all past events are meant to bring about one outcome, either realized or not. This is also known as Whig history. Are patients trying to sum up their experiences in one overarching personal narrative immune to Whig interpretations of these experiences? Were they not *meant* to arrive at *that* very specific conclusion? In that sense, is not the whole process rigged from the start, as Galen Strawson points out (Strawson, 2004, 435)?

This is not to say that the entirety of the narrative therapeutical process should be done away with, rather that it should only be one step in therapy and that RA, with its focus on the past, does not equip patients for what is really at stake, i.e., the future. Nietzsche, in his second *Unfashionable Observations*, 'On the Use and Abuse of History for Life' (1874/1995), stresses the fact that at one point, history, work on the past, must be put aside, and one must look forward, work for and toward the future. The past must be cast aside in order to build the future. This applies to individuals as well. In many ways, the RA process is an invitation to dwell on the past in as much as it tries to bring patients to realize that some predicaments in their lives were misinterpreted, in order to do away with how these interpretations determined them. But this implies that these patients remain determined by these past events, and in danger of falling back in these

false interpretations. RA does not break the cycle, does not break with the past. Rather, patients remain mired in the past, and live their present and their future in accordance to that past, albeit re-interpreted, re-authored. This is why RA can only be the first step toward an 'authoring-forth' in which patients, now freed from their pasts, really take control of the authoring process and start authoring forth the rest of their lives, which is exactly what the human brain is designed to do: evolutionary studies have indeed shown that the human brain is not conceived for introspection (Wilson, 1998, 96).

We will come back to this, but first, another criticism that can be addressed to introspection comes from Wittgenstein and the argument of private language (Wittgenstein, 1953, §256; see generally Scruton, 1994, 47–52). NT considers that patients are experts in what troubles them, that they have an expert knowledge of their states of mind, predicaments and suffering. And NT expects them to express this privileged knowledge in a narrative, in words that are their *own*. Yet, by which means other than by public language, a language that is not their own, but the world's to which they themselves belong, can they express themselves, since there is no such thing as a private language (Hacker, 1990, 5), with the result that what they express in the end is nothing private, but just a set of commonplace statements about what they went through.

That we do not have access to a private language, but are bound to use a public one, may signal the fact that we are not meant to dwell on introspection. Instead, as mentioned above, our brain evolved for what I might call 'outer-spection', i.e., to conceive scenarios that will ensure the survival of the individual, that will ensure that I will adapt to the world around me and to the way it changes. These scenarios, that often take the form of simulations in which different worlds are imagined, each one featuring the results of a given strategy, are in themselves narratives. While Strawson may be going too far when he rejects narratives as an essential part of all human beings (Schaeffer, 2020), surely what he is criticizing, rightly I think, is the type of overarching narratives that NT strives patients to create. Still, the most mundane plan one makes, e.g., 'We're out of milk, I'll have to go buy some … ' is a narrative that I just authored-forth. And human beings, if they want to survive, cannot avoid this authoring-forth, this constant WM. In fact, authoring-forth is the second step that patients must take in order to regain control of their lives, to lead fulfilling lives, a crucial step since authoring-forth is by definition geared toward the future.

THE AUTHORING-FORTH OF WORLD-MAKING

Evolutionary aesthetics, which aims to understand certain cultural practices within a biological framework, uses the evolutionary perspective to investigate the prominence of art, particularly narrative art, in human lives (Clasen, 2012). It has put forward the concept of imaginary worlds and has shown its importance in the evolution and

adaptation of Homo sapiens. This concept could prove more flexible than narrativity. According to Galen Strawson (2004), having a narrative conception of oneself is not universal. I may have an episodic rather than a narrative Self-conception, whereby I do not conceive of my life as one organized narrative, even if I am aware of my long-term continuity, instead understanding my Self through a series of loosely linked episodes. Yet, according to the imaginary world theory, I will still be an imaginary world-maker since survival requires me to constantly engage in simulations that propose several versions of how the world could be, which I will use to adapt to the actual world around me. WM does not require Self-organization into a coherent narrative, a process which may not fit all, as we have seen. Rather, in everyday life, in terms of adaptation, it can be used to posit, examine, and imagine various potentialities about one's life in order to make the best decision after comparing the result of each simulation. In fact, there are a number of ways in which WM can benefit mental health patients that should be explored by therapists. On the one hand, the inability to see options, alternatives to my actual life, as is the case with depression, are all linked to a deficit in imaginary WM. On the other hand, the inability to distinguish between imaginary worlds and the actual world, for instance in cases of delusion, can point to the incapacity to reappraise the way I engage with these virtual worlds, and the type of emotional commitment that is and should be involved.

NT, for its part, focuses on the exploitation of patients' resources, their stories and predicaments, from which a narrative is extracted. This, as I mentioned, must not be construed as negative, but simply as a first step in the therapeutic process, a step that should then be followed by WM or authoring-forth, understood as a world-dominant process, i.e., that sticks as close as possible to the real world, and that emphasizes exploration and discovery of new resources for a better life.

In narratology, a fictive world that closely resembles our real world is said to adhere to the principle of minimal departure (Searle, 1975; Ryan, 1991) or to the reality principle (Walton, 1993; Pavel, 2017). To what extent are patients supposed to adhere to this principle in order for therapy to work? Considering that patients are expected to re-work a previous narrative, their freedom is limited, much more limited than it is for a literary author. For instance, Seth Grahame-Smith re-authored Jane Austen's *Pride and Prejudice* into *Pride and Prejudice and Zombies* (2009). Whereas Austen's novel closely adheres to the reality principle and her narrative is world-dominant, can tell us a lot about the late eighteenth- and early nineteenth-century English circumstances of a specific social class, Grahame-Smith's parody, using the same material, takes the reader far away from that past world, and takes great liberties with the novel's background information [BI]. There were no zombies, one hopes, in early nineteenth-century England, whereas women were looking for husbands, and men for wives.

Patients are considered as being the experts in their own BI. They are supposed to have an intimate knowledge and a privileged access to their past and predicaments, which constitute the BI out of which their narratives are produced.

This expertise, as well as this privileged access, is debatable, as I have mentioned. But for now, I will first consider the fact that NT does not allow patients to move away from

that BI: whatever they do, it will remain the basis on which they operate, even if they operate critically away from it.

On the contrary, WM offers patients the possibility to depart from their problematic BI and to work toward creating new ones, on which they will be able to build new existences, away from what troubles them. In many ways, WM and authoring-forth may have a fictional component, but only in as much as planning can be said to be fictional, i.e. involving imagination. If I'm planning on going on a trip next week, but then am prevented to leave for whatever reason, this world in which I was going on vacation remains fictional. Yet, if, on Monday morning, I find myself relaxing on a beach, my WM, my authoring-forth, has become the real world.

Narrative therapy forces patients to remain within what may be termed a story-dominant narrative, in which their story remains the same, whereas what must be sought for them is a world-dominant narrative, in which they can radically alter their story (Ryan, 1991). And according to behavioural sciences, storytelling, far from being a conservative process, is adaptive and has evolved in order to convey and track new information, as well as to simulate the real world (Dubourg & Baumard, 2022, 9).

Thus, as a second NT phase, WM can in fact offer a world-dominant therapy that emphasizes in patients the desire to explore possibilities toward wellness. Exploration, rather than exploitation, is indeed of prime importance for adaptation, understood as the discovery of new vital resources, the avoiding of predators, and the learning of new action–outcome associations (Dubourg & Baumard, 2022, 10). Indeed, there are fitness benefits resulting from imaginary exploration as well as from spatial exploration. Thus, in this second stage, authoring-forth could help patients develop behavioural plasticity and exploratory preferences, capacities that will help them generate new goals, new interpretations of their current situation, and conversely new coping strategies when a problem occurs (Dubourg & Baumard, 2022, 14).

Behavioural plasticity and exploratory preferences are inseparable notions because exploration requires the ability to adapt to change. Similarly, exploratory preferences entail (1) openness to experiences and (2) novelty-seeking (Dubourg & Baumard, 2022, 14).

In that sense, such as it currently is, NT may in fact be much too conservative. What is at play is an evolutionary dilemma: whether to exploit well-known resources (patients' primary narratives and predicaments), even if what this exploitation may yield can be limited, or explore in order to find new unknown resources (a fulfilling future life) (Dubourg & Baumard, 2022, 14). Adverse situations decrease exploratory behaviour (Dubourg & Baumard 2022, 18), and adverse situations are what the patients are starting from, this is true. But through exploitation, NT perpetuates these adverse circumstances, when it should prepare patients to exploration by bringing them safety, from which exploration is then possible. That is to say that once exploitation, through RA, has brought safety to patients, exploration could be made less costly (Dubourg & Baumard, 2022, 19), and patients could and should then be oriented toward exploration through WM and authoring-forth.

Re-authoring is still useful since there is a constant trade-off between the respective values of exploitation and exploration which is a matter of risk assessment (Cohen et al., 2007, 933). At first, patients may find it too costly to explore new ways of life without some guarantees. The therapists' task is then to offer them these guarantees through their support. In that sense, therapists fulfil a different role, mostly as guides, instead of treating patients as experts of themselves, because once patients start exploring, they are devoid of any such expertise. Thus, therapists must assess the uncertainty and help patients in their risk assessment.

Moreover, it must be noted once again that the human brain as well as consciousness evolved as a scenario-building capacity and not as an introspective function (Wilson, 1998, 96; Carroll, 2012, 73, 80), and in many ways scenario-building can be equated to exploration, and introspection to exploitation. As E. O. Wilson puts it, the brain did not evolve to understand itself but to survive (Wilson, 1998, 96). As he further explains (1998, 109):

> Mind is a stream of conscious and subconscious experiences. It is at root the coded representation of sensory impressions and the memory and imagination of sensory impressions. The information composing it is most likely sorted and retrieved by vector coding, which denotes direction and magnitude. […] Consciousness consists of the parallel processing of such coding networks. […] All together they create scenarios that flow realistically back and forth through time. The scenarios are a virtual reality. They can either closely match pieces of the external world or depart indefinitely far from it. They re-create the past and cast up alternative futures that serve as choices for future thought and bodily action.

In this sense, there is a further argument in favour of exploration since, as Wilson explains (1998, 115), the mind is naturally creative as opposed to designed for introspection (Wilson, 1998, 96). Understanding, the past especially, is important. But what really matters is planning for the future, and how to better survive through adaptation.

Conclusion

The problem with the narrative model chosen by NT is that narratives are, in a large part, determined by a literary model, by typologies and by a common language that leave no freedom to patients, or a very limited one, to express what troubles them.

On the contrary, WM proposes to embrace an aesthetic paradigm, in the sense of *aisthesis*, understood as what concerns not only beauty and art, but also perception, epistemology, and even ontology (Vichnard & Armand, 2017, 1), a paradigm that takes into account the totality of an individual's experiences and feelings, not just the narrative-linguistic/artistic ones, so that NT is able to escape the reductive artistic model that determines aesthetic appreciation (Saito, 2007). As Dubourg and Baumard

point out (2022, 28), WM is not limited to narratives. This means that WM is not only the possibility of creating a story based around an event, but also includes descriptions, expositions, arguments, lyrics (Porter Abbott, 2008, 13), as well as sounds, and can involve different senses, for instance smells, touch, visual effects, etc.

As Ellen Dissanayake has shown, the artification process is a "making special" process that sets some artefacts apart from everyday life, and in doing so creates an alternate reality (Dissanayake, 1990, 92). The problem with NT is that while being about everyday real life, it tries to create, out of the past, an alternate reality which is, in many ways, unreal. Instead, therapy should be future-oriented, geared toward adaptation and the construction of one's Self in future real-world circumstances.

Acknowledgements

I would like to thank Dr John Z. Sadler without whom I would not have written this essay.

References

Adam, M. (1972). Flaubert et la bêtise. *Bulletin de l'Association Guillaume Budé 2*, 189–208.
Booker, C. (2004). *The seven basic plots. Why we tell stories.* Bloomsbury.
Booth, W. C. (1983). *The rhetoric of fiction*, second edition. University of Chicago Press.
Bruner, J. (1991). Self-making and world-making. *The Journal of Aesthetic Education* 25(1), 67–78.
Carey, M., & Russel, S. (2003). Re-authoring: Commonly asked questions. *The International Journal of Narrative Therapy and Community Work 3*, 1–20.
Carroll, J. (2012). *Literary Darwinism.* Routledge.
Clasen, M. (2012). Review of on the origin of stories: Evolution, cognition, and fiction by Brian Boyd. *British Journal of Psychology 103*, 430–431.
Cohen, J. D., McClure, S. M., & Yu A. J. (2007). Should I stay or should I go? How the human brain manages the trade-off between exploitation and exploration. *Philosophical Transactions of the Royal Society B 362*, 933–942.
Dissanayake, E. (1990). *What is art for?* University of Washington Press.
Dubourg, E., & Baumard, N. (2022). Why imaginary worlds? The psychological foundations and cultural evolution of fictions with imaginary worlds. *Behavioral and Brain Sciences 45*, E276.
Grahame-Smith, S., & Austen, J. (2009). *Pride and prejudice and zombies.* Quirk Books.
Hacker, P. M. S. (1990). The private language arguments. In P. Hacker (Ed.), *Wittgenstein: Meaning and mind* (pp. 1–16). Blackwell.
Hutto, D. D., & Gallagher, S. (2017). Re-authoring narrative therapy: Improving our self management tools. *Philosophy, Psychiatry, & Psychology 24*(2), 157–167.
Levinson, J. (1992). Intention and interpretation: A last look. In G. Iseminger (Ed.), *Intention and interpretation* (pp. 221–256). Temple University Press.
Levinson, J. (2007). Aesthetic contextualism. *Postgraduate Journal of Aesthetics 4*(3), 1–12.
Livingston, P. (2005). *Art and intention.* Oxford University Press.

Nietzsche, F. (1995). *Unfashionable observations*, translated by R. T. Grey. Stanford University Press.
Ovid. (8AD/1966). *Métamorphoses*, translated by Joseph Chamonard. Garnier-Flammarion.
Pavel, T. (2017). *Univers de la fiction*. Seuil.
Porter Abbott, H. (2008). *The Cambridge introduction to narrative*, second edition. Cambridge University Press.
Propp, V. (1968). *Morphology of the folktale*. University of Texas Press.
Roth, P. (1969). *Portnoy's complaint*. Random House.
Ryan, M.-L. (1991). *Possible worlds, artificial intelligence, and narrative theory*. Indiana University Press.
Saito, Y. (2007). *Everyday aesthetics*. Oxford University Press.
Schaeffer, J.-M. (2020). *Les troubles du récit*. Éditions Thierry Marchaise.
Scruton, R. (1994). *Modern philosophy*. Bloomsbury.
Searle, J. R. (1975). The logical status of fictional discourse. *New Literary History 6*(2), 319–332.
Strawson, G. (2004). Against narrativity. *Ratio 17*(4), 428–452.
Vichnard, D., & Armand, L. (2017). Aisthesis. In D. S. Lynch (Ed.), *Oxford research encyclopedias*. Literature. Available from: https://oxfordre.com/view/10.1093/acrefore/9780190201098.001.0001/acrefore-9780190201098-e-104 [last accessed 6 October 2024].
Walton, K. L. (1993). *Mimesis as make-believe: On the foundations of the representational arts*. Harvard University Press.
Wilson, E. O. (1998). *Consilience. The unity of knowledge*. Alfred A. Knopf.
Wittgenstein, L. (1953). *Philosophical investigations*. Revised fourth edition by P. M. S. Hacker and J. Schulte. Blackwell Publishing.

CHAPTER 19

SPATIAL AND NARRATIVE ATMOSPHERES

Social Aesthetic Perspectives

GUENDA BERNEGGER

Introduction

From an aesthetic perspective, atmosphere is a central dimension of the human experience (Böhme, from the 1990s on), which plays a crucial role in medical practice: it affects the quality of the encounter, can open or close exchanges and provide a framework that encourages or discourages the patient's trust in the therapist and the adherence to the treatment. However, like other aesthetic dimensions included in clinical settings, its importance often goes unrecognized. In contrast, we propose that the recognition of—and the reliance on—atmosphere is essential and can be advantageous to effective medical treatments.

Through the tools offered by the social aesthetics (Berleant, 2005), that draws on the phenomenological approach, including new phenomenology (Schmitz, 1964–1969, 2019; Griffero, 2011), it is possible to identify, designate, and recognize the elements that make up the atmospheres of a setting as well as highlight the role they play in the experience of the subjects (Böhme, 1995, 2017a, 2017b; Schmitz, 2014; Griffero, 2014, 2017, 2019). It will be the role of narrative theory (Jauss, 1982; Eco, 1979, 1989, 1994) to show how experience is also conditioned by the atmospheric features carried by narration.

Each atmosphere is influenced primarily by spatial, intersubjective, and narrative elements. In turn, the particular atmosphere of a place affects the quality of the relationship that can happen within it (Böhme, 2017a, chapter 6). In the medical and particularly psychiatric context, atmosphere turns out to be a vitally important dimension, both on a diagnostic level (from Tellenbach, 1968 to Francesetti & Griffero, 2019) and a

therapeutic one, including the adherence to treatment. Atmospheric features can affect the 'sense of the possible' ('*Möglichkeitssinn*'—Musil, 1930–1933, chapter 4) experienced by the patient, supporting or hindering the therapeutic process conceived as one that aims at 'making possible the possible' (Musalek, 2011).

Particularly in the psychiatric field, where treatment is understood not as *restitutio ad integrum* but as a process that restores the patient's possibilities of existence, an attentive recognition of that seemingly invisible but influential dimension which is atmosphere—if we understand these with Seel (2003), as a 'space of possibilities'—is imperative. The quality of care and the success of the treatment can therefore significantly benefit from the understanding and control of the atmospheric component of clinical settings. What does a given atmosphere allow to happen? Conversely, what does it prevent or discourage from happening? What possibilities does it prompt subjects to realize? These are crucial questions to be asked when we come to explore the role of atmosphere in the experience of care. Although in psychiatry, even more than in other clinical disciplines, atmosphere conditions—whether one likes it or not—the therapeutic relationship, it tends not to attract scholarly attention, with the resulting risk of uncontrolled, adverse clinical effects.

From a reflection on atmosphere, which is representative of the epistemological paradigm of social aesthetics, psychiatry and medicine more broadly can furthermore be led to a more general aesthetics-oriented attitude towards care. They can also learn humility with regard to what they can achieve: opening a space of possibility for something to happen, never imposing it.

This contribution is structured in three parts. First, it will attempt to provide a definition of atmosphere and demonstrate the pervasiveness of atmosphere as an aesthetic component that conditions—in a favourable or unfavourable manner—the healthcare relationship. Secondly, we will show how atmospheres as we understand them determine existential possibilities and inevitably play a part in the clinical setting, so that it is crucial to take them into account in order to achieve favourable therapeutic outcomes. Thirdly, we will focus on the need to become aware of and to study the aesthetic power of atmospheres, to better control them and to use them in clinical practice: this is what we can learn in particular from architecture, literature, and the performing arts. The intersubjective and intercorporeal dimensions of the atmosphere—namely the aura, the appearance, as well as the social perception (Carnevali, 2020)—will not be explored here.

Our claim is that working on atmospheres can be a good way to develop an aesthetic attitude (Böhme, 2017a, 111 ff.) and a form of clinical knowledge which is oriented to the sense of the possible, in the therapeutic setting as well as in the education of future health professionals. The reflection will move within a framework that is ascribable to 'social aesthetics' (Berleant, 2005, 23 ff.), whose 'philosophical roots in phenomenology and the phenomenological method' and 'empirical roots in the arts' can be recognized (Berleant, 2010, xiii).

Atmospheres and Their Pervasiveness

Each place has its particular atmosphere—at the spatial, narrative, and relational levels—and the atmosphere of a place influences the quality of the encounter and the experience, with implications for what can and cannot take place in it.

We understand atmosphere—in concurrence with Martin Seel, Gernot Böhme, and Hermann Schmitz—as 'the way in which a situation appears through temperatures, smells, sounds, visibilities, gestures and symbols whereby those who are present in the situation are somehow touched or affected' (Seel, 2003, 153, my translation) and as having a variety of possible qualities. Atmospheres also involve subjects in their bodily and sensitive dimension: they are 'a qualitative-sentimental *prius*, spatially poured out, of our sensible encounter with the world' (Griffero, 2014, 5), they are 'what is experienced in the bodily presence of humans and things, or in spaces' (Böhme, 2017a, 20).

Given its formal characteristics, atmosphere has the power to 'foster, prevent, suggest, deny, incite, allow, hinder, invite, open up, make possible or suggest given ways of perceiving, living, enjoying or being within them, as well as given ways of engaging in relations, exchanges and care practices' (Bernegger, 2015, 187, my translation). And these relations, exchanges and practices contribute to the creation of the atmosphere itself.

The importance of atmospheres may be observed in different areas of medicine: in the environment (architecture etc.); in the epistemological models (nosography etc.); in the techniques (diagnostic procedures, therapeutic measurements, drugs, instruments etc.); in our manner of relating to others, on the verbal level (rhetoric, narrative styles, figures of speech, metaphors …), but also on the paraverbal level (behavioural style, rhythm, ways of keeping silent …). For instance, the different modes of silence (Dinouart, 2003)—prudent, guileful, complaisant, mocking, spiritual, stupid, appreciative, scornful, political, humorous, capricious … —can engender very different atmospheres.

In all these areas, the formal qualities of atmospheres either open or close particular pathways of experience, by promoting, stimulating and facilitating or precluding them: for instance, encouraging a certain kind of interpersonal relationship.

Indeed, 'atmospheres are present, even if no one pays special attention to them'—writes Martin Seel—'We are surrounded by the atmosphere of a room and feel it, even if we have no idea about it' (Seel, 2003, 152, my translation). However, even though atmospheres are all-pervasive, they are often not considered. A reason for it could be that they are extremely difficult to objectify or define. This difficulty seems to derive first of all from the indeterminacy of atmosphere: but is this a semantic (*de dicto*) or a metaphysical (*de re*) issue (Griffero, 2014, 7)? Is atmosphere just difficult to translate into words, or does this indeterminacy stem from its very nature (like shadows)? Does atmosphere fall into the category of appearance ('*Erscheinung*') (Seel, 2003, 152 ff.) or of thing (or 'quasi-thing', following Griffero, 2017)? Is atmosphere a subjective dimension

(concerning the perceived qualities of a given situation) or an objective one (concerning the objective qualities of a given situation) (Griffero, 2017)? Is it intersubjective? Or quasi-objective (Griffero, 2017, 23)? That is to say: do atmospheres fall under the heading of 'human experience' or of 'qualities of the environment'? Are they more a question of 'emotionally tuned space' (Ströcker, 1977, in Griffero, 2014, 6) or 'spatialised feeling' (Griffero, 2014, 36)?

These polarizations are actually wrong: 'The … new aesthetics is concerned with the relationship *between* environmental qualities *and* human states. This *and*, this in-between, through which environmental qualities and human states are related, is atmosphere' (Böhme, 2017a, 14, my emphasis). At one and the same time, we perceive (and are affected by), we recognize, and we produce atmospheres: 'Atmosphere is the shared reality of the perceiver and the perceived' (Böhme, 2017a, 23).

But not only this: we are exposed to, touched or affected by (Seel, 2003)—wittingly or unwittingly—the aesthetical effects of atmospheres. Atmosphere has a force related to materiality, which affects bodies: 'an atmosphere evolves continually, and even dissolves: it is a force field in a constant state of becoming. And in this ambient midst, subjects are corporeally involved' (Bruno, 2022, 30). This effect of atmospheres on the sensibility is independent—as mentioned above—of one's awareness of it: 'The perception of atmospheres … may not enter the consciousness, but it influences moods' (Böhme, 1995, 97, my translation). Tellenbach calls 'atmospheric' 'this something-more, exceeding real factuality and which nonetheless we feel with and in it' (Tellenbach, 1968, 47, in Griffero, 2014, 5).

Atmosphere has also been defined as 'a sensorially and affectively perceived, and therefore existentially meaningful, *articulation of possibilities of existence that are or are not realized*' (Seel, 2003, 152, my translation and emphasis). For the purpose of our analysis, it is significant to focus on the impact of atmospheres—like other aesthetical features—on the qualities of our experience and the forms of existence: on the *possibilities* of such forms of existence. Such possibilities of existence and forms of experience, as already mentioned, can be facilitated or precluded, proposed or prescribed, encouraged or restricted, by atmospheres. And atmospheres can do all these things in any case: with or without our explicit awareness of them.

It is necessary to consider the role played by atmospheres in order to better understand how they can intervene positively in—or risk being detrimental to—the clinical setting, for or against the purposes of therapy.

Relevance of the Atmosphere on the Clinical Level: (Re)enabling Existence

The relevance of atmosphere for clinical practice has been recognized foremost at the diagnostic level, especially in the field of mental health (from Tellenbach, 1968 to

Francesetti & Griffero, 2019; see also Costa et al., 2014; Sass & Ratcliffe, 2017; Brencio, 2018; Costa et al., 2018). Leaving the specifically diagnostic aspect aside, we will delve into the therapeutic perspective: a conception of the process of care that sets out a notion of therapy as a revival of the patient's 'innermost possibilities' (Ricoeur, 1986, 128, my translation) cannot remain indifferent to the role played by atmospheres as an 'articulation of possibilities of existence that are or are not realized' (Seel, 2003, 152, my translation). Atmospheres are indeed carriers of potential happenings. In that, we can see a convergence between Martin Seel's definition of atmosphere and a definition of the therapeutic process as a process of '(re)possibilisation', as defined by Viktor von Weizsäcker (1985).

In psychiatry, which Henri Ey poignantly characterized as the 'medicine applied to impairments of liberty' and thus the 'pathology of liberty' (Ey, 1948, 77; see also AA. VV., 2021), the therapist, who works with subjects suffering from a 'loss of liberty', can then choose as their goal 'to make them feel ... how free they can be in the possibility of living their own internal experiences and their mutual relations' (Di Petta in Bernegger, 2017, 74, my translation). Thus, the treatment is identified 'in conquering possible degrees of ever greater freedom from the shackles of mental illness, prison walls, and drugs, and in making these persons experience a feeling of a more authentic habitability of the world: of the inner world, the world in between and the external world' (2017, 74, my translation). The therapeutic setting is thereby 'concerned with *opening up spaces and creating atmospheres in which it becomes possible* for the individual […] *to realise their possibilities*' (Musalek, 2010, 530, my emphasis).

Many approaches to therapy aim to restore possibilities and freedom: this is the case of the approaches which, based on an anthropology which sees the human being as a being of possibility, recognize in the disease the limitation of possibilities, and in the 'restoration of its possibilities' ('*Wiederermöglichung*'—von Weizsäcker, 2008) the goal of therapy. Furthermore, these approaches aim to open up new, unprecedented possibilities, to be constructed, in a process of 'flourishing' (Nussbaum, 2011), in the sense of 'making the possible possible' ('*Das Mögliche möglich machen*', according to Musalek, 2012; see also Bernegger, 2015). The therapist therefore plays the part of 'enabler' ('*Ermöglicher*', for von Weizsäcker, 1985) who is responsible for bringing about the advent of the other as other (Benaroyo, 2006, 2022).

However, even the medical anthropological traditions concerned with this crucial re-instatement do not clearly show how it is to be attained. In this particular sense, it may be relevant to understand the particular role of atmospheres (Bernegger, 2015, 186 ff.). The task at hand is then to recognize the function of the atmosphere—as an 'articulation of possibilities of existence that are or are not realized' (Seel, 2003)—that can enable people to access certain possibilities of existence, i.e. to offer the opportunity of a certain quality of experience. A therapeutic action that pursues the extension of the subject's own possibilities can then take advantage of the perspective of social aesthetics.

In the perspective of such social aesthetics, 'The human being *with its aesthetic possibilities and impossibilities* becomes the measure of all things. Experiencing the possible, making the possible possible, and the future possibilities that arise from this,

generate new fields of activity and experience for both the sick and the healthy people caring for them', the ultimate goal being the achievement of 'the most self-determined and joyful life possible' (Musalek, 2011, 36, my translation; see also Scheibenbogen et al., 2021). Joy is itself a matter of atmosphere (Schmitz, 2014, 134 ff.).

The aesthetic experience offered by art is precisely an experience of revelation of the innermost possibilities of each person when they are genuinely engaging with the work of art. In doing so, they are safely yet in non-trivial manner exploring unfolding dramas, conflicts or, say, structures of implicit or explicit values and meaning, with which they can 'play'. From this aesthetic experience of the Other they can pick up suggestions of other ways of being themselves, even activate subjective possibilities, which is relevant for therapy.

'The challenge in the therapeutic process is not only to recognise the significance of the disorders' pathology but also *to find ways out of the imagined impossibilities by opening up new possibilities* and uncovering resources of the suffering human' (Musalek, 2010, 530, my emphasis).

How, then, can the atmosphere within the therapeutic setting fulfil a favourable role, which strengthens the tools and goals of the treatment—reopening the patient's possibilities, via his or her compliance—instead of risking interfering negatively with them? To better understand how the relational, spatial, narrative atmospheres can intervene positively in (or risk interfering with) the clinical setting, it is useful to learn from the artistic disciplines, which work with the matter of atmosphere.

Engaging with the Arts, to Better Control Atmosphere and Have a Benefit on the Clinical Practice

To learn how to benefit from a more attentive and conscious attitude towards atmospheres, with regard to treatment purposes, it is necessary to be informed, even as health professionals, through an engagement with the arts that work with atmospheres (architecture, music, literature, theatre …), i.e., which are concerned with the production of spatial, acoustical, narrative, and scenographic environments.

From this perspective, it is possible to learn about formal conditions, linked to the 'how' (Böhme, 2017b, 26), that influence the experience of a given atmosphere; to learn that we can control atmospheres, but only partially; that to educate ourselves on their effects, we must patiently observe them from the users' side; that the immediate effect of atmospheres is difficult to escape and that it is therefore worth striving to exercise responsibility for their use and effects.

This dialogue with the arts will turn out to be instructive both in terms of the production of atmospheres and the reception of them (Böhme, 2017b, 29 ff.), and their conditions of efficacy: all necessary elements for understanding the interplay between this dimension and the praxis of care.

Spatial Atmospheres

The arts, the performing and applied arts, can be—consistently with the perspective of social aesthetics—quite instructive for the clinical practice, regarding the atmospheric dimension which is a constituent of their very nature. If there is an applied art that par excellence brings this dimension into play, it is architecture: 'In everything it creates, architecture produces atmospheres' (Böhme, 1995, 97, my translation). Architecture, intended not just as 'an art of physical structures', but rather as 'an art of complex social and environmental organization' (Berleant, 2005, 30).

The existence, and consequently the effect, of atmospheres in the spaces (given and constructed) is inescapable. Their impact on sensitivity also has the character of immediacy. 'We perceive the atmosphere through our emotional sensibility—a form of perception that works incredibly quickly, and which we humans evidently need to … survive … We are capable of immediate appreciation, of a spontaneous emotional response, of rejecting things in a flash' (Zumthor, 2006, 13). The immediacy of the response, unmediated by reflection, proper to any aesthetic experience, stresses the need to pay attention to the effect of the atmosphere on the subject, and to the direction in which it orients their emotional response.

It needs to be recognized that this response cannot be fully controlled or foreseen (for better or for worse). The creators of the built spaces themselves, such as the architect Peter Zumthor, just mentioned above, are prominent witnesses to this phenomenon: 'when things have come out well they tend to assume a form which often surprises me when I finally stand back from the work and which makes me think: you could never have imagined when you started out that this would be the outcome. And this is something that only happens sometimes' (Zumthor, 2006, 71).

Only the user can reveal the effect to the artist himself, who must modestly defer to the power of the work, independently from his own intention: 'But if, at the end of the day, the thing does not look beautiful … if the form doesn't move me, then I'll go back to the beginning and start again' (Zumthor, 2006, 71). Readers might identify a congruence between this claim and the work of Wolfgang Iser (1978) and Hans Robert Jauss (1982).

The production of atmospheres is the result of a craft, in which we must not forget what von Bonsdorff calls 'naturally unplanned', i.e., 'those elements of the built environment that are not the result of decision-making. As experienced, the environment is also dependent on elements that are independent of human intentions, such as topography, climate, and weather' but also of 'the way a building is "worn" through contact with human bodies' (von Bonsdorff, 2005, 73). 'These "naturally unplanned" elements are not only present in the built environments between the buildings, they also have real effects on buildings, effects that are visually perceptible on the surface of the building or present in the quality of the air inside, as humidity or smells' (von Bonsdorff, 2005, 73).

Nevertheless, the unpredictable dimension can be integrated as a gift rather than an obstacle: 'If you allow light to enter and play with your building, there is always an unpredictable part, the non-measurable side of your project: this is the gift of nature to the architect' (Gmür, 2014, min. 58.57–59.12; see also Brnić, 2019, 220).

Despite the component of unpredictability, which makes every architectural work an 'open work' (Eco, 1989), the competence of the specialist leads him or her to consciously work on the conditions under which a certain atmosphere is pursued and achieved.

Zumthor thinks that twelve elements are involved in the process of generating a certain atmosphere: the 'Light on Things', the 'Body of Architecture' (i.e., the 'material presence of things in a piece of architecture ... That kind of thing [which] has a sensual effect on me'), the 'Material Compatibility', the 'Sound of a Space', the 'Temperature of a Space', the 'Surrounding Objects', the 'Tension between Interior and Exterior', the 'Levels of Intimacy', the '[Architecture as] Surroundings', the 'Coherence', the 'Beautiful Form', the 'Balance between Composure and Seduction' (Zumthor, 2006, 21–23).

The work on atmosphere is then profoundly, in architecture, a work on 'possibilisation' (a work on that 'articulation of possibilities of existence that are or are not realised' (Seel, 2003, 152)): on openness to freedom or, conversely, on control—related to an '"atmospheric authority", a kind of 'prestige or "force" through which an atmosphere constrains and enthralls the perceiver, in the absence of physical coercion' (Griffero, 2018, 86). Zumthor again: 'It was incredibly important for us *to induce a sense of freedom of movement*, a milieu for strolling, a mood that had *less to do with directing people than seducing them*' (Zumthor, 2006, 41, my emphasis).

'The feeling that I am not being directed but can stroll at will—just drifting along, you know? And it's a kind of voyage of discovery. As an architect I have to make sure it isn't like being in a labyrinth, however, if that's not what I want. So I'll reintroduce the odd bit of orientation, exceptions that prove the rule—you know that sort of thing. Direction, seduction, letting go, granting freedom' (Zumthor, 2006, 43). 'So that appeals to me. So that it appeals to you, too, and more especially, so that it supports the uses of the building. Guidance, preparation, stimulation, the pleasant surprise, relaxation—all this' (Zumthor, 2006, 45).

Something dynamic is at stake in the impact of the atmosphere: 'Quality architecture to me is when a building manages to *move me* ... One word for it is atmosphere' (Zumthor, 2006, 11, my emphasis). No wonder that the architect acknowledges a temporal dimension in his work (as in any aesthetic object, always involving a temporalization of space, according to Dufrenne, 1973): 'Architecture is a spatial art, as people always say. But architecture is also a temporal art' (Zumthor, 2006, 41). 'It has to do with the way architecture involves movement' (Zumthor, 2006, 41). 'So what moved me? Everything. The things themselves, the people, the air, noises, sound, colours, material presences, textures, forms too—forms I can appreciate. Forms I can try to decipher. Forms I find beautiful. What else moved me? My mood, my feelings, *the sense of expectation that filled me* while I was sitting there' (Zumthor, 2006, 17, my emphasis).

Back to clinical practice. The aesthetic experience of the architectural space brings to the fore general elements of atmospheres that are at play, in this very generality, in all aspects of existence. As far as therapy is concerned, these elements remain partially veiled, by design. Granted this, it may well be part of a therapist's education, perhaps even training, to embrace both the aesthetic and creative position, i.e., both the position of the user of built space and of the architect. In that, therapists can inform their

own practice with a raised awareness of atmospheres, and engage with clients with subtler ways of directing, suggesting, seducing, releasing, orienting, fostering, denying, allowing, inviting, inciting, opening up, making possible or preventing, suggesting given ways of perceiving, living, enjoying or being within them, as well as given ways of engaging in relations, in a way that facilitates a favourable outcome for the patient.

What is certain is that, also in the clinical setting, the effect of the atmosphere on the patient's experience will influence, but not decide, the quality of the encounter and of the process of treatment: first, the adherence to the setting and the therapeutic project; then, via the adherence, the opportunity of transformation or vice versa the closure of the horizon of possibilities, the hindrance to change, the imposition of a certain way of seeing and perceiving the situation.

The tension between prescription and 'possibilisation' is played out at the architectural level similarly to what happens in the therapeutic relationship, between constraint and invitation: 'Hospital corridors are all about directing people, for example, but there is also the gentler art of seduction, of getting people to let go, to saunter, and that lies within the powers of an architect. The ability I am speaking of is rather akin to designing a stage setting, directing a play' (Zumthor, 2006, 41–43).

The artists' expertise leads them to work on the conditions of possibility for a specific event, for a certain kind of personal and relational experience. For instance, how to create a space that generates a feeling of both liberty and safety? How to foster flourishing and play? Thus, the orchestra conductor Alondra De la Parra: 'Conducting has always been based on fear: control through fear. The way I grew up as a musician was instead about trust: making sure that musicians can be as musical as possible and for that to happen you must create an atmosphere where they can be vulnerable and make mistakes, but where they can also have space and be brilliant' (de la Parra 2015, min. 3.35–4.02).

Narrative Atmospheres

Narrative atmospheres, as well as, of course, intersubjective atmospheres—which, by choice, will not be directly addressed here—act alongside spatial, architectural atmospheres. 'Narrative atmosphere' refers to that quality of space generated by discourse which, despite lacking the material and bodily component proper to spatial atmospheres, nevertheless has the capacity to touch, move, liberate or bind, enable or hinder the person, by means of the 'how', which conditions the reception and effect of the contents conveyed (the 'what' of the discourse). We will not focus here on the speech act in itself.

The aim is to understand, with the help of narrative theories, the main features of narrative atmospheres and their modes of effectiveness, so that one can then draw a lesson for thinking about the effects of the narrative atmosphere that condition the context of medicine and psychiatry in particular.

What can narrative theories teach, by analogy and difference, to medicine and psychiatry? The narrative woods—to use Umberto Eco's spatial metaphor (1994)—are in fact also a space through which the walkers can get lost or find their way, in which they can immerse themselves or remain on the threshold, from which they can make, under certain conditions, an experience of opening up new possibilities or not.

A lesson can be drawn from narrative theory about the conditions of possibility for an atmosphere to perform an enabling role (or not). Even if narrative atmospheres are lacking the material component, capable of activating an immediate adhesion (or repulsion) of the subject towards the experience that the space offers, in the narrative woods there is also something at stake which touches (or does not touch) the subject and, by touching them, moves them in one direction (or another), arouses their adhesion (or not). In the narrative space, this happens mostly through contact and identification with the characters, facilitated by the narrative atmosphere.

About characters, Martine de Gaudemar writes that 'they open up possibilities' (2011, 385, my translation), as 'operators of subjectivity' (2011, 386). It is precisely the exposure to fictional narratives, to characters living between the intimate and the collective, that enables the subject to open up to different forms of life and possibilities of existence.

Characters act precisely as 'operators of contingency' (de Gaudemar, 2011, 386), insofar as they are 'capable of varying the fates' (de Gaudemar, 2011, 386). Thus, 'The individual trajectories carried by the characters do indeed exhibit possibilities of varying the course of the narrative. They stimulate our imagination by offering several ways of living, several versions of the character' (de Gaudemar, 2011, 386).

The adherence to the invitation offered by the narrative atmosphere, however, is not obvious; nor is the beneficial character of this adherence. For there to be adhesion to the atmosphere deployed by the narrative, there must in fact be what Samuel Taylor Coleridge (2014) called a 'willing suspension of disbelief'. The condition for adherence and the related emotional effects to occur is thus twofold: both the 'suspension of disbelief' and its voluntariness are necessary.

The 'suspension of disbelief' is the prerequisite for entering into and surrendering to the world of the text. It entails assuming a mental posture, which accepts the world that the narration proposes, accepting even its unreal and unlikely elements. It means adopting a kind of 'poetic faith'—as Coleridge called it (2014)—, in which one voluntarily lets the imagination run free, adhering to the experience offered by the text, and allowing oneself to be moved.

The concept of 'voluntariness' must be underlined. The adherence to the narrative universe of the text, to a character capable of moving the individual, as an operator of subjectivity and contingency, is only possible when there is free participation, in the same way that the adherence to that spatial atmosphere that moves the subject should be free.

As adherence to the spatial atmosphere must be accompanied by freedom of movement and seduction rather than constraint, so must adherence to the narrative atmosphere.

Allowing the free play of the atmosphere and its effects involves that space of freedom of experience that is characteristic of the aesthetic experience—of the experience of beauty, of the experience of delight ('*Genuss*' Musalek, 2017, 78 ff.). It implies the ability 'to be catered for' ('*sich beschenken lassen*') (Musalek, 2017, 106), to embrace a beautiful life ('*was als bejahenswert erscheint*') (Schmid, 2000, 177).

'Once the viewer engages in the … experience, or willingly suspends disbelief, there is some type of flow, much like a needle following the groove on an old analog record. Jolt or shove the record, and the needle will fall out of the groove and you will lose that sound. You become aware of being out of that musical state. You become aware of the change in mental state' (Ferri, 2007, 36).

If individuals are to adhere to the 'world of the text', they need—and these conditions are never granted—to share the world of the narrative, and to have an appropriate encylopaedia and cultural conventions to cooperate in the text's actualization, filling in the gaps that the indeterminacy of the text encompasses (Eco, 1979).

In general, as far as space and narratives are concerned, there is a correlation between a subject's willingness to adhere to an atmosphere and what it offers—in terms of enablement, freedom or constraint, openness or closure, directionality or otherwise. Indeed, it is necessary that he or she is willing to adhere, knows how to adhere (suspending disbelief), and is able to adhere (sharing the world of reference and its aesthetic-perceptual coordinates). In the absence of the 'suspension of disbelief', the adherence will be partial and the grasp on experience will be limited. On the other hand, in the absence of a voluntary dimension, in cases where adherence is forced, the atmosphere's opening and enabling capacity will be lost.

Back to clinical practice. The clinical discourse is already a form of narrative because it operates, in the register of science, a plotting of the history (past, present, and future) of the person, by turning him or her into a patient—and thus a character.

In this context, the patient must be able to voluntarily adhere to the story, identifying with the character being narrated. Condition for the patient to adhere to the narrative proposed by or co-constructed with the physician is the establishment of an atmosphere, 'a climate of trust … [which] seems to be essentially based on the presupposition that there is a community of meanings between the patient and the doctor on the notions of good, bad, suffering, health, illness, therapy and restoration of the potentiality-for-Being' (Benaroyo, 2006, 77, my translation).

While on a narrative level, fictional characters provide reassurance regarding the possibility of deviating from a predetermined existence and act as 'contingency operators' (de Gaudemar, 2011, 386, my translation), capable of varying destinies and opening up new possibilities, on the contrary, in the clinical discourse, the forced adherence to figures with locked destinies—think of the designation 'psychiatric patient'—may well lead to closing the subject's possible options. It is possible that the diagnoses themselves perform the function of defining some characters as 'typical individualities' (de Gaudemar 2011, 127–129) to which the subject is nevertheless here forced to adhere, with the result of stigma.

As spaces can be directive ('Hospital corridors are all about directing people' (Zumthor, 2006, 41)), so too can clinical narratives. In such situations, one forfeits the opportunity for openness, transformation, and possibility offered by the atmosphere, as a proposal and invitation to let oneself be moved, to let oneself be seduced and transported. The atmosphere—both narrative and spatial—still acts on the person, but in a divergent direction from the desired openness and 'repossibilisation' of existence, pursued in an anthropological and social aesthetic view of therapy.

Theatrical Atmospheres: The Chance and Responsibility to Manage the Effects of Atmospheres

Consequently, as a therapist, one must take responsibility for knowing how atmospheres act, for identifying where atmospheres (in their various components) support and where they hinder the direction in which the therapeutic process is intended to move. It is even more necessary to be aware of this as this opportunity can be well exploited or squandered. And the worst thing that can happen is perhaps that it remains unexploited, according to Daniele Finzi Pasca, theatre director and choreographer, who represents the last perspective to be introduced, between architecture and narration: theatre. Theatre as a space in which precisely through atmosphere—through space and through speech—the creation of a context in which certain events can take place is pursued.

'Theater also embodies a social aesthetic' (Berleant, 2005, 30). In spectatorial situations—and this applies to theatre as well as cinema—a milieu of 'public intimacy' is created as Giuliana Bruno has called it (Bruno, 2007). In this milieu, a 'space is experienced materially, through corporeal presence and interconnectedness' (Bruno, 2022, 29) and as 'Mikel Dufrenne observes, experienced space is temporalized space, space made intimate' (Dufrenne, 1973, in von Bonsdorff, 2005, 86). In such a space, the 'viewer is not passive in this transitive environment but responds to being in space in forms of projection that are even empathic. One becomes responsive to an atmosphere, that is, to the emotion or tonality that is exuded and irradiated from space' (Bruno, 2022, 29).

It is important that the director engages the audience and presents their content in an incisive way, emotionally or even physically. 'This is precisely the intention of the artistic creator in the performing arts. It is, after all, the purpose of the stage set to provide the atmospheric background to the action, to attune the spectators to the theatrical performance and to provide the actors with a sounding board for what they present' (Böhme, 2017b, 30).

Artists strive to use atmosphere to put the spectator in a state of receptivity, as described by Finzi Pasca in an interview: 'the strategy of an artist develops in two phases: the first is where you try and must try to destabilise the spectator. In the sense that when you go into a theatre, the lights go out, before you can really enter another dimension, before your pores are totally open and ready to be surprised, before your

attention is riveted, before you get to that, you have to destabilise. In the second phase of the strategy, what happens is that when you've managed to put the viewer in a certain dimension, then you can maybe take the hit: you can manage to say, if there's something to say at all, hoping that it will have a repercussion … We all hope that our steps leave traces' (Finzi Pasca in Bernegger & Martignoni, 2011, 58–59, my translation).

Even if fiction is involved and a willing suspension of disbelief is required to a measure, theatre and cinema engage their audiences in a genuine sense, provided that they are willing to adhere to the proposition they are presented with. Short of this adherence, the artistic effort is stripped of its ability to move.

This can occur in the performing arts, when the persuasive power of the atmosphere weakens, and the viewer 'becomes aware of his or her incredulity. It's as if the lights have been brought up and the magic in the theater has ended … the viewer is now aware of his or her expectations. They are aware that they are *watching*. There is a void in the theater. Something is missing' (Ferri, 2007, 35–36). Viewers might also disengage with the performance to protect themselves from a threatening atmosphere, thus foregoing in equal measure the opportunity to be moved.

While theatre is faced with the distinct possibility of losing the spectator's full adhesion to the atmosphere and experience which it proposes, health care, in turn, is at risk of being unable to use the adherence to atmosphere to best effect. As a matter of fact, the key element is not so much the adherence to atmosphere *per se*, but the ability to use adherence in the best possible way. This is what leads theatre professionals to even express envy towards those who work in the context of care. So states Daniel Finzi Pasca, regarding 'the envy—the envy of an actor, the envy of an artist—vis-à-vis a medical doctor' (Finzi Pasca in Bernegger & Martignoni, 2011, 58, my translation).

'So why envy? Because when one finds oneself in a doctor's waiting room, and … maybe it's something … really worrying … what happens is that the very worry, the fear, the empathy with those close to us who are suffering, our questioning about life at that moment, makes one totally—let's say—sensibilized. Because one is on the edge of one's seat, all of a sudden, every action, every single gesture—from the secretary or the nurse who greets you, to the doctor who invites you in—, everything, every gesture is constantly being interpreted. You feel like understanding why. And the repercussion is enormous, which a doctor cannot account for … There is a deadly repercussion. Which is what we basically, in art, try to recreate—each of us. So there is envy, on the one hand, because one says: you have it for free. You have that for free. People come in there and they are already put in a position where each of your gestures can have a repercussion. And so the problem is this: the problem is no longer what you are communicating, but how you can unwittingly bring about disaster. Because the disaster is that you miss extraordinary opportunities' (Finzi Pasca in Bernegger & Martignoni, 2011, 59, my translation).

'What is interesting is that we all trace, etch the future in a particular way. There are gestures, there are actions that dig into memory … There are some moments where, because we are in a particular condition, on edge, everything remains as if stuck, deeply …

Having said that, what do I mean? I mean that a creator, an actor when he goes on stage, hopes to be able to put his audience in that state and then engrave it' (Finzi Pasca in Bernegger & Martignoni, 2011, 60, my translation).

Back to clinical practice. A valuable lesson that clinicians can draw from theatre is that the bodily experience which they enact as healers can be rejected by the subjects, like they would, as part of a theatre audience, refuse propositions from the theatrical space. Patients may become estranged from their own bodies, stripped from themselves, as it were, to leave only a disembodied version of themselves for the clinician to interact with (Young, 1997). This disembodiment is more than trivially metaphorical: it is a part of a *real* situation, insofar as the health-care practice, as we've been describing it, revolves around atmospheres that are nothing but realities. In such situations of rejections, even atmosphere may be dissipated, just like it is when the Shakespearean character of Claudius dissipates it upon demanding that lights be put back on, when he recognizes himself as the assassin being portrayed in the play that he had been watching.

Whereas in the artistic sphere the production of atmospheres is consciously pursued and the desired effect is intentionally sought, in clinical practice atmospheres are mostly given and connoted by the setting itself. The health professional can indeed do something to influence them, particularly on a narrative level. However, it is essential that he or she is first of all aware of the influence exerted by the context (architectural, epistemological, etc.) in which his or her actions take place, and that he or she knows how to responsibly manage the great power to which the atmosphere of care exposes the patient.

Conclusion: Lessons for the Clinic from a Social Aesthetic Reflection on Atmospheres

Psychiatry, and medical practice in general, can learn from an analysis of atmospheres as we have discussed, but also stands to gain a more aesthetically oriented stance: 'an "aesthetic attitude" ... namely an attitude that permits the self to be affected by atmospheres' (Böhme, 2017a, 21, drawing on Hermann Schmitz).

First and foremost, one can gain an awareness of the aesthetic dimensions that *nolens volens* condition the experience of treatment: dimensions to be known and opportunities not to be wasted. The aesthetic efficacy at play cannot be ignored, which interferes with other active elements of the therapeutic process, and the effect of aesthetic vectors—such as attractive/repellent, alongside good/not good, effective/not effective—must be taken into account.

Atmospheres sensitize to that which *moves* the subject *towards* something, which leads them to adhere to something (to a narrative, to a space ...), that is of the order of the 'how' rather than the 'what'—the question of the 'how' being at the very core of

the research field of social aesthetics (Musalek et al., 2022). Finzi Pasca again: 'What makes the profession of the medical doctor extraordinary is that it has the possibility of impacting the future in an extremely marked way. But do you know that what you are doing, *how* you are greeting, *how* you are sitting, *how* you are talking, *how* you are answering the phone in the process is all a matter for later thought? As a patient you leave there, you go home, and you are asked: what did the doctor tell you? And you answer: he told me that. Yes, but *how* did he tell you?' (Finzi Pasca in Bernegger & Martignoni, 2011, 59, my translation and my emphasis).

On the basis of the analysis of the role of atmospheres, medicine can also learn a general lesson regarding its own nature: although medicine is a science, it is exposed to a form of efficacy which in many areas is closer to the aesthetic than to the causal-scientific. From this point of view, the task at hand is to create the conditions of possibility for a given occurrence rather than aspiring to cause the desired results.

Atmospheres are indeed carriers of potential happenings: they are always about 'creating the conditions' (Böhme, 1995, 98 my translation) for something to happen. This also involves a modest and patient posture, since the desired happenings can only be favoured, induced, but never entirely provoked and completely controlled (Griffero in Bernegger, 2013, 65; Griffero, 2019, chapters 15 and 16).

The fact that the aesthetic effect of an atmosphere (spatial, narrative, relational) on the user is always in part uncontrollable and unpredictable should not, however, lead one to see such an effect as arbitrary and ungovernable, but rather to choose to privilege the point of view of the users over the intentions of the authors, in order to understand which aesthetic effect is being produced on the individual involved.

This certainly does not entail that the health professional renounce the intentional pursuit of the therapeutic goals, but rather that they recognize between the proposed pathway and the effects of it, a singular way of interpreting the pathway by the patient intervenes, a way of making it their own, of following it, which may in the best of cases have a positive aesthetic efficacy (opening, enabling their possibilities), but which does not comply with a rigid logic of cause and effect.

The analysis of atmospheres teaches medicine that the active participation of the user is unavoidable: 'Ultimately, to experience an atmosphere, one must be engaged, open to, and in resonance with the phenomenic character and lived quality of our ever-shifting surroundings' (Bruno, 2022, 30). The patient's adhesion is thus not only an element that favours therapy, but the very condition of possibility for the desired transformative effects to be produced: 'One must enter into the work in an intimate fashion, active not as a pure spectator but as an involved viewer. These characterizations of aesthetic experience vary in the degree of engagement they recognise between perceiver and object' (Berleant, 1991, 17, drawing on Dufrenne, 1973).

If the patient's adherence is to imply abandonment, this can only be played out on the level of voluntariness, constraint being incompatible with letting something happen, in the space opened up by the atmosphere: an aspect to which the whole medical practice must value.

The reflection on atmospheres, finally, teaches medicine—psychiatry in particular—that it must exercise its responsibility towards a situation in which receptivity is high, where it benefits by default from the user's adherence, which may nevertheless fail suddenly.

References

AA.VV. (2021). Pathologies de la liberté d'hier à aujourd'hui. *Cahiers Henri Ey, 47–48*.
Abbé Dinouart. (2003). *L'art de se taire* (1771). Jérôme Millon.
Benaroyo, L. (2006). *Éthique et responsabilité en médecine*. Médecine & Hygiène.
Benaroyo, L. (2022). The significance of Emmanuel Levinas' ethics of responsibility for medical judgment. *Medicine, Health Care and Philosophy 25*, 327–332.
Berleant, A. (1991). *Art and engagement*. Temple University Press.
Berleant, A. (2005). Ideas for a social aesthetic'. In A. Light & J. M. Smith (Eds.), *The aesthetics of everyday life* (pp. 23–38). Columbia University Press.
Berleant, A. (2010). *Sensibility and sense. The aesthetic transformation of the human world*. Arnold Imprint Academic.
Bernegger, G. (Ed.) (2013). Atmosferologia. A colloquio con Tonino Griffero. *rivista per le Medical Humanities 26*, September–December, 61–67.
Bernegger, G. (2015). 'Das Mögliche möglich machen'. Der Therapeut als Seiltänzer. In M. Poltrum & U. Heuner (Eds.), *Ästhetik als Therapie. Therapie als ästhetische Erfahrung* (pp. 171–195). Parodos.
Bernegger, G. (Ed.). (2017). Al termine della psichiatria. A colloquio con Gilberto Di Petta. *rivista per le Medical Humanities 3*, July–September, 69–80.
Bernegger, G., & Martignoni, G. (Eds.). (2011). Che cos'è vero? A colloquio con Daniele Finzi Pasca e Maria Bonzanigo. *rivista per le Medical Humanities 19*, July–September, 57–76.
Böhme, G. (1995). *Atmosphäre*. Suhrkamp.
Böhme, G. (2017a). *Atmospheric architectures. The aesthetics of felt spaces*. Bloomsbury Academic.
Böhme, G. (2017b). *The aesthetics of atmospheres*. Routledge.
Brencio, F. (2018). Disposition. The 'pathic' dimension of existence and its relevance in affective disorders and schizophrenia. In J. Cutting & G. Cusinato (Eds.), Psychopathology and philosophy in relation to the existence of human being. *Thaumàzein. Rivista di Filosofia 6*, Verona, 138–157. Available from: www.rivista.thaumazein.it.
Brnić, I. (2019). *Nahe Ferne. Sakrale Aspekte im Prisma der Profanbauten von Tadao Andō, Louis I. Kahn und Peter Zumthor*. Park Books.
Bruno, G. (2007). *Public intimacy. Architecture and the visual arts*. MIT Press.
Bruno, G. (2022). *Atmospheres of projection: Environmentality in art and screen media*. University of Chicago Press.
Carnevali, B. (2020). *Social appearances. A philosophy of display and prestige*. Columbia University Press.
Coleridge, S. T. (2014). *Biographia literaria or biographical sketches of my literary life and opinions* (1817). Edited by A. Roberts. Edinburgh University Press.
Costa, C., Carmenates, S., Madeira, L., & Stanghellini, G. (2014). Phenomenology of atmospheres. The felt meanings of clinical encounters. *Journal of Psychopathology 20*, 351–357.

Costa, C., Carmenates, S., Madeira, L., & Stanghellini, G. (2018). Atmosphere and clinical encounter. In G. Stanghellini, M. Broome, A. Raballo, A. Vincent Fernandez, P. Fusar-Poli, & R. Rosfort (Eds.), *Oxford Handbook of phenomenological psychopathology* (pp. 872–881). Oxford University Press.

de Gaudemar, M. (2011). *La voix des personnages*. Les Éditions du Cerf.

de la Parra, A. (2015). *ttt titel-thesen-temperamente*. Das Erste, ARD. Available from: www.youtube.com/watch?v=qDyojCAtImg [last accessed 6 October 2024].

Dufrenne, M. (1973). *The phenomenology of aesthetic experience*. Northwestern University Press.

Eco, U. (1979). *The role of the reader: Explorations in the semiotics of texts*. Indiana University Press.

Eco, U. (1989). *The open work*. Harvard University Press.

Eco, U. (1994). *Six walks in the fictional woods*. Harvard University Press.

Ey, H. (1948). *Études psychiatriques*. Tome 1. Desclée de Brouwer.

Ferri, A. J. (2007). *Willing suspension of disbelief: Poetic faith in film*. Lexington Books.

Francesetti, G., & Griffero, T. (Eds.). (2019). *Psychopathology and atmospheres: Neither inside nor outside*. Cambridge Scholars Publishing.

Gmür, S. (2014). *Lecture and exhibition opening: Silvia Gmür, 'A Hospital is a House for a Man'*. Harvard University, Graduate School of Design. Available from: www.gsd.harvard.edu/event/lecture-and-exhibition-opening-silvia-gmr-a-hospital-is-a-house-for-a-man/ [last accessed 6 October 2024].

Griffero, T. (2011). Come ci si sente qui e ora? La 'Nuova Fenomenologia' di Hermann Schmitz. In H. Schmitz, *Nuova Fenomenologia. Una introduzione* (pp. 5–23). Christian Marinotti Edizioni.

Griffero, T. (2014). *Atmospheres: Aesthetics of emotional spaces*. Routledge.

Griffero, T. (2017). *Quasi-things: The paradigm of atmospheres*. State University of New York Press.

Griffero, T. (2018). Something more. Atmospheres and pathic aesthetics. In T. Griffero & G. Moretti (Eds.), *Atmosphere/atmospheres. Testing a new paradigm* (pp. 75–89). Mimesis International.

Griffero, T. (2019). *Places, affordances, atmospheres. A pathic aesthetics*. Routledge.

Iser, W. (1978). *The act of reading*. Johns Hopkins University Press.

Jauss, H. R. (1982). *Toward an aesthetic of reception*. University of Minnesota Press.

Musalek, M. (2010). Social aesthetics and the management of addiction. *Current Opinion in Psychiatry 23*, 530–535.

Musalek, M. (2011). Estetica sociale e medicina: teoria e prassi. *rivista per le Medical Humanities 19*, July–September, 36–41.

Musalek, M. (2012). Das Mögliche und das Schöne als Antwort. Neue Wege in der Burnout-Behandlung. In M. Musalek & M. Poltrum (Eds.), *Burn-out. Glut und Asche* (pp. 177–203). Parodos.

Musalek, M. (2017). *Der Wille zum Schönen II*. Parodos.

Musalek, M., Bernegger, G., & Scheibenbogen, O. (2022). Social aesthetics and mental health. In M. Diaconu & M. Ryynänen (Eds.), *'Liber Amicorum for Arnold Berleant'. Popular Inquiry 1*, 143–152.

Musil, R. (1930–1933). *Der Mann ohne Eigenschaften*. Rowohlt Verlag.

Nussbaum, M. (2011). *Creating capabilities: The human development approach*. The Belknap Press of Harvard University Press.

Ricoeur, P. (1986). *Du texte à l'action*. Seuil.
Sass, L. A., & Ratcliffe, M. (2017). Atmosphere: On the phenomenology of 'atmospheric' alterations in schizophrenia – Overall sense of reality, familiarity, vitality, meaning, or relevance. *Psychopathology 50*, 90–97.
Scheibenbogen, O., Mader, R., & Gottwald-Nathaniel, G. (Eds.). (2021). *Auf der Suche nach einem autonomen und freudvollen Leben. Ressourcenorientierte Suchtbehandlung*. Parodos.
Schmid, W. (2000). *Schönes Leben? Einführung in die Lebenskunst*. Suhrkamp.
Schmitz, H. (1964–1969). *System der Philosophie*. Bouvier.
Schmitz, H. (2014). *Atmosphären*. Verlag Karl Alber.
Schmitz, H. (2019). *New phenomenology. A brief introduction*. Mimesis International.
Seel, M. (2003). *Ästhetik des Erscheinens*. Suhrkamp.
Ströker, E. (1977). *Philosophische Untersuchungen zum Raum*. Klostermann.
Tellenbach, H. (1968). *Geschmack und Atmosphäre*. Müller.
von Bonsdorff, P. (2005). Building and the naturally unplanned. In A. Light & J. M. Smith (Eds.), *The aesthetics of everyday life* (pp. 73–91). Columbia University Press.
von Weizsäcker, V. (1985). Körpergeschehen und Neurose (1928). In P. Achilles, D. Janz, M. Kütemeyer, W. Rimpau, W. Schindler, & M. Schrenk (Eds.), *Viktor von Weizsäcker. Gesammelte Schriften* Bd 6 (pp. 119–238). Suhrkamp.
von Weizsäcker, V. (2008). *Warum wird man krank? Ein Lesebuch* (1947). Suhrkamp.
Young, K. (1997). *Presence in the flesh: The body in medicine*. Harvard University Press.
Zumthor, P. (2006). *Atmospheres. Architectural environments. Surrounding objects*. Birkhäuser Verlag AG.

CHAPTER 20

APPLIED SOCIAL AESTHETICS IN CLINICAL PRACTICE

The Will to Beauty and Its Impact on Mental Health

MICHAEL MUSALEK AND OLIVER SCHEIBENBOGEN

Introduction

As a branch of science, social aesthetics can be understood in three ways: firstly, in very general terms, as a field of inquiry into sensuously experienced encounters and relationships *of all kinds;* secondly, as a science in which research is confined to the sensuous experience in and of *interpersonal* encounters and relationships and, thirdly, as a science that focuses primarily on *beautiful* encounters and *flourishing* relationships in the sense of successful social coexistence. The focus of research in the field of social-aesthetics is thus always the sensual experience in the context of encounters and relationships.

The definition of aesthetics as a science of sensual perception and cognition can be traced back to Alexander Gottfried Baumgarten (1717–1762), the founder of aesthetics as a distinct field of philosophical inquiry. He derived the term from the Greek aesthesis (sensation, perception from the senses) and in his opus magnum *Aesthetica* described it as a hitherto rather neglected epistemology that not only deals with beautiful objects in nature and art, but above all with the faculty of sensual perception and cognition (Baumgarten, 2007). He made a distinction between this aesthetic epistemology, which he construed as a 'lower epistemology' as distinct from a 'superior epistemology' that is guided by understanding and reason. Attaching greater value to cognitive-rational knowledge than to emotional-aesthetic knowledge has a long tradition. Early indications of this type of comparison and an undervaluation of emotional-sensual knowledge can be found in Parmenides of Elea, and were passed on by Plato and

Aristoteles via Leibniz and Descartes to the present day (Marcinkowska-Rosól, 2010; Curd & Graham, 2008; Baird & Kaufmann, 2008; Clark, 2012).

However, Baumgarten saw aesthetics as more than just a science of sensual cognition. He understood it as a special way of approaching the world, a distinct scientific methodology, a special form of thought, which was then comprehensively elaborated some two-and-a-half centuries later by Wolfgang Welsch (2003a, 2021) as 'aesthetic thinking' with all its specificities in terms of its figures of thought and patterns of thought. Baumgarten considered sensuous perceptions to be more than just dark and unreliable sources of truth. He regarded thinking in analogies based on sensual perceptions as a distinct form of knowledge of the world worthy of investigation (Majetschak, 2007). However, for Baumgarten, aesthetics is more than just a science and method of knowledge; it is also art. In his *Prolegomena* he explained that art in this context referred not just to a practice, but also very fundamentally to a reflecting thought system, a theory of the liberal arts (Schneider, 2002). In other words, aesthetics is not just a science dedicated to the philosophical-scientific discourse on beauty or the creation of art and artwork, it is also always a science and an art that is directed towards 'aesthetic thinking' itself.

Wolfgang Welsch (2003a,b) deepened this approach in his book *Ästhetisches Denken* in which he demanded that aesthetics must be about more than just reflecting on what is aesthetic, but that thought itself must have an aesthetic signature, an aesthetic cut. According to Wolfgang Welsch, aesthetic thought patterns and figures of thought do not have their point of origin solely in sensory perceptions, but above all in sensual perceptions (Caroll, 2006). In this respect, aesthetic thought differs from other forms of thinking, such as, for example, mathematical thinking, economic thinking, or empirical-scientific thinking.

In many respects, aesthetics has evolved since Baumgarten. Today, the discipline's scientific objectives are by no means limited to the beauty of art, but have an essential focus on natural beauty and beauty in everyday things. Thus it can no longer be reduced to a science that is for artists what ornithology is for birds. Nor can it be equated with 'callistics', the 'pure' science of beauty, which is only one aspect of aesthetics (Waibel, 2009). Aesthetics, as a science, not only focuses on discernment in respect of art or natural beauty, it also deals much more generally with sensual perception and all that is sensually perceptible, regardless of whether it is beautiful or no-longer-beautiful (Böhme, 1995/2017).

The widening scope of aesthetics as a field of research therefore made it necessary to establish specialized fields of inquiry in order to retain sight of the essentials in the wide-ranging terms of reference. 'Social aesthetics' is one such field of inquiry. Arnold Berleant (2005), who introduced the term into the philosophical literature, defines social aesthetics as the aesthetics of the situation. Like any aesthetic it is always contextual and perceptual, its indispensable foundations are intense perceptual attention and mindfulness, its main focus is everyday life. It is therefore an aesthetic that seeks to study the *how* of encounters and relationships in general and those of human social coexistence in particular, and to bring more light into the darkness of human behaviour and sensual ways of experiencing otherness and hospitality (Musalek, 2011).

Applied Social Aesthetics as Life Practice and the Art of Living

As humans, we are genuinely relational beings and social animals (Musalek et al., 2022). In an age of 'individualization', where human beings are isolated from one another, there is a widespread belief that humans are genuinely individual beings, who only painstakingly learn to become social animals over the course of their lifetimes. Against this, it can be argued that human beings live in community with other human beings from the day they are born (and even before); indeed, as an unfinished being entering the world, a baby is dependent on living with and from others—first in a symbiosis with its mother, and then living together with the loved ones who are closest to them. Over the course of our lives we become more independent and sometimes even believe we can live just for ourselves, although this soon turns out to be an illusion. Without others we cannot solve the many and varied problems with which we are confronted in the course of our lifetimes in an effective and meaningful way, and without others there can be no progress either (Levinas, 1979; Métais & Villalobos, 2021). The importance of living in relationships with others becomes especially clear to us in case of illness and also in old age, when physical infirmities set in as part of the ageing process and we become increasingly dependent on the assistance of our fellow human beings.

To believe that we can get along without others is nothing more than a delusion born of a forgetfulness of community. We need others, we need the companionship of others. We are, and always remain social animals (Musalek et al., 2022)—communication with others is our lifeblood. Even if we wanted to, we cannot avoid communication with others—because even breaking off contact with someone is nothing more than a particular way of communicating with them. In other words, we are—in a variation of Sartre's words on freedom (Stöcklin, 2005)—condemned to communicate. One cannot not communicate (Trunk et al., 2011).

Thus, the question is no longer so much *whether* we communicate with others or not, but rather *how* we shape these interactions with other people, how we shape our interpersonal encounters and our relationships with our fellow human beings. The science that deals with this *how* of encounters and relationships is social aesthetics (Musalek et al., 2022). Given the far-reaching nature and complexity of questions concerning the conditions and effects of encounters and relationships in the diverse areas of life, this can only be done in multi-professional cooperation, of the kind that takes place, for example, in the Institutes for Social Aesthetics and Mental Health at the Sigmund Freud University in Vienna and in Berlin (Musalek, 2023a,b). In this context, it should be noted that to create successful and flourishing encounters and relationships, we have to make use of our interactional resources. They have to be recognized, unfolded, developed, and activated if we are to be able to use them effectively in everyday life. This is especially true for the clinical-therapeutic process. Resource-oriented treatment can

only be successful if the patient's available resources—and also those of the therapist—are recognized in a process of dialogue and then activated accordingly (Musalek, 2023c).

As humans, we are the only living beings known to us that are capable of highly complex linguistic expression and thus also of differentiated verbal communication—which is why, when we talk about people's communicative or interactional resources, we think first and foremost of everything that we can pass on to them or receive from them verbally. However, communication is much more than just an exchange of words and thoughts, and in addition to the aspect of content, it always has a relationship aspect (Trunk et al., 2011). When we communicate something of substance to someone, we always also convey to them how we relate to them. This relational aspect of interpersonal communication is not just an interactional accessory, to a large extent it also determines the message that is passed on (Trunk et al., 2011). When we interact with someone linguistically, we do so on both a specific thematic level and on an emotionally effective meta-level.

Every verbal expression is accompanied by a para-verbal one, and the latter often contains more information both in terms of content and on the relational level than a verbose statement. Each one of us has an entire arsenal of different paraverbal communication tools at our disposal, whereby one person's paraverbal reserve can be greater than that of another. Non-verbal and para-verbal forms of expression include mimic movements, gestures, various forms of posture and, above all, diverse means of linguistic expression. Depending on the volume, the speed and modulation of our speech, timbre, intonation and, above all, where we pause, we can lend greater or less weight to what is said, make our words seem more forceful or more half-hearted, more meaningful, loftier, or more banal.

Mimic movements that are congruent with what is said can reinforce what has been expressed in words. If facial expressions contradict what was said, they can counteract or even cancel out the original meaning of the words. As a rule, paraverbal information overrides verbal information; we give greater credence to what is expressed in facial expressions than to what is communicated verbally. Verbal statements and facial expressions that contradict one another can also lead to uncertainty on the part of the person to whom they were addressed. It then remains unclear whether what was said can be believed or not, whether it was meant seriously or not. But we can also let the other person know without words how we react to what we have just seen, heard, and experienced. We can convey joy, fear, surprise, disgust, sadness, and contempt to the other person in an unerring and easily understandable way. Accompanying gestures and physical bearing then underline what was communicated by the facial expression. The time, place, and context in which information is communicated or exchanged and how the communication is punctuated play a decisive role both in verbal and especially in paraverbal communication (Bateson & Jackson, 1964; Trunk et al., 2011). One and the same sentence can thus take on completely different meanings when spoken in different times, places, and contexts, or used as punctuation.

The importance of all the aforementioned individual factors of paraverbal communication in combination with verbal expressions can be demonstrated by the example of a spoken simple sentence consisting of only a subject, predicate, and object. The sentence 'I love you' can be used to express very different things, depending on the paraverbal expressions that accompany it and the situations and contexts in which the words are spoken, and above all, the time they are spoken. The meaning, significance, and weight of this simple statement depend not least on whether the speaker looks deeply into the eyes of the person to whom it is addressed, or speaks with their eyes lowered or with their eyes directed towards the sky; whether the words are accompanied by a warm-hearted smile or a sly or a disparaging grin; whether the statement reaches the person to whom it is addressed after a preceding short general pause or embedded in a monotonous flood of words, at the wrong time, too early, too late, too loud, too quietly, with a tender timbre or shouted out loud, in a frenzy of passion or in quiet companionship.

These few examples alone make it clear how different the statements are and how they are to be evaluated both on the substantive-informational level and on the emotional-relationship level. Interpersonal interaction and communication are therefore a highly complex process that has to be learned and cultivated. On the one hand, we can access a bigger or smaller interactional verbal or paraverbal reservoir, but we are also capable of learning something new. In other words: we are not just condemned to communication, we also have the chance to shape, develop, and cultivate it in a way that suits us. Applied social aesthetics as a practical science of encounters and relationships provides us with the science-based know-how to do so.

It is precisely in situations where people are suffering from relationship problems, where they find themselves in places of hopeless crisis, that we have to recognize the interactional resources they possess but that have been buried by the crisis. Where such resources are lacking, the acquisition of new communication strategies and forms of communication is of the utmost importance, as they are the key to successful life management in community with fellow human beings. To lead a successful life, it is therefore necessary to identify the interactional resources that are often available but which, because they receive too little attention, remain largely unused. They can then be used effectively within the context of reorientating and managing life in the future without addictive substances. Where such resources are inadequate, it is incumbent upon all of us to create opportunities for ourselves and our fellow human beings to complete, develop, and refine them. These interactional and communication resources enable us to make fruitful and profitable contact with other people. They make it possible for us to meet others and to enter into relationships with them or to build relationships together that we experience as beautiful and rewarding (Musalek, 2023c).

Making contact with someone, communicating with someone, does not in itself mean encountering them or entering into a relationship with them. There are no encounters without contact being made; but there are certainly forms of establishing contact and communicating that do not involve an encounter in the real sense of the word. In contrast to communication, to which—as already stated—we are condemned, from which

we can never escape, we can enter into contact with someone without encountering them. Likewise, meeting someone does not inevitably mean building a relationship with them for that reason alone. The encounter is the initial spark for a relationship—but the spark alone does not constitute a relationship. To use the terminology of mathematical set theory, one could say that encounters and relationships are subsets of the basic set of contact and communication types.

Examples of contact without an encounter in the true sense of the word are communication situations where a stranger asks a local for directions to a place of interest, but the answer does nothing but provide directions. Or think of an interview situation, where the specialist aspects of the position are discussed on a factual level only with no possibility given for a genuine encounter between the interlocutors. Even physical contact does not necessarily have to be experienced as an encounter; physical contact in an overcrowded underground train does not necessarily result in encounters between the passengers who are packed together so tightly. A verbal apology for the unwanted proximity does not in itself usually mean an encounter in the true sense, despite verbal contact with a fellow human being.

Even in situations where an encounter is intended, this does not necessarily mean that it will be successful. Encounters are always two-way events: person A encounters person B, simultaneously person B encounters person A. If one of them withdraws from the encounter it can no longer take place. But there are also many cases where two or more people actually do want an encounter, but—for whatever reason—fail to complete it. The Italian psychiatrist and psychopathologist Bruno Callieri coined the psychopathological term 'mis-encounter' for these forms of failed encounters (Callieri & Maldonato, 1998). In certain forms of chronic idiopathic psychoses, such 'mis-encounters' are a typical patho-social behavioural feature. However, 'mis-encounters', be they intended or unintended, also happen to healthy people in their everyday lives—with interpersonal thoughtlessness, lack of empathy, and above all, an unwillingness to open oneself to others being the main causes (Rossi Monti & Cangiotti, 2011; Musalek & Bernegger, 2013).

As human beings, however, we are not only capable of creating and cultivating interpersonal encounters and relationships with our fellow human beings, we are capable of establishing them with other living beings such as animals and plants. Moreover, we can also encounter objects, works of art, certain life situations and living spaces, buildings, cities, rivers, and even the universe in its infinity as we sense it. When encounters and relationships are referred to here, it is always as 'two-way processes.' A encounters B, at the same time, B encounters A. We no longer view the individual object, work of art or a certain city from one perspective, the object, work of art or a certain city come to us, talk to us, move us. It is then no longer just we who make contact, but the object, the work of art, a certain city, a situation in life or a certain living space also makes contact with us, offers itself to us in its own special way and thus moves us emotionally.

Even when gazing at the stars in the night sky, we can, if we wish, keep a distance to them, observing them only from our own perspective—making contact but without encountering them. Or we can allow ourselves to encounter them, we can open ourselves

up to them and then experience quite directly how the infinite sea of stars comes to us and in our encounter with the universe, we can also become one with it. In this way, we can encounter everything in our world and enter into a two-way relationship with it. In the words of Martin Buber, this means stepping out of an I-It encounter (I look at something from a distance—what, or whoever, I am looking at it remains It) with an object or situation and into an I-Thou encounter (into a two-way mode of communication supported by a high degree of reciprocity—the vis-a-vis becomes a Thou who is in contact with us on an equal footing) and so we become a We with the other (Buber, 2010).

The two-way relationship between a work of art and the one who experiences it as such is also the core element of Arnold Berleant's (1992, 2005) theory of social aesthetics. In a keynote lecture given at a symposium organized by the Institute for Social Aesthetics and Mental Health at the Sigmund Freud University Vienna/Berlin together with the Aesthetics in Mental Health Network of the Collaborating Centre for Values-based Practice, St. Catherine's College, University of Oxford, in 2017, he explained that the basic idea of what he then elaborated into the theory of social aesthetics is based on the observation that when we engage with a painting in a sensual experience, when we do not just look at it from a distance as a subject, but open up to it sensually, we feel how the painting comes towards us, how it touches and moves us (Berleant, 2017). Not only do we touch the image with our gaze, the image touches us too. When we enter into a relationship with the painting, the contemplation of a painting is thus not a one-way relationship, but always a two-way relationship, an encounter in the actual sense (Musalek et al., 2022).

Arnold Berleant (2005) then gradually developed this concept, which initially focused on the experience of art, into a comprehensive aesthetic of everyday life, which he henceforth understood as an 'aesthetic of the situation.' An aesthetic experience always takes place in two dimensions, in a sensuous and also in an imaginative dimension, and can bring us into both positive and negative affective states. Without a doubt, 'priority goes to positive aesthetic qualities: aesthetics has to do primarily with pleasure, and secondly with pain' (Leddy, 2005). However, aesthetic experience is always a two-way process: when we experience something sensually, be it a work of art or an everyday situation, we encounter the other and at the same time the other also encounters us (Berleant, 2005). Aesthesis, sensual experience or aesthetic perception is thus always a social-aesthetic process, which advances social aesthetics to a basic aesthetic science (Musalek et al., 2022). All aesthetics is therefore ultimately social aesthetics.

The aim in applied social aesthetics is to incorporate the scientific achievements of theoretical and empirical social aesthetics into life practice. Applied social aesthetics focuses on the sensual experience of encounters and relationships in everyday life. Its main task is to examine social aesthetic theories and maxims for their application, implementation, and feasibility in life as it is lived and experienced in reality. Applied social aesthetics is thus not only practical science, but also an art—the art of living. Core research areas are the phenomenology and circumstances of the various forms of touching, hospitality, and atmospheres that open the doors to successful encounters and relationships.

The questions to be addressed here are: How do we encounter the other in real everyday life? How do we approach, how do we open up to the other, how do we experience the other coming towards us in the encounter? How do we experience interpersonal encounters, but also encounters with animals and plants? How do we encounter certain objects, works of art, but also living spaces and living situations and how do they encounter us? How do we experience ourselves in the encounter with ourselves? Above all, however, questions arise here about the hows of further developing, broadening, unfolding, and cultivating our ways of encountering. As human beings we are not only how we are, we are always also how we could be. We are not only reality beings, we are always also possibility beings (Musil, 1997) and as such are capable of active change. We can cultivate our encounters: we can learn to open up to the other in a very special way thus enabling ourselves to experience encounters more intensively, but we can also turn towards and encounter new others.

Encounter is the first step in establishing a relationship. But encounters are not only the beginning of relationships, they also accompany them, facilitate them, drive them forward and keep them alive. By repeatedly encountering the other, we intensify and cultivate the relationship. Cultivation involves more than just carefully nurturing something, above all it means taking it to a higher level, developing and refining it, in order to improve both the quantity and quality of what needs to be cultivated: 'semper sursum'. In terms of the sensual experience of encounters and relationships in our everyday lives, this means expanding and deepening our overall ability to encounter others and engage in relationships. However, it also means exploring how we can enrich the quantity and quality of our interpersonal encounters and relationships with a view to moving toward a life that is experienced as beautiful. The prime goal of cultivating our sensual experience of encounters and relationships in this way can only be to live more and more beautiful encounters and relationships with greater frequency in our everyday lives.

The Will to Beauty as a Natural Force and Cultural Event

If the goal is a beautiful life, a life enriched with beauty, the question arises as to what constitutes a beautiful life, what is the beauty in life? The philosophical discourse on beauty begins in Western intellectual history with the dialogue between Socrates and Hippias in Plato's work *Hippias Major* (Woodruff, 1981). Here, Plato has Socrates ask Hippias to define the beautiful. And Hippias replies: A beautiful girl is beautiful. Socrates then points out to him that he obviously has not understood the question, as he did not ask what is beautiful, but what is *the* beautiful. And Hippias again replies: a beautiful girl is beautiful, which could very well have been the end of the Western philosophical discourse on beauty. For beauty is indeed the expression of an inescapable dimension of human existence (Liessmann, 2010). What is beautiful is beautiful and that

is that. We all know what we find beautiful and what we do not. We all feel with great immediacy what we find beautiful. Recognizing something as beautiful is an immediate fundamental experience and as such its essence is ultimately closed to debate. Much more relevant than the question of what is beautiful are the *hows* of beauty. How is it that we experience something as beautiful? What are the effects on us and on others of something we consider beautiful? How can encounters with beautiful things and situations take place and how can we build, develop, and intensify relationships with something beautiful?

Something beautiful is not simply just beautiful for us; it cannot simply be perceived as such at a distance, registered and then just judged to be beautiful. Something beautiful always has an effect on us and makes something happen inside us. It affects us by attracting us and touching us, it makes something happen inside us by moving us emotionally and setting our feelings in motion. But it also moves us by giving us strength. Beauty is at once attraction, an impact and a source of strength. Its attractiveness draws us to it, its effect on us sets us in emotional motion and thus in the end releases life energy, power to live. Beauty therefore moves us in several ways. Saint Augustine (1966) pointed out in his *Sermones* that everything we see on the earth, in the sea, and in the skies cannot merely be experienced as such by us, but that all beauty quite evidently moves us. It moves us because it is beautiful!

Beauty thus draws us under its spell. This 'fascination' in turn has two sides to it: on the one hand, it is the beauty on the outside that captivates us on the inside, but at the same time, we also feel that we are being pushed from within towards the outer beauty. The experience of beauty is thus both a 'pushing' and a 'pulling'. We are drawn to the beautiful object, and yet at the same time we are pushed towards the beautiful object. We encounter beauty and beauty encounters us. It is here that the elemental force to beauty that works on us and in us, namely the *Will to Beauty* (Musalek, 2017), is impressively revealed in the truest sense of the word. This Will to Beauty expresses itself first in the form of an inner urge, an obscure push toward the beautiful, which we then interpret and experience as the attraction of the beautiful. The Will to Beauty also shows itself in those affective movements that immediately appear together with the beautiful. Here, too, an irreducible elemental force is at work, i.e., a will as described by Schopenhauer or Nietzsche, which allows us to experience beauty in affective emotion.

What is on the outside, the something facing us, which we identify and describe as beautiful, is quite obviously also capable of triggering inner forces in us (Perniola, 2013). We rightly say that beauty gives us strength—and we experience it as such: beauty really does give us strength very directly. Just think how much more powerfully we walk when hiking through beautiful countryside than when we are walking or running on a treadmill in a gym. Or think of how we feel we are bursting with energy on a beautiful summer morning with sunshine and a gentle breeze and contrast that with how we feel on a damp and windy cold day in late autumn. And last but not least, how much strength do we derive from a beautiful relationship and how much energy does a relationship cost us that is no longer so beautiful. As something that generates strength, beauty becomes the central force that drives us and thus also the fundamental moving

moment of our existence. In this way, too, the Will to Beauty can be experienced as a general primal force working in and on us.

However, the beautiful is not just an indispensable source of strength for our human existence; beauty is also a source of strength for animals, and certainly at least a life-determining primal force for mammals—and above and beyond that for all living beings, perhaps even for plants. Even more: given all we know today about the strength-generating power of beauty and its effects, beauty is more than just something that produces a 'blind', i.e., an aimless and directionless natural force, but rather the Will to Beauty is also always a central force for ordering our world. In terms of its essence as a universal primal force, the Will to Beauty is certainly comparable with Nietzsche's Will to Power and also with Schopenhauer's Will to Life—the essential difference though is in its orientation. If according to Schopenhauer (1996) life (also, and above all, in the sense of survival) is still the goal and purpose of the Will to Life, and if according to Nietzsche (2019) it is precisely the striving for ever greater power, i.e., a striving beyond oneself for the sake of striving beyond oneself, or as Martin Heidegger (1961/1989) so aptly put it: the becoming of the human being, [is] what the human being aims for, then in the Will to Beauty this primordial will and hence we ourselves, in and according to our deepest inner being, strive for Beauty for the sake of experiencing Beauty for its own sake (Musalek, 2017).

The experience of beauty is inseparable from the feeling of pleasantness. What is pleasant is beautiful and what is beautiful is pleasant. In fact, both are actually one! It is only the perspective from which we view beauty that makes the difference: from one perspective (the 'cognitive-linguistic' perspective) beauty appears to us as something that can be described by the term *beautiful*; from another perspective (the 'emotional-pre-linguistic' perspective), beauty is simply a pleasant feeling that arises in the face of beautiful objects, beautiful situations, or beautiful relationships. Beauty can therefore already be perceived preconsciously by a new-born baby, long before it has the possibility to know anything about beauty, to name it accurately or even to be able to refer to the 'essence' of beauty. One does not have to understand the essence of the sea to swim in it. We can evidently perceive complex processes and make complex connections (even if only rudimentarily) without yet having the ability to express them with language.

The sensation of pleasant and unpleasant and thus also the first perception of what is beautiful or not beautiful still has, for the time being, its locus in the unconscious. In some cases, it remains there, namely when the sensation has not (yet) crossed the threshold of consciousness or—as in the case of a new-born—cannot yet cross it at all. The sensation of what is pleasant or unpleasant then remains there, what Slavoj Žižek calls the 'known Unknown' (Žižek, 2014) and Jacques Lacan the 'unknown knowledge', a knowledge which the subject does not know it knows (Žižek, 2011). In the case of the preconscious perception of beauty discussed here, a Will to Beauty also appears as a force that pushes us towards beauty, as an archaic primal force that unfolds its potency in us in the unconscious, in the known unknown, in our dark inner being, which we then perceive as an intuitive feeling and knowledge of beauty, irrespective of whether we are aware of it, want to be aware of it, or not.

The perception of beauty and with it the Will to Beauty that manifests itself to us as an experience of being attracted to beauty, are thus first and foremost to be considered as belonging to the broad field of the intuitive and thus as very basal and immediate modes of experience that exist completely independently of a possibility of linguistic expression or a self-reflexive consciousness. Even new-born babies, i.e., long before they develop the use of language and also long before they are capable of describing something beautiful as beautiful and thus judging it to be so intellectually, grasp what is beautiful for them through the immediate feeling of pleasantness. That they are sensible to what is pleasant is proven by the enthusiasm and meticulous care with which they seek out the nipple of their mother's breast and once they have found it with what joy (I am almost tempted to say: with what fervour, with what passionate surrender) they perform the act of suckling. This is an observation that can be easily replicated.

It is doubtful whether a preconscious Will to Beauty is really restricted to mammals, if only because beauty also plays a major role in lower species of animal, at least (but by no means exclusively) in connection with the act of reproduction. Think of the peacock's display of plumage or the glorious birdsong during the mating season. As pointed out above in connection with the motivation for the sexual act in humans, the main motivator for the sexual act in animals is also not procreation, but the beautiful experience of the act itself. Animals can have no knowledge of procreation because they lack the areas of the brain that make such reflection possible in the first place. But even where no union with the opposite sex is required for reproduction, beauty in nature clearly has a special role to play. There is so much beauty in the world: the entire beautiful animal world with its wonderful colours and countless comely life forms; the plant world with its almost infinite wealth of forms and colours and even in the realm of fossils we find immensely beautiful fossils that point to a beauty in the Earth's natural history even in the most distant primeval times. One example of this is a parapuzosia seppenradensis, an ammonite of impressive dimensions (diameter: approximately one and a half metres) that lived during the Upper Cretaceous period and is approximately seventy-two million years old, and which can be seen in the LWL Museum of Natural History in Münster. Other examples of beautiful fossils, some of which are even 150 million years old, can be admired in the Upper Austrian State Museum in Linz, among other places.

They all bear witness to the fact that nature was of almost unbelievable beauty even more than 150 million years ago. One cannot help thinking that a universal Will to Beauty has always been at work. How else can we explain why there is so much beauty in this world, in the nature that surrounds us. It must be considered highly improbable that this beauty exists solely for us humans, that all the beauty was put into the world hundreds of millions of years ago merely to please humankind as beauty hundreds of millions of years later! How can we explain that the proportions of a snail that lived millions of years ago already conformed to the mathematical algorithm for superlative beautiful harmony that people much later on named the 'Golden Ratio'.

The Will to Beauty, however, not only always strives for beauty, it *also* strives for more and more beauty (Irvine, 2006). It not only strives for more and more beauty although it will never be able to achieve satisfaction in this way. A persistent, uninterrupted striving

for more and more beauty is predestined to end in an absence of satisfaction; because, as soon as the 'more' has been achieved, it would immediately have to strive for even more just as is the case with Schopenhauer's Will to Life, which can also never be satisfied. The Will to Beauty, however, also strives for satisfaction in beauty, in that it also invites us to dwell in the harmoniously beautiful, as already illustrated by the example of the intuitive preconscious perception of beauty experienced by the infant at its mother's breast.

At least since Friedrich Nietzsche's (1993) work *The Birth of Tragedy from the Spirit of Music*, we have made a distinction between an Apollonian and a Dionysian beauty (Vogel, 1966). The former encompasses all that is harmonious, balanced, well-formed, and well-designed, the latter all that is fascinating, intoxicating, and ecstatic. Aesthetics in general and applied social aesthetics in particular deal with both forms, because both are necessary for us to experience life as beautiful and thus to lead a beautiful life (Goldman, 2005; Sepp & Embree, 2010; Musalek, 2013). The Janus-faced nature of beauty, with the Apollonian on the one hand and the Dionysian on the other, matches the dual orientation of the Will to Beauty. On the one hand, it pushes us towards Apollonian beauty and thus to what is pleasant, harmonious, calming, and relaxing, and on the other towards Dionysian beauty and thus to what is fascinating, intoxicating, ecstatic, disturbing, and exciting. The Will to Beauty draws us on towards what we know, towards the traditional, the familiar and thus to what gives us a sense of security, and on the other, towards what is new, not-yet-known, not-yet-familiar, what is alien and thus to what brings joyful suspense. Neither of these alone bring satisfaction. The Will to Beauty, this inner urge towards what is beautiful, only experiences real satisfaction in the virtuoso, contrapuntal synergy and harmony of the Apollonian and the Dionysian. Such a synergy of Apollonian and Dionysian beauty then also provides us with the basis for a way of life in which life can become a symphony, for a way of shaping life and the world in beauty (Musalek, 2017).

It is the Will to Beauty as a natural primal force, as a universal generator of power and energy that makes all life in nature and all experiences of nature possible. This Will to Beauty referred to here thus manifests itself as a perceptible, tangible phenomenon that we can experience, not only as a force that works 'blindly', but beyond that also as the ordering force of our world par excellence. For Immanuel Kant, it is still reason that determines (or should determine) our lives as the supreme ordering force. Beauty not only moves us affectively and emotionally in a very special way and is thus also a general basal driving force. The Will to Beauty that lies behind all this works in us not only as a natural inner primal force in the form of an inner compulsion or attraction to beauty, not only as affective mover and not only as a natural archaic source of power, it also expresses itself above all by driving us humans to create beauty of our own volition. It is thus also essentially manifested in the fact that we humans are able to actively beautify our world.

On the one hand, this beautifying of our world happens because we can increase, enrich, and 'cultivate' our experience of beauty ourselves, but on the other, we can also put beauty into the world of our own volition. In this act of putting beauty into the world, the Will to Beauty becomes apparent as a phenomenon that is more than a natural

force but is a force of culture, a motor of cultural development. With and through us humans, nature not only succeeds in reflecting on itself and thus also in perceiving and experiencing both intellectually and emotionally its own beauty as beautiful—but through us humans it can also design and produce beautiful things itself auto-actively. The shaping of a beautiful world can now take place either in the act of a superficial 'beautification' (an embellishment, ornamentation, cosmetics, decoration, etc.) or in far-reaching and profound transformations of our world away from ourselves toward the beautiful in the sense of a 'deep aesthetic beautification', be it through change, development and unfolding of the world given to us or through the creation of beauty in general (Welsch, 2021). When we refer here to the beauty of the world as we experience it, we mean on the one hand an Apollonian beauty and on the other, a Dionysian beauty. In both, we experience the Will to Beauty not only as a natural force of beauty that leads us to ever more inevitable beauty, but rather also as a force that enables the process of 'beauty', in which beauty is brought forth autonomously through and by us humans.

The goal of this Will to Beauty as a cultural event is to increase the beautiful in our world. This, too, requires strength, which in turn is provided by the Will to Beauty. This multiplication of the beautiful by human hands can take place in three ways: firstly, as an increase in beauty by dint of the 'intensification' of our perception of beauty—we humans are capable of augmenting a rudimentary perception of beauty, such as a primitive pleasurable sensation until it becomes a delightful experience; secondly, by increasing beauty by expanding and broadening our field of experience of all that is beautiful—we humans are also capable, within the framework of a learning process, of identifying something as beautiful that we do not yet primarily perceive or experience as such. Thirdly, by increasing beauty in the world through our autonomous, self-willed creation—as human beings we are also capable of creating beautiful things, beautiful events, beautiful situations, beautiful relationships, and much more, and thus placing them in our world in order to make all the beauty we create our own. In all these three areas of life and experience, the Will to Beauty manifests itself as a cultural event and becomes tangible as an almost infinite driving force.

The Will to Beauty and Mental Health

The Will to Beauty as a natural force, but above all as a cultural event, which allows us to live a joyful life, plays a central role in what we mean by attaining and maintaining mental health. Establishing a link between a joyful, beautiful life on the one hand and mental health on the other might seem audacious at first glance. However, if we look closely at the World Health Organization's (WHO) definition of mental health (1949), it quickly becomes clear that there is indeed an inextricable link between a joyful and a healthy life. According to the WHO, 'health is a state of complete physical, mental and social well-being and not merely the absence of disease or infirmity'.

This raises the question of what is meant by 'complete mental well-being' and when it can be considered to have been achieved. Much has been published on mental health since it was defined by the WHO. Summarizing all the literature on the subject, it is possible to identify two main streams of thought. One is the health theory put forward in 1981 by the American philosopher of science Caroline Whitbeck (1981) in the anthology *Concepts of Health and Disease* edited by Arthur Caplan et al. which defines mental health as the ability to act and participate autonomously. Those who are able to live a self-determined life, make decisions independently and who can participate in community life without giving up their autonomy are mentally healthy. The second finds its culmination in the work *On the Nature of Health* by the Swedish philosopher Lennart Nordenfelt, published in the mid-nineties of the last century (1993, 1995). He emphasizes that a person can be considered mentally healthy if he or she is able to achieve certain vital goals, although he sees these vital abilities as components that are essential for 'a state of affairs that is necessary for the realization of this person's state of minimal long-term happiness'. He explicitly notes that the state of 'minimal long-term happiness' is not only to be understood as a specific state of mind, but rather as an expression of a joyful life in all its facets.

Autonomous and joyful living are not only closely linked; they are mutually dependent and mutually reinforcing. Without a minimum degree of self-determination, it is impossible to live a self-directed, joyful life; conversely, joy in life is the key driver for a life that is largely self-determined. If we regard health as being more than just the absence of illness and infirmity and instead define it as well-being, then it is only logical to define it as the ability to lead a largely autonomous as well as a beautiful life in the sense of an essentially joyful life (Musalek, 2013). This line of argument also convinced many early sceptics that an autonomous and joyful life is a profoundly medical therapeutic goal—because what else should be the goal in the treatment of the mentally ill if not the achievement of mental health (Musalek, 2010).

The experience of beauty is directly linked to joy—beauty delights us, joyful things are also experienced as beautiful. Beauty is not only fun, it can also be a source of joy. As early as the 1970s, Erich Fromm (1976) quite rightly pointed out the difference between having fun and being joyful in his opus magnum *Sein oder Haben*. The one is a short-term peak experience that calls for constant repetition. In the case of joy, however, we encounter a plateau experience, a basic mood that persists over longer periods of time and cannot be made to disappear, even by short-term negative impressions. A careful distinction between pure pleasure and mere fun on the one hand, and joy, joyful living on the other, is of immense importance in the discourse on achieving a beautiful life and complete well-being (Musalek 2011). Joyful, beautiful living can be best understood when equated with the experience of music (Distaso, 2009; Levinson, 2009)—here, too, it is not just about brief emotional flares of pleasure and their satisfaction, but about a loving and joyful devotion to the beauty of sounds as experienced in the contrapuntal union of Apollonian and Dionysian beauty in the individual composition.

The central task of well-being, a medicine that places a beautiful life and thus mental health at the heart of its endeavours, must therefore be to develop methods and

procedures that enable a joyful experience of beauty. Regaining a life that is as autonomous and joyful as possible is also the most important therapeutic goal of the Orpheus programme, a new treatment programme for addicts (Musalek, 2010). The Orpheus programme is committed to a human-based medicine, a medicine by people for people, in which the patient, rather than a disease construct, is at the heart of diagnostic and therapeutic activities (Musalek, 2015).

Human-based medicine is no longer concerned with just making diseases disappear, but above all with health in the deepest sense, with health as a state of comprehensive well-being for the patient that is achieved when they regain as autonomous and joyful a life as possible (Taylor & Brown, 1988; Bech et al., 2003). In order to achieve this therapeutic goal, however, it is not enough to simply make the deficiencies caused by disease disappear. Rather, the individual's resources must be identified or, where they are lacking, new ones must be generated (Musalek, 2022; Musalek, 2023c). The desired state of complete well-being defined as a beautiful, joyful life is not, however, a fixed quantity, a predefined goal that simply has to be achieved. Complete well-being is always a utopia, a not-yet-place that only comes into being when we set out on the path towards it. Each and every one of us has to create, develop, and cultivate our complete well-being by seeking it. However, the beauty of life created in this way is not merely a cultural achievement, it is at the same time an inherent Will to Beauty that drives us towards beauty, and in this way becomes the life force that enables us to raise our very own island of Utopia called complete well-being out of the sea of the unconscious in the sense of the not-yet conscious (Musalek, 2013).

Conclusion

Social aesthetics as a fundamental aesthetic science is the study of sensually experienced encounters and relationships of all kinds. By focusing on the practically relevant circumstances of the sensual experience of encounters and relationships in everyday life events, the sub-discipline of applied social aesthetics provides the foundations for the development of a life practice that strives for an essentially autonomous and joyful life. Since mental health as defined by the World Health Organization (WHO, 1949) is achieved when we are able to experience well-being in everyday life, and this mental well-being should be equated with a largely autonomous and essentially joyful life, the results of research in the field of applied social aesthetics are of indispensable value for achieving and maintaining mental health. But applied social aesthetics is not only a science, it is an art. As a practical art of living it helps the individual to develop behaviours that make it possible for them to live as joyful and therefore as healthy a life as possible. As human beings, we are not only capable of experiencing beauty, we are also capable of creating beauty. As cosmopoets we are capable of creating a beautiful world for ourselves. The Will to Beauty as an all-determining natural force gives us the necessary power to do so and at the same time points us to our ultimate goal of making our life and thus our world

a beautiful one—because it is joyful and full of joy. In times when the bad, the horrible, the threatening, and the frightening seem to be gaining ground, it is especially necessary for us to reflect on the possibilities we have to create worlds (cosmopoiesis), especially the possibilities to create beautiful worlds ('cosmopoesia'), and to tackle the great social-aesthetic project of contributing to the transformation of our world with our own transformation. We must follow Rainer Maria Rilke's call in his Orpheus Sonnets: 'travel out and in./ Where does your deepest suffering begin?/ If drinking makes you bitter, become wine…'. (Rilke, 2012; Rosenwald, 2022). Applied social aesthetics, as science and as an art, provides us with the necessary knowledge to develop new effective behaviours in order to make the possible become possible on our shared path to a more beautiful world.

REFERENCES

Augustine, S. (1966). *Selected sermons*. Translated and edited by Q. Howe Jr. Holt, Rinehart, and Winston.

Baird, F. E., & Kaufmann, W. (2008). *From Plato to Derrida. Upper Saddle River*. Pearson Prentice Hall.

Bateson, G., & Jackson, D. (1964). Social factors and disorders of communication. Some varieties of pathogenic organization. *Research Publications – Association for Research in Nervous and Mental Disease 42*, 270–283.

Baumgarten, A. G. (2007/1750). *Aesthetica. Philosophische Bibliothek 572a*. Felix Meiner.

Bech, P., Olsen, R. L., Koller, M., & Rasmussen, N. K. (2003). Measuring well-being rather than the absence of distress symptoms: A comparison of the SF-36 Mental Health subscale and the WHO-Five Well-being Scale. *International Journal of Methods in Psychiatric Research 12*, 85–91.

Berleant, A. (1992). *The aesthetics of environment*. Temple University Press.

Berleant, A. (2005). Ideas for a social aesthetics. In A. Light & J. M. Smith (Eds.), *The aesthetics of everyday life* (pp. 23–38). Columbia University Press.

Berleant, A. (2017). Honorary keynote lecture on 'social aesthetics'. Advanced Studies Conference: Hospitality and Mental Health organized by the Institute for Social Aesthetics and Mental Health, Sigmund-Freud-University Vienna and the Aesthetics in Mental Health Network of the Collaborating Centre for Values-based Practice, St. Catherine's College, University of Oxford, at the Sigmund Freud University Vienna, Austria, 19–20 May, 2017.

Böhme, G. (1995). *Atmosphäre*. Suhrkamp.

Böhme, G. (2017). *The aesthetics of atmospheres*. Routledge.

Buber, M. (2010). *I and thou*. Martino Publishing.

Callieri, B., & Maldonato, M. (1998). Fenomenologia dell'incontro. In B. Callieri & M. Maldonato (Eds.), *Ciò che non so dire a parole. Fenomenologia dell'incontro* (pp. 19–50). Alfredo Guida.

Caroll, J. (2006). *Art at the limits of perception. The theory of aesthetics of Wolfgang Welsch*. Peter Lang.

Clark, S. (2012). *Ancient Mediterranean philosophy: An introduction*. Bloomsbury.

Curd, P., & Graham, D. W. (2008). *The Oxford handbook of Presocratic philosophy*. Oxford University Press.

Distaso, L. V. (2009). On the common origin of music and philosophy: Plato, Nietzsche, and Benjamin. *Topoi* 28(2), 137–142.

Fromm, E. (1976). *To have or to be.* Harper Collins.

Goldman, A. (2005). The aesthetic. In B. Gaut & D. Mc IverLopez (Eds.), *The Routledge companion to aesthetics,* second edition (pp. 255–266). Routledge.

Heidegger, M. (1961/1989). *Nietzsche.* Erster und Zweiter Band. 5.Aufl. Neske.

Irvine, W. B. (2006). *On desire.* Oxford University Press.

Leddy, T. (2005). A defense of arts-based appreciation of nature. *Environmental Ethics* 27(3), 299–315.

Levinas, E. (1979). *Totality and infinity: An essay on exteriority.* Duquesne University Press.

Levinson, J. (2009). Philosophy and music. *Topoi* 28(2), 119–123.

Liessmann, K. P. (2010). Vom Zauber des Schönen. Reiz, Begehren und Zerstörung. In K. P. Liessmann (Ed.), *Vom Zauber des Schönen.* Philosophicum Lech. Bd. 13 (pp. 7–16). Paul Zsolnay.

Majetschak, S. (2007). *Ästhetik zur Einführung.* Junius.

Marcinkowska-Rosól, M. (2010). *Die Konzeption des "nein" bei Parmenides von Elea.* Walter de Gruyter.

Métais, F., & Villalobos, M. (2021). Levinas' otherness: An ethical dimension for enactive sociality. *Topoi 41,* 327–339.

Musalek, M. (2010). Social aesthetics and the management of addiction. *Current Opinion in Psychiatry 23,* 530ff.

Musalek, M. (2011). Medizin und Gastfreundschaft. In M. Musalek & M. Poltrum (E. *Medica. Zu einer neuen Ästhetik in der Medizin* (pp. 25–65). Parodos.

Musalek, M. (2013). Health, well-being and beauty in medicine. *Topoi 32,* 171–178.

Musalek, M. (2015). Human-based medicine – Theory and practice. From modern to postmodern medicine. In T. Warnecke (Ed.), *The psyche in the modern world: Psychotherapy and society* (chapter 6, pp. 92–116). Council for Psychotherapy Series.

Musalek, M. (2017). *Der Wille zum Schönen I – Als alles bestimmende Naturkraft.* Parodos.

Musalek, M. (2022). *Das Orpheus-Projekt. Mit der Liebe zum Schönen in ein freudvolles Leben.* Amalthea Verlag.

Musalek, M. (2023a). Institute for Social Aesthetics and Mental Health. Sigmund Freud University Vienna, Austria. Available from: http://socialaesthetics.sfu.ac.at [last accessed 6 October 2024].

Musalek, M. (2023b). Institute for Social Aesthetics and Mental Health. Sigmund Freud University Berlin, Germany. Available from: www.sfu-berlin.de/de/ueber-sfu-berlin/institut-fuer-sozialaesthetik-und-psychische-gesundheit/ [last accessed 6 October 2024].

Musalek, M. (2023c). *Ressourcen-orientierte Suchttherapie. Grundlagen und Methoden des Orpheus-Programms.* Kohlhammer.

Musalek, M., & Bernegger, G. (2013). Bruno Callieri e l'estetica sociale. *Comprendere 23,* 202–204.

Musalek, M., Bernegger, G., & Scheibenbogen, O. (2022). Social aesthetics and mental health. *Journal of Kitsch, Camp and Mass Culture 1,* 143–152.

Musil, R. (1997). *The man without qualities.* Vintage.

Nietzsche, F. (1993). *The birth of tragedy: Out of the spirit of music.* Edited by Michael Tanner and translated by Shaun Whiteside. Penguin Classics.

Nietzsche, F. (2019). *The will to power.* Dover Publications.

Nordenfelt, L. (1993). Concepts of health and their consequences for health care. *Theoretical Medicine and Bioethics 14*, 277ff.

Nordenfelt, L. (1995). *On the nature of health: An action theory approach*, second edition. Kluwer.

Perniola, M. (2013). *20th Century aesthetics. Towards a theory of feeling* (translated by M. Verdicchio). Bloomsbury.

Rilke, R. M. (2012). *Die Sonnette an Orpheus. Duineser Elegien*. Anaconda.

Rosenwald, J. (2022). *Die Sonette an Orpheus / The Sonnets to Orpheus* translated from German by John Rosenwald. Available from: https://plumepoetry.com/from-rainer-maria-rilkes-die-sonette-an-orpheus-the-sonnets-to-orpheus-translated-from-german-by-john-rosenwald/ [last accessed 6 October 2024].

Rossi Monti, M., & Cangiotti, F. (2011). Intervista a Bruno Callieri. Fenomenologia e psichiatria: l'incontro mancato. *Comprendre 23*, 219–225.

Schneider, N. (2002). *Geschichte der Ästhetik. Von der Aufklärung bis zur Postmoderne*. Reclam.

Schopenhauer, H. (1996). *The world as will and idea*. Phoenix Publishing.

Sepp, H. R., & Embree, L. (2010). *Handbook of phenomenological aesthetics*. Springer.

Stöcklin, S. (2005). *Zur Freiheit verurteilt. Eine Untersuchung von Satres Freiheitsbegriff*. Grin Verlag.

Taylor, S. E., & Brown, J. D. (1988). Illusion and well-being: A social psychological perspective on mental health. *Psychological Bulletin 103*, 193–210.

Trunk, T., Watzlawick, P., & Schulz von Thun, F. (2011). *Man kann nicht kommunizieren: Das Lesebuch*. Hogrefe.

Vogel, M. (1966). *Apollinisch und Dionysisch. Geschichte eines genialen Irrtums*. Gustav Bosse Verlag.

Waibel, E. (2009). *Ästhetik und Kunst von Pythagoras bis Freud*. Facultas.

Welsch, W. (2003a). *Ästhetisches Denken*. 6.Auflage. Reclam.

Welsch, W. (2003b). Aesthetics beyond aesthetics. Action, criticism, and theory for music education, volume 2, #2. 20 June 2003. http://act.maydaygroup.org/articles/Welsch2_2.pdf

Welsch, W. (2021). *Undoing aesthetics*. Sage Publications.

Whitbeck, C. (1981). A theory of health. In A. L. Caplan, H. T. Engelhardt Jr., & J. J. McCartney (Eds.), *Concepts of health and disease: Interdisciplinary perspectives* (pp. 611–626). Addison Wesley.

Woodruff, P. (1981). *Plato: Hippias Major*. Hackett Publishing.

World Health Organization (WHO). (1949). Preamble to the constitutions of the World Health Organization as adopted by the International Health Conference, New York, 19–22 June, 1946; signed on 22 July, 1946 by the representatives of 61 states (Official Records of the World Health Organization, No. 2, p. 100) and entered into force on 7 April, 1948 (the definition has not been amended since 1948).

Žižek, S. (2011). *How to read Lancan*. Granta Books.

Žižek, S. (2014). *Event. A philosophical journey through a concept*. Melville House.

CHAPTER 21

INQUIRY ON HOSPITALITY, COMPASSION, AND 'ANTLITZ' BY EMMANUEL LEVINAS

LAZARE BENAROYO

Introduction

Considered as a scientific endeavour, contemporary medicine understands itself as an application of scientific knowledges oriented towards efficacy in terms of diagnosis, therapy, prognosis, and prevention to achieve these goals.[1] In practice, however, scientific aspects are immersed in a sense of know-how, a practical wisdom taking its roots in another kind of knowledge based on experience and dialogical skills—essential ethical and aesthetical moments of clinical care.

Art or science? Contemporary medicine strives to articulate both kinds of knowledge in a paradoxical way leading sometimes to misunderstanding (Benaroyo, 2018).

In this chapter, I explore challenging paths to overcome the paradoxical nature of contemporary medicine. A first step will be to investigate to what extent practical wisdom, as understood by Paul Ricoeur, may help us to grasp the moral dimensions of clinical care. Against this background, reflecting on Emmanuel Levinas' conceptions of hospitality, compassion and 'Antlitz' will then help us to unfold the significance of the ethical responsibility which constitutes, in my view, the foundational moral core of clinical care.

Epistemological and Ethical Dimensions of Clinical Care

Let's start with some reflections on the nature of clinical medicine. Edmund D. Pellegrino has championed this issue for several decades. In his seminal paper 'Toward

a Reconstruction of Medical Morality' he lays out what he believes are universal characteristics of the practice of medicine (Pellegrino, 1979). He calls these the *Fact of illness,* a state of 'wounded humanity', of vulnerability, an assault upon the unity of the body and self, *the Act of profession,* professionals literally 'profess' that they will use their skills for the benefit of the sick, and *the Act of medicine,* a shared intention to seek healing for the patient, inherently a moral activity that arises out of the link between scientific knowledge about human bodies and the care of individual human persons, an act involving practical wisdom.

Hence, profound moral obligations arise from the essence of medicine itself. The predicament of the patient requires *trust*, which in turn requires trustworthiness of the clinician. The asymmetry between the healer and the sick person requires patient involvement in decision making to help restore the 'wounded humanity' of the patient. This means that in the realm of clinical activity the respect for autonomy, far from being a separate and competing external principle of medical ethics, becomes an integral aspect of beneficence. Pellegrino and Thomasma call this model of the patient–physician relationship 'beneficence-in-trust' (Pellegrino & Thomasma, 1981).

So understood, according to Pellegrino, caring for a patient requires a commitment to an understanding of the essence of being human as a patient, and an understanding of the form of agency known as medicine. One should presume that careful reflection, even in a morally pluralistic society, will allow rational persons of good will to come to a shared understanding of the central ethical core of the clinical encounter, as an ethical foundation of the moral duties for patient and physician that are inherent to medical praxis.

Although some criticisms have been addressed to Pellegrino's essentialist view of medical ethics, we cannot help but note that in spite of all this criticism, the ethical core of the clinical encounter as he understands it retains a powerful appeal, especially for physicians, clinicians, and those who have been seriously ill. It seems to capture and explain the unarticulated intuitions of many centuries of medico-moral humanistic thinking. However, one should confess, the influence of this way of looking at the philosophical and epistemological foundations of medical ethics depends in a large measure on what happens to the discretionary space of physicians and patients in a society.

Hence, what we are interested in is a critical assessment of the epistemological foundations of medical praxis laid down by Pellegrino and many others. This epistemological inquiry makes clear from the start how problematic the current concept of medicine as a natural science is—and by the same token, the concept of bioethics as the new ethics of medical science—and more particularly, how problematic the relationship between theory and practice is in the realm of clinical bioethics.

From an epistemological perspective, medicine may be characterized as a practical science. Its goal is not primarily to know but to act and intervene in a natural and social world. The aim of medicine is not merely the application of the cognitive results of theoretical sciences. Hence, praxis poses its own problems and questions. Although medicine employs theories, its practical requirements determine the choice of treatments.

Medicine is constituted through actions that are carefully reviewed, planned, and rationally motivated in the light of practical wisdom deriving from rational choices. Thus, instead of formulating 'grand theories', we would suggest that philosophy of medicine should analyse in detail the nature of practical wisdom and its relationship to ethical responsibility in concrete practices.

The genuine significance of ethics is thus preserved from the danger 'that ethics might become a technique for problems posed by techniques, that might be carried on as a supplementary technique' (Van Tongeren, 1994, 200).

Hence, in the realm of clinical ethics, considering that each patient has a particular profile, it would be out of the question to arbitrarily and generally apply standardized decisions to every case. Clinical practice cannot be restricted to an exclusively objectifying approach, but rather it must put its scientific knowledge at the service of the life plan that has been altered by the illness and which seeks to be restored.

In this view, the healer should pay attention to the fact that illness is not usually experienced by the patient solely as a technical incident, a deregulated organic functioning or a meaningless accident. As Georges Canguilhem states, feeling ill does not mean feeling abnormal in the sense of a deviation from the norm, from the standard of rightness and truth: for the patient, illness is characterized by a new configuration in his organism, a new form of adaptation to disruptions from the external environment, which translates into the development of a new individual norm (Canguilhem, 1989 [1966]). In this context, illness is a decrease in the ability to be normative. In this sense, illness is not, in the eyes of the sick person, a loss of his normality but rather a reduction in his ability to establish new vital norms.

Hence, the patient's quest for health can be interpreted as a search for the restoration of his organism's autonomy—illness being experienced by the patient as the reduction of autonomy in the form of a decrease in the level of normative activity, or even a reduction of the whole organism to a unique norm.

Bearing in mind this phenomenology of the pathic experience, clinical action thus transforms itself into a solicitude oriented towards an interpretation process—a hermeneutics—of signs and symptoms, bearer of a reconstruction of meaning, time, and the individual vital norm altered by illness. Accordingly, the healer should deliberate, taking incidental circumstances into account, in order to decide on the best possible good for each particular individual. The determination of this good rests on the clinician's ability to make *choices* which guide his/her actions towards the relief of the patient's suffering and recovery.

This approach enables an understanding of the individual as a being anchored in space and time, as demonstrated by his life's narrative. Such an anamnesis can be of great help here: it enables, for example, engagement with the patient in a reconstructive task, through language, by examining the following themes:

- What is the patient's lifestyle?
- What was the patient's existence aimed at until now?

- What are the conflicts or tensions present in his/her existence?
- In what way does the patient involve his/her body in this confrontation?
- How does he/she adapt his/her time and vital space in relation to the illness?
- In what way does the patient put his/her existence at stake through his/her illness?
- What changes happened in his/her social network in relation to his/her illness?

These concerns for the patient as an individual can draw the clinician's attention towards the way in which illness affects his/her patient's identity. The physician should explore the narrative registers through which suffering is expressed and especially what makes the patient's suffering particular; insights that emerge in the narrative.

Consequently, listening attentively to the patient's narrative (i.e., to the way he/she refers to him-/herself as the subject of his/her own story), and watching body language (during technical procedures for examples), are elements enabling perception of how the patient's identity has been affected by illness. The narrative registers convey how we perceive our belonging to a community, how suffering becomes inscribed in its own temporal evolution and alters the intimate perception of experienced time (Brody, 2003).

As Cheryl Mattingly notes, 'Therapeutic success depends in part upon the therapist's ability to set a story in motion which is meaningful to the patient as well as to herself. One could say that the therapist's clinical task is to create a therapeutic plot which compels a patient to see therapy as integral to healing' (Mattingly, 1994, 814).

This dual character of medical practice unveils the paradoxical nature of contemporary medical care.

The Paradox of Care

As Owsei Temkin already pointed out (Temkin, 1977), the responsible healer has a double face of Janus: on the one side, the naturalistic attitude, to recall Husserl terms, is necessary to observe the patient with objectivity in order to master his disease processes, and on the other side, the personal attitude entails hospitality and in some sense interruption of the mastery of the other and of the self. It is out of an elusive synthesis of both opposite attitudes—which respectively call on radically different goals—that responsibility-for-the-other may be implemented in clinical medicine.

Indeed, whereas until modern times the art and science of medicine focused on care of the patient, since the nineteenth century the increased importance of scientific approaches has broken this link by dissociating art and science. In the perspective introduced by modern science, recovery of health depends on an ethics of technical skill aimed at correcting measurable biological disorders. Since the mid-nineteenth century, the classic art of medicine has lost its place within an epistemological approach based on the natural science model, which draws its strength from the fragmentation of

knowledge and the disciplinary differentiation that allows specialization in the field of organ pathology. To quote Georges Canguilhem:

> The [scientific] method has set aside patients, understood as seeking elective attention to their own pathological situation ... Like all sciences, medicine has had to go through the stage of temporarily eliminating its specific initial subject matter.
>
> (Canguilhem, 1988, 29)

In 1926, the professor of medicine at Harvard University, Richard Cabot, stated that it was time for medical and nursing science to start focusing on a conception of care understood as a 'curing attitude' and abandon an approach based on overall care, since medicine, he said, should focus on the body; other facets of care belonged, according to him, to other disciplines (Cabot, 1926, 16). The development of medical science would henceforth be progressively structured by the world of expertise.

However, this view was not universally accepted. It triggered a vigorous reaction from clinicians, who deplored this new conception of care and the erasure of the accompanying art of medicine. In 1927, Cabot's colleague Francis Weld Peabody thus wrote:

> One of the essential qualities of the clinician is interest in humanity, for the secret of the care of the patient is in caring for the patient.
>
> (Peabody, 1927, 882)

Some authors, such as William Osler, joined Peabody in promoting a humanist clinical approach capable of paying equal attention to the technical and human dimensions, and stressed the importance of being able to restore the balance in the organism while correcting organic dysfunction, so that patients could once more live lives in which they could fulfil their potential and regain their freedom.

In the mid-twentieth-century post-war setting, this trend faded in response to scientific and technical developments from across the Atlantic; but in the 1980s it was revived in both Europe and the United States. We are faced with a paradox, said many clinicians in the closing decades of the twentieth century: care should precede the technical act, whereas at present it is the technical act that guides care.

As they saw it, the paradox lies in the twofold injunction that structures care in the nascent technological world: attention to organic pathologies must be based on knowledge of the general, yet attention to the organism as a whole must be based on knowledge of the specific. How are these two kinds of knowledge to be reconciled? How are we to revive a conception of care that enables medicine to perform its task, a conception that combines science and art, taking account of the organism and the human factor as a whole, while paying particular attention to organ and tissue damage? This question had already been raised in Germany in the 1930s, when medical anthropology (*medizinische Anthropologie*) was emerging (ten Have, 1994).

This challenge to contemporary medicine seems hard to overcome in a technological world. How are we to create the conditions that will allow caregivers to listen to, and hear, what patients are saying? At the end of the 1980s this question led to reflections heralding an ethical approach that would serve as the foundation for the development of a philosophy of care.

As Michael Schwartz and Osborne Wiggins point out (Schwartz & Wiggins, 1985, 1988), dealing with these two conceptions is not self-evident, for they are first and foremost paradoxical injunctions that call for different kinds of knowledge and methods. Health-care professionals' responsibility calls on them to adapt their technical actions (based on mastery and control) to welcoming and listening (which presupposes self-effacement, lack of mastery, openness to others). Confronted with the universal and the specific, the objective and the subjective, the wish for infinity in the presence of human finiteness, contemporary clinicians thus face the need to give their technical practice a place in the care plan, while accepting that the scientific approach runs into its own limitations in the clinical setting: the difficulty it has in understanding other people's suffering and in grasping the profound issues of otherness and singularity that are associated with it. As Canguilhem wrote:

> We have to admit to ourselves […] that there can be no homogeneity and uniformity in attention and attitude towards the illness and the patient, and that caring for a patient does not involve the same responsibility as rationally fighting disease.
>
> (Canguilhem, 1978, 408)

Canguilhem therefore stresses the importance of being attentive to the 'point of conversion of the value of medical rationality', a crucial point 'that is not a point of withdrawal', as he puts it. He believes that physicians should be able to 'step aside' along with the scientific approach directed towards the translation of symptoms into objective signs—a step that will allow them access to the interpretative aspect of patients' own experience of their illness. Patients interpret their symptoms in their own registers of interpretation of the world and themselves; and they call on health-care professionals to explain them based on their own words and narratives. 'Failing this,'—says Céline Lefève in a commentary on Canguilhem's work—'a register of medicine (rather than an addition to it) is missed, adding new sufferings to the pathological ones. Ignoring patients' subjective experience adds emotional harm to the risk of diagnostic and therapeutic error' (Lefève, 2014, 211).

This 'step aside', this 'shift in physicians' attention from illness to the patient', which is closely linked to their moral commitment as health-care professionals, echoes the twofold reference to our conception of the body that is pointed out by Maurice Merleau-Ponty when he says that our body is a 'two-sided being' that contains 'a double belongingness to the order of the 'object' and to the order of the 'subject' (Merleau-Ponty, 1964, 180).

Mirroring this, Canguilhem stresses that the status of contemporary medicine lies in its dual character. Medicine must therefore create a link between 'knowledge and understanding that is inherent in clinical work' (Lefève, 2014, 213).

How to gain access to this 'conversion of medical rationality', the source of 'the shift of focus in the physician's attention' on which an approach to care that pays attention to the individual depends? To what extent could an aesthetics bear significance for this conversion?

THE ART OF PERCEPTION: AESTHETICS GAZE AND THE PARADOX OF CARE

One may usefully think of the field of philosophical aesthetics as having three foci (Levinson, 2003, 3–4): (1) one involves the practice of art, making those manifold objects that are works of art; (2) a second focus involves a certain kind of property, feature, or aspect of things, such as beauty or grace or dynamism; and (3) the third focus involves a certain kind of attitude, experience, or perception, which could be called aesthetic experience.

I shall focus here on the third kind, namely aesthetics being understood in its etymological sense (aísthesis means perception). Classical conception defines perception as a preconscious human experience that determines the structure of our reality (Hick, 1999).

Furthermore, the essences of objects, the reality of our world in time and space are outlined by the direction of our 'perceptual interests'. These perceptual interests determine our perceptual movements. The resulting object reached by this interest-guided kinesthesia is always a relative object, deemed to be sufficient in particular circumstances.

Hence, every perception is, as Husserl already indicated, perception with horizons. In the patient–doctor relationship, there are not two worlds which are essentially different: there are two different perceptual experiences, creating different perceptual worlds (Hick, 1999, 133).

In the early Paris clinic, the medical view was still the epistemological incarnation of an 'open perception', ideally perceived in the absence of any theoretical preconception of the object in question, leading the aesthetic contemplation of the symptoms of illness (Foucault, 1963; Hick, 1999, 135).

Everything changes in medical perception—according to Foucault—with the introduction of pathologic anatomy. Xavier Bichat, for the first time, breaks up and tries to penetrate under the surfaces of perceptual reality. Bichat's work is directed at finding below the 'simple' perceptual reality the verity of the pathological lesion. The medical perception gains a new dimension. It goes vertically from the manifest surfaces of the body to the hidden surfaces of tissues (Foucault, 1963, 137–149).

This new way of medical perception, this pathological view, is no longer characterized by an open, 'ordinary' perception (as defined by Husserl). The adventurous perception,

going below the visible surface of the patient, is no longer a mundane, ambiguous perception. The medical perception, by choosing to follow the lines of pathological anatomy, becomes absolute perception: 'regard absolu' (Foucault, 1963). Evidently, our modern practice of medicine is characterized foremost by the scientific form of medical research, committed along a certain type of 'perceptual interest' to healing the living by knowledge gathered from analysing the dead.

In this view, two archetypal perceptual patterns may be interpreted as being relevant to medicine: (1) The 'open', ordinary pattern of perception with its mixture of knowledge and ignorance, and (2) the 'closed', scientific way of perceiving reality, constituting 'absolute' knowledge. This knowledge is absolute not in the sense that it cannot be modified at all, but in the sense that it can only be modified by perceptions of the same closed type, staying within the framework of scientific perceptual patterns, thus methodologically banning any ordinary perceptions from infiltrating the scientific 'knowledge base'.

In clinical medicine as well as in theoretical medicine and medical ethics, a distinction between open and closed perceptions can be helpful and a 'stepping back' to open perception patterns could help to understand how open perceptions, not abstract principles, are at the root of any ethical experience or behaviour (Hick, 1999, 136).

These analyses show that there are many levels at which it might be useful to recognize that these two modes of perception may permit a more fruitful access to empirical as well as conceptual problems in medicine. An 'art of perception'—an exploration that concerns a special sub-field of medical philosophy that may be called medical aesthetics—could be seen as a technique for adequately dealing with different perceptual patterns in medicine. It would consist, above all, in the art of changing perceptions, of acknowledging differences in perceptual patterns and of choosing the most adequate pattern for any given situation.

Medical practice must incorporate both modes of perception we have identified to be able to grasp a 'conversion of medical rationality': the 'absolute' perception of science as well as the 'open' perception of ordinary life. To gain a view as complete as possible of a medical problem we need to obtain a stereoscopic view on the reality of the patient, which in turn demands mastery of these two perceptual modes.

Paul Ricoeur's work on medical judgement seems particularly relevant when responding to this challenge, for it provides the conditions for overcoming the dual character of contemporary medicine as part of a revival of Aristotelian 'practical wisdom'.

Relevance of Paul Ricoeur's Thought for Medical Care

Paul Ricoeur scrutinized medical practical wisdom in his study of prudential judgement (Ricoeur, 2000). Calling upon Aristotelian's and Kant's legacy, Ricoeur characterizes

three different and complementary stages in the elaboration of prudential judgement in the realm of clinical activity (Benaroyo, 2011):

- The first level, called the *teleological level*, the health-care professional seeks to clarify—in dialogue with the patient—the ethical individual aim and the medical goal to be pursued, namely explore what 'wounded humanity' means in this singular case, to what extent the autonomy of the patient has been altered, and how it could be restored. At this level, the ethical fundament of the clinical judgement is laid, for Ricoeur, in the *pact of care based on trust* that seals the doctor's promise to answer to the call of the patient. The agreement owes its moral character to the tacit promise shared by the physician and the patient to fulfil faithfully their respective commitments.
- The second level, called *deontological level*, performs the universalization of the first-order individual judgement described above, treating, among other things, conflicts within or outside the sphere of clinical intervention, as well as dealing with socially and institutionally acknowledged norms, such as informed consent, distributive justice, and rules of health-care allocation.
- The third level, called the *prudential level*, the moment of implementing practical wisdom, that reaches completion after a common—usually team-based—deliberative process. It is the moment of the wise decision, taking into account first- and second-order (teleological and deontological) judgements and integrating them to formulate an individualized decision. In Ricoeur's view, this decision is ethically rooted in the teleological level that gives meaning to the whole medical act, namely that orients the *telos* of the medical intervention.

This three-stage architecture of medical ethics characterized by the integration through practical wisdom of three different orders of ethical judgements may be viewed, I would argue, as the paradigmatic basic structure of practical wisdom in clinical medicine. Ricoeur revives here an almost forgotten trend of clinical anthropology that had developed in interwar Germany (ten Have, 1994; Lawrence & Weisz, 1998) under the influence of physicians and philosophers such as Viktor von Weizsäcker, Victor von Gebsattel, Otto Guttentag, and Hans Jonas, who themselves influenced Pedro Lain Entralgo in Spain, or Georges Canguilhem in France as well as Pellegrino in the United States.

Yet, Ricoeur emphasizes the ethical dimension of the clinical encounter, namely the teleological layer where the telos of the medical intervention can be specified in dialogue with the patient. For Ricoeur, the ethical core of this encounter lies, as mentioned, in the *pact of care based on trust*. This pact configures the clinical act: on the one side the patient, with the desire to be relieved from the burden of suffering and on the other side, the health caregiver who promises to help the patient.

However, I think that the ethical core of this first level of clinical judgement, as conceived by Ricoeur, should be in some way thoroughly worked out from a clinician's perspective. Indeed, I cannot help but note that establishing a *pact of care based on trust* is precisely one of the most challenging issues of clinical practice: instead of being a

starting point of prudential judgement—as Ricoeur seems to take for granted—I see it rather as the cornerstone to achieve before being able to reach to completion in practical wisdom.

In other words: due to the fact of illness, instead of relying on the assumption that a pact of care may be sealed by two autonomous partners, as Ricoeur suggests, clinical experience shows that the asymmetry of the clinical encounter is first and foremost an ethical call for the clinician's 'response-ability'—a response to the call of the patient's vulnerability starting with the words: 'Here I am listening to the meaning of your suffering and helping you to restore your wounded self'. This answer is, in my view, the basic ethical layer upon which trust may be built and constitute the crucible of a pact of care.

My suggestion is then the following: it is precisely at this level that Levinas' thought may shed light on the very nature of a caring approach in a clinical world; it is on this basis that a practical wisdom may be realized in a clinico-technical and social world according to Ricoeur's view. This reverse understanding of the basic ethical foundation of ethical responsibility is precisely what Levinas' philosophy can help us to grasp and implement in clinical care.

The Significance of Levinas' Philosophy for an Ethics of Care: Hospitality, Compassion, and 'Antlitz'

It may seem at first glance a betrayal of Levinas' thought to call upon it in an attempt to build up a philosophy of clinical care. I am fully aware of this potential pitfall. Nevertheless, I endeavour to explore Levinas' ethical insight in order to approximate the ethical core of the face-to-face with the patient. By drawing on this aspect of Levinas' thought, I would like to get closer to the ethical foundation of an ethics of clinical care.

Emmanuel Levinas was born in Kovno, Lithuania in 1906, of Jewish parents. In 1923, he went to Strasbourg (the closest French City to Lithuania) in order to study philosophy under such teachers as Charles Blondel and Maurice Pradines. At this time, the writings of Henri Bergson were making a strong impact among the students, and Levinas in particular. He quickly made friends with Maurice Blanchot, who introduced him to the work of Marcel Proust and Paul Valery. In 1928–1929, he attended a series of lectures given in Freiburg by Husserl on phenomenological psychology and constitution of intersubjectivity. It was at this time that he began to write his dissertation on Husserl's theory of intuition. He also discovered Heidegger's *Being and Time*.

His career started in the 1930s with the completion of his excellent dissertation, a translation of the *Cartesian Meditations* and several essays on Husserl's and Heidegger's phenomenology. In the 1930s, he took French nationality, married, and moved to Paris, where he worked in the administrative section of the *Alliance Israélite Universelle*. At the outbreak of war, he was mobilized and was quickly made a prisoner of war. Meanwhile,

most members of his family were murdered during the pogroms that began in June 1940, with the active collaboration of Lithuanian nationalists.

Because Levinas was an Officer in the French army, he was not sent to a concentration camp, but to a military prisoner's camp, where he did forced labour in the forest. By this time, he read Hegel, Proust, and Rousseau in between periods of forced labour. His book *De l'existence à l'existant*, published in 1947, described his anonymous existence, his personal experiences of insomnia, sleep, horror, vertigo, appetite, fatigue, and indolence, his real-life in captivity. This book attracted little attention, although Jean Wahl invited him in the same year to give a course for his students, the text of which was published soon after under the title *Le temps et l'autre*. This situation changed however, when in 1961, Levinas published *Totalité et infini. Essai sur l'extériorité*. Suddenly a master was revealed, who not only renewed twentieth-century phenomenology but also combined a radical critique of Western philosophy with a Platonizing retrieval of the pre-Platonic tradition of Judaism. Translations into many languages spread his fame; he was invited to give lectures in many countries, and he received honorary doctorates from several universities. Levinas became then prolific and the growth of secondary literature related to his work was overwhelming. In 1967 he was appointed Professor of Philosophy at the newly establishment University of Paris-Nanterre and in 1973, he was appointed Professor of Philosophy at the Sorbonne.

The difficulty of Levinas' language and revolutionary thought was such that widely held agreement among scholars with regard to its interpretation and evaluation was not immediately possible. His publications after 1961 clarified certain questions, but they also posed new ones, since his thinking had continued to evolve. His second major book *Autrement qu'être, ou au-delà de l'essence*, which appeared in 1974, represents a new stage in his thinking, one even more original than the former. The philosophical work of Levinas became known in America through the early translation of his main texts, *Totality and Infinity. An Essay on Exteriority* in 1969 and *Otherwise Than Being, or Beyond Essence* in 1987.

Levinas' philosophy starts by taking a critical distance from Heidegger to the extent that he maintains that the significance of a question—any question—does not lie in some possible answer or response, but in the question itself. That is, the question is already a manifestation of our relationship with Being, of our astonishment at the mere fact of existence. However, Levinas asks whether this is the only meaning or content of philosophical wonder. Is the question of ontology—or why there is something rather than nothing—the most fundamental philosophical question? In distinguishing his own project from Heidegger's, Levinas states that philosophy is more than the questioning of Being, but strives to move beyond the tension between being and a good beyond being—between ontology and ethics—which is constitutive of his mature philosophy and guides the unfolding of the ethical problematics of his major work (Levinas, 1982, 37–44).

Through his reflection in his work on the absolute alterity of the other and on the ethical relationship as an infinite, irrecusable responsibility, Levinas proposes a radical rethinking of the central categories of ethical life—self, other, subjectivity, autonomy, rationality, freedom, will, obligation—and the very meaning of the ethical.

For Levinas, ethics is not merely one branch of philosophy among others, secondary to the question of ontology, epistemology, or theory of knowledge. It is not a superstructure grafted onto an antecedent relationship of cognition. Rather, he maintains, ethics is 'first philosophy'. As he himself makes clear, the aim of his work is not to construct an ethics, or a morality, in the sense of a system of rationally justified precepts or norms capable of guiding human action and behaviour; rather, his work opens the question of the ethical as the 'extreme exposure and sensibility of one subjectivity to another'.

It is a question here of how the other concerns me, or makes a claim on me—not in the sense of a demand whose legitimacy I could recognize or refuse, but an exigency which takes the form of a radical patience, an extreme vulnerability and exposure to the other to the point of expiation. This offering of oneself is not a role that is assumed, but is a goodness that occurs despite oneself. The biblical 'Here I am, answering for everything and for everyone' (Levinas, 1981, 114), which is offered as a responsibility for the other prior to commitment, does not involve the reduction of subjectivity to consciousness. Instead, it is *subjectum*, subjectivity as substitution and expiation for the other. The philosophical language of Levinas enacts a discourse in terms of 'otherwise than being' that frees the subjectivity from the ontic or ontological programme. The individual is not just *Dasein*, he is also the site of Transcendence, responding to the unfulfillable obligation towards the Other: *being-for-itself* is conditional to the unconditioned responsibility of *being-for-the-other*.

This moral combat, based on peace for the other, is an indication of the radical challenge to thought posed by the philosophy of Levinas. In our age, Levinas shows that to be or not to be is not the ultimate question: it is but a commentary on the better than being, the infinite demand of the ethical relation.

To sum up, Levinas endeavours to conceptualize the preconscious experienced responsibility for the other, that is the fundamental ethical layer of the responsible self (Benaroyo, 2016). A responsibility that is a radical heteronomy—though not a principle of heteronomy—but an inescapable preconscious subjection to the other. This condition is, for Levinas, first of all reflected in the human sense of corporeity that is vulnerability. The incarnated subject, experienced as vulnerability—rather than as a detached game of consciousness—is for Levinas the place of the call for the other, a call before any choice, before the birth of liberty. Embodiment as vulnerability is the cornerstone of Levinas moral approach: the body—might it be healthy or ill—experienced as vulnerability, is the locus of my exposure to the others—of a call for responsibility (Levinas, 1981). Again, not a responsibility assumed by conscious decision, but an inescapable call, not a free choice, but the ethical condition of my own self.

For Levinas, this responsibility is unveiled by the other's 'face' (Levinas, 1982, 85–92). The face of the other reminds us that the ethical meaning of an encounter is not totally encompassed within the limits of consciousness or with social superstructures of a world of moral strangers.

Now, what do Levinas' fundaments of an ethics of response mean in the realm of clinical activity? As I explored thoroughly elsewhere (Benaroyo, 2022), it means that the healer's first order responsibility consists in patiently receiving the 'visitation' of his

patient, without too hastily closing the encounter of a specific technical kind. In other words, it means that the physician's first ethical task is to recognize the extraordinary 'otherness' of the ill person who is in front of him/her, that is revealed by the ill person's vulnerable face, and that constitutes an ethical call for help and care.

To better grasp the depth of Levinas' insight, let us now look at what the expression 'vulnerable face' means in this context.

In Levinas' thought, vulnerability does not mean frailty, dependency, or loss of social autonomy. Vulnerability, that is increased in suffering, is intimately tied to 'sensibility'. In turn, sensibility does not mean reception of information or knowledge. Rather, as Robert Gibbs points out (Gibbs, 2000), sensibility is an opening to others, a nearness, the one-for-the-other, precisely being vulnerable means being in a state of 'sensibility' to others.

Thus, for Levinas, the other's vulnerability, particularly in the case of illness, is the very incarnated locus of ethics, eliciting one's own vulnerability as a healer and therefore responsibility-for-the-other human being:

> the content of suffering merges with the impossibility of detaching oneself from suffering. (…) In suffering, there is an absence of refuge. It is the fact of being directly exposed to being. It is made of the impossibility of fleeing or retreating (…). Is not the evil of suffering – extreme passivity, helplessness, abandonment and solitude – also the unassumable, whence the possibility of a half opening, and, more precisely, the half opening that a moan, a cry, a groan or a sigh slips through – the original call for aid, for curative help, help from the other me whose alterity, whose exteriority promises salvation? Original opening toward merciful care, the point at which (…) the anthropological category of the medical, a category that is primordial, irreducible and ethical, imposes itself. For pure suffering, which is intrinsically senseless and condemned to itself with no way out, a beyond appears in the form of the interhuman.
>
> (Levinas, 1985; Levinas, 1998, 93–94)

What does this way of conceiving responsibility-for-the-other mean in the realm of clinical medicine?

In clinical medicine, the unfolding of the responsibility-for-the-other entails being aware of the radical otherness of the other as well as being at the same time aware of the common vulnerability that links healer and patient, namely to the inescapable responsibility one owes to the other, more particularly for the healer, to the responsibility to care for the other in his radical otherness.

As Levinas points out, this responsible posture requires a personal availability ('disponibilité' in Gabriel Marcel's vocabulary) to be open to welcome the otherness of the other. In Levinas' thought, 'availability' is the correlative central issue to ethical responsibility-for-the-other, it is the support on which rests the unfolding of this responsibility. Availability means the ability of the self to assume a place for the other in oneself: namely open a space for otherness in oneself. Ethics *as* hospitality in Jacques Derrida's words (Derrida, 1999), is, I think, the most appropriate way to qualify the ethical core of clinical care in the wake of Levinas conception of responsibility.

In the clinical realm, this means that the health-care giver should be able to listen to the otherness *first in himself* before opening himself to the radical otherness of the patient. This understanding of *hospitality* paves the way for setting up a trustful caring environment. In this environment the healer's welcoming of the other can be perceived by the patient as a sign of common and shared meaning—of ethical community—that is not a response but a question, a question always open.

That's why I consider the Levinasian understanding of common humanity as the inescapable condition of elaborating a pact of care based on trust. This pact may be conceived, in this view, as a second-order ethical dimension of the clinical activity. This dimension rests on a preconscious Levinasian order of ethical awareness necessarily coupled to an effort the healer needs to face in order to reach availability and to pave the way to the human breadth of *responsibility-for-the-suffering-other*. In this view, the face of the suffering other always inescapably lends itself to a welcome.

And to go a step further, we could argue with Derrida:

> [The health care giver] must first think the possibility of the welcome in order to think the face and everything that opens up or is displayed with it: ethics, metaphysics or first philosophy, in the sense that Levinas gives to these words. The welcome determines the receiving, the receptivity of receiving as the ethical relation.
>
> (Derrida, 1999, 25–26)

In other words, ethical discourse starts with the interruption of the self by the self, so that 'I' become a responsible or ethical 'I' to the extent that I agree to dethrone my self—to abdicate my position of centrality—in favour of the vulnerable other (Levinas, 1969, 36–37; Levinas, 1981, 112–113).

In this sense, one might call this moral stance, ethics *as* hospitality. In the light of Levinas' thought, it appears then that the practice of care relies on the health professionals' awareness of the importance of building first and foremost—in an atmosphere of trust and hospitality—a project of care's 'emplotment' which enables the sick person to become (once more) the actor in the recovery of his narrative identity that has been altered by illness. In this view Levinas' approach may help us indeed to face the *paradox* that lies at the ground of the unfolding of ethical responsibility.

Towards an Ethics of Responsibility in Healthcare: The Very Significance of Levinas' Approach

It is by perceiving the Other not as an object, as in scientific perception, but by perceiving him or her perceiving, that we approach him or her as an alter ego. Here, Levinas seems to help us to rethink ethics as rooted in the primary world of perception. For Levinas,

ethics is not a system of normative rules and orders; ethics originally is founded in the preconceptual stratum of an open perception of the Other's face. For medical ethics it becomes thus important to regain access to this primary, ethical vision of the patient's face, often buried under the scrutinizing examination of this patient as a medical object. Such an authentic ethical and aesthetical perception of the Other is attained, as Levinas indicates, when I am face-to-face with the patient, looking at him but yet not realizing the colour of his eyes (Levinas, 1982, 85).

Hence, a Levinassian reading of the clinical relationship reveals the dimension of the primary moral commitment at the heart of concern for others on which any clinical relationship must be based. The latter calls on health-care professionals to perceive ethical responsibility as focusing on the 'visitation' of the patient, rather than on reducing the singular conversation (which leads from diagnosis to treatment and prognosis) to its technical aspects. In other words, this means that health-care professionals' ethical awakening involves accepting their patients' profound otherness, which is expressed through their face and their associated vulnerability—vulnerability seen, as already said, not so much as a loss of autonomy that is to be dealt with as far as possible by medicine in conformity with the model of usual medical expertise, but rather as an appeal, an ethical injunction to take care of this particular patient by opening up a space in which he/she may experience a possible future.

This approach to care allows room for the unknowable at the heart of the patient's experience of existence, which it is important to preserve—especially as the medical-technology approach tends to try to control it. The carer's attention to the preservation of this unknowable aspect, encouraged by a shift of focus from medical rationality alone, opens prospects of recognition and trust for the patient, comforting him with the idea that he owns his suffering. It is here that the thinking of Emmanuel Levinas, a source of shared humanity, seems to me able to nourish such reflection on the healer's ethical responsibility.

This conception of responsibility calls for an ability on the part of the healer to welcome the patient, to show hospitality, which, through its openness to the patient's radical otherness, is one of the ways of shifting focus that he needs to express his/her own vulnerability as a healer. It is in this dialogue between two vulnerabilities that trust can start to grow and be deployed in a manner of caring that can respond in a responsible way to the core of suffering as perceived by the patient.

In the context of the challenge a humanistic approach to medicine should face today to tackle head-on the paradoxes inherent in clinical practice, Levinas' and Ricoeur's thoughts might help us by means of an attentive, listening, and welcoming ethics hinging on the necessary complementarity of both sides of the Janus face: I would suggest that both sides may take—one intermingled with the other—the following ethical steps blazing the trail for practical wisdom (Benaroyo, 2022, 31):

- First, an ethical awakening to the vulnerability of the suffering other in his radical otherness—ethics *as* hospitality and love drawing upon Levinas' thought.

- Second, elaborating, on the basis of the first step, a pact of care based on trust—ethics *as* justice and care drawing upon Ricoeur's thought.
- Third, performing the technical step leading to healing and curing—ethics *as* social norms regulating applied science drawing upon Ricoeur's thought.
- Fourth, reaching to completion the prudential judgement drawing on practical wisdom that chooses and decides what is the right individualized treatment in this case—ethics *as* practical wisdom drawing upon Ricoeur's and Levinas' thoughts.

Epilogue and Perspectives

Thus, attention to the different moments in the clinical action that I highlighted appears to mark the path of an ethics of responsibility—drawing its basic source from an ethics of hospitality and responsiveness—which revitalizes the links between ethics and medicine (Benaroyo, 2021). The figures of care which mark out these different moments thus become living metaphors attesting to the intimate ties between ethics and medicine.

I would suggest that these different steps are articulated—each at his own epistemological, anthropological, ethical and linguistic level—to build together a practical judgement in clinical medicine; they constitute the pillars of a philosophy of medicine grounded in medical practice offering the resources needed to construct an ethics of responsible care echoing the ethical and aesthetical requirements proper to clinical medicine. The ethical professional gaze enlightening this philosophy looks at clinics and ethics as the two sides of the same coin.

The challenge to medicine today is therefore to tackle head-on the paradoxes inherent in the practice of medicine by means of an attentive listening and welcoming ethics backed by a medical aesthetics, that will reveal the various interpretative registers of care.

It is by patiently rising to this challenge in the context of a philosophy of care that clinical practice can, in my view, be perfected.

Note

1. Part of this chapter is translated and adapted from "L'éthique et les paradoxes du soin". In Jean-Philippe Pierron, Didier Vinot and Elisa Chelle (Eds.) (2018), *Les valeurs du soin. Enjeux éthiques, économiques et politiques* (pp. 175–186). Paris: Seli Arslan. Reproduced with permission.

References

Benaroyo, L. (2011). Implementing medical wisdom. The significance of healing narratives for clinical practice. In A. Neschke & H. R. Sepp (Eds.), *Sprache und Wissenserwerb. Ein*

interdisziplinärer und interkultureller Zugang. Language and Acquisition of Knowledge (pp. 233–244). Verlag Traugott Bautz GmbH.

Benaroyo, L. (2016). Le visage au-delà de l'apparence. Levinas et l'autre rive de l'éthique. *Lo Sguardo 20*(1), 217–223.

Benaroyo, L. (2018). L'éthique et les paradoxes du soin. In J.-P. Pierron, D. Vinot, & E. Chelle (Eds.), *Les valeurs du soin. Enjeux éthiques, économiques et politiques* (pp. 175–186). Seli Arslan.

Benaroyo, L. (2021). *Soin et bioéthique. Réinventer la clinique*. Presses Universitaires de France.

Benaroyo, L. (2022). The significance of Emmanuel Levinas' ethics of responsibility for medical judgment. *Medicine, Health Care and Philosophy 25*, 327–332.

Brody, H. (2003). *Stories of Sickness*, second edition. Oxford University Press.

Cabot, R. C. (1926). *Adventures on the Borderlands of Ethics*. Harper and Brothers.

Canguilhem, G. ((1983) [1978]). Puissance et limites de la rationalité en médecine. In G. Canguilhem. *Etudes d'histoire et de philosophie des sciences* (pp. 392–411). Vrin.

Canguilhem, G. (1988). Le Statut épistémologique de la médecine. *History and Philosophy of the Life Sciences 10*, 15–29.

Canguilhem, G. (1989) [1966]. *The Normal and the Pathological*, translated by C. R. Fawcett. Zone Books.

Derrida, J. (1999). *Adieu to Emmanuel Levinas*. Stanford University Press.

Foucault, M. ((1963) [1978 fourth edition]). *Naissance de la clinique*. Presses Universitaires de France.

Gibbs, R. (2000). *Why Ethics? Signs of Responsibilities*. Princeton University Press.

ten Have, H. (1994). The anthropological tradition in the philosophy of medicine. *Theoretical Medicine 16*, 3–14.

Hick, C. (1999). The art of perception: From the life world to medical gaze and back again. *Medicine, Health Care and Philosophy 2*, 129–140.

Lawrence, Ch., & Weisz, G. (1998). *Greater than the Parts. Holism in Biomedicine 1920–1950*. Oxford University Press.

Lefève, C. (2014). De la philosophie de la médecine de Georges Canguilhem à la philosophie du soin médical. *Revue de Métaphysique et de Morale 82*(2), 197–221.

Levinas, E. (1969) [1961]. *Totality and Infinity: an Essay on Exteriority*. Translated by A. Lingis. Duquesne University Press.

Levinas, E. (1981) [1974]. *Otherwise than Being or Beyond essence*. Translated by A. Lingis. Martinus Nijhoff.

Levinas E. (1985) [1982]. *Ethics and Infinity: Conversations with Philippe Nemo*. Translated by R. Cohen. Duquesne University Press.

Levinas, E. (1985) [1947]. Suffering and death. In E. Levinas. *Time and the Other*. Translated by R. Cohen. Duquesne University Press.

Levinas, E. (1998) [1991]. Useless suffering. In E. Levinas. *Entre Nous: On Thinking-of-the-Other* (pp. 91–101). Translated by M. B. Smith and B. Harshav. Columbia University Press.

Levinson, J. (2003). Philosophical aesthetics: An overview. In J. Levinson (Ed.), *Oxford Handbook of Aesthetics* (pp. 3–24). Oxford University Press.

Mattingly, Ch. (1994). The concept of therapeutic « emplotment ». *Social Science and Medicine 38*, 811–822.

Merleau-Ponty, M. (1968) [1964]. *The Visible and the Invisible*. Translated by A. Lingis. Northwestern University Press.

Peabody, F. (1927). The care of the patient. *Journal of the American Medical Association 88*(12), 877–882.

Pellegrino, E. D. (1979). Toward a reconstruction of medical morality: The primacy of the act of profession and the fact of illness. *Journal of Medicine and Philosophy 4*, 32–56.

Pellegrino, E. D., & Thomasma, D. C. (1981). *A Philosophical Basis of Medical Practice. Toward a Philosophy and Ethic of the Healing Professions.* Oxford University Press.

Ricoeur, P. (2000). Prudential judgment, deontological judgment and reflexive judgment in medical ethics. In P. Kemp, J. Rendtorff, & N. Mattsson Johansen, (Eds.), *Bioethics and Biolaw. Judgement of life*, volume 1 (pp. 15–26). Rhodos International Science and Art Publishers.

Schwartz, M. A., & Wiggins, O. (1985). Science, humanism, and the nature of medical practice: A phenomenological view. *Perspectives in Biology and Medicine 28*(3), 331–361.

Schwartz, M. A., & Wiggins, O. (1988). Scientific and humanistic medicine: A theory of clinical methods. In K. L. White (Ed.), *The Task of Medicine: Dialogue at Wickenburg* (pp. 137–171). The Henry J. Kaiser Foundation.

Temkin, O. (1977). *The Double Face of Janus and Other Essays in the History of Medicine.* Johns Hopkins University Press.

Van Tongeren, P. J. M. (1994). Moral philosophy as a hermeneutics of moral experience. *International Philosophical Quarterly 34*(2), 199–214.

CHAPTER 22

PHILOSOPHICAL AESTHETICS IN PSYCHIATRIC PRACTICE AND EDUCATION

MICHAEL LANEY AND JOHN Z. SADLER

Introduction

A central goal of psychiatric diagnosis is to come to an understanding of the patient that helps make sense of their ordeal in a way that alleviates that ordeal. While the philosophy of psychiatry has clarified the importance of epistemic and moral dimensions of the diagnostic process (Sadler, 2005; Kendler & Parnas, 2017), aesthetic concerns have been less appreciated and certainly less discussed. For this paper we suggest that form and beauty play a crucial role, alongside truth and goodness, in the clinical encounter. Further, we argue that the form and beauty of the psychiatric diagnostic process is worthy of cultivation in our interactions with and understandings of our patients and in clinical practice and education. Indeed, concepts and frameworks derived from philosophical aesthetics are a rich resource for illuminating what makes for good diagnostic and therapeutic practice.

Psychiatric interactions are multifaceted affairs and touch upon nearly the full range of human values, concerns, and abilities. We, as clinicians, sit down with people who ask for our help. From the start, the clinical encounter makes complex moral, epistemic, and practical demands upon clinicians. For instance, a man complains of debilitating malaise and describes feelings of anger and confusion about others' confidence to move about the world and pursue their seemingly unfettered interests. We sometimes hear him make disparaging comments about those in his world—his mother, his mentor, his colleagues—but at other times he can speak quite tenderly about those same people. He questions how long he can bear his internal turmoil and these states of affairs. We feel compelled to provide this man with hope, to understand what makes his life difficult or unbearable, to help him see where things have gone wrong and how they might go right.

We, the authors, want to add to these demands—moral, epistemic, and practical—the claim that psychiatric diagnosis and treatment also have aesthetic facets, and cultivating these can augment the moral, epistemic, and practical aims of clinical work.

Elsewhere (Laney & Sadler, 2021), we have written about the demands that psychiatric practice makes upon our characters, emphasizing Aristotelian virtues and vices as useful, even necessary lenses through which to refine our work as psychiatrists, therapists, and as educators of clinical trainees. This emphasis has primarily been on matters moral and epistemic, doing the clinically right thing in the former and making use of credible knowledge in the latter. We will show that virtues operate in an even-larger scope of human endeavours, here being the aesthetic realm. Our first task is to discuss just what is meant, or what we mean, by the term 'aesthetic' in reference to clinical care and clinical education. Then, we introduce some aesthetic concepts that point to a more fruitful understanding of aesthetic virtue and its cultivation in clinical practice. Overall, our discussion here is at most exploratory, with much work to do in the future regarding aesthetics in psychiatric practice and education.

The Aesthetic and Psychiatric Practice

Our discussion of psychiatric aesthetics moves from the more familiar domain of the arts proper, into the clinical and back again; making the connections as we go. To begin, the concept of the aesthetic has been elusive to define. Philosophical aesthetics ranges from questioning the existence of experiences and judgements that are distinctly aesthetic, to distinguishing the aesthetic from moral, epistemic, practical, or personal interests. Modern philosophical aesthetics has no clear starting point but can be said to have begun in its most recognizable form in the early eighteenth century with the works of Shaftesbury, Wolff, Addison, Crousaz, and Du Bos, who began addressing the major questions that continue to define the field today (Kristeller, 1951; Guyer, 2014). These discussions explore what constitutes the aesthetic—whether best considered a distinctive form of knowledge, a particular emotional experience, or a uniquely free and playful exercise of the imagination and understanding. In a practical sense, aesthetics relates to human practices—whether painting, sculpting, dancing, or diagnosing. This praxis of aesthetics relates to both the performance of the creator and the creative product itself, an interaction which will inform our analysis to follow. For the purposes of this paper, aesthetics comes into play when we apprehend the form or beauty of something—a landscape, a sculpture, a story, a human interaction. Like other kinds of values, aesthetic values may be positive or negative—attractive and absorbing as well as repulsive and disquieting—but whichever pole the aesthetic value falls upon, we are still in a distinctive mode of experience, apart from the purely moral, epistemic, or pragmatic.

The aesthetic praxis in clinical work is dependent upon the experienced object and the experiencing subject—a person. Certain artefacts, by nature of their content or manner of presentation, demand to be experienced aesthetically, but even in the case of films, paintings, ballets, and other objects with clear aesthetic intention, we must render ourselves open to an aesthetic mode of experiencing the world, an aesthetic 'mode of being'. A classic example of how our frame of mind influences our mode of experiencing is Marcel Duchamp's 1917 readymade sculpture entitled *Fountain*, which consists of a conventional porcelain urinal signed 'R. Mutt' and submitted to the inaugural exhibition of the newly formed Society of Independent Artists (Parkinson, 2008). Normally, of course, urinals only serve the most basic of human needs, but through presenting a urinal as something to be regarded aesthetically, our way of experience shifts, and we are moved by a such a 'found object' to consider the nature and status of art, how the setting of an artefact shapes its meaning, how a urinal could be beautiful rather than just functional, the craft of visual puns, and even what constitutes the identity of an artist. The process of rendering ourselves open to aesthetic experience can be applied to psychiatric interactions as well. Stepping into the aesthetic mode of being is the moment when the aesthetic praxis begins in clinical work, and we look at clinical work as beautiful, mediocre, or foul, rather than just effective, mediocre, or inept.

Sadler (2005) has described two meanings of 'diagnosis' as typically practised by clinicians. The first meaning of diagnosis is the characterization of a morbid condition, typically in standard nosological language, such as the mental disorders described in the American DSM diagnostic manuals and the ICD classification of mental and behavioural disorders (American Psychiatric Association, 2013; World Health Organization, 1992). The second meaning of diagnosis according to Sadler is the more global grasp of 'what is going on' with a patient, incorporating a more narrative understanding of patients' ordeals, such as their socioeconomic status and cultural context, their historical development in illness and health, and their self-understanding of the situation. This more holistic notion of diagnosis, however, omits an appreciation of the value and impact of aesthetic perceptions of both the patient as well as the aesthetic aspects of well-executed clinical skills exhibited by clinicians. We aim to describe how an appreciation of diagnostic aesthetics, understood this way, can enhance the clinician's enjoyment of clinical work, cultivate a more empathic, and possibly more clinically effective treatment relationship, and enhance the recognition and training of excellent clinical skills in young psychiatrists.

Among the more influential attempts to describe the kind of thinking involved in aesthetic experience was that made by Immanuel Kant toward the end of the eighteenth century (Kant, 2000). Kant is concerned with how our minds represent and make sense of the things presented to it. In one way of making sense of experience, our aim is to categorize them such that we derive discrete units of our experience. We do this by subsuming our experience under ready concepts, such as when we are viewing one of Monet's paintings of his Giverny gardens, noting the brushstrokes, compositional style, and subject matter and classifying them as an example of French Impressionism. In the clinical realm, we might encounter a patient lamenting his lack of meaningful

academic success in a way that seems inaccurate and overblown given his known academic accomplishments. Clinicians in turn classify this lament as a feeling of worthlessness and a symptom of a major depressive episode given other signs and symptoms consistent with that diagnosis.

In another way of making sense of clinical experience, we resist or set aside this kind of categorization and instead immerse ourselves in the experience of the painting or the patient. We are struck by the variation of colours and brushstrokes, how bits of red on the waterlilies lure our eyes over the canvas, and wonder just why we are drawn to the patch of blue water between the waterlilies and the reflection of trees in the pond. When clinicians engage in an aesthetic praxis, they wish to engage the patient's expressions into a kind of dance, where the clinician facilitates and conjointly builds a multiplicity of queries with the patient. Such a multiplicity of queries and dialogue (Stanghellini, 2016) then permits an imaginative blooming of possibilities of interpretation, enriching both clinician and patients with possibilities for healing and change. The richer the dance of aesthetic praxis, the richer the blooming of possibilities of meaning, opportunity, and indeed, pleasure. In both cases, the aesthetic praxis may provoke an exhilaration that sustains us through resisting closure about 'what is going on' in the painting or with the patient. This imaginative play of the aesthetic mode of sense-making also leads us to vividly appreciate how the parts of each experience work together to make up the whole, the unity in the varieties of experience.

In considering diagnosis as characterization (as in the DSM or ICD), it becomes a component, and perhaps not a particularly crucial one, to the conjoint project of the clinician and patient figuring out 'what is going on'. In the former, the potentially foreclosing, pre-structured, and often presupposed concepts and rubrics could include symptom-based diagnostic interviewing (First et al., 2016) but also the 'automatic thoughts', 'schemas', and 'distortions' in cognitive behavioural therapy, or the 'splitting', 'selfobjects', and 'compromise formations' in various psychoanalytic theories. Interviewing a patient with these theoretical concepts taken-for-granted can lead us to fit the doctor–patient dialogue into our preconceived notions. Concepts do play a role in aesthetic experience, however. What we can notice, imagine, understand, or appreciate about what is going on will be limited by our own, as well as our patient's, horizons and experiences, and for this reason much of our aesthetic experience will depend upon the concepts and vocabulary available to us. However, just as characterizing a Monet Giverny painting as 'French Impressionist' provides a starting point and contributes to practical utilities (fitting into a thematic exhibition, calling attention to similar artists' styles, etc.), starting points are not themselves particularly aesthetically pleasing. Similarly, a theory-laden characterization of 'major depression' or 'punitive superego' or 'maladaptive schema' as starting-points are not particularly aesthetically pleasing either. What is aesthetically pleasing for clinician and patient is the imaginative play and the joy of discovery, like the surprise at the melodic reworkings within a jazz musician's improvisation.

In aesthetic experience, though, imaginative free play not only resists closure but also stands to enrich our conceptual store with the multiplicity of connections thereby

perceived. We may acquire a more profound, vivid, and varied sense of what it means to 'split' or to have our experience distorted by 'schemas' or arrive at elegant, novel concepts that allow us to better appreciate what we are hearing from a patient. Aesthetic imagination opens up viewpoints that are rewarding for both art appreciation and clinical understanding, while offering to both new understandings heretofore overlooked.

This description of aesthetic experience as involving resisted closure while focusing on the particularity of the thing as experienced bears some resemblance to Husserl's phenomenological attitude of suspending preconceptions and theories in understanding phenomena (Husserl, 2012). This is not entirely coincidental, considering Kant was a major influence on Husserl's emphasis on going 'back to the things themselves.' Husserl conceived of the phenomenological method as an epistemic project, one where we 'bracket' off our potentially distorting preconceptions about an object or phenomenon we experience. This bracketing permits imaginative variations on the phenomenon; facilitating recognition of what features are essential, necessary to the object itself—constituting Husserl's method of 'free phantasy variation' (Zaner, 1973). Husserl himself had something to say about aesthetic experience that helps us to distinguish it from these aims of the phenomenological method. According to Husserl, the aim of aesthetic experience is not to arrive at a knowledge of essential features of the world but to imaginatively 'live-in' or empathically immerse ourselves in an experience to be able to see 'the ways in which the parts of an aesthetic whole reciprocally exert [their effects]' (Husserl, 2005; see also Crowther, 2021). This 'living-in' is undertaken in order to produce interpretations adequate to the moods, attitudes, and features of the object responsible for our experience. This is true not just of interpretations in a psychoanalytic or obscurely hermeneutical sense but in answering the fundamental diagnostic question of 'what is going on.'

Aesthetic experience in this way is not supererogatory but operates even in our would-be objective, atomistic attempts at classifying psychiatric disturbance. Consider as one example the patient who seems to meet criteria for narcissistic personality disorder, who is described (American Psychiatric Association, 2013, 670–671) as 'appearing boastful and pretentious' and 'fish[ing] for compliments.' Clearly, certain aspects of this and other personality disorders have a moral dimension, as when the people diagnosed with them are exploitative, selfish, or lacking in empathy. However, other aspects involve only aesthetic—not moral—harm. We cringe at their fishing for compliments and find their boastful pretensions repellent—literally dis-taste-ful. These seem to be primarily aesthetic, not moral or epistemic, perceptions that emerge from our experience of the patient and the way they present themselves, and these aesthetic perceptions in our case are experiences that provide evidence for the narcissistic individual's need for admiration or grandiose fantasies leading to the DSM diagnosis. In histrionic personality disorder, too, we depend in part on perceiving someone as presenting themselves in both a 'theatrical' and 'shallow' manner (American Psychiatric Association, 2013, 667). These are, again, aesthetic perceptions we have of the patient; 'bad acting' in that emotions are overblown and insufficiently felt by even the most empathic viewer. In borderline personality disorder (American Psychiatric Association, 2013, 663), we are

listening for 'feelings of emptiness,' less an emotion than an aesthetic perception that the patient in this case has of the world as they experience it, often linked with boredom—linked in the diagnostic criteria as well! Lest we think that aesthetic perception is limited to descriptions of personality disorder, in major depression, a patient's mood may be inferred from perceiving them as 'brooding' (American Psychiatric Association, 2013, 164). During manic episodes, the 'forcefulness' (American Psychiatric Association, 2013, 123) of a patient's speech is often more diagnostically important than what is actually being said. A cursory review of the diagnostic and associated features listed in the DSM-5 reveals aesthetic terms like these scattered throughout. We suggest that for every patient encounter, a distinct aesthetic perception can be recognized with that patient or encounter that has diagnostic and therapeutic implications. In the next section, we turn our focus specifically to aesthetic perception, more fully explaining what is meant by that term and exploring its role in psychiatric practice and education.

Aesthetic Perception in Psychiatric Education

We have suggested that there is something essential, inescapable even, about aesthetic experience and perception in psychiatric practice. We initially got interested in aesthetics in psychiatric education when we started paying more attention to the terms of praise describing clinical interviews performed by senior, respected clinicians in case conferences. As educators, we are interested in improving clinicians' epistemic and moral skills through teaching them reliable methods of collecting clinical information and instructing them in moral codes and standards of the profession. For this chapter, we consider how we might improve both our and our trainees' aesthetic perception and aesthetic skills as we conduct interviews and formulate diagnoses. Improving aesthetic perception has a two-way payoff. For the educator, witnessing beautiful, or awful, clinical assessments and other patient interactions raises the aesthetic question about what makes these practice-events beautiful or awful—and even, just average. To recognize aesthetic content of clinical practices offers the opportunity to describe, refine, and even measure 'beautiful' or elegant clinical practice. For the trainee, cultivating aesthetic perception may well enhance the joy of practice while immersed in the labour of learning good practice. Cultivating aesthetic perception also enables the trainee to look more closely at her own experiences of elegant or awful practice, to become practised in the art of aesthetic reflection and description. These practised aesthetic experiences in turn structure how the trainee thinks about the ingredients of good clinical work. To our view, attention to aesthetic perception and skill is an important part of psychiatric education. In observing students and residents conducting psychiatric interviews, we find that much of the feedback we give is focused on noticing just how a patient was describing their experience and how the trainee's style of comments and questions

opened up or closed off a richer understanding of that experience. Similarly, when hearing trainee's patient presentations, many of our questions and comments are aimed at filling in narratives or diagnostic formulations. On reflection, this is generally driven by the negative aesthetic perceptions of the interview as being dull, fragmented, superficial, or naïve, making the diagnostic formulation overly simplistic. Instead, we may note the positive aesthetic perception of a particularly evocative interview or presentation, an artful arrangement of factual circumstances, or descriptive turns of phrase that recapture a seemingly ambiguous moment.

Consider that in responding aesthetically to a beautifully conducted psychiatric interview, often we don't first think to ourselves, 'all of the information was queried efficiently and precisely' or 'a diagnosis of major depression was clearly obtained' or even 'the interviewer displayed care and concern.' Rather, we are struck by the liveliness or depth of the interview, the evocative linking of parallel narratives as the story unfolds, the unfolding of an intriguing mystery posed by the patient's experiences, or even by a more general sense of beauty as we are drawn into the events of the clinical dance—the easy back-and-forth between clinician and patient, the awakening and processing of emotions, the surprising revelation(s), the opening of new possibilities. In short, we are taken up and transported by the clinical event. Importantly, while these aesthetic responses will certainly depend on precision, efficiency, clarity, and care—epistemic, moral, and pragmatic terms for the most part—the judgement itself is a uniquely and immediately aesthetic one.

However, if we are to learn to conduct or appreciate psychiatric practice aesthetically, we should not simply tell ourselves or others to be more elegant or sublime. Ideally, there would be general aesthetic principles such that we could be quite concrete and technical about just what we should say, how we should say it, and when we should say it. Unfortunately, not only would this be formulaic and therefore likely aesthetically banal, but as Frank Sibley (1959, 1965) argued, no necessary logical relationship exists between non-aesthetic and aesthetic features of an object. That is, we cannot say that a work with a certain non-aesthetic feature or collection of non-aesthetic features (line, colour, composition, etc.) will entail that the work will have certain aesthetic features (liveliness, depth, beauty, etc.). In this way, aesthetic perception is more akin to 'taste', an immediate 'given' that is not deliberative, reason-based, or inferred.

Sibley argues that what contributes to aesthetic value is particular to the work considered (Sibley, 1959), and that the same features in another work may very well provoke a different aesthetic response. In making this argument, however, he makes an important distinction between aesthetic judgements and aesthetic verdicts. An aesthetic verdict is our determination about whether this or that object is in the end aesthetically good, while aesthetic judgements are exemplified by conceptually thicker terms with both evaluative and descriptive components, like balanced, witty, sentimental, trite, and so on. As mentioned above, Sibley is clear that there is no possibility of us determining from non-aesthetic features the aesthetic features of a work, but argues aesthetic judgements result in what he calls 'merit terms', referring to the work as moving, unified, balanced, and fresh, for example. These and other terms we have used earlier have *prima*

facie aesthetic meaning and do contribute to global aesthetic verdicts even if they are not absolute. Leading up to some of our later comments, what Sibley calls merit terms we would simply refer to as positive aesthetic values, noting that negative aesthetic values are possible too. In the latter case, we might notice a trainee's *maladroit* presentation, his *stilted* interview style, or her *hurried* questioning. Indeed, even the descriptive naming of a clinical interview can convey aesthetic merit or lack thereof: consider a trainee's *interrogation* of a patient.

As mentioned above, aesthetic perception is a matter of 'taste', an emergently aesthetic feature that is perceived with immediacy despite being dependent on non-aesthetic features of the phenomenon. Thus, we use taste not in the sense of things being a 'matter of taste', personal preference or liking—but rather in Sibley's sense (1959, 423) of an ability to *notice* things, to *discern* certain features. Importantly, while there may not be rulebook that allows us to derive aesthetic from non-aesthetic features, that does not mean aesthetic perception is not educable. On the contrary, Sibley argues that cultivating taste, our ability to notice or perceive aesthetically relevant features, is the vital activity of the critic, who has 'the task of bringing people to see things for what, aesthetically, they are, as well as why they are… [and] is successful if his audience began by not seeing, and ends by seeing for itself, the aesthetic character of the object.' (1965, 141) Critics succeed when they draw our attention to some overlooked non-aesthetic feature or have us see that feature in relation to other features of the aesthetic object in question, the result being that we now perceive the emergent aesthetic quality dependent on the interaction of non-aesthetic properties. Cultivating aesthetic perception is about learning to see the object from a particular standpoint, seeing it from a certain perspective, comparing it to other examples of the genre, acquainting us with concepts and language necessary to perceive what is being done, and so on. The critic facilitates the blooming of the phenomenon, whether artefact or patient encounter, through these processes of describing possibility and surprise.

As supervisors of psychiatric trainees, we may rightly see ourselves as 'critics' in the pedagogical, positive way just described. When a trainee's stilted interview has dulled our attention, we might wonder just what about this exchange has provoked our minds to wander (and in the process, re-awakened our attention). Perhaps a patient's vague, formulaic, or malapropos responses have contributed, or it may be the trainee's listless, incurious, or diffuse interview style. Here is where imaginative play enters in. We then may play with the idea—'What if they had said this here or not said that? How might the interview have unfolded? How would my aesthetic response have been different? What was lacking or different in perception or understanding, that led the interview in this direction rather than another that would perhaps have been richer?' Experienced psychiatric educators will recognize these kinds of post-interview queries as the very stuff of interview education. The senior clinician may conduct an interview immediately afterward, covering much of the same ground, but in a more aesthetically perceptive way and then ask them to compare the results—'How different did it feel observing this interview? What was different and why did that make us feel differently, have us think about this case differently? Was there something about the case material evoked from

this alternative approach that compelled your interest?' Through the habitual attention to aesthetic qualities and the non-aesthetic features from which they emerge, we—and our trainees—become increasingly more discriminating in our ability both to perceive and produce aesthetically valuable psychiatric interactions and diagnostic formulations. Aesthetic perception and production in this way depend upon the refinement of skills particular to psychiatric practice, in recognizing aesthetic values in action.

Taken further, aesthetic values may describe habits of seeing and doing that may be properly considered virtues—aesthetic virtues in this case—analogous to moral and epistemic virtues in the Aristotelian tradition of character ethics.

Aesthetic Virtue in Psychiatric Practice and Education

The applicability of virtue to aesthetic matters may not be obvious. In the tradition of virtue ethics, the focus of ethical evaluation is not so much on the action or its outcome but on the character of the person acting, whether excellent or vicious (Anscombe, 1958). Virtues can be considered deep and abiding dispositions, or habits of character, to do the right things for right reasons arising from both cognitive (beliefs, judgements) and non-cognitive (motivations, feelings) attitudes. Actions are morally worthy in the fullest sense when they result from the virtues of the person performing them. Representative moral virtues include benevolence, fairness, and fortitude. As an illustration, consider two therapists who fill up their schedules to see as many patients as possible, one so that they may help as many people as possible, the other so that he may be remunerated as much as possible. Even assuming both perform equally well in terms of providing relief, we would be inclined to see the former as morally praiseworthy for their benevolence and the latter less so because of self-interest.

The virtue approach has also been applied to matters of epistemological evaluation. In virtue epistemology, the beliefs we hold are evaluated with respect to how they came about, specifically whether these beliefs are the results of reliable and credible habits of inquiry for which we are responsible and that reflect our intellectual character (Sosa, 2010; Zagzebski, 1996). Knowledge in its fullest sense consists of true beliefs that are the direct result of epistemically virtuous activity, representative epistemic virtues being inquisitiveness, humility, rigour, and resolve. As an example, consider two diagnosticians, both of whom correctly diagnose a patient with bipolar disorder. One arrived at this diagnosis as the result of a detailed inquiry in which many possibilities were considered, and the other because he fashions himself an expert on bipolar disorder and tends to find manic tendencies in most patients he encounters. Again, we would be inclined to find the first diagnostician more intellectually praiseworthy for his rigour, and we might want to say only of the first that he actually 'knows' the diagnosis, the latter clinician only being correct as a result of epistemic luck while exhibiting the vice of hubris.

Now consider two trainees, both of whom carry out a vivid interview, beautifully eliciting an image of their patient's life that evokes in our imagination a complex web of understanding. One trainee was motivated in his questioning by an honest, authentic search for evocative connections that unified the thematic material of the patient's experience. He was courageous in that making these connections risked treading over fraught emotional ground. This interview could have turned out quite poorly if not skillfully handled. Aesthetic courage and honesty are just some of the aesthetic virtues that have been described (Roberts, 2018), and like virtues in the moral and epistemic domain, they can suffer from vices of deficit or excess and be hampered by competing vices. We can be cowardly by refusing to take risks, but we can also be rash by disregarding them. Both polarities miss the mark of true courage. Moreover, competing vices may undermine our ability to fully live up to our virtues. An excessive need for admiration may have us express ourselves less honestly, expressing rather what we think will garner us the most praise. Also, we might not be open-minded enough to consider different aesthetic choices. Finally, we may lack the skill to pull off aesthetically risky choices, hindering our ability to fully display our aesthetic courage. We could borrow the 'regulatory virtue' of practical wisdom from moral-virtue theory to understand this interplay of aesthetic virtues and vices. Practical wisdom regulates the complexity of virtues and vices in conflict, though such wisdom is won typically through experience (Radden & Sadler, 2009). The uninitiated trainee interviewer may wisely pursue the low-risk direction of interview convention, even if aesthetically ordinary, rather than pursuing the fraught, emotionally sensitive moment offered by a vulnerable patient.

The difference and interaction between virtue and skill is worthy of further comment. Virtues, as mentioned above, are deep and abiding dispositions to do the right things for right reasons arising from both cognitive (beliefs, judgements) and non-cognitive (motivations, feelings) attitudes. Skill, on the other hand, makes no direct claim on our beliefs or motivations. An expert painter may skillfully vary hue, shade, and line to create a particular effect, and this skill can be in service of any motivation that painter may have. However, the development of skill is something that is dependent upon our resolve to cultivate it, our patience to struggle through failed attempts, our curiosity to see how varying one or another technique creates different effects, and so on. Certain virtues are therefore critical to refining our skills. Possessing a certain amount of skill also opens opportunities for the cultivation of virtue. In the moral domain, learning new therapeutic techniques as a physician presents us with new opportunities to cultivate benevolence. In the epistemic domain, learning new methods of diagnosis presents us opportunity to cultivate rigour. In the aesthetic domain, too, cultivating empathy in order to perceive the poignancy of comments, to sensitively but evocatively inquire, presents us the opportunity to be aesthetically courageous. To venture into fraught emotional terrain without requisite skill may lead to the vice of rashness more than the virtue of courage.

In the next discussion, we present a case as reported by a trainee to his supervisor. We use both the patient–trainee and trainee–supervisor interactions to illustrate the role

that attention to aesthetic values can play in psychiatric practice and education. The case is a fictionalized amalgam of prior cases with invented details.

Case Example and Discussion

Shared Case Background

Mr. K is a thirty-year-old Black man with a history of depression dating at least to adolescence who presented to clinic six months ago for worsening depression, reporting a mounting sense of purposelessness and dissatisfaction with life. He had attended a highly regarded university and completed undergraduate degrees in archaeology and art history with plans to curate the collections at some of the most prestigious institutions across the world. Though he performed quite well in his undergraduate studies, he struggled much more than expected with an honours thesis requirement. He was to make an original contribution to an area of concern, and for this he focused on the intersection of colonialism and dissemination of African art throughout the European world. It had been necessary for him to work hard before, struggling through coursework and assignments, but this time he felt lost. His advisor, a middle-aged White man, commented on an early draft that 'nothing new was really being said' but seemed to provide some helpful suggestions about the direction of his research and themes he might explore. The advisor ultimately was very engaged and encouraging in their meetings but didn't quite understand the frame of mind from which Mr. K was approaching the topic—that even seemingly benign attempts to elevate Black art was harmful by means of losing the cultural context in which they were created, instead placing it in a White cultural-historical context, making that the dominant lens through which Black art was seen. While he completed the requirement and received commendations for his work, the effort left him stricken with lingering doubts that significantly impaired his subsequent graduate coursework and ensuing internship. After completing his internship, he had few employment prospects with the kinds of museums and collections that interested him. Instead, he hired on as a poorly compensated, adjunct lecturer at a small university in his hometown.

He was the only child born to parents with stable but lower incomes and raised primarily in a middle-class neighbourhood that was probably just beyond the family's financial means. His earliest years were spent in a poorer area of town, and concerns about the quality of schools was the apparent motivation for the move. He showed early promise in school, and his parents took great delight in his precocious academic discipline, encouraging his pursuits at the expense of incurring additional debt. This economic fragility sometimes meant that a utility bill went unpaid and often meant that the young Mr. K had to forgo many extracurriculars that his peers enjoyed. It seems that Mr. K was acutely aware of these hardships, and he excelled throughout primary

and secondary education as he began sensing in himself the promise that his parents had encouraged, and the sacrifice that made it possible. It occurred to him that he had the opportunity to emerge from the financially hampered life of his parents into which he was born. However, despite their encouragement of or even indulgence in his academic interests, he considered their practical academic, professional, and general life guidance lacking both in terms of modelling and insight. This disappointment was always conveyed in comparison to his peers, almost entirely White, who seemed to operate in the world with an easy confidence about who they were and where they were going that he couldn't comprehend. He became increasingly convinced of two things—that others had advantages he could never overcome and that he was in some way fundamentally lacking, that he was both inextricably part of and inescapably separate from their world. As he experienced more and more of the academic and then professional world, his mother's encouragement seemed more and more idealistically naïve, not acknowledging his fundamental lack, seeming like inane motivational posters begging for satire.

The Resident's (Dr. R's) Work with Mr. K

Dr. R's diagnostic and therapeutic work with Mr. K had generally focused on his apparent narcissistic vulnerabilities and frustrated idealistic grandiosity, though Mr. K had sedimented interpretations of himself as fundamentally lacking, due to ineptitude both inborn and acquired through unfortunate models and naïve guidance. While he would speak quite fondly of his mother, there was also a resentful undercurrent aimed at her credulously believing him to be more gifted, more capable, and having more opportunity than he really had. In meetings with the resident, a young White man, he would dismiss outright any attempts to reframe both his grandiose idealism and self-ascribed lack of requisite intellectual and practical abilities. The resident would ask him to imagine another person who had achieved some of the things he had and whether it would be accurate to describe that person as devoid of ability. The invariable response to this and other attempts to introduce ill-fitting facts into his self-assessment was that the resident was seeing something that just didn't apply to him, however much they might apply to the hypothetical beings of thought experiments. The resident typically left these encounters feeling like an 'unwelcome cheerleader scampering off to the sound of jeers'.

The difficulty of this case prompted Dr. R to bring it up for discussion in a weekly case conference, in which he presented the above background along with the following excerpt from a recent interaction.

> MR. K: Well ... I tried to sit down and write some more, but I just couldn't do it. (*Mr. K has been working on a paper investigating fin-de-siècle French cultural colonialism to submit for peer-reviewed publication.*) There is just so much I don't know. I mean, my French isn't even that good, and I have to rely on translations of some of the sources I'm drawing on. How can I write about something, pretend to

have anything to say about a culture when I can't even really speak the language? I've been working on it for so long now. I take a break, and after a while I think I have a great idea. When I actually try to start writing, though, I realize how completely hollow and ill-considered—perhaps even offensive—the idea was that I had something to say. (*Dr. R notes to himself that this is how most of their meetings begin—recounting what he hasn't done and explaining why he can't.*)

MR. K (CONTINUED): You know, my mom, she always tells me that I just have to work hard, that I'm smart enough, that it will come to me, but she just doesn't get it. I remember, it seems like every day when I went off to school, she would write me some inspirational quote. Something like, 'we grow by great dreams' or 'hold fast to dreams' or something to that effect. I call her, and she still says those things to me. I just want to laugh at her. (*brief silence*) She doesn't get it. She convinced me to go to that private university, to study art and archaeology, paying no mind to the kind of debt I'd be incurring because 'no one should negotiate their dreams.' Who lives by these kinds of quotes? Not once have I been able to make even the means-adjusted minimum payments on my loans. It's crushing. All to be here at some inconsequential university giving inconsequential lectures getting paid an inconsequential sum. My promotion is contingent upon not only publication, which I can't seem to do, but also curricular development. My department chair held a meeting a while back and assigned me the role of developing a series of art history seminars open to both students and the public. We have the first follow-up meeting in a week, and I haven't done anything substantial. I have some slides, an outline, and some general idea of what I want to say, but really, I'm not sure what these people want to hear. I know what I'd like to talk about. You remember my thesis? It still nags at me—the idea behind it—and think there's something that people need to understand about it but just can't. I imagine the question-and-answer session following each talk, and I get sick. 'But what about XYZ artist who was benefitted by association with ABC White artist?' That I get questions like that makes me feel all the more that the central point is just completely missed. I'm not saying that these are bad people but that nevertheless a harm is done even if unintentional. In the end, I feel just as stuck with these seminars as I do with the publication, but every time my chair asks how it's going, if I need any help, I just say I'm making progress and that I'm excited about how it's going to turn out. I shouldn't need help with these kinds of things, and I doubt even with more guidance that I'd be able to pull it off the way other people seem to be able to pull off things like this. (*prolonged silence*)

DR. R: It seems to me that you have ideas and abilities, but something else just keeps getting in the way. (*The resident was thinking of the patient's narcissistic vulnerability but recognized immediately the quote-like inspirational sentiment he often felt pulled into making.*)

MR. K: How could you say I have any ability? (*The resident considered supporting his point but realized that he had often done so and furthermore noticed that Mr. K seemed to be ruminating on something.*) I was online the other day, and I was getting into an argument with some guy from high school. I know him, and really he's not a bad guy. He just makes an ass out of himself sometimes, always trying to take edgy positions on whatever topic of the day. Well, the other day, he was arguing that cultural appropriation is actually a good thing, that it was a sign

primarily of respect except in the most egregious cases where credit is actively withheld. I'm summarizing here. I shouldn't have, but I couldn't help responding. I acknowledged that respect was sometimes operative, but even in these cases there was the very real potential harm of snuffing out a culture when what was born from one culture becomes primarily part of the history of another. Then this guy brings up Bob Marley, saying 'What about Bob Marley? Clapton covered Marley's "I Shot the Sheriff" and brought him welcome attention. Clapton also played with Marley and championed many Black artists after that. That doesn't seem to fit your narrative.' I know it seems benign, but it's another example of someone just trying not to understand. I pointed out to him that while it did bring attention to Marley, Clapton's version ended up getting far more airplay than Marley's... even in Jamaica! Clapton reportedly didn't even know what the lyrics meant, and yet his version is in the Grammy Hall of Fame. So who's song did it become in the end, even in Jamaica? Do you know what this guy said back to me? 'I don't know. It still seems like Marley came out better with Clapton's cover even if not better than Clapton.' Now I still see him posting here and there about the Bob Marley and Eric Clapton thing with some clickbait mention of cultural appropriation followed by the caption, 'But what about Bob Marley?' Was he really even listening?

DR. R: (*He had been listening raptly to the above, his mind swirling with allusions to the therapeutic relationship between the two of them when a particular connection suddenly occurred to him.*) And here, I'm the guy saying, 'But what about Bob Marley?'

MR. K: (*smiling, chuckling*) I guess so. You know. It occurs to me that's my experience with most people—this guy, you, my mom—that there's something people just don't get about what I'm trying to tell them. At least you're trying, I suppose. That guy definitely wasn't. My mom, well, she wants the best for me and that blinds her to some of what I'm trying to get her to understand. Maybe that's you, too. Hell, even my advisers or really just anyone I imagine trying to explain myself to.

Commentary

As supervisors, the trainee's summary presentation of the case is often the first target for aesthetic judgement. Sometimes, we are given a bare-bones, disjointed sense of the case such that we are left with little to respond to. We are unable to transport ourselves into the narrative, much less wonder at how it all hangs together. Other times, we can visualize what it was like to be with that patient or to enter their world. A case presentation is a selection among a nearly infinite number of facts with the purpose of conveying some impression or understanding we have of the patient. In this way, a presentation is dependent upon the theory we have of 'what's going on' with the patient—in life and in treatment—and therefore also reflects the depth of our understanding. Philosophers and scientists both have commented on the implications of our aesthetic appreciation of theories. Henri Poincaré, a French polymath of the late nineteenth and early twentieth centuries, who laid the groundwork for chaos theory, claimed that scientists are having an aesthetic experience when they appreciate how diverse phenomena are

harmoniously accommodated by a theory, that beauty is experienced when we have grasped how different and apparently disconnected phenomena are unified, suggesting that this experience of beauty is one of the values that motivate their understanding (Ivanova, 2017; Poincaré, 2001). Paul Dirac (Dirac, 1980, 40), a British physicist of the twentieth century, quite famously claimed that 'one has great confidence in [a] theory arising from its great beauty.'

The idea that beauty stands in special epistemic relationship to truth has been taken up by philosophers of science, and one of the more well-known arguments regarding this relationship is that the link between beauty and truth is based on an aesthetic induction (McAllister, 1996). Briefly, we tend to aesthetically prefer a certain type of art with certain aesthetic features the more we are exposed to it, a finding called the 'exposure effect' (Cutting, 2003). Scientists, being habitually exposed to theories useful in explaining natural phenomena, come to appreciate recurring aesthetic features—simplicity, symmetry, harmony, clarity, visualization, elegance—which in turn become non-epistemic markers for truth, though whether these are merely 'masked' epistemic assessments is an area of debate (Todd, 2008).

Whether we link beauty to truth, aesthetic appreciation of our case presentations and diagnostic formulations—our theories of 'what's going on'—do reflect and promote understanding, which differs from ascertaining truths in that understanding involves an ability to grasp how the facts fit together, how certain truths relate and apply to different contexts. This is what we respond to aesthetically when we hear a trainee present a case. When trainees have been able to synthesize a patient's narrative and convey a layered understanding of their experience, we are more likely to find their formulation elegant and richly evocative of the patient's world. In the above case summary, we would argue that the patient's experience is elaborated compellingly. The story is textured without being overwrought, each detail working with the others to depict a man with talent and drive who is hampered by experiencing himself as having some incompletely expressible privation. However, we are somewhat dissatisfied by the dangling issue of race and its lack of more complete integration into the story of the interaction between the patient and trainee, despite that theme surfacing many times. From this dissatisfaction, we are roused to consider how we might incorporate racial dynamics into our understanding of what's going on with the patient and with the therapy.

After listening to the patient describe his aggravation at repeatedly receiving overused, insipid encouragements that did not engage his experience of himself and his situation, we hear the trainee re-enact such insipid sentiments. Though superficially benign, that kind of encouragement in the context of what the patient had just been describing, particularly with its generic, almost stock quality, reinforced the patient's sense that other people couldn't really engage with what he was trying to communicate about the particularity of this experience. With that statement, he became yet another generic recipient of psychological 'support'.

The patient went on to recount an interaction online in which a white peer demonstrates his unwillingness to consider the validity of the patient's argument about the harm Bob Marley experienced in having his work appropriated, even with some

financial benefit. However, the trainee's next comment was altogether different from his first. By satirically identifying himself with the argumentative, white saboteur, he playfully acknowledged his struggle to understand and simultaneously signaled his willingness to do so. It also called back to and integrated in a brief comment a number of themes, including the dangling issue of racial difference and the tension that misunderstandings of this kind can generate. The Marley story contains something that seems fundamental about the patient's grievance—that he was operating in a historical narrative that wasn't entirely his, determined in significant part by his parents' and society's expectations. This economical expression of multiple understandings, while also being facilitating and in effect supportive, makes for a good example of clinical elegance (as an expression of aesthetic virtue). With this moment, Dr. R was able to execute an elegant clinical response, pulling together a genuine uptake of the patient's experience, conveying empathic understanding, all the while building rapport by expressing said insight with good-natured humour. Good show!

Conclusion

We have presented an introductory discussion of how philosophical aesthetics may figure into the work of clinical practice and clinical education in mental health. We have sketched an aesthetic praxis for psychiatry, which involves attending to an aesthetic frame in working with patients, identifying aesthetic values reflected in our nomenclature, clinical phenomenology, and hypothesizing about patients, and attending to aesthetic values and skills in working with patients as diagnosticians and as therapists. In the psychiatric education arena, we have identified aesthetic virtues as excellent habits of character possessed by experienced clinicians which contribute recognizable elements of form and beauty to their clinical work. By identifying aesthetic values which are demonstrated by others, we can begin to cultivate key aesthetics like clinical elegance into teaching rubrics, even ultimately systematizing them into measurable features of clinical interviewing.

This sketched introduction aside, much remains to be done with the describing of an aesthetic praxis for psychiatry. The questions are both conceptual and empirical. We could investigate which kinds of aesthetic values emerge in observing skilled and experienced clinicians at work. The multivalent interplay of moral and intellectual values and virtues, along with aesthetic ones, should be sorted out. We anticipate salience questions: Some clinical situations, with unique patients and circumstances, (not to overlook unique clinicians and circumstances), may evoke different kinds of aesthetic values, and call for different kinds of aesthetic virtues in clinicians. For an example of the latter, a beautiful diagnostic clarification is likely to differ in at least some ways from a beautiful handling of termination in psychotherapy. The potential for describing aesthetic dimensions of care is limitless, a problem Sibley encountered when he embarked on cataloguing aesthetic terms in art criticism and analysis in the 1960s (Sibley, 2001).

This realization raises another salience question: which aesthetic virtues are 'core', or most important, to being a good psychiatrist? We wonder if the development of a psychiatric aesthetic praxis should be process-oriented (e.g., addressing how to recognize aesthetic values in practice, and how to train clinicians into recognizing and enacting them) rather than content-oriented (e.g., like rating clinicians on a list of aesthetic virtues).

In any case, we predict the other chapters of this *Handbook* may raise new hypotheses, and even answer some of the questions we have raised here.

References

American Psychiatric Association. (2013). *Diagnostic and statistical manual of mental disorders: DSM-5* (volume 5). American Psychiatric Association.
Anscombe, G. E. M. (1958). Modern moral philosophy. *Philosophy* 33(124), 1–19.
Crowther, P. (2021). *The phenomenology of aesthetic consciousness and phantasy: Working with Husserl*. Routledge.
Cutting, J. (2003). Gustave Caillebotte, French Impressionism, and mere exposure. *Psychosocial Bulletin & Review* 10, 319–343.
Dirac, P. A. M. (1980). The excellence of Einstein's theory of gravitation. In M. Goldsmith, A. Mackey, & J. Woudhuysen (Eds.), *Einstein: The first hundred years* (p. 40). Pergamon Press.
First, M., Williams J. B. W., Karg, R. S., & Spitzer, R. L. (2016). *Structured clinical interview for DSM-5 disorders – clinical version*. American Psychiatric Association.
Guyer, P. (2014). *A history of modern aesthetics*. Cambridge University Press.
Husserl, E. (2005). *Phenomenology, image consciousness, and memory* (1898–1925), translated by J. B. Brough. Springer.
Husserl, E. (2012). *Ideas: General introduction to pure phenomenology*. Routledge.
Ivanova, M. (2017). Aesthetic values in science. *Philosophy Compass* 12(10), e12433.
Kant, I. (2000). *Critique of the power of judgment* (edited and translated by E. Matthews & P. Guyer). Cambridge University Press.
Kendler, K. S., & Parnas, J. (Eds.). (2017). *Philosophical issues in psychiatry IV: Psychiatric nosology*. Oxford University Press.
Kristeller, P. O. (1951). The modern system of the arts: A study in the history of aesthetics Part I. *Journal of the History of Ideas* 12(4), 496–527.
Laney, M., & Sadler, J. Z. (2021). Psychiatric diagnosis. In S. Green & S. Bloch (Eds.), *Psychiatric ethics*, fifth edition (pp. 97–120). Oxford University Press.
McAllister, J. W. (1996). *Beauty and revolution in science*. Cornell University Press.
Parkinson, G. (2008). *The Duchamp book: Tate essential artists series*. Harry N. Abrams.
Poincaré, H. (2001). *The value of science: Essential writings of Henri Poincaré*. Edited by S. Gould. Modern Library.
Radden, J., & Sadler, J. (2009). *The virtuous psychiatrist: Character ethics in psychiatric practice*. Oxford University Press.
Roberts, T. (2018). Aesthetic virtues: Traits and faculties. *Philosophical Studies* 175(2), 429–447.
Sadler, J. Z. (2005). *Values and psychiatric diagnosis*. Oxford University Press.
Sibley, F. (1959). Aesthetic concepts. *Philosophical Review* 68(4), 421–450.
Sibley, F. (1965). Aesthetic and nonaesthetic. *Philosophical Review* 74(2), 135–159.

Sibley, F. (2001). *Approach to aesthetics: Collected papers on philosophical aesthetics*. Clarendon Press.
Sosa, E. (2010). *Knowing full well*. Princeton University Press.
Stanghellini, G. (2016). *Lost in dialogue: Anthropology, psychopathology, and care*. Oxford University Press.
Todd, C. (2008). Unmasking the truth beneath the beauty: Why the supposed aesthetic judgements made in science may not be aesthetic at all. *International Studies in the Philosophy of Science* 22(1), 61–79.
World Health Organization. (1992). *The ICD-10 classification of mental and behavioural disorders: Clinical descriptions and diagnostic guidelines*. World Health Organization.
Zagzebski, L. (1996). *Virtues of the mind: An inquiry into the nature of virtue and the ethical foundations of knowledge*. Cambridge University Press.
Zaner, R. M. (1973). The art of free phantasy in rigorous phenomenological science. In *Phenomenology: Continuation and criticism. Phaenomenologica*, volume 50. Springer. https://doi.org/10.1007/978-94-010-2377-1_12.

CHAPTER 23

UNLEASHING THERAPEUTIC GAIN BY DEPLOYING SOCIAL AESTHETIC VALUES IN CO-PRODUCING HEALTHCARE DECISIONS

WERDIE VAN STADEN

Introduction

THIS chapter considers the therapeutic utility of social aesthetics in ordinary health-care decision-making. In the specialized contexts of art therapies, the therapeutic utility of social aesthetics is well-established (Case & Dalley, 2014; Henley, 1992; Lotter & Van Staden, 2019), expounded in for example the journal *The Arts in Psychotherapy*. The same applies for cosmetic medicine as practised in for example dermatology and plastic surgery (Arora & Arora 2021; Wu et al., 2019), as well as in psychotherapy and the treatment of addiction (Musalek, 2010, 2017; Scheibenbogen & Musalek, 2021). The interest of this chapter, however, is more general and extends to ordinary health-care decisions that cut across health services and specialities of various kinds. Two key questions are: How may social aesthetics come into therapeutic play in ordinary health-care decision-making? How may we therapeutically utilize in health-care decision-making, evaluations and creations of beauty and ugliness, of good and bad taste—not merely in works of art or in nature but as qualities in the lives of people?

The connection between social aesthetics and ordinary health-care decision-making[1] may be clarified and practically informed by values-based practice (VBP). Before this is described, the conceptual scope and the reach of social aesthetic actions that underpin and derive from social aesthetic values are first clarified in relational terms. So clarified, too narrow an understanding of social aesthetics may be averted. Too narrow

an understanding would preclude the various people in health-care, participating specifically in health-care decision-making, from recognizing both shared and divergent social aesthetic values. It would preclude therapeutic utility and gain from deploying social aesthetic values in its far-reaching meaning, considered in the second part of the chapter that describes how relationship-based mediators may potentially unleash therapeutic gains when social aesthetics is deliberately pursued in co-producing decisions as prescribed by VBP. Co-producing decisions in VBP is thus described as a potential pivot between social aesthetics and therapeutic gains.

The Scope and Reach of Social Aesthetic Values

Against the rich backdrop of philosophy of aesthetics (Cohen & Guyer, 1982; Crowther, 1989; Kant, 1987; Kivy, 2004), the scope and the reach of social aesthetic values are clarified here following cues from the philosophy of relations (Van Staden 2002, 2006) that highlight the actions pervasive in social aesthetics, people's positions in these actions, and the variety of items acted upon in these actions (Coleman et al., 2013; Huron 2016). Once the actions of social aesthetics are so described, social aesthetic values underpinning and deriving from these actions are described as a distinct set of values that overlap partially with other kinds of values (Van Staden 2005). The subsequent section locates a potential practical place for social aesthetic values to be mobilized—that is, in healthcare decision-making.

People and Items in the Actions of Social Aesthetics

We may recognize the scope and the reach of social aesthetics by considering the actions 'to value', 'to evaluate', and 'to create', which are pervasive in social aesthetics notwithstanding other actions such as 'to recognize', 'to reflect', 'to appreciate', and 'to perceive'. We *value* and *evaluate* something as beautiful or ugly, as tasteful or lacking in taste. We *create* beauty, ugliness, and items that are beautiful or ugly. We *appreciate, recognize*, and *reflect* (on) beauty, ugliness, taste, and distaste.

These actions do not feature exclusively in social aesthetics, but being so identified, we may describe people's involvement, both as agents of these actions and when we, or something to do with us, are valued or evaluated in aesthetic terms. Identifying these actions further clarifies the range of items other than people that may be valued, evaluated, or created in aesthetic terms.

Social aesthetics necessarily involve people and their practices rather than being merely located in nature, pieces of art, thoughts, or minds of people (Coleman et al.,

2013). We may recognize the scope of involvement of people in social aesthetics in broadly two relational ways: as agents in certain actions; and where people, or something to do with people, are acted upon within these actions. People may *value* or *evaluate* an item as beautiful, ugly, in good or bad taste, or somewhere in between. People may also evaluate in these very terms when concluding that an item is neither beautiful nor ugly, but pleasing, disgusting, or of artistic merit. Items so valued or evaluated may be in nature or these may be items that people produce regardless of whether pieces of art.

People may *create* items in accordance with the evaluations of being beautiful, ugly, in good or bad taste, somewhere in between, or even as neither here nor there in these very terms. We may create items drawing on aesthetic values and in evoking aesthetic evaluations. These items may be artistic work but need not be so constrained. People may create more or less anything that may be evaluated as beautiful, ugly, or tasteful, without necessarily drawing on aesthetic values, even without the intention to evoke these evaluations.

People may value, evaluate, and create in aesthetic terms using any of the five senses in our evaluations, but not necessarily so. Our visual, auditory, gustatory senses are obvious in evaluating respectively paintings and musical compositions as beautiful, or a meal as tasting good. So are a pleasing fragrance or silky texture respectively capturing olfactory and tactile evaluations. Our senses, however, are less obviously involved if involved at all when we evaluate as beautiful, for example, a mathematical theorem, a scholarly essay, a metaphor, the way someone interacts with another person, a culture, and someone's life. These examples defy the idea that social aesthetics would necessarily be about visual or sensory experiences.

Conversely to people valuing and evaluating, people and more or less anything to do with people also qualify as items that may be valued or evaluated in aesthetic terms. For example, we may value and evaluate in aesthetic terms the state(s) in which people are, their bodily features, attitudes, that which they do, their habits and practices. These states and features may be valued or evaluated as beautiful, ugly, or in good or bad taste. Valuing or evaluating such items in aesthetic terms necessarily expresses social aesthetic values.

An interplay between aesthetic evaluations and creations is the rule rather than exception. For example, in one sense any evaluation comprises a creation of sorts. One may evaluate creatively and may create evaluatively. Evaluations may vary in how creative these are. Whilst a spectator's perspective may fall short in creative participation, evaluations may very well be a tacit way of creating perspectives. In this way aesthetic evaluations are created, which means that aesthetic values are dynamically produced rather than all 'out there' for discovery. Social aesthetic actions of valuing, evaluating, and creating invoke a variety of responses including new actions, creative possibilities, satisfaction, joy, flourishing, enrichment, social commentary, discovery, revelation, sophistication, capabilities, and capacity. These responses may in turn also be evaluated in social aesthetic terms.

Social Aesthetic Values amongst Values of Various Kinds

Within this complexity of interactions, the values by which one performs social aesthetic actions may aptly be qualified as social aesthetic values. All values are not social aesthetic values, however. Consider the following kinds of values: good, better, and best; bad, worse, and worst; right and wrong; norms; principles; virtues and vices; duties and obligations; and values that are prescriptive, aspirational, legal, religious, cultural, societal, personal, scientific, professional, etc. (Van Staden, 2005).

Social aesthetic values overlap nonetheless with various of these kinds of values. For example, a beautiful painting may also be valued or evaluated as good, precisely because it is beautiful (and vice versa). Here 'good' may operate as a social aesthetic value, but this is not necessarily so. The 'good', for example, may refer not to its artistic qualities, but that its moral message is good. Similarly, a painting may be good aesthetically, but wrong in another respect. One may imagine for example a painting that is beautiful, but sinful and wrong by religious values. Conversely, evaluations of right and wrong may also concern aesthetic qualities, for example, when a wrong note is produced in music.

As for these examples from art, an overlap of social aesthetic values and other kinds of values extends to evaluations and creations in ordinary discourse. One may create a beautiful plan that would be good, or wrong and illegal to execute, for example. A treatment plan may be beautiful yet wrong medically. A treatment may be ugly or disgusting (as in surgery on a large peri-anal abscess, for example), yet this same treatment may be good and the right treatment.

Both Shared and Divergent Aesthetic Values

Amongst the values of various kinds, VBP draws a general distinction between those values that are (commonly) shared and those values about which we (tend to) disagree (Fulford & Van Staden, 2013). As for values in general, this distinction also applies for social aesthetic values. Consider a scene where a lion has torn someone apart. We would easily agree and evaluate this scene as ugly. A rose is commonly evaluated as beautiful. These evaluations are commonly shared. We are agreeable in these evaluations.

In contrast, we would quickly proclaim 'beauty is in the eye of the beholder' when someone evaluates heavy metal music as beautiful or evaluates the paintings by Francis Bacon of Lucian Freud as ugly. We tend to disagree about some aesthetic evaluations and some aesthetic values may even conflict.

That social aesthetic values are such that these may be divergent and 'in the eye of the beholder', poses challenges in clinical decision-making. Clinicians may shy away from these divergent values, since much of medical endeavours are in pursuit of shared rather than diverging values (Van Staden & Fulford, 2015). Clinicians ascribe to shared scientific values, for example, in using the *best* evidence in evidence-based medicine (Sackett et al., 1996). In the relationship with a patient, a clinician may be working

hard in generating common ground guided by a shared value in what *ought* to be done. Pursuing these shared values may already be demanding, such that aesthetic values that are 'in the eye of the beholder' might seem to be too daunting.

Diverging values, however, are not confined to social aesthetic values (Fulford & Van Staden, 2020). Many diverging values are crucial in clinical decision-making in addition to values commonly shared (Fulford et al., 2012). VBP provides the knowledge and skills set to process values in decision-making, with explicit provisions for divergent and even conflicting values. How VBP works practically, has been described elsewhere (Fulford et al., 2012; Van Staden & Fulford, 2015). It concerns values of various kinds, inclusive of social aesthetic values, but being designed to address diverging values in clinical decision-making, VBP is most apt for the processing of social aesthetic values, particularly when (prone to) being 'in the eye of the beholder'.

A Location Where Aesthetic Values May Feature: Decision-Making in Values-Based Practice

Whilst VBP necessarily concerns values, the values in a particular VBP decision are not necessarily of a social aesthetic kind. However, VBP aptly provides ways by which to deliberately incorporate aesthetic values in the decision-making. A reason to do so is considered in a subsequent section—that is, to unleash potential therapeutic thrust. But first, briefly consider the tenets of VBP, summarized in Table 23.1.

Demonstrated in clinical case examples elsewhere (Van Staden & Fulford, 2015; Van Staden, 2021a), the point and the premise of VBP are crucially about values that are shared as well as differences between values—a distinction described in the preceding section. The shared values serve as common ground and framework (Crepaz-Keay et al., 2015; Van Staden, 2020). These may exist from the outset or may be established through a process of consensus. Within the safety of this common ground and framework constituted by the shared values, the values that are different, are specially provided for in a process of dissensus as guided by VBP. The latter is much more than an agreement to disagree but requires that each stakeholder takes the specific difference seriously by accounting in the decision-making for the value with which he or she disagrees.

To this end, VBP's ten-part process in co-producing decisions espouses an interpersonal relationship context that draws on four skills areas for working in partnerships, and it links values-based practice with evidence-based practice. Interpersonally, VBP necessarily requires that people participate in a process in which their respective values feature. VBP's process is notably not merely pursuing the values of the patient, nor merely those of the physician, nor those of any other singular stakeholder. True, the person whose health is at stake, that is the patient, takes a central and substantive place in

Table 23.1 Summary of values-based practice (VBP) in decision-making (Van Staden & Fulford, 2015)

Elements of VBP	Brief explanations
POINT	Rather than giving us answers as such, VBP aims to support **balanced decision-making within frameworks of shared values** appropriate to the situation in question
PREMISE	The basis for balanced decision-making in VBP is the premise of **mutual respect for differences of values**
TEN-PART PROCESS	Values-based practice supports balanced decision-making through **good process** rather than prescribing pre-set right outcomes. The process of VBP includes four areas of **clinical skills**, two aspects of **professional relationships**, three principles **linking VBP with evidence-based practice**, and **partnership in decision-making** based on 'dissensus'
The four skills areas are	
1 Awareness	The first and essential skill for VBP is raised awareness of values and of the often-surprising diversity of individual values
2 Reasoning	Values reasoning in VBP may employ any of the methods standardly used in ethics (principles reasoning, case-based reasoning, etc.) but with an emphasis on opening up different perspectives rather than closing down on 'solutions'
3 Knowledge	A key skill for VBP is knowing how to find and use knowledge of values (including research-based knowledge) while never forgetting that each individual is unique (we are all an 'n of 1')
4 Communication	Values-based practice communication skills include skills, (1) for eliciting values, in particular StAR values (Strengths, Aspirations and Resources), and (2) for conflict resolution
The two aspects of professional relationships are	
1 The extended MDT	The role of the MDT (multi-disciplinary team) in VBP is extending from its traditional range of different professional skills to include a range of different value perspectives
2 Person-values-centered-care	In VBP, patient-centred care means focusing crucially on the patient's values though other values (including those of the clinician) are important too
The three principles linking values with evidence are	
1 'Two feet' principle	The 'two feet' principle of VBP is that all decisions in health are based on values as well as evidence even where (as in diagnostic decisions) the values in question may be relatively hidden
2 'Squeaky wheel' principle	The 'squeaky wheel' principle of VBP is that we tend to notice values when they are conflicting and hence causing difficulties (based on the saying 'it's the squeaky wheel that gets the grease')

(continued)

Table 23.1 Continued

Elements of VBP	Brief explanations
3 'Science-driven' principle	The 'science-driven' principle of VBP is that the need for VBP is driven by advances in medical science (this is because such advances open up new choices and with choices go values)
Partnership in decision-making	
… based on dissensus	Consensual decision-making involves agreement on values with some values being adopted and others not. In dissensual decision-making, by contrast, different values remain in play to be balanced sometimes one way and sometimes in others according to the particular circumstances of a given case

VBP, captured elsewhere as *person-values-centered practice* (Fulford et al., 2012, chapter 9). However, the patient is not the only person whose values are pertinent in VBP. The values that differ typically originate from respective stakeholders, including individuals and even professional teams (Van Staden, 2011). VBP is accordingly well-aligned with *person*-centred medicine (PCM) that extends in scope further than *patient*-centred medicine (Kirmayer et al., 2016; Van Staden et al., 2023). All the stakeholders feature in the process of VBP, in which each holds values that may be pertinent in co-producing a decision.

The challenge of accounting for differences between values in an interpersonal process of VBP, requires skills summarized into four areas—see Table 23.1. The first and essential skill for values-based practice is raised awareness of values and the often-surprising diversity of individual values. Deliberately deploying skills in be(com)ing aware of values goes against a tendency for having blind-spots in seeing and recognizing values. There are several reasons for this tendency, described in more detail elsewhere (Fulford et al., 2012; Fulford & Van Staden, 2013, 2020; Rashed et al., 2015; Van Staden & Fulford, 2015; Van Staden, 2020). These include a default assumption that another person would evaluate and value the situation the same as 'I do' or 'we do'; that values when shared in a specific context often operate tacitly; that reflecting on which values pertain in a given situation would be a rather unusual, if not weird, activity in most of the ordinary decisions of daily living; and that values are typically attributed to 'the other' when differences between values emerge.

Primed through a raised awareness of values, VBP guides further that the skills of reasoning be deployed for exploring interpersonally the various values in play. Reasoning as used in any of the methods standardly used in ethics (principles reasoning, case-based reasoning, etc.) may be helpful to this end, but the emphasis in VBP-reasoning is on opening up different perspectives rather than closing down on 'solutions'. Different to a persuading agenda of reasoning, VBP-reasoning does not require a stakeholder to relinquish or change his or her values. Without sacrificing the individual's unique voice in a matter, VBP-reasoning is informed furthermore by the third key skills area of knowing how to find and use knowledge of values including research-based knowledge.

Complimentary to the preceding skills areas, communication skills include skills for eliciting values and conflict resolution whereby communication is substantive and not merely a means to an end but an end in itself. Substantive communication is crucially about the different values that bear on the situation as well as the shared values. The shared values direct the substantive pursuit towards shared decision-making and also frame the process within which differences of values are incorporated. An African version of VBP captures this kind of meeting as an indaba (Van Staden & Fulford, 2015). The word 'indaba' comes from isiZulu, which may be partially translated with 'meeting', 'matter', and 'story'. As a common way of doing in sub-Saharan Africa, an indaba is thus a meeting to discuss a matter where everyone has a voice and generates a shared story to tell about a matter.

Substantive communication in VBP opens up an interpersonal engagement on that which matters to each of the stake holders in their circumstances. It is guided by the key questions: What shall we decide as to account for the *differences* of values? Which decision may we co-produce that would incorporate the *differences* between values?

Championing the *differences* between values in this way should not be confused with any party 'compromising' his or her values, or 'consensus' decision-making whereby agreement would be reached on which values would be adopted and which not. In *dissensual* decision-making, by contrast, different values remain in play to be balanced sometimes one way and sometimes in others according to the conjoint deliberations and the particular circumstances of a given case.

A key interpersonal orientation of VBP within which the skills from the four skills areas are meant to be deployed, is that of partnership. Decisions are accordingly co-produced in a creative way that would meet the demands of accounting for the differences. Partnership in dealing with value differences in ordinary living is known well-enough. Consider for example two life partners who are in the process of deciding on their next holiday. The one partner values a holiday at the seaside as the best place for a holiday whereas the other partner values a holiday in a game reserve as the best. If neither is to relinquish their value 'of the best place for a holiday', they need to co-produce a decision that would account for this difference, each taking seriously the value that disagrees with their own. Accordingly, creative decision may be co-produced by which, for example, they take turns from one holiday to the next in choosing to which place they would go, or split the holiday period in two halves and go to both places, or go on holiday apart from each other and join each other later for a third kind of holiday that they both value highly.

In contrast with decision-making in ordinary living as in the example of a holiday, the clinician may rightfully enquire at this point: where does the science fit in decision-making considering the emphasis on values in VBP (Fulford et al., 2012; Van Staden, 2021b)? VBP takes its connection with evidence-based practice (EBP) as fully complementary. VBP makes the connection explicit in three principles. The first, the 'two feet' principle, is that all decisions in health are based on values as well as evidence even where (as in diagnostic decisions) the values in question

may be relatively hidden. This principle goes against the idea that the uncovering and underscoring of the values of the patient and other role players would be undermining, relativizing or trivializing the scientific values guiding clinical decision-making.

The second principle, the 'squeaky wheel' principle of VBP, is that we tend to notice values when they are conflicting and hence causing difficulties. When scientific values and the values of the patient diverge and even conflict, the turning of the 'wheels' of decision-making is not smooth but squeaky. The squeak should alert the clinician that a value difference is pertaining, requiring that 'grease'—that is, the skills and insights provided by VBP—be applied to the 'wheels' of decision-making.

The third principle connecting VBP and EBP is the 'science driven' principle. It states that the need for values-based practice is driven by advances in medical science in that these advances open up new choices and with choices come values.

Deploying Social Aesthetic Values in the Decision-Making of Values-Based Practice

The tenets of VBP as described in the preceding section may all be applied specifically to social aesthetic values. VBP decision-making may deploy social aesthetic values through processes of awareness, recognition, and unpacking these values through interpersonal exploration and reasoning. VBP emphasizes the skills required to do so—see the four skills areas in Table 23.1. These include conceptual skills by which to raise awareness and recognize the broad variety of social aesthetic values outlined in the first part of this chapter. Recognizing the social aesthetic values is about spotting these values when they emerge. It is also to recognize social aesthetics in another sense—that is, to give these values an appreciated place in decision-making.

The aesthetic values about which we are agreeable may be utilized in establishing common ground for which processes aiming for consensus are well-suited. In contrast, regarding 'beauty is in the eye of the beholder', the aesthetic values that diverge, these constitute the uncommon ground. To hold the differences of aesthetic values in high regard, processes should aim for dissensus. The latter entails that an apposition (that is, being on the same side) between people and the common ground be utilized as a framework within which the differences, even opposing values, can be taken seriously and be accounted for in creative decision-making.

Thereby, VBP may co-produce health-care decisions through substantive communication about aesthetic values, The agenda of this pursuit is threefold: (i) co-producing a shared aesthetic appreciation of the patient's situation; (ii) co-producing decisions with social aesthetic qualities of choice; and (iii) co-producing decisions to bring about desirable aesthetic qualities in the patient's life. This may be a worthwhile purpose in itself. But more is possible and useful clinically, considered in the next section—that is, to unleash potential therapeutic gain.

Therapeutic Utility and Gain from Social Aesthetic Values

Although the values accounted for in a particular VBP-decision are not necessarily of a social aesthetic kind, social aesthetic values may nonetheless feature in decision-making when these values matter to any of the stakeholders in the decision-making. The point of this section, however, goes further. Social aesthetic values[2] can be made to feature deliberately in the VBP decision-making whereby relationship-based mediators may unleash potentially therapeutic gains.

Relationship-Based Mediators of Therapeutic Gains Afforded by the Decision-Making of Values-Based Practice

Table 23.2 highlights relationship-based therapeutic mediators in the pursuit of social aesthetics through decision-making in VBP. The mediators are raising awareness, communication, interpersonal sharing, story-making, trust, alliance, and hope for improvement.

Increased awareness is a therapeutic mediator that features necessarily in various kinds of psychotherapies (Lane et al., 2022). In cognitive behavioural therapy (CBT), the therapeutic process requires that the patient becomes aware of automatic negative thoughts, dysfunctional thinking, thought schemata, and the behavioural consequences thereof (Wright et al., 2017). Therapies that use mindfulness as a technique are per definition aiming for more awareness of familiar things including one's activities, body, and environment (Hinchey, 2018). In therapies that focus on relationships (for example, transactional analysis; interpersonal therapy), increased awareness of the interpersonal patterns is pursued (Gordon-King et al., 2018; Zivkovic, 2022). In analytic and psychodynamic kinds of therapies, increased awareness of subconscious processes in thoughts, emotions, and interpersonally is the key ingredient for personal growth, resolution of internal conflicts, and venturing into new and less restricted ways of being and interacting (Høglend & Hagtvet, 2019; Lane et al., 2022).

Raised awareness is also the first skills area of VBP. As a skill, becoming aware of the values constitutes an active pursuit in uncovering the values of the patient, the professional team, and other role players, utilizing to this end knowledge, reasoning, and communication (from the other skills areas of VBP). By using this skill deliberately for uncovering social aesthetic values, the various stakeholders may become aware of the beauty and ugliness in the past and currently, and which beauty is worthwhile pursuing.

Communication is an obvious and necessary mediator to therapeutic gain in any of the various kinds of psychotherapies, and it features as a key skills area in VBP, requiring

Table 23.2 Relationship-based therapeutic mediators in the pursuit of social aesthetics through decision-making in values-based practice

Relationship-based therapeutic mediators	Decision-making in values-based practice (verify with Table 23.1)	Social aesthetic values: beauty and ugliness in the past, present, and future
Raising awareness	**Awareness** features as the first skills area of VBP. As a skill, becoming **aware** of the values constitutes an active pursuit in uncovering the values of the patient, the professional team, and other role players, utilizing to this end knowledge, reasoning, and communication (from the other skills areas of VBP)	Become **aware** of the beauty and ugliness in the past and currently, and which beauty is worthwhile pursuing henceforth
Communication	**Communication** features as a key skills area in VBP, requiring necessarily interpersonal interaction with the various role players including the patient and the multi-disciplinary team	**Communication** in the interpersonal process of decision-making about the aesthetic values in a person's life in the past, currently, and as envisaged in the future may mediate therapeutic gains. The **communication** in the decision-making process may be evaluated and valued for its beauty
Sharing	Values-based practice requires that the reasoning and communication skills be used in a decision-making process whereby the various participants **share** with each other which values are important to them in that context. VBP ascribes to **shared** decision-making in partnership	**Sharing** in the inter-personal process of decision-making about the aesthetic values in a person's life in the past, currently, and as envisaged in the future may mediate therapeutic gains. The **sharing** in the decision-making process may be evaluated and valued for its beauty
Story-making	Values-based practice's communication pointer and the making of decisions in partnership inevitably require an interpersonal process that necessarily entails the generation of a context-specific **narrative**	A context-specific **narrative** in the decision-making may deliberately be **created** to be about beauty (and ugliness) in the past, beauty generated in the decision-making process, and the desired beauty in the future
Trust	Reasoning and communication in VBP are dependent on an interpersonal space and process where the participants in the decision-making **trust** that mutual respect for differences of values will prevail.	Therapeutic gain may be mediated by venturing to **trust** participants in the decision-making with the beauty and ugliness in one's past and current life, and desires for the future

Table 23.2 Continued

Relationship-based therapeutic mediators	Decision-making in values-based practice (verify with Table 23.1)	Social aesthetic values: beauty and ugliness in the past, present, and future
Alliance	The partnership in VBP decision-making is also dependent on **trust** among the decision-makers	
	Participants in VBP decision-making find **alliance** in the shared values among participants, serving as a safe space and framework within which differences of values may be accounted for. **Alliance** among the participants is necessary for shared decision-making and partnership	Therapeutic gain may be mediated by an **alliance** in exploring and setting of beautiful goals
Hope for improvement	The practical decision-making process of VBP is premised on the **hope** and **expectation** that mutual respect for differences of values will prevail and that a shared decision will be made in partnership	Therapeutic gain may be mediated by the **expectation** and **hope** that beauty may be created through decision-making

necessarily interpersonal interaction with the various role players including the patient and the multi-disciplinary team. In the pursuit of social aesthetics through decision-making in VBP, communication is deliberately about the aesthetic values in a person's life in the past, currently, and as envisaged in the future. In addition, the communication in the decision-making process may be evaluated and valued for its beauty.

Sharing interpersonally is another prerequisite in therapies of various kinds (Gehman et al., 2022; Khurgin-Bott & Farber, 2011). In CBT, the patient has to share his thoughts, including automatic negative thoughts. In analytic and dynamic therapies, the sharing of experiences is not only a first step, but at the core of the healing process (Malan & Parker, 1995). Sharing serves accordingly to lighten the burden of suffering. Through sharing, suppressed emotional contents may surface, and past traumatic events that have been experienced only partially, with pending emotions about these still haunting the patient, may be experienced and become more integrated through sharing. Sharing features in VBP in two ways. First, it requires that the reasoning and communication skills be used in a decision-making process whereby the various participants share with each other which values are important to them in that context. Second, VBP also ascribes to shared decision-making in partnership. Sharing in the inter-personal process of decision-making about the aesthetic values in a person's life in the past, currently, and as envisaged in the future may mediate therapeutic gains. The very process of sharing in the decision-making process may also be evaluated and valued for its beauty.

That therapeutic gain may be mediated by story-making is well-known (Bergner, 2007). Narrative therapy and story therapy espouse this as their key therapeutic orientation (Ghavibazou et al., 2022). Narrative therapy guides patients to develop alternative stories about their lives so they better match who and what they want to be, leading to positive change. Story-making is also described as a therapeutic technique by which patients are enabled to express, explore, and communicate that which matters to them within the safety of a story. The idea is that the story reveals themes, relationships, and problems, which are informative regarding the experiences and patterns in a patient's life. VBP's communication pointer and the making of decisions in partnership inevitably require an interpersonal process that necessarily entails the generation of a context-specific narrative. The African version of VBP foregrounds this substantive communicative process explicitly as a story-generating process (Van Staden & Fulford, 2015). Drawing then specifically on social aesthetic values, the narrative may entail the (hi)story of beauty (and the lack thereof) in a patient's life. The narrative may also be co-created as a story about the beauty that the patient wants to pursue, generate, and practise in his or her current and future life. In other words, co-produced decision-making guided by aesthetic values may comprise story-making with beautiful and ugly, tasteful, pleasing, reflective, and appreciative contents—becoming thus a story with aesthetic value.

Trusting the therapist is common mediator in various psychotherapies (Malan & Parker, 1995; Rathod et al., 2019). Reasoning and communication in VBP are similarly dependent on an interpersonal space and process where the participants in the decision-making trust that mutual respect for differences of values will prevail. The partnership in VBP decision-making is also dependent on trust among the decision-makers. Drawing specifically on social aesthetic values, therapeutic gain may be mediated by the patient's venturing into trusting the participants in the decision-making with the beauty and ugliness in his or her past, current life, and desires for the future.

The positive relationship between alliance and therapeutic outcome has been robustly established, as reported in a meta-analysis of 295 independent studies that involved more than 30,000 patients (Flückiger et al., 2018). Alliance among participants in VBP decision-making may be found in the shared values that serve as a safe framework and space within which differences of values may be accounted for. Alliance among the participants is also necessary for shared decision-making and partnership. In social aesthetic terms, therapeutic gain may be mediated by an alliance in exploring beauty in the past and current life of the patient, and by setting beautiful goals.

Hope, or more specifically, the expectation of improvement has been identified as a common therapeutic mediator (Cheavens & Guter, 2018; Gallagher et al., 2020; Hernandez & Overholser, 2021). The practical decision-making process of VBP is premised on the hope and expectation that mutual respect for differences of values will prevail and that a shared decision will be made in partnership. In social aesthetic terms, therapeutic gain may be mediated by the expectation and hope that beauty may be created through decision-making. VBP deliberately draws on an expectation for participation in shared decision-making and story-making. This expectation may be imbued

with an expectation of beauty whereby participants in shared decision-making may look forward to creating the desired beauty in that person's life.

Therapeutic Gains Potentially Unleashed by Deploying Social Aesthetic Values in the Decision-Making of Values-Based Practice

Table 23.3 highlights therapeutic gains that may be unleased when deploying social aesthetic values in the decision-making of VBP. The therapeutic gains are recognition, understanding, insight, agency, and liberty.

Recognition may serve as therapeutic mediator in one sense—that is, in as much as it is about knowing that which one perceives (Slade & Holmes, 2019; Voutilainen et al., 2010). Recognition in this sense is dependent on the therapeutic mediator, raising awareness, considered in Table 23.2. VBP uses recognition in this sense in that it recognizes that values originate from various perspectives, requiring practically that both the shared and the diverging values be recognized actively through awareness, knowledge, reasoning, and communication.

In another sense, recognition may be a therapeutic gain (Lindhiem et al., 2016). This sense is about giving recognition for the important place of something. VBP recognizes theoretically and practically the inevitable place of values in decision-making, conflicts and scientific advances, captured in the principles that link values with evidence. By deploying social aesthetic values in VBP decision-making, participants may recognize (in the former sense) the beauty and ugliness in the past and currently, and which beauty is worthwhile pursuing henceforth. Recognizing the social aesthetic values in this way may mediate therapeutic gains. Giving recognition to the importance of beauty (and other social aesthetic values) would constitute a therapeutic gain when these values are given an important place in one's life such that beauty and taste, especially in the way one is living, are pursued.

Various psychotherapeutic approaches pursue understanding as a gain. For example, dynamic psychotherapies aim for the patient understanding (subconscious) patterns in intra—and interpersonal processes (Malan & Parker, 1995; Wallace, 1983). Cognitive behaviour therapies aim for the patient understanding his or her automatic and dysfunctional thoughts and behaviours as well as how these should change (Hawton et al., 1996). Outside formal therapy in ordinary living, one may also anticipate that improved understanding holds promise of therapeutic change. In VBP decision-making, mutual understanding of the values of each other may be achieved through (the skills of) awareness, knowledge, reasoning, and communication. By deploying social aesthetic values in VBP decision-making, understanding may be generated and gained of the beauty and tastefulness (and lack thereof) in one's situation, how this aesthetic situation came about, and which beauty and taste in one's life will be worthwhile pursuing in future.

Table 23.3 Therapeutic gains potentially unleashed by deploying social aesthetic values in the decision-making of values-based practice

Therapeutic gains	Decision-making in values-based practice (verify with Table 23.1)	Deploying social aesthetic values therapeutically in decision-making
(Giving) Recognition	Values-based practice **recognizes** that values originate from various perspectives, requiring practically that both the shared and the diverging values be **recognized** actively through awareness, knowledge, reasoning, and communication. VBP gives **recognition for** the theoretical place of values in decision-making, conflicts, and scientific advances, captured in the principles that link values with evidence	**Recognize** the beauty and ugliness in the past and currently, and which beauty is worthwhile pursuing henceforth, by identifying such beauty and ugliness as well as giving beauty its due place
Understanding	Mutual **understanding** of the values of each other may be achieved through (the skills of) awareness, knowledge, reasoning, and communication	Generate **understanding** by evaluating the beauty and the ugliness in one's situation, how this aesthetic situation came about, and imagine creatively the beauty worthwhile pursuing in the future
Insight	**Insight** regarding which actions to take in the given context may result from (the skills of) knowledge, reasoning, and communication, creating conjointly decisions in partnership that account for both shared and diverging values	Make **insightful** decisions by which to take action and create the beauty desirable in the future. **Implement** the decisions in pursuing beauty in living
Agency	**Agency** of the various role-players is recognized and facilitated in the reasoning and the communication as required by VBP. VBP deliberately generates space and opportunity for **agency** by requiring that decisions be created conjointly in partnership	Become an **agent** in recognizing and understanding beauty and ugliness in life, and take action in creating beauty
Liberty	Values-based practice deliberately creates **space** and **opportunity** for the values of the various role players to feature in creative decision-making **without suppressing** those values that conflict or the values of some of the role-players	Create **space** and **opportunity** for an evaluation of beauty and ugliness in the past and currently. Be inspired both by beauty and the pursuit of it, by which one may be **liberated from restriction** (from) **and opposition** (to such beauty)

Insight is a therapeutic gain pursued in various kinds of therapies (Høglend & Hagtvet, 2019; Jennissen et al., 2018; Startup et al., 2006). One kind of dynamic psychotherapy, for example, even highlights this in its name, that is, insight-oriented psychotherapy (Wallace, 1983). Insight depends on understanding a particular context but extends to taking action in accordance with this understanding. In VBP decision-making, insight may be gained therapeutically regarding which actions to take in the given context resulting from an understanding of the values pertaining in that situation. By deploying social aesthetic values in VBP decision-making, insightful decisions may be made and implemented by which to take action and create the beauty and the tastefulness that are desirable in the person's life.

Increased agency is also recognized as a therapeutic gain (Adler, 2012; Anderson & Perlman, 2022; Williams & Levitt, 2007). In VBP, the agency of each of the role-players is facilitated in the reasoning and communication about values. VBP deliberately generates space and opportunity for agency by requiring that decisions be created conjointly in partnership. By deploying social aesthetic values in VBP decision-making, agency is taken up in various social aesthetic actions. Thereby, participants become agents in recognizing and understanding beauty and ugliness in someone's life, and they take action in creating beautiful goals, a beautiful plan, and a beautiful life story. The increased agency is not merely that of an individual but is co-produced by the prescripts of VBP. Interpersonal skills are utilized to nurture an appositional (i.e., being on the same side) attitude when the (social aesthetic) values are clashing. Thereby the clinician remains on the side of the patient even when the patient's (social aesthetic) values are very different from, and even in conflict with those of the clinician. This generates a 'we' in the actions of clinical decision-making—that is, co-agency and co-authorship in these actions, in which clinician and patient join forces, so to speak, towards creating the beauty that the patient desires for his or her life.

Some patients experience therapy as liberating them from restriction, oppression, and opposition (Comas-Díaz, 2020; Lotter & Van Staden, 2019; Paul et al., 2020; Thompson, 2019). They also experience liberation to pursue their wishes (Lotter & Van Staden, 2022). VBP deliberately creates space and opportunity for the values of the various role players to feature in creative decision-making without opposing, restricting, or suppressing those values that conflict. Nor does VBP disallow, restrict, or suppress the values of some of the role-players, but deliberately seeks out the values of all the role-players. By deploying social aesthetic values in VBP decision-making, liberty is created for an evaluation of beauty and ugliness in one's past and currently. By espousing social aesthetic values in VBP decision-making, one may be liberated from restriction (from beauty) and opposition (to such beauty). Moreover, beauty may conversely inspire the liberty to create and pursue it in one's life.

The therapeutic gains that may thus be pursued and unleashed by deploying social aesthetic values in the decision-making of VBP are: (i) that the importance of aesthetic values in the patient's life is given **recognition**; (ii) **understanding** the aesthetics and its origins in one's situation, and imagining creatively the beauty worthwhile pursuing;

(iii) making and implementing **insightful** decisions by which to take action and create the beauty desirable in future; (iv) becoming an **agent** in recognizing and understanding beauty and ugliness in one's life, and taking action in creating beauty; and (v) being inspired by beauty and the pursuit of it, by which one may be **liberated** from restriction from and opposition to such beauty. These therapeutic gains may be mediated by **raising awareness, communication, interpersonal sharing, story-making, trust, alliance,** and **hope** for improvement—all in terms of social aesthetic values.

Conclusion

This chapter has drawn connections between social aesthetics, decision-making in VBP, and therapeutic gains. In virtue of these connections, therapeutic gains may potentially be unleashed by deploying social aesthetic values in the decision-making of VBP. A prerequisite for yielding the therapeutic gains from deliberately deploying social aesthetic values in clinical decision-making, is recognizing the broad variety of social aesthetic values outlined in the first part of this chapter. If the clinician does not recognize a social aesthetic value, it cannot be made the focus of (therapeutic) attention. Recognizing the scope and the reach of aesthetic values is a conceptual skill in the first place. It is also a practical interpersonal skill that hinges on substantive communication, as prescribed by VBP.

Values-based practice creates a decision-making process for becoming aware and recognizing aesthetic values, which may potentially unleash therapeutic gains by generating an appreciation of both the beauty, lack thereof, ugliness, and tastefulness in a patient's situation, and by co-producing a therapeutic pursuit that generates and creates beauty in a patient's situation, including a beautiful plan to achieve this. VBP decision-making, furthermore, may champion social aesthetic values by utilizing interpersonal skills in deliberately generating space for the uncovering and exploring of aesthetic values, and generating a shared story (of beauty) in the substantive communication of VBP decision-making. This process of increased awareness, engagement, and story-making in the decision-making of VBP may inspiringly unleash therapeutic gains in a similar way that various kinds of psychotherapies do.

The main claim of this chapter, that therapeutic gains may be unleashed by deploying social aesthetic values in co-producing health-care decisions, has neither been argued for as a logical necessity nor has it been a claim in terms of probability and efficacy. The efficacy of VBP decision-making in deploying social aesthetic values for yielding therapeutic gains would require an empirical study that follows ideally a randomized controlled designed. To this end, this chapter proffered both an intervention and a hypothesis regarding the intervention's efficacy. However, each instance of co-producing a decision in VBP is not dependent on such a study before it can be enriched by deploying social aesthetic values deliberately.

NOTES

1. Decision-making is taken as being distinct from the process of informed consent, notwithstanding that these processes may overlap practically in some instances (Van Staden, 2015).
2. In this section on the therapeutic mediators and gains, beauty and ugliness are used as examples of social aesthetic values. One may apply other examples too: whether tasteful, in poor taste, pleasing, joyful, evocative, disgusting, reflective, appreciative, etc.

REFERENCES

Adler, J. M. (2012). Living into the story: Agency and coherence in a longitudinal study of narrative identity development and mental health over the course of psychotherapy. *Journal of Personality and Social Psychology* 102(2), 367.

Anderson, T., & Perlman, M. R. (2022). Therapist and client facilitative interpersonal skills in psychotherapy. In J. N. Fuertes (Ed.), *The other side of psychotherapy: Understanding clients' experiences and contributions in treatment* (pp. 99–124). American Psychological Association.

Arora, S., & Arora, G. (2021). Recognizing 'medical aesthetics' in dermatology: The need of the hour. *Indian Journal of Dermatology, Venereology and Leprology* 87(1), 1–2.

Bergner, R. M. (2007). Therapeutic storytelling revisited. *American Journal of Psychotherapy* 61(2), 149–162.

Case, C., & Dalley, T. (2014). *The handbook of art therapy*. Routledge.

Cheavens, J. S., & Guter, M. M. (2018). Hope therapy. In M. W. Gallagher & S. J. Lopez (Eds.), *The Oxford handbook of hope* (pp. 133–142). Oxford University Press.

Cohen, T., & Guyer, P. (1982). *Essays in Kant's aesthetics*. University of Chicago Press.

Coleman, E. B., Hartney, C., & Alderton, Z. (2013). Defining 'social aesthetics'. *Literature & Aesthetics* 23(1), 1–11.

Comas-Díaz, L. (2020). Liberation psychotherapy. In L. Comas-Díaz & E. T. Rivera (Eds.), *Liberation psychology: Theory, method, practice, and social justice* (pp. 169–185). American Psychological Association.

Crepaz-Keay, D., Fulford, K. W. M., & Van Staden, C. W. (2015). Putting both a person and people first: Interdependence, values-based practice and African Batho Pele as resources for co-production in mental health. In J. Z. Sadler, C. W. Van Staden, & K.W.M. Fulford (Eds.), *Oxford handbook of psychiatric ethics* (pp. 60–87). Oxford University Press.

Crowther, P. (1989) *The Kantian sublime: From morality to art*. Oxford University Press.

Flückiger, C., Del Re, A. C., Wampold, B. E., & Horvath, A. O. (2018). The alliance in adult psychotherapy: A meta-analytic synthesis. *Psychotherapy* 55(4), 316.

Fulford, K. W. M., & Van Staden, W. (2013). Values-based practice: Topsy-turvy take home messages from ordinary language philosophy. In K. W. M. Fulford, Davies, R. Gipps, G. Graham, J. Sadler, G. Stanghellini, & T. Thornton (Eds.), *Oxford handbook of philosophy and psychiatry* (pp. 385–412). Oxford University Press.

Fulford, K. W. M., & Van Staden, W. (2020). Finding a word for it: An ordinary language philosophical perspective on the role of values-based practice as a partner to evidence-based practice. In D. Stein & I. Singh (Eds.), *Global mental health and neuroethics* (pp. 17–36). Elsevier Academic Press.

Fulford, K. W. M., Peile, E., & Carroll, H. (2012). *Essential values-based practice: Linking science with people*. Cambridge University Press.

Gallagher, M. W., Long, L. J., Richardson, A., D'Souza, J., Boswell, J. F., Farchione, T. J., & Barlow, D. H. (2020). Examining hope as a transdiagnostic mechanism of change across anxiety disorders and CBT treatment protocols. *Behavior Therapy 51*(1), 190–202.

Gehman, R. M., Pinel, E. C., Johnson, L. C., & Grover, K. W. (2022). Emerging ideas. A ripple effect: Does I-sharing with a stranger promote compromise in cohabiting couples? *Family Relations 72*(3), 794–801. https://doi.org/10.1111/fare.12677.

Ghavibazou, E., Hosseinian, S., Ghamari Kivi, H., Ale Ebrahim, N., & Ale Ebrahim, N. (2022). Narrative therapy, applications, and outcomes: A systematic review. *Preventive Counseling 2*(4). https://doi.org/10.2139/ssrn.4119920.

Gordon-King, K., Schweitzer, R. D., & Dimaggio, G. (2018). Metacognitive interpersonal therapy for personality disorders featuring emotional inhibition: A multiple baseline case series. *Journal of Nervous and Mental Disease 206*(4), 263–269.

Hawton, K. E., Salkovskis, P. M., Kirk, J. E., & Clark, D. M. (1996) *Cognitive behaviour therapy for psychiatric problems: A practical guide*. Oxford University Press.

Henley, D. R. (1992). Aesthetics in art therapy: Theory into practice. *The Arts in Psychotherapy 19*(3), 153–161.

Hernandez, S. C., & Overholser, J. C. (2021). A systematic review of interventions for hope/hopelessness in older adults. *Clinical Gerontologist 44*(2), 97–111.

Hinchey, L. M. (2018). Mindfulness-based art therapy: A review of the literature. *Inquiries Journal 10*(05), 1.

Høglend, P., & Hagtvet, K. (2019). Change mechanisms in psychotherapy: Both improved insight and improved affective awareness are necessary. *Journal of Consulting and Clinical Psychology 87*(4), 332.

Huron, D. (2016). Aesthetics. In S. Hallam, I. Cross, & M. Thaut (Eds.), *Oxford handbook of music psychology* (pp. 233–245). Oxford University Press.

Jennissen, S., Huber, J., Ehrenthal, J. C., Schauenburg, H., & Dinger, U. (2018). Association between insight and outcome of psychotherapy: Systematic review and meta-analysis. *American Journal of Psychiatry 175*(10), 961–969.

Kant, I. (1987). *Critique of judgment*. Hackett Publishing.

Khurgin-Bott, R., & Farber, B. A. (2011). Patients' disclosures about therapy: Discussing therapy with spouses, significant others, and best friends. *Psychotherapy 48*(4), 330.

Kirmayer, L. J., Mezzich, J. E., & Van Staden, W. (2016). Health experience and values in person-centered assessment and diagnosis. In J. E. Mezzich, M. Botbol, G. Christodoulou, C. R. Cloninger, & I. Salloum. (Eds.), *Person centered psychiatry* (pp. 179–199). Springer.

Kivy, P. (2004). *The Blackwell guide to aesthetics*. Blackwell.

Lane, R. D., Subic-Wrana, C., Greenberg, L., & Yovel, I. (2022). The role of enhanced emotional awareness in promoting change across psychotherapy modalities. *Journal of Psychotherapy Integration 32*(2), 131.

Lindhiem, O., Bennett, C. B., Orimoto, T. E., & Kolko, D. J. (2016). A meta-analysis of personalized treatment goals in psychotherapy: A preliminary report and call for more studies. *Clinical Psychology: Science and Practice 23*(2), 165–176.

Lotter, C., & Van Staden, W. (2019). Verbal affordances of active and receptive music therapy methods in major depressive disorder and schizophrenia-spectrum disorder. *The Arts in Psychotherapy 64*, 59–68.

Lotter, C., & Van Staden, W. (2022). Patients' voices from music therapy at a South African psychiatric hospital. *South African Journal of Psychiatry 28*, a1884.

Malan, D., & Parker, L. (1995). *Individual psychotherapy and the science of psychodynamics*. Butterworths.

Musalek, M. (2010). Social aesthetics and the management of addiction. *Current Opinion of Psychiatry 23*, 530–553.

Musalek, M. (2017). *Der Wille zum Schönen (I und II)*. Berlin: Parados Verlag.

Paul, N., Lotter, C., & Van Staden, W. (2020). Patient reflections on individual music therapy for a major depressive disorder or acute phase schizophrenia spectrum disorder. *Journal of Music Therapy 57*(2), 168–192.

Rashed, M. A., Du Plessis, R. R., & Van Staden, W. (2015). Culture and mental health. In W. Weiten, & J. Hassim (Eds.), *Psychology: Themes & variations* (pp. 486–505). Cengage Learning.

Rathod, S., Phiri, P., & Naeem, F. (2019). An evidence-based framework to culturally adapt cognitive behaviour therapy. *The Cognitive Behaviour Therapist 12*, E10.

Sackett, D. L., Rosenberg, W. M., Gray, J. M., Haynes, R. B., & Richardson, W. S. (1996). Evidence-based medicine: What it is and what it isn't. *British Medical Journal 312*, 71–72.

Scheibenbogen, O., & Musalek, M. (2021). The will to beauty as a therapeutic agent: Aesthetic values in the treatment of addictive disorders. In D. Stoyanov, B. Fulford, G. Stanghellini, W. Van Staden, & M. T. H. Wong (Eds.), *International perspectives in values-based mental health practice: Case studies and commentaries* (pp. 59–67). Springer.

Slade, A., & Holmes, J. (2019). Attachment and psychotherapy. *Current Opinion in Psychology 25*, 152–156.

Startup, M., Jackson, M. C., & Startup, S. (2006). Insight and recovery from acute psychotic episodes: The effects of cognitive behavior therapy and premature termination of treatment. *Journal of Nervous and Mental Disease 194*(10), 740–745.

Thompson, C. E. F. (2019). *A psychology of liberation and peace*. Springer.

Van Staden, C. W. (2002). Linguistic markers of recovery: Theoretical underpinnings of first person pronoun usage and semantic positions of patients. *Philosophy, Psychiatry, & Psychology 9*(2), 105–121.

Van Staden, C. W. (2005). The need for trained eyes to see facts and values in psychiatric diagnosis. *World Psychiatry 4*(2), 94.

Van Staden, C. W. (2006). Conceptual and experiential estrangement of the self: A neo-Fregean elucidation. *South African Journal of Psychiatry 12*(2), 16–21.

Van Staden, C. W. (2015). Informed consent to treatment. In J. Z. Sadler, C. W. Van Staden, & K. W. M. Fulford (Eds.), *Oxford handbook of psychiatric ethics* (pp. 1129–1142). Oxford University Press.

Van Staden, C. W., Cloninger, C. R., & Cox, J. (2023). Holistic framework in person-centered medicine. In J. E. Mezzich, J. W. Appleyard, P. Glare, & R. Wilson (Eds.), *Person centered medicine* (pp. 85–104). Springer.

Van Staden, C. W., & Fulford, K. W. M. (2015). The Indaba in African values-based practice: Respecting diversity of values without ethical relativism or individual liberalism. In J. Z. Sadler, C. W. Van Staden, & K. W. M. Fulford (Eds.), *Oxford handbook of psychiatric ethics* (pp. 295–318). Oxford University Press.

Van Staden, W. (2011). African approaches to an enriched ethics of person-centred health practice. *International Journal of Person Centered Medicine 1*(1), 14–17.

Van Staden, W. (2020). Culture in person- and people-centered health care. *International Journal of Person Centered Medicine* 10(1), 69–80.

Van Staden, W. (2021a). 'Thinking too much': A clash of legitimate values in clinical practice calls for an indaba guided by African values-based practice. In D. Stoyanov, B. Fulford, G. Stanghellini, W. Van Staden, & M. T. H. Wong (Eds.), *International perspectives in values-based mental health practice: Case studies and commentaries* (pp. 179–187). Springer.

Van Staden, W. (2021b). Values constitute the boundaries in between the rules of nature and social recognition. *Philosophy, Psychiatry, & Psychology* 28(4), 315–317.

Voutilainen, L., Peräkylä, A., & Ruusuvuori, J. (2010). Recognition and interpretation: Responding to emotional experience in psychotherapy. *Research on Language and Social Interaction* 43(1), 85–107.

Wallace, E. R. (1983). *Dynamic psychiatry in theory and practice*. Lea and Febiger.

Williams, D. C., & Levitt, H. M. (2007). Principles for facilitating agency in psychotherapy. *Psychotherapy Research* 17(1), 66–82.

Wright, J. H., Brown, G. K., Thase, M. E., & Basco, M. R. (2017). *Learning cognitive-behavior therapy: An illustrated guide*. American Psychiatric Press.

Wu, S., Pan, B. L., An, Y., An, J. X., Chen, L. J., & Li, D. (2019). Lip morphology and aesthetics: Study review and prospects in plastic surgery. *Aesthetic Plastic Surgery* 43(3), 637–643.

Zivkovic, A. (2022). The use of interpretive dynamic transactional analysis psychotherapy (IDTAP) in facilitating structural integration when working with reenactments of developmental trauma in the psychotherapeutic setting. *Transactional Analysis Journal* 52(2), 120–133.

CHAPTER 24

IMAGES OF CARE

'To the Things Themselves!'

GIOVANNI STANGHELLINI AND GEORGE IKKOS

Introduction

In this chapter we argue for the relevance to psychiatry of philosophical phenomenology's motto 'To the things themselves!' and the relevance of clinical phenomenology's tenet 'To understand is to care'. Taken together, the result is that psychiatry should take care of the things themselves. Yet, what does it mean to say: 'To the things themselves!'? Which 'things' are we talking about? What does it mean to 'understand'? How do we get to the 'things themselves' and understand them? And, ultimately, what does 'care' consist of?

Both psychiatry and clinical psychology stifle the phenomenon, its presence, the presence of the Other, of 'things themselves'. Psychiatry does not deal with meanings, but certainly not because it aims to 'things themselves'. It deals with the *causes* of phenomena, tries to explain (*scire per causas*), not to understand in a sense. The dream of psychiatry is to trace the causes of the symptoms and neutralize the symptoms *in statu nascendi*. Psychiatry is (would like to be) a mechanical science of the symptom. Compared to the intentions of psychiatry, the intentions of psychological hermeneutics, which deals with the *meanings* of phenomena, seem a relief and progress. The dream of psychology, or at least of certain psychology (such as that of psychodynamic inspiration), is to bring to light the authentic meaning of a symptom. Psychodynamic psychology is (would like to be) an archaeology of the symptom (Stanghellini & Mancini, 2017).

We don't propose to renounce the search for causes and meanings, or for conceptual operational definitions of psychopathological phenomena whose aim is diagnosis. Rather we suggest that, to *understand and offer healing care for* a given psychopathological phenomenon, clinicians need *also* to develop the capacity to create images. Therefore, we introduce the work of Walter Benjamin (15 July 1892–26 September 1940)

(Eiland & Jennings, 2016; Ikkos, 2020), especially his search for 'dialectical images' and his engagement with Charles Baudelaire's poems and the poet's 'spleen'. We suggest that Benjamin's philosophy and poetics can enrich clinical understanding of both care giver and care seeker as active personal and social agents situated in their complex relationship and historical moment.

Understanding and the Importance of Images

Understanding is not interpreting, attributing a meaning that is replacing a manifest content considered superficial and misleading with a latent content which is considered profound and authentic. As the fumes of machines poison the atmosphere, interpretations and explanations cloud our sensitivity (Sontag, 2003). Transparency is the highest value and the most liberating. Transparency means letting the brightness of the phenomenon—or its darkness (which is the same), in a single word its 'luminescence'—of the thing itself, of things as they are, of the Other—manifest themselves freely. As artificial light abolishes twilight (Benjamin, 1999b) the slow transition from day to night and from night to day and, with it, the aura that lets the unpredictable shine through; thus the thinking that searches for explanations and interpretations transforms the sensitive and concrete presence of phenomena into a world of simulacra made of meanings and causes. It trades the concrete world of the senses for the abstract world of thought. Thinking in terms of latent causes and meanings also implies seeing everything and every person, including oneself, as particular instances of a general category. Explaining and interpreting, therefore, involve bringing the particular to the general and then returning to the particular to explain it or interpret it, as an example of the general. In this way we may become deeply alienated from our living experience and our humanity (Stanghellini, 2022a).

Understanding originates from witnessing the phenomenon, letting the Other manifest itself. Understanding means to go to the 'things themselves'. The 'things themselves' in the clinical context is the experience of the world from the patient's perspective. Thus, understanding requires a *descriptive* vocabulary and not interpretative or explanatory. Understanding originates from the suspension or bracketing of the search for causes and meanings. The ultimate goal of understanding, whether attainable or not, is to settle in the place of the phenomenon, that is in the place of the Other; or, in the clinical context, in the place of the patient's experience—or to approximate it as much as possible (Stanghellini & Fuchs, 2013). Not 'in front of' the phenomenon, but at least next to it, side by side to it; if not in the place of the Other, at least in the perspective of the Other. To borrow Rilke's words (VIII Elegy), understanding means that this is not destiny: to be in front and in front always (Rilke, 1963).

If this is understanding, why is such understanding caring or healing? The first act of care is to let the phenomenon manifest itself. Let the Other be. Carelessness is

disregarding the phenomenon. Letting the Other *be* is the positive compared to leaving the Other *alone*, which is the negative. The Other is left alone when he is disregarded, and this often happens under the pretext of seeking the meaning or cause of the phenomenon he embodies. Going in search of causes and meanings is equivalent to moving away from the Other, from his concrete and incandescent presence. That said, the Other without my presence implodes in himself.

Madness is the implosion of the Self in itself, which happens when it is deprived of the counterweight of the Other. For this reason—because it avoids implosion, sinking, closing the Self in itself—to understand, insofar as letting the Other be, the phenomenon, in its *luminescence*, freeing it from suffocating opacity or from the dazzling light that explanations and interpretations throw on it, is equivalent to healing. Understanding prevents the Other from imploding into itself and its aroma dispersing in the desert air. In this form of understanding in which sense experience is in the foreground with respect to the abstractions of thought, images play a crucial role more so than concepts. However, we must distinguish *images* from *representations*. Representations are artificial, dummy formulas through which we believe we are domesticating the phenomenon, the Other, superimposing on it something—a lens, a film, a map—that reassures us, suggesting that the Other is reappearing identical to how we had previously met him, or at least analogous to something else we had already known.

From this perspective, phenomenology is the *discipline of sensibility*, that is the method (perhaps the only one) that allows us to abandon our perspective on the phenomenon and try instead to give the word to the phenomenon, in the sense of reintegrating its original sensoriality, letting it speak, listening in silence to its voice—finally crossing the threshold of the limit that lets oneself be invested by the phenomenon to the point that the difference (that is the distance) between me and the phenomenon almost cancels itself, almost as if the phenomenon and I end up settling in the same place. Phenomenology, however, is not only this: it is also the search for the so-called 'transcendental' conditions of possibility of the manifestation of the phenomenon itself. Yet this goes beyond the purpose of this paper.

Phenomenology is the art of reflecting the singularity of the phenomenon, of the material fact as it is. However, there is a difference between *giving the word to the phenomenon* (that is letting it speak for itself, avoiding overwriting, and helping bring it to light, cleansing it from the encrustations of the multiple speeches that do not let its luminescence manifest) and *finding the words to express the phenomenon*. The first is an *ethical* instance, the second *aesthetic*—in the fully positive sense of the term. In the first case it is the voice of the phenomenon that invests me. I let myself be invested by the voice that *emanates from* the phenomenon itself. But sometimes this voice is weak or drowned out by the din of the voices of others. In the second, it is *I* who try to give body to the sometimes faint and inaudible voice of the phenomenon through my voice. Finding a way to give voice to the phenomenon—this is an *art*. It is *my* voice that tries to get closer to things themselves. It is *I* who give my voice to give voice to the things themselves. To do this *I* need to create images. This is exactly Benjamin's focus—and our own too.

Dialectical Images

Benjamin's dialectical images (*dialektisches Bilder*) are a central category in his thinking. The term 'image' (*Bild*) does not primarily refer to the sphere of vision or visual perception, but to the properly linguistic sphere. Thus, images to Benjamin are not pictures like photographs, paintings, etc., but *ideas—Denkbilder*, which can be translated as 'images of thought'. They are also unlike *concepts*. Whereas ideas are evoked by objects when they show themselves to us if we engage with them in their terms, concepts reflect our theories as they emerge in philosophy and science, often as part of our ambition to manipulate nature in our interests.

Benjamin's images are 'dialectical' because in them the tension between opposites is at its highest: when they fuse two terms between which there is an opposition, instead of merely showing a dichotomy, dialectical images show an unresolved tension. In dialectical images, opposing moments coexist plastically, without this opposition being resolved in a superior synthesis (Pinotti, 2018). 'Ideas are to objects like constellations to stars'—writes Benjamin (1988, 34). This means that just as the constellations we see in a starry night are not the way in which stars aggregate according to the laws of nature, but according to the human eye that sees them from afar and groups them into perspicuous configurations, so too dialectical images are 'constructed' in the eye of the beholder— they depend on the way the beholder *engages* with what he sees. Thus, what is revealed in dialectical images are not atemporal essences, but rather the outcome of the here-and-now subject–object engagement.

Dialectical images are 'montages' in the cinematographic sense of the term. That is, by means of shock-inducing juxtapositions, they show similarities, correspondences, contrasts, etc. that would otherwise have remained invisible. An example of a dialectical image is the prostitute, seen as both seller and commodity.

A dialectical image, and the relative shock it produces, can arise in various ways. An example given by Benjamin is that of the rolled-up socks he received as a gift as a child; when unrolling the socks he was stunned by the discovery that the gift is its own wrapping—both the case and what is in it. Ultimately form and content coincide (Benjamin, 2006). This means that a dialectical image can arise as a sudden intuition not sought by the subject. Another example, which this time consists of a deliberate montage of images, is provided by Georges Bataille (2016) through the juxtaposition of images of the legs of cancan dancers and that of ox quarters in a slaughterhouse. The juxtaposition of these two images reveals the extent to which the body of the dancers can be seen as slaughterhouse meat. The aim is to reduce to the point of elimination the perceptual habit in which objects from our everyday world and history remain enveloped, and to allow unimagined and even unheard-of profiles of such objects to emerge. This aim is not at all distant from what phenomenology wants to achieve through the practice known as *epochè*—the bracketing of preconceptions, gateway to 'the things themselves' (De Monticelli, 2018).

For dialectical images to emerge, we must actively adopt a passive stance, overcome the errors of 'prattling' human language and rediscover their proper names in things. To achieve this, we need to attend to *nonsensuous similarities* (Ikkos, 2022). Though never defining the term tightly, Benjamin discusses nonsensuous similarities in his 1933 essay 'On the Mimetic Faculty' (Benjamin 2002a) and continues using the phrase later. He reminds us that imitation is a natural phenomenon, most obviously in the form of mimicry. It suggests a 'reading' of surroundings resulting in correspondence between organism and environment. An example of this is dancing (to the stars)—an early form of 'reading' based on a pre-conceptual resonance or attunement between the dancers' bodies and the stars. We may therefore understand nonsensuous similarities as referring to *non-conceptual attunement* to our world. Dancing to the stars has been a form of embodying meaning and conviction of truth. Though entirely nonverbal and non-conceptual, dance had truth content for the dancer. This early confidence in its truth was justified, as it must have had evolutionary survival value. Over time, however, both organism and environment have changed, and dance and related communal practices (e.g., cultic rituals) have weakened in persuasiveness.

'Reading' the firmament had survival value for a hunting and migrating species. Naturally acquired fascination with the sky then led to astrology and, later, astronomy and physics, contributing to previously unimaginable insights and manipulation of nature. Through astrology, 'reading' the stars also led to psychology and finally to psychopathology, which share with astrology the same purpose of 'reading' the human soul and forecasting human behaviour, although in a more sophisticated technological manner. Benjamin was excited by the promise of technology, but anxious that any decline in ability to perceive nonsensuous similarities impoverishes experience. The language we speak, for example, has over time become an archive of nonsensuous similarities. To Benjamin, language is not merely a set of conventional names arbitrarily given to things in the world. Adam does not betray things by subjugating them to an arbitrary sign, but rather translates what things themselves communicate to him into a name. The First Man while naming things in the world does not perform an impositional task, but a receptive one. The similarities we are able to consciously grasp are only the tip of the iceberg of infinite unconsciously grasped, nonsensuous similarities. Alluding for support to his theory that words have onomatopoeic origin, he speculated that language embodies non-sensuous similarities. Benjamin writes: 'If words meaning the same thing in different languages are arranged about that signified as their centre, we have to enquire how they all—while often possessing not the slightest similarity to one another—are similar to the signified at their centre.' In this sense, there is something ineffable about nonsensuous similarities, a characteristic of Benjamin's thought more broadly. Still, there is always a sense of the mimetic about them.

Through his youthful engagement with Zionist student politics and life-long friendship with Gershom Scholem, pioneer researcher and later first Professor of Jewish Mysticism in the newly established Hebrew University of Jerusalem (Scholem, 1981), Benjamin had a strong interest in mysticism. In the biblical paradisical state everything spoke its true name as given by Adam. Now the language of man is fallen and corrupted

and nature has fallen silent, or whispers at best. But it is in this imperfect medium that we may find the archive of nonsensuous similarities 'to read what was never written' (Benjamin, 2002a). Benjamin takes a wide view of what is language and believes that art offers a privileged avenue to the truth he seeks. However, to reach this target, art must be completed through art criticism. Susan Buck-Morss argues that for Benjamin aesthetics becomes 'a central cognitive discipline, a form of secular revelation' (Buck-Morss, 1977, XIII). Or, in Benjamin biographer Michael Jennings's words: 'We bring the salient- albeit hidden or unconscious features of our own age to consciousness through the representation of important synchronic moments of the past as they are preserved in works of art' (Jennings, 1987, 40).

A beloved analogy used by Benjamin to illustrate his methodology and sense of truth was that of forming the beautiful image of a mosaic through combining fragments. Each fragment may appear trivial by comparison to the whole yet be vital to completion. 'Just as mosaics preserve their majesty despite their fragmentation into capricious particles, so philosophical contemplation is not lacking in momentum. Both are made up of the distinct and the disparate; and nothing could bear more powerful testimony to the transcendent form of the sacred image and the truth itself. The value of fragments of thought is all the greater the less distinct the relationship to the underlying ideas and the brilliance of the representation depends as much on this value as the brilliant mosaic does on the quality of the glass paste. The relationship between the minute sion of the work and the proportion of the sculptural or intellectual whole demonstrated that the truth-content is only to be grasped through immersion in the most minute details of subject matter' (Benjamin, 1988, 28–29). As in Leibniz' monads, each of the fragments carries within it the whole of the cosmos and its significance.

Benjamin believes that whereas knowledge is reached with concepts and is open to challenge, truth is achieved intuitively and is not. Kant specified three faculties that make experience possible, and their forms, categories and transcendental ideas respectively: intuition (space and time), understanding (unity, plurality, totality, reality, negation, limitations, substance, causality, community, possibility/ impossibility, existence/ non-existence, and necessity/ contingency) and reason (God, World, Soul). According to Caygill (1998, 5) 'to a large extent Benjamin's thought may be understood as an attempt to extend the limits of experience treated within philosophy to the point where the identity of philosophy itself is jeopardized'. He 'questions not only the structure of Kant's concept of experience, but also its basic assumptions that (a) there is a distinction between the subject and the object and (b) there can be no experience of the absolute' (Caygill, 1998, 2). 'Philosophy is absolute experience deduced in a systematic, symbolic framework, as language' (Benjamin, 1996a).

It is 'critical for Benjamin's argument that space and time, Kant's forms of intuition, be regarded as forms of configurations whose plasticity, or openness to other forms of patterning, can "decay" or otherwise be transformed' (Caygill, 1998, 5). We are tempted to say that Benjamin, who had an active interest in mathematics and geometry in youth, had a conception of time and space which was closer to modern physics (Rovelli, 2018) than Kant's Newtonian one. A glimpse of his sense of immanent totality may be had

from his early piece 'The Rainbow: a dialogue on Phantasy'. In this text 'Margarethe' recounts to a painter her dream about a rainbow. She speaks of her own transformation in the dream from a Self into colour: 'I too was not, nor my understanding, that resolves things out of the images of the senses. I was not the one who saw, but only seeing. And what I saw were not things but only colors. And I too was colored into the landscape' (quoted in Caygill, 1998, 11). This is an experience the painter can relate to. As he explains in his response, when he paints, he does not represent scenes or objects but is *immersed in colour*. He says, 'Colors see themselves, they have in themselves the pure seeing and are simultaneously the object and organ of vision' (quoted in Caygill, 1998, 12). In this text, space and time defer to the primacy of colour and the medium of painterly surface becomes the vehicle for intuition in the foundational sense discussed here. Both 'The Rainbow: a dialogue on Phantasy' and its related piece 'The Rainbow or the Art of Paradise' (quoted in Caygill, 1998, 9) remained unfinished and unpublished during Benjamin's time. Nevertheless, he maintained his conviction that space and time transform into surface configurations where marks are inscribed. His attention is then focused on those marks/ words/ ideas/ dialectical images. He argues that, like in a palimpsest, we need to look meticulously in the detail to find the original script which has been overwritten by the new more dominant one.

Benjamin (1999a) considered Kant's time and space to be empty formalities and wrote in 'Trauerspiel and Tragedy': 'Historical time is infinite in every direction and unfulfilled at every moment. This means we cannot conceive of a single empirical event that bears a necessary relation to the time of its occurrence. For empirical events time is nothing but a form, but, what is more important, as a form it is unfulfilled. The event does not fulfill the formal nature of the time in which it takes place. For we should not think of time as merely the measure that records the duration of a mechanical change. Although such time is indeed a relatively empty form, to think of its being filled makes no sense. Historical time, however, differs from this mechanical time. It determines much more than the possibility of spatial changes of a specific magnitude and regularity—that is to say, like the hands of a clock—simultaneously with spatial changes of a complex nature. And without specifying what goes beyond this, what else determines historical time—in short, without defining how it differs from mechanical time—we may assert that the determining force of historical time cannot be fully grasped by, or wholly concentrated in, an empirical process'.

Simply to recount is just another form of counting (Italian: raccontare/contare; French raconter/compter) contaminated with modernity's obsession for numbers and quantification. The past does not lie there to be discovered and narrated, but to be engaged with in the light of our interests. In engaging so, we must research in detail the endangered, discarded, forgotten, and ridiculous. In Benjamin's words: 'The past does not throw its light onto the present, nor does the present illuminate the past, but an image is formed when that which has been and the Now come together in a flash as a constellation. In other words, image is a dialectic at a standstill. For while the relationship of the present to the past is a purely temporal one, the relationship of that which has been to now is dialectical: not temporal in nature but figural (*bildlich*). Only dialectical images are

genuinely historical' (Benjamin, 1999b, 463). It is in this arena that 'immersion in the most minute details of the subject matter' and the 'relationship between the minute precision of the work and the proportion of the sculptural or intellectual whole' reveal their truth content. The aim of history, that can be reached via dialectical images, is a *telescopage* of the past through the present, a vision of the past seen from the angle of the present—in the *now of knowability* (*Jetzt der Erkennenbarkeit*).

Benjamin's dialectics depends on the (manner of) engagement of the critic with the object. However, in his dialectical image there is no Hegelian synthesis of thesis and antithesis. The image emerges at the point of maximum tension. 'To thinking belongs the movement as well as the arrest of thoughts. Where thinking comes to a standstill in a constellation saturated with tensions - there the dialectical image appears. It is the caesura in the movement of thoughts. Its position is naturally not an arbitrary one. It is to be found, in a word, where the tension between dialectical opposites is the greatest' (Benjamin, 1999b, 475). To use once more Benjamin's words, the world, history, and human existence 'break down in images, not into stories' (Benjamin, 1999b, 476).

In his 'Epistemo-Critical Preface' to the 'Origin of the German Mourning Play', Benjamin averred that 'Terms for concepts are to be introduced that never appear in the entire book, except where they are defined'. Hence, in his writing, terms 'meander in meaning' (quoted in Fenves, 2011, 19). However, though always minimizing the use of concepts he never eschewed them altogether. And though he never abandoned his early terminology, particularly in relation to language, he turned to Marxism in his early thirties. This was after reading Georg Lukacs' 'History and Class Consciousness' (Lukács, 1971). Also, through his affair with Latvian Soviet children's theatre director Asja Lacis (Ikkos, 2023) and his close friendship with the German Marxist poet, playwright, and director Bertolt Brecht (Wizisla, 2016). His was a somewhat idiosyncratic Marxism which, according to Adorno, 'settled at the crossroads of magic and positivism'. 'That place is bewitched' Adorno admonished (quoted in De Cauter, 2018, 12). However, an explicit implication of Benjamin's criticisms of Kant's epistemology was that he could not account for history. At the same time, his criticism of contemporary German historicism, including in the history of art, was that it did not account for power and ideology and their effect on what is preserved, deemed worthy of study and, indeed, is studied. Or, as he put it in his final work: 'There is no document of culture which is not at the same time a document of barbarism' (Benjamin, 2003a).

If the reader is beginning by now to feel weary of the proliferation of quotations, it should be noted that Benjamin is eminently quotable, and, crucially, quotations were at the heart of his method. His use of quotations is best illustrated in his unfinished grand opus 'The Arcades Project' (Benjamin, 1999b). This detailed study of the nineteenth-century Paris Arcades which brought together the engineering, commercial, and cultural genius of the age, is saturated with quotations. Together with Benjamin's own pithy fragments they contribute to a montage. Some have argued that it remained incomplete because he lost his way and realized the impossibility of his aim. Whether this is true or not, we would argue that the apparent incompleteness is both true to his philosophy and a measure of its greatness. It perfectly illustrates his statement 'Method

of this project: literary montage. I needn't say anything. Merely to show' (Benjamin, 1999b, 460).

BAUDELAIRE'S PORTRAITS OF *SPLEEN* AS AN EXAMPLE OF THE POWER OF IMAGES

Out of the *Arcades Project* arose two of Benjamin's most significant late essays 'Paris, the Capital of the Nineteenth Century' (Benjamin, 2002b) and 'On Some Motifs in Baudelaire' (Benjamin, 2003b). Benjamin had been Baudelaire's German translator and, of course, this is extremely relevant for our purpose, as poets paint pictures with words. T.S. Elliot (1888–1965) considered Charles Baudelaire (1821–1867) the greatest poet in any language and complete innovator, a prototype of the new experience of the nineteenth century (Garland, 1950). Writing at the zenith of classical capitalism during the Paris of the second Empire, Baudelaire coined the term *'modernity'* defining it as 'the transient, the fleeting, the contingent. It is one half of art, the other being the eternal and the immovable' (Baudelaire, 2010, 17). Its emblem is Paris itself (Baudelaire, 2001, 153):

> *Paris changes! but naught in my melancholy*
> *Has stirred! New palaces, scaffolding, blocks of stone,*
> *Old quarters, all become for me an allegory,*
> *And my dear memories are heavier than rocks*

The Poet goes on to say that in front of this vision of the changing City, suddenly, an image is formed—that of a swan, the title of the poem:

> *Passing the Louvre, one image makes me sad:*
> *That swan, like other exiles that we knew,*
> *Grandly absurd, with gestures of the mad,*
> *Gnawed by one craving!*

The image of the swan—in the Poet's imagery—is inextricably connected to Andromache, Hector's widow who fell from her great husband's arms and bowed down on the side of an empty tomb in ecstasy. Andromache serves as the paradigm of those who've lost what they cannot recover, those who slake with tears their lonely hours, those who fill themselves with tears sucking the pain like a good she-wolf.

> *So in the forest of my soul's exile,*
> *Remembrance winds his horn as on he rides.*
> *I think of sailors stranded on an isle,*
> *Captives, and slaves — and many more besides.*

This train of associations—one image producing another image: Paris' buildings, the swan, Andromache, the pain-sucking she-wolf, the stranded castaways—portrays Baudelaire's mood, when he confronts the inexorably changing City. It is as if there were two mirrors, facing each other. Each mirror reflects the image contained in the mirror in front of it, in an infinite reflection and co-production of images. In between the two mirrors, there is a mood, an atmosphere. One cannot distinguish the City's atmosphere from the Poet's mood. Decadence is on both sides. The mood at issue here is *spleen*. Spleen is the mood characterizing Baudelaire's *Fleurs du mal*, and the Poet tries (and succeeds) in encapsulating it in images.

Baudelaire's spleen is neither sadness—the feeling of sinking down due to the feeling of sorrow for the loss of the beloved object—nor melancholy—a sublime spiritual state associated with this condition of non-possession. Benjamin argues that spleen is the effect of three main changes brought about by modernity and massive urbanization— the weakening of senses (and especially atmospheric ones like taste and smell), the commodification of relationships and the desynchronization of human existence from the time of nature. The result is the sense of 'permanent catastrophe':

> Rain, irritated with the whole town,
> From his urn pours in great waves a dark cold
> On lifeless dwellers of the neighbouring cemetery
> And death on foggy hovels

A further remark can help us encapsulate the power of images and their connection to moods/atmospheres. It is also taken from Benjamin's reflections on Baudelaire's spleen. 'Baudelaire's *spleen* is the sorrow for the decline of the aura: "Le printemps adorable a perdu son odeur"' (Benjamin, 1999b). In modern cities, like in the *ville lumière*, artificial illumination overtakes day's slow retreat, amplifies stimulation, and blunts the senses. Before modernity invaded the City with massive production of light—and, we may add, of advertising images—evening twilights challenged vision with fading light and our senses sharpened in compensation, generating greater perceptual alertness and an aura—a dreamlike vision and experience of a transcendent reality. Artificial light also affects circadian rhythms. Spleen is the self-estrangement caused by the technological desynchronization of human activity from nature. Time is sick, and its emblem is '*la pendule enrhumée*'—literally: time has caught a cold! (Baudelaire, 2001, 129).

CLINICAL REFLECTION

If the above is so in philosophy, poetry, and criticism, what is the relevance to clinical practice? We would argue that Benjamin's later philosophy and criticism is consistent with our aspiration to understand psychopathological symptoms in a manner that

avoids their reduction to mere signs. The importance of 'quotation' is immediately evident here! Further still, his materialist dialectics demands we reach an image which accurately captures the powerful tensions that underly symptoms. The distinction between signs and symptoms is at issue here. Whereas the sign is an object, 'the symptom is a movement' writes French art historian Didi-Huberman (Didi-Huberman & Lacoste, 1995, 199). The symptom, in this perspective, as it is thought by clinical phenomenology and psychoanalysis, has a *dialectical* character. It is the perpetual oscillation between opposites, which never comes to a synthesis—*pace* Hegel. That's why we need images—namely dialectical images which portray the tension-filled standstill—rather than only concepts to portray psychopathological symptoms. Used in isolation, the latter can be and are often experienced by patients as harmful.

Which 'opposites' are involved here? As illustrated by the dialectical model of psychopathology (Stanghellini, 2017), psychopathological symptoms are the outcomes of the dialectics between the *Who* of the patient and his/her *What*. Each symptom is an attempt by the side of the *Who* (the person) to struggle against, to make sense of, and to heal one's vulnerability and suffering (the *What*). The Who is *engaged* in trying to make sense of the What. In a nutshell, if we want to understand a given symptom, we need to keep in mind a fundamental principle: patients are not merely passive recipients of abnormal experiences but also active constructors of their mental worlds, at least partially leading and guiding this building process with their own cognitive resources, feelings, and personal meanings and values. Assessing the individual's cognitive-emotional-ethical framework is indispensable for understanding symptoms. Symptoms are born from the interplay between what affects the patient as a *distressing phenomenon*, on the one hand, and his or her *attempts at healing*, on the other. They display the tension between distressing experiences and the patient's attempts to react and respond to them—including their individual elaboration and explanatory insights. Recognizing patients' efforts at healing is quintessential to understand the process that takes place between the onset of distressing experiences and the development and solidification of full-blown symptoms. The consequence of all this is—we suggest—that in order to portray this *dialectical tension* between the patient and his or her vulnerability and sufferings *we need dialectical images*, not simply operationalized signs. We consider the overweening emphasis on operationalized signs in recent decades in mental health to have been and continue to be a major source of dissatisfaction and protest by mental health service users. Its legitimate uses notwithstanding, it is not too much to say that it has been a catastrophe of a kind.

Of course, there is another dialectic in the clinic and that is the one between clinician and patient. How are we to think about this in Benjamin's terms? It is not difficult to see here the relevance of his ideas of time and history, particularly the importance he places on engagement and his challenge for any suggestion that there is a past simply waiting somewhere to be discovered and be understood. Rather what matters is the tension leading to the dialectical image which appears 'in a flash'. Looking at it from this point of view undermines any naïve commitment to orthodox ways of interpreting both the

patient's history and the clinician–patient relationship. Rather there is a requirement for interpenetration during which the clinician maintains a commitment to giving voice to the patient, or even finding a voice for him. Arguably, this demands of the clinician that she adopts an attitude towards the patient which is similar to that of Benjamin towards poetry who sees in it the potential for 'secular revelation'.

Benjamin's concept of the 'poetized', i.e., the truth motivating the poem, may be helpful here. It emerged through another early work, his analysis of 'Two poems by Friedrich Hoelderlin: "The Poet's Courage" and "Timidity"'. Benjamin pursued this whilst aware of Goethe's conclusion that 'Beauty can never become lucid about itself' (Benjamin, 1996b). It is for this reason that he seeks the poetized in neither of the two works by Hölderlin but in their *comparison*. As he writes elsewhere: 'Let us assume that one meets a person who is beautiful and engaging but who remains closed because he carries a secret with him. It would be futile to wish to press him on this account. It would certainly be permissible, however, to inquire whether he has siblings and whether their nature might not in some part explain the enigmatic aspect of the stranger. In exactly this way criticism inquires after siblings of the work of art. And all true works have siblings in the realm of philosophy' (quoted in Jennings, 1987, 123).

And how does this translate into clinical practice? Surely this should not be comparing one 'case' against another, but through the relationship between the clinician and the cared for and the opportunities that it presents to reflect one through the other. 'Comparison' here is a form of connectedness and reciprocal engagement. This kind of relatedness is transformational (Meares, 2004; Stanghellini, 2017). Transformation is mediated by a kind of dialogue consisting of more than its content, the simple transmission of information. Privilege is given to feeling-tones and how they arise in particular forms of relatedness, and to emotions out of which 'meaning' frequently comes correcting maladaptive forms of relatedness, fostering a new form of relatedness that Russel Meares calls 'aloneness-togetherness' (Meares, 2001). In this the two partners, clinician and patient, share their feeling of being alone—feel together in their being alone. This experience generates a Self in dialogue as a Self *between* people. The development of the Self in the context of therapeutic care cannot be generated by 'linear' forms of language, rather by a kind of *play* akin to Benjamin's poetized. Care is directed towards a jointly created imaginative effort arising out of play, a non-linear mental activity. The success or failure of therapeutic dialogues is not judged by their theoretical correctness, but by the evolution of aloneness-togetherness reflected in changes in the totality of experience of Self, bodily feelings, sense of movement, spatiality, and temporality.

The kind of dialogue at issue here is not merely a vehicle for pieces of *information*, and not only the *content* of language. To borrow H.U. Gumbrecht's (2004) words, this form of relatedness that orients care is based on *presence effects* rather than on meaning effects, as genuine dialogue points to what is irrevocably non-conceptual in our lives (Stanghellini, 2022b). Of central importance is the *form* of language, that is, the ways words are used—that is, their *poetic force*, their capacity to form images; or the tone of voice—that is, the *sensuous* component of language.

Conclusions

We have argued that both psychiatry and clinical psychology—searching for causes and meanings of psychopathological signs—stifle the phenomenon, its presence, the presence of the patient. And suggested that to go to the 'things themselves'—that is, the world as experienced from the patient's perspective—we should rather develop a poetics for clinical practice and a kind of practice centred on presence-effects to balance those centred on meaning—and causes-effects.

The use of images, and in general the relevance of aesthetics to care, raises a number of clinical issues: why should clinicians learn to use images and not just concepts? Which kind of images are useful? How can images contribute to reveal hidden features of personal experience? What is the relationship between images and language? How can images help to encapsulate the highlights of personal history?

Suggestive but neither comprehensive nor conclusive as it is, this chapter can only be considered introductory, partial, and not unproblematic. The introductory nature of the chapter is obvious. What may be less obvious but true is the limited way some key concepts of Benjamin have been discussed compared to their variety, breadth of associations, and their richly meandering meaning in his thought over time. We refer here to dialectical images, nonsensuous similarities, mimesis, montage, constellation, palimpsest, intuition, engagement, dialectic at a standstill, maximum tension, limits of experience, secular revelation, the use of history, ideology, barbarism, power, quotations, and more.

The above is also not unproblematic because the approach suggested is open ended and not prescriptive. Certainly, it is not a recipe for production of a therapeutic manual. On the one hand, this frees the clinician to expand her range of curiosity and creativity with obvious potential for benefit to the patient. On the other hand, it risks sliding into arbitrariness, with destructive potential in the hands of the wrong clinician. Here it is critically relevant that Benjamin took early interest in poems by Hölderlin that are about courage and timidity. Karl Jaspers, a very different philosopher and a psychiatrist, suggests that the ideal clinician is one who combines 'scientific attitudes of the sceptic with a powerful impressive personality and a profound existential faith' (quoted in Clare, 2001, 71). This is good advice, not in the sense that the clinician must impose her or his powerful and impressive personality, not at all. But she must have curiosity about herself and have the courage to question what she sees and adopt the required passivity to receive the ideas that emerge as the patient shows himself. The resultant form of relatedness would not be for the purpose of evaluation, that would be 'evil' in Benjamin's terms, but to gain insight through the dialectical image which arises in the *in-between* the patient and the clinician and through the engagement between them.

The clinician must also have a profound sense of the weight of clinical power she carries and its destructive potential, over and above or against such beneficial elements as she brings to the consultation. This sense must include a detailed and persistent

curiosity about the ideological element in psychiatry (Bouras & Ikkos, 2013), in addition to the narrowly understood scientific or evidence-based elements. Also required is detailed and persistent curiosity about any role psychiatry may play in illegitimate domination in society (Ikkos & Bouras, 2021). In practice, these risks may be most acutely perceived though attention to fragments and the incongruous, and through tolerance of tensions that flash suddenly and lead to the dialectical image.

A further objection may be raised. This refers to comparing the clinical approach to patients, on the one hand, to the literary-critical approach to poems, on the other. No doubt, the analogy can be drawn too far. It can only serve to illuminate a key aspect of care. It is appropriate however to highlight the great care Benjamin took in his literary criticism. His essays on Hölderlin, Goethe, Proust, Kafka, Baudelaire, and others have achieved their classical status because of the meticulous care he took in approaching them. A keen collector of books, we can confidently say that his love for the objects of his expertise was not just abstract but embodied in looking after their very material existence. His mission was to preserve and give them voice, not to dominate them. When reading and thinking about Benjamin, it is wise not to take what we read as concrete but consider his oeuvre as allegorical (Pensky, 1993; Ikkos & Stanghellini, 2022) and devotional in a materialist sense. Well beyond the technical and business like, perhaps even beyond the vocational (Weber, 1978), such an approach may be rewarded with or redeemed in dialectical and materialist revelation.

References

Bataille, G. (2016). *Dictionnaire critique, édition à part extrait de Documents*. Éditions Prairial.
Baudelaire, C. (2001). *Le Cygne*. In C. Baudelaire (Ed.), *Les Fleurs du mal* (pp. 152–154). www.mozambook.net.
Baudelaire, C. (2010). *The painter of modern life in Selected Writings on Art and Literature*. Translated by P. E. Charvey. Penguin Books - Great Ideas.
Benjamin, W. (1988). *The origin of German tragic drama*. Verso Books.
Benjamin, W. (1996a). 'On perception'. In M. Bullock & M. W. Jennings (Eds.), *Walter Benjamin: Selected writings, volume 1* (pp. 93–96). Belknap Press of Harvard University Press.
Benjamin, W. (1996b). Goethe's elective affinities. In M. Bullock & M. W. Jennings (Eds.), *Walter Benjamin: Selected writings, volume 1* (pp. 297–360). Belknap Press of Harvard University Press.
Benjamin, W. (1999a). Trauerspiel and tragedy. In M. Bullock & M. W. Jennings (Eds.), *Walter Benjamin: Selected writings, volume 1* (pp. 55–57). Belknap Press of Harvard University Press.
Benjamin, W. (1999b). *The arcades project*. Translated by H. Eiland & K. McLaughlin. Belknap Press of Harvard University Press.
Benjamin, W. (2002a). On the mimetic faculty. In M. W. Jennings, H. Eiland, & G. Smith (Eds.), *Walter Benjamin selected writings volume 2 Part 2 1931–1934* (pp. 720–722). Belknap Press of Harvard University Press.
Benjamin, W. (2002b). Paris, the capital of the nineteenth century. In H. Eiland & M. W. Jennings (Eds.), *Walter Benjamin: Selected writings, volume 3* (pp. 32–49). Belknap Press of Harvard University Press.

Benjamin, W. (2003a). On the concept of history. In H. Eiland & M. W. Jennings (Eds.), *Walter Benjamin: Selected writings, volume 4* (pp. 389–400). Belknap Press of Harvard University Press.

Benjamin, W. (2003b). On some motifs in Baudelaire. In H. Eiland & M. W. Jennings (Eds.), *Walter Benjamin: Selected writing, volume 4* (pp. 313–355). Belknap Press of Harvard University Press.

Benjamin, W. (2006). *Berlin childhood around 1900*. Belknap Press of Harvard University Press.

Bouras, N., & Ikkos, G. (2013). Ideology, psychiatric practice and professionalism. *Psychiatriki*, 24(1), 17–27.

Buck-Morss, W. (1977). *The origin of negative dialectics: Theodore W. Adorno, Walter Benjamin and the Frankfurt Institute*. Free Press.

Caygill, H. (1998). *Benjamin: The colour of experience*. Routledge.

Clare, A. (2001). *Psychiatry in dissent: Controversial issues in thought and practice*. Routledge.

De Cauter. L. (2018). *The dwarf in the chess machine: Walter Benjamin's hidden doctrine*. naio10 Publishers.

De Monticelli, R. (2018). Edmund Husserl. In G. Stanghellini, M. R. Broome, A. V. Fernandez, P. Fusar-Poli, A. Raballo, & R. Rosfort (Eds.), *The Oxford handbook of phenomenological psychopathology* (pp. 11–19). Oxford University Press.

Didi-Huberman, G., & Lacoste, P. (1995). Dialogue sur le symptome, *L'inactuel* 5, 191–226.

Eiland, H., Jennings, M. W. (2016). *Walter Benjamin: A critical life*. Belknap Press of the University of Harvard Press.

Fenves, P. (2011). *The Messianic reduction: Walter Benjamin and the shape of time*. Stanford University Press.

Garland, R. (1950). T. S. Eliot and the impact of Baudelaire. *Yale French Studies* 6, 27–34.

Gumbrecht, H. U. (2004). *Production of presence: What meaning cannot convey*. Stanford University Press.

Ikkos, G. (2020). An almost preventable suicide: Walter Benjamin (15 July 1892–26 September 1940) – psychiatry in literature. *The British Journal of Psychiatry* 217(6), 709. https://doi.org/10.1192/bjp.2020.199.

Ikkos, G. (2022). Non-sensuous similarities. *Psychiatric Times*, published online 9 January 2022. Available from: www.psychiatrictimes.com/view/non-sensuous-similarities-language-poetics-and-psychiatry.

Ikkos, G. (2023). Anna 'Asja' Lācis (1891–1979): Drama, trauma and neuropsychiatry—Psychiatry in Theatre. *The British Journal of Psychiatry* 222(1), 6. https://doi.org/10.1192/bjp.2022.98.

Ikkos, G., & Bouras, N. (Eds.). (2021). *Mind state and society: A social history of UK psychiatry and mental health 1960–2010*. Royal College of Psychiatrists and Cambridge University Press.

Ikkos, G., & Stanghellini, G. (2022). Walter Benjamin: Brooding and melancholia. *The British Journal of Psychiatry* 220(5), 294–294. https://doi.org/10.1192/bjp.2021.180.

Jennings, M. W. (1987). *Dialectical images: Walter Benjamin's theory of literary criticism*. Cornell University Press.

Lukács, G. (1971). *History and class consciousness*. MIT Press.

Meares, R. (2001). *Intimacy and alienation: Memory, trauma and personal being*. Routledge.

Meares, R. (2004). The conversational model: An outline. *American Journal of Psychotherapy* 58(1), 51–66.

Pensky, M. (1993). *Melancholy dialectics: Walter Benjamin and the play of mourning*. University of Massachusetts Press.

Pinotti, A. (2018) (Ed.). *Costellazioni. Le parole di Walter Benjamin*. Einaudi.
Rilke, R. M. (1963). *Duino Elegies*. Translated by J. B. Leishman & S. Spender. W. W. Norton.
Rovelli, C. (2018). *The order of time*. Penguin Books.
Scholem, G. (1981). *Walter Benjamin: The story of a friendship*. Translated by H. Zohn, H. New York Review Books.
Sontag, S. (2003). *Against interpretation*. Penguin Books.
Stanghellini, G. (2017). *Lost in dialogue. Anthropology, psychopathology, and care*. Oxford University Press.
Stanghellini, G. (2022a). From the patient's perspective. Understanding: Engaging with the other. *Philosophy, Psychiatry, & Psychology, 29*(4), 287–289.
Stanghellini, G. (2022b). Understanding other persons: A guide for the perplexed. In M. Biondi, A. Picardi, M. Pallagrosi, & L. Fonzi (Eds.), *The clinician in the psychiatric diagnostic process* (pp. 71–80). Springer Nature.
Stanghellini, G., & Fuchs, T. (Eds.). (2013). *One century of Karl Jaspers' general psychopathology*. Oxford University Press.
Stanghellini, G., & Mancini, M. (2017). *The therapeutic interview in mental health. A values-based and person-centered approach*. Cambridge University Press.
Weber, M. (1978). Politics as a vocation. In W. G. W. Runciman (Ed.), E. Matthews (Trans.), *Weber: Selections in translation* (pp. 212–226). Cambridge University Press.
Wizisla, E. (2016). *Benjamin and Brecht: The story of a friendship*. Verso.

SECTION V

LITERATURE, STORYTELLING, MOVIES, AND MENTAL ILLNESS

INTRODUCTION
Literature, Storytelling, Movies, and Mental Illness

MARTIN POLTRUM

THE section 'Literature, Storytelling, Movies, and Mental Illness' deals with the role of literature, storytelling, and film for therapy and the representation of mental disorders. Four articles treat the written or spoken word and five articles discuss the medium of film. Mental disorders and their treatment, psychotherapists, psychologists, and psychiatrists are not only to be found in the real world of medicine, but also in the world of fiction. If and what there is to learn from these literary and cinematic representations is addressed in the articles in this section, as is the criticism of the fictional representation of psychiatry and psychotherapy. Arts scholars and researchers from the field of medical humanities are not infrequently convinced that artistic and fictional representations are sometimes even closer to the truth of inner life than abstract nomenclatures and diagnostic categories of the soul that are detached from real-life contexts. As important and beneficial as it is that we have diagnostic manuals such as ICD-11 and DSM-5, which are indispensable for collegial communication, epidemiological research and empirical therapy studies, they are anaemic and poor in visualization when it comes to the phenomenological, in-depth hermeneutic and holistic understanding of disorders. To put it more pointedly, one could say that the mentioned manuals capture the skeletal dimension of mental disorders, while the fictional media of film and literature are capable of depicting the whole, physical human being in flesh and blood.

It remains to be seen whether the diagnostic criteria for bipolar I disorder, as found in the European and American Manual of Mental Disorders, really illustrate the phenomenon of the pathological rejoicing-to-high-heaven and plunging-to-depths-of-despair. Where these mood swings and the ensuing, partly serious turbulences of the lifeworld, including attempted suicide and psychosis are brought to life is, for example, in the film *Mr. Jones* (1993) or in Thomas Melle's novel *The World at My Back* (2023). For lectures on psychopathology, such world explorations provided by film and literature are indispensable if students of psychology, psychotherapy, and psychiatry are

to recognize this disorder in reality at some point. At this point, we can only agree with Virginia Woolf, who once said: 'There is more truth in fiction than facts, … (1977, 6).' In addition, not every patient and not every psychotherapist, who may be good patients and good psychotherapists, can speak and write in such a way that it becomes evident, tangible, and vivid what they are talking about when they report on disorders or treatments. Perhaps Stefan Zweig's *Mental Healers* (2012) and the film *Good Will Hunting* (1997) are more likely to teach us about the essence of psychotherapy than a dry and austere textbook, which may be accurately written, but has little power to open up the world. Similarly, not every artist is able to talk about their work of art in an enlightening and illuminating way and not every psychopathologist is able to talk about their field of research with great phenomenological explicative power, nor is able to grasp and interpret it in its full depth. Not to mention patients, who are often left speechless, silent, and petrified by their disorder anyway and who cannot be expected to provide profound information about what it is that actually troubles them psychologically. We must let artists, poets, and filmmakers help us when it comes to understanding the life of the soul and its disorder, because artists and poets are characterized precisely by the fact that they are able to express and visualize even the most inconspicuous things in a clear and precise manner.

This section, therefore, features articles on the representation of mental disorders and psychotherapy in literature and film, on the book and the film as a therapeutic medium, on the subject of storytelling, on the power of the spoken word, as well as articles on the topic of filmmakers with lived experiences and on the cinematic representation of emotions in childhood.

In the context of this publication, a further step has thus been taken to make the world of fiction fruitful for therapeutic concerns and complement the currently justifiable booming orientation of the therapeutic towards evidence-based psychotherapy with aesthetic-based psychotherapy. In the latter, art and the humanities, and above all what has long been known as the medical humanities and health humanities, play a decisive role. The idea is not only to include philosophy, religion, music, literature, art etc. in psychotherapy or to reflect on the significance of these disciplines, which are classified as humanities for psychotherapy, but also to understand the current practice of psychotherapy from its history and to pose relevant epistemological, humanistic, and medical ethical questions in order to ultimately fertilize this practice. The same applies to psychopathology.

In addition to such wonderful works as *The Oxford Handbook of Phenomenological Psychopathology* (Stanghellini et al., 2019), which represents a milestone in phenomenological endeavours in the field of psychopathology, this field could be supplemented precisely by letting poets, filmmakers, and artists who are experts by experience tell and show us what suicidality, psychosis, intoxication, ecstasy, and addiction, among others, are. We can study intoxication, ecstasy, and addiction phenomenologically and measure them empirically. However, we can also let the great

writers and experts on intoxication and their literary power of explication help us to understand what kind of phenomena we are actually dealing with (cf. Resch, 2009).

In addition to the topics dealt with in this section, which only represent a small selection from the inexhaustible cosmos of contributions relevant to the humanities, it would be highly desirable for our publication as a whole, and the following section in particular, to inspire further research into the field of literature, storytelling, movies, and mental illness.

REFERENCES

Filmography

Figgis, M. (1993). *Mr. Jones.*
Melle, T. (2023). *The world at my back*. Biblioasis Internationals Translation Series.
Resch, S. (2009). *Rauschblüten. Literatur und Drogen von Anders bis Zuckmayer*. Vandenhoeck & Ruprecht.
Stanghellini, G., Broome, M. R., Fernandez, A.V., Fusar-Poli, P., Raballo, A., & Rosfort, R. (2019). *The Oxford handbook of phenomenological psychopathology*. Oxford University Press.
Van Sant, G. (1997). *Good Will Hunting.*
Woolf, V. (1977). *A room of one's own*. Panther.
Zweig, S. (2012). *Mental healers. Mesmer, Eddy and Freud*. Pushkin Press.

CHAPTER 25

MENTAL ILLNESS IN LITERATURE BETWEEN PHENOMENOLOGY AND SYMBOLISM

DIETRICH V. ENGELHARDT

Introduction

THE conceptions of mental illness, its causes, and consequences change profoundly in the course of modern times, as do the forms of medical treatment and social reaction. The life situation and self-image of the sick person are not unaffected by this change; at the same time, the individual person, albeit to varying degrees, gives the illness his own form, can understand and live it in his own way. Humanity in psychiatry can rightly mean respecting and strengthening this relative freedom and distinctive individuality of the sick person in therapy, care, and communication.

The essential dimensions of mental illness and psychiatry in theory and practice are also depicted and interpreted in works of literature—in the centre or rather on the periphery; but descriptions can also be exemplary in peripheral places. A long and rich tradition leads from antiquity through the Middle Ages to modern times, from the Renaissance through Classicism, Romanticism, and Realism to the present. The theme has undergone many changes in the development of literature, in the different tendencies and epochs; the insane in Romanticism is by no means identical with the insane of the Enlightenment, Naturalism, or the present.

Literary contributions also come from writers who are themselves physicians and psychiatrists, in the nineteenth and early twentieth centuries from Justinus Kerner, Anton P. Chekhov, and Alfred Döblin, in the twentieth and twenty-first centuries from Louis-Ferdinand Céline, Gottfried Benn, Mario Tobino, Heiner Kipphardt, Ernst Augustin, Walter Vogt, and Irvin David Yalom. Patients also represent their

mental suffering, often probably of neurotic rather than psychotic nature, in texts that stand between art and autobiography (Maria Erlenberger, Allen Ginsberg, Caroline Muhr, Sylvia Plath, Theodore Roethke). The reproduction of psychiatric themes in literature not only has consequences for the work of art and is not merely a stimulus and help for the psychiatrist, it also contributes beyond literary studies and psychiatry to a general understanding of mental illness in the public and in every person. From literary rendering of mental illness, it can be understood how much art reflects or questions not only the cultural and political but also the medical and psychological views of its time; literarized mental illness does not remain in the medium of art but shapes established ideas. For the psychiatrist and philosopher Karl Jaspers, poets portrayed 'in Gestalten des Wahnsinns wie in Symbolen das Wesen des Menschseins, seine höchsten und entsetzlichsten Möglichkeiten, seine Größe und seinen Fall' (Jaspers, 1913, [9]1973, 657).

Literature also has limits. The dangers of literary representations must not be overlooked. The sick person and his illness appear in literature in the consciousness of the writer; the writer is able to describe the feelings and ideas of the sick person, the appearance and inner side of the illness in a holistic way that science generally does not intend and does not think it needs for its therapeutic goals, but he can also fail, is dependent on his own prejudices and common clichés, on political and ideological convictions that can also obscure his view of the illness.

The writer is rarely familiar with mental illness and therapeutic procedures from his own experience. To equate the mentally ill and mental illness without further ado with social progressiveness and political utopia, as writers and literary scholars always tend to do, does justice neither to the reality of the sick nor to the nature of art, succumbing to the danger of inappropriately aestheticizing reality. Art is not science, science is not art. Art and science are also different from the reality they reproduce or interpret, although there are many connections or similarities between them. Differences in the nature and function, history and language of medicine and literature are obvious. The literary representation of the mentally ill should not be confused with scientific analysis and therapeutic practice, nor with accounts of self-experience by the sick.

The value of literature cannot be decided by its correspondence to real phenomena or scientific theory alone. Works of literature not infrequently describe illnesses in a far more concrete and nuanced way than science; this is especially true of the subjectivity of the sick person. All the arts, including literature, have healing powers. Especially for the mentally ill, literary works can become a help in coping with suffering. Writing (graphotherapy) and reading (bibliotherapy) by patients can also support the psychiatrist in his diagnosis and therapy and in his relationship with the patient.

Psychiatry adopts terms and phenomena from literature, certain diseases receive their names from literature ('Lilliputian hallucination syndrome', 'Munchausen syndrome', 'Rapunzel syndrome', 'Oblomov syndrome'). In modern literature, some connections to the language of mental illness can be discerned; from the writer Hugo von Hofmannsthal comes the contemporary diagnosis: 'Diese Spaltung des Ich scheint die Daseinsform des reproduzierenden Genies zu sein' (Hofmannsthal,

2013, 301) The proximity of literary language and the language of the mentally ill is manifested in works by William Faulkner, Gottfried Benn, Robert Musil, and Virginia Woolf.

Psychiatrists repeatedly point out the limitations of literature in adequately portraying mental illness. From the nineteenth century, the psychiatrist Wilhelm Griesinger made the harsh judgement: 'Alle nicht-ärztlichen, namentlich alle poetischen und moralistischen Auffassungen des Irreseins sind für dessen Erkenntniss nur von allergeringstem Wert'. The literary image of mental illness would always be one-sided if writers who had occasionally captured certain traits well, such as William Shakespeare or Miguel Cervantes, understood mental illness 'mit Umgehung ihrer organischen Grundlagen, nur von der geistigen Seite, als Resultate vorausgegangener sittlicher Konflikte' (Griesinger, 1845, 8). The psychiatrist Kurt Schneider explains that the literarization of mental illness is only possible to a limited extent: 'Das Wesen der Psychose ist das Abreißen der Verständlichkeit; das Dichterwerk aber verlangt durchgehende Motivzusammenhänge wenigstens in seinem hauptsächlichsten Geschehen'. Psychoses could be described artistically, but their essence is not captured. Hermann Hesse's novel *Unterm Rad* (1906) is instructive in this regard; out of artistic necessity and in contradiction to psychiatric experience, the poet believed that he had to derive the boy's schizophrenic misery 'aus dem Leiden der Schule' and fill it 'ganz mit verständlichen Inhalten' (Schneider, 1922, 10).

As the concept of illness and the understanding of art change, so do perceptions of the possibilities and limits of literature. Declaring mental illnesses to be neuroses—a tendency of the recent past—means at the same time making them accessible to literary representation. In these judgements, however, a distinction must always be made between the dimensions of illness (objective findings, subjective state of mind or social phenomenon), what is meant by understanding, what is meant by person, what is meant by subjectivity, what is meant by evidence. The literary rendering of the phenomenology, aetiology, and pathogenesis of mental illness, the language, feelings, and ideas of the mentally ill, the medical institution, the relationship of the insane to the psychiatrist, the therapeutic procedures, the social background and reactions each have their own specific conditions and each pose particular challenges.

Change in Time and Space

Literary portrayals of psychiatric themes are related to the history of literature and medicine, which are themselves related to the change in the general relationship between art, science, and social reality.

Illnesses have an epochal character in literature; depictions of mental illness by Lodovico Ariosto, Jonathan Swift, E.T.A. Hoffmann, Honoré de Balzac, Charles Dickens, Fyodor M. Dostoevsky, Émile Zola, Francis Scott Fitzgerald, Robert Musil, William Faulkner, Virginia Woolf, Saul Bellow, Conrad Aiken, and Thomas Bernhard

are also diagnoses of their times. New observations and new theories of mental illness are taken up. The individual situation of the sick person and the social background of his or her illness and therapy increasingly complement or supersede religious or magical views, which nevertheless persist into the present.

An apt example for the Renaissance is Orlando in Lodovico's Ariosto's epic *Orlando Furioso* (Ital. 1516/32, 2009). Orlando's madness reflects the transition of the Middle Ages into modern times as well as Europe's clash with the Orient, is not only the consequence of disappointed love of a single person, is by no means absorbed in the description of the individual manifestation of illness.

Mental illness in eighteenth-century texts reflects the Enlightenment's pathos of reason, that epoch's search for a clear separation of emotion and reason. Mental illness is a provocation for rationalist convictions; the concept of reason seems to be called into question by madness, and at the same time a humanitarian commitment now develops. Jonathan Swift's satire *A Digression Concerning the Original, the Use and Improvement of Madness in a Commonwealth* (Engl. 1704) corresponds to the thinking of that era and at the same time has a biographical background in the writer's personality and fears of succumbing to mental illness himself.

At the turn of the nineteenth century, the reform of psychiatry is under the legendary or symbolic motto 'freeing the lunatics from the chains', attributed to the French psychiatrist Philippe Pinel with widespread resonance in other European countries. However, the reform movement by no means excludes drastic therapy methods in the hope of a cure. The literary treatment of mental illness in the Romantic period, in turn, is supported by a metaphysical-religious perspective, which was also shared by physicians and natural scientists of that era—in clear contrast to the empirical-positivist view prevalent in other European countries. Romantic poets were inspired by the idealistic natural philosopher Friedrich Wilhelm Joseph Schelling as well as by the Romantic naturalist and physician Gotthilf Heinrich von Schubert in their interpretation of mental illness and its cure. The physician and psychotherapist Franz Anton Mesmer, with his animal magnetism, also influenced writers of the time as well as later. Mental disorders in the stories of the Romantic writers Novalis, E.T.A. Hoffmann, Heinrich von Kleist, and Achim von Arnim are documents of sensitivity and heightened consciousness, of overcoming the banal world of everyday life, of hope for mystery, poetry, and transcendence.

In the *Russian Nights* (Russ. 1884) by Vladimir F. Odoevskij, the usual sharp demarcation between reason and madness is abolished in a romantic sense: 'One of the observers of nature went still further: he provoked a doubt even more bitter for man's pride: examining the psychological history of men who are ordinarily considered insane, he asserted that it is impossible to draw a true and definite line between a healthy thought and a mad one. He maintained that for each craziest thought taken from a madhouse, it is possible to find an equally strong thought circulating in the world daily.' Poets and geniuses resembled the madman, and in everyday life, too, behaviour patterns were repeatedly found that could be observed in madmen: 'Thus, isn't there a thread weaving through all the actions of human soul and joining ordinary common sense with the

disturbance of concepts observable in a madman?' In keeping with the spirit of Balzac's story *Louis Lambert* (1832), it is asked: 'In a word, isn't what we frequently call madness and delirium sometimes the highest degree of intellectual human instinct, a degree so high that it becomes completely incomprehensible, unattainable to ordinary observation?' (Odoevskij, 1997, 56 f.)

In the positivist nineteenth century, Émile Zola saw nervous diseases, along with diseases of the blood, as the decisive causes for the decline of his Rougon-Macquart family. In his novel *War and Peace* (Russ. 1868/69, 1952), Lev N. Tolstoy recognizes the social-cultural dependencies of melancholy: 'To please Moscow girls nowadays one has to be melancholy' (Tolstoy, 1952, 310).

The literature of the twentieth century continues the interest in mental illness that has not ceased in the decades to come until today. In Francis Scott Fitzgerald's novel *Tender is the Night* (Engl. 1934/48, 2012), the failure of the doctor Dick Diver takes on a contemporary diagnostic significance; this failure is supposed to have its adequate counterpart in the spirit of the modern American way of life, that means for Fitzgerald in the domination of money, in the collapse of values, in militarization. The epidemic spread of mental illness in Boris Pasternak's novel *Doctor Zhivago* (Ital. 1957) is traced back to the political and warlike unrest in the transition from Tsarism to Bolshevism, and a corresponding plea is made for preventive psychiatry: 'We are faced with the rise and spread of a form of mental illness which is typical of our time and is directly caused by the historical circumstances' (Pasternak, 1958, 309).

Literature always develops interpretations of mental illness that can be at odds with the prevailing psychiatry and, especially in past years, reveal similarities with the era of Romanticism and anti-psychiatry, which, however, has long since passed its zenith. Contemporary psychiatry is itself not uniform; different approaches stand side by side in theory and practice in the spectrum between biology and anthropology, and are also sought to be combined, which makes the comparison between psychiatry and literature particularly complex and stimulating. Furthermore, even today art and literature face the danger of idealising mental illness in a one-sided way or deriving it exclusively from social causes.

In addition to the change of time, the difference of space affects the literary presentation of psychiatric phenomena. Differences result from historical changes and, at the same time, social-cultural change in individual countries or specific regions of the world. Balzac's *Louis Lambert* (French 1832) is a French novel; for all its timeless significance, it depicts an individual fate and specific medical conditions in France. Nikolai V. Gogol's *Diary of a Madman* (Russ. 1835, 2020), Fyodor M. Dostoevsky's *The Idiot* (Russ. 1868/69, 1913) and Anton P. Chekhov's *Ward No. 6* (Russ. 1892, 1921) were written by Russians and reflect Russian reality: Russia's confrontation with Western Europe, the conflict between Eastern faith and Western civilization, the development of democratic tendencies in the Tsarist world, the reception of modern medicine. The novel *The Alienist* (Port. 1882, 2012) by Joaquim Maria Machado de Assis describes a general figure of a doctor and at the same time remains related to South America, to the development of psychiatry in Brazil under the model of European scientific development. The same

applies to mental illness in novels by Charles Dickens and their dependence on the English world of life and science in the nineteenth century.

The history of literature is not detached from the progress of psychiatry, from the development of natural sciences and medicine, their emancipation from theology and philosophy, their diagnostic and therapeutic innovations. Existing similarities between scientific and poetic depictions of certain illnesses and specific therapeutic methods can be traced back to common preconditions or mutual influences. New approaches can first appear in psychiatry and then be taken up in literature and from there have a renewed impact on psychiatry. Progress and tradition cannot be distributed unilaterally between science and literature. Literature is by no means always ahead of psychiatry or medicine in general; remembering past positions can, moreover, also have a progressive value.

The Patient and the Disease— Phenomenology and Subjectivity

In addition to the phenomenology and aetiology of mental illness, special attention is paid in modern works to the relationship between mental health and illness, the subjectivity of the mentally ill person, the relationship to the psychiatrist, the stay in psychiatric institutions, social contacts, and the symbolic or ideal meaning.

At the beginning of the modern era, Lodovico Ariosto describes in *Orlando Furioso* (Ital. 1516/32, 2009) the mental illness and recovery of the Christian knight Roland in the subjective perception of the person affected and in the reactions of the environment. In *El licenciado Vidriero* (Span. 1613, 2013), Miguel de Cervantes describes a man's delusions of being made of glass, his heightened insights into this illness, which is triggered by the consumption of a quince and initially manifests itself in a seizure and unconsciousness. The recognition and fame that the sick man receives during the illness and the rejection and loss of importance after his recovery are reported.

For his 1704 satire *A Digression Concerning the Original, the Use and Improvement of Madness in a Commonwealth*, Jonathan Swift collects concrete observations in Bedlam, a famous English lunatic asylum that was frequented by the populace in those days on Sundays and holidays for amusement like a zoological garden. 'If the *moderns* mean by *madness*, only a disturbance or transposition of the brain, by force of certain vapours issuing up from the lower faculties, then has this *madness* been the parent of all these mighty revolutions, that have happened in *Empire*, in *Philosophy*, in *Religion*.' A man with a balanced brain will want to abide by customary rules and conditions and will not feel the need 'of subduing multitudes to his own *power*, to his *reasons* or his *visions*' (Swift, 1965, 107 f.), Samuel Johnson in *The History of Rasselas, Prince of Abissinia* (Engl. 1759) gives the delusions of an astronomer, the causes and his cure as well as reactions of the environment. 'All power of fancy over reason is a degree of insanity' (Johnson, 1990,

150). In his romantic novellas and novels, E.T.A. Hoffmann is repeatedly fascinated by mental deviations and approaches to psychotherapy. Incidentally, as the writer Jean Paul points out in the novel *Selina oder über die Unsterblichkeit der Seele* (Germ. posthum 1821), mental illness should not totally destroy consciousness any more than physical illness completely destroys the human body, otherwise any therapy would be pointless: 'Auch der Wahnsinn muss der Seele eine uneroberte heilige Nervenstelle lassen, wie die vernünftigen Träume und vernünftigen Sterbeaugenblicke der Wahnsinnigen beweisen' (Jean Paul, 2000, 1214).

Consciousness-expanding abilities relativize widespread distinctions between health and illness. In *Nachtwachen des Bonaventura* (Germ. 1804) by Ernst August Friedrich Klingemann, the irritating question is asked: 'Ja, wer entscheidet es zuletzt, ob wir Narren hier in dem Irrenhause meisterhafter irren, oder die Fakultisten in den Hörsälen? Ob vielleicht nicht gar Irrtum, Wahrheit; Narrheit, Weisheit; Tod, Leben ist' (Klingemann, 1974, 120).

Balzac repeatedly takes up the theme of mental illness—in the perspective of the sick person and their relatives, of the doctor, science, society, and philosophy. The extraordinary sensitivity, nervous hysteria, and heightened spirituality of Louis Lambert in the 1832 novel of the same name is said to be due to a disease or a 'perfection de ses organes' (Balzac, 1980, 643). Louis Lambert's constitutional and family conditions are reinforced by social conditions. The genesis of his mental illness takes place in three phases of a dialectical process of expansion and contraction. The first expanding phase of precocious fantasies and boundless reading is followed as the second contracting phase by school education with its restriction to reality and the individual person; the third phase is a synthesis of contraction and expansion, signifies an extension of the individual ego into the world of the mind and at the same time leads to mental breakdown. With the mental illness, the physical appearance of the sick person also changes. The face becomes wrinkled, the hair white, the eyes lose their lustre, 'tous ses traits semblaient tirés par une convulsion vers le haut de sa tête' (Balzac, 1980, 682 f.).

In his stories about mental suffering and illness, Edgar Allan Poe is consistently characterized by the combination of rationality and irrationality; his interpretations, like those of the Romantics, go beyond any Enlightenment positivist standpoint, while at the same time leaving open concrete therapeutic possibilities. Social commitment determines Charles Dickens' rendering of mental illness. The insanity of the physician Dr. Manette in *A Tale of Two Cities* (Engl. 1859) is related to the downfall of the 'Ancien Régime' in France and the political and cruel turmoil of the French Revolution. In *Le Horla* (French 1887), Guy de Maupassant follows—anticipating or foreshadowing his own illness—a man's path to mental derangement in his physical and subjective manifestations, with the attempts to resist, the despair, the hallucinations and delusions, the final succumbing and decision to commit suicide: 'Alors... il va donc falloir que je me tue, moi!...' (Maupassant, 1979, 938).

Subjectivity and objectivity usually fall apart. The mentally ill Septimus Warren Smith from Virginia Woolf's *Mrs Dalloway* (Engl. 1925) doubts not himself but the sense of the world: 'His brain was perfect; it must be the fault of the world then—that he

could not feel' (Woolf, 1976, 98). The sick man sees himself persecuted by doctors, has hallucinations and visions and finally throws himself out of the window to avoid being committed to an institution.

Christian Moosbrugger in Robert Musil's *Mann ohne Eigenschaften* (Germ. 1930–1952) is a mentally ill sexual offender; his thoughts and actions seem to stem from a common origin of illness and crime at the beginning of human history, with the overcoming of the separation of subject and object—the goal of every mystical immersion, referred to in the novel as the 'other state' ('anderer Zustand'). Moosbrugger feels imbued with an increase in the ego that psychiatry with its diagnosis fails to grasp; he hated 'niemand so inbrünstig wie die Psychiater, die glaubten, sein ganzes schwieriges Wesen mit ein paar Fremdworten abtun zu können' (Musil, 1968, 72).

The story *La chambre* (French 1939) by Jean-Paul Sartre depicts Pierre's mental illness from the perspective of his lover Ève and her family; the sick person's behaviour, language, feelings and thoughts, social reactions of relatives, and inability to sympathize are rendered in the existentialist perspective of the philosopher Sartre with an emphasis on humane commitment and insight into the ever-possible decline of solidarity.

The Doctor and Therapy

The psychiatrist, his therapy, and relationship to the sick person as well as the medical institution receive special attention in literary works. Psychiatrists are often, but by no means always, portrayed negatively. Satire and criticism, fear and hope, and disinterest and empathy run through the texts.

The relationship between doctor and patient in literature is shaped by scientific progress and socio-cultural change. A professional distance between doctor and patient is contrasted with existential attachment, friendship, and love, but also rejection and hatred.

In Henry James's novel *The Wings of the Dove* (Engl. 1902), the doctor Sir Luke Strett offers his patient Milly Meale a 'great empty cup of attention' and in just a few minutes gives her the certainty of being understood, of having found a scientific friend; in the doctor's attention she feels the reassuring feeling of being safe in the world of science— 'in some current that would lose itself in the sea of science' (James, 1969, 194). Esther encounters her doctor Nolan in Sylvia Plath's *The Bell Jar* (Engl. 1963, 1999) with 'trust on a platter' and is sure that she will be informed appropriately and in good time, also about possible electroshock therapy; 'she had promised, faithfully, to warn me ahead of time' (Plath, 1999, 211). The psychiatrist in Mario Tobino's *Le libere donne di Magliano* (Ital. 1953) is committed to a humane psychiatry and is moved by the great desire to make his asylum for the mentally ill a place of humanity, of communication, of sympathy: 'un tranquillo, ordinato, universale parlare' (Tobino, 1990, 76).

For Dr. Boulbon in Proust's *À la recherche du temps perdu* (French 1913–1927), the relationship between patient and doctor should be based on a reciprocity, on a closeness

fostered by the doctor's own experience of illness: 'Je vous ai dit que sans maladie nerveuse il n'est pas de grand artiste, qui plus est, ajouta-t-il en élevant gravement l'index, il n'y a pas de grand savant. J'ajouterai que, sans qu'il soit atteint lui-même de maladie nerveuse, il n'est pas, ne me faites pas dire de bon médecin, mais seulement de médecin correct des maladies nerveuses' (Proust, 1988, 601 f.).

The sense of right measure, but in a conventional and inhuman way, is the highest ideal of the doctor Sir William Bradshaw in Virginia Woolf's novel *Mrs Dalloway* (Engl. 1925): 'Naked, defenceless, the exhausted, the friendless received the impress of Sir William's will. He swooped; he devoured. He shut people up. It was this combination of decision and humanity that endeared Sir William so greatly to the relations of his victims' (Woolf, 1976, 113). Mrs Dalloway, although she considers Bradshaw an able and respected doctor, is convinced 'one wouldn't like Sir William to see one unhappy. No; not that man' (Woolf, 1976, 200).

The writer–doctor Louis-Ferdinand Céline's *Voyage au bout de la nuit* (French 1932) leads into the world of war with its wounds, disease, and death. In order to encourage the mentally ill, the chief physician in this novel, Professor Bestombes with the beautiful supernatural eyes, has developed 'un appareillage trés compliqué d'engins électrique' (Céline, 1981, 89) to whose blows the patients have to submit at regular intervals. Bestombes works on a psychology of war that is also supposed to take into account earlier observations of the behaviour of soldiers in war; a specific phase of the illness had already been given the plastic name 'diarrhée cogitive de libération' (Céline, 1981, 92).

The psychiatrist Dr. Friedenthal in Robert Musil's novel *Der Mann ohne Eigenschaften* (Germ. 1930–1952) considers his discipline a 'halb künstlerische Wissenschaft' (Musil, 1968, 714) and limited in its therapeutic possibilities, also inadequate in the conditions of the psychiatric institution. 'Ordnung wie in einer Kaserne oder jeder anderen Massenanstalt, Linderung vordringlicher Schmerzen und Beschwerden, Bewahrung vor vermeintlichen Verschlimmerungen, ein wenig Besserung oder Heilung; das waren die Elemente seines täglichen Tuns'. Madhouses, he said, were basically poorhouses. 'Sie haben etwas von der Phantasielosigkeit der Hölle' (Musil, 1968, 986). Visitor Clarissa, guided by Dr. Friedenthal through the asylum with its various departments, is impressed by the creativity and artwork of the mentally ill. 'Es erschien ihr offenkundig falsch, so begabte Menschen einzusperren; die Ärzte verstünden ja wohl die Krankheiten, dachte sie, aber wahrscheinlich doch nicht in ihrer ganzen Tragweite die Kunst' (Musil, 1968, 984).

Francis Scott Fitzgerald's *Tender is the Night* (Engl. 1934/48) describes the schizophrenic illness of Nicole Warren, her cure, and her love for her psychiatrist, who marries her but fails her personally and professionally. Emotions, intellect, physiognomy, language, and behaviour of the patient are described in detail, the healthy states and relapses, the distance to reality, the strategy of therapy: 'A "schizophrène" is well named as a split personality—Nicole was alternately a person to whom nothing need to be explained and one to whom nothing could be explained. It was necessary to treat her with active and affirmative insistence, keeping the road to reality always open, making the road to escape harder going. But the brilliance, the versatility of madness is akin

to the resourcefulness of water seeping through, over, and around a dike' (Fitzgerald, 2012, 218).

The psychiatrist and supporter of existential psychotherapy Irvin David Yalom recalls real persons in the history of philosophy and psychiatry in his novels. *When Nietzsche Wept* (Engl. 1992) describes the therapeutic relationship between the philosopher Friedrich Nietzsche and the psychiatrist Josef Breuer, including their personal fates, their philosophical conversations and the reversal of the doctor–patient relationship. *The Schopenhauer Cure* (Engl. 2005) takes up the philosopher's convictions and ideas in a group therapy—with the psychoanalyst and group therapist Julius Hertzfeld, who suffers from skin cancer and is also dying of it, and the philosopher Philip Slate, who is freed from his sex addiction by reading Schopenhauer (bibliotherapy) and plans a philosophical practice.

In Mario Tobino's *Le libere donne di Magliano* (Ital. 1952), established diagnostic and therapeutic procedures are used, and at the same time psychopathology, which is increasingly neglected in psychiatry worldwide, is considered equally necessary; there are similarities with anthropological medicine and philosophically influenced psychiatry. The doctor gets involved with the delusions of his schizophrenic patients in his asylum, reproduces their behaviour and thoughts, considering the approach of a solely biological psychiatry to be inadequate. For him, the delusions of the patient Palazzo are not just nonsense, but an expression of something 'superhuman' ('di sopra dell'umano'), which escapes the scientific perspective. This patient's mental illness is not only determined symptomatically according to the *International Classification of Diseases* (ICD-10), but placed in an anthropological-cosmological context: The mentally ill are a victim of nature, which wants to show them the senselessness of a will that is not accompanied by tenderness—'dimostrare quanto sia folle la volontà, la sola volontà, senza essere accompagnata dalla tenerezza' (Tobino, 1990, 130 f.).

The doctor Dick Diver in Fitzgerald's *Tender Is the Night* marries his schizophrenic patient Nicole Warren; her recovery runs parallel to his personal decline and professional downfall, several times he tries a new beginning after divorce and return—'but evidently without success' (Fitzgerald, 2012, 352). In contrast, the marital union between psychiatrist and patient in Ernst Augustin's *Raumlicht. Der Fall Evelyne B.* (Germ. 1976) did not fail; limits to the affection are, however, also drawn here by the ironic final sentence: 'Man ahnte, ich habe meine Patientin geheiratet, anders wäre es nicht gegangen. Außerdem ist das sicherlich der Mindesteinsatz, den der Psychiater leisten sollte. Glaube ich' (Augustin, 1976, 271). This therapy can only be offered to a few patients.

Since ancient times, there has been the topos of the sick doctor and the sick as doctor. Insane physicians and psychiatrists are portrayed by Charles Dickens (1859, 1965), Robert Louis Stevenson (1886), Anton P. Chekhov (1892), Gottfried Benn (1916), and Walker Percy (1987). Sick people can in turn become doctors and have therapeutic abilities.

Louis Lambert (Balzac) does not cure the sick, but observes the process of his mental illness like a doctor who is sick—'comme un médecin qui étudierait le progrès de sa propre maladie' (Balzac, 1980, 644). Proust is convinced that a successful psychiatrist

should have undergone a mental-spiritual illness: 'Dans la pathologie nerveuse, un médecin qui ne dit pas trop de bêtises, c'est un malade à demi guéri' (Proust, 1988, 601 f.). In Poe's story *The System of Doctor Thaer and Professor Fether* (1845, 2008), the usual roles are reversed, sick people take over the duties of doctors, doctors become sick people. Stevenson's *Strange Case of Dr. Jekyll and Mr. Hyde* depicts the splitting of the ego and the moral decline of a doctor. In his psychiatric work, the psychiatrist Ragin in Chekhov's *Ward No. 6* succumbs to mental illness and becomes a patient in his own asylum. Ego loss also determines the development of Dr. Rönne in Benn's novella cycle *Gehirne* (1916).

The main character of Percy's novel *Love in the Ruins* (Engl. 1971) is a psychiatrist who is simultaneously a patient and therefore cannot be elective in his choice of patients: 'Not that I make much money. Sensitive folk, after all, don't have much use for a doctor who sips toddies during office hours. So I'm obliged to take all kinds of patients, not merely terrified and depressed people, but people suffering with bowel complaints, drugheads with beri-beri and hepatitis, Bantus shot up by the cops, cops shut up by Bantus' (Percy, 1971, 11).

Social Relations

Illness is a physical, psychological, spiritual and, above all, social phenomenon—in the reactions of the healthy to the sick, of the sick to the healthy, of the sick to each other, and also of the healthy to each other in their relationship to the sick and to the illness.

In Achim von Arnim's story *Der tolle Invalide auf dem Fort Ratonneau* (Germ. 1818), Rosalie wants to save her husband Francoeur, who is ill with madness, even at the risk of her own life, which she then succeeds in doing. She knows him, she wants to summon the devil in him: 'ich will den Teufel beschwören in ihm, ich will ihm Frieden geben, sterben werde ich doch mit ihm, also ist nur Gewinn für mich, wenn ich von seiner Hand sterbe, der ich vermählt bin durch den heiligsten Schwur' (v. Arnim, 1992, 50).

Illness can offer protection and nurture illusions; the return to health can be fraught with real burdens and disappointments. The fact that the young Rudolf von Schlitz has concealed his past and overcome mental illness from his bride Anna out of shame and fear in Theodor Storm's novella *Schweigen* (Germ. 1883, [4]1978) makes him guilty before her and puts a strain on the young marriage when Anna finds out about it.

Louis Lambert (Balzac) is no longer capable of contact with other people after the onset of his schizophrenic illness—'une espèce de conquête faite par la vie sur la mort, ou par la mort sur la vie'. Only a few words are still spoken by him, among them: 'Les anges sont blancs' (Balzac, 1980, 681)—a phrase expressing madness or a mystical vision. His fiancée Pauline de Villenois stays with him, loves and understands him, does not consider him insane. 'Aux autres hommes, il paraîtrait aliéné, pour moi, qui vit dans sa pensée, toutes ses idées sont lucides' (Balzac, 1980, 683).

But understanding attention does not always succeed—in reality as well as in literature. Ève in Sartre's story *La chambre* (French 1939) wants to leave the normal world of the healthy, her parents and friends and participate in the uncanny reality of her sick husband Pierre and fails: '"Un jeu", pensa- t- elle avec remords; "ce n'était qu'un jeu, pas un instant je n'y ai cru sincèrement. Et pendant ce temps-là, il souffrait pour e vrai"' (Sartre, 1981, 259). She is determined to actively put an end to Pierre's life at a certain stage of his illness and decline: 'Un jour ces traits se brouilleraient, il laisserait pendre sa mâchoir, il ouvrirait à demi des yeux larmoyants. Ève se penchait sur la main de Pierre et y posa ses lèvres: "Je te tuerai avant"' (Sartre, 1981, 261).

Mental illness can infect and make healthy people ill (folie à deux). The story *Light and Shadows* (Russ. 1896) by Fyodor Sologub shows the contagious power of mental illness; the son draws his mother into the unreal, mad world of shadow plays. 'Madness shines in their eyes, blessed madness. Night is falling over them' (Sologub, 1977, 29).

An impressive example of the connection between doctor and patient, between self-therapy and therapy by others is described in Charles Dicken's *A Tale of Two Cities* (Engl. 1859). For the mentally ill doctor Dr. Manette, awareness of reality, self-analysis, and social communication are not possible in the phases of illness, but they are possible in healthy times, when he can even give the environment meaningful hints about the causes of his suffering and also the therapy—admittedly not to a doctor or his daughter, but to a family friend. Using the example of a similar case, which he tells Manette, he learns from him in what way he could be cured, which is then carried out with success. 'The less it was occupied with healthy things, the more it would be in danger of turning in the unhealthy direction' (Dickens, 1965, 224). A mentally ill doctor and a 'lay doctor' who is his friend are connected in an empathic-existential relationship and achieve healing.

Symbolism

If scientific medicine is interested in empirical facts, their objective correlations and statistical dissemination, for literature the ideational typology and symbolic meaning remain the decisive perspective. Literary works are suggestions to change, unsettle and humanize established views of mental illness and the mentally ill, are admonitions not to succumb to the ever-present dangers of the perversion of medicine as well as society.

At the beginning of the modern era, Erasmus of Rotterdam, in *The Praise of Folly* (Latin 1511), brings Platonic wisdom, paradisiacal simplicity, and religious enthusiasm into close proximity with physically caused mental illness, which makes recovery and a return to normality seem undesirable to the sick: 'And therefore they are sorry they are come to themselves again and desire nothing more than this kind of madness, to be perpetually mad. And this is a small taste of that future happiness' (Erasmus von Rotterdam, 1913, 187).

Madness is supposed to be able to open the consciousness to truths that are closed in the sane state. Novalis lets *Heinrich von Ofterdingen* (Germ. 1802) suffer 'freiwilligen Wahnsinn' in order to guess 'den Sinn der Welt' (Novalis, 1950, 344.) 'Der Unterschied zwischen Wahn und Wahrheit liegt in der Differenz ihrer Lebensfunktionen. Der Wahn lebt von der Wahrheit, die Wahrheit hat ihr Leben in sich' (Novalis, 1965, 414).

The mental illness of Balzac's *Louis Lambert* also brings madness and wisdom into an inner connection or even makes them identical. Madness appears not only as a decay of the spirit, but as its heightening. Louis Lambert sought the victory of the spiritual over the material; his falling silent can be interpreted as a descent, as destruction, but equally as an ascent into ingenious or supernatural possibilities. 'Les philosophes en regretteront les frondaisons atteintes par la gelée dans leurs bourgeons; mais sans doute ils en verront les fleurs écloses dans des régions plus élevées que ne le sont les plus hauts de la terre' (Balzac, 1980, 646).

The first-person narrator in Gérard de Nerval's story *Aurélia ou la rêve et la vie* (French 1855) wonders whether the states of mental suffering that gave him a great sense of well-being and deep insight were really mental illness. He feels better than ever, thinks his strength and activity have doubled, 'car jamais, quant à ce qui est de moi-même, je ne me suis senti mieux pourtant. Parfoi, je croyais ma force et mon activité doublées; il me semblait tout savoir, tout comprendre; l'imagination m'apportait des délices infinies. En recouvrant ce que les hommes appellent la raison, faudra-t-il regretter e les avoir perdues?' (Nerval, 1993, 695).

In *Lettre aux Médecins-Chefs des Asiles de Fous* (French 1926), the writer Antonin Artaud declares delirium to be 'aussi légitime, aussi logique que toute autre succession d'idées ou d'actes humains'; mad people are 'les victimes individuelles par excellence de la dictature sociale' (Artaud, 1976, 221) their fate shows the widespread intolerance against any form of deviation.

The medical student in Thomas Bernhard's novel *Frost* (Germ. 1963) is touched by the mental illness of the painter Strauch, whom he has to observe during his clinical traineeship, to a depth that makes him doubt medicine and the usual distinction between healthy and sick: 'Das Medizinische ist finster, das sind nur finstere Wege, ich gehe augenblicklich mit meinem "schutzlosen Kopf" durch das Labyrinth unserer Wissenschaft, die ich wohl als die glorreiche unter allen unseren Wissenschaften bezeichnen möchte, als die Schreckensherrschaft aller Wissenschaften, zusammen, die alle, im Gegensatz zu der unsrigen, nur Scheinwissenschaften sind, obwohl auch die unsere eine reine Vorstufenwissenschaft ist' (Bernhard, 1976, 307).

Not only individuals, but also societies, philosophical movements and literary trends can be described as 'insane'. Insanity shapes André Breton's definition of surrealism in the 1924 *Manifest*. 'Le surréalisme repose sur la croyance à la réalité supérieure de certaines formes d'associations négligées jusqu'à lui, à la toute-puissance du rêve, au jeu désintéressé de la pensée. Il tend à ruiner définitivement tous les autres mécanismes psychiques et à se substituer à ceux dans la résolution des principaux problèmes de la vie' (Breton, 1988, 328). Even animals and plants can be considered insane. Apollinaire

counts carp among 'poissons de la mélancolie' (Apollinaire, 1965, 25), and also writes poetry about the 'tristesse' of a star or autumn.

Mental illness separates and connects, and can affect anyone. Doris Lessing is convinced: 'The dark is in us, and if we lower the barriers it will penetrate us and we'll show the symptoms' (Torrents, 1980, 12). All the sane characters in Musil's novel *Der Mann ohne Eigenschaften* (Germ. 1930–1952) are linked in their own specific way to the mentally ill sexual offender Christian Moosbrugger, carry his abysmal nature within them, and draw attention to the connection between normality and abnormality, guilt and punishment, health and illness. Christian Moosbrugger is placed in a universal context. 'Wenn die Menschheit als Ganzes träumen könnte, müsste Moosbrugger entstehn' (Musil, 1968, 76).

Conclusion

Mental illness is a frequent and widespread theme in literature—in its manifestations, causes and therapy, in the subjectivity of the mentally ill person, in the image of the psychiatrist, in the medical institution, social reactions and spiritual-symbolic interpretations.

Literary texts question common attitudes towards mental illness and the mentally ill and promote understanding and humane reactions, design suggestions for psychiatry, psychotherapy, and art therapy, manifest the equally substantial and complex relationship between objectivity and subjectivity, normality and deviation, health and illness, freedom and loss of freedom, need and help, social rejection and solidarity.

Again and again, the basic question must be examined as to where the limits and possibilities of literature lie, how realistically literature is able to describe individual feelings and general perceptions, how appropriate in typification, how far-sighted or even one-sided. Literature is not science, nor is it the reality of the sick. Literature, science, and reality differ and are at the same time related to each other.

Besides the 'transcendent transcendence' of religion, an 'immanent transcendence' of culture exists, which can be experienced by reading books, listening to music, or looking at paintings. Culture—meaning literature and all the arts—enables the acceptance of the limits of individual life, pain, disease, and death. 'Medical humanities' stands for the connection of natural sciences, humanities, literature, and arts in medicine. Physical as well as mental illness is always understood as a physical, psychological, social, and spiritual phenomenon—in other words as 'spiritual-socio-psycho-somatic'.

Personalized medicine cannot merely mean biological and genetic individuality, but must also take into account the personality and social situation of the patient. Evidence-based medicine cannot be limited to empirical-statistical evidence, but must also include immediate insights of the physician. Precision medicine has to consider—beyond objective accuracy—the precision of subjective observations of the doctor and

self-observations of the patient. Medicine as 'medical humanities' is both human and humane—for the benefit and dignity of suffering, sick, and dying men and women.

References

Apollinaire, G. (1965). La carpe, French 1911. In G. Apollinaire, *Œuvres poétiques*. Gallimard.
Ariosto, L. (2009). *Orlando furioso*, Ital. 1516/32. Belknap Press of Harvard University Press.
Arnim, A. v. (1992). Der tolle Invalide auf dem Fort Ratonneau, Germ. 1818. In A. v. Arnim, *Sämtliche Erzählungen 1818–1830. Werke*, volume 4 (pp. 32–55). Deutscher Klassiker Verlag.
Artaud, A. (1976). Lettre aux médecins-chefs des Asiles de Fous, French 1926. In A. Artaud, *Œuvres complètes*, volume 1, 2 (pp. 220–221). Gallimard.
Augustin, E. (1976). *Raumlicht. Der Fall Evelyne B.* Suhrkamp.
Balzac, H. de (1980). Louis Lambert, French 1832. In H. Balzac, *La Comédie humaine*, volume 11 (pp. 589–692). Gallimard.
Benn, G. (1916). *Gehirne*. Wolff.
Bernhard, T. (1976). *Frost*, Germ. 1963. Suhrkamp.
Breton, A. (1988). Manifeste du surréalisme, French 1924. In A. Breton, *Œuvres complètes*, volume 1 (pp. 309–346). Gallimard.
Céline, L. F. (1981). *Voyage au bout e la nuit*, French 1932. *Romans*, volume 1. Gallimard.
Cervantes Saavedra, M. (2013). The glass graduate, Spanish. El licenciado vidriera, 1613. In M. Cervantes, *The complete exemplary novels* (pp. 271–308). Aries & Phillips.
Chekhov, A. P. (1921). Ward No. 6, Russ. 1892. In A. P. Chekhov, *The horse stealers and others stories* (pp. 29–112). Macmillan.
Dickens, C. (1965). *A tale of two cities*, Engl. 1859. Oxford University Press.
Dostoevskij, F. M. (1913). *The idiot*, Russ. 1868/69. *The novels of Fyodor Dostoevsky*, volume 2. Macmillan.
Erasmus von Rotterdam. (1913). *The praise of folly*, Lat. 1511. Clarendon Press.
Fitzgerald, F. S. (2012). *Tender is the night*, Engl. 1934/48. Cambridge University Press.
Gogol, N. V. (2020). Diary of a madman', Russ. 1835. In N. V. Gogol, *The nose and other stories* (pp. 155–180). Columbia University Press.
Griesinger, W. (1845). *Die Pathologie und Therapie der psychischen Krankheiten*. Krabbe.
Hesse, H. (1906). *Unterm Rad*. Fischer.
Hofmannsthal, H.v. (2013). *Aufzeichnungen*, Germ. 1894. *Sämtliche Werke*, volume 38. Fischer.
James, H. (1969). *The wings of the dove*, Engl. 1902. Bodley Head.
Jaspers, K. (1913, 91973). *Allgemeine Psychopathologie*. Springer.
Jean Paul (2000). Selina oder über die Unsterblichkeit der Seele, Germ. posthum 1821. In Jean Paul, *Sämtliche Werke*, dept. 1, volume 6 (pp. 1105–1236). Wissenschaftliche Buchgesellschaft.
Johnson, S. (1990). The history of Rasselas, Prince of Abissinia, Engl. 1759. In S. Johnson, *Rasselas and other tales* (pp. 1–176). Yale University Press.
Klingemann, E. A. F. (1974). *Die Nachtwachen des Bonaventura*, Germ. 1804. Insel.
Machado de Assis, J. M. (2012). *The Alienist*, Port. 1882. Melville House.
Maupassant, G. de (1979). Le Horla, French 1887. In G. de Maupassant, *Contes et nouvelles*, volume 2 (pp. 913–938). Gallimard.
Musil, R. (1968). *Der Mann ohne Eigenschaften*, Germ. 1930–52. Rowohlt.

Nerval, G. de (1993). Aurélia ou la rêve et la vie, French 1855. In G. de Nerval, *Œuvres complètes* (pp. 693–756). Gallimard.
Novalis (1950). Paralipomena zum 'Heinrich von Ofterdingen'. In Novalis, *Schriften*, volume 1 (pp. 335–369). Kohlhammer.
Novalis (1965). Vermischte Bemerkungen und Blütenstaub, Germ. 1798. In Novalis, *Schriften* volume 2 (pp. 412–470). Kohlhammer.
Odoevskij, V. F. (1997). *Russian nights*, Russ. 1844. Oxford University Press.
Pasternak, B. (1958). *Doctor Zhivago*, Ital. 1957. Collins and Harvill Press.
Percy, W. (1971). *Love in the ruins*. Farrar, Straus & Giroux.
Percy, W. (1987). *The Thanatos syndrome*. Farrar, Straus & Giroux.
Plath, S. (1999). *The Bell Jar*, Engl. 1963. Harper Perenniel.
Poe, E. A. (2008). *The system of Doctor Tarr and Professor Fether*, Engl. 1845. In E. A. Poe, *Selected Tales*, second edition. Oxford World's Classics. Oxford University Press.
Proust, M. (1988). *À la recherche du temps perdu*, French 1913–27, volume 2. Bibliothèque de la Pléiade.
Sartre, J.-P. (1981). La chambre, French 1939. In J.-P. Sartre, *Œuvres romanesques* (pp. 234–261). Gallimard.
Schneider, K. (1922). *Der Dichter und der Psychopathologe*. Rheinland Verlag.
Sologub, F. (1977). Light and Shadows, Russ. 1896. In F. Sologub, *The Kiss of the Unborn* (pp. 3–29). University of Tennessee Press.
Stevenson, R. L. (1886). *Strange case of Dr Jekyll and Mr Hyde*. Cambridge University Press.
Storm, T. (41978). Schweigen, Germ. 1883. In T. Storm, *Sämtliche Werke in vier Bänden*, volume 3 (pp. 436–501). Aufbau Verlag.
Swift, J. (1965). A digression concerning the original, the use and improvement of madness in a commonwealth, Engl. 1704. In J. Swift, *A tale of a tub* (pp. 102–114). Blackwell.
Tobino, M. (1990). *Le libere donne di Magliano*, Ital. 1953. Mondadori.
Tolstoy, Lev. N. (1952). *War and peace*, Russ. 1868/69. Encyclopaedia Britannica.
Torrents, N. (1980). Testimony to mysticism. Interview with Doris Lessing. *Lessing. Newsletter* 4, 2(1), 12–13.
Woolf, V. (1976). *Mrs. Dalloway*, Engl. 1925. Hogarth Press.
Yalom, I. D. (1992). *When Nietzsche wept*. Basic Books.
Yalom, I. D. (2005). *The Schopenhauer cure*. HarperCollins.

Further Reading

Ansermet, F., Alain Grosrichard, A., & Méla, Ch. (Eds.). (1989). *La psychose dans le texte*. Navarin.
Benedetti, G. (1975). *Psychiatrische Aspekte des Schöpferischen und schöpferische Aspekte der Psychiatrie*. Verlag für Med. Psychologie, Vandenhoeck & Ruprecht.
Bogen, H. v. Mayer, Th., Meyer zu Schwabedissen, S., Schierke, D., & Schnorr, S. (Eds.). (2015). *Literatur und Wahnsinn*. Frank & Timme.
Burwick, F. (1996). *Poetic madness and the romantic imagination*. Pennsylvania State University Press.
Califano, M. B. (Ed.). (2005). *Sapere & narrare. Figure della follia. Ciclo di conferenze, settembre - dicembre 2003*. Olschki.

Copelman, L. S., Cantacuzène, J., & Zamfiresco, I. (1961). Le reflet de la psychiatrie dans le miroir de la littérature universelle. *Annales Médico-Psychologiques 119*, 316–332.

Cueva Tamariz, A. (1958). Literatura y psiquiatría de profundidad. *Anales de la Universidad de Cuenca 14*(4), 375–420.

Daemmrich, H. S., & Daemmrich, I. (21995). Wahnsinn. In H. S. Daemmrich & I. Daemmrich (Eds.), *Themen und Motive in der Literatur, ein Handbuch* (pp. 368–372). Francke.

Dolfi, A. (Ed.). (1993). *Nevrosi e follia nella letteratura moderna*. Bulzoni.

Eckart, W. U. (2005). Wahn. In B. v. Jagow & F. Steger (Eds.), *Literatur und Medizin. Ein Lexikon* (col. 842–852). Vandenhoeck & Ruprecht.

Engelhardt, D. v. (2008). Geisteskrankheit im Medium der Literatur. *Zeitschrift für medizinische Ethik 54*(3), 221–234.

Engelhardt, D. v. (2018, 22021). Medizin in der Literatur der Neuzeit, volumes 1–5. Mattes.

Feder, L. (1980). *Madness in literature*. Princeton University Press.

Finger, S., Boller, F., & Stiles, A. (Eds.). (2013). *Literature, neurology, and neuroscience. Neurological and psychiatric disorder*. Elsevier.

Gandelman, C. (1989). *Littérature et folie*. Ciba-Geigy.

Geyer, H. (1955). *Dichter des Wahnsinns. Eine Untersuchung über die dichterische Darstellbarkeit seelischer Ausnahmezustände*. Musterschmidt.

Gillibert, J. (1990). *Folie et création*. Champ Vallon.

Gilman, S. L. (1988). *Disease and representation. Images of illness from madness to AIDS*. Cornell University Press.

Glatzel, J. (1986). Literatur und Schriftsteller in psychiatrischer Betrachtung. In R. Langner (Ed.), *Psychologie und Literatur* (pp. 18–45). Psychologie-Verlags-Union.

Graham, P. W. (Ed.). (1985, reprint 2005). *Psychiatry and literature*. Johns Hopkins University Press, reprint Germantown, Periodicals Service Company, New York.

Heseltine, H. (Ed.). (1992). *Literature and psychiatry. Bridging the divide*. Australian Defence Force Academy, Department of English.

Hoche, A. E. (1939). *Die Geisteskranken in der Dichtung*. Lehmanns.

Irle, G. (1965). *Der Psychiatrische Roman*. Hippokrates-Verlag.

Jacerme, P. (1985, again 1989). *La 'folie' de Sophocle à l'antipsychiatrie*. Bordas.

Köpf, G. (2006). *ICD-10 literarisch. Ein Lesebuch für die Psychiatrie*. Deutscher Universitätsverlag.

Köpf, G., & Faust, V. (2003). *Psychiatrie in der Literatur*. Deutscher Universitätsverlag.

Kudszus, W. G. (Ed.). (1977). *Literatur und Schizophrenie. Theorie und Interpretation eines Grenzgebiets*. Niemeyer.

Mentzos, St., & Münch, A. (Eds.). (2004). *Psychose und Literatur*. Vandenhoeck & Ruprecht.

Müller-Seidel, W. (1984). Psychiatrie im erzählten Text. Zur Problematik von Diagnosen in Literatur und Literaturwissenschaft. In H. Hippius (Ed.), *Ausblicke auf die Psychiatrie* (pp. 55–68.). Springer.

Olaru-Poşiar, S. (2015). *Literatur und Medizin. Wahn und Wahnsinn in der Medizinwissenschaft und in der Literatur*. Mirton.

Oyebode, F. (Ed.). (2009). *Mindreadings. Literature and Psychiatry*. RCPsych Publications.

Plaza, M. (1986). *Écriture et folie*. Presses Universitaires de France.

Poltrum, M. (2016). *Philosophische Psychotherapie. Das Schöne als Therapeutikum*. Parodos.

Rose, F. C. (2004, reprint 2007). *Neurology of the arts. Painting, music, literature*. Imperial College Press.

Rouge, D. (2012). *Écrire et lire la folie. Rencontrer le fou dans ses textes*. Wydawnictwo Naukowe Uniwersytetu Pedagogicznego.

Sass, L. A. (1992, ³1998, revised edition 2017). *Madness and modernism. Insanity in the light of modern art, literature, and thought*. Basic Books; Cambridge, Harvard University Press ³1998, revised edition; Oxford University Press.

Saunders, C., & Macnaughton, J. (Eds.). (2005). *Madness and creativity in literature and culture*. Palgrave Macmillan.

Schmitt, W. (1998). Psychiatrie und Literatur. In W. Gaebel & P. Falkai (Eds.), *Zwischen Spezialisierung und Integration – Perspektiven der Psychiatrie und Psychotherapie* (pp. 91–98). Springer.

Tellenbach, H. (1992). *Schwermut, Wahn und Fallsucht in der abendländischen Dichtung*. Pressler.

Thiher, A. (1999, paperback edition 2004, e-book 2009). *Revels in madness. Insanity in medicine and literature*. University of Michigan Press.

Vaccarino, G. L. (2007). *Scrivere la follia. Matti, depressi e manicomi nella letteratura del Novecento*. EGA.

Valentine, K. (2003). *Psychoanalysis, psychiatry and modernist literature*. Palgrave Macmillan.

Vallejo Nágera, A. (1950). *Literatura y psiquiatría*. Barna.

Wübben, Y. (2012). *Verrückte Sprache. Psychiater und Dichter in der Anstalt des 19. Jahrhunderts*. Konstanz University Press.

CHAPTER 26

BIBLIOTHERAPY OR THE HEALING POWER OF READING IN THE CONTEXT OF CULTURAL HISTORY

Basics—Development—Dimensions—Perspectives

DIETRICH V. ENGELHARDT

Introduction: Fundamentals—Development

THE conviction of the healing power of literature—as generally of the arts—runs through history from antiquity to the present and corresponds to a form of medicine that can be described as 'medical humanities' or as the connection of the four (and not only two) cultures: the culture of natural sciences, the culture of humanities, the culture of arts, and the culture of life. Again and again, the healing effects of literary as well as philosophical and theological texts can be extended beyond the individual human being to apply to society and culture. Repeatedly, literary works themselves contain inspiring examples of coping with suffering, illness, and dying.

Reading (bibliotherapy)—like writing (graphotherapy)—as a remedy and aid to life traditionally held a firm place as a therapy compromising not only the treatment of illness, but simultaneously the preservation of health and support in the contexts of illness and dying. In antiquity, literature is assigned to dietetics, the third pillar of medicine alongside medications and surgery—dietetics as dealing with the so-called 'six non-natural things' (*sex res nonnaturales*): light and air (*aer*), food and drink (*cibus et potus*), movement and rest (*motus et quies*), sleeping and waking (*somnus et vigilia*), excretions (*secreta*), and emotions (*affectus animi*) (Craik, 1995; v. Engelhardt, 1995; Rather, 1968;

Schipperges, 1968, Schmitt, 2005; Trémolières, 1975). These central areas of life are called 'non-natural' (*nonnaturales*) because they are not self-regulating but instead require the agency of healthy and sick people, acting as an interface between nature and culture, or as cultivated nature. From the perspective of such holistic dietetics, literature and all the arts are attributed a great influence on the sixth of these of non-natural things: feelings or emotions.

From the visit of tragedies, the philosopher Aristotle (384–322 BC) expects catharsis through the experience of shock and relief: 'through pity (*éleos*) and fear (*phóbos*) accomplishing catharsis of such emotions' (Aristotle, 1995, 47 f.). The exact meaning of this phrase is disputed: purification through representation or represented purification is the alternative.

The Bible, like corresponding texts of other religions, is a timeless basic work of bibliotherapy—for the educated as well as the illiterate, for young as well as old, for men as well as women, for poor as well as rich. The proximity of word and sound is also evident here, with music therapy finding an impressive model in David's harp playing, with which he knew how to relieve Saul's depression: 'And whenever the evil spirit from God came upon Saul, David took the lyre and played it with his hand, and Saul would be relieved and feel better, and the evil spirit would depart from him' (1 Samuel 16:23).[1] Music also received attention in the medicine of Greece and Rome. The ancient physician Galen (129–199 AC) reported that the Greek god of medicine Asclepius cured the mentally ill through music and song.

The Romans also recommended reading or listening to speeches to overcome mental instability. The philosopher Cicero (106–43 BC), in his writing *On Old Age* (Lat. 45/44 BC), strives to facilitate the acceptance of this phase of life with all its burdens: 'lighten both for you and me our common burden of old age' (Cicero, 1992, 11). He states himself that against 'cruel sorrows and the various troubles which beset me from all sides' her found 'no other consolation (*levatio*)' (Cicero, 1989, 547) than by penning the *Tusculan Disputations* (Lat. 45 BC). Seneca (1–65 AC) also finds inner reassurance from philosophical texts and, at the same time, a cure for his external suffering from consumption: 'Honourable consolation results in a cure; and whatever has uplifted the soul helps the body also. My studies were my salvation. I place it to the credit of philosophy that I recovered and regained my strength' (Seneca, 1991, 183). Seneca writes several consolations for people who have lost their relatives or who live in exile (Seneca, 2015).

The Consolation of Philosophy (Lat. around 523) of the roman politician and philosopher Boethius (around 489–524) is also able to dampen Dante's (1265–1321) grief over the death of his beloved Beatrice (Dante, 2018, 54 f.). With the *Divine Comedy* (Ital. 1307–1321) he, for his part, wants to free people from despair and put them in a joyous state: 'to remove those living in this life from the state of misery and lead them to the state of felicity (*perducere ad statum felicitatis*)' (Dante, 1904, 351). The abbess, naturalist, and physician Hildegard von Bingen (1098–1179) gains strength and courage to cope with her lifelong suffering by writing down visions (Godefridus & Theodericus 1968, ³1980, 56). Author Hartmann von Aue (d. between 1210–1220) hopes that his epic verse *The Poor Heinrich* (Germ., around 1195) 'could make oppressive hours more pleasant'

(Hartmann von Aue, 2001, 217; 'swaere stunde möhte senfter machen', id. 2015, 9); the example of Heinrich, a leper, and his recovery through a moral turnaround should give readers strength in dealing with illness and suffering.

Bibliotherapy is not bound to a particular religion. The Arabic Al-Mansur Hospital in Cairo always offers the *Koran* (seventh century) alongside medical treatment and surgery to support therapy. The Arab-Jewish physician and philosopher Moses Maimonides (c. 1135–1204) praises the healing and dietetic power of literature and emphasizes the responsibility of the sick person in dealing with their own illness and with the therapy recommended by the physician: 'medicine merely recommends what is beneficial and warns against what is harmful, but does not enforce it nor punish for it (*non tamen super hoc condemnat vel renumerat*)' (Maimonides, 2021a, 517; s. a. id. 2021, 479).

In modern times, the tradition of bibliotherapy or the healing power of literature runs from the Renaissance to the present. Numerous theoretical contributions and practical experience reports on the healing power of reading provided by physicians, philosophers, theologians, and writers serve as valuable and enduring contributions to the understanding of Bibliotherapy. Literature is considered essential for the art of living (*vivendi*), the art of being ill (*ars aegrotandi*), the art of dying (*ars moriendi*), and also the art of assisting (*ars assistendi*).

The therapeutic function of literature in medicine has been addressed repeatedly. Sacred and secular texts are said to be able to support certain therapies, for example during bath cures, bloodletting, and the treatment of mental illnesses. When the Spanish King Philip II (1527–1598) had to undergo surgery on a knee abscess shortly before his death in July 1598, his confessor, standing at the head of his bed, read to him from the sacred oratorio *St. Matthew Passion* in a quietened voice (Pfandl, 1938, 496). The medical revolution spurred by anesthesia in the nineteenth century rendered such means superfluous or at least caused medics and patients to lose sight of their deeper meaning.

Modern literature on bibliotherapy is rich in examples, which are frequently drawn from biographies and autobiographies.

Books offered to her by her father from his library are said to have consoled Lavinia in William Shakespeare's (1564–1616) *Titus Andronicus* (1594) as she grieved over her dishonour and the amputation of her hands and tongue: 'Come and take choice of all my library, and so beguile thy sorrow' (Shakespeare, 1951, 888). Robert Burton (1577–1640) recommends in his *Anatomy of Melancholy* (1621) *mercy* stories 'to batter down the walls of melancholy,' and compares the Bible to an apothecary with 'remedies for all infirmities of mind' (Burton, 2001, 94, 119). With his novel *Gargantua et Pantagruel* (1532–1564) the physician and writer François Rabelais (c. 1494–1553) promises relief ('*soulaigement*') to the afflicted and sick far away ('*affligez et maladies absens*'), similarly to how he might offer his medical treatment ('*de mon art et service*') in person ('*présens*') to those nearby (Rabelais, 1985, 517). Charles de Montesquieu (1689–1755) and Jean Paul (1763–1825) both gave concrete bibliotherapeutic suggestions, offering ironic and sarcastic proposals of particular works in theology, philosophy, medicine, and literature for certain physical and mental diseases (Montesquieu, 2004, 522; Paul, 2000, 220 f.).

In 1705, the theologian Georg Heinrich Götze (1667–1728) published a *Kranken-Bibliothek* [sick library] with references to texts for coping with illness. In 1795–1798, a *Medizinisches Vademecum für lustige Ärzte und lustige Kranken* [medical *vade mecum* for lighthearted doctors and patients] was published by the physician Ernst Ludwig Wilhelm Nebel (1772–1854). The writer and actor Christian Heinrich Spieß (1755–1799) wanted to help prevent suicides with his collection *Biographien der Wahnsinnigen* [biographies of lunatics] (Germ., 1795/96): 'Wie herrlich, wie erhaben würde ich mich belohnt dünken, wenn meine Erzählungen das leichtgläubige Mädchen, den unvorsichtigen Jüngling an der Ausführung eines kühnen Plans hinderten, der ihnen einst den Verstand rauben könnte [How glorious, how sublime I would think myself rewarded if my tales prevented the gullible girl, the careless youth, from carrying out a bold plan that might one day rob them of their sanity]' (Spieß, 1976, 7 f.). On the completion of his work *The Sorrows of Young Werther* (Germ. 1774), Johann Wolfgang von Goethe (1749–1832) felt 'as glad and free again as after a general confession, and entitled to a new life' (Goethe, 1987, 432), while contemporary readers may rather find themselves bolstered in their suicidal tendencies or even inspired to commit suicide by reading this novel.

In Samuel Warren's (1807–1877) story *Cancer* (1830), a woman with cancer relieves her terrible pain during mastectomy—before the era of anesthesia—by reading the love letters written by her husband, from whom she has concealed the surgical procedure: 'her eyes continued revited, in one long burning gaze of fondness, at the beloved handwriting of her husband' (Warren, 1831, 49). Adalbert Stifter (1805–1868), too, perceived his work on *Die Mappe meines Urgroßvaters* [the diaries of my great grandfather] (Germ. 1841/42, 41870) as a 'liebevolle Arznei [loving medicine]' (Stifter, 1972, 181) for himself; his stories and novels, however, were also meant to unfold a therapeutic power for readers. In Conrad Ferdinand Meyer's (1825–1898) *Angela Borgia* (Germ. 1891), the poet Ludovico Ariost (1474–1533) comforts the blinded Giulio d'Este (1478–1561) in response to the loss of his eyes with the experiences in his poem *Orlando furioso* (Ital. 1516/32) 'bis sich nach und nach das Dunkel heller färbte und in der entzückten Seele des Blinden eine Sonne aufging [until little by little the darkness turned brighter and a sun rose in the rapt soul of the blind man]' (Meyer, 1976, 842).

The philosopher John Stuart Mill (1806–1873) is pulled out of his 'habitual depression' by the *Mémoires d'un père pour servir à l'instruction de ses enfants* (1800) by the French writer and encyclopedist Jean-François Marmontels (1723–1799) and especially by the poems of the English poet William Wordsworth (1770–1850): 'What made Wordsworth's poems a medicine for my state of mind, was that they expressed, not mere outward beauty, but states of feeling, and of thought coloured by feeling, under the excitement of beauty.' The melody, rhythm, and theme of Wordsworth's ode *Intimations of Immortality* (1807) would have been particularly appealing to Mill, being, as he humbly refers to himself, an unpoetic person: 'But unpoetical natures are precisely those which require poetic cultivation' (Mill, ³1960, 104 f.).

At the beginning of the twentieth century, the writers Marcel Proust (1871–1922) and Rainer Maria Rilke (1875–1926) also understood their literary work as self-treatment,

as overcoming suffering and death. Proust sees writing as serving the author with 'une function saine et nécessaire don't l'accomplissement rend heureux, comme pour les hommes physiques l'exercice, la sueur, le bain' [a healthy and necessary function, whose fulfillment makes one happy, as for physical men exercise, sweating, bathing] (Proust, 1989, 481). The writer Rebecca West (1892–1983), interested in psychoanalytic themes, calls literature 'powerful medicine' (Rollyson, 1996, 27). In Thomas Mann's (1875–1955) *Magic Mountain* (Germ. 1924) the sick Settembrini is planning 'a compilation and brief analysis of such masterpieces of the world's literature as come into question by depicting one or another kind of conflict—for the consolation and instruction of the suffering' (Mann, 1962, 245). For Graham Greene (1904–1987), writing is a kind of self-therapy that, surprisingly, people have rarely taken up: 'Writing is a form of therapy; sometimes I wonder how all those who do not write, compose or paint can manage to escape the madness, melancholia, the panic and fear which is inherent in a human situation' (Greene, 1980, 9). Writing as a form of healing or document of freedom is also the perspective underpinning numerous contemporary accounts of personal experience.

But literature can also be a burden; artistic talent is ambivalent. In 1802, at the beginning of his mental illness, the poet and philosopher Hölderlin (1770–1843) felt 'geschlagen [beaten]' by 'Apollo' (Hölderlin, 1969a, 462) as the symbolic source of his creativity, yet at the same time expected poetry to have a salutary influence on the education of people; poetry was supposed to be able to act as a 'Panazee' of the sufferings and unrest of the time, since the 'politisch-philosophische Kur' (Hölderlin, 1969, 330) had obviously failed in this respect. The naturalist and poet Novalis (1772–1801), for whom poetry is the 'Konstruktion der transzendentalen Gesundheit' [construction of transcendental health] and the poet the 'transzendentale Arzt [transcendental physician]' (Novalis, 21965, 535), warns his brother Erasmus Novalis (1774–1797) against the contemporary 'gespannten, fantasiereichen, individuelleren [tense, imaginative, individualistic]' novels of Romanticism and refers him instead to the soothing works of the Enlightenment, which would surpass the 'Brunnenkur und Pillen [fountain cure and pill]' in effect and give the 'gespannten Unterlieb eine sehr dienliche Relaxion [tense abdomen a very serviceable relaxation]' (Novalis, 21975, 117 f.). The poet Rainer Maria Rilke (1875–1926) advises against reading his *Aufzeichnungen des Malte Laurids Brigge* (Germ. 1910), since younger readers in particular would not know how to read this book '*gegen den Strom* [against the current]' (Rilke, 1977, 92, cf. a. id. 1950, 363), something, however, that is necessary in order to grasp, as the essence of the work, the glory of life as the background to the misery depicted.

At the beginning of the nineteenth century, the psychiatrists Philipp Pinel (1745–1826), Vincenzo Chiarugi (1759–1820), Johann Christian Reil (1759–1813), Benjamin Rush (1745–1813), and Jean Étienne Esquirol (1772–1840) provided important and stimulating initiatives, experiences, and proposals for the dietary or psychological treatment ('moral treatment') of the mentally ill that harness literature and the arts and are still significant today.

Reil pleads for the connection of physical and psychic methods in therapy; art and bibliotherapy are extremely useful, since all the senses, smell, taste, touch, sound, image,

and word can prove to be therapeutically useful. A personal union, or combination of part doctor of the body and part doctor of the soul is always necessary: 'Wer sich daher mit der Heilung der Seelenkrankheiten befassen will, sei beides, Arzt der Seele und Arzt des Körpers [Whoever therefore wants to deal with the healing of soul diseases, be both, doctor of the soul and doctor of the body].' (Reil, 1803, 137).

Esquirol also recognizes the potential of literature in the treatment of the mentally ill in combination with manual labour and gardening ('les promenades, la musique, la lecture, les reunions [walks, music, readings, gatherings]'), addresses recognizable social and gender differences, addresses contraindications for melancholics ('les mélancoliques qui sont sous l'empire de la superstition doivent éviter les lectures, les conversations sur le mysticisme [melancholics under the grip of superstition must avoid readings, conversations on mysticism]'), and emphasizes the importance of both the general and individual causes of the diseases ('connaître toutes les causes générales et individuelles et cette maladie [know all the general and individual causes of this disease]') (Esquirol, 1838, 143, 472).

Rush discusses the effects of secular and religious texts on illness in general and psychiatric illness in particular. For Rush, who also introduced the term bibliotherapist in 1810, reading was part of 'occupational therapy.' He suggested that every hospital should have a library, with books for 'amusement' and for 'instruction'; magazines could also prove helpful. In addition to reading, the mentally ill are also encouraged to write about given topics: 'to read and write upon subjects suggested from time to time by the attending physicians'. Reading aloud to others could also be beneficial. In every case, the treatment must pay equal attention to body and soul: 'The disease affects both the body and mind, and can be cured only by remedies applied to each of them' (Rush, 1951, 1064, cf. a. id. 1811).

Such contributions of physicians, psychiatrists, psychologists, pedagogues, and librarians remain relevant, and as such the abundance of theoretical considerations and practical experiences should not be overlooked today.

In his study *On Reading, Recreation and Amusement for the Insane* the physician John Minson Galt (1819–1862), declares five functions of literature to be particularly important from an educational–therapeutic point of view: (1) 'effacement of delusions and morbid thoughts', (2) 'passing away time', (3) 'information', (4) 'exhibition of the kindly disposition to their afflicted charge', (5) 'more manageable' (Galt, 1853). The arts, he considers—including music and theatre in active and passive forms—should be utilized as well, always with attention to individual inclinations and abilities.

In his writing *Über die Anlegung und Einrichtung von Irren-Heilanstalten* [On the establishment and provision of psychiatric asylums] from 1834, psychiatrist Maximilian Jacobi (1775–1858) explicitly addresses the establishment of a library and its benefits for the mentally ill. In addition to practical skills, the teaching provided there should include natural sciences and foreign languages, and should be based on the individuality of the sick person and the nature of his or her illness. The physician and philosopher Georg Friedrich Most (1794–1845) included among the 'psychischen Mittel gegen Hypochondrie und Hysterie [mental remedies for hypochondria and hysteria]' (Most,

1973, 508) light and cheerful works like *Don Quixote* (1605/15) by Miguel de Cervantes (1547–1616), *Gargantua et Pantagruel* (1532–64) by François Rabelais (1494–1533), comedy plays by August von Kotzebue (1761–1819) and travelogues by Hieronymus Carl Friedrich von Münchhausen (1720–1797). In 1884, psychiatrist Karl Ludwig Kahlbaum (1828–1899) reported the inclusion of literary and ethical texts in his therapeutic programme for adolescent 'Nerven und Gemütskranke [nervous and emotionally ill]', patients, emphasizing the poetic inclinations of these patients and advocating the combination of physical and mental exercise—always taking into account the individual interests and abilities of the sick person. 'Kurz, es muss vielfach individualisiert werden [In short, it must be individualized in many cases]' (Kahlbaum, 1884, 871).

Since that time, libraries have been established at numerous hospitals around the world. The origins of hospital libraries in the United States date back to the eighteenth century. A hospital library was established in Philadelphia in 1762, and many hospitals followed suit in the coming decades.

The positivistic and empirical orientation of nineteenth-century science and medicine led to the neglect of bibliotherapy and dietetics in the holistic sense of antiquity; mechanism and positivism hailed—with impressive and beneficent successes—but also suffered the loss of anthropological–psychological understandings of disease and the sick individual, of diagnostics and therapy and of the doctor–patient relationship. Curing disease has come to be expected predominantly from surgery and bacteriology, illness being increasingly reduced to objective appearances and less understood as subjective suffering; patient history (subjectivity) has become medical history (objectivity). Bibliotherapy and art therapy in general are in this sense considered less effective.

The term bibliotherapy, as far as can be determined, was first used in the English language in 1916 (after the use of bibliotherapist in 1810 by Benjamin Rush) by the Reverend Samuel McCord Crothers (1857–1927) in his fictional account *A Literary Clinic* about the founding of the 'Bibliopathic Institutes', with the additional title 'Book Treatment by Competent Specialists'. Crothers presented a programme of bibliotherapy for physical and psychological disorders and hoped that literature would provide an antidote to the negative movements and attitudes of the time ('literary antitoxins'). The decisive factor in the selection of books was to be their effect on the feelings of the patient, on his mood, his thoughts and desires, his activity and passivity. 'A book may be a stimulant or a sedative or an irritant or a soporific. The point is that it must do something to you, and you ought to know what it is. A book may be of the nature of a soothing syrup or it may be of the nature of a mustard plaster.' (Crothers, 1916, 292, a. 1917, 5).

Especially in the United States, in England, and the Scandinavian countries, work in the field of bibliotherapy is abundant. In the United States, World War I promoted its development of bibliotherapy by establishing libraries in military hospitals; clearly, books proved to be of help to wounded soldiers. In England, literature is also employed in military hospitals, and such initiatives were also adopted in civilian hospitals following the war. The status of patient libraries in various countries was reported at the international congresses for hospital libraries in Paris (1936) and Bern (1938) (Wirz, 1939).

In Sweden, Denmark, and Finland, training courses for librarians are being developed in collaboration with physicians. In Paris, France, the Social Welfare (Assistance publique) has been trying to provide reading services in hospitals since 1934. In her lecture *L'organisation en France des bibliothèques d'hôpitaux* [The organization of hospital libraries in France] at the Premier Congrès International des Bibliothèques d'Hôpitaux in Paris in 1936, Marie Madeleine Famin (1900–1989) distinguished three essential functions of reading for the sick: (1) Connection to reality and recognition as a person ('lien avec la vie normale... on s'adresse à sa personalité'), (2) recreation and distraction ('réconfort et distraction'), (3) intellectual and moral formation ('formation intellectuelle et morale') (Famin, 1965).

Some writers have also been committed to the institutionalization of bibliotherapy. In 1938, Roger Martin du Gard (1881–1958) strongly advocated the establishment of libraries in sanatoriums by founding the association La Lecture au Sanatorium. In 1946, he published an *appel pressant* in the newspaper Le Figaro: 'Il me paraît urgent d'attirer l'attention sur les buts et sur l'utilité de cette œuvre [It seems to me urgent to draw attention to the goals and usefulness of this work]'. Especially in sick young people, pernicious idleness ('l'oisiveté pernicieuse') could only be counteracted in one way: 'la lecture et l'étude [reading and learning]' (Martin du Gard, 1946).

In 1937, the American psychiatrist Karl A. Menninger (1893–1990) discusses the possibilities and limitations of bibliotherapy in his work *The Human Mind*: 'The whole matter of bibliotherapy, of the relief of suffering by the psychological processes induced by reading, is a field in which we have little scientific knowledge. But our intuition and our experience tell us that books may indeed "minister to a soul disease" and come to the aid of the doctor or even precede him.' (Menninger, 1930, 21937, 31945, XIII).

Psychologist and librarian Alice Isabel Bryan (1902–1992) addresses the question of the scientific evidence of bibliotherapy in her 1939 study *Can There be a Science of Bibliotherapy* (Bryan, 1939). Librarian Ilse Bry (1905–1974) published the systematic study *Medical Aspects of Literature* in 1942 (Bry, 1942). In 1940, Elbert Lenrow (1903–1993) provided a bibliotherapeutic list of literary works, assigning texts to specific situations, events, and emotional needs (Lenrow, 1940). One of the first comprehensive empirical analyses was published in 1949 by the psychologist Caroline Shrodes (1908–1991) with her dissertation *Bibliotherapy. A Theoretical and Clinical-Experimental Study* (Shrodes, 1949).

Bibliotherapeutic societies and journals were founded in various places. In hospitals, libraries were increasingly set up for patients and people were even hired to look after them. In 1959, guidelines for hospital libraries were adopted in Warsaw by the International Federation of Library Associations, with instructions not just on setting up the library and stocking books, but also on what was required of library staff beyond their professional knowledge, 'une bonne culture générale, la connaissance des langues et des livres [a good general culture, knowledge of languages and books]' and above all communicative competence, 'intuition et ouverture d'esprit, facilité de trouver le contact avec des malades, même quand il s'agit de cas repoussants [intuition

and open-mindedness, ease of contact with patients, even when dealing with repulsive cases]' (Schmid-Schädelin, 1960, 144). In 1959 the Poetry Therapy Association was founded in Cumberland, UK, followed by the Association for Poetry Therapy (APT) in New York in 1969, and the Poetry Therapy Institute in Los Angeles in 1973. The journal *Literature and Medicine* has been published since 1982, the journal *Art Psychotherapy* since 1973, and the German-language journal *Kunst und Therapie* since 1982.

In the Federal Republic of Germany, music and painting therapy have so far been more successful than bibliotherapy and have seen a significant uptake in comparison with other countries. Many, but by no means all, hospitals have fully staffed patient libraries. The German Library Association issued guidelines for hospital libraries in 1971. In 1985, an interdisciplinary workshop organized by Dietrich v. Engelhardt at the Robert Bosch Foundation provided an overview of the current state, possibilities, and perspectives of bibliotherapy, with the printed proceedings following in 1987 (Engelhardt, 1987). Courses for vocational training and further education in poetry and bibliotherapy are today offered at various institutes, for example the Fritz Perls Academy in Düsseldorf, the Institute for Creative Writing in Berlin, as well as in several art-therapy colleges. The German Society for Poetry and Bibliotherapy has existed since 1984.

Like all psychotherapeutic methods, bibliotherapy also faces the problem of control against empirical standards; 'evidence', however, does not only mean empirical, statistical proof, but also immediate insight. The healing effects of reading can and should be judged not only by *objective* data, but also by the *subjective* self-perception of the patient and the observations of the therapist. Subjectivity also has an objective value—proven and documented not least by empirical tests.

Today, the names given to the healing power of reading are diverse, and perceptions and theories as to reading's effects on and relationship to conventional medical therapy and psychotherapy also vary. In addition to bibliotherapy, there is talk of poetry therapy, reading therapy, and biblio-counseling. Widely used is the definition of bibliotherapy from Webster's *Third International Dictionary* from 1961: 'Bibliotherapy: the use of selected reading materials as the therapeutic adjuvants in medicine and psychiatry; also: guidance in the solution of personal problems through directed reading' (Gove, 1961, 212). In other words, bibliotherapy as a planned and supervised contribution of literature to medical treatment and psychotherapy.

Dimensions

Based on the practical experiences and theoretical concepts of the past and present, six dimensions seem to be essential for bibliotherapy, like in any area of art-therapy: (1) reading during health and disease; (2) influence of different diseases; (3) dependence on the form of therapy; (4) personality of the sick person; (5) provision and communication of the literary text; (6) job profile of the bibliotherapist.

Reading During Health and Illness

The reading of the sick person has its basis in the reading of the healthy person and depends, besides physiological and psychological preconditions, on the form and content of the literary text. 'Form' refers to vowels, consonants, rhyme, rhythm, and style, as well as font size, type of letters and graphic distribution of the text, from which specific feelings, volitions, and thoughts can be evoked. This can all affect the way in which the sick person deals with their illness, with diagnostics, therapy, and their relationship to the doctor and psychotherapist.

The general manifestations of an illness play an important role for the patient alongside the affects of reading. In the state of being sick, in which attention is usually focused more internally on a person's own body and situation, the problems and demands of the environment, relatives and friends recede into the background, lose importance, and the resonance of the texts is not infrequently amplified for the patient. In response to the external environment but also the nature and severity of the illness, the patient's awareness of reality can become restricted and self-orientation and isolation can progress. Illness is always an interaction between physical, psychological, spiritual, and social factors, is always a perspective on being and value, and is both perceived and judged; by no means only negatively as loss and restriction, but also positively, as an opportunity or challenge.

The production and reception of literary works do not fundamentally translate as activity and passivity; reception is also active, production likewise passive. If the individual is expressed through the production of a literary text, then the general or universal is internalized through their reception. Reading and writing can be practised separately or together; bibliotherapy and graphotherapy can be combined. Often, reading to a sick person is also called reading aloud or, even better, oral narration, and is associated with specific demands on the reader in terms of their tone of voice, the speed of reading, their gestures, and facial expressions.

The content can be real, fictional, fantastic, or fairy-tale. The plot can be static or dynamic, simple or sophisticated, emotional or intellectual. The characters of a text can seem familiar or strange, sympathetic or unpleasant. The language can be easy to understand or complicated, prosaic or poetic.

Bibliotherapeutically, reading can be distraction or direction, generalization or concretization, can serve as an example or deterrent, can contribute to ambivalence and confusion or finding meaning, can be related to one's own life and a present illness or lead away from these very situations. It can serve concrete goals of coping with illness or point to metaphysical interpretations of illness, pain and suffering, dying and death.

Influence of the Different Diseases

In addition to the general manifestations of being ill, there are conditions specific to each different disease. Rheumatism, multiple sclerosis, cancer, heart attack, skin diseases, loss of sight or hearing, depression, schizophrenia, post-traumatic stress disorder, dementia,

all have a specific influence on the patient's own body, on his space and time relations, social relations and self and world relations, and upon which reading and writing can have an effect and to which bibliotherapy must be oriented and measured.

Different requirements and possibilities for reading and writing are presented during acute or chronic disease courses, the phases between symptom-free states, diagnostic–therapeutic interventions, stays in hospital and partial or complete remission.

Literary texts can mean world-gaining and stimulating impulses in thinking, feeling, and willing for the sick person, and can counteract the mostly passive and restricted state of being ill. Literature can create a space of freedom for plans, thoughts, and wishes that do not always have to be weighed against reality or subject to the pressure of justifying themselves to the demands and expectations of the environment, friends, and relatives.

However, literature can also lead to self-deception and escape from reality, can reinforce neurotic tendencies, and can give rise to illusory worlds and illusory hopes. Reading and writing trigger emotional and cognitive processes that can have a meaningful effect on the healing process or on dealing with illness. The fact that negative consequences are also to be expected proves how important professional support and guidance are.

According to empirical observations, people with schizophrenia prefer poems with clear meaning, simple rhymes, and simple rhythms; their existing predisposition to tense and autistic thinking can be counteracted with uncomplicated texts. Reading literature, as an occupation, encourages self-expression and likewise openness to social interaction. Accounts of the personal experiences of other ill people can also prove helpful, as can texts that border art and reality, such as Sylvia Plath's (1932–1963) *The Bell Jar* (1963) or Hannah Green's (1932) *I Never Promised You a Rose Garden* (1964).

The possible dangers of reading must always be considered. In 1938, the psychiatrist Jakob Wyrsch (1892–1980) said about the reading of those with schizophrenia: 'Die größte Beeinflußharkeit und eine unheilvolle Ergriffenheit durch das Gelesene finden wir bei ihnen und daneben eine kühle Sachlichkeit und Unberührtheit, wie sie nirgends anders vorkommt [We find the greatest influence and an ominous emotion through what is read, and next to it a cool objectivity and unaffectedness, which does not occur anywhere else]'. The often highly impressionable nature of those with schizophrenia must therefore be taken into account when recommending reading material, so that the patient does not descend 'aus dem gemeinsamen Miteinandersein in das private schizophrene Sein [out of the common togetherness into the private schizophrenic being]' (Wyrsch, 1939, 108 f.). Bibles and daily newspapers are said to be a higher risk in this sense than novels and scientific literature. Bookcases and book catalogues are insufficient in their ability to direct readers, and unsupervised they can even equate to malpractice; doctors must advise and accompany the sick in their reading selection, or even discourage them from reading.

Until now, bibliotherapy has been used mainly for neurotic disorders and cognitive and psychosomatic illnesses. Patients can better understand their feelings, anxieties, desires, and hopes through literary works and often communicate them to their doctors and nurses, relatives and friends in this way more easily than in direct contact. They can

learn through reading that other people have also suffered from comparable thoughts and emotions, and were able to live with them or even be cured.

Through the production of their own literary texts and personal accounts, children in particular can better understand and accept their illness and therapy, develop motivation and creativity to help cope with their illness, and forge positive relationships with parents and doctors; something that can prove more difficult to do through direct contact and verbal dialogue. Encouraging children to tell and write stories is a valuable form of therapy and can be successfully combined with painting, making music, and other forms of artistic expression.

Illness, whatever its nature, represents a physical-psychic and social-cultural phenomenon, and in this respect is susceptible to cultural influences, including those of literature and all other art forms. For people with diabetes, asthma, cancer, deaf and blind people, the overweight and anorexic, psychological aspects always play an accompanying role to somatic symptoms. Mental equilibrium has an effect on metabolism and can be shaped both positively and negatively by reading. Many questions still require empirical investigation; one example being whether narratives with concrete descriptions and symbolic interpretations of epilepsy are really useful for adolescents with epilepsy.

Essentially, for bibliotherapy, as for medicine in general, the mode of being (ontology) of the cause (etiology) does not necessarily determine the mode of being of the therapy; physical diseases can also be treated psychically and mental diseases physically.

A special challenge as well as opportunity for bibliotherapy lies in the context of dying; reading and writing can contribute to verbal communication with the dying person or even partially replace it. In many stories and novels, dying and death are portrayed in an affirmative and positive way, something that can give strengthening orientation to the dying person. Descriptions do not have to be euphemistic and sentimental; even painful and sad accounts can provide comfort and insight and do not necessarily have to deal with dying and death. The needs and abilities of the dying person should always be respected; those who do not want to confront their own death or are not able to do so, should not be pressured to do so. Above all, bibliotherapy reminds conventional medicine of the original meaning of therapy: assistance and accompaniment, not just treatment and healing.

Dependence on the Form of Therapy

The different forms and modes of therapy, such as the times and contexts of treatment, in turn play an important role in the possibilities for bibliotherapy and graphotherapy. The healing power of literature does not have to be limited to the hospital either; reading can also be used in outpatient practice. Because of ever-shorter hospital stays, reading at home or in other non-medical locations is becoming increasingly important.

A patient's situation prior to surgery requires different texts than during convalescence. The conditions in a children's ward differ from those in adult wards, as they do

between departments for internal medicine, gynecology, surgery, psychosomatics, or psychiatrics. At the beginning of a hospital stay, texts can be offered that strengthen an acceptance of illness and a readiness for diagnostic and therapeutic procedures; texts that bolster understanding of the clinical surroundings, that distract from concerns about family left behind or a possibly endangered job. More important in the further course of an in-patient stay and before discharge are texts that remind of daily life, of private, social, and professional obligations and that appeal to self-responsibility and understanding of the value of health or the opportunity of a fulfilled life, perhaps also with a chronic disability.

In the twentieth century, bibliotherapy was first applied primarily in group therapy, in the joint reading and discussion of literary texts and practising theatre. The psychiatrist and founder of psychodrama Jacob Levy Moreno (1889–1974) and the group therapist Samuel R. Slavson (1890–1981) were particularly inspired by Greek dramas and medieval plays (Moreno, 1953; Slavson, 1947).

Experience has shown the extent to which bibliotherapy can be usefully applied in individual therapy, which probably better represents its true field. As in psychotherapy, in bibliotherapy the individual and the group are not alternatives; depending on the respective goals and possibilities, one might choose between them and combine them.

In psychotherapy, bibliotherapy can be taken up when verbal or communicative discussion becomes difficult or is rejected. Reading behaviour and the way people read can have diagnostic significance, give information about certain personality traits and specific crises, and can also indicate phases of recovery, a regained awareness of reality, and revived interest in the environment.

Literature can also be successfully applied in the follow-up treatment of psychiatric illnesses. The psychiatrist Wolfgang Klages (1924–1999), who highlighted the difference between schizophrenic and manic-depressive patients, sees this 'Phase der Selbstwertlabilität, der intrapsychischen Auseinandersetzung mit der überstandenen Psychose [phase of self-esteem instability, the intrapsychic confrontation with the survived psychosis]' (Klages, 1964, 179) as the original domain of bibliotherapy in psychiatry.

In psychoanalysis, the bibliotherapeutic value of scientific reading is controversial. Sigmund Freud (1856–1939) warns against the reading of scientific texts, since this could lead to a slide into intellectualism, whereby the therapy of those with neurotic disorders focused precisely on the confrontation with one's own problems; it should not be doubted that patients in self-observation 'will acquire wider and more valuable knowledge than the whole literature of psycho-analysis could teach them'. Freud, on the other hand, expects a benefit from specialized literature during stays in institutions; here it could be advantageous 'to employ reading as a preparation for patients in analysis and as a means of creating an atmosphere of influence' (Freud 1995, 120).

Carl Gustav Jung (1875–1961) explicitly recommended high literature because, in contrast to scientific works, the individual difficulties experienced by the sick person could be relativized by archetypes or recurring artistic motifs, and fundamental possibilities for encountering the world and the self could be opened up. The healing power of

reading, he expects, is derived essentially from 'symbolic art' as the creation of the collective unconscious, in contrast to the 'symptomatic art' as a product of the personal unconscious: 'This re-immersion in the state of *participation mystique* is the secret of artistic creation and of the effect which great art has upon us.' (Jung, [4]1978, 105).

Personality of the Sick Person

At the centre of bibliotherapy is the sick or afflicted reader, with their own unique personality, social background, age, gender, interests, intelligence, and education. Bibliotherapy depends on psycholinguistics and sociolinguistics, which themselves have their basis in the anthropology and psychology of art and malady.

The role of social background and education should not be overestimated; in principle, all people can be led to reading, regardless of differences in aptitude, inclination, and knowledge; indeed, illness and hospitalization offer particularly opportune contexts for gaining access to reading—as do prisons for criminal therapy. Illness may also narrow social divisions in this regard: people who are generally inclined to more sophisticated literature may learn to appreciate simpler texts, and those who are less interested in reading may be encouraged to take up substantial works. In any such case, however, sick people must not, on top of their existing illness, become overwhelmed by reading or burdened by feelings of boredom, failure, or inferiority.

Several descriptions of how illness can become an occasion and medium for personality development and the expansion of interests can be found in the literature. In the story *Clock Without Hands* (1961) by the writer Carson McCullers (1917–1967), the pharmacist Malone (Malone = I am alone), who suffers from cancer, loneliness, and despair, takes up the offer of the hospital library and borrows Sören Kierkegaard's (1813–1855) book *Sickness unto Death* (Dan, 1849). Malone is not well educated; the name of the philosopher Kierkegaard means nothing to him. However, as he reads, he understands the sentences in their immediate meaning; they give him existential insights and spiritual strength independent of any theoretical and philosophical meanings. Above all, he is moved by Kierkegaard's observation that the 'greatest hazard of all, losing one's self, can occur very quietly in the world, as if it were nothing at all. No other loss occurs so quietly; any other loss—an arm, a leg, five dollars, a wife, etc.—is sure to be noticed' (Kierkegaard, 1954, 165). Malone, however, was not ready for this insight until he became ill and ended up in hospital: 'If Malone had not had an incurable disease those words would have been only words' (McCullers, 1961, 161). The meaning of illness and the meaning of life can touch each other in the sense of the literary word. The sick Élisabeth Alione in *Détruire dit-elle* (1969) by Marguerite Duras (1914–1996) takes books to the sanitorium: 'Quand on est toute seule ... pour avoir une contenance [When you are all alone ... to have a countenance]' (Duras, 1969, 94).

The fact that not only reading (bibliotherapy) but also writing (graphotherapy) can assist and provide orientation for the sick and suffering is also repeatedly illustrated in literature. In the philosophical tale *Un drame au bord de la mer* (1835) by the writer

Honoré de Balzac (1790–1850), the mentally ill Louis Lambert is challenged by his understanding and sympathetic lover Pauline de Villenoix to free himself from the tragic fate of a Breton family by writing. 'J'étais si cruellement tourmenté par les visions que j'avais de ces trois existences, qu'elle me dit: "Louis, écris cela, tu donneras le change à la nature de cette fièvre [I was so cruelly tormented by the visions I had of these three existences, that she said to me: "Louis, write that, you will deceive the nature of this fever]"' (Balzac, 1979, 1177 f.) The doctor Antoine Thibault (*Les Thibaults*, 1922–40), a character of the writer Roger Martin Du Gard (1881–1958), begins to write a liberating diary with the onset of his serious illness: 'Dans le cerveau d'un malade, d'un insomnieux, tout tourne à l'obsession. Écrire, ça délivre [In the mind of a patient, an insomniac, everything turns to obsession. Writing delivers' (Martin du Gard, 1957, 918).

Sick people should be encouraged to read; a stay in hospital offers favourite opportunities. In the narration *Outside the Machine* (1930) by Jean Rhys (1890–1979), 'soothing English novels' (Rhys, 2017, 192) are distributed to the sick, but—as in Carson McCuller's *Clock Without Hands*—no counselling accompanies the prescribed or recommended reading.

Writers know that literature can also burden and confuse. The first-person narrator in Edgar Allen Poe's (1809–1849) *Berenice* (1835) notices an ominous connection between his reading and his suffering. 'My books, at this epoque, if they did not actually serve to irritate the disorder, partook, it will be perceived, largely, in their imaginative and inconsequential nature, of the characteristics qualities of the disorder itself' (Poe, 1978, 212 f.)

In Conrad Ferdinand Meyer's (1825–1898) fragment *Der Gewissensfall* (Germ. 1890), Silvio Pellico's (1789–1854) memoirs *My Prisons* (ital. 1832/43) trigger in a woman an enduring melancholy that leads to her suicide. In *Ward No. 6* (Russian, 1892) by writer Anton P. Chekhov (1860–a) reading is described as one of the 'morbid habits' (Chekhov, 2003, 95) of the mentally ill Ivan D. Gromov who, as his illness progresses and he loses his memory, increasingly loses all interest in reading.

This begins to answer then the fundamental question of what is meant by bibliotherapy: healing of illnesses, support in chronic diseases, emotional stabilization, finding meaning in suffering and dying, broadening spiritual horizons.

That not all literary content can be absorbed or every literary form appreciated in every context and mood is a concept familiar to writers; most have experienced it painfully themselves and await, therefore, a deep and reciprocal accordance with the reader. Honoré de Balzac (1799–1850), states that his short story *Madame Firmiani* (1832) demands the sympathy of 'âmes naturellement mélancoliques et songeuses [naturally melancholic and pensive souls].' Adopt an analogy from medicine, he states: 'Si l'écrivain, semblable à un chirurgien près d'un ami mourant, s'est pénétré d'une espèce de respect pour le sujet qu'il maniait, pourquoi le lecteur ne partagerait-il ce sentiment inexplicable? [If the writer, like a surgeon at the side of a dying friend, felt a kind of respect for the subject he was handling, why should the reader not share this inexplicable feeling?]' (Balzac, 1976, 141). An intimacy between writer, reader, and work—or between the production and reception of texts—should increase the strengthening and healing effects of literature.

Bibliotherapy is also by no means dependent on classical or high literature; more trivial works, non-fiction, travelogues, historical accounts, biographies, and autobiographies can prove to be just as effective. Literary works do not have to be recommended and read in their entirety; excerpts, shorter passages, striking quotations, memorable aphorisms, lines of poetry, and sayings are also useful.

Relaxation, undemanding pleasure, and the passing of time are legitimate functions of literature. The pain of an illness, fear of its further course, and its consequences for private and professional life, or the concerns about diagnostic examinations or a surgical procedure can be overpowering and rightly demand distraction. Depending on the situation and overall goals of therapy, distraction or redirection can be beneficial.

Provision and Communication of the Literary Text

The success of bibliotherapy depends essentially on the nature of available options, the form of conveyance of literary texts and the guidance or help provided during reading. Patients cannot just be handed library catalogues or have book carts pushed to their beds. Hospital libraries do not in themselves constitute bibliotherapy, and librarians are not all predestined bibliotherapists. Essential to the success of bibliotherapy in practice is direct contact, empathy, communication, and imagination.

The connection between literary texts and the particular effects they have on the patient reading them should not be thought of mechanically or according to scientific causality; the book is not a medicine and cannot be 'prescribed'. The sick person cannot just 'take' literature like a pill with statistically researched efficacy, but must rather consider the individual consequences for themselves, potentially interrupting or stopping their reading, referring to other works or asking for support in their understanding and emotional responses.

Knowledge about the predictable effects of reading, about connections between literary texts and certain illnesses or stages of illness is still relatively lacking and also fundamentally limited. However, tendencies in the effects of reading are known and can be predicted and observed in the course of bibliotherapy—indications that suggest that certain literary texts are to be recommended or advised against in the case of a particular diseases and offstage of illness or therapy.

The logic behind the principle of analogy should not be applied to bibliotherapy; a thematic correspondence between a disease and literary content should not serve as the guideline when provisioning patients with reading material. Cancer patients do not necessarily have to resort to portrayals of other cancer sufferers. Occasionally, however, such parallels may be appropriate. Novels and stories featuring hospitals can ease apprehensions about real-life hospitalization; reading literary descriptions or personal accounts of disabilities and illnesses can help patients cope with their afflictions; exciting and cheerful descriptions of everyday situations can help sick children return to their normal lives.

When communicating empathically with a sick person, it is necessary to recognize their individual capabilities and needs in order to appropriately interpret their reactions, to draw meaningful conclusions, and to tailor suggestions on how to approach a selected text, recommend alternative texts and to provide basic support in dealing with the emotional and intellectual effects of a text. It should also be accepted that not all of a patient's own reading preferences can be fulfilled during therapy.

At the same time, the autonomy of the patient must be appreciated; ethical principles also apply to bibliotherapy. Those who want to select their own books and to read them without guidance or support must be respected in this wish. Bibliotherapy is also centred on the sick person as a reader; after all, it is about their illness and their health.

Hospital libraries are still in need of considerable development and improvement in terms of both their prevalence but, above all, quality; they should be designed according to therapeutic rather than literary or library criteria. This applies to the selection of books, the layout of the catalogues, the brief descriptions of the texts, the conditions of lending, as well as the provision of ergonomic options for reading, such as when recumbent in bed—a position frequently experienced as unusual and uncomfortable.

Job Profile of the Bibliotherapist

Art therapy requires an art therapist; bibliotherapy a bibliotherapist. With their classical training, neither librarians nor literary scholars, psychologists or physicians, are predisposed to fulfill the fundamental demands required of a bibliotherapist: (1) Holding a knowledge of literature, (2) knowledge of medicine, and, above all, (3) empathic communication skills.

Fully realizing a combination of these qualities is likely an unattainable task. Bibliotherapy is currently practised mainly by librarians, psychologists, hospital chaplains, and physicians; all of whom must reach beyond their professional limitations while seeking to avoid occupational hazards. The physician must overcome the limitations of scientific convention in diagnosis and therapy, the librarian the confines of their library's structure. Librarians can work under the supervision of a physician or psychotherapist. The curricula of university medical degrees should already cover the types and potentials of biblio- and art therapy.

Knowledge of fiction and non-fiction, a familiarity with literary genres and their structures and attributes are all required of the bibliotherapist. Reading catalogues with titles and suggestions can provide direction, but cannot replace a person's own choice and approach. Bibliotherapists must be capable of engaging with the sick person in order to suggest and introduce healing works. A bibliotherapist does not need to have studied medicine, but must be familiar with the fundamentals of disease, illness, diagnosis, and therapy. In this sense, they should understand the anthropology of illness, diagnosis, and therapy at six central levels: (1) Body relationship, (2) space relationship, (3) time relationship, (4) social relationships, (5) self relationship, (6) world relationship—and this

specifically in acute and chronic, somatic, psychosomatic, and psychological illnesses. The healing success of reading depends on the attention paid to these dimensions of illness and therapy, and should accordingly be measured against them respectively.

Teaching bibliotherapy can help foster talent, but it cannot generate it. Choice of profession corresponds to personality traits; someone attracted to library work will not necessarily possess the skills required to deal psychologically with sick people, just as someone who takes up a medical profession may have no pronounced inclination towards literature. While common lines of education continue to orientate towards specialization, practical bibliotherapy comprises a fully interdisciplinary undertaking.

Of central importance is the complex formation of the relationship between patient, text, and bibliotherapist. Mediated by the experiences of their illness, the patient encounters and responds to a text, its content and its form, and a dialogue is initiated; the interaction between the patient and bibliotherapist is similarly a multi-level process of communication. Another dimension unfolds in this triad when the sick person takes up a text by a writer who is sick themselves and who has been able to alleviate or accept suffering through their creativity; this creative healing is something to which the sick person can refer, even beyond the reading of the text. Personal accounts in literature are written and received within this context. Here, reading can also turn into writing, offering new impulses for the bibliotherapist in his relationship to the sick person.

Conclusion—Perspectives

Bibliotherapy or literature as a therapeutic agent is a central theme in the history of medicine and culture and poses many challenges not only to the doctor and the sick, but also to the family, to schools, society, politics, and the media. If people no longer read and are no longer encouraged to read by parents and teachers, reading can no longer develop its healing and educational effect throughout life and also in dealing with suffering, illness, and death.

Meaningful applications of reading and bibliotherapy exist in medical diagnostics and therapy, in prevention as well as rehabilitation, in doctor–patient relationships as well as in the patient's coping with their illness and relationships with family and friends. Bibliotherapy, like all other art therapies, stands to gain relevance in all medical disciplines and is not bound to a specific psychological or psychotherapeutic approach.

At the same time, the potential of bibliotherapy and graphotherapy should not be overstated; reading and writing cannot replace medication and surgery, but can make a specific contribution to coping with drug therapy and surgery.

Theoretical analysis, empirical research, personal experience, and institutionalization remain vital for the development of the field. The insights of writers and reading experiences of the sick, from antiquity to the present, should be systematically collected and analytically arranged. Knowledge and understanding of the physiological,

individual, and socio-psychological aspects of reading and writing should be deepened and made usable for bibliotherapy.

Literary therapy can be combined with painting therapy, music therapy, and dance therapy. The possibilities of integrating the arts have hardly been explored theoretically, educationally, or in practice. Both healthy and sick people, however, perceive reality with all senses and not just through sight and sound. The effect of a poem can be accentuated by accompanying images or music. At the same time, professional specialization cannot be dispensed with; not all therapists have a talent and inclination for all of the arts, and patients themselves have their own predilections.

Literature cannot be reduced to its contribution to coping with illness or supporting therapy. Literature and medicine are not interchangeable in any circumstance. Literature transcends all immediate goals of adaptation, reassurance, and healing; it is a means of education and contributes to a person's self-understanding and understanding of the world.

The writer Franz Kafka (1883–1924) was convinced: 'Ein Buch muß die Axt sein für das gefrorene Meer in uns [A book must be the ax for the frozen sea within us]' (Kafka, 1999, 36). Physician and writer Gottfried Benn (1886–1956) proposed that literature offers far more than a psychological aid to the suffering individual: literature should rather free us from the 'Zivilisationsschotter [debris of civilization]' of the present, should form a buffer against the 'analytisch applanierten Psychen, hedonisierten Genitalien, Flucht in die Neurose [analytically dulled psyches, hedonized genitalia, flight into neurosis]' (Benn, 1975, 638). For the theologian and philosopher Romano Guardini (1885–1968), the book is an 'Urgestalt [primordial representation]'; in the book, existence is captured in all the fullness of its possibilities: 'seine Fruchtbarkeit, aber auch seine Gefahr. Denn, wenn das Buch uns beschenken, uns trösten und stärken kann—wie tief kann es auch beunruhigen, irreführen und zerstören [its potence but also its danger. For if the book can give us gifts, comfort and strengthen us—how deeply can it also disturb, mislead and destroy]' (Guardini, 1952, ²1954, 37).

Bibliotherapy, like any other art therapy, belongs to medicine as a connection of the four cultures: the natural sciences, the humanities, the arts, and life. Man is a natural and spiritual being, an individual, and a social entity. Medicine is human science in a double sense of the word 'human': of humans and for humans.

Literature opens up a transtemporal world or 'immanent transcendence' that is able to reconcile the individual human being with their own finitude, with illness, and with death. For the writer Joseph Conrad (1857–1924), literature awakens a sense of the togetherness of all people, 'the dead to the living and the living to the unborn' (Conrad, 2017, 6).

NOTE

1. https://biblehub.com/1_samuel/16-23.htm [last accessed 6 October 2024].

References

Aristotle (1995). *Poetics*, c. 335 v. Chr. Harvard University Press.

Balzac, H. de (1976). Madame Firmiani. 1832. In H. de Balzac, *La Comédie humaine*, volume 2 (pp. 141–161). Gallimard.

Balzac, H. de (1979). Un drame au bord de la mer, 1835. In H. de Balzac. *La comédie humaine*, volume 10 (pp. 1159–1178). Gallimard.

Benn, G. (1975). Zur Problematik des Dichterischen, 1930. In G. Benn. *Gesammelte Werke*, Bd. 3 (pp. 628–642). Deutscher Taschenbuch Verlag.

Bry, I. (1942). Medical aspects of literature. *Bulletin of the Medical Library Association 30*, 252–266.

Bryan, A. I. (1939). Can there be a science of bibliotherapy. *The Library Journal 64*, 773–776.

Burton, R. (2001). *The anatomy of melancholy*, Second Partition, 1621. Review of Books.

Chekhov, A. P. (2003) Ward No. 6, russ. 1892. In J. Coulehan (Ed.), *Chekhov's doctors. A collection of Chekhov's medical tales* (pp. 91–134). Kent State University Press.

Cicero, M. T. (1989). *Tusculan disputations*, lat. 45 BC. Cicero in Twenty-Eight Volumes, volume 18. Harvard University Press.

Cicero, M. T. (1992). *On old age*, lat. 45/44 BC. Harvard University Press.

Conrad, J. (2017). *The Nigger of the 'Narcissus'*, 1897. Cambridge University Press.

Craik, E. (1995). Diet, diaita and dietetics. In A. Powell, (Ed.), *The Greek world* (pp. 387–402). Routledge.

Crothers, S. M. (1916). A literary clinic. *The Atlantic Monthly 118*, 291–373, a. id. (1917). *A Literary Clinic*. Houghton Mifflin Company.

Dante Alighieri (1904). The epistle to Cangrande, lat. c. 1316. In *A translation of the Latin works of Dante* (pp. 343–368). Dent.

Dante Alighieri (2018). *Convivio*, lat. c. 1306. Cambridge University Press.

Duras, M. (1969). *Détruire dit-elle*. Les Éditions de Minuit.

Engelhardt, D. v. (Ed.). (1987). *Bibliotherapie. Arbeitsgespräch der Robert Bosch Stiftung 1985 in Stuttgart*. Bleicher.

Engelhardt, D. v. (1995). Lebenskunst im Spektrum von Diätetik und Diät. In D. v. Engelhardt (Ed.), *Krankheit, Schmerz und Lebenskunst* (pp. 139–172). Beck.

Esquirol, J. É. (1838). Des maladies mentales, volume 1. Baillière.

Famin, M.-M. (1965). L'organisation en France des bibliothèques d'hôpitaux', 1936, n. Gelderblom, G. 'Die Krankenhausbücherei. In J. Langfeldt (Ed.), *Handbuch des Büchereiwesens*. II. Semi-vol. (pp. 589–627). Harrassowitz.

Freud, S. (1995). Recommendations to physicians practising psycho-analysis, Germ. 1912. In S. Freud (Ed.), *Complete psychological works*, volume 12. *The Case of Schreber, Papers on Technique and Other Works* (pp. 109–120). Hogarth Press.

Galt, J. M. (1853). On reading, recreation and amusement for the insane. *The Journal of Psychological Medicine and Mental Pathology 6*, 581–589.

Godefridus, M., & Theodericus, M. (1968, ³1980). *Das Leben der Heiligen Hildegard*, lat. 1180–1190. Edited by Adelgundis Führkötter. Müller.

Goethe, J. W. v. (1987). *From my life. Poetry and truth*, Germ. 1808–1831. In J. W. v. Goethe, *Collected Works*, volume 4 (pp. 523–800). Suhrkamp.

Götze, G. H. (1705). *Krancken-Bibliothek*. Urban.

Gove, P. B. (Ed.). (1961). *Webster's Third New International Dictionary of the English Language*, 1. Webster.

Greene, G. (1980). Preface. In G. Greene, *Ways of Escape* (pp. 9f.). Dennys.

Guardini, R. (1952, ²1954). *Lob des Buches*. Hess.

Hartmann von Aue (2001). Poor Heinrich, Germ. c. 1200. In *Arthurian romances, tales, and lyric poetry. The complete works of Hartmann von Aue*, transl. with comment. by F. Tobin, K. Vivian, R. H. Lawson (pp. 215–235). Pennsylvania State University Press.

Hartmann von Aue (2015). *Der Arme Heinrich*, c. 1200. Reclam

Hölderlin, F. (1969). [Letter to Karl Gok, 1 January, 1799]. In F. Hölderlin, *Sämtliche Werke*, volume 6 (pp. 325–331). Kohlhammer.

Hölderlin, F. (1969a). [Letter to Casimir Ulrich Böhlendorf, November 1802]. In F. Hölderlin, *Sämtliche Werke*, volume 6 (pp. 462–464). Kohlhammer.

Jean Paul (2000). Dr. Katzenbergers Badereise, Germ. 1809. In Jean Paul, *Sämtliche Werke*, div. 1, volume 6 (pp. 77–363). Darmstadt: Wissenschaftliche Buchgesellschaft.

Jung, C. G. (⁴1978). Psychology and literature. In S. Freud, *Collected works*, volume 15, *The Spirit in Man, Art and Literature* (pp. 84–105), Germ. 1950. Princeton University Press.

Kafka, F. (1999). [Letter to Oskar Pollak, 27 January, 1904]. In F. Kafka, *Briefe 1900–1912* (pp. 36 f). Fischer.

Kahlbaum, K. L. (1884). Über jugendliche Nerven- und Gemütskranke und ihre pädagogische Behandlung in der Heilanstalt. *Allgemeine Zeitschrift für Psychiatrie und psychisch-gerichtliche Medizin 40*, 863–872.

Kierkegaard, S. (1954). *Sickness unto Death*. Doubleday Anchor Books.

Klages, W. (1964). Zur Bibliotherapie bei psychiatrisch Kranken. *Psychiatrie, Neurologie und medizinische Psychologie 148*, 178–190.

Lenrow, E. (1940). *Reader's guide to prose fiction. An introductory essay, with bibliographies of 1500 novels selected, topically classified and annotated*. Appleton-Century.

Maimonides, M. (2021). On the regimen of health, lat. c. 1198. In M. Maimonides, *Medical aphorisms. The medical works of Maimonides*, volume 17 (pp. 468–498). Edited by G. Bos. Brill.

Maimonides, M. (2021a). De causis accidentium apparentium, lat. c. 1200. In M. Maimonides, *Medical aphorisms. The medical works of Maimonides*, volume 17 (pp. 499–517). Edited by G. Bos. Brill.

Mann, T. (1962). *The magic mountain*, Germ. 1924, volume 1. George Macy Co.

Martin du Gard, R. (1946). La grande misère des bibliothèques des sanatoriums. *Le Figaro* (29 May, 1946).

Martin du Gard, R. (1957). *Les Thibaults (suite)*, 1922–40. Oeuvres complètes, volume 2 (pp. 9–1011). Bibliothèque de la Pléiade.

McCullers, C. (1961). *Clock without hands*. Cresset Press.

Menninger, K. A. (1930, ²1937, ³1945). *The human mind*. Knopf.

Meyer, C. F. (1976). Angela Borgia, Germ. 1891. In C. F. Meyer, *Sämtliche Werke*, volume 1 (pp. 798–907). Dt. Taschenbuch-Verlag.

Mill, J. S. (³1960). *Autobiography*, posthum. 1873. Columbia University Press.

Montesquieu, C. de (2004). *Lettres persanes*, 1721. (= Oeuvres complètes, volume 1). Voltaire Foundation.

Moreno, J. L. (1953). *Who shall survive? Foundations of sociometry, group psychotherapy and Sociodrame*. Beacon House.

Most, G. F. (Ed.) (1973). *Encyklopädie der gesammten Volksmedicin*, 1843. Nachdruck Graz: Akademische Druck- u. Verl.-Anstalt.

Novalis (²1965). Vorarbeiten zu verschiedenen Fragmentsammlungen. In Novalis, *Schriften*, volume 2 (pp. 522–651).Kohlhammer.

Novalis (²1975). [Letter to Erasmus Hardenberg, 16 March, 1793]. In Novalis, *Schriften*, volume 4. Tagebücher, Briefwechsel, Zeitgenössische Zeugnisse (pp. 117f.). Wissenschaftliche Buchgesellschaft.

Pfandl, L. (1938). *Philipp II. Gemälde eines Lebens und einer Zeit*. Callwey.

Poe, E. A. (1978). Berenice, 1835. In E. A. Poe, *Collected works* (pp. 209–219), volume 2. Belknap Press.

Proust, M. (1989). *À la recherche du temps perdu*, 1913–1927, volume 4. Gallimard.

Rabelais, F. (1985). Gargantua et Pantagruel, 1532–1564. In F. Rabelais, *Oeuvres complètes* (pp. 1–729). Gallimard.

Rather, L. J. (1968). The 'six things non-natural'. A note on the origins and fate of a doctrine and a phrase. *Clio Medica 3*, 337–347.

Reil, J. C. (1803). *Rhapsodieen über die Anwendung der psychischen Curmethode auf Geisteszerrüttungen*. Curt.

Rhys, J. (2017). Outside the machine, 1930. In J. Rhys, *The collected short stories* (pp. 180–199). Penguin Books.

Rilke, R. M. (1950). [Letter to Artur Hospelt, 11 February, 1912]. In R. M. Rilke, *Briefe*, volume 1 (pp. 362–364). Insel.

Rilke, R. M. (1977). [Letter to Nanny Wunderley-Volkart, 9 January, 1920]. In R. M. Rilke, *Briefe an Nanny Wunderley-Volkart*, volume 1 (p. 92). Insel.

Rollyson, C. (1996). *Rebecca west. A life*. Scribner.

Rush, B. (1811). On the construction and management of hospitals, 1802. In B. Rush, *Sixteenth introductory lectures* (pp. 182–209). Fry and Kammerer.

Rush, B. (1951). [Letter to the managers of the Pennsylvania Hospital, 24 September, 1810]. In L. H. Butterfield (Ed.), *Letters of Benjamin Rush*, volume 2 (pp. 1063–1066). Princeton University Press.

Schipperges, H. (1968). Geschichte und Entwicklung der Diätetik. *Physikalische Medizin und Rehabilitation 9*, 274–278.

Schmid-Schädelin, I. (Ed.). (1960). Mémoire indicateur sur les Bibliothèques d'Hôpitaux. *Libri 10*, 141–146.

Schmitt, W. (2005). Diätetik. In B. v. Jagow & F. Steger (Eds.), *Literatur und Medizin. Ein Lexikon* (pp. 172–175). Vandenhoeck & Ruprecht.

Seneca (1991). Moral letters to Lucilius'. Letter 78, lat. 62 AD. In Seneca, *Epistles 66–92* (pp. 180–199). Harvard University Press.

Seneca (2015). *Selected dialogues and consolations*, lat. c. 30–65 AD. Hackett Publishing Company.

Shakespeare, W. (1951). Titus Andronicus, 1594. In Shakespeare, *The complete works* (pp. 870–901). Edited by P. Alexander. Collins.

Shrodes, C. (1949). *Bibliotherapy. A theoretical and clinical-experimental study*. Ph.D. thesis, University of California, Berkeley.

Slavson, S. R. (Ed.). (1947). *The practice of group therapy*. International Universities Press.

Spieß, C. H. (1976). *Biographien der Wahnsinnigen*, Germ. 1795/96, volume 1–2. Luchterhand.

Stifter, A. (1972). [Letter to Gustav Heckenast, 12 February, 1864]. In A. Stifter, *Sämtliche Werke*, volume 20, *Briefwechsel*, volume 4 (pp. 178–181). Gerstenberg.

Trémolières, J. (1975). A history of dietetics. *Progress in Food and Nutrion Science 1*, 65–114.

Warren, S. (1831). Cancer, 1830. In S. Warren, *Affecting scenes. Being passages from the diary of a physician* (pp. 44–50). Harper.

Wirz, Hg. G. (Ed.). (1939). *Zweiter internationaler Kongress für Krankenhausbibliotheken, Bern, 7.-10. Juni 1938, Bericht = Deuxième Congrès international des Bibliothèques d'Hôpitaux, Berne, 7–10 juin 1938*. Huber.

Wyrsch, J. (1939). Bücher in Anstalten für Geisteskranke. In H. G. Wirz (Ed.), *Zweiter internationaler Kongreß für Krankenhausbibliotheken*, Bern 7 to 10 June 1938 (pp. 98–114). Huber.

Further Reading

Beatty, W. K (1962). A historical review of bibliotherapy. *Library Trends* 11(2), 106–117.
Blaschka, A. (1956). Der Topos scribendi solari – Briefschreiben als Trost. *Wissenschaftliche Zeitschrift der Martin-Luther-Universität Halle-Wittenberg, Gesellschaftlich-sprachliche Reihe* 5, 637–638.
Bryan, A. I. (1939). Can there be a science of bibliotherapy? *The Library Journal* 64, 773–776.
Duda, A. (2018). *Licht in der Nacht der Seele. Wie Lesen bei Depressionen hilft*. Patmos Verlag.
Engelhardt, D. v. (1987). Bibliotherapie – Entwicklung, Situation und Perspektiven. In D. v. Engelhardt (Ed.), *Bibliotherapie. Arbeitsgespräch der Robert-Bosch-Stiftung 1985 in Stuttgart* (pp. 3–45). Bleicher.
Greest, A. (2020). *Bibliotherapie in Bibliotheken* (= Berliner Handreichungen zur Bibliotheks- und Informationswissenschaft, Nr. 456). Institut für Bibliotheks- und Informationswissenschaft der Humboldt-Universität zu Berlin.
Heimes, S. (2012). *Warum Schreiben hilft. Die Wirksamkeitsnachweise der Poesietherapie*. Vandenhoeck & Ruprecht.
Hynes, A. M., & Hynes-Berry, M. (1986, ³2011). *Biblio/poetry therapy. The interactive process. A handbook*. North Star Press of St. Cloud.
Kittler, U., & Munzel, F. (1984). *Was lese ich, wenn ich traurig bin. Angewandte Bibliotherapie*. Herder.
Leedy, J. J. (Ed.). (1969). *Poetry therapy. The use of poetry in the treatment of emotional disorder*. Lippincott.
Mazza, N. (2003). *Poetry therapy. Theory and practice*. Brunner-Routledge.
Merkle, R. (1989). *Bibliotherapie. Der Einfluß des therapiebegleitenden Lesens auf das emotionale Befinden bei ambulant behandelten Patienten*. PAL.
Morrison, M. R. (Ed.). (1994). *Poetry as therapy*. Human Sciences Press.
Munzel, F. (2000). Das Buch als Therapeutikum. Die Wiederbesinnung der Literatur auf ihre therapeutische Funktion. Perspektiven bibliotherapeutischer Forschung. In D. Kerlen & I. Kirste (Eds.), *Buchwissenschaft und Buchwirkungsforschung. VIII. Leipziger Hochschultage für Medien und Kommunikation* (pp. 131–144). Universität Leipzig (Institut für Kommunikations- und Medienwissenschaft).
Ouaknin, M.-A. (1994). *Bibliothérapie. Lire c'est guérir*. Éd. du Seuil.
Petzold, H., & Orth, I. (Eds.). (1985). *Poesie und Therapie. Über die Heilkraft der Sprache. Poesietherapie, Bibliotherapie, Literarische Werkstätten*. Junfermann.
Rossi, B. (Ed.). (2009). *Biblioterapia. La lettura come benessere*. La meridiana.
Rubin, R. J. (Ed.). (1978). *Bibliotherapy sourcebook*. Oryx Press.
Rubin, R. J. (Ed.). (1978). *Using bibliotherapy. A guide to theory and practice*. Mansell
Shrodes, C. (1949). *Bibliotherapy. A theoretical and clinical-experimental study*. Ph.D. thesis, University of California, Berkeley.
Werder, L. v. (²1995). *Schreib- und Poesietherapie. Eine Einführung*. Belz.
Zifreund, W. (Ed.). (1996). *Therapien im Zusammenspiel der Künste*. Attempto Verlag.

CHAPTER 27

AN AESTHETICS OF RELATING AND ITS (THERAPEUTIC) POTENTIALS

A Transcultural Perspective on Literature, Storytelling, and the Power of the (Spoken) Word

KATHARINA FÜRHOLZER AND JULIA PRÖLL

INTRODUCTION: (MENTAL) HEALTH CARE IN THE AGE OF GLOBALIZATION OR THE POTENTIALS OF A MIGRATORY AESTHETICS

As the World Health Organization (WHO) states in numerous reports, increased migration constitutes one of the most important challenges to the health care systems of mostly Western host societies. The necessity—and responsibility—to deliver adequate care to migrants and refugees—who are, in comparison to 'rooted' patients of host populations, more prone to be exposed to various kinds of distress (WHO, 2021)—raises questions about the fundamental role of culture in medicine, and this even more when considering that the hegemonic biomedical paradigm has to accept the challenge to 'meet, clash and grapple' (Pratt, 1991, 34) with 'unfamiliar' and 'uncommon' concepts of health, illness, and care anchored in traditional medicine and folk beliefs. As Julia Kristeva—psychiatrist, novelist, migrant—and her co-authors remind us in the programmatic article 'Cultural crossings of care: An appeal to the Medical Humanities' (2018), the Lancet Commission of Culture and Health highlighted already in 2014 the 'cultural dimensions of health and well-being' (55)—a claim with considerable impact on the Medical Humanities, a trans-discipline flourishing at the intersection of medicine and humanities:

> We will argue that the medical humanities should fully acknowledge the pathological and healing powers of culture, and approach the human body as a complex biocultural fact. Accordingly, these cultural dimensions should no longer be constructed as mere subjective aspects of medical care, but as being constituent of, and 'hard' factors behind, sickness and healing. (55)

While Kristeva et al. focus on the benefits and healing powers of Western—high—culture,[1] an approach that might be criticized as an elitist view, the *Diagnostic and Statistical Manual of Mental Disorders* (DSM) draws attention on 'non-Western' pathologies. In this regard, the DSM-5 (2013) differentiates between various cultural concepts—'cultural syndromes', 'cultural idioms' and 'cultural explanations' of distress—that sensitize for 'cultural ways of understanding and describing illness experiences that can be elicited in the clinical encounter' (15, see also 758), such as, for instance, *dhat*, associated with the Indian Subcontinent and referring to an anxiety disorder marked by the fear of semen loss, and therefore a loss of energy, or *koro*, a panic linked to the shrinking of genital organs that can be found in China, Africa, and partially in Europe.

Even though the 'marginal', 'accessory' emplacement of those disorders as a glossary at the end of the DSM instead of its main corpus may insinuate that Westerners get in touch here with 'exotic', 'abnormal' ways of being 'crazy',[2] the mere existence of the annex encourages thinking about the fundamental impact of culture as 'shaper' of disease concepts. This concern goes back to the development of ethnopsychiatry, a discipline developed by the French ethnologist and psychiatrist Georges Devereux and his disciple Tobie Nathan. Guided by a (too?) strict cultural relativist approach,[3] they consider, as the following quote shows, (mental) health and illness as profoundly cultural-bound phenomena which implies deep respect for folk beliefs, with respective languages, objects and healing strategies:

> I believe that traditional therapies (for example: rituals for the possessed, the battle against witchcraft, returning order to the world after breaking a taboo, creating 'therapeutic objects') are neither illusions, nor suggestions nor placebo. I believe that these practices are exactly what the users believe they are: techniques used to influence and that are very often effective and therefore worthy of serious investigation. Since we are not alone in this world – others too think, at times with a lot of imagination, often with wisdom.
>
> (Nathan, 2006, 115)[4]

Especially the—often forgotten or ignored—evidence of 'not [being] alone in this world', brings to mind the importance of an ethics and, as we will see in the following, an aesthetics of relating, especially in mental health contexts and therapeutical encounters. Instead of an hierarchizing attitude that considers the biomedical paradigm as a superior kind of knowledge and as the only valid reference point from which 'strange' pathologies have to be judged and classified, ethnopsychiatric research and therapeutical practice as realized, for instance, at the Parisian Centre Georges Devereux,[5] want to focus 'on the logic and rationales of therapeutic practices of all kinds, Western and non-Western,

"without hierarchy or exclusivity"' (Nathan *apud* Zajde, 2011, 189). Highly sceptical towards Western psychiatry 'when it reigns as a master ideology' (Nathan, 1994, 12, transl. J.P.), this attitude implies caring for the special needs of migrants and accepting the challenge of offering 'specialized' therapies integrating 'non-Western' agents as, for instance, healers, shamans, etc.

While this might sound like an entirely salutary crossing of different perspectives on (mental) health and illness, it nonetheless bears risks and side effects. According to critics such as Didier Fassin (2011, 223–246) or Richard Rechtman (1995, 125),[6] Nathan's cultural relativism may result in essentializing culture and cultural difference. In their eyes, the claim for 'special' treatments and therapies especially shows the (highly problematic) consequences of the understanding of cultures as monolithic entities: the migrant, once arrived in the Western host society, is almost naturally attached to his *roots* without taking sufficiently into account his travel *routes* (and the cultural set pieces he absorbed during his journey).[7] He finds himself, so to speak, attached to his culture of origin and imprisoned into a supposedly culture-specific set of symptoms and remedies, without taking into account that cultures—as well as concepts of illness and health and the ways of dealing with them—are not always grounded in only one (cultural) tradition but, especially in an era of globalization, appear as mixed, hybrid, and composite.

Aware of those traps and fallacies consisting in either absolutizing the Western medical paradigm and claiming, arrogantly, its universal applicability or, on the contrary, 'chaining' the 'stranger' to his culture of origin, our article aims to draw attention to the potentials of a literary production governed by a 'migratory aesthetics' that—following Mieke Bal (2007, 31)—'endorses and explores the mobility of the current social world'. To analyze such a corpus of texts, a postcolonial theoretical framework—with key concepts such as 'transculturality', 'rhizome' or 'Relation'—seems highly relevant, as the following part will illustrate.[8]

THE PRODUCTIVITY OF A POSTCOLONIAL THEORETICAL FRAMEWORK: TRANSCULTURAL—DIVERSE—RELATED

In his article 'When was "the post-colonial"? Thinking at the limit', Stuart Hall (1996, 257–258) reminds us that the post-colonial is not so much to be understood in a chronological sense, as a caesura or rupture between colonized and independent society. More broadly, it can rather be considered a critical thought putting into question and destabilizing binary oppositions of any kind:

> [i]ts theoretical value … lies precisely in its refusal of this 'here' and 'there', 'then' and 'now', 'home' and 'abroad' perspective. … It is about how the lateral and transverse *cross-relations* of what Gilroy calls the 'diasporic' (Gilroy 1994) supplement and

simultaneously dis-place the centre-periphery, and the global/local reciprocally re-organise and re-shape one another.

(Hall 1996, 247, my emphasis)

Also the history of hegemonic Western medicine can be read through this postcolonial, non-binary lens, especially when we consider its status in our globalized world, more and more shaped by—as Tobie Nathan (2006, 114) has put it—the 'fluctuation of humans, [the] fluctuation of concepts'. In fact, in an era of 'medical globalization' (Hörbst & Wolf, 2011, 240), Hörbst and Wolf (2014) observe the accelerated formation of what they call 'medicoscapes' (184). Drawing on Arjun Appadurai's suffix of '-scapes'[9]—suggesting network-like spaces—their neologism refers to 'worldwide dispersed landscapes of individuals; national, transnational and international organizations and institutions as well as heterogeneous practices, artifacts and things, which are connected to different policies, power relations and regimes of medical knowledge, treatments and healing' (Hörbst & Wolf, 2014, 184). Related to the outlined postcolonial background, these complex cartographies illustrate the 'decentred, diasporic or "global" rewriting of earlier, nation-centred imperial grand narratives' (Hall, 1996, 247) intended by the Hallian thought. But they also tie up with the postcolonial concept of transculturality developed by the German philosopher Wolfgang Welsch. Contradicting '[t]he old homogenizing and separatist idea of cultures' (Welsch, 1999, 197) as defended by the idealist romantic philosopher Johann Gottfried Herder in *Ideas on the philosophy of the history of mankind* (Herder 1968), Welsch highlights in articles such as 'Transculturality – the Puzzling Form of Cultures Today' (1999) the ideas of cultural encounter, exchange, and transfer that tie up with Homi Bhabha's statement that cultures are no monolithic entities, but the result of an ongoing process of negotiation in a hybrid 'third space' (Rutherford, 1990, 207).[10] According to these premises, in Welsch's eyes

> [t]he concept of transculturality aims for a multi-meshed and inclusive, not separatist and exclusive understanding of culture. It intends a culture and society whose pragmatic feats exist not in delimitation, but in the ability to link and undergo transition. In meeting with other lifeforms there are always not only divergences but opportunities to link up, and these can be developed and extended so that a common lifeform is fashioned which includes even reserves which hadn't earlier seemed capable of being linked in. Extensions of this type represent a pressing task today.
>
> (Welsch, 1999, 200–201)

If we try to orient our reflection more onto aesthetics, the rhizome, as developed by the philosopher Gilles Deleuze and the psychiatrist Félix Guattari in *A thousand plateaus*, could be seen as the emblem par excellence of a de-territorialized thought and an ideal metaphor for transculturality. As 'underground horizontal stem' (Clarke, 2000, 19), characterized by horizontal lines of movement, connectivity and networks, it challenges arborescent, tree-like or genealogic models aiming to organize the world hierarchically and trying to subject, in doing so, multiplicities to one central idea.[11]

Not surprisingly, the Martinique-born poet, writer, and philosopher Édouard Glissant takes up the Deleuzian metaphor by coining the concept of 'rhizome identity', largely inspired by the Caribbean as a (cultural) space of creolization and hybridity, characterized 'by the horizontal encounter, not depth, and infinite, multiple network of branching roots' (Glissant, 1997, 179), what stresses 'the indispensability of the other' (Clarke, 2000, 20) in the identity-forming process.[12] Diametrically opposed to this 'alteridentity' Glissant describes—unfortunately creating himself a binary opposition— the root identity model, characterized by a 'central, predatory downward-growing shaft' (Glissant, 1997, 179) alluding to any kind of nationalism, euro-, or ethnocentrism trying to control multiplicity by its subordination to the totalitarian rootstock, i.e., the blood and the soil of one's ancestry, never freely chosen.

As it can be shown in the following quote 'I speak and above all write in presence of all languages of the world', Glissant (2008, 2, transl. J.P.) himself seems to personify the rhizome identity imbued by and related to the other. It is, in fact, the concept of Relation that is fundamental and vital for his thought. It is the core essence of his *Poetics of relation* (1997), a book where the Caribbean, a space profoundly shaped by cultural contact—one might, for instance, think of the History marked by cultural encounters in the context of slave trade, colonialism,[13] or the emergence of creole language—becomes a kind of matrix for an identity paradigm possessing transformative power in a broader sense because conscious about the evidence that identity is, as we can read on the website of the publisher of the English translation of Glissant's book, 'constructed in relation and not in isolation..., that relation in all its senses – telling, listening, connecting, and the parallel consciousness of self and surroundings – is the key to transforming mentalities and reshaping societies.'[14]

The key concept of 'Relation' will be fundamental and leading in the following analytical part. Examples borrowed from a corpus of anglophone and francophone (migrant) literature, read in the theoretical framework we outlined, will illustrate the productivity of a migratory aesthetics in (mental) health and illness contexts. What seems crucial is, that the analyzed texts never remain in an attitude of 'cheap exoticism' when the hegemonic culture is confronted to other forms of healing. Instead of playing what Jean-Paul Sartre called in his foreword to the book of photographs *From one China to the other*, the sterile 'game of anomalies' (Sartre, 1954, 3, transl. J.P.) in order to find the highest amount of differences between 'them' and 'us', Glissant's notion of 'Relation' encourages us to look for intersections, in-betweens spaces, and 'contact zones' (Pratt, 1991, 34–40).

Applied to medical contexts in general and mental illness- and health-related topics in particular this means, from the standpoint of the hegemonic (medical) culture, to be receptive to 'other voices' without hastily silencing them either by a Eurocentric perspective or by relating them 'automatically' to a 'typical' culture-bound pathology. While a first array of examples deals particularly with the power of the spoken word and narration as a transnational cultural technique highlighting that the West does not hold a monopoly on narrative medicine, the second group of examples focuses more closely on bicultural, often also plurilingual authors, capable of a productive 'double vision' that allows them to focus simultaneously on topics related to (mental) health and illness in

their homeland and in their host societies, as for instance, on the Western 'talking cure' exported to China.

The Power of the Spoken Word: Narration as Transnational Cultural Technique

As the Grand Dame of American Literature Joan Didion (2009 [1979]) once said: 'We tell ourselves stories in order to live' (11)—an observation that seems also true when it comes to illness and health: The field of Narrative-Based Medicine has led to a high awareness for the correlations between storytelling, illness, and health, especially since Josef Breuer, Sigmund Freud, and Bertha Pappenheim, who coined the term 'talking cure', one of the fundaments of psychoanalysis, proposed that the finding and sharing of our life's stories are also inextricably linked to mental health care. While Didion as an author was particularly concerned with the written word, stories narrated in medical settings are generally shared orally, this way contrasting the dominance of the written medium in Western culture. In this respect, and despite their apparent other differences, mental health care stands with an intriguing connection to indigenous (healing) practices which—as in indigenous cultures in general—are commonly associated with a strong tradition of oral storytelling (e.g., Redvers & Blondin, 2020, 15; Mahuika, 2019). As Morris (1996) points out by the example of Native American culture:

> Oral tradition in fact is the ground of Native American life, maintaining "the sacred knowledge and practices" of the tribe, and oral tradition often takes the shape of narrative. … Of course, traditional Native American cultures had no books and no written language with which to record the history and lore of the community. Storytellers functioned – and continue to function – as interactive, embodied libraries for the people, holding crucial information in memory and bringing this information to life through spoken words, facial expressions, and bodily gestures. (n. p.)

(Not only) in Native American healing traditions, the telling of stories is also an integral part of the healer's work.[15] What many indigenous and Western forms of (mental) health care thus share is a firm belief in the power of the spoken word. An example for this is the Navajo *Night Chant* (also *Nightway Chant*), a nine-day ceremonial consisting of, above others, hundreds of songs, rituals, dances, and sand paintings[16] that is, above others, conducted with the purpose to cure head-related ailments, such as impaired hearing or seeing or also mental disturbances (e.g., Francis, 2004, 138; Ramsey, 1989, 86). In correspondence to the Navajo's holistic understanding of illness and health, the ceremonial focuses, however, not only on single components of the body but integrates it as a whole.

The textual-physical closeness of the various parts of the human body in the following excerpt may give an idea of this:

> My feet restore for me.
> My limbs restore for me.
> My body restore for me.
> My mind restore for me.
> My voice restore for me.
>
> (Matthews, 1902, 143)

According to the Navajo notion of holism, the term 'body', as we just used it, has to be thought in a twofold sense, namely as that of an individual and that of a collective: For one, the health of a person is understood to be dependent on the interconnectedness of mind[17] and body; '[i]n Indian healing, physical afflictions invariably have spiritual implications, and vice versa: treatment of the body or of the spirit alone, then, would not suffice' (Ramsey, 1989, 79). At the same time, 'Indian praxis recognizes that the illness and debilitation of one person diminishes, and perhaps threatens, the whole community, human and otherwise, and conversely his or her restoration to physical and mental health enhances the health and good order of the community' (Ramsey, 1989, 79). What the *Night Chant* thus 'endeavours to *make* ... is nothing less than a symbolic re-creation of the whole Navajo universe, *around the patient*, with him or her as its focal point' (Ramsey, 1989, 88; original emphasis).[18]

In the *Night Chant*—and the ceremonial seems quite representative for a multitude of indigenous salutary traditions in this regard—healing is fundamentally linked to the faith in the power of the spoken word. 'In the Navajo view, things *are* because they are first known, then thought, and finally spoken. ... It is the word itself which has psychological life. *The word is the speaker, the mover, the healer*' (Schenk, 1988, 232; original emphasis).[19] Laguna Pueblo Indian writer Leslie Marmon Silko puts it quite beautifully in her novel *Ceremony* (1977), when it says:

> I will tell you something about stories,
> [he said]
> They aren't just entertainment.
> Don't be fooled.
> They are all we have, you see,
> all we have to fight off
> illness and death.
>
> (Silko, 1977, [2])

Even though therapeutic disciplines such as psychoanalysis as well as research fields like Narrative-Based Medicine have raised awareness of the meaning of (oral) patient–physician communication, such a strong belief in the power of the spoken word as expressed in Silko's quote is (still) hard to find in Western medicine. As Ramsey (1989)

notes: 'In our [Western] culture, patients may—if lucky—hearken to the cheering but usually incidental words of a doctor's "bedside manner"; more likely, we are only left to ponder in silence the rather mythic-sounding names on the prescription bottle label: *Ornade, Tetracycline, Tagamet, Inderol, Librium …*' (81). In contrast to that, the therapeutic purpose of indigenous ceremonials such as the Navajo *Night Chant*

> is couched in powerful *language*—in words both invocative of beneficial powers and evocative of feelings of assurance in the patients and their well-wishers. One is struck forcibly by how different it is with doctors and patients in our own culture! When in standard medical practice today is a physician likely to emphasize to a patient the idea that one or several communities have a stake in his or her recovery? And where—either in medical education or in practice—is the affective power of language likely to be brought into play?
>
> <div align="right">(Ramsey, 1989, 91–92; original emphasis)</div>

The potentials indigenous perceptions of illness, health, and (oral) storytelling may also imply for Western health systems still needs to be researched in more detail. While Narrative-Based Medicine certainly seems like a more than suitable environment for such an endeavour, also literary studies may come into play in this regard. A close at the Navajo *Night Chant* may help to convey a better idea of the role aesthetic scholarship may assume in this regard. As the following verses exemplarily illustrate, 'beauty' (*hozho*) is fundamentally anchored in the Navajo healing concept:

> In beauty, I shall walk.
> In beauty, you shall be my picture.
> In beauty, you shall be my song.
> In beauty, you shall be my medicine.
> In beauty, my holy medicine.
>
> <div align="right">(Matthews, 1902, 182)</div>

As well as:

> With beauty before me, I walk.
> With beauty behind me, I walk.
> With beauty below me, I walk.
> With beauty above me, I walk.
> With beauty all around me, I walk.
> It is finished (again) in beauty,
> It is finished in beauty,
> It is finished in beauty,
> It is finished in beauty.
>
> <div align="right">(Matthews, 1902, 145)</div>

As already insinuated above, the Navajo holistic concepts of illness and health are essentially based on a concept of order that, as Ramsey (1989) explains, 'is denoted by a virtually untranslatable word, *hozho*, meaning "balance", "symmetry", "equilibrium of many parts", "ideal order", "beauty", (88–89).[20] *Hozho* or—to follow the quoted translation of Washington Matthews—'beauty' can thus be described as a 'unifying force that is within all things, connects all things, and creates all things' (Alvord, 2007, 666). With that said, the two excerpts of the *Night Chant* seem like an inherent embodiment of this notion: After all, the verses' mantra-like use of anaphoric and epistrophic frames creates a textual fabric that prevents the individual lines from splintering into detached, isolated fragments but unites them into a larger whole. In consequence, the 'beauty' so explicitly accentuated in the chant is echoed on the level of form, which, in the verses' interwoven iterations, insinuates a harmony due to which the chant corresponds in its very own way to the premise of a higher physical and spiritual equilibrium inherently entailed in the concept of *hozho*. As Ramsey's just-mentioned list of synonyms abundantly accentuates, the range of meanings linked to the original Navajo term thus clearly transcends the lexical definitions of its English translation. Instead, 'beauty' in the Navajo sense of the word has to be understood as follows:

> Beauty does not lie within an object to be preserved, nor does it lie in the eye of the beholder; it is an 'in-between' phenomenon. Westerners are surprised to find, for example, that sandpaintings, the equivalent of our masterpieces, are destroyed after each ceremony. To the Navajo, the sandpaintings in themselves are not beautiful but *they create beauty through their healing*.
>
> (Schenk, 1988, 226; original emphasis)[21]

In the *Night Chant*, beauty, aesthetic, healing can thus be hardly separated from each other. Rather, the Navajo concept of 'beauty' (*hozho*) invites us to look more closely at the link between the *ars medicinae* and the *ars litterae*: From the perspective of (Western) writing cultures, chants such as that of the Navajo touch the borders of the genre of poetry.[22] While an oral form of expression such as a chant cannot be equated with a written form of expression such as a poem, they have, however, obvious similarities, which is why it will come as no surprise that research has also juxtaposed Native American healing practices with the fine arts. Arguing that 'physical and psychological restoration of the person [is] a primary function of literature in Native American cultures' (Jaskoski, 1979, 1), Jaskoski, to give an example, draws an explicit connection between (indigenous) oral healing practices and the (Western) genre of poetry:

> The importance of the word, the poem, is preeminent in medical practice among the groups I discuss here. The crucial aspect of Navaho chantway practice is singing, and while practitioners have been called "medicine men" they are more properly termed "singers." ... The power inherent in language lies at the root of poetry's curative potency in American Indian theory. (2)

Also Navajo surgeon Alvord (2007) stresses art as being part and parcel of (not only) Native American healing practices:

> When the mind encounters certain forms of art, the joy, delight, or awe it experiences can relieve stress or counteract depression, thereby possibly helping the immune system. ... Navajo ceremonies include layers upon layers of art—from multiple sources, but designed to be woven together, integrated. From the power and beauty of the chants and the images they evoke, to the powerful rhythms of the drums, and the music that carries the words forward, art moves through ceremonies as both the background and the foreground, as both the earth and the air. (667)

Writers, Shamans, Curanderas

While the Navajo *Night Chant* allows an approach to the interconnections between indigenous healing practices and the arts with the aid of an (at least originally) oral source, the semi-autobiographical book *Borderlands/La Frontera* (1987) by Texas-born Chicana author Gloria Anzaldúa permits further exploration of this relationship with the help of a source that—regarding content as well as form, or rather, medium—tensely oscillates between its anchoring in both indigenous and Western (writing) cultures. *Borderlands/La Frontera*, a bilingual book that consists of both poetry and prose, confronts us with a range of individuals whose wounds mirror, as Hartley (2010) argues, the physical, psychological, and spiritual trauma caused by external as well as internalized colonialism (50).[23] According to Hartley, in Anzaldúa's book, '[b]ody, mind, soul, and writing are intimately and intricately interwoven ... just as they are in the embodied experience of colonialism in the borderlands. The body's pain is the psyche's pain, and vice versa.' (43) Despite the overwhelming intensity of their pain, those suffering are, however, not powerless before it, as the following verses out of the poem *La curandera*[24] suggest:

> Juan Dávila saw pain crawling toward him.
> He backed away.
> Still it followed him,
> until he was pressed into the wall.
> He watched the pain climb up his feet, legs.
> When it reached his heart,
> it began to eat him.
> 'My thoughts cause this,' he cried out.
> In his head he made a picture of the pain backing off,
> of the pain sliding down his leg,
> of the pain crawling toward the door.
>
> (Anzaldúa, 2007, 199)

In Anzaldúa's poem, pain is depicted as a menacing force, threatening to consume body and 'heart',[25] to destroy the sufferer. However, with just as much might, the poem's protagonist reminds himself of his mental power to let pain either become a toxic threat to his life or to create an antidote against it by his mere faculty of imagination. While his pain had just seemed to creep up on him like a venomous snake, he is now able to reject this evil creature, to control it, to vanquish it. The sufferer has become his own *curandero*, who can use the power of thought, of imagination to help cure himself.

Wounds, pain, and healing are, however, not only metaphors in *Borderlands/La Frontera*; instead, Anzaldúa (2007) equates the telling of a story with a shamanistic practice: 'The ability of story (prose and poetry) to transform the storyteller and the listener into something or someone else is shamanistic. The writer, a shape-changer, is a *nahual*, a shaman.' (88) As such, writing itself gets ascribed the ability to affect our health:

> When I create stories in my head, that is, allow the voices and scenes to be projected in the inner screen of my mind, I 'trance'.... Some of these film-like narratives I write down; most are lost, forgotten. When I don't write the images down for several days or weeks or months, I get physically ill. Because writing invokes images from my unconscious, and because some of the images are residues of trauma which I then have to reconstruct. I sometimes get sick when I *do* write. I can't stomach it, become nauseous, or burn with fever, worsen. But, in reconstructing the traumas behind the images, I make 'sense' of them, and once they have 'meaning' they are changed, transformed. It is then that writing heals me, brings me great joy.
>
> (Anzaldúa, 2007, 91–92; original emphasis)[26]

When looking more closely into literary history, literary writing and shamanistic healing practices are ascribed a potential kinship by ('Western') authors who have no indigenous heritage themselves. An example for this is Ted Hughes, one of the most famous British poets of the twentieth century, whose deep interest in shamanism left a clear mark in his own poetic work. As Madhukumar (2019) notes:

> *Crow* includes some of the most profound shamanic initiatory experiences like the dismemberment of the body, cataleptic trances and the similar death rituals. It is full of songs, macabre dances and compressed rituals and great emphasis is put upon the search for initiatory experience. In *Gaudete* and *Prometheus on His Crag* both the initiatory and expiatory elements are combined together in terms of shamanic meditation. They include the shamanic practices like dismemberment of the body, torture by helping spirits, descent into the underworld, and abduction by spirits, symbolic birth and regeneration....
>
> In *Gaudete*, ... [t]he sudden, psychotic breakdown, the cessation of ordinary reality and entry into a spirit world, the threats, violence and symbolic teaching undergone there, the provision of a new body and the transformed return of [the poem's protagonist] Lumb, all correspond to the basic concepts of shamanism. (137, 138)[27]

It is, however, not so much on the level of content and motif on which Hughes' pronounced preoccupation with shamanism comes into play. As Leadbetter (2018) even argues, 'given the importance of shamanism in Hughes's thinking, it is striking that relatively few of Hughes's poems, among his vast output, stand out as "shamanic" in anything but the loosest (and therefore least critically valuable) sense' (193). To comprehend the link Hughes made between shamanism and poetry, it is, instead, helpful to look at his review of Mircea Eliade's *Shamanism: archaic techniques of ecstasy* (1964), a study that fundamentally influenced the poet's own concept of shamanism:

> The initiation dreams, the general schema of the shamanic flight, and the figures and adventures they encounter, are not a shaman monopoly: they are, in fact, the basic experience of the poetic temperament we call 'romantic'. ... The shamans seem to undergo, ... one of the main regenerating dramas of the human psyche: the fundamental poetic event.
>
> (Hughes, 1964, 677–678)[28]

Like Eliade, Hughes understood 'shamanic experience as a trans-cultural, transhistorical manifestation of spontaneous hierophany, common to the psychobiological constitution of the human species and characterised by an inward, imaginative and regenerative response to psychic crisis' (Leadbetter, 2018, 193–194). For Hughes, both poetry and shamanism are manifestations of an impulse to cure such a psychic crisis (Leadbetter, 2018, 190–191). 'I think the shamanistic phenomenon is basically the same as the phenomenon behind artistic creation of any kind. It is a universal human way of dealing with the difficulties of experience, the damages and pains of life' (Hughes 2007a, 628). Like a shaman, a poet can, as Hughes is convinced, become a healer—both of himself and of those connected to the poet via the written text:

> telling stories, writing poems or fantasizing performs the mythic function of taming a devil ... Myth, then, is the objectified story of a psychic healing, a taming of the dragon, a coming-to-terms-with drama. ... The poet, according to Hughes, is the healer of the community as well as of himself, a medicine man, a marabout, a shaman ... The poem sets out to resolve the poet's or the community's ill. Thus myth is not only a making or a renewing of the old world. Subjectively, the making itself is also therapeutic, in a deep and immemorial sense as well as an everyday, practical sense.
>
> (West, 1985, 36–37)

The salutary potential Hughes ascribes to both shamanism and poetry[29] is essentially linked to their respective orientation towards the equilibrium of the mind:

> Hughes regards myth and folklore as a healing force to the divided psyche. He, from the beginning, has been arguing that the scientific inquiry, rational scepticism and puritanical idealism have split man's psyche. ...

He considers shamanism as a force of equilibrium because it deals with the control and harnessing of energy expressed through ecstasy, energy that can revitalise and empower or bring chaos and destruction. Ted Hughes's poetry is addressed to a world that has lost his balance. It is poetry that can not only portray the crisis, but also has a healing force. The healing comes through its emphasis on the holiness of the natural world and the mystery of the human psyche.

<div style="text-align: right">(Madhukumar, 2019, 133, 138)</div>

Notwithstanding their patent differences, the Navajo *Night Chant*, Anzaldúa's *Borderlands/La Frontera* and Ted Hughes' poetic as well as poetological approaches towards shamanism all share one commonality: They all stress the fundamental power of language to affect illness and health. While these examples are all fundamentally linked to indigenous (healing) and thus—whether this link is explicated or not—oral traditions, the mere mediality in which they are preserved (and also quoted in this very paper) implicitly corroborates an imbalance that stands in harsh contrast to e.g., the Navajo's holistic pursuit of a (literally 'beautiful') order between various parts of a greater whole. After all, given the dominance of the written (Western) health discourse, oral forms of (medical) knowledge are at severe risk of falling into oblivion: 'As knowledge transmission ... most often does not include a written record, historical and present-day information on community practice in this area is rightfully held within Indigenous communities themselves. ... This knowledge is the true knowledge that is most often not reflected in written academic scholarship' (Redvers & Blondin, 2020, 15). When looking at the example of North America, despite 'the approximately 7.5 million Indigenous peoples who currently reside in Canada and the United States', widespread knowledge about 'traditional healing methods, modalities and its associated practitioners by Indigenous groups across North America' is thus 'elusive amongst most Western-trained health professionals and systems' (Redvers & Blondin, 2020, 1; see also Hill, 2008)—a phenomenon that can be observed around the globe.

Against this backdrop, literary representations of mental health (care) within indigenous cultures may serve as one possible means to strengthen the equilibrium (or *hozho*, if we may) between oral and writing cultures—as two components of the greater whole of the human collective—to at least some degree: The fictional realm of a novel may, for instance, give voice to both indigenous and Western cultures, be it in the form of verbalized speech (dialogues etc.) or of inner monologues; next to that, the poetic play with figures and tropes out of the realm of, e.g., pain and trauma, embedded in a distinct (e.g., typographic) juxtaposition of texts, contexts, and gaps charged with implicit, tacit meaning that in its totality upends the hegemony of the written medium may provide an inkling of the complexity of oral healing rituals. Either way, literature may translate indigenous knowledge for a Western audience and vice versa and serve as a mediator between oral and writing cultures, while at the same time illustrating both possible frictions and junctures.

Also for China-born migrant authors living in France and writing in French, fiction functions as a contact zone, where France meets China, where different kinds of (therapeutic) knowledge meet, clash, and grapple with each other.

OEDIPUS IN CHINA: RISKS, SIDE EFFECTS, AND POTENTIALS

François Cheng and Dai Sijie, two emblematic figures of the 'transculturation' of French 'national' literature—the first elected as the first Chinese person to the prestigious French Academy, the latter author of international bestsellers translated around the globe—deal in their writing, guided by a migratory aesthetics in the above-outlined sense, frequently with (mental) illness and (mental) health care.[30] As the French original titles of novels such as the Chengian *Le dit de Tianyi* (translation: *The river below*) or *Le complexe de Di* (translation: *Mr. Muo's Travelling Couch*) suggest, a major interest is paid to the healing powers of the (spoken) word. While 'the idealist' François Cheng re-contextualizes the salutary narration of one's life story, i.e., *le dit*, 'the spoken', in a sinicized aesthetic framework, so that Western readership may understand the key concepts of a Taoist vision of the world, Dai Sijie opts for a less didactic and more ironic approach to the spoken word and the 'talking cure'.[31] Confronting (Western) readership with the ridiculous figure of Muo, the first Chinese psychoanalyst, whose 'speaking' name seems to be a Freudian slip evoking the 'great helmsman' Mao Zedong and his megalomania, encourages us to question the universalist claim of psychoanalysis, a Western-style therapy, impossible to 'export' into other cultural contexts without reflecting its presuppositions and premises.[32]

Dai Sijie, the son of two doctors, grew up during the years of Mao's Cultural Revolution and spent part of his youth in a Chinese re-education camp—an experience described, not without acerbic humour, in his autobiographical first novel *Balzac and the little seamstress*. Writing fiction—and even more so in a foreign language allowing a salutary distancing from a potentially traumatic Chinese past—seems to be a comforting strategy to cope with the 'dumb night'[33] of muteness and to re-member[34] his own life which was marked by oppression and humiliation. For the narrator and his friend Luo, two boys also interned in a Maoist re-education camp during the Cultural Revolution, reading (Western) Literature—and narrating then all the 'devoured' stories—appear in fact as strategies of survival provoking a salutary 'sentimental (re-)education' diametrically opposed to the objectives of Mao Zedong. Thanks to their contact with (Western) Literature—an aesthetic experience with life-changing or even life-saving value—the young boys are confronted with individuals who suffer, love, revolt—subjectivities silenced in Mao's *Little red book*, where the collective revolutionary subject alone reigns.[35]

But the ironist Dai Sijie is highly aware of the risk of an unconditioned idealization of (Western) master narratives as can be seen in his second novel *Mr Muo's Travelling Couch*—thanks to the motif of the suitcase, an ironic response to *Balzac and the little seamstress*. While the suitcase containing numerous literary 'classics' of Western, especially French literature, functions in Dai Sijie's first novel literally as a 'survival kit' for the young boys during their re-education, the suitcase of Muo, filled with 'milestones' of psychoanalytic theory,[36] becomes the symbol of the madness and the megalomania of the first Chinese psychoanalyst (as well as of his grotesque 'civilising mission' reminiscent of Western colonialism). Quite programmatically it is a Chinese that undertakes the absurd, comical crusade to proselytize his compatriots—a constellation that blends imperialistic and (neo-)colonial abuses in the West *as* in the East.

Muo, a caricatural figure with his 'bony toe[s], pale as skimmed milk' (Dai, 2005, 3) and his thick glasses underlining his symbolically charged short-sightedness, not only continues the literary tradition of mad doctors, but also the one of readers gone crazy because of taking fiction for reality, as, for instance, Emma Bovary or Don Quixote. In fact, the first contact with the Chinese translation of Sigmund Freud's *Interpretation of Dreams* in the dormitory of a Chinese university in 1980 is hyperbolically described as a religious experience of conversion: We learn that the lines of the father of psychoanalysis 'ignited a joyful flame in the spirit of his disciple-to-be, [who] in a state of utter beatitude, read and reread the sentences of this living God out loud …' (Dai, 2005, 10). The logical next step in the metamorphosis from Muo to 'Freud-Muo' (Dai, 2005, 10) is his training analysis in France. Because conceived as radically monocultural, this training, instead of encouraging Muo to work through his own neuroses (comprising his idealization of Freud's thought) and to open, as the typographical sign in his nickname suggests, a hyphenated space in the sense of a contact zone, is perverted into a ridiculous staging, a dialogue between two persons hard of hearing:

> Having no French at first, Muo spoke Chinese, of which his psychoanalyst understood not a word…. At times, during these early sessions, Muo's super-ego … would cast his memory back to the Cultural Revolution, whereupon Muo would laugh and laugh until the tears streamed down his cheeks and he was obliged to take off his glasses to wipe them under the watchful eye of the Mentor, who, although superficially unperturbed, suspected deep down that the joke was on him.'
>
> (Dai, 2005, 11–12)

Foremost because of the absence of an absolutely necessary translator in this transcultural therapeutical setting, the training analysis inevitably does not take place 'without its comic moments' (Dai, 2005, 11). Without a 'third in the room' (Kluge & Kassim, 2006, 177), essential to create a third space of exchange and negotiation, Muo and his analyst cannot help but misunderstand each other. The disciple, feeling constraint to obey to a memorial duty, does not push forward to repressed material in his mind; the analyst, on his side, fears losing his status of a god-like *Übermensch* proud about 'receiv[ing]

Muo … with the calm and patience of a Christian missionary lending a forgiving ear to the fantasies and intimate secrets of a convert newly touched by the grace of God' (Dai, 2005, 11). In summary, each of the men involved in the sterile encounter remains blocked, surrounded by the defense wall of their 'root identities' and therefore unable to relate—that means to listen as well as to 'really' rising to speech.

Since the analysis never addresses Muo's neuroses, it is not surprising that he returns to his Chinese homeland with a megalomaniac mission. Ironically mirroring communist campaigns like Mao's 'Great Leap Forward', he wants to convince his compatriots of Freud's theory and unlock their deepest secrets and fantasies. This postmodern picaresque crusader sets off on a journey by bicycle through his homeland as a 'traveling psychoanalyst' (Dai, 2005, 80, chapter 6, 'A travelling couch'), whose (Eurocentric) knowledge seems to be sufficiently attested by the black-and-white banner fixed on the embossed carrier where we can read the following lines: ' "Interpreter of Dreams" (large script), followed by "Psychoanalyst returned from France" and "Schooled in Freud and Lacan" (smaller script)' (Dai, 2005, 81). This ridiculous attempt to showcase his therapeutic knowledge and competencies does not conceal the fact that Muo uses psychoanalysis only as a strategy to achieve his own goals, that is, to find—thanks to the confessions of his only female clients—a virgin for the (neurotic) judge Di keeping imprisoned Muo's supposedly great love Volcano of the Old Moon—who never paid any attention to the sexually completely inexperienced bachelor.

Given this megalomania (with erotomaniac accents) it is not surprising that Muo, especially at the beginning of his journey, is entirely sure of the universalism of Freudian thought. With regard to Tobie Nathan, we can consider him convinced of 'being alone in this world', what means not accepting the challenge to relativize and to relativize himself (Kristeva, 2007, 16). Considering psychoanalysis as universal, he has great difficulties in accepting the existence of folk beliefs that may question the all-pervading power of Freudian thought. This can be illustrated by a conversation in a train with a local girl:

> 'I am a psychoanalyst.'
> 'What' s that? A job?'
> 'Indeed it is. I analyse … how shall I explain? I do not work in a hospital, but soon I shall have my own private practice.'
> 'You're a doctor, then?'
> 'No. I interpret dreams. …'
> 'My goodness! You don't look anything like a fortune-teller to me.'
> 'I beg your pardon?'
> 'You, a fortune-teller!' she exclaims, and without giving Muo a chance to redress this common misconception of psychoanalysis, she points to a cardboard box in the luggage rack …'
>
> (Dai, 2005, 14–15)

Although feeling offended by this 'attack' against his (imagined) authority and superiority, he has to recognize, during his journey, that psychoanalysis perhaps cannot be

exported 'naturally' in other cultural contexts. His own obsession—the judge Di—for instance never seems to be afraid of being castrated:

> Freud and Judge Di did not share the same world. In fact, ever since Muo had set foot in China, he had been assailed by doubts concerning psychoanalysis. Take Volcano of the Old Moon: was she suffering from the famous Oedipus complex like everyone else? Were the men she loved, lovers past, present or future, including himself, nothing but substitutes for her father? Why would Judge Di desire to savour a slashed red melon [metaphor for the female vagina – J.P.], if it meant losing his penis? How could he not suffer from a castration complex?
>
> (Dai, 2005, 77)

These questions—resonating in Muo's head and destabilizing his (artificial) certainties—may allude to the theoretical concept of an 'ethnic unconscious' referring to repressed material shared by the members of an ethnical group (Herron, 1995, 521–532). However, Muo's 'fieldwork' among his compatriots shows that the supposition of fixed, properly 'Chinese' rules prescribing culture-specific ways and contents of repression does not correspond entirely to a complex, multi-layered and 'rhizomatic' reality. Not without a certain satisfaction he crosses two sorceresses who, as their mutual 'accusations' during a conversation about their father show, seem to know very well what penis envy means: '"You even hid in the dark to spy on him when he peed. You were fascinated." "You're lying! Only a few weeks ago you told me how you had dreamed of him peeing in the courtyard, and that you'd imitated him and made him laugh. True or false?"' (Dai, 2005, 86).

This emblematic and unexpected crossing of 'Freudian style' fantasies with witchcraft, thus folk beliefs, reveals that the novel, according to its migratory aesthetics of relating, considers neither universalism nor strict cultural relativism as satisfying approaches to a complex reality that can never be entirely 'domesticated' by generalizing and simplifying theories. And although Muo enthusiastically proclaims after having listened to the sorceresses: '... the magic of psychoanalysis! Long live the uninhibited tongue!' (Dai, 2005, 87), he abandons his mission, as we can read in the fragments of his diary where he finally rises to his own speech—surrendering to a world where, according to Glissantian Relation, 'all is deeply intertwingled' (Nelson apud Han, 2005, 15): '[He] lowered [his] banner with its ancient "dream" ideogram' (Dai, 2005, 110), this emblem of his supposed superior knowledge, and throws it into the Yangtse river; and once returned to his parent's home, he drowns another insignia of power—his glasses, the proof of his Frenchness and thus of his status as '(re-)educated' Chinese intellectual: 'Muo lowered himself into [the white bathtub] until his glasses were dislodged by the water and sank like a vessel that had sprung a leak' (Dai, 2005, 113).[37]

Despite these highly symbolically charged actions he remains stuck in his neuroses, unable to build up satisfying relations to others. However, the abandonment of his 'psychoanalytical mission' can be read as the successful attempt to overcome, at least, his intellectual hybris—a productive failure liberating a Nietzschean view of the world 'eternally justified only as an aesthetic phenomenon' (Nietzsche, 1999, 33). During

his continuing search for a virgin, he makes the stupendous experience of (surrealist) beauty: Strolling with an old observer, he is overwhelmed by the strange coincidence of a butterfly settled down on a Panda's feces[38]—an unexpected aesthetic experience reminiscent of Segalenian and Chengian diversity that engages him entirely and unfolds even healing effects:

> This confrontation shakes Muo to the core of his being. Animal droppings, a butterfly, an old convict – there is, in this timeless trinity, a touch of the sublime, of eternity. Suddenly his life, his books, his dictionaries, his notebooks, his emotions, his worries all strike him as futile and superficial.
>
> (Dai, 2005, 237)

Conclusion: The Power of a Migratory Aesthetics in Globalized Mental Health Care Contexts

The (life-changing) power of the aesthetic experience in the above-quoted scene emerges, above others, from its character as 'synchronistic event' (López-Pedraza, 1990, 24), or, in other words, from the simultaneity of components unexpectedly put together. Reminiscent, in this way, of the rhizome's 'principle of multiplicity' (Deleuze & Guattari, 1987, 8), it mirrors the complex, 'rhizomatic' condition of our globalized world, characterized by the 'fluctuation of humans, [and the] fluctuation of concepts' (Nathan, 2006, 114). Such a complexity, hardly to be reduced to a common denominator, is also inherent to 'medicoscapes', these network-like spaces illustrating the heterogeneity or even 'transculturality' of the medical field in an era of medical globalization. The resulting, but frequently repressed, evidence that 'a cultural plurality of bodies requires a plurality of medical interventions' (Le Breton, 2003, 195, transl. J.P.), obviously challenges the hegemonic biomedical paradigm, especially in mental health contexts, where 'other stories' of health, illness, and cure have to be heard and have to be recognized—without silencing them either by excessive universalism, exotic curiosity or a too rigorous cultural relativism, reactivating, via the backdoor, the category of race.

As we have seen, literature, especially when governed by a non-binary, migratory aesthetics anchored in a postcolonial theoretical framework, could encourage mental— and clinical (?)—cartographies of 'Relation'; it could open contact zones where different concepts of cure and care, illness and healing meet, clash, and grapple with each other without the doubtful comfort of a reassuring master narrative that ultimately risks to silence, or even to suffocate pluralities. Especially the analyzed texts' 'double vision', focusing simultaneously on the 'own' and the 'foreign', seem particularly able to open in-between spaces, where hegemonic medical and therapeutic paradigms, such as psychoanalysis, are constrained to face the evidence of not being alone in this world—an

insight, resulting in salutary self-limitation. We have seen that such an epistemologically modest attitude focuses not so much on the differences between (medical) cultures and their healing strategies—in order to establish hierarchies and concurrencies—but pays attention to possible intersections, junctions, and similarities, for instance by drawing parallels between shamanism and (Western) poetical practice, or by highlighting the transcultural (healing) power of the spoken word.

Given these premises of openness and (self-)relativization, represented in the possibility-space of literature, therapeutic encounters, especially when involving migrants on the one hand and medical staff anchored in the dominant culture on the other, can result in 'co-naissance' and 'exchange-change' (Cheng, 2012, 275)—two (visionary) Chengian notions stressing reciprocity, particularly important in a globalized world where medicine and the Medical Humanities can be considered more than ever as cultural 'boundary work' (Kristeva et al., 2018, 56) constrained to (get in) touch (with) the other.

Notes

1. They report the case of an Arab girl who, exiled in France, 're-connected' with herself by reading—and writing—poems in French, her newly 'adopted' language.
2. To prevent, at least in part, the risk of an 'exotization' of the above-mentioned disorders, the DSM-5 (2013, 749–759) refrains notably from the term 'culture-bound syndrome' (14) as coined in the DSM's fourth edition. Furthermore, it offers guidelines for the so-called 'Cultural Formulation Interview' that shows the evolution of cultural assessment in psychiatry.
3. We will deal later on with the side effects of this viewpoint, i.e., 'imprisoning' the 'stranger' in a set of fixed syndromes.
4. For the translation of the German source, see: www.ethnopsychiatrie.net/mantovani.htm [last accessed 6 October 2024].
5. https://www.ethnopsychiatrie.net/index.html [last accessed 6 October 2024].
6. '[B]y suggesting the existence of fundamental differences between the functioning of the human psyche according to one individual's culture of origin, [Nathan] risks not only to reactivate the concept of race, which paradoxically he claims to actively contest in his militancy, but also to inaugurate a theory of human species based on ethnic belonging.' (Rechtman, 1995, 125).
7. We have borrowed the inspiring wordplay of 'roots' and 'routes' from Elizabeth DeLoughrey's intriguing publication *Routes and Roots: Navigating Caribbean and Pacific Island Literatures* (2009).
8. See also the introduction to the edited volume of Fürholzer and Pröll (2023, especially pp. 13–21).
9. In his book *Modernity at Large: Cultural Dimensions of Globalization* (1996), he coins the concept of 'ethnoscapes', referring to spaces and places shaped by migration, cultural encounters, and transfers.
10. Bhabha states in this interview that 'no culture is full unto itself, no culture is plainly plenitudinous, not only because there are other cultures which contradict its authority, but also because its own symbol-forming activity, its own interpellation in the process

of representation, language, signification and meaning-making, always underscores the claim to an originary, holistic, organic identity' (Rutherford, 1990, 210).

11. It seems highly pertinent to note in this context that the cover of the *Edinburgh Companion to Critical Medical Humanities* (Whitehead & Woods, 2016) is decorated with a rhizome-like structure.
12. This importance of the 'other' productively de-centering the 'self' in the identity-building process brings to mind another postcolonial concept, coined by the French physician writer Victor Segalen, an indispensable Glissantian reference. In his *Essay on Exoticism. An Aesthetics of Diversity* he is concerned about re-defining 'diversity' no longer as 'local color' that simply 'charms' or 'amuses' the traveller. It does not mean 'the melting-pot, the pulp, the mish-mash, etc. Diversity is differences that encounter each other, adjust to each other, oppose each other, agree with each other and produce the unpredictable' (Glissant *apud* Forsdick, 2014, 161). As these remarks suggest, diversity dis-places the self in a productive way, quite like François Cheng, a Chinese-born migrant author writing in France and in French states in an essay (2008a, 120) devoted to his tutelary figure Segalen: 'le Divers ne divertit point,/Il déroute' ('Diversity does not entertain/it baffles', transl. J.P.).
13. As Stanka Radovic (2007, 475) has demonstrated, the slave ship traversing the Atlantic from Africa to the new World, is, according to Glissant, not only a place of suffering and trauma, but simultaneously a 'generative matrix, and therefore a womb, that produces an indissoluble link between the multilingual and initially disconnected peoples for whom the unknown and abysmal experience of slavery and deportation will become a source of "unanimité", of shared suffering'.
14. See www.press.umich.edu/10262/poetics_of_relation.
15. '[T]he position of shaman has essentially communal functions including healing, leading sacrifice, storytelling, fortunetelling and the general guidance of souls' (Dahms, 2012, 10).
16. The most detailed description of the Navajo *Night Chant* has been provided by Washington Matthews (1902); for a more condensed overview see Bierhorst (1974, 279–352).
17. Needless to say, 'mind' itself is a concept that refuses a universal definition but is understood very differently in various cultures.
18. As Jane Robinett (2003) points out, despite the differences between indigenous curative practices such as shamanic healers and, e.g., Latin American *curanderas/os*, they can also 'parallel each other closely in intent, purpose, and practice' (122). Also the holistic appreciation of illness and health as being fundamentally bound to a balance of body, mind, and soul or spirit, as well as of the individual and the collective thus constitutes, of course, the core of a multitude of (indigenous) cultures. In the indigenous people of the Mexica, for instance, the 'conception of psychopathology consisted of social, physiological, and psychological elements. Relevant to the social component, the presence of a disturbed person was viewed as a disruption of the normal equilibrium of a community and as something that affected the entire community through bad weather resulting in the loss of crops or by an invasion from an enemy. It was thus important to cure patients not only for their own sake, but also to restore equilibrium to the community' (McNeill & Cervantes, 2008a, xix).
19. Catherine L. Albanese (1980) emphasizes in this context that 'if any of the senses was given priority in Navajo healing, it would have to be the sense that carried the rhythmic repetitions of the song as well as the noises of the winds and the animals. The first Navajo word was "listening"; the first healing sense was sound' (388).
20. 'Health is a manifestation of *hozho* in all these aspects; illness is taken to indicate that, for the patient, things have gotten out of their proper balance' (Ramsey, 1989, 88–89). Beauty

heals, it conciliates, (re-)creates order even or maybe particularly in times of dis-order. In his seminal study *The Discovery of the Unconscious* (1994), Canadian psychiatrist Henri Ellenberger delineates the connections of 'modern' Western psychotherapy to shamanism, exorcism, magnetism, and hypnotism and explicitly emphasizes the role of beauty in the context of healing: 'the ceremony may be effective through the sheer beauty of the rites, the costumes, the music, and the dances. ... There are several conspicuous facts in this treatment. (1) It is a collective treatment, organized and performed not by one man, but by a healing society. (2) It is a psychodrama: The three main healers, wearing the costumes and masks of the three gods, are assisted by the other members of the society, while the patient plays an active role in the rites. (3) It is a therapy, since the gods are brought near and their myths re-enacted. (4) It is also a "beauty therapy" because of the magnificence of the songs, the rites, and the costumes' (29–30). The healing ceremony allows the space and time to leave the mundane behind by taking recourse to rituals, to costumes and masks, music and singing—and thus not least by taking recourse to beauty. For more insight into the role of beauty in the context of psychotherapy see in particular Poltrum (2016).

21. A similar conception of beauty as 'co-production' between watcher and watched echoes in the work of François Cheng. In his essay *Cinq meditations sur la beauté. Nouvelle edition* (2008b) he outlines the (also holistic) Taoist conception of beauty as an appeal, a challenge 'disturbing' and productively 'de-centering' the subject exposed to it. Instead of a more or less sterile encounter between the active watcher and the passive watched as frequently in European conceptions, the aesthetic experience is based on mutual engagement of the parties involved and culminates in what he describes in French as '*co-naissance*' (93, my emphasis). This neologism, built upon the French word for 'knowledge' means, written with a hyphen materializing an in-between space of relation and exchange, the salutary (re-)naissance of the subject *together* with the object. But Cheng's reflections cannot be limited to a mere listing of the differences between cultures and their aesthetic traditions. Especially aware of the junctions and intersections, he draws attention to the aesthetic experience of the French painter Paul Cézanne and his overwhelming encounter with the St. Victoire mountain (134) conceivable in Taoist terms.

22. See Kenneth M. Roemer (2012) for a problematization of the common attempt to apply (e.g., genre) concepts of writing cultures on oral ones.

23. *Borderlands/La Frontera* is traversed by metaphors of wounds, pain, and the like; see for example a quote from the book's very first chapter: 'The U.S.-Mexican border *es una herida abierta* [is an open wound] where the Third World grates against the first and bleeds. And before a scab forms it hemorrhages again, the lifeblood of two worlds merging to form a third country––a border culture.' (Anzaldúa, 2007, 25; original emphasis). For a detailed analysis of pain in Anzalduás' work, see Bost (2009, 77–113).

24. The term 'curandera' or 'traditional (female) healer' derives from 'curanderismo', a term that denominates 'mestiza/o folk healing practices and traditions that represents a fusion of Judeo-Christian religious beliefs, symbols, and rituals along with indigenous herbal knowledge and health practices. Curanderas/os are believed to have supernatural power or access to such power, and their abilities are perceived as *el don*, a gift from God.' *Curanderas/os* treat a variety of physical, mental, spiritual and social problems (McNeill & Cervantes, 2008a, xxiii–xxvi). A comprehensive study of indigenous healing practices in Latin America is provided by McNeill and Cervantes 2008b. For perhaps the most famous fictional *curandera*, read Rudolfo Anaya's coming of age novel *Bless me, ultima* (1972).

25. 'Physiologically, the Mexica identified the heart as the origin of feelings, passions, and emotions, and therefore responsible for the affective and behavioral functioning of the person. One who was severely emotionally disturbed was said to have lost his heart' (McNeill & Cervantes, 2008a, xix).
26. Hartley (2010) thus explicitly describes Anzaldúa 'as a healer—the *curandera* of conquest' (42; original emphasis); see also Dahms (2012) analysis of shamanism in Anzaldúa.
27. A comprehensive analysis of *Gaudete* is provided in Kupferschmidt-Neugeborn (1995, 131–226); for at least a brief analysis in English see Roberts (2007, 29–31, 58–60).
28. In his review, Hughes (1964) suggests that poets such as Shakespeare, T.S. Eliot, Keats, or Yeats were not least driven by a shamanic quest (678; see also Roberts, 2007, 59; Leadbetter, 2018, 190; Schuchard, 2011, esp. 51; Brandes 2015, 198–210). A similar interest can also be observed with regards to artists, one may, for instance, think of Beuys fascination for the character of the shaman (see Bohnet & Strieder, 2022).
29. See in this regard also Hughes' (2007b) following thoughts: 'The Shamanic state of mind is—in many ways—unconditioned, non-adapted, infantile or even pre-birth, half animal. Or can be. That is a great part of its "affliction"—schizophrenia, even psychosis, are fairies at that cradle, bearing their magic mushrooms. One can live a life struggling with the successive crises of that—or, with exceptional character, one can actually "heal" it, & become, if only precariously, fully adult, wholly human. In our society, the pressures to force the individual to heal him or her self & go through the whole psychic transformation, becoming "adult" and so to speak "normal", are immense. Ideally, the result should be—a saint, a sage' (616).
30. The title of this section is drawn upon the French documentary *Œdipe en Chine*, produced by ARTE France. See also www.youtube.com/watch?v=x8mzbg3ZIng [last accessed 6 October 2024].
31. In fact, the 'complex of Di' does not only refer to the neurotic judge Di who is greedy for virgins to satisfy his sexual desire and to Muo's own neurotic fixation onto the person of the judge, but also, given the homophony between 'Di' (name of the judge) and 'dit' (the 'spoken' in French), to a megalomaniac overestimation of Western psychoanalysis (i.e., 'the complex of the spoken [word]'). Such a viewpoint productively ties up with recent discussions in which the complete conviction that 'self-expression through narrative is fundamentally healthy and desirable, particularly in the case of illness' is seen as a kind of Western 'master narrative' (Woods, 2011, 75).
32. It is interesting to note that Dai Sijie's novel, written against the backdrop of the experience of the Chinese Huo Datong, the first 'real' Chinese psychoanalyst, nicknamed 'Chinese Lacan', as stated on the blurb of his book *La Chine sur le divan. Entretien avec Dorian Malovic* (2008), is an important reference in publications about intercultural psychotherapy (see, for instance, Wenzel et al., 2019, 58–77). Given this importance of the novel for (Western) therapeutic contexts, we will limit our study, also due to the limited space of the article, to Dai Sijie's book. However, some concepts and reflections of François Cheng will enter our conclusion. For more detailed analyses of the two novels, see Pröll (2013).
33. The formulation is inspired by Rainer Maria Rilke's poem 'Death of the Beloved', see www.artofeurope.com/rilke/ril6.htm [last accessed 6 October 2024].
34. Spelled this way, the verb does not only refer to memory but also to the activity of rebuilding, reassembling, and recomposing a fragmented life.
35. The main storyline of *Balzac and the Little Seamstress* is concentrated in the 2007 autobiographical short story 'La nuit du conteur' ('The storyteller's night'). Like Scheherazade in

One Thousand and One Nights, the narrator, interned in a Maoist re-education camp, tells night by night stories borrowed from (Western) literature, an activity procuring evasive moments for his public composed of all those 'exiled without explanation' (332).

36. It contains, above others, 'the two-volume *Dictionary of Psychoanalysis* in its slipcase, weighing a total of five kilos, Freud's essay on psychoanalysis in the 1928 French translation of Marie Bonaparte ... a volume in the "Connaissance de l'inconscient" series edited by J.-B. Pontalis, *Journal psychanalytique d'une petite fille*, translated by Malraux' wife ...; Lacan's *Subversion of the Subject and the Dialectics of Desire*, which Muo held to be the best text on female orgasm' (Dai, 2005, 111). It is the omnipresence of translation in this quote that illustrates quite well Tobie Nathan's statement of a 'fluctuation of concepts' characterizing a 'world in motion'.
37. Already during his training analysis Muo took off his glasses, but without the resignation inherent to this intellectual shipwreck.
38. This 'strange coincidence' echoes the surrealist definition of beauty referring to the French writer Lautréamont and quoted in André Breton's *First Surrealist Manifesto*: 'beautiful as a chance encounter on a dissecting table of a sewing-machine and an umbrella' (Matthews, 1965, 105).

References

Albanese, C. L. (1980). The poetics of healing. Root metaphors and rituals in nineteenth-century America. *Soundings* 63(4), 381–406.

Alvord, L. A. (2007). Navajo spirituality. Native American wisdom and healing'. In Arri Eisen & Gary Laderman (Eds.), *Science, religion, and society. An encyclopedia of history, culture, and controversy*, vol. I (pp. 665–669). M.E. Sharpe.

American Psychiatric Association. (2013). *Diagnostic and statistical manual of mental disorders*, 5th edn (DSM-5). American Psychiatric Association Publishing.

Anaya, R. A. (1972). *Bless me, ultima*. Warner Books.

Anzaldúa, G. (2007). *Borderlands/La Frontera. The New Mestiza* [1987], 3rd edn. Aunt Lute Books.

Appadurai, A. (1996). *Modernity at large. Cultural dimensions of globalization*. University of Minnesota Press.

Bal, M. (2007). Lost in space, lost in the library. *Thamyris/Intersecting Place, Sex, and Race* 17, 23–36.

Bierhorst, J. (1974). The night chant. A Navajo ceremonial. In John Bierhorst (Ed.), *Four masterworks of American Indian literature. Quetzalcoat, the ritual of condolence, Cuceb, The night chant* (pp. 279–352). Farrar, Straus, and Giroux.

Bohnet, U., & Strieder, B. (2022). 'Joseph Beuys und die Schamanen': eine interdisziplinäre Ausstellung im Museum Schloss Moyland im Beuys-Jubiläumsjahr 2021. *Museum Schloss Moyland. Schriften* 35, 6–14.

Bost, S. (2009). *Encarnacion. Illness and body politics in Chicana feminist literature*. Fordham University Press.

Brandes, R. (2015). Mercury in taurus. W.B. Yeats and Ted Hughes. In Catherine E. Paul (Ed.), *Writing modern Ireland* (pp. 198–210). Clemson University Press.

Cheng, F. (2000). *The river below*. Welcome Rain.

Cheng, F. (2008a). *L'un vers l'autre. En voyage avec Victor Segalen*. Albin Michel.

Cheng, F. (2008b). *Cinq meditations sur la beauté. Nouvelle edition.* Albin Michel. [English translation: Cheng, F. (2009). *The way of beauty. Five meditations about spiritual transformation.* Inner Tradition].

Cheng, F. (2012). *À l'orient de tout.* Gallimard.

Clarke, R. L. W. (2000). Root versus rhizome: An 'epistemological break' in Francophone Caribbean thought. *Journal of West Indian Literature* 9(1), 12–41.

Dahms, B. (2012). Shamanic urgency and two-way movement as writing style in the works of Gloria Anzaldúa. *Letras Femeninas* 38(2), 9–27.

Dai, S. (2001). *Balzac and the little seamstress.* Anchor Books.

Dai, S. (2005). *Mr Muo's travelling couch.* Vintage.

Dai, S. (2007). La nuit du conteur. In Michel Le Bris and Jean Rouaud (Eds.), *Pour une littérature-monde* (pp. 321–337). Gallimard.

Deleuze, G., & Guattari, F. (1987). *A thousand plateaus.* University of Minnesota Press.

DeLoughrey, E. (2009). *Routes and roots: Navigating Caribbean and Pacific Island literatures.* University of Hawai'i Press.

Didion, J. (2009). *The white album* [1979]. Farrar, Straus and Giroux.

Ellenberger, H. F. (1994). *The discovery of the unconscious. The history and evolution of dynamic psychiatry* [1970]. Fontana Press.

Fassin, D. (2011). Ethnopsychiatry and the postcolonial encounter: A French psychopolitics of otherness. In Warwick Anderson, Deborah Jenson, & Richard C. Keller (Eds.), *Unconscious dominions: Psychoanalysis, colonial trauma, and global sovereignties* (pp. 223–246). Duke University Press. https://doi.org/10.2307/j.ctv11cw6zj.

Forsdick, C. (2014). From the 'aesthetics of diversity' to the 'poetics of relating'. *Paragraph* 37(2), 160–77.

Francis, S. T. (2004). The role of dance in a Navajo healing ceremonial. In Uwe P. Gielen, Jefferson M. Fish, & Juris G. Draguns (Eds.), *Handbook of culture, therapy, and healing* (pp. 135–150). Erlbaum.

Fürholzer, K., & Pröll, J. (2023). Migration, Kulturkontakt und Sprachbewegung im Spiegel der Medical Humanities. In Katharina Fürholzer & Julia Pröll (Eds.), *Fluchtlinien der Sprache(n). Migration, Kulturkontakt und Sprachbewegung im Spiegel der Medical Humanities* (pp. 3–30). De Gruyter.

Glissant, É. (1997). *Poetics of relation.* Translated by Betsy Wing. University of Michigan Press.

Glissant, É. (2008). J'écris en présence de toutes les langues du monde. *Sens public. Revue international/International Webjournal* 11, 1–4. Available at: www.sens-public.org/IMG/pdf/SensPublic_EGlissant_Toutes_les_langues_du_monde.pdf.

Hall, S. (1996). When was 'the postcolonial'? Thinking at the limit. In Iain Chambers & Lidia Curti (Eds.), *The post-colonial question: Common skies, divided horizons* (pp. 257–258). Routledge.

Han, B.-C. (2005). *Hyperkulturalität und Globalisierung.* Merve.

Hartley, G. (2010). 'Matriz sin tumba. The trash goddess and the healing matrix of Gloria Anzaldua's Reclaimed Womb. *Melus* 35(3), 41–61.

Herder, J. G. (1968). *Reflections on the philosophy of the history of mankind.* University of Chicago Press.

Herron, W. G. (1995). Development of the ethnic unconscious. *Psychoanalytic Psychology* 12(4), 521–532.

Hill, L. P. (2008). Understanding Indigenous Canadian traditional health and healing. PhD dissertation, Wilfred Laurier University. Available from: https://scholars.wlu.ca/cgi/viewcontent.cgi?article=2049&context=etd [last accessed 6 October 2024].

Hörbst, V., & Wolf, A. (2011). Medizinische Globalisierung. In Fernand Kreff, Eva-Maria Knoll, & Andre Gingrich (Eds.), *Lexikon der Globalisierung* (pp. 240–243). Transcript.

Hörbst, V., & Wolf, A. (2014). ARV and ART: Medicoscapes and the unequal place-making for biomedical treatments in sub-Saharan Africa. *Medical Anthropology Quarterly 28*(2), 182–202.

Hughes, T. (1964). 'Secret ecstasies'. Review of Mircea Eliade, *Shamanism. Archaic techniques of ecstasy. The Listener 72*(29), 677–678.

Hughes, T. (2007a). [Letter to Anne-Lorraine Bujon, 16 December 1992]. In Christopher Reid (Ed.), *Letters of Ted Hughes* (pp. 621–636). Farrar, Straus and Giroux.

Hughes, T. (2007b). [Letter to Nick Gammage, 21 October 1992]. In Christopher Reid (Ed.), *Letters of Ted Hughes* (pp. 616–617). Farrar, Straus and Giroux.

Huo, D. (2008). *La Chine sur le divan. Entretien avec Dorian Malovic*. Plon.

Jaskoski, H. (1979). A word has power. Poetry and healing in American Indian cultures. Paper presented at the 94th annual meeting of the Modern Language Association, San Francisco, California, December 27–30, 1979. Available from: https://files.eric.ed.gov/fulltext/ED193660.pdf [last accessed 6 October 2024].

Kluge, U., & Kassim, N. (2006). 'Der Dritte im Raum'. Chancen und Schwierigkeiten in der Zusammenarbeit mit Sprach- und Kulturmittlern in einem interkulturellen psychotherapeutischen Setting. In Ernestine Wohlfahrt & Manfred Zaumseil (Eds.), *Transkulturelle Psychiatrie – Interkulturelle Psychotherapie. Interdisziplinäre Theorie und Praxis* (pp. 177–198). Springer.

Kristeva, J. (2007). *Étrangers à nous-mêmes*. Gallimard.

Kristeva, J., Moro, M. R., Ødemark, J., & Engebretsen, E. (2018). Cultural crossings of care: An appeal to the medical humanities. *Medical Humanities 44*, 55–58.

Kupferschmidt-Neugeborn, D. (1995). *Heal into time and other people. Schamanismus und analytische Psychologie in der poetischen Wirkungsästhetik von Ted Hughes*. Narr.

Le Breton, D. (2003). *Schmerz*. Diaphanes.

Leadbetter, G. (2018). Hughes and shamanism. In Terry Glifford (Ed.), *Ted Hughes in context* (pp. 187–196). Cambridge University Press.

López-Pedraza, R. (1990). *Cultural anxiety*. Daimon.

Madhukumar, V. (2019). Shamanism in Ted Hughes's poetry. *Language in India 19*(1), 132–139.

Mahuika, N. (2019). *Rethinking oral history and tradition. An Indigenous perspective*. Oxford University Press.

Matthews, J. H. (1965). *An introduction to surrealism*. Pennsylvania State University Press.

Matthews, W. (1902). *The night chant, a Navaho ceremony*. American Museum of Natural History.

McNeill, B. W., & Cervantes, J. M. (2008a). Introduction. Counselors and curanderas/os-- parallels in the healing process. In Brian W. McNeill & Joseph M. Cervantes (Eds.), *Latina/o healing practices. Mestizo and Indigenous perspectives* (pp. xvii–xxxiii). Routledge.

McNeill, B. W., & Cervantes, J. M. (2008b). *Latina/o healing practices. Mestizo and Indigenous perspectives*. Routledge.

Morris, R. J. H. (1996). The whole story. Nature, healing, and narrative in the Native American wisdom tradition. *Literature and medicine 15*(1), 94–111. https://doi.org/10.1353/lm.1996.0009.

Nathan, T. (1994). *L'influence qui guérit*. Odile Jacob.

Nathan, T. (2006). Die Ethnopsychiatrie, eine Psychotherapie für das 21. Jahrhundert. In Ernestine Wohlfahrt and Manfred Zaumseil (Eds.), *Transkulturelle Psychiatrie – Interkulturelle Psychotherapie. Interdisziplinäre Theorie und Praxis* (pp. 113–126). Springer.

Nietzsche, F. (1999). *The birth of tragedy and other writings*. Translated by R. Speirs. Cambridge University Press.
Poltrum, M. (2016). *Philosophische Psychotherapie. Das Schöne als Therapeutikum*. Parodos.
Pratt, M. L. (1991). Arts of the contact zone. *Profession*[s.n.], 33–40.
Pröll J. (2013). *Changer la menace en chance … : Krankengeschichten in narrativen Texten französischsprachiger MigrationsautorInnen chinesischer und vietnamesischer Herkunft in Frankreich*. Habilitation at the University of Innsbruck, not published.
Radovic, S. (2007). The birthplace of relation. *Callaloo* 30(2), 475–481.
Ramsey, J. (1989). The poetry and drama of healing: The Iroquoian *Condolence ritual* and the Navajo *Night chant*. *Literature and Medicine* 8(1), 78–99.
Rechtman, R. (1995). De l'ethnopsychiatrie à l'a-psychiatrie culturelle. *Migrations Santé* 86, 113–129.
Redvers, N., & Blondin, B. (2020). Traditional indigenous medicine in North America. A scoping review. *PloS One* 15(8), e0237531.
Roberts, N. (2007). *Ted Hughes. New selected poems*. Tirril.
Robinett, J. (2003). Looking for roots. 'Curandera' and shamanic practices in Southwestern fiction. *Mosaic* 36(1), 121–134.
Roemer, K. M. (2012). It's not a poem. It's my life. Navajo singing identities. *Studies in American Indian Literatures* 24(2), 84–103.
Rutherford, J. (1990). The third space. Interview with Homi Bhabha. In Jonathan Rutherford (Ed.), *Identity, community, culture, difference* (pp. 207–221). Lawrence & Wishart.
Sartre, J.-P., & Cartier-Bresson, P. (1954). *D'une Chine à l'autre*. Delpire.
Schenk, R. (1988). Navajo healing. Aesthetics as healer. *Psychological Perspectives* 19(2), 223–240.
Schuchard, R. (2011). T.S. Eliot and Ted Hughes. Shamanic possession. *South Atlantic Review* 76(3), 51–73.
Segalen, V. (2002). *Essay on exoticism. An aesthetics of diversity*. Duke University Press.
Silko, L. M. (1977). *Ceremony*. Penguin.
Welsch, W. (1999). Transculturality - the puzzling form of cultures today. In Mike Featherstone & Scott Lash (Eds.), *Spaces of culture: City, nation, world* (pp. 194–213). SAGE Publications.
Wenzel, T., Drožđek, B., Fu Chen, A., & Kletecka-Pulker, M. (2019). The significance of intercultural psychotherapy in further education and professional training. In Meryam Schouler-Ozak & Marianne C. Kastrup (Eds.), *Intercultural psychotherapy. For immigrants, refugees, asylum seekers, and ethnic minority patients* (pp. 58–77). Springer.
West, T. (1985). *Ted Hughes*. Methuen.
Whitehead, A., & Woods, A. (2016). *The Edinburgh companion to the critical medical humanities*. Edinburgh University Press.
Woods, A. (2011). The limits of narrative: Provocations for the medical humanities. *Medical Humanities* 37, 73–78.
World Health Organization (2021). Mental health and forced displacement. Available from: www.who.int/news-room/fact-sheets/detail/mental-health-and-forced-displacement [last accessed 6 October 2024].
Zajde, N. (2011). Psychotherapy with immigrant patients in France: An ethnopsychiatric perspective. *Transcultural Psychiatry* 48(3),187–204. Available from: https://journals.sagepub.com/doi/10.1177/1363461511406465 [last accessed 6 October 2024].

CHAPTER 28

'EVERYONE HAS A STORY'

Aesthetic Experiences of Storytelling in
The Strangers Project

ERZSÉBET STRAUSZ

IN THE PLACE OF AN INTRODUCTION

BRANDON Doman tells me a story about an elderly gentleman visiting his story-collecting stand at Washington Square Park early in the lifespan of the project. He was in his eighties, appearing cold and dismissive at first. They chatted for a bit, then he sat down and started to read the stories—at that time, compiled in binders—and ended up staying for at least two hours. Brandon recalls the gentleman's words when he stood up: 'I completely forgot that younger people are still people!' He adds: 'he started out isolated but as he began reading the stories, he warmed up, realizing that all these other people walking around have lives as well.'[1]

The founder and story collector of *The Strangers Project*[2] in New York, Brandon Doman and I were reflecting on what storytelling can do: where does its power lie? We met in 2013, in the fourth year of what was initially intended as a 'weekend experiment.' 'I didn't know what to expect'—he notes, 'I was curious of people, I made a sign, and people started stopping.' Brandon spends roughly four to ten hours a day at different public spaces with a stack of papers, notepads, and pens, inviting passers-by to share their stories anonymously, that is, whatever may respond to the call 'tell me anything about your life'. The sign, written in block capitals, is hard to miss:

> 'Hi there, I'm collecting your stories!
> Stop & share anonymously or just say hi and ask "What for?" '

Strangers come and go, over a thousand people stop by every day, some of them sit down and share a story (about two hundred to three hundred per day), others stay for a chat or browse through the expanding archive of fellow strangers' handwritten stories.

In the past fourteen years Brandon collected more than 65,000 anonymous stories born out of a 'moment of spontaneous intimacy.' Clipped to strings, the paper sheets holding a snapshot of someone's life are now displayed as an installation that visitors can walk around. They also mark the designated space of the project, be that a bench in a park or a pop-up store in a shopping mall. Since the project's inception, stories have travelled far beyond these mobile frames. They appeared in two collections and at various exhibitions; they have made their ways into schools, therapy sessions, and psychiatric research while circulating widely on social media. On the project's website, stories are archived both as texts transcribed by volunteers and as scans, where the original image of the handwriting is preserved, keeping visible the exact visual form in which they were given. Visitors can also respond and leave a comment, expanding the plane of interactions between people who, beyond being strangers to each other, might discover that they have more in common. Yet the intensifying online presence of stories and the connections enabled by them circle back to generative moments with specific locations: one's story can only be written on the spot, by hand, in the unmediated space stretching between the tip of a pen and a blank sheet of paper.

Over the years the 'five basic principles' of the project have crystallized in the following way:

1. People can write about anything they want as long as it's true.
2. Stories are collected face-to-face in public spaces with a stack of blank paper, clip boards, and a lot of pens.
3. Stories are shared anonymously.
4. Stories must be spontaneously handwritten.
5. Everyone has a story. (2015, 7, emphasis in original.)

The stories, indeed, are about anything and everything, about what can and importantly, *cannot* be said, otherwise or perhaps, at all. Ranging from one-liners through detailed streams of consciousness to wordless drawings, signs, and other traces, each story enacts a gesture of communication, and with that, engenders connection. Some speak the unspeakable: 'I am dying and nobody knows.'[3] Others reach out to the unknown other in a gesture of care: 'I hope whoever enters this space finds all the reasons to return home to yourself.'[4] Happy, sad, but mostly unclassifiable life fragments take on a specific articulation prompted by the invitation to share and the open, undefined materiality of the blank page. Stories come into being in a public space that has been created and curated as *private*, invoking a sense of intimacy that is open and non-judgemental, embracing fully what 'being human' might mean right there. This is a 'great equalizer,' writes Brandon in the introduction to his first collection *Hearts minds & flesh*: 'for a moment, it doesn't matter who you are' (Doman, 2011, 1).

The project's trajectory has spanned nearly a decade and a half by now, shaped and fuelled by the people themselves—the strangers—who engage with it. Brandon writes in the FAQ of the website:

> I want to create a space for people to connect with the stories of the people they share their world with, and to connect with their own story. To put it simply, I do this because someone just might need it.[5]

The spark of the initial idea illuminated an immense need for telling, sharing, receiving; what Eric Selbin describes as 'the ancient human need for connection to each other and to ourselves' (2010, 4). In the foreword to his second collection *What's Your Story*, Brandon notes: 'my burning curiosity to listen to people was met with their equally intense desire to be heard' (Doman, 2015, 6). Yet storytelling is never just telling and receiving stories, and stories do more than convey a message through words. Among other things, the project (re)organizes public and virtual space, it gives rise to an economy of practices, moves bodies around, stages encounters between 'strangers' and facilitates new ways of relating to both self and other.

Engaging the power of storytelling in *The Strangers Project* is best done through experiencing it, on site, online, or preferably both. As the first collection's title alludes to, handwriting a story, reading handwritten stories, or just being present with the archive of life fragments move hearts, minds, and our embodied being. Giving *this* typewritten account of storytelling can only align with the project's ethos of 'connection' if it makes a conscious effort to go beyond the trained aesthetic sensibility of social scientific analysis and cultivates a practice of sensing and sense-making that espouses a resonant intention of openness and curiosity. Petra Munro Hendry suggests an understanding of research 'as an ethico-onto-epistemology, a mode of being in the world that requires that we listen and be present' (Eaton, Mitchel, & Munro Hendry, 2018, 10). In an ongoing effort of presencing as I re-visit my conversation with Brandon and engage the multiple dimensions of his project, I embrace the subject position of what Eve Kosofsky Sedgwick describes as being a 'reparative reader,' one who continues to look for what may be 'additive and accretive' (2002, 149). I 'read' the project as an extended archive of stories and ethical possibility—of relations to self, other, and world—that go beyond what has already gained articulation through the vehicle of words. I commit to listening deeply and with care for that invisible archive which may escape the familiar frames of social and academic recognizability. Caleb Smith comments that the ethical stance of reparative reading seeks to both confer a 'plenitude' on to what is engaged and enact a 'therapeutic effort to draw resources from the object for the benefit of the self' (2019, 907). Yet the resources drawn from the study of relations that also encompass me as a visitor, observer, fellow stranger, and storyteller are not for my own learning only. In line with Brandon's aspiration, whatever this story about storytelling may yield should serve and support whoever might need it.

Honouring the irreducible complexity of the processes and practices that continue to unfold within the space of *The Strangers Project*, instead of attempting analysis, I choose

to pull out threads from whatever may present itself as *tellable*. I offer points of entry into thinking about and thinking with the project as it continues to generate new experiences of selfhood, otherness, and community in navigating everyday life, celebrating stories within and outside us that reveal the unknown as non-threatening, friendly difference that connects us all. To highlight the limitless ways in which we may become enriched upon encountering these stories there is no marked 'introduction' and 'conclusion' to this narration either, only placeholders that invite attentive reading and exploration. Working with illustrations and inspirations arising from the interview, the archive of stories, social media activity, and academic knowledge, I aim to create aesthetic textures with and around these threads, conveying yet unworded sentiments that both the reader and I can attend to as raw material and take further for weaving new stories. Through three fragmentary, incomplete yet conjoined vignettes I set out to trace the traces of strangers and what may be empowering in the practice of telling stories through the realm of philosophical thought, the visible surface of discourse and interactions, as well as what may otherwise remain invisible to our eyes.

Narrating (Our)Selves

I wondered why and how stories may matter in the first place, and for our times, *now*. Walter Benjamin lamented the gradual disappearance of 'the art of storytelling' (2006, 362) already in the aftermath of World War I. The 'tiny, fragile human body' found itself in a state of deep shock and alienation, surrounded by machines, explosions, and the new form of communication Benjamin describes as 'information.' He writes that 'as if something that seemed inalienable to us, the securest among our possessions, were taken from us: the ability to exchange experiences' (2006, 362). With the decrease of the communicability of experience came another loss: without telling and receiving stories 'we have no counsel either for ourselves or others' (2006, 364). By 'counsel' Benjamin means wisdom that threads through the 'fabric of real life.' In Richard White's words, 'it is not factual information or anything merely objective but a living truth that can be absorbed and reflected upon and later communicated to others' (White, 2017, 3). For Benjamin, real stories are not exhausted in the act of telling, quite the contrary: they retain their 'strength', that is, their meaningfulness and ability to provoke reflection over time as they are told and re-told. Wisdom is generated and re-generated in circulation. Yet as lines of separation continue to compartmentalize life in both physical and mental spaces, the 'living truth' of person-to-person encounters—especially beyond the information-driven instrumentality of everyday life—can barely arise, let alone travel.

Both access to experience and its communicability suffered in the decades after. As Selbin points out, 'story' was the first casualty of 'the increasing sway of Northern/Western liberal bourgeois conceptions in which the basic unit of analysis was the atomistic individual.' This came with an atomized social ontology that necessitated to 'divvy up our understanding of the world into discrete and manageable packages' (2010, 7). Fast

forward to what Mark Deuze calls 'media life,' that is, our contemporary condition 'lived *in*, rather than *with*, media' (2011, 138). More connectivity, by default, has not resulted in more connection either, neither within ourselves, in our constitution as subjects and practices of self-making, nor in our relationship to others. Deuze notes that 'the moment media become invisible, our sense of identity, and indeed our experience of reality itself, becomes irreversibly modified, because mediated' (2011, 140). We construct ourselves and our relations in and through media where the de facto mediatedness of lived experience gradually slips out of the plane of awareness.

Yet stories—whether as 'real' stories with the potential of 'counsel' as per Benjamin's account—remain fundamental both at the macro-level of social governance and the micro sites of personal conduct. Selbin notes that 'people are storytellers and that the stories we tell define us as people (*a* people or even *the* people); we create, understand, and manage the world through the stories we tell' (2010, 5–6). The making of national, social, and personal identity implies and implicates the story-form. Patrick J. Lewis describes story as nothing less than the principal way of understanding the lived world: 'without a story there is no identity, no self, no other' (2011, 505). As Laura Béres and Jim Duvall point out in their account of narrative therapy, stories are never only *about* life, they are constitutive of people's lives, including 'their values, language, significant events, hopes, dreams, commitments, preferences, and cultural beliefs' (2011, 73). Stories also participate in the making of social and individual realities in endless forms and formations. Selbin highlights how, besides their information content, we use them 'to guide, to warn, to inspire, to make real and possible that which may well be unreal and impossible.' The stakes, in this regard, are high: 'stories allow us to imagine the transformation of our lives and our world' (2010, 3).

Stories may open or close down possibilities; reify, subvert, remake, or otherwise negotiate the social and the personal. What forms 'counsel' may take in our times, and where and how we may be able to locate the transformational potential of stories and storytelling is an ethical and political task that comes with a sense of urgency. In an era where the recognition of the power of stories, deriving specifically from the life wisdom they may offer and channel, has faded, what stories can do the work of undoing separation and *enabling* connection in the first place, and through what modes of expression?

Benjamin remarks that 'to seek […] counsel one would first have to be able to tell the story' (2006, 364). While storytelling is an irreducibly social activity—it is told to someone and received by someone—Béres and Duvall draw attention to how individual agency may be unlocked in telling a life story. A gesture of telling is already telling anew, and a potentially therapeutic process. They write that 'people are invited to become full participants and primary authors as they engage in the revisions of the events located within their life stories' (2011, 70). Narrating a life story activates a sense of authority in articulating meaning. This may be a transformational gesture already as it makes possible a 'restorying of life and identity' while it also creates an opportunity to weave in, as Melanie Rogers and Laura Béres write, the 'previously unstoried events' of life (2017, 55). The latter exposes a terrain of multiple storylines vis-à-vis unitary notions of 'truth', or the instrumentality of 'rational solutions' offered to simplified framings of 'problems.'

Béres and Duvall highlight that as we journey through our stories 'we increase our working knowledge of ourselves' (2011, 70–71) reflecting on meaning and significance as 'events, experiences, and feelings' are narrated. Through reflexivity, our capacity to connect to ourselves, and through that, our resourcefulness are also enhanced. Citing Michael White, Rogers and Béres note that in the process the need to 'problem solve' may also lead to 'problem dissolving': 'as people become reminded of, and able to identify, their meaning-making practices and hopes (their spirituality) they are better able to see ways out of problematic situations' (2017, 56).

The sense of authorship and authority that become accessible in telling a life story, while potentially deeply empowering, may only capture one specific register of life's intimate entanglement with the story-form. Beyond the frames of social recognizability and the ways in which we may appear recognizable to ourselves, Adriana Cavarero draws our attention to the fact that 'each person reveals that he or she is absolutely unique and singular' not only through their words and in negotiating the words addressed and attached to them, but through their acts, movements, and gestures that leave a trace behind (2000, vii). Cavarero's philosophy is a response to the observation that, in Paul A. Kottmann's words, 'philosophical discourse is […] unable to determine in words the individual *uniqueness* of a human being.' Quoting Hannah Arendt, he highlights that 'the moment we want to say *who* someone is, our vocabulary leads us astray into saying *what* he is' (2000, vii; Arendt, 1957, 181). The same applies to the language of science, government, and social normativity: categories and definitions necessarily turn the 'who' into a 'what.' Cavarero foregrounds 'existence that has not been reduced to an essence' (2000, xii) and suggests that what really is unique in a human being is 'that unrepeatable design that each life traces with its course' (2000, 140).

While such traces are temporary and certainly not ineffable, it is in a relationship of 'narration' with another—in a story told by someone else—that the 'finite in its fragile uniqueness' is revealed (2000, 3). In her reading of Karen Blixen's storytelling and philosophy, Cavarero illustrates the significance of the 'unrepeatable design' and its narratability in the following way:

> Karen Blixen recounts a story that she was told as a child. A man, who lived by a pond, was awakened one night by a great noise. He went out into the night and headed for the pond, but in the darkness, running up and down, back and forth, guided only by the noise, he stumbled and fell repeatedly. At last, he found a leak in the dike, from which water and fish were escaping. He set to work plugging the leak and only when he had finished went back to bed. The next morning, looking out of the window, he saw with surprise that his footprints have traced the figure of a stork on the ground.
>
> At this point Karen Blixen asks herself: 'When the design of my life is complete, will I see, or will others see a stork?'
>
> (Cavarero, 2000, 1)

The stork, the unity of a figure, captures all the confused marks that the man leaves while he runs around and stumbles into things in the darkness. It is the design of those unforeseen and uncontrolled trajectories that our actions expose as we do things in life. As Cavarero writes, 'the design is what that life, without ever being able to predict or even imagine it, leaves behind' (2000, 1). Yet the design as a unitary, recognizable figure complete onto itself is only discernible at the end, from what is left behind. It is rarely visible to the person living, and it is mostly by what other spectators pick up from such traces, 'looking from above', that fragments of it can be brought to light. Our stories of selfhood and personal experience are necessarily elusive, incomplete, and open-ended. With the help of others though, through their narrations of what we do and how we move around in life, it might be possible to catch a glimpse of the design of our lives, in constant making.

Cavarero's concept of the 'narratable self' affirms a profound interconnectedness and relationality among human beings through our ability to observe what may be inaccessible to the person and offer them a complementary piece of their life design as a story. In fact, emphasizes Cavarero, 'the design *is* the story' (2000, 2). She notes that '*what* the life story says is not, finally, at issue' and as such, what is foregrounded is not what we may tell about our lives but rather, our relationship to that uncapturable excess of our being and ongoing journey that we are not able to see and make sense of. 'The self is narratable and not narrated' (2000, xii), and therefore the possibility of a story—our fundamental narratability—is inexhaustible by whatever form a narration may take. In Kottmann's reading

> it is this *sense* of being narratable—quite apart from the content of narration itself—and the accompanying sense that others are also narratable selves with unique stories, which is essential to the self, and which makes it possible to speak of a unique being that is not simply a 'subject'. (2000, xvi)

Our desire for our story told to us by another is also a desire to connect with our own and others' narratability as a foundational aspect of our being. Ethically and politically, the life stories that may unfold from otherwise ephemeral and unnoticed moments captured by someone else's attention, in Maria Tamboukou's words, creates an opportunity 'for narratable selves to make connections, sense their vulnerability and become exposed to their dependence on others' (2008, 290). Laurie E. Naranch writes that

> the narratable self as a concept enables us to be attuned to humanization in ordinary moments of exposure to others—those places of absolute locality, the exchange of 'you' and 'me' that, when affirming the uniqueness of the self, is an example of ethical and political success, even if only momentarily and as part of an ongoing process. It also asks us to be aware of these as political moments of shared humanity in our mutual dependency in a particular time and space. (2019, 437)

'Do You Ever See a Stranger and Wonder ... "What's It Like Being You?"'

Brandon's first story collection refers to the project as *Talk to Strangers*, alluding to the presumed danger of the unknown located in the other that we have been trained to fear from a young age (Doman, 2011, 1). *The Strangers Project* encourages us to move beyond the socially engrained anxiety that acts as a barrier to interpersonal connection. It invites us to enter a place of curiosity from where a different experience of the world becomes accessible, one that encompasses 'the lives happening around us at every moment' just as much as our own, transgressing the lines of separation that quietly mark out the contours of the normal. As the introduction of the book illuminates: 'every moment billions of stories are unfolding—this is a glimpse into some of those things we may normally not notice. These are our lives' (Doman, 2011, 1). *The Strangers Project* 'unmutes' (Salim, 2022, 2) these otherwise untold, unshared stories and makes them visible by staging encounters with what would otherwise remain unexpressed both in ourselves and others. The stories, or in any case, the life experiences from which they may arise are always-already present: it is our capacity to notice them and approach them with an open mind—both in ourselves and others—that needs to be unlocked. Brandon tells me how surprised people were when they first saw the sign with the invitation to share a story: ' "Do you really want to hear my story? Why?" I don't think people are used to being asked that.'

The sign's invitation to stop is already a disruption in our daily routines. From the space opened by a question that touches upon our 'capacity for being human' beyond any social role or identity, visitors are free to inhabit the frames of the project in any way they like. Brandon sees a possibility of empowerment in 'allowing people to get whatever they want out of the project.' Key moments of participation may involve giving a story, reading the stories of others, experiencing the archive of stories as an exhibition space, and interacting with fellow strangers on the spot or online, while the 'imprint' of encounters continues to travel. For Brandon it doesn't matter if someone may be pulled in for entertainment or seeking connection as a response to a personal need. Each gesture calls for slowing down and paying attention *differently*. He writes that 'while there is power in telling your own story, there is an equal bravery that comes with bearing witness to another's sorrows and joys' (Doman, 2015, 7). As such, diving into the archive of stories is an 'unusually active reading experience' (2015, 7).

Making space and marking space for what would otherwise escape our normalized everyday sensibilities are indispensable features of *The Strangers Project*. Benjamin located storytelling in the pre-industrial workshop where seemingly disparate worlds could come together, conjoined by the relatability of human experience as 'the resident master craftsman and the travelling journeyman worked together in the same rooms' (2006, 363). The space—where 'a community of listeners' emerged seized by the rhythm of their work, listening deeply, forgetting about the chore at hand—is key for stories

to be received as gifts, at a depth that they become 'impressed upon' the memory of participants. Benjamin notes that the more self-forgetful the listener is, the more likely stories imprinted in this way will be retold as the listener turns into a storyteller themselves. As the workshop is squeezed out by the factory, and the site of work gradually becomes the isolated workstation, coupled with the inner wiring of the self as per the neoliberal ideal of individual productivity, the exchange of the 'living truth' of living life as a communal experience loses its spatial coordinates, both within and outside.

At the time of writing, the project is running in one of the stores of the Oculus building in Manhattan, a shopping centre and transportation hub constructed as part of the effort to rebuild the World Trade Center after 9/11. The architecture symbolizes a bird leaving a child's hand while the name itself means 'eye,' which, in this specific conception, is invited to look up through the skylight windows and see the sky (including the edges of Freedom Tower). The design of the store embraces the affective registers of what Brandon describes as 'the human condition' revealed through the collection of stories (Doman, 2015, 7). Gentle affirmations pave the path to the location of story, either within ourselves as we put pen to paper or reading the handwritten stories of others, accommodating whatever may come to the surface in sharing the otherwise unshared 'strands that connect us all' (Doman, 2011, 1). A mark on the floor says: 'This space is for you.' The designation of the tissue box indicates: 'in case of feelings.' A caption on the sketch pad reads: 'here is a piece of my story.' Takeaway memorabilia state that 'This card is proof that on this day, someone made the choice to share a piece of their story with the world.' Online comments and stories written on the spot often comment on the properties of the curated space as an atmosphere, that is, in Gernot Böhme's words, 'an indeterminate spatially extended quality of feeling' (1993, 118) that informs experience. The 'energy' of the place shifts moods.[6] Someone notes that 'I never felt like I belonged in a space more than I do here.'[7] The daily social media feed of the project documents an outpour of gratitude and appreciation, and states of having been moved, transported, and transformed by the intensity of encounters with self and other. Some moments may feel life changing. 'You've given me a reason to <u>KEEP LIVING.</u> I live for all of you + me now. You give me power. YOU ARE LOVED.'[8] Even if the space is seen as irregular, something stays and the imprint of the experience travels: 'I have never felt so at peace before. All my worries in life were put on pause. Now back to reality... but I'll remember this moment forever.'[9]

People sometimes cry or laugh while writing and reading. Emotional responses invite *more* engagement: strangers have bonded over asking one another what may have touched them in this way. In the space of the project, random conversations emerge between people who are meeting for the first time. Other stories are prompted by an unexpected resonance with someone else's story. Connections are both revealed and created as the 'living truth' of everyday life. Yet what forms 'counsel' may take in giving and receiving stories, and how wisdom may arise in experiences generated by such encounters and exchanges is nothing readily discernible. While each act of communication harbours its own unique and singular truths, engendering a multiplicity of relations within and between life worlds, some of the power of storytelling and what *The Strangers Project* may enable are exposed in the very acts of telling.

Stories and comments reiterate the meaningfulness of the simple act of writing out the contents of an inner world in a safe and accommodating space. Marco Bernini notes that inner experience, while not immediately narratable, has the potentiality to be transformed into a storyworld. What he calls 'latent narrativity'

> can be activated by the double movement of structuring quasi-perceptual thoughts, images, sounds and emotions into a world-like ecology (worlding) and by threading these inner events into some sort of narrative cohesiveness (storying)
>
> (Bernini, 2018, 299)

The opportunity to express experiences and reflect on life events that have been *worlded*—noticed, felt, carried, often suppressed—but likely not yet been *storied* is empowering for many. A commenter browsing through the website writes:

> I'm laying awake in bed right now at 5:22am feeling anxious and alone and reading through some the stories here gives me some solace. I know you know the power in your project—this gift you've given people wo are often scared and afraid to talk to anyone the ability to speak and openly spill their hearts and minds. It's beautiful and need this, we've always needed this. Thank you for giving us this space to finally stop holding it all in and exhale a little bit. (heart)[10]

How the invitation to express and a space that holds these expressions responds directly to a 'need', which may not have been obvious to the visitors themselves, is echoed frequently in comments. Someone notes that 'I came all the way here just to get this off my chest'[11] while others discover after some hesitation that there is a life fragment awaiting attention. The transformational potential of (hand)writing, re-appropriated from the instrumentality of everyday transactions, shows its connective and healing potential in various ways:

> I am so proud of me, as I sit here writing, releasing the pain, pain that made me strong that you wouldn't believe. I wear a smile every day but the pain is there! Being undocumented is hard but I can't be sad! I am happy I have a better life now. But what a difference a paper makes, your residency, your identity![12]

Writing a story becomes part of life struggles and negotiations, as a re-affirmation of strength to self and in the eyes of the unknown other, who—even if only imagined—is called upon to bear witness as the storyteller works through grief, loss, addiction, illness, separation, and other demanding situations. The space of storytelling emerges as both private and public, reflected also in remarks that frame the need to be recognized in a non-objectifying manner as a social demand: 'Every city needs a place like this, a place for people to be heard.'[13] Witnessing, on the witness's part, transforms loneliness and lessens isolation, removing stigma and shame from going through rough patches. An

abundance of notes affirms this sentiment: 'This really showed me that I am not the only one that is not okay. Everyone is struggling. So, thank you. THIS HAS SAVED ME.'[14] Another story shares a feeling of belonging through the exposure of struggles and the relationality of being that transpires from the collective display of life fragments: 'It feels like community even though everyone's a stranger. A beautiful reminder that none of our struggles are isolated. It is so raw and authentic.'[15] The feeling of love upon entering and inhabiting the space, and as a result of a transformation from less hopeful places is another recurring theme. 'I walked in here with a pain in my heart but now I am leaving with love after reading all these amazing stories.'[16]

The archive abounds with expressions of positive emotions, some of which are meant specifically for the unknown other as the anticipated reader. Strangers often address fellow strangers directly, offering affirmations, even guidance or advice when it comes to the complexity of life issues. Someone identifying as 'birthday girl' writes that

> I'm important and if you are struggling just know that you're important too not because someone says so but because you are alive and you have a story—big or small—you matter. So live life with a smile on your face, regardless of the pain. And it it's your birthday too, happy birthday![17]

Another note serves as a reminder of forgotten yet accessible dimensions where connection and the ease that it comes with is present by default:

> Dear Stranger,
> You are nice. Please do not forget: that one time, 'long time ago, we were all babies on the playground of life. (In fact, we still are!)
> Have fun, your friend,
> Other Stranger[18]

Yuriko Saito observes that the gateway to unlocking 'the aesthetic texture of ordinariness'—other, uncommon planes of sensing and making sense—is to 'pay attention to what we are experiencing rather than acting on autopilot' (2017, 3). Attentiveness takes us deeper into the sensuous quality of how we are immersed in what surrounds us from moment to moment. Beyond what may appear as trivial and mundane, by using our attention differently, we may touch into what she describes as the 'considerable power everyday aesthetics wields on humanity's ongoing project of world-making' (2017, 4). This requires overcoming our 'normal attitude', letting go of preconceived ideas as a gesture of defamiliarization and developing receptivity and open-mindedness towards whatever or whoever we may be engaging with (2017, 17–18). In *The Strangers Project* strangers do not change: our relationship to the unknown other and the unknown in ourselves does. As a familiar sense of the fearful 'strange' turns into an experience of strange(r)ness that connects rather than separates, worlds are re-made. Brandon links attention, connection, and care in the following way:

When I initially started this project, I wanted to create a physical and mobile space to give people the opportunity to be curious about their lives and the lives of others. What I've discovered is that the world needn't be so full of strangers. This project isn't just about reading and writing stories. It's about the connection that forms between storyteller and listener—and really, this connection is something we can explore every day in our own lives. It's about taking a moment of our day in which we give our time and undivided attention to one another. It's about acknowledging the people we share the world with and asking one simple question: 'What's your story?'

(Doman, 2015, 8)

'The Second Story'

The imbrications of life and story extend beyond what may be told. Benjamin notes that the story 'does not aim to convey the pure essence of the thing, like information or a report.' Rather, 'it sinks the thing into the life of the storyteller, in order to bring it out of him again' (2006, 367). Stories with the potential of counsel weave through lives, carrying their marks forward. He observes that 'the traces of the storyteller cling to the story the way the handprints of the potter cling to the clay vessel' (2006, 367).

During the interview Brandon draws my attention to something that had completely escaped me until then. As we browsed through hundreds of handwritten stories carefully arranged in multiple folders, he started to reflect on the aspect of handwriting. 'We have fewer and fewer opportunities to write something up by hand,' he says, and this is echoed by those who visit his project, too, remarking that what they would normally write is 'their name and numbers.' Yet 'sitting down, putting pen to paper allows people to slow down and reflect as they write.' In this unmediated space Brandon observed long stretches of thinking before someone would make a start and begin to populate the blank sheet of paper with words and other signs. Often there is a pause—time taken out of the mechanical scripting and instrumentality of everyday life—before a story starts to emerge. 'I also like how live the process is'—he adds. 'There is no real going back deleting and changing it like on a computer. People cross things out but that is great'—sometimes whole lines, or they rip part of the paper off, put arrows to indicate where and what to read, or flip the paper and start over on the other side. All these micro-moves are significant in multiple senses as life fragments are shared and received by strangers. What happens on and *to* the page makes visible what would otherwise not be accessible to the physical eyes. Brandon says, 'you can see the progression of their thoughts as they share their story.' And strangers seem to be OK with letting others into the complexity of their inner sense-making process in this way: less than 10 per cent ask for a new, blank page to start again.

In fact, 'a whole different story is created by the subtext of how someone writes.' There is a 'second story' emerging from the 'drawings, rip-offs, cross-outs.' What we come to see are 'portraits in texts,' as if 'taking a picture of somebody with what [and how] they

choose to share in writing instead of a camera.' While there is 'a lot of personality' that shows in the handwriting—oftentimes further enhanced by actual portraits drawn on the page or by arranging the text into an image of a face—the singularity and uniqueness of the person also comes through how they use the space. 'People tend to fill up whatever space I give to them,' remarks Brandon, the page itself functions as a 'container.' Stories that describe surface-level phenomena—such as 'I'm here, visiting New York, it's a really nice day'—frequently expose another level of experience that unfolds from how the page is filled with drawings, signs, other marks. The page as a container also holds the writer and their life. Brandon remembers the story of a young woman who first started to write about finishing college. She then crossed it all out and continued instead with a sexual assault that happened to her, realizing in the process of writing that it was something else that she needed to share.

The 'untold stories' that unfold through the very act of telling carry special significance. As Brandon says 'the writing of the story is part of the story, of a life story. It is a great part of the story to see the handwriting and how someone chooses to write the story.' And whatever people choose to do on, to, or around the page: 'the whole process is part of their story.' This applies also to truth-content of what is written down. The first principle of the project stipulates that 'people can write about anything they want as long as it's true.' 'Is it always the case, though?'—I ask Brandon. He responds that only a small fraction of stories would read completely absurd or fictional. In any case, however someone may choose to negotiate the space of telling in giving their account, he emphasizes that there is still 'a participation' involved that writes their life story.

In the earlier years of the project volunteers used to attach tags to the transcribed stories on the website, marking what each story talked *about* so that the archive would be easier to search and navigate. I immediately recognized the incredible diversity that appeared through these curated bits of content, represented by a growing cloud of tags. With hindsight, there were no tags, however, for the *untold* stories that come with each story *told*. The movements that not only contributed to but also often reoriented the 'meaning' of stories resisted both noticing and categorization. Cross-outs—perhaps as 'change of mind while writing'—or infinite floral patterns framing the words written had not been identified and offered as points of connection for fellow strangers, reading. This comes as little surprise in the light of our familiar educational trajectories. We learn to read by extraction: by locating information and distilling meaning down as we make judgements about what may (and may not) carry importance in the text (see Klinkenborg, 2012, 18). Yet beyond what the story says through the vehicle of words and in the plane of language, the 'second story' turns our attention to what the story *expresses* of the person writing. The portrait of the person emerges as something that resists text-based interpretation, as an image in the text that shifts our focus away from the meaning of words while we remain connected to it. Zooming out of the location of the written word and the mind-set of reading that may only recognize this narrow corridor of signs, the portrait, in fact, encompasses both stories. I tease Brandon about what he finds more powerfull: seeing the thought process on the page or reading the life story? He

wouldn't take his pick—the uniqueness of each submission—and we might add, that of the person—arises from the unity of both.

The anonymity of the practice helps to make the 'second story' more apparent. Brandon tells me, however, how interesting he found it that almost half of the participants start writing by identifying themselves in one way or another still, most often, by their age, or gender, or being a parent. Some are inclined to sign their full name, which Brandon discourages. 'The first name is part of the story, that's OK' but there is a preference for not knowing the name of the person at all. The name is 'too much of an identity:' it is too revealing while the aim is to 'level the playing field of all these stories.' In anonymity there is also a sense of equality. As Brandon explains, 'the experience I am trying to help create for other people is them creating their own character in their head when they read the story.' Without the name it is more ambiguous what and whose life world yields the story. There is more space for imagination in this way and importantly, for imagination to *fail* at the same time. People who stay around chatting often try to guess the identity of the writer of those stories that they resonated with. 'How accurate are the guesses?'—I wonder. Most of the time, as I find out, 'they guess wrongly.' I smile and nod, wondering about whether Brandon actually tells people that. 'Strangers are supposed to remain strange?'—I follow up. 'Yes, a little bit, and connected at the same time. I'm trying to create that juxtaposition that there is someone you don't know but you can connect with.' The emphasis is on the connection and the kind of connection that an *attempt to imagine* may enable, both beyond familiar frames, in what imagination—let alone interpretation—can never fully capture, yet still within familiar frames, the points of reference that we live by. Brandon writes in the foreword to *What's your story?* that 'these are the stories of the strangers we pass every day – people we don't know—and yet their hopes, dreams, and fears are as real as yours and mine' (Doman, 2015, 7). In the next line he invites readers to participate in a micro-experiment that brings the possibility of sharing 'in the real' even closer by activating our ability to imagine and make connections beyond the readily apparent as well as our normalized modes of sense perception:

> Close your eyes: These strangers could be your friends, your family, or your colleagues.
>
> (Doman, 2015, 7)

Shelley Sacks and Wolfgang Zumdick describe the space of imagination as a 'workspace' that is 'a permanent rent-free space available to all' (2013, 8). Yet imagination and its generative force participates in the co-construction of reality in multiple ways. They emphasize that 'we can enter the real world with imagination, or create an unreal world. Both depend on our ability to create inner images' (2013, 66). The work of imagination may contribute to deepening lines of separation as much as it can serve as a resource in transforming them and conjuring up new horizons of more connected, less estranged modes of being, both within ourselves and with others. How imagination is used can equally block or expand our ability to sense and make sense, depending on the

intention and our degrees of awareness in how and what we may imagine—what images we create and are created within us—in any given moment. Sacks and Zumdick engage possibilities for deep understanding and open, respectful, non-judgemental receptivity of what presents itself both as inner and outer phenomena. The '*art of imagination*'— when imagination is not an act of escape or closure—opens a space of encounter. It can be a way of 'staying close' to the complexity of life worlds and lived experience without trying to change or manipulate them. This calls for a specific mode of relation: 'it means I must also become conscious of what I bring to the perception, of what I want or do not want to see' (2013, 66).

Entering the physical archive of *The Strangers Project* we encounter the 'portraits in text' as the 'second stories' that co-exist with what is told without the need for telling. The pictorial aspect of writing constitutes a parallel register that may become accessible if we direct our awareness to the not immediately recognizable. Reading beyond what the lines say we can engage with the lines as traces in themselves, as parts of the 'design' of the practice of storytelling and the lives that embed and give rise to them. In this way, in Cavarero's terms, 'that unrepeatable design that each life traces with its course' becomes an actual, visible design, yet at the same time, without the unitary figure of the stork (2000, 140). The trace remains a trace, that of an anonymous person: a fragment which, at the same time, is expressive of the *who*, of the person-as-such (see Edkins, 2011). It is in the eyes of the reader as observer that the person—beyond their words and the visible marks left by them—may come alive, transgressing the normalized aesthetics of the ordinary that seeks to fix and control what is perceived. With a heightened sense of attentiveness, we may be able to observe the work of imagination for what it is: as a practice of image-ing that does not have to essentialize the image conjured, neither of the other, nor that of the self. Staying on the threshold, in a state of *attempting* to imagine without wanting to fill out the details or attach to the truth of any possible form, a zone of ethical possibility opens where the irreducible singularity of both self and other may be encountered. Mapping the realm of the imaginable and relatable while acknowledging the infinite terrain that falls outside it, we might tap into our own narratability and that of others as a shared property of our already connected being, feeling into what neither images, nor words can capture.

Learning to read 'the second story' might serve as another kind of counsel, one that connects us with what may be singular about our lives beyond language and imagination. The wisdom of the inexhaustible narratability of ourselves and others may help us think of and relate to stories—both life stories and social narrations of selfhood and community—as gateways into a register of sensing and being-with that is not confined either to sense perception or the habitual operations of intellectual sense-making. The multiplicity of stories with a 'second story' may act as signposts towards the place where imagination fails on its familiar terms and touches into the unknown, the astounding richness of what does not yet have a name or recognizable form, the 'strange' in others and ourselves. Cavarero stresses that 'the design' of a life '*is* the story' (2000, 2), which, however, is never just one story, as life fragments are witnessed and narrated by series of observers throughout a lifetime. Whether or not we may be able to physically see 'the second story' made up of the often-unconscious traces of the 'unique existent'

(Cavarero, 2000, 21), we can teach ourselves to imagine its presence, remembering that the irreducible uniqueness of the other (and self) only comes alive in *relation*, in a state of connectedness facilitated by a gaze that is able to perceive it and acknowledge it.

In the Place of a Conclusion: 'Everyone Has a Story'

Benjamin notes that explicitly or implicitly, 'every real story' contains 'something useful' and it is this potential for counsel that endows stories with a compactness that makes them travel beyond their first telling (2006, 364, 367). We might wonder, however, if the life fragments expressed through the textual and pictorial dimensions of handwriting, which often illuminate fleeting moments of personal experience rather than account for a journey through the conventional elements and narrative arc of the story-form, may be called stories at all? For the participants of *The Strangers Project*, what they write, read, and share in certainly *are* stories. Brandon's life-affirming statement—'everyone has a story'—connects us with the power of story as an intimate relationship of inquiry into the yet-unexplored terrains of personal and communal being. This relationship of curiosity is possible to cultivate for everyone, within themselves and towards everyone, be that the unknown 'stranger' or someone more familiar. There is an infinite pool of stories residing in each of us and none of them is ever the full story.

Yet in times when neither access to lived experience nor its communicability are straightforward, for stories to take on a transformational potential in how we relate to ourselves and others, first their stakes and potential must be revealed. Thinking with Benjamin, we not only need to be able to tell the story to receive counsel, but first we have to recognize the value of articulation and its reception as vehicles that may enable more connected, more wholesome modes of living. Brandon's announcement did exactly that: it authorized and unlocked stories that are 'true', and because of that, meaningful. After all, as Benjamin notes, the storyteller's 'gift' is the ability to 'relate his life' (Doman, 2006, 378) in and through telling a story. 'Everyone has a story' is already a story that shows its power in the extraordinary volume of responses that has taken up and taken further its energy. Restoring access to lived experience through the invitation to share and the corresponding set of practices cultivated in the physical and online spaces of storytelling may well be the kind of counsel that we need the most.

This is how far the threads that I have pulled from a complex and thoughtfully crafted project have taken me. I embrace 'the gift' of relating—both as ability and ethical possibility—and the wisdom of the condition of being always already in relation as a different aesthetic sensibility to everyday life. In the place where these sentences come to a rest, I also find my counsel in the intensities generated by this reading that will gradually release their wisdom in words and realizations on other occasions, in their own time. With all that, and presumably more, I have been enriched.

'What's *your* story?'

Notes

1. Interview with Brandon Doman, 9 April 2013, New York. Unless otherwise indicated, quotes attributed to Brandon have been extracted from the transcript of this conversation.
2. Please visit www.strangersproject.com/ [last accessed 6 October 2024] to explore and experience the project online.
3. www.strangersproject.com. Story published on 26 November 2022.
4. www.strangersproject.com. Story published on 26 July 2022.
5. http://strangersproject.com/about/faq/ [last accessed 6 October 2024].
6. https://www.facebook.com/strangersproject Facebook feed, 5 February 2023.
7. https://www.facebook.com/strangersproject Facebook feed, 5 February 2023.
8. https://www.facebook.com/strangersproject Facebook feed, 2 April 2023.
9. https://www.facebook.com/strangersproject Facebook feed, 25 March 2023.
10. https://www.facebook.com/strangersproject Facebook feed, 27 January 2023.
11. https://www.facebook.com/strangersproject Facebook feed, 15 December 2022.
12. https://www.facebook.com/strangersproject Facebook feed, 4 February 2023.
13. https://www.facebook.com/strangersproject Facebook feed, 23 March 2023.
14. https://www.facebook.com/strangersproject Facebook feed, 5 February 2023.
15. https://www.facebook.com/strangersproject Facebook feed, 5 February 2023.
16. https://www.facebook.com/strangersproject Facebook feed, 12 February 2023.
17. https://www.facebook.com/strangersproject Facebook feed, 28 January 2023.
18. https://www.facebook.com/strangersproject Facebook feed, 3 February 2023.

References

Arendt, H. (1957). *The human condition*. University of Chicago Press.
Benjamin, W. (2006). The storyteller. In D. J. Hale (Ed.), *The novel: An anthology of criticism and theory 1900–2000* (pp. 361–378). Blackwell.
Béres, L., & Duvall, J. (2011). *Innovations in narrative therapy: Connecting practice, training, and research*. W. W. Norton & Company.
Bernini, M. (2018). Affording innerscapes: Dreams, introspective imagery and the narrative exploration of personal geographies. *Frontiers of Narrative Studies 4* (2), 291–311. https://doi.org/10.1515/fns-2018-0024
Böhme, G. (1993). Atmosphere as the fundamental concept of a new aesthetics. *Thesis Eleven 36* (1), 113–126.
Cavarero, A. (2000). *Relating narratives: Storytelling and selfhood*. Routledge.
Deuze, M. (2011). Media life. *Media, Culture & Society 33* (1), 137–148.
Doman, B. (2011). *Hearts minds & flesh*. Self-published by Brandon Doman.
Doman, B. (2013). Interview with Brandon Doman, 9 April 2013, New York.
Doman, B. (2015). *What's your story?* Harper Design.
Eaton, P., Mitchel, R., & Munro Hendry, P. (2018). *Troubling method: Narrative research as being*. Peter Lang.
Edkins, J. (2011). *Missing: Persons and politics*. Cornell University Press.
Klinkenborg, V. (2012). *Several short sentences about writing*. Vintage.
Kosofsky Sedgwick, E. (2002). *Touching feeling: Affect, pedagogy, performativity*. Duke University Press.

Kottmann, P. A. (2000). Translator's introduction. In A. Cavarero (Ed.), *Relating narratives: Storytelling and selfhood* (pp. vii–xxxi). Routledge.

Lewis, P. J. (2011). Storytelling as research/research as storytelling. *Qualitative Inquiry 17* (6), 505–510. https://doi.org/10.1177/1077800411409883

Naranch, L. E. (2019). The narratable self: Adriana Cavarero with Sojourner Truth. *Hypatia 34* (3), 424–440.

Rogers, M., & Béres, L. (2017). How two practitioners conceptualise spiritually competent practice. In J. Wattis, S. Curran, & M. Rogers (Eds.), *Spiritually competent practice in health care*. CRC Press.

Sacks, S., & Zumdick, W. (2013). *Atlas of the poetic continent: Pathways in ecological citizenship*. Temple Lodge Publishing.

Saito, Y. (2017). *Aesthetics of the familiar: Everyday life and world-making*. Oxford University Press.

Salim, U. (2022). Decolonial dialogues: COVID-19 and migrant women's remembrance as resistance. *Globalizations 20* (2), 332–342. https://doi.org/10.1080/14747731.2022.2080391

Selbin, E. (2010). *Revolution, rebellion, and resistance: The power of story*. Zed Books.

Smith, C. (2019). Disciplines of attention in a secular age. *Critical Inquiry 45* (4), 884–909.

Tamboukou, M. (2008). Re-imagining the narratable subject. *Qualitative Research 8* (3), 283–292.

White, R. (2017). Walter Benjamin: 'The storyteller' and the possibility of wisdom. *Journal of Aesthetic Education 51* (1), 1–14.

CHAPTER 29

'FILM IS PSYCHOSIS'

Filmmakers with Lived Experience

SAL ANDERSON AND DOLLY SEN

INTRODUCTION

COLLABORATIONS by co-authors Anderson and Sen include mental health advocacy, academic writing, and film projects. The films *Outside* and *Inside,* discussed in this chapter, were written and directed by Sen and produced by Anderson.

Sen's provocation, 'film is psychosis' (Sen, 2022b), lies at the heart of this examination of the conjunction of concepts of reality, delusion, and narrative construction. The focus, through the lens of the filmmaking process as aesthetic and autobiographical practice, is the representation of psychosis by filmmakers with lived experience of the condition.

The assumption that psychosis lies outside the norm of everyday human experience would suggest a discussion that engages with a commensurately wide sphere of disciplines. Film, a medium that could be conceived as existing without physical substance, which emerged around the birth of modern psychiatry and neuroscience, conjures evanescent visions of the real. Phantoms and ghosts are never far when light and electric impulses illuminate the mind's eye in a darkened room for an encounter with the enigmatic protagonist (or antagonist) of both film and psychosis: reality (Hourigan, 2022).

Following an examination of key terms underscoring the medical profession's definition of psychosis, and the role of cognitive and aesthetic engagements of filmmakers with different experiences of reality, this chapter draws parallels between mechanisms within the brain in processing vision and those relating to film language and spectatorship.

Cinema's unique ability to embody illusion and delusion and its complex evocation and representation of reality within a given film world is explored through two in-depth case studies.

The chapter concludes by proposing research into alternative frameworks, and questions whether the subjective vision of filmmakers with lived experience of the condition can offer a radically different approach to, reflection on, and understanding of, psychosis.

Literature

Academic publications featuring film and psychosis focus predominately on two areas of research. Firstly, the portrayal and/or analysis of films that represent or feature psychosis (Byrne, 2009; Wedding, 2014; Heath, 2019). The misrepresentation of mental health conditions in general is well documented within this literature. And the authored or author-approved point of view of individuals with experience of psychosis is rarely presented in academic publications, whose primary intention is an engagement with psychosis as subject, offering analysis *about* the condition presented in film. This also appears to be the case with medical literature regarding academic research into psychosis. Fusar-Poli et al. (2022, 169) state: 'To our best knowledge, there are no recent studies that have successfully adopted a bottom-up approach (i.e., from lived experience to theory), whereby individuals with the lived experience of psychosis (i.e., experts by experience) primarily select the subjective themes and then discuss them with academics to advance broader knowledge.'

Therapeutic use of film in relation to mental health is the other predominant area of research. Cinema therapy, with film as facilitator (Poltrum, 2016), is further addressed by Poltrum elsewhere in this publication. Where research specifically addresses the experience of filmmakers with mental ill-health, these studies also tend to focus on therapeutic aspects of the medium (Parr, 2007); the benefits of the arts on mental well-being in general are increasingly acknowledged (Fancourt & Finn, 2019). Finally, references to films used as educational tools in the training of psychiatrists also exist in academic journals (Bhugra, 2003; Bhugra & De Silva, 2007). Although there is an increasing commitment by organizations such as the Wellcome Trust (wellcome.org) and Hearing the Voice (hearingthevoice.org) to collaborate with 'experts by experience', academic film literature representing the points of view of those with experience of psychosis is largely absent.

A wide range of alternative sources engaging with, or representing, those with lived experience does exist, however systematic research has not yet been undertaken. Such sources include online platforms, forums, and other forms of communication such as conferences; charities such as MIND (see mind.org.uk); advocacy and grass roots organizations; websites; blogs; groups such as Hearing

the Voice; websites such as Time to Change (see time-to-change.org.uk); and non-academic publications.

Articles in newspapers and magazines featuring interviews where filmmakers reveal or discuss personal experience of mental health conditions rarely present a systematic discussion of the experience, its connection with the filmmaking process, a given film, or oeuvre. Such connections have been explored with other conditions, for example, bipolar affective disorder (Coleman, 2014). Publications on mental health conditions underscore ethical issues, for example: failure to seek approval for publication by featured individuals with a given condition; lack of inclusion of filmmakers with lived experience as authors; cited filmmakers being 'othered' or 'outed' by inclusion; and sensationalization of the filmmaker or subject matter.

As noted, films, in particular mass-entertainment fiction films in the West, frequently misrepresent medical conditions and mental health issues in particular; the experience is not conducive to a 'Hollywood' ethos. MIND and other mental health organizations respond to damaging misrepresentation with recommended film lists (see MIND, Time to Change). The history of documentary filmmaking is underpinned by a preoccupation with contentious concepts of truth and pedagogical imperatives, reflecting or championing issues, or individuals, or highlighting injustices. Frederick Wiseman's radical 1967 film *Titicut Follies*, set in a hospital for the criminally insane, represents a turning point, brutally exposing the inhumanity of the institution. 'The asylum', although not central to this discussion, will be revisited in the first case study, René Féret's 1975 autobiographical drama *Histoire de Paul*, a cause célèbre hailed by Michel Foucault, which likewise opened the asylum to scrutiny.

Byrne (2009) states, in relation to the representation of those with mental health conditions in commercial films: 'Worse than in documentaries, people with mental illness in fiction films are either victims in melodrama … or objects of comedy' (p. 296). … 'Patients are passive foils: even as investigators, they go along with stronger characters in the narrative' (p. 295). Byrne goes on to say: 'Either filmmakers became bored with psychosis without homicide or they needed conflict, in its extreme forms, to heighten drama' (p. 293). Misleading renderings of mental health conditions in film are not only injurious to those living with mental ill-health; issues of stigma and distress are also exacerbated for relatives and friends (one in four adults experience mental illness according to NHS England).

The question of whether films written and directed by filmmakers with lived experience of mental ill-health can contribute to addressing misrepresentation, ignorance, and stigma, and raise awareness of mental ill-health, underlies this discussion. It should be noted that the nature of filmmaking itself, due to economic and emotional pressures, excludes many from the film industry (van Raalta, 2021; Block, 2021); ill-health contributes to such stresses. Unless this is acknowledged and addressed, autobiographically authentic representations of mental health conditions will remain a rarity. In summary, there is a lack of representation in academic literature of, or by, those with experience of psychosis; their voices are largely excluded. Without explicit collaboration

and consultation, or shared authorship, those with lived experience are more likely to be objectified, and their authentic voices unheard.

Psychosis

> Schizophrenia spectrum and other psychotic disorders ... are defined by abnormalities in one or more of the following five domains: delusions, hallucinations, disorganized thinking (speech), grossly disorganized or abnormal motor behavior (including catatonia), and negative symptoms.
>
> (DSM-5, 2013, 87)

Reality, as a psychosocial concept, with its multiplicity of meanings and alternative states, is the life blood of commercial filmmakers, with parallel universes, wormholes, and multiverse protagonists slipping from one space-time world to another, even from one fictive or film franchise to the next—with scant regard for contemporary physics (Rovelli, 2019). Where the multiplicity of concepts of reality in cinema appear infinite, manifestations of experienced reality are frequently relegated within the medical literature to categories such as delusions, fantasies, and figments of the imagination.

According to Anderson (2017), subjective experience appears to be marginalized within the medical profession. More than 95 per cent of papers delivered at the 2009 and 2010 European Congresses of Psychiatry presented scientific methods and approaches: neuroimaging, statistical and pharmaceutical analysis, whereas less than 5 per cent of papers addressed topics that included medical humanities, the arts, and patients' subjective experience. Constraints intra and inter subject disciplines are nevertheless challenged within the medical community. Cermolacce et al. (2018, 1) state: 'Delusion is usually considered in DSM-5 as a false belief based on incorrect inference about external reality ... but the issue of delusion raises crucial concerns, especially that of a possible (or absent) continuity between delusional and normal experiences, and the understanding of delusional experience.' Varga (2015, 299) writes: 'In most western countries, the publication of the influential DSM-5 has initiated new debates about conceptual philosophical problems in psychiatry, and about psychiatry's status as a medico-scientific discipline ...'. Goulart (2019) quotes Basaglia who stands at the turning point in the history of psychiatric treatment: 'the rejection of the inhuman condition to which the mentally ill are relegated, the rejection of the degree of objectification to which [the mentally ill] are abandoned, appears to be forcefully and very closely linked to the questioning of the psychiatrist, of the science on which he is based and of the society he represents' (p. 12).

According to DSM-5 (2013) a psychotic patient is out of touch with reality and a delusion is defined as: 'A false belief based on incorrect inference about external reality ...' (p. 819). The use of concepts of reality and delusion as the foundations on which to define psychosis, as markers for diagnosis, is pertinent in an exploration of filmmakers

with experience of psychosis, these concepts underlying, as they do, key tools in the filmmaker's armoury of narrative construction.

Incongruities can be seen to underlie scientific methods based on philosophical concepts. In a study by Rikandi et al. (2017), for example, reality is not defined, but its meaning is nevertheless assumed, in the evaluation of recordings of brain activity during viewings of scenes of the fantasy film *Alice in Wonderland*. The paper states 'Scenes of varying degrees of fantasy were selected based on the distortion of the "sense of reality" in psychosis' (p. 495).

Foucault (2009, 116) generalizes the above concerns: '… madness as a domain of experience could never be exhausted by a medical or paramedical knowledge'. Elsewhere in *History of Madness* Foucault (2009) writes: 'The linearity that led rationalist thought to consider madness as a form of mental illness must be reinterpreted in a vertical dimension. Only then does it become apparent that each of its incarnations is a more complete, but more perilous masking of a tragic experience – an experience that it nonetheless failed to obliterate' (p. 28). Sen (2022a) affirms this from first-person experience in her biography of Lorina Bulwer who was incarcerated in a female lunatic ward in 1893:

> Thinking you are Queen Victoria's child can be seen as a delusion of grandeur, but maybe it can be also seen as an expression of something that is hurting deeply within that person. I have experienced psychosis myself, if that's what Lorina had. … There were also times I had ideas above my station. I did think I was God, but then I stopped believing in myself. Then I thought I was Jesus. What I realised once I was out of those modes of thinking is that I thought I was these famous figures when I felt ignored, neglected, a nobody, a person completely without power.
>
> (p. 28)

Lorina Bulwer's 12- to 14-feet long 'embroidered furies' reveal 'the observable data of an unobservable world' (p. 3). Lorina's raw text-image textiles speak with vision and permanence as no diagnosis could. Their larger-than-life statements strike the observer like precursors of animated films. Pursuing Foucault's (2009) idea of a vertical trajectory, the authors suggest that the filmmaker with lived experience of psychosis may provide privileged access, as interlocuter, to this subterranean 'unobservable world' (Sen, 2022a, 3).

The filmmaking process itself could be seen as constituting a parallel mechanism, or form part of a third-party reality, or hybrid object along the lines of the Cermolacce et al. (2018) proposal: 'We have meant to illustrate in these clinical references how the Multiple Realities Theory (MRT) may be used to approach the reality of delusion, by investigating the issue of [Double Book-Keeping] and the flexibility of delusion' (p. 8).

Roland Barthes (2000) ends *Camera Lucida* thus: 'The choice is mine: to subject [the Photograph's] spectacle to the civilised code of perfect illusions, or to confront in it the awakening of intractable reality' (p. 119). It is the latter choice, the awakening of intractable reality—with all that this might imply in the present context—that underscores this

reflection on the moving image and the representation of psychosis by filmmakers with experience of the condition.

The philosophical questions presented here concern definitions of reality and illusion—concepts which are key to the diagnosing of psychosis. Such questions draw attention to the possible limits and restrictions in imagining or comprehending the experience of psychosis and thus, the authors suggest, of psychosis itself.

Film

'Humankind cannot bear very much reality'. T.S. Eliot's (2001, 4) famous line on the confounding, phenomenological encounter with reality continues to reverberate.

In his life of James Tilly Matthews, Mike Jay (2012) recounts: 'The disjunction between a past where schizophrenia is so elusive and a present where it is so tragically common has led some to conclude that it must be a disorder spawned and spread by modern industrial societies' (p. 32). Reconnecting key elements of the discussion and the products of 'modern industrial societies', Derrida (1998) states:

> Cinema can stage phantomality almost head on ... This must be distinguished from the thoroughly spectral structure of the cinematic image. Every viewer while watching a film, is in communication with some work of the unconscious that, by definition, can be compared with the work of haunting, according to Freud ... Cinematic perception has no equivalent: it is alone in being able to make one understand through experience what a psychoanalytic practice is: hypnosis, fascination, identification, all these terms and procedures are common to film and to psychoanalysis...
>
> (p. 26)

Westfall (2018) writes that Stiegler: 'takes the structure of consciousness itself to be cinematographic. And to see oneself as a self, according to Stiegler, to objectify oneself, is always already montage: self-reflection, self-awareness, self-consciousness—these are cinema' (p. 616). Christian Metz (1990) saw cinema in terms of Freud's dream-work, the unconscious transformation of latent content, connecting real life to hallucinatory spectacle. And, although cinema is not real, the spectator, according to Fuery (2004) reacts as if it is, and thus it can be seen as universal psychosis; film as a paranoid experience because everything in a film is real, everything is symbolic and has meaning.

This statement may share in the melodrama inherent in the majority of representations of psychosis in classical narrative film. Cinematic narrative, in Deleuze's (2005) eyes, is constructed through a process of exclusions: 'The historical fact is that cinema was constituted as such by becoming narrative, by presenting a story, and by rejecting its other possible directions' (p. 24). Psychosis in this context is frequently treated as an extension of an alternative state, using visual signifiers, markers to inform an audience of

the given frame of mind in which a character exists at a particular point in their trajectory. Film language in classical narrative cinema functions in this modality, using conventional codes in establishing a norm in presenting reality, which usually conform to an objective narration as opposed to subjective reality (Bordwell et al., 2019).

Films exploring alternative states manipulate these codes of reality within given constructs in conveying the effect of drugs, alcohol, mental health conditions, et cetera, for example: Darren Aronofsky's *Requiem for a Dream* and *Black Swan*, David Cronenberg's *Spider*, Martin Scorsese's *Mean Streets*, and the Wachowskis' *The Matrix*.

Traditional narrative films about psychosis frequently use a greater range of narrative and *mise-en-scène* devices, more often than not exaggerating or distorting perspectives of consensus reality, as dictated by the film's dramatic needs and fuelled by creative invention (Matthews & Anderson, 2010; Byrne, 2009). The case study films presented will demonstrate, by contrast, the creation of alternative or multiple realities that anchor their representations of reality on experience, that of the autobiographically based protagonist. There is a logic and coherence to the trajectory of the psychosis, whether or not it is understood by the protagonist themselves or by the other characters in the film. 'No matter how bizarre the ideas expressed by patients, it is usually possible to identify events in their lives that have contributed to their content' (Bentall, 2003, 308).

To summarize, analogous connections of consciousness and the unconscious are proposed in relation to the nature of film and the experience of a spectator. However, psychosis as typically configured within the narrative structures of commercial film, is predominantly expressed through exaggeration and distortion; thus, the perception of a protagonist experiencing psychosis is almost invariably reduced to a deformation of consensus reality.

Two case studies, each comprising two autobiographical films, will now be analyzed as framing devices in the discussion of key themes used to illustrate mechanisms of representation of the subjective experience of filmmakers who have lived with psychosis.

Case Study 1: René Féret

Histoire de Paul, 1975

After his incarceration in a psychiatric hospital in Armentières following a suicide attempt, the twenty-one-year-old French actor René Féret felt compelled to make a film about his experience. *Histoire de Paul*, Féret's first film, won the Prix Jean Vigo in 1975, attracted the attention of Michel Foucault (O'Farrell, 2018), and established Féret as an internationally recognized filmmaker. Féret turned to film because it is the language of spectacle; the experience had a 'fabulously spectacular' side to it (Ciment & Jeancolas, 1977, 41).

In an interview, Féret (2012) speaks[1] of profound problems of identity which became apparent at the death of his father. In the psychiatric asylum he describes existing in 'a

state of catastrophic autism'... 'in which I had an absolute, powerful, highly developed, anecdotal and passionate response to "image". I had an inner life of madness. I took from reality, mixed it with dreams, recurring dreams, where I gave my father back his life ...' Within this state of 'catastrophic autism' Féret highlights his heightened mental activity, explaining that this was crucial to his choice of film as medium of expression. He felt compelled by 'a strong desire, a conviction, a need, to make a film' (Féret, 2012).

Féret had absolute faith in cinema's ability to render the truth of his inner state: 'The image ... cinema, never betrays' he says thirty-seven years after making the film (Féret, 2012). He does not analyze his belief in cinema as the medium to express his inner truth, reminiscent of Godard's (1986) statement: 'Truth is [films'] truth', to say: "It is the most beautiful of films" is to say everything. Only film can permit this sort of childish reasoning without pretending shame. Why? Because it is the cinema. And because the cinema is sufficient unto itself' (p. 75).

Both the compulsion to recount his 'catastrophic' experience, and the conviction that film is the quintessential medium of authenticity in portraying Féret's interior world, present underlying themes in this discussion: the necessity to communicate inner experience fortified by the knowledge that the experience is itself *hors du commun*, and that it is not, but needs to be, shared. *Histoire de Paul* is the vehicle for that impulse to give voice to the experience. 'Let's say that cinema needed to be invented to fulfill a certain desire for relation to ghosts. The dream preceded the invention' (Derrida, 1998, 29). For Féret the ghosts were indeed real: in the asylum he conflates reality and dreams and 'gives life back' to his recently deceased father.

It was essential for Féret (2012) 'to give an account of what was within' him, using images. Yet the filmmaker does not show, in a literal sense, what is going on inside his head in *Histoire de Paul*. The film presents the world of the asylum, not the inner world of the protagonist. We know nothing of why Féret's alter ego, Paul, is incarcerated in a psychiatric hospital. The film situates us in the asylum, it offers up the point of view of Paul focusing exclusively on what lies within the hospital walls: other patients, interns, and medical staff. An intern at the time of Féret's incarceration in the asylum says of the film that it was 'the absolute truth' (*Histoire de Paul* special feature). We see Paul's catatonic muteness, but Féret chooses not to visualize his inner 'spectres' and turmoil. He makes a sole exception with a shot of borderless flowing water used at key points in the film. 'This water ... ' according to Foucault 'is both a mark of [Paul's] subjectivity and a reflection of the film's perspective' (O'Farrell, 2018, 149).

In a 1976 interview with Féret, Foucault refers to: 'The great beauty of your film, where each gesture is stripped down to its maximum intensity ... ' (O'Farrell, 2018, 150), highlighting the role of essentializing what is visually presented. The 'stripping down' enhances the potential for projection by the spectator: '[T]he installation of the viewer as subject depends on reserving for him or her, the reciprocal in front of the image of the vanishing point "behind" it ... the spectator completes that image as its subject ...' (Carrol, 1988, 128).

It is this vacating of space for the spectator that Derrida (1998, 27) articulates in terms of cinema's 'spectral dimension' which: 'is that of neither the living nor the dead, of

neither hallucination nor perception, the modality of believing that relates to it must be analysed in an absolutely original manner.' It is precisely in this light that Foucault (O'Farrell, 2018) offers his elucidation of the haunting that Féret's film inheres in the spectator, through the reduction of visual elements. Derrida (1998, 27) goes on to say:

> This particular phenomenology was not possible before the movie camera because its experience of believing is linked to a particular technique, that of cinema. It is historical through and through, with that supplementary aura, that particular memory that lets us project ourselves into films of the past. That is why the experience of seeing a film is so rich. It lets one see new specters appear while remembering (and then projecting them in turn onto the screen) the ghosts haunting films *already* seen.

Although there is no 'backstory' of Féret's alter ego, Paul, in the film—we do not know the cause of his suicide attempt or of his father's recent death—there is, beyond the supplementary of the apparatus and those inhabiting the mind of the spectator, Paul's response to the world about him 'as if he sees a ghost': ghosts of the screen, past screenings, and the protagonist's past. A language of experience of a mind in extremis has of necessity to surmount the everyday of common parlance.

Foucault begins the interview with Féret: 'When I saw your film, I rubbed my eyes. I rubbed my eyes because I recognised the professional actors, yet what I saw in the film, I have to say, was not *like* the asylum, it *was* the asylum' (O'Farrell, 2018, 145). 'Right from the outset,' Féret responds 'we wanted to construct a film from the point of view of a group of mad people ... During the fortnight of rehearsals they were placed in the settings, costumes, and accessories specific to an asylum ... The actors experienced the actual conditions of an asylum' (O'Farrell, 2018).
To which Foucault replies:

> You took the actors, put them into a space, into a system of coexistence, gave them asylum clothes, and let them follow their own inclination. If you took mentally ill people, dressed them, divided them up, and let them follow their own inclination in the way you have done, you'd end up with the same thing. The space of the asylum, its walls, its system of coexistence and hierarchy, produce a specific effect, and you can set these things in motion, you can make them appear in the same way in someone who is ill, in someone who is in a state of terrible anxiety, or in somebody who is just doing his job as an actor for a living. So this is an amazing experiment with the strength and plastic effects of the asylum's power. The way these characters behave, in such typical and stereotypical ways, is not, strictly speaking, indicative of symptoms or illness.
>
> (O'Farrell, 2018)

Foucault's argument regarding the creation of hierarchies by means of fabricated superstructures and enrobing 'architectures', and the inducing of 'asylum states' that, in Féret's 'experiment', enabled the actors to evolve simulacra of hospital patients and configured power structures, can also be seen to exist within the domain and

paraphernalia of filmmaking itself. The influence on behaviours, induced through the act of documentary or reality filmmaking, is evident in participants, performers, dramatizations, and audience response. *Histoire de Paul* recreates for the viewer the structural mechanisms for the experience of the asylum: 'This idea of the madness of the spectator…' (Fuery, 2004, xii).

Barthes (2000, 3), who claimed he 'failed' to separate Photography from Cinema, liked to call the person or thing photographed 'the *Spectrum* of the Photograph, because this word retains, through its root, a relation to "spectacle" and adds to it that rather terrible thing which is there in every photograph: the return of the dead' (p. 9). The spectre of Féret's dead father haunts his protagonist, Paul, whose gaze appears to suck in everything in sight, as if feeding on all that his eyes encounter. Drawing attention to the patient's relationship to consumption, Foucault states: '… everything in the asylum, when it comes down to it, revolves around absorption. Food and drugs must be absorbed; the good patient is the one who eats' (O'Farrell, 2018, 149).

Paul's eyes fixate as if filling a void, inner substance having lost cohesion; a vacuum in which the spectator sees themselves, visions in a mirror that offers up a recognizable self, with the precision of identifiable reality. The heightened register of the film's images underscores this feeling of authenticity, 'where each gesture is stripped down to its maximum intensity.' … 'I would say this is a highly constructive experiment,' Foucault tells Féret: 'An experiment like this with the actual effects of that fiction that is asylum has never been undertaken before' (O'Farrell, 2018, 148).

Fundamental to the protagonist's mind in this first case study, are issues of identity which lie at the heart of the crisis that led to his suicide attempt. '… at moments of significant shift or rupture, we may not know precisely who we are or what is meant by "I" when we say it' (Butler, 2015, 9). The film demonstrates an inextricable connection between uncertain or precarious identity and the protagonist's relationship with reality. And in Féret's powerful use of film language in creating the world of the asylum, he conjures a domain or repository in which the viewer inserts themselves, as if they too reside behind the protagonist's eyes.

La Place d'un Autre, 1993

Despite Féret's (2012) intention to show his inner life, in the interview he states that *Histoire de Paul* 'is not my story'. Nearly twenty years after his incarceration, Féret makes a second autobiographical film, *La Place d'un Autre* (1993), which provides both the circumstances that led to his suicide attempt and dramatizations of his subjective experience in the asylum. *La Place d'un Autre* reveals two other deaths besides that of his father which contributed to Féret's state of mind. A young man is killed in a car accident while Féret is at the wheel. And we learn that Féret 'took the place' of a brother who died before he was born, raising again questions regarding issues of identity.

Unlike *Histoire de Paul*, in *La Place d'un Autre* Féret visualizes the protagonist's inner life, his dream-hallucinations; we see him dig up his father from the grave. Yet it is the first film, *Histoire de Paul*, that evokes more forcefully the trauma of the filmmaker's interior world. *La Place d'un Autre*'s explicit intention to provide contextual background to events that precipitated Féret's breakdown results in a cinematic aesthetic and *mise-en-scène* adhering to a greater extent to conventional tropes, orientating the film to a closer alignment with consensus reality. This in turn creates a less radical encounter with the protagonist's subjective experience, disavowing the powerful suturing of spectator to 'inner life' in *Histoire de Paul*. 'It seemed to us that cinema, precisely through its automatic or psychomechanical qualities, was the system of pre-linguistic images and signs, and that it took utterances up again in the images and signs proper to this system…' (Deleuze, 2005, 252). Féret's mute protagonist in *Histoire de Paul*, denuded of exposition and literal depictions, conjures lived experience with greater eloquence than a version replete with external facts and internal representation.

'We recognise here the very specific genre of *description* which …' Deleuze (2005, 67) writes, 'instead of being concerned with a supposedly distinct object constantly both absorbs and creates its own object. Ever vaster circuits will be able to develop, corresponding to deeper and deeper layers of reality and higher and higher levels of memory or thought.' Representations in *La Place d'un Autre* of the protagonist's mind's eye, the exhumation of the father's body—inner experience acted out—loses the numinous quality evoked in non-depiction, summoned up in the super-reality of the protagonist's manner of seeing. The multiple layers invested in and generated by new spectres fall away in the second film, leaving reality devoid of its haunting essence. 'You go to the movies to be analysed, by letting all the ghosts appear and speak. You can, in an economical way… let the specters haunt you on the screen' (Derrida, 1998, 27).

The protagonist's 'state of witnessing' in the first film exists as if he is both the incarcerated, and the carapace, the asylum itself; the strangeness of the seen and heard appears to be siphoned into him, as if he sees and hears for the first time. Like life stripped away, raw perception rawly felt. Essence outperforming 'fact-ness' of this outside-interior asylum world, of elemental life laid bare before Paul's eyes. The intensity of portrayal reflects the unvarnished vision of someone who has lost the veneer that makes reality bearable. The inner experience of the protagonist is palpable, affording substance greater than the construct of the asylum. Laying claim to the spectator's inner world, the film upends consensus reality, substituting psychosis. Féret's original desire to show the patient's point of view hinges on conferring greater validity to the psychotic experience, more authenticity to it, than to the banal configuration of outer objects, architecture, and societal norms. The filmmaker changes the rules of reality: 'I wanted to place Paul's subjective experience at the center of this "objective" experiment, allowing viewers to enter into the asylum themselves' (O'Farrell, 2018, 148). The alignment of viewer and protagonist allows the audience to experience psychosis as reality, thus suggesting 'film as psychosis'.

Case Study 2: Dolly Sen

Sen's films *Outside* (2013) and *Inside* (2021) demonstrate complementary approaches to the representation of subjective experience in extremis. As recorded in Sen's memoir, *The World is Full of Laughter* (Sen, 2006), an abusive childhood and the early onset of psychosis thwarted her youthful desire to become a doctor. A trained filmmaker, Sen works with multiple art forms. Her creativity centres on advocacy for those with mental ill-health and an engagement with the ambiguity and insubstantiality of reality. 'Reality' says Sen, 'is a bastard' (Sen, 2022b).

Outside, 2013

Terrifying hallucinations are triggered when protagonist Donna takes her doctor's advice and goes 'outside' in *Outside*, the first of Sen's autobiographical trilogy (the third film is in development). A leaflet thrust at Donna transforms into maggots and dolly mixture sweets; a demon terrorizes her from a telephone box. The protagonist cannot trust her senses. When a businessman with a briefcase comes skipping past, it is the amused reaction of passers-by that tells Donna that he is real—at least in their eyes. This vicarious process of deduction does not alter the protagonist's perception or her sense of reality. It directs her to a certainty she does not intuit, the reality for others, identifying the physical world indirectly in coping with the miasma of perception.

This mechanism brings to mind the deductive processes employed by some people with vision-related brain disorders (Kapur, 1997), certain forms of visual agnosia for example, where an object can be identified by logical elimination of descriptive elements enabling recognition of the object. Analysis takes the place of meaning accrued through sense perception as seen in Anderson's short film *Eye-See* (Anderson, 2004). 'Making sense of the world around us must be based on some sort of system, some swift and sure way of parsing the environment', Sacks (2011, 73) writes on how we function in the physical world. 'We do not see objects as such', Sacks continues, 'we see shapes, surfaces, contours, and boundaries … From this complex, shifting visual chaos, we have to extract invariants that allow us to infer or hypothesise objecthood' (Sacks, 2011, 73).

This basis for an apprehension of the world—seemingly so precarious—underlies an inferred conjecture of reality. How then does a robust adherence to consensus reality arise? The 'swift and sure way' required for survival encourages conviction in hypothesizing of the world about us, and by extrapolation, belief in a shared reality. However, assuming a greater variance of interpretation may be more scientifically sound than the certitude of consensus reality. Sen's alter ego Donna's process of extracting 'invariants' in her struggle in make sense of the world seems to fit within the mechanisms described by the neuroscientists cited. 'Visual object recognition depends on the millions of neurons in the inferotemporal cortex, and neuronal function here is very plastic, open and highly responsive to experience and training, to education'

(Sacks, 2011, 73). Connecting the perception of reality with identity, Butler (2015) states: 'If I can come to touch and feel and sense the world, it is only because this "I", before it could be called an "I", was handled and sensed, addressed, and enlivened. The "I" never quite overcomes that primary impressionability' (p. 11).

The construction of a world view based on sensory systems of such plasticity and responsiveness to experience reminds us of Sen's concrete example of Foucault's idea of 'vertical dimension'. Sen's memoir (2006) gives insight into her early life, her experience, training, and education: 'One time I had the misfortune of having hiccups whilst Dad was sleeping in his usual 15 hours a day. "Shut the fuck up! … ", I drank glasses of water, but my hiccups came back even louder. "That's it!" he snapped as [he] whipped out of bed. He grabbed my lips.

> "SHUT … THE … FUCK … UP!"
> "Hic!"
> Punch after punch after punch into a child's body.
> He stopped my hiccups.
>
> (p. 41)

'The process of perception' according to neuroscientist Michael Morgan (2003), 'involves selecting an internal model and then checking it against the data. The best model is the one that best fits the data. As Richard Gregory says, perceptions are hypotheses. Sometimes two equally likely hypotheses fit the data, like the ambiguous figures of the duck–rabbit and Necker cube …' (p. 97). After quoting Max Clowes: 'Perception is nothing more than successful hallucination', Morgan (2003) goes on to say: 'Hallucinations tell us that the brain can generate perceptions with minimal support from the retinal image. There is probably very little difference between a drug-induced hallucination and a perception of faces in clouds and random textures. In both cases the input consists of semi-random input from the eye' (p. 100). Deleuze (2005) draws on an analogous, or perhaps inverse, process when referring to the construction of interior models conjured by an audience: 'The cinema does not just present images, it surrounds them with a world' adding: 'This is why, very early on, it looked for bigger and bigger circuits which would unite an actual image with recollection-images, dream-images and world-images' (p. 66). Film lends itself to, and reflects mechanisms for, creating inner-eye models which, in the biological sphere, we use 'to make informed guesses about the outside world' (Morgan, 2003, 97) in constructing diverse entities of existence. The interplay and feedback systems in film spectatorship could be seen to mirror the processing of perception.

'Functional specialisation has many important implications' according to Semir Zeki (1999, 68), in discussing 'how the final image is assembled together in the brain … It has raised the question of whether 'seeing' and 'understanding' are indeed two separate processes, … The brain, then, is no mere passive chronicler of the external physical reality but an active participant in generating the visual image, according to its own rules and programs. This is the very role that artists have attributed to art … ' (Zeki,

1999). '"Our reality", says Seth, "is merely a controlled hallucination, reined in by our senses"' (Webb, 2022, 67). Anil Seth extends this line of thought to the perception of self: 'there are also many ways we experience being a self … a self with a name, an identity and a set of memories. I argue that each of these aspects of selfhood can be understood as a distinctive form of controlled hallucination' (Seth, 2022, 96).

In cinema, engagement with a 'self', or character, in deciphering fictive contexts enhances empathetic connection (Bordwell et al., 2019). And transgressing boundaries of reality is a common trope in the arts, in solidifying or breaking this bond. Referring to the artist Francis Bacon's use of bodily distortion, the painter Jenny Saville (2021) articulates how depictions that transgress rules of reality build tension and conflicting impulses in the spectator:

> Each canvas is designed with precision, with his figures framed by cages, apertures or other geometric devices … But … his human and animal figures are always breaking out of these devices, going beyond their frames, creating a sense of visual panic. There is a leakage that makes you deeply anxious. Something similar happens in his depiction of flesh. When we see an image of an out-of-shape body, you try and repair it in your mind, to confine it to its correct proportions. Bacon exploits that innate process, breaking down reality to find explicit truth.
>
> (p. 44)

As Saville identifies, it is the breaching of precisely wrought co-existent frames of reference that elicits an emotional response in the viewer: anxiety, panic, et cetera. In the case of film, the severing of established, assumed, or consensus realities elicits an audience reaction. The cognitive dissonance inherent in the juxtaposition of incompatible spheres of existence, invented worlds, or alternative realities, is employed for dramatic effect.

Film's facility in formulating divergent realities through the use of point-of-view shots (Pye, 2000, 2007), editing, and *mise-en-scène* in general, has the potential to elicit 'that innate process' (Saville, 2021, 44), arising from the inner tension and the desire to cohere the ruptured world views experienced by the protagonist. A reconfiguration of discrepancies and the impulse to mend a perceived fissure in the world, can arouse a sense of healing within the spectator. This can elicit inherent recognition of a shared experience of disharmony and subsequent feeling of solace and consolation. After screenings of films written and directed by Sen, certain audience members have been compelled to tell the director that the film is 'their story', and that they know that the film is made by someone with lived experience. Film curators and medical staff have also reported requests from patients that their doctor or carer watch Sen's films in order to better understand what they, the patient, experiences (Sen, 2022b). How, the question arises, does the conviction of authenticity manifest itself in Sen's films?

When the protagonist in *Outside* lifts the telephone receiver, a demon speaks to her. The physical world is suddenly 'blanched out'. The spectator, like the protagonist, is disorientated. 'We lose our grip on reality as strong light, reflecting off the glass that

separates us from the young woman, renders it opaque. Rather than illuminating the protagonist, sunlight reflects back at us … as we struggle, with the protagonist, to determine if the demonic voice at the end of the phone is real or not' (Anderson, 2017, 8). The filmmaker did not invent this scene. Nor the story. Rather, as with Féret's films, it is an excavation of a subterranean world. The film is not fiction, it is a disinterring of memory and meaning, a process of interpretation; translating the remembered to *mise-en-scène*; a rigorous scrutiny of, and obligation to, the inner visual, auditory, and chronological perception of experience. It is not created primarily for effect, but as dramatization employed to establish and affirm lived reality. This commitment to truth may account, at least in part, for the recognition of authenticity, of veritable life lived, by members of the audience. Recognition of authenticity may also arise from Sen's learnt methods for negotiating the world; the possibility that a deeper conscious engagement with the construction of internal models informs the mirroring nature of how an audience unconsciously perceives a film. The film's facilitation of the 'modality of believing', according to Derrida (1998), 'lets one see new specters appear while remembering (and then projecting them in turn onto the screen) the ghosts haunting films *already* seen' (p. 27). This '*already* seen' resonates on multiple levels, and in the recognition afforded by Sen's films for those who have a shared lived experience.

This case study begins with an exploration of how the brain's perception of the world brings into question the validity of consensus reality. The protagonist's deductive process in constructing reality accords with the neuroscientific model of perception which can be understood as little more than successful hallucination. Furthermore: 'the self is a perception too. Experiences of "being you" are collections of brain-based best guesses' (Seth, 2022, 96). This 'best guessing' for 'reading reality' and the concomitant effect on self-perception underscores and highlights the significance of attending to authentic first-hand representation; of listening to the voices of those with experience of psychosis.

Inside (2021)

Playing with multiple readings of psycho-spatial manifestations of 'inside', we see the protagonist, again named Donna, in an office space; vertical blinds suggest confinement. The soundtrack alerts the spectator to the protagonist's inner perspective. Experienced from Donna's point of view, her increasingly tumultuous internal world evolves throughout the film, an inner state populated by abusive voices that are also physically present, demonic personae strategically positioned one by each ear, the seemingly real and the imaginary co-existent. An occupational therapist entering the room is later understood to be part of Donna's inner reality. At a key point in the film, this female therapist momentarily ceases to be a physical presence for Donna, subsequently becoming a new resident among Donna's inner coterie, another voice, also corporate. However, the new voice is not abusive. '[Your life] does not have to be this way', she says as the therapist. Now, smiling, she takes her place alongside the demonic voices.

Sen, who wrote the script years prior to filming, says the arrival of the new voice reflects a key moment in her own life (Sen, 2022b). Fernyhough (2017, 250) quotes Sen: 'My voices saved my life ... I could have just said, "It's not worth living, my dad tried to kill me, nobody cares, better to die." And, you know, I could have committed suicide. What my voices did was protect me ... I couldn't look at the truth directly at the time, so voices helped me not to do that'.

The new voice is significant. It is the first positive voice to manifest itself in Sen's life, however the way it operates within the film's structure does not follow the conventional narrative turning point outcome. Protagonist Donna's awareness that there has been a positive shift signals the end of the film, but the abusive voices do not leave her. This is not the end of Donna's nightmare. She is not 'made well again': the status quo of reality/ies remains unaltered; consensus reality has not been affirmed, nor is it seen to have 'won out'.

Conventional codes of narrative film alert the audience to a character's state of mind if portrayed as delusional or at variance to the norm; the rules of reality within the film are predominantly aligned with a perceived consensus. *Inside*, on the other hand, does not imply that a consensus world view is morally superior, nor does it denigrate the reality of the protagonist. Sen's protagonists live and survive 'as they are' with their voices and their reality, in the world as it exists for the protagonist, regardless of how, and by whom, reality is defined.

The film *A Beautiful Mind*, directed by Ron Howard (2001), also uses a crucial turning point to indicate a changed perception, but in its case, it is the audience, not the character, whose perception changes. It reveals at that moment that we were, but are no longer, aligned with the protagonist's point of view. The switch from the protagonist's perception to a consensus reality—that the film infers is 'true reality'—identifies the protagonist as delusional. There is no liminal state of, for example, Féret's protagonist Paul in the asylum, where social constructs are seen as just that, in which most must, of necessity, accommodate themselves. Classic narrative films about psychosis predominantly present the polarities of the 'real' and 'delusional', underscoring the dominant consensus from a neurotypical perspective, subjugating and pathologizing 'othered', authentically lived experience.

But consensus reality is compelling. As is the power of narrative continuity. Westfall (2018, 320), invoking Lacan and Baudry, writes: 'Our sense of our own integrity and continuity as psychical beings can be reinforced in cinema ... cinematic narrative continuity ultimately can help us to retain the synthetic unity of the subject that is ourselves.' On the other hand, according to William Egginton (2016, xv): 'That ability to experience different and at times even contradictory realities without rejecting one or the other is one of the main reasons we are so drawn to fiction, in all its forms.' In conveying a psychotic reality, Sen creates a further layer of the subconscious in the film *Inside*. We see Donna with her abusing, corporeal voices, no longer in the office-lit space but now thrust into subterranean darkness—a Dantean realm of hell. We experience Donna's utter aloneness, abstracted, and cast out from all worlds. In this distressing place, the new voice, reaching her hands out towards Donna, is profoundly moving, for she has

breached its world membrane bridging realities to make the connection. 'The narrative ...', Sen says (2022b), 'can reflect differently on the inner perception of realms of what is real and what is illusion as implied by structural aspects of narrative construction that film offers.' Narrative structures themselves constitute elements of interior worlds of memory and perception for all persons. Transgressing rules of reality in film, breaching and forging links across boundaries, recalls Saville's (2021) reference to 'that innate process, breaking down reality to find explicit truth' (p. 44). Part of the power of Sen's film derives from the multiple realities that the redeeming figure must traverse to bring succour to the protagonist, and thus to the viewer.

The precision and subtlety of Sen's manner of conveying her inner experience appears to contradict medical research reporting diminished autobiographical memory and metacognition in people with experience of psychosis (Kwok, 2021; Anscombe, 1987). Impairment of autobiographical memory and mentalizing and the concomitant impact on narrative (Dimaggio et al., 2012) is not evidenced in either of the case studies presented here. Impairment implies reduction of, and difference from, the norm. This is not reflected in the veracity and sophistication of the filmmaking witnessed in the films directed by Féret and Sen. Claims of diminished capabilities of individuals with a different experience of autobiographical memory and mentalizing ignore a wider perspective and potential for learning from different life experiences. These claims can also undermine the value of acknowledging and celebrating the creative potential of alternative perceptions.

While shooting *Outside* Sen became aware that the act of directing the film came close to triggering a psychotic episode. Transforming a lived event into a dramatic scene may have reconfigured it into a coexistent state, creating a tipping point to an ambiguous reality. The cognitive process of systematizing a scene, re-creating an inner scenario and its transference to the physical world in mobilizing action through *mise-en-scène*, with actors and cast, could disorientate; aways present, real time, and simultaneously multiple timelines, facilitating a segue between realities or states of being. It is also in this context that Sen's statement 'film is psychosis' may be understood.

If interpreting a memory into the physical world can create a sliding door moment into psychosis, then the question is whether an examination of experiential modes of enquiry can lead to further insight into the condition. Collaboration with filmmakers as interlocutors into the artistic process could offer a radically different approach to research. The value of findings derived from cinema's 'system of pre-linguistic images and signs' (Deleuze, 2005, 252) could present benefits to medical knowledge, the creative process itself, and constitute 'observable data of an unobservable world' (Sen, 2022a, 3).

Conclusion

Where the majority of conventional film narratives show mental health conditions as something that can or must be cured, Sen and Féret's films confirm the reality of

the protagonist with lived experience. The protagonist is neither diminished nor undermined because of a psychiatric label or diagnosis, on the contrary, their reality and life, in these films, are authenticated.

The authors of this chapter are not suggesting that a fundamentally different film language is being used by filmmakers with lived experience, nor that, as yet, the syntax of cinematic forms employed extends the field of experimentation, but that expression through autobiographical narrative constitutes an aesthetic process that has the potential to affirm the filmmaker, and that a deeper understanding and insight into the experience of psychosis can emerge.

Many years after filming *Histoire de Paul*, Féret says in his 2012 interview that he phoned the asylum to ask if he could shoot his second autobiographical film there. The man at the other end of the phone, who had been an intern during Féret's incarceration, replied: 'I have been waiting for this call for twenty years' (Féret, 2012). The affection Féret feels for this man, now a psychiatrist, is palpable. The relationship between patient and medic is transformed through the intervention of the film itself. It constitutes a common language, a conduit to a shared vision of inner life experienced, bringing to mind Derrida's (1998, 26) statement: 'cinematic perception has no equivalent; it is alone in being able to make one understand through experience what a psychoanalytic practice is: hypnosis, fascination, identification, all these terms and procedures are common to film and to psychoanalysis, and this is the sign of a "thinking together" that seems primordial to me.'

The evident mutual regard between Féret the filmmaker and the psychiatrist is one of equals, highlighting an underlying issue expressed by Foucault (2011, 11): 'power is a relationship, it is not a thing.' Authority in relation to, for example, psychiatric diagnosis, or consensus reality, concerns power. The filmmaker articulates in a medium accessible to the public, therefore the more equitable dialogic engagement afforded by the film extends beyond the personal, and the medical, to all people.

The stories of Féret and Sen share this re-equilibrated relationship between patient and doctor. Sen interviews psychiatrist, Dr Ahmed Hankir, in the documentary film *The Wounded Healer* (Anderson, 2017) reconfiguring the status quo of the doctor's consulting room. The artifice of clinical interaction becomes apparent through the re-lensing of the camera; a confrontational aspect of a medical encounter is revealed. Both Sen and Féret are empowered through the medium of film, which has the potential to create a common border object, or third modality, facilitating a genuine patient–doctor connection.

The lack of collaboration between academics and individuals with lived experience is highlighted in the work of Fusar-Poli et al.: 'This double perspective on psychosis represents an innovative methodological attempt in the existing literature. It is only by following different paths and languages that it is possible to look at psychosis with fresh eyes that can capture the vividness of the subjective experience of suffering. This is best achieved by allowing personal insights to re-emerge into life and putting ideologies and traditional ways of thinking in brackets' (Fusar-Poli et al., 2022, 184).

The authors of this chapter propose research into film as a vehicle through which filmmakers with lived experience of psychosis can lead, or collaborate on equal terms, in the development of original approaches to comprehending and in conveying the condition. Research that is not *about*, but *with*, and *by*, the filmmakers, enabling voices to be heard, seen, and celebrated, in order to confront 'the awakening of intractable reality' (Barthes, 2000, 119).

Acknowledgements

The authors wish to thank all those involved in the making of the films *Outside* and *Inside*. And for their contribution to this chapter: Martin Poltrum, Matthew Coleman, Peter Matthews, Edward Lamberti, Fiona Malpass, Mona Lamotte, and University of the Arts London.

Note

1. The interview is in French. The statements quoted here are translated into English by Sal Anderson.

References

Anderson, S. (2004). EYE SEE. In B. Arends & V. Slater (Eds.), *Talking back to science* (pp. 41–42). Wellcome Trust.
Anderson, S. (2017). Psychiatry and the subjective: Art's role in challenging objectification in medicine (pp. 1–11). Available from: https://ualresearchonline.arts.ac.uk/id/eprint/11446/1/Art-Sci_24.3.17-PG2.doc [last accessed 16 June 2023].
Anscombe, R. (1987). The disorder of consciousness in schizophrenia. *Schizophrenia Bulletin* 13 (2), 241–260.
Barthes, R. (2000). *Camera lucida*. Vintage.
Bentall R. P. (2003). *Madness explained: psychosis and human nature*. Penguin.
Bhugra, D. (2003). Teaching psychiatry through cinema. *Psychiatric Bulletin 27*, 429–430.
Bhugra, D., & De Silva, P. (2007). The silver screen, printed page and cultural competence. *The Psychologist 20* (9), 340–358.
Block, P. (2021). Mapping mental health in the film and television industry. *Commissioned by the Film and TV Charity*. Available from: https://filmtvcharity.org.uk/wp-content/uploads/2021/11/Mental-health-training-report-Issue-v3.pdf [last accessed 16 June 2023].
Bordwell, D., Thompson, K., & Smith, J. C. (2019). *Film art*. McGraw-Hill Education.
Butler, J. (2015). *Senses of the subject*. Fordham University Press.
Byrne, P. (2009). Why psychiatrists should watch films (or What has cinema ever done for psychiatry?). *Advances in Psychiatric Treatment 15* (4), 286–296.
Carroll, N. (1988). *Mystifying movies: Fads and fantasies in contemporary film theory*. Columbia University Press.
Cermolacce, M., Despax, K., Richieri, R., & Naudin, J. (2018). Multiple realities and hybrid objects: A creative approach of schizophrenic delusion. *Frontiers in Psychology 9* (107), 1–9.

Ciment, M., & Jeancolas, J. (1977). *Revue de cinéma positif n° 192 by Collectif* (pp. 34–42). philippe arnaiz.

Coleman, D. (2014). *The bipolar express. Manic depression and the movies*. Rowman & Littlefield.

Deleuze, G. (2005). *Cinema 2: The time-image*. Bloomsbury Academic.

Derrida, J. (1998). Cinema and its ghosts: An interview with Jacques Derrida. By Antoine de Baecque and Thierry Jousse. Translated by Peggy Kamuf. Interview conducted 10 July, 1998 and 6 November, 2000 in Paris. Transcribed and formatted by Stéphane Delorme. Available from: www.sas.upenn.edu/~cavitch/pdf-library/Derrida_interview_Cinema_and_Its_Ghosts.pdf [last accessed 6 October 2024].

Dimaggio, G., Salvatore, G., Popolo, R., & Lysaker, P. H. (2012). Autobiographical memory and mentalizing impairment in personality disorders and schizophrenia: Clinical and research implications. *Frontiers in Psychology 3*, 529.

DSM-5. (2013). American Psychiatric Association. Available from: http://repository.poltekkes-kaltim.ac.id/657/1/Diagnostic%20and%20statistical%20manual%20of%20mental%20disorders%20_%20DSM-5%20%28%20PDFDrive.com%20%29.pdf [last accessed 16 June 2023].

Egginton, W. (2016). *The man who invented fiction: How Cervantes ushered in the modern world*. Bloomsbury.

Eliot, T.S. (2001). *Four quartets*. Faber & Faber.

Fancourt, D., & Finn, S. (2019). What is the evidence on the role of the arts in improving health and well-being? A scoping review. *World Health Organization*. Available from: www.culturehealthandwellbeing.org.uk/news/blog/introduction-new-who-evidence-report-arts-and-health-daisy-fancourt [last accessed 16 June 2023] and www.culturehealthandwellbeing.org.uk/sites/default/files/9789289054553-eng.pdf [last accessed 16 June 2023].

Féret, R. (1975). *Histoire de Paul*. DVD special feature.

Féret, R. (2012). Video interview: Comment le cinéma vint à René Féret. Available from: www.universcine.com/articles/comment-le-cinema-vint-a-rene-feret [last accessed 16 June 2023].

Fernyhough, C. (2017). *The voices within. The history and science of how we talk to ourselves*. Wellcome Collection.

Foucault, M. (2009). *History of madness*. Routledge.

Foucault, M. (2011). *Manet and the object of painting*. Foucault cited by N. Bourriaud in the introduction. [Michael Foucault: Manet and the Birth of the Viewer]. Tate Publishing.

Fuery, P. (2004). *Madness and cinema: Psychoanalysis, spectatorship and culture*. Palgrave Macmillan.

Fusar-Poli, P., Estradé, A., Stanghellini, G., Venables, J., Onwumere, J., Messas, G., Gilardi, L., Nelson, B., Patel, V., Bonoldi, I., Aragona, M., Cabrera, A., Rico, J., Hoque, A., Otaiku, J., Hunter, N., Tamelini, M. G., Maschião, L. F., Puchivailo, M. C., et al. (2022). The lived experience of psychosis: A bottom-up review co-written by experts by experience and academics. *World Psychiatry 21* (2), 168–188.

Godard, J. (1986). *Godard on Godard: Critical writings by Jean-Luc Godard*. Da Capo Press.

Goulart, D. M. (2019). *Subjectivity and critical mental health. Lessons from Brazil*. Routledge.

Hearing the Voice. Available from: https://hearingthevoice.org [last accessed 16 June 2023[.

Heath, E. (2019). *Mental disorders in popular film: How Hollywood uses, shames, and obscures mental diversity*. Lexington Books.

Hourigan, J. (2022). Private correspondence.

Jay, M. (2012). *Influencing machine: James Tilly Matthews and the air loom.* Strange Attractor Press.

Kapur, N. (1997). *Injured brains of medical minds.* Oxford University Press.

Kwok, S. C., Xu, X., Duan, W., Wang, X., Tang, Y., Allé, M. C., & Berna, F. (2021). Autobiographical and episodic memory deficits in schizophrenia: A narrative review and proposed agenda for research. *Clinical Psychological Review 83*, 101956.

Matthews, P., & Anderson, S. (2010). Cinema, subjectivity and psychosis: Towards a phenomenological approach. *European Psychiatry 25* (1), 72.

Metz, C. (1990). *Film language: A semiotics of the cinema.* University of Chicago Press.

MIND. See www.mind.org.uk/donate/?gclid=EAIaIQobChMIu8vrianH-AIVCc13Ch1nvgVBEAAYASAAEgL17PD_BwE [last accessed 16 June 2023].

Morgan, M. (2003). *The space between our ears: How the brain represents visual space.* Oxford University Press.

NHS England. See www.england.nhs.uk/ [last accessed 16 June 2023].

O'Farrell, C. (2018). Part 2. Michel Foucault on film. 'The asylum and the carnival'. In C. O'Farrell (Ed.), *Foucault at the movies* (pp. 145–151). Columbia University Press.

Parr, H. (2007). Collaborative film-making as process, method and text in mental health research. *Cultural Geographies 14* (1), 114–138. https://doi.org/10.1177/1474474007072822.

Poltrum, M. (2016). *Philosophische Psychotherapie. Das Schöne als Therapeutikum.* Parodos Verlag.

Pye, D. (2000). Movies and point of view. *Movie 36*, 2–34.

Pye, D. (2007). Movies and tone. In J. Gibbs & D. Pye (Eds.), *Close-Up 02 Movies and Tone* (pp. 14–17). Wallflower Press.

Rikandi, E., Pamilo, S., Mäntylä, T., Suvisaari, J., Kieseppä, T., Hari, R., Säppä, M., & Raij, T. T. (2017). Precuneus functioning differentiates first-episode psychosis patients during the fantasy movie *Alice in Wonderland*. *Psychological Medicine 47* (3), 495–506.

Rovelli, C. (2019). *The order of time.* Penguin.

Sacks, O. (2011). *The mind's eye.* Picador.

Saville, J. (2021). The truth in Francis Bacon's work. *Royal Academy of Arts Magazine 153*, 44.

Sen, D. (2006). *The world is full of laughter.* chipmunka publishing.

Sen, D. (2022a). *Lorina Bulwer.* red herring press.

Sen, D. (2022b). Private correspondence.

Seth, A. (2022). We need to solve the problem of consciousness. In R. Webb (Ed.), *Consciousness. Understanding the ghost in the machine* (pp. 93–96). New Scientist. Essential Guide No.12.

Time to Change. See www.time-to-change.org.uk/ [last accessed 16 June 2023].

Van Raalte, C., Wallis, R., & Pekalski, D. (2021). State of play 2021. Management practices in UK unscripted television. Available from: https://eprints.bournemouth.ac.uk/35897/1/BU_State_of_Play_2021%20%281%29.pdf [last accessed 16 June 2023].

Varga, S. (2015). *Naturalism, interpretation, and mental disorder.* Oxford University Press.

Webb, R. (2022). The power of hallucination. In R. Webb (Ed.), *Consciousness. Understanding the ghost in the machine* (pp. 67–68). New Scientist. Essential Guide No.12.

Wedding, D. (2014). *Movies and mental illness: Using films to understand psychopathology.* Hogrefe Publishing.

Wellcome Trust. See https://wellcome.org/ [last accessed 16 June 2023].

Westfall, J. (2018). *The continental philosophy of film reader.* Bloomsbury.

Zeki, S. (1999). *Inner vision: An exploration of art and the brain.* Oxford University Press.

Filmography

Anderson, Sal. (2006). *Eye-See*
Anderson, Sal. (2017). *The Wounded Healer*
Aronofsky, Darren. (2000). *Requiem for a Dream*
Aronofsky, Darren. (2010). *Black Swan*
Cronenberg, David. (2002). *Spider*
Féret, René. (1975). *Histoire de Paul*
Féret, René. (1993). *La Place d'un Autre*
Howard, Ron. (2001). *A Beautiful Mind*
Scorsese, Martin. (1973). *Mean Streets*
Sen, Dolly. (2013). *Outside*
Sen, Dolly. (2021). *Inside*
Wachowski, Lana & Lilly. (1999). *The Matrix*
Wiseman, Frederick. (1967). *Titicut Follies*

CHAPTER 30

CINEMA THERAPY—THE FILM AS A MEDICINE. FROM THE SILENT FILM ERA TO THE PRESENT DAY

MARTIN POLTRUM

INTRODUCTION

In his book *The Film Club* (2007), the Canadian writer, television journalist, and film critic David Gilmour recounts in a very touching manner all that films can accomplish. When his son was sixteen years old and school became a nightmare for both father and son, as Jesse hardly took part in class and when he did show up once in a while, he only switched off and got very bad grades, the film specialist made a deal with his son. Realizing fairly soon that a 6'4" teenager cannot be forced to graduate, he gave up and told Jesse that it would be okay if he quit school. He also would not have to look for a job or pay rent and was welcome to sleep until five in the afternoon if he felt like it. The only condition, however, was that he had to watch three films with him every week and that these were selected by his father. If he refused the deal, he would have to look for a job immediately. Jesse agreed, father and son spent a wonderful year together. The films inspired them to talk about girls, music, heartbreak, work, drugs, friendship and all sorts of existential topics, and Jesse gradually matured into a confident young man.

Everyone has at least once experienced that films can act as educators. In any case, a film to which this predicate must be ascribed, at least for my generation, is *Dead Poets Society* (1989). Robin Williams plays an unorthodox teacher who strives to explain to his students that medicine, law, technology, and science are noble and worth striving for, yet, literature, art, poetry, and beauty are what make life worth living.

Films not only have an educational, but also a therapeutic function. They can promote mental health and well-being and are used in the framework of psychotherapy (cf.

Fatemi, 2022). Psychiatrist and novelist Steven Schlozman, who teaches psychiatry, film, and creative writing at Harvard, not only affirms that 'one can utilize popular film[s] to help parents and teens to better understand one another' (2021, 37), but also that the application of films 'in therapeutic settings' is an 'emerging field' (2021, 23). For instance, everyone knows how beneficial it is to switch on the TV and simply tune out and let yourself be entertained during acute intrapsychic conflicts. Due to their hypnotic nature, films promote an escape from reality that is necessary from time to time, which is especially desirable when the experienced present is conflict-laden and thus supports the mental defence that is also needed from time to time. By means of a well-dosed escape from reality, stress is reduced, emotions are regulated, and psychological well-being is increased (2021, 4–5), just to introduce one aspect of what effects films can have. The idea that it is imperative to utilize films in a clinical context for various reasons had already been born in the silent film era and it is astonishing to see the insights that had already been gained in early cinema therapy discourse.

Cinema Therapy at the Time of the Silent Film

In the 1910s and 1920s of the past century, besides the conviction that films had a therapeutic effect on the mentally ill, there were of course also moral, pedagogical, psychological, and medical concerns about the effect of cinema. These will be briefly mentioned here first, before we deal with the affirmative discourse on cinema therapy of the silent film era.

Theologians and pedagogues worried about the harmful suggestive power of cinematographic images and had concerns about the imitation of immoral acts and the transfer of these from the film world to reality—in particular young people needed to be protected from the cinema. Psychologists and doctors warned that the flickering images could place excessive strain on viewers' nerves, which had a certain plausibility in the age of neurasthenia (Poltrum, 2016). Even official medical reports existed on how films should be rated for health reasons. In 1912, a doctor and professor named Lojacono, a film sceptic and critic of the first hour, noted in an expert opinion about a sixty-year-old alcoholic who suffered from severe hallucinations as a result of a visit to the cinema:

> It is self-evident that persons suffering from hysteria, neurasthenia, alcoholism or hereditary predisposition exhibit a tendency to hallucinatory disorders. It is particularly clear in this case [of the alcoholic man] that the cinematographic influence was an occasional trigger for the hallucinations' and that the 'optical-acoustic fluttering of the projector affected the nerves weakened by alcohol.
>
> (Lojacono 1912, in Caneppele & Balboni, 2006, 62)

Besides these early concerns about the medium of film, however, in the era of silent films, there had already existed a firm conviction that films could have a therapeutic effect. Even though the sources on cinema therapy or film therapy in the silent film era are rather fragmentary, there is some exciting evidence in early film therapy discourse (cf. Caneppele & Balboni, 2006). Most likely, the earliest document on the use of film in a hospital dates from 1912: 'A Power's Cameragraph 6A has been ordered through the General Film Company of Boston, for installation in the New Hampshire State Hospital for the Insane' (2006, 72). Two years later, the *Kinematographische Rundschau* reported in a note that twenty-four institutions had already been equipped with a cinema projector. Under the heading 'Cinema and the Care of the Insane' it said: 'Twenty-four lunatic asylums in the United States have so far been equipped with projection theatres, fourteen are still under construction. The living picture is said to have a great healing effect on some insane people' (2006). In 1915, a short commentary in an Italian journal on the cinema–therapeutic use of films to treat neurasthenia said: 'In Denmark, special screenings are organised to cure the minds of neurasthenics. In an American hospital it was noticed that such a screening had an extraordinary effect on the patients' (2006). According to Canappele and Balboni (2006), the most important report on the therapeutic use of films in clinics from the silent film era is found in the Italian daily newspaper *La Tribuna* in 1913. The translated report also appeared in the Swiss journal *Kinema* and in the Austrian journals *Die Filmwoche* and *Österreichischer Komet*. A journalist from *La Tribuna* wrote an article about his experience as a participating observer during a cinema screening for the 'mentally ill'.

> The cinema in the lunatic asylum. Now the lunatic asylum has also opened its doors to the cinematograph: In the lunatic asylum of Perugia, experimental cinema screenings were organised on a regular basis, attempting to introduce the motion pictures into the healing system. (…) The first impression of the spectacle on the unfortunate sick people was quite different from what one would have expected. The film presented a Spanish ball. The first glances I caught spoke in wondrous concealment of a mixture of curiosity and doubt; but the longer the screening lasted, the more the faces changed. Gradually, an expression of undeniable pleasure passes over the faces of the spectators. (…) Now the lunatics have become livelier, in semi-loud voices they comment on the flashing images, but when a drunkard who has beaten up a policeman with his cane in a drunken rage is arrested and locked up, they laugh loudly and roister so that the hall echoes. The spirit of rebellion seems to awaken in all of them, especially among the convicts; soon, however, this sensation is replaced by another, for on the screen appears the figure of a woman who is meant to embody spring. She appears as if risen from the earth, loose veils flow around her body, and in the auditorium a long, deep silence ensues before this image. It is as if the unfortunate people awaken to bright memories of better times.
>
> (Caneppele & Balboni, 2006, 73 f.)

Affirmatively, the original article in *La Tribuna* continues:

> The science which revolutionised the old methods of curing mental illness wants to accommodate cinematography in its ranks today. Cinema must transmit its curative effects to the sick spirits and will achieve more than forced washing, straitjackets and padded cells.
>
> (Caneppele & Balboni, 2006, 72)

Cinema–therapeutic efforts seem to have been widespread in the early years of film. There is evidence or rather references of this in the United States (US), Denmark, Italy, and England. In 1926, among other things, a London institution organized screenings for melancholics, as can be read in the Austrian film magazine *Der Filmbote*.

> The cinema as a cure. The inpatients visit the asylum cinema once a week on a regular basis. It has been found that these weekly visits to the cinema have a very beneficial influence on the mood and the whole condition of the sick. Even incurable melancholics have been observed to show a certain brightening of their temper. According to a report by the attending physician, the interest aroused in the patients by the cinema has generally produced a distinct feeling of well-being; they are less preoccupied with themselves and show more sympathy for things in the outside world. Humorous films are the most popular, yet exciting dramas are also in high favour.[1]

FILM THERAPY IN THE SILENT FILM *LE MYSTÈRE DES ROCHES DE KADOR* (1912)

In my view, however, the most exciting document from the silent film era showing a film therapy intervention and its effect does not stem from the medical and psychological literature of the time, but from a silent film itself: Léonce Perret's (1912) *Le mystère des roches de Kador*[2] features the first cinema therapist in film history. In this brilliant flick, Professor Williams, a pioneer and expert in cinema–therapeutic interventions, cures a patient through the medium of film. To the relative of this patient, who has fallen into a sort of apathy due to psychological trauma, he shows one of his publications with the title: 'Communications of the Medical Society in Paris on the experiences Professor Williams has had with the application of cinematography to the mentally ill' (Kessler & Lenk, 2006, 47).

Since the plot is relatively complex, only as much of the storyline as is necessary for understanding the film therapy intervention and the implicitly assumed mechanism of action will be presented here.[3] Frank Kessler and Sabine Lenk (2006) go into detail about this cinema–therapeutic film document elsewhere.

About the plot: Eighteen-year-old Suzanne de Lormel, the film's protagonist, inherits her uncle's estate after his death. Until Suzanne comes of age, her uncle's cousin, Count Ferdinand de Kéranic, is appointed legal guardian and property administrator of the

estate. Should anything happen to Suzanne—illness or death—the cousin will be the universal heir in Suzanne's place, according to the provisions in the last will and testament. At the time of the reading of the will, Suzanne, who lives with the Count in Brittany, is in love with Captain Jean d'Erquy, who discloses in a letter to her that he shares the same feelings. Suzanne is overjoyed when she reads this. Since the Count de Kéranic is very much in debt and his creditors are pressuring him, he pursues a plan to marry Suzanne and get the money that way. On a walk along the coastal cliffs of Kador, he proposes to Suzanne and becomes slightly importunate. Suzanne is not very enthusiastic about the idea to get married, and in her indignation flees and loses her purse, which contains Captain Jean d'Erquy's love letter. De Kéranic finds the purse, reads the letter, and devises a devious plan to write to the captain in Suzanne's name and ask him to a rendezvous on the coastal beach at the Kador rocks. He apologizes to Suzanne and decides to shoot clay pigeons with her on the beach to reconcile. What Suzanne does not know is that the Count has mixed a narcotic into the coffee she drank just before the trip. On the beach, Suzanne eventually loses consciousness. The Count waylays Captain Jean d'Erquy, who comes paddling in a boat, and shoots him in an ambush. He is wounded but survives the assassination attempt and finds Suzanne lying unconscious on the beach. With the last of his strength, he drags her and himself into the boat and tries to row away. After a few metres, he collapses and lies apathetically in the boat next to Suzanne. Shortly afterwards, Suzanne awakes and does not know what has happened. At first, distraught and later with dissociated affect—she laughs—she reacts to this situation until she faints again. The boat floats in the water for a while until it is found by people passing by and the unconscious couple are rescued. The captain recovers completely after his stay in hospital. Suzanne, who has missed the essence of the events and lacks almost all the crucial connections, but above all the fact that her lover has survived, has lapsed into a kind of stupor or apathy since this trauma. When the captain's recovery is so far advanced that he can be discharged from hospital, he seeks out Professor Williams, an expert in the field of mood disorders and, as it turns out, a cinema therapist of the first hour. After d'Erquy has told his story, Professor Williams comes to the conclusion that only cinema therapy would help here. As Suzanne has missed the essential events of the crime and suddenly awoke from her unconsciousness on the drifting boat, finding her beloved once believed dead, it is necessary to give her an understanding of the missed connections and to show her what she had not seen and could not consciously perceive, up to the crucial fact that her beloved had survived. Yet, since Suzanne is in a stupor or apathy and she has become non-reactive to verbal interventions, a medium is needed, one that is so strongly moving and touching that it is capable to even break through the indifference and inaccessibility of the stuporous–apathetic state. Professor Williams comes up with the idea of having actors re-enact and film the events surrounding the assassination attempt on the beach. In the clinic, the apathetic Suzanne is led to the screen and is shown the film, which visualizes what she has not consciously witnessed: the true story and the events surrounding the traumatic shock. Initially still being apathetic, the first distinct stirrings in Suzanne's mind begin at the moment she sees her lover being shot on the screen. A second, even more distinct surge of excitement becomes

apparent on Suzanne's face as she watches her beloved drag an unconscious woman—who represents her—into the boat and then break down exhausted. Now Suzanne is so thrilled that she jumps up and runs towards the screen, towards her injured beloved. The light comes on, Suzanne collapses and is placed in an armchair by the nursing staff and doctors, and realizes that her beloved, who has witnessed the cinematic healing process, is standing next to her, alive. Suzanne and the captain are overjoyed, Professor Williams is immensely proud, and a nurse who witnessed it all is deeply moved to tears.

If one asks about the mechanism of action of this cinema–therapeutic healing depicted in a feature film from 1912, there are several possible interpretations: Firstly, the motion pictures show and make visible what has escaped the traumatized person, and secondly, the apathetic patient, who can no longer be affected by mere speech, is moved so deeply by the power of the images that she can follow the depicted events and realizes what has happened to her and her beloved. The cinematic image makes visible what would otherwise have remained invisible and hidden, and this can only be achieved primarily through the arousal of the affects. The fact that emotional affection is not only responsible for healing in this particular case, but also represents a main mechanism of action in film therapy, is yet to be shown.

Modern Film Therapy and its Mechanism of Action

The preceding media of film, book, and theatre had already been attributed therapeutic effects in antiquity. The library was considered a healing place for the soul (see contribution on bibliotherapy by von Engelhardt, this volume), and Aristotle attributed catharsis, a cleansing effect, to tragedy. With the introduction of the terms 'bibliotherapy' (Crothers, 1916) and 'Cinematherapy' (Berg-Cross et al., 1990), this knowledge was taken up again centuries later and developed into two creative treatment methods. While bibliotherapy uses literary texts, cinema therapy utilizes commercial feature films to provide therapeutic interventions. Both methods can support processes of education, reinterpretation, and awareness (Dermer & Hutchings, 2000) and are closely linked to a primal human need, because 'storytelling (…) is a basic need and prerequisite for the zest of life' (Grafl, 2008, 63).

Nevertheless, film therapy might have a greater benefit for clinical practice than bibliotherapy:

(1) Most patients are more willing to watch a film than to read a book (Hesley & Hesley, 1998) because the reception time is shorter (Grafl, 2008).
(2) The viewer is addressed multidimensionally by the total artwork of film, which sets the scene for narrative events through music, mood (Sinnerbrink, 2012) and above all through moving images. This combination of different aesthetic stimuli can result in a higher learning effect (Wolz, 2005), as well as easier access to unconscious content and emotions (Grafl, 2008).

(3) In addition, a positive influence on affect regulation is assumed: Overthinking or alexithymic patients get into the emotion more easily (Zur, 2022) and, for example, sob inconsolably in the cinema, even though they could not or would never do so in real life (Mangin, 1999). Distressing or unclear feelings can be more easily connected and expressed with metaphors, in that one's own issues can be explained on the basis of the film protagonists. According to the sentiment: I felt the same way as this or that character in the film (cf. Bliersbach, 2002).

(4) A film therapy intervention can loosen up the general therapy process (Bliersbach, 2002), deepen the therapeutic relationship (Berg-Cross et al., 1990; Hesley & Hesley, 1998; Zur, 2022) and facilitate the work with patients who are withdrawn or have little understanding of their illness (Sharp et al., 2002). In one of our interviews on cinema therapy at the Anton Proksch Institute in Vienna,[4] where the author of this contribution worked as a cinema therapist for several years, a thirty-six-year-old patient put her experience with film therapy into the following words:

> Now you can say what you want, but everyone identifies with someone when they watch a film. And that's why you let your thoughts come to you more than when you simply talk to someone, to a psychologist or a doctor. One does not readily admit things. But when you see a film and it plays out before your eyes (...), you are more willing, I think, to open up.

Among the pioneers of film therapy are Hesley & Hesley, 1998, who present their method 'Video Work' in the book *Rent two films and let's talk in the morning*. The authors believe that films have a therapeutic effect when attention is drawn to the development of the protagonists during film viewing, when identification processes are analysed and newly gained ideas and perspectives are discussed. The authors add that with films alone negative views of the world cannot be changed, but at least hope can be raised.

> No film can by itself reverse a negative worldview. But therapists can select films that begin in despair and end in triumph, thereby giving rise to hope. Clients who can identify with characters trapped by their circumstances and who can share the characters' disappointments as well as unsteady steps towards liberation may find reason for optimism in their own situations.
>
> <div align="right">(Hesley & Hesley, 1998, 18)</div>

Birgit Wolz (2005,[5] 2008), another pioneer of cinema therapy, calls her method 'Cinema Alchemy' and provides guidance on how films can be healing and transformative in three different ways. In the 'Prescriptive Way', the film is used as a teaching story that imparts skills, suggests solution strategies, and warns against negative effects. The 'Evocative Way' is less solution-oriented and aims more at self-awareness: the patient is instructed to watch the film with 'conscious awareness' so that the emotional reactions to certain film scenes or protagonists can gain access to unconscious content. With pent up emotions, the 'Cathartic Way' finally comes into play. The function of film is to make people laugh and/or cry in order to enable

a catharsis—a cleansing discharge—of pent-up emotions. No matter which methodology is chosen, film therapy can be integrated into many different settings. It can be used in individual, couple, or group therapies and is applied in outpatient as well as inpatient settings (Wolz, 2008). The film does not necessarily have to be watched together with the patient, it can also be given as homework between two psychotherapeutic sessions. In this case, however, precise instructions for film viewing and a joint debriefing in the next session will then be indispensable (Hesley & Hesley, 1998). A contraindication for film therapy only appears in acutely psychotic patients. Increased caution in film selection is also required for traumatized patients (Dermer & Hutchings, 2000; Sharp et al., 2002; Wolz, 2008), as *overly* dramatic scenes may trigger and conjure trauma. Since anything effective can also have undesirable side effects, the films should be chosen with great care, because images have enormous power. In principle, film therapy is compatible with any therapeutic approach. A study by Lampropoulos et al. (2004) shows that film therapy interventions are frequently applied by psychotherapists with an integrative, behavioural, or humanistic orientation. In the context of psychoanalytic cinema therapy considerations, film can be seen as a 'transformational object' (Bollas, 1987) that is able to open a symbolic space of transformation and can bring about an expansion of the capacity for experience (Gross, 2012, 116). In the light of psychoanalytical considerations, film can also function as a 'ready-made container' according to Salman Akhtar (2000) and thus serve to 'absorb and even make conscious of feelings that previously were inaccessible to consciousness' (Gross, 2012, 117). Films apparently offer the possibility of 'trial-identification' or 'trial-feeling'. 'A stage is offered for cautiously trying out new behaviours, relationship initiations and perhaps also for practising alternative strategies for problem solving' (2012, 116).

Now there are numerous studies on individual cinema–therapeutic phenomena (Izod & Dovalis, 2015), as well as theoretical considerations on the evidence of efficacy of clinical interventions (Powell, 2008) and, above all, empirical studies that attempt to prove the effect of films in different settings and with different patient groups. Cinema therapy is used for a wide variety of therapeutic considerations: for anxiety reduction in students (Dumtrache, 2014), in patients with eating disorders (Gramagalia et al., 2011), in patients suffering from chronic schizophrenia (Gelkopf et al., 2006), in preadolescents whose parents get divorced (Marsik, 2010), to externalize children's problems (Turns & Macey, 2015), to deal with relationship problems (Egeci & Gencöz, 2017), to support grieving adolescent girls (Molaie, Abedin, & Heidari, 2010) or parents of children with mild mental delay (Abedin & Molaie, 2010). In my own film therapy work at the Anton Proksch Institute in Vienna, which lasted from 2009 to 2018 and will be reported on in the following, films were utilized in a group therapy setting with patients suffering from addictive disorders within a wide variety of philosophical–therapeutic considerations.

Philosophical Cinema Therapy in Addiction Treatment

When I established a cinema therapy programme in 2009 at the Anton Proksch Institute in Vienna, an institution specializing in the treatment of addiction, the first task was to develop a suitable cinema–therapeutic setting. In the pioneering phase (2009–2013), our cinema therapy consisted of: a film shown about once a week; the debriefing session on the film and the actual film therapy intervention was then carried out either the same evening after the screening, or the next day in the morning. Since showing an entire film, especially extended versions, and a debriefing afterwards or the next day, was a very time-consuming task overall, and since many other interventions for the treatment of addicts are required in an inpatient facility, which also take up a lot of time, I decided to shorten the films to about forty-five minutes each, as well as reserving forty-five minutes for the debriefing, during the establishment phase of the film therapy (2014–2018). On average, about twenty to forty patients with a diagnosis of alcohol dependency, drug dependency, or pathological gambling participated in cinema therapy, and in the establishment phase of cinema therapy, participation in these groups was mandatory. Patients were assigned and the intervention took place during the main treatment hours of 9.00–10.30, which was a strong signal to patients and therapeutic colleagues that cinema therapy was a legitimate therapeutic method and not just a leisure activity. This was not self-evident in the beginning and had to be enforced first. In addition to the cinema–therapeutic intervention in the group, patients were offered the opportunity to come to me for an individual film–therapeutic debriefing if topics and questions arose on which a more in-depth discussion was desired.

Shortening the films brought decisive advantages. Firstly, the corpus of possible films could now be expanded, as disturbing or brutal scenes could be cut out of the films, which was actually ideal and thus many more films were made available for therapeutic purposes. No cinema therapist should use films that, due to problematic scenes, further destabilize an already emotionally unstable patient or even have a re-traumatizing effect in the worst-case scenario. Secondly, time could be gained for the therapeutic group discussion and the duration of forty-five minutes of film and forty-five minutes of film–therapeutic debriefing turned out to be an ideal time span to be integrated into an inpatient setting carrying out multiple interventions. Moreover, a ninety-minute treatment is ideal to avoid overstretching the attention span of patients. Thirdly, shortening films meant that I, as a film therapist, also took on the role of a narrator. I had to retell some of the content that had been cut out, or verbally recount what had happened between the viewed scenes, so that the patients would understand the plot. This narration of moments of action created a bond and a binding atmosphere between

the film, myself as a cinema therapist, and the listening patients, that should not be underestimated.

Perhaps the most obvious sphere of influence of cinema therapy, which my almost ten years of experience as a film therapist has shown, is that of influencing the moods of the recipients. A thesis could be put forward that cinema–therapeutic interventions do not only directly influence the moods of patients, but that specifically selected films have 'drug-like' effects; effects as 'mood stabilizers'—if you will. Depressed moods in which patients have lost confidence in themselves and the world can be temporarily lifted by films that show protagonists mastering their lives as they pass through a crisis. This can go so far that the feeling of being in good hands is conveyed and produced by cinematic interventions, creating a temporal, emotional dwelling in which patients, induced by feel-good films, find stability for a while.

The aesthetic experience of the work of art, in the case of the film's cinema therapy, is able to affect the recipient or patient in such a way that the psychological or spiritual (noetic) unconscious can be thematized and gently lifted. For it is only within the appropriate mood that one can reach repressed contents. Without rhetorical mood induction, without rhetorical téchne (see Mainberger, 1996), there will be no psychotherapy. Film–therapeutical interventions loosen the defence mechanisms, the defences of repressed feelings and contents. However, film–therapeutical interventions also increase the permeability for metaphysical considerations and this is an especially interesting approach for *Philosophical Cinematherapy*. Here, among other things, it is about the thematization of metaphysical needs, inducing certainty of being and primordial trust, as well as enabling spiritual experiences.

Incidentally, it has always been the task of philosophy, especially rhetoric, to create moods in order to allow the necessary coherence and credibility in what is being discussed. To ensure that what is said touches the feelings of the listeners and viewers by choosing suitable metaphors, images, and idioms (topoi) and that it unfolds the required coherence to convince and to persuade in the service of the good (the ethos). The one delivering a laudation had to create a different mood than the one delivering a eulogy or a speech in court. The cinema–therapeutic film screening, which also creates moods that are then utilized in the psychotherapeutic debriefing to additionally touch the open soul of the patients by means of therapeutic words, should make it possible to address what wants to be addressed. The idea of a *Philosophical Cinematherapy* which uses the essence of moods (Bollnow, 2009; Heidegger, 1996) is in the tradition of philosophical rhetoric.

Another reason why I am speaking of *Philosophical Cinematherapy* is because it is my fundamental conviction that the philosophical dialogue, which stands for the greatest possible open-mindedness and without any predetermined sovereignty of discourse and interpretation by one of the dialogue partners, is a necessity if patient and therapist are to really meet. If a film therapist wants patients to open up and switch off their speech autopilot, then as a practitioner, one also has to think without handrails. This is what the term philosophy has always stood for.

For several years, in the course of their eight-week inpatient stay, I was philosophizing together with patients on what love, addiction, healing, and psychotherapy are, as conveyed in love films, addiction films, or films portraying psychotherapists. This was an incredibly exciting and enriching experience for me, one for which I am grateful and which I have missed ever since becoming a professor. All that this experience gave me and my patients to think about will be concluded later.

Films with Portrayals of Psychotherapy

What psychotherapy is, was, and above all, can become in the future is something that each generation of psychotherapists has to determine anew. On the one hand the effect and side effect of psychotherapies are to be determined, and on the other hand the 'medication' of psychotherapy is to be reinvented. Obviously, psychotherapists or professors of psychotherapy science can say a lot when asked what psychotherapy is. Yet, in the context of *Philosophical Cinematherapy* I was interested in what patients believe psychotherapy is or could be, what broad or narrow ideas they have about what psychotherapy can do and achieve, what positive or negative images they have in their minds when they think of psychotherapy, which prejudices, defences or even positive experiences they bring along in relation to psychotherapy. Many addicted patients may for the first time in their lives be confronted with one or two one-on-one psychotherapeutic sessions per week during their inpatient stay and have to cope with this novel, perhaps even somewhat strange situation. In fact, often the prevailing opinion among patients is that addiction treatment is only about learning how to most effectively avoid drinking situations and potential abstinence violations and everything else will work itself out, and that psychotherapy is basically nothing that one necessarily needs or has to seriously engage in. However, addiction treatment very often implies a fundamental life change and going down new paths, and psychotherapy can help to ensure that one does not take a wrong turn along those paths.

Another specific feature of inpatient psychotherapy is that a psychotherapist cannot be chosen, one is simply assigned to one for practical reasons, which can trigger the most diverse positive and negative transferences. Therefore, there are many good reasons to philosophize with patients about what psychotherapy is, for example to break down prejudices or to expand and enrich the image of psychotherapy or to whet the appetite for the weekly sessions that are on the treatment plan for the duration of the stay. I opened up space for such conversations, for example, with films such as *Good Will Hunting* (1997), *Don Juan DeMarco* (1995), *Lars and the Real Girl* (2007), *The Prince of Tides* (1991) or *Analyze This* (1999), films that feature 'Dr. Wonderfuls' or 'Dr. Dippys' (on the psychotherapist in the feature film see Poltrum, this volume). From the many cinema therapy protocols that have been created over the years, a few statements from patients are rendered here to briefly illustrate which considerations psychotherapy scenes, in the context of cinema therapy, can be triggered in patients.

One patient, for example, said: 'Psychotherapy is only needed by those who are crazy, those who are left or right of their centre, those who have moved out of the centre'. Another patient countered this with the words: 'Everyone needs psychotherapy' and a third patient said: 'For me, the most important thing here is that I discover and get to know my own inner psychotherapist'. Such statements are of course wonderful for discussing the deeper question of what psychotherapy actually is, whether someone would dare to define it or could say what actually constitutes the essence of psychotherapy? When you ask this question, you hear answers like: 'Psychotherapy is about trust, you have to be able to trust your therapist' or: 'A good psychotherapist takes the patient to the window so that the patient can look outside, but doesn't tell what there is to see'. Such statements then again open up the potential question of what trust is or makes trust possible or what one sees when one looks out into the open. One question leads to another and philosophy virtually thrives on honest questions, for 'Questioning is the piety of thought' (Heidegger, 1994, 40).

Love Films

Everything that can be felt in relation to love, fulfilment, completion, pain and frustration, jealousy, separation, reconciliation, unrequited longing, shyness when falling in love, etc.—all this can be found in the products of art. Looking at the great love stories of the Occident, it becomes noticeable that love often hurts and ends tragically. Narcissus and Echo, Orpheus and Eurydice, Abaelard and Heloise, Tristan and Isolde, Romeo and Juliet, Hölderlin and Diotima, Rick and Ilsa seem to confirm the thesis of the Swiss philosopher Denis de Rougemont: 'Happy love has no history' (1987, 19)—at least none handed down, engraved in cultural memory. On the other hand, Paracelsus says: 'The supreme reason for medicine is love' (1988, lxiv).[6] Plato speaks of the experience of love opening the heart and giving wings to the soul (Plato, 2002, 33). The 'spatiality of love' is 'home' and the 'temporality of love' is 'eternity', we read from the phenomenological psychiatrist Ludwig Binswanger (1962, 69 f., 138f.). Love is not only home, but also the eternal power of rejuvenation, as we can see from the painting *Fountain of Youth* (1546)[7] by Lucas Cranach the Elder. For Cupid and Venus can be seen on the fountain column in the water basin from which the rejuvenating elixir gushes. They illustrate that the fountain of youth is a fountain of love and that the power of love is the actual source of everlasting youth. In short: love is actually a medication. Doctors, philosophers, and psychotherapists testify to this—but above all art and film.

Love films played an important role in my cinema therapy for more than one reason. Love relationships, along with parent–child relationships, friendship love, sibling relationships and agape love, are probably the most intense, if not the most intense relationships of all and there also are many various manifestations of love (Doering & Möller, 2014) and unfortunately, sometimes also pathologies of love. More than

that, but not least because in the background of addictions, somehow, love is always a theme. Love films were used not only because the topic of love always touches everyone in every situation in life, but also because I wanted to specifically strengthen the 'erotic resources' and our patients' ability to love. Increasing the ability to work, to enjoy, and above all to love have been psychotherapy's objectives since Freud at the latest, and if it is true that love achieves all that was indicated above, then love is *the* psychological resource and source of strength that needs to be reinforced. In addition to cognitive, emotional, physical, financial, social, and spiritual resources, there are also erotic resources that are to be activated or reminded of as part of the treatment—love films serve this purpose. Films such as *Homo Faber* (1991), *Elegy* (2008), *The Prince of Tides* (1991), *Eat Pray Love* (2010), *Broken Embraces* (2009), *Love Happens* (2009), *Lovers of the Arctic Circle* (1998), *Last Tango in Paris* (1972), *Hunting and Gathering* (2007), *The Unbearable Lightness of Being* (1988), *Beginners* (2010), *Forrest Gump* (1994), and *Casablanca* (1942) were part of my love film repertoire. When you activate resources or, in the case of 'erotic resources', remind people of the power of Eros and love, you inevitably also emphasize the building sites and problematic areas of love. Especially in the treatment of addictive disorders, pathologies and irritations of love often play a not insignificant role. Many patients' love relationships are burdened by addiction and not infrequently the motive for seeking treatment is a partner threatening separation: either addiction therapy or relationship breakup! Many patients also report negative love experiences (cheating, separation, jealousy, etc.) and not infrequently have developed a resulting attachment fatigue. In the worst case—which can often be observed with dependent attachment behaviour and insecure or ego-weak women—the persons concerned are even stuck in pathological relationships. Addiction and prostitution are another well-known problematic union, and sexualized violence in the background of addictions unfortunately also is an issue more often than one would like. Now and then it also happens that patients fall in love with one of their fellow patients or even with their psychotherapist during therapy, both of which present a certain challenge.

Love films were certainly not used in my cinema–therapeutic efforts to show and magnify the difficult and problematic facets of love, which would thus discourage our patients from engaging in Eros, love, and sexuality. Despite and precisely because Eros can have many dark sides in the context of addictive disorders, I used love films in treatment to remind our patients, by means of the depiction of love in film, of the power of beautiful and valuable love relationships. The purpose was to show and emphasize the healing aspect of Eros, the Eros Therapeuticus. Sometimes my 'love film therapy' was also about broadening our patients' concept of love, or about illustrating the different forms of love with their beautiful and painful sides—romantic love (eros), playful love (ludus), friendly love (storge), possessive love (mania), pragmatic love (pragma), altruistic love (agape)—through showing selected lovers in the feature film, making them subject of discussion and debate with the patients (cf. Lee, 1973).[8]

Interesting in this context is a discussion that once took place between two of my patients. One woman spoke up after watching a film and inquired why I was always showing love stories with happy endings (which was not true, but that does not matter at the moment). She could hardly stand it because she had already been in several relationships in her life, all of which had broken up, and she felt that she was incapable of having a beautiful love relationship. Now when she repeatedly sees films with happy endings, it gives her the feeling that she is a total failure and that everyone else can do what she cannot, namely be in a fulfilling love relationship. Immediately afterwards, another patient spoke up and said that the exact opposite was the case for her. She also had many failed relationships and for this very reason she hates films that show chaotic or problematic love relationships, because she wants to be encouraged by love films showing that love can work out. This anecdote says a lot about the effect of films and shows that it is very complex and should not be confused with the effect that chemical substances make. For instance, I have been encouraged countless times at national and international congresses, where I have lectured on film therapy, that I should compile a list of films for the therapeutic community that would help with depression, anxiety disorders, addiction and others, as such a list would be very helpful. Yet, such a list cannot exist, because film as an open artwork with its multiple ways of interpretation becomes a subjectively unique film through the direction of reception, the tendency of reception and the reception habits of the viewer or patient, whose reception cannot be predicted. In addition to the objective film shown in cinema therapy—e.g. *Eat, Pray, Love* (2010), which offers many possibilities of reception, it is ultimately the patient's previous experience of love, the happy, depressing, or neutral love history of the respective viewer, as well as the taste of the recipient, that makes the film that is shown subjective.

Addiction Films

In the context of inpatient addiction treatment, it was natural to show films in which intoxication, ecstasy, and addiction play a role. Patients were confronted with addicted protagonists in films such as *The Lost Weekend* (1945), *The Man with the Golden Arm* (1955), *Requiem for a Dream* (2000), *Vollgas* (2002), *Ray* (2004), *Spiele Leben* (2005), *Shame* (2011), and *Flight* (2012), and then the following questions were debated: What is addiction, what is the specific reason why the particular protagonist became an addict, how could the particular film character be helped, what do the relatives in the film say, and what would the character have to do in order to sustainably quit their addiction, just to hint at a few questions. Addiction is a very destructive disease. In severe forms, cells are destroyed on the biological level (e.g., nerve cells, cells of the digestive tract, liver cells), on the social level relationships (e.g., parent–child relationships, sibling relationships, love relationships), on the psychological level, the mood and the future perspective, and on the spiritual (noetic) level, the primordial trust and trust in the

world. Addiction films often depict this destructive potential, so it is particularly important when such films are shown in cinema therapy, that violent scenes are cut out so that the event does not become too confrontational and hope induction remains possible. This is not always successful, not even with the most careful efforts, because how can it be clarified in advance which scene might trigger which reaction, in which modulation, in which patient, with which consciously accessible or unconsciously buried previous experiences? Everything that is effective has side effects and films have an incredibly strong effect and unfortunately sometimes even undesirable side effects. The fact that unintended, undesirable, bad side effects can sometimes even have positive effects can be explained by means of a reaction of a patient in regards to the film *The Lost Weekend* (1945). After a cinema therapy group session in which I showed the aforementioned Billy Wilder film, a fifty-six-year-old patient, who had just completed her second inpatient stay, was completely distraught late in the evening and went to the nursing support centre of our department. She complained of strong suicidal thoughts and had tried to slit her wrists with blunt scissors. The doctor on duty was able to calm the situation through medication and conversation. The patient said that the film shown in the cinema therapy had completely stirred her up and made her realize how hopeless her situation was, that she was full of self-hatred and only caused problems for her family and that she obviously was not even capable of putting an end to her life, which was her most ardent wish. When I arrived at the clinic the next morning, the question of whether cinema therapy was a dangerous method was a heated topic of discussion. Fortunately, the medical director was a great advocate of cinema therapy and had been able to calm the situation in the morning meeting. What had actually happened?

My intention to show *The Lost Weekend* (1945) followed a simple therapeutic consideration. The film, showing an alcoholic writer—Don Birnam (Ray Milland)—who repeatedly tells his bartender Nat (Howard Da Silva) in a very illuminating way why he drinks so much, is surely one of the best addiction films ever, as it is full of profound insights into the psychodynamics of addiction (on mental disorder in film, see Poltrum, this volume). The film also shows Don's girlfriend Helen (Jane Wyman) and his brother Wick (Phillip Terry), who both movingly take care of him. Towards the end of the film, it becomes really dramatic one more time before it ends in a realistically implied happy ending. Dramatically, Don goes through an alcoholic delirium, screaming like a stuck pig as he hallucinates about a bat eating a mouse and this scene, like the film as a whole, is staged in a film-noir way. At the very end, Don, in a suicidal crisis, is saved by Helen and a happy ending is implied, which was a necessity in an addiction film from 1945 and helped me to induce hope that addiction can be overcome. The patient, I had already noticed during the cinema therapy, had left the film prematurely. For this reason, she did not see that everything culminates in a happy ending. Now it could be said that, as a film therapist, I should have been more careful. There are some points that would support this statement and other points that would contradict it. Firstly, I was cautious and secondly, it is difficult to control the reception of scenes, and thirdly, if therapy is

not allowed to have confrontational aspects, then it might miss the dramatic aspects of disorders, which occasionally also need to be made conscious and be kept conscious. The sole use of overprotective coddle therapy is empty, the sole use of confrontational therapy is blind. The fact that the film had a happy ending and offers many insights into the psychodynamics of addiction were the reasons why I chose it. What was unpredictable and unwanted in the aforementioned case was that the patient missed the happy ending and overreacted so strongly to the film. I had intended to stabilize the patients through the film, not destabilize them. However, there is another consideration in this context and that is whether the adverse reaction in this case was really all that bad. Firstly, the film made the patient realize what a dire situation and poor emotional state she actually was in. Secondly, the therapeutic team, from the personal psychotherapist to the nursing staff and doctors, realized through the reaction that the film *The Lost Weekend* (1945) triggered, that this patient is particularly vulnerable, and requires more attention than other patients. The film obviously had diagnostic value for the patient herself and for the therapeutic team by bringing to light the fact that the patient needs more attention and care, something that had escaped everyone's notice until the screening.

I would like to close this sub-chapter by pointing out that film characters sometimes say incredibly exciting things. In *The Man with the Golden Arm* (1955), Molly (Kim Novak), a friend and later the beloved of Frankie Machine (Frank Sinatra), says the following to her friend Frankie, a heroin addict, when he asks her for money for one last shot:

> FRANKIE: 'All I need is one shot, just one.'
> MOLLY: 'Alright. [She fishes money out of her bedside cabinet and says aggressively, on the verge of crying]. Right, you take it. Go on and take it all! Cos all that you're gonna need after that one shot is another, and then another, and then another. Take it! [She throws the bills at him]. Take it! Why should you hurt like other people hurt? Yes, so you had a dog's life but never a break. Why try to face it like most people do? No just roll up all your pains into one big hurt and then flatten it with a fix.'[9]

Conclusion

Films that show psychotherapists can have a psycho-educational character when it comes to broadening the patient's view on psychotherapy. Screen colleagues can also be used as co-therapists if they say existentially significant things and are referred to in the film debriefing. Love films are able to activate the 'erotic resources', to expand the patient's concept of love or to address the different forms of love. Addiction films have confrontational potential and addicted characters who overcome their dependence can serve as role models and provide discussion material on how an addiction-free life can

be successful. The silent film era already knew of film's therapeutic effect, and modern film therapy has confirmed this experience.

What is imperative for cinema therapy is phenomenological and in-depth hermeneutic studies that show the diversity of possible applications and empirical impact studies with clever research designs. Above all, however, what is needed is a courageous and creative generation of psychotherapists who implement cinema–therapeutic treatment programmes in outpatient and inpatient settings. For what must not be forgotten is that psychotherapy is not only a profession, science, ethics, and wisdom, but also art (Poltrum, 2020). Perhaps it is even the art of touching and moving patients with film.

Picture gallery

Le mystère des roches de kador, **Léonce Perret,** 1912 Source: *Le mystère des roches de kador* live@stadtkino Basel.mov www.youtube.com/watch?v=SYLjxp5CAPk [last accessed 6 October 2024].

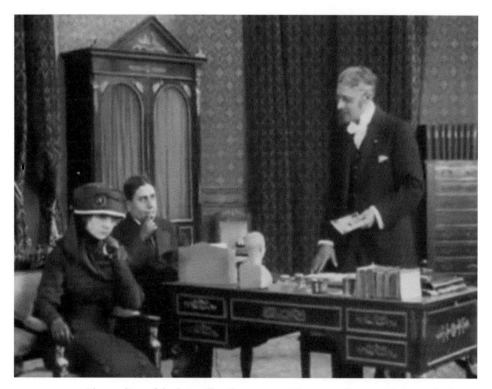

FIGURE 30.1 The reading of the last will and testament: The minor Suzanne de Lormel inherits the estate of her deceased uncle. His cousin Ferdinand de Kéranic is appointed as her legal guardian and property administrator until Suzanne comes of age. Out of financial necessity, he initially decides to marry Suzanne, but she refuses. After this failed attempt, de Kéranic plans an assassination of the man she loves.

FIGURE 30.2 At the time of the reading of the will, Suzanne is happily in love with Captain Jean d'Erquy (man in the boat). The deceased uncle's cousin asks him to a rendezvous at the Kador rocks in a forged letter signed in Suzanne's name. He ambushes the captain and shoots him. Suzanne is also lured to the beach and faints from the effect of knock-out drops administered to her earlier.

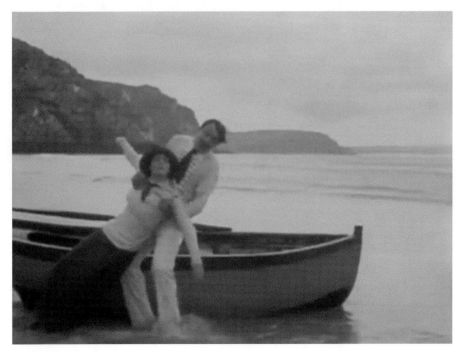

FIGURE 30.3 The captain survives the assassination attempt, he regains consciousness but is wounded. Now he finds Suzanne lying unconscious on the beach. With his last ounce of strength, he drags her into the boat and tries to get help. Eventually he breaks down from exhaustion and faints.

FIGURE 30.4 Sometime later Suzanne comes round and sees that her lover is wounded and bleeding. Presumably, she thinks he is dead. Suzanne is shocked and faints again. A little later they are both found and taken to hospital.

FIGURE 30.5 Since this trauma, Suzanne has lapsed into a stupor and her late uncle's cousin seems to have reached his objective, because the will states that the estate remains in the possession of the guardian in the event of Suzanne's death or serious illness.

FIGURE 30.6 The recovered beloved, Captain Jean d'Erquy, cannot and will not forget Suzanne. He seeks out a pioneer of cinema therapy and tells him the whole story. The pioneer shows the captain a paper he has recently given a lecture on. It reads: 'Communications of the "Medical Society" in Paris on Professor Williams's experiences with the application of cinematography to the mentally ill. This wonderful invention, hitherto used by a small number of physicians, will soon acquire a leading place in medicine.'

FIGURE 30.7 According to the idea of using film as a 'wake-amine' (analeptic amine), the first film–therapeutic medication in the history of cinema therapy is developed. On the beach by the Kador rocks, what happened is re-enacted and filmed.

FIGURE 30.8 The film is successful and contains the scenes that had taken place before the terrible moment that traumatized Suzanne. The sight of something terrible makes people freeze, we have known that since the myth of Medusa.

FIGURE 30.9 The petrified Suzanne is now shown what she missed due to the knock-out drops and her unconsciousness.

FIGURE 30.10 The stimulus and emotion of the experienced and recounted story touch and move the traumatized woman.

FIGURE 30.11 The light turns on. Suzanne stands up and wants to reach for her beloved.

FIGURE 30.12 The couple embraces. Professor Williams is immensely proud of the successful therapeutic intervention. Assistant physicians discuss the mechanism of action and head nurse Hildegard is moved to tears by the story's happy ending. The film is a medication.

Notes

1. *Der Filmbote*, No. 30, 24 July 1926, p. 20. Available at: https://anno.onb.ac.at/cgi-content/anno?aid=fib&datum=19260724&seite=20&zoom=33 [last accessed 10 August 2023].
2. The film is available at www.youtube.com/watch?v=SYLjxp5CAPk [last accessed 10 August 2023]. See also https://fr [last accessed 6 October 2024].
3. To give a visual impression and to better understand the cinema–therapeutic intervention of the film, see the picture gallery at the end of this contribution.
4. The Anton Proksch Institute in Vienna is one of the largest addiction clinics in Europe, where all forms of addiction are treated.
5. The author has compiled a bibliography on cinema therapy on her homepage, available at: www.cinematherapy.com/bibliography.html [last accessed 6 October 2024].
6. Or in a different translation: 'the greatest foundation of medicine is love' (Gantenbein, 2017, 2).
7. See https://en.wikipedia.org/wiki/The_Fountain_of_Youth_(Cranach) [last accessed 6 October 2024].
8. Cf.: https://en.wikipedia.org/wiki/Colour_wheel_theory_of_love [last accessed 6 October 2024].
9. The literal translation of the German dubbed version would be: Frankie: 'I just need one more kick, one more shot.' Molly: 'Oh, I see. Here's the money. I'll give it to you, I'll give it all to you. Because you know what comes after this last shot. The very last one and then another and then another. Here take it. Keep it! Why should you suffer like other people! Yes, you

haven't had much luck in your life so far. Why should you bear it gracefully like most people do. No, you make a big pain out of everything that hurts and then you numb it with a shot.'

References

Abedin, A., & Molaie, A. (2010). The effectiveness of Group Movie Therapy (GMT) on parental stress reduction in mothers of children with mild mental retardation in Teheran. *Procedia – Social and Behavioral Sciences 5*, 988–993. https://doi.org/10.1016/j.sbspro.2010.07.223.

Akhtar, S. (2000). Mental pain and the cultural ointment of poetry. *International Journal of Psychoanalysis 81*, 229–243. https://doi.org/10.1516/0020757001599690.

Berg-Cross, L., Jennings, P., & Baruch, R. (1990). Cinematherapy: Theory and application. *Psychotherapy in Private Practice 8*, 135–156. https://www.tandfonline.com/doi/abs/10.1300/J294v08n01_15.

Binswanger, L. (1962). *Grundformen und Erkenntnis menschlichen Daseins*. Third edition. Ernst Reinhardt Verlag.

Bliersbach, G. (2002). Die Therapie im Kinosessel. *Psychologie heute 2*, 36–41.

Bollas, C. (1987). *The shadow of the object: Psychoanalysis of the unthought known*. Columbia University Press.

Bollnow, O. F. (2009). *Das Wesen der Stimmungen*. Verlag Königshausen & Neumann.

Caneppele, P., & Balboni, A. L. (2006). Film als Heilmittel? Die Kino-Debatte in der medizinischen Welt während der Stummfilmzeit. In T. Ballhausen, G. Krenn, & L. Marinelli (Eds.), *Psyche im Kino. Sigmund Freud und der Film* (pp. 55–76). Verlag Filmarchiv Austria.

Crothers, S. M. (1916). A literary clinic. *Atlantic Monthly 118*, 291–301.

de Rougemont, D. (1987). *Die Liebe und das Abendland*. Diogenes Verlag.

Dermer, S. B., & Hutchings, J. B. (2000). Utilizing movies in family therapy: Applications for individuals, couples, and families. *The American Journal of Family Therapy 281*, 163–180. https://doi.org/10.1080/019261800261734.

Doering, S., & Möller, H. (Eds.). (2014). *Mon Amour trifft Pretty Woman. Liebespaare im Film*. Springer Verlag.

Dumtrache, S. D. (2014). The effects of a cinema-therapy group on diminishing anxiety in young people. *Procedia – Social and Behavioral Sciences 127*, 717–721. https://doi.org/10.1016/j.sbspro.2014.03.342.

Egeci, I. S., & Gencöz, F. (2017). Use of cinematherapy in dealing with relationship problems. *The Arts in Psychotherapy 53*, 64–71. http://dx.doi.org/10.1016/j.aip.2017.02.004.

Fatemi, S. M. (2022). *Film therapy. Practical applications in a psychotherapeutic context*. Routledge.

Gantenbein, L. (2017). Poison and its dose: Paracelsus on toxicology. In P. Wexler (Ed.), *Toxicology in the middle ages and renaissance* (pp. 1–10). Elsevier Academic Press.

Gelkopf, M., Gonen, B., Kurs, R., Melamed, Y., & Bleich, A. (2006). The effect of humorous movies on inpatients with chronic schizophrenia. *The Journal of Nervous and Mental Disease 194* (11), 880–883. https://doi.org/10.1097/01.nmd.0000243811.29997.f7.

Gilmour, D. (2010). *The film club. No school. No work. Just three films a week*. Ebury Press.

Grafl, F. (2008). Lust am Schauen & Freude am Lesen? Zur Rezeptionsästhetik zweier Medien – Nachdenken über Buch und Film. *Medienimpulse 64*, 63–68.

Gramaglia, C., Abbate-Daga, G., Amianto, F., Brustolin, A., Campisi, S., De-Bacco, C., & Fassino, S. (2011). Cinematherapy in the day hospital treatment of patients with eating

disorders. Case study and clinical considerations. *The Arts in Psychotherapy 38*, 261–266. https://doi.org/10.1016/j.aip.2011.08.004.

Gross, R. (2012). *Der Psychotherapeut im Film*. Kohlhammer Verlag.

Heidegger, M. (1994). Die Frage nach der Technik. In M. Heidegger (Ed.), *Vorträge und Aufsätze* (pp. 9–40). Verlag Günther Neske.

Heidegger, M. (1996). *Being and time. A Translation of Sein und Zeit*. State University of New York Press.

Hesley, J. W., & Hesley, J. G. (1998). *Rent two films and let's talk in the morning: Using popular movies in psychotherapy*. Wiley.

Izod, J., & Dovalis, J. (2015). *Cinema as therapy. Grief and transformational film*. Routledge.

Kessler, F., & Lenk, S. (2006). Die Anwendung der Kinematographie auf Gemütskranke. Le Mystère des roches de kador (1912). In T. Ballhausen, G. Krenn, & L. Marinelli (Eds.). *Psyche im Kino. Sigmund Freud und der Film* (pp. 41–54). Verlag Filmarchiv Austria.

Lampropoulos, G. K., Kazantzis, N., & Dane, F. P. (2004). 'Psychologists' use of motion pictures in clinical practice. *Professional Psychology: Research and Practice 35*, 535–541.

Lee, J. A. (1973). *The colors of love. An exploration of the ways of loving*. New Press.

Mainberger, G. K. (1996). Rhetorische Techne (Nietzsche) in der psychoanalytischen Technik (Freud). Prolegomena zur Rationalität der Psychoanalyse. In J. Figl (Ed.), *Von Nietzsche zu Freud. Übereinstimmungen und Differenzen von Denkmotiven* (pp. 59–69). WUV-Universitätsverlag.

Mangin, D. (1999). Cinema therapy: How some shrinks are using movies to help their clients to cope with life and just feel better. *Health and Body*. 27 May. Available at: www.salon.com/1999/05/27/film_therapy/ [last accessed 6 October 2024].

Marsik, E. (2010). Cinematherapie with preadolescents experiencing parental divorce: A collective case study. *The Arts in Psychotherapy 37*, 311–318. https://doi.org/10.1016/j.aip.2010.05.006.

Molaie, A., Abedin, A., & Heidari, M. (2010). Comparing the effectiveness of group movie therapy (GMT) versus supportive group therapy (SGT) for improvement of mental health in grieving adolescent girls in Tehran. *Procedia – Social and Behavioral Sciences 5*, 832–837. https://doi.org/10.1016/j.sbspro.2010.07.194.

Paracelsus (1988). *Selected writings*. Edited by J. Jacobi, translated by N. Guterman. Princeton University Press.

Plato (2002). *Phaedrus*. Translated by R. Waterfield. Oxford World Classics. Oxford University Press.

Poltrum, M. (2016). Nervöse Zeiten. Modediagnose Neurasthenie. In M. Poltrum, *Philosophische Psychotherapie. Das Schöne als Therapeutikum* (pp. 248–253). Parodos Verlag.

Poltrum, M. (2020). Therapeutisches Wissen im Lichte der Nikomachischen Ethik des Aristoteles. Psychotherapie als Kunst, Profession, Wissenschaft und Weisheit. In A. Pritz, J. Fiegl, H. Laubreuter, & B. Rieken (Eds.), *Universitäre Psychotherapieausbildung, am Beispiel der Sigmund Freud Privatuniversität* (pp. 169–186). Pabst Science Publishers Verlag.

Powell, M. L. (2008). *Cinematherapy as a clinical intervention: Theoretical rationale and empirical credibility*. University of Arkansas: UMI Dissertation Publishing.

Schlozman, S. (2021). *Film. Arts for health*. Emerald Publishing Limited.

Sharp, C., Smith, J. V., & Cole, A. (2002). Cinematherapy: Metaphorically promoting therapeutic change. *Counselliing Psychology Quaterly 15*, 269–276.

Sinnerbrink, R. (2012). Stimmung: Exploring the aesthetics of mood. *Screen 53* (2), 148–163. https://doi.org/10.1093/screen/hjs007.

Turns, B., & Macey, P. (2015). Cinema narrative therapy: Utilizing family films to externalize children's 'problems'. *Journal of Family Therapy 37*, 590–606. https://doi.org/10.1111/1467-6427.12098.

Wolz, B. (2005). *E-motion picture magic. A movie lover's guide to healing and transformation.* Glenbridge Publishing Ltd.

Wolz, B. (2008). *And the Oscar goes to … Sigmund Freud.* Available from: www.springermedizin.at/fachbereiche-a-z/p-z/psychiatrie-undpsychotherapie/?full=835

Zur, O. (2022). *Cinema therapy.* Available at: www.zurinstitute.com/clinical-updates/cinema-therapy/ [last accessed 6 October 2024].

Filmography

Almodóvar, Pedro. (2009). *Broken Embraces*
Aronofsky, Darren. (2000). *Requiem for a Dream*
Berri, Claude. (2007). *Hunting and Gathering*
Bertulucci, Bernardo. (1972). *Last Tango in Paris*
Camp, Brandon. (2009). *Love Happens*
Coixet, Isabel. (2008). *Elegy*
Curtiz, Michael. (1942). *Casablanca*
Derflinger, Sabine. (2002). *Vollgas*
Gillespie, Craig. (2007). *Lars and the Real Girl*
Hackford, Taylor. (2004). *Ray*
Kaufman, Philip. (1988). *The Unbearable Lightness of Being*
Leven, Jeremy. (1995). *Don Juan DeMarco*
McQueen, Steve. (2011). *Shame*
Medem, Julio. (1998). *Lovers of the Arctic Circle*
Mills, Mike. (2010). *Beginners*
Murphy, Ryan. (2010). *Eat, Pray, Love*
Perrets, Léonce. (1912). *Le mystère des roches de Kador.* Available at: www.youtube.com/watch?v=SYLjxp5CAPk [last accessed 6 October 2024].
Preminger, Otto. (1955). *The Man with the Golden Arm*
Ramis, Harold. (1999). *Analyze This*
Schlöndorff, Volker. (1991). *Homo Faber*
Streisand, Barbara. (1991). *The Prince of Tides*
Svoboda, Antonin. (2005). *Spiele Leben*
Van Sant, Gus. (1997). *Good Will Hunting*
Weir, Peter. (1989). *Dead Poets Society*
Wilder, Billy. (1945). *The Lost Weekend*
Zemeckis, Robert. (1994). *Forrest Gump*
Zemeckis, Robert. (2012). *Flight*

CHAPTER 31

CONNOISSEURS OF THE SOUL, PSYCHO VILLAINS

Psychotherapists, Psychologists, and Psychiatrists in Feature Films and Series

MARTIN POLTRUM

INTRODUCTION

ANYONE who wants to understand the changing image of psychiatry and the social perception of the mentally ill in the twentieth and twenty-first centuries cannot ignore the mass medium of film. In a society that is shaped by mass media, reality is increasingly what is constructed as reality via the use of media. This is especially true for the representation of psychotherapy in film, for the first psychotherapists appeared on the screen shortly after the establishment of cinema. The image of psychologists and many key concepts of psychoanalysis were thus popularized by Hollywood (Illouz, 2008, 53). According to estimates, there are now well over five thousand feature films on the subject of psychotherapists, psychologists, and psychiatrists in film (cf. Rabkin, 1998; Flowers & Frizler, 2004a, 2004b) whereby film, like lay people, struggles to neatly distinguish these professions. The fact that psychotherapy has been able to triumph over the last two centuries to such an extent that by now every fifteen-year-old knows what the unconscious, repression, and projection are, is certainly not due to a sense of mission of a small Viennese circle that met every Wednesday from autumn 1902 onwards.[1] It is rather due to the fact that film broadcast the image of the therapist into the living rooms of an audience of millions.

Casually speaking, one could say that Europe invented modern psychotherapy, falling on fertile ground in Hollywood, which was then modified and cinematically processed by the hegemony of the American film industry, sent all over the world, and re-imported into its continent of origin, as Eli Zaretsky aptly put it (cf. Zaretsky, 2004).

The reasons why Hollywood became interested in the portrayal of the psychotherapist were manifold. Firstly, many influential film producers, such as David O. Selznick, who had Hitchcock under contract, were themselves undergoing psychoanalytic treatment, as was the fashion in 1940s Hollywood to have the world's as well as one's own personal problems explained through analysis (cf. Illouz, 2008, 53). Psychoanalysis was in the air everywhere, so to speak. Secondly, the portrayal of psychotherapists and their patients could serve 'a romantic interest for misunderstood individuals' and the portrayal of mental disorders and their treatment could offer 'convincing explanations for mysterious behaviour', thus increasing the emotional grip on the film audience (Gabbard & Gabbard, 1987, 252). Thirdly, psychoanalysis was particularly predisposed to the film world, 'because it could generate new visual symbols (e.g., so-called phallic symbols), help introduce interesting variations to well-known genres (e.g., the psychoanalyst becomes the detective, and the clues to be deciphered are dream fragments), give added psychological depth to characters (as when the psychoanalyst interprets a character's psyche), and bestow on the movie a new (fantastical) aesthetic through dream sequences' (Illouz, 2008, 54).

The representation of psychotherapy or psychotherapists in film is not only found in feature films and series, but also in documentaries such as the *Sigmund Freud Home Movies* (1930–1939)[2] or *Let There Be Light* (1946),[3] semi-documentaries such as *My Name Was Sabina Spielrein* (2002), experimental films such as *Starring Sigmund Freud* (2012),[4] journalistic reportage films such as *Yalom's Cure* (2014) and (scientific) educational films such as *Three Approaches to Psychotherapy I* (1965), *II* (1977), and *III* (1986),[5] *Kind of Blue: James Hillman on Melancholia & Depression* (1992),[6] or in *How to Change your Mind* (2022). In the following article, primarily feature films and series will be discussed.

The Beginnings of the Psychotherapist Film

The history of modern psychotherapy and the beginnings of cinema date to the year 1895—in Vienna, Breuer and Freud published their studies on hysteria, and the Lumière brothers organized the first public film screenings in Paris. Or to give another coordinate: at the same time as Freud published *The Interpretation of Dreams* (1900), the French film pioneer Georges Méliès shot his astonishing short films, which impressively show that film had visionary potential very early on, as documented by the film *Le voyage dans la lune* (1902). This new medium has always taken up avant-garde themes, which is also shown by the fact that the first therapists appeared on screen as early as 1906,[7] 1909,[8] and in the 1910s[9] and 1920s,[10] i.e., shortly after the birth of psychoanalysis.

In Fritz Lang's *Dr. Mabuse the Gambler* (1922), for example, the super criminal Dr Mabuse, endowed with demonic hypnotic power, appears in the second act in his

bourgeois profession as a psychoanalyst and gives a lecture entitled: 'Psychoanalysis as a factor in modern medicine'. The auditorium is enthusiastic, as Mabuse opines:

> If I succeed in establishing contact between doctor and patient in such a way that disturbing influences from third parties are absolutely excluded, then I harbour a strong conviction that in the future 80% of all nervous diseases can be cured by psychoanalysis.

Cure rates like these can only make one envious these days. Mabuse, who in one scene is announced as one of the 'most famous psychoanalysts' to the waiting guests at a Séance, manipulates stock market prices, murders, and goes on a criminal rampage until almost the end of the second part, where he is confronted by the police, goes insane, and his murder victims appear to him as hallucinations. Paul Federn, one of Freud's first peers, was outraged and, shortly after the film's premiere on 1 November 1922, proposed a notice of protest at a meeting of the psychoanalytical Wednesday Society, against the malicious use of psychoanalysis in film. Freud rejected this, advised restraint, suggesting one should ignore this provocation and not touch upon the low points of the mass medium of film (cf. Gross, 2012, 22). Freud did not want anything to do with the film and even Sam Goldwyn's $100,000 offer, which was made in 1924 to the father of psychoanalysis, could not change that. This was unfortunate for Goldwyn as he would have liked Freud to collaborate on 'a really great love story' (Zaretsky, 2004, 145). As written in a letter to Karl Abraham on 9 June 1925, Freud's objection as to why he did not want psychoanalysis to be associated with film was: 'My chief objection is still I do not believe that satisfactory plastic representation of our abstractions is at all possible. We do not want to give our consent to anything insipid' (Freud in Gross, 2012, 23).[11] In 1926, the time had come and there was no stopping a full-length feature film on psychoanalysis. With Goldwyn's financial support, Austrian film director Georg Wilhelm Pabst shot *Secrets of a Soul* (1926). Karl Abraham and Hans Sachs, two of Freud's companions, acted as psychological advisors (Zaretsky, 2004, 145). The story itself is a little overloaded and bizarre. An impotent chemistry professor, who suffers from a phobia of touching knives after having had a nightmare in which he stabbed his wife with a dagger, is cured by psychoanalysis. This was a silent film about speech cure that was intended to educate the people. A brochure handed out before the screening and the film's opening credits explained what psychoanalysis was. In 1926 it was obviously still necessary to elucidate in a clear way at the beginning of the film:

> Inside every person there are desires and passions which remain unknown to the 'consciousness'. In the dark hours of psychological conflict, these 'unconscious' drives attempt to assert themselves. Mysterious illnesses arise from such struggles, the resolution and cure of which form the field of psychoanalysis. In the hands of the 'psychoanalytically trained' doctor, the teachings of university professor Sigmund Freud represent an important advance in the treatment of these types of psychological

illnesses. The events in this film are taken from life. They do not deviate in any important factual way from the actual medical case history.

Explanations of this kind in the opening credits of a 'psychoanalytic film' can still be found in later productions, e.g., in Hitchcock's *Spellbound* (1945)[12] but no longer, as exhibited by *The Snake Pit* (1948). Yet, by the time Hitchcock's *Marnie* was released in 1964, a broad cinema audience could be assumed to know what psychotherapy and especially what psychoanalysis was. Significantly, in one scene the title character Marnie (Tippi Hedren), said to her husband Mark Rutland (Sean Connery), who posed as the amateur analyst for his frigid, kleptomaniac, and traumatized wife by constantly analyzing her symptoms:

> You're really dying to play doctor, aren't you? Okay, I'm a big movie fan. I know the games. Come on, let's play. Shall I start with dreams or should we free-associate? Oh, Doctor, I'll bet you're just dying to free-associate. All right now, you give me a word and I'll give you an association.

Psychoanalysis has obviously become so widespread that now it does not need a lengthy explanation to understand what it is. Film played an essential part in the establishment of psychotherapy, to which Marnie even alludes to with 'okay, I'm a big movie fan. I know the games'.

Therapists on Screen Are More Than Dr Dippys, Dr Evils, Dr Wonderfuls, or Dr Hornys

The psychotherapists or psychiatrists of very early film, who dealt with the psyche in a rather 'amateurish' way and with 'manipulative intention' (Herb, 2012, 30), are portrayed either as 'hypnotists', 'clairvoyants', or other dubious bogus experts (1999, 37), according to Karin and Glen Gabbard, who wrote *Psychiatry and the Cinema*, probably still the most readable book on the subject. Throughout film history, there have been four main recurring ways in which screen colleagues are portrayed. According to Irving Schneider (1985, 1987, 2002), to whom we owe the most famous, repeatedly cited typology of the psychotherapist in film, there are the following three types: Dr Dippy, Dr Evil, and Dr Wonderful. The author even goes so far as to state: 'All movie depictions of therapists can be seen as featuring one or another of these types (Schneider, 2002, 402)'.

Dr Dippy is the 'familiar comical movie psychiatrist – the one who is crazier or more foolish than his patients. (…) Whatever theory Dr. Dippy uses, in his hands it lacks or defies common sense. His treatment methods tend to be bizarre, impractical, or unusual. Fortunately, they seldom do any harm' (Schneider, 1987, 997). Classic, older, and

more recent films featuring these lovable, quirky shrinks with their comical advice and bizarre treatment methods include *Carefree* (1938), *What's New Pussycat?* (1965), *High Anxiety* (1977), *What About Bob?* (1991), *Analyze This* (1991) or *Analyze That* (2002). Dr Ben Sobel (Billy Crystal in *Analyze This*), who is more or less forced to treat mob boss Paul Vitti (Robert De Niro), who suffers from panic attacks, is perhaps one of the most famous portrayals of a Dr Dippy. Dr Sobel is disempowered by his patient from the very first moment. Paul Vitti sits down in the therapist's chair in the first session, dominates the proceedings, gains the upper hand, and makes his therapist, whom he even harasses during his honeymoon, look quirky and ridiculous. Two contrasting milieus clash in the film, that of the hard men and that of the empathetic softies. In the course of the plot, the mafia and therapist milieus interpenetrate more and more. At one point Dr Sobel is forced to accompany his patient and gets involved in a shooting. He only survives it by a hair's breadth, and shortly afterwards he is shown in a therapy scene treating a couple and the joy that he is still alive flows into this session.

> ELAINE: 'I want to please him when we're in bed … but whatever I do, it seems like it's never enough. Now he wants me to say things when we're making love.'
> DR SOBEL: 'What kind of things does he want you to say?'
> ELAINE: 'Well, he wants me to call him … "big boy" … and he's my "bucking bronco" … and I'm supposed to "ride him hard" … and "put him back in the barn wet."'
> HUSBAND: (sits silently beside her and nods).
> DR SOBEL: (leans his head back in the armchair and smiles).
> ELAINE: 'Are you okay, Dr Sobel?'
> DR SOBEL: 'Well, it's … (sighs contemplatively) … Here's what I think you should do, Elaine. I would do whatever he says. If he wants you to talk, talk. I'd get down and bark like a dog. I'd do whatever it takes. Smoke some joints, drink wine, whatever it is … to get off on each other and be happy. Look at the two of you … Where are you running? This is the time to be happy! Because life is just too short. It's just too fucking short.'
> ELAINE: 'Okay.'
> HUSBAND: (grins delightedly).

In addition to such peculiar and rather unusual therapeutic interventions and advice, it may happen that a Dr Dippy makes phone calls or falls asleep during the session, such as Dr Saul Benjamin in *Lovesick* (1983).

It is anything but harmless when a Dr Evil is at work, who 'has an urge to master or control, often for criminal purposes, but just as often for the sheer pleasure in power. He is willing to experiment without regard to human consequences, and those who come under his control are often driven to murder, suicide, or crime. When he treats patients, he is likely to use methods seen as coercive: electroconvulsive therapy (ECT), lobotomy, drugs' (Schneider, 2002, 402). Examples of Dr Evils would include Dr Caligari in *The Cabinet of Dr. Caligari* (1920), Dr Robert Elliott in *Dressed to Kill* (1980), Dr Victoria Siebert in *Side Effects* (2013), the psychologist Jean Holloway in the Netflix series *Gypsy*

(2017), or Dr Lilith Ritter in *Nightmare Alley* (2021). Incitement to murder, intrigue, emotional exploitation and manipulation are the methods of these evil therapists.

A whole army of Dr Evils can be found in anti-psychiatry films, for example in Miloš Forman's *One Flew Over the Cuckoo's Nest* (1975), which won all five Oscars in the main categories in 1976 and till then had been United Artists' biggest financial success (Shorter, 1997, 275). The film's protagonist, Randle Patrick McMurphy (Jack Nicholson), had had consensual sex with a minor, was sent to prison for it and shortly afterwards was transferred to a psychiatric ward to determine whether he was mentally ill, according to the film's plot. He finds his antagonist in the passive-aggressive head nurse Mildred Ratched (Louise Fletcher). The psychiatrists soon agree that McMurphy indeed is a potentially dangerous rebel, but certainly not so mentally ill[13] that he belongs locked up in a psychiatric ward. Since the real powerhouse of the clinic, the icy and heartless Nurse Ratched, asserts herself with the argument that he should be kept in the clinic for further observation, a 'duel' between the patient and the head nurse ensues during the course of the film. Randle hijacks a bus parked outside the hospital, drives to a lake with his fellow patients and takes a boat there, which can be read as an allusion to Michel Foucault's *Madness and Civilisation: A History of Insanity in the Age of Reason* (1988) and to the topic of the ship of fools[14] discussed in the book. After Randle sets sail with his crew to go fishing, he is brought back to the psychiatric ward and is subjected to ECT[15] as punishment.

Eduard Shorter (1997, 282 f.) reports that ECT became the predominant treatment for bipolar disorder and major depression in the United States in 1959 and at that time no one had anticipated that this form of treatment would fall out of favour and almost vanish into thin air as a result of the anti-psychiatry movement and *One Flew Over the Cuckoo's Nest* (1975), the main film of this movement.

After Randle commits another intolerable transgression by organizing an illegal party with alcohol and easy girls and the ward is found chaotic and trashed the next morning, the head nurse retaliates by threatening Billy Bibbit, one of Randle's fellow patients. She threatens to tell his mother, that he has had sex for the first time in his life that night which has resulted in his stutter being stopped. (We are in the wild sixties—in 1962 the novel of the same name was published—and the seventies, in which the idea that 'sex cures' was widespread.) Enraged, McMurphy attacks his antagonist, lunges on her and begins to strangle her. Overpowered by nurses and carers, he is punished by a lobotomy[16] a few days later.

Between 1936 and 1951, 18,608 people underwent lobotomies[17] in the United States (cf. Shorter, 1997, 228) and were thus maimed in a similar way to Randle in the film. Probably one of the most prominent patients ever treated with a lobotomy was the eldest sister of John F. Kennedy. Rosemary Kennedy's mental abilities were reduced to those of a two-year-old child after her lobotomy (performed in 1941 at the age of twenty-two); she could neither walk nor speak intelligibly and was incontinent.[18] By the time the lobotomy was staged in *One Flew Over the Cuckoo's Nest* (1975),[19] this intervention had long been history in the United States and the cinematic depiction of this treatment can be read as the anti-psychiatry movement's late revenge on the atrocities of psychiatry.

Besides Miloš Forman's film, based on Ken Kesey's 1962 novel of the same title, there was another film that won all five Oscars in the main categories and was also anything but a promotional film for the profession of psychiatry. In *The Silence of the Lambs* (1991), we meet the psychiatrist, cannibal, and serial killer Dr Hannibal Lecter (Anthony Hopkins) in the high-security wing of a forensic psychiatric ward, who occasionally even consumes a patient with a glass of Chianti and who is to be persuaded by CIA agent Clarice Starling (Jodie Foster) to find another serial killer through his expertise as a psychopath and psychiatrist.[20]

Fortunately, the image of Dr Wonderful—ironically speaking, the way psychotherapists are in reality—can also be found again and again in the film, which according to Schneider can be characterized as follows:

> Dr. Wonderful is all that Dr. Evil is not. He is humane, earnest, modest, and deeply caring. He is always ready to come to the patient's rescue, whatever the time or circumstance. He is gifted at improvisation, especially when necessary to uncover traumatic events, and thereby achieves instant cures. His treatment is almost always the talking cure, seldom drugs or procedures seen as coercive.
>
> (2002, 403)

This archetype of the good and caring therapist was incomparably portrayed by Robin Williams in *Good Will Hunting* (1997). In this film, psychologist Sean Maguire offers his most personal experiences to his patient Will Hunting (Matt Damon) for the purpose of corrective relational experience and presumably out of sympathy as well. Will is a maths genius, highly talented, and has a photographic memory. Yet unfortunately, he is socially very difficult, does not let anyone get close to him, and always gets into fights. After one beating the judge is eventually fed up with Will and sends him to prison. Shortly before, Will, who works as a janitor at the renowned *Massachusetts Institute of Technology*, one evening while mopping the corridors there, effortlessly solves a mathematical problem that has been written on the blackboard and had been intended for students. Professor Lambeau, who discovers that it was the janitor who wrote the solution on the blackboard and had him searched, discovers that he is in prison and persuades the judge to let Will go. On the condition of attending therapy rather than serving time and on the condition that the professor takes care of his new protégé, he is released. After Will causes two of the professor's psychotherapist friends to fail in their first session, Sean Maguire comes into the picture. Gerald Lambeau and the psychologist know each other from their student days. Despite Sean Maguire's intensive efforts to take important steps towards establishing a therapeutic relationship in the first session, his socially incompetent patient completely abandons him. More than that, he gets personal and badmouths Dr Maguire in a very demeaning way. Through the malicious and insulting interpretation of a watercolour painting that Will discovers in the therapist's office and that was painted by the therapist, the session goes completely off the rails. The expressionistic-looking picture shows a man rowing a boat through storm and waves.

WILL: (and behind him the therapist, looking at the painting). 'You ever heard the saying, "Any port in a storm"?'
SEAN MAGUIRE: 'Yeah.'
WILL: 'Yeah, maybe that means you.'
SEAN MAGUIRE: 'In what way?'
WILL: 'Maybe you're in the middle of a storm. A big fucking storm. Yeah, maybe. The sky's falling on your head, the waves are crashing over your boat, the oars are about to snap, you're just pissing your pants, you're crying for the harbour. So maybe you do what you gotta do to get out. You know, maybe you became a psychologist.'
WILL: (turns to the therapist and looks directly at him).
SEAN MAGUIRE: 'Bingo. That's it. Let me do my job now (he taps Will on the shoulder and gestures to him where the door is). You're stopping me. Come on.'
WILL: (again looking at the painting). 'Maybe you married the wrong woman.'
SEAN MAGUIRE: 'Maybe you should watch your mouth. (Will now looks at the therapist again). Watch it right there, chief, all right?'
WILL: 'Well, that's it, isn't it? You married the wrong woman. What happened? What, she leave you? Was she, you know, banging some other guy?'

At this point the psychologist has had enough. He grabs his patient by the neck, shows that he overstepped the boundary and the patient is only able to say that the lesson is over. Will has unerringly hit the therapist's wound and poked it. In reality, such an argument would in most cases mean the end of the therapy, but not when a Dr Wonderful is at work. After the therapist has regained control of his countertransference feelings and they have cooled down overnight, Will shows up on time for the second session the next day, probably because he has to. Sean Maguire has decided to hold this session in a park and, sitting on a bench with his patient, finds clarifying words.

SEAN MAGUIRE: 'I thought about what you said to me the other day. About my painting. I stayed up half the night thinking about it. Something occurred to me. I fell into a deep, peaceful sleep and I haven't thought about you since. You know what occurred to me?'
WILL: 'No.'
SEAN MAGUIRE: 'You're just a kid. You don't have the faintest idea of what you're talking about.'
WILL: 'Why, thank you.'
SEAN MAGUIRE: 'It's all right. You've never been out of Boston.'
WILL: 'Nope.'
SEAN MAGUIRE: 'So if I asked you about art, you'd probably give me the skinny of every art book ever written. Michelangelo. You know a lot about him. Life's work, political aspirations, him and the pope, sexual orientation, the whole works, right? But I bet you can't tell me what it smells like in the Sistine Chapel. You've never actually stood there and looked up at that beautiful ceiling. Seen that (he looks up into the sky). If I ask you about women, you'll probably give me a syllabus of your personal favourites. You may have even been laid a few times. But you can't tell me what it feels like to wake up next to a woman and feel truly happy. You're a

tough kid. And I ask you about war, you'd probably throw Shakespeare at me, right? "Once more unto the breach, dear friends." But you've never been near one. You've never held your best friend's head in your lap and watched him gasp his last breath, looking to you for help. I ask you about love, you'd probably quote me a sonnet. But you've never looked at a woman and been totally vulnerable, known someone that could level you with her eyes. Feeling like God put an angel on earth just for you, who could rescue you from the depths of hell. And you wouldn't know what it's like to be her angel, to have that love for her be there forever, through anything, through cancer. You wouldn't know about sleeping sitting up in a hospital room for two months holding her hand, because the doctors could see in your eyes that the terms "visiting hours" don't apply to you. You don't know about real loss because that only occurs when you love something more than you love yourself. I doubt you've ever dared to love anybody that much. I look at you. I don't see an intelligent, confident man. I see a cocky, scared-shitless kid. But you're a genius, Will. No one denies that. No one could possibly understand the depths of you. But you presume to know everything about me because you saw a painting of mine. You ripped my fucking life apart. You're an orphan, right? Do you think I'd know the first thing about how hard your life has been, how you feel, who you are, because I read *Oliver Twist*? Does that encapsulate you? Personally, I don't give a shit about all that because you know what? I can't learn anything from you I can't read in some fucking book. Unless you wanna talk about you, who you are. Then I'm fascinated. I'm in. But you don't wanna do that, do you, sport? You're terrified of what you might say. Your move, chief.'

WILL: (is visibly touched by these honest and sincere words).

The film shows a total of seven[21] therapeutic sessions lasting approximately twenty-two minutes, with a total duration of two hours. In addition to the therapy scenes, we get to know Will's friends, see where and how he lives and, above all, how he meets the student Skylar and how a love affair develops between them. When things get serious and she wants Will to come with her to Stanford, where she intends to study medicine, he panics. Will, who had grown up in a working-class neighbourhood in Boston, as incidentally did his therapist, was an orphan who was repeatedly beaten up by his foster father. Therefore, he feels inferior, has a fear of loss and commitment and blocks the relationship with Skylar. In therapy he learns that he needs to overcome his fears and learns what it could mean to really commit to someone. Sean Maguire takes on the role of nurturing and wise father, the role of the caregiver of whom Will has been deprived so far in his life. In one of the last encounters, therapist and patient embrace, which is fitting for the way psychotherapy is portrayed in the film and not inappropriate. After all, they both benefit and learn from each other. Overall, the film has some of what Sándor Ferenczi described as 'mutual analysis' (Ferenczi, 1985; Dupont, 1988) and what Martin Buber (1970) referred to as real 'encounter' or what can be considered humanistic psychology and psychotherapy, in which open and honest interpersonal attention and a real relationship between patient and therapist is the medium of healing. Of course, the picture that *Good Will Hunting* (1997) paints of treatment is idealized and dramatized, and anyone who in reality intends to treat patients as the therapist does in

the film, would be well advised to treat only one patient a week, as Sean Maguire does. Everything else would be exploiting one's empathy with the danger of developing compassion exhaustion syndrome. Incidentally, when the film was released, many patients said that they wanted their therapists to show a similar commitment to the one Robin Williams demonstrated in *Good Will Hunting* (1997) (Gross, 2012, 97).

Many films show these good therapists and if there are film characters who motivate young people to become psychotherapists, psychologists, or psychiatrists, they are Dr Kick in *The Snake Pit* (1948), Dr Dysart in *Equus* (1977) Dr Rene in *Kopfstand* (1981), Dr Mickler in *Don Juan DeMarco* (1995), Dr Powell in *K-Pax* (2001), the psychologist Michael Hunter in *The Unsaid* (2001), Dr Blake in *Veronika Decides to Die* (2009), the psychologist Anna Kieffer in *Le Patient* (2022), and many others.

According to Irving Schneider, the distribution rates of Dr Dippys, Dr Evils, and Dr Wonderfuls are as follows: 35 per cent of films he studied[22] feature a Dr Dippy, 15 per cent feature a Dr Evil, and 22 per cent feature a Dr Wonderful (Scheider, 1987, 998), and as far as film history as a whole is concerned, the author believes that the two negative film images outnumber the positive image of the Dr Wonderful (Schneider, 2002, 403). Experts estimate that these distribution rates are relatively stable with minor fluctuations (Herb, 2012, 29) and recent research (Wahl et al., 2018) suggests that the behavioural repertoire of screen colleagues has not changed significantly.

From a sociological point of view, Dr Evil and Dr Dippy are probably seen as an expression of society's fears of the system of psychiatry and psychotherapy, and the figure of Dr Wonderful probably reflects society's wishes and longings for psychotherapy. Let there be at least one institution that can heal and make whole again what the exploitative and alienation-promoting society has broken, that which politics and education fail to protect. In short, the longing for an unscathed life. In any case, the portrayal of vicious, incompetent, and therapeutic 'boundary violating' (Gharaibeh, 2005, 316) psychotherapists who exploit and manipulate patients is likely to permanently undermine public trust in psychiatry and psychotherapy, fuel mistrust and fear (cf. Gabbard, 2001) and perhaps even lead to 'viewers (who) may be discouraged from seeking help' (Wahl et al., 2018, 238).

The presented typology, which Schneider empirically examined and substantiated in 1985, was supplemented by Harvey Roy Greenberg with the introduction of a fourth type, Dr Horny (Greenberg, 2000, 336). Indeed, there have always been psychotherapists in film who fall in love with their patients or their relatives, as in *The Prince of Tides* (1991), yet '[t]he spectacular eroticism of *Final Analysis* (1994) and *Basic Instinct* (1992) was a far cry from the chaste patient–therapist romance of earlier decades, and prompted the author 'to add another subtype to the Schneiderian categories – *Dr Horny*' (2000, 336). Dr Horny is the love-crazed and lustful therapist who focuses on seduction and erotic adventures and wants to get his patients in a horizontal position, and not just on the therapeutic couch.

As exciting and legitimate as it is to consider and ask which archetypal psychotherapy portrayals can be found in films and series—the recurring reference to Dr Dippy, Dr Evil, Dr Wonderful and Dr Horny—as great is the danger to overlook the

many mixed types and thus unclassifiable therapeutic film characters.[23] Above all, screen colleagues can also be used for didactic purposes and thus, we can learn from them beyond these stereotypical descriptions, for example, within the framework of training psychotherapists. A lecture on the portrayal of psychotherapists in film, e.g., as part of the study of psychotherapy science,[24] offers manifold possibilities to reflect on what psychotherapy is and can be. The analysis of screen colleagues can help to get a first idea of how psychotherapy could be designed. Should the therapist's personal life experiences and the communication of these be included in psychotherapy? If so, how much personal information can therapeutic sessions tolerate? What do the different schools say about this? … Similar questions to these can be thematized through films such as *Good Will Hunting* (1997). Needless to say, negative portrayals of therapy can also be used to draw attention to ethical problems in psychotherapy (Eichinger, 2021), or to address transference and countertransference. Not to mention the illustration and manifestation of lectures on the history of psychotherapy by showing and discussing historically accurate scenes from feature films such as *Freud—The Secret Passion* (1962), *A Dangerous Method* (2011), or from the BBC miniseries *Freud: the Life of a Dream* (1984),[25] or the *Sigmund Freud Home Movies* (1930–1939) screened by Marie Bonaparte and Mark Brunswick, allowing Freud himself to appear on film.

It is also exciting to take up Freud's idea that psychoanalysis is actually a 'cure by love' (Freud, 1907, 90) or, as stated in a letter to C.G. Jung of 6 December 1906, a 'cure [is] effected by love' (Freud, 1906, 12f.; see Kerr, 1993, 123) and that this topic is thematized via film scenes in which screen colleagues struggle with erotic transferences and countertransferences and discuss with training candidates how to deal with such emotional turbulence in therapy.

Erotic Infections, Therapists in Love, Healing Through Love

The first generation of psychoanalysts had great problems handling erotic infections between psychotherapists and patients, or expressed more nobly and technically, transference and countertransference love. What to do when the arrow of Cupid hits the centre of a therapeutic relationship? Carl Gustav Jung (Sabina Spielrein, Antonia Wolff), Sándor Ferenczi, (Gizella and Elma Palos), Georg Groddeck (Emmy of Voigt), Wilhelm Steckel (several patients), Victor Tausk (Hilde Loewi), August Aichhorn (Margarete S. Mahler), Otto Rank (Anaïs Nin), René Allendy (Anaïs Nin), and many others found it difficult to adequately handle the erotic turbulence that a therapeutic relationship can involve (cf. Krutzenbichler & Essers, 2010). Such turbulence is also naturally found in psychotherapist films.

In *Psychiatry and the Cinema* (1999), Krin and Glen Gabbard count 464 American films (from 1906 to 1998) in which psychotherapists appear. In forty-six films (between

1935 and 1998)—thus in almost every tenth therapist film—there is an extra-therapeutic erotic relationship between the treating psychotherapist and their patient. Sometimes the romantic desire for love predominates, sometimes sexual desire and lust are in the foreground. In terms of gender distribution, female therapists (twenty-nine films) are more often involved in erotic relationships compared to their male colleagues (seventeen films). More interesting than this distribution rate, however, might be the fact that female psychotherapists in film are very rarely able to heal male patients, unless they fall in love with their protégés and ultimately ensure their patients' recovery through the healing power of loving attention. From 1933 to 1987, there were thirty-two successful treatments of a female patient by a male psychotherapist as opposed to merely two successful treatments of men by their female therapists.

'We have only been able to find two American films in which a female psychiatrist effectively treats a male patient without falling in love with him. *Private Worlds* (1935) and *The Last Embrace* (1979) portray such successful treatments, but also in these two films, treatment involves hospitalization after a "breakdown" rather than analysis or therapy. Male therapists are more successful in treating female patients' (Gabbard & Gabbard, 1999, 161).

Women do not heal men in the film primarily with their skills, but with their love. A finding that should particularly interest feminist theorists and probably gives rise to the interpretation that women in the film are worse than their male colleagues. Interestingly, these encroachments and extra-therapeutic relationships are hardly presented in film as a problem of professional ethics, but as quite natural events of a therapy (Gross, 2012, 89). Unfortunately, no one can say exactly how large the total corpus of films is in which erotic infections between therapists and patients play an important role; at least I am not aware of any recent research in this regard.

Probably the most important film showing healing with and out of love is Hitchcock's *Spellbound* (1945), which 'presented to a wide audience the notion of the unconscious, the importance of dreams, the mechanism of repression, and the importance of language in the analytical cure' (Illouz, 2008, 53; Richter, 2000).

Ingrid Bergman plays Dr Constance Peterson, an initially emotionally closed psychoanalyst who is called 'iceberg' by one of her colleagues. The fact that Ingrid Bergman played the role of the therapist was an efficacious and ideal casting, since she had portrayed the epitome of the loving and suffering woman in *Casablanca* (1942) three years earlier (cf. Poltrum, 2014). In *Spellbound* (1945), Dr Peterson falls in love with her new boss and later patient Dr John Ballantine (Gregory Peck). When Dr Ballantine shows strange psychological symptoms—amnesia, traumatic attacks, and an identity disorder—it turns out that he is not the new head doctor of the psychoanalytic specialist clinic, Green Manor, that he claims to be. Additionally, he is even suspected of having murdered the actual head doctor Dr Edwardes. Dr Peterson and her patient flee to her teaching analyst Dr Brulov. He immediately recognizes that Dr Peterson is in love and that something is wrong. When he confronts her, she says:

DR PETERSON: 'You know only science, you know his mind but you don't know his heart.'
DR BRULOV: 'We are talking about a schizophrenic and not a valentine.'
DR PETERSON: 'We are speaking of a man.'
DR BRULOV: 'Oh, (laughs) a love. Look at you, Dr Peterson, the promising psychoanalyst, is now all of a sudden a school girl? In love with an actor, nothing else!'
DR PETERSON: 'Alex, let me tell you about him.'
DR BRULOV: 'What is there for you to see? We both know that the mind of a woman in love is operating at the lowest level of the intellect.' (…)
DR PETERSON: 'But you're right, I'm not an analyst, not even a doctor here. I'm not talking to you as one, but believe me, not what I say, but what I feel. The mind isn't everything, but the heart can see deeper sometimes. The shock of a police investigation might ruin his chances for recovery and I can save him.'
DR BRULOV: 'My dear, he killed Dr Edwardes, how can you help him?'
DR PETERSON: 'He didn't, he didn't!'
DR BRULOV: 'My dear, if it turns out, he did, which I am good and certain it will.'
DR PETERSON: 'It won't. You yourself taught me what Freud says: A man cannot do anything in amnesia other than his real character wouldn't have done.'
DR BRULOV: 'And how do you know what his real character is?'
DR PETERSON: 'I know. I know.'
DR BRULOV: 'She knows. This is the way science goes backward. Who told you what he is? Freud or a crystal ball?'
DR PETERSON: 'I couldn't feel this way toward a man who was bad, who had committed murder. I couldn't feel this pain for someone who was evil.'

With the trust that comes with love, Dr Peterson ultimately manages to persuade Dr Brulov to join her in the subsequent analytical treatment—an extremely brief short-term therapy (cf. Wulff, 1995, 123). Subsequently, she independently applies a final exposure therapy, which finally cures the patient and solves the murder of Dr Edwardes. *Spellbound* (1945) shows a variant of healing that can be found time and again in therapist films: healing as well as mutual liberation through love. Without her highly committed, loving attention, which can probably only be given to a loved one, Dr Peterson, like all the other actors in the film, would have believed Dr Ballantine to be guilty and malicious. This would have prevented the ultimately successful healing attempt and landed her lover in prison. Towards the end of the film, Dr Peterson recapitulates the events and says to her ex-patient: 'Well, you saved me.' Dr Ballantine counters, 'Ah, let's not have any confusion about who saved whom.' He is rid of his symptoms and she is no longer an 'iceberg'—love has 'cured' her too. It is interesting that already five years before Paula Heimann (1950, 81) wrote in her essay, *On Countertransference*, 'I have been struck by the widespread belief among candidates that the counter-transference is nothing but a source of trouble', thus pointing to a new, 'more comprehensive function of countertransference' (Gross, 2017, 220)—one that sees countertransference as an important instrument for exploring the unconscious—this idea is apparently alluded to

in the dialogue between Dr Peterson and Dr Brulov (cf. Gross, 2017, 219 f.). Dr Brulov: 'And how do you know what his real character is?' Dr Peterson: 'I couldn't feel this way toward a man (…), who had committed murder.'

The topic of the extra-therapeutic erotic relationship is dealt with in a humorous way by Woody Allen, as for example in *Deconstructing Harry* (1997). Allen has Helen (Demi Moore), a Jewish analyst, begin a love affair with one of her patients. Years later, she falls in love again with another patient. Both times, in the middle of treatments, she is heard saying: 'I think we should terminate your treatment and give it a substantial period of time and then if we both still feel the same way, then I think we could start to see each other, socially.'

What is only briefly but humorously hinted at in this film, is the topic of healing through love, which was an explicit theme in *Zelig* (1983). The film, conceived as a 'mockumentary' (Eichinger, 2017, 79), is about the fictitious autobiography of Leonard Zelig (Woody Allen), a New York patient from the 1920s who suffers from a peculiar disorder and symptoms. Zelig is afflicted with a diffusion of identity that extends into the somatic system, which baffles doctors and results in doctors passing the patient on and on. He is a kind of human chameleon. Depending on the situation and who he is dealing with, he is haunted by strange personality mutations. If his interaction partners are obese, Zelig's belly swells. When he talks to Asians, his eyes turn into slit eyes, and in the presence of people of colour, his skin darkens. Since it turns out after a short time that it is obviously a complex psychosomatic reaction and Zelig also suffers psychologically from a considerable identity diffusion, he soon ends up with Dr Eudora Fletcher (Mia Farrow), an uptight but cleverly intervening psychiatrist. In conversation with Dr Fletcher, Zelig pretends to be a psychiatrist—what else could he do, given his disorder. Dr Fletcher's therapeutic ploy is to now say that she is not actually a psychiatrist. This plunges Leonard into an identity crisis, as he now has no counterpart to imitate, and he realizes that one can only get through life with an identity of one's own. Woody Allen stages a 'universal parable about the desire to be loved and recognised, which (…) affects almost everyone' (Gross, 2012, 70). It is also funny that Zelig claims to have worked with Freud. However, there would have been a dispute and a rift over the question of penis envy. Unlike Freud, Zelig did not want the concept to be limited to women, because penis envy allegedly also existed among men. Here, however, it was not about having or not having that causes the envy, but about the shape and size. The psychoanalyst Dr Eudora Fletcher eventually finds out that already in his childhood, Zelig had been panic-stricken about being different and attracting attention. In conversation with her and due to the caused identity crisis, Zelig realizes that he has been living without an identity of his own. He then lets Dr Fletcher help him to have his own opinions and not to constantly conform. But in the end, the lasting and actual healing is achieved by love. Dr Fletcher and Leonard Zelig fall in love, get engaged, and marry. At the end of the film we hear from off-screen: 'Wanting only to be liked, he distorted himself beyond measure, … In the end it was, after all, … the love of one woman that changed his life.'

The theme of healing through love is impressively, and perhaps most beautifully demonstrated in a film directed by and starring a woman: Barbra Streisand's *The Prince of Tides* (1991). The film is about Dr Susan Lowenstein (Barbra Streisand), a New York analyst who has a seventeen-year-old son and is married to a world-famous and very narcissistic violinist. Dr Lowenstein treats the respected poet Savannah Wingo, who has just attempted suicide once more and has blocked out large parts of her life due to a dissociative disorder. Dr Lowenstein contacts Savannah's family in the South, because she suspects that the causes of Savannah's mental problems lie in her childhood and wants to close the gaps in the poet's memory by taking third-party anamnesis. This brings Savannah's twin brother Tom Wingo (Nick Nolte) into play. A burnt-out teacher and sports coach who has three daughters and who is in a marital crisis, as his wife Sally has met another man. Tom goes to New York and takes on the role of Savannah's lost memory, telling the psychoanalyst what happened in Savannah's childhood. The conversations between Dr Lowenstein and Tom Wingo, which are tedious and slow due to Tom's initial resistance, gradually uncover the causes of Savannah's problems: multiple traumas in the Wingo home. Tom talks about his despotic father, his eccentric mother, and his deceased brother. Soon he realizes that these conversations also have a therapeutic effect on him, which he initially resists. He, too, suffered greatly in his childhood. In contrast to his sister, however, he could not simply split off the traumas and fade them out through dissociation. With great and constant psychological effort, he managed a kind of incomplete repression over the years. In the course of the events, Tom Wingo and Susan Lowenstein get to know each other better and better and eventually fall in love. An extra-therapeutic love story begins, but it is short-lived. One day, when Tom sees children playing in the street and his wife calls at the same moment, he realizes that he belongs with his family in the South. Loving both women, he chooses his marriage and his children. At the end of the film we see a series of very touching images compressed into a few minutes: the farewell to Susan and New York and the return home to his family. We hear Tom's voice from off-screen:

> We [Susan and Tom] spent our last few hours together at the Rainbow Room, dancing a slow dance. Just like in my dream. I held her in my arms as I told her that it was her doing that I could go back. Six weeks before, I was ready to leave my wife, my kids. I wanted out of everything. But she changed that. She changed me. For the first time, I felt like I had something to give back to the women in my life. They deserved that. So I returned to my Southern home and my Southern life. And it is in the presence of my wife and children that I acknowledge my life, my destiny. I am a teacher, a coach and a well-loved man. And it is more than enough. In New York, I learned that I needed to love my mother and father in all their flawed, outrageous humanity. And in families, there are no crimes beyond forgiveness. But it is the mystery of life that sustains me now. And I look to the North and I wish again that there were two lives apportioned to every man and every woman. At the end of every day, I drive through the city of Charleston and as I cross the bridge that'll take me home I feel the words building inside me. I can't stop them or tell you why I say them. But as I reach

> the top of the bridge these words come to me in a whisper. I say them as prayer. As regret. As praise. I say 'Lowenstein'. 'Lowenstein'.

Love heals the injuries of the soul. In this film, too, the actual and lasting healing, the healing in the existential sense, the reconciliation with life and one's biography, is something that love brings about.

There are probably many speculative[26] answers to the question of why the theme of extra-therapeutic love relationships and healing through love is found so often in therapist films (e.g., also in *Mr. Jones* 1993). Possibly, the theme emerges in the feature film because an unconsciously repressed taboo vents itself here. An undesirable side effect of psychotherapy, the occurrence of extra-therapeutic, erotic love affairs between therapists and patients—which happens more often in reality than ethics committees, professional associations, and colleagues would like to admit—finds an outlet in the feature film. Another explanation would be that the topos of forbidden love creates an erotic tension as this love must not exist but is therefore particularly appealing. This can be elegantly served by such films—*The Thorn Birds* (1983) for therapists, so to speak. Perhaps, there is a truthfulness rooted in the love phenomenon, which is why the theme of healing through love appears again and again in psychotherapeutic films. A truth content that is vouched for and known in an occidental way of understanding love: namely, that love is a kind of medicine, a therapeutic agent for strengthening the ego and increasing self-esteem (on the subject of love in film, see also my contribution on cinema therapy in this volume). In the words of Paracelsus: 'the greatest foundation of medicine is love' (Paracelsus in Gantenbein, 2017, 2).

The fact that we can learn from film characters and that they occasionally problematize therapeutic concepts at a high level is also shown by the series[27] *In Treatment* (2008, season 1; 2009, season 2; 2010, season 3; 2021, season 4). In the first season, psychotherapist Paul (Gabriel Byrne), who has not had any physical closeness for some time, struggles with his amorous feelings for his patient Laura (Melissa George)—an anaesthetist who is very attractive and is constantly trying to seduce him. Of course, Paul discusses this with his supervisor Gina (Dianne Wiest), but this does not change the fact that Laura is right when she passionately accuses Paul that interpreting love as an event of transference from the past is a poor business.

> Laura: 'I know that, as a therapist, you tell yourself it's part of therapy to find out why I'm in love with you and how that's linked to my past ... but isn't that always the way it works, Paul? Doesn't our past always determine who we fall in love with? So what if you can trace it back to the withholding mother, the narcissistic father, the parent who's missing? Does that make our love any less real?'

How would Freud respond to this? Apart from the fact that he would agree with Laura[28] and perhaps would add: 'Transference-love has perhaps a degree less of freedom than the love which appears in ordinary life (...)' (Freud, 1915, 168).

Perhaps like this: 'He [the doctor] has evoked this love by instituting analytic treatment in order to cure the neurosis. For him, it is an unavoidable consequence of a medical situation, like the exposure of a patient's body or the imparting of a vital secret.' Perhaps even with the following addition: 'The lay public, about whose attitude to psycho-analysis I spoke at the outset, will doubtless seize upon this discussion of transference-love as another opportunity for directing the attention of the world to the serious danger of this therapeutic method. The psycho-analyst knows that he is working with highly explosive forces and that he needs to proceed with as much caution and conscientiousness as a chemist' Freud (1915, 169, 170).

Conclusion

Unfortunately, many aspects could not be addressed in this overview paper, partly for the sake of brevity and partly because we simply know too little. For example, the question of how couple therapy is portrayed in film, on which there is at least a small study (cf. Schlederer, 2019), or e.g., the question of how group therapies are shown in film or the question of how dream interpretation is staged in film and much more.

In regards to the narrative pattern of the representation of healing in psychotherapeutic films, it has been indicated time and again (Gabbard & Gabbard, 1999, 27–34; Gross, 2012, 112) that the successful cure in film very often has strong cathartic elements[29] and thus many aspects of a real therapy are kept quiet and unaddressed. Dramatic-emotional staging under violent surges of emotion lead to a therapeutic breakthrough, a cleansing discharge of negative emotions and the washing out of a trauma monster. Needless to say, such portrayals are also due to the fact that films have to focus on suspense and often only have ninety minutes to score points with the audience. The phases that often occur in real psychotherapy when nothing much happens, would hardly be suitable for a film.

In the vast majority of academic contributions on the topic of psychotherapists in feature films, the predominant perspective is that films represent the reality of mental disorders and their treatment in a truncated way and that we therefore cannot learn anything from films. Moreover, the prevailing attitude towards this medium is that it is the task of members of psycho-disciplines to elucidate the misrepresentations of films and to expose stereotypes. Initially, there is much legitimacy about this perspective. As the sole positioning on the subject of psychotherapists in film, it overlooks several things: Firstly, that historically it was film that contributed significantly to the popularization and establishment of psychotherapy.

Secondly, what an enormous didactic potential such films can have. Especially for young colleagues who first have to find out what psychotherapy is all about and can become. Thirdly, that engaging with screen colleagues can be very pleasurable, and fourthly, that some of them say very wise things if you listen to them carefully.

Film is an incredibly inspiring medium for psychotherapists. Even when, or perhaps especially when, it does not abide with depictions of reality. If film shows idealized or fairytale depictions of psychotherapy, as for example in *Don Juan DeMarco* (1995), then this does not detract from its learning potential. Moreover, it would be an indictment of one's shortcomings to believe that truth exists only in reality. Sometimes there is even more truth to be found in poetry, art, and film than in reality.

Notes

1. From this circle the *Viennese Psychoanalytical Association* emerged from 1908 onwards and finally in 1910 the *International Psychoanalytical Association* was formed.
2. The *Sigmund Freud Home Movies*, filmed by Princess Marie Bonaparte and Mark Brunswick, provide an intimate glimpse into Sigmund Freud's domestic life. See https://shop.freud.org.uk/products/dvd-sigmund-freud-home-movies-1930-39 [last accessed 6 October 2024].
3. See https://en.wikipedia.org/wiki/Let_There_Be_Light_(1946_film) [last accessed 6 October 2024]. This great documentary film about the treatment of war-traumatized American soldiers by John Huston can be seen in full here: www.youtube.com/watch?v=lQP0YVKeQEs [last accessed 6 October 2024].
4. The experimental film edited by John Menick, which contains documentary film scenes showing Freud, and Freud scenes from feature films assembled into an avant-garde found footage film, can be found at: www.youtube.com/watch?v=J6vw1Eos4S4 [last accessed 15 June 2023].
5. See https://psychedfilms.com [last accessed 6 October 2024].
6. See www.youtube.com/watch?v=V_sYFlhLrDY [last accessed 6 October 2024].
7. *Dr. Dippy's Sanitarium* (1906) shows one of the first 'mental health professionals' in the film (Gabbard & Gabbard, 1999, 35).
8. *The Criminal Hypnotist* (1909) by D. W. Griffith shows one of the first therapists in the film, who however, uses an older method: hypnosis.
9. *Le mystère des roches de Kador* (1912) by Léonce Perret—see also the contribution on cinema therapy in this volume—shows a film therapist using a film for psychotherapeutical purposes. For the film, go to: www.youtube.com/watch?v=SYLjxp5CAPk [last accessed 6 October 2024].
10. See *The Cabinet of Dr. Caligari* (1920) by Robert Wiene, *Dr. Mabuse the Gambler* (1922) by Fritz Lang, and *Secrets of a Soul* (1926) by G. W. Pabst.
11. Freud, S. (1925). Letter from Sigmund Freud to Karl Abraham, 9 June, 1925. The Complete Correspondence of Sigmund Freud and Karl Abraham 1907–1925, 52:546–547. Psychoanalytic Electronic Publishing. See https://pep-web.org/browse/document/ZBK.052.0546A [last accessed 6 October 2024].
12. In *Spellbound* (1945) the opening credits read: 'Our story deals with psychoanalysis, the method by which modern science treats the emotional problems of the sane. The analyst seeks only to induce the patient to talk about his hidden problems, to open the locked doors of his mind. Once the complexes that have been disturbing the patient are uncovered and interpreted, the illness and confusion disappear … and the devils of unreason are driven from the human soul.'

13. Rainer Gross (2012, 63) believes that most therapists would certainly immediately think of borderline personality disorder in the case of McMurphy, and Wulf Rössler (2017, 154) says that the main character of the film fulfils the criteria of a dissocial or antisocial personality.
14. Foucault (1988, 7 ff.) writes: 'Something new appears in the (…) Renaissance (…): the Ship of Fools (…). (…) Sebastian Brant's *Narrenschiff* (1494), (…). Bosch's painting (…). But of all these romantic or satiric vessels, the *Narrenschiff* is the only one that had real existence—for they did exist, these boats that conveyed their insane cargo from town to town.'
15. For the representation of electroconvulsive therapy (ECT) in film, see e.g., the films: *The Snake Pit* (1948), *Kopfstand* (1981), and *Veronika Decides to Die* (2009). In the film *The Snake Pit*, in which ECT is shown not as a punishment but as a successful and legitimate method of treatment, it is ultimately this intervention that rehabilitates the film's protagonist, Virginia Cunningham, to the point where she can be submitted to subsequent psychoanalysis. See also: Gabbard and Gabbard (1999, 26 f.). In anti-psychiatry films or films with an anti-psychiatry flavour, ECT is always used as a punishment, as in *One Flew Over the Cuckoo's Nest* (1975), *Kopfstand* (1981), or *Veronika Decides to Die* (2009).
16. The lobotomy (leucotomy) was a primitive neurosurgical procedure in which nerve tissue of the frontal lobe was destroyed. Highly agitated patients with severe psychoses were usually calmer after such an operation, but their personality was massively altered in the sense of an organic psychosyndrome.
17. Alongside Walter Freeman, who performed transorbital lobotomies, António Egas Moniz preferred to penetrate the brain tissue of the prefrontal cortex through boreholes in the skullcap. As he was the first to perform such a primitive psychosurgical method on a human being, he was awarded the Nobel Prize for it in 1949. For, as the Nobel Prize Committee reasoned: 'his discovery of the therapeutic value of leucotomy in certain psychosis'. See www.nobelprize.org/prizes/medicine/1949/moniz/facts/ [last accessed 6 October 2024].
18. See https://en.wikipedia.org/wiki/Rosemary_Kennedy [last accessed 6 October 2024].
19. For the portrayal of lobotomy in film, cf. also: *Suddenly, Last Summer* (1959) in which an alleged patient (Catherine Holly, played by Elisabeth Taylor) who is keeping an unpleasant secret, is to be sedated by a lobotomy. This is quite different in the film *Oberarzt Dr. Solm* (1955), in which the lobotomy is celebrated as a rescue measure for schizophrenia.
20. The unabated fascination with the topic of the evil psychiatrist is also shown in the German-speaking world in the Tatort episodes 1211 (*Tor zur Hölle*, translated as Gate to Hell—broadcast on 2 October 2022) and 1213 (*Leben Tod Ekstase*, translated as Life Death Ecstasy—broadcast on 16 October 2022) which further explore this subject. See also https://de.wikipedia.org/wiki/Tatort:_Das_Tor_zur_Hölle and https://de.wikipedia.org/wiki/Tatort:_Leben_Tod_Ekstase [last accessed 6 October 2024].
21. If you add the two short sessions (3 minutes, 39 seconds) that Will had with other therapists before Sean Maguire, it would be nine sessions.
22. Schneider studied 207 American feature films at the time (cf. Herb, 2012, 28).
23. Such an unclassifiable mixed type would be, for example, Dr Carter (Kevin Spacey) in the film *Shrink* (2009). Dr Carter smokes pot and is funny, which would fit with Dr Dippy. He has aspects of a Dr Wonderful in that he is a really good therapist for Jemma, Jack, and many others. Since he does not want to see Kate (another patient) professionally so that he can see her privately, he also has something of a Dr Horny, though his feelings are romantic and not primarily sexual for him to be categorized under that term. In addition,

Dr Carter is also a 'helpless helper' and a 'suffering therapist' and thus altogether not really classifiable.

24. Such lectures are offered, for example, at the Sigmund Freud Private University in Vienna.
25. See https://en.wikipedia.org/wiki/Freud_(miniseries) [last accessed 6 October 2024].
26. Speculation is the opposite of phenomenology. But even as a professed phenomenologist, one is allowed to make exceptions and speculate now and then.
27. On the subject of series depicting psychotherapy, cf. also the Israeli series *BeTipul* (2005–2008), the French series *En thérapie* (2021–2022) and the German series *Safe* (2022). The latter is dedicated to the topic of child and youth psychotherapy in a very impressive way. See https://de.wikipedia.org/wiki/Safe_(deutsche_Fernsehserie). The series can be viewed at: www.zdf.de/serien/safe [last accessed 6 October 2024].
28. Freud (1915, 168) 'In other words: can we truly say that the state of being in love which becomes manifest in analytic treatment is not a real one? (…) The part played by resistance in transference-love is unquestionable and very considerable. Nevertheless the resistance did not, after all, *create* this love; it finds it ready to hand, makes use of it and aggravates its manifestations. Nor is the genuineness of the phenomenon disproved by the resistance. (…) We have no right to dispute that the state of being in love which makes its appearance in the course of analytic treatment has the character of a "genuine" love.'
29. Such moments can be found e.g., in the following films: *Secrets of a Soul* (1926), *Home of the Brave* (1949), *The Three Faces of Eve* (1957), *Ordinary People* (1980), *Good Will Hunting* (1997) and *Love Happens* (2009).

References

Brant, S. (1494). *Das Narrenschiff*. https://digital.slub-dresden.de/werkansicht/dlf/11823/1 [last accessed 6 October 2024].

Buber, M. (1970). *I and thou*. Translated by W. Kaufmann. Charles Scribner's Sons.

Dupont, J. (1988). *The clinical diary of Sándor Ferenczi*. Translated by M. Balint and N. Jackson. Harvard University Press.

Eichinger, T. (2017). Ein Triumph der ärztlichen Instinkte. Zelig. In M. Poltrum & B. Rieken (Eds.), *Seelenkenner, Psychoschurken. Psychotherapeuten und Psychiater in Film und Serie* (pp. 75–93). Springer-Verlag.

Eichinger, T. (2021). Psychotherapy ethics in film. In M. Trachsel, J. Gaab, N. Biller-Andorno, S. Tekin, & J. Z. Sadler (Eds.), *The Oxford handbook of psychotherapy ethics* (pp. 1027–1040). Oxford University Press.

Ferenczi, S. (1985). *Ohne Sympathie keine Heilung. Das klinische Tagebuch von 1932*. S. Fischer Verlag.

Flowers, J., & Frizler, P. (2004a). *Psychotherapists on film, 1899–1999. A worldwide guide to over 5000 films*, Volume 1. McFarland & Company, Inc.

Flowers, J., & Frizler, P. (2004b). *Psychotherapists on film, 1899–1999. A worldwide guide to over 5000 films*. Volume 2. McFarland & Company, Inc.

Foucault, M. (1988). *Madness and civilization. A history of insanity in the age of reason*. Vintage Books.

Freud, S. (1900/1999). *The interpretation of dreams*. Oxford University Press.

Freud, S. (1906). Letter to C.G. Jung from 6.12.1906. In W. McGuire (Ed.), *The Freud/Jung letters: The correspondence between Sigmund Freud and C.G. Jung*. (1974). Translated by R. Mannheim & R. F. C. Hull. Princeton University Press.

Freud, S. (1907). Delusions and dreams in Jensen's *Gradiva*. In *Sigmund Freud. The standard edition of the complete psychological works of Sigmund Freud*, volume IX (1906–1908) (pp. 7–93). Translated by James Strachey. The Hogarth Press.

Freud, S. (1915). Observations on transference-love. Further recommendations on the technique of psycho-analysis III. In *Sigmund Freud. The standard edition of the complete psychological works of Sigmund Freud*, volume XII (pp. 159–171). Translated by James Strachey. The Hogarth Press.

Freud, S. (1925). Letter from Sigmund Freud to Karl Abraham, June 9, 1925. *The complete correspondence of Sigmund Freud and Karl Abraham 1907-1925* 52, 546–547. Available from: https://pep-web.org/browse/document/ZBK.052.0546A [last accessed 6 October 2024].

Gabbard, G. O. (2001). Psychiatry in Hollywood cinema. *Australien Psychiatry* 9, 365–369. https://doi.org/10.1046/j.1440-1665.2001.00365.x.

Gabbard, K., & Gabbard, G. O. (1987). *Psychiatry and the cinema*. University of Chicago Press.

Gabbard, G. O., & Gabbard, K. (1999). *Psychiatry and the cinema*, second edition. American Psychiatric Press, Inc.

Gharaibeh, N. M. (2005). The psychiatrist's image in commercially available American movies. *Acta Psychiatrica Scandinavia* 111(4), 316–319. https://doi.org/10.1111/j.1600-0447.2004.00489.x

Greenberg, H. R. (2000). A field guide to cinetherapy: On celluloid psychoanalysis and its practitioners. *American Journal of Psychoanalysis* 60(4), 329–339.

Gross, R. (2012). *Der Psychotherapeut im Film*. Kohlhammer Verlag.

Gross, R. (2017). Verliebte Ärztin spielt Traumdetektiv … Spellbound (USA 1945). In M. Poltrum & B. Rieken (Eds.), *Seelenkenner, Psychoschurken. Psychotherapeuten und Psychiater in Film und Serie* (pp. 205–225). Springer-Verlag.

Heimann, H. (1950). On counter-transference. *International Journal of Psycho-Analysis* 31, 81–84.

Herb, S. (2012). *Psychoanalytiker im Spielfilm. Mediale Darstellungen einer Profession*. Psychosozial-Verlag.

Illouz, E. (2008). *Saving the modern soul: Therapy, emotions, and the culture of self-help*. University of California Press.

Kerr, J. (1993). *A most dangerous method. The story of Jung, Freud, and Sabina Spielrein*. Alfred A. Knopf, Inc.

Kesey, K. (1962). *One Flew Over the Cuckoo's Nest*. Viking Press & Signet Books.

Krutzenbichler, H. S., & Essers, H. (2010). *Übertragungsliebe. Psychoanalytische Erkundungen zu einem brisanten Phänomen*. Psychosozial-Verlag.

Paracelsus In Gantenbein, L. (2017). Poison and its dose: Paracelsus on toxicology. In P. Wexler (Ed.), *Toxicology in the middle ages and renaissance* (pp. 1–10). Elsevier Academic Press.

Poltrum M. (2014). 'Uns bleibt immer Paris' – Ewigkeit und Endlichkeit der Liebe. In S. Doering & H. Möller (Eds.), *Mon Amour trifft Pretty Woman. Liebespare im Film* (pp. 185–200). Springer Verlag.

Rabkin, L. Y. (1998). *The celluloid couch. an annotated international filmography of the mental health professional in the movies and television, from the beginning to 1990*. The Scarecrow Press, Inc.

Richter, V. (2000). Strangers on a couch. Hitchcock's use of psychoanalysis in *Spellbound* and *Marnie*. In I. Hotz-Davis & A. Kirchhofer (Eds.), *Psychoanalytic-ism. Uses of psychoanalysis in novels, plays and films* (pp. 114–131). Wissenschaftlicher Verlag Trier.

Rössler, W. (2017). Karriere einer Filmrolle: vom rebellischen Helden der 1970er zur dissozialen Persönlichkeitsstörung 2016. Einer Flog über das Kuckucksnest. In M. Poltrum & B. Rieken (Eds.), *Seelenkenner, Psychoschurken. Psychotherapeuten und Psychiater in Film und Serie* (pp. 143–156). Springer-Verlag.

Schlederer, L. (2019). Paartherapie in Spielfilmen und Serien. *SFU Research Bulletin 7*(1), 1–13. https://doi.org/10.15135/2019.7.1.1-13.

Schneider, I. (1985). The psychiatrist in the movies: The first fifty years. In J. Reppen & M. Charney (Eds.), *Psychoanalytic studies of literature* (pp. 53–67). Analytic Press.

Schneider, I. (1987). The theory and practice of movie psychiatry. *American Journal of Psychiatry 144*(8), 996–1002. https://doi.org/10.1176/ajp.144.8.996.

Schneider, I. (2002). Cinema and psychotherapy. In M. Hersen & W. Sledge (Eds.), *Encyclopedia of psychotherapy* (pp. 401–406). Elsevier Science. Available from: www.sciencedirect.com/referencework/9780123430106/encyclopedia-of-psychotherapy [last accessed 6 October 2024].

Shorter, E. (1997). *A history of psychiatry. From the era of the asylum to the age of prozac*. John Wiley & Sons, Inc.

Wahl, O., Reiss, M., & Thompson, C. A. (2018). Film psychotherapy in the 21st century. *Health Communication 33*(3), 238–245. https://doi.org/10.1080/10410236.2016.1255842.

Wulff, H. J. (1995). *Psychiatrie im Film. Film- und Fernsehwissenschaftliche Arbeiten*. MAkS Publikationen.

Zaretsky, E. (2004). *Secrets of the soul: A social and cultural history of psychoanalysis*. Alfred A. Knopf.

Filmography

Allen, Woody. (1983). *Zelig*
Allen, Woody. (1997). *Deconstructing Harry*
Armstrong, Moira. (1984). *Freud: The Life of a Dream*
Bonaparte, Marie, & Brunswick, Mark. (1930–1939). *Sigmund Freud Home Movies*
Brickman, Marshall. (1983). *Lovesick*
Brooks, Mel. (1977). *High Anxiety*
Camp, Brandon. (2009). *Love Happens*
Charrier, Christophe. (2022). *Le patient*
Chryssos Nikias. (2022). *Leben Tod Ekstase* – Tatort Episode 1213
Cronenberg, David. (2011). *A Dangerous Method*
Curtiz, Michael. (1942). *Casablanca*
De Palma, Brian. (1980). *Dressed to Kill*
del Toro, Guillermo. (2021). *Nightmare Alley*
Demme, Jonathan. (1979). *The Last Embrace*
Demme, Jonathan. (1991). *The Silence of the Lambs*
Donner, Clive. (1965). *What's New Pussycat?*
Duke, Daryl. (1983). *The Thorn Birds*
Figgis, Mike. (1993). *Mr. Jones*
Forman, Miloš. (1975). *One Flew Over the Coockoo's Nest*

Gisiger, Sabine. (2014). *Yalom's Cure*
Griffith, David Wark. (1909). *The Criminal Hypnotist*
Hitchcock, Alfred. (1945). *Spellbound*
Hitchcock, Alfred. (1964). *Marnie*
Huston, John. (1946). *Let There Be Light*
Huston, John. (1962). *Freud – The Secret Passion*
Joanou, Phil. (1992). *Final Analysis*
Johnson, Nunnally. (1957). *The Three Faces of Eve*
Kidel, Mark. (1992). *Kind of Blue: James Hillman on Melancholia & Depression*
La Cava, Gregory. (1935). *Private Worlds*
Lang, Fritz. (1922). *Dr. Mabuse the Gambler – Dr. Mabuse der Spieler*
Lauscher, Ernst Josef. (1981). *Kopfstand*
Leven, Jeremy. (1995). *Don Juan DeMarco*
Levi, Hagai. (2005–2008). *BeTipul*
Levi, Hagai. (2008–2021). *In Treatment*
Link, Caroline. (2022). *Safe*
Litvak, Anatole. (1948). *The Snake Pit*
Lumet, Sidney. (1977). *Equus*
Mankiewicz, Joseph L. (1959). *Suddenly, Last Summer*
Marton, Elisabeth. (2002). *My Name Was Sabina Spielrein*
May, Paul. (1955). *Oberarzt Dr. Solm*
McLoughlin, Tom. (2001). *The Unsaid*
Méliès, Georges. (1902). *Le voyage dans la lune*
Menick, John. (2012). *Starring Sigmund Freud*
Oz, Frank. (1991). *What About Bob?*
Pabst, Georg Wilhelm. (1926). *Secrets of a Soul*
Pate, Jonas. (2009). *Shrink*
Perret, Léonce. (1912). *Le mystère des roches de Kador*
Psychological and Educational Films. (1965–1986). *Three Approaches to Psychotherapy I* (1965), *II* (1977), and *III* (1986)
Ramis, Harold. (1991). *Analyze This*
Ramis, Harold. (2002). *Analyze That*
Redford, Robert. (1980). *Ordinary People*
Robson, Mark. (1949). *Home of the Brave*
Roth, Thomas. (2022). *Tor zur Hölle* – Tatort Episode 1211
Rubin, Lisa. (2017). *Gypsy*
Sandrich, Mark. (1938). *Carefree*
Soderbergh, Steven. (2013). *Side Effects*
Softley, Iain. (2001). *K-Pax*
Streisand, Barbara. (1991). *The Prince of Tides*
Toledano, Èric, & Nakache, Olivier. (2021–2022). *En thérapie*
Unbekannt. (1906). *Dr. Dippy's Sanitarium*
Van Sant, Gus. (1997). *Good Will Hunting*
Verhoeven, Paul. (1992). *Basic Instinct*
Walker, Lucy, & Ellwood, Alison. (2022). *How to Change your Mind*
Wiene, Robert. (1920). *The Cabinet of Dr. Caligari – Das Cabinet des Dr. Caligari*
Young, Emily. (2009). *Veronika Decides to Die*

CHAPTER 32

MENTAL DISORDERS IN FEATURE FILMS—ADDICTION, SUICIDE, DELUSION, PSYCHOSIS, AND SCHIZOPHRENIA

MARTIN POLTRUM

Introduction

SCIENTIFIC interest in the portrayal of mental disorders in feature films and series is booming, as evidenced by book publications and national and international congress programmes. This interest in film makes it clear that in the field of psychopathology there is again an increased longing for case histories, which counters the current orientation of psychiatry towards numbers, facts, data, and guidelines with a narrative and hermeneutic element and emphasizes the value of the descriptive and understanding approach to mental suffering.

The narratives and stories on which feature films and series are based, create an artificial reality of their own that encourages reflection on the reality outside the film. Even though it may be true that many films that report on and about mental disorders often only reflect reality of mental illnesses to a certain extent. Despite such tendencies, there are many great productions from which doctors, psychiatrists, psychotherapists, social workers, carers, experts by experience, relatives of mentally ill people, and interested laypeople can learn a great deal. For better or for worse, feature films and series featuring mental disorders have a didactic value that can be made fruitful for the training of psychologists, psychotherapists, and psychiatrists (Rodenhauser & Leetz, 1987; Hyler & Moore, 1996; Nissim-Sabat, 1979; Bhugra 2003a, 2003b, 2006; Bhugra & Silva, 2007; Cape, 2009; Byrne, 2009). Oftentimes, there is more truth to be found in fiction than

in reality, and only a very impoverished concept of reality could entertain the idea that truth can only be found in reality. Poetry, film, fiction, this is perhaps even the place of actual truth, as it challenges, reflects and interrogates ordinary reality.

Despite the affirmative and enthusiastic approach to film, what must not be overlooked is that diagnosing film characters is clearly problematic, because many of the findings and information that would be necessary for a proper diagnosis require exploration and questioning. The minimum requirement for a psychotherapeutic-psychiatric diagnosis would be the possibility of interacting with a psychologically suffering person and this is not naturally given with film characters. In addition to this flaw which needs to be raised from a psychopathological point of view, many filmmakers do not portray mental disorders for didactic purposes, but rather to advance a film plot and therefore do not show all the symptoms of a disorder that would be necessary for an exact diagnosis. Despite these limitations, it is worthwhile to look into the portrayal of mental disorders in film and to explore the didactic potential of well-made films and utilize them for teaching future therapists. In the following article, this will be primarily addressed by the cinematic representation of the following disorders: First, through the representation of substance use, intoxication, ecstasy and addiction; second, by addressing suicide, self-murder and voluntary death; and third, by discussing delusion, psychosis, and schizophrenia.

Substance Use, Intoxication, Ecstasy, and Addiction

Legal and illegal drugs play a major role in popular feature films and the addiction motif has been a popular theme in American and European cinema for over 100 years. From the silent film era to the present, the theme of hedonistic drug use and addiction has been treated either critically or affirmatively, and film thus reflects fears, longings, values systems, and historical attitudes towards alternative states of consciousness. After a general introduction to the early history of alcohol and drug cinema, this paper deals with exemplary representations of alcoholism in film. Furthermore, it is shown that heroin addiction can be portrayed in cinema in highly different ways and that film images are generated which deal with the whole spectrum of this substance altering between heroization, criticism, and shocking portrayal. However, a series of stoner comedies or so-called stoner movies indicate that the drug problem can be depicted in films in more than just a tragic way. More than that, in many 'normal' and non-addiction-centred feature films there are 'stoner scenes' which suggest that Tetrahydrocannabinol (THC) use is a fun and harmless affair. This is probably an expression of the fact that hashish consumption is now part of the recreational pleasures of normal citizens and cannabis has already been legalized in many countries. In film, as will be briefly shown in this chapter, phenomena are found that do not occur in reality, such as risk addiction, bug powder

junkies, or vampires in a blood frenzy. As far as the portrayal of non-substance-related addictions in film is concerned, which unfortunately cannot be elaborated on within the frame of this article, at least three films on the topic of sex addiction or hyper-sexuality should be mentioned here—*Shame* (2011), *Nymphomaniac* (2013), and *Don Jon* (2013).

Alcohol and Drugs in Early Cinema

Many educated people were initially very sceptical about film and cinema. In the eyes of many intellectuals of that time, cinema was for the uneducated and belonged to the pleasures of the working class. The film sociologist Siegfried Kracauer has summarized these early reservations about cinema very beautifully and vividly:

> During that whole era the film had the traits of a young street Arab; it was an uneducated creature running wild among the lower strata of society. (…) An attraction for young workers, salesgirls, the unemployed, loafers and social nondescripts, the movie theatres were in a rather bad repute. They afforded a shelter to the poor, a refuge to sweethearts. Sometimes a crazy intellectual would stray into one.
>
> (Kracauer, 1947, 16)

Very early on, comparisons were also drawn between the flashing of images and the proletariat's need for wine and schnapps, as for example with Konrad Haemerling, who published his *Sittengeschichte des Kinos* under the pseudonym Curt Moreck and said:

> The cinema frenzy is just as real as an intoxication of wine or schnapps. In it, cinema has become an end in itself. The film maniacs go to the cinema to forget themselves, to be more easily accessible to the sensation of some active urge. What buzzes across the white screen is of no importance to them.
>
> (Moreck, 1926, 78)

The cinema-goers, we read on,

> usually belong to that class of society which splashes out their last penny for the cinema without hesitation instead of buying a piece of bread for the starving, growling stomach. There, cinema addiction has become a deeply gripping passion, such as morphine addiction in higher classes.
>
> (Moreck, 1926, 71)

In addition to this social propagandist parallel between cinema frenzy, film addiction, and narcosis, the theme of drug use in film emerged very early on. One of the most recent studies on the early history of drugs in cinema counts as many as seventy-nine films (Henkel & Karenberg, 2019a, 4–6; Henkel, 2019) devoted to this topic in the period 1901–1931. Intoxication and addiction are examined from different perspectives in early

drug cinema. What attracted the film pioneers to the depiction of ecstasy and drunkenness was that they could explore the distorted and surreal images illustrating intoxication phenomena and show what the new medium of film could offer visually. Fantastic, aesthetic, and hallucinatory images of intoxication can be found, for example, in Georges Méliès' film *Le rêve d'un fumeur d'opium* (1908). A man visits an opium den, smokes, and hallucinates how a beer flies to the moon and turns into a provocative woman.

A popular genre of early cinema in which the theme of illegal alcohol consumption was dealt with is the gangster film; a cinematic reflex of the Prohibition era. From 1920 to 1933, as is commonly known, there was a nationwide ban on the production, sale, and consumption of alcohol in the United States. Officially, this substance disappeared from the scene and went underground. Alcohol barons were up to their mischief, alcohol was produced and traded illegally everywhere, speakeasy bars and mafia-like structures emerged. What was going on underground during Prohibition was then reflected in the gangster films of the 1930s and brought to the screen, e.g., in films like *The Public Enemy* (1931), *Scarface* (1932), or *The Roaring Twenties* (1939). Another popular genre dealing with alcohol consumption and drunkenness were comedies, e.g., those by Charlie Chaplin. Early film audiences loved drunkards who could barely get out of a taxi and walk as in *One A.M.* (1916) or characters like the alcoholic millionaire in *City Lights* (1931), who gives away bundles of banknotes while intoxicated, or the alcoholic played by Charlie Chaplin in *The Cure* (1917), who wants to get a grip on his addiction problem in a sanatorium and, to be on the 'safe' side, disposes of the spirits he brought along for fear of abstinence in a curative spring, from which the patients of the sanatorium then drink and stagger drunkenly through the screen. Besides gangster films and comedies, the alcohol problem could also be dealt with melodramatically. In *Broken Blossoms* or *The Yellow Man and the Girl* (1919), for example, a prizefighting boxer and bad drunkard is portrayed who bullies his daughter and beats her to death during a drunken rage. Also interesting from a historical perspective are the anti-drug propaganda films made with the cooperation of the Federal Bureau of Narcotics[1] in the 1930s. They bristle with medical untruths and warn against the corrupting drug marijuana, such as *Marijuana—Weed With Roots in Hell* (1936), *Reefer Madness* (1936), or *Assassin of Youth* (1937). *Reefer Madness* shows how good American adolescents turn into criminals and become sexually depraved through marijuana consumption. One hit of hashish is enough to totally lose control over one's sexuality, cause moral decay and according to the film's propaganda, marijuana is more addictive than cocaine or heroin. That there were also serious attempts to treat the alcohol and drug problem in the context of prevention and educational films is shown by *Narkotika—Die Welt der Träume und des Wahnsinn* (1924). Produced by the staatliche Filmhauptstelle in Vienna (Vienna State Film Headquarters) on behalf of the League of Nations (Goette & Röllecke, 2008, 14), the film was intended to warn against the dangers of addictive substances such as alcohol, cocaine, or opiates. The storyline woven into the educational concept is designed like an adventure film. A researcher returns from a two-year study trip dedicated to the worldwide fight against opiates and discovers that there are also addiction problems at home. The fate of a woman from the upper class, a morphine addict, is used to educate

about addiction, partly with a moralizing undertone, and the film provides insights into the contemporary treatment of addict patients in Austrian hospitals. The medical part of the film is explained in the opening credits as having been made with the collaboration of medical specialists.

The representational perspectives that can already be discerned in early film, to illuminate substance consumption, intoxication, ecstasy and addiction in a funny-comic, melodramatic-tragic, preventive-educational, propagandistic, socially critical, or aesthetic way, can all be found in colour and sound film, and it seems that these are ultimately the ways in which the subject can be approached.

Alcoholism and Drinking Talk in *The Lost Weekend* (1945), *Barfly* (1987), and *Another Round* (2020)

In *The Lost Weekend* (1945), an often discussed (Wulff, 1985; Henkel & Karenberg, 2019b) and probably one of the most interesting feature films on the subject of addiction, which won four Oscars and is based on the novel of the same name by Charles R. Jackson, Billy Wilder portrays the unsuccessful New York writer and long-term alcoholic Don Birnam. Only his brother Wick, who he lives with and who supports him financially, and his girlfriend Helen manage to sober him up from time to time. According to the film plot, Wick plans to take his brother to the country for the weekend to visit relatives so that Don can recover from his escapades in fresh air surroundings. Don does everything he can to miss the train and spends a whole weekend getting drunk to the point of delirium. Again and again he is seen in Nat's bar telling his bartender in a mixture of therapy and confession why he likes to drink so much.

> DON: 'Nat, weave me another.'
> NAT: 'You'd better take it easy.'
> DON: 'Oh, don't worry about me.' (…)
> DON: 'Come on, Nat join me. One little jigger of dreams'.
> NAT: 'No, thanks'.
> DON: 'You don't approve of drinking?'
> NAT: 'Not the way you drink'.
> DON: 'It shrinks my liver, doesn't it, Nat? It pickles my kidneys, yes. But what does it do to my mind? It tosses the sandbags overboard so the balloon can soar. Suddenly, I'm above the ordinary. I'm confident, supremely confident. I'm walking a tightrope over Niagara Falls. I'm one of the great ones. I'm Michelangelo moulding the beard of Moses. I'm van Gogh painting pure sunlight. I'm Horowitz playing the "Emperor Concerto". I'm John Barrymore before the movies got him by the throat. I'm Jesse James and his two brothers. All three of them! I'm William Shakespeare. And out there, it's not 3rd Avenue any longer. It's the Nile Nat, the Nile … and down it floats the barge of Cleopatra'.

In another scene at the bar, he tells Nat how he met his girlfriend Helen and how he initially tried to hide his drinking from her and how it eventually came to light. After

he confessed to Helen that he was an alcoholic, she said that it didn't bother her, that it could be treated.

> HELEN: 'But there must be a reason why you drink, Don. The right doctor could find it.'
> DON: 'Look, I'm way ahead of the right doctor. I know the reason. The reason is me, what I am. Or rather, what I'm not—what I wanted to become and didn't'.
> HELEN: 'What is it you want to be so much that you're not?'
> DON: 'A writer'.

What follows is a very exciting self-analysis that shows that Don suffers from his ego ideal and drowns this suffering with alcohol. The film contains many illuminating dialogues and scenes, which unfortunately cannot be elaborated on at this point. Only this much: In the end, it looks as if the writer in disguise will get his act together after all and finally continue writing his novel with the apt title *The Bottle*.

A film with a completely different thrust and drinking talk is *Barfly* (1987). The screenplay was written by the German-American writer Charles Bukowski and directed by Barbet Schroeder. Mickey Rourke plays Henry Charles 'Hank' Chinaski, Bukowski's literary alter ego, who is the main character in many of his stories. Henry, an alcoholic living in an extremely run-down flat in Los Angeles, spends his days drinking, listening to classical music, and occasionally writing short stories and poems. In the evenings he visits bars, gets drunk and provokes fights. The relatively plotless film captivates with its decadent atmosphere and the eccentric dialogues that show that the 'philosopher of life' Henry sees further than the average humdrum person. After a failed job interview, he ends up in his favourite bar, *The Golden Horn*, and speaks to his bartender Jim, who asks how the application went:

> HENRY: 'This is a world where everybody's gotta *do* something. You know, somebody laid down this rule that everybody's gotta *do* something. They gotta *be* something. You know, a dentist, a glider pilot, a nark, a janitor, a preacher, all that. Sometimes I just get tired of thinking of all the things that I don't wanna do, all the things that I don't wanna be, all the places that I don't wanna go like India, like get my teeth cleaned aahhh, save the whales all that. I don't understand it.'
> JIM: 'You're not supposed to think about it. (Pours himself a glass of brandy). I think the whole trick is not to think about it (downs the liquor and symbolically all that one should not think about).'

Alcoholism is not presented as a problem in this film, but as a way of life that is voluntarily chosen and desired, a lifestyle in which 'philosophical' insights certainly have a place, as one can see from the above quoted conversation.

Also philosophical is the last alcohol film to be reviewed here, the Danish, Swedish, Dutch production *Another Round* (2020). The film, which won two Oscars in 2021 (Best International Feature Film, Best Director), directed by Thomas Vinterberg, is about four burnt-out teachers in a Copenhagen high school who start a drinking experiment. Nicolaj celebrates his fortieth birthday together with Martin, Tommy, and

Peter at a boozy dinner and speaks of the Norwegian philosopher and psychiatrist Finn Skårderud, who spreads the thesis that people are born with a too-low blood-alcohol level and that therein lies the reason for many problems.

> NICOLAJ: (raises his glass and takes a sip of champagne): 'Heavy stuff (the thesis report follows). He (Finn Skårderud) says that if you always have a blood alcohol level of 0.5 per ml, then you are just …'
> TOMMY: 'Yes?'
> NICOLAJ: 'Well, he says you are much more relaxed. You are more self-confident, more musical and more open. Just altogether braver' (Martin listens longingly).
> PETER: 'I could definitely do with a bit more confidence and courage' (Peter holds up a glass and whoops. Tommy pats him on the shoulder approvingly).
> NICOLAJ: 'We all could, including me.'

What follows is the drinking experiment and one sees how the lessons and the private lives of the four first become more lively, joyful, and exhilarating and how later the collateral damage and side effects follow (cf. Römer, 2021).

Heroin Addiction (1955, 1981, 1996, 2000)—Four Approaches

The Man with the Golden Arm (1955), *Christiane F.—Wir Kinder vom Bahnhof Zoo* (1981), *Trainspotting* (1996), and *Requiem for a Dream* (2000) show that heroin addiction can be treated cinematically in very different ways. Otto Preminger's 1955 social drama with film noir-like elements, in which Frank Sinatra plays Frankie Machine, a junkie released from prison who soon relapses despite good intentions and plans for a clean life, is characterized by the fact that it became style-defining for the genre of the heroin film. The regular appearance of content such as 'injection needle, spoon' or the 'close-up of the intravenous injection', 'background music announcing and accentuating' and the explicit depiction of quitting cold turkey shaped the 'modern iconology of the drug film' (cf. Springer, 1982a; Springer, 1982b, 36).

Many of the elements mentioned can also be found in the German drug classic *Christiane F.—Wir Kinder vom Bahnhof Zoo* (1981). *Christiane F.*[2] shows the Bahnhof Zoo, which was Berlin's biggest hub for hard drugs at the end of the 1970s, and especially the fate of the eponymous heroine. The tragic life of Christiane F. touched millions, became a bestseller as a book[3] and a box-office hit in the cinema.[4] Originally conceived as a drug education film, the production directed by Ulrich Edel offered a double entendre. For adults, the film was a harrowing document of how young people lose themselves to the drug heroin and drift into drug prostitution. For teenagers 'seeking identity and rejecting the bourgeois world of their parents' it offered a 'fascination not to be underestimated' as Christiane became a junkie with 'star status'[5] (Arenz, 2015, 22; cf. also Arenz, 2019).

The heroin problem is portrayed very differently in another drug cult film, Danny Boyle's *Trainspotting* (1996). Infused with black British humour, it portrays a heroin clique from the Scottish capital Edinburgh and presents substance use as a surreal hedonistic leisure experience. In a paradigmatic and now famous scene, Renton, the main character, dives down into the 'filthiest toilet in Scotland' to fish out the opium suppositories he had previously ingested and accidentally excreted while going to the toilet. He disappears down the toilet bowl and is shown swimming in the azure waters of the ocean and shortly afterwards emerges with the retrieved suppositories. An overdose, actually a medical emergency, is accompanied by pathetically comic images and Lou Reed's song *Perfect Day* (1972). Addiction could hardly be depicted in a more glamorous and problematic way.[6]

In radical contrast to this, drug dependency is brought to the screen with all its powerful destructive potential in *Requiem for a Dream* (2000) by US director Darren Aronofsky. Structured according to the chapters Summer, Autumn, and Winter, the film shows the brutal decline of four protagonists—amphetamine addict Sarah Goldfarb, her son Harry and his girlfriend Marion, and his buddy Tyron, all three of whom are heroin addicts. The couple Marion and Harry come from the Jewish middle class of New York and sex under the influence of drugs gives them great pleasure. Tyron and Harry are 'gourmets' in their drug consumption. Sarah Goldfarb is a pensioner, widowed, lonely, and lives in Brooklyn. What they all have in common is that they have a dream. Harry would like to become a successful businessman, Marion a fashion designer, Tyron has promised his mother that he will manage to have a good life and Sarah, who is slightly overweight and eats too many sweets, is desperate to be on television. One day she receives a phone call and is told that she has a chance to appear on her favourite show. Now she wants to lose weight to fit into her red dress, sees a doctor who prescribes her amphetamines as appetite suppressants and becomes addicted.

In a touching scene, Harry visits his mother, is overwhelmed by her drive and when she grinds her teeth he is horrified to discover that she is taking amphetamines. She describes her loneliness and provides a sadly true reason for her son and the audience as to why she has slipped into addiction.

> SARAH: 'Ah, come on! I almost fit in my red dress. The one I wore to your high school graduation. The one your father likes so much. Oh, I remember how he looked at me in that red dress.'
>
> HARRY: 'Ma, what's the big deal about the red dress?'
>
> SARAH: 'I'm going to wear it at ... You don't know. I'm gonna be on television. I got a call and an application ... you'll be proud when you see your mother in her red dress on TV.'
>
> HARRY: 'What is the big deal to be on TV? Those pills will kill you before you get on.'
>
> SARAH: 'Big deal? I'm somebody now, Harry. Everybody likes me (Sarah has risen socially in her community of lonely women since she told them she would soon be appearing on television). Soon millions of people will see me and they'll all like me. I'll tell them about you and your father. How good he was to us. Remember? It's a reason to get up in the morning. It's a reason to lose weight, to

fit in the red dress. It's a reason to smile. It makes tomorrow all right (she sighs). What have I got, Harry? Hmm? Why should I even make the bed or wash the dishes? I do them, but why should I? I'm alone. Your father's gone, you're gone. I got no one to care for. What have I got, Harry? I'm lonely (she sheds some tears). I'm old.'

HARRY: 'You got friends, Ma.'

SARAH: 'It's not the same. They don't need me. I like the way I feel. I like thinking about the red dress and the television and you and your father. Now when I get the sun, I smile.'

After Harry says goodbye to his mother, gets into a taxi and is moved to tears by the loneliness and desolation of her account, he pushes aside this touching intimacy and the accompanied misery with a shot of heroin. The final scene of the film shows four broken characters in embryonic positions—Sarah in a bed in a psychiatric ward after electroconvulsive therapy due to amphetamine psychosis, Tyron on a prison cot, Harry in a hospital bed after an arm amputation due to a necrotic syringe abscess, and Marion at home on a couch after brutal group sex due to drug prostitution. The technically ingenious film, which is extremely difficult to endure due to its brutality and which captivates through avant-garde montages, such as the close-ups and detail shots of objects and body parts that are mounted in the narrative flow or through rapid successive cuts accompanied by sounds, ends with shocking images and psychologically destroyed, dismembered, imprisoned, and amputated protagonists whose dreams have turned into nightmares (cf. Springer, 2008).

Stoner Comedies, Risk Addicts, Bug Powder Junkies, Vampires in a Blood Frenzy

Stoner comedies, stoner movies,[7] stoner films[8]—*Up in Smoke* (1987), *Saving Grace* (2000), *Paulette* (2012), *The Beach Bum* (2019), etc.—or funny stoner scenes in feature films in which hashish use is not central to the plot—*American Beauty* (1999), *Shrink* (2009), *Intouchables* (2011), etc.—prove that drug use is perceived completely differently in artefacts of culture, in pop music, literature, or film than in medical discourse. Psychiatric societies may warn of the dangers of cannabis use, pointing out that there are vulnerable groups at risk of psychosis, that the substances available on the black market are specially cultivated and therefore have far too high and indigestible THC content, and that hashish use is harmful to brain development until the age of twenty-five and which can lead to amotivational syndrome if consumed daily and in high doses. Stoner comedies care little for such findings and report that alternative states of consciousness bring fun, joy, wit, ecstasy, and irony and that there is a comic catharsis which is at least as valuable as the medical concerns. It is good that there are different narratives on THC use and culture media should not be demanded to be the handmaidens of medicine.

Film, a product of the imagination that autonomously determines what is true and real, knows forms of addiction that are rarely encountered in reality. In *Basic Instinct 2* (1992), for example, the criminal psychologist Dr Michael Glass reports that the writer Catherine Tramell (Sharon Stone), whom he has examined as a forensic expert, suffers from risk addiction.

David Cronenberg's *Naked Lunch* (1991) attempted to make a film adaptation of the fictionalized origin story of William S. Burroughs' cult novel of the same name. We see the exterminator William 'Bill' Lee accidentally shooting his wife in a drug frenzy and, after the crime, he goes underground in the Tangier International Zone (Interzone) and takes refuge in the world of drugs. He and his wife Joan had been genuine bug powder junkies and had enjoyed the intoxication of this exquisite powder, the effect of which Joan describes to her husband as 'Kafkaesque'.

Another film that is also partly set in Tangier, which in the 1940s and 1950s was an El Dorado for people seeking the meaning of life, eccentrics, hippies, and dropouts, is Jim Jarmusch's *Only Lovers Left Alive* (2013). Ethically sound vampires Adam and Eve, who have decided not to bite humans, have known each other for centuries and have a long-distance relationship. The sophisticated Eve, who devotes herself mainly to literature, lives in Tangier and Adam in Detroit, where he has made a name for himself with psychedelic music. After both unfortunately witness Marlowe, a friend of Eve's who supplies them with blood reserves, dying of contaminated blood, they relapse and attack two lovers. The depiction of intoxication and the entire aesthetic of the film are clearly in the iconology of the drug film and show vampires in a bloodlust.

SUICIDE, SELF-MURDER, AND VOLUNTARY DEATH

The question of whether books, films, and music protect against suicidal tendencies or perhaps even trigger them is hotly debated (Kasahara-Kiritani et al., 2015; Stack et al., 2012; Till, 2017). The topic of suicide is not only dealt with in the field of psychiatry and psychotherapy, but also just as much in the field of medical humanities, in sociology, philosophy, religion, and world literature. In the case of literature, take Shakespeare for example, in whose work thirteen suicides occur or the suicide epidemic triggered by Goethe's novel *The Sorrows of Young Werther* (1774/1787, 1999)[9] (Frances, 2013, 123 f.; Ziegler & Hegerl, 2002). Also consider E.T. A Hoffman, Herman Hesse, Arthur Schnitzler, Thomas Bernhard, Peter Handke and many others who have dealt with this topic, as well as the many literary figures who laid hands upon themselves, such as Georg Trakl, Virginia Woolf, Sylvia Plath, Heinrich von Kleist, Stefan Zweig, Jean Améry or Paul Celan. There are eleven suicides to be found in the Bible and countless operas[10], folk songs, ballads, and works of pop music which deal with suicidality and/or suicide. Additionally, film has always been interested in the topic

of tiredness of life and longing for death. The American Film Institute, for example, counts more than 2,100 feature films[11] in which suicidal acts occur or play a role, and Dennis Henkel (2020, 4–6) alone names seventy-eight productions from 1899 to 1933 in his study of suicide in silent films. No one can say exactly how many films and series in total have dealt with the subject of suicide, self-murder, and voluntary death. As far as the most important suicide motives are concerned, especially in American productions, the largest study (Stack & Bowman, 2012) shows that in film it is less psychiatric illnesses that motivate suicide, but rather social difficulties and conflicts such as the end of a love relationship (*Go Naked to the World*, 1961), parent–child conflicts (*Dead Poets Society*, 1995), partnership problems (*The English Patient*, 1996), financial ruin (*I Dreamed of Africa*, 2000), bullying and interpersonal harassment (*To Save a Life*, 2009), societal prejudice against ethnicities (*Sayonara*, 1957), sexual orientation (*The Children's Hour*, 1961), guilt (*The Reader*, 2008) and shame (*The Last Sunset*, 1961) that lead film protagonists to take their own lives. Film thus challenges the common psychiatric doctrine that 80–90 per cent of all suicidal acts happen with the background of a mental disorder. At least in terms of film characters, this assumption is empirically difficult to prove and not true at all, since only about 20 per cent of all film protagonists (this figure refers to the study mentioned above) take their own lives due to a psychiatric problem.

Besides social factors and suicidal acts due to a mental disorder (*Le locataire* (1976), *Ordinary People* (1980), *Das weiße Rauschen* (2001), *The Hours* (2002)), other suicide motifs in film include: altruistic suicide (*Gran Torino* (2008)), villain suicide (*Spellbound* (1945), *Peeping Tom* (1960)), suicide in the form of a suicide bombing (*Paradise Now* (2004), *Sof Shavua B'Tel Aviv/For My Father* (2008)), suicide due to a terminal diagnosis or serious physical illness (*Valley of the Dolls* (1967)) and assisted suicide (*Mar Adentro* (2004), *Les invasions barbares* (2003)), or rather killing on request due to paraplegia (*Million Dollar Baby* (2004)) or dementia (*Die Auslöschung* (2013)).

Just as the death of a loved one is a relatable and understandable cause for the desire to draw a line and end one's life, the reverse is also true. A new love is not only like a new life, but an excellent reason to overcome suicidality and tiredness of life. In reality, as in film—*I Hired a Contract Killer* (1990), *Willbur Wants to Kill Himself* (2002), *Veronica Decides to Die* (2009), and *A Single Man* (2009) demonstrate this impressively.

In my opinion, the most exciting contribution to the subject of suicide in film comes from Stephen Daldry, who portrays the suicide of two characters and a severe suicidal crisis of another in *The Hours* (2002). Based on Michael Cunningham's novel of the same name, for which he won the Pulitzer Prize in 1999, he interweaves the lives of three unhappy and depressed women from three different generations. Virginia Woolf (Nicole Kidman) is shown in 1923. She lives in Richmond, outside London, with her husband Leonard, hears voices, is depressed, suicidal, and begins writing her novel *Mrs Dalloway*.[12] With the exception of Virginia Woolf's 1941 suicide, the film covers one day in the lives of the three protagonists, alternating between stories and times. Laura Brown (Julianne Moore), is a pregnant housewife living in California in 1951, who is desperately unhappy and depressed with her husband and her young son. Clarissa Vaughn

(Meryl Streep), a New York editor, is shown preparing a big party in 2001 for her AIDS-stricken ex-boyfriend Richard, with whom she once had a relationship in her younger years. Richard throws himself out of a window while Laura aborts a long-planned suicide attempt and chooses a life without her husband, son and daughter, whom she still gives birth to and then abandons. The film captivates with its desolate atmosphere and, like the novel, with the interweaving of the life stories. Virginia writes *Mrs Dalloway*, Laura reads the book, and Clarissa 'is' Mrs Dalloway and is named so by Richard, who is Laura's abandoned son.

Virginia, who has endured several nervous breakdowns and suffers from tormenting delusions, auditory hallucinations, anorexia, and severe depression that lasts for months, feels trapped in her Richmond home. Intimidated by servants, she is under constant surveillance by her husband Leonard. She flees to the railway station, intending to catch a train to London. Leonard, who just notices and suspects where she is, intercepts her and the following conversation ensues:

LEONARD: 'Virginia, we must go home now. Nelly is cooking dinner, she's already had a very difficult day. It's just our obligation to eat Nelly's dinner.'
VIRGINIA: 'There's no such obligation. No such obligation exists!'
LEONARD: 'Virginia, you have an obligation to your own sanity.'
VIRGINIA: 'I've endured this custody, endured this imprisonment!'
LEONARD: 'Oh Virginia!'
VIRGINIA: 'I'm attended by doctors, everywhere, I am attended by doctors who inform me of my own interests.'
LEONARD: 'They know your interests.'
VIRGINIA: 'They do not. They do not speak for my interests.'
LEONARD: 'Virginia, I can… I can see that it must be hard for a woman of your…'
VIRGINIA: 'Of what? Of my what exactly?'
LEONARD: '..of your talents to see that she might not be the best judge of her own condition!'
VIRGINIA: 'Who then is a better judge?'
LEONARD: 'You have a history! You have a history of confinement. We brought you to Richmond because you have a history of fits, moods, blackouts, hearing voices. We brought you here to save you from the irrevocable damage you intended upon yourself. You've tried to kill yourself twice! I live daily with that threat. I set up the press, we set up the printing press not just for itself, not just purely for itself, but so that you might have a ready source of absorption and a remedy.
VIRGINIA: 'Like needlework?'
LEONARD: 'It was done for you! It was done for your betterment! It was done out of love! If I didn't know you better, I'd call this ingratitude.'
VIRGINIA: 'I am ungrateful? You call me ungrateful? My life has been stolen from me. I'm living in a town I have no wish to live in. I'm living a life I have no wish to live. How did this happen? (Sits down on a bench) It is time for us to move back to London. I miss London. I miss London life.'
LEONARD: 'This is not you speaking, Virginia. This is an aspect of your illness.'
VIRGINIA: 'It is me…'
LEONARD: 'It's not you.'

VIRGINIA: '… it is. It is my voice.'
LEONARD: 'It's not your voice.'
VIRGINIA: 'It's mine and mine alone.'
LEONARD: 'It's the voice that you hear.'
VIRGINIA: 'It is not. It is mine! I'm dying in this town!'
LEONARD: 'If you were thinking clearly, Virginia, you'd recall it was London that brought you low.'
VIRGINIA: 'If I were thinking clearly. If I were thinking clearly.'
LEONARD: 'We brought you to Richmond to give you peace.'
VIRGINIA: 'If I were thinking clearly, Leonard, I would tell you that I wrestle alone in the dark, in the deep dark and that only I can know, only I can understand my own condition. You live with the threat you tell me, you live with the threat of my extinction. Leonard, I live with it too. This is my right, it's the right of every human being. I choose not the suffocating anaesthetic of the suburbs, but the violent jolt of the capital. That is my choice. The meanest patient, yes even the very lowest, is allowed, some say in the matter of her own prescription. Thereby she defines her humanity. I wish, for your sake Leonard, I could be happy in this quietness, but if it is a choice between Richmond and death, I choose death.'

In 1941, the time has come. Virginia Woolf loses all hope and ends her life. In the film, which portrays the writer's suicide in the river Ouse (Sussex) in a very moving way, Virginia's voice reads her farewell letter to Leonard as she writes it. To conclude this chapter on suicide in film, it is reproduced here:

Dearest, I feel certain that I am going mad again: I feel we can't go through another of those terrible times. And I shan't recover this time. I begin to hear voices, and I can't concentrate. So I am doing what seems the best thing to do. You have given me the greatest possible happiness. You have been in every way all that anyone could be. I don't think two people could have been happier till this terrible disease came. I can't fight any longer. I know that I am spoiling your life, that without me you could work. And you will, I know. You see I can't even write this properly. I can't read. What I want to say is I owe all the happiness of my life to you. You have been entirely patient with me and incredibly good. I want to say that—everybody knows it. If anybody could have saved me it would have been you. Everything has gone from me but the certainty of your goodness. I can't go on spoiling your life any longer.
I don't think two people could have been happier than we have been. V.

(Woolf, 1941, in Cunningham, 2003, 6 f.)

Delusion, Psychosis, and Schizophrenia

The portrayal of mental disorders and illnesses in the field of schizophrenia, delusion phenomena, and psychoses, and the aesthetic realization in film and series is extremely varied. On the one hand, there is the topic of the mad psychiatrist who knows delusion particularly well because it also dwells in him, as for example in *The Cabinet*

of *Dr. Caligari* (1920), *The Testament of Dr. Mabuse* (1932), and *Dressed to Kill* (1980). Furthermore, paranoid and schizophrenic murderers can be found in films such as in *Psycho* (1960), *Shining* (1980), *Spider* (2002), or *Joker* (2019) which paint a very unrealistic image of these disorders and which unfortunately is reproduced manifold in media. Moreover, film negotiates the topic of the insane genius, coined by Schopenhauer and then taken up by Romanticism, for example in cinema films such as *Pi* (1998), *A Beautiful Mind* (2001), *Proof* (2005), or the series *Perception* (2012–2015). In antipsychiatry films, another subject in our thematic field, the psychotic inmates of asylums are often portrayed as victims of the institution of psychiatry—*The Snake Pit* (1948), *One Flew Over the Cuckoo's Nest* (1975), and *I Never Promised You a Rose Garden* (1977).

Since many feature films contain a love plot, which is often at the centre of the cinematic narrative, the darker sides of Cupid and the pathologies of love are naturally also portrayed. Mad love, stalking, delusional jealousy and erotomania can be found in films such as *Fatal Attraction* (1987), *L'Enfer* (1994), *À la folie... pas du tout!* (2002), *House of Fools* (2002), *Enduring Love* (2004), *Lars and the Real Girl* (2007), and *Obsessed* (2009).

In reality, psychoses are very often extremely anxiety-ridden and painful matters under which patients and relatives almost crack. They are thus suitable for cinematic character studies, such as *Das weiße Rauschen* (2002), *Canvas* (2006), *Die Summe meiner einzelnen Teile* (2011), or *Hirngespinster* (2014).

Delusion can also be understood psychoanalytically as a form of self-healing and self-medication. In Freud's treatise *Psycho-analytic Notes on an Autobiographical Account of a Case of Paranoia* (1911), the father of modern psychotherapy argues that delusional phenomena can also be interpreted in such a way that the world of a suffering person implodes and the delusional formation can be read as an attempt to rebuild the shattered and downfallen world in which the sick person can no longer live. 'And the paranoid builds it again, not more splendid, it is true, but at least so that he can once more live in it. He builds it up by the work of his delusion. The delusional formation, which we take to be the pathological product, is in reality an attempt at recovery, a process of reconstruction' (Freud, 1911, 70f.). This idea from Sigmund Freud's early paranoia theory is central in a number of excellent feature films—e.g., *The Fischer King* (1991), *Don Juan DeMarco* (1995), *K-PAX* (2001), and *Shutter Island* (2010). The living environments of Parry, Don Juan, Prot, and Teddy/Andrew from the above-mentioned films are submerged by traumatizing events, and through their delusion they create a reality in and with which they can somehow continue to live.

As far as the representation of schizophrenia in film is concerned—Thomas Stompe (2019, 135) counts 102 films (in the period from 1932 to 2018)—there is a tendency to depict primarily the positive symptoms—delusions, visual and/or acoustic hallucinations, ego disturbances—of acute episodes (Owen, 2012, 655). This is understandable, because showing affective flattening, impoverishment of gestures and facial expressions, anhedonia, reduced drive, social and professional isolation and other negative symptoms is likely to be too boring for entertainment purposes. A popular way to portray delusional phenomena is through unreliable narration. Films such as *The Cabinet of Dr. Caligari* (1920), *Fight Club* (1999), *A Beautiful Mind* (2001) or *Shutter Island* (2010), in which a

story is built up and told over a long period of time and then collapses in a surprising twist, ultimately debunk the originally presented narrative and plot—which the film recipient has followed without suspicion—as a delusional system of the respective protagonist (Stompe, 2019, 139).

Conclusion

In addition to substance use, intoxication, ecstasy, addiction (Cornes, 2006; El-Khoury et al., 2019; Poltrum et al., 2019), suicide (Stack & Bowman, 2012; Poltrum et al., 2020), delusion, psychosis, and schizophrenia (Owen, 2012; Poltrum et al., 2023), there are many other mental disorders featured in films and series. Overview papers (Noll Zimmermann, 2003; Wedding & Niemiec, 2014; Doering & Möller, 2008; Möller & Doering, 2010; Wijdicks, 2020, chapters 6, 7, and 9) and treatises dedicated to specific topics such as bipolar disorder (Coleman, 2014), dementia (Segers, 2007; Gerritsen et al., 2011; Henkel, 2023), trauma (Wollnik & Ziob, 2010) or autism (Conn & Bhugra, 2011) show that the analysis of the subject is well advanced and many exciting studies are now available.

Since film production worldwide is and will remain unmanageable, especially if the claim is to not only capture English-language films, there is still a great deal to be done in the field of research that has unfortunately only been outlined very selectively in the scope of this article for reasons of space. Especially if one is convinced that the scientific reception of mental disorders in film is important and that film itself has a didactic value (Rodenhauser & Leetz, 1987; Hyler & Moore, 1996; Nissim-Sabat, 1979; Bhugra, 2003a, 2003b, 2006; Bhugra & Silva, 2007; Cape, 2009; Byrne, 2009) from which doctors, psychiatrists, psychotherapists, social workers, carers, experts by experience, relatives of the mentally ill, and interested lay people can learn.

Notes

1. See https://en.wikipedia.org/wiki/Federal_Bureau_of_Narcotics [last accessed 6 October 2024].
2. See https://en.wikipedia.org/wiki/Christiane_F._(film) [last accessed 6 October 2024].
3. See https://en.wikipedia.org/wiki/Christiane_F.#The_book [last accessed 6 October 2024].
4. See www.youtube.com/watch?v=OpaChBjgexg [last accessed 6 October 2024].
5. In 2021, Amazon's online service Prime Video released the eight-part miniseries *Wir Kinder vom Bahnhof Zoo* (We Children from Bahnhof Zoo), which translates the original film into the present and shows the fate of Christiane and five other teenagers as well as Berlin's drug and club scene (Poltrum, 2021). See https://de.wikipedia.org/wiki/Wir_Kinder_vom_Bahnhof_Zoo_(Fernsehserie) [last accessed 6 October 2024].
6. Danny Boyle brought *T2 Trainspotting* to the cinemas in 2017. The film shows what has become of the heroes of that time twenty years later. See https://en.wikipedia.org/wiki/T2_Trainspotting [last accessed 6 October 2024].

7. See https://de.wikipedia.org/wiki/Stoner-Movie [last accessed 6 October 2024].
8. See https://en.wikipedia.org/wiki/Stoner_film [last accessed 6 October 2024].
9. See https://en.wikipedia.org/wiki/The_Sorrows_of_Young_Werther [last accessed 6 October 2024].
10. Claudio Monteverdi *L'Arianna* (1608), *L'incoronazione di Poppea* (1642); Henry Purcell *Dido and Aeneas* (1689); Georg Friedrich Händel *Tamerlano* (1724); Wolfgang Amadeus Mozart *Die Zauberflöte* (1791); Jean Paul Egide Martini *Sapho* (1794); Gaetano Donizetti *Lucia di Lammermoor* (1835); Richard Wagner *Der fliegende Holländer* (1843); Giuseppe Verdi *Il Trovatore* (1853); Richard Wagner *Tristan und Isolde* (1865); Charles Gounod *Roméo et Juliette* (1867); Giuseppe Verdi *Otello* (1887); Peter Iljitsch Tschaikowski *Pique Dame* (1890); Hector Berlioz *Les Troyens* (1890); Jules Massenet *Werther* (1892); Giaccomo Puccini *Tosca* (1900), *Madame Butterfly* (1904), *Schwester Angelica* (1918); Alban Berg *Wozzeck* (1925); Giaccomo Puccini *Turandot* (1926); Benjamin Britten *Peter Grimes* (1945), *The Rape of Lucretia* (1946); Gian Carlo Menotti *Der Konsul* (1950); Bernd Alois Zimmermann *Die Soldaten* (1965); Matthias Pintscher *Thomas Chattertron* (1998); Peter Maxwell Davies *Mr Emmet Takes a Walk* (2000); Brian Ferneyhough *Shadowtime* (2004); Hans Werner Henze *Phaedra* (2007) ...
11. See https://catalog.afi.com/Search?searchField=Subjects&searchText=Suicide&sortType=sortByTitle [last accessed 6 October 2024]. In 2012, Stack and Bowman reported that the American Film Institute had listed over 1,600 films.
12. For the biography of Virginia Woolf see Bell (1973).

References

Arenz, D. (2015). Sucht im Film. Zwischen Realitätsverzerrung und Gefahr. *Spectrum Psychiatrie 1*, 20–22.

Arenz, D. (2019). Underground-Ophelia: Hoffen und Scheitern der Berliner Drogenszene. Christiane F. – Wir Kinder vom Bahnhof Zoo (1981). In M. Poltrum, B. Rieken, & T. Ballhausen (Eds.), *Zocker, Drogenfreaks & Trunkenbolde. Rausch, Ekstase und Sucht in Film und Serie* (pp. 105–118). Springer Verlag.

Bell, Q. (1973). *Virginia Woolf. A biography in two volumes*. The Hogarth Press.

Bhugra, D. (2003a). Teaching psychiatry through cinema. *Psychiatric Bulletin* 27(11), 429–430.

Bhugra, D. (2003b). Using film and literature for cultural competence training. *Psychiatric Bulletin* 27(11), 427–428.

Bhugra, D. (2006). *Mad tales from Bollywood*. Psychology Press.

Bhurga, D., & De Silva, P. (2007). The silver screen, printed page and cultural competence. *The Psychologist* 20(9), 538–540.

Byrne, P. (2009). Why psychiatrists should watch films (or What has cinema ever done for psychiatry?). *Advances in Psychiatric Treatment* 15(4), 286–296. https://doi.org/10.1192/apt.bp.107.005306.

Cape, G. (2009). Movies as a vehicle to teach addiction medicine. *International Review of Psychiatry* 21(3), 213–217. https://doi.org/10.1080/09540260902747094.

Coleman, D. (2014). *The bipolar express. Manic depression and the movies*. Rowman & Littlefield.

Conn, R., & Bhugra, D. (2011). The portrayal of autism in Hollywood films. *International Journal of Culture and Mental Health* 5(1), 54–62. https://doi.org/10.1080/17542863.2011.553369.

Cornes, J. (2006). *Alcohol in the movies, 1898–1962: A critical history*. McFarland.

Cunningham, M. (2003). *The hours*. Harper Perennial.

Doering, S., & Möller, H. (Eds.). (2008). *Frankenstein und Belle de Jour. 30 Filmcharaktere und ihre psychischen Störungen*. Springer Verlag.

El-Khoury, J., Bilani, N., Abu-Mohammad, A., Ghazzaoui, R., Kassir, G., Rachid, E., & El Hayek, S. (2019). Drugs and alcohol themes in recent feature films: A content analysis. *Journal of Child & Adolescent Substance Abuse 28*(1), 8–14. https://doi.org/10.1080/1067828X.2018.1561575.

Frances, A. (2013). *Saving normal. An insider's revolt against out-of-control psychiatric diagnosis, DSM-5, big pharma, and the medicalization of ordinary life*. HarperCollins Publishers.

Freud, S. (1911). Psycho-analytic notes on an autobiographical account of a case of paranoia. In Sigmund Freud, *The standard edition, volume XII (1911–1913). The case of Schreber, papers on technique and other works* (pp. 9–80). Translated by J. Strachey. The Hogarth Press.

Gerritsen, D. L., Kuin, Y., & Nijboer J. (2011). Dementia in the movies: The clinical picture. *Aging & Mental Health 18*(3), 276–280.

Goethe, J. W. (1774/1787, 1999). *Die Leiden des jungen Werthers*. Paralleldruck der Fassungen von 1774 und 1787. Edited by M. Luserke. Reclam Verlag.

Goette, S., & Röllecke, R. (2008). *Illegale Drogen in populären Spielfilmen*. Forschung und Praxis der Gesundheitsförderung, Band 23. Bundeszentrale für gesundheitliche Aufklärung.

Henkel, D. (2019). *Silent craving: Sucht und Drogen im Stummfilm (1890–1931)*. Kassel University Press.

Henkel, D. (2020). Stummes Sterben – Suizid im frühen Kino (1899–1933). In M. Poltrum, B. Rieken, & O. Teischel (Eds.), *Lebensmüde, todestrunken. Suizid, Selbstmord und Freitod in Film und Serie* (pp. 1–18). Springer Verlag.

Henkel, D. (Ed.). (2023). *Demenz im Film: Wie das Kino vergessen lernte*. Springer Verlag.

Henkel, D., & Karenberg, A. (2019a). Stumme Filme, Sucht und Drogen – Die Erkundung einer cineastischen Terra incognita. In M. Poltrum, B. Rieken, & T. Ballhausen (Eds.), *Zocker, Drogenfreaks & Trunkenbolde. Rausch, Ekstase und Sucht in Film und Serie* (pp. 1–20). Springer Verlag.

Henkel, D., & Karenberg, A. (2019b). Don der Trinker und Don der Schriftsteller. In M. Poltrum, B. Rieken, & T. Ballhausen (Eds.), *Zocker, Drogenfreaks & Trunkenbolde. Rausch, Ekstase und Sucht in Film und Serie* (pp. 31–48). Springer Verlag.

Hyler, S., & Moore, J. (1996). Teaching psychiatry: Let Hollywood help. *Academic Psychiatry 20*(4), 212–219.

Kasahara-Kiritani, M., Hadlaczky, G., Westerlund, M., Carli, V., Wasserman, C., Apter, A., Balazs, J., Bobes, J., Brunner, R., McMahon, E. M., Cosman, D., Farkas, L., Haring, C., Kaess, M., Kahn, J. P., Keeley, K., Nemes, B., Bitenc, U. M., Postuvan, V., … Wasserman, D. (2015). Reading books and watching films as protective factor against suicidal ideation. *International Journal of Environmental Research and Public Health 12*, 15937–15942.

Kracauer, S. (1947). *From Caligari to Hitler. A psychological history of the German film*. Princeton University Press.

Möller, H., & Doering, S. (Eds.). (2010). *Batman und andere himmlische Kreaturen. Nochmal 30 Filmcharaktere und ihre psychischen Störungen*. Springer Verlag.

Moreck, C. (1926). Sittengeschichte des Kinos, Aretz Verlag, Dresden. In S. Werder, S. (2015), 'Kinofusel' – Bilderrausch im frühen Film, *Cinema. Unabhängige Schweizer Filmzeitschrift 60*, 10–19.

Nissim-Sabat, D. E. (1979). The teaching of abnormal psychology through cinema. *Teaching of Psychology 6*(2), 121–123.

Noll Zimmermann, J. (2003). *People like ourselves. Portrayals of mental illness in the movies.* The Scarecrow Press, Inc.

Owen, P. R. (2012). Portrayals of schizophrenia by entertainment media: A content analysis of contemporary movies. *Psychiatric Services 63*(7), 655–699.

Poltrum, M. (2021). Broken home – Christiane und ihre Heroin-Clique sind zurück. Zur Online-Serie 'Wir Kinder vom Bahnhof Zoo'. *rausch. Wiener Zeitschrift für Suchttherapie 1/2 10,* 130–131.

Poltrum, M., Rieken, B., & Ballhausen, T. (Eds.). (2019). *Zocker, Drogenfreaks & Trunkenbolde. Rausch, Ekstase und Sucht in Film und Serie.* Springer Verlag.

Poltrum, M., Rieken, B., & Heuner, U. (Eds.). (2023). *Wahnsinnsfilme. Psychose, Paranoia und Schizophrenie in Film und Serie.* Springer Verlag.

Poltrum, M., Rieken, B., & Teischel, O. (Eds.). (2020). *Lebensmüde, todestrunken. Suizid, Freitod und Selbstmord in Film und Serie.* Springer Verlag.

Rodenhauser, P., & Leetz, K. L. (1987). Complementing the education of psychiatry residents. *Journal of Psychiatry II,* 243–249.

Römer, M. (2021). Selbstmedikation, regression, progression. Assoziative Anmerkungen zu Thomas Vinterbergs Film 'Der Rausch'. *rausch. Wiener Zeitschrift für Suchttherapie 10,* 58–63.

Segers, K. (2007). Degenerative dementias and their medical care in the movies. *Alzheimer Disease & Associated Disorders 2,* 55–59.

Springer, A. (1982a). Drogenfilme und Antidrogenfilme. I. Teil. *Wiener Zeitschrift für Suchttherapie 5*(3), 23–31.

Springer, A. (1982b). Drogenfilme und Antidrogenfilme. II. Teil. *Wiener Zeitschrift für Suchttherapie 5*(4), 35–52.

Springer, A. (2008). Requiem für einen Traum. Requiem for a Dream – Amphetamin-induzierte Psychose (ICD-10: F15.56). In S. Doering & H. Möller (Eds.), *Frankenstein und Belle de Jour. 30 Filmcharaktere und ihre psychischen Störungen* (pp. 27–47). Springer Verlag.

Stack, S., & Bowman, B. (2012). *Suicide movies. Social patterns 1900–2009.* Hogrefe.

Stack, S., Lester, D., & Rosenberg, J. S. (2012). Music and suicidality: A quantitative review and extension. *Suicide and Life-Threatening Behavior 42*(6), 654–671. https://doi.org/10.1111/j.1943-278X.2012.00120.x.

Stompe, T. (2019). Der psychotische Mörder im Spielfilm. In T. Stompe & H. Schanda (Eds.), *Der psychisch kranke Täter in Film und Massenmedien* (pp. 133–154). Medizinische Wissenschaftliche Verlagsgesellschaft,

Till, B. (2017). The impact of suicide portrayals in films on audiences: A qualitative study. In T. Niederkrotenthaler & S. Stack (Eds.), *Media and suicide. International perspectives on research, theory, and policy* (pp. 762–813). Routledge.

Wedding, D., & Niemiec, R. M. (Eds.). (2014). *Movies and mental illness: Using films to understand psychopathology,* fourth revised and expanded edition. Hogrefe.

Wijdicks, E. (2020). *Cinema, MD. A history of medicine on screen.* Oxford University Press.

Wollnik, S., & Ziob, B. (Eds.). (2010). *Trauma im Film. Psychoanalytische Erkundungen.* Psychosozial-Verlag.

Woolf, V. (1941). In M. Cunningham (2003). *The hours.* Harper Perennial.

Wulff, H. J. (1985). Die filmische Analyse des Alkoholismus. Einige Anmerkungen zu Billy Wilders The Lost Weekend. In H. J. Wulff (Ed.) *Filmbeschreibungen* (pp. 143–172). MAkS Publikationen.

Ziegler, W., & Hegerl, U. (2002). Der Werther-Effekt. Bedeutung, Mechanismen, Konsequenzen. *Nervenarzt 73,* 41–49.

Filmography

Abu-Assad, Hany. (2004). *Paradise Now*
Adler, Lou. (1987). *Up in Smoke*
Aldrich, Robert. (1961). *The Last Sunset*
Amenábar, Alejandro. (2004). *Mar Adentro*
Aronofsky, Darren. (1998). *Pi*
Aronofsky, Darren. (2000). *Requiem for a Dream*
Bach, Christian. (2014). *Hirngespinster*
Baugh, Brian. (2009). *To Save a Life*
Biller, Kenneth, & Sussman, Mike. (2012–2015). *Perception*
Boyle, Danny. (1996). *Trainspotting*
Boyle, Danny. (2017). *T2 Trainspotting*
Caton-Jones, Michael. (1992). *Basic Instinct 2*
Chabrol, Claude. (1994). *L'Enfer*
Chaplin, Charlie. (1916). *One A.M.*
Chaplin, Charlie. (1917). *The Cure*
Chaplin, Charlie. (1931). *City Lights*
Clifton, Elmer. (1937). *Assassin of Youth*
Cole, Nigel. (2000). *Saving Grace*
Colombani, Laetitia. (2002). *À la folie ... pas du tout!*
Cronenberg, David. (1991). *Naked Lunch*
Cronenberg, David. (2002). *Spider*
Daldry, Stephen. (2002). *The Hours*
Daldry, Stephen. (2008). *The Reader*
De Palma, Brian. (1980). *Dressed to Kill*
Denys, Arcand. (2003). *Les invasions barbares*
Eastwood, Clint. (2004) *Million Dollar Baby*
Eastwood, Clint. (2008). *Gran Torino*
Edel, Ulrich. (1981) *Christiane F. – Wir Kinder vom Bahnhof Zoo*
Enrico, Jérôme. (2012). *Paulette*
Esper, Dwain. (1936). *Marihuana – Weed with Roots in Hell*
Fincher, David. (1999). *Fight Club*
Ford, Tom. (2009). *A Single Man*
Forman, Miloš. (1975). *One Flew Over the Coockoo's Nest*
Gasnier, Louis J. (1936). *Reefer Madness*
Gillespie, Craig. (2007). *Lars and the Real Girl*
Gilliam, Terry. (1991). *The Fisher King*
Gordon-Levitt, Joseph. (2013). *Don Jon*
Griffith, David Wark. (1919). *Broken Blossoms or The Yellow Man and the Girl*
Greco, Joseph. (2006). *Canvas*
Hawks, Howard. (1932). *Scarface*
Hitchcock, Alfred. (1945). *Spellbound*
Hitchcock, Alfred. (1960). *Psycho*
Howard, Ron. (2001). *A Beautiful Mind*
Hudson, Hugh. (2000). *I Dreamed of Africa*
Jarmusch, Jim. (2013). *Only Lovers Left Alive*

Kadelbach, Philipp, &Hess, Annette. (2021). *Wir Kinder vom Bahnhof Zoo*
Kaurismäki, Aki. (1990). *I Hired a Contract Killer*
Konchalovsky, Andrei. (2002). *House of Fools*
Korine, Harmony. (2019). *The Beach Bum*
Kubrick, Stanley. (1980). *Shining*
Lang, Fritz. (1932). *Das Testament des Dr. Mabuse*
Leven, Jeremy. (1995). *Don Juan DeMarco*
Leytner, Nikolaus. (2013). *Die Auslöschung*
Litvak, Anatole. (1948). *The Snake Pit*
Logan, Joshua. (1957). *Sayonara*
Lyne, Adrian. (1987). *Fatal Attraction*
MacDougall, Ranald. (1961). *Go Naked to the World*
Madden, John. (2005). *Proof*
McQueen, Steve. (2011). *Shame*
Méliès, Georges. (1908). *Le rêve d'un fumeur d'opium*
Mendes, Sam. (1999). *American Beauty*
Michell, Roger. (2004). *Enduring Love*
Minghella, Anthony. (1996). *The English Patient*
Nakache, Oliver, & Toledano, Éric. (2011). *The Intouchables*
Niernberger, Leopold (1924). *Narkotika – Die Welt der Träume und des Wahnsinns*
Page, Anthony. (1977). *I Never Promised You a Rose Garden*
Pate, Jonas. (2009). *Shrink*
Phillips, Todd. (2019). *Joker*
Polański, Roman. (1976). *Le locataire*
Powell, Michael. (1960). *Peeping Tom*
Preminger, Otto. (1955). *The Man with the Golden Arm*
Redford, Robert. (1980). *Ordinary People*
Robson, Mark. (1967). *Valley of the Dolls*
Scherfig, Lone. (2002). *Willbur Wants to Kill Himself*
Schroeder, Barbet. (1987). *Barfly*
Scorsese, Martin. (2010). *Shutter Island*
Shill, Steve. (2009). *Obsessed*
Softley, Iain. (2001). *K-PAX*
Walsh, Raoul. (1939). *The Roaring Twenties*
Weingartner, Hans. (2002). *Das weiße Rauschen*
Weingartner, Hans. (2011). *Die Summe meiner einzelnen Teile*
Weir, Peter. (1995). *Dead Poets Society*
Wellman, Willian A. (1931). *The Public Enemy*
Wiene, Robert. (1920). *The Cabinet of Dr. Caligari – Das Cabinet des Dr. Caligari*
Wilder, Billy. (1945). *The Lost Weekend*
Wyler, William. (1961). *The Children's Hour*
Vinterberg, Thomas. (2020). *Another Round*
von Trier, Lars. (2013). *Nymphomaniac*
Young, Emily. (2009). *Veronica Decides to Die*
Zahavi, Dror. (2008). *Sof Shavua B'Tel Aviv / For My Father*

CHAPTER 33

IMAGING CHILDREN'S REALITIES IN FILMS

Visual Anthropological Approaches and Representations of Emotions in Childhood

ALISON L. KAHN

Introduction

Children present a puzzle to the filmmaker. They belong to an elusive social group, with its own rules and rituals. They jealously guard the secrets of their private lives. Their relations with adults are ambivalent and variable. They can be distrustful and keep their distance and yet at other times show astonishing candour and affection. They have their own distinctive ways of speaking and thinking – a fact now confirmed by neuroscientists, although long assumed by Jean Piaget and many developmental psychologists. So why film children? To find out where we adults came from? To discover other ways of being? To learn, perhaps, where the human experiment went wrong?

(MacDougall, 2019, 39)

WHEN my son was two years old, we were walking through a farmyard and suddenly a cow made a loud bellow as we passed by. He immediately fell asleep; he was wide awake one moment and fast asleep the next. He had been so shocked by the loud noise, he turned off and only woke up after some cajoling several minutes later. Although this reaction to noise surprised me, I was not unfamiliar with extreme mental responses to moments of stress. I grew up with a severely epileptic father when medication for this complicated affliction was hit or miss. My father's first epileptic attack happened at the age of sixteen in front of his own father shortly after they arrived in England from India in 1948 after independence. My grandfather, who had been a highly revered school Mathematics teacher and choir master in a prestigious school in India, stood over him angrily chastising him, telling him how slow and stupid he was, as he was incapable of

understanding the mathematical problem that he was tasked to do. My father had already experienced trauma before, and this episode tipped him over the edge, and led to a life-long struggle with epilepsy. I was thus sensitized to the fragility of the human mind at an early age, although the effects of forced migration on our family were understood much later in my life. There is no doubt that witnessing my father's regular 'black outs' and the aftermaths taught me how delicately trauma and emotion is attached to our intellectual understanding of the world, and how much our childhood shapes the rest of our lives.

Filming Children for Research Purposes

Many studies have been carried out with regard to children's acquisition of cognitive skills, most notably Piaget's Theory and Stages of Cognitive Development in Children, but far fewer have been undertaken of children representing themselves as subjects or as participants in documentary and ethnographic films; in most recent times children have become filmmakers themselves, creating, distributing, and consuming their own audio-visual representations of the world. At Oxford University in the twentieth century, anthropological research was not advised as a subject for study for young adults who had not completed a first degree; academic anthropology was seen as an advanced stage of study for students had already gained enough knowledge of their own culture.[1] There are moments in time during the process of filmmaking where the filmmaker and subject are participants and observers, both in a state of limbo, at the threshold of the adult world and child's world, looking in and out of the situations they immortalize on film. From an ethnographer's point of view, adult access to children in their domestic setting is often seen as intrusive and inappropriate, and there are many good reasons for assuming this as children are inherently the most vulnerable of humans. Only a few examples of children as anthropological informers are extant in the canon of ethnographic audio-visual data, most famously the deceiving of Margaret Mead in her early fieldwork studies in Samoa, and on camera in her films with Gregory Bateson in the 1940s and 1950s.[2]

Visual Anthropology and Ethnographic Film

The discipline of visual anthropology has, in many senses, grown up with the idea of ethnographic filmmaking. Ethnographic film was associated with methods of research that were deemed valid enough to be part of the 'anthropological project'.[3] This illusion that the ethnographic style of filmmaking was somehow more observational or more

connected with 'objective truth' has been much discussed and has often confused students of visual anthropology rather than illuminated them. Ethnographic film methods, as prescribed by academics, were often written by those who had little or no interest in using film, and very few anthropologists, even now, know how to make films at all (see Ruby, 1975; Banks & Morphy, 1999; and Heider, 2006). Documentary filmmakers and film theorists have been more helpful, defining certain styles and positions of documentary filmmakers in relation to their subjects (see Barnouw, 1993; Heider, 2006; and Nichols, 2017). The relationship between the anthropologist-turned-ethnographic filmmaker and subject requires scrutiny and ethical reflection; today's ethnographic film practice includes an explicit agenda that makes room for collaborative and reflexive forms of representation at every stage of the study (see Figure 33.1).

Most histories of visual anthropology begin with A.C. Haddon's Cambridge University expedition to Torres Straits in 1898, when he brought back film footage of Islanders dancing. This event is linked with the history of film itself, as most film courses will begin with excerpts of the Lumière brothers' footage of factory workers leaving their work place in Paris and the arrival of a train at La Ciôtat station in the South of France. Both academic and commercial practices of early factual filmmaking included people going about their daily lives, but only the latter ever saw themselves in films, seated in an audience. The Lumière brothers would charge a small fee for the screening of films they had made during the day, usually projecting it to an audience inside a tent to those subjects who had just been filmed. In contrast, academic endeavours

1. Appropriateness of sound	
2. Narration	
3. Ethnographic basis	
4. Explicit theory	
5. Relation to printed materials	
6. Voice: point of view	
7. Holism: behavioral contextualization	
8. Physical contextualization	
9. Reflexivity: the ethnographer's presence	
10. Whole acts	
11. Narrative stories	
12. Whole bodies	
13. Whole interactions	
14. Whole people	
15. Distortion in the filmmaking process	
15a. Inadvertent distortion of behavior	
15b. Intentional distortion of behavior	
15c. Explanation of distortions	
16. Culture change	

FIGURE 33.1 This figure shows Heider's 'attribution dimension grid', which is a prescriptive and descriptive chart that lists the essential ingredients for a film to be considered ethnographic.

were screened only to exclusive audiences, usually in the institutions that had funded the trip. This practice continued in anthropological circles in the UK until the end of the twentieth century. The intertwinement with the history of film as a new medium of representation has irked and aided the discipline of anthropology. An overview of the anthropologist's ethnographic film canon reveals that it would be empty without all the additional films deemed by the academy to have ethnographic value regardless of any anthropological training by the filmmakers involved. A classic of its era was Robert Flaherty's feature film, *Nanook of the North* (1922), a surprising hit in the box office in New York, and although the construction of its realities was far from authentic and devoid of ethnographic methods, Flaherty is still considered the Father of ethnographic film. Twentieth-century ethnographic film arrived in institutions from different parts of the world and is now divided up into smaller categories, such as travel films, ethnomimetic dramas, records of fieldwork, and cinematographic film art.[4]

WOMEN FILMMAKERS

One of the most important advances in the study of ethnographic film in the twenty-first century is the digitization of archive film material from the nineteenth and twentieth centuries and the democratization of filmmaking through access to digital technologies. The British Film Institute has funded film digitization and conservation projects that have been made accessible to the general public. With the advent of YouTube as a free broadcaster of these pieces, we have been able to study audio-visual material made during the twentieth century by a host of different filmmakers, previously unmentioned in written historical accounts. Much of the footage was made by amateur filmmakers who filmed their holiday trips and witnessed events undocumented by the professional filmmakers or researchers (see Nicholson, 2014). As a student of visual anthropology in the late 1990s it was incredibly difficult to access films made by or with anthropologists, and much was yet to be discovered in museums, archives, libraries, schools, and people's homes. I remember accidentally damaging a copy of Jean Rouch's *Chronicle of a Summer*, in a faulty video machine, and it cost me 240 British pounds to replace it. When we viewed Rouch's *Mad Masters* (*Les Maîtres Fous*) and the MacDougalls' *The Wedding Camels*, they were rented from the Royal Anthropological Institute and projected onto a large screen from 16mm film.

Margaret Mead and Gregory Bateson were a rare breed of anthropologists who filmed children in the interwar and post-war period. Their *Bathing Babies in Three Cultures* (1952) set a precedent for students of film to consider filming children; this was no doubt an area that Mead felt comfortable in, and had an advantage of being a woman in the field as men were, and often still are, banned from filming intimate, domestic activities. In Britain, filmmaking was not encouraged as forming part of ethnographic fieldwork, especially when carried out simultaneously. Many scholars would still doubt that it is a good idea today, often based on the change of relationship between the researcher and

her subject; a camera always brings about a different dynamic to the scene. I would add that smart phones have made 'picture taking' and short video filming more acceptable, notably because it is not just the anthropologist or an official filmmaker that does it now. People who would never have had access to cameras ten years ago are now fluent with the use of smart phones and all their attributes. In conversation with Cambridge anthropologist Professor Alan MacFarlane, he underlined the point that for most of the twentieth century in academic training, ethnographic filmmaking was seen as 'too expensive and too difficult', and in the field, researchers would be told that they 'should not attempt to do both' (Kahn, 2011; *Captured by Women*). Since 2010, many more amateur filmmakers have been included in university curricula, such as the ethnographic film material of Beatrice Blackwood and Ursula Graham Bower.[5]

Blackwood had screened her footage to her students in her apparently energetic classes at the museum. Interviewees for my project on women's ethnographic films revealed that she projected the film in the museum's seminar room for her Oxford University anthropology students, whilst vigorously demonstrating the use of objects such as the 'bull roarer', a wooden instrument that made a loud whirring noise when she rapidly spun it around. She had acquired artefacts on a collecting tour for the Director of the Pitt Rivers Museum, Henry Balfour, and the 1936 New Guinea expedition was the third of such trips; for this one, she took a film camera. She had managed to film men, women, and children using the artefacts now in the museum, revealing the craftsmanship to her 16mm camera. Such images are invaluable to an ethnographic museum. When she passed away in the mid-1970s her films remained in the archive and were never used for teaching again until I digitized them in my *Captured by Women* project in 2011.

Ursula Graham Bower also used 16mm film to capture the everyday life of the Naga people with whom she lived in Manipur, Assam, and Nagaland in northeast India, for about eleven years from 1937 to 1948. Her footage reveals children assisting adults in daily chores, taking part in ritual dances and wearing some of the intricately woven shawls that depict their status in the tribes. She also catches them on camera at ease, laughing, eating, playing, and hunting with the adults; mostly, Bower's subjects do not engage directly with the camera, and seem quite oblivious to her attempts at capturing ceremony and the ordinary alike, which shows how comfortable they were with her and her use of a camera. When I took the digitized films back to Nagaland in 2019, there was great excitement from the Zeme Naga communities, some of whom could still identify the people in the film. A host of stories were provoked by the screenings in Jalukie Town, Nagaland, and special guests were invited to watch the films. They remembered Bower's contribution to medical assistance for women and children during the 1930s and 1940s. The act of watching children in the past reinvigorated a collective memory, revealing childhood memories of games, traditions, and sports. A strong emotional response was witnessed by the tribal audience, and the films were shared on Facebook and other social media to other members of the community who could not attend. These digitized films are now on display on a large interactive screen at the Pitt Rivers Museum.

The main objective of these films made by Blackwood and Bower was to gather visual information for lectures and monographs, and they used them to screen alongside talks to experts back home in the UK. Despite film being used by various professionals and amateurs between and after the World Wars of the twentieth century, the academic turn towards the inclusion of audio-visual as an element worth discussing in anthropological discourse did not happen until the 1960s. When it did, it was to hail cinema art movements as worthy of analysis, not to celebrate the silent film footage made by 'amateurs' whose fragments of film universities possessed in the archive. Anthropologists celebrated the work of the film duo, Edgar Morin and Jean Rouch, as part of a new wave movement, *Cinema Vérité*; and in the US, *Direct Cinema*, Richard Leacock, Robert Drew, and Albert Maysles, who, like their European counterparts, took advantage of the technological breakthrough in filmmaking, which was sync sound; the ability to record audio and visual simultaneously on a handheld portable camera. Now anthropologists and documentary filmmakers could enter the centre of the action and reach a new level of realism in their films.

Art-House Film and Anthropology

Although film reels were relatively expensive, and still a luxury item for a researcher, black and white and colour film was widely available in high street shops, partly due to wartime necessity in the 1940s. It was a gift to filmmakers post-war, who wanted to make observational style documentaries 'on the hoof', and movement of the camera in long one-shot sequences became the mainstay of action film shooting. It could be argued that Morin and Rouch did treat their subjects with 'kid gloves' in *Chronicle of a Summer* (1961). The unforgettable opening reveals the aims of the film simultaneously to their main informants and audience. It begins: 'This is a film about how people live', asking the man or woman in the street, 'Are you happy?' Explicitly the film investigated an emotional state of being, 'happiness', but the underlining methodology that included collaborative, reflexive, participatory approaches to the process of making the film set the film apart from its predecessors as it implicitly asked the audience and those in the film: Do people represent themselves authentically when in front of a film camera? For social science students, it was a revelation that method and result could be acquired simultaneously on film.

Rouch and Morin revealed an aesthetic that has now passed, a moment in time when audio-visual experiences were rare elements in the daily lives of people. This innovative method that has since become part of the ethnographic filmmaker's endeavour reveals a shared anthropological approach where the participants in the film help to shape the way the film is made and the way they are represented in it. It still seems strange and uncomfortable to witness someone reveal such depth of emotion on camera, close up and raw. In the interview with one of the participants, Marylou, the subject was criticized. At the end of the film all the participants watch the footage, and the reaction

of other participants was unforgiving as they felt that too much emotion on camera is like revealing a naked truth, a truth that may be seen as histrionic, or a performance made just for the camera. This search of 'authenticity of self' has preoccupied visual anthropologists ever since.

Here we look at three audio-visual projects where children have been placed at the centre of the research, where their actions and voices are seen and listened to, and I offer some form of analysis at the outcome of these projects and their possible impact on understanding the emotional worlds children inhabit. Froerer (2014) reminds us that:

> It was not until the early 1970s, with the publication of Charlotte Hardman's (1973) seminal article addressing the possibility of an anthropology of childhood that children began to be more formally recognised as valid subjects, whose lived experiences should be taken seriously, who had different but valid perspectives on the world around them and who could indeed reveal something unique about aspects of social life and the transmission of culture. (474)

Britain's 'Sociological' Television Series: *Seven Up!* (1964–2019)

In Britain, a worthy contender of filmmakers attempting to work with children can be seen in the *Seven Up!* series, led by documentary filmmaker, Michael Apted. Although not anthropologically trained, he was a pioneer, interviewing children on camera, and as the years went by, his long-term relationship with almost all of the original set of participants gained international acclaim and academic status as the first documentary film experiment of its kind. He begins the series with an expository approach to documentary, but over the years, his relationship with the subjects in his film changes and evolves. We see more of a participatory and reflexive approach to filmmaking as he becomes emotionally involved with the lives of ten boys and four girls from England beginning in 1964, when they were seven years old. The series was inspired by the Jesuit motto 'Give me the child until he is seven and I will give you the man'. Every seven years the film crew revisited the group, with the most recent instalment, *63 Up!*, airing in 2019. The first episode states the social facts that the series goes on to explore, that a child's destiny in 1960s Britain is dictated from the cradle. The school they attend at seven years old will set them on a path of expectation. These episodes engage the audience in a way that had not been witnessed before by a public television audience; children answering questions about what they would like to be, their innocent verbal responses and passivity in the process of their enculturation, was witnessed by all, and it began a set of narratives that the general public would follow for a life time. Michael Apsted asked a question that interested scholars as it got to the root of major philosophical questions that spawned a wave of research in nurture/nature debates, as well as philosophical

questions about structures of societies: how do children see themselves and how much control will they have over their destinies? Barrie Thorne (2009) remarks in his article about the *Seven Up!* series that the strength of the project is the 'emotional' pull on the audience, and as time goes by, the subjects become aware of themselves in different ways over time. He says:

> the centrality of emotions in human experience; the complex dynamics of age, social class, and gender; complex resonances between this sort of documentary filmmaking and ethnographic research; and – striking dimension of all—the films' evocation of different ways of inhabiting time. (328)

Anthropologists still have a lot to learn from filmmakers who can entice an audience into the emotional worlds of children. A point is also raised about the changing identity of subjects in the *Seven Up!* series as their lives move into different spheres and their individuality is challenged by partners and circumstances. 'The dramatic arc of each life—such as Neil's promise, decline, and redemption, compared with other, more steadily unfolding individual trajectories and patterns of emotional maturation—carries emotional weight' (339).

Apted died in 2021, so it may be the end of this series as we know it, unless someone else takes the helm. He is known for bringing to light the socially conscious documenting of children; he was able to reveal emotion and connect with them about their aspirations and lived experience from childhood through to adulthood. This emotional attachment between filmmaker and his subjects is also felt between Apted's audience and the participants of his film, who we grew to care for and worry about the destiny of each child, as time went by. Thorne notes that 'the films demonstrate a point that sociologists all too often tend to forget: each individual is unique, with a distinctive personality' (330). In the second set of films, at the age of fourteen, Sue says to Lynn and Jackie, 'When you look at the seven-year-olds, it's difficult to believe it's us' (330). This statement has an emotional effect on the audience as we realize how much of those young beings has been lost in the journey towards adulthood. My own child, now of a similar age, remarked upon seeing videos I took of her at aged two and five: 'I can't remember being like that. Who was I then? The time has gone so quickly'. Likewise, my youngest son, bursting into tears at the age of eight, said he felt he was growing up too quickly and he wanted to be 'young' again.

All carers of young people will have their own stories of children's ability to 'see' themselves in the world and have moments of realization that time is passing and life does not stay the same. Mutability is the subject of many films about childhood, but childhood is short-lived by many due to circumstances beyond the control of families, communities, and nations. Personally, filming young people has always been more about listening to them. Children have an ability to show and tell in a way that is both innocent and wise; outside the perimeters of control, they can shed light on problems that adults find confusing. Apted's ability to share his concerns and reflect upon the class struggles (fate,

chance, and endurance) with his large audience is testament to the documentary as a vital medium to reveal not only childhood emotion, but the emotions that adults have about their childhood selves.

MacDougall's Films on Childhood

David MacDougall has enlightened us with filmed observations of childhood in Indian schools and institutions in his *Doon School* films (1999–2008), *SchoolScapes* (2007), and *Gandhi's Children* (2011). The *Doon School* films are a quintet of interrelated films about one elite school in India. They are a departure for MacDougall, technologically and content-wise. They are the first of his films that he made on a digital camera, and the subject matter would concentrate on the lives of school boys at a private school, sometimes known as the 'Eton of India'. This 'child-centred-turn' in MacDougall's work reveals a preoccupation with intuitional enculturation, although his first wish was to explore diversity of the boys' background and how they played out in a shared space. He observes life as it is lived by school boys passing through stages of their secondary education from the ages of eleven to eighteen. MacDougall spent weeks at a time filming the students at the Doon School, and comments on the process of change that he experienced as a filmmaker, as he, along with the children he filmed, changed into a different state of consciousness:

> There are several aspects of the Doon School project that I feel, perhaps unreasonably, I should have understood earlier. Although there was a shift in my perceptions of the school soon after I started, I was unaware for some time of a more gradual shift that was taking place in how I was filming it. The actual experience of filming was in fact changing a number of my ideas about the characteristics of social spaces.
>
> (MacDougall, 2006, 120)

MacDougall's *Doon School* films take on a Joycean quality as the narrative disperses and folds in, descriptive but distant to the core of the humanity in which he presided. Themes such as the microscopic moments of school regimes become magnified, such as a scene of shoes outside the assembly hall delayed by the pause in the edit, to an extent that the viewer is forced to ponder images that force questions about one's own childhood, ritual behaviour, unremembered spaces. We also witness as an audience the borders and boundaries in the film, as lessons begin, bells ring, exercise is done, food is eaten, and all go to sleep at the same time: the adults are also expected to follow the same regime as the children, which also prompts questions about how formal education is a set of constants in an unbreakable cycle of rituals: 'The cultures of childhood and the worlds that children inhabit are beginning to be understood as distinct from adult worlds and not just childish versions of them' (MacDougall, 2006, 75). MacDougall remarks that his presence as a filmmaker was ignored by the children after a short while as they realized

he was not always exactly looking at them, but focused on his craft. This quiet understanding evokes an emotional response on film as we see fleeting moments of interest in the process of filmmaking, but ostensibly, the students are more interested in their own worlds, quite happy to tolerate the presence of another, the 'other' from the adult world as long as they could continue to be themselves.

In *SchoolScapes* (2007), a film made at the Rishi Valley School in Andhra Pradesh in South India, we are reminded of the rituals that help us slow down the passing of time. On viewing the empty shoes outside the assembly hall, that the children shed before they enter, and fill again as they leave to go to their lessons: 'Time moves on to the next part of the day, the next moment in the life of the child, of the school and of the rituals that form the individual who grows apart from, but as a piece of, the collective experience. As a moving image it is not confined, but understood at once universally as well as where time and place is secondary to the connections it presents as a continual narrative' (Troiani & Kahn, 2016, 59). MacDougall invites us into this world as if we are a child waking up in it. It is always the birds we hear first, a car passing and the wind blowing through the trees; the world of discovery is evoked through the senses of sound, smell, and touch. He films the lives of children as expressed through an artistic curriculum, inspired by the educationalist Jiddu Krishnamurti, who believed in a co-educational environment that incorporated liberal arts at the centre of learning, and where emotion is channeled through music and arts, rather than the all-male, military-style sports discipline of the Doon School. Contrasting the lives of children at the Doon School and Rishi Valley School, we observe how diverse the formal school experience can be for children, and how we might begin to understand the fully grown adult when we are reminded of the rich tapestry of teachings they have undertaken.

In *Gandhi's Children*, we witness a very different type of childhood institution in the Prayas Children's Home for Boys in Jahangirpuri, Delhi. The constant emotional distress of one of the young boys is palpable, witnessed visually in the agitation of a young boy scratching his scabies, and immortalized by the doctor asking 'Who is looking after this child?'. The child's vulnerability is literally laid bare when we see him trying to apply the benzyl benzoate cream to his dry skin with his trousers down in the middle of the compound. Many of the scenes are pitiful and difficult to watch, but there is also an ethos of humanity in the institution and the words of the doctor and the teachers are often kind and reassuring. One of the stark realities we notice is the absence of women; each boy learns to cope in a world that is void of a sense of home. We see young boys crying as the pack mentality of boys is often cruel and dispassionate, and their place in the order shuffles to the biggest and oldest boys verbally and physically chastising the younger ones. It is sad to see that tears of emotion must be quickly wiped away, and distress gives way to acceptance; an emotional understanding in each boy who knows intuitively that to survive in this place you must adjust and learn to push emotion away. Explicit displays of love or affection between the boys are fleeting, and their survival depends on abstraction of emotion replaced by stoic patience. It is this suppressing of emotion in the young boys that is most heartbreaking to watch.

That gradual shift that MacDougall mentions with regards to his experience in filming schools and institutions in India culminated in the 'Childhood and Modernity' Project, which took place in India from 2012 to 2016. He handed over the cameras to eleven- to thirteen-year-old children from low- and middle-income families. He comments: 'More recently I've been directing a project during which, over five years, I held workshops for different groups of Indian children in which they made films on topics that interested them. I've found many of the films very revealing about the children's emotions and perspectives'.[6] What resulted has highlighted how important and adept children are in capturing aspects of society, and how fluidly they portray their realities though audio-visual means.

Childhood Project: *Delhi at Eleven*

MacDougall's 'Childhood and Modernity' Project in Delhi revealed some fascinating angles of filmmaking as a tool of insight into a child's mind. Here I analyse four films: Ravi Shivhare's *My Lovely General Store*, Anshu Singh's *Why not a Girl?*, Aniket Kashyap's *My Funny Film*, and Shikha Dalsus's *Children at Home*. MacDougall argues that children are often thought to reach a stage of perfection at eleven or twelve, when the processes of becoming an adult begin. The moment of liminality brings qualities of otherness to this phase of childhood where a hybrid person is about to be released to the world, as this unfinished person is still powerless in many areas of life. By working with the children and allowing them space to create something out of nothing on their own terms, we are allowed a privileged insight into the secret world of children, who in most formal circumstances, would never reveal how they really feel to adults. Banerjee observes, 'MacDougall has helped dismantle the myth of a disinterested and detached filmic gaze. Often his subjects participate in shaping the intellectual concerns of his films, taking the reins to direct both the filmmaker and the audience towards what interests them' (Banerjee, 2014, 465). In Ravi Shivhare's *My Lovely General Store,* Ravi details a shop where his uncle works. The texture and rhythms of life in the store are seen through the eye of a young boy preparing to take his place as head of the family. 'The first film in the series, Ravi Shivhare's *My Lovely General Store*, is the most "public" of the four, with its detailed account of work practices and transactions that take place in a general shop in his neighbourhood' (Doron, 2014, 470). He shows emotions of happiness and concern, detailing the insights into the daily life of adults that he has observed. Film, in this case, shows how proud children are when they feel they can emulate their elders: it reminds us also of the attention they pay to what adults do, and how habits, disciplines, and the small interactions we have with each other are learned, right or wrong.

In *Why Not a Girl?*, set in a slum area of Delhi, Anshu Singh chooses 'articulate girls to capture the fears, wants and frustrations that so many young girls experience in India, with their lives, daily movements and opportunities restricted and defined by others' (Doron, 2014, 472). This reveals that the young filmmaker is aware of her friends'

views and know they will highlight her concerns in the film. It also shows how astute she is about understanding the power of film as a tool of protest. The dialogue between the young preteen girls and boys reveals the unequal place they have in a society that curtails the potential of girls and women. The scenes are well shot as they document the unedited conversations in class and in the street of the children, and the girls speak out about their fate as women. They often keep a smile on their face as they are empowered by the filmmaker; they externalize their angst and convey a veneer of contempt and dark humour that they develop from a young age. The film's quality is that it makes its point well; that innate sense of fairness that most children espouse as an intuitive part of their connection with the world through the treatment of their peers is documented in public, as the filmmaking process gives them a voice as never before.

Aniket's *My Funny Film* is an almost ironic comment on a world that is far from amusing, but seen through the eyes of its young filmmaker, when the future is yet unloved, it is acceptable and stimulating. The audience is allowed into the private confines of another slum neighbourhood, where we witness the external manifestation of the child filmmaker's friends through performance and joviality. 'Towards the end we meet the bejewelled daughter-in-law, whose recent arrival into the home becomes a source of ceaseless fascination for the boy. … It is Aniket's intimate, almost invasive shots of her coy, uneasy bodily comportment, and her pensive and lonely expressions, that render this film memorable' (Doron, 2014, 473). Her silence is a contrast to the rest of the film which leaves the spectator with space to think only about her and to witness her vulnerability and powerlessness in the face of cultural norms. Banerjee comments that the 'Childhood and Modernity' Project was a 'pioneering effort in theorising and practising the observational mode of ethnographic filmmaking. In this mode, meditative frames unfold in ways that allow for an immersive engagement with the sensory, aesthetic and material worlds of filmed subjects' (2014, 465). The liminal moments of participating in the film project exist for the young filmmakers as they briefly lead their companions and their teachers into their worlds, experiencing a shared ritual of being part of something other than their daily lives. The filmmakers are liminal with senses here as they continue to evolve into adulthood long after the camera is taken away. A touching statement from one child was not lost on MacDougall when he said that when the camera was taken back from the children after the project, one child said that it was like losing a friend. This comment reminds us of how children attach emotional importance to things, and we must be aware of how much attachment is invested in material objects. Their connections to the world are different and values attached in a commercial world are not the same values a child might have for an object.

Parents of small children will recognize the importance of special teddy bears, or blankets, but the feelings are just as strong for children with regard to sticks and stones. Leaving Nagaland with my seven-year-old son, we had to take his two newly acquired bamboo sticks: when we tried to leave them, he protested, 'We can't leave Bob One and Bob Two!' Banerjee concludes: 'If children are indeed one of anthropology's last tribes, these films take part in a collective movement in ethnographic film to finally disavow any lingering hierarchies about who might represent and who might be represented' (466).

Digital Children

My *Digital Children*[7] project is a current work in progress studying how children engage with the digital audio-visual material. Marshall McLuhan predicted an inevitable tsunami of digital content in his seminal work on communication technology, *Understanding Media* (1967), in which he compares the global village to the central nervous system, explaining that society is interconnected by the influence of electronic technology. If that comparison is still relevant, then YouTube is the largest sciatic nerve of audio-visual dissemination, containing the most varied reflection of everyday-life that has ever been recorded. It is an ever-growing archive of audio-visual material, mostly produced by the masses in a fragmentary way that presents the lives and preoccupations of the merging of a visible global culture in the early twenty-first century. We have an infinite source of ethnographic film at our disposal to interpret and analyse at length. Much of the audience of the audio-visual content on YouTube and related broadcast channels that have since emerged, such as Twitch, are watched by children. I am conducting research into how children use digital media, and here I touch upon the outputs of children as YouTube content makers, as it has intrigued me how this content has reached a specific audience of children, who now spend much of their childhood watching this material.

We observe the audio-techniques used by YouTubers to reach and sustain an audience of millions. All YouTubers make content such as: challenges, endurance tests, 'myth busting' experiments, pranks and humorous dialogue. Young audiences have an emotional attachment to their favourite content creators and show hilarity, surprise, concern, and sadness, as they share many hours in the company of their 'friends'. Feedback from children, aged ten to sixteen, from a focus group in the UK, reveals YouTubers' connections with their audience is based on a strong emotional attachment to their audience; there is a constant feed of direct contact with their 'target' viewers who begin as gamers interested in improving their skills in games like Minecraft, Valorant, Fortnite, and Roblox. A child (aged fifteen) has informed me that her favourite YouTuber has contracted COVID-19 and she is concerned by his 'real-life' problem, despite the fact that she usually watches him in his digital landscape, Minecraft. There is obviously a connection beyond the game that connects both ethnographic landscapes. The audience normally see the gamer in a corner box on the screen, and this is his physical self presented to his audience: through this small frame he connects his real life to those of his gaming audience.

Another example of a new digital ethnographic landscape inhabited by children is The Dream SMP, which was developed into a platform to tell stories. Before 2020 the global audience was predominantly young teenage males, but after a successful event on the platform, it suddenly became open to a wider demographic of all genders. By combining a popular digital landscape such as Minecraft, with an interesting narrative, the real-life personalities from the gaming community created avatars that live out an action drama in real time. It created a new 'ethnographic landscape' that included

emotional content, between the players in the game and the young audience sitting on the edge of their seats, excitedly engaged to see what happened next. Content Creators on the Dream SMP understood the power of storytelling in gaming and had the talent and means to put it into practice. By playing on the 'nostalgia' in early Minecraft users (playing Minecraft as under-ten-year-olds in 2009), they succeeded in enveloping an audience of three generations: Y, Z, and Alpha. They now command a massive cult-like following online, their audiences entranced by the unfolding narrative of characters with whom they could emotionally identify. One successful YouTuber, Tom Simons, known on YouTube as Tommy Innit, comments on his personalized experience with an audience that amounts to millions of children and young adults: 'I'm not known for being any good at the video games. I just make the jokes'.[8]

Some YouTubers, who have become famous individually, join together to form companies and give themselves identities much like characters in a movie. They use the techniques of 'vlogging' where they use professional teams to record them in off-line situations undertaking various tasks and adventures. The Sidemen[9] are an example of this kind of content-making machine for an eager online audience, for example, most recently, the *Abandoning Challenge* (8 May 2022). The Sidemen tasked themselves to make their way back to Amsterdam from a rural location in the Netherlands, equipped with only their backpacks, food, and their film crew. In their recorded non-scripted films, they convey a value system based on camaraderie and adventure as a way to live life to the full. They demonstrate personal skills, good humour, and teamwork, as they navigate their way to their destination. Filming their escapades shows the merging of on- and off-line behaviour, which is attractive to the present generation of children aged between ten and eighteen: there is obviously a great deal to learn from how Generation Z and Alpha relate to each other. This study is the latest attempt by the author to keep up with the fast-moving development of audio-visual content that has been flooding our screens since the foundation of YouTube in 2006. Some early results in this area show that emotional attachment to the lives of their favourite YouTubers is felt by the audience of children as young as five years old, who move easily between their analogue and digital identities.

Conclusion

The power of films lies in their ability to reach our emotions in a way that creates immediate physical and neurological responses. This 'magic' of engagement with the moving image is now the apothecary of the masses: children can make watchable, thought-provoking pieces of audio-visual material within minutes, which they can broadcast to millions within seconds. The speed of such productions is both marvellous and terrifying, as the follies of youth are forever archived in networks far beyond the understanding or control of most filmmakers. We are now in an era of soundbite and audio-visual-bite experiences, where anyone with a smart phone can film and broadcast

slithers of factual films at any time of day or night. It is hard to keep up with the social media platforms and YouTube channels that facilitate this outpouring of digital material. There has been an audio-visual turn in the way people consume information since the creation of YouTube in 2006. As visual anthropologists we are interested in understanding the ethnographic content of the productions, and most importantly, the approach used and the intent of the filmmaker to reach a cross-cultural audience. Creating ethnographic films for anthropological scrutiny is seldom the first intention of a filmmaker unless trained as such, and even so, many films that are not made by anthropologists form the core of a visual anthropology teaching archive. When Rouch wrote about the future he said:

> And tomorrow? Tomorrow will be the time of completely portable colorvideo, video editing, and instant replay [instant feedback]. Which is to say, the time of the joint dream of Vertov and Flaherty, of a mechanical cine-eye-ear and of a camera that can so totally participate that it will automatically pass into the hands of those who, until now, have always been in front of the lens. At that point, anthropologists will no longer control the monopoly of observation; their culture and themselves will be observed and recorded. And it is in that way that ethnographic film will help us to 'share' anthropology.
>
> (Rouch, 2003, 46)

However, he probably assumed that the camera would be in the hands of most adults, not children. It is unclear if anyone could have predicted how advanced children would be in understanding and using new audio-visual technologies as soon as they became available to them.

Today's world boasts a generation of children who have attained a level of authenticity and truth articulation in their films surpassing many adults using the medium in the previous generation: their ability to create audio-visual narratives is as familiar to them now as a form of expression, as storytelling and drawing were to the children who came before them. Being taught ethnography equals 'being untaught' your adult self. Alan MacFarlane explains the liminal space that ethnographers occupy: 'When you undertake fieldwork, when you go to different lands like Nepal or Nagaland, you go into another world, a bit like your childhood. A bit like Alice though the Looking Glass' (MacFarlane in *Captured by Women*, 2011). The problem of communication between adults and children has always been rooted in the power relationships that exists between them. Enculturation is a society's attempt at fulfilling that delicate balance of socializing an individual spirit or soul without destroying the child's natural sense of being in the world. Holding a piece of equipment such as a camera empowers a relationship with the external world, and is, uniquely, a twenty-first-century experience. The power that children have in their hands through smart phone technology and the understanding of how the Internet is unprecedented, and we must 'recognise the important insights that the child-as-researcher can bring to

our understanding of the world around us' (Froerer, 2014, 474). Their ability to use the technology, that was once a currency to be bought and sold by adults in Film schools, is now almost as natural to a child as is turning a door handle to enter a room, or tying her laces.

Notes

1. E. Evans-Pritchard's view promoting anthropology as a second degree.
2. Of course, children should be protected at all times, and I would only suggest, even in today's climate where transparency and child welfare is a priority the world over, that children can be informants and subject to academic study under very few circumstances. Essentially these occasions would be where all ethical guidelines are followed and where parents and carers are close at hand to inform and be informed as to what might be asked of the child.
3. For more on the 'anthropological project' see Ruby (1975), Banks and Morphy (1999), and Banks and Ruby (2011).
4. Some classics among the early twentieth century to the post-war period include John Marshall's films among the Ju/hoansi in the Kalahari desert of South Africa, Timothy Asch and Napoleon Chagnon's films among the Yanoumani in North Amazonia, and Marcel Griaule's films among the Dogon in Mali (see Henley, 2020). Feature arthouse films made by Dziga Vertov's *Man with a Movie Camera* (1927), Fritz Lang's *Metropolis* (1927), and Luis Buñuel's *Land Without Bread* (1932) have also been included in the canon as early film classics of their time and important in the study of ethnographic filmmaking and worthy of serious anthropological critique. In Anglo-Saxon anthropological circles, the work of Robert Gardner, Frederick Wiseman, and Judith and David MacDougall is still recognized as having had an important influence on our understanding of factual filmmaking and the anthropological project, especially in terms of audio-visual ethnographic documents.
5. In 2010, I earned a grant from the British Film Institute to digitize the ethnographic film material of Beatrice Blackwood and Ursula Graham Bower from 16mm film to DV Cam. The films had been residing in the archives at the Pitt Rivers Museum, University of Oxford, for more than half a century but never used or included in the books written about ethnographic film. The result was my documentary film *Captured by Women* (2011).
6. Email correspondence between David MacDougall and Alison Kahn.
7. Digital Children: a cross-cultural study of online educational resources for Children (Under 18s), Primary Care Givers and Educators. This project seeks to improve the delivery of online education based on the 'Lockdown Evidence' of school children, primary care givers (PCG) and teaching staff within the national education systems in India and the UK. Based on the data provided in the form of audio-visual, photographic, and textual feedback from interviews and questionnaires from stakeholders, we will draw up an online school education policy that accounts for cross-cultural observations in order to address the current gap between the delivery of online classes and the diversity of groups that need to be served.
8. See www.youtube.com/watch?v=qOY8F_ngNWI [last accessed 6 October 2024].
9. The Sidemen consist of Ethan/Behzinga, JJ/KSI, Simon/Miniminter, Tobie/Tobjzl, Josh/Zerkaa, Harry/Wrotashaw, and Vik/Vikkstar123.

References

Banerjee, D. (2014). The last tribe: *Delhi At Eleven*. *The Asia Pacific Journal of Anthropology* 15 (5), 464–466.
Banks, M., & Morphy, H. (Eds.). (1999). *Rethinking visual anthropology*. Yale University Press.
Banks, M., & Ruby, J. (Eds.). (2011). *Made to be seen: Perspectives on the history of visual anthropology*. Chicago University Press.
Barnouw, E. (1993). *Documentary: A history of non-fiction film*. Oxford University Press.
Doron, A. (2014). Deciphered by children: The city's view from below. *The Asia Pacific Journal of Anthropology* 15 (5), 470–473.
Froerer, P. (2014). Children's films: A response from anthropology. *The Asia Pacific Journal of Anthropology* 15 (5), 473–477.
Heider, K. G. (2006). *Ethnographic film: Revised edition*. University of Texas Press.
Henley, P. (2020). *Beyond observation: A history of authorship in ethnographic film*. Manchester University Press.
MacDougall, D. (2006). *The corporeal image: Film, ethnography and the senses*. Princeton University Press.
MacDougall, D. (2019). *The looking machine: Essays on cinema, anthropology and documentary filmmaking*. Manchester University Press.
Nichols, B. (2017). *Introduction to documentary*, 3rd ed. Indiana University Press.
Nicholson, M. (2014). *Amateur film: Meaning and practice c. 1927–1977*. Manchester University Press.
Rouch, J. (2003). The camera and man. *Cine-ethnography*. Translated by S. Feld. University of Minnesota Press.
Ruby, J. (1975). Is an ethnographic film a filmic ethnography?. *Studies in the Anthropology of Visual Communication* 2 (2), 104–111.
Thorne, B. (2009). The *Seven Up!* films: Connecting the personal and the sociological. *Ethnography 10* (3), 327–340.
Troiani, I., & Kahn, A. (2016). Beyond the academic book: New 'undisciplined' corporeal publication. *Architecture and Culture 4* (1), 51–71.

Filmography

Apted, Michael. (1964–2019). *Up! (documentary series)*.
Kahn, Alison. (2011). *Captured by Women: The Ethnographic Films of Beatrice Blackwood and Ursula Graham Bower*. ODFI Ltd.
MacDougall, David. (1997–2008). The Doon School Quintet. Centre for Cross-Cultural Research, Australian National University.
MacDougall, David. (2007). *SchoolScapes*. Fieldwork Films & Centre for Cross-Cultural Research, Australian National University.
MacDougall, David. (2008). *Gandhi's Children*. Fieldwork Films, Prayas Institute of Juvenile Justice, New Delhi, & Centre for Cross-Cultural Research, Research School of Humanities, Australian National University.
The 'Childhood and Modernity' Project: *Delhi at Eleven* (2012)
Dalsus, Shikha Kumar. *Children at Home*
Kashyap, Aniket Kumar. *My Funny Film*
Singh, Anshu. *Why Not a Girl?*
Shivhare, Ravi. *My Lovely General Store*

SECTION VI

PSYCHOPATHOLOGY, ART, AND CREATIVITY

INTRODUCTION
Psychopathology, Art, and Creativity

KATHLEEN GALVIN

THE present section comprises nine essays that explore the place of art and creativity in promoting human well-being. A background is given by psychopathology in the widest sense, with an exploration of timely cultural challenges. Collectively human experience is a crucial focus and a source for deep new understandings, alongside a range of creatively gained insights for improvements in supportive practices, a deepening of sustainable community approaches and efforts valuable in promoting a more humanly sensitive society.

AN 'AESTHETIC MOVE' IN PSYCHOPATHOLOGY CARE PRACTICE

Working within a knowledge remit in the context of the absence of well-being, we are particularly interested in these three questions: (i) how we can become more faithful to the depth and detail of what people go through? (ii) what new insight can be gained from such complex human situations? (iii) how can this new knowledge usefully (and creatively) promote well-being at individual and community levels?

Here the particular focus is drawing on more embodied and participative forms of knowledge, as manifest in the arts, with the overall aspiration to invite *deep* and *palpable* understanding and may bring readers up close to 'what is it like'. This offers one way to inform knowledge relevant to psychopathology with applications helpful to caring practices, both in communities and in varied human care services.

In embodied and participative forms, our understanding is never 'cognitively alone', but always intertwined with its senses, its moods, qualities, as well as intersubjective and cultural contexts. Such understanding then is enriched by aesthetic qualities that the arts and humanities know something about, richly illustrated in the many creatively informed writings in this present text.

Quite a long time ago now, as outlined by Bergner (1997), from a historical perspective, many concerns have been intertwined with misuse of the term psychopathology, where it has legitimized social stigma, social control, and even political oppression (citing Foucault, 1964/65; Goffman, 1963; Szasz, 1974), he calls for a more relational focus to time, to culture, and to situations as a long-standing principle in the integration of the range of theoretical perspectives relevant to psychopathology. In this section, specific essays collectively illustrate the value of the 'thickness of living', as a resource for relational understanding and as a way of bringing us up close to the rich and moving flow of the contextual world as it is humanly lived (including its 'insides'). Any understanding that is relevant to caring in psychopathology can be helpfully informed by such complexity in knowing; such complex knowledge is aesthetically textured and sensitive to specific, unique situations.

Gendlin (2004) has helpfully laid a philosophical foundation fundamentally relevant to such an aesthetic focus, that is, he shows us how the epistemic body (the body that senses and knows) is a crucial faculty for holistic knowing, building on the idea of the epistemic body in his notion of a bodily 'felt sense': In which meaning is sensed as an inner feeling in the body before it is reflectively articulated and named in language. This is a holistic pre-reflective knowing and it is at the heart of the arts and creative practice. Further, such bodily understanding is where meaning 'comes home' to persons. Words on the page are not just technical, words can carry a 'human bond'. Images on the page are not just technical, images can carry a human bond. Some essays in the collection therefore aim to offer an invitation to 'embodied relational understanding' as coined by Todres (2007). As readers connect to an image, a phrase, or specific wording that is manifest from their felt experience, they get closer to something that personally 'fits' and may be considered resonant: That is, the specific form of art, image, or language is already synchronized with what is deeply known, and where they may not yet be any fitting words.

In addition to such a necessary experiential ethos, and what can be understood in depth between us, we are also interested in what is shared, how it can be shared, and what can be authentically shared that impacts collective understanding. The realm of a collective sense of well-being and the impacts of community participation in creative processes are part of this rich picture. After all, although creative processes are often deeply personal, and creativity is understood from unique perspectives, creativity cannot be separated from everyday manifestations of social and cultural life. Creative expressions manifest as a universal human phenomenon with innumerable variations, and while grounded in culture also impact culture itself. Essays comprising this section therefore explore such grounding and impacts relevant to some of the significant challenges of our times. The section aims to offer directions to show how the creative endeavour can be channelled for understanding and promoting human well-being generally, simultaneously surfacing the values attached to creative efforts and

providing illustrations of creative expressions relevant to mental health and in particular emotional well-being.

References

Bergner, R. (1997). What is psychopathology? And so what? *Clinical Psychology: Science and Practice 4*, 235–248. Available from: https://www.researchgate.net/publication/229669904_What_Is_Psychopathology_And_So_What [last accessed 6 October 2024].

Foucault, M. (1965). *Madness and civilization: A history of insanity in the age of reason*. Pantheon. (Original work published 1964)

Gendlin, E. (2004). The new phenomenology of carrying forward. *Continental Philosophy Review 37*, 127–151. https://doi.org/10.1023/B:MAWO.0000049299.81141.ec

Goffman, E. (1963). *Stigma: Notes on the management of spoiled identity*. Prentice-Hall

Szasz, T. (1974). *The myth of mental illness: Foundations of a theory of personal conduct* (rev. ed.). Harper & Row.

Todres, L. (2007). *Embodied enquiry: Phenomenological touchstones for research, psychotherapy and spirituality*. Palgrave Macmillan.

CHAPTER 34

SOCIAL-AESTHETIC STRATEGIES FOR A CHANGE OF HEART

SHELLEY SACKS

INTRODUCTION: SOCIAL AESTHETICS FOR CONNECTIVE PRACTICE THE RESURRECTION OF THE WORLD IN US

WE are standing on the edge of the old world, crucified by disconnected ideas and destructive behaviours despite millennia of wondrous creations and understandings. The new world of interconnected perception begins here, in the chaos, at the edge of the old world; in the liminal zone of disturbance and possibilities. Now we are called—for the first time in history—to engage in forms of individual and social envisioning, healing, and decision-making, to consciously decide on and shape a living eco-social future. But this is hampered by non-relational modes of thinking, fear of upheavals and uncertainties, and an inner emergency in which panic leads to standstill. In this state of panic, inner crises and emergencies are easily separated from outer crises, and disconnected mindsets in the 'humanosphere'—which lead to biosphere and technosphere disastersare often denied and veiled. How can these veils be lifted? How can we reach the habit level in our thinking as individuals, groups, and larger collectives, to recognize and transform views that cause unnecessary suffering? How can we shift from mindsets of freedom-as-self-interest to freedom as the '*ability*-to-respond' (Sacks, 2011a, 2011b), and from *metanoia* as repentance—to its

original meaning in Greek—as a 'change of heart'? How can we develop capacities for thinking, envisioning, and planning in relational, life-enhancing ways?[1] (Sacks, 2018; Strausz, 2018).

In the field of connective practice, we find nourishment for this task[2] in the 'making social honey'[3] process (Sacks, 2017a) and 'instruments of consciousness'[4] (Sacks & Kurt, 2013b; Sacks, 2024). Committed to consciousness as a powerful driver of change we develop 'inner technologies' (Sacks, 2018) for distilling lived experience and doing other forms of imaginal work, as well as social-aesthetic strategies for enlivenment, and relational capacities for eco-social transformation and paradigmatic shifts. 'Connective distance' is one of these capacities for resurrecting the crucified world in us and mobilizing us internally to respond to its sufferings.

Connective Distance, Imaginal Thinking, and 'Instruments of Consciousness'

'Connective distance'[5] (Sacks, 2013a) is an image[6] in which two forces challenge each other. One moving towards, one moving away. In the image 'the resurrection of the world in us', reanimation of something from which we have become estranged and disconnected is suggested: a world that has been crucified but could come alive again. Practising the art of 'connective distance' sounds contrary to this process of reanimation and resurrection. But they are intimately bound together. The re-enlivening and resurrection of inner and outer worlds in us needs 'connective distance'. And this depends on imaginal thinking that is different from what the poet Samuel Taylor Coleridge describes as phantasy or fancy[7] (Fenner, 1817). Phantasy severs and dislocates imagining[8] from both inner and outer contexts. One could call the kind of imagination that re-enters, lives into, and inhabits what is—'making sense' in life enhancing, relational ways—'connective imagination'. Both 'connective distance' and 'connective imagination' are central capacities in the *Connective Practice Approach*[9] (Sacks, 2017a) outlined below, which includes root methods, guiding images, creative strategies, and 'instruments of consciousness'. Together these methods and strategies 'make space'[10] for grounded perception, develop capacities for generative thinking-together, and offer ways to imagine forms of living together on one planet, rooted in 'connective imagination', not disconnected phantasy.[11]

The Evolution of Connective Practice and Its Questions

The interdisciplinary *Connective Practice Approach*—linking inner and outer transformation, social healing, a paradigm shift in practice, and an 'expanded conception of art'[12]—has evolved over four decades through working with challenging questions embedded in diverse contexts. One context is personal. It has to do with being an artist surrounded by extreme injustice, and childhood insights about the reality of imagination,[13] where 'real' meant externally visible and quantifiable. This approach is also informed by the insights of many others into the aesthetic dimension, education for democracy, participatory social forms, contemplative enquiry, dialogue processes, consciousness studies, regenerative worldviews, pedagogies of transformation, and by the ever increasing ecological and social suffering across the planet. Growing up in apartheid South Africa, surrounded by conflicting mindsets[14] (Sacks, 2017b) and fierce debates about art as a tool for change,[15] exacerbated my existing questions about social art and transformation, as did the training for cooperative social enterprises we were offering in village and township communities.[16] Here further questions about transformation became visible. How could people overcome top-down patterns and find horizontal ways to think together? What was the significance of individual responsibility in co-created processes? What capacities for the future were needed to develop ways of working together without leaders and chiefs? What could explorations in how 'attitudes become form'[17] (Szeeman, 1969) contribute to understandings about agency and transformation within the dominant materialist-rationalist paradigm of revolution and progress, and its instrumentalist attitudes about nature, work, education, and art?

One way of working with these questions was offered by Joseph Beuys' social sculpture ideas and 'expanded understanding of art'.[18] Perhaps this approach could return art to the life of society, without art becoming a tool. And so began an in-depth exchange with Beuys and engagement with his ideas,[19] to find methods of working with his expanded conception of art and related sources in Goethean phenomenology[20] and Steiner's 'philosophy of freedom' and 'education as art'.[21]

Today issues about the relationship between inner transformation and social change are amplified by the extreme emergencies on the planet and for the soul. Alongside the outer ecological emergencies, there is the racism, prejudice, and unrecognized privilege emergency; the state and corporation interface emergency; the increasing forms of manipulation, control, and fake truth emergency; the independence of technological innovations from democratic process emergency; the life-negating 'human substitute robots' emergency, and the bigger materialist-rationalist emergency confusing human being and machine. The fear and panic engendered by such emergencies has given rise to internal emigration and benumbing, mirrored in the self-harming, not able to digest, fetishizing of pain and violence emergency: an emergency of inner resource depletion and despair, making it difficult to work through challenges in the soul without

excarnating into avatars, mutilating the body, or moving into social media as sustenance for one's soul.

These emergencies are entangled in the vast world of innovation through design teams and 'creatives' who often support the unchecked phantasies of corporations and individuals for emigration to Mars, robots with desires for personhood, avatars that eclipse the need for coming to oneself, genetically modified square tomatoes to make packaging easier, and seductive AI tools, like ChatGPT, that confuse human reflective thinking with computational synthesis, perpetuating a world where the image of the human being and the relationship between freedom and responsibility is fuzzy and uncertain. On this planet, badly damaged by phantasies of supremacy, control, and greed, the potential and value of the human being needs urgent consideration. For E. F. Schumacher, sustainability scientist and author of 'Small is Beautiful'[22] there could be no sustainable future without the inner culture of the human being.

Amidst this complex matrix of phantasies where confusion about human and machine intelligence reigns, the *Connective Practice Approach* has evolved a set of principles and practices, that, like sacraments, facilitate transformation and connectedness with oneself, each other, and the world. Recognizing the need for an ethics of interconnectedness in which freedom and responsibility are not opposed, and, owning the damage human beings have brought to the world, the *Connective Practice Approach* has developed an expanded understanding of aesthetics and connective modes of engagement that enable us to remedy and 'work on what has been spoiled'[23] whilst exploring new and viable connective imaginaries of self, the other, and the social. In activating the inner field, connecting inner and outer action, and enabling new narratives and connective imaginaries, we begin to discover our potential as artists of self and society, and healers doing 'warmth work'[24] in a world whose biosphere and 'humanosphere' are dominated by a technosphere with a heart of steel.

Time is also significant in the *Connective Practice Approach*. Its strategies, guiding images, and 'instruments of consciousness' are the fruit of long practice-based enquiries, emerging through many iterations in a wide variety of contexts.[25] This iterative, reflexive process is deepened in the intuitive, imaginal mode, taking the maker on an uncharted journey into its unfolding.

Aspects of Connective Practice

The *Connective Practice Approach* involves a set of interrelated understandings, strategies, and capacities for 'making space' by means of 'connective distance' and 'connective imagination' to enable observation and perception not alienated from personal or social context. The perception gained in using these strategies and capacities for 'making space' lessens the potential for 'disconnected phantasy'. Core aspects of this approach, detailed below, include: (1) Making Sense; (2) Different Modes of Thinking and the Imaginal Mode; (3) New Organs of Perception; (4) Guiding Images for the

Journey; (5) The 'Making Social Honey' Theory of Change and 'inner atelier' Root Methodology; and (6) 'Instruments of Consciousness'.

Making Sense

'Making sense' is an astonishing capacity human beings possess—as individuals and in groups—to turn the raw material of experience into insights and understandings. In the *Connective Practice Approach*, there is an explicit emphasis on this inner distillation and inner sense-making process as well as on enhanced ways to re-enter lived experience. These inner sense-making and distillation processes can be experienced as inner sculpting or inner 'Gestaltung', which make tangible the art of shaping and forming with what Joseph Beuys called social sculpture's 'invisible materials' of thought, discussion, and speech (Tisdall, 1979). However, because the 'making sense' process is affected by the lenses with which we see, I widened these 'invisible materials' to include attitudes, values, perceptions, questions, and habits of thought (Sacks, 2017a, 2018, p. 172). The *Connective Practice Approach* therefore also emphasizes the need to be aware of one's lenses. As in phenomenology, a core practice in this approach is that of 'bracketing' or 'epoché',[26] in which we explore the lenses through which we see as a point of departure. This 'clearing process' helps us recognize that: (a) The 'making sense' process—in which experiences become perceptions and concepts—is not neutral; (b) We have the potential to see things with different lenses, which says something about the freedom and responsibility to look again, and, at least, to recognize our lenses; (c) The 'making sense' process does not end with the first individual distillation. It can be continued individually and together, to deepen understanding and distil further insights; and (d) 'Making sense' can be liberatory.

Although it might sound complex, the 'making sense' process is simple to experience. Through engaging in it one also realizes that each instance of 'making sense' or creating meaning, is also an instance of the shaping of oneself, and 'we are all artists'[27] making sense of and shaping the raw material of experience into a world of forms and actions. This illuminates something fundamental about the relationship between freedom and responsibility in the *Connective Practice Approach*, which is also central in social sculpture and Beuys' 'expanded conception of art' (Tisdall, 1979).

Different Modes of Thinking and the Imaginal Thinking Process

'Imaginal thinking' or 'bildhaftes Denken' is a term used by the artists Joseph Beuys, Wassily Kandinsky, and Paul Klee (Bunge, 1996), as well as by archetypal psychologist James Hillman (Hillman, 1998; Hillman, 1979/2000) to describe a mode of thinking that is an alternative to linear analysis, logical argument, and what Heidegger described as 'calculative thinking'[28] in contrast to meditative thinking (Heidegger, 1955). Alongside

this calculative, analytical thinking, Goethe, scientist, poet, and phenomenological philosopher, emphasizes an imaginal mode for enabling synthetic thinking (Naydler, 1996) that Goethe describes as intuitive consciousness (Bortoft, 1996). In the *Connective Practice Approach*, we learn to allow images about inner and outer situations to arise, without censoring, pre-empting, and judging. This gives rise to visual images, non-visual images and to language-images. These non-visual images occur not only because some people do not see internal images in visual form, but because feelings, atmospheres, questions, and attitudes can also be 'seen' and 'observed' and contribute to making sense and perceiving meaning. Word-images—like 'straining to hear', 'broken hearted', 'twisting my arm', 'flooded with information', and 'feet planted on the ground'—although not externally visible or seen internally as visual images, enable 'seeing' in ways that link realities in everyday situations with the inner realities of the soul. The *Connective Practice Approach* seeks to restore ways of working in this often eclipsed and ignored sphere of the imagination, that the philosopher-scientist Henri Corbin calls the *Mundus Imaginalis* (Corbin, 1972/2000).

New Organs of Perception

'Every object truly seen opens up in us a new organ of perception' said Goethe (Robbins, 2005). In the connective practice work of distilling insights and coming to connective perceptions, close observation, close noticing, and contemplative enquiry (Seamon & Zajonc, 1998) enable a mode of engagement that Goethe described as the 'intuitive power of judgment', 'exact sensory imagination' and 'delicate empiricism' (Bortoft, 1996; Brook, 1998). In this mode, one can see a phenomenon in its 'wholeness', a living being in its integrity (Sacks, 2007; Seamon & Zajonc, 1998). Goethe focused this work on plants. I recognized parallels between Goethe's close noticing of the 'formative forces' in a plant to perceive what he called the 'Urform' or 'the organising idea' (Bortoft, 1996; Harlan, 2004) and how Beuys perceived the questions, needs, and possibilities for transformation in a situation (Sacks, 2007, 2020).

This mode of engagement is also integral to the *Connective Practice Approach* in which social-aesthetic strategies specially designed for different contexts and questions, and generic root methods like the 'inner atelier' work, described below (Sacks 2017a, 2018; Sacks & Kurt, 2013b), give rise to 'new organs of perception', revealing the 'gestures', signatures, intentions, deep patterns, values and other not-visible forces in forms and situations. By living into 'what is'—whether an outer form or an inner experience—then seeing the observation again (Sacks & Kurt, 2013b; Sacks, 2018), we also develop new organs of perception for perceiving the character or 'essence' that runs through different instances of one's own life, or a context. Such processes of 'seeing what is seen' or 'double seeing' highlight the relationship between developing new organs of perception and 'connective distance', both central to the connective practice root methodology and 'inner atelier' work (Sacks, 2018), and for enhancing 'connective imagination', and social-aesthetic planning and action.

Guiding Images for the Journey

Many guiding images inform the *Connective Practice Approach*.[29] Some are visual, some are verbal, or a combination of both. Foundational images like 'a tree knows how to be a tree'[30] and 'making social honey' have arisen in me as image-insights in response to rumbling questions, often carried for many years. Once unpacked and understood—as one might work with a dream—these visual word-images reveal principles and understandings that enrich the thinking and practices in the field. They are useful in lectures and workshops as vehicles for transporting layered meanings[31] in non-abstract ways and can shift the mode of comprehension from one of *information-reception* to *imaginal-thinking*. In this sense, they not only reflect and inspire the overall *Connective Practice Approach* but are 'instruments of consciousness' themselves. *Sustainability without the I-Sense is Nonsense*[32] and *Responsibility as an ability-to-respond*[33] are core guiding images highlighting the role of language in this expanded art practice. Such multidimensional guiding images formed in the *mundus imaginalis* (Corbin, 1972/2000) also nourish the 'humanosphere'[34] with social imaginaries linking the inner and outer worlds. As connective instruments, they can bring us closer to the life and sufferings of the world and contribute to the shaping of an eco-social future.

But the imaginal sphere also has its disconnected mode, in which images of anything can be created. By using examples of images 'emancipated'[35] from life, in the early stages of every connective practice, the dangers of disconnected imagination or 'fancy' can be directly experienced.[36] They serve to underline that all visions and innovations in the sphere of imagination, not least inventions that cross machine-life borders, need to be carefully and imaginatively re-entered and lived into, to try and perceive their implications. The excitement of design teams and the economic potential of visions easily eclipses the need for such 'connective distance', leading to a tsunami of exploitation, dangerous inventions, and confusion. Human look-alike robots are one contemporary example.

Although many guiding images are used in the *Connective Practice Approach* some are central. One of these—'a tree knows how to be a tree'[37]—highlights that the human being, unlike a tree, does not unfold according to plan. We are freedom beings, as Sartre said, condemned to freedom![38] The capacity to make choices and be creative, but related to this, to disconnect from instincts and biological patterns, makes us the most dangerous of earth's creatures with the power to imagine not only meaningful and useful things but things 'out of this world'! This 'freedom'—easily 'emancipated' from reality—highlights that we need to develop capacities of connective imagining, rooted in compassion and care beyond self, if we are to find ways to shape a viable future on one shared planet. In this sense, the human being is only at the beginning of its development.[39] Connective practice initiatives like *7000 HUMANS*[40] are motivated by questions in this guiding image about similarities and differences between human beings, other life forms, and machines.

Another key guiding image is 'making social honey'[41] as both a goal and a process. Recognizing the role of individual bees gathering nectar alone as the basis for making honey has inspired this key social imagining and thinking-together process, which mirrors how insights from individual engagement with a question or issue become the primary substance and essential first step in a social-aesthetic group enquiry. Although the similarities between bee honey-making and social honey making should not be overemphasized, the parallels between individual nectar gatherers and individual insight producers are useful, as is the image of the successive distillations and intensive work needed to transform nectar into honey. Rounds of deep listening and active imagination are needed in a group so that social honey understandings can emerge. The exploration of emergent insights and 'answers' in this process is different from debate and discussion, as well as from collective intelligence or 'hive intelligence'. Applied to humans the 'hive intelligence' notion undermines the necessity for individual consciousness that produces insights—as the nectar equivalent—for the thinking-together process. The 'warmth body'[42] in the social honey making process involves the generation of understandings by attuned, present, and listening individuals. The mystery of social honey making is no less profound than the bee honey process.

The link between 'connective imagination' and the '*ability-to-respond*' instead of responsibility as duty (Sacks, 2011b, 2017b) is also a core aspect of the field of connective practice. It is closely related to another guiding image: *the aesthetic in contrast to the anaesthetic or numbness* (Sacks, 2017b). The alternative view of the aesthetic that this conveys, redefines aesthetic as that which enlivens, reclaiming the aesthetic for the life of the society and connecting it to the sphere of responsiveness and care. Aesthetic forms and processes no longer confined to taste, style, and traditional art forms can be understood as everything that enlivens and inspires connective action. Many 'aesthetic strategies'[43] have been developed as part of this widened understanding. They include forms of disruption or 'making strange'[44] that make 'connective distance' possible, mobilizing us out of familiar perspectives and making space for fresh perceptions—provided that the 'making strange' strategy is not too shocking. This can give rise to the opposite effect, promoting withdrawal.

These guiding images are a few examples[45] of how connective practice understandings and principles are conveyed in the imaginal mode. Unlike abstractions that *stand for* something, guiding images *embody* the realities of which they speak. The lemniscate[46] or infinity symbol used in connective practice embodies the continuum between inner and outer work, thought and action, as well as the transformation that takes place in the 'making sense' and 'making social honey' distillation process. Each time I go out—beyond who I am now—crossing the middle point of the lemniscate, or come back in—with the fruits of new awareness—an expansion takes place, no matter how small. A student using the connective practice journaling process[47] for 'making sense' said: 'In this process I not only experience making sense: I am making myself'.[48]

The 'Making Social Honey' Theory of Change and 'Connective Imagination' Root Methodology

Drawing on seminal experiences about how the imagination works (Sacks & Kurt, 2013b), studies in aesthetics and imaginal thought (Hillman, 1979/2000), a mindfulness practice,[49] Goethe's process for 'exact sensory imagination' (Bortoft, 1996), and dissatisfaction with most 'new' dialogue processes that continue familiar forms of debate and argumentation, I developed this 'connective imagination' methodology. It is inspired by the 'making social honey' guiding image: of individual bees needing to gather nectar before honey-making can begin and then working together, repeatedly, to distil the nectar into honey. For dialogue processes to go beyond debates and argumentation, individual insights are distilled from an initial process of engagement with a question, information, or situation, and then shared to provide the substance for further distillations that can then be taken onto a collaborative, co-creative level. This process highlights the significance of the self-aware individual in the social-aesthetic thinking-together process, in which the active 'I' enables the emergence of a social 'We'. In this sense, the methodology is designed to contribute capacities for horizontal, co-creative 'leadership'.

The 'making social honey'[50] theory of change and 'connective imagination' root methodology for co-creative thinking-together progresses through five stages for coming to individual insights: (1) Seeing or observation; (2) Seeing what I see; (3) Seeing what I think; (4) Thinking about what I think; and (5) Having the opportunity to choose and change what I think. All five stages have to do with imaginal work in the space of imagination. **The first stage**—'seeing or observation'—takes place in the inner and/or outer field. This observation not only provides the raw material for the ongoing individual and group distillation process, but an introduction to the workspace—the 'inner atelier'—where this distillation occurs. **In the second stage**—'seeing what I see'—the observation or experience is re-entered, relived, and seen again in the 'inner atelier' or workspace, to perceive what it carries. **The third stage**—'seeing what I think'—has to do with recognizing the thoughts in the perceptions and seeing the lenses, assumptions, and biases that shape one's perceptions. **The fourth stage**—'thinking about what I think'—is a process of internally standing to one side, creating inner space, and inhabiting what and how I think. **The fifth stage**—'having the opportunity to choose and change what I think'—is the space of freedom: for connecting inner perception and conscious choice with outer action.

In a group process that builds on the insights of all participating individuals—whether in a school, community, or think-tank—a round of sharing takes place after each stage of distillation in the 'inner atelier'. To enable the distillation process in a group, this sharing depends on active listening and strategies for not judging. There is no discussion in each round of sharing until the last stage, if at all. It is from the rounds of distillation in the group space, not discussion, that a 'solution' or plan of action emerges. If this does not happen, the individual and collective insights can be used as starting points for further distillation: in and out, until there is an 'answer', understanding, or plan of action. This

staged process echoes how archetypal psychologists sometimes work with alchemical principles in the therapeutic process—with successive stages of contemplation, activation, and distillation—for coming to enlivened perceptions, empathic ways of thinking, and enabling new 'productive' behaviour.[51]

The 'inner atelier' is integral to both the 'making social honey' theory and the 'connective imagination' root methodology. It is the space where individual insights are generated to take into the 'making social honey' process. Because the 'inner atelier'—introduced as a space of memory for seeing personal images and experiences from the past—can be directly experienced by all participants, it is useful for acquainting people with the 'making sense' process and as a precursor to 'making social honey'. Furthermore, because the capacity for recalling experience is shared by all human beings across cultures, whether they read and write or not, a certain equality is implicit in the process from the outset. Without veiling and negating differences in circumstance and power, all people can draw insights from past, present, and future images. We do this all the time, at least on a functional level, without noticing it.[52]

In addition to generating individual insight as the basis for co-creative thinking-together, this methodology includes: (a) Developing capacities for active imagining and deep listening into the present and future as well as the past, enabling 'answers' to unfold and ways forward to show themselves; (b) Using images to differentiate between 'connective imagination' and disconnected phantasies, before embarking on processes to develop new imaginaries; (c) Working with questions to enable emergent outcomes, through following their trajectory, instead of working out answers; (d) Ways of getting to the habit level and pre-judgments, so as to re-enter the situation with different lenses; (e) A method for perceiving the characteristics, gestures, essences, and forces that run through the specific instances of a being or situation, and the changes that have taken place between past and present; (f) An approach to 'living planning' by distilling insights through several stages of reflection, and (g) Imaginative thinking that is under one's control and diminishes the fear of going into the unknown.

The four stages of the 'inner atelier' practice—as described above—are the most widely used version of the 'connective imagination' root methodology.[53] It is, however, possible to adapt these stages for engaging individuals and communities in many different cultural and political contexts and situations.[54] This means too that an unlimited number of practices and 'instruments of consciousness' can be designed and shaped based on this theory of change and related root methodology.

In addition to enabling insights and pathways to action, this 'connective imagination' methodology offers a simple experiential understanding of a profound epistemological process. Instead of thinking about a 'theory of knowledge' we live it through a 'practice of knowledge'. It does this by means of everyday examples—like shopping to make soup for friends—revealing the role and necessity of imagination and the 'inner atelier', albeit often unconscious, in our everyday thinking, conceptualizing, knowing, reflecting, and decision-making (Sacks, 2017b). In the *Earth Forum* process, such 'ways of knowing' capacities or 'inner technologies' (Sacks, 2018) are made conscious and strengthened by a reflective 'dialogue with oneself in the world' that begins with 'a walk on the planet'.

Making these taken-for-granted processes conscious enables us to see the prejudgments and lenses with which we see, activating the potential for conscious shifts in habitual and inherited ways of seeing. In *FRAMETALKS*, an initial process in the 'inner atelier' akin to 'bracketing' or 'epoché' enables individuals to explore perceptions in themselves for sharing insights in the 'making social honey' process.

Instruments of Consciousness

'Instruments of consciousness'[55] are a key aspect of connective practice enabling imaginal work with individuals and in groups. They are all based on the 'making social honey' theory of change and 'connective imagination' root methodology and most include some version of working in the 'inner atelier'. Each 'instrument of consciousness' nevertheless operates in a particular context with specific concerns, engendering a unique set of forms and processes. They may have a physical, visible component or not, linked to a 'process-score'. This integration of physical elements and processes of reflective engagement create opportunities—on both an individual and social level—for new consciousness that is not only cognitive. Despite differences in themes, core images, and specific purposes, they all create non-hierarchical processes for 'activating the inner field' and coming to a lived and grounded connection with a question, issue, or situation. They enable individuals and groups to work consciously with the 'invisible materials' of thought, attitudes, and values, and to use the 'inner atelier' to work actively with the lenses and paradigms through which we see. Although most 'instruments of consciousness' involve group processes, individuals develop capacities for grounded thinking and thinking-together that are transferable across contexts. They use different creative strategies for 'landing',[56] re-entering and exploring what is 'hidden, ignored, and denied';[57] for disrupting, intervening, and 'making strange';[58] for partnering with other living beings, and creating anchor places in the world;[59] for deep listening to situations,[60] and for uncovering, inhabiting, and following the trajectories of questions.[61]

STRATEGIES OF ENGAGEMENT IN 'INSTRUMENTS OF CONSCIOUSNESS'

'Instruments of Consciousness' Are Not Tools

Exchange Values: Images of Invisible Lives[62] is an 'instrument of consciousness' whose focus is very different from other 'instruments of consciousness'—like *Earth Forum*,[63] *FRAMETALKS, New Eyes for the World,* and *7000 HUMANS*—although all involve the same principles and root methodology. *Exchange Values* was originally designed to

connect small producers of bananas in the Caribbean and global consumers, with 'absence' as its key strategy for 'connective distance'. The opportunity for intimate contact with twenty invisible farmers is created through hearing their voices and never seeing their faces. Their faces are replaced by 'sheets of skin' stitched from the dried skins of bananas each farmer has grown (see Figure 34.1a and b). This visible 'absence' not only amplifies the invisibility of the person who grows the banana I eat but awakens a lived awareness of the painful realities in the global economy that sucks us into processes, alienating person from person. This intimate contact with twenty invisible farmers through their skins and voices, precedes the individual 'inner atelier' work and the thinking-together, 'making social honey' process, which take place after listening to the farmers' voices around a mound of about ten thousand loose banana skins—blackened by time, of unknown origin, from invisible lives. The success of this instrument lies not only in having engaged thousands of people in exchanges and lived experiences of the global economy. It has opened a space for social love (Sardello, 2001; Zajonc, 2009) and care-at-a-distance[64] that motivates new perceptions, commitments, and changes of heart at different scales.

FIGURE 34.1a One of the twenty sheets of stitched, naturally blackened banana skin, strung up under tension on a metal cross. The banana skins here are the produce of farmer No. M190725, whose invisible life is only experienced through a voice on headphones and inscribed in the skins, but whose face will never be seen. First created for the NOW Festival, Nottingham, UK, 1996. In collaboration with independent growers in the Windward Islands.

['Instrument of consciousness' and image copyright Shelley Sacks]

FIGURE 34.1b Close-up of one of the twenty stitched sheets of banana skin, embodying the pain of alienated labour in the global economy. The skins, each from one box of bananas, were stitched together by Sacks and studio assistants. Stitching each skin was a three- to four-day process, and drying it took another week of constant care.

[Both the 'instrument of consciousness' and image: copyright Shelley Sacks]

Some 'instruments of consciousness', like *New Eyes for the World,* developed during the COVID-19 pandemic, use the root methodology in a hybrid format that includes a 'walk on the planet' strategy for moving between chair, digital screen, and the wider world of experience. *Earth Forum* (for detailed description see Sacks, 2018) is a group process using minimal physical material, in which an oiled cloth creates a 'sacramental' space (Sacks, 2016) for meeting and gathering insights. Due to its portability and the training offered in its 'connective imagination' processes, *Earth Forum* is easily replicated for multipliers and widely scalable (see Figure 34.2). In others, like *Exchange Values* and *FRAMETALKS,* a complex set of objects create the connective practice arena.[65] *Journaling for Change* is a generic sense-making process for individuals—working alone—in a notebook.[66] *Landing Strip for Souls* and *7000 HUMANS* work with questions, using the 'inner atelier' process, online and on the ground. Despite their differences, they all have multi-layered functions. None of them are tools. They do not instrumentalize or focus on conclusions. And they all offer a lived experience of the connection between inner and outer work and the continuum between thought and action.

FIGURE 34.2 The Earth Forum oiled cloth creates a 'sacramental' space for deep listening to oneself, each other, and the world. It is a place for meeting, for holding elements gathered on the 'walk on the planet', and for distilling insights about ways of working toward the future we want. Participants standing around the cloth at the end of a two-day Earth Forum, Bonn, 2013.

['Instrument of consciousness' and image copyright Shelley Sacks]

FRAMETALKS: For Resurrecting the World in Us

In *FRAMETALKS: Making Social Honey*[67]—which has a specific focus on 'resurrecting the world in us'—the skin of a huge deer, destined for handbags and shoes, is removed from the supply chain. A square cut from the centre of its being speaks of human power over nature. This creates a frame to explore five significant realities in ourselves, in each other, and the world: nature, human being, love, freedom, and future.[68] The 'crucified' deerskin on wheels creates a place of encounter—in the museum, market hall, conference space, meeting room, and on the streets—around a once-living being whose existence is easily overlooked (see Figure 34.3). Other elements include a workbook for participants and interested passers-by, small blackboards for sharing insights and making interventions, a second wagon with chairs that creates a pop-up space for exploring five significant realities in the world, and a 'process-score' that guides the 'inner atelier' work and the 'making social honey' process through successive distillations. Training is offered to create a local team for guiding the process which varies according to context and need.[69] Whether scientific think-tank,

FIGURE 34.3 In FRAMETALKS, the 'crucified' deerskin on wheels creates a place of encounter in indoor contexts and on the streets. A second wagon with chairs creates a pop-up space for passers-by to explore five significant realities. July 2021, as part of the Kassel21-Social Sculpture Lab for the Joseph Beuys Centenary, hosted by the Documenta Archive, the Neue Galerie, Kassel and City of Kassel.

['Instrument of consciousness' and image copyright Shelley Sacks]

university seminar, city museum, or school, the root method and principles remain the same. In the past two decades, *FRAMETALKS* has been adapted in many ways that include a 24-hour indoor action; a week-long, twelve-hour daily process; and, exploring one reality per week, with a final week for synthesizing insights into a co-created *Humanifesto for an Eco-Social Future*.[70] A version of *FRAMETALKS* was also developed using small frames for groups and communities unable to work with the deerskin, and for teachers, who become multipliers, to use when introducing 'imaginal thinking'. A hybrid live-online version is available for global groups. Whatever its form or duration *FRAMETALKS* progresses through three phases: (1) perceiving the realities in oneself: gathering and distilling individual insights, shared without discussion; (2) perceiving the realities in the world: going out with the deerskin frame—or small, individual frames if necessary—to enter each reality, and listening without discussion to what each person perceives; and (3) enabling possibilities to be perceived and directions

to emerge: sharing and listening into insights from phases one and two, and through successive group distillations.

Designed to lift taken-for-granted narratives, habits of thinking, prejudices, and phantasies out of oblivion and forgetfulness into consciousness, *FRAMETALKS* enables us to enter the 'dead-zones' (Sacks, 2013b) as individuals and groups for illuminating how we see and think, and to explore the future we want.[71] Despite the 2000-year-old crucifixion of 'the good shepherd' and as many years of self-flagellating repentance, human beings have continued to crucify the world with clever but often very disconnected inventions. The crucified deerskin not only reminds us how we abuse and crucify the world but is a place to inhabit a world badly damaged by human deeds. In *FRAMETALKS* as in most therapeutic processes, 'lifting things out of oblivion' and facing the damage and pain, can be a redemptive process that goes beyond emotional-cathartic release, enabling a more enduring 'change of heart' and the likelihood of behaviour change too.

Commonalities and Differences

Like all the 'instruments of consciousness' *FRAMETALKS* also contains elements for connecting with oneself, each other, and the world that function like sacraments. One can even see the entire *FRAMETALKS* 'instrument of consciousness'—described in its accompanying workbook as 'a pilgrimage into the everyday'[72]—as a sacramental place of redemption. The sudden appearance of the crucified deer on the streets—on its pilgrimage into the world—disrupts the veiling of thought structures, attitudes, and behaviours. It is a call to consciousness: to stop, to see how we see and think, and to discover what might provoke a 'change of heart'. It is a 'ritual' in the sense that it returns us to the stream of being.[73] Without this kind of *metanoia* or 'change of heart', the arrogant anthropocentric narratives of control-over-all-life-forms reign—loaded with all the shadows of fear they engender. Living into our deeds and potential for a 'change of heart', reclaims from top-down religion the space for the redemptive work in which we become true lovers of the world, and freedom and responsibility are synonymous. An eighteen-year-old school pupil in Germany, from Afghanistan as a refugee, said at the end of a *FRAMETALKS* process: 'Today I realized that I can see what I think, and think about what I think. This makes me free!' In another school, where pupils have participated several times in the *FRAMETALKS* process, many pupils have asked to begin all classes by working in their 'inner atelier' and to use their small individual frames for 'seeing what they see' and 'thinking about what they think'. The *FRAMETALKS* 'instrument of consciousness' is in this sense a 'technology' or 'apparatus' for going beyond the frame [Ge-stell]: for 'enframing'—and, further, as Heidegger perceived the potential of Ge-stell in enframing—as an apparatus for uncovering truth (Huttunen & Kakkori, 2022).

Conclusion: Is It Real Change? Is It Relevant? Is It a Priority?

In a world of extreme inner and outer crises, it is easy to doubt the role and meaningfulness of this connective practice work. Questions about creative capacities for ecosocial transformation are challenged and confused by notions of 'real' change that are often one-dimensional and deflected by imaginaries of progress that give an upper hand to technological solutions. With institutional and government reliance on techno-fixes now the order of the day, innovating spaces for deliberation, enhancing capacities for working with conflicting positions and for connective vision, and developing education for thinking-together about a humane and ecologically viable future is, in most countries, a low priority or not even on the agenda.

The reasons for this are not only lack of resources, time, and complexity, but also because ideas and values-based transformation are often seen as 'idealist'. This not only adds to side-lining the role that perception, thinking, and reflection play in shaping our future but privileges a culture of techno-fixes that includes 'nudging' humans with machines. If societal transformation is increasingly outsourced to generative AI, and we do not take seriously the significant relationship between thought and action, mind-sets and behaviour, world views and decisions, and criteria and choices, we are stuck where we are. Developing the inner culture of the human being through social aesthetic and connective forms of education—that strengthens the *ability-to-respond,* develops the capacity to care at a distance (Sacks, 2011b), and enhances 'connective imagination' for new ways of living on the planet—will fade into the distance. We will not develop creative ways to deal with different world views and conflicts, and wars of machines against humans, regimes against people, and ideologies of destructive progress will continue to grow.

In an analysis of different schools of transformation thinking (Schneidewind & Augenstein, 2016), three main drivers of change are described—idealist, institutional, and technological. Although the authors argue for the significance of all three, in the everyday institutional world of finding 'solutions' to problems, the term 'idealist' has negative power and casts deep shadows. Categories like 'idealist' for drivers of change concerned with human insight, agency, ethics, care, and other forms of consciousness-led transformation, exacerbate the inadequate attention given—locally and globally—to exploring what needs to be done to develop capacities and values that support living together compassionately on one planet and recognizing the interconnectedness of all life forms.

The *Connective Practice Approach* has evolved in a period on earth when humans are inventing life forms as well as machines. In this materialist-rationalist context, a focus on developing new *ethical* organs of perception and capacities for 'connective imagination' in all fields and disciplines is a priority. Claiming the space of decision-making about the future from machines also includes urgent and very careful reflection on

'intelligence', including 'collective' or 'hive intelligence'. We need to remind ourselves that how we think about the human being and the future of humanity, is not only shaped by often unconscious criteria and views but determines the criteria and choices we are making about a living future.

The *Connective Practice Approach* offers experiential insight into capacities for 'connective imagination' and thinking-together amidst different worldviews. From the early 1990s when such work was described as 'art and social healing' to the present, connective practices—like *Exchange Values, FRAMETALKS, New Eyes for the World, University of the Trees,* and *Earth Forum*, and related pedagogic practices shared in the university programmes—have inspired thousands of individuals, groups, and thought leaders with their insights, formulations, and strategies. Several hundred multipliers have also been trained to use instruments like *FRAMETALKS* and *Earth Forum*. Work with small groups of changemakers in the past decade in China, the UK, and India, even whilst these practices were still evolving, confirmed the viability of these instruments in different cultures. Since 2020 the *Connective Practice Approach* through the *FRAMETALKS* methodology has also been used, very successfully, with teachers and hundreds of school pupils in Germany. Despite such successes, the transformative potential of this slow, long-term work in a world of calculative thinking[74] is severely limited, unless scaled globally, especially in educational contexts. This is why there are plans for the 'imaginal thinking' work being done in schools to become an action-research project linked to a university. In this research phase that will further validate the effectiveness[75] of connective practice, we intend to link up with relevant initiatives[76] to scale out this approach for training multipliers in specific practices as well as the 'connective imagination' root methodology and 'making social honey' process.

Working with people on the edge of the widening abyss—between technosphere and 'humanosphere'—though challenging, is also encouraging. Not only do co-created initiatives and plans begin to emerge. People recognize the relationship between the 'invisible materials' of thought, attitudes, and what they see in the world. They are mobilized by the experience of 'connective imagination' for transforming habits of thinking and shaping new imaginaries. And they are inspired by their experience of the role of individual insight in thinking-together, 'making social honey', and what this offers for developing capacities for the future and evolving a conscious 'We'.

In a world so damaged by humans, and an inner climate crisis of anger, fear, and despair, experiencing how essential individual insight is for thinking-together about the world *is* relevant, real, and a priority. It affirms the urgent, post-anthropocentric role of humans in developing conscious, connective criteria for making decisions about how a living future might look. It reminds us too that the human being is the most difficult of all earth's creatures—a species learning how to use our freedom in connective ways, that does not simply unfold—and at the beginning of our development.

Although more difficult to articulate, the redemptive and sacral value of the connective practice work is also palpable. Lifting the unloved, forgotten, and denied world

into consciousness through individual and collaborative connective practice goes way beyond bringing cathartic relief. In addition to new energy, commitment, insight, and imaginative power is activated. This transformative work in the 'inner atelier' and co-creative workspace—where we resurrect the crucified world in us, and a 'change of heart' takes place—redeems thinking as an imaginal, enlivening, social aesthetic process and helps us recognize the careful shaping of one's attitudes and paths towards an eco-social future as a sacred practice.

Notes

1. Erzsebet Strausz' work in the field of International Relations shares certain ways of working in the liminal zone with Sacks' *Connective Practice Approach*. This reflects the increasingly interdisciplinary terrain of people arriving at similar understandings and ways of working, from very different points of departure. See Strausz (2018).
2. The emphasis on humans as the only ones in a position to undertake this task, should not be confused with an anthropocentric worldview. See above in the Guiding Images section: 'A tree knows how to be a tree'.
3. 'Making Social Honey' is a focus in *7000 HUMANS*, https://www.7000humans.com/faqs as well as in *FRAMETALKS: Making Social Honey*, https://socialsculpturelab.com/the-enquiry-labs/connective-practices/frametalks-kassel/ and https://universityofthetrees.org/news/2018/frametalks-artikel-in-evolve-19.
4. This term 'instruments of consciousness' was used in the *University of the Trees* project in 2006—linked to the *Centre for Contemporary Art and the Natural World* [CCANW]—in response to a forester's question about where the art was that I was making for the forest. I replied that I was making 'instruments of consciousness, not objects of attention'. See http://ccanw.org.uk/pdf/CCANW_January-March-2007.pdf [last accessed 16 October 2023] and the section on *University of the Trees* in the new CCANW online archive (forthcoming 2024) supported by Bath Spa University, covering 25 years from 1995 to 2020. One section describes the evolution of the University of the Trees (UOT), being the most important of CCANW's long-term projects during the period 2006–11, in which UOT's principles, guiding images and first practice-based prototypes were developed.
5. In Sacks and Zumdick (2013a), I developed the term 'connective distance' to describe an important connective practice strategy that echoes the nineteenth-century notion of 'aesthetic distance' but without the connotations of suppressing emotion. Instead, the focus is on coming closer to things by actively making inner space for engaged perception.
6. 'Image' is used here in a broad sense meaning any form that carries meaning, understandings, principles, sense impressions and other contents embodied in sounds, words, visual forms, body language, and other experiential forms.
7. Samuel Taylor Coleridge's theory of imagination and fancy was first exhibited online in 2014 at the British Library in 'Discovering literature: Romantics and Victorians'.
8. Coleridge uses 'emancipated' to mean disconnected and to refer to the 'arbitrary' connecting of ideas, experiences, and forms through 'fancy' (Coleridge & Fenner, 1817).
9. The term 'connective practice' was first used in 2006 to refer to the set of strategies and aims in Sacks' social sculpture arenas like *Exchange Values* (see https://exchange-values.org/) and *University of the Trees* (see https://universityofthetrees.org/) and to the pedagogies

and methods of engagement developed in the Master and Doctoral programmes in Social Sculpture at Oxford Brookes University, UK. After the closure of the programme and from late 2023—when the last of sixteen doctoral students will graduate—the *Connective Practice Approach* is being shared through the projects and training programmes of the *global Social Sculpture Lab* (see https://socialsculpturelab.com/) and the *Lab for New Knowledge and an Eco-Social Future* (see https://universityofthetrees.org/).

10 Richard Tarnas, in an online video lecture entitled *James Hillman and Archetypal Psychology: An Introduction* says 'the Renaissance philosophers, according to James Hillman, recognised that the imagination must have a place […] a realm for envisioning' and that 'imagination's place might be […] the theatre of memory of Giulio Camillo'. Lecture at California Institute of Integral Studies, 2 March 2012, Part 11; see www.youtube.com/watch?v=vNHz-Ib5qLs (0.15–1.46). In the *Connective Practice Approach* this space is a workspace not just for memory and imagination, but for what I call 'grounded perception' and other forms of conscious realization.

11 The use of 'connective imagination' and 'disconnected imagination' in this chapter have strong similarities with Coleridge's distinction between imagination and fancy. Paracelsus, the healer, speaks of 'true imagination' and false imagination', as discussed in Lachman (2017).

12. Joseph Beuys uses the term 'Erweiterte Kunstbegriff' [expanded concept of art] as a synonym for 'Soziale Plastik' [social sculpture] from the early 1970s. A distinction needs to be made between Beuys' 'expanded conception of art' and Rosalind Krauss' art in the expanded field'. Though often used synonymously, they are in fact quite different. See Sacks, 2011a.

13. A profound early childhood experience relating to the space of imagination—in which I take in the image of a red flower, 'carry' the image to share with my mother, and notice how my spoken image made her smile, i.e., moved matter—is described in *Die rote Blume* (Sacks & Kurt, 2013b).

14. This formative experience of mind-sets colliding is described in Sacks (2017b). See TEDxUCLWomen at: www.youtube.com/watch?v=rE_5Yaad2-U [last accessed 16 October 2023].

15. In the debates of the South African Liberation struggle, this was one of the key cultural questions. In the 1980s, I began to explore the difference between this notion of art as a 'weapon' or 'tool for change' and Joseph Beuys' expanded 'conception of art' and social sculpture ideas, which, although expanding 'art' to include all forms of social-cultural forming and 'Bildung', are more related to Schiller than to movements like Proletkult. See Sachs, De Kok, and Press (1990). Digitized 3 April 2009, University of Virginia.

16. In 1978, I set up the NGO, *ZAKHE, Resources for Cooperative Development*, in Cape Town, South Africa, in which many early insights and methods related to the *Connective Practice Approach* were developed. A report for Oxfam that included a section entitled 'Beyond the Labour Unit Mentality' (1980) about these methods emphasizes their focus on strengthening cooperative self-directed work and other related 'capacities for the future' crushed by racial capitalism. I coordinated ZAKHE with Ferdinand Engel, until 1982.

17. Harald Szeeman's radical exhibition in 1969 entitled *When Attitudes become Form* had strong parallels with my understandings from Vedantic philosophy of how thought becomes form. Both played an important role in my early performance work exploring what Joseph Beuys describes as the 'invisible materials' of social sculpture.

18. I took up Beuys' invitation (unpublished letter, 1970) to study with him and spent from 1973 until his death in 1986, in dialogue with him and his social sculpture proposals [see letter from Beuys to Sacks from 1976 in Hinrichsen (2023)].
19. From 1973 until 1986, I explored Joseph Beuys' social sculpture ideas in depth, first as a student (1973–75) and then as a co-worker in the Free International University (FIU) in Germany. In 1976 I created a branch of the FIU in Cape Town, exploring ways to work with these ideas in the very different context of the South African struggle. (See History of the FIU, South Africa, and documents on www.shelleysacks.com.)
20. An entire volume of the journal *Janus Head* 8(1), May 2005, is devoted to Goethean science and phenomenology; see http://janushead.org/volume-8-issue-1/ [last accessed 6 October 2024].
21. Joseph Beuys' theory of social sculpture is closely aligned to Rudolf Steiner's early philosophical work *The Philosophy of Freedom* (Die Philosophie der Freiheit). The first English translation (1916) and the only one sanctioned by Steiner himself, was translated by Prof. and Mrs. R. F. Alfred Hoernlé. See also Steiner et al. (1970).
22. Schumacher (1975).
23. *I Ching* or *Book of Changes*, Hexagram 18, Richard Willhelm translation rendered into English by Cary F. Baynes (1965). Routledge, Keegan Paul.
24. 'Warmth work' is a key concept in the work of Joseph Beuys, and central to the pedagogies and practices of Sacks' *Connective Practice Approach*. See *7000 HUMANS* for an example (2022): www.7000humans.com/the-field [last accessed 6 October 2024].
25. For a sense of the many iterations of *Exchange Values* from 1974 to 2018, see www.exchange-values.org. For more about *Earth Forum* see https://universityofthetrees.org/news/2019/erdforum-earth-forum-training-in-english-and-german-2019 and Sacks (2018).
26. See Heinämaa, S. *Epoché as Personal Transformation: On the Similarities between the Philosophical Change of Attitude and Religious Conversions* in Phänomenologischen Forschungen, Special issue on Phenomenology and Pragmatism/Phänomenologie und Pragmatismus, eds. Sonja Rinofner-Kreidl, Niels Weidtmann and Sebastian Luft, 2019. She highlights how Husserl sees the parallel between personal transformation and religious conversion in epoché: 'Perhaps it even will become manifest that the total phenomenological attitude and the epoché belonging to it are called [berufen] in essence to effect first a complete personal transformation [Wandlung], comparable first to a religious conversion [Umkehrung], which, however, over and above this, bears within itself the sense of the greatest existential transformation which is assigned to mankind as such'.
27. 'Every human being is an artist, a freedom being, called to participate in transforming and reshaping the conditions, thinking and structures that shape and inform our lives.' My translation of my notes taken in a seminar led by Joseph Beuys, Hamburg University, 1975.
28. In 1955, Martin Heidegger gave a Memorial Address for the composer, Conrad Kreutzer (1780–1849). His speech focused on two kinds of thinking—calculative and meditative.
29. Examples of Connective Practices that are scalable, portable, and usable in many contexts are *Exchange Values, Earth Forum, Field of Commitment, University of the Trees, Landing Strip for Souls, FRAMETALKS, Journaling for Change*. See www.socialsculpturelab.com and Sacks (2024, in preparation). See also www.shelleysacks.com.
30. This key guiding image—'a tree knows how to be a tree'—in *University of the Trees* (UOT) was first used in 2006 when the initiative was launched at the Centre for Contemporary Art and the Natural World (CCANW), and is discussed in many lectures and articles. Hear Sacks' talk about this on the panel *Aesthetics, Community and Ecology toward a Culture*

of Sustainability, Radius of Art Conference, Heinrich Böll Foundation, Berlin, February 2012, available at: https://www.youtube.com/watch?v=LgdCNrLBQxk [34.40 mins].

31. Metaphora in Greek means 'transport'. From this the term 'metaphor' is derived: 'vehicles' that take us into new spaces and understandings.
32. This is also the title of both a book chapter (Sacks, 2018) and a connective practice shared in Haus der Kulturen der Welt, in the Überlebenskunst Festival, Berlin, August 2011.
33. This differentiation between responsibility as duty and as an ability-to-respond that mobilizes from within, has led to the exploration and development of many strategies that enhance the ability-to-respond. First discussed in Sacks' unpublished lecture for the UNESCO Stockholm Summit for Culture and Development (2000) Also in Sacks (2011b, 2017a).
34. 'Humanosphere' is a key image-idea in the *7000 HUMANS* initiative. See https://www.7000humans.com/7000-humans. 2022. From the website. '*7000 HUMANS* is a global warmth-work process that connects thought, heart and will and counters the cold thought that has led to climate crisis, war, racism, colonization, and an increasingly disconnected technosphere.
35. This contrast between imagination and fancy is documented in Coleridge and Rest (1817). Coleridge says that '[…] Fancy is indeed no other than a mode of Memory emancipated from the order of time and space; […]'. This distinction and its implications for new imaginaries, is one that the *Connective Practice Approach* aims to make experiential.
36. Integral to our introduction in most connective practices—of the imaginal thought work that we do in the 'inner atelier'—is a description of our living planet entirely covered with asphalt, the last blades of grass being plastered over, turning the earth into something like a giant parking lot. When sharing this awful and ridiculous image, the point is made that although it is utterly absurd and could never be, one can picture it, and that this is what makes it so dangerous. Once an image, it is only a step away from having a techno-design team find ways to make it a reality. The world abounds with myriad examples of brilliant ideas and designs—from unnecessary profit extracting items to deathly inventions including atom bombs, nuclear power stations and autonomous weapons/decision-making systems.
37. See footnote 30. www.youtube.com/watch?v=LgdCNrLBQxk [34.40 mins].
38. From a lecture by J. P. Sartre, entitled *Existentialism Is a Humanism*, at the Club Maintenant, Paris, 1946.
39. See footnote 30. www.youtube.com/watch?v=LgdCNrLBQxk [34.40 mins].
40. The *7000 HUMANS 2.0* (2023) initiative has begun a global exploration of the question: *What is a Human Being? What is a Tree? What is a Machine?* Responses to this set of questions will be gathered in a publication linked to *7000 HUMANS* in 2024.
41. Sacks (2022). Texts for *7000 HUMANS* initiative. See www.7000humans.com/faqs in the Glossary section.
42. A key guiding image in *7000 HUMANS*. See Glossary in the FAQs. www.7000humans.com/faqs related to Joseph Beuys notion of 'warmth work'.
43. For twenty-seven years in two UK universities 'Creative Strategies'—and related 'aesthetic strategies'—constituted the core module in the Interdisciplinary Arts programmes at Undergraduate and Postgraduate levels, including a taught component for several doctoral programmes in Sound Art, Contemporary Arts, and Social Sculpture-Connective Practice. See Sacks (2024, in preparation).
44. The 'making strange' strategy, central in the *Connective Practice Approach*, is inspired by the Verfremdungseffekt strategy in Bertolt Brecht's work. See notes of this in Andrew

Dickson's article at: www.bl.uk/20th-century-literature/articles/bertolt-brecht-and-epic-theatre-v-is-for-verfremdungseffekt

45. For further examples, see Sacks (2024, in preparation). Publication linked to *Kassel21-Social Sculpture Lab*, hosted by documenta archiv www.documenta-archiv.de/en/aktuell/termine/2475/kassel-21-social-sculpture-lab
46. See www.socialsculpturelab.com for images of 'The Survival Room' installation using the lemniscate as part of a 'walking' practice in the *Kassel21-Social Sculpture Lab*.
47. Entitled *Dialogue with Oneself/Dialogue with the World*: *Journaling for Change*, this is one of core 'instruments of consciousness' developed by Sacks in 1992, for her *Art and Social Healing* programme at Nottingham Trent University, UK. It continued to be used as a foundational 'connective practice' for three decades in all her university curricula. This practice is also offered in non-institutional settings for training 'connective practice' facilitators in the *University of the Trees*, and *Social Sculpture Lab for New Knowledge and an Eco-Social Future*. It offers a way of gathering and documenting thoughts and experience that activates one's intuition and enables new insights to emerge. From feedback received, once the process begins to work, it becomes an on-going life practice.
48. Verbal statement by Master student, Lorelien Latour, in 'Reflective Analysis' session in Master in Social Sculpture and Connective Practice in 2016, about the effects of using the *Dialogue with Oneself/Dialogue with the World*: *Journaling for Change* practice.
49. Swami Nisreyasananda (1899–1992), with whom I studied for four decades, from 1968 until his death, was a philosopher, mindfulness teacher, and editor of the *Prabuddha Bharata*, the journal of the Ramakrishna Vedanta Society. The 'inner atelier' work is strongly influenced by his explanations of how we work in the inner space, combined with Goethe's phenomenological process of going from 'close noticing' to seeing the 'formative forces' and the 'organising idea' in the outer form.
50. Outlined in FAQs on *7000 HUMANS* initiative. See www.7000humans.com See also: https://universityofthetrees.org/news/2018/frametalks-day-6-7-towards-making-social-honey. Extensive description in Sacks (2024, in preparation).
51. This is akin to the process of 'dreaming on the dream' that C. G. Jung described for following a dream, allowing its contents to emerge. See Raff, J. (2004). *Jung and the alchemical imagination*. Nicolas-Hays. Inc. It also relates to Goethe's methodology, taken up by Rudolf Steiner, about the path from observation and imagination to intuition, and how deeply explored insights and images can become 'moral intuitions' and provoke connective actions.
52. In this TEDx talk (Sacks, 2017b) *Rethinking 'home' and the art of changing one's mind-set*, the example of making tomato soup highlights how this profound capacity for connecting past, present, and future is used at a basic level, usually unconsciously in everyday life. Making it conscious gives it a hugely extended scope for deeper dialogue with oneself and the world.
53. The four stages for coming to insights—that connect inner and outer work—follow this sequence in *Earth Forum* and *FRAMETALKS*, whilst in *New Eyes for the World* and *7000 HUMANS* they are greatly reduced.
54. The root method is adapted in several ways for different age groups, cultural contexts, and issues, by shortening descriptions and bringing in local and humorous examples. Training multipliers to scale these instruments requires them to understand the principles and reasons for each aspect of the process. Then they can use it flexibly and appropriately.

55. My earliest understanding of 'instruments of consciousness' appeared in a dream about an altar, where each person in a community used it to overcome being trapped in their own reflection. Once the last person had managed this, rain fell! I made this altar as an instrument for use and entitled it: *Ritual Aids for the Impasse*. In later instruments of consciousness—like *FRAMETALKS* for example—a methodology of engagement accompanies the physical objects.
56. *Landing Strip for Souls* (2000, ongoing) is an instrument that begins by enabling participants to perceive significant instances and situations in one's life as 'landings', and to develop the capacity to uncover the questions embedded in events and places. Extensive description in Sacks (2024, in preparation).
57. *Hidden, Ignored, Denied* is an creative strategy and exploratory process in the *Connective Practice Approach*, first used in the *Creative Strategies* core module in the Interdisciplinary Arts Programme (Oxford Brookes University, 1997) to enable students to develop work connecting inner realities and outer events, and in response to the questions: 'What needs addressing? What needs warming up?'
58. See footnote 44.
59. Creating 'anchors points in the world' with a 'tree partner or piece of land', is a key aspect of *7000 HUMANS*. See www.7000humans.com/
60. *Earth Forum* is subtitled: *Listening to Oneself, Listening to Each Other, Listening to the World*—with processes designed to enable 'deep listening to situations'.
61. *Landing Strip for Souls* and *7000 HUMANS* both centre around learning to uncover, enter, and follow questions as the basis for new awareness and enabling emergent thinking.
62. www.exchange-values.org. Devised by Shelley Sacks in collaboration with small producers in the Windward islands, started in 1996 and showed at thirteen venues in the UK, Africa, EU, from 1996 to 2018. First form of the process: 1972–74 'Reading the World Economy in the Banana Skins'.
63. For a description of *Earth Forum* training see: https://universityofthetrees.org/news/2018/sign-up-now-earth-forum-training-english-german-oxford-1-4-november-2018
64. Cultural Geographer, Prof. Paul Cloke, used this term to discuss as essential aspect of Exchange Values. In an unpublished paper presented at a conference on Exchange Values, University of Birmingham, 2004. See reference in http://exchange-values.org/wordpress/wp-content/uploads/2016/07/shelleysacks1.pdf
65. An extensive list of the 'instruments of consciousness' developed by Shelley Sacks in the field of Connective Practice are in *Making Social Honey* (2024, in preparation).
66. See note 47 where 'Journaling for Change' is referred to.
67. See *FRAMETALKS* https://socialsculpturelab.com/the-enquiry-labs/connective-practices/frametalks-kassel/ and https://socialsculpturelab.com/the-enquiry-labs/connective-practices/frametalks-fluxus-potsdam/
68. See *FRAMETALKS* booklet https://universityofthetrees.org/news/2018/peak-inside-the-frametalks-workbook
69. See https://socialsculpturelab.com/multiplier-training/ and https://universityofthetrees.org/news/2018/training-the-frametalks-team
70. Creating this 'Humanifesto' in the Fluxus-Museum, Potsdam, in October 2021, was the culmination of a two-week intensive research process with a group of graduate students from the University of Potsdam.
71. Joseph Beuys often said: The future we want must be invented, otherwise we will get one that we don't want, and in fact, this is already here!

72. *FRAMETALKS* workbook: see footnote 71.
73. Moore, Thomas. (1984). *Rituals of the Imagination*: Dallas: Dallas Inst Humanities & Culture. This essay offers insights into the way that true rituals that help us to connect with the stream on being, as opposed to those where contact with the meaning has been lost and an 'empty' form is held onto instead of being a portal.
74. Heidegger, M. (1968). *What Is Called Thinking?* English translation by Fred D. Wieck and J. Glenn Gray. New York/London: Harper and Row (Harper Perennial Modern Thought).
75. See Oxford Brookes University (2013) Impact Case study: 'Every human being is an artist': Social sculpture practice enables new forms of creative engagement and action within the sustainability agenda. https://impact.ref.ac.uk/casestudies/CaseStudy.aspx?Id=16776
76. E.g. through UNESCO's *Futures of Education* programme. https://en.unesco.org/futures ofeducation/

References

Bortoft, Henri. (1996). *The wholeness of nature: Goethe's way of science*. Floris Books.

Brook, Isis. (1998). Goethean science as a way to read landscape. *Landscape Research*, 23(1), 51–69.

Bunge, Matthias. (1996). *Zwischen Intuition und Ratio: Pole des Bildnerischen Denkens bei Kandinsky, Klee und Beuys*. Franz Steiner Verlag.

Coleridge, Samuel Taylor, & Fenner, Rest. (1817). Biographical sketches of my literary life and opinions. *Biographia Literaria*. British Library. Chapter 13. (British Library Uniform Title: Single Works. Biographia Literaria Identifier: System number: 000742313. Copy at 1163.c.4.)

Corbin, Henri. (1972/2000). Mundus Imaginalis: or the imaginary and the imaginal. In Benjamin Sells (Ed.), *Working with images: the theoretical base of archetypal psychology* (pp. 71–89). Spring Publications.

Harlan, Volker. (2004). *Das Bild der Pflanze in Wissenschaft und Kunst. Aristoteles – Goethe – Klee – Beuys*. Verlag Johannes Mayer.

Heidegger, Martin. (1955). Memorial address. In *Discourse on thinking*, trans. John M. Anderson and E. Hans Freund (pp. 44–46). Harper and Row.

Hillman, James. (1979/2000). Image-sense. In Benjamin Sells (Ed.), *Working with images: the theoretical base of archetypal psychology* (pp. 170–185). Spring Publications.

Hillman, James. (1998). *The thought of the heart and the soul of the world*. Spring Publications.

Hinrichsen, Kristina. (2023). But you're an artist, Shelley! You must not stop making things. Begegnung mit der Künstlerin und Beuys-Schülerin Shelley Sacks. In Claudia Scholtz (Ed.), *Beuys in Hessen* (pp. 216–225). Wieland Verlag.

Huttunen, Rauno, & Kakkori, Leena. 2022. Heidegger's critique of the technology and the educational ecological imperative. *Educational Philosophy and Theory* 54(5), 630–642. https://www.tandfonline.com/doi/full/10.1080/00131857.2021.1903436.

Lachman, Gary. (2017). *Lost knowledge of the imagination* (pp. 85–87). Floris Books.

Naydler, Jeremy. (1996). *Goethe on science: an anthology of Goethe's scientific writings*. Floris Books.

Raff, Jeffery. (2004). *Jung and the alchemical imagination*. Nicolas-Hays. Inc.

Robbins, Brent D. (2005). New organs of perception: Goethean science as a cultural therapeutics. *Janus Head* 8(1), 113–126.

Sachs, Albie, De Kok, Ingrid, & Press, Karen. (1990). *Spring is rebellious: arguments about cultural freedom*. Buchu Books. Digitized 3 April 2009, University of Virginia.

Sacks, Shelley. (1980). 'Beyond the labour unit mentality' is a paragraph in an unpublished report to Oxfam, on funding allocated to 'ZAKHE: for co-operative development'.

Sacks, Shelley. (2007). Seeing the phenomenon and imaginal thought: trajectories for transformation in the work of Joseph Beuys and Rudolf Steiner. In Allison Holland (Ed.), *Imagination, inspiration, intuition* (pp. 37–52). National Gallery of Australia.

Sacks, Shelley. (2011a). Social sculpture and new organs of perception: new practices and new pedagogy for a humane and ecologically viable future. In Christa-Maria Lerm Hayes and Victoria Walters (Eds.), *Beuysian legacies in Ireland and beyond: art, culture and politics* (pp. 80–97). L.I.T Publishers.

Sacks, Shelley. (2011b). Geben und Ökologisches Bürgerschaft: Aus innerer Bewegung zur passenden Form. In Antje Tönnis (Ed.), *'Da Hilft nur Schenken: Mit Schenken und Stiften die Gesellschaft gestalten* (pp. 38–42). Info3-Verlag.

Sacks, Shelley. (2016). Das Sakrament der Zukunft ist Begegnung. *The Missing Link, Karlsruhe 15–17 July 2016*. Abstract for Kongress available at: www.missinglink2016.de/pdf/abstract_sacks.pdf.

Sacks, Shelley. (2017a). Contemporary social sculpture and the field of transformation. In Joachim Kettel (Ed.), *Übergangsformen von Kunst & Pädagogik in der Kulturellen Bildung* (pp. 75–90). Athena Verlag.

Sacks, Shelley. (2017b). *Re-thinking home and the art of changing one's mind-set*. Online video available at: www.youtube.com/watch?v=rE_5Yaad2-U.

Sacks, Shelley. (2018). Sustainability without the I-sense is nonsense: inner 'technologies' for a viable future and the inner dimension of sustainability. In Oliver Parodi (Ed.), *Personal sustainability: exploring the far side of sustainable development* (pp. 171–188). Routledge, Taylor and Francis.

Sacks, Shelley (2020). Stimmigkeit Und Zukunft Unsere Vorstellungskraft Als Menschliches Wahrnehmungsorgan. *EVOLVE, 27/2020*. evolve Magazin für Bewusstsein und Kultur (pp. 42–46).

Sacks, Shelley. (2022). *Social honey* in Glossary section of FAQs for 7000 HUMANS initiative. https://www.7000humans.com/faqs.

Sacks, Shelley. (2024, in prep). *Making social honey in the field of transformation: social sculpture and the connective practice approach in times of change*. Social Sculpture Lab.

Sacks, Shelley, & Zumdick, Wolfgang. (2013a). *Atlas of the poetic continent: pathways to ecological citizenship*. Temple Lodge.

Sacks, Shelley, & Kurt, Hildegard. (2013b). *Die rote Blume: Aesthetische Praxis in Zeiten des Wandels*. Drachen Verlag.

Sardello, Robert. (2001). *Love and the world: a guide to conscious soul practice*. Lindesfarne Books.

Schneidewind, Uwe, & Augenstein, Karoline. (2016). Three schools of transformation thinking. The impact of ideas, institutions, and technological innovation on transformation processes. *GAIA 25*(2), 88–93.

Schumacher, Ernst Friedrich. (1975). *Small is beautiful: economics as if people mattered*. Harper Collins.

Seamon, David, & Zajonc, Arthur. (1998). *Goethe's way of science: a phenomenology of nature* (pp. 1–32). SUNY Press.

Steiner, Rudolf. (1916). *The philosophy of freedom*. Trans. from the 1894 German edition by Prof. and Mrs. R. F. Alfred Hoernlé. G. P. Putnam's Sons.

Steiner et al. (1970). *Education as an art*. Garber Communications.

Strausz, Erzsébet. (2018). *Writing the self and transforming knowledge in international relations: towards a politics of liminality*. Routledge.

Szeeman, Harald. (1969). *Live in your head: When attitudes become form: works-concepts-processes-situations-information*. Kunsthalle Bern.

Tisdall, Caroline. (1979). *Joseph Beuys*. Thames and Hudson.

Zajonc, Arthur. (2009). *Meditation as contemplative inquiry: when knowing becomes love*. Lindesfarne Books.

CHAPTER 35

BODILY AESTHETICS

Challenging Damaging Imaginaries of the Body

KATHLEEN LENNON

BODILY AESTHETICS

ACCORDING to Tobin Siebers in his book on *Disability Aesthetics* (Siebers, 2010, 1) bodily aesthetics is about how some bodies make other bodies feel. Here I am concerned with how we feel about our own bodies, hand in hand with how we feel about the bodies of others. And in the majority of cases the feelings we have about our own bodies are negative. Most women and an increasing number of men, people of all cultures, many people with disabilities, and many old people, dislike aspects of their bodies and are damaged by dominant aesthetic bodily norms from which they are excluded. Most of us at some time in our lives, and many of us for all of our lives, feel bad about our bodies. Common quick questionnaires of celebrities include a question concerning which aspect of their appearance they most dislike. It is almost none who respond that they are quite happy with their body. Even the most idolized feel there is something wrong. At its most severe these feelings trigger mental health crises of anxiety and depression and low self-esteem. They can trigger eating disorders and self- harm. They cause a great deal of unhappiness. Here is an everyday example from Margaret Atwood:

> After school I walked home across the football field ... I carried my big leather binder full of notes in front of me, hugging it to my chest with both arms, my textbooks piled on top of it. All the girls did this. It prevented anyone from staring at our breasts, which were either too small and contemptuous, or else too big and hilarious.
>
> (Atwood, 2006, 59–60)

The widespread circulation of images on social media, and the capacity to photoshop images, has the consequence that an increasingly restricted set of norms limit the range of those bodies which can evoke responses of pleasure and appreciation. Bodies outside

of this range often invoke feelings of revulsion or disgust. It is unsurprising, in this context, that teenagers doctor their own photos and then feel inadequate because their bodies fail to live up to them.

There is also often negativity about racialized bodies in terms of colour (colourism) and facial features. Famously in Toni Morrison's *The Bluest Eye* (Morrison, 2022, 1970) a little Black girl yearns for the blue eyes of a little white girl. Such norms of whiteness, while still in play, are now accompanied by aesthetic norms of Blackness in which shades of colour are a key aesthetic feature. Bodies which are perceived as disabled, elderly, or vulnerable are also excluded from the norms. There is a horror of aging bodies and bodies perceived as fat. Faces are particularly crucial. Heather Talley in her recent book *Saving Face* (Talley, 2014) points out that 'living itself may be compromised by a face that looms too close to the devalued end of the appearance spectrum' (6). 'Such faces are treated as social death rather than "a variation of human life"' (11). It is in this context that parents of children with Down's syndrome seek surgery to make their children's faces look more like the perceived norm. Websites advertising cosmetic surgery talk of 'correcting' various physical features.[1] As 'correcting' means making right, by implication the body that needs correcting is defined as a wrong body. The norms of bodily appearance are intersectional. Norms of femininity and masculinity, for example, are interwoven with racialized positions, culture, and age. But there are 'restrictive models of beauty that pressurise women in most cultures to mould and decorate their bodies in conformity with local norms' (Korsmeyer, 2013, xv). And there are many overlaps globally. Most current aesthetic norms privilege young, strong bodies looking healthy and not vulnerable. Following the global range of social media an increasingly narrow range of body types predominate (for women, small straight noses, large firm breasts, flat stomachs, wrinkle free, lifted faces; for men, angular chins, straight noses, flat stomachs, defined 'pecs', and so on). And these ideals 'display values rooted in class, ethnic type, race, lineage' (Korsmeyer, 2013, xv).

We experience our own bodies in relation to these norms. Simone De Beauvoir famously characterized her reaction to her own aging body: 'I loathe my appearance now: the eyebrows slipping down towards the eyes, the bags underneath, the excessive fullness of the cheeks, and that air of sadness around the mouth that wrinkles always bring. When I look, I see my face as it was, attacked by the pox of time' (Beauvoir, 1965, 672). 'With horror I see the copper coloured blotches of old age appear upon my hands' (Beauvoir, 1972, 299). And Audre Lorde heartbreakingly recounts a childhood memory, which shows how feelings of horror towards our own body can be generated:

> The AA subway train to Harlem. I clutch my mother's sleeve, her arms full of shopping bags, Christmas heavy. The wet smell of winter clothes, the trains lurching. My mother spots an almost seat, pushes my little snow-suited body down. On one side of me a man reading a paper. On the other, a woman in a fur hat staring at me. Her mouth twitches as she stares and then her gaze drops down, pulling mine with it. Her leather gloved hand plucks at the line where my blue snow-pants and her sleek fur coat meet. She jerks her coat closer to her. I look. I do not see whatever

terrible thing she is seeing on the seat between us—probably a roach. But she has communicated her horror to me. It must be something very bad from the way she is looking, so I pull my snowsuit away from it too. When I look up the woman is still staring at me, her nose holes and eyes huge. And suddenly I realise that there is nothing crawling up the seat between us; it is me she doesn't want her coat to touch.

(Lorde, 1984, 147–148)

Here her comforting sense of her body, pressed up against her mother with Christmas-heavy bags, becomes transformed by the horror she invokes in the woman next to her. The example here is focused on the aesthetics of the Black body in a culture segregated by colour. But for others with bodily features which fail to match the norm, their own dislike of their body is generated by encounters with a parallel structure. (Those perceived as fat for example, when traveling on public transport.)

DISCIPLINARY PRACTICES AND OBJECTIFICATION

Norms of bodily appearance are ones which we are initiated into as part of our cultural training. In the introduction to her book *Beauty Matters* (Brand, 2000), Peg Zeglin Brand discusses an image from Carrie Mae Weems' wonderful *Kitchen Table* series (Weems, 1990). In Figure 35.1, a woman sits at a table applying lipstick, in front of a mirror. A child sits near her, also with a mirror, applying lipstick, copying the woman. Brand comments: 'it is not only an instance of beauty, it is also about beauty ... Time stands still for the brief and trivial act of applying lipstick ... they imagine future judgments of their looks by others ... [the empty chair invites us in] ... There is concentrated effort here: studied imitation ... bridging a generation gap between an adult's notion of "beauty" and a child ... an induction into the secrets and codes of beautification' (Brand, 2000, 2).

The actor Jennifer Aniston (whose body has been the object of constant scrutiny for thirty years) wrote: 'Sometimes cultural standards just need a different perspective so we can see them for what they really are—a collective acceptance ... a subconscious agreement. We are in charge of our agreement. Little girls everywhere are absorbing our agreement, passive or otherwise. And it begins early. The message that girls are not pretty unless they're incredibly thin, that they're not worthy of our attention unless they look like a supermodel or an actress on the cover of a magazine is something we're all willingly buying into. This conditioning is something girls then carry into womanhood' (Aniston, 2016).

The process Aniston is highlighting here was theorized by Simone de Beauvoir in her ground-breaking text, *The Second Sex* (1949/2010), where she argues girls are brought up to experience their bodies as objects to be disciplined into compliance with a predominantly visual norm: 'the little girl pampers her doll and dresses her as she dreams

FIGURE 35.1 Mary Duffy as the Venus de Milo.

Used with permission from Sharon Snyder & David Mitchell. (1995). Vital signs: Crip culture talks back. Courtesy Icarus Films. Published by MW Editions.

of being dressed […] she thinks of herself as a marvellous doll […] … […] she is taught that to please … she must make herself object […] she is treated like a living doll' (304–305). Beauvoir articulates this process in terms of *objectification*, a concept which has been widely used since. We are attempting to produce our body as a particular kind of object, one that conforms to some desired prototype. We are aware of our bodies in terms of how they appear in a mirror or under the gaze of another, aware of ourselves

as if in a picture. This, Beauvoir claims, produces a relation of alienation to our bodily selves. We treat our bodies like objects, reorganizing their features in the same way in which we might arrange a room, and treating their relation to ourselves as no different from the way the room or table is related to the self. The body becomes 'a thing outside my subjectivity' (Sartre, 1943/1969, 353), a source of constant uneasiness. This alienated relation to the body is contrasted by Beauvoir and other phenomenologists with a more authentic relation to it, in which our focus is the body that senses, perceives, and acts; the body as that by which we engage in the world. Maurice Merleau-Ponty (2012) gives a detailed account of such bodily intentionality, in which the body as an '*I can*' is the primordial mode of experiencing our body's existence (Part I, III). For Beauvoir this more authentic relation to the body was one which was made available to boys, but which girls had to struggle to achieve: 'the great advantage for the boy [is his] free movement towards the world... climbing trees, fighting with his companions... he grasps his body as a way of dominating nature and as a fighting tool' (2010, 305). (Since she wrote girls have become more active and boys are also experiencing objectification.) To counter the damaging effects of bodily objectification, for Beauvoir, we must therefore promote a sense of the body as capable and active, an agent in the world, not an object for scrutiny.

Bodily Imaginaries

This analysis of a damaging objectifying relation to the body, which produces alienation from our bodily selves, is an important one. So is the strategy of promoting awareness of our bodies in terms of what they can do, can sense, can feel, rather than what they look like. But it is not the whole story. The body is that by which we engage in social interactions with others. We perceive the feelings and moods of others and the possibilities for interaction with them, immediately, from bodily features. The bodies of ourselves, and those of others, are experienced, not just as objects to be aesthetically improved in accordance with some cultural norm, but also as *expressive*. Expressive bodies tell us how things are with a person, whether they are anxious or exuberant, relaxed or watchful, whether they want company or want to be left alone. But they also tell us about the positions of those bodies in a wider social sphere. Certain physiological features are experienced directly as carrying significance, social possibilities, in the way that a smile carries joy. As some of us have put it, our relations with others are mediated by bodily imaginaries, which inform the ways in which we immediately experience particular bodily shapes (Gatens, 1996; Lennon, 2004, 2006, 2015). Certain physiologies carry an imaginary of desirability. Other bits of anatomy are invested with an imaginary of youthful energy and charm. And some (the drooping of the corners of the mouth, for example) carry sadness and decline. It is because we experience bodies in terms of dominant imaginaries, because physiology carries with it an immediate salience, positioning us within certain patterns of social encounter, that people wish to modify such physiology, when they wish to engage in different social practices in relation to others. People think of perfecting their bodies as a way of improving *themselves*, and

making *themselves* happier. Bodily makeovers are presented, sought, and, sometimes, experienced, as transformations of *self*, as a consequence of offering possibilities for enhanced social relations; either personal relations or relations in a wider sphere of work and public life. When we want to reshape our bodies (Alsop & Lennon, 2018), we want bodies that carry a different imaginary than the ones we have, express a different kind of positionality, evoke a responsive recognition from others that facilitates a different set of inter-subjective relations. What is wanted is a body able to produce particular affective responses in others, and therefore a body in social space; a modification of the embodied self's lived relations with others.

In the way I am using the term imaginary here it refers to the shape we experience our own bodies and those of others as having, a shape which has an affective texture. The imaginary is the significance and salience which bodily form has for us. Our modes of experiencing our bodies and those of others is not as a mere materiality. Rather it invests particular contours with affective significance. Bodies as experienced make us feel a certain way. They suggest possibilities of response. Such salience is a result of social and cultural mediation. In the terms of Moira Gatens the imaginary body is 'the social and personal significance of the body as lived' (1996, 11). It is such bodily imaginaries which yield our integrated awareness of the bodies of ourselves and others, which inform and enable our expressive and intentional interactions. The imaginaries in terms of which we experience bodies are myriad, they vary across contexts, times, and places. All imaginaries are intersectional. They yield the shape and significant features which our bodies are experienced as having.

The imaginaries in terms of which we experience bodies are part of our immediate perceptual experience. We perceive certain bodily shapes directly as requiring/suggesting responses of our own or others. The phenomenology here is crucial. There is no two-stage process by which we detect a materiality and infer to a salience or social significance, or go through a process of interpretation to assign such significance. Rather the significance is part of our immediate experience of the bodies of others and ourselves. This significance gives shape to our corporeality. Linda Alcoff discusses 'visible identities' (Alcoff, 2006), those in which the position of bodies within sets of social practices becomes immediately evident. This is (often) true of sexed identities, 'raced' identities, which are anchored in material bodily features, identity categories surrounding many disabilities, and, as Beauvoir has made clear, the identity category of old age. Discussing racialized identities Alcoff points out 'the processes by which racial identities are produced work through the shapes and shades of human morphology, the size and shape of the nose, the breadth of the cheekbones, the texture of the hair, and the intensity of the pigment' (Alcoff, 1999, 23; see also Gilman, 1992). These fix how we respond to bodies, what characteristics we attribute to them, where we feel they fit in society. Alcoff makes clear how such perceptual identities work phenomenologically, by means of an example from Richard Rodriguez's book *Days of Obligation*:

> I used to stare at the Indian in the mirror. The wide nostrils. The thick lips. Such a long face—such a long nose—sculpted by indifferent, blunt thumbs, and of such

common clay. No one in my family had a face as dark or as Indian as mine. My face could not portray the ambition I brought to it.

(Alcoff, 2006, 191)

Ambition is something imagined in a body of a different kind. Consequently the face he looks at points to a positioning at odds with what he desires. The horror which Beauvoir describes on encountering her old face in the mirror is a horror at the imaginaries in terms of which such a face is experienced. And for a trans man the body he finds himself with, one assigned female at birth, is perceptually experienced as signalling a social positionality, to himself and others, which conflicts with the one he feels able to occupy.

It is important to remind ourselves of the multiplicity of bodily imaginaries and of the way these are dependent on background and context. But the body's imaginary form conditions our perception of it. And it is the immediacy of such imaginary-laden perception which makes imaginaries difficult to dislodge. We have perceptual sensitivity to embodied imaginaries. This is a sensitivity into which we are initiated by cultural training (think of the example from Audre Lorde above). Such patterns of sedimented and habitual perception commonly operate below the level of belief and are difficult to dislodge by explicit reflection. Our habits of perception, together with other embodied practices, are interwoven with the workings of power, a power that can be at its most insidious when conditioning the way we experience our own bodies. This basic problem remains, even while we recognize that there is no single imaginary that bodily contours yield, but a raft of intersecting, contrasting, and sometimes conflicting ones.

DAMAGING IMAGINARIES

Damaging bodily imaginaries are ubiquitous. Slim bodies with certain kinds of facial features are desirable. Others are ugly or repulsive. Some bodies signal power and strength, others lack of capacity, weakness, and dependency. Some speak entitlement and worth, others impoverishment and powerlessness. Some are the epitome of humanity, in others humanity is barely recognized. In the monumental paintings of Jenny Saville (1992, 1999), we gain a powerful insight into the body dysmorphia experienced by bodies whose fleshiness has been imagined as 'too much' by a judgemental society. As Diana Meyers describes these extraordinary paintings, 'unprepossessing nude giantesses are stationed on little stools … Small heads recede above these avalanches of flesh'. The expressions are of 'unbearable anguish and shame. Not one of these figures caresses herself. Not one takes any delight in her body' (2013, 145). Nonetheless she confronts us with a thinking and feeling human being.

In *Black Skins, White Masks*, Fanon describes the imaginaries attached to his body when he arrived in France. 'I [am] battered down by tom-toms, cannibalism, intellectual deficiency fetishism, racial defects, slave ships and above all sho' good eating' (Fanon, 1968, 112). Some of these still haunt us today. And in contemporary times Paul Taylor points out 'Black people *look* dangerous, or unreliable, or like bad credit risks' (2016, 22). That is why they are

stopped and searched, shot at, refused jobs. Imaginaries of 'terrorist' inform many European responses to middle eastern bodies or imaginaries of 'subjugation' when confronted with a veil or hijab. Rosemarie Garland Thomson discusses the 'cultural figures that haunt' the social imaginary attaching to the disabled body (1997a, 288) in which the disabled body is reflected back as 'grotesque spectacle' (285). Mairs admits experiencing shame of her body: 'It is a crippled body. Thus it is doubly other, not merely by the ... standards of patriarchal culture but by the standards of physical desirability erected for everybody in our world' (1997, 299, 301). Bodies imagined as fat carry accompanying imaginaries of laziness, unattractiveness, lack of discipline. Old bodies speak neediness, vulnerability, lack of vigour.

Such problematic imaginaries cannot be changed simply by our drawing attention to them. For the way we feel about our own bodies and those of others is deeply ingrained. What is needed is that we learn to *feel* differently about bodily morphologies. But how is this to be done? Alcoff remarks that 'perceptual practices are dynamic even when congealed into habit' (2006, 276). Change is possible even though difficult. Given the damaging nature of many of our interwoven personal and social imaginaries it is important to consider how bodies can be experienced in different ways, so that we can return to that snow-suited child the sense of her bodily self comfortably integrated with her mother's Christmas-heavy form. Any such re-imagining will involve altering the perceptual sensitivity which we have to our own bodies and the bodies of others, a modification which goes hand in hand with change in the sets of inter-subjective interactions which it is possible for us to engage in. We have to learn to perceive different patterns of significance in the bodies we encounter and in our own.[2] A change in ways of experiencing bodily morphology is needed to challenge damaging imaginaries of age, sex, (dis)ability, or culture. For these determine how we feel and respond to our own bodies and those of others, and are the source of much distress, some of which leads to serious illness. We need a more indeterminate relation between anatomy and expressive force, so that sexual attractiveness, charm, authority, effectiveness, warmth, and energy (and indeed femininity and masculinity) can be experienced across many different kinds of bodies.

Artistic Interventions

Imaginaries are the domain of artists and the artists within ourselves. Creative thinkers of all kinds, visual artists, writers and musicians, all deal in images. But also journalists, television producers, and teachers. We are all dealing with imaginaries, offering them as ways of understanding the world. Those images are offered to frame how we think and feel about the materialities with which we are presented. All our perceptions and all those things which are offered as knowledge are mediated through imaginaries (Lennon, 2015). We need to cultivate sensitivities to what we are offering and creativity in its transformation. Creative responses to the aesthetics of embodiment engage and transform our responses to bodies of all kinds. We need to change our perception of the expressive possibilities of bodies, change the imaginaries we associate with them,

destabilize currently circulating meanings. In the words of Anita Silvers we have 'to explore [an] aesthetic process that offsets the devalued social positioning of real people whose physiognomic or other ... features are anomalous ... to enlarge our aesthetic responsiveness to real people' (Silvers, 2000, 200). An important aspect of this creativity surrounds an ability to detect beauty in different kinds of embodiment. Artists have been central in reinforcing dominant bodily norms, but, as Siebers points out, art can also use its expressive resources to yield a different imaginary, tutoring 'new affective responses' (Siebers, 2010, 40). Or as Anita Silvers puts it 'Art shapes and therefore can reshape which appearances seem familiar and commonplace, as well as which strike us as strange and disturbing' (2000, 214). Peg Brand reminds us that: 'A revolution took place, ... in the period after World War II, beginning in the 1960s, with women artists creating innovative works that expressed feminist challenges to traditional, mainstream depictions of the female body. Such artworks also served to subvert narrow interpretive strategies of outdated aesthetic theories. Under-represented minorities within the artworld—women, Blacks, Latinos, Asians, artists with disabilities, queer artists—began to portray themselves in unique and creative ways that conveyed independence, power, and dignity. Familiar norms of beauty were upended' (Brand, 2017).

Here is an example in which the imaginary investments a painter presents us with are shifted as the poet imagines the experience of the sitter:

A Nude by Edward Hopper

> The light
> drains me of what I might be, a man's dream
> of heat and softness:
> or a painter's
> -breasts of cosy pigeons
> arms gently curved
> by a temperate noon
> I am
> blue veins, a scar,
> a patch of lavender cells,
> used thighs and shoulders;
> my calves
> are as scant as my cheeks,
> my hips won't plump
> small, shimmering pillows;
> but this body
> is home,
> my childhood
> is buried here, my sleep
> rises and sets inside,
> desire
> crested and wore itself thin
> between these bones

(Mueller, 1983)

For examples from visual art we can return to Saville. Meyers points out the complexity in her paintings. They do not just signal the suffering involved in experiencing our own bodies as grotesque. In an extraordinary way they also 'redeem overlooked beauty in the figures … Saville discovers beauty in individual persons whose bodies are marked by life, as opposed to the formulaic beauty of idealised nudes' (2013, 149).

Rosmarie Garland Thomson draws our attention to disabled characters[3] in the writings of Toni Morrison and Audre Lorde. In these writings 'disability neither diminishes or corrupts … but affirms the self … and augments power and dignity' (Thomson 1997a,b). Paralympic sport, particularly the high profile Paralympic Games, significantly changed the imaginaries surrounding bodies previously imagined as simply *not able*. But such changes also require theatre and film in which bodies marked as disabled are engaged in regular lives, relationships, and families. Transformations of our imaginary of differently shaped bodies into something beautiful explicitly informs the work of the sculptor Marc Quinn. In the series the *Complete Marbles*, he echoes the tradition of fragmentary classical sculpture, by sculpting people in a way that, as Siebers points out, establishes 'a powerful resonance between artworks long considered beautiful … and people … excluded from the category of aesthetic beauty' (Siebers, 2010, 41). This was manifest most famously in his statue of a pregnant Alison Lapper which occupied the fourth plinth in Trafalgar Square.[4]

The presence of bodies of all shapes, sizes, and colours in fashion shows, magazines, and social media sites, shift our perceptions concerning which bodies can be imagined as sexy, glamorous, and desirable, and thereby changes how we feel about bodies of others and ourselves. Changing imaginaries therefore needs specific interventions in the public realm. We need, for example, to see the way an aging body can be shaped for possibilities of interaction with the world and others, and not simply as expressive of decline and dependence. The videos of Matisse, in his wheelchair, revolutionizing art with his cut outs, are an example here (Tate Modern, 2014). Changing the imaginary impact of bodily forms can happen as a result of high profile role models, but also as a result of changes in everyday practices. Encountering women in the boardroom, Black professors in philosophy seminars, differently-abled bodies in sexual relations, and every kind of body in social relationships, shifts our perceptual responses, and the potential such bodies express for us. All of this work takes place in intersectional spaces in which the impact and consequences of the images present are complex and indeterminate. Shirley Tate's work on Black beauty (2009) shows the indeterminacy, dynamism, and fluidity of meaning, which can be attached to beauty practices. The young women she interviewed were creating specifically *Black* identities, while using techniques (hair dye, hair straightening, etc.), which had previously been taken to reflect the dominance of White beauty ideals. In her analysis these practices resist both White ideals and those Black ideals which insist on certain norms of appearance to express Black political solidarity, changing what kinds of bodies can manifest Black identity and transforming the beauty norms with which they were playing.[5]

The consequences of interventions are often unpredictable. We might have hoped that having Obama as US President would change the way a Black male face was experienced. However, in the light of many recent shootings of Black men in the US,

such a face, particularly if borne by a young man, still expresses criminality, particularly to a White policeman.[6] If we had a Native American US President we might come to view such a face as authoritative and we would hope this would change things for Rodriguez and his desire that his face could capture his ambition (Alcoff, 2006, 191). But many other artistic interventions are required alongside to achieve this result.

RE-IMAGINING OURSELVES

The task of reimagining, as the previous sections have made clear, requires intervention in the public domain, to shift the socially instituted imaginaries which are damaging our relationships to our own bodies and those of others. But the creative task is also one which we can engage in for ourselves. Gloria Anzaldua suggests: 'temporally suspend your usual frame of reference … while your creative self seeks a solution … by being receptive to new patterns of association … urge yourself to cooperate with your body instead of sabotaging its self-healing' (2015, 133). And, inspired by Anzaldua, Mariana Ortega (Symposium 2021), has been developing the conception of *Autoarte*, a creative process, a 'self-constituting and transforming practice … for self-making … being otherwise', resisting and destabilizing the dominant and damaging imaginaries into which we have been initiated, to enable us to feel differently about the bodies we find ourselves with, disrupting the 'I cannot see myself otherwise.'

It would be naive to think that such a reimagining of the self is something which we can simply do at will. Our responses to our own bodies are culturally learnt and sedimented into our everyday ways of being in the world. Particular strategies are required to unsettle them. In Paul Taylor's terms our circumstances must 'create the conditions for self-interrogation and counter-habituation' (2020, 121). But around us we can see examples of such re-imaginings, which 'allow us to breath' with the bodies we have. bell hooks counters the negative images of the Black male body by finding that the skin of the man lying next to her is 'soot black like my granddaddy's skin'. This is skin which can evoke 'a world where we had a history … a world where … something wonderful might be a ripe tomato, found as we walked through the rows of daddy Jerry's garden' (hooks, 1990, 33). This attention to the historical roots of Black Americans in a Southern rural world, is not an act of 'passive nostalgia, but a recognition that there were habits of being, which we can re-enact' to provide ways of re-imagining Blackness in livable ways (1990, 35). Nancy Mairs re-imagines her previously shameful body with her claim 'as a cripple I swagger' (Mairs, 1986, 90). Cheryl Marie Wade 'insists on a harmony between her disability and her womanly sexuality in a poem characterizing herself as 'The Woman with Juice' (Garland Thomson, 1997a, 285). And, wonderfully, Mary Duffy reimagines herself as the Venus de Milo (Snyder & Mitchell, 1995).

Such acts of reimagining can happen on a smaller scale. The blotches on the skin which are signs of aging were a source of horror to both Beauvoir and my own father, because of the imaginaries they carry. My father would attempt to cover them with

plasters. Now I have those spots and I regard them affectionately, my own body echoing that of his and evoking his presence sitting in his chair and gazing at his hands. In one of Jenny Saville's pictures we see the lip of flesh and underlying scar which is caused by a caesarean section (Saville, 1999). The painting has the ambiguity which marks her work. It both reflects the shame we feel for our imperfect bodies and opens the possibility for experiencing them differently. The scar also features as a badge of honour, a trace of the sitter's life experiences, which gives it and the little sack above it, an aura of pregnancy and life produced. I have such a scar and a fold of flesh above, which I can now regard with a certain pride and tenderness.

Conclusion

In this chapter I have highlighted the centrality of the concept of the imaginary to articulating the way we feel about our own bodies and the bodies of others. There are dominant imaginaries within and across cultures concerning which bodily features are a source of pride and which a source of shame. We are initiated into these patterns of seeing and feeling in being initiated into culture. They mediate our relationship to our own bodies in ways that can lead to a damaging shame and trigger crises in our self-image, self-esteem, and mental health. It is urgent that these damaging imaginaries are destabilized. But this is not an easy job. They structure our perception and our responses, but normally operate below the level of reflective consciousness. Destabilization requires the creative tasks of reimagining bodies in more liveable ways, to shift our aesthetic gaze to enable joyful responses to a much more diverse range of bodily features. This is a task for all of us, but particularly for creative artists: writers of all kinds, visual artists, film makers, choreographers, musicians, advertisers. We need to find images which in the words of Ortega 'allow us to breathe' (2021).

Notes

1. Retrieved from www.harleymedical.co.uk/cosmetic-surgery-for-men/the-face/chin-implants
2. Living with someone whose facial muscles have suffered paralysis, we may at first be unable to detect emotion in this face; or may respond to it as though it is expressing some untold terror. Living closely alongside such a face, however, we come to grasp what range of movement there is, as expressive of pain or joy. Here is it not that we experience the very facial features initially experienced as expressing terror, and re-inscribe them. The way the face is experienced by us comes to carry a different imaginary, one in which the flicker of the eyelashes or the movement of one side of the mouth become expressive.
3. I was led to this discussion in Garland Thomson by Anita Silvers.
4. http://marcquinn.com/artworks/single/alison-lapper-pregnant
5. See also the *Feminist Theory* (August 2013 14(2)) Special Issue 'Beauty, race and feminist theory in Latin America and the Caribbean' for discussions of the intersections of race and

beauty in Latin America and the Caribbean, introduced by Monica G. Moreno Figueroa and Megan Rivers-Moore (2013).
6. Including the high profile cases of Travyon Martin (2012); Michael Brown (2014); George Floyd (2020) and many, many others.

REFERENCES

Alcoff, L. (1999). Towards a phenomenology of racial embodiment. *Radical Philosophy 095* (May/June), 1–12.

Alcoff, L. (2006). *Visible identities: Race, gender and the self.* Oxford University Press.

Alsop, R., & Lennon, K. (2018). Aesthetic surgery and the expressive body. *Feminist Theory* 19(1), 2018. https://journals.sagepub.com/doi/abs/10.1177/1464700117734736#:~:text=In%20much%20feminist%20work%20on,to%20conform%20to%20social%20norms.

Aniston, J. (2016). For the record. *Huffington Post*, July. Available at: www.huffpost.com/entry/for-the-record_b_57855586e4b03fc3ee4e626f

Anzaldua, G. (2015). *Light in the dark/Luz en lo oscuro: Rewriting identity, spirituality, reality.* Duke University Press.

Atwood, M. (2006). My last duchess. In *Moral disorder and other stories* (pp. 59–60). Doubleday, New York.

Beauvoir, S. d. (1965). *The force of circumstances.* Translated by R. Howard. Penguin.

Beauvoir, S. d. (1972). *Old age.* Translated by Patrick O'Brian. Andre Deutsch.

Beauvoir, S. d. (2010). *The second sex.* Translated by C. Borde and S. Malovany-Chevallier. Vintage. (Original work published 1949.)

Brand, P. Z. (2000). *Beauty matters.* Indiana University Press.

Brand Weiser, P. Z. (2017). How beauty matters. In L. B. Brown & D. Goldblatt (Ed.), *Aesthetics: A reader in philosophy of the arts.* Routledge.

Duffy, M. (1995). Video-still taken from Sharon Snyder and David Mitchell, *Vital signs: Crip culture talks back*; Venus de Milo, circa 100 B.C.E. The Louvre, Paris; Broken Beauty: Disability and Vandalism.

Fanon, F. (1968). *Black skins white masks.* MacGibbon and Kee.

Figueroa, M. G. M., & Rivers-Moore, M. (2013). Introduction, Special Issue 'Beauty, race and feminist theory in Latin America and the Caribbean'. *Feminist Theory* 14(2), 131–136.

Garland Thomson, R. (1997a). *Extraordinary bodies: Figuring physical disability in American culture and literature.* Columbia University Press.

Garland Thomson, R. (1997b). Disabled women as powerful women in Petry, Morrison and Lorde: *Revisiting Black female subjectivity.* In David T. Mitchell & Sharon L. Synder (Eds.), *The body and physical difference: Discourses of disability.* University of Michigan Press.

Gatens, M. (1996). *Imaginary bodies.* Routledge.

Gilman, S. (1992). *The Jew's body.* Routledge.

hooks, bell. (1990). *Yearning: Race, gender, and cultural politics.* South End Press.

Korsmeyer, C. (2013). Foreword. In Peg Zeglin Brand (Ed.), *Beauty unlimited.* Indiana University Press.

Lennon, K. (2004). Imaginary bodies and worlds. *Inquiry* 47(2), 107–122.

Lennon, K. (2006). Making life livable. Transsexuality and bodily transformation. *Radical Philosophy* 140, 1–9.

Lennon, K. (2015). *Imagination and the imaginary.* Routledge.

Lorde, A. (1984). *Sister outsider*. The Crossing Press.

Mairs, N. (1986). *Plain text*. University of Arizona Press.

Mairs, N. (1997). Carnal acts. In K. Conboy, N. Medina, & S. Stanbury (Eds.), *Writing on the body: Female embodiment and feminist theory* (pp. 293–309). Columbia University Press.

Merleau-Ponty, M. (2012). *Phenomenology of perception*. Translated by Donald A. Landes. Routledge. (Original work published 1945)

Meyers, D. T. (2013). Jenny Saville remakes the female nude. In P. Z. Brand (Ed.), *Beauty unlimited*. Indiana University Press.

Morrison, T. (2022). *The bluest eye*. Vintage Classics. (Original work published 1970)

Mueller, L. (1983). In the pink. In *The Raving Beauties*. Bloodaxe Books.

Ortega, M. Auto arte. Phenomenology & Ethics—Online Symposium. British Phenomenology Society Symposium, 12 April, 2021.

Quinn, M. *The complete marbles*. http://marcquinn.com/artworks/the-complete-marbles

Sartre, J. P. (1969). *Being and nothingness*. Translated by H. Barnes. Routledge. (Original work published 1943)

Saville, J. (1992). *Prop*. Gagosian Gallery, New York.

Saville, J. (1999). *Hem*. Gagosian Gallery, New York.

Siebers, T. (2010). *Disability aesthetics*. University of Michigan Press.

Silvers, A. (2000). From the crooked timber of humanity, beautiful things can be made. In Brand (Ed.), *Beauty matters*. Indiana University Press.

Talley, H. L. (2014). *Saving face*. New York University Press.

Tate. (2014). *Henri Matisse: The cut-outs*. Exhibition April to September 2014.

Tate, S. (2009). *Black beauty: Aesthetics, stylization, politics*. Ashgate.

Taylor, P. (2016). *Black is beautiful: A philosophy of Black aesthetics*. Wiley-Blackwell.

Taylor, P. (2020). Black reconstruction in aesthetics. *Debates in Aesthetics 15*(2), British Society of Aesthetics. https://debatesinaesthetics.org/vol-15-no-2/#taylortarget

Weems, C. M. (2022, 1990). Untitled. From the *Kitchen Table Series*, Silver Print.

CHAPTER 36

ART AND TRAUMA
An Aesthetic Journey

TANIA L. ABRAMSON AND PAUL R. ABRAMSON

We knew what we wanted to say but couldn't quite figure out how to say it. It wasn't like we were trying to make sense of scattered puzzle pieces. Quite the opposite, in fact. We were at the threshold, or so we thought, of putting it all together, relying as it were on lifetime commitments to the psychological study of trauma, personal insights wrested out of the anguish associated with our own childhoods, and decades of devoted artistic practice. Yet, try as we might, the critical linkage between 'Art and Trauma' still remained elusive. What were we overlooking; an axiom hiding in plain sight?

Then it came to us without warning. It was in January of 2016, and we were in Germany. The weather was murky, snow was in the offing, but rarely materialized—scattered flurries at best—and the temperatures were hovering in the mid-thirties Fahrenheit. Quite nippy for Californians, but by no means dismal. Starkly beautiful came to mind instead, which undoubtedly also fed into our unfolding revelation, occurring as it did in the most unlikely of places. Though, in retrospect, how could it have been otherwise? Curated sites of appalling torment, The *Dachau Concentration Camp Memorial* site outside of Munich, and the *Memorial to the Murdered Jews of Europe* in Berlin.

OUR MANTRA: THE NARRATIVE MATTERS

What are we looking at, we asked ourselves? A grid of over twenty-seven-hundred grey rectangular concrete stelae arranged in rectilinear patterns on four-plus acres of undulating fields (Figure 36.1). The title, of course, leaves no room for doubt, a *Memorial to the Murdered Jews of Europe*, but that notwithstanding, why was this configuration so compelling? What was it about this memorial that made it capable of transforming a wretchedly catastrophic epoch—the murdering of approximately six million Jews

FIGURE 36.1 Field of Stelae, Memorial to the Murdered Jews of Europe, Berlin, Germany.

Photo Credit: Tania L. Abramson

during World War II—into a riveting site of devastating illumination and singular enlightenment?

Despite avowing its tacit power to strengthen insight, empathy, and identification with the trials and tribulations of misery (Abramson & Abramson, 2019b; Dewey, 1934; Saito, 2010, 2017), it still begged the question of why it worked so successfully. What was giving this memorial such intrinsic force besides its location in Berlin and its manifest designation? The arrangement itself one could argue conveys a likeness, at least allegorically, to a graveyard, whereby the stelae, as proxies for grave markers, are now bearing witness to a vast tragedy. But if so, it still seemed as if there was something more. The coveted nexus, perhaps, between *Art and Trauma*.

Though the experience of moving through this evocative space—expressly devoted to murdered Jews in Europe—pretty much says it all, the *Information Centre*, built directly underneath the memorial itself, markedly enhanced this realization. It did so by presenting an abundance of archival data and artefacts, thereby decisively bringing the horrifying details to light. We then reduced that insight into a tentative maxim. Augmented comprehension can enhance aesthetic experience (Abramson & Abramson, 2019b).

Perhaps even more instrumental to our formulation of *Art and Trauma*, assuredly in terms of artistic visions, was a visit to the *Dachau Concentration Camp Memorial Site*. Though the commemoration in Berlin embodied manufactured stelae, the Dachau Memorial, in contrast, relied almost exclusively on imagination. It conceived of a way of reconceptualizing a defunct, yet no less notorious, concentration camp—gruesome artefacts included—into hallowed space for commemorating the victims of the Nazi Holocaust (Figure 36.2). And by doing so—accompanied by supporting archival documents—this site was now actively serving as a medium for grasping the unbridled depths of human depravity, while simultaneously providing a stark remedy against contemptuous denials of murderous iniquity. The strength of the inescapable narrative, combined with the reconstructed camp, formed the staggering vitality of this curated site, well beyond the circumscribed aesthetic underpinnings. It then became apparent to us that heightened comprehension, even in the absence of a compelling sculptural configuration, such as the above mentioned memorial in Berlin, could still nonetheless intensify how the viewer engages with an artistic vision, and by doing so, would inevitably transfigure the aesthetic experience more generally (Abramson & Abramson, 2019b; Saito, 2010).

FIGURE 36.2 Crematorium, Dachau Concentration Camp Memorial Site, Dachau, Germany.

Photo Credit: Paul R. Abramson.

Germany is not by any means the only country forever peering into its lamentable past. The indelible stains of slavery, and the massacre of Indigenous Americans, continue to shadow a country—the United States of America—that steadfastly adheres to the tenuous claim that it is the land of the free. The depth of that hackneyed artifice is readily apparent in the *National Memorial for Peace and Justice*, in Montgomery, Alabama. Unlike its counterpart in Berlin, the *National Memorial for Peace and Justice* prioritized the honouring of every Black person murdered by terror lynching. Inscribed on the 800-plus six-foot tall Corten steel pillars are the names of all acknowledged victims and the counties where the terror lynching occurred. Even the artistic composition of the columns themselves is hauntingly emblematic, most certainly when the pillars are looming over head (Figure 36.3).

Like the concentration camp memorial in Munich, *The National Memorial for Peace and Justice* is also a multifaceted exhibition that incorporates both artistic and curatorial visions that are further supplemented by data and archival artefacts. When we visited in November of 2019, we observed countless daunting reminders, imaginatively rendered, of this abhorrent storyline. There was, for example, a wall displaying hundreds of sizable glass jars of varicoloured soil excavated from known terror lynching sites. That soil was meant to represent not only the blood, sweat, and tears of every victim of terror

FIGURE 36.3 National Memorial for Peace and Justice, Montgomery, Alabama, United States.

Photo Credit: Tania L. Abramson

lynching, but equally importantly, to function as an emblem for restoration and reflection. Unlike the Victorian era equivalent—museums of anatomical curiosities displayed in rows of glass jars of formaldehyde—these jars of soil, by contrast, were primarily displayed for their moral and contemplative authority.

Even the grounds of the courtyard were dominated by riveting sculptures that depict the agony of the slave trade, as well as contemporary racism itself. Notably among them was the emotionally wrenching work by the gifted Ghanaian artist Kwame Akoto-Bamfo. The sheer aesthetic power of all of these collective artistic and curatorial visons—combined, of course, with the animating weight of the despicable narratives—elicited such profound and compassionate understanding that its effect, immediate no less than long-lasting, could not fail to help galvanize social and legislative action designed to better insure racial justice and equality, as well as perhaps, give more credence to the question of restitution for Black Americans (Abramson & Abramson, 2019b; Allen, 1998; Dewey, 1934; Saito, 2010).

The final clue to our *Art and Trauma* formulation came courtesy of the philosopher Nelson Goodman (1976). When looking at two paintings, ostensibly by Rembrandt, would there be an aesthetic difference, Goodman asked, in how these paintings are experienced if we knew that one of the two paintings was a forgery? Most certainly, he declared, noting that even this small bit of knowledge 'makes the consequent demands that modify and differentiate my present experience in looking at the two [Rembrandt] paintings' (p. 105; Goodman, 1976).

The more fundamental question to us however was *why*? It can't simply be the delivery of a sliver of information; if so, digital advertisements that annoyingly pop up on websites—which we then quickly delete—would still nevertheless be forever modifying how we were engaging with the content itself. It must be, instead, something more dynamic. Goodman's thought experiment was simply descriptive. He imagined observing a difference, and he was then describing the assumed result. Though we had no reason to doubt Goodman's prediction—since we had experienced it ourselves in how we engaged with the three aforementioned memorials—we still wanted a better understanding of *why*? What cognitive process was this tapping into?

Then it occurred to us that this modicum of knowledge was profoundly altering viewers' expectations. That idea, we realized, was the best explanation of our own experiences as well. Informed by the animating weight of narration, our expectations had an especially pronounced effect on how we were perceiving—that is, identifying, interpreting, and understanding—the artworks and memorials that we had been looking at, including the grievous implications of such. Our engagement with those artworks and memorials was now arguably different because the embedded documentation directly transformed our expectancies, which in turn, transfigured our aesthetic experience.

We then felt that we also needed to strengthen how we were describing Goodman's demonstration, something besides merely stating that a modicum of knowledge, like evidence of forgery, was changing how viewers engage with artworks. Though, indeed, Goodman relied on only a sprinkling of information—reducible to eight words, in fact,

one of the two paintings was a forgery— that short phrase was decisive because it was capable of profoundly altering viewers' expectancies about detecting evidence of forgery. Thus, we now believe that it was the change in expectancies—borne of enhanced awareness and comprehension—that drastically modified how viewers engaged with the two foregoing paintings by Rembrandt in Goodman's reflective proposal (Rosenthal & Jacobson, 1968).

Even more relevant to this line of thinking, assuredly where our conceptualization of *Art & Trauma* was concerned, are the recent studies on how expectancies operate as the mediator of placebo effects in antidepressant clinical trials (Rutherford et al., 2017). Simply knowing that you received an active antidepressant showed significantly more improvement in reducing depression than a comparable group of patients who received the exact same active antidepressant, but without knowing anything about what they had received. The importance of this finding, to us at least, was that the effect of the drug was dependent on one's expectations. It need not be, as Goodman predicted, simply a matter of modifying how one engages with something external, two artworks, in his hypothetical, but one's *internal* experience, and thus the full power of aesthetics, can be altered by expectancy as well. None of these effects, however, are necessarily mutually exclusive. In some cases, it may be knowledge alone that is modifying how viewers engage with artworks, while in other instances, transformed expectancies are now altering how viewers engage with artworks.

Engaging with Artistic Visions That Emerged in the Aftermath of Traumatic Experiences

Fusing these insights into an exploratory aesthetic model, we then shifted our attention to artists and their artworks. We began by gathering distinctive artistic visions that had emerged in the aftermath of traumatic experiences. Two lines of inquiry were then pursued. The first was to assess if brief informatory input would significantly transform how viewers engage with these works. And no less importantly, we also wanted to consider whether viewers obtained appreciable intuitions from such input. Would they, for instance, gain greater understanding of the nuances of torment? Its intractability, or its capacity to destabilize (Abramson, 2019b; Abramson & Abramson, 2019, 2019b, 2019c, 2019d, 2020a).

Here is a concrete example. Between the ages of four and seven, the first author was the victim of chronic sexual abuse by her father's close friend, Gene Hartman. Several years later, Hartman took his own life. Shortly after his death, the first author received a call from Hartman's wife Eleanor. *He's dead*, she said, *and it's all your fault*. The first author's troubled childhood became markedly more imperiled.

Has this brief narrative influenced how the reader now engages with the first author's 2017 sculpture *In Case of Shame* (Figure 36.4)? Is the reader, for instance, perceiving it differently? Did the reader gain more appreciation of the abiding nature of shame, along with its tenacity and destructive power? Or conversely, would the reader's perception of the sculpture be dissimilar without the narrative?

One of the best ways of understanding the language of *In Case of Shame* is through the lens of analogical thinking. This artwork takes a source—a locked red metal safety cabinet with a glass window that typically holds a fire extinguisher—and then translates it into a target—which, in this instance, is a custom-fabricated locked red metal safety cabinet now holding a sledgehammer, wittingly repurposed for the abatement of shame. Markedly pronounced side effects are noted, and the cracked glass speaks for itself.

What's most striking about this piece is that viewers effortlessly grasp its meaning. A literal step-by-step explanation is unnecessary because this analogy works seamlessly. The cautionary label, 'use may have unintended consequences,' also fortifies the sledgehammer's association with the destructive power of this debilitating emotional state (Abramson, 2019b; Abramson & Abramson, 2020a).

FIGURE 36.4 *In Case of Shame,* 2017, Tania Love Abramson. Courtesy of the artist.

Here is yet another example of the power of expository input—Luzene Hill's 2012 installation, *Retracing the Trace* (Figure 36.5). Does knowing that Ms. Hill was the victim of rape alter the readers' engagement with, or expectancies about, this artwork? Does knowing that Ms. Hill is an enrolled citizen of the Eastern Band of Cherokee Indians also modify the readers' perception of this work? What about learning that the incidence of violence against Native American women is almost three times greater than the United States national average—and ninety per cent of the assailants are non-Native men?

The ultimate power of Hill's artwork is clearly in its narrative chronology. *Retracing the Trace* re-enacts Ms. Hill's own experience as a victim of violent sexual assault. She lays down on a gallery floor where blood-red, Khipu-style knotted cords are scattered around her body. The Khipu cords themselves are meant to symbolize an endangered indigenous language, which in turn, is also meant to represent the oppressive silencing of the victims of rape. The quelling of Native American voices and cultures more generally is symbolized by the Khipu cords as well.

When Ms. Hill eventually arises off the floor, she leaves an imprint comparable to the impression that her body made in the mud after she had been brutally raped, and nearly strangled using the cords of her jacket, while jogging in a park early one morning. Viewer awareness of this accompanying storyline most assuredly augments how Ms. Hill's installation is aesthetically experienced (Abramson & Abramson, 2020a).

Countless other artists would characterize this aesthetic linkage too; the confluence between engaging with their artworks, and the weight of additional commentary that

FIGURE 36.5 *Retracing the Trace*, 2012, Luzene Hill. Courtesy of the artist.

recounts their traumatic histories. Artists like Artemisia Gentileschi, Käthe Kollwitz, Ana Mendieta, Vannak Prum, Martin Ramirez, Charlotte Salomon, and David Wojnarowicz. The list is long, strikingly so, and unmistakably diverse. The latter discovery resulted in yet another development in the progression of our scholarship, whereby *feminism* also came to the foreground within our work.

It would be hard not to recognize the prevalence of so many female artists that had either experienced, or have allied with, relentless hardships in their lives—the first author included among them (Abramson, 2017a, 2017b, 2019a, 2019b). Child sexual abuse, erasure/invisibility, bodily autonomy, the denial of reproductive rights, slavery/racism, the experience of war from a female perspective, the death of child, and so much more—all continuously surface within the artworks of so many women—from Käthe Kollwitz to Nancy Spero to Kara Walker—to name just a few. When sexual violence is added to that mix, the representation of agonizing traumas to women becomes even more pronounced. Which, perhaps, isn't unexpected. Sexual assault is nearly five times more likely than any other severely traumatic event to precipitate Post-Traumatic Stress Disorder (Kessler et al., 2017). If the victims of sexual violence are largely women who have been targeted because of their gender—and if gender is an immutable personal characteristic that is fundamental to self-identity—we shouldn't be surprised to discover that female artists who have unchained their personal and collective memories of sexual assault place such recollections, either directly or allegorically, into their artworks. That recognition alone led us to then prioritize *feminism* as another organizing linchpin within *Art & Trauma*, principally as a framework for scrutinizing visual manifestations of anguish, persistence, and reckoning that are so abundantly evident in artworks by female artists (Abramson, 2019b).

Pedagogy and the Art of Engagement

At this point, we started thinking about creating an *Art & Trauma* course. Not that anyone was asking for such, quite the opposite, in fact. The surer bet was that there would be no interest in this course whatsoever, certainly in the way that we have conceptualized the subject matter, except perhaps among the artists and scholars who avidly follow our work. That cluster of individuals is a far cry, however, from the necessary quorum needed to influence departmental decision-making. Why, then, the reader might wonder, would we ever put the time and energy into creating a course without any encouragement for doing so, especially given the possibility that such a course might be considered unnecessarily circumscribed?

A reasonable question, no doubt, but from our vantage point, it still seemed a worthwhile pursuit. We had nothing to lose, and there were no hurdles to jump over. We simply created the *Art & Trauma* class that we wanted to teach. If we kept the bar high, there was a chance, or so we reasoned, that someone might eventually want it. A folie

à deux, perhaps; one might even call it arrogance. But either way, we were guardedly optimistic.

The surprise of it all, no less to us than anyone else, is that shortly after we had created our *Art & Trauma* course—with a comprehensive syllabus and a nearly-complete series of lectures—the Honours Collegium at UCLA approved it (Abramson & Abramson, 2019c). When that course turned out to be successful, we were then encouraged to create a sequel, which became the second course we teach, *Feminism, Art & Metaphors of Trauma*. Both classes have now become popular mainstays for the UCLA Honours Collegium.

Soon thereafter, the Feminist Studies Department at the University of California, Santa Barbara, approached the first author about developing yet another course that would also build upon our preferred methodology—scrutinizing visual representations of personal and political reckonings drawn from a sample of indisputable categories of anguish. *Keep Your Hands Off: Reproductive Justice, Mass Incarceration, and Ecofeminism*, was the result. These three courses, combined with the lectures and workshops that we deliver in the United States and Europe, now comprise our current scholarly and pedagogic outreach.

Besides gathering all the relevant materials to support our lectures and workshops—which proved to be a vast, and forever growing undertaking—we also spent a considerable amount of time crafting an operational game plan for maximizing the effectiveness of our instruction; a pedagogic to-do list, so to speak. The first thing we realized was that we wanted our classes to be participation-dominated seminars. Slide presentations of artworks were also integral to our formulation, as was the prospect of inviting artists, scattered throughout the globe, to join us remotely for talks. Required readings were then carefully selected to appeal to gifted undergraduates—vividly rendered graphic memoirs, for instance—and those materials were further strengthened by an extensive supplemental reading list. Our syllabi were nothing less than thorough.

But none of this amounts to a teaching strategy. Thus far, we've introduced the nuts and bolts for creating a course. Though obviously essential, what soon became even more important was the process by which, at least theoretically, we could enhance the actual *experience* of attending these lectures (Ellis-Hill et al., 2021; hooks, 1998). We settled on three basic principles: spontaneity, engagement, and autonomy; the acronym of SEA, for short. Our goal was to make the *experience* of participating in each lecture supersede the content itself. Because there were no sacred doctrines, or lionized practitioners, we felt that we had considerable flexibility when proceeding. The absence of calcified shibboleths helped, too.

Eventually, it boiled down to one characteristic. Insuring active student engagement. We felt that emphasizing spontaneity would be the best device for achieving that, particularly if we put a priority on autonomous student contributions. This precedence, we ultimately surmised, would best serve the goal that we wanted to achieve—productively teaching students about the power of aesthetics, using the *Art & Trauma* framework as a springboard for doing so (Abramson & Abramson, 2019c, 2019d).

We did not, however, limit ourselves solely to artists and their artworks. *Art & Trauma,* by its designation alone, is the aggregate of two disciplines, merged as a pair, the psychology of trauma, no less than artistic visions that have emerged in the aftermath of suffering. Though the process of building and teaching these courses provided us with an extraordinary opportunity for plunging deeply into the configurations of art and aesthetic theory, those efforts were always pursued concurrently with equal attention devoted to the psychological nuances and complexities of severe trauma. The latter being steadily compiled by the second author, who is a professor of psychology at UCLA. The aetiology and manifestation of abiding anguish are his areas of expertise. Two recent cases, both of which were presented in our classes, are paradigmatic of his work. The first involved a perpetrator (now deceased) who went on a two-decades long rampage of child sexual abuse that targeted over two hundred teenage Latino male victims. One survivor, as well as a long-term co-worker of the perpetrator, joined the second author for this presentation (Abramson & Bland-Abramson, 2021b). The subsequent case involved a lawsuit committed to obtaining restitution for a twenty-two-year-old Black male who had been wrongly convicted of murder, and then spent twenty years in maximum security prisons before his conviction was finally overturned (Abramson & Bland-Abramson, 2021a). That survivor, along with his two civil rights attorneys, also joined the second author for this discussion.

Bumping into Metaphors

While screening a slideshow of artworks in our *Art and Trauma* class, it slowly dawned on us that we'd been exhibiting a parade of metaphors. Which, in retrospect, wasn't surprising. The more we kept thinking about it, the more it seemed like something important had once again fallen into our laps. How, we asked, can an artist represent the ravages of child sexual abuse, or any other unspeakable act, without unreasonably terrifying or distressing the viewer? Though, of course, many artists have produced works that offer glaring affirmations of appalling brutality, Otto Dix among them, the pressing question to us, nonetheless, was whether such depictions, arresting in their severity, can fully engage viewers without simultaneously repelling them? If the latter is impossible, what's the alternative? The use of metaphor, we then realized, could solve the problem by allowing an artist to depict one thing, but to mean something else.

Take the line *strange fruit hanging from poplar trees*, which comes from a song titled *Strange Fruit,* originally composed by Abel Meeropol in 1937. *Strange Fruit* gained worldwide notoriety *only* after it was recorded by Billie Holiday. It was her performance of those lyrics, relying as they did on the power of metaphoric linkages, that transformed a line—ostensibly about a fruit-laden tree—into the grisly details of terror lynching of Black Americans.

Though effective analogies work seamlessly as both imaginative leaps and conceptual combinations, and as such contribute to creative thinking, there is yet another

benefit to metaphors, particularly where tragedy is concerned (Holyoak, 2019). The song *Strange Fruit*, once again, is a haunting paragon. Besides capturing a despicable offense, this metaphor also operates as a non-linear way of understanding the unfathomable horror of terror lynching itself. That added comprehension, contributing to the power of aesthetics, is assuredly emotional no less than cognitive. In many instances, in fact, it is a prerequisite for a deeper appreciation of the nuances of anguish, and the provocative power of psychological distress, especially when accompanied by data-driven narratives (Abramson & Abramson, 2019, 2020a, 2023). In the latter case, metaphor then becomes an extremely forceful way of expressing emotional adversity, without unduly offending its audience, thereby also serving as a didactic medium for facilitating compassionate understanding for victims who have been overwhelmed by torment. Awareness, once again, has the capacity to impact viewers acutely.

After many years of mining artworks to identify artists who fit squarely within our *Art & Trauma* framework—scrutinizing hundreds of viable candidates and vast amounts of archival materials while doing so—we now want to introduce yet another artist with a patently appalling traumatic history who has nonetheless used metaphor to reconfigure the traumas that he survived. This is the Cambodian artist Vannak Anan Prum.

Captured and enslaved for four years on a fishing vessel in the South China Seas, Vannak Prum's metaphor, (Figure 36.6), is an extremely evocative drawing that depicts

FIGURE 36.6 *Days Stretch Out* from the graphic memoir *The Deadeye and the Deep Blue Sea*, 2018, Vannak Anan Prum. Courtesy of the artist.

the desperation of enslavement, and the protracted nightmare of modern slavery, with an extraordinary message in a bottle. Though never minimizing the horror of his plight, this artwork nonetheless deftly draws viewers into this despicable world, without ever overpowering them. The hopelessness of emancipation may be softened, but never abated, perhaps implied by the floating bottle. Vannak—and the fishing vessel that is keeping him captive—are tucked therein.

Vannak eventually jumped overboard and made it to the shores of Malaysia, only to be captured and enslaved, yet again. Ultimately, however, Vannak was freed from this series of tragic ordeals. After returning to Cambodia, he then completed his graphic memoir, thanks in large part to his as-told-to co-author, the film-maker Jocelyn Pederick (Prum et al., 2018). Titled *The Dead Eye and the Deep Blue Sea*, Vannak's memoir is a *firsthand account of modern slavery, told in powerful, detailed full-color drawings that feel as if they've been inscribed in blood* (Publishers Weekly, 2018).

The second artwork we're now introducing in this section to evince the metaphoric power of art—also created to grapple with the repercussions of severe trauma—is Trina McKillen's *Bless Me Child for I Have Sinned (2010–2018)* (Figure 36.7). This magnificently designed and meticulously crafted sculptural edifice operates on several dynamic levels. *Bless Me Child for I Have Sinned* consists of a full-scale transparent glass confessional box that makes it readily apparent—aided by a metaphoric leap—that the role of the priest and the child penitent have now been reversed. Though neither priest nor child is visible, the viewer nonetheless intuitively grasps that it is the priest who has been exposed as the confessor of the crime of child sexual abuse, and it is *he* who is asking forgiveness from a child who has been a victim of his crime.

FIGURE 36.7 *Bless Me Child for I Have Sinned,* 2010–2018, Trina McKillen. Courtesy of the artist.

This confessional box also functions to symbolize a fervent departure from church policy, whereby the crime of child sexual abuse is no longer banished from sight, but instead, is now transparent, literally, for all to see. Whether absolution is also imagined by the viewer, or even whether the viewer believes that priests should, in turn, be criminally punished for their crimes, this artwork is ultimately a powerful metaphor of public reckoning. And as such, its aesthetic impact, and therapeutic value, cannot be emphasized enough. It gives voice to a particular category of victims of child sexual abuse, using an iconic Catholic symbol, the confessional, in an institution devoted, at least implicitly, to the values of Catholicism. It is thus an extraordinarily persuasive way of expressing psychological distress, without purposely alienating the viewer, while simultaneously serving as an edifying medium for facilitating compassionate appreciation for victims who have been overwhelmed by suffering the after-effects of child sexual abuse (Abramson & Abramson, 2020b, 2023).

Dr. Payne's Electroshock Apparatus

After making inroads in our theoretical work, and building the classes that we wanted to teach, we then decided to create an artwork that would concretize *Art & Trauma*, whereby the expository details—the title and the signage—would be integral to the artwork itself. The ghost in the machine, as it were. We also wanted that artwork to make implicit references to anguish but without ever directly identifying it as such.

Our first task was to create an apparatus that could reasonably pass as an electroshock therapy device. In the mid-1950s, electroshock therapy units came in small wooden boxes that could be transported like a suitcase, with latches and a handle on the outside. Once fully opened, with the lid extended in an upright position, the electroshock therapy unit would display wires, gauges, and dials. For our purposes, however, we didn't want to use an actual electroshock therapy unit. We wanted our apparatus, instead, to operate as a sculptural object, not simply as a mass produced, and reprehensibly misused, machine. We then fortuitously discovered a 1950s tube-tester—designed to check the functional characteristics of vacuum tubes—that was a close approximation of an electroshock therapy unit, right down to the dimensions and look of the vintage wooden box, plus the presence of gauges, wires, and sockets. Our tube-tester—which has now become the backbone of our sculpture—has been permanently rechristened as *Dr. Payne's Electroshock Apparatus* (Figure 36.8) (Abramson & Abramson, 2023).

Despite the conspicuous title, it is the fictive signage that conclusively activates the artwork, especially in terms of intuitively grasping its allegoric meaning. This brief signage, which consists of variations on patently contemptible characterizations, identifies the purported owner of Dr. Payne's apparatus, followed by its alleged usage. The signage itself references a specific year, 1955 to be precise. Besides acknowledging the actual vintage of Dr. Payne's box, 1955 also alludes to an era that was known for its contemptible iniquity, discrimination, and flagrant transgressions. Examples of our signage include:

FIGURE 36.8 *The 1955 Bellevue Hospital Motivator for Depraved Women: Dr. Payne's Electroshock Apparatus,* 2022, Paul R. Abramson and Tania Love Abramson.

Courtesy of the artists.

The Bellevue Hospital 1955 Motivator for Depraved Women (depicted in Figure 36.8), and *The City of New York Police Department's 1955 Interrogation Facilitator*.

Two reasons prompted this tell-tale methodology. First, we wanted to ensure that the signage faithfully represented the kinds of traumatic experiences encountered by the artists we've been studying, but no less importantly, we wanted to ensure that the viewer would come to understand the invidious implications of such—be it racism, torture, or whatever the case may be. In doing so, the inescapable implications of the signage could then function as a parable; an oblique lesson in empathy, a marker of gross inequity. Much like the recognition of a metaphor, our conceptual manipulation was designed to say one thing, but to mean something else. Though only one version of the signage can fit in the artwork at any one time, the remaining labels can still be exhibited along with *Dr. Payne's Electroshock Apparatus*, in book or photographic form, such as, *The Many Uses of Dr. Payne's Electroshock Apparatus*.

Our first source of inspiration for this artwork came from Marcel Duchamp's 1917 ready-made sculpture, *Fountain*, where the perception of an everyday object, a urinal, was altered by turning it upside down, signing it, and then displaying it in an art exhibition. Noah Purifoy's 2000 assemblage *White/Colored*—which we'd seen at his permanent exhibition site, The Noah Purifoy Desert Art Museum of Assemblage Art, in Joshua Tree,

California—influenced us even more so. Purifoy's artwork used a standard drinking fountain which had been labelled Whites, while the adjacent toilet—the replacement for a second drinking fountain—had now been labelled Colored. Viewers not only engaged differently with these two everyday objects, but Purifoy's signage—two words—had an extremely pronounced influence on the viewer, particularly in terms of U.S. racist Jim Crow policies. Purifoy's artwork was thus no less profound than it was political.

Unbound by Institutional Constraints: Real-World Encounters with Art and Trauma

We've always intended *Art & Trauma* to be something more than a quest into the viability of an aesthetic theory. Our classes, lectures, and workshops are obvious extensions of our theoretical work, but those efforts have been restricted entirely to the academy. It's an in-house quest, at best.

But it need not be so. The common theme throughout all our efforts—whether addressing memorials, artworks, or music—is that *awareness impacts viewers acutely*. This is especially true where trauma is concerned, particularly when it's the centre-point of the convergence between an artistic vision and narrative input. That conclusion, however, is no less relevant within, than it is outside of the academy. It's also not bound by artworld conventions or aesthetic traditions either (Abramson & Abramson, 2018). It's an adage, we believe, that can stand on its own, regardless of its utilization.

We thus began our journey into formulating a real-world application with a very simple idea. To create an exhibition that didn't lend itself to the priorities of a museum or a gallery. Something, in fact, that was even hard to imagine either of them ever hosting. Like an exhibition that was closely aligned with relentless trauma, and as such, distressing to think about. Child sexual abuse, for example.

Instead of trying to get the public at large to come to an exhibition of that nature, our idea was to take the exhibition to an especially relevant audience, a medical school, for instance. Paediatricians have a stake in the incidence and psychological consequences of child sexual abuse; the same argument could be made about Public Health Departments; child sexual abuse is a global crisis of epidemic proportions (Carole et al., 2013; World Health Organization, 2017). Medical students might also be interested in this topic; there is some likelihood that they would encounter it as a potential emergency in their rotations, or later in their professional lives.

With that in mind, we began conceptualizing an exhibition that included visceral psychological portraits of survivors of child sexual abuse—along with other related artworks—all of which would be accompanied by relevant explanatory text. We also conceived of this exhibition as including symposiums, catalogues, and choreographed activities performed by medical students, implicitly designed to underscore the grievous repercussions of this incomprehensible crime.

Why, the reader might ask, would a medical school want to feature an exhibit devoted to this issue? It is, as noted above, a paediatric and public health crisis of epidemic proportions, but in addition to that, we might also insist that displaying an exhibition of this nature would have enormous pedagogic value to the field of medicine, too. This would surely be the case if these artworks, and their accompanying expository particulars, could serve as alternative conduits for grasping the truth about this dreadful ordeal (Abramson & Abramson, 2020b).

On the other hand, rejecting such an exhibition would certainly be understandable, if only to eliminate potential controversy and rebuke, but the counter argument, we believe, is the more persuasive one. The atrocities of child sexual abuse are well known, but their concealment makes them even worse. Overlooking artworks that grapple with child sexual abuse would certainly be regrettable, but on the other hand, we believe that it is imperative to stage exhibitions of this nature—particularly when harnessed to pedagogic objectives—because their existence alone affirms the putative *value* of art—the connecting of dots, the power to rankle. Failing to exhibit artistic visions that emerge in the aftermath of child sexual abuse would also unduly constrict the language of art. The allegory, the storyline, the history, or more generally any linguistic form that can enlighten without constraint, and educate without evasion, no matter how indirectly it is represented and narrated (Abramson & Abramson, 2020b).

What we were envisioning was an exhibition—something on the order of *Portraits of Abiding Despair and Steadfast Determination*—that could induce a transcendent experience, while simultaneously facilitating recognition of all the ramifications of child sexual abuse (Figure 36.9). This is also why we put a priority on including active participation, symposiums, performances, and catalogues in addition to static artworks.

Though we have emphasized the need for this exhibition to resonate with candour, we further believe that it should be allusive enough to provoke countervailing emotions—outrage, vulnerability, and shame, no less than courage and tenacity, plus of course empathy and concern, all without ever being wilfully antagonistic. While nightmares of abiding despair, just like steadfast determination, are obviously part of this picture, so too are the stubbornly docile or actively conciliatory bystanders who unconscionably acquiesce to the reassurances of sexually abusing perpetrators (Abramson & Abramson, 2020b).

Shortly after our article that proposed this exhibition was published in an American Medical Association journal (Abramson & Abramson, 2020b), the COVID-19 pandemic hit with a vengeance. Though we had received some initial feelers about creating such an exhibition, the prospect for doing so—in a medical school or any other public institution, for that matter—was temporarily put on hold. That result made it apparent to us that we should likewise coordinate our outreach to incorporate online opportunities that might make it easier to operationalize our real-world applications.

Though we continue to pursue these exhibitions, we were also, fortuitously enough, asked to join the editorial board of the journal *breatheeveryone.net*; an online poetry and arts periodical devoted to themes of social justice. This opportunity also gave us a platform for introducing artworks—inspired by our *Art & Trauma* conceptualization—to a more diversified audience; two examples of which are presented herein. The former is by the first author, titled *Say Her Name* (Abramson, 2020). It was the cover art for the

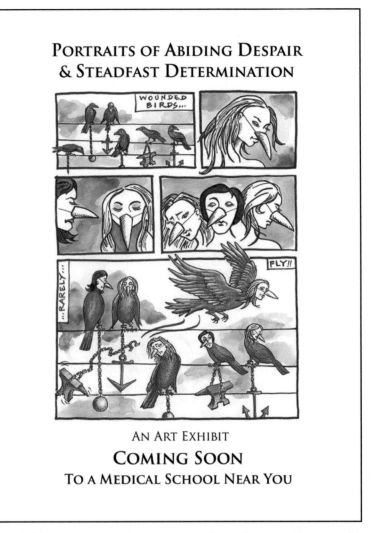

FIGURE 36.9 Exhibition poster mock-up, 2019, Tania Love Abramson. Courtesy of the artist.

September 2020 issue of *breatheeveryone.net*. The narrative testimony, as the reader will note, has been integrated into the artwork itself, and is figuratively encapsulated in the title, too (Figure 36.10). The published artwork was also accompanied by an essay, also by the first author, that describes its origin and meaning. Collectively, this awareness, as the reader might imagine, markedly impacted reader.

More specifically, *Say Her Name* was meant to acknowledge the names and tragedies of nine women and girls—each of whom was a target of racial animus, or worse. Three, in fact, had lost their lives. Breonna Taylor's killers have yet to be arrested or charged, and Cyntoia Brown lost fifteen years of her life to prison. There were no justifications for any of these police actions, except to say that the perceived tyrannical entitlements of racial hate, oppression, stereotypes, and narratives that demean Black women and girls was the authorization to do so. Worse yet, these nine women and girls are simply stand-ins

ART AND TRAUMA 679

FIGURE 36.10 *Say Her Name*, 2019, Tania Love Abramson. Courtesy of the artist.

for the thousands upon thousands more—all of whose lives have been shattered by extreme injustice and inhumanity. *Say Her Name* is thus fundamentally about empathy. It's also about humanity, equality, justice, dignity, and respect, too.

The second example is an essay by the second author, an addendum, so to say, to the Billy Holiday song, *Strange Fruit*, that was introduced previously. Titled *On the Road with Music and Outrage: The Legacy of Lynching and Child Sexual Abuse,* this essay reviews two integral compositions—*Strange Fruit* and Crying 4 Kafka's *Fuck Mom/Fuck Dad*—that correspond to the two atrocities in the title, lynching and child sexual abuse, respectively (Abramson, 2021). Both songs are ostensibly about one thing but mean something else entirely. It is the backstory that makes that apparent. Awareness, once again, impacts listeners acutely.

Fuck Mom/Fuck Dad is a quintessential punk rock song that is punctuated by the word Fuck, which is uttered throughout. A casual listener might find the song amusing if she or he has had a passing familiarity with punk rock. On the other hand, the song

might confuse the undiscerning listener, who doesn't know what to make of it. Either way, the lyrics were written, and the song performed, by the second author. The song can be heard on *Crying 4 Kafka's SoundCloud* page.

The story behind *Fuck Mom/Fuck Dad* is no less telling than it was for the story behind *Strange Fruit*. Both songs are narrating deplorable events. Where *Fuck Mom/Fuck Dad* is concerned, the second author is describing two cases that he worked on, the first of which involved a five-year-old girl who had been raped by her mother's nineteen-year-old boyfriend. The mother, a thirty-seven-year-old law enforcement officer in Montana, deliberately concealed the sexual assaults.

The second case was equally despicable. This one occurred in New Mexico. A savage monster of a stepfather was sexually terrorizing his ten-year-old stepdaughter. Is there no end in sight to such wretched misery, the second author wondered? At the same time, a chorus spontaneously materialized in his head. *Fuck Mom, Fuck Dad, Fuck all the memories I never had. Fuck honour, Fuck obey, Fuck the wrath of judgement day.* This repeating chorus is now entombed in this fittingly titled song.

It's not all bombs and sledgehammers, however. The verses begin artfully enough. The first one, for example, starts with an axiom about domestic child sexual abuse. *Secrets hidden well, weary infidels. Pity spread on thick, morphine and the fix. Buddha hooked on meth, clown that quotes Macbeth. Spirit handed down. Saint and his crown*—and then—*Fuck Mom, Fuck Dad, Fuck all the memories I never had.*

Purposely envisioned as a parable, this song was also meant to transcend the narrative storyline. At its core, *Fuck Mom/Fuck Dad* expresses a willingness to wrest meaning from the psychological pain of child sexual abuse. The hope was that by doing so, the song would provide a credible voice, a mantra perhaps, for survivors of this grievous crime. When the backstory to the song is told to audiences—ranging from rock & roll clubs to UCLA students—listeners are uniformly appreciative; no less intrigued than moved by it. The infamous *Viper Room* on Sunset Boulevard, in Los Angeles, in fact, wrote to the second author thanking him for *gracing their stage*.

Though we've only just begun to put our *Art & Trauma* rationale into practice, the take-home message thus far has been consistently encouraging. One might even call it perceptive; audiences getting exactly what we're trying to convey. There have been, fortunately, plenty of opportunities for us to harness narrative input to artistic visions, even when those visions have been anchored in extreme duress. Viewers—and listeners—don't seem to mind; if anything, the opposite is true. They've clearly been impacted by such, as our theory would predict. That effect is the impetus for us to continue to persevere.

Conclusion

There was a popular song, released in 1945, titled *Sentimental Journey*. It was sentimental because the singer was heading home, ostensibly to renew old memories. Our journey,

however, is something else entirely, whereby nostalgia plays no part therein. We're looking for a better path to reach an agreed-upon destination. If awareness impacts viewers acutely, what facilitates awareness? Understanding the latter is our Aesthetic Journey.

We live in a world that fluently manufactures catastrophe. Though tragedy is deplorable, artistic imaginations encumbered by the configurations of adversity are nonetheless essential to how art is understood. If the manifestation of art is an interplay between artists, audiences, and contextual cues in the environment, the flood of information accessible to viewers inevitably impacts their judgements. How could it be otherwise? This effect is most striking where artistic visions manifested in the aftermath of severe trauma are concerned. Or, to state it more bluntly, what we know, influences what we see, especially with artworks that arise out of the rubble of despair. That, perhaps, is the best soundbite version of *Art & Trauma*.

This point is especially significant, and worth emphasizing once again. The viewing of artistic visions that have materialized as residuals to calamity can, we believe, enlighten, no less then inform (Abramson & Abramson, 2023). What we ultimately gain from such visions is an unparalleled opportunity to engage with, and learn from, the intuitive side of torment. The allegories, the metaphors, the allusions (Abramson & Abramson, 2019, 2020a, 2020b, 2023). This effect is most evident when such creations are accentuated by inescapable narratives of evidentiary ferocity. This discovery is also further confirmation of the power of aesthetics (Dewey, 1934; Saito, 2010).

References

Abramson, P. R. (2021). On the road with music and outrage: The legacy of lynching and the agony of child sexual abuse. *Breathe*. Available from: www.breatheeveryone.net/may-2021 [last accessed 6 October 2024].
Abramson, T. L. (2017a). *Shame and the eternal abyss*. Asylum 4 Renegades Press.
Abramson, T. L. (2017b). *Concern*. Asylum 4 Renegades Press.
Abramson, T. L. (2019a). *Truth lies*. Asylum 4 Renegades Press.
Abramson, T. L. (2019b). Unchain my anguish: A feminist take on art and trauma. *Feminist Review 122*, 189–197.
Abramson, T. L. (2020). Say Her Name. *Breathe*. Available from: https://www.breatheeveryone.net/sept-2020-cover.
Abramson, T. L., & Abramson, P. R. (2018). Art and trauma: Yet another Arthur Danto zombie. *Contemporary Aesthetics 16*, 3–4.
Abramson, P. R., & Abramson, T. L. (2019). David Wojnarowicz and the surge of nuances: Modifying aesthetic judgement with the influx of knowledge. *Aesthetic Investigations 1*, 146–157.
Abramson, T. L., & Abramson, P. R. (2019b). Charting new territory: The aesthetic value of artistic visions that emanate in the aftermath of severe trauma. *Contemporary Aesthetics 17*, 1–2.
Abramson, T. L., & Abramson, P. R. (2019c). The UCLA Art and Trauma Course: A serendipitous journey. *Studies in Art Education 60* (1), 58–62.
Abramson, T. L., & Abramson, P. R. (2019d). Arkoun Vannak: A tribute to a heroic Cambodian artist. *Visual Inquiry 8* (1), 79–83.

Abramson, P. R., & Abramson, T. L. (2020a). Visual and narrative comprehension of trauma. *American Medical Association Journal of Ethics* 22 (6), E535–543.

Abramson, P. R., & Abramson, T. L. (2020b). Should art about child abuse be exhibited in corridors of health professional schools? *American Medical Association Journal of Ethics* 22 (6), E525–534.

Abramson, P. R., & Abramson, T. L. (2023). Illuminating psychological torment of child abuse. *American Medical Association Journal of Ethics* 25 (2), E153–158.

Abramson, P. R., & Bland-Abramson, S. (2021a). Racial animus, police corruption, and a wrongful conviction of murder: Complex PTSD and the vestiges of anguish. *Wrongful Conviction Law Review* 2, 103–120.

Abramson, P. R., & Bland-Abramson, S. (2021b). Hiding under the color of authority: Eric Wess Ulller and his decades-long rampage of child sexual abuse. *Journal of Child Sexual Abuse*. Available online at: https://doi.org/10.1080/10538712.2021.2014613.

Allen, R. L. (1998). Past due: The African American quest for reparations. *The Black Scholar* 28 (2), 2–17.

Carole, J., Crawford-Jakubiak, J. E., & the Committee on Child Sexual Abuse and Neglect (2013). The evaluation of children in the primary care setting when sexual abuse is suspected. *Pediatrics* 132 (2), 567–588.

Dewey, J. (1934/2005). *Art as experience*. Perigee.

Ellis-Hill, C., Pound, C., & Galvin, K. T. (2021). Making the invisible more visible: Reflections on practice-based humanizing life world-led research – existential opportunities for supporting dignity, compassion, and well-being. *Scandinavian Journal of Caring Sciences* 36 (4), 1037–1045. https://doi.org/10.1111/scs.13013.

Goodman, N. (1976). *Languages of art*. Hackett Publishing.

Holyoak, K. J. (2019). *The spider's thread: Metaphor in mind, brain, and poetry*. MIT Press.

hooks, bell (1998). *Engaged pedagogy: A transgressive education for critical consciousness*. Praeger.

Kessler, R. C., Aguilar-Gaxiola, S., Alonso, J., Benjet, C., Bromet, E. J., Cardoso, G., Degenhardt, L., de Girolamo, G., Dinolova, R. V., Ferry, F., Florescu, S., Gureje, O., Haro, J. M., Huang, Y., Karam, E. G., Kawakami, N., Lee, S., Lepine, J.-P., Levinson, D., … & Koenen, K. C. (2017). Trauma and PTSD in the WHO World Mental Health Surveys. *European Journal of Psychotraumatology* 8, 1–28.

Prum, V. A., Pederick, B., & Pederick, J. (2018). *The deadeye and the deep blue sea: A graphic memoir of modern slavery*. Seven Stories Press.

Publishers Weekly. (March 26, 2018). *The deadeye and the deep blue sea: A graphic memoir of modern slavery*. [comics book review]. Retrieved from: www.publishersweekly.com/978-1-60980-602-6

Rosenthal, R., & Jacobson, L. (1968). *Pygmalion in the classroom: Teacher expectation and pupil's intellectual development*. Holt, Rinehart & Winston.

Rutherford, B. P., Wall, M. M., Brown, P. J., Choo, T. H., Wager, T. D., Peterson, B. S., Chung, S., Kirsch, I., & Roose, S. P. (2017). Patient expectancy as a mediator of placebo effects in antidepressant clinical trials. *American Journal of Psychiatry* 174 (2), 135–142.

Saito, Y. (2010). *Everyday aesthetics*. Oxford University Press.

Saito, Y. (2017). *Aesthetics of the familiar: Everyday life and world-making*. Oxford University Press.

World Health Organization. (2017). Responding to children and adolescents who have been sexually abused. WHO Guideline. Available from: https://www.who.int/news/item/19-10-2017-responding-to-children-and-adolescents-who-have-been-sexually-abused

CHAPTER 37

THE PSYCHOLOGY OF ART-VIEWING

Insights from Interpretative Phenomenological Analysis

RACHEL A. STARR AND JONATHAN A. SMITH

THE relationship between artistic engagement and well-being has been the subject of a substantial body of psychological research (Stuckey & Nobel, 2010). In a systematic review, Daykin et al. (2008) identified over 600 papers concerned with the impact of the arts within the field of mental health care alone. This makes sense, 'art' may refer to any number of activities and outcomes, from shaping physical material into something touchable like sculpture, to linking a string of representations into something invisible like the musical notes in a song. This broad and diverse sea of engagements invites an equally broad and diverse range of approaches to its psychological investigation. Engagement with art has thus been conceptualized in numerous ways in the context of empirical study. Research may focus on art-*making* or doing, such as the role of arts activities in developing well-being in children (Zarobe & Bungay, 2017) or university students (Margrove, 2015), the well-being benefits of crafting practices (Kaimal et al., 2017) or the creative engagements of art therapy (Hogan, 2001). The role of art *appreciation* may also be explored and research of this type has identified positive outcomes associated with engagement in a diversity of art forms such as listening to music (Aldridge, 1993) or to fictional audiobooks (Poerio & Totterdell, 2020), reading (Djikic et al., 2009), or watching dance (Karkou et al., 2017). This chapter concerns the latter, art appreciation, and focuses in particular on art-viewing and the experience of looking at paintings.

The literature regarding the appreciation of visual art and associated impacts on well-being echoes the aforementioned diversity. For example, the presence of visual art has been linked to positive well-being outcomes in a variety of settings. In hospitals, the addition of visual art has been suggested to improve the environment and, in turn, patient

experiences (Nielsen et al., 2017). It has also been linked to positive changes in patient mood and stress levels (Karnik et al., 2014). Such benefits have similarly been reported in the workplace (Smiraglia, 2014) whilst public artworks in urban areas are suggested to facilitate social well-being (Innocent & Stevens, 2021). The positive outcomes associated with engaging with visual art extend beyond environmental enhancement. In consumer research, experience of artworks such as paintings has been associated with improved well-being due to the inspiration it evokes (An et al., 2022), whilst viewing emotionally laden artworks has been proposed as a means of encouraging positive attitude change in prisoners (Oguda et al., 2021). The benefits of art-viewing have also been highlighted for a range of populations, e.g., older people (Curtis et al., 2018) those with dementia (Camic et al., 2014; Johnson et al., 2017), those detained in psychiatric facilities (Nanda et al., 2011), mental health service users (McKeown et al., 2016) and the family carers of people with mental health problems (Roberts et al., 2011).

As expected, much of this research concerns art viewed in person such as in galleries (Binnie, 2010; Mastandrea, Maricchiolo, et al., 2019) prompting a growing body of literature exploring art-viewing in museums as a well-being facilitator (as reviewed by Šveb Dragija & Jelinčić, 2022). However, these beneficial outcomes have also been reported in cases of virtual (Averbach & Monin, 2022; Cotter et al., 2022) or other screen-based viewings (Tyack et al., 2017).

Art-viewing has also been considered in the context of community well-being such as the prior referenced work on public art by Innocent and Stevens (2021). Gallery experiences are suggested to facilitate a sense of connectedness (Lee & Northcott, 2021) and exhibitions used to promote social understanding (Barnett et al., 2019). Koh and Shrimpton (2014), for example, reported that visitors to an exhibition of art by people with mental health problems described feeling that they had better and more sympathetic attitudes towards mental illness as a result. Other exhibitions have similarly been identified as improving understanding of mental illness and promoting mental health (e.g., Harris et al., 2018; Riches et al., 2019; Tischler, 2018).

Given this expansive and growing acknowledgement that art-viewing is beneficial to well-being, better understanding of this relationship could offer valuable opportunities to facilitate and harness the connection, for example, by 'promoting a focused use of art as a tool for improving well-being and health' Mastandrea, Fagioli, et al., (2019, 1). With such aspirations in mind, whilst evidence linking art appreciation to improved health and well-being continues to grow, it has been argued that the nature of this relationship and the ways that it may be evaluated would benefit further exploration (Daykin et al., 2008; Mastandrea, Fagioli, et al., 2019; Staricoff, 2006; Trupp et al., 2021).

This is a challenging task. What we mean by, and how we might measure, art-appreciation,[1] particularly in the context of well-being benefits, are by no means agreed upon and even when limiting the focus to art-viewing and visual art, we find a considerable diversity. In some cases, art-viewing is approached as cultural and social engagement (e.g., the activity of visiting a gallery (Colbert et al., 2013)) and may facilitate feelings of connectedness (Lee & Northcott, 2021). Another perspective towards art-viewing is to explore it as a cognitive–emotional experience, here it may serve to

regulate mood (Trupp et al., 2021). Art-viewing may be approached as a processing operation in which material parsed more efficiently may reduce cognitive strain and give rise to feelings of reduced stress (Law et al., 2021), or it may be considered as a sense-making activity which is rewarding in and of itself (Lomas, 2016). Furthermore, there are innumerate conceptualizations of responses to art and how we might measure them. Taking emotional reactions as an example, measures have included *emotional heat maps* (Tinio & Gartus, 2018) electroencephalography (EEG) (Cheung et al., 2019) pupillary response (Kuchinke et al., 2009), facial electromyography (EMG) (Leder et al., 2014) and many different self-report questionnaires and rating scales (e.g., Marín-Morales et al., 2019; Pelowski, 2015; Schindler et al., 2017).

Pelowski and Akiba, (2011, 81) refer to Funch's (1997) condemnation that 'if appreciation of a specific work of art really has an impact on the viewer's life... it would be difficult, if not impossible, to give evidence of such influences through empirical studies.' This might well be true of experimental endeavours but there is more than one way of being empirical.

Qualitative psychology differs from experimental or quantitative research in the way that it approaches the study of human mental life. Notwithstanding that there is also more than one 'qualitative' psychology and within the field there are oppositions and positionings, these approaches are unified in that they do not quantify mental processes. In quantitative psychology, people and their environments are treated more as one would the objects under examination of the natural sciences. Studies are based on existing theory and designed to be rigorously objective in exploring manipulations of tightly delineated and controlled variables. The researcher takes a third-person perspective, understanding what participants report or indicate from a detached, dispassionate position.

Arguably, art represents something about human beings and our world that makes us essentially different from the objects investigated by the natural sciences. A full understanding of what art-viewing encompasses therefore requires tools in addition to those of quantification and experimentation. Rather than attempting to capture human behaviour in numerical form, in qualitative approaches personal experience and subjective understandings are valued and sought out. Kinds of things, rather than amounts of things, are explored. The aim is not to make predictions and prove or disprove them, but to be inductive and flexible, lead not by what we think *is*, but to ask what it *is like*.

In their review of well-being outcomes in adults engaging with visual art, Tomlinson et al. (2018) report 'The most convincing evidence has emerged from focused qualitative research designs'. Examples of such work include Smiraglia's (2014) Thematic Analysis[2] of the impacts of workplace art. Here familiar results such as promotion of social interactions, personal connection-making, and emotional responses were confirmed but were also linked by the viewers to particularities of the art installed such as its creativity and relevance to the ethos of the company. Gelo et al. (2015) also used Thematic Analysis to explore how art-viewing might be beneficial during hospitalization. Narrative images were described as a potent tool to connect with various aspects of spirituality and promote discussions patients found helpful in coping with their experiences

of illness. Colbert et al. (2013) used Narrative Analysis[3] to shed light on the relationship between art-viewing and impacts on mental health and notions of stigma. Patients with psychosis and the staff who cared for them shared an exhibition visit. Positive outcomes were connected to the visit through the detail of individuals' interactions with artworks exhibited such as the insights generated during very personal identification with perceived states of mind of painted figures, to a reduction of barriers between patients and staff. Brook (2022) used Q-methodology[4] to shed light on emotional responses to art (the conceptualization of which, as we saw, generated a diversity of measures experimentally). Differences in the ways participants *perceived* negative emotions provoked by artworks were found to be important in shaping the character of their responses.

As demonstrated by the above, the detail of what occurs during experiences with art seems pertinent in any discussion of the role of art-viewing in well-being. Here, qualitative, experiential accounts of art-viewing are slowly accumulating. Csíkszentmihályi and Robinson (1990) in their book, *The Art of Seeing*, described viewers' accounts of visits to museums and galleries exhibiting sculptures, paintings, and other art objects, and identified affective, intellectual, communicative, and perceptual aspects of these engagements. Mikal Lagerspetz (2016) considered data collecting experiential accounts of art-viewing in the context of the stages of aesthetic experience proposed by Leder et al., (2004) thus providing a different lens on the model.

Phenomenology is an area of philosophy which has been drawn upon in psychology to develop approaches to research that foreground the study of human experience on its own terms (see e.g., Smith, 2004). Tone Roald (e.g., 2008, 2015) has made numerous contributions, both empirical and philosophical, to our understanding of art-viewing from a phenomenological perspective (see also Roald & Køppe 2015). On Tam (2008) conducted a phenomenological enquiry into art-viewing which involved analysing participant interviews using the 'lifeworld existentials' suggested by van Manen (2016) as guidance.

Both the work of Roald (2007, 2008) and On Tam (2008) address the experience of art-viewing based on interactions in museums and involving a number of paintings. Although individual paintings are referred to, the approach is towards art-viewing as a consolidated activity produced as an aggregate of interactions with multiple images and discussions of the experience are primarily retrospective. All studies involve making choices about focus and Roald (2008) described an intention to explore early impressions of art-works and 'the first aesthetic meeting' rather than intending to 'dive deeply into the particular constituents of the experiences' (p. 200). Room here is left to address the idiographic, individual encounter with a painting—the *what happens when we look at a single image*, rather than discussing broader notions of art-viewing or interactions with paintings.

The following is the result of an exploration to this end. The qualitative experiential approach Interpretative Phenomenological Analysis—IPA (Smith et al., 2022; Smith & Nizza, 2021) was used to ask, what is it like to look at a painting?

Interpretative Phenomenological Analysis and Art-Viewing

Interpretative Phenomenological Analysis is a qualitative approach to psychological research wherein an understanding of lived experience in the form of individual, first-person, subjective knowledge is regarded as integral to developing our understanding of the world. Participants (and researchers) are considered culturally and socially situated in a world of linguistic, physical, and historical structures; the human structures which we form about ourselves in our own inimitable ways. Experiences are had by sense-making beings and shaped by the meanings through which they understand the world. Therefore, there is not considered to be a direct connection to experience that a researcher may access, rather, a process of subjective and inter-subjective meaning-making allows the researcher to become 'experience-close' (Smith et al., 2022, 27). This dually interpretative activity is often referred to as a double hermeneutic, the participant involved in sense-making, the researcher making sense of this sense-making (Smith & Osborn, 2008).

Insofar as we are considered inherently interpretative beings, researchers using IPA are encouraged to be aware of and consider how their own sense-making, ideas, and preconceptions might shape their research. We have already reviewed some of the literature exploring how we might view art or what art-viewing 'is'; in addition, there is a long, rich history of thinking about how we ought to view art (as anyone who has ever been shushed in a gallery will tell you). Images themselves come with implied or intended meanings. They may depict their own 'worlds' which engender an additional layer of potential assumptions and biases. Figures, colours, and meanings shape, but are also shaped by, the image totality and may have their own diverse historical, social, and cultural embeddedness.

Paying special attention to sense-making, context, and the role of presuppositions, when considering such a phenomenon, seems particularly advantageous and, due to the central commitment to being 'idiographic, inductive, and interrogative' (Smith, 2004, 1), it is this kind of attention that Interpretative Phenomenological Analysis affords.

The idiographic commitment of IPA allows a detailed examination of the experience in question to be undertaken. Interestingly much of the language used to describe this has suggestions of an artistic nature, for example, Eatough & Smith (2017) describe 'the texture and qualities of an experience as it is lived by an experiencing subject' (p. 194). In its detailed approach, IPA produces *thick* descriptions, identifies 'patterns of meaning' (Larkin & Thompson, 2011, 104), and addresses 'layered meanings' akin to layers of paint (e.g., Finlay, 2014). The idiographic approach offers an alternative to nomothetic enquiry which collects group information and seeks to establish general laws. The aim is to produce an in-depth examination rather than uncover broadly generalizable statements. Generalizability in art-viewing research can be challenging, where

processes are difficult to delineate, define, or compartmentalize, and where points of comparison are difficult to identify (consider the many ways to measure emotional responses mentioned). A more fine-grained and detailed exploration of the phenomenon can provide foundations for the development and clarification of broader, more general constructs.

The inductive nature of IPA lends itself to research questions where little is known about the phenomenon or that are more exploratory in nature. Smith (2004) writes 'IPA researchers employ techniques which are flexible enough to allow unanticipated topics or themes to emerge during analysis' (p. 43). Often art-viewing research is driven by the content of the 'stimulus' or the art (e.g., is it abstract or representational) or by pre-existing expectations of the viewers' responses (measured by preferences or either/ors). An inductive approach allows aspects to disclose themselves to us and guide the research rather than constrain it or categorize it artificially by naturalizing subjective divisions. IPA allows the *what is it like* to be developed from the data rather than have the a priori be imposed upon it; the aim is for research to proceed from a place of orientation towards discovery.

Interpretative Phenomenological Analysis encourages researchers to take up two hermeneutic positions. Following Ricoeur (1970), a hermeneutics of empathy and a hermeneutics of suspicion are employed. The former involves remaining close to the participant's account, imagining oneself in their position; the latter involves adopting a more sceptical or questioning stance and 'probing for meaning in ways which participants might be unwilling or unable to do themselves' (Eatough & Smith, 2017, 198). Interactions with art may be particularly complex (On Tam (2008), for example, described his participants' difficulties in disclosing their experiences with artworks), requiring both fine-grained and multi-layered interpretative consideration.

Ultimately, IPA involves a commitment to exploring experience without pre-emptive or post-emptive reductions to 'predefined or overly abstract categories' (Smith et al., 2022, 1), the like of which are in abundance where art-viewing is concerned.

The Study

Participants were self-described art enthusiasts. Art enthusiasts were chosen as people who actually engaged in the experience of interest. There were no strict criteria used to categorize 'art-enthusiasm', in order to resist presumptive definitions. Rather, people who 'liked art, were interested in art and would be comfortable enough to talk about art' were sought during recruitment.

Twelve participants separately viewed the painting 'Las Meninas' by Diego Velázquez (1656) (Figure 37.1) and were interviewed as they looked at it. They were all Londoners, six male and six female, aged between thirty-five and sixty-five and educated to at least degree level. Half had seen the image before and half had not. The interview was semi-structured and began with the question 'What are your first impressions looking at the painting?'. Discussion then continued organically as participant and researcher looked at the image.

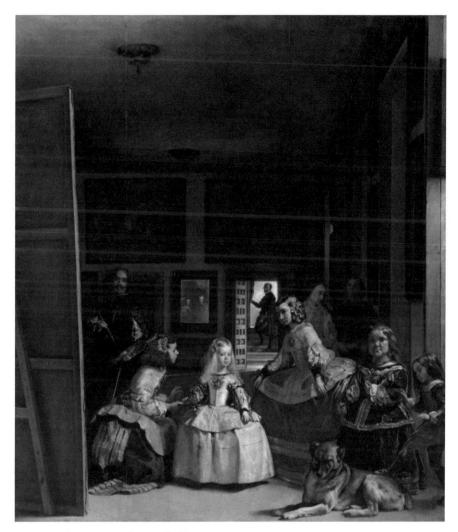

FIGURE 37.1 'Las Meninas', Diego Velázquez, 1656.

The Rationale for Looking at the Painting in Real-Time

Visual methodologies have recently been fruitfully incorporated into qualitative psychology (Reavey & Johnson, 2017). Often images are presented to participants to help elicit or access what is otherwise difficult to engage with. Photographs and art created by participants (particularly by marginalized groups) have also been used. This has suggested a range of benefits. Participants have been given the opportunity to generate their own research material and creating images has been demonstrated to aid communication and exploration of difficult topics (Attard et al., 2017).

The use of the painting here was not related to any conception of a particular social group or to aid the expression of a specific type of content. Nor was it intended as an alternative to language or as a conduit for some other type of experience. Instead, viewing

the painting and discussing it together allowed the researcher and participant to engage in the activity which was the subject of the research. The painting was part of the experience so was present in its unfolding.

There is a complex relationship between our inner thought and public speech and no claim is made here to replicate or capture the exact content of a participant's internal thoughts when viewing a painting simply by asking them about it in the moment. However, by conducting the interview whilst looking at and talking about the image together, as one might look at a painting and consider it, the hope was to become closer to the experience.

The resulting transcribed accounts were analysed following Smith et al. (2022) to develop a structure of group experiential themes (GETs)[5] and subthemes. Each of the twelve interviews was analysed individually and each analysis was completed before progressing to the next. Extended details of the design and method can be found in Starr and Smith (2021, 2023) but briefly, the analysis of each individual case involved the following:

> The transcript was read several times for familiarization. Notes were made concerning language, recurring motifs, ideas, and points of interest. These notes were developed into a series of experiential statements. Here, interesting and significant aspects of the participant's account, as suggested during the initial noting, were given concise, more abstracted descriptors, each associated with a short meaningful unit of text. Smith and Osborn (2008) stress the importance of staying 'grounded in the particularity of the specific thing said' (p. 68) at this stage and the goal, when developing these statements, was to apply an increased level of interpretation to the data whilst remaining anchored to the participant's account. The experiential statements were then clustered to develop a structure of personal experiential themes (PETs) and subthemes. Clustering involved looking for patterns of meaning amongst the experiential statements and drawing related statements together to begin to build themes whilst remaining attentive to both convergence and divergence.

Once analysis of all twelve cases was complete, the PETs for each person were compared and clustered into a new thematic structure representing qualities shared by the group. When looking for patterns at group level, the criteria described in Smith (2011)[6] and Smith et al. (2022) for determining and evidencing prevalence were followed. This process resulted in a series of GETs and subthemes.

The GET presented here is 'The self-conscious viewer: concerns with the "right" way to view art' and is the third of three making up the findings.[7] It concerns the demands and expectations viewers apparently place on their viewing encounters and the questions which appear to shape their viewings. *How should we go about viewing art? How should we meaningfully engage? What should we feel? What should we understand?* In the following discussion, ideas are expressed by participants concerning the form viewing should best take, how viewing should feel, and what 'understanding' a painting might mean. Crucially, a constant interaction between the tangled values of 'subjective' internal responses and 'objective' externally ascribed meanings is suggested.[8] Viewers discuss how they want to approach an image and the information they want to bring

to their encounter, they wrestle with the question, 'is there a right way to look at a painting?' and reflect on how this all makes them feel and think about themselves.

Subtheme One: *Getting It Right*

This subtheme captures two concepts which emerged from the data inherently interlinked. Ideas about the right way to approach art-viewing and ideas about right or wrong understandings (or answers). Much of this discussion concerned the role of established meanings and knowledge of paintings. Many of the viewers reflected upon the influence of such information in light of their (ideal) responses to art. They wondered to what degree, when, and if, contextual information should influence viewing.

Here Owen introduces us to the issues involved:

> *I want to look at the painting when I'm in a museum for instance I don't want to read the little thing at the side, I will eventually but I want I don't want I want my … judgement to be prejudiced but at the same time it can give me grounding in general I certainly want to know when this was painted … who it was painted for, who these people are, um … possibly why he painted it*

Owen considers the idea of approaching an artwork, in the first instance, in a state of unknowing or impartiality. He suggests that this is preferable to familiarizing oneself with information regarding the image before viewing. Indeed, there is seemingly a value judgement associated with the latter. Owen describes the information typically supplied with museum exhibits as 'the little thing at the side' a physical description of course, but with additional tones of disparagement.

Owen does, however, consider some information potentially useful; that which is 'factual', details of historical context for example. He is less sure of the desirability when the information begins to (arguably) rely more on interpretation 'possibly why he painted it'. Owen explains that he wants to exercise his judgement, unprejudiced. We might infer from this that there is some esteem associated with an un-aided individual response. And yet he uses the term 'judgement' (rather than say 'feelings' or 'reaction') as though there is some existing measure of correctness applicable.

Gwen discusses this interplay in more detail:

> *I think I in some ways prefer to think about it yourself. So I have to say sometimes in art galleries when there's just too much information […]– I really don't like that I particularly if you can't help reading words because that's what you do and then you you're just really cross that you've done that so I prefer … […] Obviously there's a balance its, it is useful sometimes to have some knowledge and often obviously name and then the period and even a little bit but on the whole I would prefer thinking well actually, the painter painted it and you the viewer …. You know it's up for you to do the work to interpret it and look at it and imagine it I think …*

Gwen similarly distinguishes between approaching an image having familiarized oneself with associated information and what she feels is the converse 'to think about it yourself'. She too expresses a preference for one mode of viewing over another. Again,

there are suggestions of value placed on different types of engagement. Like Owen, Gwen identifies factual information that she feels is acceptable to access. Overriding this allowance, however, is a sense of some demand made of the viewer and viewing. Gwen talks about the difficulty she finds in resisting reading information provided, and the regret she feels when she fails to avoid it. She further explains 'the painter painted it and you the viewer… You know it's up for you to do the work'. It is as if there is a requirement for effort to be made in order to respond fittingly. Indeed, Gwen suggests that interpreting an image should involve an active and effortful engagement. The viewer does the work. They look, interpret, and imagine. Doing this work is seemingly something worthwhile and important for Gwen as part of her viewing experience.

Linda similarly places value on independently evaluating art:

> *I think it is useful to know who this is painted by, when it is painted, the context, but I think actually come to it first and then the information – and I do it myself. I'm not being a snob about this but you go around galleries and you see people reading the information rather than looking at the bloody thing and I sometimes do that rather than just say, look at it and what is your reaction to that? And I think this is a painting that calls out for you to just encounter it.*

Linda's delineation of approaches to art-viewing is more pronounced. Engaging with the painting first and accessing information after is preferred. However, Linda is simultaneously in agreement with, and wary of, such 'rules', explaining 'and I do it myself. I'm not being a snob about this but'. Apparently such an attitude to viewing is both valuable and potentially overly judgemental and elitist (or snobby).

Here is an example of a double-edged sword that art-viewers seemingly struggle with. Linda has ambitions to view paintings in a way that she feels is superior. But there is also the implication or undertone in her discussion, that there is something unreasonable in this standard. More clearly, Linda's extract suggests that she aspires to a particular art-viewing approach. She tells us 'look at it and what is your reaction to that?' The idea of interacting with the image uninfluenced by outside knowledge is privileged over first pursuing extraneous information. There is again the sense of some kind of intrinsic value related to coming to one's own personal conclusions about an artwork and doing so unaided. And this is comparably better than gathering information about the painting first.

In a more positive iteration of this theme, William suggests a freedom associated with naïve viewing:

> *It's really interesting looking at a painting without any er exhibition you know the little sort of card things*

Looking at a painting without additional information can be genuinely interesting and enjoyable rather than work or a test of ability.

A number of commonalities are identifiable regarding the favoured or 'right' ways to approach a painting. According to the participants', the viewing encounter should

be independent and uninfluenced, it should involve intellectual or imaginative labour and meaning should be made by the viewer rather than extracted from external sources. Some quite particular information is considered useful, but an individually generated independent interaction is held in highest esteem.

It is as if viewers approach art as some kind of introspective evaluation, *Can I view this well? In the right way? Am I good enough not to need the 'little card'?*, as reflected by Kitty when she assesses her understanding of the image:

> *I sort of feel smug for knowing that [Laughs] But it's only cos I've probably read it*

Kitty's remark encapsulates a contradiction which participants apparently struggle with throughout the theme. Her feelings of reward for a 'correct' interpretation of the image are laced with self-deprecating humour. You can feel 'smug' because you understand something about the painting, but this understanding is tainted if it was sourced externally. Apparently going about understanding in the wrong way can undermine any sense of reward.

Existing knowledge and external understandings appear to be both impediments to, but also the goals of, a successful viewing. This opposition plays an additional role with implications for the viewers' experiences. Although viewers tended to value 'subjective' independent engagement with art over accessing existing knowledge, they also expressed the notion of a correct way to understand a given painting—a right answer. Importance was placed on being able to respond to an image, uninfluenced by external material, and yet the accuracy of such personal judgements might well be considered in light of these same presumed orthodoxies. Indeed, much discussion involved the viewer's ability to make sense of the painting and this 'sense' was located in the prevailing meanings commonly ascribed to it. Floyd explains:

> *For example the position of an apple or a stack of cards would be purposeful and it would have kind of been a deliberate or conscious decision so it kind of has a right answer.*
> *I mean obviously art can mean whatever you want it to but ... you can you can kind of say 'oh well a red apple in this context means infidelity everyone knows that if you've read poetry' something like that - that's just hypothetical then!*

For Floyd, there are prescribed meanings which viewers may glean from artworks. These meanings are properties of the images. They are embedded in cultural knowledge and context and are 'real' insofar as they concern deliberately attached content that viewers can know. The example he gives here is a meaning intended by the painter and the understanding of the symbolism used to convey this meaning. This type of responding, based on shared understandings, depends on knowledge of a wider contextual structure, as Floyd indicates of his hypothetical example 'if you've read poetry'. Rather than being confined to the boundaries of the image, meaning is understood through wider culture and society. Floyd introduces another tension common to the participants' accounts: Paintings can mean whatever you want but... they also don't.

For Floyd, paintings have meanings a viewer can extract which are sewn into a greater social tapestry. In the existence of such meanings a right or wrong answer becomes possible, as William remarks:

> *And so I would say yeah I'd say someone had commissioned this piece specifically to capture er a sense of importance of of the of this family I think I might be completely wrong* [laughs]

William too describes ideas of correct and incorrect meanings associated with the painting. Here they are related not only to the artist's intention but also to that of the person commissioning the image. Right and wrong are by no means simplistic. With a foreign, historical painting, answers to these questions may remain contestable. There is inevitably some room for ambiguity regarding any artwork so it seems unlikely that William could be 'completely wrong'. However, there is an idea in his account, of an accepted understanding of the image and the available knowledge surrounding it. This does not simply depend on the intention of the artist, but also on a wider social understanding of the painting, its context, and generally agreed meanings.

At the beginning of the theme, viewers described wanting to generate their own individual, independent responses to the image, considering this a valuable activity. In addition, a co-concern with locating and understanding the 'correct' meaning of the painting (and paintings) also emerged. These two desires were apparently somewhat antithetical; 'understanding' the image involved discerning meanings which agreed with 'objective' or external information. However, the correct way to do this was to reject outside information over forming a personal response.

Cumulatively this suggests that where and how meaning exists (with regard to experiencing art) is conceived dynamically. Meaning is developed through personal responses and so can be fluid or actively constructed. What a painting means is also something which exists independent of the viewer, it can be found or deciphered, but it isn't solely theirs to create.

The second subtheme continues the focus on viewers' concerns with the manor of their viewing, but present in an alternative form.

Subtheme Two: *Getting It Real: The Authenticity of My Response*

Remember Linda told us 'I think this is a painting that calls out for you to just encounter it'? She alluded to the common belief that becoming too aware of received wisdom regarding an image might intrude upon one's experience of it. Conceptions did not only exist regarding the value of 'just' encountering art. The nature of this 'just' encountering was also of considerable concern. The desire to just encounter art came with expectations of what this might feel like, presenting an ongoing conundrum for viewers. To what extent did their desire to 'just' experience it intrude upon their experiences? They wondered, *did I actually feel that or was it just what I wanted to feel?* Such wants were pervaded by concerns with authenticity and legitimacy. The importance of a response being 'real' was apparently just as significant and weighty upon expectations as the importance of it being 'right'.

Here Owen describes the way expectation might cast doubt on experience:

*I know it, I've seen it in reproduction I've read about it so I'm kind of half expecting
I'm half expecting to. . . . Feel like that anyway um um so you bring all that expectation
to bear. Um it's very easy in a sense to go and be awestruck by something like this because you kind of know you're supposed to but you think you're supposed to but I genuinely was*

In this extract, Owen reflects upon a particular type of response to art, that of being 'awestruck'. Rather than describing the experiencing of this response per se, he is interested in how it comes about—the potential for ambiguity in its derivation. The term 'awestruck' is not without notable connotations. 'Struck' suggests an action which happens to the viewer rather than one which the viewer creates or induces. It suggests force and momentum, more something that happens in the moment, than something premeditated. In contrast, Owen suggests that an awestruck reaction to an image may be based upon more than just what is seen in the moment. He describes how the expectation of certain experiences and ideas of an artwork's prestige may potentially contribute to such a response. One might induce feelings of awe or 'go and be awestruck' in response to an image. These awe experiences have a different value and desirability not, it seems, because of how enjoyable they are, but because of something related to their perceived authenticity.

Strong feelings of awe may be induced by the known reputation of a painting or by the feelings it is supposed to evoke. Although not an overt or deliberate process, such feelings are apparently not considered commensurate to an authentic reaction like when 'I genuinely was' for Owen.

Owen suggests reacting to an image as influenced by its reputation is a perfunctory response. Feeling the way you are supposed to 'it's very easy'. This comment could be understood in two ways. First, such responding is passive. The viewer reacts in accordance with the status quo and does not have to actively form their own understanding. Second, Owen talks about the weight of expectation one brings to an image and there is a sense of it being easy to get caught up in this. He uses the bear as in bear down or overwhelm. The type of responding Owen deems less desirable gives an indication of what is considered more desirable, that involving active work and difficulty, notions with which we are more than familiar.

Nora expresses similar sentiments concerning the legitimacy of her responses:

This thing that they talk about the magic of sort of a kind of transcendent moment when you're kind of looking at a piece of art, and because you're kind of a little bit cynical as well you wonder if you're convincing yourself you're having it or you're really having it or it's the art that's doing it or is it just that you kind of want to pass this on um this kind of religious feeling about art this kind of reverence

She similarly describes the desire for certain types of experiences with art. Again, there is contention between 'convincing yourself you're having it or you're really having it'. For

Nora, like Owen, it seems to be the origin of the experience that is important, 'or it's the art that's doing it or is it just that you kind of want to pass this on um this kind of religious feeling about art this kind of reverence.'

Nora differentiates between her desire and the nature of the painting as the primary provocation for her reactions. It is not the content or actual experience of her response which is doubted but rather where it is derived from. Apparently, the origin (or why) of one's reaction, the will of the viewer or the power of the painting, defines its worth. It would be hard to consider the idea of having an experience in order to pass it on like an heirloom frivolous or vacuous, yet Nora suggests that this desire de-authenticates any feelings of reverie.

On the surface, Jay's discussion seems a little different from the previous two. However, he too describes the influence of a specific and desired response upon his eventual reaction:

So for him to have been as it were, um lording and um erm favourably representing the people who were committing that and in charge of it is pretty horrible so that that's the reason um, which is why maybe I want to uh fabricate some er alternative narrative in his court paintings to ensure that I still like him [laughs] But I think it's there! I think it's there

Jay's feelings about Velazquez and his ideas about the artist's political leanings cause him to reflect upon the authenticity of his response. Rather than second-guessing a sense of awe or transcendence (as Nora and Owen did), he appears to question a different legitimacy. Jay is concerned about the authenticity of what he feels is in the painting. He describes an internal friction between desires. Is what he sees as genuine as he wishes, or, is it prejudicially embellished by his additional desire to regard the artist in a positive light?

As with Nora and Owen, there is a struggle or blurring between what in the response is being primarily generated by the image and what is the result of being willed into existence by the viewer. Do I really see and feel it, or do I just want to? How do I tell the difference? We begin to get into a sort of perverted Magritte 'ceci n'est pas une pipe' territory here. What is the difference between convincing oneself that one is having an experience and 'really having it'? More pertinent perhaps may be the question, why is this distinction important to viewers? Is there a performative nature to art viewing, even in a viewer's own private headspace? What is clearer, is that viewers apparently do not uni-linearly respond to art, they respond to their responses. They desire particular responses, and this desire causes self-doubt and questioning of reactions. Experiencing a reaction when engaging with an image sometimes isn't enough to convince a viewer their response is 'real'. There is a collision of the sensuous and the would-be censorious. Potentially this relates to the level of expectation that viewers place upon themselves to encounter art in particular ways (as has pervaded the whole theme).

In this GET, viewers raised notions of the correct way to view paintings which appeared to have multiple implications on their viewing experiences: they evaluated

their viewing against how they felt a painting should be viewed (and this in itself was not straightforward). Of particular concern was the role of extant knowledge and information in viewing. This has clear relevance for a line of research discussed at the beginning of this chapter where considerable efforts have been made to investigate the art–well-being link in the context of gallery displays or curated exhibitions, or to use art to communicate a particular message. In such instances, decisions are made about the amount, type, and mode of information provided to viewers. The findings reported here give insight into viewers' interactions with such material and with notions of the knowledge one might have about an image, and how their responses and experiences might then be shaped for better or worse. Ideas about the 'work' one ought to do when viewing a painting and the effort that should be involved were sometimes associated with notions of regret or self-admonishment if viewing was undertaken differently. Viewers also discussed the notion of 'the right answer' to a painting. Although an internal, independent generation of understanding was previously valued, getting it wrong in relation to perceived orthodoxies was also possible and something viewers aspired to avoid. Arriving at these correct understandings was felt to be an achievement and considered a measure of successful viewing.

Notions of 'Is there a right way to view this painting?', 'Have I understood the painting correctly?', 'Is my reaction authentic?', contributed to a multi-layered and dynamic responding as demonstrated in this extract from Nora:

> *Coming in here and thinking maybe I'll say the wrong thing, to which you're inclined to say there isn't a wrong thing but that's not going to convince me. I know that there are ways to look at paintings which er which you know kind of, having the knowledge is gonna.*
>
> *Although there's no wrong thing to say, you can say you don't like a painting or you do like a painting but um but knowing about it is going to make that count more, mean more, to you. And that's the important thing, I think it's what art like this can give you personally, and I think it can give you more if you know more.*

Nora's comments are packed with the interplay of competing demands and ideas. She describes the contrasting notions of 'maybe I'll say the wrong thing' and 'there isn't a wrong thing' and fluctuates between one view and the other explaining 'that's not going to convince me' and 'there's no wrong thing to say'.

The rightness of responses is measured according to several standards. The right thing relates to knowledge and knowing how to look at paintings, but there is also the consideration of a painting meaning something and what it 'can give you personally'. For Nora, experiences with art can count more or less and this depends on whether certain conditions are met. The experience may be more personally meaningful when it is an informed one. To like or dislike a painting may be part of a subjective response and yet is similarly dependent on external 'objective' ideas and 'knowing about it'. These interactions, between how meaningful an experience might be and what knowledge, expectations, or actions inform it, echo sentiments about authenticity described in the

first subtheme. Feeling one's experience with art is authentic and valid appears to involve an inter-tangling of notions of personal significance and intellectual understanding.

Ultimately this GET is characterized by such evaluations of authenticity via a constant interplay between different forms and locations of 'meaning' (in relation to art). Meaning as pre-existing, associated with the painting and its context, real, and something that can be found and understood. Meaning as something that can, and should, be created by the viewer, from themselves and by themselves. Authentic responding then involves a constant negotiation been the internal and external as location of meaning.

Notions of authenticity become particularly pertinent in the context of well-being, the relationship between the two having generated a significant body of research (Galinha et al., 2022; Sutton, 2020; Wood et al., 2008). Despite this, and the strong association between aesthetic engagement and well-being, research regarding authenticity in art-viewing has retained a somewhat restrictive focus tending to be concerned with the perceived authenticity of art-objects (e.g., Grüner et al., 2019; Locher et al., 2015; Specker et al., 2021).

Not only do both aesthetic and authentic experience have large bodies of research connecting them to well-being, both areas have been subject to criticism concerning construct definition and the challenges of experimental measure. Similar to the complicated task of defining art or art-viewing in order to measure it as described in the introduction, questions have been raised as to whether research concerning authenticity inadvertently taps into other positive self-assessments or indeed how we might know when we truly know ourselves (Rivera et al., 2019). Both areas arguably involve the complex subjectivity which is particularly challenging to measure and quantify, invoking questions as to the extent to which experimental designs inhibit understanding through the necessity to treat as independent, a human consciousness which is always conscious of something?

These issues are not to be taken as a reason to abandon exploration; we have seen the benefits of applying qualitative approaches such as IPA to art-viewing research and the associated insights into well-being, and it has been argued this may be similarly applied to understanding authenticity. Wilt et al. (2019) for example suggest bottom-up approaches may be particularly useful in facilitating exploration of experiences of authenticity and help counter the restrictions of analysis shaped by a priori concepts and Rivera et al. (2019, 113) stress the importance of studying 'subjective feelings of authenticity'. Subjective feelings are, as described, a central concern in IPA, as is the inductive approach to exploring them. This, with the privileging of idiography and attention to convergence and divergence allows us to get insight into human mental life even if it defies or resists our original conceptions and definitions. By taking into account and embracing sense-making, space is made for new or different senses to emerge.

The findings described here suggested an interplay of reactions: how we feel about a painting, how we feel viewing a painting, how we feel about viewing a painting, and how we feel about ourselves. This implication of subjective authenticity and self-knowledge as important in shaping experiences could be further pursued by using IPA to explore

disruptive or transformational viewings, experiences of looking at surreal or abstract works, or continuing research such as that of Morrey et al. (2022, 1) where IPA is used in combination with looking at images to facilitate access to tacit experiences 'which may not have been articulated or recognised.'

More broadly, the descriptions of encounters with paintings reported here tell us something of what it is like to look at art, which seems crucial to developing our understanding of how that might make us feel good, nourished, or enriched. They indicate the potential nuance and complexity of a viewer's relationship with the viewed and perhaps even a little of what being a person in the world is like. Continuing to pursue investigation of the experience of viewing art has the potential to provide insights into many aspects of human experience, such as how we respond to others, our emotionality, and the nature of our creative and abstract thought processes. Hickman (2005, 13) writes 'The concept of art does not reside in art objects but in the minds of people.' In this sense, exploring our encounters with art is unavoidably an exploration of human being, and thus has great potential to further our understanding of and so enhance the relationship between artistic engagement and well-being.

Notes

1. And indeed well-being, discussion of which is beyond the bounds of this chapter, but see for example Alexandrova (2021).
2. Thematic Analysis is a qualitative method developed by Virginia Braun and Victoria Clarke; see Braun and Clarke (2006) for an overview.
3. See Josselson and Hammack (2021) for further information regarding Narrative Analysis.
4. Q-methodology is a mixed qualitative and quantitative methodology devised by William Stephenson in 1930; see Stephenson (1993).
5. The analytic process involved in IPA is outlined in 'Essentials of Interpretative Phenomenological Analysis' (Smith & Nizza, 2021) and 'Interpretative Phenomenological Analysis' (Smith et al., 2022).
6. Smith (2011) also offers criteria for quality assessment in IPA and additional guidance is detailed in Nizza et al. (2021).
7. The first GET 'The Gaze' is detailed in Starr and Smith (2021) and the second GET 'Meaning-Making: Interpretative Content' in Starr and Smith (2022).
8. The terms 'objective' and 'subjective' are used here not to designate 'fact' from 'opinion'. Rather they should be taken to suggest external, commonly agreed-upon perspectives and internal personal ideas and interpretations.

References

Aldridge, D. (1993). Music therapy research 1: A review of the medical research literature within a general context of music therapy research. *The Arts in Psychotherapy* 20(1), 11–35. https://doi.org/10.1016/0197-4556(93)90029-2

Alexandrova, A. (2021). *A philosophy for the science of well-being* (reprint edition). Oxford University Press.

An, D., Jeong, B., & Youn, N. (2022). Effects of art consumption on consumer well-being. *Journal of Consumer Affairs* 56(2), 685–702. https://doi.org/10.1111/joca.12429

Attard, A., Larkin, M., Boden, Z., & Jackson, C. (2017). Understanding adaptation to first episode psychosis through the creation of images. *Journal of Psychosocial Rehabilitation and Mental Health* 4(1), 73–88. https://doi.org/10.1007/s40737-017-0079-8

Averbach, J., & Monin, J. (2022). The impact of a virtual art tour intervention on the emotional well-being of older adults. *The Gerontologist* 62(10), 1496–1506. https://doi.org/10.1093/geront/gnac089

Barnett, T., de Deuge, J., & Bridgman, H. (2019). Promoting mental health through a rural art roadshow: Perspectives of participating artists. *International Journal of Mental Health Systems* 13(1), 44. https://doi.org/10.1186/s13033-019-0302-y

Binnie, J. (2010). Does viewing art in the museum reduce anxiety and improve wellbeing? *Museums & Social Issues* 5(2), 191–201. https://doi.org/10.1179/msi.2010.5.2.191

Braun, V., & Clarke, V. (2006). Using thematic analysis in psychology. *Qualitative Research in Psychology* 3(2), 77–101. https://doi.org/10.1191/1478088706qp063oa

Brook, L. (2022). Evaluating the emotional impact of environmental artworks using Q methodology. *Athens Journal of Humanities & Arts* 9(3), 211–232. https://doi.org/10.30958/ajha.9-3-2

Camic, P. M., Tischler, V., & Pearman, C. H. (2014). Viewing and making art together: A multi-session art-gallery-based intervention for people with dementia and their carers. *Aging & Mental Health* 18(2), 161–168. https://doi.org/10.1080/13607863.2013.818101

Cheung, M.-C., Law, D., Yip, J., & Wong, C. W. Y. (2019). Emotional responses to visual art and commercial stimuli: Implications for creativity and aesthetics. *Frontiers in Psychology, 10*. www.frontiersin.org/articles/10.3389/fpsyg.2019.00014

Colbert, S., Cooke, A., Camic, P. M., & Springham, N. (2013). The art-gallery as a resource for recovery for people who have experienced psychosis. *The Arts in Psychotherapy* 40(2), 250–256. https://doi.org/10.1016/j.aip.2013.03.003

Cotter, K., Harrouche, M., Rodriguez-Boerwinkle, R., Boerwinkle, M., Silvia, P., & Pawelski, J. (2022). Virtual art visits: Examining the effects of slow looking on well-being in an online environment. *Psychology of Aesthetics, Creativity, and the Arts*. https://doi.org/10.1037/aca0000548

Csíkszentmihályi, M., & Robinson, R. E. (1990). *The art of seeing: An interpretation of the aesthetic encounter* (illustrated ed.). Getty Publications.

Curtis, A., Gibson, L., O'Brien, M., & Roe, B. (2018). Systematic review of the impact of arts for health activities on health, wellbeing and quality of life of older people living in care homes. *Dementia* 17(6), 645–669. https://doi.org/10.1177/1471301217740960

Daykin, N., Byrne, E., Soteriou, T., & O'Connor, S. (2008). Review: The impact of art, design and environment in mental healthcare: A systematic review of the literature. *Journal of the Royal Society for the Promotion of Health* 128(2), 85–94. https://doi.org/10.1177/1466424007087806

Djikic, M., Oatley, K., Zoeterman, S., & Peterson, J. B. (2009). On being moved by art: How reading fiction transforms the self. *Creativity Research Journal* 21(1), 24–29. https://doi.org/10.1080/10400410802633392

Eatough, V., & Smith, J. A. (2017). Interpretative phenomenological analysis. In C. Willig & W. Stainton-Rogers (Eds.), *The Sage Handbook of Qualitative Research in Psychology* (2nd ed., pp. 193–211). Sage.

Finlay, L. (2014). Engaging phenomenological analysis. *Qualitative Research in Psychology* 11(2), 121–141. https://doi.org/10.1080/14780887.2013.807899

Funch, B. S. (1997). *The psychology of art appreciation*. Museum Tusculanum Press.

Galinha, I. C., Balbino, I. F., Devezas, M. Â., & Trigo, B. R. (2022). Authenticity is associated with psychological and subjective well-being: Convergence between the self-report and informant's report. *The Journal of Humanistic Counseling* 63(2), 77–96. https://doi.org/10.1002/johc.12173

Gelo, F., Klassen, A. C., & Gracely, E. (2015). Patient use of images of artworks to promote conversation and enhance coping with hospitalization. *Arts & Health: An International Journal of Research, Policy and Practice* 7(1), 42–53. https://doi.org/10.1080/17533015.2014.961492

Grüner, S., Specker, E., & Leder, H. (2019). Effects of context and genuineness in the experience of art. *Empirical Studies of the Arts* 37(2), 138–152. https://doi.org/10.1177/0276237418822896

Harris, M. W., Barnett, T., & Bridgman, H. (2018). Rural art roadshow: A travelling art exhibition to promote mental health in rural and remote communities. *Arts & Health* 10(1), 57–64. https://doi.org/10.1080/17533015.2016.1262880

Hickman, R. (2005). *Why we make art and why it is taught*. Intellect.

Hogan, S. (2001). *Healing arts: The history of art therapy*. Jessica Kingsley Publishers.

Innocent, T., & Stevens, Q. (2021). Urban play as catalyst for social wellbeing post-pandemic. *Frontiers in Computer Science*, 3. https://www.frontiersin.org/articles/10.3389/fcomp.2021.634145

Johnson, J., Culverwell, A., Hulbert, S., Robertson, M., & Camic, P. M. (2017). Museum activities in dementia care: Using visual analog scales to measure subjective wellbeing. *Dementia* 16(5), 591–610. https://doi.org/10.1177/1471301215611763

Josselson, R., & Hammack, P. L. (2021). *Essentials of narrative analysis*. American Psychological Association. www.apa.org/pubs/books/essentials-narrative-analysis

Kaimal, G., Gonzaga, A. M. L., & Schwachter, V. (2017). Crafting, health and wellbeing: Findings from the survey of public participation in the arts and considerations for art therapists. *Arts & Health* 9(1), 81–90. https://doi.org/10.1080/17533015.2016.1185447

Karkou, V., Oliver, S., & Lycouris, S. (2017). *The Oxford handbook of dance and wellbeing*. Oxford University Press.

Karnik, M., Printz, B., & Finkel, J. (2014). A hospital's contemporary art collection: Effects on patient mood, stress, comfort, and expectations. *Health Environments Research & Design Journal* 7(3), 60–77. https://doi.org/10.1177/193758671400700305

Koh, E., & Shrimpton, B. (2014). Art promoting mental health literacy and a positive attitude towards people with experience of mental illness. *International Journal of Social Psychiatry* 60(2), 169–174. https://doi.org/10.1177/0020764013476655

Kuchinke, L., Trapp, S., Jacobs, A. M., & Leder, H. (2009). Pupillary responses in art appreciation: Effects of aesthetic emotions. *Psychology of Aesthetics, Creativity, and the Arts* 3(3), 156–163. https://doi.org/10.1037/a0014464

Lagerspetz, M. (2016). Lay perceptions of two modern artworks. *Art & Perception*, 4(1–2), 107–125. https://doi.org/10.1163/22134913-00002047

Larkin, M., & Thompson, A. R. (2011). Interpretative phenomenological analysis in mental health and psychotherapy research. In D. Harper & A. R. Thompson (eds.), *Qualitative research methods in mental health and psychotherapy: A guide for students and practitioners* (pp. 101–116). John Wiley & Sons, Ltd. https://doi.org/10.1002/9781119973249

Law, M., Karulkar, N., & Broadbent, E. (2021). Evidence for the effects of viewing visual artworks on stress outcomes: A scoping review. *BMJ Open* 11(6), e043549. https://doi.org/10.1136/bmjopen-2020-043549

Leder, H., Belke, B., Oeberst, A., & Augustin, M. D. (2004). A model of aesthetic appreciation and aesthetic judgments. *British Journal of Psychology 95*, 489–508. https://doi.org/10.1348/0007126042369811

Leder, H., Gerger, G., Brieber, D., & Schwarz, N. (2014). What makes an art expert? Emotion and evaluation in art appreciation. *Cognition and Emotion 28*(6), 1137–1147. https://doi.org/10.1080/02699931.2013.870132

Lee, C. J., & Northcott, S. J. (2021). Art for health's sake: Community art galleries as spaces for well-being promotion through connectedness. *Annals of Leisure Research 24*(3), 360–378. https://doi.org/10.1080/11745398.2020.1740602

Locher, P., Krupinski, E., & Schaefer, A. (2015). Art and authenticity: Behavioral and eye-movement analyses. *Psychology of Aesthetics Creativity and the Arts 9*(4), 356–367. https://doi.org/10.1037/aca0000026

Lomas, T. (2016). Positive art: Artistic expression and appreciation as an exemplary vehicle for flourishing. *Review of General Psychology 20*(2), 171–182. https://doi.org/10.1037/gpr0000073

Manen, M. van. (2016). *Researching lived experience: Human science for an action sensitive pedagogy*. Routledge.

Margrove, K. L. (2015). Promoting the wellbeing and social inclusion of students through visual art at university: An open arts pilot project. *Journal of Further and Higher Education 39*(2), 147–162. https://doi.org/10.1080/0309877X.2013.778967

Marín-Morales, J., Higuera-Trujillo, J. L., Greco, A., Guixeres, J., Llinares, C., Gentili, C., Scilingo, E. P., Alcañiz, M., & Valenza, G. (2019). Real vs. immersive-virtual emotional experience: Analysis of psycho-physiological patterns in a free exploration of an art museum. *PLoS ONE 14*(10), e0223881. https://doi.org/10.1371/journal.pone.0223881

Mastandrea, S., Fagioli, S., & Biasi, V. (2019). Art and psychological well-being: Linking the brain to the aesthetic emotion. *Frontiers in Psychology 10*, 739. https://doi.org/10.3389/fpsyg.2019.00739

Mastandrea, S., Maricchiolo, F., Carrus, G., Giovannelli, I., Giuliani, V., & Berardi, D. (2019). Visits to figurative art museums may lower blood pressure and stress. *Arts & Health 11*(2), 123–132. https://doi.org/10.1080/17533015.2018.1443953

McKeown, E., Weir, H., Berridge, E.-J., Ellis, L., & Kyratsis, Y. (2016). Art engagement and mental health: Experiences of service users of a community-based arts programme at Tate Modern, London. *Public Health 130*, 29–35. https://doi.org/10.1016/j.puhe.2015.09.009

Morrey, T., Larkin, M., & Rolfe, A. (2022). 'Screaming isolation' when is a chair more than a chair? Photographic encounters, IPA and capturing out of awareness experiencing: A novel approach to working with temporal, spatial and embodied dimensions. *Qualitative Research in Psychology 19*(4), 1064–1093. https://doi.org/10.1080/14780887.2021.2001704

Nanda, U., Eisen, S., Zadeh, R. S., & Owen, D. (2011). Effect of visual art on patient anxiety and agitation in a mental health facility and implications for the business case. *Journal of Psychiatric and Mental Health Nursing 18*(5), 386–393. https://doi.org/10.1111/j.1365-2850.2010.01682.x

Nielsen, S. L., Fich, L. B., Roessler, K. K., & Mullins, M. F. (2017). How do patients actually experience and use art in hospitals? The significance of interaction: A user-oriented experimental case study. *International Journal of Qualitative Studies on Health and Well-Being 12*(1). https://doi.org/10.1080/17482631.2016.1267343

Nizza, I. E., Farr, J., & Smith, J. A. (2021). Achieving excellence in interpretative phenomenological analysis (IPA): Four markers of high quality. *Qualitative Research in Psychology 18*(3), 369–386. https://doi.org/10.1080/14780887.2020.1854404

Oguda, B. G. A., Vikiru, G., & Wasanga, C. (2021). Effect of viewing emotionally laden paintings on attitudes of male sex offenders. *International Journal of Multicultural and Multireligious Understanding 8*(2), Article 2. https://doi.org/10.18415/ijmmu.v8i2.2461

On Tam, C. (2008). Understanding the inarticulateness of museum visitors' experience of paintings: A phenomenological study of adult non-art specialists. *Indo-Pacific Journal of Phenomenology 8*(2), 1–11. https://doi.org/10.1080/20797222.2008.11433967

Pelowski, M. (2015). Tears and transformation: Feeling like crying as an indicator of insightful or 'aesthetic' experience with art. *Frontiers in Psychology 6*. https://www.frontiersin.org/articles/10.3389/fpsyg.2015.01006

Pelowski, M., & Akiba, F. (2011). A model of art perception, evaluation and emotion in transformative aesthetic experience. *New Ideas in Psychology 29*(2), 80–97. https://doi.org/10.1016/j.newideapsych.2010.04.001

Poerio, G. L., & Totterdell, P. (2020). The effect of fiction on the well-being of older adults: A longitudinal RCT intervention study using audiobooks. *Psychosocial Intervention 29*(1), 29–37. Article 1.

Reavey, P., & Johnson, K. (2017). Visual approaches: Using and interpreting images. In C. Willig & W. S. Rogers (Eds.), *The SAGE handbook of qualitative research in psychology* (2nd ed., pp. 354–373). Sage.

Riches, S., Maskey, R., Dishman, P., Benjamin MBE, J., Waddingham, R., Tebrook, C., Mundy, E., Roberts, P., & Fisher, H. L. (2019). Development, implementation and evaluation of altered states of consciousness: An immersive art exhibition designed to increase public awareness of psychotic experiences. *Arts & Health 11*(2), 104–122. https://doi.org/10.1080/17533015.2018.1443948

Ricoeur, P. (1970). *Freud and philosophy: An essay on interpretation*. Yale University Press.

Rivera, G. N., Christy, A. G., Kim, J., Vess, M., Hicks, J. A., & Schlegel, R. J. (2019). Understanding the relationship between perceived authenticity and well-being. *Review of General Psychology 23*(1), 113–126. https://doi.org/10.1037/gpr0000161

Roald, T. (2007). *Cognition in emotion: An investigation through experiences with art*. Rodopi.

Roald, T. (2008). Toward a phenomenological psychology of art appreciation. *Journal of Phenomenological Psychology 39*(2), 189–212. https://doi.org/10.1163/156916208X338783

Roald, T. (2015). *The subject of aesthetics: A psychology of art and experience*. Brill. https://brill.com/view/title/32602

Roald, T., & Køppe, S. (2015). Sense and subjectivity. Hidden potentials in psychological aesthetics. *Journal of Theoretical and Philosophical Psychology 35*(1), 20–34. https://doi.org/10.1037/a0038435

Roberts, S., Camic, P. M., & Springham, N. (2011). New roles for art galleries: Art-viewing as a community intervention for family carers of people with mental health problems. *Arts & Health 3*(2), 146–159. https://doi.org/10.1080/17533015.2011.561360

Schindler, I., Hosoya, G., Menninghaus, W., Beermann, U., Wagner, V., Eid, M., & Scherer, K. R. (2017). Measuring aesthetic emotions: A review of the literature and a new assessment tool. *PLoS ONE, 12*(6). http://doi.org/10.1371/journal.pone.0178899

Smiraglia, C. (2014). Artworks at work: The impacts of workplace art. *Journal of Workplace Learning 26*(5), 284–295. https://doi.org/10.1108/JWL-11-2013-0097

Smith, J. A. (2004). Reflecting on the development of interpretative phenomenological analysis and its contribution to qualitative research in psychology. *Qualitative Research in Psychology 1*(1), 39–54. https://doi.org/10.1191/1478088704qp004oa

Smith, J. A. (2011). Evaluating the contribution of interpretative phenomenological analysis. *Health Psychology Review 5*(1), 9–27. https://doi.org/10.1080/17437199.2010.510659

Smith, J. A., Flowers, P., & Larkin, M. (2022). *Interpretative phenomenological analysis: Theory, method and research* (2nd ed.). Sage.

Smith, J. A., & Nizza, I. E. (2021). *Essentials of interpretative phenomenological analysis*. American Psychological Association.

Smith, J. A., & Osborn, M. (2008). Interpretative phenomenological analysis. In J.A, Smith (Ed) *Qualitative psychology: A practical guide to research methods* (2nd ed., pp. 51–80). Sage.

Specker, E., Fekete, A., Trupp, M. D., & Leder, H. (2021). Is a 'real' artwork better than a reproduction? A meta-analysis of the genuineness effect. *Psychology of Aesthetics, Creativity, and the Arts* 17(3), 294–306. https://doi.org/10.1037/aca0000399

Staricoff, R. L. (2006). Arts in health: The value of evaluation. *Journal of the Royal Society for the Promotion of Health* 126(3), 116–120. https://doi.org/10.1177/1466424006064300

Starr, R. A., & Smith, J. A. (2021). 'People are gazing'—An interpretative phenomenological analysis of viewing Velázquez. *Art & Perception* 9(3), 241–259. https://doi.org/10.1163/22134 913-bja10027

Starr, R. A., & Smith, J. A. (2023). Making sense of an artwork: An interpretative phenomenological analysis of participants' accounts of viewing a well-known painting. *Qualitative Psychology* 10(1), 107–120. https://doi.org/10.1037/qup0000231

Stephenson, W. (1993). Introduction to Q-methodology. *Operant Subjectivity* 17(1/2), 1–13.

Stuckey, H. L., & Nobel, J. (2010). The connection between art, healing, and public health: A review of current literature. *American Journal of Public Health* 100(2), 254–263. https://doi.org/10.2105/AJPH.2008.156497

Sutton, A. (2020). Living the good life: A meta-analysis of authenticity, well-being and engagement. *Personality and Individual Differences* 153, 109645. https://doi.org/10.1016/j.paid.2019.109645

Šveb Dragija, M., & Jelinčić, D. A. (2022). Can museums help visitors thrive? Review of studies on psychological wellbeing in museums. *Behavioral Sciences* 12(11), 458. https://doi.org/10.3390/bs12110458

Tinio, P. P. L., & Gartus, A. (2018). Characterizing the emotional response to art beyond pleasure: Correspondence between the emotional characteristics of artworks and viewers' emotional responses. In J. F. Christensen & A. Gomila (eds.), *Progress in brain research* (vol. 237, pp. 319–342). Elsevier. https://doi.org/10.1016/bs.pbr.2018.03.005

Tischler, V. (2018). 'It takes me into another dimension': An evaluation of mental health-themed exhibitions in outdoor urban areas. *Arts & Health* 10(1), 1–16. https://doi.org/10.1080/17533015.2016.1233440

Tomlinson, A., Lane, J., Julier, G., Grigsby Duffy, L., Payne, A., Mansfield, L., Kay, T., John, A., Meads, C., Daykin, N., Ball, K., Tapson, C., Dolan, P., Testoni, S., & Victor, C. (2018). *A systematic review of the subjective wellbeing outcomes of engaging with visual arts for adults ('working-age', 15-64 years) with diagnosed mental health conditions* [Research Report or Working Paper]. What Works Centre for Wellbeing. Available at: https://whatworkswellbeing.org/resources/visual-art-and-mental-health/

Trupp, M., Bignardi, G., Chana, K., Specker, E., & Pelowski, M. (2021). *Can a brief interaction with online, digital art improve wellbeing? A comparative study of the impact of online art and culture presentations on mood, state-anxiety, subjective wellbeing, and loneliness*. PsyArXiv. https://doi.org/10.31234/osf.io/93atj

Tyack, C., Camic, P. M., Heron, M. J., & Hulbert, S. (2017). Viewing art on a tablet computer: A well-being intervention for people with dementia and their caregivers. *Journal of Applied Gerontology* 36(7), 864–894. https://doi.org/10.1177/0733464815617287

Velázquez, D. (1656). *Las Meninas* [Oil on canvas]. Available at: www.museodelprado.es/en/the-collection/art-work/las-meninas/9fdc7800-9ade-48b0-ab8b-edee94ea877f

Wilt, J. A., Thomas, S., & McAdams, D. P. (2019). Authenticity and inauthenticity in narrative identity. *Heliyon* 5(7), e02178. https://doi.org/10.1016/j.heliyon.2019.e02178

Wood, A. M., Linley, P. A., Maltby, J., Baliousis, M., & Joseph, S. (2008). The authentic personality: A theoretical and empirical conceptualization and the development of the Authenticity Scale. *Journal of Counseling Psychology* 55, 385–399. https://doi.org/10.1037/0022-0167.55.3.385

Zarobe, L., & Bungay, H. (2017). The role of arts activities in developing resilience and mental wellbeing in children and young people: A rapid review of the literature. *Perspectives in Public Health* 137(6), 337–347. https://doi.org/10.1177/1757913917712283

CHAPTER 38

PSYCHOANALYSIS AS AN ART OF MEETING THE OTHER

Now Moments, Moving Along, and the Possibility of Change

TIMO STORCK AND RAINER M. HOLM-HADULLA

Introduction

SIGMUND Freud, the founder of psychoanalysis was a pioneer in interdisciplinary research. Deeply rooted in the natural sciences and neurology, in 1895 he published a model of the 'psychic apparatus' that focuses on the integration of emotions and cognitions—he talked about 'Affekt' (affect) and 'Vorstellung' (mental representation) (Freud, 1895a). A certain amount of coherence between affect and representation as well as between inner and outer reality seems to be necessary to control chaotic impulses and to behave in a rational way. It was one of his most influential intuitions that rational behaviour results out of a dynamic interaction between Id, Ego, and Super-Ego. Today, we would tentatively set this model in relation to the interconnectivity between neuronal networks in the limbic system, hippocampus /amygdala region, and prefrontal cortex (see Carhart-Harris & Friston, 2010). Soon afterwards, Freud (1895b) learned from his patients that their psychopathological symptoms didn't disappear through direct manipulations of the brain but rather through the development of coherent narratives. Consequently, Freud immersed himself in cultural studies to elaborate his theory and practice. His most famous patient Anna O., who became famous as the women's rights activist Bertha Pappenheim, coined the term 'talking cure'. In the cure, the patient evokes in the psychoanalyst memories, fantasies, and feelings etc. These sensations should be worked through and understood by the analyst and afterwards shared with the patient in an elaborated narrative form. Thus, therapy becomes a special form of aesthetics, hermeneutics, and rhetorics (Gadamer, 1977; Ricoeur, 1981; Holm-Hadulla,

2003, 2004, 2017). Not to forget, that until his latest writings (e.g., 1940) Freud held a firm natural scientific stance as well as a cultural one.

Aesthetic experience is essential in human development from the beginning. Freud focuses on children's playing: 'Might we not say that every child behaves like a creative writer, in that he creates a world of his own …' (1908, 143). The pediatrician and psychoanalyst Donald W. Winnicott (1971) elaborated on the therapeutic function of play as a transitional space between external and internal reality. Following Melanie Klein, Donald Meltzer (1988) and Hanna Segal (1991) state that aesthetic forms are necessary to shape archaic affects and to overcome destructiveness. In this respect Christopher Bollas (1992) refers to an actual biological need for aesthetic shaping. How can we conceive of such creative shaping processes when it comes to those kinds of 'meetings' that psychodynamic psychotherapy as well as aesthetic experience have to offer?

Moments

The authors grouped together under the term Boston Change Process Study Group (BCPSG) put emphasis on the conception of an 'implicit relational knowing' both in mental development and in psychotherapeutic processes. They propose a layer in the experience and formation of contact to others which operates outside of conscious, verbal awareness, or reflection while still being at the core of how we view ourselves and others in terms of relating. The dynamics of relating to others have to do with temporality, embodiment, and interpersonality.

The authors resort to various concepts and models from developmental psychology, first and foremost the idea of 'attunement' between infant and caregiver. Both persons modulate and 'agree' upon certain types of interaction, bodily and affectively. This is an interpersonal process of tuning in that can serve as a blueprint for internalization and representation. 'Tuning in', however, is not to say that it is all about harmonious processes and finding the right swing; moreover, successful attunement at the same time makes it possible to partially move away from each other, it allows an 'open space' for development and relations to emerge (Sander, 1987). In such attunement, 'rhythmization' is pivotal (cf. Hamburger, 2018; Leikert, 2017). We will discuss the major concepts at play in BCPSG's thinking.

Vitality Affects

Part and parcel of this process are vitality affects (cf. Stern, 2004, 55ff.), which are to be understood as 'subjective experiences', consisting of the 'temporal dynamics of changes in feelings consisting of analogic shifts, split second by split second in real time, of affects, thoughts, perceptions, or sensations'. Vitality affects are 'synonymous' with 'temporal feeling shapes, feeling shapes or temporal shapes'. Thus, Stern uses the term 'temporal

contours' (244). These 'temporal contours' are transposed into 'feeling contours', which shows the pivotal role of movement and process (no wonder the authors rely on dynamic systems theory as well as on psychoanalysis[1]). Stern (1992) also coins the term 'pre-narrative envelopes' to denote the interplay of temporality, mutuality, and 'narration' of lived life. Vitality affects are to be felt by means of an intentional flow of feelings and they create a dramatic line of tension that gives coherence to the unfolding of a present moment. Thus, vitality affects provide the present moment with the dramatic character of a 'lived (micro-) story' (Stern, 2004, 244). Later, Stern (2010) explored 'forms of vitality' (these hold special relevance in the Arts, especially dance, theatre, and film music as 'time-based arts' (Stern, 2010, 75ff.; e.g., filmic shots are understood as present moments).

Forms of vitality are what bring life to narratives of implicit relational knowing and offer access to it. They are part of an implicit relational knowing and have a meta-modal character with regard to different areas of sensual perception and experience. They are conceived of as temporal/dynamic, as a pentad of movement, time, force, space, and intention. Stern thinks of vitality as a gestalt, something undivided (Stern, 2010, 3ff.). Thus, shared play can be a play with vitality forms (99ff.).

Present Moments

Present moments, as conceived by the BCPSG, have to do with the subjective perspective on identity and temporality, with experiencing a 'subjective now' (caveat! This is not yet what a now moment is all about; see below). Although present moments do not appear in permanent succession at all times, they are not rare. They come into being as soon as we neither simply reminisce the past nor anticipate what lies ahead. We are 'in the moment' (disturbances in this way of living in the moment can be found in ways of experiencing temporality in depression). Present moments are about the experience of an 'uninterrupted now', they are structured 'as a micro-lived story with a minimal plot and a life of dramatic tension made up of vitality affects'. Thus, they are 'the basic building block of relationship experience' (Stern, 2004, 245). Present moments are about being aware of all that which is part of the moment we live in.

Links between or successions of present moments constitute implicit relational knowing, a stream of subjective now which can only be described as interpersonal segments that are both affective and interpersonal. Implicit relational knowing 'typically operates outside focal attention and conscious experience'. The authors view it as a 'construct that raises "internal object relations" to a more general representational systems conception', where 'affect, fantasy, behavioral, and cognitive dimensions' are integrated (Lyons-Ruth et al., 1998, 285).

Moving Along

The interpersonal level in present moments shows itself in processes of micro regulation. Within present moments, there is a 'negotiating and defining of the intersubjective

environment' (Stern et al., 1998, 910), which is called 'moving along'. Moving along can be understood as a 'process that subjectively is divided into moments of different quality and function that we call "present moments"' (Stern et al., 1998, 303, likens this to 'pure improvisation'). Present moments 'are the steps of the moving along process' (Stern et al., 1998, 911). A present moment 'is a unit of dialogic exchange that is relatively coherent in content, homogeneous in feeling and oriented in the same direction towards a goal' (Stern et al., 1998, 910f.). To the ones partaking in a present moment, these strike as familiar because present moments are about repetition of patterns with little variation. This is how implicit relational knowing forms itself, or, in other terms: 'Representations of Interactions that have been Generalized' (RIGs; see Stern, 1985).

Now Moments

Then again, now moments serve as a distinct form of present moments (Stern et al., 1998, 911), they are 'hot' present moments (Stern et al., 1998, 304), 'disruptive moments' (BCPSG, 2013, 736). For both persons involved, now moments are disturbing because common and familiar patterns are called into question; there is something unforeseen, some sort of new potential for process, meeting, and change. In case present moments can become '"hot" affectively', they turn into now moments (Stern et al., 1998, 909). They do so in a certain way, because in now moments the 'habitual framework—the known, familiar intersubjective environment of the therapist-patient relationship—has all of a sudden been altered or risks alteration' (Stern et al., 1998, 911). The state of (implicit) relating is on the line, there is a disruption and a need to react to it. The major difference between now moments and present moments (of which the former are a subcategory) is that now moments are not part of a sound succession of (present) moments but something alien in the linkage of subjective now—unfamiliar, disturbing, uncanny.

Stern et al. (1998, 912) differentiate three phases of a now moment: First, the 'pregnancy phase' (the feeling of imminence); second, the 'weird phase' (the feeling of something unknown and unexpected entering the intersubjective space); and third, the 'decision phase' that decides whether a now moment is being seized and thus a moment of meeting (see below) can follow—or is missed. In a now moment, there is a prescience of a 'potential emergent property of a complex dynamic system' (912), a change in implicit relational knowing. A now moment functions at a 'threshold to an emergent property of the interaction' (912), it is a moment that 'challenges or threatens the stability of the ongoing initial state' (Stern et al., 1998, 304). The intersubjective state is pushed 'into a zone of transition that is unstable' (305). Hamburger (2019, 248; translated by the authors) writes: 'The capacity to think (about) the other and oneself develops by walking through despair.'

Moments of Meeting

Now moments can turn into moments of meeting, in case there is something happening between the two people involved which is sustainable and can be remembered, that is,

in case both answer to the now moment 'with an authentic, specific, personal response' (Stern et al., 1998, 909), that is, the now moment is 'seized and mutually realised' (913). Moments of meeting are 'the emergent property of the "moving along" process that alters the intersubjective environment, and thus the implicit relational knowing' (909). This can be described both developmentally and clinically—moments of meeting are special turning points in which connecting/linkage can lead to an emotional understanding and therefore to change. Moments of meeting are a way to re-arrange implicit relational knowing (which can either be successful or not!). Thus, the moment of meeting is described as 'the basic unit of subjective change in the domain of "implicit relational knowing"' (Stern et al., 1998, 906). It 'captures the subjective experience of a sudden shift in implicit relational knowing for both analyst and patient' (909). Key to this, as is in developmental processes, is some sort of 'mutual regulation of state' (908). This is what constitutes relating and its mental representation.

It is noteworthy that the relational events described here are marked by passivity, tolerance for uncertainty, and a state of expectancy. The persons partaking commit themselves to what is happening. Intersubjective meeting is understood as something they need to let happen (cf. Schneider's (2020) proposal of a 'Losigkeit'/lessness in psychoanalysis).

By means of present moments, now moments and moments of meetings implicit relational knowing can be experienced and change becomes possible—in interpersonal interaction. Relational knowing can only be felt by means of concrete 'enacted' relating. It only develops through interactional, intersubjective processes (Stern, 2010).

What does the other in these kinds of relating have to offer? Entering in an affective dialogue requires the capacity to lend oneself to what meeting brings along, to tune in and build contact by means of a moving along with mindful intuition. The therapeutic process in psychoanalysis calls for maintaining a stance of reverie and containment, of role responsiveness and affective resonance and the capacity of metabolizing that which is yet formless (in terms of mental representation).

Stern (2004) developed an interview instrument to assess present moments. Furthermore, some empirical trials have been conducted on microprocesses in psychotherapy, in the broader context of BCPSG's concepts (cf. Buchholz, 2018; Hamburger, 2018)—but also with witnesses of social trauma (Hamburger & Heberlein, 2018) or on artistic/aesthetic processes (Stankovic et al., 2018, on Pina Bausch and dance performances). In this, Hamburger and colleagues developed the method of a scenic-narrative microanalysis (Hamburger, 2017; Blattmann et al., 2021).

Metapsychology of Meeting

Against this conceptual background we can pinpoint more distinctly what 'meeting' in moments of meeting is supposed to mean. This will lay the groundwork for transferring the conceptual model of moments of meeting on the field of arts and aesthetic processes.

As we have previously discussed, mutual attunement is key for now moments turning into moments of meeting and thus leading to change. In this, something uncanny or dangerous is at play, given the fact that now moments shake up previous blueprints of how one relates to others. Moments of meeting are not just about harmonious 'fitting together', the conceptual model has a notion of tension built in. Now moments are about uncertainty, with varying degrees of how bearable they are for each individual. The intersubjective moving along can be hindered so that actually nothing moves on in terms of relating. Moments of meeting can be missed, moving along can fail.

Even though BCPSG authors do not relate to that much, this bears resemblances to philosophical phenomenology inasmuch as meeting the other is to be conceived of as the experience of difference (also, we ourselves are inevitably *Strangers to ourselves*; cf. Kristeva, 1994). Coming into contact with another person is, say, delicate. To meet the other person, one has to relatively move away from oneself and lean towards the other. It is unclear what and who it is you connect with, or which kind of link will be established—and whether you find your way 'back to yourself'. Massive anxieties concerning intimate emotional contact in severe mental disorders have to do with this (e.g., psychosis; cf. Storck & Stegemann, 2021). Meeting up raises questions of identity of self and other, of being welcomed by the other and, in turn, welcoming the other. Also, meeting is about which (vitality) affects are actually about to be felt, what it is you attune with.

Meeting the other thus is 'bipolar', not only in terms of self and other, but also in terms of attunement and wariness, or even repulsion or miss. Therefore, the process of attunement is to be conducted not only interpersonally but also mentally by each of the two individuals. Also, the eventual meeting up is the result of acknowledging the uncanny and repairing micro ruptures. Psychotherapy research shows that—besides other 'facilitative interpersonal skills'—these are key elements to psychotherapeutic change when working with the therapeutic relationship (Anderson et al., 2009).

Conceiving of moments of meeting as being enacted as part of a bipolar conceptual model means thinking about identity and that which is alien to it. Moments of meeting, then, relate to experiences being 'one's own', or: in tune with oneself, in the presence of the other person; of being oneself while in contact with another person. And they also relate to meeting the other in concordance with what we think of as our identity (we are well aware of the complexities of thinking about personal identity, sameness or 'own'-ness which should be taken into account here).

Put another way: In moments of meeting, an ego-centric level is balanced with an ex-centric level (which calls into remembrance the perspective of philosophical anthropology and authors such as H. Plessner). Setting these two levels in place dialectically prevents derailments of meeting the other, meaning either neglecting the person-ness and identity of the other or losing oneself while fusing with the other's inner world and perspective.

Now, psychotherapy can justly be regarded as touching upon artistic features (Holm-Hadulla, 2004). What does that mean for conceiving 'moments' and 'meeting' in aesthetic processes in art?

Moments in Art and Aesthetic Response

Aesthetic response can be thought of in terms of moments and in terms of relating, as some sort of kairos-like meeting which also takes place within a bipolar sphere of own-ness and alien-ness. From a psychoanalytic perspective (cf. Soldt, 2007), aesthetic response can be said to occur while grappling with the work of art's 'quasi-subjectivity'. Following Hegel, Bergande (2007) shows the way the work of art is experienced in its aesthetic form and structure. Soldt (2009) discusses how we view the work of art as if it was a person we relate to intersubjectively (see also Storck, 2013; this allows for addressing some of the pivotal methodological problems of psychoanalysis and art).

Resorting to the concept of quasi-subjectivity and quasi-intersubjectivity allows us to describe the notion of meeting in greater detail; and it also allows for a transfer of the concepts developed by the BCPSG authors to the experience of works of art.

Obviously, primary caregiver and child as well as psychotherapist and patient relating in a process of now moments becoming—via moving along—moments of meeting, is in some ways a different story than a person relating to a work of art. They are different fields of attunement, uncanniness, and meeting. Yet, there is a conceptual bridge that might help to shed some more light on both.

As in confronting the other in interpersonal relations (while aiming at an attunement), experiencing art is a potentially disturbing experience. As with the former, we can get shaken up as our common blueprints of experiencing the world and ourselves in it do not offer a proper way to assess what is going on. Thus, the conceptual model put forward by BCPSG appears to be suitable to discuss the polarity of an ego-centric and an ex-centric level of experience in artistic fields.

When coming into contact with a work of art (may it be literature, dance, music, or something else—notwithstanding the respective medium's specific nature) we are shaken up. Usually, a work of art challenges our way of viewing ourselves and (part of) the world. Of course, there might be a sense of familiarity with our favourite play, song, or book, yet it is safe to say that we are at least touched by it, supposedly each time in a slightly different way. As with persons we know, the experience of works of art is part of a succession of present moments—art offers us a unique way of subjective now.

Being the quasi-subject it is, the work of art offers forms of vitality: We connect with certain forms of temporality, rhythm, movement, space, and intention (directedness), with temporal contours. This offers a moving along, the aforementioned succession of present moments, a flow of subjective now—by means of the work of art's quasi-subjectivity (cf. Danckwardt, 2017, who links this perspective to the conceptual notion of a 'process identification'). One could say, aesthetic response is all about moving along with a quasi-subject against the backdrop of our respective implicit relational knowing.

However, again as in interpersonal relating, there is something uncanny in experiencing a work of art, inasmuch as we hit upon something which is unexpected, unknown, or lies beyond our capacities to make sense of it. Put in other words, there are now moments in the quasi-intersubjective process of aesthetic response. At this point, attunement calls for some sort of emotional 'negotiating' to come to terms with one's own experience.

This process has to do with keeping the ego-centric and the ex-centric level in balance (or, to restore that balance). The work of art, as quasi-subject, confronts us with otherness, in what could be coined 'willfull suspension of identity' (in the wake of Coleridge). We immerse ourselves in aesthetic experience, we fuse with the other (ex-centric)—but at the same time we find ourselves in a structure of radical self-ness with the work of art orbiting around us and our way of spectatorship (ego-centric).

This is decisive for whether moments of meeting occur. Again, this is meant to be thought of as a quasi-interpersonal, quasi-intersubjective meeting with the work of art and what we think of as 'intention'. In cases where this happens, where negotiating between the ego-centric and the ex-centric level is successful, dealing with works of art has the potential for personal growth and change as they are able to bring awareness to implicit relational knowing and thus can expand it. As the work of art is part of culture and society, dealing with issues beyond subjective identity alone, this is also the case for a broader context.

We propose that psychoanalysis, more specifically BCPSG's conceptual groundwork of implicit relational knowing, vitality forms, present moments, moving along, now moments and moments of meeting, and the notion of a balance between an ego-centric and an ex-centric level of relating to others and otherness, offers a way to think about how aesthetic responses can be 'life changing' on a smaller or broader scale.

Conclusion

Let us return to our starting point in considering psychoanalysis, aesthetic response, and creative shaping processes: The kind of meetings we have described can be thought of as giving shape to experience in the face of the other—in all its relatedness to ourselves and its otherness. Psychoanalytic concepts of creativity (nothing less than creating something through play) underline how transitional spaces between mental and social spheres offer room for connection and thus interpersonal shaping. BCPSG's concepts allow for the inclusion of 'temporal contours' and implicit relational knowing in these moments, in psychoanalysis as well as in artistic processes.

In a broader societal perspective, we would like to highlight that for psychoanalysis, aesthetic experience and cultural activity are essential means to overcome human destructivity. After World War I, destructiveness became a central issue in Freud's work (see, e.g., 1920). In 'Why war?' (1933) he resumes that cultural activity is mankind's only

chance to cope with destructivity. Frequently he refers to Goethe who had elaborated that individuals and societies are composed out of good and bad, light and dark (see Holm-Hadulla, 2019). From the cradle to the grave we are challenged to creatively shape our individual and collective future. The creative battle between constructive and destructive efforts resounds in all known cultures and is re-enacted again and again, e.g., in the most influential Pop-Song 'Sympathy for the Devil' (see Holm-Hadulla, 2023). In our interpretation the song tells us that we have to confront ourselves with hate and violence in order to overcome it through love and creativity.

Note

1. The authors discuss the relationship between psychoanalytic interpretation and moments of meeting with regard to change processes; they also discuss the role of conflict, defence (mechanisms), and unconscious processes (BCPSG, 2007).

References

Anderson, T., Ogles, B. M., Patterson, C. L., Lambert, M. J., & Vermeersch, D. A. (2009). Therapist effects: Facilitative interpersonal skills as a predictor of therapist success. *Journal of Clinical Psychology 65*, 755–768.

Bergande, W. (2007). *Die Logik des Unbewussten in der Kunst*. Turia + Kant.

Blattmann, K., Hochberger, K., Lechat, K., Obens, K., Schmidt, S., Wittmann, L., & Hamburger, A. (2021). 'Now moments' im therapeutischen Dialog. Ein Einblick in die Praxis der szenisch-narrativen Mikroanalyse (SNMA). *Psyche – Z Psychoanal 75* (11), 1053–1076.

Bollas, C. (1992). *Being a character*. Routledge.

Boston Change Process Study Group. (2007). The foundational level of psychodynamic meaning: Implicit process in relation to conflict, defense, and the dynamic unconscious. *International Journal of Psychoanalysis 88*, 843–860.

Boston Change Process Study Group. (2013). Enactment and the emergence of new relational organization. *Journal of the American Psychoanalytic Association 61*, 727–749.

Buchholz, M. B. (2018). Momente und ihre Menschen. *Paragrana 27*, 41–61.

Carhart-Harris, R. L., & Friston, K. J. (2010). The default-mode, ego-functions and free-energy: A neuro-biological account of Freudian ideas. *Brain 133*, 1265–1283.

Danckwardt, J. F. (2017). *Die Wahrnehmung der Bilder*. Psychosozial.

Freud, S. (1895a). Project for a scientific psychology. *S.E. 1*, 281–397.

Freud, S. (1895b). Studies on hysteria. *S. E. 2*.

Freud, S. (1908). Creative writers and day-dreaming. *S.E. 9*, 141–154.

Freud, S. (1920). Beyond the pleasure principle. *S. E. 18*, 1–64.

Freud, S. (1933). 'Why war?'. *S.E. 22*, 195–216.

Freud, S. (1940). An outline of psychoanalysis. *S.E. 23*, 139–208.

Gadamer, H. G. (1977). *Philosophical hermeneutics*. Translated and edited by D. E. Linge. University of California Press.

Hamburger, A. (2017). Scenic-narrative microanalysis: Controlled psychoanalytic assessment of session videos or transcripts as a transparent qualitative research instrument. In D. Laub

& A. Hamburger (Eds.), *Psychoanalysis and holocaust testimony: Unwanted memories of social trauma* (pp. 166–182). Routledge.

Hamburger, A. (2018). Rhythmus, Störung und Reenactment. *Paragrana 27*, 62–77.

Hamburger, A. (2019). Von Freuds psychischem Apparat zur Ko-Konstruktion. Psychoanalytische Erkenntnis und der 'Begegnungsmoment'. *Internationales Jahrbuch für Philosophische Anthropologie 8*, 241–258.

Hamburger, A., & Heberlein, P. (2018). Scenic reenactment in holocaust testimonies. In A. Hamburger, *Trauma, trust and memory: Social trauma and reconciliation in psychoanalysis, psychotherapy and cultural memory* (pp. 171–178). Routledge.

Holm-Hadulla, R. M. (2003). Psychoanalysis as a creative shaping process. *International Journal of Psychoanalysis 84*, 1203–1220.

Holm-Hadulla, R. M. (2004). *The art of counselling and psychotherapy*. Routledge.

Holm-Hadulla, R. M. (2017). *The recovered voice—Tales of practical psychotherapy*. Routledge.

Holm-Hadulla, R. M. (2019). *Goethe's path to creativity. A psycho-biography of the eminent politician, scientist and poet*. Routledge.

Holm-Hadulla, R. M. (2023). *The creative transformation of despair, hate and violence - What we can learn from Madonna, Mick Jagger & Co*. Springer International, Switzerland.

Kristeva, J. (1994). *Strangers to ourselves*. Cambridge University Press.

Leikert, S. (2017). 'For beauty is nothing but the barely endurable onset of terror': Outline of a general psychoanalytic aesthetics. *International Journal of Psychoanalysis 98*, 657–681.

Lyons-Ruth, K., Bruschweiler-Stern, N., Harrison, A. M., Morgan, A. C., Nahum, J. P. Sander, L., Stern, D. N., & Tronick, E. Z. (1998). Implicit relational knowing: Its role in development and psychoanalytic treatment. *Infant Mental Health Journal 19* (3), 282–289.

Meltzer, D. W. (1988). *The apprehension of beauty*. Cluny press.

Ricoeur, P. (1981). *Hermeneutics and the human sciences*. Cambridge University Press.

Sander, L. W. (1987). Awareness of inner experience: A systems perspective on self-regulatory process in early development. *Child Abuse & Neglect 11*, 339–346.

Schneider, G. (2020). Eine (un)zeitgemäße Stellungnahme zu Kenneth Israelstams Projekt einer kategorienfundierten Beurteilung der psychoanalytischen Kompetenz von Kandidaten. *Psyche 74* (2), 142–157.

Segal, H. (1991). *Dream fantasy and art*. Routledge.

Soldt, P. (Ed.). (2007). *Ästhetische Erfahrungen*. Psychosozial.

Soldt, P. (2009). Die Subjektivität der Bilder. Eine empirische Untersuchung zur Psychodynamik kunstästhetischer Erfahrungen. In P. Soldt & K. Nitzschmann (Eds.), *Arbeit der Bilder* (S. 129–153). Psychosozial.

Stankovic, B., Bleimling, J., & Hamburger, A. (2018). How to do (awkward) things with just a few words: Moments of meeting in Pina Bausch's 'Kontakthof. Damen und Herren über '65'. *Paragrana 27*, 368–385.

Stern, D. N. (1985). *The interpersonal world of the infant*. Routledge.

Stern, D. N. (1992). The 'pre-narrative envelope': An alternative view of 'unconscious phantasy' in infancy. *Bulletin of the Anna Freud Centre 15*, 291–318.

Stern, D. N. (2004). *The present moment in psychotherapy and everyday life*. W.W. Norton.

Stern, D. N. (2010). *Forms of vitality*. Oxford University Press.

Stern, D. N., Sander, L. W., Nahum, J. P., Harrison, A. M., Lyons-Ruth, K., Morgan, A. C., Bruschweiler-Stern, N., & Tronick, E. Z. (1998). Non-interpretive mechanisms in psychoanalytic therapy: The 'something more' than interpretation. *International Journal of Psychoanalysis 79*, 903–921.

Storck, T. (2013). Entzugserscheinungen. Oder: Was die Psychoanalyse von der Ästhetik hat. *Imago – Interdisziplinäres Jahrbuch für Psychoanalyse und Ästhetik 2*, 169–180.

Storck, T., & Stegemann, D. (2021). *Psychoanalytische Konzepte in der Psychosenbehandlung.* Kohlhammer.

Winnicott, D. W. (1971). *Playing and reality.* Tavistock.

CHAPTER 39

THE AESTHETICS OF DEMENTIA

JULIAN C. HUGHES

Introduction

It is very easy when writing in a particular vein about people living with dementia to be soppy, idealistic, over-optimistic, or mawkish. This is particularly so when discussing aesthetics and dementia. We can see the world as bright and beautiful. People lovingly engage in activities involving touch, movement, uplifting sounds and sights; we see alluring visions of people in artistic communion, enjoying friendship and effulgence. Indeed, all of this can be true. Yet the opposite reality is also true. Whatever they were like before, people living with dementia can become malodorous, aggressive, obstinate, vulgar, and cruel even. After all, some people (a minority) have always been this way; we're not all attractive and we're not all saints. Keeping both of these realities in view is one of my intentions in this chapter. The aesthetic approach to people living with dementia does not inevitably ensure a world of unalloyed beauty and delight. It may, however, involve seeing, not the mien, but something else essential about the person.

I shall start by considering how art is being used to help people living with a diagnosis of dementia. I present, merely, a scoping review of the literature based on what is conveniently available to me. But look, even if I had attempted to be thoroughly systematic, I should still have failed to capture the full extent of the wonderful work that is going on. The school group that goes into a care home to sing to the residents; the occupational therapist in a hospital who organizes painting for some of the patients; the day centre which arranges a trip to a local museum, and so on: all such parochial, unrecorded initiatives are examples of how art is used to help people living with a diagnosis of dementia. But they are not captured by a systematic review.

Here I need to declare a major bias in my review of such activities, because I have *no doubt* they are helpful. They will not help everyone. But, from Wigan to Warsaw, I'm certain that when someone comes to sing, some of those listening who live with dementia

will be uplifted, moved, cheered, made to smile and to tap a toe. In a sense, then, I don't feel compelled to find all the evidence. Just a snippet of evidence will do, because it will confirm what we all know: art can help (Killick & Allan, 1999). We can add caveats to this bald statement (e.g., some art helps some people, some does not, etc.), but generally, art helps!

In the second section of the chapter, I turn to consider how the arts, and aesthetics more generally, might contribute to our understanding of dementia. Central to this is the idea that people living with a diagnosis of dementia require an aesthetic approach. This is in contrast to a more limited biomedical approach; but it is also in contrast to any approach that tends to limit the perspective of what it is to live with dementia. Instead, recognizing the aesthetic nature of our lives should broaden our view in a potentially positive manner.

This leads to the third section of the chapter, which considers what aesthetics and dementia themselves have to teach us all about our humanity. In considering what it is for us to live fully human lives as aesthetic beings with or without dementia, I shall draw on a little-known work by the Dominican friar, Thomas Gilby (1934), entitled *Poetic Experience*, in which he reflects on the work of St. Thomas Aquinas in connection with an aesthetic viewpoint.

The Arts and Dementia

In a rather beautiful piece for *The Observer* newspaper, Nicci Gerrard (2015) reflected on dementia and the ways in which the impenetrable mystery associated with the experience of living with dementia is reflected in an array of films, plays, books, poems, portraits, and so on. Many who work in the field of dementia would no doubt complain that the article is too negative. Although Gerrard does mention the possibility of living well with dementia, the tone is mostly about loss, summed up in the penultimate paragraph by the words: '... life returns to that state of nothing. When we cannot even say "I am". When we cannot'. Nevertheless, the main theme concerns the power of art and the possibility that it will shed light on the experience of dementia: 'One of the gifts of art is to enable us to enter into other people's lives and selves… Art … can try to enter the silent darkness' (Gerrard, 2015).

The year before Gerrard's article, Professor Gill Livingston and her team at University College London had published a systematic review of randomized controlled trials (RCTs) looking at non-pharmacological interventions for people with dementia (Livingston et al., 2014). They found a variety of approaches that might be helpful. In particular, they found three RCTs that showed music was beneficial, with an immediate reduction in symptoms of agitation. Longer-term benefit was not shown and the studies were confined to nursing homes. These same studies were cited in Livingston et al. (2017), which was a *Lancet* commission providing a definitive overview of dementia management. One of the notable points in this later review was that the response to activities, including music,

changes as dementia becomes more advanced: simple sing-alongs are less likely to be effective in terms of agitation. This reminds me of a man we looked after in a unit for people with advanced dementia and behaviours that were found challenging. He tended to walk around the corridors mumbling to himself, but on entering a lounge in which a soprano was singing, he said very clearly 'Who strangled the cat?' and beat a hasty retreat! Thus, he made the point that art interventions are perhaps best when personalized.

At the time of Livingston et al. (2014) there was a dearth of good quality evidence to support arts interventions as part of dementia care. None the less, a consensus was emerging that art and art interventions were an important part of the psychosocial or non-pharmacological approach to care of people living with dementia. Young et al. (2016) concluded both that the literature was largely made up 'of small-scale studies with methodological limitations including lack of control groups and often poorly defined samples' and yet that it suggested arts activities were 'helpful interventions within dementia care'. The methodological challenges facing this sort of research have been much discussed (Beard, 2011; de Medeiros & Basting, 2014; Gray et al., 2018).

The debate can be seen as part of the tussle between biomedical approaches on the one hand and psychosocial approaches on the other. From one perspective, it can be argued that psychosocial approaches must be as rigorously validated as any drug treatment, which means that participants must be randomized to treatment or control groups (which cannot be fully blinded, of course, because you tend to know whether or not you're drawing or listening to music!). In addition, the biomedical framework forces on to researchers the need for a defined outcome, e.g., changes on a scale that measures cognition, depression, quality of life, or some such. The other perspective is to shun the comparison with biomedical approaches and instead try to look at the results for individuals and to view matters more broadly in terms of personhood for instance, perhaps using qualitative methods rather than quantitative. All this can become quite technical as new methodologies are developed. To my mind, however, Beard's (2011) wise comment that 'strictly biomedical measures will continue to fall short of adequately evaluating what are deeply psychosocial, idiosyncratic, and experiential issues' remains utterly compelling.

In addition to the methodological difficulties, there are also complexities to do with the type of art and the type of interaction with it. Painting is very different from singing. Passively watching is very different from actively doing. We have our idiosyncratic responses, which might also depend on who is leading the activity: from a volunteer to someone highly trained in psychodynamic techniques. Further, how the person reacts will depend on the severity of his or her dementia. There is nothing about this as simple as giving a tablet!

Leaving aside the many issues to do with the efficacy of different art practices, Schneider (2018) has highlighted five good reasons to support the arts in connection with dementia. In summary:

1. people with dementia usually enjoy art;
2. art—experienced in a multi-sensory manner and in-the-moment—remains accessible;

3. carers gain from arts interventions too;
4. the wider community benefits from the consequent cultural capital;
5. art does little harm and 'often fosters social interaction and a sense of belonging' (Schneider, 2018).

A consensus can be seen emerging, therefore, in favour of participative arts for people with dementia (Zeilig et al., 2014), with co-creation, so that people living with dementia are as involved as the professionals throughout the artistic process (Zeilig et al., 2018), whilst also allowing education for carers of people with dementia about artistic practices and ways of thinking (Zeilig et al., 2015). In line with the consensus about the usefulness of art-based therapies, the apparent need for them remains intact (Elliott, 2021). In order to investigate this further, I shall consider literature to do with some specific forms of art.

Visual Art

A Cochrane review of the effects of art therapy 'as an adjunctive treatment for dementia' found 'insufficient evidence about the efficacy of art therapy for people with dementia' (Deshmukh et al., 2018). This sums up the methodological difficulties to which I was just referring. The authors found only two studies that satisfied their selection criteria. But, 'It was not possible to pool the data for analysis from the included studies, due to heterogeneity in terms of differences in the interventions, control treatments and choice of outcome measures. ... we judged the quality of evidence for these outcome measures to be "very low"' (Deshmukh et al., 2018). This is a very different conclusion from that of Young et al. (2016) mentioned above, where the deficiencies in studies were not felt to compromise the evidence that art therapies were helpful.

Indeed, the evidence from all sorts of sources supports the intuition that art is beneficial for those living with dementia (Newman et al., 2019). Although amenable to scientific study (we could study pulse and blood pressure, cortisol levels, skin conductance, and so on), the statement that art is beneficial for human beings does not depend on such study. It is of a different kind, referring more to our existential experience and to what it is to flourish as human beings. It is part of what we might call (with homage to Hans-Georg Gadamer (1900–2002); see Gadamer, 2013) our pre-understanding, so that the evidence from the literature, however deficient, merely confirms our knowledge rather than entirely constituting it.

In any case, the literature also reveals a good deal of complexity and nuance. The data emerging from studies of the use of visual arts in dementia is rich. Windle et al. (2018) developed, from the literature and from qualitative work with stakeholders, a conceptual model of how visual art programmes may 'work'. This involved looking at two contextual factors, namely, first, 'the role of the artists and facilitators' and, second, the setting and the way this provides a 'provocative and stimulating aesthetic experience' (Windle et al., 2018). The literature they used reflected projects in which there were activities involving either producing visual art or viewing and discussing it, or both. The

studies took place in shared public environments, such as museums and galleries, or in specialist dementia care facilities.

The mechanisms involved in the aesthetic encounters included: social interaction, time together, support, shared experience, fun, new learning, intellectual stimulation, engagement, communication, the ability to contribute, attention, creativity, confidence, mastery or control, autonomy, and self-expression. Outcomes were in terms of well-being (pleasure, mood, enjoyment, quality of life), cognitive processes (memory recall of activity and people, memory for artistic process, verbal fluency), social connectedness (continued connection with gallery and activity, social inclusion, less isolation), and improved perceptions of dementia (deeper insights from staff and carers) (Windle et al., 2018).

Thinking about 'what works?' in connection with visual art interventions led Shoesmith et al. (2021) to very similar themes. What should we conclude? Well, one obvious conclusion is that this sort of work is multi-layered and specific. Participants have specific responses, but much also depends on the specific facilitator and his or her ability to engage with people living with dementia. Engagement will be at many possible levels and such engagement is an end in itself.

These effects were seen in a study in the United Kingdom (UK) that looked at art-gallery-based dementia care programmes and concluded: 'Offering programs to people with dementia, in a valued place such as an art gallery, facilitated intellectual stimulation, and social interaction, which in turn helped to promote positive affect, relational benefits, and changed perceptions of dementia' (Camic et al., 2016).

In Australia, a programme of visits to an art gallery once a week for six weeks produced no lasting changes in the participants (MacPherson et al., 2009). Yet engagement was high for those who participated and those who lived in residential care facilities showed increased confidence, capacity, and positive affect during the intervention, suggesting there was excess disability (i.e., disability not caused by the brain pathology, but by the social environment (see Sabat, 2001, 91–113)) when they were under-stimulated in the care facility. One carer commented on the programme that 'You do it for the moment' (MacPherson et al., 2009).

Similar findings emerged from a UK study involving contemporary and traditional art galleries and using both quantitative and qualitative methods (Camic et al., 2014). The former showed no significant differences before and after the visits to both types of gallery. There was, however, 'a non-significant trend towards a reduction in carer burden over the course of the intervention'; and the qualitative data 'revealed well-being benefits … that included positive social impact resulting from feeling more socially included, self-reports of enhanced cognitive capacities for people with dementia, and an improved quality of life'; moreover, 'Participants were unanimous in their enjoyment and satisfaction with the programme, despite the lack of significance from standardised measures' (Camic et al., 2014). This mixed picture of improvement in some aspects but not all, has been seen in other studies (Rusted et al., 2006).

The Museum of Modern Art in New York famously pioneered a programme of visits to the gallery for people living with dementia (Parsa et al., 2010). Very incisive

reflections on one of these visits occurs in Selberg (2015, 150–155). The beneficial effects of such visits and programmes have also been seen in visits to museums conducted in the Netherlands (Hendriks et al., 2021).

Another UK evaluation of a twelve-week visual art programme showed positive quantitative findings, with better scores (in comparison with an alternative activity without art) in terms of well-being for the domains of interest, attention, pleasure, self-esteem, negative affect, and sadness (Windle et al., 2018). Participants living with dementia showed no quantitative improvements in terms of quality of life, whereas their (qualitative) verbal reports described '… a stimulating experience important for social connectedness, well-being, and inner-strength' (Windle et al., 2018).

Enough has been said maybe to give a feel for research that has been undertaken using visual arts for people living with dementia. For instance, Tucknott-Cohen and Ehresman (2016) report a case of art therapy being used for someone with late-stage dementia, where engagement could be demonstrated, but where difficulties in communication limited what could be achieved or known to have been achieved. Still, as in many other studies, engagement and communication were clear gains. Overall, it seems possible to argue that the benefits of visual art interventions can be seen qualitatively as well as sometimes quantitatively.

Music

I have already alluded to the empirical evidence that music can be helpful in dementia (Livingston et al., 2017). Interestingly, a Cochrane systematic review of music therapy for people with dementia in 2003 (which was updated in 2010) found that studies were methodologically flawed so that there was: '… no substantial evidence to support nor discourage the use of music therapy in the care of older people with dementia' (Vink et al., 2003). By 2018, however, some of the same authors were producing a new Cochrane systematic review of music-based therapeutic interventions for people with dementia in which they concluded: 'Providing people with dementia who are in institutional care with at least five sessions of a music-based therapeutic intervention probably reduces depressive symptoms and improves overall behavioural problems at the end of treatment. It may also improve emotional wellbeing and quality of life and reduce anxiety, but may have little or no effect on agitation or aggression or on cognition. We are uncertain about effects on social behaviour and about long-term effects' (van der Steen et al., 2018).

A more recent systematic review looked at RCTs in which older people with mild cognitive impairment (MCI) or dementia physically participated in music; the effects on cognitive functioning, emotional well-being, and social engagement were considered. The results showed that 'music-making has a small but statistically significant effect on cognitive functioning for older adults with probable MCI or dementia' (Dorris et al., 2021).

Given all the difficulties around producing high-quality methodological studies in this field, these systematic reviews of RCTs of music interventions in dementia care are

striking. Added optimism comes from a thematic synthesis from the qualitative literature, which concluded overall that engaging with music provided a number of psychological, social, and emotional benefits: the researchers found 'four key benefits of music engagement for people with dementia, namely: Taking Part, Being Connected, Affirming Identity and Immersion "in the moment"' (Dowlen et al., 2017). These themes chime with those that emerged in connection with the visual arts (Windle et al., 2018). Dowlen et al. (2017) also urge the idea that 'musicking' should be participatory.

There seems little doubt that music can be beneficial to people living with dementia. Questions about what types of music, how and where it should be provided, and by whom, its effects in different people, how long those effects last, and so forth, will continue to bedevil researchers. But no one who has watched the YouTube clip of Naomi Feil singing with Gladys Wilson (www.youtube.com/watch?v=CrZXz10FcVM) or of Henry listening to music on an iPod in the clip from 'Alive Inside: A Story of Music and Memory' (www.youtube.com/watch?v=8HLEr-zP3fc) can have any doubt as to the potential power of music for people with dementia. Both Gladys and Henry had advanced dementia and normally conversations were sparse or non-existent. 'What does music do to you?' Henry is asked. 'It gives me the feeling of love. . . . You've got beautiful music here', says Henry, 'I feel a band of love, of dreams'.

Dance

The literature on dance movement therapy has also been subjected to a Cochrane systematic review (Karkou & Meekums, 2017). The researchers identified 102 studies, of which nineteen were reviewed in full. But they did not meet the inclusion criteria so there was none for the review! The review mentions the methodological difficulties studies of dance encounter, as recorded in a review by Guzmán-García et al. (2013). The lead author in this systematic review, Azucena Guzmán-García, subsequently went on to complete empirical research as part of her Ph.D. in which a novel methodology, involving a multiple-baseline single-case study, was used (Guzmán et al., 2016). Ten residents from two care homes and one nursing home were recruited. Measures of behaviour and mood, selected individually for each resident from a standard tool, were applied at variable times across the three-to-six-week baseline. There were then twice-weekly dancing sessions over twelve weeks, with a twelve-week follow-up period. In effect, each participant acted as his or her own control (i.e., an individual's baseline measures were compared to his or her scores during the intervention and follow-up periods). It was possible to demonstrate improvement in a number of areas for nine participants, with lower behaviour and mood scores (Guzmán et al., 2016). Staff and family members were keen for the project to continue after the formal study was over (Guzmán et al., 2017).

Central to dance is movement and key to movement is the body. Coaten and Newman-Bluestein (2013) wrote with passion about the importance of embodiment—awareness of which is inherent to dance—in interactions with people living with dementia. They

concluded: '... body movement and dance as creative expression, as aesthetic feeling, as meaningful interaction and as richly enlivened aspects of physical engagement can no longer be left out of critical scholarship and discourses concerning embodiment and dementia without missing a critical part of the overall narrative' (Coaten & Newman-Bluestein, 2013).

Continuing the theme of embodiment, Kontos et al. (2021) examined how dance can 'enhance social inclusion by supporting embodied self-expression, creativity, and social engagement of persons living with dementia and their families'. They highlighted two themes. The first, playfulness, 'refers to the ways that the participants let go of what is "real" and became immersed in the narrative of a particular dance ... '; the second, sociability, shows how embodied connectivity and intersubjectivity is established 'between participants and their community' in a programme that relied on co-construction and collaborative embodied animation of the dance narratives (Kontos et al., 2021). Although dance is different from both music and visual art, what we see here are similar ways in which the lives of persons living with dementia are enhanced through art.

Play, Poetry, and Photography

Creativity turns out (albeit not unexpectedly) to be a complicated phenomenon. Beghetto and Kaufman (2007) delineate three forms of creativity: 'mini-c' (everyday and intrapersonal), 'little-c' (everyday and interpersonal), and 'Big-C' (interpersonal, historical, and related to genius). Just as dance can be playful, so too can play itself be creative. In dementia, play can be used, not to infantilize, 'but as a way to explore potential for expression, meaning-making, and relationship-building in later life' (Swinnen & de Medeiros, 2018). Play can be used to contribute to our understanding of selfhood or personhood, where we might wish to talk in terms of the 'aesthetic self' (Li, 2021). Playfulness is also evident in the reciprocal nature of engagement seen in the interactions between clowns and people living with dementia (Kontos et al., 2017). Recognizing the potential for creativity in play, where this might mean 'little-c' everyday creativity, helps with our understanding of persons as situated, embodied agents (Hughes, 2011, 29–54). 'Understanding dementia through an everyday creativity lens ... has the potential to offer profound insights into the relational and embodied experience of dementia. Importantly, this approach places the person with dementia and their family members and friends centre-stage ...' (Bellass et al., 2019).

Play has been used by John Killick (2013) as a means to engage people with dementia, as has poetry (Killick & Cordonnier, 2000; Killick, 2018). Killick and Cordonnier (2000) record some of the poetry co-produced by Killick with people living with dementia, but also include beautiful photographs which present a vivid account of life with dementia. Cathy Greenblat (2012) has subsequently produced a volume of photographs which show the positive side of living with dementia, in particular how art activities can bring joy and laughter to people. Some have suggested that photography might be used as a research tool, but also as a memento of the research for participants and their families

(Evans et al., 2016). This idea has been pursued in a beautiful bit of research, just after a diagnosis has been made, where people living with dementia were co-researchers wrote:

> When you are diagnosed with dementia, you are told what you are *not* capable of doing. The key thing is that there are things you can do, not endless things you cannot. … When I took up photography, I felt like I could do something. You can learn new skills – there is a part of your brain that is great. You can learn new things, and that is what we wanted to show people. … The photographs gave them the opportunity to speak about things. It made them feel better because they got something out. … That's the thing about dementia – once you are over the initial shock of the diagnosis, your brain does work in a different way. You get to see things in a different way. A photograph is a way of recording that difference.
>
> (Dooley et al., 2021)

Reflecting on the use of photography—and keeping in mind Roland Barthes (1915–1980) writing of the possibility that the photograph might achieve 'utopically, *the impossible science of the unique being*' (Barthes, 2000, 71; see also Hughes, 2014)—takes us nicely into the next section of this chapter, which looks at what the arts might tell us about the reality of dementia. But before moving on, I should reiterate that I've merely scratched the surface of the literature and ignored some important art forms. Nevertheless, this seems enough to establish the deep benefits that can emerge from using the arts to unlock the potential for aesthetic experience.

Understanding Dementia: The Aesthetic Approach

In his very thoughtful chapter in *Popularizing Dementia*, Scott Selberg (2015) reviews the works of, and arguments concerning, Willem de Kooning (1904–1997) and William Utermohlen (1933–2007). Both were artists who developed dementia but produced self-portraits as their conditions progressed. Thus, through their art, they provide insight into the subjective reality of living with dementia. In this section I consider how art helps us to understand dementia. Selberg (2015) suggests that pondering the paintings of these two artists is likely to be useful. We need to map 'the way creativity has historically structured claims of personhood, interiority, authenticity, and value' (Selberg 2015, 156). Selberg's stance is nuanced. The importance of art is not in doubt; but he raises a doubt in connection with how art tells us something about personhood and thereby about dementia. We need to understand, '… how art fits into a more diverse regime of mediated personhood rather than hailing it as special, magical, or unique. By honoring creativity as a banal process of the everyday rather than as heroic or genius, we might lessen the social insistence on creativity's value while still allowing for and honoring minor, humble performances of self' (Selberg, 2015, 157).

This seems to me an important insight, although it does not preclude the importance of even grand art as a way to understand more about what it is to have dementia. I have written elsewhere (with artist Ashley McCormick) about this (Hughes & McCormick, 2003; Hughes & McCormick, 2014, 202–218). Our conclusion was that art, '… encourages a broad view of the person with dementia in which people are seen as inter-relating and interconnected. Art exerts a tug on the objectivity of science, which should make us more sensitive to the selfhood of people with dementia' (Hughes & McCormick, 2014, 202).

Art—and perhaps we should have emphasized mini-c and little-c creativity—leads us to the aesthetic sense, which in turn tells us something about personhood. Alexander Gottlieb Baumgarten (1714–1762), regarded as the father of aesthetics in the modern era, wrote: *Aesthetices finis est perfectio cognitionis sensitiuae, qua talis. Haec autem est pulcritudo.* ('The end of aesthetics is the perfection of sense cognition [knowledge] as such. This, however, is beauty') (Baumgarten, 1970, §14). Whatever the exact standing of his thesis (famously criticized by Immanuel Kant (1724–1804)), according to Mary Gregor, Baumgarten's *Aesthetica* accepts, '… the rationalist account of knowledge but insists that our distinct, intellectual knowledge is inherently defective and needs to be complemented by the kind of cognition achieved in the production and appreciation of art' (Gregor, 1983, 364). The emphasis on cognitive knowledge and aesthetics b science of sense cognition' (Baumgarten, 1970, §1) is precisely what might be to: don't we need a different paradigm to understand art rather than the scientific one? But Gregor goes on to say: 'Baumgarten's claim for art is a modest one: given the nature of man, his perfection requires the development of his potentialities for both perception and discursive reasoning. Because the two modes of perfection, perceptual and discursive, are different, there can be no displacement of art by science' (Gregor, 1983, 384).

Sense cognition, then, is decidedly different from cognitive knowledge. Our understanding of sense cognition need not be labelled a science. Aesthetic understanding is simply not the same as scientific understanding.

This stance helps to ameliorate the hypercognitivism which has historically infected thinking about dementia. Post first referred to this hypercognitive bias, which he saw as 'a persistent bias against the deeply forgetful' (Post, 2006, 231). Early scientific investigations of people living with dementia focused on cognitive function, which was something that could be measured. But we are not solely cognitive and rational beings: our *selves* are multi-layered and persist, as well as being undermined, in the course of living with dementia (Sabat, 2001, 274–308). We are situated or embedded, qua persons, in contexts which cannot be circumscribed; and we cannot be totally reduced to things that can be measured (Hughes, 2011). We understand, indeed, through our bodies (Hughes, 2013). A truly person-centred approach (Kitwood, 2019), which at its best includes not only psychosocial but also biomedical, spiritual, legal, ethical, and other perspectives, should now therefore be considered to include a hugely important aesthetic component. Baumgarten's insights remain pertinent: we are not simply 'discursive' beings (using language to convey facts and knowledge), we have perceptions and feelings too.

We must approach people with dementia, therefore, not necessarily, or not purely, as rational agents, but as aesthetic, feeling, beings (Hughes, 2014). 'O for a life of Sensations rather than of thoughts' exclaimed John Keats (1795–1821) the poet (Keats, 1990, 365). I've commended Keats's concept of 'negative capability' as a way to characterize this aesthetic approach (Hughes, 2014). Keats explained 'negative capability' (albeit somewhat gnomically) thus: '... when man is capable of being in uncertainties, Mysteries, doubts, without any irritable reaching after fact & reason' (Keats, 1990, 370). This has been fleshed out by Jackson Bate: 'In our life of uncertainties, where no one system or formula can explain everything ... what is needed is an imaginative openness of mind and heightened receptivity to reality in its full and diverse concreteness. This, however, involves negating one's own ego' (Jackson Bate, 1963, 208, cited in Cornish, 2011).

If I think of people living with advanced dementia with grave speech difficulties, the ability to understand them cognitively may be impossible. But it always remains possible to *be with* them in a feeling way and thus to explore, tentatively, what might or might not be, for instance, the cause of their agitation. Carers, who are very close to the person, tend to be better at this sort of non-conceptual intuition.

> So an open-mindedness, a receptivity and degree of humility are required as we struggle to understand the world, ... the life of the person with dementia. We shall not only learn about them by their brain functioning, we shall also learn about them by observing closely their gestures, their actions and their interactions. Our intuitions may be uncertain. But our approach must be aesthetic, so that we hear what they say and see what they do 'without any irritable reaching after fact & reason.'
>
> (Hughes, 2014)

How else might we make an aesthetic approach real? Well, Gilby, to whom we shall return shortly, has set out characteristics which can be regarded as typical of aesthetic knowledge or experience: individuality, a focus on the here-and-now, closeness and attachment (attachment being one of Kitwood's main psychological needs of people with dementia (Kitwood, 2019, 92)), 'completeness in itself' (no need to reach (irritably) for further facts and reasons), and inspiration or 'the absence of deliberation' (Gilby, 1934, 83–102). Perhaps these characteristics tell us something about what an aesthetic approach to the person living with dementia might look like. Certainly, thinking in an aesthetic vein can shine a light on shared aspects of our humanity by which connections and relationships might yet endure, despite the dysfunctions brought by dementia.

BEING HUMAN: AESTHETICS AND DEMENTIA

What I am suggesting is that '... understanding anyone is more like an aesthetic judgement than a cognitive act' (Hughes, 2013). When we truly engage with another human being, that engagement cannot be pinned down. It involves all our being: how

we feel, how we listen, how we understand, how we present ourselves, what we notice both consciously and sub-consciously, and so on. We carry out this aesthetic engagement through our bodies; through our minds too, but our minds are embodied, just as our bodies are minded! Our engagement with the person with dementia, as well as being cognitive (for cognitive function is not inevitably absent (Sabat, 2001, 24–90)), is also perceptual or sensual, a matter of feeling, a matter of art and aesthetic intuition. But what is this and what does it tell us more broadly about being human?

Thomas Gilby OP (1902–1975) was an English Dominican friar and eminent scholar. He was the General Editor of the sixty-volume Latin and English translation of St. Thomas Aquinas's *Summa Theologiae*; and many of those volumes he translated and edited himself. He wrote much more besides. He was also a man of the world, having served as a naval chaplain during World War II. Moreover, he had an affair with Catherine Walston, the longstanding married mistress of his friend Graham Greene! In 1934, he wrote *Poetic Experience*.

Poetic experience (as opposed to rational knowledge) is: 'intensely individual, not general ... concrete, not abstract ... real, not conceptual ... complete in itself, not pedagogic ... an end, not a means ... a moment of unpremeditated inspiration' (Gilby, 1934, 9–10). There is a resonance here with Baumgarten, who noted that while reasoning can be exact, it was impoverished because it involves throwing stuff away; and he asked, 'What is it to abstract, if not to throw away?' (Baumgarten, 1970, §560) (see Gregor, 1983, 365).

A strictly scientific account of human nature, therefore, was bound to overlook or ignore the poetic (aesthetic) aspects of a life. Logic and rational judgement are not always appropriate; instead, we must sometimes seek 'a mysterious experience, ... a sympathy, a knowledge by affinity, nature, compassion' (Gilby, 1934, 42). Science tends to isolate things, so that the scientific study of the heart involves, not a heart, 'but a piece of meat working as part of a mechanical apparatus' (Gilby, 1934, 47); and Alzheimer's is seen solely as dysfunction in the hippocampus. Also, in keeping with the whole tenor of Sabat's (2001) *The Experience of Alzheimer's Disease*, Gilby writes: 'By their very variety, individuals cannot be submitted to an unvarying standard' (Gilby, 1934, 13–14).

Gilby points, too, to the importance of seeing personhood aright. He says: 'It is not the mind that knows, as if the mind were the actor, but the person, the concrete substance, who knows through the mind. The same is true of all activity. It is the person who loves, imagines, sees and so on, always through the appropriate faculty' (Gilby, 1934, 46). Aesthetic experience, then, highlights how we engage as human beings. We do this through our minds, but our mental life should not be thought of as circumscribed; rather, as minded beings, we reach out. The mind is 'a noble energy by which the subject, unlike a material substance ..., goes out and mingles in the life of others without ceasing to be itself. It is the power of possessing them, not of caging them in concepts' (Gilby, 1934, 20–21).

This reaching out and engagement with the world and with others is, according to Gilby, a manifestation of love. He writes: '*Loving draws us to things more than knowing does. ... love takes up where knowledge leaves off*' (Gilby, 1934, 34). And later he describes

conscious love as, 'the desire of the will for things just as they exist in themselves' (Gilby, 1934, 69). For me, this resonates with Martin Heidegger's (1889–1976) notion of solicitude (see Hughes 2011, 47–48, 215–216), which is the sort of care or concern we have for other human beings *just as* human beings. Being in the world of human beings inevitably entails this sort of engagement. This is what it is *to be* human. And this remains the case even if the person is one living with dementia, whatever his or her appearance, behaviour, or cognitive state.

The aesthetic approach to people living with dementia is, therefore, encapsulated by these words, where the 'object' can be regarded as the person:

> Love establishes a medium of experience more intimate than a notion. … the experience lies in the mind, but the instrument is the love which penetrates the object, not a notion gathered from a scientific inspection. The knowledge is not a detached judgement about the object, but a vivid appreciation in the object through a profound attachment. The experience is not immediately concerned with meaning. It is not explicitly directed on a formal truth so much as on a whole-thing, felt to be intimately present, and in correspondence with our deepest and most primitive desires. In this experience love dominates.
>
> (Gilby, 1934, 81)

Conclusion

Aesthetic experience is a manifestation of our being-in-the-world, of our being-with, as human beings. It is a manifestation of our ability to flourish, to be authentic, to love and connect as persons with or without dementia. Art helps to make this possible (Hughes et al., 2021). For, as Stanley Cavell (1926–2018) recognized, knowing and understanding a work of art is like knowing and understanding a person (see Cavell, 1969, 198). A work of art means something to us as a person does, albeit in the end it is a person, not a mere object, who elicits our solicitude.

References

Barthes, R. (2000). *Camera Lucida* (translated by R. Howard). Vintage.
Baumgarten, A. G. (1970). *Aesthetica*. G. Olms [Originally published in 1750].
Beard, R. L. (2011). Art therapies and dementia care: A systematic review. *Dementia* 11, 633–656.
Beghetto, R. A., & Kaufman, J. C. (2007). Toward a broader conception of creativity: A case for 'mini-c' creativity. *Psychology of Aesthetics, Creativity, and the Arts* 1(2), 73–79.
Bellass, S., Balmer, A., May, V., Keady, J., Buse, C., Capstick, A., Burke, L., Bartlett, R., & Hodgson, J. (2019). Broadening the debate on creativity and dementia: A critical approach. *Dementia* 18(7–8), 2799–2820.
Camic, P. M., Baker, E. L., & Tischler, V. (2016). Theorizing how art gallery interventions impact people with dementia and their caregivers. *The Gerontologist* 56(6), 1033–1041.

Camic, P. M., Tischler, V., & Pearman, C. H. (2014). Viewing and making art together: A multi-session art-gallery-based intervention for people with dementia and their carers. *Aging & Mental Health* 18(2), 161–168.

Cavell, S. (1969). Music discomposed. In *Must we mean what we say? A book of essays* (pp. 180–212). Scribner.

Coaten, R., & Newman-Bluestein, D. (2013). Embodiment and dementia – Dance movement psychotherapists respond. *Dementia* 12(6), 677–681.

Cornish, J. (2011). Negative capability and social work: Insights from Keats, Bion and business. *Journal of Social Work Practice: Psychotherapeutic Approaches in Health, Welfare and Community* 25, 135–148.

de Medeiros, K., & Basting, A. (2014). 'Shall I compare thee to a dose of donepezil?': Cultural arts interventions in dementia care research. *The Gerontologist* 54(3), 344–353.

Deshmukh, S. R., Holmes, J., & Cardno A. (2018). Art therapy for people with dementia. *Cochrane Database of Systematic Reviews* 9, CD011073. https://doi.org/10.1002/14651858.CD011073.pub2.

Dooley, J., Webb, J., James, R., Davis, H., & Read, S. (2021). Everyday experiences of post-diagnosis life with dementia: A co-produced photography study. *Dementia* 20(6), 1891–1909.

Dorris, J. L., Neely, S., Terhorst, L., VonVille, H. M., & Rodakowski, J. (2021). Effects of music participation for mild cognitive impairment and dementia: A systematic review and meta-analysis. *Journal of the American Geriatrics Society* 69(9), 2659–2667.

Dowlen, R., Keady, J., Milligan, C., Swarbrick, C., Ponsillo, N., Geddes, L., & Riley, B. (2017). The personal benefits of musicking for people living with dementia: A thematic synthesis of the qualitative literature. *Arts & Health* 10(3), 197–212.

Elliott, M. (2021). Expanding arts therapies provision: A pilot project in Older Adult Mental Health Services, Aneurin Bevan University Health Board. *Public Health* 194, 270–273.

Evans, D., Robertson, J., & Candy, A. (2016). Use of photovoice with people with younger onset dementia. *Dementia* 15(4), 798–813.

Gadamer, H.-G. (2013). *Truth and Method* (translation and revision by J. Weinsheimer & D. G. Marshall). Bloomsbury. (First published as *Wahrheit und Methode* in 1960; and in English by Sheed & Ward in 1975, with a second edition in 1989 and a revised second edition in 2004.)

Gerrard, N. (2015). Words fail us: Dementia and the arts. *The Observer* (19 July). Available at: www.theguardian.com/culture/2015/jul/19/dementia-and-the-arts-fiction-films-drama-poetry-painting [last accessed 6 October 2024].

Gilby, T. (1934). *Poetic experience: An introduction to Thomist aesthetics*. Sheed and Ward.

Gray, K., Evans, S. C., Griffiths, A., & Schneider, J. (2018). Critical reflections on methodological challenge in arts and dementia evaluation and research. *Dementia* 17(6), 775–784.

Greenblat, C. (2012). *Love, loss, and laughter: Seeing Alzheimer's differently*. Lyons Press.

Gregor, M. J. (1983). Baumgarten's 'Aesthetica'. *The Review of Metaphysics* 37(2), 357–385.

Guzmán, A., Freeston, M., Rochester, L., Hughes, J. C., & James, I. A. (2016). Psychomotor Dance Therapy Intervention (DANCIN) for people with dementia in care homes: A multiple-baseline single-case study. *International Psychogeriatrics* 28(10), 1695–1715.

Guzmán, A., Robinson, L., Rochester, L, James, I. A., & Hughes, J. C. (2017). A process evaluation of a Psychomotor Dance Therapy Intervention (DANCIN) for behaviour change in dementia: Attitudes and beliefs of participating residents and staff. *International Psychogeriatrics* 29(2), 313–322.

Guzmán-García, A., Hughes, J. C., James, I. A., & Rochester, L. (2013). Dancing as a psychosocial intervention in care homes: A systematic review of the literature. *International Journal of Geriatric Psychiatry* 28(9), 914–924.

Hendriks, I., Meiland, F. J. M., Gerritsen, D. L., & Dröes, R.-M. (2021). Evaluation of the 'Unforgettable' art programme by people with dementia and their care-givers. *Ageing & Society 41*, 294–312.
Hughes, J. C. (2011). *Thinking through dementia*. Oxford University Press.
Hughes, J. C. (2013). 'Y' feel me?' How do we understand the person with dementia? *Dementia 12*(3), 348–358.
Hughes, J. C. (2014). The aesthetic approach to people with dementia. *International Psychogeriatrics 26*(9), 1407–1413.
Hughes, J. C., Baseman, J., Hearne, C., Lie, M., Smith, D., & Woods, S. (2021). Art, authenticity and citizenship for people living with dementia in a care home. *Ageing & Society 42*(12), 2784–2804.
Hughes, J. C., & McCormick, A. (2003). When to forget is to remember. *Journal of Dementia Care 11*(3), 12.
Hughes, J. C., & McCormick, A. (2014). The art and practice of memory and forgetting. In J. C. Hughes (Ed.), *How we think about dementia* (pp. 202–218). Jessica Kingsley.
Jackson Bate, W. (1963). Keats's 'negative capability' and the imagination. In J. S. Hill (Ed.), *The romantic imagination: A casebook* (pp. 196–210). Macmillan.
Karkou, V., & Meekums, B. (2017). Dance movement therapy for dementia. *Cochrane Database of Systematic Reviews 2*, CD011022. https://doi.org/10.1002/14651858.CD011022.pub2.
Keats, J. (1990). *The major works* (edited by E. Cook). Oxford University Press.
Killick, J. (2013). *Playfulness and dementia: A practice guide*. Jessica Kingsley.
Killick, J. (2018). *Poetry and dementia: A practical guide*. Jessica Kingsley.
Killick, J., & Allan, K. (1999). The arts in dementia care: Tapping a rich resource. *Journal of Dementia Care 7*, 35–38.
Killick, J., & Cordonnier, C. (2000). *Openings: Dementia poems & photographs*. Journal of Dementia Care and Hawker Publications.
Kitwood, T. (2019). *Dementia reconsidered, revisited: The person still comes first* (edited by D. Brooker). Open University Press.
Kontos, P., Grigorovich, A., Kosurko, A., Bar, R. J., Herron, R. V., Menec, V. H., & Skinner, M. W. (2021). Dancing with dementia: Exploring the embodied dimensions of creativity and social engagement. *Gerontologist 61*(5), 714–723.
Kontos, P., Miller, K.-L., Mitchell, G. J., & Stirling-Twist, J. (2017). Presence redefined: The reciprocal nature of engagement between elder-clowns and persons with dementia. *Dementia 16*(1), 46–66.
Li, B. Y. (2021). Cocomposing an aesthetic self through play: Toward a transformative framework for dementia care. *Gerontologist 20*, 1–11.
Livingston, G., Kelly, L., Lewis-Holmes, E., Baio, G., Morris, S., Patel, N., Omar, R. Z., Katona, C., & Cooper, C. (2014). Non-pharmacological interventions for agitation in dementia: Systematic review of randomised controlled trials. *British Journal of Psychiatry 205*, 436–442.
Livingston, G., Sommerlad, A., Orgeta, V., Costafreda, S. G., Huntley, J., Ames, D., Ballard, C., Banerjee, S., Burns, A., Cohen-Mansfield, J., Cooper, C., Fox, N., Gitlin, L. N., Howard, R., Kales, H. C., Larson, E. B., Ritchie, K., Rockwood, K., Sampson, E. L., ... & Mukadam, N. (2017). Dementia prevention, intervention, and care. *Lancet 390*(10113), 2673–2734.
MacPherson, S., Bird, M., Anderson, K., Davis, T., & Blair, A. (2009). An art gallery access programme for people with dementia: 'You do it for the moment'. *Aging & Mental Health 13*(5), 744–752.
Newman, A., Goulding, A., Davenport, B., & Windle, G. (2019). The role of the visual arts in the resilience of people living with dementia in care homes. *Ageing & Society 39*, 2465–2482.

Parsa, A., Humble, L., & Gerber, C. (2010). Two art museum programs for people with dementia. *Museums & Social Issues* 5(2), 217–234.

Post, S. G. (2006). *Respectare*: Moral respect for the lives of the deeply forgetful. In J. C. Hughes, S. J. Louw, & S. R. Sabat (Eds.), *Dementia, mind, meaning, and the person* (pp. 223–234). Oxford University Press.

Rusted, J., Sheppard, L., & Waller, D. (2006). A multi-centre randomized control group trial on the use of art therapy for older people with dementia. *Group Analysis* 39(4), 517–536.

Sabat, S. R. (2001). *The experience of Alzheimer's disease: Life through a tangled veil.* Blackwell.

Schneider, J. (2018). The arts as a medium for care and self-care in dementia: Arguments and evidence. *International Journal of Environmental Research & Public Health* 15, 1151. https://doi.org/10.3390/ijerph15061151.

Selberg, S. (2015). Dementia on the canvas: Art and the biopolitics of creativity. In A. Swinnen & M. Schweda, *Popularizing dementia: Public expressions and representations of forgetfulness* (pp. 137–162). Bielefeld: transcript.

Shoesmith, E. K., Charura, D., & Surr, C. (2021). What are the elements needed to create an effective visual art intervention for people with dementia? A qualitative exploration. *Dementia* 20(4), 1336–1355.

Swinnen, A., & de Medeiros, K. (2018). 'Play' and people living with dementia: A humanities-based inquiry of TimeSlips and the Alzheimer's Poetry Project. *Gerontologist* 58(2), 261–269.

Tucknott-Cohen, T., & Ehresman, C. (2016). Art therapy for an individual with late-stage dementia: A clinical case description. *Art Therapy* 33(1), 41–45.

van der Steen, J. T., Smaling, H. J. A., van der Wouden, J. C., Bruinsma, M. S., Scholten, R. J. P. M., & Vink, A. C. (2018). Music-based therapeutic interventions for people with dementia. *Cochrane Database of Systematic Reviews* 7, CD003477. https://doi.org/10.1002/14651858.CD003477.pub4.

Vink, A. C., Bruinsma, M. S., & Scholten, R. J. P. M. (2003). Music therapy for people with dementia. *Cochrane Database of Systematic Reviews* 4, CD003477. https://doi.org/10.1002/14651858.CD003477.pub2.

Windle, G., Joling, K. J., Howson-Griffiths, T., Bob Woods, B., Jones, C. T., van de Ven, P. M., Newman, A., & Parkinson, C. (2018). The impact of a visual arts program on quality of life, communication, and well-being of people living with dementia: A mixed-methods longitudinal investigation. *International Psychogeriatrics* 30(3), 409–423.

Young, R., Camic, P. M., & Tischlerb, V. (2016). The impact of community-based arts and health interventions on cognition in people with dementia: A systematic literature review. *Aging & Mental Health* 20(4), 337–351.

Zeilig, H., Killick, J., & Fox, C. (2014). The participative arts for people living with a dementia: A critical review. *International Journal of Ageing and Later Life* 9(1), 7–34.

Zeilig, H., Poland, F., Fox, C., & Killick, J. (2015). The arts in dementia care education: A developmental study. *Journal of Public Mental Health* 14(1), 18–23.

Zeilig, H., West, J., & van der Byl Williams, M. (2018). Co-creativity: Possibilities for using the arts with people with a dementia. *Quality in Ageing and Older Adults* 19(2), 135.

CHAPTER 40

SUPPORTING A MOTIVATED CREATIVE PRACTICE VIA COLLABORATION, DIALOGUE, AND MAKING

Workshop to Aid Creative Well-Being

CHRISTINA READING AND JESS MORIARTY

INTRODUCTION

SCOTT-HOY and Ellis argue that, 'The art part of the project, which creates moods and images, combines with writing, which is better at directing emotion. In many cases, published words are used more to explain the art, rather than enhance the emotional mood' (2008, 9) (see also Barone, 2003; Slattery, 2001). In our writing we choose not to make the distinction, instead image and text work together to tell an interdisciplinary story about our work as interdisciplinary researchers. Educational researchers, such as Tierney and Lincoln (1997), have suggested that multiple approaches 'may represent both the complexity of the lives we study, and the lives we lead as academics and private persons' (p. xi) and we suggest that the mixture of voices, memoir, poetry, and painting can offer an insight into this multi-layered and complex time, and the process we used to move past it. The approach offers a, 'meeting place as a mixed stream of fluids, as something multi-layered, not known, always to be created anew, as the field of many understandings' (Sava & Nuutinen, 2003, 532) that is connected to notions of intertextuality and the dialogue of texts (Bakhtin, 1981). Voices intermingle and weave but also come together to tell a shared story.

> It's all about how we understand power. Remember, Foucault defines power as a relational activity that can be exercised. You talk about power as a thing, a possession

that can be had ... We all have power. But some choose to exercise that power in ways that oppress other people.

(Tilley-Lubbs, 2018, 66)

Jess

I apply for a university sabbatical from my institution to give me the time needed to do proper research and writing for a new book. We (Chris and I) have a contract with a publisher, we have published together in the past, six amazing women have agreed to be interviewed, and I am absolutely committed to getting the work done. In 2017, I had a book contract and didn't get a sabbatical. Back then, the reviewers told me to do more, *promise to write a funding bid in addition to writing a book* and that this would help me get relief from teaching to focus on research. I completed the book anyway, on top of my full-time workload. It isn't the book I wanted to write but it is the book I could write without any dedicated space in my teaching timetable. I end up forcing out chapters, upcycling material and pushing back deadlines in order to get it out into the world on—or close to—time. And this experience isn't unique after all. Lots of writing projects make it over the line in a similar way, even when given the focus and energy they deserve, and that's if they get as far as the line in the first place. But the constant tension between wanting to write, needing to research in order to further my career, and juggling my ever-expanding commitments has left me depleted and I am looking to claw some sanity back. This year I am a good girl (Goode, 2019) I do what I'm told. I get feedback on my application from senior colleagues, I redraft, rewrite. At my staff development review, I state that I will never venture into management but see myself developing my writing practice and funding portfolio in order to become professor. Cards absolutely down on the table. On my application for a sabbatical, I detail how I am developing expertise. That this is a crucial part of my progression at the university and a move away from the mountains of admin and pastoral work I have dutifully done. Always the middling witch (Moriarty & Marr, 2019) but never the grand wizard. This time, I tell myself, this time I am having that sabbatical. By the time I submit, it is as razor sharp as it can possibly be and I wait for good news.

I don't get the sabbatical.

I am told in the panel's response that the application was very, very good but that they wonder: *is this the right step-change for your career?* I am told I cannot appeal.

At first, I email back a calm and rational response thanking them for their time. And then I break. The inner critic roars in my face, their words mingling with spittle and hot breath: YOU AREN'T UP TO THIS! THEY DON'T BELIEVE IN YOU! YOU WILL NEVER BE SEEN AS A RESEARCHER OR WRITER, YOU ARE A GRUNT DOING THE LEGWORK WHILE ALL THOSE OTHER CLEVER, CLEVER PEOPLE LAUGH AT YOU! And I don't fight back, I cry. I feel small and meek as if not only am I banging on the wrong door, but that I don't even know how to knock properly.

I decide I can't do it, can't write about recovery and well-being when it will damage my well-being to churn out another book on top of an already bloated workload. I imagine telling people I gave it up and that makes me cry even more. I am an ugly crier, snot and tears and blotches and shuddering.

Breathe.

What is a step change? Who can say for sure? What I do know is that time to write and further my research is exactly what I want for my career so who is making the decisions about my future and what are they basing it on? Where do they see me going and how do I get there? I exhale the emotional thoughts and write to my official mentor to get advice on what I might do. He suggests that I talk to a senior male colleague who was promoted without an interview and whose publishing record is miniscule next to mine. The senior colleague has also won less funding bids, devised zero courses, and been nominated for absolutely no teaching awards. This is the advice I was given last year. Advice I didn't take. At this point I snarl back at my inner critic to Shut. Up.

I don't email the senior colleague. Instead, I email Chris. I tell her I am crying with frustration, that I want to open a coffee shop in Costa Rica, run away, scream. Chris calls me immediately. Tells me it sucks. Tells me it's going to be alright.

> Helping a woman resolve her ... fear of self-assertion, helping her to emerge with a more authentic identity to handle her hostility and the hostility of others, involves an additional layer of anxiety since she will differ from the expectations of the culture
>
> (Symonds, 1991, 305)

I rely heavily on Chris and my other mentors, friends who put me back together when I hit a wall or the glass ceiling that never seems to even splinter, let alone smash. They remind me why I do what I do, why it matters, and they remind me of past triumphs—big and small—and when I'm ready, they laugh with me and I feel connected and caught instead of alone and freefalling.

> women's ethnographic and autobiographical intentions are often powered by the motive to convince readers of the author's self-worth, to clarify and authenticate their self-images
>
> (Tedlock, 2000, 468)

In earlier work (Reading & Moriarty, 2019a, 2019b) and our latest book (Reading & Moriarty, 2022), we have written about feelings of inferiority and shame that our interviews and walks have told us are shared—although not always safe to voice publicly. We identify our process of walking and talking and creative practice as strategy for pushing back against the patriarchy and institutionalized sexism we have both experienced and that continues to prevail and oppress in Higher Education (Hall, 2017). Even now, women are still paid significantly less than their male counterparts are, and only one in four professors are women. The artist and academic Susan Diab described

her experience of institutionalized sexism as, 'The kind of silent howl I carry around inside me most days' (Diab, 2017, 92), and provides insights into her process for making a gown that 'enables me to take my power on my own terms in my own way' (Diab, 2017, 94). Susan is another mentor and friend who I meet and howl with in safe spaces away from the judgement of some colleagues. We talk about our stresses with work and the feeling that our power is often taken and undermined by a system that still privileges men, and sees women vying for elusive leadership roles, often making us competitive rather than supportive of one another.

This method of mentoring, friendship, and delight in each other's company, cuts through the often hostile, isolating, and competitive work environment that can stifle our creativity and thinking as suggested by Klevan and Grant (2020). Identifying friends and mentors and extending a more holistic and supportive way of working can actually, instead of providing opportunities for procrastination, make us more motivated, willing to take risks and create rather than be fearful of judgement and who our work might matter to. This process of reaching out, connecting to other women and using our method to extend a supported community of practice is an aim of this book. By offering our personal stories of struggle with our health, family, work and practice and how we have managed to prevail and sustain our creativity, we hope other women will feel able to share autobiographical and imagined stories that help them to feel more connected to themselves and their creative work.

In this chapter we offer insights into a workshop with the Network of International Women of Brighton and Hove, a charity supporting refugee and migrant women. We identify the telling and sharing of stories via image and text as a way to extend and develop creative networks that have the potential to support and enhance well-being.

Extending Our Creative Community

During one of our many walks, Jess and I talk about ways to share the model we have developed of walking, talking, and making with other women and to learn from different communities about their own experiences as a way of sharing and inspiring our own creativity and well-being. A workshop seems a good way to do that, but what exactly would this workshop look like and who would be interested in working with us in this way? I tell Jess about a not-for-profit collective called the International Network of Women which provides safe spaces for women from a diverse range of cultures and backgrounds who live in Brighton and Hove to meet and share skills that my daughter Lizzie is volunteering for whilst on furlough. Many of the women in the network are refugees, migrants, and asylum seekers and are socially isolated for reasons such as language, cultural difference, mental health, and family demands. The Network aims to reduce social isolation, increase well-being and a sense of belonging by providing safe spaces for women to meet, share experiences and knowledge, and support one another. Lizzie has talked admiringly of the huge diversity of interesting talents and skills that

the women bring to the Network. Perhaps working with these women from different backgrounds and experiences to our own might be a way for us to extend our creative community in an interesting and challenging way? I send a speculative email to the organizer about the ideas Jess and I have for a creativity workshop to share and exchange ideas and skills. The response is cautiously positive but with questions about our approach given the vulnerability of some of the members. Jess and I ponder how we might tap into the creative interests and enthusiasms of such a group in a respectful and sensitive way and suggest a workshop using image and text that will explore our shared experiences of living in Brighton and Hove. Its common ground and the idea is well received by the Network, so we set about planning the event and look forward to working with the women and hopefully evolving our community beyond what we know and learning from new stories that the workshop will encourage and support.

A Sense of Place: The Workshop

On the day, we carefully arrange the tables in neat socially distanced rows, place a cluster of brightly coloured pens and pencils on each table along with a few sheets of drawing paper, copies of a poem, and a small ordnance survey map of Brighton and Hove.

The event takes place at the Friends Meeting House, a quiet red-bricked building set back in its own garden in the centre of Brighton. We chose this location because of the large airy rooms the building offered, its location in the heart of the city, and the friendly and helpful demeanour of the staff who continued to encourage us to run the sessions, even with all the restrictions put in place to keep us safe during COVID-19, which were sometimes off-putting and overwhelming.

At the front of the room was a much larger A0-sized map of Brighton and Hove which we stuck down on a huge piece of cardboard at the front of the room. As we waited in for the women to arrive, we cast a critical eye over the room, is it inviting enough? Is it safe? The windows are wide open to allow for ventilation and a chilly wind circulates the room, 'I'm cold,' Jess says, 'can I borrow your coat?' We hope the women will be dressed warmly and open to the possibility of sharing their stories with us, even though they don't know us and the room seems to be saying 'no'.

The principal purpose of this event is to find out whether opportunities to provide safe spaces for the members of this community to share stories and be creative might improve a sense of belonging in the city in which they now live and therefore support well-being. The city of Brighton and Hove was designated a City of Sanctuary in 2020, and finding ways to support the well-being of these groups is of increasing importance—to us but also to Brighton and Hove. These pilot workshops will explore the participants' sense of place and identity in relation to the city in which they now live and we hope that they will want to share stories and skills that will connect us all.

We have been made acutely aware that the vulnerability of some of the women means that the event is about establishing trust, building rapport, and making a more solid

connection, both with the women who have signed up for our workshop but also with the umbrella organization and its members. If this goes badly, then future events and a collective seem very much in doubt.

We are both a little apprehensive; Jess has not done any face-to-face workshops since the lockdown started back in March 2020 and I haven't done anything like this for a long while, pre-cancer (over three years ago now). But we are here: confident, curious, upbeat, sure that what we are doing is worthwhile and will make a difference, to the women taking part, and also for us.

Slowly the women arrive, one by one, some are dressed in distinctive head scarfs and beautifully billowing dresses, others are in jeans, all wear face masks. Our mouths and noses are covered so we exchange greetings with smiling eyes (see Figs. 40.1 and 40.2). The women are from diverse religious and cultural backgrounds, from Syria, Turkey, Mexico, England, Thailand, Kurdistan, and Iraq. Because English is not the first language for most of the attendees, we provide Arabic and Sorani interpreters to support the sessions. They relay what we say back to the women taking part with hand gestures and passion that is akin to an art form itself. Jess and I adjust to the new rhythm of working in this way whilst trying not to become absorbed in what the interpreters are doing, their gestures and physical storytelling compelling and alive, a theatre of words and intentions.

It is quickly apparent that a network of friendship and support already exists amongst some members of the group who are regular attenders of other events—cookery,

FIGURE 40.1 Workshop participants (2020).

Digital Photograph.

FIGURE 40.2 Workshop participants (2020).

Digital Photograph.

English lessons, and socials—hosted by the Network. The presence of a representative from the network seems to reassure and settle the group, a familiar face in unfamiliar surroundings. Jess and I are the outsiders here. We are acutely aware that the personal histories of some members of the group mean that they may feel vulnerable sharing and so we emphasize the need to focus only on what they want to share, keeping themselves safe and establishing a positive focus—no-one will be obliged to disclose painful details or share work that makes them feel vulnerable.

The two-hour session begins, and we progress steadily through the exercises that we have devised, hoping to build a sense of shared endeavour and rapport. The women respond freely and generously sharing stories of being creative, of singing, of sewing, of cooking, of drawing, of painting, of parenting, of gardening, of performing, of travelling, of adjusting, and reflect on how this is linked to their well-being and also, to their identity. Some have been unable to do the creative tasks they love whilst fleeing war-torn countries where their lives were in danger and they had to leave behind materials and utensils that supported their creative lives. Talking about what they enjoyed doing in the past, what they were keen to do more of, what they could offer to the group, seemed to strengthen the existing connection and mutual respect between the women and was also moving and inspiring to us.

We talk to the women about our own stories—how having cancer had forced our creativity into hibernation and how our search for a way to recover using walking, dialogue,

and the opportunity to share our stories, had supported our recovery and sense of well-being. They ask us questions and we explain how our work had developed our connection and helped our creativity shift and evolve and that we see this as being intrinsic to our sense of self and also, to feeling well.

As we move through the creative exercises, we evolve the large Ordnance Survey map of Brighton and Hove at the front of the room with their writing and their drawings, their calligraphy, their ways of perceiving the city. They named the places that are significant and special to them in the City, telling stories and drawing images about their favourite places: The Old Steine, Devil's Dyke (which they rename The Mountain), Taj is the most popular supermarket, smells they notice, the sounds they hear, the conversations they have had and where. They mention the mall and the beach most notably, but also name the suburbs and roads where they now live. The images they make and the writing that they produce are collaged onto the map—their creative responses disrupting and changing the surface and meaning of the map of Brighton and Hove that we started with. In doing so, they seem to reclaim the city as their own, as a place they are part of and engaged with enhancing (see Figs. 40.3 and 40.4).

There are several tears in response to the evocative and personal poems the women wrote, where they detail happy memories but also some sorrow for the places and loved ones they have left behind. By laying down their own histories and memories onto the map of Brighton and Hove (see Figs. 40.5 and 40.6)., the women are able to assert their presence here and add a new layer of meaning to the stark original map. Their stories on the map make it new again, more colourful (see Figs. 40.7 and 40.8), their very presence and interaction with the City is perhaps changing them, but they are also changing and improving the City they now call home. The act of embedding their individual and collective memories into the gridlines serves as a reminder that whilst they must adjust to the city, Brighton must also learn to accommodate them and embrace the histories, memories, and experiences that they bring.

In her essay, *Dreaming the Territory,* Marina Warner looks at the artist Jumana Emil Abbound, and her method of memory mapping in her search for lost stories in the landscape that have been erased which she then records in a different media to reignite the memory of the lost place.

> *In 1932, Alfred Korzybski coined the phrase' the map is not the territory'; he meant that an exact survey, as in an ordnance survey map, does not capture the way we relate to a landscape or a place. He was thinking in neuroscientific terms about the relationship of our minds to what we know and wanted to point out how every individual's experience of reality is formed by their interactions with their surroundings.*
>
> (Warner, 2018, 181)

What we asked the women to do here differs in the sense that we are asking them to lay down their memories and histories in a new place and redraw the map of their

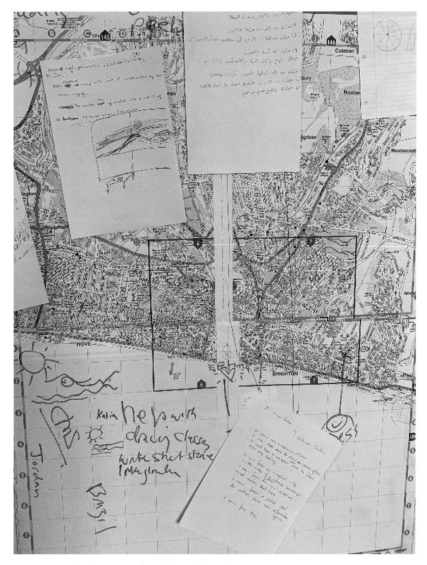

FIGURE 40.3 Workshop Map of Brighton 1 (2020).

Digital Photograph.

adopted city to accommodate these stories. In other words, we are interested in using creative methods to begin overlaying the official map of the Brighton with the subjective experiences of the women, and to bring into a being a new map that records and includes these experiences, motivated by a belief that this approach can support these women to deepen their sense of connection and belonging to this place and in doing so, perhaps begin to recover and nurture their well-being after seismic changes to how and where they live.

FIGURE 40.4 Workshop Map of Brighton 2 (2020).

Digital Photograph.

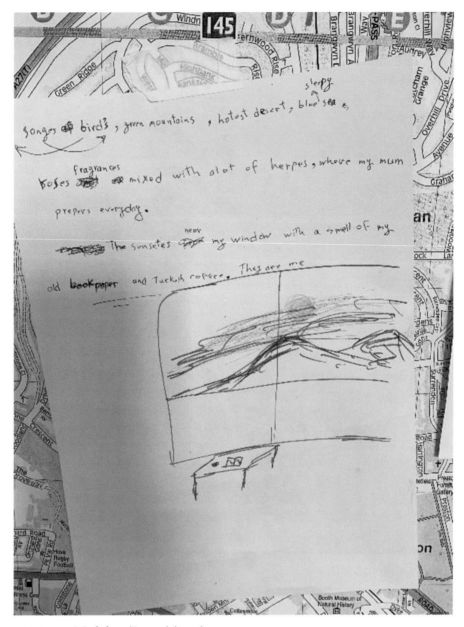

FIGURE 40.5 Workshop (Poem 1) (2020).

Digital Photograph.

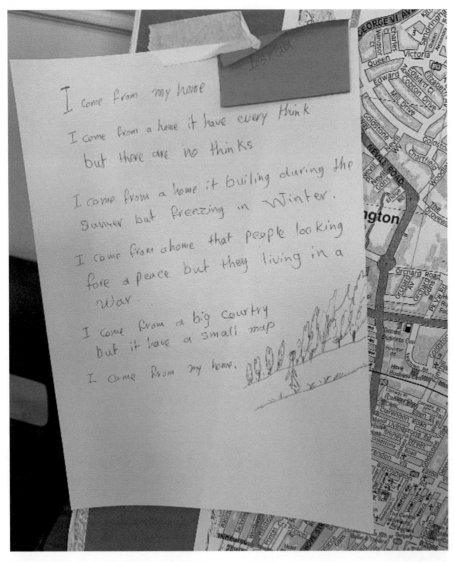

FIGURE 40.6 Workshop (Poem 2) (2020).

Digital Photograph.

SUPPORTING A MOTIVATED CREATIVE PRACTICE

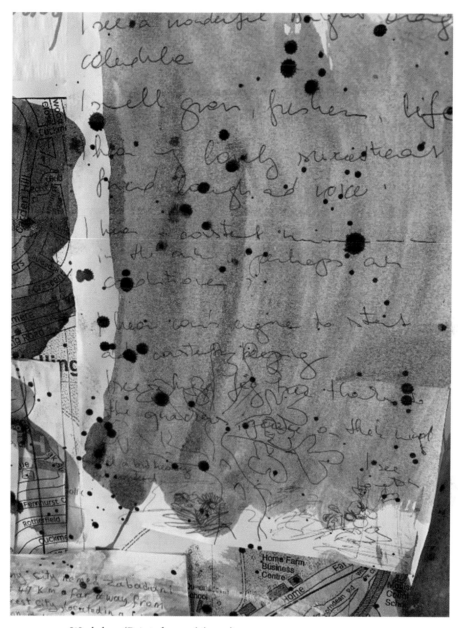

FIGURE 40.7 Workshop (Painted poem) (2020).

Digital Photograph.

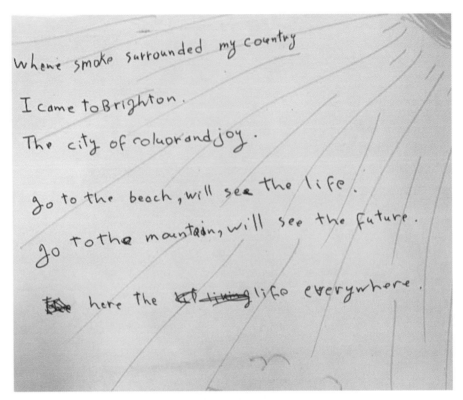

FIGURE 40.8 Workshop (Poem 3) (2020).

Digital Photograph.

Conclusion

The workshop ended with a group discussion about how storytelling/art/talking/walking can deepen our connection with place and our own well-being. We asked the women to consider what might help them to deepen their connection with Brighton and how we could design the workshops to make this useful. The women graciously and generously filled in feedback forms, detailing their experiences of the morning's events and requesting more opportunities to gather and share, not just their stories but also the skills that they could offer. These were many and diverse: Greek translation, drama and dance, sewing, cooking and more. Alongside this they asked for support with their creativity to support individual efforts to write, to draw, to paint. We add these requests to the map.

كانت ورشة العمل ناجحة ، تمت بأجواء ايجابية و مريحة ،حيث الجميع شارك بطريقة تفاعلية عبروا عن أفكارهم ومشاعره بطريقة جميلة من خلال الرسم وكتابة الشعر. المكان مناسب جدا وكبير و الجميع ملتزم بالتباعد الاجتماعي ووضع الماسك ،المحاضرين كريستينا وجيس كانتا لطيفتان مع النساء جميعا ومتعاطفات مع ما كتبوا و رسموا. الجميع تمنى جلسات أكثر و طلبوا المزيد من ورشات العمل الخاصة بالرسم والتلوين. Ohood Abou Zidan

(Translation—The workshop was successful, conducted in a positive and relaxed atmosphere, where everyone participated in an interactive way, expressing their thoughts and feelings in a beautiful way through drawing and writing poetry. The place is very suitable and large and everyone is committed to social distancing and masking, the lecturers Christina and Jess were kind to all women and sympathetic to what they wrote and drew. Everyone wished for more sessions and requested more drawing and painting workshops. (Ohood Abou Zidan)).

The process of telling and sharing stories can deepen connections with other women and enhance our sense of who we are. As two white female academics, privileged in many regards, but still struggling against patriarchy in others, we have found that the telling and sharing of stories using image and text can help to initiate and extend creative communities that develop knowledge and understanding amongst women, helping us to be more creative, empathetic, and supportive of one another. We have developed an approach to creative workshops that is aligned with work that:

- is about women and can be used by women
- does not oppress women
- develops feminist perspectives that challenge dominant intellectual traditions and can be used to support a variety of intersectional struggles. (Acker, J., Barry, K., & Esseveld, J. (1983, January))

We suggest that by working in this way, we can initiate academic work that also enhances our well-being. We are now developing this model in future work with the International Women's Network that seeks to explore experiences with menopause and life post-COVID-19 using storytelling. As part of this work, our own well-being and the well-being of the women who take part will be evaluated using a WEMWBS questionnaire and we will strive to work in equal partnership with the Network, co-producing creative spaces and workshops that will enable the production of lived-experience stories. We aim to develop a co-produced research methodology that includes and values space for creative reflective practice and includes participants as researchers (rather than participants). We argue that working in this way, we are trying to disrupt and challenge conventional academic discourse that has led to universities becoming 'anxiety machines' (Hall, 2017) and instead devise ways of working in higher education that value feminist collaborations and an exchange of personal storytelling that can and will help our sense of self and well-being.

References

Acker, J., Barry, K., & Esseveld, J. (1983, January). Objectivity and truth: Problems in doing feminist research. In *Women's Studies International Forum* (Vol. 6, No. 4, pp. 423–435). Pergamon.
Bakhtin, M. M. (1981). *The dialogic imagination: Four essays*. Translated by C. Emerson & M. Holquist. University of Texas Press.

Barone, T. (2003). Challenging the educational imaginary: Issues of form, substance, and quality in film-based research. *Qualitative Inquiry 9*, 202–207.

Diab, S. (2017). Writing gown: The challenges of making a new artwork about sexism in academia. In *Surviving sexism in academia* (pp. 89–97). Routledge.

Goode, J. (Ed.). (2019). *Clever girls: Autoethnographies of class, gender and ethnicity*. Springer Nature.

Hall, R. (2017). Gender pay gap in academia will take 40 years to close. *The Guardian*, 26 May. Available from: www.theguardian.com/higher-education-network/2017/may/26/gender-pay-gap-in-academia-will-take-40-years-to-close [last accessed 6 October 2024].

Klevan, T., & Grant, A. (2020). Performing wild time: Workshopping friendship as critical autoethnographic paraversity method. *Critical Education*, *11*(1), 1–18.

Moriarty, J., & Marr, V. (2019). Reclaiming the book of spells: Storying the self as a for of resistance. In J. Moriarty (Ed.), *Autoethnographies from the neoliberal academy: Rewilding, writing and resistance in Higher Education* (pp. 87–103). Routledge.

Reading, C., & Moriarty, J. (2019a). Walking and mapping our creative recovery: An interdisciplinary method. In *Autoethnographies from the neoliberal academy* (pp. 51–66). Routledge.

Reading, C., & Moriarty, J. (2019b). Supporting our inner compass: An autoethnographic cartography. In *Autoethnographies from the neoliberal academy* (pp. 67–82). Routledge.

Reading, C., & Moriarty, J. (2022). *Walking for creative recovery*. Triarchy Press.

Sava, I., & Nuutinen, K. (2003). At the meeting place of word and picture: Between art and inquiry. *Qualitative Inquiry 9*(4), 515–534. https://doi.org/10.1177/1077800403254218.

Scott-Hoy, K., & Ellis, C. (2008). Wording pictures: Discovering heartful autoethnography. In J. G. Knowles & A. L. Cole (Eds.), *Handbook of the arts. Qualitative research: Perspectives, methodologies, examples, and issues* (pp. 127–141). SAGE. https://doi.org/10.4135/9781452226545.n11.

Slattery, P. (2001). The educational researcher as artist working within. *Qualitative Inquiry 7*(3), 370–398.

Symonds, A. (1991). Gender issues and Horney theory. *American Journal of Psychoanalysis 51*(3), 301–312.

Tedlock, B. (2000). Ethnography and ethnographic representation. In N. K. Denzin & Y. S. Lincoln (Eds.), *Handbook of qualitative research* (pp. 455–486). SAGE.

Tierney, William G., & Yvonna, S. Lincoln. (1997). Introduction: Explorations and discoveries. In *Representation and the text: Re-framing the narrative voice* (pp. 1–3). SUNY Press.

Tilley-Lubbs, G. (2018). Am I there yet? Reflections on Appalachian critical consciousness. In L. Turner, N. P. Short, A. Grant, & T. E. Adams (Eds.), *International perspectives on autoethnographic research and practice*. Routledge. https://doi.org/10.4324/9781315394787.

Warner, W. (2018). *Forms of enchantment, writing on art and artists* (p. 181). Thames and Hudson.

CHAPTER 41

AESTHETIC EXPERIENCE AND AESTHETIC DEPRIVATION IN HOSPITALS

HILARY MOSS

Introduction

The field of arts in health care embraces a wide range of practices. These range from exhibitions and music performances in hospital buildings, to medical humanities (such as hosting a mental health film festival with post film discussion with medical and film students); use of various arts in aging care (for example music and movement programmes as part of physiotherapy rehabilitation, specialist music therapy for stroke rehabilitation, choirs for people with dementia); arts in hospice/end of life care (such as painting classes as part of hospice day care), arts therapies, and medical education (Stuckey & Nobel, 2010; Clift & Camic, 2016). Arts and Health practice is a contested term but has been defined as arts-based activities that aim to improve individual and community health and health-care delivery and which enhance the environment by providing artwork or performances (Wynn Owen et al., 2013).

Whilst reviewed elsewhere, examples of strategic use of the arts can create a sense of welcome, choice, control, and beauty conducive to improved health and well-being (Ulrich et al., 2008; Anderson et al., 2018). For instance, sculptural commissions are common in hospital entrance areas and receptions. Examples include 'The Acrobat', a stunning eighteen-foot sculpture by Allen Jones that transforms the atrium of the Chelsea and Westminster Hospital from a clinical space to a site for an artwork (Woodham, 2002). Similarly, from children's hospitals to cancer clinics, the colours, interior design features, choice of artwork and music on the radio are designed to communicate a welcome to the service user, professionalism, and care for the person (Frampton, 2001). Research indicates, for example, that choosing music to listen to pre surgery reduces anxiety (Bradt et al., 2013).

Choice and control over one's environment is a basic psychological need and the arts contribute to a person's sense of agency during the frightening experience of medical treatment. For example, live music performed by a music therapist is also well established as an alternative to sedation for children receiving scans (Loewy et al., 2005). The arts are recognized in many sources as being capable of inducing a sense of possibility, hope, and enjoyment of the present moment, and have a role in lifting people out of the arguable misery of human existence (Ettun et al., 2014). For example, as Arts Manager in a hospital, this author organized a live performance of a string quartet in a hospital ward. A man who had a stroke commented during the concert that he never thought he'd be able to attend a live music event. He described the concert as 'medicine for the soul' and pointed to a renewed hope and a brief lifting of mood that was born out of a moment of musical beauty on the ward (Moss, 2021). Further examples include a significant study of creativity on mental health which concluded that active engagement in art and cultural activities was inversely associated with depressive symptom onset and this association was confirmed regardless of age, gender, and socioeconomic status. Authors concluded that promoting art and cultural engagement could be important to protect service users' mental health (Noguchi et al., 2022).

A strong body of evidence indicates that the arts can contribute to health, well-being, and improved clinical outcomes, although further research with larger sample sizes is needed in most areas of arts and health practice (Fancourt, 2017; The All-Party Parliamentary Group on Arts, 2017; Arts Council England, 2018; Fancourt & Finn, 2019; Baxter & Fancourt, 2020; Daykin, 2020). The World Health Organization (WHO) report on arts and health is the largest scoping review of the literature to date, detailing significant evidence of benefit in key areas of health care (Fancourt & Finn, 2019). Cochrane reviews on music, dance, and art therapy for depression, dementia, and schizophrenia similarly evidence some benefit to psychological health, although all recommend further research with larger samples (Vink Annemiek et al., 2003; Ruddy & Milnes, 2005; Maratos et al., 2008; Xia & Grant Tessa, 2009; Mössler et al., 2011; Meekums et al., 2012; Ward et al., 2012; Karkou & Meekums, 2017). While acknowledging the evidence that exists, and the role of the arts in positively impacting health and well-being, there is an undeniable need for further quantitative and qualitative investigation.

This chapter demonstrates the various aspects of aesthetic enrichment in healthcare settings and gives several examples of the role of the arts, and beauty, in hospital settings.

Aesthetics and Aesthetic Experience in Health Care

The specific role of aesthetics, aesthetic experience, and engagement have received little attention in recent reviews of arts in health care. The components of aesthetic experience and effects of this engagement are rarely explored. It is important to clarify the

term 'aesthetics', in this chapter and its relationship with art. The definition of aesthetics used in this chapter is 'an attempt to theorise about art, to explain what it is and why it matters' (Graham, 1997). For this chapter, therefore, aesthetics encompasses all artforms and a reflection on the role the arts play in society. The focus is on the role of the arts in hospital contexts and aesthetics includes a range of experiences, including appreciating the beauty of art works arising in spectatorship, engaging the senses (such as observation, seeing, hearing, walking through); participation in experiences (be they beautiful or ugly), to deeper engagement through contemplation with activated thought and imagination that may lead to new insights and deeper meanings. 'Aesthetics' and 'aesthetic experience' may also include sensory experiences such as pleasure, delight, enjoyment, and relaxation, but can also be experienced in everyday experiences. For example, in the hospital where this author worked, live music performances were reported to lift service users' mood, stimulate their hearing and cognition, and create a pleasant waiting room experience. Similarly, negative aesthetic experiences were reported on wards such as noise pollution from machines, staff and busy activity, smells of disinfectant and incontinence pads, as well as appreciation expressed for the aesthetic quality of hospital crockery and sheets. 'Aesthetic experience' in this chapter includes receptive experiences (for example, visual art exhibitions, music performances and environmental design). This includes the role of aesthetics in giving pleasure, enjoyment, relaxation, awe, and wonder. Aesthetic experience can also be participatory for example painting, writing poetry or playing musical instruments. In an art group for people receiving renal dialysis treatment, participants engaged in spontaneous art making while in their hospital bed. Conversations began while painting, sharing experiences about coping with chronic illness. A sense of hope, engendered through enjoying this activity during a very stressful stage of life, may have motivated people to be active when health issues make this difficult. Participants reported that they were coming to dialysis treatment with their 'next art idea' rather than bringing a sense of 'wasted time' and sadness. Aesthetic experiences arose from creating art in various forms and a sense of achievement arose from hosting an exhibition in the community art centre of this group's work. The sensory qualities of the materials and immediate expression of inner feelings may have provided an opportunity to articulate complex lived experience that words alone cannot convey. Seeing the renal dialysis participants selling their artwork (which they completed while on dialysis in hospital) communicated a powerful message to health-care providers and the general public that disability or chronic illness does not stop people creating and expressing beauty, meaning, and hope.

It is important to note that aesthetic experience can arise in the 'everyday' aspects of hospital also, not just in art works. Saito explores this fully in terms of the importance of bed sheets and mugs for coffee being more important than high art such as paintings on the walls of hospitals. Saito also points out aesthetic experience not only pertains to the beautiful and pleasing but also to the ugly (Saito, 2008, 2017).

Examples of aesthetic experiences in hospitals include bad smells, ugly wounds, listening to recorded music, viewing art on the walls, the presentation of food on a hospital tray, the feel of the bed sheets, dancers leading exercise sessions alongside

physiotherapists, performances in the atrium, music at religious services and end of life care, creative writing programmes as part of rehabilitation, singing in a hospital choir, intense individual physical rehabilitation using music, watching films on an iPad, and noise on the ward. This author's ambition, while managing a hospital arts programme, was to engage with all these approaches and leave none out, to create an environment, using the arts, to communicate care, professionalism, and the intrinsic value of caring and creativity in life, as well as recognizing the need to be a champion for addressing noise pollution, ugliness, and the physical comfort of hospital buildings (Moss, 2016). The arts play an instrumental role in assisting wayfinding, making the intangible tangible (for example, communicating a welcome or caring atmosphere), and affecting pain perception (Moss & O'Neill, 2016; Moss, 2021). Lawson states that hospital spaces need to do what they seldom do; they need to counteract the loss of independence and identity the service user feels. A common mistake is to concentrate too much on the central purpose of the space and forget the rest of the human condition. This can lead to wonderfully efficient and clinically sterile hospital that treats the body but numbs the spirit (Lawson, 2001).

Hospitals are places of fear, uncertainty, and discomfort. In hospital we are confronted daily with mortality, disfiguration, and scars. Most literature in the field of arts and health focuses on practical, active engagement with the arts rather than receptive or spectatorship arts, perhaps indicating a bias in arts and health researchers who value participation over receptive engagement (Moss, Donnellan, & O'Neill, 2012). For example, comfortable bed sheets and a good book are simple pleasurable aesthetic experiences when we are sick. Choice is an important facet of aesthetically pleasing hospital environments. The aesthetic quality of everyday objects can also affect how we perceive the quality of the facility. This author remembers a service user commenting that she felt valued and cared for by the hospital because the management had deemed her important enough to engage distinguished musicians from a visiting orchestra to play on her ward. When one is ill and low in energy, receptive arts such as reading, watching films, and listening to music are more accessible and popular, and can bring sensory comfort, control over choice of aesthetic input, and a sense of safety in familiar preferred arts activities. In hospital, the ill person is normally at the mercy of the hospital staff choice of aesthetics and has no recourse other than to cope with this aesthetic injury or pleasure for a longer or shorter period. The entire person is affected by their surroundings, physically and psychologically, mentally and spiritually; signals are received throughout the entire body (Caspari, Eriksson, & Naden, 2011). Hospitals can also be aesthetically deprived, with people denied access to a choice of music, colour, or artworks (Moss, 2014a, 2014b). Of course, positive aesthetics are highly subjective. The context in which we experience aesthetics is central: for example, in some African countries a deformed lower lip is a sign of beauty and tattoos are viewed as beautiful or ugly depending on context and culture. The current political context is crucial in deciding what might be considered beautiful and whether investment is made in hospital aesthetics (Cuypers et al., 2011a, 2011b). Public policy regarding investment in aesthetics is critical. For example, the provision of music in hospitals competes

with utilitarian demands, and as beauty and music have no obvious use, they can be undervalued by public policy makers. The importance of beauty, and the arts, often lies in its absence, and it may only be noticeable to policy makers when it is absent or provided badly (De Botton, 2006). Financial concerns also dominate any discussions on aesthetics in hospital environments. In an age of financial austerity, it is tempting to think of the arts as needless decorative expenses (Kieran, 2005; Bauman, 2010). The temptation is to cover up the unpleasant aspects of hospital (needles, bodily fluids, the spilling of food while eating) with cleanliness, hygiene, and sterility accompanied by 'pleasant' music in the waiting room (Forsey & Aagaard-Mogensen, 2019). Human experience and the suppression of the aesthetic experience is often experienced within health-care settings. For example, people with serious illnesses often describe people avoiding them, not knowing what to say. How, then, do we approach arts engagement in hospital if we do not allow the dissonance of human experience to be heard? We must balance the need to communicate safety, welcome and support through the arts in hospital with the expression afforded by the arts to give voice to the pain, hope, and struggle experienced by many living with serious illness. One must also be careful of the strong link between the arts and emotional responses which, whilst often positive, can result in distress if presented in an insensitive way (Juslin & Sloboda, 2009; MacDonald et al., 2012).

Hospital design and environment is often celebrated within health-care settings (the internet is awash with 'beautiful hospital design' examples), ugliness is rarely written about, reported, or considered. Books on negative aesthetics, noise pollution, or potential negative aspects of music are relatively rare (Sibley et al., 2001; Stecker, 2006). Whilst the field of architecture and design features many studies on the hospital environment, this chapter focuses more on the the social and psychological experience of people using the space, including the need for stimulation, security, and a sense of personal identity within the environment (Frampton, 2001; Lawson, 2001). Similarly, commentary on the negative effect of music is scarce, with much of the narrative within the aesthetics in health-care field focusing on false claims such as 'the arts make us feel better' or 'the arts are good for our health'. Experiences such as music being used as a means of torture (Guantanamo Bay) or as a tool to create division within communities (Northern Ireland) are rarely presented in the arts and health field (Sibley et al., 2001; Stafford Smith, 2008; Shaffer, 2013; Ross, 2014; Moss, 2021).

According to evolutionary theory, humans rebuild their environments to suit their preferences (Rolston, 1995). In health-care settings, patients often have little control over their environment. Hospital service users are rarely encouraged to decorate their room or bed space in their own way, to bring in images or photos that they enjoy. The subjective nature of the benefit of the arts means that evidence is relatively weak for these sorts of interventions. As a result, these small but significant personalizations of health-care spaces are often overlooked by health service managers.

Hospitals usually aim to offer security and a sense of safety and reassurance rather than stimulation, but for sick people, feeling vulnerable or undergoing traumatic experiences, it is important to retain a sense of identity and some control over their

environment. Being able to influence one's aesthetic experience is basic and fundamental. Lawson writes about the three psychological needs humans have in any physical space; namely stimulation, a sense of security, and a sense of identity. In hospital spaces, it can be noted that often people will sit in cold corridors waiting for an appointment rather than go for coffee because they need the security of knowing that they will not miss their appointment. The need for security in this instance overcomes the need for comfort (Lawson, 2001). However, for longer stay patients the need for stimulation and a sense of identity may override the need for safety.

Aesthetics play a part in how the doctor looks and dresses and how much we trust in staff. The design of the clinic and choice of colours on the wall might even affect whether we choose one doctor over another. How a patient views their institution affects how they engage in treatment and sometimes how willing they are to stay and comply with treatment. When we lack sufficient knowledge about the precision of a diagnosis or treatment option, we turn to aesthetic intuition to make decisions regarding our trust of a doctor (Mandoki, 2007). Mandoki claims that the hospital is made up of a variety of aesthetic costumes, to distinguish personnel and perhaps distance them from patients and relatives. Exhibiting diplomas on the wall can be seen as an aestheticization of the skill and identity of a doctor!

Caspari et al. (2011) carried-out interviews with sixteen experts on aesthetics (who had also been hospital patients). These participants were all considered to be persons educated within an aesthetic field, who worked in a profession or occupation within an aesthetic field (for example, interior designer, architect, visual artist, chef). All participants had experience of having been patients in hospital themselves or having had someone close to them as a patient.

The aesthetic environment of hospital was defined as being made up of the following important considerations: (i) Nature, view and light; (ii) Sounds and smells; (iii) Architecture and rooms; (iv) Design and aesthetics; (v) Food; (vi) Hygiene and maintenance; (vii) Art, colours and water; (viii) Variation and atmosphere; (ix) Harmony, humour, and play. This provides a useful starting guide as to the aesthetic considerations that matter most in hospital. The Norwegian authors noted, from their extensive research in this field, that patients in their country have rarely been asked their opinion on the aesthetics of hospital, nor what they consider important in this area. No Norwegian hospitals had written strategies aimed at how to attend to the aesthetic environment and the majority of nurses and patients surveyed by the authors were dissatisfied with the aesthetics of their hospital (Caspari et al., 2007).

'The goal is to create aesthetic environments in the hospitals, where the patient is the primary figure, an environment where aesthetics can contribute to recovery of health and well-being and can serve to make both daily existence and the entire stay in hospital more pleasant' (Caspari et al., 2011). Dose suggests that no-one, given the choice, would actively prefer medical treatment in a setting devoid of the arts, or life in a community with no arts provision (Dose, 2006).

Examples of Practice

The next section draws on real-life examples from one busy acute hospital in Dublin, Ireland, to illuminate and reflect on the role of aesthetics to support mental health recovery. These examples are drawn from the author's practice as Director of Arts and Health at Tallaght University Hospital, Dublin from 2003 to 2016.

Aesthetic Deprivation in Hospital: Mapping the Aesthetic Interests of 150 Older People in Hospital

Negative aesthetics take the form of both the absence of positive aesthetics (for example, blandness) and negative aesthetic experiences such as noise pollution (Saito, 2017). Blandness, boredom, and lack of creative stimulation are commonplace in nursing homes and hospitals. Noise pollution is common on hospital wards. This author mapped the aesthetic experiences of 150 older people in hospital in Ireland a year before being in hospital, during hospital stay, and post hospital. In this case, aesthetic experience was divided into two areas. Firstly, engagement in arts and cultural activities (such as watching films, listening to music, painting, dancing, acting). Secondly, aesthetic experiences in hospital were examined, namely access to arts activities while in hospital; the most popular art forms—music, dance, reading—and their availability in hospital; noise disturbance (sharing rooms; noise from staff, patients, and machines); control over the environment; choice of arts and leisure activities while in hospital; interest in receptive arts, and noticing the visual art on the walls.

Less than 50 per cent of the sample in an acute hospital ward had control over whether the radio or television was on or off or choice of what to listen to or watch (Moss et al., 2015). Most of the sample identified dance, listening to music, and watching films as key aesthetic interests prior to in-patient stay but less than 2 per cent could continue these activities satisfactorily in hospital. Quiet spaces in hospital were in short supply and there was a marked decline in attendance at cultural events and activities post hospital stay. This brief snapshot indicates that much work needs to be done to enable people to continue cultural and leisure interests while in hospital, and to access cultural institutions post hospital stay. Given the well documented link between quality of life, well-being, and cultural and leisure pursuits, it is important to give this area of health more attention.

Regarding aesthetic experiences in hospital, only one-third of this sample had control over whether the TV or radio was on or off (see Table 41.1). However, the majority stated that these sounds did not disturb them. Research suggests that people in hospital are reluctant to complain and this may be reflected in this seemingly contradictory result.

Table 41.1 Noise in hospital (n = 150)

Item number	Survey question	Agree n (%)	Disagree n (%)	Other n (%)
1	I had control over whether the TV was on or off while in hospital	50 (33.3)	99 (66)	1 (0.7%)
2	Sounds from TV or radio disturbed me when I was in hospital	26 (17.3)	124 (82.7)	0 (0%)
3	I had control over whether the radio was on or off while in hospital	52 (34.7)	97 (64.6)	1 (0.7)
4	Music being played on the ward disturbed me when I was in hospital	14 (9.3)	136 (90.7)	0 (0%)
5	I was able to choose whether to share a room with other patients while in hospital	42 (28)	108 (72)	0 (0%)
6	I had access to a quiet place when I needed it in hospital	92 (61.3)	58 (38.7)	0 (0%)
7	I had access to company and conversation when I needed it in hospital	126 (84)	24 (16)	0 (0%)

Patients generally reported low expectations of being able to influence the aesthetic environment of hospital or continue arts interests while sick (see Table 41.2). This concurs with Caspari's research that reports a lack of any strategic planning for aesthetics in hospital. Put simply, aesthetic experience is rarely a priority in hospital. Most evidence for caring about the aesthetic experience was seen in palliative care facilities at the hospital and in rooms where bad news was routinely broken to patients. Colours of walls, furnishings, and artwork were often employed to create a softer, caring environment. Lack of aesthetic concern was reflected in recent practice during the COVID-19 pandemic. Most hospitals ceased all arts therapies services and arts practice in hospitals. This researcher has heard of only one hospital, in the United States (US), that considered music therapy a crucial intervention in the hospital ICU and continued it during the pandemic.

Music Interventions in the Management of Chronic Pain

The debate about the value of music in health-care settings can be seen as a split between politicians and policy makers who value the 'instrumental value' of the arts and cultural professionals who are dedicated to the 'intrinsic value' of the medium. This debate has been seen throughout the history of aesthetics (Gaut & McIver Lopes, 2005). This author has engaged in art and music therapy interventions with people living with chronic pain for over fifteen years (Moss, 2020). Chronic pain can be defined as persistent and

Table 41.2 Popular art forms—music, dance, art, writing, film (n = 150)

Item number	Survey question	Agree n (%)	Disagree n (%)	Don't know n (%)
1	I listened to music while in hospital	88 (58.7)	62 (41.3)	0
2	I listened to live music when I was in hospital	21 (14)	129 (86)	0
3	I played a musical instrument in hospital	2 (1.3)	148 (98.7)	0
4	I wrote in hospital	12 (8)	138 (92)	0
5	I painted or drew in hospital	8 (5.3)	142 (94.7)	0
6	I watched films in hospital	50 (33.3)	100 (66.7)	0
7	I put my own art, pictures, or photographs on the wall in my room or ward	12 (8)	135 (90)	3 (2)

unremitting pain which is present for more than six consecutive months (Aldrich, Eccleston, & Crombez, 2000). It is a worldwide health problem and accounts for one of the main reasons for seeking medical care (Jackson et al., 2015). It is complex, multidimensional, and has experiential features. These include biological, psychological, sociological, and spiritual factors that modulate the pain threshold and its intensity. The arts therapies often support the person regarding the mental health impacts of living with chronic pain.

One of the benefits of engaging in arts programmes as part of the journey of living with chronic pain is making the invisible visible. A common problem for people living with chronic pain is not being believed. Pain is invisible and it is a lonely journey. The arts afford people an opportunity to express themselves freely, without having to attend a 'talking' therapy. People who paint alongside each other, or sing together in a choir, often report socializing, sharing issues and feeling part of a group more quickly than in other therapy groups (Dingle et al., 2019). Depression is closely associated with chronic pain. It is possible to attend an art therapy group or a choir and participate nonverbally, making social connection through the art form possible for those who struggle to make verbal social connections. The motivation to get out of bed and attend a community art centre can be an important part of recovery and instillation of hope. Finding a new interest, and something one can do whilst living with pain, can be a positive step towards building new relationships, activities, and interests, when so much is lost to illness (Collins et al., 2022; Fitzpatrick, Moss, & Harmon, 2019; O'Neill & Moss, 2015). Critical success factors in this programme include (i) engaging with service users in a collaborative process to design arts programmes to serve the needs of this population; (ii) interdisciplinary collaboration with clinicians; and (iii) high quality arts interventions. Research conducted during this period is detailed in the references (O'Neill & Moss 2015; Fitzpatrick et al., 2019; Collins et al., 2022).

Arts Activities as Part of Cardiac Care

In 1991 Gablik wrote: 'If modern aesthetics was inherently isolationist, aimed at disengagement and purity, my sense is that what we will be seeing over the next few decades is art that is essentially social and purposeful, art that rejects the myths of neutrality and autonomy. The subtext of social responsibility is missing in our aesthetic models, and the challenge of the future will be to transcend the disconnectedness and separation of the aesthetic from the social that existed within modernism' (Gablik, 1991). This can be seen in the development of the work undertaken by this author within a cardiac rehabilitation service in a hospital. This project could be described as socially engaged art, engaging in music making, singing, creative writing, and making visual art which directly reflected the experience of people living with pain. Participants engaged in art for enjoyment, therapeutic exploration and self-expression. A poem by one participant aptly sums up the experience of creative writing as part of his rehabilitation and the importance of socially relevant artistic experiences as part of his recovery.

Pacelli was a sixty-five-year-old retired teacher of History and English. He enjoyed amateur dramatics and the craft of wood turning and had an active retirement pursuing these two creative activities. One day, out of the blue, Pacelli suffered a cardiac event, a heart attack, and was rushed to the emergency department for surgery. He attended the hospital cardiac rehabilitation programme following discharge from hospital and then signed up when he saw an advert for a hospital creative writing programme available to people who had completed the rehabilitation programme. The hospital employed a writer in residence, who offered a twelve-week course of poetry workshops at the local library for people living with chronic illnesses who were attending the hospital out-patients department. Following the group, Pacelli shared a poem, which was later published in an anthology of poems by servicer users from the hospital (Moss & Granier, 2006). Despite going through surgery, excellent care from cardiologists, and a comprehensive rehabilitation programme, Pacelli described needing to reflect and re-story his life. He had lost confidence in his body and was afraid to return to his normal creative activities in case he strained his heart again (despite knowing logically that this would not happen). He felt the creative writing workshops allowed him time to reflect on the issues not covered by clinical care, namely, the sudden shock of losing his healthy body, the changes to his life that happened dramatically, his fear and lack of trust in himself, his plans turned upside down in a moment, the emotional fallout of missing a major family event and facing his mortality. Anxiety and depression are common experiences during such periods of readjustment. His poem speaks of a positive energy in starting again after a major scare. For more on narratives of health and illness see Moss (2021).

'Beginnings: In Praise of Cardiac Care' by Pacelli O'Rourke
 To begin with,
 All focus on the Attack,
 Dramatic
 Traumatic

Aftermath.
Professional brilliance in theatres and cathlabs
Mounts the counterattack.
Benign wounding starts the long haul back to health.
The beginning of a new beginning.
Their task executed,
Cardiac Rehab
Reaches down with the unforced forceps of knowledge, understanding and reassurance
To plait together the damaged fibres of Confidence,
Offering the empowering tools of
Restoration.
Nurturing insight into the skills of management,
Embedding the Mighty Truth
That life and the living can and must and will go on.
For the Event was not the beginning of the end,
But is
The beginning of a new beginning.

A Song Writing Project for Mental Health Service Users

'It Made You' is an album of original songs written by songwriters of St. Patrick's Mental Health Services and renowned Irish songwriter Sean Millar. Sean worked with service users, facilitating ten weeks of collaborative song writing workshops through which stories about life, love, loss, strength, and recovery were told. The result is a very special album of nine original songs, written as part of the service's initiative called 'Walk in my shoes'. The album was recorded and produced by Gavin Glass at Orphan Recording. The project was managed and facilitated by music therapist Paula Higgins, who describes the album as a celebration of the creativity that exists within each of us, the creativity that connects us so meaningfully to each other. 'Central to being emotionally healthy is the gift of being able to find meaning in our lives. For many, music, and the process of creating music is a central part of finding meaning. Connecting with our creative selves can help us overcome even the deepest challenges and can lift us beyond the everyday to experience the beauty of the arts' (Higgins, P., quoted in Moss, H., 2021).

Beauty and Aesthetics as Part of End-of-Life Care

Whilst beauty is a highly contested phrase with multiple meanings, in this context it refers to the role of the arts in lifting one out of misery, a transcendence above everyday concerns, as described by many who engage in profound musical experiences (Gabrielsson, 2011). An example here is a client this author worked with as a music therapist.

John was seventy-eight-years old, married with three adult daughters and had worked as an accountant until he retired. John attended music therapy in the last weeks of his life in hospital. He was receiving palliative care in hospital, following a major stroke. There were no more rehabilitative options for John, and he had no ability to communicate

verbally. He needed twenty-four-hour care, was doubly incontinent, and reportedly in pain. His wife kept vigil by his bedside. She reported that he was a happy man, who enjoyed golf and quiet pursuits such as reading the newspaper and hill walking.

The music therapist visited to offer a receptive activity, whereby a service user would listen to the therapist play live music at the bedside. The aim was to create a moment of enjoyment, relaxation, or solace. By offering music, it was hoped to offer a break or distraction from the bleak reality of ill health, institutional care, and social isolation. A personally significant song or piece of music might transport a person, for a few minutes, to another mental space or time. The ability that music has to change the atmosphere of a room or evoke a memory is extremely helpful in hospital. A piece of music can significantly transform the atmosphere of a ward, treatment room, clinic, or hospital bedroom and can sometimes dissipate the tension between family members. It can offer a moment of beauty in a dark, difficult time of life and some people find music helps them transcend the everyday and grasp something spiritual. Music may lift mood or be a brief distraction from pain.

John's wife agreed that she would like to hear some music and thought John would too. John was unsettled and in pain and she thought maybe he would like to hear a song. The therapist played a song he reportedly liked. Something in the moment after the song propelled the therapist to offer John's wife a song also. She seemed exhausted and worried. She asked for an Elvis Presley song, as they loved his music throughout their forty-year marriage. The therapist played and sang 'Love me tender' gently and quietly and John's wife joined in singing. She stroked John's hand and his groaning quietened. She cried and said John had responded positively. The intimacy of this moment of singing and being together as a couple was an honour to witness.

This approach to engaging musically with people in hospital serves three aesthetic purposes: firstly, music transformed the hospital bedroom for a few moments, just as music is used on an aeroplane to calm nervous passengers, or in aerobics classes to promote movement. Music is a powerful way to change the atmosphere of shops, restaurants, homes, and workplaces (Jones & Schumacher, 1992; McIntosh, 2003). Secondly, music created a moment of emotional expression and intimacy. Irene cried and expressed her love for John. Thirdly, music calmed John and possibly reduced his experience of pain and discomfort. Music is often used in hospitals to calm people who may be agitated and is used in many religions to create a feeling of transcendence. A moment of music might offer a brief window of life and positivity in the dark experience of loss and trauma of illness. Choosing music to listen to offers a person in hospital a moment of choice and control in an environment in which decisions are often made without any input from the person receiving care.

Higgins facilitated group and individual therapy for people at all stages of the mental health journey. One of her innovations was to create a music therapy room which doubles as a music space for service users to use as they please. The room is attractive, relaxing, and inviting, a space away from the wards and busyness of hospital. Service users can obtain a pass from their ward manager or security officer, sign themselves in, and make use of this quiet space out of hours. The simple gesture of availability of

this beautiful space reminds service users that their musical interests are part of them, and they matter. Unlimited access to the music room gives service users an opportunity for self-expression, reflection, or quiet listening when they need it. There is a body of work on the role of the arts on spiritual health and well-being, an overlooked area of health care but an area that can be rich in aiding recovery and rehabilitation (Moss, 2019; Connolly & Moss, 2021). Throughout time, music has been associated with the divine. Music is used in all religious traditions to enhance prayer and faith, provide a means for petition, prayer, and praise. Music can remind people of their connection with creativity and ultimately with the creative life force. Music has been used in important life rites and rituals throughout the ages (e.g., Gregorian chant, Masses and Passion, Gospel music, humanist funeral music) and music can create very strong physical reactions during religious services (such as shivers and tears at funerals) (Gabrielsson, 2011). Magill, an experienced music therapist in end-of-life care, reports examples of people who experience transcendence through musical experiences; namely being transported to other places, times, and images, and experience a sense of calm and serenity on listening to music in palliative care. Music may reach beyond words to restore, refresh and soothe, ease pain, promote relaxation, and diminish fatigue, through the compassionate presence of a qualified music therapist. If spirituality is a search for meaning and hope at times of distress or failing health, then music can arguably help to meet these needs in health-care settings (Magill, 2006). Further research is recommended regarding the relationship between spirituality, music, and health, and the role of aesthetics within health-care spaces in creating moments of spiritual health and connection (Moss, 2019; Connolly & Moss, 2021).

Workplace Choirs for Well-being

This author established a workplace choir for health-care staff and conducted research on the benefits of the same (Moss et al., 2017; Moss & O'Donoghue, 2019; Helitzer & Moss, 2022). Singing in choirs has become increasingly popular in recent years, with the growth of workplace choirs and choral competitions. There are an increasing number of 'singing for health' projects in the United Kingdom (UK), with a focus on mental health (Clift et al., 2008; Clift, Hancox, et al., 2010; Clift, Nichol, et al., 2010; Williams et al., 2018). Workplace choirs are introduced for various reasons, including staff entertainment, to promote social connections, and to increase teamwork and productivity. This author's study of six Irish choirs for health-service staff gave some preliminary evidence that choir attendance may increase positive perception of workers' mental health as well as affect depression rates. However, evidence is relatively limited quantitatively and difficulties in measuring the health benefits of arts interventions are noted.

Qualitative data is also important in exploring the rich, lived experience of people in hospital. The subjective nature of personal experience of health conditions, coupled with the subjectivity of the arts, makes qualitative research important in the world of aesthetics and health care. For example, this author has qualitatively researched the experience of people with dementia engaging in singing; art therapy for people living with chronic pain and the role of the curator in hospitals (O'Neill & Moss, 2015; Moss

& O'Neill, 2017; Lee et al., 2020, 2021). Qualitative research regarding workplace choirs confirms previous quantitative study findings, namely that a workplace choir can promote social connectedness, enjoyment at work, and staff engagement. One participant noted: 'Choir has offered a place to meet new people. I never would have met certain people, or had the opportunity to, outside of choir. Getting to know staff in non-work contexts, this is something that is lacking, there's little socialization outside of work'. Another stated that 'There are benefits right across the board for me—physical, emotional, social—I pull out all the stops to make it to choir. I feel it benefits my mind, body and soul. As a nurse I know that there are respiratory benefits—expanding oxygen intake, exercises completed during choir practice—and my posture improves from singing as I am standing straight. I find choir a mental health booster, it is relaxing, destressing and I sleep better after choir. Choir brings me to a calm equilibrium' (Moss & O'Donoghue, 2019).

Conclusions

Creativity matters in hospital; it can lift spirits, bring beauty into a clinical atmosphere, and offer support at a time of ill health, pain, and vulnerability. The arts can give voice to the lived experience of humanity in coping with serious illness. This field, however, can suffer from over-zealous and unsubstantiated claims of effectiveness, a perception that engagement in the arts is only for the minority elite, and financial barriers when the arts are seen as less urgent priorities for health-care spending (Moss & O'Neill, 2009; Moss & O'Neill, 2014b). Nonetheless, a body of work is well established that attests to the importance of creative engagement and access to the arts in improving the aesthetic environment of health-care spaces, as a vehicle for self-expression, and in supporting the mental well-being of people using hospital services (Cameron et al., 2013).

'Art serves as a significant diversion from pain and discomfort. At a deeper level, the arts can link people to inner spiritual resources needed to promote their own healing' (Frampton, 2001). Curators in health-care contexts have a delicate role in balancing support for the intrinsic value of the arts while meeting both service users' preferences and health priorities. Clearly articulated aims are paramount in this field.

In summary, evidence suggests that arts in health-care settings can contribute to a sense of well-being and quality of care, as well as improving service users' experience of hospital. It also suggests that hospitals neglect aesthetics and that improving aesthetics is important to service users. The aesthetic experience, as defined at the start of this chapter, was deliberately broad: aesthetics refers to the broad philosophy of arts and the role the arts play in society. In hospital contexts aesthetics encompasses all art forms as well as broader issues such as the physical environment and everyday experiences related to beauty. This author argues that any engagement by patients with the arts in hospital is an aesthetic experience, whether participatory or receptive, whether as part

of building design or through the blanket wrapped around them. Service providers need to be cognizant of the unique context of hospital, how art will be perceived here and the importance of aesthetics on health and well-being. Artists need to be aware of the vulnerability of their 'audience' in hospital and the need to consider issues other than artistic creation when designing for hospital.

Rather than try to prove the benefit of arts and to make them fit into a scientific model, it may be better to concentrate on the stress and ill health associated with aesthetically neglected environments and to normalize health-care environments by ensuring that arts are available to people in hospital who want them.

There is insufficient literature about the negative effects of music or contraindications of music in health care (Moss & O'Neill, 2014b; Moss et al., 2015). Very few writers have focused on negative effects of cultural activities. Two notable examples exist (Kreutz & Brünger, 2012; DeNora & Ansdell, 2014) but critical writing in this area is relatively scarce. More often we read anecdotal reports of wonderful music programmes in hospital, with little critique of potential noise pollution, poor quality performance, or lack of choice for service users. Critique is urgent in this field of work, along with standards of care and training for all musicians working in health-care settings.

Any aesthetic enrichment undertaken in a hospital must serve a function—to address a clinical need or system problem. Simple changes using colour, art, music, and video imagery can improve the experience for service users and staff by creating a reassuring, safe environment whereby people can relax, receive a more successful investigation, build positive clinical engagement, and hopefully improve clinical outcomes. However, first we must explore the many negative aesthetic experiences in hospital and address aesthetic injury or deprivation.

We can never hope to know, or anticipate, the effect that art will have on people in hospital, people who are vulnerable or have heightened emotion due to the stress of major illness or diagnosis. That is why a suitably trained clinical professional is required to curate arts sensitively and, more importantly, to be able to support people who have an unexpected or unusually strong reaction to the arts (Gabrielsson, 2011). Ultimately, we must ask if the arts matter in health-care settings, and if so, are they provided to meet certain health promotion or clinical aims or are they intrinsically valuable in health-care contexts? (Moss & O'Neill, 2014a, 2014b; Moss & O'Neill, 2016). 'The arts are not about being right or wrong. It's much more flexible than that. It is about weaving arts and creativity into the rigidness of the hospital environment and this I think softens the institution … and it makes space for people's feelings and expression and fears, allowing them to think beyond what is happening to them' (Kilroy et al., 2007).

Acknowledgement

The author would like to thank all the colleagues and service users who made these projects possible and contributed substantially to this work.

References

Aldrich, S., Eccleston, C., & Crombez, G. (2000). Worrying about chronic pain: Vigilance to threat and misdirected problem solving. *Behaviour Research and Therapy 38*, 457–470.

Anderson, D. C., Pang, S. A., O'Neill, D., & Edelstein, E. A. (2018). The convergence of architectural design and health. *Lancet 392*(10163), 2432–2433. http://dx.doi.org/10.1016/s0140-6736(18)33009-5.

Arts Council England. (2018). *Arts and culture in health and well-being and in the criminal justice system: A summary of evidence*. Arts Council England. Available at: www.artscouncil.org.uk/sites/default/files/download-file/Arts%20and%20Culture%20in%20Health%20and%20Wellbeing%20and%20in%20the%20Criminal%20Justice%20system-%20a%20summary%20of%20evidence.pdf [last accessed 11 August 2023].

Bauman, I. (2010). *Beauty, localism and deprivation*. Commission for Architecture and the Built Environment.

Baxter, L., & Fancourt, D. (2020). What are the barriers to, and enablers of, working with people with lived experience of mental illness amongst community and voluntary sector organisations? A qualitative study. *PLoS ONE 15*(7), e0235334–e0235334. http://dx.doi.org/10.1371/journal.pone.0235365.

Bradt, J., Dileo, C., & Shim, M. (2013). Music interventions for preoperative anxiety. *Cochrane Database of Systematic Reviews 6*. http://dx.doi.org/10.1002/14651858.CD006908.pub2.

Cameron, M., Crane, N., Ings, R., & Taylor, K. (2013). Promoting well-being through creativity: How arts and public health can learn from each other. *Perspectives in Public Health 133*(1), 52–59.

Caspari, S., Eriksson, K., & Naden, D. (2007). Why not ask the patient? An evaluation of the aesthetic surroudings in hospitals by patients. *Quality Management in Health Care 16*(3), 280–292.

Caspari, S., Eriksson, K., & Naden, D. (2011). The importance of aesthetic surroundings: A study interviewing experts within different aesthetic fields. *Scandinavian Journal of Caring Sciences 25*(1), 134–142.

Clift, S., & Camic, P. M. (2016). *Oxford textbook of creative arts, health, and wellbeing: International perspectives on practice, policy and research*. Oxford University Press.

Clift, S., Hancox, G., Morrison, I., Hess, B., Kreutz, G., & Stewart, D. (2010). Choral singing and psychological wellbeing: Quantitative and qualitative findings from English choirs in a cross-national survey. *Journal of Applied Arts & Health 1*(1), 19–34. http://dx.doi.org/10.1386/jaah.1.1.19/1.

Clift, S., Hancox, G., Staricoff, R., Whitmore, C., Morrison, I., & Raisbeck, M. (2008). *Singing and health: A systematic mapping and review of non-clinical studies*. Canterbury Christ Church University. Available at: https://repository.canterbury.ac.uk/item/84woz/singing-and-health-a-systematic-mapping-and-review-of-non-clinical-research

Clift, S., Nicol, J., Raisbeck, M., Whitmore, C., & Morrison, I. (2010). Group singing, wellbeing and health: A systematic mapping of research evidence. *UNESCO Observatory 2*(1), 1–25.

Collins, M., Fitzpatrick, K., Kiernan, A. M., Moss, H., & Harmon, D. (2022). Pilot study on music in the waiting room of outpatient pain clinics. *Pain Management Nursing 23*(1), 318–323. http://dx.doi.org/https://doi.org/10.1016/j.pmn.2021.09.002.

Connolly, L., & Moss, H. (2021). Music, spirituality and dementia: Exploring joint working between pastoral care professionals and music therapists to improve person-centred care

for people with dementia (Innovative Practice). *Dementia 20*(1), 373–380. http://dx.doi.org/10.1177/1471301219885560.

Cuypers, K., Knudtsen, M., Sandgren, M., Krockstad, S., Wikstrom, B.-M., & Theorell, T. (2011a). Cultural activities and public health: Eesearch in Norway and Sweden. An overview. *Arts and Health 3*(1), 6–26.

Cuypers, K., Krockstad, S., Holmen, T. L., Knudtsen, M., Bygren, L. O., & Holmen, J. (2011b). Patterns of receptive and creative cultural activities and their association with perceived health, anxiety, depression and satisfaction with life among adults: The HUNT study, Norway. *Journal of Epidemiol Community Health Online 66*(8), 698–703. https://doi.org/10.1136/jech.2010.113571.

Daykin, N. (2020). *Arts, health and well-being: A critical perspective on research, policy and practice*. Routledge.

De Botton, A. (2006). *The architecture of happiness*. Penguin Books.

DeNora, T., & Ansdell, G. (2014). What can't music do? *Psychology of Well-Being: Theory, Research and Practice 4*(1), 1–23. https://pubmed.ncbi.nlm.nih.gov/34688552/

Dingle, G. A., Clift, S., Finn, S., Gilbert, R., Groarke, J. M., Irons, J. Y., Bartoli, A. J., Lamont, A., Launay, J., Martin, E. S., Moss, H., Sanfilippo, K. R., Shipton, M., Stewart, L., Talbot, S., Tarrant, M., Tip, L., and & Williams, E. J. (2019). *Music & Science 2*, 2059204319861719. https://journals.sagepub.com/doi/10.1177/2059204319861719.

Dose, L. (2006). National Network for the Arts in Health: Lessons learned from six years of work. *The Journal of the Royal Society for the Promotion of Health 126*(3), 110–112.

Ettun, R., Schultz, M., & Bar-Sela, G. (2014). Transforming pain into beauty: On art, healing, and care for the spirit. *Evidence-based Complementary and Alternative Medicine 2014*, 7 pages. http://dx.doi.org/10.1155/2014/789852.

Fancourt, D. (2017). *Arts in health designing and researching interventions*, first edition. Oxford University Press.

Fancourt, D., & Finn, S. (2019). *What is the evidence on the role of the arts in improving health and well-being? A scoping review*. World Health Organization. Available at: https://apps.who.int/iris/handle/10665/329834

Fitzpatrick, K., Moss, H., & Harmon, D. (2019). Music in the chronic pain experience: An investigation into the use of music and music therapy by patients and staff at a hospital outpatient pain clinic. *Music and Medicine 11*, 6–22.

Forsey, J., & Aagaard-Mogensen, L. (Eds.). (2019). *On the ugly: Aesthetic exchanges*. Cambridge Scholars Publishing

Frampton, S. B. (2001). Planetree patient-centred care and healing arts. *Complementary Health Practice Review 7*(1), 17–19.

Gablik, S. (1991). *The reenchantment of art*. Thames and Hudson.

Gabrielsson, A. (2011). *Strong experiences with music*. Oxford University Press.

Gaut, B., & McIver Lopes, D. (Eds.). (2005). *The Routledge companion to aesthetics*, second edition. Routledge.

Graham, G. (1997). *Philosophy of the arts, an introduction to aesthetics*. Routledge.

Helitzer, E., & Moss, H. (2022). Group singing for health and wellbeing in the Republic of Ireland: The first national map. *Perspectives in Public Health 142*(2), 102–116. https://journals-sagepub-com.proxy.lib.ul.ie/doi/epub/10.1177/17579139221081400.

Higgins, P. as quoted in Moss, H. (2021). *Music and creativity in healthcare settings: Does music matter?* (p. 40). Routledge.

Jackson, T., Thomas, S., Stabile, V., Han, X., Shotwell, M., & McQueen, K. (2015). Prevalence of chronic pain in low-income and middle-income countries: A systematic review and meta-analysis. *The Lancet 385*, S10. https://doi.org/https://doi.org/10.1016/S0140-6736(15)60805-4.

Jones, S. C., & Schumacher, T. G. (1992). Muzak: On functional music and power. *Critical Studies in Mass Communication 9*(2), 156–169. http://dx.doi.org/10.1080/15295039209366822.

Juslin, P., & Sloboda, J. (2009). *Music and emotion: Theory and research*. Oxford University Press.

Karkou, V., & and Meekums, B. (2017). Dance movement therapy for dementia. *Cochrane Database of Systematic Reviews 2*(2), CD011022–CD011022. http://dx.doi.org/10.1002/14651858.CD011022.pub2.

Kieran, M. (2005). Value of art. In B. Gaut & D. McIver Lopes (Eds.), *The Routledge companion to aesthetics*, second edition (pp. 293–307). Routledge.

Kilroy, A., Garner, C., Parkinson, C., Kagan, C., & Senior, P. (2007). *Towards transformation: Exploring the impact of culture, creativity and the arts on health and wellbeing. A consultation report for the critical friends event*. Arts for Health, Manchester Metropolitan University.

Kreutz, G., & Brünger, P. (2012). A shade of grey: Negative associations with amateur choral singing. *Arts & Health 4*(3), 230–238. https://www-tandfonline-com.proxy.lib.ul.ie/doi/pdf/10.1080/17533015.2012.693111?needAccess=true

Lawson, B. (2001). *The language of space*. Architectural Press.

Lee, S., O'Neill, D., & Moss, H. (2020). Promoting well-being among people with early-stage dementia and their family carers through community-based group singing: A phenomenological study. *Arts & Health 14*(1), 85–17. https://www-tandfonline-com.proxy.lib.ul.ie/doi/pdf/10.1080/17533015.2020.1839776?needAccess=true.

Lee, S., O'Neill, D., & Moss, H. (2021). Dementia-inclusive group-singing online during COVID-19: A qualitative exploration. *Nordic Journal of Music Therapy 31*(4), 308–326. https://www.tandfonline.com/doi/pdf/10.1080/08098131.2021.1963315?needAccess=true.

Loewy, J., Hallan, C., Friedman, E., & Martinez, C. (2005). Sleep/sedation in children undergoing EEG testing: A comparison of chloral hydrate and music therapy. *Journal of PeriAnesthesia Nursing 20*(5), 323–332.

MacDonald, R.A.R., Kreutz, G., & Mitchell, L. (2012). *Music, health, and wellbeing*. Oxford University Press.

Magill L. (2006). Music therapy and spirituality and the challenges of end-stage illness. In D. Aldridge & J. Fachner (Eds.), *Music and altered states: Consciousness, transcendence, therapy and addictions* (pp. 172–183). London: Jessica Kingsley.

Mandoki, K. (2007). *Everyday aesthetics: Prosaics, the play of culture and social identities*. Ashgate Publishing Ltd.

Maratos, A., Gold, C., Wang, X., & Crawford, M. (2008). Music therapy for depression. *Cochrane Database of Systematic Reviews 2008*(1), CD004517–CD004517. https://spiral.imperial.ac.uk/bitstream/10044/1/56028/2/Aalbers%20et%20al%202017%20FULL.pdf.

McIntosh, I. B. (2003). Flying-related stress. In Bor, R. (ed.), *Passenger Behaviour* (pp. 17–31). Routledge.

Meekums, B., Karkou, V., & Nelson, E. A. (2012). Dance movement therapy for depression. *Cochrane Database of Systematic Reviews 2016*(6), CD009895–CD009895. https://www-cochranelibrary-com.proxy.lib.ul.ie/cdsr/doi/10.1002/14651858.CD009895.pub2/full.

Moss, H. (2016). Arts and health: A new paradigm. *Voices: A World Forum for Music Therapy 16*(3). https://voices.no/index.php/voices/article/view/2301.

Moss, H. (2019). Music therapy, spirituality and transcendence. *Nordic Journal of Music Therapy* 28(3), 212–223. https://www-tandfonline-com.proxy.lib.ul.ie/doi/pdf/10.1080/08098131.2018.1533573?needAccess=true.

Moss, H. (2020). The aesthetics of space. In Brown, Charise & Crawford (Eds.) *The Routledge companion to health humanities* (pp. 430–435). Routledge.

Moss, H. (2021). *Music and creativity in healthcare settings: Does music matter?* Routledge.

Moss, H., Donnellan, C., & O'Neill, D. (2012). A review of qualitative methodologies used to explore patient perceptions of arts and healthcare. *Journal of Medical Ethics and Medical Humanities* 38, 106–109. http://dx.doi.org/10.1136/medhum-2012-010196.

Moss, H., Donnellan, C., & O'Neill, D. (2015). Hospitalization and aesthetic health in older adults. *Journal of the American Medical Directors Association* 16(2), 173.e11–173.e16. http://dx.doi.org/10.1016/j.jamda.2014.10.019.

Moss, H., & Granier, M. (Eds.). (2006) *Patient Voices: Poems by patients of The Adelaide and Meath Hospital, Incorporating the National Children's Hospital, Dublin*. Colour Books Ltd.

Moss, H., Lynch, J., & O'Donoghue, J. (2017). Exploring the perceived health benefits of singing in a choir: An international cross-sectional mixed-methods study. *Perspectives in Public Health* 138, 160–168. https://journals-sagepub-com.proxy.lib.ul.ie/doi/epub/10.1177/1757913917739652.

Moss, H., & O'Donoghue, J. (2019). An evaluation of workplace choir singing amongst Health Service staff in Ireland. *Health Promotion International* 35(3), 527–534. https://academic.oup.com/heapro/article/35/3/527/5498940?login=true.

Moss, H., & O'Neill, D. (2009). What training do artists need to work in healthcare settings? *Medical Humanities* 35(2), 101–105. http://dx.doi.org/10.1136/jmh.2009.001792.

Moss, H., & O'Neill, D. (2014a). The aesthetic and cultural interests of patients attending an acute hospital: A phenomenological study. *Journal of Advanced Nursing* 70(1), 121–129. https://onlinelibrary-wiley-com.proxy.lib.ul.ie/doi/pdfdirect/10.1111/jan.12175.

Moss, H., & O'Neill, D. (2014b). The art of medicine: Aesthetic deprivation in clinical settings. *The Lancet* 383(9922), 1032–1033. https://www.thelancet.com/pdfs/journals/lancet/PIIS0140-6736(14)60507-9.pdf.

Moss, H., & O'Neill, D. (2016). The role of the curator in modern hospitals: A transcontinental perspective. *Journal of Medical Humanities* 40(1), 85–100. https://link-springer-com.proxy.lib.ul.ie/content/pdf/10.1007/s10912-016-9423-3.pdf.

Moss, H., & O'Neill, D. (2017). Narratives of health and illness: Arts-based research capturing the lived experience of dementia. *Dementia* 18(6), 2008–2017 https://journals-sagepub-com.proxy.lib.ul.ie/doi/epub/10.1177/1471301217736163.

Mössler, K., Chen, X., Heldal Tor, O., & Gold, C. (2011). Music therapy for people with schizophrenia and schizophrenia-like disorders. *Cochrane Database of Systematic Reviews* 2011(12), CD004025–CD004025. https://www.cochranelibrary.com/cdsr/doi/10.1002/14651858.CD004025.pub3/full.

Noguchi, T., Ishihara, M., Murata, C., Nakagawa, T., Komatsu, A., Kondo, K., & Saito, T. (2022). Art and cultural activity engagement and depressive symptom onset among older adults: A longitudinal study from the Japanese Gerontological Evaluation Study. *International Journal of Geriatric Psychiatry* 37(3). https://onlinelibrary.wiley.com/doi/am-pdf/10.1002/gps.5685.

O'Neill, A., & Moss, H. (2015). A community art therapy group for adults with chronic pain. *Art Therapy* 32(4), 158–167. https://www-tandfonline-com.proxy.lib.ul.ie/doi/full/10.1080/07421656.2015.1091642.

Rolston, H. (1995). Does aesthetic appreciation of landscapes need to be science based? *British Journal of Aesthetics* 35(4), 374–385.

Ross, A. (2014). As if music could do no harm. *The New York Times*, 20 August, 2014. Available at: www.newyorker.com/culture/cultural-comment/music-harm [last accessed 6 October 2024].

Ruddy, R., & Milnes, D. (2005). Art therapy for schizophrenia or schizophrenia-like illnesses. *Cochrane Database of Systematic Reviews* 2005(4), CD003728–CD003728. https://doi.org/10.1002/14651858.CD003728.pub2.

Saito, Y. (2008). *Everyday aesthetics*. Oxford University Press.

Saito, Y. (2017). *Aesthetics of the familiar everyday life and world-making*. Oxford University Press.

Shaffer, R. (2013). The soundtrack of neo-fascism: Youth and music in the National Front. *Patterns of Prejudice* 47(4–5), 458–482. https://www-tandfonline-com.proxy.lib.ul.ie/doi/full/10.1080/0031322X.2013.842289.

Sibley, F., Redfern, J., Roxbee, B., & Cox, J. (Eds.) (2001). *Some notes on ugliness in approach to aesthetics: Collected papers on philosophical aesthetics*. Clarendon Press.

Stafford Smith, C. (2008). How US interrogators use music as a tool of torture. *The Guardian*, 18 June, 2008. Available at: www.theguardian.com/world/2008/jun/19/usa.guantanamo [last accessed 6 October 2024].

Stecker, R. (2006). Carroll's bones. *British Journal of Aesthetics* 46, 282–286.

Stuckey, H. L., & Nobel, J. (2010). The connection between art, healing, and public health: A review of current literature. *American Journal of Public Health* 100(2), 254–263. https://www.culturehealthandwellbeing.org.uk/appg-inquiry/

Ulrich, R. S., Zimring, C., Zhu, X., DuBose, J., Seo, H. B., Choi, Y. S., Quan, X., & Joseph, A. (2008). A review of the research literature on evidence-based healthcare design. *Health Environments Research & Design Journal* 1(3), 61–125.

Vink Annemiek, C., Birks, J., Bruinsma Manon, S., & Scholten Rob, J. P. M. (2003). Music therapy for people with dementia. *Cochrane Database of Systematic Reviews* 2004(3). CD003477–CD003477. https://www.cochranelibrary.com/cdsr/doi/10.1002/14651858.CD005315.pub2/full?highlightAbstract=sensory%7Csensori.

Ward, D., Mackenzie, H., Stores, R., Higgins, B., Gal, D., & Dean, T. (2012). Sensory environment on health-related outcomes of hospital patients. *Cochrane Database of Systematic Reviews* 2012(3), CD005315. https://www.cochranelibrary.com/cdsr/doi/10.1002/14651858.CD005315.pub2/full.

Williams, E., Dingle, G. A., & Clift, S. (2018). A systematic review of mental health and wellbeing outcomes of group singing for adults with a mental health condition. *European Journal of Public Health* 28(6), 1035–1042. http://dx.doi.org/10.1093/eurpub/cky115.

Woodham, A. (2002). The art of healing. *The Times Newspaper*, 3 December 2002. https://www.thetimes.co.uk/article/the-art-of-healing-dncwqqht2lm.

Wynn Owen, J., Phillips, R., Thorne, P., Camic, P., Clift, S., Crane, N., & Donaldson, D. (2013). *Arts, health and wellbeing: Beyond the Millenium*. Royal Society for Public Health.

Xia, J., & Grant Tessa, J. (2009). Dance therapy for schizophrenia. *Cochrane Database of Systematic Reviews* 2009(1). https://doi.org/10.1002/14651858.CD006868.pub2.

SECTION VII

AESTHETIC EXPERIENCE IN THE CLINIC

Perspectives and Reflections from Practice

SECTION VII

CRITICAL
DIFFERENCES IN
AGEING
Perspectives and Alternatives
from Practice

INTRODUCTION

Aesthetic Experience in the Clinic: Perspectives from Practice

HELENA FOX

The field of medicine is replete with evocative images and processes. These occur in everyday clinical practice, in small actions as well as pronounced issues of life and death. Healthcare practitioners can be moved in aesthetic ways. However, the capacity for awareness of aesthetic experience may be suppressed in clinical practice where the positivist objective evidence base has primacy. Bureaucracy, technology, financial restraints, and high workloads may also detract from space to notice the aesthetic dimension in the human encounter in care. Aesthetic experience has been linked with values in different contemporary fields and could also be important in health care.

Whilst the word 'aesthetics' has several meanings, in this section it is taken from its Greek origins and will relate to sense perception. The imaginative dimension that arises during immersive participation will also be included. 'Aesthetic experience' also embraces human sensibilities, emotions, the tacit, haptic, pre-reflective, and the embodied. Awareness and articulation of this complexity may extend beyond words and only be fully realized during experiential practice itself.

Thus, these nine chapters take a *'practice first'* approach. Rather than being limited by the boundaries of any one tradition, theory, or concept of philosophical thought, the focus is on noticing aesthetic experience as it arises in clinical practice. Authors offer perspectives and reflections from their practice within health care and other disciplines. They also weave in links with existing practices and theory that they feel resonate.

These chapters reach into a developing area of practice in innovative ways. They contribute examples that reveal facets of aesthetic experience in clinic work and aim to stimulate new and exciting cross-disciplinary connections, thinking, and creative synthesis of practice-based processes. Awareness of such experience may bring benefits related to values and quality in the clinical encounter. This section offers a platform for an expansion of ideas.

The first chapter (A. Cribb and G. Pullin) proposes that aesthetic considerations are relevant and important for healthcare quality and improvement in everyday practice. Written from combined perspectives of applied philosophy and design, the authors particularly draw on the sensibility in Saito's 'everyday aesthetics' (Saito, 2007, 2017). They regard aesthetic experience as an intrinsic part of the experience of everyday clinical life, upholding that such awareness can contribute to enhancing quality alongside more technical issues. For example, in relation to interpersonal connection, inclusivity, equality, co-production, the environment, and design. This chapter provides an important opening for this section as it links core concerns in this Handbook with issues of quality and improvement in the world of healthcare practice and policy. 'Practice-facing' questions and examples are presented along with a resource of references from different disciplines. The authors wish to encourage discussion between scholars and practitioners across disciplines.

The second chapter (L. Younie) draws on the author's practice-based clinical experience as a General Practitioner (GP) and medical educator. This included innovating, pioneering, and establishing a 'Creative Enquiry' pedagogy that employs expressive arts strategies to facilitate engagement with, and reflection on the human dimension in clinical practice for medical students in GP placements.

The author discusses how Creative Enquiry is a way to activate and become aware of aesthetic experience to gain deeper insights that enrich meaningful interpersonal human connection between patient and doctor or medical student. This can be embraced alongside objective biomedical facts. The author upholds that by being present to aesthetic experience in this encounter, fresh perspectives and new learning for the clinician become possible that may nurture patient and clinician alike. This chapter also draws on concepts of 'everyday aesthetics' amongst other literature and shows how awareness of aesthetic experience is relevant in the clinical encounter.

The third chapter (H. Fox) offers an empirical description of the nature of aesthetic experience built through a research inquiry in relation to the everyday work of healthcare practitioners. An innovative arts, practice-based methodology, called 'Connective Aesthetics in Medicine', was designed to explore and articulate the rich complexity of everyday aesthetic experience. New participatory processes combined familiar everyday clinical actions with poetic twists to activate aesthetic experience for healthcare participants to observe and describe.

The author's background experience in clinical medicine, psychiatry, and the arts was combined in research inspired by 'connective aesthetic' arts practices from Social Sculpture, aspects of phenomenology, contemporary aesthetics, informal mindfulness, and functioning of the imagination. These were adapted and synthesized into new practice-based methods.

The nature of aesthetic experience in this study is given with examples. Awareness of aesthetic experience coupled with reflective practice may bring new insights and deeper understandings related to values and issues in quality in humane care. The

human capacity for awareness of this type of aesthetic experience may offer an important resource in healthcare work.

The fourth chapter (S. Stuart-Smith) is written from the author's experience in clinical psychiatry, psychotherapy, and horticulture. The author has recently developed a community garden in the UK aimed at helping transform people's health and well-being through spending time in nature.

An overview of the history of the therapeutic benefits of horticulture on mental health and well-being sheds light on the complex nature of aesthetic experience that may arise. The author discusses how engaging in gardening, being in gardens and nature can activate all the senses together with emotional, physical, social, vocational, and spiritual aspects of life and how people may also experience feeling empowered and creative. In addition, deep existential meanings can emerge through working with the cycle of life in the garden. This chapter reveals the interrelated connective aesthetic engagement of the mind-body-environment complex rather than the objectified view of a disconnected spectator in horticultural practice.

The fifth chapter (C. Blowers) describes the 'Moving Pieces Approach' (MPA) in which sensory awareness of personal embodied experience and the intersubjective space with others in a group process are key components. The author developed this innovative practice-based approach to facilitate therapeutic understanding and amelioration of stress and trauma often held as medically unexplained symptoms in the body. The aim is to achieve sensorimotor integration through awareness of tacit knowledge and more unconscious embodied experience as these emerge and are expressed through different art forms. The approach draws on aspects of practice from the arts, psychotherapy, body-based approaches to working with trauma, somatic movement education, particularly the Feldenkrais Method and Le Coq-based physical theatre approaches.

Six core concepts of MPA are described. This model offers a therapeutic example of ways of working in an aesthetic mode to raise awareness of broader experiential knowledge than through words alone.

The sixth chapter (F. Oyebode) is written from practical experience as a psychiatrist and medical educator. The author uses literature to expand the awareness of medical students' experiential knowledge. Examples in this chapter are used to explore characteristics of aesthetic values in the clinical encounter between doctor and patient.

The author touches briefly on evolutionary and scientific theories that uphold that aesthetic appreciation is hardwired and influences all social encounter. However, this chapter also reflects on how further factors may be involved in the role of aesthetics in the clinical consultation and setting to transform this into a more humane and connected interrelationship. In health care where the predominant value system is objectivity with doctor and patient cast in expected roles, this chapter proposes that awareness of aesthetic considerations may implicitly influence the nature and quality of care.

Sartre's ideas of 'perfect' and 'privileged' moments are proffered as a way of thinking about attention and attunement between patient and doctor as is Martin Buber's 'I-Thou' relationship. The use of language in the clinic is discussed. Prose, poetic usage, sharing of subjective descriptions and analogy are considered in comparison with clinical words that maintain distanced objectivity. Examples from various authors are cited, illustrating how this could offer a more connected, sensitive interaction for sharing of meaning beyond technical words alone and offer a more aesthetically satisfying consultation.

The seventh chapter (A. West) explores and reflects on how close attention paid to each moment in free musical improvisation (FMI) requires an aesthetic attitude and may offer a model for understanding pivotal moments in the therapeutic encounter. The author discusses commonalities between these two settings from the perspective of experience in both clinical psychiatry and as a musician. By drawing on the aesthetic experience that may arise in immersive practice of FMI, this chapter reflects on how a parallel nature of such aesthetic experience may also arise and be noticed in the therapeutic encounter. This includes attention to the intrinsic qualities of the moment, awareness of relational process, and responsivity in unique and unscripted moments that may contribute opportunities for developmental and therapeutic change. The author proposes that a better understanding of improvisational process thus becomes an ethical responsibility, given the uniqueness of individual experience. Lived experiences and imagined clinical examples are provided alongside relevant literature from psychotherapeutic theory and musical improvisation to illustrate this view.

The eighth chapter (J. Tan et al.) describes how rich aesthetic experience may come into play in the field of eating disorders alongside the objective evidence base in treatment and outcomes. The authors focus on exploring how engagement with the arts can offer a way of exploring the domain of aesthetic experience that is 'felt' as embodied experience, allowing it to be expressed, for emotion to be accessed, and for meaning to unfurl that may be hard to express through spoken words. They illustrate this with a range of examples from research quotes, song lyrics, poetry, creative art, and practice. They suggest that acknowledging aesthetic experience in the field of eating disorders is important in understanding and exploring these disorders, for both people who have eating disorders and also for those to seek to treat them.

The ninth chapter (A. Dempsey) offers reflections combined from the author's practice-based experience in aerial dance; as a doctor leading a trauma group; from teaching medical students, and aspects of doctoral research in theological aesthetics.

The author considers how disparate concepts can be held in mind conjointly. Parallels are drawn between the immediacy of connection between technical and experiential knowledge required in ariel dance with components required in facilitating a trauma healing group. The latter similarly combines factual knowledge balanced with felt sense and awareness of being present to to others as a participant. Further

analogies for holding disparate concepts in mind, such as earthly and spiritual, are explored in relation to theological imagination and aesthetic experience. The first relates to Kierkegaard's dancer especially in the landing back to earth. The second, arises as the author perceives the priest's movements in the Eucharist which are sensed as a way of uniting spirituality with everyday lives in the human world.

The author considers how these examples including aesthetic experience may reveal how awareness of different realms of knowing may be united and drawn upon in teaching for reflection on offering more holistic and compassionate care.

References

Saito, Y. (2007). *Everyday aesthetics*. Oxford University Press.
Saito, Y. (2017). *Aesthetics of the familiar: Everyday life and world-making*. Oxford University Press.

CHAPTER 42

AESTHETICS FOR EVERYDAY QUALITY

Enriching Health-Care Improvement Debates

ALAN CRIBB AND GRAHAM PULLIN

Introduction

In this chapter we aim to illuminate the importance of aesthetics for health-care quality and encourage more discussion of aesthetics in health-care improvement scholarship and practice.[1] We will not be focusing directly on arts-based initiatives in health—although we see that as a hugely important topic, clearly linked to our concerns, and one we will touch on in a few places. Here we are more interested in what has been called 'everyday aesthetics' (Light & Smith, 2005; Saito, 2007) and its place in understanding and pursuing what might be called 'everyday quality'. Our argument is that there is much to be gained by making debate about aesthetics a more routine and pervasive part of health-care quality improvement.

We hope to explore and contribute to the hinterland between arts-based initiatives in health care and the 'normal business' of health-care quality improvement. The idea of quality improvement can be interpreted in an expansive way or in a more restricted way. The former accommodates the full range of means through which, and respects in which, health-care can be made better. The latter typically refers to a specialist domain now incorporated within health-care policy and organizations—which we will label with the capitalized 'QI'—in which professionals with specific improvement-related expertise set out to systematically monitor and strengthen indicators of quality. Arts-based work unquestionably has a huge contribution to make to quality improvement in the broader sense and can also provide important complementary insights and tools for QI more narrowly understood (Gardner et al., 2021). But the relevance of aesthetics extends beyond the arts. This is something perfectly familiar from routine experience outside health care. People take aesthetic considerations into account, so far as they are

in a position to do so, in their decisions about where to live, where to spend their leisure time, what to eat and drink etc. Aesthetics is also something recognized within health-care QI discourses although this emphasis is often confined to specific areas of concern, such as, for example, health-care architecture.

The idea of 'aesthetics' is the subject of a fundamental, wide-ranging, and complex set of philosophical debates. For example, there are debates about how far aesthetic qualities should be seen as belonging to 'objects' such as paintings or landscapes (and so on) or to the experiences or judgements of people encountering such 'objects'. There are disagreements about whether, or the senses in which, aesthetic judgements should be seen as 'objective' or 'subjective'. And there are rival candidates for defining the subject matter of aesthetics (Budd, 2008). Obviously, we will not be trying to resolve these foundational debates here. For our purposes we can largely leave such philosophical questions open. But we will be suggesting that there are a number of important practice-facing questions, with roots in these fundamental debates, that deserve attention within health-care improvement.

The approach we adopt in this chapter will draw on Yuriko Saito's account of 'everyday aesthetics' (2007) and we will expand on this construction of the aesthetic shortly. However, the account we employ will, in large measure, overlap with a quite familiar 'common sense' usage of the term. As already indicated, no-one is a stranger to aesthetics and we make aesthetic judgements on a regular basis without the idea seeming mysterious to us. We can admire someone's coat or we can feel dismayed by the massively cluttered state of a room, and we can do so without feeling the need for an account of the nature of aesthetics. These examples are enough to indicate that aesthetic considerations represent an additional dimension to both technical and ethical considerations (although, as we will go on to discuss, these different dimensions can inform one another in significant ways). To admire the look, style, and feel of a coat is not to say that it is a 'good coat' in other respects—it may not, for example, be particularly weather-resistant or made of eco-friendly materials. Similarly, if we have a cluttered room this may make it a poor room for us to occupy and make use of, and we may also feel it represents a kind of ethical failure on our part but, in addition, we can regard it as aesthetically unsatisfactory.

This familiar usage also occurs in the QI literature. For example, in Donabedian's (1989) classic account of health-care quality he identifies three quality components; 'the goodness of technical care, judged by its effectiveness, the goodness of the interpersonal relationship, judged partly by its contribution to technical care, and the goodness of the amenities' (p. 3). He goes on to expand on the last component as follows: 'the goodness of the amenities of care, by which I mean convenience, creature comforts, and even the aesthetic attributes of the setting in which care is provided' (p. 4). A similar, but much more recent, example is found in Slater et al.'s Person-centred Practice Inventory (2017) that sets out to operationalize person-centred practice as 'an internationally recognized standard of quality care' by using seventeen constructs (informed by a Delphi study of experts) including one summarized as: '*The physical environment*: Healthcare environments that balance aesthetics with function by paying attention to

design, dignity, privacy, sanctuary, choice/control, safety and universal access with the intention of improving patient, family and staff operational performance and outcomes' (p. 544). Here aesthetics is invoked in relation to person-centredness and health-care environments and we will return to both these ideas and the links between them as we proceed.

For the most part, mainstream QI literature does not feature prominent discussion of aesthetics. An important exception is that part of the literature that makes use of design thinking where the relevance of aesthetics is accepted as standard (Parsons, 2016). For example, work on Experience Based Co-Design (which we come back to in the final section) embraces aesthetics as a key concern (Bate & Robert, 2007). Nonetheless there is a clear tendency in the QI literature for aesthetics to fall into the background and, in particular, for overt discussion of aesthetics to be marginal. There is perhaps something 'off-putting' or alienating about the term 'aesthetics', but leaving this thought aside for now, some of the reason for the relative marginality might be indicated by the examples cited above. In particular, the QI examples mentioned suggest that aesthetic considerations are first, related to a relatively circumscribed portion of health-care quality evaluation and second, form a relatively low priority compared to technical and ethical considerations. It is notable that Donabedian, whilst mapping out what he sees as the essence of quality, includes aesthetics using the phrase '*even* the aesthetic attributes' (our emphasis). In the remainder of this chapter, we will push against these associations. We will suggest: (i) that aesthetic considerations should be seen as of universal relevance across quality debates (just as technical and ethical considerations are accepted as being); (ii) that they should never be assumed to have a marginal or even secondary status; and (iii) that taking aesthetic considerations seriously entails some explicit discussion of associated uncertainties and dilemmas and a readiness to welcome aesthetics expertise into improvement scholarship.

Everyday Aesthetics: Key Ideas and Implications

Here we are drawing upon the growth of scholarship on the aesthetics of everyday life (e.g., Light & Smith, 2005; Naukkarinen, 2017), and in particular to Saito's first two books on the subject (2007, 2017). This contemporary scholarship builds on earlier contributions, including notably that of Dewey (1958), that separate out 'aesthetic experiences' from art. Saito's account of everyday aesthetics builds upon, but is not reducible to, work in environmental aesthetics, Japanese aesthetics, and feminist aesthetics. It seeks to uncover and explore the importance of aesthetic considerations beyond the sphere of art (obviously without denying the important place of the arts in the field of aesthetics.) This involves two key moves. First, it involves not seeing aesthetics as primarily 'art-centred' such that things only become of interest to aesthetics purely for

the reason that, and to the extent that, they are either art or proximate to art. For example, we do not need to be able to 'translate' our aesthetic appreciation of some aspect of nature into its 'art-like' qualities and status for it to be valid. Second, it involves not limiting the category of the aesthetic to a sub-set of 'special' experiences that fall outside the normal 'flow of life'. Clearly this does not involve denying that some aesthetic experiences can somehow stand out from, 'cut-across', transcend, or transform life in profound ways. It is rather simply asserting that not all experiences need to fall into this set to qualify as aesthetic.

These two moves have very substantial implications. They help enable us to see how aesthetic concerns need not be 'distanced' from routine concerns but are deeply embedded in all aspects of our lives. The risk, otherwise, is that the 'assumptive worlds' we occupy place aesthetic considerations either 'outside' ordinary life or, when they are acknowledged as 'inside' it, position them as thereby relatively inconsequential. (A rough comparator here might be 'play'—if we see 'play' as bracketed off from normal life and chiefly only having significance in its own terms, it is tempting to see it as being unimportant 'in real life'.) These two moves encourage us to approach and think about the way aesthetics, in the context of our day-to-day lives, is entangled with a range of practical and substantive agendas and activities. We will illustrate some of these questions shortly but before that we should sketch in the notion of the 'aesthetic' that Saito operates with (drawing on the work of other thinkers including Noel Carroll (2001).

Her summary and very broad account of the aesthetic is 'any reactions we form towards the sensuous and/or design qualities of any object, phenomenon or activity' (2007, p. 9). We can fill this in a little further, showing how it is continuous with but also 'stretches' the common-sense use of the aesthetic mentioned above. In this effort it is still worth keeping in mind some of the well-established associations of aesthetics with the arts, because at the same time as rejecting the idea that aesthetics are to be wholly equated with, or defined in terms of, the arts, we can still see the arts as a powerful set of analogues for extra-artistic aesthetic concerns. Our reactions to 'sensuous' qualities obviously include our attraction to or aversion from the 'appearance' of 'objects' (here used as shorthand to also encompass the 'phenomena' and 'activities' mentioned in the summary account)—crudely the delight, displeasure, or even disgust we take in the way things look. But, of course, these basic ideas are equally applicable to the way things sound, feel, smell, or taste too. For Saito this already indicates one potential gap between art-centred aesthetics and everyday aesthetics because the former has traditionally been centred more around some senses rather than others. An interest in everyday aesthetics, as well as extending beyond the appearance of objects, includes the possibility of noting and considering the beauty manifested by 'everyday things': mundane objects, including such things as domestic utensils, that might not usually be thought worthy of such consideration (Yanagi, 1926).

But the kinds of appreciation, satisfaction, or fulfilment we can take in experiencing or actively engaging with 'objects' extend well beyond their immediate sensory qualities. When we engage with a garden, for example, whether as a spectator or a gardener, our appreciation can also relate to its overall composition and form, how it relates

to our own and others' identities and biographies, the garden's recent and/or longer-term history and the allusions made or conjured up by it, the ambience it sits within and produces and so on. In short, in aesthetic appreciation 'sensuous qualities' are mixed with, and shaped by, many other qualities including those relating to the 'forms', 'meanings', and 'purposes' that objects embody. This is well understood in the arts where we would never imagine that the aesthetic significance of a novel or a musical piece was somehow wholly contained by our direct sensory experience of a particular series of words or sounds. In the summary account above, Saito uses the shorthand 'design' to point towards these broader features of objects that includes their composition and significance which also inform our aesthetic appreciation of them as, for example, harmonious, elegant, or uplifting. The language of 'design' of course brings into view all kinds of artefacts, spaces, events, or organizational processes that are consciously designed but it is here being used in a much more extensive, including metaphorical, sense in which 'design' need not imply a designer. This is because one of the contrasts that Saito wants to make between art-centred aesthetics and the aesthetics of everyday life is that the latter does not require a clearly demarcated object produced by an artist or team of artists or equivalent. One of the examples she offers is the way that we can have complex aesthetic reactions to visiting cities like New York which arise from constellations of interacting experiences—ordered and disordered—that have not been deliberately or coherently assembled or curated and which have no clear boundaries.

To conclude this very brief summary of everyday aesthetics, it is worth highlighting a few key points that begin to indicate the potential implications for health-care quality. Most important, once we recognize the way aesthetic concerns are routinely entangled in everyday life, experience, and activity (and do not only 'sit outside' ordinary life) then it follows that in order to understand and influence our practical affairs we need to ensure the aesthetic dimension is included in the frameworks that we use to understand and change things. Aesthetic reactions inform the choices we make and the preferences and priorities we have in both our private and public lives and this happens without us labelling them as such or even necessarily noticing. Nor is there any reason to think of these aesthetic considerations as being confined to relatively superficial or trivial matters. One area that clearly illustrates this—where the interface between the aesthetic and the practically urgent is something people are increasingly conscious of—is the impact of our aesthetic choices on the environment. As Saito puts it, 'seemingly insignificant everyday preferences and decisions can have serious environmental, moral, social, political, and existential implications' (2007, p. 53). The example of rising environmental consciousness can also serve as a reminder of a couple of other insights about everyday aesthetics. First, as already indicated, aesthetic reactions can be negative as well as positive—we can, for example, have aversive aesthetic reactions to polluted beaches and waters. Second, whilst people's aesthetic reactions can serve an important explanatory function, we do not need to treat them as fixed. Rather it is possible for them to be socially and culturally influenced and shaped in various ways—this is illustrated by the way that both commercial branding and many people's habitual tastes have evolved in the light of the green movement.

In the following two sections we will use a few examples both to illustrate the central relevance of aesthetics to health-care quality and to assemble some related questions for improvement scholarship. We aim to highlight the centrality of aesthetics for both the 'Q' and the 'I' of QI—for both the evaluative and explanatory work that is needed to determine what 'good health care' is and to understand how and why we might succeed or fail to bring it about. In these two sections we will concentrate on the relevance of aesthetics to understanding the nature of quality but we will begin to indicate some implications for scholarly debate, and then turn to the theme of improvement scholarship more explicitly in the subsequent section. Our examples all combine both sensory and symbolic elements—a compound which we are treating as characteristic of aesthetics. We begin with those that have a strong material and sensuous dimension where it might be taken for granted that aesthetic considerations apply. After that we move on to examples which are equally socio-material but where we will put more emphasis on the arguably more neglected dimension that we are labelling as the 'aesthetics of sociality.'

The Material Dimension of Health Care: Making and Revising Aesthetic Discriminations

To indicate the non-marginal place of aesthetic considerations, perhaps a good place to start is 'medicine'—here, primarily referring directly to tablets, potions, infusions, creams, or ointments; but, of course, 'medicine' is also a suggestive synecdoche. Medicines are a key interface between the health-care system and patients and carers. When prescriptions are well judged, medicines can do a significant proportion of the work of health care. They are also symbolically important, sometimes representing the trust and hope that people place in health care but also, some of the time, representing anxiety, dread, and an authoritative stamp of 'sickness'. However—stressing materiality for now—aesthetic considerations are at the heart of medicines' acceptability. This includes the shape and size of tablets, the taste, smell, and viscosity of liquids, and the feel of, and sensations caused by, ointments. In turn, acceptability is an important determinant of adherence (Liu et al., 2014). So aesthetic considerations, in the basic sense of the relative appeal or lack of appeal to various senses, are central to the design of pharmaceuticals and to supporting their use in practice (e.g., help with splitting or crushing tablets, administering treatments, and even 'disguising' the unpleasantness of certain medicines).

This familiar example provides an illustration of both the explanatory and evaluative importance of aesthetic considerations. It can also be used to show how aesthetic responses can both be constitutive of and a distraction from questions of technical effectiveness. A medicine that is relatively agreeable (as opposed to disagreeable) can be

seen as better in that sense alone but may also be more effective for that same reason. The aesthetic reactions we have cited here are a part of what makes medicines work. They are one of the factors that can be used to explain non-adherence or altered to improve adherence. They are, in this regard, core to the technical effectiveness of medicines. Of course, someone could argue that it is really only the 'active ingredients' of medicines that determine their effectiveness and technical quality; but that line can be defended only on an implausibly narrow construction of what makes medicines 'fit for purpose'. In the real world, especially in a world where health care is seen as about the interaction of biomedical and human factors, then these aesthetic reactions cannot be pushed outside of conceptions of technical quality.

However, even though we should not always seek to drive a wedge between aesthetic and technical considerations, a wariness about conflating them makes sense. There are cases where we might wish to question an appeal to aesthetics and problematize it as both superficial and potentially misleading. We can treat aesthetic acceptability as an important aspect of medicines' quality in its own right, and as relevant to effectiveness, whilst also stressing that it clearly need not always coincide with what is best overall. This is something, for example, that critical consumers need to take into account when choosing over the counter (OTC) medicines. Pharmaceutical manufacturers and marketers are mindful of the aesthetic dimension of medicines and the need to respond to consumer perceptions and preferences. Work on acceptability in the OTC marketplace encompasses both sensory and symbolic appeal, characterizing the 'aesthetic attribute' of medicines as:

> the outward appearance of the product, feeling of comfort (ergonomics), utility, style, ... as well as factors such as shape, dimensions, propositions, color and finish of the product. The products' aesthetic appeal can be built on emotional connection with the product. This can have a dramatic effect on patients' compliance and can increase brand loyalty.
>
> (More & Srivastava, 2010)

By raising the question of emotional appeal and by going on to discuss the role of aesthetics not only in the physical properties of drugs but in packaging, advertising, and branding of products, More and Srivastava effectively flag up the potential dangers of an elision between aesthetics and technical quality, because OTC medication is an area where it is well known that choices based on brand loyalty do not necessarily coincide with what is technically best.

This example raises the question of how we should frame the nature and boundaries of 'aesthetic' reactions and, in addition, whether there are means of discriminating between more and less well-grounded or meaningful aesthetic reactions and judgements. When, if ever, should we resist using aesthetic reactions as a guide to quality? We could, for example, simply describe anything that people say they 'like' or 'feels good' as an account of their aesthetic judgements. Whilst this category of things is extremely important in explanatory accounts and must not be ignored, it also seems too 'thin' and

open-ended to be sufficient on its own to play a major role in determining evaluative judgements about the quality of care. Indeed one of the criticisms sometimes made of the 'everyday aesthetics' literature is that is can operate with too elastic, inclusive, and hence vague conception of the aesthetic, rendering the idea 'contentless' (e.g., Forsey, 2012, p. 203). However, as a counterweight to this, scholars working on everyday aesthetics (Leddy, 2005; Irvin, 2009) have argued that to treat something as an aesthetic judgement is to treat it as part of socio-cultural life and, as such, to see it as a matter of 'taste' about which—whilst accepting that tastes are diverse—we can also deliberate and make and debate discriminations.

This discussion indicates that the suggestion made in Slater et al.'s account (2017, cited above) that the physical environments of health care need to 'balance aesthetics with function' is worth underlining but also unpacking. There may be times when aesthetics and functionality can point in different directions and some 'trade-off' is necessary, but there will also be times when the two are more closely integrated. More broadly, as indicated with the example of 'green' consumption or activism mentioned above, we can ask what scope there is to better integrate and align aesthetic, technical, and ethical lenses so as to ensure, so far as possible, that our conceptions of each of these things informs the other, thereby enlarging and enriching our evaluative sensibilities. So, to be clear, in arguing that aesthetic considerations are of universal relevance in quality debates, we are certainly not suggesting that they should always play an overriding role, nor even that aesthetic judgements should consistently feature prominently in all determinations of quality, but rather that we should always be open to the possibility that they may emerge as having a very important, and sometimes decisive, role. Furthermore, as the case of medicines illustrates, it may be that we sometimes cannot properly identify and articulate technical or ethical dimensions of quality without attention to aesthetics.

The design and choice of prostheses is another area where aesthetics has conspicuous relevance. Of course, direct work on and with bodies, including links with 'body image', is the area of health care most associated with the word 'aesthetic'. This usage sometimes refers, in a relatively restricted way, to people's 'looks'—to increasing a sense of attractiveness or, equally contested, to offering 'naturalness' or 'normalcy'. However, whilst once again aesthetics can be used to refer to something relatively superficial in this context, it definitely need not. In the case of prosthetics for people with limb difference, for example, it is also deeply embedded, with profound questions about identity, management of potential stigma, as well as ethical questions about how to understand and respectfully engage with the values, inclusion, and agency of people with disabilities. It also clearly poses aesthetic questions about a range of senses and feelings, and about self-expression and activity, not just 'looks' in a narrow sense.

Given this rich and demanding agenda, the way that aesthetic questions are framed by those monitoring user experiences is very disappointing and typically neglects many of the serious questions that arise. For example, in the Prosthesis Evaluation Questionnaire (PEQ) (Legro et al., 1998; Boone & Coleman, 2006) wearers are asked to rate 'how your prosthesis has looked' over the previous four weeks from 'Terrible' to 'Excellent'; and

whether the prosthesis has restricted choice of clothing, or damaged clothing. Clearly these concerns are significant but they do not go very far. There are a growing number of complex aesthetic possibilities in the field of prosthetics and these intersect with the identities of users in multiple ways (Pullin, 2020). For example, a combination of technical and social developments has meant that the design of prosthetic hands has moved away from a paradigm in which (i) aesthetics was largely equated with cosmetic adequacy and/or simulation of a 'realistic look', and hence (ii) the demands of form and function—or aesthetic adequacy and technical adequacy—were often assumed to be in conflict. The design and 'choice landscape' is now more contested. Some people, for example, may welcome high-tech robotic hands and see them as embodying a look and feel that they prefer (at least some of the time). And this may apply whether or not the technology is covered by silicone cosmetic gloves that are also available (in various skin tones). Importantly, design and choice are always underdetermined by technological considerations, e.g., a robotic hand need not reflect the art direction of science fiction films (Murray, 2020). Not all people with limb difference want 'realism' and some are happy to embrace or play with making their differences overt in various ways including by invoking a 'transhuman' identity. By contrast, others prefer more nuanced identity statements which neither deny nor 'play up' difference but seek to naturalize and normalize it. This context increases the importance, and some of the complexities, of shared decision-making in this area and highlights the centrality of aesthetic discussion and deliberation within it.

Interpretations of aesthetics which focus on the 'surfaces' of things rather than their underlying constitution and their associated personal and social meanings are obviously inadequate here. The danger of missing the 'depth' of objects also applies temporally. Our relationships with things evolve over time and our aesthetic discriminations also evolve and are shaped by these emergent relationships. This includes the way that the design of prostheses helps to shape the experiences and meanings of disability. These, and many other, designed objects can reflect or contradict, project or undermine, a range of different values and attitudes. They are very unlikely to be able to be neutral in this respect. Yet often the working assumption, overtly or implicitly, is that they are. The exhibition *Hands of X: design meets disability* exhibition at the V&A Dundee (Pullin et al., 2019) explored this range of questions about prosthetics, identity, and aesthetic discriminations including asking:

> what might a prosthetic hand look like that was obviously artificial, unashamedly so, yet at the same time understated and *unremarkable*?

To further these debates, the exhibition also explored the valuable lessons that might be learned from the materials and craft traditions that informed the earlier development of prosthetics. This is an area where more can and should be done to explore the entanglement of aesthetic, technical, and ethical questions. This includes: (a) promoting greater reflexivity about the balances, and the possibilities of integration and alignment, between clinical-technical and aesthetic considerations; and (b) ensuring future

developments include, and are responsive to, a broad range of perspectives, including those coming from art and design and, of course most importantly, the diverse voices of people who have reason to make use of prostheses.

We have deliberately started from examples where material elements are prominent. But the example of prosthetics shows not only that, once we pay attention, our notion of what counts as aesthetic and aesthetically valuable can evolve, but also that this will likely include attention to personal and cultural meanings and to identities, biographies, and self-expression. Whilst we may start by thinking about discriminations in terms of what is more or less pleasant to the senses, we soon have to turn our attention to what, in Hume's terms, gives more or less 'satisfaction to the soul' (Hume, 1740, p. 99). And, as Leddy has argued (2005, p. 7) we do not need to (nor can we easily) separate out these two things. As noted in our initial account of everyday aesthetics, sensory and symbolic elements are entangled together and our aesthetic judgements respond to this combination.

We hope to have begun to illustrate how aesthetic reactions are often central to understanding what counts as success in health care such that our explanatory and evaluative frameworks are incomplete without them. If a health-care system aspires to be 'person-centred' this automatically opens up aesthetic considerations. This follows from recognizing that person-centredness includes, at a minimum, being responsive to 'values and preferences', and people navigate the world partly through their aesthetic values and preferences. Interacting sensory, affective, and cultural experiences inform both unconscious motivations and the overt reasons people offer for choices and actions. Aesthetics is not an 'add-on' agenda for health-care quality. But nor is it an agenda that can be embraced without some debate as to how it should be interpreted and applied both in contrast to, and in combination with, ethical and technical aspects of quality.

The Social Dimension of Health Care— Shaping and Reshaping Relationships

As we noted earlier, one domain where aesthetic considerations already get some recognition within quality discourses is the physical environment. A focus on this domain makes sense and maintains the link with materiality—for example: the architecture of health-care institutions; the division and organization of space; furniture and furnishings; lighting; the overall configuration, arrangement, and amenities attached to waiting, Working, and social areas, and so on. These are all topics with obvious aesthetic relevance. As with the objects discussed in the previous section, they can all be understood as what service designers call 'touchpoints'—points where users interact with services, which can be seen as somehow 'speaking for' the service as a whole. A thoughtful and poetic example is designer Kenya Hara's signage for Umeda Hospital,

Yamaguchi, Japan, in which printed white cotton sleeves are tied to signs (Cardenas, 2016). That the fabric signs need to be frequently laundered and re-tied is a deliberate embodiment of the cleanliness of this maternity hospital as a whole. In a hospital, as in a range of settings, cleanliness indicates service, trust, and security (Hara, 1998).

However, health-care environments are a compound of physical and social elements. As we all know, physical environments can be designed to be welcoming, comfortable, peaceful, nurturing, and/or enlivening, exciting etc., but they will not succeed in being any of these things without people making them so. In this section we will place emphasis on the 'social' dimension of socio-material environments—on 'social touchpoints.'

People entering a health-care setting will encounter something like an 'ambience', 'atmosphere', or 'climate' that is both material and social (e.g., see Julmi, 2017; Wright, 2019). The language here is self-consciously open and vague rather than definitive. As mentioned above, one of the insights developed within everyday aesthetics scholarship is that there need be no clear-cut, single, or stable entity, or obvious demarcating boundaries, to the 'objects' under investigation. Part of such a climate will be the result of the dispositions, comportment, and ways of relating embodied in health-care actors. Reactions to, and evaluations of, such climates and encounters have important aesthetic components that, once again, can be distinguished from (but intermingle with) technical and ethical considerations. Broadly speaking, people can find their health-care encounters more or less unpleasant, enjoyable, engaging, motivating, or fulfilling. Obviously, reactions will also vary between people. In a policy context where person-centredness is valued, then attending to such differences is key, because person-centredness overlaps with aspects of equity and inclusion. There is a need to be mindful that health care that feels welcoming and safe to some people may feel much less so to others (sometimes in a way that maps onto axes of difference such as class, gender, ethnicity, or disability).

In addition to variations between people's expectations, health-care settings themselves play a range of very different functions. But some broad-brush generalizations about the aesthetic requirements of settings are possible. What counts as 'fitting' will reflect the role of the setting—some spaces may be intended to be more restful, cosy, or even 'homely', others to be less warm but more functional or task oriented, still others to be diverting, stimulating, and conducive to activation, and so on. One of countless possible examples are psychotherapy spaces. Devlin Jackson (2018) characterizes these spaces as typically combining home-like with office-like features designed to support the 'holding environment' that therapists seek to create by communicating 'stability, comfort, and protection'. It is the role of the therapists and the space to offer a sanctuary or refuge. To work as a holding environment, in the sense derived from Winnicott (1953), the client must feel secure enough to confront painful subjects and to be able to contemplate the possibility of adaptation, and the therapist must also be able to be still and present and to feel that they are in an effective workplace. Not all care settings need to work as holding environments in this therapeutic sense, but the idea can be applied more widely or extended by analogy. For example, it has been applied to therapeutic

residential care for young people that combines accommodation and a garden space with roles and relationships designed to enable 'emotional holding' and 'containment' of difficult feelings (Vishnja, 2007). Many other settings are partially comparable because patients can easily feel lost within, or threatened by, experiences of ill-health or by health care itself. The risks of feeling vulnerable, disengaged, or disempowered are widespread—and as we will go on to highlight—given the increasing aspirations towards co-production, this gives the aesthetics of sociality particular significance.

The crucial role of aesthetics in the area of professional comportment has long been recognized, for example, in discussions of etiquette and 'bedside manner'. The Hippocratic corpus itself includes recommendations on appearance and demeanour including:

> Be solicitous in your approach to the patient, not with head thrown back (arrogantly) or hesitantly with lowered glance, but with head inclined slightly as the art demands.
> (cited in Silverman, 2012, p. 59)

Similarly, John Gregory's advice on medical etiquette, written in the late eighteenth century, warns about the risk of appearing too superior in dress or comportment, especially when dealing with certain patients including seriously unwell people or children:

> the visit of a physician, even when wished for, is often particularly dreaded, as it naturally awakens the apprehensions of danger; apprehensions, which a formal dress, and a solemn behaviour, are ill calculated to dispel.
> (Gregory, 1772, p. 61; cited in Maio, 1999)

Most recently, the rise of online consultations (fuelled substantially by the COVID-19 pandemic) has given rise to discussion of 'webside manners' that brings together approaches to physical-technical and social comportment. For example, the *Journal of Palliative Medicine* has published recommendations on 'Maintaining Human Connection' (Chua et al., 2020) which includes advice on multiple factors including: body position and posture, best eye-level, the structure and rhythm of conversation, and how to signal an emotional response, e.g., 'place hand over heart to convey empathy' (p. 1508).

These examples illustrate the relevance of 'negative aesthetics' to health-care quality—in these instances this means, for example, ways in which health-care encounters may produce apprehension or alienation. There are obvious parallels with the discussion of medicines above. The factors that make settings and encounters aesthetically satisfactory or unsatisfactory will sometimes be constitutive of technical and ethical quality and may sometimes diverge. This may vary as we move along the spectrum between threshold notions of quality and 'ideal' notions. At the most negative end, insufficient attention to aesthetic considerations may be an indicator that health care is poor. A setting that is inhospitable, shabby, unpleasant, and possibly even unclean may be both unsafe and demotivating to both staff and patients. Here aesthetic, ethical, and technical

concerns can coincide—in circumstances where bad conditions are avoidable, such a setting may not only produce needless risks but also signal too little care or respect. However, some aesthetic concerns may be of relatively superficial benefit or even become positively misleading. The latter connects to well-recognized worries about someone's appealing bedside manners potentially concealing bad judgements and practices, or too much weight being attached to well-appointed spaces and not enough to whether the basic building blocks of effective care are also in place.

These examples also evoke a parallel with the successful 'performance' of roles and effective 'staging' in arts contexts such as theatre. There are good reasons to question how far such parallels are apt but there is no reason to entirely reject them. Of course, health care is not to be equated with art, and is oriented towards practical imperatives, but it is also a multi-sensory, multi-modal set of cultural forms that rely on performances and dialogue, the construction and interpretation of narratives and metaphors, rhythm and improvisation etc. (Geller, 2018). Embracing this comparison opens up a potentially rich set of resources for talking about the aesthetics of health-care encounters. For example, Maio (1999) suggests that attention to aesthetics is a way of opening up a consideration of a variety of forms and styles of communication that are underdetermined by ethics. As he notes, there is an obligation to communicate with a patient before commencing the administration of chemotherapy, and this obligation determines some of the content of the communication, but leaves open a range of styles. As with the case of prosthetics discussed above, this allows for responsiveness to patients and for professionals to modulate, adapt, and expand their approaches (assuming they do so within an authentic and broadly effective repertoire).

Alan Bleakley and colleagues have long ago (2006) highlighted the possibility of viewing medical professionalism as a whole in aesthetic terms by placing an emphasis on 'sensibility' including, for example, 'artistry' and 'connoisseurship' in knowledge and practice. They have also demonstrated the value of directly 'translating' aesthetic categories into health-care practice by, for example, showing the central relevance of a Homerian 'lyrical aesthetic' to the achievement of a form of professional practice that is empathic and does not over-emphasize cure at the expense of person-centred care (Bleakley & Marshall, 2012)—the very notion of 'cure', of course, being problematic in many instances including in the area of disability. This is one reminder that another fundamental way in which settings and encounters can 'fail' aesthetically, and with substantial practical consequences, is that—however professionally maintained and fronted they are—they may be experienced as barren, inert, or 'cold'. This will also amount to a critical technical and ethical failure in cases where engagement, connection, and partnership working are seen as crucial facets of care (and of course these ambitions are increasingly core features of quality discourses).

It is noteworthy that Allwood et al.'s (2021) recent high-profile critique of the industrialization of care echoes some of the language cited above about rhythm and the aesthetics of sociality by arguing for what the authors call 'elegance' in communication. In contrast to 'hurried' conversations—motivated by efficiency but actually inefficient—elegance,

the authors argue, may not require more time and can also save much waste of time and other resources elsewhere. Rather, 'Elegance involves protecting the ability of patients and clinicians to set the tempo of their interaction, a tempo that encourages noticing what is the matter and responding in a way that reflects what matters' (2021, p. 2). In this context, attention to work on the aesthetics of conversations might provide some helpful clues. For example, Puolakka (drawing on both Dewey and Davidson) analyses aesthetically successful conversations as those in which meaning is conserved, grows, and is accumulated, in which there is genuine mutual engagement, the exercise of empathy and imagination, the possibility of absorption and an internal momentum that, ideally, moves towards a consummation rather than a mere cessation (Puolakka, 2017). Anyone with experience of health-care encounters will recognize the relevance of this to their experiences. Even when—arguably especially when—the substantive ground is practically and emotionally challenging, our encounters can vary hugely in terms of how satisfactory we judge them to be through this aesthetic lens.

Allwood et al.'s critique is motivated by a conception of person-centredness that stresses the primacy of kindness and compassion, but which also hopes to shift the centre of gravity towards the coproduction of care. Aspirations for coproduction arguably reframe what count as 'negative aesthetics'. As the comportment examples above indicate, power is mediated aesthetically—and of course this is also well known from extreme cases such as Canetti's (1962) work illuminating the aesthetics of Fascism— and so successful efforts to create environments and encounters that support coproduction will depend upon considerable investment of thought and discussion into aesthetic re-imagining. For a space to support coproduction it will not be enough for it to be non-silencing, or even to feel welcoming, but it will need to help facilitate power sharing. In crude terms we might suggest that for health-care encounters to support coproduction, we need to know how to shift them along a spectrum from cold to warm to 'very warm'.

One way to investigate the aesthetics of sociality in health care is to draw upon experience of arts-based interventions. These cover an immensely wide range of possible forms of enrichment and styles of working against 'aesthetic deprivation' (Berleant, 2010; Moss & O'Neill, 2014). Arts-based working is advocated as contributing directly to health and well-being, as enabling inclusion and a degree of tailoring to cultural difference and as fostering self-expression and creativity (Fancourt & Finn, 2019; Gardner et al., 2021). We will just mention one indicative example, namely Guddi Singh's account (2021) of the introduction of regular dancing sessions—involving both patients and staff—into paediatric wards. This account points towards the dramatic difference such an initiative can make—in terms of breaking down barriers, encouraging confidence, mobilizing energy, renewing relationships, building community, strengthening staff well-being and teamwork, and not least in terms of simple joy. One important way of taking this kind of intervention seriously is, obviously, to advocate for more arts-based working in quality improvement. But, alongside that, we should look for some broadly analogous ways for us to re-imagine and extend routine (non-arts-based) working practices.

Extending Improvement Scholarship

We are arguing that being ready to talk about everyday aesthetics provides an important additional resource for QI. This, we propose, entails improvement-related scholarship also embracing aesthetics so it is better able to support these discussions on the ground. Many people working in health-care improvement are already interested in aesthetic factors but relatively few talk openly in these terms. Nor are aesthetic aspects of working often consolidated together or treated as a professionally or institutionally recognized dimension of quality. Putting everyday aesthetics on the map may not be easy because, as signalled earlier, for some people the very idea of aesthetics may be off-putting—perhaps because it seems to refer to something superficial or, on the other hand, to something esoteric and obscure. Hopefully we have said enough to underline the clear relevance of aesthetics and to show that embracing this relevance entails some explicit attention to potential complexities and tensions. We see a potential parallel here with the growth of ethics discussion in health-care settings including in QI. Ethics is still seen as an area where some scholarly fields and communities have particular expertise but, at the same time, it has increasingly become a normalized part of di' such that all kinds of health-care actors feel comfortable about raising and everyday ethical issues. Of course, things can go wrong in this process—e.g., may sometimes operate with overly simplified—perhaps unhelpfully rigid or loose— conceptions of ethics (or here aesthetics). This should make us cautious about *how* aesthetics is incorporated into QI. In particular, we should be very wary of anything like a 'checklist' approach to aesthetics that indirectly encourages would-be improvers to quickly identify and attach weight to specific aesthetic judgements. As we have seen, aesthetic considerations need to be sifted, filtered, and carefully weighed. For the same reasons, the incorporation of aesthetics into QI courses, or medical education more broadly, should centre on the cultivation of imagination and critical debate rather than on a rush towards practical operationalization. But some such incorporation still seems to us a substantial improvement over silence or complete deference to the 'experts'.

In terms of improvement scholarship, Experience Based Co-Design (EBCD) provides a strong platform for others to build around. EBCD is a well-established current within the broad family of health-care quality improvement that takes as its starting point the way people feel about their health-care experiences (as users and providers)—explicitly underpinned by the language of aesthetics as a core component of design; for example, it applies the heuristic of 'touchpoints' from design aesthetics (Donetto et al., 2015). It is also directed towards improvement as a co-productive process. Our thoughts are that there is considerable scope for extending and 'normalizing' such conversations about everyday aesthetics across the many others (beyond those working in EBCD) interested in the theory and practice of quality improvement and, in so doing, also to enhance the breadth and depth of conversations and debates by welcoming many voices

from academic aesthetics and design, arts-based working, as well as those of patients, families, and professionals, into QI more broadly.

Our suggestion simply encourages processes that are already underway. The knowledge base of QI has broadened in recent years such that 'improvement science' is increasingly extending and becoming 'improvement scholarship' (Cribb, 2018). This is partly because the heavily technicist and psychological roots of QI in the industrial sector from which it sprang have needed to be complemented to make it suitable for the health-care sector, especially as models of health-care provision, and conceptions of health-care purposes and processes, have broadened out. But it is also a product of the raised profile and growth of the QI sector which has attracted interest in, and involvement from, social movements and scholars from the social sciences such as sociology who have often added critical as well as problem-solving perspectives to the interdisciplinary mix (e.g., Allen et al., 2016). Ethics and medical humanities (e.g., Cribb et al., 2020; Palmer et al., 2019; Boulton et al., 2020) are now also seen as potentially valuable contributors to what is becoming a more diverse and liberal field, and given this trajectory it makes sense for health-care aesthetics to find a more prominent place at the table.

Our core argument is threefold: (i) deciding what counts as 'good' health care has to encompass debate about aesthetic as well as ethical and technical considerations; (ii) aesthetic considerations can play a critical explanatory as well an evaluative role and therefore can inform approaches to improvement; and (iii) as QI is increasingly embracing broader paradigms, including co-production models, an aesthetics lens may now prove especially valuable. We have touched on these points in passing but we will briefly summarize them here and, following that, we will also pull together some of the questions our account raises for debate within both practice and scholarship.

Of course, the central case for the relevance of aesthetics to QI is that aesthetic quality is an important dimension of health-care quality. And unless would-be improvers have an informed and relatively broad picture of the range of things that constitute success, then they cannot go about planning their improvement activities in a defensible way. As we have also tried to illustrate, aesthetic factors are not an overriding consideration. Sometimes they may play a key constitutive role in supporting technical and/or ethical quality, even at quite a basic level, but sometimes they may pull against these concerns.

We have also tried to indicate that aesthetics can make a crucial contribution to explanations and thereby to steering possible change. There can be aesthetic reasons for action (or inaction) (Lesser, 1972) and aesthetic reactions may also underpin unconscious motivations. Unless we are aware of this explanatory role our 'theories of change' will sometimes be incomplete or even mistaken. In a crude way this is captured in the example of the influence of sensory responses on medicines adherence but it applies far more broadly. If the sensory and symbolic textures of health care make people experience and envisage health care as threatening or cold then this will not only make them slow to come forward, but may also make them feel unseen, unheard, and uncared for when they do, resulting in fundamental failures in both effectiveness and person-centredness. Equally these features can make professionals feel disconnected from their workplaces and alienated from their vocational identities.

Returning to person-centredness takes us on to the reason the kinds of aesthetic considerations we have discussed are arguably particularly salient in this phase of the development of QI and improvement scholarship. Mary Dixon-Woods has written about the need for QI to move 'beyond effectiveness' (Dixon-Woods, 2019). This signals that it is not just the knowledge base but also the substantive agenda and 'logics' of improvement practice that needs to expand—of course clinical effectiveness matters but other things also matter and it is important for QI to reflect on the full range of values and norms that inform it and that it serves. This, as Dixon-Woods makes clear, includes attention to themes such as power and inequality and includes responding to the calls for the co-production of health care and health-care improvement. Related work on QI has also stressed the importance of 'context-strengthening' approaches to QI as well as approaches based on specific interventions (noting that contexts and interventions are co-constitutive) (Liberati et al., 2019). In their work on 'very safe maternity care', for example, Liberati et al. identify—amongst other things—important factors contributing to success that might be thought of as 'soft' aspects of health care sociality including collegiality, mutual respect, open discussion, organizational citizenship, attention to 'soft intelligence' not just hard data, and space for staff to mix socially and professionally.

It would be reasonable, at this point, for someone to argue that we could accept the central relevance of aesthetic considerations but still avoid the potentially off-putting language. That practical discussions and debates about aesthetics could be had in terms of what people find 'satisfying' or 'appealing' etc. This sounds plausible but only up to a point. First, it seems much would be gained by opening up richer, more differentiated, aesthetic vocabularies, whether by drawing on academic aesthetic discussions or qualitative research traditions (such as in EBCD). Second, we would, again, invoke the parallel with ethics and suggest that there are important uncertainties and tensions raised by the inclusion of aesthetic considerations in QI that it is valuable to 'name' and debate. There is the question of when we should be suspicious of appeals to aesthetics—when it may send us in directions that are potentially damaging. The discussion of potential tensions between aesthetic, ethical, and technical dimensions of quality can contribute to an understanding of improvement goals in at least two respects. It provides another reminder that there may be trade-offs between rival conceptions of good health care that we need to navigate through. And it also poses valuable meta-questions about how far we can or should shape or 'educate' our sensibilities so that there is an optimum degree of alignment between and integration of our aesthetic judgements and those that relate to other dimensions of quality. Drawing on aesthetic considerations to plan or mould improvements is not easy. It throws up dilemmas of its own. These include dilemmas about how far to try to accommodate differences in aesthetic reactions and sensibilities (e.g., to respond to cultural differences), and how to think about and manage such balances in settings where both public and more personalized activities and 'spaces' come together.

Emerging emphases and paradigms in QI pose some exceptionally difficult challenges. They involve trying to forge new roles and relationships including much more meaningful forms of partnership working between staff and across

professional–patient and organizational boundaries (Cribb & Collins, 2021). On older paradigms what mattered was arguably that health-care settings were not too aversive but sufficiently non-threatening to enable professionals to engage effectively with patients. Newer paradigms call for spaces and encounters that positively welcome, inspire, and help mobilize the interest, self-expression, and agency of patients and which foster ongoing mutual understanding and co-creation. If we want to improve health care by making it more inclusive and co-productive, we are unlikely to do that without being attentive and sensitive to what health-care environments and encounters express, communicate, and open up for discussion. It is no coincidence that a movement such as EBCD that is organized around co-production asks these questions and acknowledges the importance of aesthetics. The challenge is to translate the metaphors used above about the need for more 'dancing' in health care into a revitalized and enlarged 'choreography of relationships.'

Conclusion

What we are proposing is perhaps nothing much more than a trick of perspective. It is a re-framing of health-care improvement which involves something like switching around figure and ground. Normally it seems that the technical–functional aspects of QI are placed in the forefront and that ethical and to some extent aesthetic considerations are included, but make up the background. We are raising the question about how the way we see, and our approach towards, technical–functional questions might evolve if we spent some of the time placing aesthetics in the foreground.

The language, and the growing current of work on, everyday aesthetics helps to mainstream aesthetics as both a routine and pervasive feature of our lives, including our professional and institutional lives. As we have tried to indicate, it allows us to use an aesthetics lens to think not only about a sub-set of relevant 'designed objects' but also about the more diffuse and sometimes inchoate 'objects', like 'climates', that we create without any discernible design or designer. In so doing we can pursue many of the agendas that are associated with arts-based working but apply them to a much more extensive and mundane territory. For example, we can see how the distinction between 'presentational' and 'participatory' arts-based working (e.g., Cao et al., 2021) has implications for both the material and social dimensions of everyday aesthetics. This distinction is mirrored, for example, in each of the two discussions above—of medicines and prostheses, and of 'bed-side manners' and co-production—and is indicative of the potential for everyday aesthetics to help support the shift from 'consumption' to 'co-creation'. Indeed, we have suggested, it is this shift of emphasis within health care and QI discourses that make now a good time to more wholeheartedly embrace, and make use of, the theoretical and practical resources of aesthetics. Aesthetics is an everyday matter and talking about it should, we think, become more of an everyday norm in health-care improvement.

Note

1. This chapter is a slightly revised version of material previously published in *Medical Humanities*. See Cribb, A. and Pullin, G. (2022). Aesthetics for everyday quality: One way to enrich healthcare improvement debates. *Medical Humanities* 48, 480–488. Available online at: http://dx.doi.org/10.1136/medhum-2021-012330.

References

Allen, D., Braithwaite, J., Sandall, J., & Waring, J. (Eds.). (2016). *The sociology of healthcare safety and quality*. Wiley Blackwell.

Allwood, D., Koka, S., Armbruster, R., & Montori, V. (2021). Leadership for careful and kind care. *BMJ Leader* 6, 125–129. https://doi.org/10.1136/leader-2021-000451

Bate, P., & Robert, G. (2007). *Bringing user experience to healthcare improvement: The concepts, methods and practices of experience-based design*. Radcliffe Publishing Ltd.

Berleant, A. (2010). *Sensibility and sense: The aesthetic transformation of the human world*. Imprint Academic.

Bleakley, A., & Marshall, R. (2012). The embodiment of lyricism in medicine and Homer. *Medical Humanities* 38, 50–54.

Bleakley, A., Marshall, R., & Brömer, R. (2006). Toward an aesthetic medicine: Developing a core medical humanities undergraduate curriculum. *Journal of Medical Humanities* 27, 197–213. https://doi.org/10.1007/s10912-006-9018-5

Boone, D., & Coleman, K. (2006). Use of the prosthesis evaluation questionnaire (PEQ). *Journal of Prosthetics and Orthotics* 18 (6), 68–79.

Boulton, R., Sandall, J., & Sevdalis, N. (2020). The cultural politics of implementation science. *Journal of Medical Humanities* 41 (3), 379–394. https://doi.org/10.1007/s10912-020-09607-9

Budd, M. (2008). *Aesthetic essays*. Oxford University Press.

Canetti, E. (1962). *Crowds and power*. The Viking Press.

Cao, E., Blinderman, C., & Cross, I. (2021). Reconsidering empathy: An interpersonal approach and participatory arts in the medical humanities. *Journal of Medical Humanities* 42, 627–640. https://doi.org/10.1007/s10912-021-09701-6

Cardenas, D. (2016). Umeda Hospital / Kengo Kuma & Associates. *ArchDaily*, 31 July 2016. Available at: www.archdaily.com/792313/umeda-hospital-kengo-kuma-and-associates [last accessed 6 October 2024].

Carroll, N. (2001). *Beyond aesthetics: Philosophical essays*. Cambridge University Press.

Chua, I. S., Jackson, V., & Kamdar, M. (2020). Webside manner during the COVID-19 pandemic: Maintaining human connection during virtual visits. *Journal of Palliative Medicine* 23 (11), 1507–1509. http://doi.org/10.1089/jpm.2020.0298

Cribb, A. (2018). Improvement science meets improvement scholarship: Reframing research for better healthcare. *Health Care Analysis* 26 (2), 109–123.

Cribb, A., & Collins, A. (2021). Strengthening citizenship: A healthcare improvement priority. *Future Healthcare Journal* 8 (1), e174–e177. https://doi.org/10.7861/fhj.2020-0122

Cribb, A., Entwistle, V., & Mitchell, P. (2020). What does 'quality' add? Towards an ethics of healthcare improvement. *Journal of Medical Ethics* 46, 118–122. https://doi.org/10.1136/medethics-2019-105635

Dewey, J. (1958). *Art as experience*. Capricorn Press.

Dixon-Woods, M. (2019). How to improve healthcare improvement. *British Medical Journal* 367, l5514. https://doi.org/10.1136/bmj.l5514

Donabedian, A. (1989). Institutional and professional responsibilities in quality assurance. *International Journal for Quality in Health Care 1* (1), 3–11. https://doi.org/10.1093/intqhc/1.1.3

Donetto, S., Pierri, P., Tsianakas, V., & Robert, G. (2015). Experience-based co-design and healthcare improvement: Realizing participatory design in the public sector. *The Design Journal 18* (2), 227–248.

Fancourt, D., & Finn, S. (2019). *What is the evidence on the role of the arts in improving health and well-being? A scoping review*. World Health Organization Regional Office for Europe.

Forsey, J. (2012). *The aesthetics of design*. Oxford University Press.

Gardner, H., Leeding, J., Stanley, E., Ball, S., Leach, B., Bousfield, J., Smith, P., & Marjanovic, S. (2021). *Arts-based engagement with research*. The Healthcare Improvement Studies Institute, University of Cambridge.

Geller, J. D. (2018). Introduction: The transformative powers of aesthetic experiences in psychotherapy. *Journal of Clinical Psychology 74* (2), 200–207. https://doi.org/10.1002/jclp.22582.

Gregory, J. (1772). *Lectures on the duties and qualifications of a physician*. Strahan and Cadell.

Hara, K. (1998). Umeda Hospital. Available at: www.ndc.co.jp/hara/en/works/2014/08/umedahospital.html [last accessed 6 October 2024].

Hume, D. (1740/1988). *A treatise of human nature*. Oxford University Press.

Irvin, S. (2009). Aesthetics of the everyday. In S. Davies, K. J. Higgins, R. Hopkins, R. Stecker, & D. Cooper (Eds.), *A companion to aesthetics* (pp. 136–139). Wiley-Blackwell.

Jackson, D. (2018). Aesthetics and the psychotherapist's office. *Journal of Clinical Psychology 74* (2), 233–238.

Julmi, C. (2017). The concept of atmosphere in management and organization studies. *Organizational Aesthetics 6* (1), 4–30.

Leddy, T. (2005). The nature of everyday aesthetics. In A. Light & J. M. Smith (Eds.), *The aesthetics of everyday life* (pp. 3–22). Columbia University Press.

Legro, M., Reiber, G., Smith, D., del Aguila, M., Larsen, J., & Boone, D. (1998). Prosthesis evaluation questionnaire for persons with lower limb amputations: Assessing prosthesis-related quality of life. *Archives of Physical Medicine and Rehabilitation 79* (8), 931–938. https://doi.org/10.1016/s0003-9993(98)90090-9

Lesser, H. (1972). Aesthetic reasons for acting. *The Philosophical Quarterly 22* (86), 19–28.

Liberati, E. G., Tarrant, C., Willars, J., Draycott, T., Winter, C., Chew, S., & Dixon-Woods, M. (2019). How to be a very safe maternity unit: An ethnographic study. *Social Science and Medicine 223*, 64–72. https://doi.org/10.1016/j.socscimed.2019.01.035

Light, A., & Smith, J. M. (Eds.). (2005). *The aesthetics of everyday life*. Columbia University Press.

Liu, F., Ranmal, S., Batchelor, H., Orlu-Gul, M., Ernest, T., Thomas, I., Flanagan, T., & Tuleu, C. (2014). Patient-centred pharmaceutical design to improve acceptability of medicines: Similarities and differences in paediatric and geriatric populations. *Drugs 74* (16), 1871–1889. https://doi.org/10.1007/s40265-014-0297-2

Maio, G. (1999). Is etiquette relevant to medical ethics? Ethics and aesthetics in the works of John Gregory (1724–1773). *Medicine, Health Care and Philosophy 2*, 181–187.

More, A., & Srivastava, R. (2010). Aesthetics in pharmaceutical OTC marketing. *SIES Journal of Management 7* (1), 65–96.

Moss, H., & O'Neill, D. (2014). Aesthetic deprivation in clinical settings. *The Lancet 383* (9922), 1032–1033. https://doi.org/10.1016/S0140-6736(14)60507-9

Murray, S. (2020). Disability, technology and the stuff of science fiction. Imagining Technologies for Disability Futures website. Available at: https://itdfproject.org/disability-technology-and-the-stuff-of-science-fiction/ [last accessed 6 October 2024].

Naukkarinen, O. (2017). Everyday aesthetics and everyday behavior. *Contemporary Aesthetics* 15, Article 12.

Palmer, V., Weavell, W., Callander, R., Piper, D., Richard, L., Maher, L., Boyd, H., Herrman, H., Furler. J., Gunn, J., Iedema, R., & Robert, G. (2019). The participatory zeitgeist: An explanatory theoretical model of change in an era of coproduction and codesign in healthcare improvement. *Medical Humanities* 45, 247–257.

Parsons, G. (2016). *The philosophy of design*. Polity Press.

Pullin, G. (2020). Ottobock Bebionic hand. *Domus 1046*, 50–55.

Pullin, G., Cook, A., More, M., Bassam, L., Clark, B., Gannon, A., & McMullan, C. (2019). *Hands of X: Design meets disability*. V&A Museum of Design Dundee, 27 June to 1 September 2019. Available at: www.vam.ac.uk/dundee/exhibitions/hands-of-x [last accessed 6 October 2024].

Puolakka. K. (2017). The aesthetics of conversation: Dewey and Davidson. *Contemporary Aesthetics* 15 (1). Available at: https://digitalcommons.risd.edu/liberalarts_contempaesthetics/vol15/iss1/20/

Saito, Y. (2007). *Everyday aesthetics*. Oxford University Press.

Saito, Y. (2017). *Aesthetics of the familiar. Everyday life and world-making*. Oxford University Press.

Silverman, B. D. (2012). Physician behavior and bedside manners: The influence of William Osler and the Johns Hopkins School of Medicine. *Baylor University Medical Center Proceedings* 25 (1), 58–61. https://doi.org/10.1080/08998280.2012.11928784

Singh, G. (2021). *Why dance matters, Episode 6*. Royal Academy of Dance. Available at: www.listennotes.com/podcasts/why-dance-matters/episode-6-dr-guddi-singh-FYkRePuMwOI/ [last accessed 6 October 2024].

Slater, P., McCance, T., & McCormack, B. (2017). The development and testing of the person-centred practice inventory—staff (PCPI-S). *International Journal for Quality in Health Care* 29 (4), 541–547. https://doi.org/10.1093/intqhc/mzx066

Vishnja, A. (2007). The concept of the therapeutic holding environment. Available at: https://goodenoughcaring.co.uk/the-journal/the-concept-of-the-therapeutic-holding-environment-and-how-it-has-been-implemented-in-the-residential-home-for-young-people-in-which-i-work/ [posted 22 May 2007].

Winnicott, D. (1953). Transitional objects and transitional phenomena. *International Journal of Psychoanalysis* 34, 89–97.

Wright, S. (2019). From 'holding pen' to 'a space to breathe': Affective landscapes in a newly-integrated sexual health clinic. *Sociology of Health and Illness* 41 (4), 806–820.

Yanagi, S. (1926/2018). The beauty of miscellaneous things. Reprinted in *The beauty of everyday things*. Penguin.

CHAPTER 43

DEVELOPING CLINICIAN INSIGHT INTO PRACTICE THROUGH THE AESTHETIC LENS

LOUISE YOUNIE

INTRODUCTION

I am a canvas,
As blank as can be,
Inexperienced in suffering,
Ill-health still a mystery to me,
I sit waiting for your paintbrush,
For the colours to unveil,
I sit, I wait...

By Georgina Maguire,
Year 1 medical student, 2010 (Younie, 2014)

IN my daily practice as a General Practitioner (GP), I find myself engaging with a *technical clinical dimension* drawing on my knowledge of disease, diagnosis, and treatment. There is also the *human dimension,* which includes for example witnessing suffering, compassion, and the therapeutic alliance. The human dimension engages the *self of the clinician, the other of the patient,* and *the space in between* (Sweeney, 2005; Scannell, 2002). Before starting out as a GP, I thought the good doctor needed to be able to diagnose and treat. Learning at the feet of my patients, I realized the complexity and messiness of the embodied, emotional, and interpersonal dimension of clinical practice that I was faced with. Gradually I learned to move my focus from '*what is the diagnosis*' to '*how can I help today?*'

Helping might involve a new diagnosis, but it might also mean listening, writing a sick note, a letter for housing, or engaging with the burden of poverty or inequity in the lives

of the patients we meet. Perhaps today I need to help the patient hear their own voice or explore the connections between the symptoms they carry and their life story. Trauma for example is responsible in people's lives for increasing both mental health problems and physical disease (Van der Kolk, 2014), but often remains an unarticulated and unrecognized embodying driver for suffering in people's lives. Taking a human dimension approach, I may stop and call out the strength and courage of the person sitting in front of me, having lived through the stories they tell me and, to still be here. Patients are surprised but grateful, it seems, to have been *seen* in this way.

The human dimension, though important to so much of what I do as a clinician, rarely finds space in the medical education curriculum. At one point I found myself in a small group with fourth year medical students and a question emerged from the group 'but are we allowed to cry with patients—no one will talk about this'. The human dimension is hard to articulate and even harder to assess.

This chapter proposes that engaging the human dimension may be supported by bringing in the lens for noticing aesthetic experience where there are moments of being fully present in a dialogical way. The consultation itself may be viewed as an aesthetic experience with meaningful encounter between patient and doctor, going beyond mere clinical transaction.

Reflection on clinician lived experience might also be experienced as aesthetic, our discovering this possibility when we unpack it, for example, through a process of *creative enquiry*. *Creative enquiry* is multilingual processing of lived experience through creative expression drawing on any of the arts from poetry to painting, music to mime, coupled with written reflection (Younie & Swinglehurst, 2020; Younie, 2019c).

Inviting understanding of our consultations as an aesthetic experience allows the student/clinician to re-invoke their imagination, to enable sensory, emotional, and embodied exploration, to slow down perception, potentially making the familiar strange. This may bring disruption to the biomedical objectification of the patient.

Enabling aesthetic processing within clinical reflection may support extension of epistemology, or ways of knowing beyond propositional knowing (i.e., knowing that . . .) to also include personal, emotional, relational, and tacit ways of knowing all relevant and necessary in the realm of clinical practice.

In the following section, I will consider the human dimension in medical education, explore the concepts of aesthetic experiencing and everyday aesthetics, and propose the consultation as a possible place of aesthetic experience. This will be followed by proposing creative enquiry as a way in medical education to open reflection on lived experience as an aesthetic experience potentially enhancing understanding.

The Human Dimension

Attending to the human dimension is not new. Calls for the human dimension in medical education have been ongoing on both sides of the Atlantic since the early twentieth

century. In 1927 Francis Peabody wrote a paper in *Journal of the American Medical Association* titled 'The care of the patient'. He describes the recent expansion of scientific knowledge and the critique by older clinicians of new doctors being 'taught a great deal about the mechanism of disease, but very little about the practice of medicine – or, to put it more bluntly, they are too "scientific" and do not know how to take care of patients' (Peabody, 1927, 877). He goes on to write that learning to be a clinician requires 'continued study and prolonged experience in close contact with the sick'. Six years later and in the United Kingdom (UK) Andrew Macphail (1933) continued this thread:

> When a student must be converted into a physiologist, a physicist, a chemist, a biologist, a pharmacologist, and an electrician, there is no time to make a physician of him. That consummation can only come after he has gone out in the world of sickness and suffering, unless indeed his mind is so bemused, his instincts so dulled, his sympathy so blunted by the long process of education in those sciences, that he is forever excluded from the art of medicine.
>
> (Macphail, 1933, 445)

Much later on Strode (1976) wrote a paper with the title 'Can the human dimensions in medical education be re-established?', noting that science and technology were growing at a faster rate than the 'human relations skills' of the people who make use of them. Cribb and Bignold (1999, 195) join the conversation describing the 'humanising' and 'objectifying' currents 'inherent in the professional socialisation of doctors'. They suggest that curricular reforms for the human dimension fail in the face of the hidden curriculum and process of assimilation of future doctors into a culture of objectivity. This is perhaps supported by research by Bansal et al. (2022) demonstrating through realist research, that our positivist approach to teaching medicine coupled with communication skills training does not greatly help future clinicians to engage in holistic 'person-centred care'. Person-centred care has been called for by the General Medical Council (2018) and is sometimes described as moving from asking the patient 'what is the matter with you' to 'what matters to you' (Health Improvement Scotland, 2022). It is about enabling patient engagement in their care and treating patients as individuals and equals (Coulter & Oldham, 2016). Bansal et al. (2022) suggest that to move medical students towards person-centred practice which is inevitably an intersubjective (and perhaps an aesthetic pursuit), there needs to be space for *meaningful patient experiences*, for *sense-making*, *engagement with emotion*, and for the *development of self-awareness*. These spaces are rarely found in the current medical education context. Rather than connection with the patient, with self, with emotion, the tendency is towards disconnection.

> *Medical education distances students from their own felt experience, and encourages them to see patients not as unique individuals, but filtered through the expectations that have been instilled as part of their instruction… 'The thing itself' – the person of both the patient and student – is all too easily lost.*
>
> (Shapiro, 2009, 8)

Development of self-awareness or meaningful encounters with patients requires presence and personhood, yet 'self' is one thing that can be lost through the process of medical education. Personal voice is silenced as students learn to present 'cases' through an impersonal passive voice, reducing the 'three-dimensional patient to a two-dimensional caricature', and 'hindering the student from engaging their own humanity' (Shapiro, 2009). This disconnection, it has been proposed, may even be a contributing factor to student burnout (Gordon, 1996).

At medical school, students become immersed in a process of reconstructing the person as the 'object of the medical gaze' (Good & Good, 1993). The interior of a person, their 'thoughts, experiences, personality' comes to hold different meanings in the process of the body being explored in anatomy, biochemistry, and physiology labs (Good & Good, 1993). Good and Good (1993) suggest that cultural 'work' is needed in order to 'reconstitute the person', i.e., to engage with the patient as a person with a lived experience of illness.

Understanding personhood/illness and understanding disease require different kinds of knowing. Understanding disease requires an intellectual objective knowing ('objective knowledge') about measurable facts thought to be universally true (Marcum, 2008, 97–108).

Understanding the patient or their illness experience is necessarily more subjective, complex and uncertain ('subjective knowledge', Marcum, 2008, 108–118) and is often termed the 'soft stuff', euphemistically suggesting either that the source of knowledge is less reliable (Tilburt & Geller, 2007), or that this is the easy dimension of practice. Neither of these are necessarily true. There is significant research pointing to the value and importance of relationships, lived experience, and meaning-making in terms of health, for example in the newly named field of 'Compassionomics', gathering evidence for the impact of compassion on clinical care (Trzekiak & Mazzarelli, 2019). Further, communication, connection, and understanding of our patients is far from easy. As Lehman (2018) writes in his *British Medical Journal* blog:

> *This art of medicine is in many ways more difficult than the science, because it forces us to examine ourselves critically in every encounter. It is the shared application of that science with individuals through the imperfect medium of our own understanding, intelligence, and empathy. And it is also the place where uncertainty intrudes.*

Although Lehman presents the complexity of the human dimension, Engel, writing in 1997 and famous in medical circles for proposing the bio-psycho-social model, suggests the problem of the human dimension is not that it is unteachable, overly complex, or subjective. Instead 'medical students receive no formal instruction, perpetuating generation after generation the myth of unteachableness...[because] no teachers interested or qualified exist' (Engel, 1997, 527).

In order to engage with human dimension or person-centred care, perhaps the 'clinical expert' needs to be humble in the face of the patient expertise of their own embodied

lived experience. This resonates with the clinician DasGupta's 'narrative humility'—recognizing what we cannot know about our patients and their stories (DasGupta, 2003) and Keats' (clinician and poet) 'negative capability' being able to be present in uncertainties (Keats, 1899).

The image in Figure 43.1 has been created to hold this vision for the human dimension as central in the double stranded DNA of medical education or the medical consultation. It juxtaposes the *mastery* of the *clinical dimension* of disease-based and depersonalized fact alongside the *mystery* of the *human dimension,* relating to, for example, humility, curiosity, self-awareness, and personhood more broadly.

In this section I have proposed the importance and some of the barriers of the human dimension in clinical practice and medical education and described the interweaving of the mastery of the clinical dimension and the mystery of the human dimension as two inevitable but (in terms of the human dimension) contested strands, to our patient encounters. Bringing the concept of aesthetic experience to bear in the clinical consultation may be one approach to support further development of the human dimension. This will be explored further in the next two sections.

FIGURE 43.1 The clinical and human dimension strands of the DNA of medical education (commissioned from Camille Aubry).

Aesthetic Experiencing and Everyday Aesthetics

Through the nineteenth century, Western aesthetics became increasingly narrowly focused on the fine arts (Saito, 2021). Modern aesthetics however could be seen as restoring the scope of aesthetics to a much broader conceptualization regarding *what* can become a source of aesthetic experience (Saito, 2021). Everyday aesthetics contributes to this widening scope beyond the sphere of art, by including objects, events, and experiences from the everyday that we might encounter as part of our normal flow of life, as a potential place for an aesthetic experience (Cribb & Pullin, 2022).

Aesthetic experience has been variously described. Definitions that resonate when thinking about medical practice include an experience where there is high arousal, cognitive engagement and a feeling of unity with the experience of our attention (Marković, 2012). Another conceptualization of aesthetic experience describes perception and surface engagement followed by the grasping of new meaning or concept of personal relevance (Tinio, 2013). From the field of contemporary aesthetics, according to Berleant (2013) the sensory and embodied nature of our experience or encounter also plays a key role in aesthetic experience. Edmonston (1998) proposes that aesthetic experience has a sense of timelessness or connection with the infinite, focusing in the moment or on a person or place, for example when encountering beauty or where we find ourselves responding with awe, elation, or mystery. When engaging aesthetically we might have fresh openness and receptivity to what is encountered allowing the ordinary to become extraordinary (Edmonston, 1998).

John Dewey, American philosopher and educational reformer, wrote the seminal work 'Art as Experience' published in 1934 (Dewey, 1934). This work inspires writing about everyday aesthetics in health care today (Cribb & Pullin, 2022). Dewey described aesthetic experience as related to the richest and most complete experiencing possible, tying together the sensory with the practical, emotional, and intellectual into a single whole (Dewey, 1934). He further proposes that aesthetic experience is necessarily participatory. There needs to be active engagement and meaning making for an experience to be described as an aesthetic experience. This kind of aesthetic experiencing, he suggests, is fundamental to our humanity and necessary for our well-being, growth, and transformation, enabling new ways of seeing and interacting with the world (Dewey, 1934). What Dewey might be describing in terms of aesthetic experience could perhaps be seen as a kind of 'participatory sense-making'. These are words used by De Jaegher (2021) working in the field of philosophy and cognitive science in her exploration of 'engaged human knowing'. She describes participatory sense-making as relating to embodied meaningful engagement between subjects or as when agents participate in each other's sense-making (De Jaegher, 2021, 855). This might be the case where there is a therapeutic alliance between doctor and patient for example, where each are present

to the other in more than a diagnostic encounter, rather a healing encounter, where suffering might be expressed, received, and held.

In the next section I will further relate these ideas of 'everyday aesthetics', 'participatory-sense making', and 'engaged human knowing' to the patient–doctor (or patient–student) encounter.

The Consultation as Aesthetic Experience

There is a risk that clinical practice, as any other practice, may become routine and humdrum, operating with taken-for-granted norms and pre-established patient–doctor roles. The consultation may however, become a place for participatory aesthetic experiencing, opening new ways of hearing and seeing. Understanding may emerge through renewed sensory and embodied awareness and attention to the experience in a mindful and curious way. For the medical student still learning, practice may not yet be routine or humdrum, however, as they become inculcated in the medical model, this often brings a more blinkered approach to patient encounters where much of the human dimension is shut out and the focus is on diagnosis and treatment. 'Discrete rational knowing' may triumph over, rather than live alongside 'engaged human knowing' (De Jaegher, 2021, 847).

Perhaps 'engaged human knowing' is a means however by which we could extend our learning 'out in the world of sickness and suffering' (Macphail, 1933, 395) to help us with 'continued study ... in close contact with the sick' (Peabody, 1927, 877), responding to the laments of our predecessors. Perhaps attention to aesthetic experiencing might support this work, allowing the lenses of imagination, sensory, emotional, and embodied exploration.

In the consultation we might become aware of the direction of our gaze, the movement of our hands on the computer keys, or a literal drawing closer to someone in distress. We might notice the patient's body language, the visual cues or (in)congruence of what we see and read in the situation alongside what is being said. We may apprehend the shadows, the sighs, or a silent tear in the eye, the unspoken and that which cannot yet be given voice. Perhaps we see the contours between the doctor and patient, the space between two persons which might be filled with fear, questions, relief, hope, or joy. We might feel their pain or ours. We may be so fatigued that pain or suffering no longer register. Our surroundings might disappear as we focus and are present in the here and now, or we may hear the clock tick reminding us of the queue of patients outside and the thought or wanting to be far, far away. These are examples of becoming aware of self, other, or the space in between allowing a body consciousness or an emotion consciousness to enter. Embodied or emotional perspectives may be frowned upon because of a dualistic worldview which assumes rationality or irrationality, the cognitive as separate

from the affective. It is traditionally thought that allowing the embodied or the emotional to enter the consultation might reduce our objectivity, decision-making capacity, and quality of care. This mind-body-emotion disconnect contrasts with connected engagement as highlighted by Dewey's complete aesthetic experiencing (Dewey, 1934) and De Jaeghers' 'engaged human knowing' (De Jaegher, 2021, 847), also with writings by Bohm (physicist working with quantum and relativity theory) and Buber (philosophical anthropologist). Bohm (1996) describes dialogue as a place of mutual discovery when assumptions are suspended and parties (e.g. patients and doctors) view each other as equals, colleagues, or peers in their quest for understanding and insight. Throughout his writing, Buber (1958) proposes 'I–It' (subject–object) and 'I–Thou' (subject–subject) relating, recognizing objectification or connection respectively. In connecting (doctor to patient) we risk something of ourselves, as we confirm the other (Buber, 1958).

There are clinicians and patients likewise who call for deep connection and Dewey's kind of aesthetic awareness (1934). Scannell (2002), writing as a clinician in the medical education literature, explores quality of connection across the 'third space' between patient and clinician in the consultation, drawing upon Winnicott (1982). This space, owned by neither and shaped by both, is generative, 'making *new thoughts* and *fresh perspectives* possible' (Scannell, 2002, 780). DasGupta considers the concept of 'mutual sighting', where one party cannot see the other unless the other can see him/her in return. The 'witnessing function, so crucial to doctoring, becomes a mutual one, supporting and nourishing both individuals' (DasGupta, 2008, 981). Finally Evans (2003, 9) suggests the effective consultation is where we 'know the other in order to respond as oneself, to gain as full an encounter between whole persons as one can'.

The writings of Broyard (1992), the editor of the *New York Times* who died of prostate cancer, offers a complementary patient perspective on the encounter with clinicians. He calls the clinician to 'wake something up inside that perhaps the long years of medical training has put to sleep' ... 'to dissect the cadaver of his professional persona... to give up some of his authority in exchange for his humanity ... ' (Broyard, 1992, 57). He describes the potential for the encounter as an aesthetic experience:

> *In learning to talk to his patients, the doctor may talk himself back into loving his work ... by letting the sick man into his heart ... they can share, as few others can, the wonder, terror, and exaltation of being on the edge of being, between the natural and the supernatural.*

The quality of encounter and learning that I am proposing in this chapter may feel impossible to achieve in the pressures of day-to-day practice, not just because of a biomedical focused training, but also because potential space in the consultation has been progressively collapsed over the years, by time constraints, increasing expectations, and complexity of clinical practice (Scannell, 2002). However, to shut ourselves off from our patients and their suffering may also be costly, not just for the patient, but for the clinician too. Disconnection from patients with a resulting loss of meaningful exchanges may hasten a journey towards cynicism, one of the dimensions of burnout (Zwack &

Schweitzer, 2013). I make a personal choice to seek meaningful encounters with patients where I can still be learning after twenty years of practice, but to do so means going against the flow of modern-day practice, not least regarding the time consultations take. I suggest to students that 'only dead fish go with the flow' and recognize work that is most meaningful is often not financially reimbursed. If I keep to my hours, my own learning and satisfaction in practice would be drastically reduced. Writing about practitioner learning and knowing and practice-based evidence McIntosh suggests:

> *We constantly find ourselves in new situations which in turn prompt new feelings, new challenges to our values, and new learning experiences. It is in these experiences that we make choices as practitioners: to sleepwalk through the experience and gain nothing new from it; or to engage with it in order to understand it and our self, better through it.*
>
> (McIntosh, 2010, 27–28)

What follows is a bridge between the consultation as an aesthetic experience and creative enquiry reflective work, illustrating 'new feelings, new challenges ... new learning experiences' (McIntosh, 2010, 27–28) beginning with an example from myself as clinician. Pausing and exploring a consultation through the medium of creative writing opened up understanding that might have otherwise been hard to appreciate and led to transformative changes to future consulting.

> *During a creative writing workshop led by Rita Charon in 2005, we (as educators) were asked to engage in creative writing about a difficult consultation, describing what we saw and felt as vividly as we could. I wrote about the girl in black, someone who had seen me several times in clinic. As a result of my writing and subsequent discussion in pairs I realized that my discomfort was the helplessness engendered in me in our time together. My response to this helplessness had been to find as many solutions as possible for **her** in order to make **me** feel better.*
>
> *Perhaps instead what she needed from me was just to sit with her awhile in that place. Maybe she could find her own way out or at least come to rest where she was at, if accompanied rather than hurried along. This realization from just a short creative writing session opened a new door of awareness into my felt sense of helplessness in some consultations. Now I could begin to recognize it and respond from beyond my own fears and needs, re-focusing myself on the patient. This meant starting to use silence, presence, sitting on my hands to avoid quick fix advice, where it actually might be unhelpful.*

Creative Enquiry in Medical Education

How might we help students attend to a widened experience of practice beyond the propositional domain to include the personal, emotional, relational, and tacit, supporting future person-centred care. Reflection has long been considered an approach to learning

from practice, emerging from Donald Schön's important work in the 1980s (Schön, 1983). The risk we face today is that just like clinical practice, reflection in medical education can become routinized, a sleepwalk or a tick-box exercise and medical students often describe it this way (even more so now that ChatGPT can produce a reflection for students with minimal input). The paper 'The reflective zombie' asks the question, can you really tell the difference between real and sham reflection, zombie reflection or authentic engagement (de la Croix & Veen, 2018)? Inviting medical students into the unfamiliar space of reflective creative enquiry opens the door to multimodal exploration of their lived experience in the clinics and on the wards.

I began introducing creative enquiry into medical education in 2003 in response to my own experiences with patients as a GP. The complexity and messiness of practice as a clinician drove me to explore new and creative pedagogies in the undergraduate medical curriculum in order to open up conversations around the 'swampy lowland' of practice (Schön, 1987; Younie, 2014). I have been running a Student Selected Component (SSC) for twenty years first at the University of Bristol and later at Barts and The London, Queen Mary University of London (QMUL) with groups of approximately twelve students. The SSC is also facilitated by arts for health consultants, arts therapists, and clinician and patient artists. Students witness patient creative work, hear about the arts-based process, engage creatively, e.g., through song writing, creative writing, clay modelling, photography etc., and finally talk and share their work (Younie, 2013, 2019b). This SSC has formed the backbone of my development as a creative enquiry facilitator and is the powerhouse of innovation and development of pedagogy which I have then taken into whole year group GP placement assessments and beyond. Please see the QR code in Figure 43.2, for more student creative enquiry examples.

Examples of the introduction of creative enquiry across a whole year group include introduction of creative enquiry for Year 1 medical students to reflect on a patient home visit, University of Bristol (Younie, 2009, 2014) and into Year 3 GP placement to explore compassion and complexity, Barts and The London, QMUL (Younie, 2022). As

FIGURE 43.2 QR code for website with student examples from the SSC and more.

an external consultant I am supporting compulsory creative enquiry introduction into reflection on a Year 2 hospital placement with a focus on patient voice, compassion, and professional identity formation at Anglia Ruskin University (2022–2024).

Although the arts have their proponents in the medical education sphere evidenced through growing medical humanities programmes across the United States (US), the West (Klugman et al., 2021) and beyond (Shankar, 2009; Shankar & Piryani, 2009), they challenge the dominant medical education institutional discourse (Younie, 2021a) and often remain peripheral and optional, potentially limiting the benefits they may have in building understanding of the human dimension (Haidet et al., 2016). As in my own case, the arts are often introduced by those with 'personal interests and enthusiasm' … rather than based on 'strategic decisions made by course directors or curriculum committees' (Haidet et al., 2016, 321). Elsewhere I have described the innovations and challenges in the field of creative enquiry, and how I have sought to find the cracks in the curriculum to scatter and nurture creative seeds (Younie, 2009, 2014, 2019a, 2021b; Thompson et al., 2010; Younie & Swinglehurst, 2019).

My aim is to awaken and inspire students to see with their own eyes, to notice what they witness and hear, to respect their own questions. This may affirm their imagination, intuition and what is tacit, affective and perhaps pre-verbal in their search for knowledge and understanding of practice (Douglass & Moustakas, 1985). The ineffable dimensions of our lived experience that defy being put into reflective prose, can perhaps be approached through colours, movements, sounds, and shapes. Fish (1998), writing on the development of practitioners, argues that in order to engage students in the aesthetic and human dimension of consulting, a valid approach may be to engage students in language that is itself aesthetic. Grounded in my many years of experience as a creative enquiry facilitator I have witnessed time and again how creative expression offers a short cut or lightning wire straight into our practices, stories, interpretations, and sense-making.

What follows are three student examples illustrating engagement with the human dimension: *student encounter with self, with the other, and with the space in between*. Of note, I have chosen well-crafted student work because these convey the message well, however, to engage in creative enquiry, talent in a particular creative medium is not necessary. Deep, practice-changing reflection is enabled through openness and presence. It is more important to be ready to improvise with the materials exploring our practices, than to produce a work of great beauty (McIntosh, 2010; Fish, 1998). Full absorption in creative expression, described as flow (Csikszentmihalyi, 1990), deep listening, and participatory engagement with creative materials (Eisner, 2002) support reflective processing as an aesthetic experience.

Self-Care by Rebecca Walker (Student Encounter with Self)

Figure 43.3 is the creative enquiry text by Rebecca Walker as a medical student completed in 2021. She reflects on her image as follows.

FIGURE 43.3 *Encounter with self*, submitted for GP prize callout, 2020.

I think plants are a simpler example, compared to a human, of the importance of compassion. In the right conditions, which differs from plant to plant, a sapling can evolve into its healthiest and best form for survival. In my piece, the best form of the sapling is a sunflower. As the first hand waters the sapling, it gives it something that is essential for its survival and it is able to bloom into a beautiful sunflower. I chose this plant because it has become a symbol for people with hidden disabilities and as someone who is a part of that group, it was important to me for it to be represented in my piece.

On the other hand, there are factors, environmental and internal, that act as barriers to showing compassion. In my case, the factors that were harming me were predominantly internal, but it is a ubiquitous experience that internal conflicts are exacerbated by environmental stresses. As medical students, this can be the emotional effect of being with people who are seriously ill and dying or the frantic studying for exams that not only do you need to pass but excel in.

This brings us onto the hand holding the caterpillar. I chose the caterpillar because, from its perspective, the prospect of being able to eat all of the sapling is incredibly positive for it. It will be better off for it and be more likely to develop into a butterfly. As a medic, I have rationalised giving myself less compassion because the patients I see need it more. I have since learned that there is enough compassion to go around, and actually it is far more important to show ourselves compassion because, in the long-term, we would be unable to show other people compassion if we are burnt out.

Slipper and Shoe by Sarah Saunders (Student Encounter with the Other)

Figure 43.4 is the creative enquiry text by Sarah Saunders, a medical student in 2007. She reflects on her image as follows.

FIGURE 43.4 *Encounter with other*, submitted for Year 1 GP placement, 2010.

I have based my montage on one particular patient that I had the privilege of meeting on a home visit, whom I shall refer to as Charles (not his real name).

The centre piece of this portrait is Charles's feet. When I entered the living room where Charles was sitting I was aware he was wearing one slipper and one, shiny, polished shoe. I rationalized in my head that his ankle and foot on one leg were indeed too swollen to fit into another shoe but could not understand why he didn't simply wear a pair of slippers. Upon reflection of my sixty-minute insight into Charles's life, I feel this can be explained by the fact that through all of the adversity he has faced in his life he has remained a man of pride, dignity and respect. I think that the slipper and the shoe are a symbol of Charles's attitude to life, never to give up. He asked my colleague and I not to think of him as a 'brave man' and rather to take something away that could help us and our future careers as doctors.

During tutorials before we began GP placements a colleague asked the tutor what she should do if a patient she was with started crying and she felt she was going to cry too. I remember thinking that I was not worried about that and assured myself I would be able to control the situation through 'detachment'. However, as Charles started to talk about his cancer, and the mood in the room changed, almost without warning he began crying and I did not feel the sense of detachment that I had so hopefully thought I would. In the artwork I have shown this part of the interview by a transition of blues running down the board. I have included this because I felt that it was an important moment for Charles and for me, as I think we both thought that we were strong enough, in very different ways, not to break down ...

We are all individuals on this planet by Elle Tallgren (Student Encounter with the Space in Between)

Figure 43.5 is the creative enquiry text by Elle Tallgren, a medical student, 2020. She reflects on her image as follows.

I got introduced to this area of medicine just 6 months ago while doing an SSC with Louise ... it transformed my way of looking at myself, my future self, my personal and professional life, and the way I view creativity.

One concept we explored quite a lot is the creation of a safe space in order to practice creative enquiry ... we submerged ourselves into a quiet space for 10 minutes or so and sketched. What emerged was a piece about the importance of shared safe space. It was the feeling of creating with 10 other individuals at the same time, knowing that my creativity will not be rejected but also that my boundaries are respected. We were taught about the concept of third space, which is what doctors are encouraged to create between them and the patient to ensure a feeling of safety and comfort. It is in this space that the patient can feel it is possible to be human in front of the doctor who—needless to say—is also human, although this is often portrayed otherwise. In the end we are all individuals on this planet—hence the title of my piece.

I have been doing photography for about 10 years now and it has always been a powerful tool to explore how my mind perceives the world around me and what I think of it. However, I had never put these inner thoughts on paper let alone reflected on them to others. The

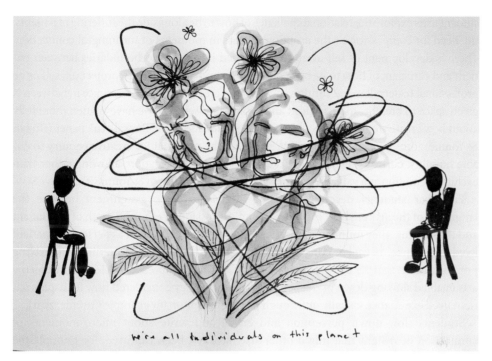

FIGURE 43.5 Encounter with Space in between.

conversation around creative enquiry makes space for that and I am able to put into words where the art piece stems from.

The student work collectively illustrates reflective aesthetic experiencing with focus on student lived experience. The languages of the arts allow exploration of students own meaning schemes and self-created metaphors. This *metaphorical* thinking counters the 'technical, objectified… impoverished and restricted language' medical students are encultured into (Shapiro, 2009, 8). Metaphors allow new conceptualization of ideas for us to imagine, grasp, and share (Langer, 1957) for example the moment of tears with the patient, captured with blue mosaic, the pathway and feet representing passing time, or the idea of the caterpillar eating the sunflower to reflect on felt patient demand and needs.

Langer (1957), a philosopher, describes our subjectivities as knowable, although difficult to apprehend, suggesting the arts as one way that can enable our engagement with our subjective existence. Subjective existence, says Langer, 'is not only met from moment to moment, but can be conceptually known, reflected on, imagined and symbolically expressed in detail and to great depth' (Langer, 1957, 7). Perhaps this is an answer to Engel's 'unteachableness' of the human dimension being a 'myth'. Langer continues to explain that artistic forms support this process because they offer congruence with our 'sensuous mental and emotional life' (Langer, 1957, 25).

The student pieces presented in Figures 43.3, 43.4, and 43.5, to differing degrees, address the areas of education called for by Bansal et al. (2022), i.e., *meaningful patient experiences*, for *sense-making, engagement with emotion* and for the *development of self-awareness*. The

student texts explore the relational challenge of how to be alongside the suffering of patients, the need for compassion or the eruption of tears in moments of meaningful connection. There is development of self-awareness captured in relating to boundaries between patient and clinician, of how to be both present as a human and also to protect oneself or be professional (caterpillar and sunflower). Through creative enquiry, the space in between is given space to breathe, to be noticed and explored. Elsewhere we have written more fully about how creative enquiry can address the points made in the Bansal et al. paper (Brown & Younie, 2022; Bansal et al., 2022). We propose the potential for creative enquiry to enable humility, curiosity, exploration, presence, and transformation, allowing rather than excluding emotion as a valuable part of reflexive practice (Brown & Younie, 2022).

First-year students describe choosing a creative piece assignment because the languages of the arts enabled exploration and expression of emotion, both of the patient and the student. They found greater space for exploration of patient as person and patient lived experience, as well as considering the patient's experience from different viewing points (Younie, 2011). Students described how seeking to express experience through the arts enabled slowing down or deepened reflection as they considered how to display patient lived experience visually or through poetic metaphor, for example (Younie, 2011).

Students slow down perception and create and write about micro-moments of connection or insight that might otherwise have not been captured, for example the moment of a patient describing 'lining up the pills on the table' but then noticing his child's toy car, captured with a staged photo of pills and car created by the student (Younie & Swinglehurst, 2020). Or listening to a patient with depression and isolation where the student seeks to articulate the heaviness conveyed by the patient and that they as the student also felt through use of imagery and colour (Younie, 2009).

Barriers

Because it is difficult to be creative without putting something of yourself into it, students or educators located scientifically within medicine can find it challenging and some find it unhelpful to engage. When facilitating students in a group, I learnt the importance of the safe or perhaps brave space, inviting group creation of ground rules, student authority of their own boundaries and how much to share. I learnt the need of a muse, a first easy creative exercise and engaging myself with the creative task (Younie, 2014, 2019a). I developed new creative exercises that could work such as choosing a postcard to resonate with one's lived experience and then bringing in Haiku writing to those reflections. I learnt to support students into process rather than outcome thinking in terms of creative technical prowess, towards an improvisational and participatory approach to the arts. In the large group GP assignments, the creative enquiry has generally been an option, and I have allowed students to be inspired and invited into the creative enquiry space by sharing great examples of student work from previous years.

Conclusion

Lived experience is messy, illness an embodied and existential threat, and the doctor–patient consultation a complex intersubjective encounter. Medicine continues to be taught and often lived within a positivist and biomedical framing of competencies, guidelines, standardization, and correct answers in line with discrete rational knowing and excluding engaged human knowing. Human knowing is however central to the doctor–patient encounter, if we are to move beyond transactional medical practice towards therapeutic or healing encounters. Such knowing is hard to live or articulate in modern day medical education or clinical practice, working in an ever diminishing space of tick boxes and complexity.

Aesthetic experience has been proposed as central and supportive philosophically to development of human understanding and knowing. Presence, slowing down perception, being more than cognitively present, allowing embodied, sensory, or emotional ways of knowing invite a more complete and holistic picture, akin to Dewey's 'Complete Aesthetic Experiencing'. This needs to be supported with time and space for reflection in medical education and the consultation. Articulation allows greater understanding of our lived experience and can be a starting point of further exploration. Aesthetically attending to our experiences through metaphor, symbolism, and ambiguity invites holistic and humanizing engagement with the reality of practice and exploration not just of what is known but also expression of the ineffable and unknown.

Allowing the human into the clinical means an inevitable engagement with uncertainty, not knowing, as the patient necessarily takes their place as expert embodied knower of their lived experience. We started with a poetic excerpt on the blank canvas, capturing a medical student's willingness to learn from the patient at the start of their medical career adopting the beginner's mind. We end with a T. S. Elliot poetic excerpt which helps to remind clinicians that after all our clinical learning, that again as we meet a new patient, through aesthetic engagement in our encounters, these encounters can become a place of fresh and new learning, where the ordinary and day-to-day can become extraordinary. This may help to prevent a humdrum routinized approach in the face of our patient suffering. If we are willing, we may be wakened from professional slumber.

We shall not cease from exploration
And the end of all our exploring
Will be to arrive where we started
And know the place for the first time.

(T. S. Eliot, 1943)

REFERENCES

Bansal, A., Greenley, S., Mitchell, C., Park, S., Shearn, K., & Reeve, J. (2022). Optimising planned medical education strategies to develop learners' person-centredness: A realist review. *Medical Education 56*, 489–503.

Berleant, A. (2013). What is aesthetic engagement? *Contemporary Aesthetics (Journal Archive) 11*, article 5. Available at: https://digitalcommons.risd.edu/liberalarts_contempaesthetics/vol11/iss1/5/

Bohm, D. (1996). *On dialogue*. Routledge.

Brown, M. E. L., & Younie, L. (2022). How creative enquiry can help educators develop learners' person-centredness. *Medical Education 56*, 599–601.

Broyard, A. (1992). *Intoxicated by my illness*. Ballantine Books.

Buber, M. (1958). *I and thou*. T. & T. Clark.

Coulter, A., & Oldham, J. (2016). Person-centred care: What is it and how do we get there? *Future Hospital Journal 3*, 114–116.

Cribb, A., & Bignold, S. (1999). Towards the reflexive medical school: The hidden curriculum and medical education research. *Studies in Higher Education 24*, 195–209.

Cribb, A., & Pullin, G. (2022). Aesthetics for everyday quality: One way to enrich healthcare improvement debates. *Medical Humanities 48*, 480–488.

Csikszentmihalyi, M. (1990). *Flow: The psychology of optimal experience*. Harper and Row.

DasGupta, S. (2003). Reading bodies, writing bodies: Self-reflection and cultural criticism in a narrative medicine curriculum. *Literature and Medicine 22*, 241–256.

DasGupta, S. (2008). Narrative humility. *Lancet 371*, 980–981.

De Jaegher, H. (2021). Loving and knowing: Reflections for an engaged epistemology. *Phenomenology and the Cognitive Sciences 20*, 847–870.

de la Croix, A., & Veen, M. (2018). The reflective zombie: Problematizing the conceptual framework of reflection in medical education. *Perspectives on Medical Education 7*, 394–400.

Dewey, J. (1934). *Art as experience*. Berkley Publishing Group.

Douglass, B. G., & Moustakas, C. (1985). Heuristic inquiry. *Journal of Humanistic Psychology 25*, 39–55.

Edmonston, P. (1998). Some characteristics of the aesthetic experience. Available at: www.collaboration.org/98/spring/text/08.aesthetic.html [last accessed 6 October 2024].

Eisner, E. (2002). *The arts and the creation of mind*. R. R. Donnelley & Sons.

Eliot, T. S. (1943). *Little Gidding*. Four Quartets: Harcourt.

Engel, G. L. (1997). From biomedical to biopsychosocial. Being scientific in the human domain. *Psychosomatics 38*, 521–528.

Evans, R. G. (2003). Patient centred medicine: Reason, emotion, and human spirit? Some philosophical reflections on being with patients. *Medical Humanities 29*, 8–14.

Fish, D. (1998). *Practice in the caring professions*. Butterworth-Heinemann.

General Medical Council. (2018). Outcomes for graduates. Available at: https://www.gmc-uk.org/education/standards-guidance-and-curricula/standards-and-outcomes/outcomes-for-graduates/outcomes-for-graduates [last accessed 6 October 2024].

Good, B. J., & Good, M. J. D. (1993). Learning medicine. The construction of medical knowledge at Harvard Medical School. In S. Lindenbaum & M. Lock (Eds.), *Knowledge,*

power and practice. The anthropology of medicine and everyday life, 79–107. University of California Press.

Gordon, L. E. (1996). Mental health of medical students: The culture of objectivity in medicine. *The Pharos Spring*, 2–10.

Haidet, P. J., Jarecke, N. E., Adams, H. L., Stuckey, M. J., Green, D., Shapiro, C., Teal, R., & Wolpaw, D. R. (2016). A guiding framework to maximise the power of the arts in medical education: A systematic review and metasynthesis. *Medical Education 50*, 320–331.

Healthcare Improvement, Scotland. (2022). *What matters to you*. Available at: www.hisengage.scot/equipping-professionals/what-matters-to-you/ [last accessed 6 October 2024].

Keats, J. (1899). *The complete poetical works and letters of John Keats*, 277. Cambridge Edition. Houghton Mifflin Co.

Klugman, C. M., Bracken, R. C., Weatherston, R. I., Konefal, C. B., & Berry, S. L. (2021). Developing new academic programs in the medical/health humanities: A toolkit to support continued growth. *Journal of Medical Humanities 42*, 523–534.

Langer, S. K. (1957). *Problems of art: Ten philosophical lectures*. Scribner.

Lehman, R. (2018). Sharing medicine—negative capability. In *BMJopinion. British Medical Journal*. https://blogs.bmj.com/bmj/2018/01/04/richard-lehman-sharing-medicine-negative-capability/

Macphail, A. (1933). The source of modern medicine. *British Medical Journal 1*(3767), 443–447.

Marcum, J. A. (2008). *An introductory philosophy of medicine: Humanizing modern medicine*. Springer.

Marković, S. (2012). Components of aesthetic experience: Aesthetic fascination, aesthetic appraisal, and aesthetic emotion. *i-Perception 3*, 1–17.

McIntosh, P. (2010). *Action research and reflective practice: Creative and visual methods to facilitate reflection and learning*. Routledge.

Peabody, F. W. (1927). The care of the patient. *Journal of the American Medical Association 88*, 877–882.

Saito, Y. (2021). Aesthetics of the everyday. In E. N. Zalta (Ed.), *The Stanford encyclopedia of philosophy*. Available at: https://plato.stanford.edu/archives/spr2021/entries/aesthetics-of-everyday/ [last accessed 6 October 2024].

Scannell, K. (2002). Writing for our lives: Physician narratives and medical practice. *Annals of Internal Medicine 137*, 779–781.

Schön, D. A. (1983). *The reflective practitioner. How professionals think in action*. BasicBooks.

Schön, D. A. (1987). *Educating the reflective practitioner: Toward a new design for teaching and learning in the professions*. Jossey-Bass.

Shankar, P. R. (2009). A voluntary medical humanities module in a medical college in Western Nepal: Participant feedback. *Teaching and Learning in Medicine: An International Journal 21*(3), 248–53.

Shankar, P. R., & Piryani, R. M. (2009). Using paintings to explore the medical humanities in a Nepalese medical school. *Medical Humanities 35*(2), 121–2.

Shapiro, J. (2009). *The inner world of medical students, listening to their voices in poetry*. Radcliffe Publishing.

Strode, O. B. (1976). Can the human dimensions in medical education be reestablished? *Educational Horizons 55*, 104–107.

Sweeney, K. (2005). Science, society, suffering and the self: A commentary on general practice for the twenty first century. *New Zealand Family Physician 32*, 221–224.

Thompson, T., Lamont-Robinson, C., & Younie, L. (2010). 'Compulsory creativity': Rationales, recipes, and results in the placement of mandatory creative endeavour in a medical undergraduate curriculum. *Medical Education Online* 15(1), 5394.

Tilburt, J., & Geller, G. (2007). Viewpoint: The importance of worldviews for medical education. *Academic Medicine* 82, 819–822.

Tinio, P. P. L. (2013). From artistic creation to aesthetic reception: The mirror model of art. *Psychology of Aesthetics, Creativity, and the Arts* 7, 265–275.

Trzekiak, S., & Mazzarelli, A. (2019). *Compassionomics: The revolutionary scientific evidence that caring makes a difference by Trzekiak*. Studer Gr.

Van der Kolk, B. (2014). *The body keeps the score. Mind, brain and body in the transformation of trauma*. Viking Penguin.

Winnicott, D. W. (1982). *Playing and reality*. Routledge.

Younie, L. (2009). Developing narrative competence in medical students. *Medical Humanities* 35(1), 54.

Younie, L. (2011). A reflexive journey through arts-based inquiry in medical education. EdD University of Bristol.

Younie, L. (2013). Introducing arts-based inquiry into medical education: Exploring the creative arts in health and illness. In P. McIntosh & D. Warren (Eds.), *Creativity in the classroom: Case studies in using the arts in teaching and learning in higher education*, 23–40. Intellect Publishers.

Younie, L. (2014). Arts-based inquiry and a clinician educator's journey of discovery. In C. L. McLean (Ed.), *Creative arts in humane medicine*, 163–180. Brush Education Inc.

Younie, L. (2019a). Vulnerability, resilience and the arts. In J. Patterson & F. Kinchington (Eds.), *Body talk: Whose language?* (pp. 64–77). Cambridge Scholars.

Younie, L. (2019b). Creative enquiry projects. Queen Mary University of London. Available at: https://sites.google.com/view/humanflourishingmeded/creative-enquiry-projects [last accessed 6 October 2024].

Younie, L. (2019c). Flourishing through creative enquiry. Queen Mary University of London. Available at: www.creativeenquiry.co.uk [last accessed 6 October 2024].

Younie, L. (2021a). Humanising medical education. *Journal of Holistic Healthcare* 18, 37–39.

Younie, L. (2021b). What does creative enquiry have to contribute to flourishing in medical education? In E. Murray & J. Brown (Eds.), *The mental health and wellbeing of healthcare practitioners: Research and practice*, 14–27. Wiley-Blackwell.

Younie, L. (2022). Compassion – walking the walk, who does the talk? *Journal of Holistic Healthcare* 19, 30–33.

Younie, L., & Swinglehurst, D. (2019). Creative enquiry and reflective general practice. *British Journal of General Practice* 69, 446–447.

Younie, L., & Swinglehurst, D. (2020). Creative enquiry and the clinical encounter. *British Journal of General Practice* 70, 26–27.

Zwack, J., & Schweitzer, J. (2013). If every fifth physician is affected by burnout, what about the other four? Resilience strategies of experienced physicians. *Academic Medicine* 88, 382–389.

CHAPTER 44

AESTHETIC EXPERIENCE IN THE EVERYDAY CLINICAL WORK OF HEALTHCARE PRACTITIONERS

A Practice-Based Description

HELENA FOX

Introduction

PRACTITIONERS in healthcare can be moved in aesthetic ways. Clinical settings are replete with emotive images and processes in everyday small interactions as well as issues of life and death. However, the objective evidence base has primacy. The capacity for, and attention to, subjective lived aesthetic experience may easily be overlooked. Amidst the current climate of bureaucracy, governance, and the growth of technology including artificial intelligence, there is a risk of crowding out the human 'being' in relation to the self and others and the 'art of medicine' being lost. How can the human capacity for awareness of subjective sense perception and the arising imagination of aesthetic experience be sustained and harnessed as an additional resource that broadens qualitative knowledge in practice? Aesthetic experience has been linked with values in other contemporary fields. In this chapter, I describe a type of aesthetic experience that I propose is similarly important and relevant to the everyday practice of workers in the field of healthcare. Here, the word 'aesthetic' refers to subjective sensory perception and the imaginative dimension that arises in experiential participation and 'aesthetic experience' also includes the complex bundle of human sensibilities, emotions, the embodied, the tacit, and the haptic: lived experience, all entwined and extending beyond words alone. Because of this complexity, aesthetic experience was explored through participation in an arts, practice-based research inquiry. Substantial experience in the clinical practice

of medicine, mental healthcare and the arts provided suitable researcher theoretical sensitivity to combine these in doctoral research that also drew on other relevant fields.

The nature of aesthetic experience was described from the research as it expanded from first-person starting points to include other healthcare practitioners and allied professionals who participated in a series of processes that activated aesthetic experience during the study. Collective feedback built the description. Postgraduate artists were also involved in the design process. In addition, existing practices and theory from various fields were drawn upon. Aspects of these were interpreted, adapted, and applied to contribute to the design. These fields include: from the arts, connective aesthetics (Gablik, 1993) and the 'Connective Practice Approach' (Sacks, 2021); the sensibility in everyday aesthetics (Saito, 2007, 2017); a phenomenological method of Goethean observation (Brook, 1998); a model for aesthetic appreciation of the environment from contemporary philosophy (Brady, 1998); the role of the imagination in relation to a neurophilosophical framework (Abraham, 2020) and exploration of present moment experience with mindful awareness (Williams, Penman, & Kabat-Zinn, 2011). The research was a form of grounded theory that took an iterative path spiraling through observations made in experiential and reflective practice whilst linking with these existing practices. A description of aesthetic experience thus emerged and its salient features are presented. Becoming aware of this type of aesthetic experience in healthcare practice may have the potential to enhance aspects of quality in clinical care. This awareness could be cultivated in a teaching model of enhanced reflective practice that has been proposed (Fox, 2023).

A critique of the limitations of a written text must be noted here. Writing 'about' experience places the reader at a distance from experiential participation itself. To bridge this gap and evoke something of the experience I wish to convey, several examples document first-person lived experience. A short practice is also included for the reader to experience.

An Initial Description of Aesthetic Experience from Starting Points

I propose that aesthetic experience, as defined above, may be present in routine, habitual, or even tiny moments of everyday clinical practice such as taking a pulse, listening with a stethoscope, the clinical touch, reading a medical investigation, a gesture, or even whilst walking down a hospital corridor. In these, the capacity for awareness of subjective perceptual detail and the arising imaginative dimension may often be suppressed, discounted, or ignored. Yet, if noticed at an appropriate time for reflection, these moments may prove to be rich in more multisensorial and imaginal detail than one 'thinks'. For instance, aesthetic experience in this chapter may include 'felt sense' (Gendlin, 2003), haptic sense (Nelson, 2013) and the tacit (Polanyi & Sen, 2009). Furthermore, some of this knowledge may steer choice of action and be related to values and possibilities for best humane caregiving, such as connective and empathic actions and thus impact on the quality of care.

Throughout years of clinical practice, I have had a recurrent expansive experience that could occur in everyday work as mentioned above. Two examples illustrate this type of aesthetic experience. These show how a sensory trigger led to a sudden expansion of thoughts, feelings, emotion, images, and imagination and how much could be noticed through close observation.

In the first example, I aimed to notice closely all that came to mind as I examined a pulse. In reflective time away from the clinic and using my own pulse, I focused mindfully on perceptual details, carefully describing these as in the clinical examination. During this, my mind rapidly wandered into an expansive imaginative dimension. I explored all that came to mind. I used a free-writing method (Goldberg, 2005) to record this at the time, then edited this in my reflective journal (Example 1):

Example 1 Pulse

As a young medical student, I approach my patient to take their pulse for the first time. I touch hesitantly in what I feel is a polite and 'clinical' way. In these moments of sensing, I am blown away with wonder at the life force that I am to experience throughout my career. For this small act of connection goes far deeper than the skin and artery palpated beneath my fingers. It has far more dimensionality than a counted number.

Now, having been a doctor for many years, I continue to reflect on how this encounter never ceases to amaze—calling me to be present with resonance and compassion for the humanity of the other.

Meditations on the Pulse

With my fingertips, I feel the expansion of your pulse. Its shape, its wave of pressure. In fifteen seconds, its immanence[1] insists. A quiet persistent force. A whole life paced out through the chambers of your heart.

We avoid each other's gaze but you beat into my imagination.

In this mortifying place, where souls are stripped, this beat resonates and catches up threads in my own life and loves and entwines me for a moment with you. Strange souls may touch tangentially in this way. Both hearts a driving force and a consequence.

I conjure up all the pulses I have felt. Ten a day, three hundred and forty days a year. For thirty years, a hundred thousand pulses, nearly two million beats.[2] Still, now, I'm blown away by the beating of each heart.

What if I hear them all at once, in the space of my imagination, all collected and beating? How would I be moved? The earth could move. What if all else were silent but for the beating of all hearts? Just for fifteen seconds. Our life-force. Would we feel our bodies as flesh of the earth and whispering souls of ether?

I think of my sons' bodies, how every single beat counts. Tender. Thus, can I attend to others.

I was left alone in the room with her, to take blood. I was twenty-one. Suddenly, I knew she was about to die. Almost imperceptibly something was slipping away from her face. Her breathing changed, her pulse, a thin thread. I ran into the corridor to find her husband. 'I think you should come, now. And hold her hand.' He did. She breathed a last sound. Blood welled up from her mouth and over her chest. Her pulse, gone. (Fox, 2023)

This piece revealed initial qualities of the type of aesthetic experience to be investigated here. With immediacy and arising from sensory perception of the pulse, I re-called, re-entered, and re-experienced many instances of 'taking a pulse' that were imprinted from medical student days to current clinical practice. The experience was full of multi-sensorial and complex imaginal detail. Description leant towards poetic[3] expression. By noticing experience as it occurred, I could describe it in more detail. Here, this small daily action of pulse taking could suddenly bring me to my senses and imagination if I noticed with full awareness. Furthermore, in the above example, I alluded to personal connections that contributed to valuing the person beyond just a number to be recorded. This connected me with compassion for the humanity of the other.

In the second example, on one occasion in my clinic, I was suddenly drawn to an awareness of sensory perception and an expanding imaginative dimension arising from a kinaesthetic trigger. Whilst organizing a pile of notes on my desk, a long paper strip of an electrocardiogram (ECG) recording flopped out of a clinical file. I wrote (Example 2):

Example 2 Electrocardiogram

' ... the ECG of a patient with anorexia who has not turned up catches my eye. Flicking through the notes, my finger runs along the trace. My attention is suddenly drawn to this small action when I notice I can 'feel' the slow beating of this heart, its low amplitude. I wonder how my patient is managing out there every day, with this struggling heart, I feel its strain into the world, and wonder what could help. I send a brief email inquiring how they are, saying I hope to see them soon. I offer a further appointment. A small connection, but an appreciative reply came back'. (Fox, 2023)

Here, the kinaesthetic trigger acted as a portal to awareness and connection with the detail in aesthetic experience. Arising thoughts, feelings, images, and imagination connected me with my patient in an empathic way and led to an action of contact.

These two examples[4] were starting points that contributed to an initial description of the nature of aesthetic experience. From first-person exploration, whilst immersed in aesthetic experience, awareness revealed the following qualities. It was evocative, resonant, full of rich, multi-sensorial detail and had an expansive reverberant imaginative dimension. It could occur in a flash where sensory perception brought a wealth of complex imaginal detail that combined images over time that would have been lengthy to describe in words alone. Through this awareness I felt a connection with others and could consider and value the whole person beyond objective parameters. A shift in mind to becoming aware of this aesthetic experience enabled noticing greater detail. Furthermore, from discussion with colleagues over the years in clinical practice, I believed that this type of experience also had meaning for others.

I was curious to know more about this phenomenon and yet it was hard to articulate exactly in words. During a Masters of the Interdisciplinary Arts, I developed participatory practices that made it possible to explore, communicate, and convey experience that could be shared with viewers in an embodied way, more rapidly and deeply than with words alone. I became interested in how non-verbal gestures

could be explored by sharing images rather than just a written or spoken description. Whilst exploring images closely, I made a video piece in which I re-enacted a series of gestures that one may witness every day in healthcare yet could be taken for granted. Sharing these as pared-down images rendered the actions poetic. I wanted to know how much was conveyed and felt by viewers in a gesture alone. To immerse viewers, I projected these images wall-sized in silence.

The following was an excerpt from my reflective journal (Example 3):

Example 3 Everyday Gestures

One gesture showed my action of simply turning two chairs inwards to a therapeutic angle[5] in preparation for meeting a client. I recorded this on video several times, editing out turning the chairs back outwards. Working in a psychotherapeutic mode, one is aware of the setting into which one welcomes the client. A small gesture of placing furniture like this can convey a sense of care. Furthermore, my own experience was that this inclusive movement brought an embodied, 'felt' sense of giving care that was very different from turning the chairs back outwards or leaving chairs carelessly scattered.

When I presented the video to postgraduate artist viewers, yet without giving this context, I was impressed by the depth of experience they perceived—not only did they rapidly feel a strong sense of inclusivity of the chair turning, but every detail in the pared-down image was noticed, felt, and led to further images and imagination. (Fox, 2009)

In a short space of time, rich detail was noticed and *felt* from the images. This generated enlivened discussion about what was experienced.

Inspired by the connective aesthetic practice approach of Sacks (2021) from the expanded art field of Social Sculpture (discussed below), I wanted to pursue a deeper research inquiry of aesthetic experience in the clinic by using arts, practice-based strategies (Fox, 2023). Additionally, I wished to explore how other participants would describe aesthetic experience arising from images in their own experiential practice. Thus, research processes were designed to activate aesthetic experience so that participants could observe their own sensing and imagination as it occurred. This also resonated with James Hillman's phenomenological approach of exploring images in psychotherapy. In his chapter, 'Image Sense', he advised 'stick with the image … the image tells all' (Hillman, 2000, 107–185).

So far, with awareness, aesthetic experience was found to be noticeable in routine, everyday moments; accessible through minimal means, 'felt' in interpersonal connections and could occur in a 'flash' or with more prolonged observation. A poetic rendering of an image or action could stir imagination. The imaginative dimension had multiple components. Awareness of aesthetic experience required shifting to a mode of mind of 'experiencing' in the moment. The sensorium noticed was found to be much broader than one 'thinks.' This only had to be noticed.

Exploring Aesthetic Experience Further

Whilst incorporating aspects from qualitative research, some uphold that arts-based research is a separate paradigm altogether (Leavy, 2009). Arts-based methodology can include a creative synthesis of methods and processes that emerge to fit the research questions and reveal practice findings. Gray and Malins refer to a 'naturalistic' approach that may include a hybrid mix of processes (Gray & Malins, 2004, 72–73). In his 'Practice as Research' model, Nelson gives three components of 'arts praxis' that are in dialogic and overlapping relationship. The arts practice has primacy, 'is at the heart of the methodology' and 'is presented as substantial evidence of new insights' (Nelson, 2013, 26). He calls knowledge arising directly from performative practice as 'know-how.' This includes 'experiential, haptic, performative, tacit, embodied ways of knowing' (p. 37). This is dynamically entwined with reflexivity and reflection called 'know-what' (p. 44), then links with existing known concepts, practice, and literature referred to as 'know-that' (p. 45). In architectural design, Zeisel outlines a process that can take a spiral iterative route that progresses back and forth through intuition, inner images, and practice (Zeisel, 1993). In all these approaches, rigour is brought to practice by transparent explanation and documentation of the research methods developed, including findings, analysis, and interpretation. My research adopted an arts, practice-based approach that afforded flexibility for creative methodology to embrace the complexity of aesthetic experience whilst being conducted with rigour and transparency.

In this way, the description of aesthetic experience relating to clinical practice discussed in this chapter emerged from an overall innovative methodology entitled 'Connective Aesthetics in Medicine'. This included new participatory processes designed to activate aesthetic experience for healthcare practitioners. Experiential knowledge that arose during participation had primacy. This 'know-how' linked with the 'know-what' and 'know-that' in Nelson's model. This also had parallels with Schön's reflective inquiry[6] (Schön, 1983). These were entwined throughout the research as discoveries were revealed and insights emerged in a spiral route from practice as described by Zeisel above. Experiential learning (Kolb, 2015) from practice throughout revealed new insights as knowledge, links with healthcare, and next research steps.

Design

The overall format of six newly designed experiential participatory processes is given next to show the basis from which the description of aesthetic experience arose.

Each newly designed process lasted one hour and aimed to activate aesthetic experience in relation to a different connective aspect of experience in everyday clinic work, i.e., connection with the self, other, community, or the healthcare environment. In practice, there was overlap, as in reality. The format for each process was similar in outline and included: a brief introduction; a poetic intervention to slightly defamiliarize an aspect of everyday clinical practice, draw attention to sensory detail, and stir the imaginative components of aesthetic experience; a guided experiential, contemplative component; feedback time for sharing experience, reflection, and discussion including links with practice in healthcare. The description of aesthetic experience was developed by analysing this feedback. Six participatory processes were designed for small groups. These came from a pool of twenty-six practitioners in healthcare recruited from different disciplines and also from allied professions.

Following a talk to introduce the research concepts, participants were invited to attend up to six different processes as desired or was practicable. These were delivered in face-to-face groups before the COVID-19 lockdown, then adapted for online groups of up to ten participants. Postgraduate artists took part in scoping the design.

Existing Practice and Theory Relevant to Aesthetic Experience in the Clinic

Several existing practices and theory where awareness of sensory and imaginal detail is central and relevant to aesthetic experience in the clinic are described next. I show how aspects of these were interpreted, adapted, applied, and synthesized into the design of the participatory practices.

Contemporary Arts: Connective Aesthetics and the Connective Practice Approach

'Connective aesthetics' was a term coined by the artist and critic, Suzi Gablik (1993). She shifted the traditional paradigm of aesthetic appreciation of art beyond the spectatorship of a distanced, separate observer to a more connected relationship. Aesthetic connection involved awareness of sensed interrelationship between each other, community, society, world issues, and the environment. Gablik endorsed the work of artists that connected this awareness with a moral responsibility to reveal insights, understandings, and values related to democracy, humanity, and sustainability through experiential participatory art.

In her introductory chapter, it is possible to see how principles in connective aesthetics could relate to healthcare practice. For instance, whilst medical practice can risk encouraging a distant objective perspective, the interrelatedness between patient and practitioner of shared human vulnerability in the human encounter is at the heart of clinical practice. Connection with one's own subjective aesthetic experience can enable empathic connection between self and others and consideration of the environment people are placed in. Such awareness arises in experiential relational participation, not spectatorship alone, and may include tacit (Polanyi & Sen, 2009) and embodied domains contributing to more holistic knowing.

The Connective Practice Approach

The connective aspect of aesthetics is similarly used in the 'Connective Practice Approach' developed by artist and Social Sculpture practitioner, Shelley Sacks (2021). Her approach contributed to the contemporary field of Social Sculpture initiated by Joseph Beuys in the 1970s that offers 'a framework for looking at the world' (Sacks, 2010). This can also embrace aspects of other fields. Sacks developed arts-based creative strategies called 'connective aesthetic practices' (hereafter 'connective practices') that deepen the human capacity for connection with inner experience of sensory and imaginal thought to discover new insights and deeper understandings that enhance democratic, humane, ecological and sustainable living. I was inspired by aspects of her practice-based approach and thought these had the potential to bring new insights and deepen understandings for humane connection in clinical practice. Next, I show how I have interpreted, applied, and adapted six aspects of Sacks' approach[7] to explore aesthetic experience in the clinic.

First, as well as tangible physical materials, Sacks works with 'invisible materials' (Sacks, 2021). These include for example, inner experience of thoughts, perceptions, images, imagination, questions and feeling the dynamic forces that drive them, sensing inter-relationships, attitudes, and values. These are considered as 'substance' that can be explored through reflection individually or collaboratively in discussion and 'shaped' to work in the beneficial connective ways mentioned above. Inner aesthetic experience arising in clinic work could be similarly viewed, reflected on, and contribute to shaping and enhancing best connective practice.

Second, in Sacks' approach, this inner experience is worked with in dialogue in reflexive and reflective ways. This 'internal activity' is an 'enlivened, aesthetic' way of working. Ideas can be developed in this 'inner workspace' then extended outwards as tangible forms, or 'outer work' to be shared with others in participatory acts, discussion, and exchange of ideas. Similarly, in my research, ideas from inner aesthetic experience related to clinic issues were extended outwards by designing practice-based tangible forms. These were participatory processes that activated aesthetic experience for others to share. The word 'aesthetic' additionally relates to an enlivened awareness of sensory and imaginal detail as opposed to suppression resulting in psychic numbness or 'anaesthesia' as also described by Hillman's 'aisthesis' (Hillman, 1992, 107, 125).

Third, Sacks describes a 'perpetual oscillation' connecting inner and outer work in dialogue. Her approach can also embrace aspects from other disciplines. In my work there is a similar dialogue and also connection with various existing practices and theories described below.

Fourth, in Sacks' connective practice approach, becoming aware of imaginal thought is at the heart of creative work and the connective practices aim to mobilize imagination. One strategy used refers to Bertold Brecht's 'making slightly strange' (Sacks, 2011). This process of defamiliarization aims to release one from habitual, fixed thinking, to reveal new insights, understandings, or notice what may be suppressed. Poetic interventions are used to mobilize imagination in this way. Similarly, in my research processes, poetic 'twists' were used to slightly defamiliarize everyday clinical actions and stir imagination to bring new insights and understandings beyond habitual thought, including awareness of issues that have been suppressed or deemed too subjective in medical practice.

Fifth, in Sacks' connective practice approach, raising awareness of the ability to respond to the sensory and imaginal detail of aesthetic experience adds an ethical dimension to the word 'response-ability' and sensing what needs to be addressed. Similarly, the ability to respond to aesthetic experience in the clinic with heightened awareness may lead to feeling what's needed in terms of caring humane connection. The connective practice approach aims to create transformative processes that bring insights for humane, democratic, and sustainable living. Similarly, processes that bring awareness to aesthetic experience in my research aim to bring attention to connection through empathy, kindness, and compassion in humane care. These are much needed human qualities in healthcare both towards the self as practitioner and through this to others, patients and colleagues alike. For instance, the need for 'Intelligent Kindness' was discussed by Ballatt and Campling (Ballatt & Campling, 2011) in the wake of the United Kingdom mid Staffordshire Report on neglect in healthcare.

Sixth, in Sacks' work, the 'invisible material' or 'substance' gathered remains malleable through processes of detailed collective exchange of perspectives and ideas in careful and lengthy shared discussion. In my research, the description of aesthetic experience is developed through shared reflection, feedback, exchange, and discussion with practitioners in healthcare from various disciplines and postgraduate artists. In this way, collating their perspectives, experiences, insights, understandings, possibilities, values, and links with practice all build the description and importance of awareness of aesthetic experience. In healthcare practice, however, time is scarce, and the research processes were designed to be deliverable in a lunch-hour meeting or equivalent. Despite this challenge, with the researcher embodying skilled care in delivery, findings demonstrated that the complexity of aesthetic experience and links with healthcare could be revealed in limited time.

The following example (Example 4) is an excerpt from my report of a lengthier process I designed for a day's Social Sculpture workshop[8] whilst a doctoral student supervised by Sacks. It illustrates how concepts discussed above were synthesized in an experiential participatory process. Fifteen postgraduate artists took part to test the design success of conveying, activating, exploring, and describing aesthetic experience.

> **Example 4 Bathe: An Encounter with Care**
>
> 'Touch,' an everyday encounter in healthcare may become habitual and taken for granted. Participants were invited into a practice to notice their experiences closely in such moments.
>
> They were first guided in a short mindfulness meditation to practice awareness of the focus of attention and deliberately follow its path through inner experiences such as sensations, thoughts, feelings and images to those related to external events. (Siegel, 2011).
>
> During a break, the studio was prepared with tables, vessels for carrying and pouring warm water and washing hands with care. The lay out rendered an ordinary space poetic.
>
> Participants were invited into this space to engage in bathing each other's hands and wrists in turn, in silence whilst paying mindful attention to what they sensed, imagined and noticed, for example how their attention travelled to 'meet' the other, how connection was experienced, if they could place their attention into the 'shoes' of the other or if they felt the need to retreat or avoid, returning their attention to inner experience of perception and imagination.
>
> In silent contemplation, participants rotated, taking turns in offering the bathing, being bathed, taking care of arranging place settings and observing. The bathing action lasted several minutes to sustain attention on experience. Time for sharing experience, reflective inquiry and discussion followed.
>
> Collective feedback indicated a felt sense of a poetic quality in the room, of gentleness in the interactions, of comfort, as if it were a ballet of hands, eyes and movements in dialogue, of feeling 'into' each other with empathy, around each other, between and with each other, apart and together, noticing closely and with sensitivity. It was also felt that the 'scene' had been set for the 'possibility of care.' Contents of imagination included recalling vulnerability, images came to mind from childhood or in hospital, of trust, of receiving and giving care, kindness, the privilege of touch, precious situations that were intimate, rare, sacred etc. This led to a wider discussion about ways of encountering the other in humane care. (Fox, 2023)

Aesthetic experience was successfully activated. The poetic design drew and sustained attention to sensing and stirred imagination. Participants were deeply immersed and connected with their inner experience of rich, multisensorial detail and arising imagination. Aware of this, they also felt connected with others as they 'met' through touch and were able to consider wider issues and values important in care. They were able to describe and share their experiences, thus building the description of aesthetic experience. A shorter one-hour version was designed for practical use in healthcare and later adapted for online delivery during COVID-19, entitled: 'Touch: An Encounter with Care' (Fox, 2023).

Contemporary Aesthetics in Philosophy

A central view of aesthetic engagement in the field of Contemporary Aesthetics is that of Berleant (Berleant, 2013). He emphasizes the immersive, rich quality of aesthetic

experience perceived in the natural environment compared to distant, disconnected, passive spectator observation, for example as in viewing art in a gallery. His description of environmental aesthetic experience is connected, participatory, 'complex and indistinct, it harbours feeling tones, bodily stance, mnemonic resonances, associations and intimations....' (Berleant, 2010, 29). A detailed description of this type of aesthetic experience can be found in *The Aesthetics of the Environment* (Berleant, 1992, 25–39). The aesthetic experience in the clinic that I am describing is similarly immersive.

Everyday Aesthetics

From the same field, Yuriko Saito expands the existing debate in Western aesthetics to include aesthetic awareness 'gained through sensory perception and sensibility' in everyday experiences (Saito, 2017, 1). 'Everyday' refers to the familiar, 'typical, usually practical attitude that people take towards what they are experiencing' in their regular everyday lives (p. 2). She says this awareness is not only gained in seeing the 'extraordinary in the ordinary' through 'defamiliarization,' but also in becoming mindfully aware of 'aesthetic texture' of the 'ordinary in the ordinary' by paying full attention to experience during action rather than being in 'autopilot' (p. 3). This includes awareness of both 'negative and positive aesthetic textures' (p. 2). Similarly, it is the aesthetic experience in the everyday-ness of healthcarers' practice that is explored in this chapter.

Saito states how awareness of the 'everyday aesthetic' is linked to values related to interpersonal, social, political, and environmental issues (p. 4). As in Gablik and Sacks connective aesthetic practices above, this brings a moral responsibility to 'worldmaking.' In her chapter entitled 'Consequences of Everyday Aesthetics' (pp. 141–186) she upholds that the 'power of the aesthetic' found in 'the awareness in small everyday actions is important and can affect daily life, the state of society and the world.' Aesthetics is 'a way of expressing moral virtues and values' thus 'reflecting our values of care.' She adds that 'care taken embodies a respectful attitude and sensitivity for the well-being of people'. More recently, in the *Aesthetics of Care*, she has expanded on the importance of active imagination in an empathic and relational move for engaging with and beginning to understand what the perspective of the other may be (Saito, 2022, 40). This also involves levels of reciprocity in interpersonal relationship. Her text covers this in depth (Saito, 2022, 47–75).

An example Saito gives is the Japanese tea ceremony (Saito, 2017, 150–151). This demonstrates taking and giving care, thinking about the other, respect and gratitude that arise during the preparation, offering, and receiving tea. Although this ceremony is not an 'everyday' event, Saito uses this to show how mindful awareness of taking care can be transferred to everyday actions. As in Dewey's writing in 1934 in *Art as Experience* (Dewey, 2005), Saito broadens the view of 'aesthetic' to the participatory aesthetic experience that arises in practical everyday actions. This experiencing of the 'everyday aesthetic' is available to everyone. I propose that this everyday-ness of aesthetic experience

is also applicable to work in the clinic. The daily action of taking a pulse, given in Example 1 above (see 'Pulse'), demonstrates this. Aesthetic sensibility in everyday clinical actions may be missed or suppressed. However, noticing this ability to respond is linked with moral implications for instance, in embracing values in values-based practice (Fulford, Peile, & Carroll, 2012). In this way, the capacity for aesthetic awareness could offer a resource for connected and humane care. Awareness of aesthetic experience is connective and participatory rather than the more usual, objective, distanced clinical stance.

Inspired by the Japanese Tea Ceremony, and considering the almost outdated regular activity of sharing a cup of tea with one's team after a ward round, I designed a process in which a small group of participants were invited to notice what they experienced whilst sharing tea, as with one's team. The next example (Example 5) is an excerpt from my reflective report:

Example 5 Tea for Ward Rounds

The piece was designed to embody care by preparing the space with simple materials of plain china and linen unpacked from a Gladstone bag. Fresh herb leaves were offered to steep in hot water with an invitation to share. The setting and care taken added a poetic twist.

By slowing down, there was time to notice aesthetic experience. It was possible to explore and describe together qualities that occurred. The practice provided a micro-environment to experience many of the competencies needed to be an empathic doctor. Offering and receiving tea was relational, connective and bonding with each other and the 'group'. It was also refreshing and revitalising. (Fox, 2023)

The next two models include the imaginative dimension arising from sensory perception. These underscore the importance of knowledge that can arise through awareness of experience whilst in relational participation 'with' aspects of the natural environment. I propose that parallels can be drawn with awareness of such aesthetic experience in the clinic setting and I designed research processes to incorporate components of these.

Goethean Observation

Isis Brook describes stages in the phenomenological method of observation of J. W. Goethe called 'delicate empiricism' (Brook, 1998). An item from nature is explored, such as a plant or landscape, using personal powers of perception and imagination rather than starting with pre-existing facts about them. Brook's example applies this to a landscape whereby coming to perceive and imagine more about the land could ultimately contribute to wider issues for sensitive ecological planning. I propose that this method could be adapted and applied in traditional clinical practice settings by similarly noticing sensory detail and the arising imaginative dimension for enhancing sensitive humane caregiving.

An outline of Brook's four stages of Goethean observation is given next. She explains how rigour is brought to this model of subjective experience by working systematically through successive stages (with some overlap). An item from nature that stirs curiosity is selected. Initial impressions and pre-existing knowledge are set aside or bracketed out. The first stage, 'exact sense perception,' is a careful description of what is sensed in detail, as if seeing the object for the first time. The second stage, 'exact sensorial imagination' is noticing what arises in imagination directly from this. In this way, the imagination is 'schooled' (Brook, 2009, 36). She gives an example of how careful observation of parts of a plant may even give an imagined 'feel' as if from inside the plant. In the third stage, 'beholding' as 'inspiration' from imagination may lead to sensing a 'gesture' of developmental change of the whole form. This subjective experience can bring a sense of connection with the plant in a form of empathic imagination arising from direct participation. By stage four, a sense of 'being one with the object' can lead to an intuitive overarching idea of the phenomenon. These stages involve perception, imagination, inspiration in feeling a gesture, and intuition as to what the whole may be and the overall archetype to which it belongs, e.g., of the overall phenomenon of 'plant' in the case of exploring a leaf sequence. Whilst this is a human-centric view, it is a way we read the world and reach beyond ourselves with imagination to sensitively consider the possible condition of the other. This subjective knowing can then be compared with existing facts.

Applying Brook's stages, and also experience in workshops given by Ewald (2016) based on Colquhoun and Ewald (Colquhoun & Ewald, 2004) in relation to plants and trees, I tried out these stages in practice whilst closely observing a plant in my garden over several days. I used painting to sustain my attention. Not only did this serve to describe the detail of the plant's form, I also perceived its growth upwards and came to imagine the felt gesture of the flowers opening, blossoming, turning towards the light, then withering and dropping down to be reabsorbed by the soil. I sensed a connection with the plant through this imaginative and empathic process and came to imagine its whole life cycle in its dynamic changeability. More widely, I became aware of needs of the plants in my garden (Fox, 2023).

A parallel experience could be given from my medical student days in the anatomy room (Example 6):

Example 6 Anatomy Room

As a medical student in anatomy, carefully observing, drawing, labelling details of organs of the body does not bring a sense of life itself. Anatomical observation can engage many senses but it is with the arising imagination that one reaches from and beyond these parts and conjures up the essence of the whole human being. Signs in the body may also lead us to imagine how this body was lived and something of the person. (Fox, 2023)

This capacity for sensing and the arising imagination is a 'connective aesthetic' which allows one to reach beyond the issue at hand and connect more holistically. For instance, in reading an ECG, as in Example 2, given earlier, one may be able to conceive of a whole life force and journey that the trace is just a part of. This subjective, personal sensing and imagining is at the root of empathic feeling for the other and could steer connective actions such as a verbal inquiry into the patient's experience or well-being, a smile and eye to eye contact that acknowledges human-to-human connection.

Environmental Aesthetics

Emily Brady proposed a model called the 'Integrated Aesthetic' based on sense perception and the arising imagination, again in participatory experience whilst immersed in the natural environment as opposed to a more traditional notion of aesthetic appreciation of art (Brady, 1998, 2003). The type of aesthetic experience I am describing in the clinic also has parallels with Brady's model. She argues that aesthetic appreciation is of value as an additional way of gaining knowledge using one's own capacities, compared to starting with pre-existing science-based facts. Similarly, one is immersed in the clinical environment, where awareness of aesthetic experience may also have the potential to bring a further dimension to knowledge alongside objective scientific evidence. As in the model described by Brook, Brady also includes 'imaginative activity' that arises from sensory detail. She presents four 'modes,' through which the imagination expands.

Brady's four 'modes' of imagination are called, 'exploratory, projective, ampliative and revelatory'(Brady, 1998, 143–145), later adding 'metaphorical imagination' (p. 153). Importantly, she discusses how 'imagining well' (p. 158) enables skillful reflection on components that are appropriate and relevant to the given situation, rather than personal issues alone or flights of fantasy. Although her 'modes' are described separately, she explains that they may overlap or not all co-exist. As with Brook's stages, I experimented by applying her model in practice whilst observing an item from nature, here a pebble on my desk. This is described next, then extrapolated to a clinical issue.

First, in Brady's 'exploratory' mode, imagination begins to link with associations and images arising from noticing sensory detail. Observation of my pebble immediately brought detailed sensory imagery of the beach where I found it. I could hear the sea, feel the wind's force on my face and other circumstances from that time. Brady's next mode, 'projective' imagination, includes adding to, or seeing the perceived object as another thing or even imagining into it, as if from inside. Respectively, I could see a shape on the pebble resembling a wing, or the entire pebble as a sculpture of a bird. I could also imagine a feeling, as if from within the pebble, of being washed up on the beach and buffeted by the waves, as empathic imagination. Brady describes the third mode of 'ampliative' imagination as the most 'active mode of aesthetic experience.' Imagination expands from previous stages to include inventive, creative aspects, even

leaps of imagination and seeing from new perspectives. Brady adds that it is through this mode that different variations or outcomes are tried out. In my example, I imagined the formation of the pebble over thousands of years and a sense of force of the weather sheering it from the cliff. I pictured hiking that coastal path and how it might be to camp nearby at the mercy of variable weather. Other associations emerged that spanned time, recalling actual and counterfactual events, including sensory imagery in different modalities. Brady explains that the fourth mode, 'revelatory' imagination, can lead to 'aesthetic truths' and new insights. Here, imagination is stretched to broader realizations and wider implications. In my example, I could imagine erosive forces at play between sea, weather, and land that created this pebble. My awareness turned to issues of climate change. Brady explains that this coming to know through one's own experience can then be positioned in relation to pre-existing scientific facts. Referring to the latter first would shortcut the chance of experiencing for oneself and the knowledge arising directly from human capacities.

Extrapolating this to a clinic issue, I tried this out using a stethoscope. Alongside actions, sketches, and diagrams, the following (Example 7) is an excerpt of recorded notes and reflections written at the time. I found that all Brady's modes of imagination were present with some overlap, as she indicates.

Example 7 Stethoscope

My stethoscope lies on an adjacent chair, its lemniscate form is not lost on me. It triggers my imagination and conjures up dynamic forces that may flow through it - the looping of the circulation through the body, heart, lungs, the breath and exchange of air, the connection of the self with another.

Listening to my own heart takes me to a vast interior space in which my imagination is amplified. This is not just a number or set of noises from the ebb and flow of liquid in a vessel, pump and conduits, I have images of walking through vaulted chambers and feel reverberations and a deeper resonance with a whole life lived. Listening thus, thrown in on myself, objectivity and subjectivity coincide and are not dualistic. It is through this experience of listening to my own heart that I can more deeply come to listen and connect with the hearts of others. As a doctor, I am privileged to listen in this way. I become aware of this deeper aesthetic experience which, as well as listening objectively to the sounds of the body, affords me a deeper connection by appreciating the other person more holistically.

I am reminded of James Hillman's comment about the heart being the 'centre of aesthesis' (Hillman, 1992), at the centre of our sensing and imagining and in its entwinement of body with mind, not only of oneself but in this way with others. It is, at once, both mechanistic and full of feeling. 'A swirling circulating physicality full of thought, feeling and imagination'.

And what of my own heart? How is it functioning? Is it capable of caring? Is it cared for? The roots of compassion, do they start from here? Should doctors listen to their own hearts and contemplate this - for a few minutes each morning? This thought, resonant with Lao Tse's idea came to mind along the lines of taking a few minutes adjusting one's hair each morning before going out. Why not the heart? What if I invited my colleagues to listen to their own hearts, what could be noticed? (Fox, 2023)

This aesthetic experience became the basis for the design of a shared participatory process, 'The Stethoscope Contemplation' (Fox, 2023). This was one of six newly designed research experiential participatory processes in which artistic poetic twists were combined with components of Brook's and Brady's models in guided contemplations. This aimed to activate aesthetic experience by drawing attention and mindful awareness to sensory perception and stir imagination. The first process was designed to introduce the concept of aesthetic experience using a nature item, for example an item collected on a walk. These items and the participants' narratives about them provided poetic components in this process. Aesthetic experience was felt to be more familiar here than starting with a clinical issue. In subsequent processes, participants were guided to apply this method of noticing aesthetic experience to various clinical issues, e.g., the 'Stethoscope Contemplation' above.

The reader may wish to sample this type of experience for themselves rather than just reading 'about' it. A shortened version of the guidance for the nature item process is given below (Example 8). Comments in parentheses show where components from the models of Brook and Brady were roughly adapted,[9] along with mindful awareness and reflection.

Example 8 Contemplation with an Item of Nature

Have to hand a small nature item that has drawn your curiosity eg. pebble, seed head, or another collected object. You may wish to take a short pause in the spaces between sections below to notice what comes to mind.

In silent contemplation, try exploring your item as if you have never seen it before.
Sensory Exploration and description (exact sensorial perception, focussed mindful awareness.)
Offering it the focus of your attention, describe it to yourself whilst exploring it fully. What do you see? How does it feel? Does it have a sound? How does it appear to all your senses?

Try without naming. Describe the direct qualities of the object, as if meeting it with new eyes, for the first time.
Imagining ('Exact sensorial imagination,' 'exploratory' imagination)
Whilst doing this, you may find your imagination wanders. Noticing where this goes. What comes to mind?
Expanding imagination (Feeling a 'gesture', 'projective' and 'ampliative' imagination, open mindful awareness)
You may be imagining something beyond the object itself or imagining something onto it or imagining it as another thing.

Imagining into it, how might it feel from the inside? Where does your imagination go?

What happens when allowing your imagination to go further, deeper or even following a leap of imagination, exploring the detail of this too?
New insights (Overarching ideas, 'Revelatory' imagination)
Now being open to whatever arises in mind, be it linked with the object or in the outer reaches of imagination. Do any new ideas or understandings come to mind?

> **Grounding**
> And now slowly coming back to your current surroundings, taking a few moments to notice what is here around you.
>
> **Experiences noticed** (Reflective inquiry)
> You may wish to note what you experienced in this time. What happened?
>
> **What learned?** (Reflective inquiry.)
> What further reflections arise? Does awareness of this type of experience bring any links with practice eg everyday and even clinical?

As a first process, research participants found this an immersive and evocative experience. They noticed multisensorial detail and described the arising imaginative dimension. They noticed how their imaginations expanded, travelling far in mind and time, making wider links beyond the object itself and how awareness of this type of aesthetic experience may have a role in clinical work in various ways.

The Role of the Imagination

Feedback in all the newly designed processes revealed that the imaginative dimension was complex. Adapting Abraham's framework of the functions of the imagination was useful for analysing this (Abraham, 2016). She proposed five categories based on current neuroimaging findings and philosophical thinking, e.g., Stevenson's 'Twelve Conceptions of Imagination' (Stevenson, 2003). Abraham explains that a key feature of imaginative function is the ability to 'time travel', i.e., holding time in mind beyond the immediate present and reaching into the past and future. The first three categories of her framework are particularly relevant to my research findings and are discussed next with examples from participant feedback.

(1) *Mental imagery*: feedback demonstrated that sensing rapidly merged into multisensorial imagery. In one participatory process, pared-down photographic images of hospital corridors taken from different angles and focal points (as may be seen by a recumbent, semi-conscious patient) were projected life size for viewers to contemplate. Some images indicated human connection by showing a personal item or touch. A sample from collective feedback demonstrated the following (Example 9):

> **Example 9 Hospital Corridors**
>
> Visual images generated synaesthetic experiences involving various senses. Viewers were able to 'feel into the space' and described a range of imagined sensing such as feeling cold, hearing silence, 'smelling carbolic', feeling a shift in gear, a feeling of being plunged into an environment, a visceral feeling of decompression and feelings similar to the 'suction of infinity' described by Broyard (1993). (Fox, 2023)

(2) *Intentional or recollective imagination*: Research participants reported travelling back in time, recollecting individual or combined memories based on reality or invented. They also projected into the future. In this category Abraham also includes empathic concern for others and moral reasoning. Example 10 continues with the Hospital Corridor process alluded to above:

Example 10 Hospital Corridors (continued)

Participants became aware of memories for example, of relatives in hospital sharing sad and frightening experiences, waiting with uncertainty for prognostic news of recovery or illness progression. Different times were imagined of when one may be hospitalised from birth to death.

Patient disempowerment came to mind on seeing images of stark hospital barriers as a 'superstructure' and imagined difficulties of the patient cast in a passive role, isolated and lonely, juxtaposed with the warmth and human connection that a touch or personal item could bring. (Fox, 2023)

The next example (Example 11) is one participant's feedback in a guided process where paper electrocardiogram (ECG) traces were contemplated, noticing aesthetic experience.

Example 11 Participant Feedback on Contemplating an ECG Trace

One senior doctor recalled being a house officer in cardiology walking around their patient and getting an image of their beating heart, including an imaginary feel for the forces of the heart from different positions. This led to wider realizations, 'the huge decisions one took were quite humbling' and 'taking an ECG is not just a piece of paper. We can think beyond it to the person—to visualise that person, not just be analytic.' (Fox, 2023, citing research participant)

Abraham places the imaginative functions in her second category as those that engage the default mode network (DMN) of the brain as revealed in neuroimaging.

(3) *Novel combinatorial imagination, generative, creative thinking, hypothetical reasoning*:

In Abraham's third category imagination can be non-linear, creative, novel, open-ended, divergent with hypothetical thinking, in the 'possibility space', including the 'what was', 'what if', and 'what might be' (Abraham, 2016, 4203) Abraham suggests that here the DMN of the brain is also active along with areas involved in semantic and cognitive evaluation, allowing combination of knowledge in novel ways. Continuing the ECG example from above (Example 12):

> **Example 12 ECG Process**
>
> Several experienced doctors recalled their panic as junior doctors when trying to read an ECG trace in an emergency, yet not feeling expert enough to read them without a senior doctor around to help. Some noticed their imaginings of the trace as if it were another thing e.g. a musical score, a recording of bird song, the heart's rhythm as poetry. Although these imaginings were not obviously related to clinical outcomes, for some, such associations appeared to calm their anxiety related to initial recollections and offer a common starting point for discussing moral distress in the face of acute illness, feeling helpless and unsupported as a junior doctor years ago. (Fox, 2023)

These three categories also appear similarly aligned with the expanding imaginative processes in Brook and Brady's models. The fourth and fifth categories (Abraham, 2020) are not detailed here. Briefly, her fourth category relates to the field of neuroaesthetics involving the reward system of the brain when active, for example, in viewing visual arts and music (Chatterjee & Vartanian, 2016). The fifth category relates to 'altered mental states'. Of note, 'aesthetic experience' defined in my research embraces all five of Abraham's categories and largely, yet not exclusively, involves the first three.

Aesthetic Experience and Mindful Awareness

In the research processes, informal mindfulness practice was adapted as a method to become aware of, explore, and describe aesthetic experience as it arose at the time. This was in comparison to formal mindfulness-based treatment programmes (MBP) (Feldman & Kuyken, 2019). However, like the 'habit breaker' in MBP (Williams, Penman, & Kabat-Zinn, 2011) the poetic intervention served to shift attention away from habitual thought to focus on noticing sensory detail of experiences in the current moment. The research processes then encompassed 'open awareness' of expansive arising imagination as in Brady's model, even embracing the far reaches or leaps of imagination[10] or the divergent thinking aligned with Abraham's third category that includes creative thought and possibility. The imaginative component of aesthetic experience also embraces time travel and these also enter as the present moment's experience of imagining and can be explored with awareness.

Summary and Implications

A type of aesthetic experience related to the everyday work of healthcare practitioners was described from an arts, practice-based research inquiry. Healthcare practitioners

participated in processes designed to activate aesthetic experience so they could observe it directly and describe it empirically. The researcher's experience in clinical and arts-based practice was combined with aspects from other contemporary existing practices and theory. These were discussed to show how they were synthesized into the design of innovative experiential participatory processes.

The description of aesthetic experience that emerged was found to be rich in multisensorial and imaginative detail, including the felt sense, the tactic, haptic, and embodied. Awareness of this experience brought connection with participants' inner experience, that of others, and the environments in which these were encountered. The imaginative dimension brought deeper insights and links with wider issues such as values and connection with others in empathic, more holistic ways. Such connectivity is at the centre of the human encounter in healthcare. Furthermore, components of the arising imagination suggested that areas of the brain involved in divergent, hypothetical, and generative thinking in the space of 'possibilities' may be active. This discovery suggests that the human capacity for awareness of the type of aesthetic experience in this chapter may offer an important resource in healthcare work rather than being suppressed as 'too subjective.' Examples are given in the research (Fox, 2023). One example of a general practitioner participant's feedback is given here:

>I wonder if I could have survived without becoming anaesthetised, not just at medical school - where it starts, but also during the stressful first days of being on the wards ... and even dealing with so many people in distress as a GP. And yet I feel the most powerful bit of being a doctor is being able to develop an aesthetic rapport with patients, and colleagues. (Research participant)

Aesthetic experience related to the everyday work of healthcare workers has not been reported empirically in this way before. This contributes a new area called 'Connective Aesthetics in Medicine' as well as offering applications to the various fields discussed above.

The new processes offer the potential for teaching students and healthcare practitioners in continuing professional development. A resulting prototype for a teaching model is in progress.[11] In COVID-19 lockdown, the participatory processes worked well online thus showing suitability for dissemination in this way. Work in the busy clinic is often task related, with little space for subjectivity. Time for aesthetic awareness to be explored in enhanced reflection, as in the research processes, could be made away from the busy clinic, and skills could be developed on how to apply such knowledge wisely in clinical practice to deepen connection and quality of care.

Additionally, awareness of aesthetic experience coupled with reflection can lead to considering values in care linked with values-based practice (Fulford, Peile, & Carroll, 2012). A new field of aesthetics in mental health and well-being is emerging and developing across related disciplines. The 'Aesthetics in Mental Health' network is now part of the Collaborative Centre for Values-Based Practice in Health and Social Care,[12] Furthermore, a recent paper from Public Policy Research, also the first chapter in this section, upholds the importance of including awareness of everyday aesthetics

(for instance as discussed by Saito above) in discussions on improving healthcare quality (Cribb & Pullin, 2022; 'Aesthetics for Everyday Quality: Enriching Health-Care Improvement Debates," this volume).

I am grateful to all the research participants and to those who consented to inclusion of their comments in this chapter.

Notes

1. Immanence—Pervading, permeating, inherent, intrinsic, essential, fundamental, built-in.
2. An average of fifteen beats in the fifteen seconds it typically takes to read a pulse.
3. Full of sensibility and imagination.
4. Others are given elsewhere (Fox, 2023).
5. Placing two chairs, one each for therapist and client at an angle of forty-five degrees. This offers the client a welcoming connection and the opportunity to look aside, avoiding eye to eye contact as needed.
6. One of the processes of reflective inquiry recommended for use by doctors by the General Medical Council, UK.
7. The Connective Practice Approach also includes terms used by Sacks taught directly in modules of 'Creative Strategies' and 'Social Sculpture' whilst Professor of Art at Oxford Brookes University.
8. A feedback forum for postgraduate artists. Oxford Brookes University.
9. Adaptations were made to fit newly designed guidances for the research practice, rather than exact replication of existing models.
10. Links with 'intentional' or 'unintentional' mind wandering are not expanded on further here.
11. Online or face-to-face.
12. See www.valuesbasedpractice.org [last accessed 6 October 2024].

References

Abraham, A. (2016). The imaginative mind. *Human Brain Mapping 37* (11), 4197–4211.
Abraham, A. (2020). The imaginative mind. In *The Cambridge handbook of the imagination*. Cambridge University Press.
Ballat, J., & Campling, P. (2011). *Intelligent kindness reforming the culture of healthcare*. RCPsych.
Berleant, A. (1992). *The aesthetics of environment*. Temple University Press.
Berleant, A. (2010). *Sensibility and sense: The aesthetic transformation of the human world*. Imprint Academic.
Berleant, A. (2013). What is aesthetic engagement? *Contemporary Aesthetics (Journal Archive) 11*, Article 5.
Brady, E. (1998). Imagination and the aesthetic appreciation of nature. *The Journal of Art Aesthetics and Art Criticism 56* (2), 139–147.
Brady, E. (2003) *Aesthetics of the natural environment*. Edinburgh University Press.
Brook, I. (1998). Goethean science as a way to read landscape. *Landscape Research 23* (1), 51–69.
Brook, I. (2009). Dualism, monism and the wonder of materiality as revealed through Goethean observation. *Philosophy Activism Nature 6*, 31–39.

Broyard, A. (1993). *Intoxicated by my illness: And other writings on life and death*. Fawcett Columbine.

Chatterjee, A., & Vartanian, O. (2016). Neuroscience of aesthetics. *Annals of the New York Academy of Sciences* 1369 (1), 172–194.

Colquhoun, M., & Ewald, A. (2004). *New eyes for plants: A workbook for observing and drawing plants*. Hawthorn Press.

Cribb, A., & Pullin, G. (2022). Aesthetics for everyday quality: One way to enrich healthcare improvement debates. *Medical Humanities* 48 (4), 480–488.

Dewey, J. (2005). *Art as experience*. Berkeley Publishing Group.

Ewald, A. (2016). *Conversations with a tree: A social sculpture workshop conducted by Axel Ewald* [Workshop].

Feldman, C., & Kuyken, W. (2019). *Mindfulness: Ancient wisdom meets modern psychology*. Guilford Press.

Fox, H. (2009). *Reflective Report from Creative Strategies Module in Masters in the Interdisciplinary Arts*. Unpublished.

Fox, H. (2023). From anaesthetic to aesthetic in the clinic: An arts, practice-based inquiry into everyday aesthetic experience for healthcare practitioners. Ph.D. Thesis, Oxford Brookes University.

Fulford, K. W. M., Peile, E., & Carroll, H. (2012). *Essential values-based practice: Clinical stories linking science with people*. Cambridge University Press.

Gablik, S. (1993). Changing paradigms. Breaking the cultural theme. In *The Reenchantment of Art*. Thames and Hudson.

Gendlin, E. T. (2003). *Focusing: How to gain direct access to your body's knowledge*. Rider.

Goldberg, N. (2005). *Writing down the bones*. Shambhala.

Gray, C., & Malins, J. (2004). *Visualizing research: A guide to the research process in art and design*. Ashgate.

Hillman, J. (1992). *The thought of the heart; and, The soul of the world*. Spring Publications.

Hillman, J. (2000). *Image-Sense*. Edited by B. Sells. Spring Publications (Classics in archetypal psychology, 4).

Kolb, D. A. (2015). *Experiential learning: Experience as the source of learning and development*. Second edition. Pearson Education, Inc.

Leavy, P. (2009). *Method meets art: Arts-based research practice*. Guilford Press.

Nelson, R. (2013). *Practice as research in the arts: Principles, protocols, pedagogies, resistances*. Palgrave Macmillan.

Polanyi, M., & Sen, A. (2009). *The tacit dimension*. University of Chicago Press.

Sacks, S. (2010). Social Sculpture Module VA63. 2010. Masters Interdisciplinary Arts. Oxford Brookes University.

Sacks, S. (2011). Exchange values on the table: Booklet on how to practice social sculpture at the exchange values round table. Social Sculpture Research Unit.

Sacks, S. (2021). *Kassel-21: A Global Lab for Joseph Beuys Centenary Celebrations*.

Saito, Y. (2007). *Everyday aesthetics*. Oxford University Press.

Saito, Y. (2017). *Aesthetics of the familiar: Everyday life and world-making*. Oxford University Press.

Saito, Y. (2022). *Aesthetics of care: Practice in everyday life*. Bloomsbury Academic.

Schön, D. A. (1983). *The reflective practitioner: How professionals think in action*. Basic Books.

Siegel, D. (2011). *Mindsight: Transform your brain with the science of kindness*. Oneworld Publications.

Stevenson, L. (2003). Twelve conceptions of imagination. *British Journal of Aesthetics 43* (3), 238–259.
Williams, J. M. G., Penman, D., & Kabat-Zinn, J. (2011). *Mindfulness: A practical guide to finding peace in a frantic world.* Piatkus.
Zeisel, J. (1993). *Inquiry by design: Tools for environment-behaviour research.* Cambridge University Press.

Chapter 45

Gardens and Human Flourishing

Sue Stuart-Smith

Introduction

A garden is, by definition, a cared for space and the gardener enters into a living relationship in which they're not completely in control. Gardening combines psychological and physical benefits. Some of these derive from the focus on caring for plants and engaging with the natural growth force, others derive from the setting itself and the direct influence of green nature on our nervous system. The safe green space of a garden is calming which reduces stress and helps promote human connection. At the same time, working with the regenerative powers of nature puts us in a direct relationship with how life is generated and sustained which can help people recover a sense of agency and give them a sense of a future.

Gardening is unique in the many levels that it works on and the extent to which it brings together the emotional, physical, social, vocational, and spiritual aspects of life. I will attempt to capture some of this complexity by drawing on findings described in my book, *The well gardened mind: rediscovering nature in the modern world* (2020).

This chapter will first provide an overview of the history of horticulture as a health intervention in Western culture and will then examine the different kinds of benefits that people can experience through gardens and gardening, with a particular focus on gardening as an aesthetic experience that involves all the senses, as well as an expression of creativity through which deep existential meanings can emerge.

A Historical Perspective

Medieval Europe

The medieval monasteries contained some of the first examples of Western therapeutic gardens. They typically contained a contemplative cloister garden which provided

a tranquil setting for meditation, as well as productive gardens in which the monks grew food and medicinal herbs. The monasteries had a duty to care for the sick and there was usually a small hospital with its own secluded garden. St Bernard (1090–1153) described the replenishing effects of the garden at the Abbey at Clairvaux in France: 'The sick man sits upon the green lawn ... secure, hidden, and shaded from the heat of the day ... the earth breathes with fruitfulness, and the invalid himself with eyes, ears, and nostrils, drinks in the delights of colours, songs, and perfumes' (p. 9, Gerlach-Spriggs et al., 2004).

The twelfth-century Benedictine abbess, St Hildegard of Bingen, was known as a composer and medicinal herbalist but she also developed a philosophy based on the connection between the human spirit and the growth force of the earth. She gave her central concept the name viriditas which she derived from combining the Latin for green and truth.

Viriditas is a source of goodness, an essential life force, and a font of energy. By contrast to 'ariditas', or dryness, which Hildegard regarded as its opposite. The greening power of viriditas is both literal and symbolic. It refers to the flourishing of nature as well as the human spirit and in placing 'greenness' at the heart of her thinking, Hildegard was asserting the existence of an inescapable link between the natural world and human health.

The Eighteenth Century

The idea that gardens and nature can help people thrive and recover from mental illness became prominent in the eighteenth century when reformers like William Tuke, recognized how much a patient's physical and social surroundings mattered. Known as Moral Therapy, the movement led to many hospitals being built in parkland settings with gardens and sometimes farms attached. The setting of the building was conceived of as a restorative environment which provided a source of meaningful and therapeutic activities to promote recovery.

In America, the physician Benjamin Rush promoted a similar model in which patients could walk and wander freely out of doors and tend flowers and vegetables in the garden. He observed that those who worked in the asylum grounds to pay for their care, often recovered more quickly whereas those 'whose rank exempts them from performing such services, languish away their lives within the walls of the hospital' (Rush, 1812).

The Nineteenth Century

One of the best descriptions of the beneficial effects of the natural world on people was written by the American Landscape Designer and creator of New York's Central Park, Frederick Law Olmsted. He was a pioneer of the public park and believed it was vital for people to have access to green spaces within cities in order to improve their

health. Spending time in nature, he wrote, 'employs the mind without fatigue and yet exercises it; tranquillizes it and yet enlivens it; and thus, through the influence of the mind over the body, gives the effect of refreshing rest and re-invigoration to the whole system' (Olmsted & Nash, 1865). This was in 1865 and the science to back up Olmsted's observations didn't exist then, but there are now hundreds of studies that prove him right.

The Scottish social reformer, Patrick Geddes was a pioneer in both environmental education and town planning. He believed that people needed to live by Voltaire's maxim 'Il faut cultiver.' The cultivation of people and place was encapsulated in Geddes's concept of 'Place-Work-Folk', a triadic relationship that was in his view, the basic building block of society. The combined effects of industrialization and city living had, he observed, weakened the connections between people and place, resulting in negative effects on social and individual health.

Gardening was at the centre of Geddes's approach. In the late nineteenth century, he re-invigorated the slum areas of Edinburgh by making community gardens on waste ground and encouraging the inhabitants of the tenements to grow flowers in window boxes. He understood that growing food and flowers creates a connection between people and place and strengthens communities almost better than anything else. Apart from beautifying the place, he also galvanized local residents to work with him on cultivating waste ground to grow vegetables that would help alleviate the shortage of fresh food and the high levels of malnourishment (see Boardman, 1944, and Meller, 1990).

Geddes was particularly concerned to help the inner-city children he saw around him who were growing up, as he put it, 'starved of nature' and he created a small garden known as the West Port garden, for children to play in. This was more than 150 years before Richard Louv coined the phrase 'nature deficit disorder' to describe the state of contemporary urban childhood (Louv, 2009).

Similar initiatives were set in motion in the United States by the social reformer, Jane Addams (1860–1935) and the philosopher and educationalist, John Dewey (1859–1952). They were both members of the Progressive movement based in Chicago. Dewey developed a school garden initiative and Addams established a playground movement. Like Geddes they were working to alleviate the detrimental effects of urban deprivation, particularly for young people.

The First and Second World Wars

The extent of the appalling destruction of the First World War revealed the power of the garden to answer to some of humankind's deepest existential needs. Gardening was important not only in the victory garden movement at home, but also on the front lines when soldiers on the Western Front created gardens in the trenches. They grew colourful and familiar flowers like morning glory, forget-me-nots, and marigolds. In that landscape of trauma and death, gardening was a spontaneous response that helped buffer the soldiers against fear and despair (Stuart-Smith, 2020).

Following the war, the huge number of wounded and traumatized service men and the extent of psychological damage many had suffered led to the development of land-based rehabilitation programmes. In many ways, this period marks the beginnings of horticultural therapy, although it was not conceived of in those terms until the 1950s.

Following the Second World War, the eminent American psychiatrist, Karl Menninger, began working with traumatized veterans in Kansas and was impressed by the extent to which working with plants helped his patients open themselves back up to life again. The treatment programme he subsequently developed at the Topeka Clinic included medication and psychotherapy, but gardening was also a central part of the programme. Menninger established the first formal training programme in horticultural therapy and throughout his life, he promoted the therapeutic power of gardens. He described it as an activity 'that brings the individual close to the soil and close to Mother Nature, close to beauty, close to the inscrutable mystery of growth and development' (Relf, 2006).

The Emergence of 'Green Care'

The legacy of the nineteenth century meant that well into the twentieth century, many hospitals continued to have large greenhouses and walled gardens in which flowers, fruit, and vegetables could be cultivated by patients. But then, in the 1950s, the treatment of mental illness was radically changed by the introduction of new and powerful drugs. The main focus of care of the mentally ill shifted to medication and the role of the environment diminished in significance, so that new hospitals invariably had little in the way of outdoor green space.

The model of Green Care that has arisen in recent decades is a response to the industrialization of medicine as well as contemporary lifestyles that have become disconnected from nature. The concept of Green Care originated in New Zealand where family doctors started prescribing exercise in the outdoors for the kind of chronic health conditions that tend to be ill-served by existing treatments.

The practice is gaining ground in the National Health Service (NHS) and in some parts of the United Kingdom (UK) 'social prescribing' programmes are up and running, enabling General Practitioners (GPs) to refer to nature-based interventions, including gardening. In 2013 the UK charity, Mind, carried out a large-scale survey of people's experiences of taking part in a pilot scheme of green activities such as green gyms, eco-therapy, and gardening. As many as 94 per cent said that it had benefited their mental health (Bragg et al., 2013).

Since then, the evidence for the efficacy of green care programmes has been accruing (Bragg & Leck, 2017). There is also evidence that this kind of approach is cost-effective. When the UK Wildlife Trusts conducted a cost–benefit analysis on nature-based and garden programmes in 2018, they found that for every £1 invested there was a £6.88 return in terms of increased well-being (Bragg et al., 2018).

Green care is about sustainability, not only in terms of care for the planet but the kind of psychological sustainability that comes from providing people with what they need in order to flourish.

Biophilia

The concept of biophilia was introduced by E. O. Wilson, who put forward the idea that humans have an innate 'emotional affiliation' to other living organisms (Wilson, 1984). His hypothesis is based on the fact that the natural world was the main influence on the evolution of much of human functioning, including learning and affect, because people who were most attuned to nature and most predisposed to learn about plants and animals would have survived better.

A phenomenon of 'urgent biophilia' has been described within conflict zones and following natural disasters by the socioecologist Keith Tidball. He describes how people seem to instinctively turn to nature: 'given the hardships and urgent safety issues faced by civilians, soldiers, and first-responders after a disaster or during war, it seems counter-intuitive that they would engage in the simple act of gardening, tree-planting, or other greening activities. Yet, intriguing and compelling examples exist of people, stunned by a crisis, benefiting from the therapeutic qualities of nature contact to ease trauma and to aid the process of recovery' (Tidball & Krasny, 2014).

Many people reported experiencing an almost instinctive urge to sow seeds and tend to plants in response to the crisis of the COVID-19 pandemic. The benefits were confirmed in a survey of 2,000 UK residents carried out by the Royal Horticultural Society (RHS) in which 70 per cent reported that access to green space had helped their mental health during lockdown and nearly 60 per cent of people who had a garden said they valued it more than previously.

The Natural Setting

Humans are a grassland species that emerged in the savannah landscapes of Africa. Inevitably, over the course of evolution, our nervous systems and immune systems have been primed to function best in response to various aspects of the natural world. This includes basic elements such as sunlight, water, and greenery which we experience as restorative.

Light has a powerful influence on us, yet many people spend the majority of their days indoors and suffer light deprivation as a result. Daylight regulates the hormone melatonin, which influences energy levels and alertness, as well as the sleep cycle, and it also regulates serotonin, which affects mood and mental well-being. It is the blue light

in the sun's rays that set our sleep–wake cycle and which regulates the rate at which serotonin is produced in the brain. In addition, sunlight on the skin promotes production of vitamin D which is crucial for human health. Low levels of Vitamin D are linked to bone and inflammatory diseases, diabetes, and depression.

Natural settings also have a direct effect on the autonomic nervous system. This has two modes of action: the adrenalin-fuelled, sympathetic drive which is coordinated by the amygdala, the fear centre located deep within the brain and the opposite, restorative parasympathetic rest-and-digest, system that generates recovery. In evolutionary terms the human stress response is a survival tool because it acts like a signal, prompting us to take action in the face of danger, and prepares us to react by raising our heart rate and blood pressure, releasing glucose, and speeding up our breathing. Following on from this, if the threat persists, the stress hormone cortisol is released. What is important for health is that the two autonomic systems are able to balance each other in a flexible way. Many mental health problems are associated with, or exacerbated by, chronic activation of the stress response and a lack of rest-and-digest time.

Green and gentle nature scenes, both real and virtual, have been shown in numerous studies to have a positive effect on the human stress response. From these findings a psycho-evolutionary theory of affective response to different kinds of natural landscapes has developed, largely based on Roger Ulrich's pioneering work in developing the Stress Reduction Theory (Ulrich et al., 1991). These studies have shown that looking at nature scenes results in a lowering of heart rate and blood pressure within minutes and also reduces feelings of anger and fear. Levels of the stress hormone cortisol typically start to drop after thirty minutes. Not all natural scenery has this effect. Dense forest scenes, for example, can produce an increase in the body's stress response. The best effects are seen where plenty of green vegetation is combined with an area of refuge and an open vista along with the presence of water. Gardens typically combine these kind of beneficial ingredients and are effective at bringing the body to a lower level of physical arousal.

Restoration of Attention

Attention Restoration Theory (ART) first emerged in the late 1980s (Kaplan & Kaplan, 1989) and describes how spending time in natural settings allows people to recover from mental fatigue. ART research demonstrates that people experience improvements in cognition, creative problem solving, and life satisfaction (Berto, 2005). Even gazing at a view of trees through a window has been shown to restore mental energy and benefit attention (Lee et al., 2015).

Other studies have looked at the effects of walking in nature. In one of these, student volunteers completed a series of challenging tests after having been on a forty-five-minute walk. One group walked through a local arboretum and the other group walked along busy urban streets. The students in the nature group experienced an improvement in mood and on average performed 20 per cent better in subsequent tests (Berman et al.,

2008). Another study that measured ruminations found that those who walked in nature dwelt less on anxious or negative thoughts (Bratman et al., 2015).

Fractals

Another component of the restorative effects of natural settings may be directly linked to the visual processing systems in the brain. We have an affinity for patterns in which regularity and order are combined with variation and repetition and the visual patterns that we find in nature typically contain these ingredients. Fractal patterning, as it is known, is perhaps most clearly illustrated in the structure of a tree. All the different parts of the tree, from the veins in a leaf, to the stems and roots, have a similar pattern of branching and yet each instance of it is subtly different.

The brain is essentially a pattern-seeking organ and needs to make rapid predictions from a vast array of incoming sensory information. Fractal patterning makes the brain's task easier because there is a strong element of predictability in it. At a glance, the visual cortex can fill in gaps and assemble a larger picture. This means that natural surroundings are conducive to 'fluent visual processing', in other words we are able to sweep over an environment with a relaxed gaze, taking it in whilst making a minimum number of eye fixations. By contrast, built environments are characterized by harsh and irregular patterns which require more eye fixations and therefore greater effort for the brain to collate the information (Hägerhäll et al., 2004).

Environmental Aesthetics

The evolutionary explanation that the brain is primed to respond to key aspects of the natural world has more recently extended to include certain types of aesthetic preferences. The researcher, Yannick Joye (Joye & van den Berg, 2010), has described how there seems to be a 'hardwired emotional affiliation with certain natural elements' that operates through 'a rapid, automatic, and unconscious process by which environments are immediately liked or disliked'. This instant appraisal and its effects on our autonomic nervous system are thought to have helped our prehistoric ancestors select environments likely to support human survival.

In writing about the psychology of landscape, the geographer, Jay Appleton identified how 'facets of behaviour like seeing, hiding, sheltering, escaping and so on, are central to our strategy of survival'. In the theory of habitat he developed in the 1970s, based on evolutionary psychology, he showed that refuge serves us best when it is combined with the possibility of prospect, that is a position from which we might have a vantage point (Appleton, 1975). Much as in our basic emotional need for holding, the combination of prospect and refuge is linked to feelings of safety. We need to feel that we can observe life

around us without being unduly exposed. Gardens typically provide a combination of vistas, views, and protected space. (on the subjects of aesthetic engagement with nature and sensible well-being see the contributions by Hughes, Berleant, Diaconu an Brook in this volume).

Beauty

Interactions with the natural environment can undeniably be aesthetically rewarding, involving feelings of pleasure, awe, and fascination. Landscapes that we find beautiful have been shown to trigger release of beta-endorphins, our natural brain-based opioids. In addition, an fMRI scan study has shown that elements of novelty and complexity in natural scenery are also a trigger for mu-opioid receptor activity (Biederman & Vessel, 2006). Endorphins are linked to pleasurable feelings of calm, largely through their action on the mu-opioid receptors in the brain. As a result, the world appears softer and we have a sense of well-being. This mood boosting effect arises through the interaction of endorphins with two other neurotransmitter systems, GABA and dopamine. There is, of course, an undeniable survival advantage in feeling pleasantly relaxed and disinclined to move on in surroundings that are flourishing and therefore able to sustain life.

Semir Zeki, Professor of Neurosaesthetics, believes that our need for beauty lies deep within our biological make up. His research has shown that the experience of beauty from any source is accompanied by a unique pattern of brain activation on fMRI scans. This pattern involves the medial orbitofrontal cortex, the anterior cingulate cortex, and the caudate nucleus (Zeki et al., 2014). These brain regions are part of our pleasure and reward pathways and are also associated with feelings of romantic love. They also play a role in integrating our thoughts, sensations, feelings, and motivations, whilst dampening down our fear and stress responses. Hence, when they are working together, we feel calmed and revitalized at the same time.

Smell

Smell is the most powerful and primitive of our senses because receptors in the nose are in direct communication with the centres for emotion and memory deep within the brain. Furthermore, the chemical constituents of some plant fragrances can influence how relaxed or alert we feel. Lavender, for example, has been shown to be calming through raising levels of the neurotransmitter serotonin, whereas rosemary is stimulating and boosts levels of dopamine and acetylcholine. The smell of citrus blossom is uplifting through a combined effect on levels of serotonin and dopamine. The smell of roses is associated with alleviating stress and has been found in one study to reduce levels of the stress hormone adrenaline by 30 per cent (Ikei et al., 2014).

The Modification of Stress

Stress disorders are a common occurrence and in recent years, stress has become the most common cause of sick leave from work. The alleviation of stress is a crucial component of nature's benefits for mental health and comes about largely through the effects on the nervous system outlined above. Stress and anxiety are reasonably straightforward to measure and the response times are relatively quick, which lends itself to study. In contrast, other aspects of gardening's benefits can be harder to measure.

A group of Danish researchers studied a group of patients diagnosed with stress disorders and compared ten weeks of gardening therapy with a Cognitive Behavioural Therapy (CBT) treatment that was known to be effective. They found that horticulture, even for this brief period, gave a similar level of benefit as the CBT (Stigsdotter et al., 2018). A study of allotment gardeners found that as little as one session a week of thirty minutes was enough to bring about significant improvements in stress levels, mood, and self-esteem (Wood et al., 2015).

A qualitative study conducted at the Alnarp Rehabilitation Garden in Sweden followed the treatment progress of a small group of participants suffering from severe stress who were on long-term sick leave (Adevi & Mårtensson, 2013). The multi-disciplinary rehabilitation team at Alnarp is comprised of professionals from horticulture, physiotherapy, occupational therapy, medicine, and psychotherapy. The programme includes art therapy and breathing techniques as well as horticulture, and aims to increase body awareness through relaxation and stimulation of all the senses, as well as increasing self-esteem through the outcome of work in the garden.

Research shows that spending time in nature not only promotes recovery from stress but can also increase resilience to stress (Gladwell et al., 2012). In other words, natural surroundings can help buffer the human stress response (Kuo & Sullivan, 2001). This has important implications for urban planning and provision of green space. In cities around the world, without fail, it is the most economically disadvantaged communities whose surroundings are the most deprived of green space.

Creating gardens and parks in run-down urban areas can be an effective strategy for improving mental health. A randomized control study that involved clearing and planting vacant lots in Philadelphia found that people living near the transformed lots experienced a 40 per cent decrease in feelings of stress and depression compared to those who lived near lots that remained derelict (South et al., 2018). And a pan-European epidemiological study of thirty-four cities concluded that having access to neighbourhood parks and gardens could reduce inequalities in mental health associated with low income by as much as 40 per cent (Mitchell et al., 2015).

These studies show that relatively low-cost landscape interventions can significantly boost people's ability to manage adversity and stress. As a result, the need to green our cities through trees and parks is increasingly recognized to be a public health issue.

Space and Time

Safe Green Space

The particular qualities of garden space and garden time mean that gardening can be understood as a form of 'space-time medicine' (Stuart-Smith, 2020). The spatial quality of a garden expands our sense of mental space and the process of gardening changes our relationship with time.

In almost every language, the etymology of the word 'garden' is an enclosed plot of land. A garden is a place that is set apart and can give people respite from the pressures of everyday life. Throughout the ages, gardens have offered people a place of sanctuary in which they can rest and recuperate. For more on the structure of healing gardens see Marcus and Sachs (2013). Gardens offer opportunities for experiencing both prospect and refuge and the proximity to plants, flowers, and trees helps promote parasympathetic activity. This sense of calm and physical safety allows people who are struggling with concentration and focus to relax their guard and become involved in the work of gardening. This can help break cycles of anxious preoccupation as well as reducing the hyper-vigilance of PTSD.

The first step of any trauma treatment is what the American psychiatrist, Judith Herman calls 'regaining a sense of safety'. This initial stage is fundamental and she explains that 'no therapeutic work can possibly succeed if safety has not been adequately secured' (Herman, 1997). This means that the safe enclosure of the garden is a therapeutic tool in its own right. Walled gardens in the UK have proved to be well suited to treatment programmes for veterans and others suffering from PTSD. Wise (2015) describes an example of this. A project for veterans in Denmark is set in an enclosed garden in the middle of the Hørsholm Arboretum. Poulsen et al. (2016) describe how much security the men derive from the presence of the trees and how incorporating mindfulness exercises into the programme alongside horticultural activities helps the veterans get the most out of the ten-week treatment programme.

Slow Time and Mindfulness

So much of our contemporary lifestyle is characterized by valuing speed. The fast pace of urban living and digital technology has led to a devaluing of the slower rhythms of natural time. But within the garden, the pace of life is the pace of plants, and gardening can be an effective way of experiencing the slower pace of natural time.

Furthermore, rhythmical activities such as weeding and sowing bring us into the present moment. In this way gardening can be a 'mindful' activity. States of mindful awareness have been shown to decrease signals to the amygdala and help restore a more

integrated state of neural activity within the brain. This gives rise to feelings of calm. A sense of fresh perspective can also follow from the increase in brain connectivity because different regions of the brain are better able to link up with each other.

Flow States

People often describe 'losing' themselves when they are immersed in the process of gardening. They feel at one with the task and lose the sense of time passing. This is typical of a 'flow' state.

Flow states were first described by the psychologist Mihalay Csikszentmihalyi in the 1980s when he identified how athletes, artists, musicians, gardeners, and craftsmen engaged in activities where they get into 'the zone' and feel at one with what they are doing. This means, as Csikszentmihalyi describes, that 'the ego falls away. Time flies. Every action, movement, and thought follows inevitably from the previous one' (Csikszentmihalyi, 2002). Csikszentmihalyi established that flow states are more likely to occur in activities that are rhythmical and where there is a matching of skills and challenge, so that the task is neither too easy or too difficult. The activity needs to be absorbing enough so that the mind does not ruminate on anxious or negative thoughts.

Future Orientation

Gardening can bring us into the moment but it is always orientated towards the future as well. Sowing seeds, for example, allows us to have a hand in the very beginnings of life and we can look forward to the outcome with a sense of positive anticipation. During the course of prehistory, people first started to plan for the future and trust in the outcomes of their efforts through cultivation.

In both depression and anxiety, people's temporal horizons become foreshortened and they find it hard to think about the future in a positive way. Gardening can provide a simple way of recovering a sense of positive anticipation. This in turn can lead to a recovery of a sense of purpose. Anticipation of reward is linked to release of dopamine in the brain which has energizing and motivating effects on us.

This forward-looking aspect of gardening is particularly helpful at times when life is anxiety provoking or feels very uncertain, as was the case in the Covid pandemic lockdown of Spring 2020 when people rushed to order seeds. This was a time when life was suddenly restricted and filled with fear. The ritual of sowing seeds and tending plants helped many people feel that they could make something good happen at a time when it was hard to feel positive about the future. This intuitive response was an instance of urgent biophilia.

Play and Creativity

Regardless of our age, gardening can be a form of play. The psychoanalyst Donald Winnicott described the psychological significance of the ability to play in the following way: 'it is in playing and only in playing that an individual ... is able to be creative and ... it is only in being creative that the individual finds the self' (Winnicott, 1971). In this sense, play is not the distraction or diversion it might seem to be, it can be a profoundly reparative activity.

One of the cornerstones of Winnicott's thinking is his concept of transitional space. This is a notional space which he conceived of as 'a resting place' or intermediate space in which our inner and outer worlds can come together and co-exist free from the pressures of everyday life. Transitional space doesn't force painful realities on us, but equally it doesn't allow us a total escape from them either.

Transitional processes are intrinsic to play as well as the arts, religion, and creativity. They allow us to imaginatively endow the world and feel part of something larger than ourselves.

Winnicott recognized the enormous importance of what he called the 'intense experiencing' that arises through creative activities and that these are in continuity with how children experience the world through imaginative play. Being able to tap into our ability to live in the world creatively and imaginatively was for Winnicott, more than anything else, what can make us feel that life is worth living (Winnicott, 1971).

Gardens are recognized to promote states of reverie (Cooper, 2006) and with their shelter and beauty, they offer a physical and emotional 'resting place'. They also constitute a physical transitional space in the way they sit between the home or the institution and the world that lies beyond. This sense of the 'in-between' is fundamental to how gardens can provide a meeting place for our innermost, dream-infused selves and the real physical world.

Observing children lost in their play, Winnicott realized that certain aspects of the environment need to be right to allow this process to happen. He called it 'being alone in the presence of the mother' (Winnicott, 1958) and his paradox captures the child's need to feel safe in their mother's proximity at the same time as feeling unscrutinized by her. Unselfconscious play gives rise to a feeling of inner freedom which is crucial for psychological health, and when children feel anxious or judged, it interferes with their ability to play. In the safe curtilage of the garden many people experience something similar as they find themselves immersed in a creative engagement with the natural world.

Play and creative activities, including gardening, can provide a safe and symbolic outlet for destructive impulses. This can allow people to work through emotions and conflicts that cannot readily be put into words. Sigmund Freud described this as a form of sublimation and he described how the process transforms raw instincts and powerful emotions into something of aesthetic value. In the garden, tasks such as cutting back overgrown vegetation, ripping up weeds, and digging the earth are all forms of care in

which aggression can be put to creative use or to put it another way, destructiveness can be discharged in the service of growth (Stuart-Smith, 2020).

In terms of brain function, entering into states of creative play is associated with increased levels of brain-derived neurotrophic factor (BDNF) which acts like a fertilizer in the brain and promotes healthy growth and repair of neural networks. BDNF plays an important role in new learning and is sensitive to environmental stimulation. A range of activities including positive social interactions, physical exercise, creative immersion, and play promote its release.

The Shaping of Physical Surroundings

A garden provides an accessible way to experience the joy of creating because not all the creativity is ours: gardening is what happens when two creative energies meet, human creativity and nature's creativity. This means we are never fully in control, but nevertheless a garden provides a little portion of reality which it is possible to shape and determine.

Being able to shape part of our physical environment has important psychological consequences. The neuroscientist Kelly Lambert describes how the 'brain appears to be tuned into the process of manipulating the environment in optimal ways to provide resources necessary for survival' (Lambert, 2008). She argues that the belief in our ability to shape our lives originates through shaping our physical surroundings. But the diminishing scope of interaction with the material world in education and everyday life in general, is leading people to experience a reduced sense of mastery.

The implications of this are that manual work and handicrafts are important to our neural development and can lead to what she calls 'learned persistence'. Conversely, a lack of these opportunities can erode people's capacity for motivation and self-belief and contribute to a state of 'learned helplessness' (Lambert, 2008). There are many avenues for this, from DIY to arts and handicrafts, but gardening is, Lambert believes, one of the best, because of the element of unpredictability which we have to contend with.

A Relationship of Care

Gardening is not so much about what you do, but how you do it. Gardening can be a way of dominating or controlling nature rather than entering into a relationship of connection and care. It is the latter that is therapeutic. But contemporary culture tends to devalue care to such an extent that as the social activist Naomi Klein has observed, it has become 'a radical idea' (Klein, 2017). Increasing levels of loneliness and fragmented social networks mean that care is no longer at the centre of everyday life, as it is in many traditional societies.

Gardening can help cultivate an attitude of care. A garden is its own living entity and gardening involves forming a relationship with place and plants. Caring for a garden can be a mindful activity because it involves paying close attention to the tasks at hand and tuning in to the needs of the plants.

In survival terms, the care system in the brain is associated with feeling safe and its neurochemistry gives rise to a sense of inner calm. This is because nurturing activities are associated with the release of beta-endorphins which have the effect of soothing and lifting mood as well as reducing psychological and physical pain. Oxytocin is also intrinsic to the care system and has a direct anti-stress effect through a dampening action on the brain's fear centre in the amygdala.

Through caring for a garden, we can come to feel connected to the web of life and feel part of something much larger than ourselves (Zelenski et al. 2015). Over the course of time, the formation of an attachment to place can have a stabilizing effect and mean that a garden can become woven into a sense of personal identity.

Simple Social Relationships

Human development and change comes about largely through relationships. The most formative and important of these on our development and well-being are our interpersonal relationships. However, these relationships are often complex and can place great demands on us, and there can be benefits to more simple relationships with elements of the non-human world. Sigmund Freud had a great love of flowers and expressed something of this when he said, 'Flowers fortunately have neither character nor complexities.'

This observation about the simplicity of plants has therapeutic significance, particularly in settings such as prisons and projects working with at risk youth, refugees, and trauma. Unlike people, plants cannot judge or attack us or invoke shame. Caring for them provides a simplified form of a nurturing relationship which can be particularly transformative for people who have experienced a lack of care or abuse in earlier life.

The American psychiatrist Harold Searles observed that patients who had experienced a breakdown would gaze at trees in the hospital grounds for many hours and find in them a form of companionship that they were not getting from humans. He thought that psychology was almost entirely focused on the human realm and had neglected the importance of relationships people can form with other aspects of the natural world (Searles, 1960). He went on to develop a hierarchy of relationships with stones and water being the most simple, then plants and trees, followed by animals and humans. The therapeutic garden at Alnarp in Sweden has been designed with these principles in mind and includes areas of water, large rocks, and trees, as well as productive parts of the garden.

Human Connection

In a therapeutic garden setting, the cultivation of people goes alongside the cultivation of plants. This is facilitated by the fact that gardens have a positive effect on human connection. The safe green space of a garden provides an unthreatening setting which allows people to connect with each other, sometimes in a way that overcomes social divides. This effect has been termed 'gardening as a social bridge' (Santo et al., 2016).

The sociability effect of green vegetation on people has also been measured in the laboratory. One study found that being in the presence of indoor plants, as well as simply looking at scenes of nature (as opposed to urban scenes) prompted people to make decisions that showed higher levels of generosity and trust (Weinstein et al., 2010). A Korean study using fMRI brain scans found that pleasing natural scenery activated parts of the brain involved in generating empathy, and when they followed the scans with psychological tests, they also found increased levels of generosity (Kim et al., 2010).

Grief and the Cycle of Life

The psychoanalyst Carl Jung believed that modern lifestyles had alienated people from the 'dark maternal, earthy ground of our being'. Jung was describing an ancient emotional and spiritual connection with the earth that puts us in touch with the mystery of how life is regenerated and sustained. He grew his own vegetables and supported the provision of allotments around cities, arguing that 'every human should have a plot of land so that their instincts can come to life again' (see Sabini, 2002).

Gardening is a symbolic action at the same time as it is a practical action and the effects on the mind derive in part from the unconscious power of metaphor and symbolism. Tilling the earth connects us through the seasons with the eternal cycle of life, death, and rebirth. As the poet and gardener, Stanley Kunitz said, our own mortality is 'the hard reality, perhaps the hardest reality that we have to reckon with', which is why in everyday life, there is an inclination to avoid the subject of death. But there is no denying that things die in the garden. Yet the beauty of plants as they start to drop their leaves and develop seed heads also carries the promise of regeneration (Kunitz & Genine, 2007).

When the fact of our mortality presses in on us, as it generally does after midlife, it can sometimes give rise to a surge of creative energy. The psychoanalyst Erik Erikson called this 'generativity' and he believed that being able to be generative in various ways during the second half of life was important for psychological health. If generativity eludes us, we can enter a state of 'stagnation' (Erikson & Erikson, 1998). Through the growing of food and the creation of beauty, gardening is intrinsically a generative activity.

In his work on the psychology of dying, the psychiatrist Robert Lifton showed that in approaching death, we can be greatly helped if we can find ways of symbolizing

immortality. In doing this he was building on Freud's idea that the unconscious mind has no way of representing our own death. Lifton argued that we need to deny death, at least in part, and that this paradoxically helps us to accept its reality. His point was that the prospect of annihilation is too terrifying. The mind cannot assimilate it and it renders death unthinkable. We need to find ways to make it less absolute and we do that through having a sense of what Lifton called 'symbolic survival' (Lifton, 1968). He regarded this as a deep existential need and described how we can derive this kind of comfort in a number of ways—through our genes living on in the next generation, through beliefs about the afterlife, through our own creativity, and through the continuity of nature.

It is one of the reasons why, when people are confronted with death, their relationship with nature often takes on a whole new significance. The ongoing existence of the natural world can bring a reassuring sense of the continuity of life. This aspect of nature is consoling not only to the dying but to the bereaved too. In Melanie Klein's account of the trajectory of the mourning process, she describes the importance of recovering a sense of goodness in the world and in oneself and how, in the aftermath of a death, a sense of these things is often lost (Klein, 1940). In this sense gardening can be a reparative activity through which the fruits of the earth lead to a recovery of a belief in the possibility of goodness in life.

CLIMATE CHANGE AND ECO-ANXIETY

The psychological distress that accompanies the planetary crisis has variously been described as eco-anxiety, ecological grief, climate trauma, and environmental melancholia. Although the effects vary from person to person, feelings of powerlessness, sadness, guilt, and dread are common. Eco-anxiety is a new phenomenon. Throughout history, people may have been plagued by apocalyptic fears but never before has the destruction been so real or the responsibility for it been so human. Grief feelings about the losses occurring in nature are also complex to navigate because what is taking place is on such a vast scale and concerns future losses as well as losses that have already happened.

The reality of our increasingly depleted natural environments means that gardening has a role to play in maintaining and restoring biodiversity. This is one positive intervention that is achievable not only for individuals but also for whole communities. Ecological studies show that gardens that are planted for variety and complexity with plenty of flowers that attract pollinators and where chemicals are not used, function as ecological hotspots, like 'safe-houses' for nature. Psychological research shows that there is a positive relationship between complexity and biodiversity in planting and the levels of psychological restoration that people experience (Fuller et al., 2007). People often feel powerless and despairing about the planetary crisis but gardening can feel empowering as a form of positive action.

The Evidence Base

It is clear that gardening can help people on many different levels and in many different ways. Whilst this breadth of action is a strength, it also makes the gathering of evidence difficult (Sempik et al., 2005). As a result, it is important to take a range of different kinds of evidence into account, including large and small studies, and both quantitative and qualitative research.

A number of studies published over the last few decades have shown that gardening helps to alleviate depression, stress, and anxiety, and improve self-esteem, but the quality and size of the studies is very varied (Gonzalez et al., 2010; Kamioka et al., 2014). The practical obstacles involved in setting up a randomized trial of a therapeutic activity such as gardening means there is a lack of randomized controlled trials. But a small number of such trials are in existence and one of these was published in the *British Journal of Psychiatry* in 2018, the first time that horticultural therapy has been included in its pages (Stigsdotter et al., 2018). This treatment was ten weeks in length and found that even for this relatively brief period, the gardening programme provided a similar level of benefit as the evidence-based Cognitive Behavioural Therapy programme. The majority of research studies are conducted over a relatively brief time frame like this, which inevitably makes it hard to capture any longer-term benefits linked to experiencing the full cycle of the seasons.

In 2016, the Kings Fund published a literature review of the effects of gardening across a wide range of health applications (Buck, 2016) with the aim of helping to guide healthcare strategy and decision making. Another publication aimed at influencing health policy emerged in 2020 when the *British Medical Journal* published a meta-analysis of research on gardening. This comprehensive review of international research analyzed the findings of a total of seventy-seven studies, including eight randomized controlled trials. The authors concluded that the existing evidence supports using gardening as form of social prescription for people with longer term health needs (Howarth et al., 2020).

Developments in Green Care

The Bethlem is one of the oldest psychiatric hospitals in the world and its name is the origin of the slang term for the madhouse, bedlam. Located in Kent, in recent years, it has been undergoing a green transformation. The project started in 2010 with a proposal to restore the ancient orchards that had once existed within the grounds. The orchards were, it turned out, not completely lost. Some of the trees had disappeared under an impenetrable mass of brambles. These languishing orchards can be seen as a symbol of neglect, but so too is their recovery, a symbol of regeneration.

Staff, patients, and volunteers were inspired by the idea and joined working parties to clear and restore them. They are now beautiful and productive orchards that staff, patients, and local residents can enjoy and there is a map of three nature trails through the orchards, bluebell woods, and meadows within the hospital's extensive grounds. Over the same period, the Bethlem has also developed a horticultural therapy programme within a newly built walled garden.

By turning the hospital grounds into a resource for the local community, the aim is to break down the stigma attached to mental illness. The grounds which for so long had been inaccessible now provide a resource for patients, relatives, and staff, and also attract dog walkers, nature enthusiasts, and people simply looking to restore themselves.

In some ways this project represents a return to the best aspects of the asylum, with therapeutic activities taking place in a peaceful natural setting. But there is an important difference, the asylums were about segregation and contemporary Green Care projects like this are about inclusivity, accessibility, and opening up.

This same pattern of breaking down barriers is illustrated in another project located in primary care. Set up in 2013, the Lambeth GP food co-operative is one of the first community led co-op's in the NHS and has won a number of awards. It is a true co-op and is managed by its thirty-eight members who are all local patients, nurses, or GPs. The idea is a simple one—to establish food-growing gardens within GP practices on what was previously unused outdoor space. The smallest one is in a paved alleyway that is furnished with raised planting beds.

Lambeth is one of the most deprived boroughs in London, with a high percentage of people with long-term health problems such as diabetes, heart disease, arthritis, and depression. Many of them are socially isolated and attend the surgery for frequent appointments. The gardening project has given the GPs an additional form of therapy they can offer. Unlike other forms of social prescribing, it has the advantage that the setting is already familiar, which makes it less intimidating. The feedback shows that the patients value the gardens highly.

The whole enterprise is about what can be achieved through cooperation. It means the participating GPs feel more like the community doctors they are supposed to be. The day to day working life of a GP is largely spent isolated within a consulting room, and counteracting this has been one of the unforeseen benefits. By popping outside, the doctors can chat to patients about what is going on in the garden in an ordinary way, which helps humanize the doctor–patient relationship. In common with many community gardening projects, these positive effects derive from the experience of shared benefit and shared pleasure.

Conclusion

Gardening involves the coming together of two creative energies: human creativity and nature's creativity. Furthermore, the gardener cultivates an attitude of care and through

caring for a garden, becomes connected to the natural cycles of life, death, and rebirth. This effect means there is potential for deep existential meaning to emerge. Through shared benefits and shared pleasure, gardening can help foster human connection and has potential, as illustrated by some contemporary Green Care projects, to promote community inclusion.

In summary, this chapter examines how gardens offer an aesthetic experience that involves all the senses and explores how, through gardening, people can experience themselves as empowered and creative. In addition, deep existential meanings and a feeling of connection to the web of life can emerge through working with the cycle of life in the garden. The author has recently developed a community garden in the United Kingdom aimed at helping transform people's health and well-being through spending time in nature. Based in Hertfordshire, the garden offers a safe green space which reduces stress and promotes human connection.

References

Adevi, A. A., & Mårtensson, F. (2013). Stress rehabilitation through garden therapy: The garden as a place in the recovery from stress. *Urban Forestry & Urban Greening 12* (2), 230–237. https://doi.org/10.1016/j.ufug.2013.01.007

Appleton, J. (1975). *The experience of landscape*. Wiley.

Berman, M. G., Jonides J., & Kaplan S. (2008). The cognitive benefits of interacting with nature. *Psychological Science 19* (12), 1207–1212.

Berto, R. (2005). Exposure to restorative environments helps restore attentional capacity. *Journal of Environmental Psychology 25* (3), 249–259.

Biederman, I., & Vessel, E. A. (2006). Perceptual pleasure and the brain: A novel theory explains why the brain craves information and seeks it through the senses. *American Journal of Science 94*, 247–253. https://doi.org/10.1511/2006.3.247

Boardman, P. (1944). *Patrick Geddes maker of the future*. University of North Carolina Press.

Bragg, R., & Leck, C. (2017). *Good practice in social prescribing for mental health: The role of nature-based interventions*. Natural England Commissioned Reports, Number 228. York.

Bragg, R., Wood, C., & Barton, J. (2013). *Ecominds effects on mental wellbeing: An evaluation for MIND*. https://www.mind.org.uk/media/4418/ecominds-effects-on-mental-wellbeing-evaluation-report.pdf

Bragg, R. Wood, C., Barton J., & Pretty, J. (2018) *Wellbeing Benefits from Natural Environments Rich in Wildlife*. A literature review for The Wildlife Trusts by the University of Essex. https://www.wildlifetrusts.org/sites/default/files/2018-05/r1_literature_review_wellbeing_benefits_of_wild_places_lres.pdf

Bratman, G. N., Hamilton, J. P., Hahn, K. S., Daily, G. C., & Gross, J. J. (2015). Nature experience reduces rumination and subgenual prefrontal cortex activation. *Proceedings of the National Academy of Sciences 112*(28), 8567–8572.

Buck, David. (2016). *Gardens and health: Implications for policy and practice*. The Kings Fund, report commissioned by the National Gardens Scheme (May 2016). Available at: https://www.kingsfund.org.uk/publications/gardens-and-health

Cooper, D. E. (2006). *A philosophy of gardens*. Clarendon Press.

Csikszentmihalyi, M. (2002). *Flow: The classic work on how to achieve happiness*. Rider.

Erikson, E. H., & Erikson, J. M. (1998). *The life cycle completed*. W.W. Norton.
Fuller, R. A., Irvine, K. N., Devine-Wright, P., Warren, P. H., & Gaston, K. J. (2007). Psychological benefits of greenspace increase with biodiversity. *Biology Letters 3* (4), 390–394.
Gerlach-Spriggs, N., Kaufman, R. E., & Warner, S. B. (2004). *Restorative gardens: The healing landscape*. Yale University Press.
Gladwell, V. F., Brown D. K., Barton J. L., Tarvainen M. P., Kuoppa P., Pretty J., & Sandercock, G. R. H. (2012). The effects of views of nature on autonomic control. *European Journal of Applied Psychology 112*, 3379–3386.
Gonzalez, M. T., Hartig, T., Patil, G. G., Martinsen, E. W., & Kirkevold, M. (2010). Therapeutic horticulture in clinical depression: A prospective study of active components. *Journal of Advanced Nursing 66* (9), 2002–2013. https://doi.org/10.1111/j.1365-2648.2010.05383.x
Hagerhall, C. M., Purcell, T., & Taylor, R. (2004). Fractal dimension of landscape silhouette outlines as a predictor of landscape preference. *Journal of Environmental Psychology 24*, 247–255.
Herman, J. (1997). *Trauma and recovery: The aftermath of violence–from domestic abuse to political terror*. Basic Books.
Howarth, M., Brettle, A., Hardman, M., & Maden, M. (2020). What is the evidence for the impact of gardens and gardening on health and well-being: A scoping review and evidence-based logic model to guide healthcare strategy decision making on the use of gardening approaches as a social prescription. *BMJ Open 10*, e036923. https://doi.org/10.1136/bmjopen-2020-036923
Ikei, H., Komatsu, M., Song, C., Himoro, E., & Miyazaki, Y. (2014). The physiological and psychological relaxing effects of viewing rose flowers in office workers. *Journal of Physiological Anthropology 33* (6), 344–369. https://doi.org/10.1186/1880-6805-33-6
Joye, Y., & van den Berg, A. (2010). *Nature is easy on the mind: An integrative model for restoration based on perceptual fluency*. At the 8th biennial conference on environmental psychology. Zürich, Switzerland.
Kamioka, H., Tsutani, K., Yamada, M., Park, H., Okuizumi, H., Honda, T., Okada, S., Park, S. J., Kitayuguchi, J., Abe, T., Handa, S., & Mutoh, Y. (2014). Effectiveness of horticultural therapy: A systematic review of randomized controlled trials. *Complementary Therapies in Medicine 22* (5), 930–943.
Kaplan, R., & Kaplan, S. (1989). *The experience of nature: A psychological perspective*. Cambridge University Press.
Kim, G. W., Jeong, G. W., Kim, T. H., Baek, H. S., Oh, S. K., Kang, H. K., Lee, S. G., Kim, Y. S., & Song, J. K. (2010). Functional neuroanatomy associated with natural and urban scenic views in the human brain: 3.0T functional MR imaging. *Korean Journal of Radiology 11* (5), 507–513.
Klein, M. (1940). Mourning and its relation to manic-depressive states. In Hanna Segal (Ed.), *Love, guilt and reparation: And other works 1921–1945* (pp. 344–369). Vintage Classics, 1998.
Klein, N. (2017). *New Statesman* interview, 2 July 2017. Available at: https://www.newstatesman.com/long-reads/2017/07/take-back-power-naomi-klein
Kunitz, S., & Genine, L. (2007). *The wild braid*. Norton.
Kuo, F. E., & Sullivan, W. C. (2001). Aggression and violence in the inner city. *Environment and Behavior 33* (4), 543–571. https://doi.org/10.1177/00139160121973124
Lambert, K. (2008). *Lifting depression*. Basic Books.

Lee, K., Williams, K., Sargent, L., Williams, N., & Johnson, K. (2015). 40-Second green roof views sustain attention: The role of micro-breaks in attention restoration. *Journal of Environmental Psychology 42*, 182–189.

Lifton, R. J. (1968). *Death in life*. University of North Carolina Press.

Louv, R. (2009). *Last child in the woods: Saving our children from nature-deficit disorder*. Atlantic Books.

Marcus, C. C., & Sachs, N. A. (2013). *Therapeutic landscapes: An evidence-based approach to designing healing gardens and restorative outdoor spaces*. John Wiley & Sons.

Meller, H. (1990). *Patrick Geddes: Social evolutionist and city planner*. Routledge.

Mitchell, R. J., Richardson, E. A., Shortt, N. K., & Pearce, J. R. (2015). Neighborhood environments and socioeconomic inequalities in mental well-being. *American Journal of Preventive Medicine 49* (1), 80–84. https://doi.org/10.1016/j.amepre.2015.01.017

Olmsted, F., & Nash, R. (1865). The value and care of parks. Report to the Congress of the State of California. Available online https://www.nps.gov/parkhistory/online_books/anps/anps_1b.htm

Poulsen, D. V., Stigsdotter, U.K., Djernis, D., & Sidenius, U. (2016). 'Everything just seems much more right in nature': How veterans with post-traumatic stress disorder experience nature-based activities in a forest therapy garden. *Health Psychology Open* 31 March 2016. https://doi.org/10.1177/2055102916637090.

Relf, P. D. (2006). Agriculture and health care: The care of plants and animals for therapy and rehabilitation in the United States. In J. Hassink & M. van Dijk (Eds.), *Farming for health: Green-care farming across Europe and the United States of America* (pp. 309–343). Springer.

Royal Horticultural Society. (2020). Available at: www.rhs.org.uk/advice/health-and-wellbeing/articles/Lockdown-lowdown

Rush, B. (1812). *Medical inquiries and observations, upon the diseases of the mind*. Grigg.

Sabini, M. (2002). *The earth has a soul: C. G. Jung's writings on nature, technology and modern life*. North Atlantic Books.

Santo, R., Palmer, A., & Brent, K. (2016). *Vacant lots to vibrant plots: A review of the benefits and limitations of urban agriculture*. Report for The Johns Hopkins Center for a Livable Future. https://clf.jhsph.edu/sites/default/files/2019-01/vacant-lots-to-vibrant-plots.pdf

Searles, H. (1960). *The nonhuman environment in normal development and in schizophrenia*. International Universities Press.

Sempik J., Aldridge, J., & Becker, S. (2005). *Health, well-being, and social inclusion: Therapeutic horticulture in the UK*. Policy Press.

South, E. C., Hohl, B. C., Kondo, M. C., MacDonald, J. M., & Branas, C. C. (2018). Effect of greening vacant land on mental health of community-dwelling adults: A cluster randomized trial. *JAMA Network Open 1* (3), e180298. https://doi.org/10.1001/jamanetworkopen.2018.0298

Stigsdotter, U. K., Corazon, S. S., Sidenius, U., Nyed, P. K., Larsen, H. B., & Fjorback, L. O. (2018). Efficacy of nature-based therapy for individuals with stress-related illnesses: Randomised controlled trial. *The British Journal of Psychiatry 213* (1), 404–411.

Stuart-Smith, S. (2020). *The well gardened mind: Rediscovering nature in the modern world*. Harper Collins.

Tidball, K. G., & Krasny, M. E. (2014). *Greening in the red zone*. Springer.

Ulrich, R. S., Simons, R. F., Losito, B. D., Fiorito, E., Miles, M. A., & Zelson, M. (1991). Stress recovery during exposure to natural and urban environments. *Journal of Environmental Psychology 11*, 201–230.

Weinstein, N., Przybylski, A. K., & Ryan, R. M. (2010). Can nature make us more caring? Effects of immersion in nature on intrinsic aspirations and generosity. *Personality and Social Psychology Bulletin 35* (10), 1315–1329.

Wilson, E. O. (1984). *Biophilia*. Harvard University Press.

Winnicott, D. W. (1958). The capacity to be alone. *International Journal of Psychoanalysis 39*, 416–420.

Winnicott, D. W. (1971). *Playing and reality*. Tavistock Publications.

Wise, J. (2015) *Digging for victory: Horticultural therapy with veterans for post-traumatic growth*. Karnac.

Wood, C. J., Pretty, J., & Griffin, M. (2015). A case-control study of the health and well-being benefits of allotment gardening. *Journal of Public Health 38* (3).

Zeki, S., Romaya, J. P., Benincasa, D. M., & Atiyah, M. F. (2014). The experience of mathematical beauty and its neural correlates. *Frontiers in Human Neuroscience 8*, 68.

Zelenski, J. M., Dopko, R. L., & Capaldi, C. A. (2015). Cooperation is in our nature: Nature exposure may promote cooperative and environmentally sustainable behavior. *Journal of Environmental Psychology 42*, 24–31.

CHAPTER 46

THE MOVING PIECES APPROACH

Poetic Space, Embodied Creativity, Polarity, and Performance as Aspects of Aesthetic Experience

CHARLIE BLOWERS

INTRODUCTION

INCREASING attention is being paid to the impact of stress and trauma on the body, particularly the autonomic nervous system (ANS), and the concomitant disruption to physical and mental health. There is also growing awareness that memory is not always declarative or present in consciousness (Van der Kolk, 1994) but held more implicitly through bodily sensations, impulses, physical movements, and habits.

For the purposes of this chapter, 'trauma' is defined as experience that creates a lasting and substantial psychophysiological impact on an individual. Many people who have experienced trauma initially feel that the body is unsafe or unreliable and are compelled to keep a distance from uncomfortable or confusing symptoms associated with that trauma. 'When it is not possible to distinguish safe sensations from dangerous ones, all sensations may become perceived as dangerous' (Rothschild, 2000, 106). In recognition of this challenge, I developed the Moving Pieces Approach (MPA), an integrative group-based approach to supporting mental health and managing persistent medically unexplained symptoms (MUS), with a primary focus on safely accessing and integrating traumatic memory held implicitly in the body. This is facilitated by combining practice from the performing arts, psychotherapy, sensorimotor integration, and the Feldenkrais Method.

This chapter will expand on core concepts relating to the impact of stress and trauma on the ANS, necessitating strategies to gain safe access to bodily sensations and the role of the arts in containing and expressing this level of experience. The first section

provides context and background on Moving Pieces, followed by a detailed review of the six sequential and core components of MPA, namely:

i. Creating a 'poetic space'.
ii. The body as a safe container: rebalancing, mutual regulation, and embodied empathy.
iii. Sensations to image making as an implicit basis for self-knowledge.
iv. Attention to polarities as they emerge through the body, movement, and imagination.
v. Performative sharing: audience as witness and collaborator.
vi. Bridging implicit to explicit experience, assimilation, and ending.

In describing these components, I aim to illustrate how aesthetic experience is integral to the process—influencing the direction of each participant journey, facilitation—coupling a felt sense (Gendlin, 1996) with other professional knowledge and shaping raw material for performative sharing.

The final section of the chapter refers to current and ongoing research into the potential benefits of MPA for people experiencing MUS.

Context and Background on Moving Pieces

In my role as a psychotherapist, I often witnessed states of anxiety or fear overwhelm thinking capacities (Lanius et al., 2003), suggesting a need to start with the body rather than verbalizing experience, particularly regulation of the ANS, supporting connection and making sense of bodily sensations (Van der Kolk, 2014). Research indicates that our experience of safety is based in the body (Porges, 2011; Van der Kolk, 2014), suggesting the need for initial stabilization by learning to self-regulate arousal states (Ogden & Minton, 2000).

A capacity to connect to a 'felt sense' (Gendlin, 1996), accessing inner and bodily felt experience, provides a basis for emotional and cognitive processing associated with trauma memories. Different art forms offer a vehicle of expression and externalization for sensory memories—initially difficult to capture in words—encouraging 'active participation' in a recovery process (Malchiodi, 2003), as well as a safe location to share with others. The art object also holds potential to consolidate multiple layers of experience and contribute to bridging the gap between implicit and explicit memory (Malchiodi, 2003; Malchiodi & Hass-Cohen, 2001).

This process relates to aesthetic experience as a capacity to notice sensations in the body, to find ways of describing these qualities and how this experience informs a way

of being in the world, as well as an awareness that this is happening in relation to other bodies in an intersubjective space (Allegranti, 2009, 2011a; Tantia, 2021).

The awareness of the need to start with the body was further reinforced by training involvement in body-oriented therapy, the Feldenkrais Method—a method of somatic movement education—and Lecoq-based physical theatre approaches. I have a longstanding interest in how principles from different disciplines can be in a continuous discourse (Allegranti, 2009, 2011a) combined with a desire to develop an approach that has the potential to be dynamic, playful, visible, and based on mutuality—qualities often corrupted by the experience of chronic stress and trauma.

Moving Pieces is the expression of these interdisciplinary principles. It is an integrative sensorimotor approach progressively developed over three decades of clinical practice, based on experiential learning, clinical supervision, evaluation from participant feedback, and more recent practice-based research. The interdisciplinary nature of MPA is congruent with a feminist perspective, integrating embodied practice with other theory. This supports the position of embodiment as a dynamic and bio-psycho-social process (Allegranti, 2013; Fausto-Sterling, 2000) rather than reinforcing the Cartesian convention of disavowing the body (Moore & Kosut, 2010; Grosz, 2005), as well as potentially deconstructing power relationships between facilitator and participants.

Inspired by feminist researcher and artist Beatrice Allegranti (2009, 2017), I have chosen to write in the first person so that I am describing MPA in a more personal 'active voice' (Tong, 1989, 228).

Core Components of the Moving Pieces Approach

Creating a 'Poetic Space'

A fundamental aim of the MPA is to create an environment that is sufficiently safe where more tacit, pre-reflective experiences can unfold, a space within which actions, images, text, and autobiographical fragments emerge from a focus on the body as a rich site of personal knowledge and experience. I refer to this as the creation of a 'poetic space', providing a holding environment with the potential to facilitate both a therapeutic process and the possibility of constructing an artefact or performance 'product' (Allegranti, 2011a).

At the start of each workshop, with emphasis at the beginning of the series, participants are invited to transition into the frame of a 'poetic space'. There is a sense of opening a space where something 'else' can happen—a different way of relating to self, others, and the environment and the potential to 'fold away' this space in a transition back to everyday life.

There are a range of ways to build a poetic space, one of which is to bring attention to an orienting response. Physical and psychological responses to both internal and external stimuli are predicated on and extrapolated from orienting responses (Ogden et al., 2006, 65). Information received by sensorimotor, emotional, and cognitive processing systems then serve to guide our actions (Kimmel et al., 1979; Sokolov et al., 2002).

People with trauma-related disorders often experience some disorientation, adopting stuck patterns and loss of flexibility in ways to orient, their attention also taken up by destabilizing emotions and symptoms. A starting point for each workshop is an invitation to walk around the studio space, noticing whether attention is drawn to details of the external environment or more towards internal stimuli, such as thoughts or images. Participants are encouraged to bring a curiosity to this, resisting the need to make adjustment or correction to an initial orienting response to assess safety.

Over time a pattern of habitual orienting response may be revealed, whether hypervigilance to threat in the external environment or rumination on internal stimuli, or appearing to orient outward towards everyday stimuli but also ruminating on internal stimuli such as intrusive memories (Ogden et al., 2006, 67). Stuck patterns in an orienting response can also be understood as a temporal disruption, the experience of time that essentially involves the senses. Trauma alters the temporal sequence of past, present, and future, thus leaving the psyche in a time-shifted dimension (Mezzalira et al., 2023).

Following observation and acceptance of their own 'orienting habits', participants are invited to 'actively' orient to the external environment, heightening different senses—sounds they can hear, changes in temperature and light, different smells, what objects they see, different textures (which can be touched and handled), including curiosity about the content of cupboards or more hidden-away places. Then to a more internal orienting noticing sensations, energy levels, qualities of movement, emotional state, and thoughts.

This process of orienting aims to create a temporal presence optimizing the possibility of transitioning fully into each session by cultivating present moment awareness and felt sense (Gendlin, 1996) combined with self-directed action. Potentially there is movement from a more defensive oriented response to an exploratory orienting response as safety is established (Levine, 2015).

The final phase of orienting invites broadening attention to moving through space with others, punctuated by brief pauses to acknowledge the presence of each member of the group. This is intended to invite orientation to a relational matrix and organizing principle, both building a sense of 'self' and agency as well as the desire to develop relationships with others (Mitchell, 1988).

Over the course of a workshop series, this process becomes more textured to include bodily responses and movement that accompany ways of orienting such as body shape, muscular tension, movements of the eyes, face, and neck (Levine, 1997) and exploration of flexibility between a more internal and external focus. Participants also reflect on what resources can be actively included or consciously left out of the space.

Opening a 'poetic space' potentially develops to become ritualized and co-created, progressively becoming more delineated and inhabited by each group member and embodied moments of mutuality (Barad, 2007). It can also be folded away to support a transition back to the demands of daily life and conjured up more imaginatively between sessions offering some participants a more continuous connection to the workshop process.

Building a Poetic Space Online

During the recent COVID-19 pandemic, like many other practitioners, I was faced with the challenge of continuing to offer embodied, creative, and performative approaches online. There is still a great deal to reflect on in terms of the experience of online facilitation, but in essence I was surprised by the creative adjustments that were possible and some of the unanticipated benefits of the work (Carroll, 2021). This was partly due to adaptions made to the process of building a poetic space.

Similar to in-person sessions, online participants are invited to orient to the room they have chosen for the workshop, recognizing familiarity of a space within their home and the range of activities typically held there. Invited to sit comfortably, each participant slowly turns their head, allowing the room to be looked at and taken in from a different perspective, augmented by the slowness of the action and present moment awareness. They have time to make choices, informed by bodily sensations and impulses, to move objects out of the 'poetic space', or to introduce small objects they are drawn to include. One participant for example included a small plant and image and removed certain work-related materials.

Music accompanies this process to support the transition, weaving together virtual spaces and the sense of co-creating a poetic space. From time-to-time participants pause to face the screen again so that they can witness others organizing their spaces. It is at these moments that there is some potential to transcend the limitations of physical absence through a shared intent (Malloch & Trevarthen, 2009). Emergence and delineation of a poetic space are heightened by participants moving around the space they have selected, locating and making 'visible' its boundaries based on a felt sense (Gendlin, 1996).

Finally, as participants lie on the floor to transition more fully into the workshop, there is potential to enliven belonging to a group, occupying a shared embodied intersubjective space.

It is important not to underestimate the limitations that the virtual context places on aspects of the workshops, for example being unable to witness the transitions (entrances) from the 'outside world' to the room and vice versa (Yariv et al., 2021) and the absence of a ritual of 'folding away' a 'poetic space' to close sessions. Offering unstructured time before and after the workshops for participants to speak to each other, to find their own timing, particularly to leave the meeting, has provided a useful approximation to the social aspect of in-person workshops.

The Body as a Safe Container: Rebalancing, Mutual Regulation, and Embodied Empathy

Awareness is growing of the impact of stress and trauma on our psychophysiology and the disruption to our capacity to meet the demands of everyday life with flexibility and responsiveness.

A particular focus in the development of MPA is the impact of stress and trauma on the ANS, how disruption to this system potentially impedes engagement with a therapeutic process, and integration of traumatic memories. It is beyond the scope of this chapter to detail responses in the ANS in depth. I will instead share core principles that inform the selection of specific body-based skills, particularly during the initial phase, to optimize rebalance in the ANS, safety in the workshop environment, and the body as a safe(r) container for experience.

This is consistent with a broad consensus of using a phase-oriented approach for trauma recovery during an initial phase of stabilization, which aims to reduce symptoms and improve affect regulation (Reddemann & Piedfort-Marin, 2017).

The role of the ANS is to regulate essential bodily functions such as heart rate, blood pressure, breathing, and digestion to maintain homeostasis. It also has a central role in our response to threat. Traditional definitions divide the ANS into two subsystems: the sympathetic branch involved in a fight or flight response, mobilizing energy and states of hyperarousal, and the parasympathetic branch predominantly activated during states of rest and relaxation and states of hypoarousal (Porges, 2017).

Polyvagal theory adds to the view of two branches of the ANS, suggesting that there are three neural pathways involved in its regulation with particular focus on the role of the vagus nerve (the tenth cranial nerve associated with the peripheral nervous system (PNS), which connects brainstem areas to visceral organs). The three pathways involve the ventral vagus, the newer branch of the vagus nerve (above the diaphragm), and the dorsal branch (sub-diaphragmatic), an unmyelinated older branch and sympathetic pathways (Porges, 2017).

Porges suggests that a first response to threat is to seek proximity with others, activating the ventral vagal circuit and social engagement behaviours. If this is not sufficient to meet the level of threat, sympathetic pathways support mobilizing into fight or flight behaviours, and finally, an ultimate response to overwhelming threat engages dorsal vagal circuits, resulting in immobilization.

For some, the impact on the ANS means becoming locked in sympathetic hyperaroused states, or parasympathetic hypoaroused states or swinging from one branch of the nervous system to another, or simultaneous activation of both branches associated with freeze states, altered states that defensively keep traumatic experience walled off from ordinary consciousness. In this way trauma memories are fragmented and encoded more implicitly as symptoms, sensations, images (Herman, 1992), and fixed action patterns (Van der Kolk, 2006) prevented from integration necessary for healing.

Connection to the body may be perceived as a threat, creating tension between establishing safety through neuroception, scanning the environment for cues of safety and danger by connecting with bodily sensation (Porges, 2017), and a need to keep sensations at a distance. There is a general loss of flexibility and responsiveness in the ANS with reduced capacity to be in present moment awareness. Body-based skills and interventions at an early stage of a workshop series are designed to create an environment that optimizes ventral vagal activation, social engagement behaviours, and balance in the ANS, to minimize the need for defensive strategies associated with activating dorsal vagal and sympathetic pathways (Porges, 2017).

Ventral Vagal Activation

A holding environment and ventral vagal activation are initially facilitated by opening a poetic space, with participants orienting to their environment through their senses, re-establishing a connection with present moment awareness, and making initial contact with each other. This is potentially enhanced by self-directed action and the sense of a co-created ritual.

Facilitation includes offering a high level of structure, sharing a map of the content for each session and, in a more nuanced way, how I use eye contact, prosody, proximity, offers of choices, and inclusive language in relation to different experiences that may emerge in the group.

Rebalancing

Rebalancing is integral to a process of becoming embodied, putting the organism back together (Allegranti, 2011b). Accessible guided movement practice and body-based skills to support rebalancing the ANS are offered throughout the workshop series with particular emphasis in the early stages. They also contribute towards dissolving movement habits and fixed action patterns in participants with a trauma history (Van der Kolk, 2006). These skills are selected from the work of Merete Holm Brantbjerg, a body-oriented psychotherapist based in Denmark and Moshé Feldenkrais (1904–1984), founder of the Feldenkrais Method. Both practitioners have produced substantial bodies of work. I will outline a selection of key skills and principles, specifically the precise movement skills and core principles that I have integrated into MPA.

Psychomotor Function

Merete Holm Brantbjerg has developed 'Resource Oriented Skills Training', based on her background in psychomotor training, which builds on the connection between psychosocial skills and our motor skills. Muscles hold psychomotor skills (Brantbjerg & Ollars, 2006; Marcher & Fich, 2010; Stauffer, 2010), maintaining psychological coping strategies represented as patterns of tension (hyperresponse) and low energy states (hyporesponse) in muscles.[1]

In an optimal situation, muscles are in a balanced state and available for conscious, responsive, and spontaneous action. Muscles in a hypo- or hyperresponsive state are seen as coping or defence strategies brought into use when we are confronted with situations

perceived as challenging or unmanageable, either by holding back or losing connection to impulses and emotions, compromising access to psychomotor skills necessary for resilience (Brantbjerg, 2021). These two defensive strategies interact and easily polarize (Brantbjerg, 2012). There is an interconnectedness between high arousal states in the ANS—both hyper- and hypoarousal—and muscle response patterns (Brantbjerg, 2012). For example, a defensive stress management strategy may reveal a polarized pattern and interaction between holding and tight muscles in the chest and a corresponding low energy or sense of emptiness around the centre of the body.

'Centering' is a presence skill within the 'Resource Oriented Skills Training' which responds to this polarized pattern in the muscle system. Like other presence skills, centering offers simple and precise movements that support present moment awareness of what is happening in the mind and the body. Tight muscles are invited to release and muscles that have lost energy or have dropped out of movement, to take up energy. Centering gives emphasis to contacting the body's balance point through continuous movement around this centre point, gently activating muscles, and engaging all parts of the body.

Participants are invited to find an individual (Brantbjerg & Stepath, 2007) dosing exploring bigger or smaller movements that support maintaining balance, ease of breathing, and a sense of well-being. This structured exercise and way of centering combines present moment awareness with tracking and responding to ANS feedback while in action—for many a safer, more accessible way to reconnect to bodily sensations. Participants often find it enjoyable to discover, in addition, expressive movements in response to emotional states that emerge. Pausing following practice is an important component and opportunity to notice new sensations, emotions, and thought patterns that accompany the skill. Observations from these different perspectives with repetition of the skill, with dosing variation in terms of size of movement, support further integration and increased capacity to observe sensations with a neutral curiosity. Potentially the muscle system rebalances, muscles become more neutral corresponding with free access to emotions and impulses (Brantbjerg, 2012) with regulation of hyper- and hypoarousal states in the ANS.

Other presence skills included in Brantbjerg's 'Resource Oriented Skills Training' include recovering flexibility, grounding, and containment through sensing into boundaries of the body, experiences often disrupted by chronic stress and trauma. Brantbjerg's work has been influenced by and has clear resonances with the Feldenkrais Method.

The Feldenkrais Method

> We override our natural learned abilities, which are often beautifully organised at the beginning with attempts to deal with emotional upheavals...
>
> (Ginsburg, 2005)

The Feldenkrais Method is a method of movement-based re-education, created in the 1940s, by Moshé Feldenkrais, originally an engineer, physicist, and expert martial artist. The initial impetus for Feldenkrais was to recover the use of his knee following a sports injury. Influenced by Paul Schilder (1942), a physiologist and physician, Feldenkrais considered the functioning of the mind–body as an inseparable unity (Buckard, 2015; Feldenkrais, 1949, 1981), an emotional state and pattern of muscular contraction as one and the same (Doidge, 2015, chapter 5) despite little understanding in society of the unity of mind and body at that time.

The method was developed on the basis of humans as 'capable learners', achieving a considerable range of actions and abilities during early development, but also capable of mis-learning in the years that follow (Ginsburg, 2005) in response to injury and emotional challenge, reflected in a 'faulty' use of oneself.

The Feldenkrais Method, practiced in two formats—Awareness Through Movement (ATM) classes for a group as well as individual sessions in Functional Integration (FI)—aims to recover an original capability for learning new capacities for movement which are responsive to current demands and integral to thoughts, sensations, and feelings. Feldenkrais even at this early stage understood the 'neuroplastic' potential of the human brain and the capability to recover and create new neural pathways to achieve this.

I will give emphasis to the potential of guided ATM lessons to rebalance the ANS, build capacity for neutral observation of bodily sensations, and dissolve habitual patterns of stress.

Feldenkrais generated a large repertoire of ATM lessons based around functional movement themes, like moving from sitting to standing or walking more easily. A group is guided through a movement sequence with emphasis on experiential learning, curiosity, and awareness of sensory information that accompanies the movement, rather than accomplishing or correcting the movement. The guided movements are often non-habitual, making it easier to notice 'habits' in relation to solutions to motor problems, and start by lying on the floor. A fundamental principle of the method is that it is the awareness of the movement that is key to improving the movement, with encouragement to go into action slowly, in an easy range, minimizing the use of effort.

Neuroscientist Michael Merzenich showed how long-term neuroplastic change occurs most readily when a person pays close attention while learning (Doidge, 2015, 171). This state of presence and relaxation typically allows sensory distinctions to be made between different movements and increased kinaesthetic awareness, sensation that informs a person where his or her body and limbs are in space and what it feels like to move (Doidge, 2015).

The movement sequence progressively introduces different variations and ways of including more of oneself in action. 'No part of the body can be moved without all the others being affected' (Feldenkrais, 1949, 76), redistributing the work of muscles and increasing efficiency of movement based on self-generated discovery. Conscious action combined with kinaesthetic knowledge have potential to rebalance the muscle system,

arousal states in the ANS, and generate new movement possibilities, dissolving stuck patterns associated with stress.

Mutual Regulation and Embodied Empathy

There is growing momentum and understanding across different disciplines that we are soaked in and suffused by the world of others (Mitchell, 1988), an individual not isolated with hidden inner states (Fuchs, 2017) but instead affected via bodily kinaesthesia and sensation by the expression of others, a body-to-body dialogue (Ogden et al., 2006). This contagion of experience from one nervous system to another constitutes a functional mechanism for empathy (Gallese et al., 2007), social understanding, and a basis for mutual regulation.

Group-based movement practices to support rebalancing have the potential to build embodied empathy and context for mutual regulation. Participants often share enhanced benefits of practising body-based skills in the presence of others rather than separately at home, between workshops. As relationships and safety build, this process is further augmented through structured activities. An example is developing Brantbjerg's 'centering skill' by inviting participants to orient to moving with others, taking up different shapes and movements as they are witnessed, and organically emerge in the group, inducing a mutual incorporation and modification of bodily and emotional states (Fuchs, 2017). There is a sense of 'trying on' or incorporating the story of others, inhabiting a point of view before orienting more internally to individual dosing needs for the centering skill.

As facilitator, I am included in this process, diminishing hierarchy whilst still maintaining appropriate asymmetry or roles and responsibilities (Cooper-White, 2006). I will return to this dynamic interplay of bodily resonance and mutual incorporation later in the chapter as it is integral to the role of ensemble exploration and performance in MPA.

Sensations to Image Making as an Implicit Basis for Self-Knowledge

Workshops are highly structured to optimize safety and potential for a more tacit knowledge to emerge, combined with a felt sense (Gendlin, 1996) as facilitator of settling and readiness in the group to move into new material and the next level of exploration. With sufficient stabilization and safety, the body can be experienced as more reliable, reducing a need to keep sensations at a distance. This next phase aims to facilitate deeper access to bodily sensation, technically called 'interoception' (Levine, 2015) as a step towards processing implicit memories, an important aspect of a successful therapeutic intervention (Rothschild, 2000), as well as continuing to build a capacity to detect nervous system changes and responsive resourcing.

The arts have a central role in safely externalizing in symbolic form memories that often lack a verbal narrative and context (Herman, 2015) but are instead encoded implicitly as sensory fragments dissociated rather than interwoven into a personal narrative (Levine, 2015). Image formation invites 'active' participation where an art object can be experimented with, altered (Malchiodi, 2003), and brought into relationship with others. There is a conscious intentionality to connect to implicit memory which otherwise has unintentional and unpredictable recall.

Art forms are introduced sequentially during this phase and include creation of visual images, improvised writing, mask making, movement, and the body as the most elemental of all arts modalities (McNiff, 2009, 179). Each provides a liminal and experimental space where sensory fragments find form and a potential relationship to each other.

Participants are guided through a body scan as they lie or sit comfortably on the floor. They are encouraged to notice with neutral curiosity different sensations that naturally arise through themselves, tracking physical impulses, mental images, and emotional states as raw material to scaffold and give shape to a visual image. The image is created with the whole body (McNiff, 2009), an embedded 'story from the body' revealed through simple, spontaneous marks on paper or in clay. Participants share their image in smaller groups with graded options to describe creating the image rather than sharing the image itself. The image forms the basis, a point of departure for improvised writing in the style of a legend, fairy tale, or poem, in vernacular language, transporting sensory and kinaesthetic experience into another art form.

A place or landscape that holds the story is visually created, then expanded imaginatively out into the studio space, to be 'roamed through'. Participants discover its typographical features, while being prompted to be generous to impulses in the body, responding to the 'world' around them by looking, touching, altering features, and revealing the emotional impact of what they encounter in each of their story landscapes. Discoveries are gathered and brought back to the original piece of writing, and participants follow impulses to add to or make changes to the content, noticing what accompanies adjustments psychophysically. Typically, stories remain in metaphor at this stage. For some participants conscious insights already begin to emerge, as aspects of the exploration resonate with an interplay of dynamics in their lives.

Ensemble exploration of each story further develops a dynamic of mutual incorporation, a shared intercorporeal space in which interacting partners are involved (Fuchs, 2017). Each participant as 'storyteller' shares a title, a compelling aspect, and gesture that spontaneously accompany a more charged part of their story. The group mirrors back the gesture, capturing as much detail as possible such as quality of breathing, facial expression, muscle tone, shape of the body, and emotional tone. The 'storyteller' finds another gesture, the group this time offering their own movement response rather than mirroring. Three people are selected to share a spontaneous sound, word, or statement from the body shape and point of view they inhabit, each story in turn enriched by these embodied moments of mutuality (Allegranti, 2017).

Each level of exploration is followed by space to process through individual journaling, adjustments to artwork created, and sharing in partners or in the wider group. The intention is to offer a kaleidoscope of perspectives through which to connect to sensory and kinaesthetic experience associated with trauma memories, potentially bringing new options to stuck action patterns, connection between sensory fragments, and bridging the gap between implicit and explicit memory (Malchiodi, 2003; Malchiodi & Hass-Cohen, 2001).

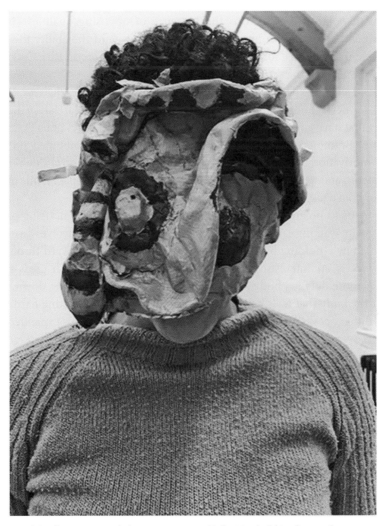

FIGURE 46.1 Tunde James, workshop participant. Polarities held in the mask.

Polarities or opposing qualities begin to emerge during the latter stages of working with different art forms, often revealed most clearly through the creation and embodiment of a 'Pochinko'[2] or expressive mask, an opportunity that presents itself during longer workshops.

Attention to Polarities as they Emerge through the Body, Movement, and Imagination

Dealing with polarities, defined as the presence of opposing qualities—big–small, smooth–rough, autonomy–connection, beautiful–ugly—and the ability to shape and process them into a unified form, is a prominent theme (Malchiodi, 2011; Case & Dalley, 2014; Haeyen, 2018) in the therapeutic art-making process.

Polarities are also expressed in the muscle system in response to stress, areas both tensing up (hyperresponse) and giving up (hyporesponse) as a polarization between the parts of us that have energy enough to push through and the parts of us that withdraw and give up (Brantbjerg, 2017, 79). Feldenkrais described this 'embodied ambivalence' as a cross-motivation in action, rather than mono-motivated action (Feldenkrais 2002/1985, chapters 4 and 14), parts of the body moving freely through space while other parts drop out or hold back, which he related to conflicting inner goals.

Giving focus to polarities in a workshop typically begins with noticing patterns of action, e.g., in walking. A common cross-motivated pattern involves over-striding accompanied by a holding back or delay in the chest moving forward through space. Partner work is an interesting and safe way of highlighting such cross-motivated patterns. A more detailed body scan invites participants, while lying down, to notice an area of the body that feels held or tight, where muscles are working hard. Then, by detecting differences in sensation, an area lacking in energy. This is expanded upon by initiating movement from the tight area, satisfying an action tendency (Ogden et al., 2006) rather than trying to resolve it, allowing accompanying qualities to emerge—movement habits, emotional states, and a particular point of view, and similarly for an area lacking in energy.

Often there is an enjoyment and theatricality attached to this embodied exploration as essential attitudes and emotional and expressive intensity are played out for each polarity, unencumbered by the presence of forces that oppose it. There is potential to fully inhabit the world of each polarity and discover a dialogue or pathway between them. Equally, polarities are explored in this way as they emerge through visual images, creative writing, and to the workshop process itself, progressively building from different perspectives an integration of conflicting needs and impulses.

Case Study Illustration 1

This case study describes the process of creating a Pochinko-style mask and the experience of one research participant,[3] who I will refer to as Owena, in relation to working with polarities held in the mask.

> Owena is a professional woman in her mid-thirties experiencing persistent medically unexplained symptoms, punctuated by states of hyper- and hypoarousal in the ANS.
>
> Alongside other research participants, Owena creates a landscape in the clay, which forms the mould for a Pochinko-style mask. Consistent with other art making, bodily sensations and impulses find expression, initially with eyes closed, through sculpting the clay, eventually choosing to exaggerate certain features. A Pochinko-style mask created in this way is essentially a landscape that can be worn on the face, with features that may or may not approximate to human features.
>
> There is a ritual around meeting the mask, placing, and slowly approaching the mask in the studio space, as if for the first time, exploring changes in proximity to it and discovering whether a potential dialogue exists between mask maker and the mask.
>
> The mask emerges more fully as papier-mâché is added, then lifted from the mould to dry, supported by creating eye holes, and adding sponges and elastic so that it can be worn on the face.
>
> There is stronger identification with the mask, imagining taking up the qualities it holds, before embodying and placing it on the face, noticing, and revealing the impulses it evokes through simple movements and gestures.
>
> Owena's exploration of the qualities of her mask revealed a strong polarity. In her exploration one aspect of the mask evoked a state of 'enormous power' accompanied by expansive, energized movement through the space. See Figure 46.2.
>
> Capturing this in her journal she writes: 'I am Gant'—a dominating stone being.'

Owena explores the world of the opposing quality in the mask, revealing a very contrasting state of 'being trapped and helpless beneath the rock' immobilized and fatigued. See Figure 46.3.

Integral to Owena's process of recovery has been finding different ways to collect and more fully inhabit the textures of each of these states and develop a potential dialogue between them.

She writes, entitled 'Feeling Towards Softness':

> ... and learning that slow recovery is still recovery and that there is a whole landscape of degrees between wellness and illness, not just polar opposites. Small movements that reach towards the softness in the landscape is tangible progress.

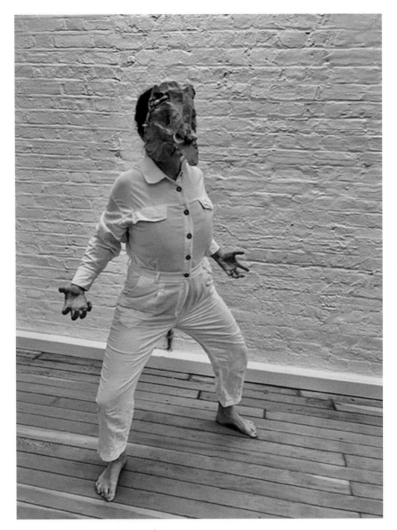

FIGURE 46.2 Polarity 1. Gant—stone being.

Performative Sharing: Audience as Witness and Collaborator

Integral to MPA is an interwovenness between psychotherapeutic and performance processes (Allegranti, 2011a). Often the material which is surfaced through this process has a level of authenticity which opens it up to create compelling performance-based work.

THE MOVING PIECES APPROACH 877

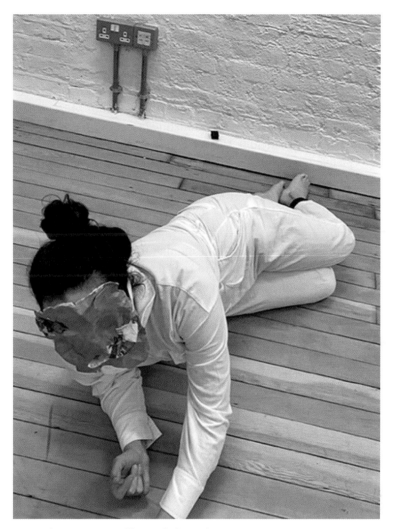

FIGURE 46.3 Polarity 2. Trapped beneath the rock.

Another important influence on MPA is the performance pedagogy of Jacques Lecoq (1921–1999), considered to have had a major influence on the development of contemporary theatre. The actor training gives emphasis to the communicative potential of the body and the need to heighten somatic awareness in the actor of the relationship between thought, feeling, gesture, and language. There is emphasis on improvisational activity as a form of play, how to recover using the whole body to both provoke, define emotion, and invest spoken language with meaningful gesture (Kemp, 2017). This is resonant with recovering 'natural learned abilities' (Feldenkrais, 1949), when Lecoq refers to how children gain an understanding of the world '… they replay with their whole body those aspects of life in which they will be called on to participate …' (Lecoq & Bradby, 2006, 1). In addition to developing skills in theatre making and performance

there is potential within this approach for greater self-knowledge and articulated ways of engaging with the world.

Performance can be defined as another art form, involving engagement with the psychophysical body (Allegranti, 2011a), including a broad range of multidisciplinary activities, and 'constellation of practices' (Huxley & Witts, 2003, 2) with a relationship between performer and spectator. Performative sharing within MPA occurs to an extent throughout the workshop process, culminating in a performance event. On longer workshop series this may extend to sharing with a wider invited audience. Common to each performative opportunity is 'storytelling', whether through movement, a conversation, sharing of an image, or through written form (Allegranti, 2011a), inclusive of different styles of sharing and decisions around grading of what to share. I will give focus to the performance event offered in the final phase of the workshop series.

A safe and holding environment continues to be paramount during this phase, as vulnerabilities surface in response to transitioning from a workshop environment to a performance space. A useful frame is to consider performance as continuous with the workshop process, with potential for specific raw material generated to be refined, a process of aesthetic (re)composition (Allegranti, 2011a) with the view to being seen. Participants work in small groups supporting each other to distil themes to shape more performatively. Personal material generated at this stage is likely to be a rich mixture of conscious emotional themes and memory held more implicitly through different art forms. I offer individual facilitation with a focus on containing personal process, establishing a 'compositional boundary' (Allegranti, 2011a), filtering what can be shared without the risk of feeling overly exposed, as well as considering what might speak to a more collective experience. Working groups are encouraged to revisit movement skills and practices to both 'rebalance' and bring to a devising process, for example how playing with different movement qualities, body shapes, ways of orienting and relating to space have the potential to transmit experience to an audience. This collaborative approach has a certain kind of 'repetition and recitation' (Butler, 1994) with potential for re-organization, a 'metabolisation' (Allegranti, 2017) of personal process as themes are distilled, witnessed by others, and repeatedly returned to from a range of different perspectives.

Whether performative sharing takes place within the context of a workshop or public realm, the role of the audience within MPA is another important element of establishing safety. Performers and audience members inhabit a shared space and embodied engagement, and the distinctions between performer and spectator are blurred as performers and audience are in a shared, participatory, and immersed dialogue (Shepherd, 2006; Shaughnessy, 2012). Audience members are additionally invited to collaborate through structured feedback in response to each performance, detailing their bodily responses, tension or relaxation, changes in temperature, and breathing rate, as well as words, phrases, images, and metaphors that spontaneously emerge. Through a dynamic interplay of mutual incorporation (Fuchs, 2017), the audience members reveal their response to the kinetics and intensity of experiences shared by performers through their own bodily kinaesthesia and sensation. Performers in a circular interaction (Fuchs, 2017)

share their experience of being witnessed and any adjustments or new insights that may have come forward. Participants often report having an impulse, a corporeal adjustment (Allegranti, 2017) to try something out not explored in rehearsal or gain conscious insight from material held more implicitly in response to being witnessed.

Case Study Illustration 2

This case study illustration outlines the experience of a research participant,[4] who I will refer to as Alane, of performative sharing within a workshop context.

Alane created a portrait, which describes her experience of withdrawing, invisibility, and silence as a child. See Figure 46.4.

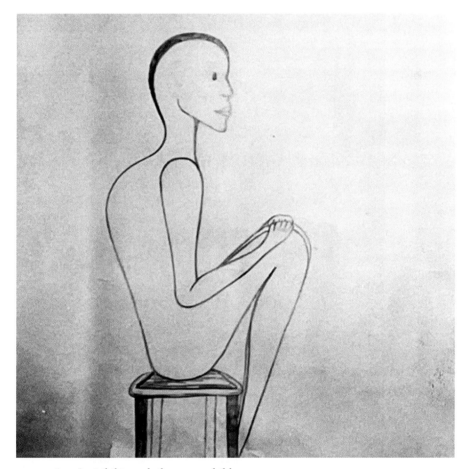

FIGURE 46.4 Invisibility and silence as a child.

During performative sharing within a rehearsal workshop, Alane responds to a new impulse to approach and interact with this figure, projected onto a screen, offering her comfort and connection, which had not previously occurred to her whilst shaping her creative work separate from the group. See Figure 46.5.

There is compelling potential for this heightened exchange between sensorimotor body schema (Fuchs, 2017) of performer and spectator to induce on a pre-reflective

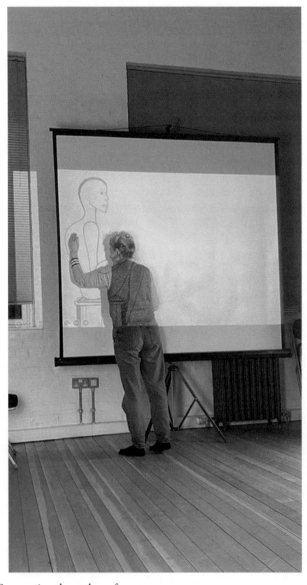

FIGURE 46.5 Connection through performance.

level, a process of mutual modification (Fuchs, 2017) and integration of memory as therapeutic issues of 'seeing and being seen' are addressed (Allegranti, 2011a).

Bridging Implicit to Explicit Experience, Assimilation, and Ending

Optimally this stage of the process marks a level of integration reflected through release of implicit survival arousal and growing capacity to meet new demands in the here and now (Levine et al., 2018). Rothschild (2000) emphasizes the importance of bridging the implicit and explicit, making sense of and encoding sensations, finding language to describe experience, to be able to think and feel concurrently, as well as this being a crucial role in intersubjectivity (Gallagher & Hutto, 2008; Hutto, 2009). Although positioned as the final component, movement from implicit to what is consciously remembered is interspersed throughout the process with variation in timing for each participant. There are more frequent and expanded opportunities to reflect together, linking sensorimotor with cognitive and emotional states (Ogden & Minton, 2000), making connections to life experiences while continuing to resist interpretative analysis (Allegranti, 2011a). Facilitation relies on continued reference to my felt sense as therapist (Gendlin, 1996) to find balance between maintaining a holding environment to integrate material, with attention to an ending process. It is often the case that participants take a more active role in facilitation at this stage, sharing reflections as witness to each other's journey, an adaptive phenomenon (Mahler, 1971; Winnicott, 1953) and process of rehearsal for separation from the group and my role as facilitator.

This process and potential for individual empowerment is supported by an opportunity for each participant to guide others through selected body-based presence skills, facilitation often inviting deeper inquiry, embodiment, and integration of a skill. For some, themes and insights that come forward through this process are surprising, with significant departure from longstanding narratives and assumptions about underlying causes of their distress. It is important to both acknowledge the importance of 'survival strategies' (Jørgensen & Brantbjerg, 2011) as well as the courage to gradually dissolve them, tolerating uncertainty as new territory is discovered, allowing more tacit knowledge to re-texture and update personal narrative.

There is no sense however that this process is complete, understanding that multiple layers of experience can be held through embodied and creative practice. Creating conditions to support self-regulation and connection to a principle of 'dosing' (Brantbjerg & Stepath, 2007) directs which layers are ready to be explored. Participants are encouraged to reflect on all their creative work, selecting what to take with them and what to leave behind, and understanding the potential for autobiographical fragments held in symbolic form to yield further insights over time. There is an open-ended invitation to stay in contact with Moving Pieces, frequently taken up by previous participants,

to share insights that have come forward from artwork and ways in which this has found expression in their lives.

A participant writes:

> ... and seeing that powerfulness in a woman can become displaced, shut down, somatised as rock that doesn't move. I'm learning how to live in this landscape, to feel towards softness. I'm learning to become the rock that moves and all the degrees in between.
>
> <div style="text-align:right">Owena, research participant[5]</div>

Evaluation and Application: A Feminist Interdisciplinary Investigation into the Efficacy of the Moving Pieces Approach to Managing Medically Unexplained Symptoms

Medically unexplained symptoms are common, with a spectrum of severity and people experiencing a range of symptoms, throughout the health-care system. People diagnosed with MUS comprise up to 45 per cent of general practice patients (Chew-Graham et al., 2017).

The development of embodied psychotherapy for MUS is already underway, supported by research which indicates that dissociation of early traumatic experiences may become embodied and placed at low levels of awareness, which results in MUS (Payne & Lin, 2014).

Practice-based research commissioned by Moving Pieces in 2016 is currently being conducted at Roehampton University by PhD student Eszter Ivan, a Dance and Movement Psychotherapist, supervised by Dr Beatrice Allegranti and Dr Leigh Gibson, due for publication in 2024. The research is conducted from a feminist interdisciplinary perspective, combining scientific and artistic inquiry inviting different disciplines to 'be in constant dialogue' (Allegranti, 2009, 17). The two research aims are: firstly, to examine the effect of MPA on recovering balance in the ANS using measurements of heart rate variability (HRV) and interoception, as outcome measures hypothesized to be associated with improved management of MUS. Secondly, to raise awareness of MUS by performing personal stories of the lived experience of people living with MUS to a public audience. The research is intended to offer rigorous evaluation and development of MPA as well as providing an evidence base for more effective treatment of MUS based on embodied, artistic, and scientific integration.

Conclusion

The Moving Pieces Approach is a group-based approach that utilizes sensorimotor integration to support mental health and manage medically unexplained symptoms.

The approach was created in response to an understanding that trauma memories are held more implicitly through encoded bodily sensations and fixed action patterns which are often confusing, uncomfortable, and an obstacle to engagement in a therapeutic process.

Developed from an interdisciplinary and feminist perspective, MPA draws on the performing arts, psychotherapy, somatic movement education, and the Feldenkrais Method, with the aim that these distinct areas of practice be in 'continuous discourse' with each other (Allegranti, 2011a).

The approach has six sequential phases with initial emphasis on rebalance in the ANS and creating a safe, textured container where unconscious embodied experiences can emerge. Implicit memory and sensory fragments, once safely accessed, can be transported and expressed through a range of different art forms, a process of externalization that affords 'viewing' from multiple perspectives in an intersubjective space.

Two case studies are shared. The first illustrates working with polarities as they emerge in the art making process. The second illustrates how new options and resources become available through a performative process.

Aesthetic experience is fundamental to each phase of MPA. A capacity to connect to bodily sensations informs the direction and timing of facilitated interventions, ways that pre-reflective experience is expressed through different art forms, and selection and shaping of material to share performatively.

Current research is ongoing, combining artistic and scientific inquiries to investigate the potential benefits of this approach, particularly for those living with MUS and other conditions where unintegrated trauma memory may be a significant factor. By continuing to build a track record of positive outcomes in practice and a potential evidence base from current research, the aim is for MPA to contribute to improved treatment options for those who have experienced trauma.

Ultimately, the Moving Pieces Approach invites active, creative, and playful levels of engagement and enables participants to explore and express unconscious embodied experiences with others in a safe and supportive environment.

Notes

1. The terms hypo and hyper response were formed by Lisbeth Marcher (Ollars, 1980; Bentzen et al., 1997).
2. Pochinko masks are created as part of Clown Through Mask, a Canadian theatre clowning technique devised by Richard Pochinko (1946–1989). See Figure 46.1.

3 PhD—Year-long research practice group—A Feminist Interdisciplinary Investigation into the Efficacy of the MPA to Working with People with MUS. Forthcoming publication in 2024.
4 PhD—Year-long research practice group—A Feminist Interdisciplinary Investigation into the Efficacy of the MPA to Working with People with MUS. Forthcoming publication 2024.
5 PhD—Year-long research practice group—A Feminist Interdisciplinary Investigation into the Efficacy of the MPA to Working with People with MUS. Forthcoming publication 2024.

References

Allegranti, B. (2009). Embodied performances of sexuality and gender: A feminist approach to dance movement psychotherapy and performance practice. *Body, Movement and Dance in Psychotherapy* 4 (1), 17–31.

Allegranti, B. (2011a). *Embodied performances: Sexuality, gender, bodies*. Palgrave Macmillan.

Allegranti, B. (2011b). Ethics and body politics: Interdisciplinary possibilities for embodied psychotherapeutic practice and research. *British Journal of Guidance & Counselling* 39 (5), 487–500.

Allegranti, B. (2013). The politics of becoming bodies: Sex, gender and intersubjectivity in motion. *The Arts in Psychotherapy* 40, 394–403.

Allegranti, B. (2017). (Im)possible performatives: A feminist corporeal account of loss. In V. Karkou, S. Oliver, & S. Lycouris (Eds.), *Dance and movement for wellbeing* (pp. 369–390). Oxford University Press.

Barad, K. (2007). *Meeting the universe halfway: Quantum physics and the entanglement of matter and meaning*. Duke University Press.

Bentzen, M., Bernhardt, P., & Isaacs, J. (1997). Waking the body ego I-II. In I. Macnaughton (Ed.), *Body, breath & consciousness* (pp. 131–204). North Atlantic Books.

Brantbjerg, M. H. (2012). Hyporesponse: The hidden challenge in coping with stress. *International Body Psychotherapy Journal: The Art and Science of Somatic Praxis* 11 (2), 95–118.

Brantbjerg, M. H. (2017). Having a map matters. *International Body Psychotherapy Journal: The Art and Science of Somatic Praxis* 16 (3), 78–80.

Brantbjerg, M. H. (2021). Sitting on the edge of an abyss together. A methodology for working with hypo-arousal as part of trauma therapy. *Body, Movement and Dance in Psychotherapy* 16 (2), 120–135.

Brantbjerg, M. H., & Ollars, L. (2006). *Musklernes Intelligens*. Om 11 Bodynamic Jeg-funktioner. Forlaget Kreatik (available in English as teaching material for Bodynamic Psychotherapist trainings).

Brantbjerg, M. H., & Stepath, S. (2007). *The body as container of instincts, emotions and feelings*. Bodynamic Brantbjerg.

Buckard, C. (2015). *Moshe Feldenkrais: Der Mensch hinter der Methode* [Moshe Feldenkrais: the human being behind the method.] Verlag.

Butler, J. (1994). Gender as performance: An interview with Judith Butler. Interview by P. Osborne & L. Segal. *Radical Philosophy* 67, 32–39.

Carroll, R. (2021). Embodied intersubjectivity as online psychotherapy becomes mainstream. *Body, Movement and Dance in Psychotherapy* 16 (1), 1–8.

Case, C., & Dalley, T. (2014). *The handbook of art therapy*. Routledge.
Chew-Graham, C. A., Heyland, S., Kingstone, T., Shepherd, T., Buszewicz, M., Burroughs, H., & Sumathipala, A. (2017). Medically unexplained symptoms: Continuing challenges for primary care. *British Journal of General Practice 67* (656), 106–107. https://doi.org/10.3399/BJGP17X690785.
Cooper-White, P. (2006). Shared wisdom: Use of the self in pastoral care and counseling (Person, Culture, and Religion Group, American Academy of Religion, 18 November 2005). *Pastoral Psychology 55* (2), 233–241.
Doidge, N. (2015). *The brain's way of healing: Remarkable discoveries and recoveries from the frontiers of neuroplasticity*. Viking Press.
Fausto-Sterling, A. (2000). *Sexing the body: Gender politics and the construction of sexuality*. Basic Books.
Feldenkrais, M. (1949). *Body and mature behaviour: A study of anxiety, sex, gravitation and learning*. International Universities Press.
Feldenkrais, M. (1981). *The elusive obvious*. Meta Publications.
Feldenkrais, M. (2002/1985). *The potent self: A study of spontaneity and compulsion*. Frog Books/North Atlantic Books.
Fuchs, T. (2017). Intercorporeality and Interaffectivity. *Phenomenology and Mind 11* (11), 194–209.
Gallagher, S., & Hutto, D. D. (2008). Understanding others through primary interaction and narrative practice. In J. Zlatev, T. Racine, C. Sinha, & E. Itkonen (Eds.), *The shared mind: Perspectives on intersubjectivity* (pp. 17–38). John Benjamins.
Gallese, V., Eagle, M. N., & Migone, P. (2007). Intentional attunement: Mirror neurons and the neural underpinnings of interpersonal relations. *Journal of the American Psychoanalytic Association 55* (1), 131–176.
Gendlin, E. T. (1996). *Focusing-oriented psychotherapy: A manual of the experiential method*. Guilford Press.
Ginsburg, C. (2005/1949). Foreword. In M. Feldenkrais (Ed.), *Body & mature behaviour: A study of anxiety, sex, gravitation and learning* (pp. vii–xxv). Frog Books/North Atlantic Books.
Grosz, E. (2005). *Time travels: Feminism, nature, power*. Duke University Press.
Haeyen, S. (2018). *Art therapy and emotion regulation problems: Theory and workbook*. Palgrave Macmillan.
Herman, J. L. (1992/2015). *Trauma and recovery*. Basic Books.
Hutto, D. D. (2009). Folk psychology as narrative practice. *Journal of Consciousness Studies 16* (6–8), 9–39.
Huxley, M., & Witts, N. (2003). *The twentieth-century performance reader* (2nd ed.). Routledge.
Jørgensen, S., & Brantbjerg, M. H. (2011). Coping skills and survival strategies in relation to trauma and traumatic stress. moaiku.dk.
Kemp, R. (2017). The embodied performance pedagogy of Jacques Lecoq. *Connection Science 29* (1), 94–105.
Kimmel, H. D., van Olst, E. H., & Orlebeke, J. F. (1979). *The orienting reflex in humans*. Erlbaum.
Lanius, R. A., Hopper, J. W., & Menon, R. S. (2003). Individual differences in a husband and wife who developed PTSD after a motor vehicle accident: A functional MRI case study. *American Journal of Psychiatry 160* (4), 667–669.
Lecoq, J., & Bradby, D. (2006). *Theatre of movement and gesture*. Routledge.
Levine, P. A. (1997). *Waking the tiger: Healing trauma*. North Atlantic Books.

Levine, P. A. (2015). *Trauma and memory: Brain and body in a search for the living past: A practical guide for understanding and working with traumatic memory*. North Atlantic Books.

Levine, P. A., Blakeslee, A., & Sylvae, J. (2018). Reintegrating fragmentation of the primitive self: Discussion of 'somatic experiencing'. *Psychoanalytic Dialogues 28* (5), 620–628.

Mahler, M. S. (1971). A study of the separation-individuation process. *The Psychoanalytic Study of the Child 26* (1), 403–424.

Malchiodi, C. A. (2003). Expressive arts therapy and multimodal approaches. In C. Malchiodi (Ed.), *Handbook of art therapy* (pp. 106–119). Guildford Press.

Malchiodi, C. A. (2011). *Handbook of art therapy* (2nd ed.). Guilford Press.

Malchiodi, C. A., & Hass-Cohen, N. (2001). *Toward an integrated art therapy mind–body landscape* (Cassette Recording No. 108-1525). National Audio Video.

Malloch, S., & Trevarthen, C. (Eds.). (2009). *Communicative musicality: Exploring the basis of human companionship*. Oxford University Press.

Marcher, L., & Fich, S. (2010). *Body encyclopedia*. North Atlantic Books.

McNiff, S. (2009). *Integrating the arts in therapy: History, theory, and practice*. Charles C. Thomas Publishers.

Mezzalira, S., Santoro, G., Bochicchio, V., & Schimmenti, A. (2023). Trauma and the disruption of temporal experience: A psychoanalytical and phenomenological perspective. *The American Journal of Psychoanalysis 83* (1), 36–55. https://doi.org/10.1057/s11231-023-09395-w.

Mitchell, S. A. (1988). *Relational concepts in psychoanalysis: An integration*. Harvard University Press.

Moore, L. J., & Kosut, M. (2010). *The body reader: Essential social and cultural readings*. New York University Press.

Ogden, P., & Minton, K. (2000). Sensorimotor psychotherapy: One method for processing traumatic memory. *Traumatology 6* (3), 149–173.

Ogden, P., Minton, K., & Pain, C. (2006). *Trauma and the body: A sensorimotor approach to psychotherapy*. W. W. Norton.

Ollars, L. (1980). Muskelpalpationstests pålidelighed. Besvarelse af specialeopgave i psykologi. Unpublished dissertation. Copenhagen University.

Payne, H., & Lin, Y. (2014). The BodyMind Approach™, medically unexplained symptoms and personal construct psychology. *Body, Movement and Dance in Psychotherapy 9* (3), 154–166.

Porges, S. W. (2011). *The polyvagal theory: Neurophysiological foundations of emotions, attachment, communication, self-regulation*. Norton.

Porges, S. (2017). *The pocket guide to the polyvagal theory. The transformative power of feeling safe*. W. W. Norton.

Reddemann, L., & Piedfort-Marin, O. (2017). Stabilization in the treatment of complex post-traumatic stress disorders: Concepts and principles. *European Journal of Trauma & Dissociation 1* (11), 11–17.

Rothschild, B. (2000). *The body remembers*. W. W. Norton.

Schilder, P. (1942). *Mind: Perception and thought in their constructive aspects*. Columbia University Press.

Shaughnessy, N. (2012). *Applying performance: Live art, socially engaged theatre and affective practice*. Palgrave Macmillan.

Shepherd, S. (2006). *Theatre, body and pleasure*. Routledge.

Sokolov, E. N., Spinks, J., Naatenen, R., & Heikki, L. (2002). *The orienting response in information processing*. Erlbaum.

Stauffer, K. A. (2010). *Anatomy & physiology for psychotherapists: Connecting body & soul*. W. W. Norton.

Tantia, J. (2021). *The art and science of embodied research design: Concepts, methods, and cases*. Routledge.

Tong, R. (1989). *Feminist thought: A comprehensive introduction*. Routledge.

Van der Kolk, B. (1994). The body keeps the score: Memory and the evolving psychobiology of post-traumatic stress. *Harvard Review of Psychiatry 1* (5), 253–265.

Van der Kolk, B. (2006). Clinical implications of neuroscience research in PTSD. *Annals of the New York Academy Sciences 1071* (1), 277–293.

Van der Kolk, B. (2014). *The body keeps the score: Brain, mind, and body in the healing of trauma*. Viking Books/Penguin Books.

Winnicott, D. W. (1953). Transitional objects and transitional phenomena: A study of the first not-me possession. *International Journal of Psychoanalysis* [online] *34*, 89–97. Available at: https://pep-web.org/browse/document/IJP.034.0089A?index=100

Yariv, A., Shalem-Zafari, Y., Wengrower, H., Shahaf, N., & Zylbertal, D. (2021). Reflections on individual webcam dance/movement therapy (DMT) for adults. *Body, Movement and Dance in Psychotherapy 16* (1), 56–63.

CHAPTER 47

AESTHETICS AND THE CLINICAL ENCOUNTER

Perfect Moment and Privileged Moments

FEMI OYEBODE

Introduction

Appreciation of beauty pervades all aspects of life. It is not simply that artistic artefacts such as paintings and sculpture attract our attention and compel an evaluative response, an aesthetic evaluative response, but that we also respond to the aesthetics of the natural environment, landscape, fauna, and flora, including the disposition of sunrise and sunset, and the signals of the seasons too. We turn our gaze upon the built environment, the paraphernalia with which we are clothed and the furnishings of our homes, the design of everyday mundane objects such as toothbrushes, vacuum cleaners, shoes, and myriad other objects with an aesthetic attitude. Then there is in the aesthetic valuation of the physical form and appearance of other people, of their faces, their proportions, their figures, the elegance or otherwise of their movements, gait, and stance. Finally, there is the grasping after aesthetic value, the evaluation of manner of speech, quality of voice, eloquence, choice of words, of style of interacting with others and of ideas expressed in language. All these go to show how comprehensive and exhaustive are our aesthetic attitudes and yet how implicit these attitudes are, that for much of the time, we are not overtly aware of the degree to which aesthetic valuation underpins practically all aspects of life.

The broad extent of the focus of aesthetic appreciation as described above demonstrates that Hegel's (1770–1831) contention that aesthetics deal exclusively with art, rather than merely being apprehension of all sensuous objects, is at the very least moot. For Hegel (1975), art rises above 'the concrete framework of matter' (1975, p. 43), and 'the work of art is not only for the *sensuous* (italics in original) apprehension as sensuous object, but its position is of such a kind that as sensuous it is at the same

time essentially addressed to the *mind* (italics in original), that the mind is meant to be affected by it, and to some extent find some sort of satisfaction in it' (1975, p. 40). And here, Hegel makes a distinction between sensuous objects that satisfy our desires such as our appetitive desires in relation to, for example, animals that we want to eat or wood that we want to use and those that are made by human beings and therefore freed from the 'fetters of rule and regularity' (1975, p. 7). Thus, for Hegel, a work of art is not a natural product but brought to pass by means of human activity, and is essentially made for man, borrowed from the sensuous and addressed to man's sense and contains an end. This view is also endorsed by Theodor Adorno (1903–1969) who wrote 'The image of beauty as that of a single and undifferentiated something originates with the emancipation from the fear of the overpowering wholeness and un-differentiatedness of Nature. The shudder in the face of this is rescued by beauty […] works become beautiful by the force of their opposition to what simply exists' (1997, p. 70). For Adorno, aesthetics is a term that is only relevant with respect to man-made artefacts and does not apply to nature or natural objects. However, these views that focus exclusively on artefacts, on artistic objects, ignore the fundamental questions that scientific and evolutionary aesthetics pose: how can we explain and understand the foundational principles of aesthetics? In other words, our predisposition to value some objects, including natural objects with respect to their aesthetic properties, must speak to something fundamental about both our psychology and neurology. Adorno skirts this issue when he says 'To be able to say with good reason why an artwork is beautiful, true, coherent, or legitimate does not mean reducing it to its universal concepts […] in every artwork […] the universal and the particular are densely intertwined' (1997, p. 225).

Kant (1724–1804) in the *Critique of Judgment*, had anticipated the notion that the properties of objects adjudged as beautiful are inherent in the mind rather than in the objects themselves. For him, beautiful objects seem universal and necessary, by which he meant that beauty behaves as if it were a universal and necessary property of an object, rather like its weight or chemical composition, but that these features are properties of the human mind since there is nothing in the object, in itself, that makes it beautiful. So, the aim of scientific and evolutionary aesthetics is to unravel what it is that inheres in mind that makes aesthetic judgements possible. Kant's approach laid the groundwork for modern conceptualizations of aesthetics and the nature of beauty. The term 'beauty' is itself problematic as it can potentially obscure rather than reveal what it signifies. The relationship between the terms 'beauty', 'aesthetically pleasing', and 'pleasure' demands exploration that is outside of the scope of this chapter. In this chapter, I will use the terms interchangeably.

Scientific and Evolutionary Aesthetics

My aim is to examine our orientation to objects and situations with a view to apprehending some quality or qualities inherent in the objects and situations that we

label as beautiful. There is a growing consensus that there is understandable and discoverable basis to our responses to beautiful objects and this is the goal of scientific and evolutionary studies of aesthetics. Gustav Theodor Fechner (1801–1887) showed that the shape and dimension of objects determine whether and how far we find them pleasing. For example, he demonstrated that the golden ratio (0.62), which is the ratio of a rectangle's width to length, was the most appealing to the eye. He wrote:

> When an object of our contemplation undergoes random variation in size and shape, then all things being equal, the mean values seem to be preferred from the aesthetic point of view or appears with the character of predominant pleasantness as the normal value in comparison with the others, which, according to their degree of variation from the mean, can appear less pleasing or, if certain limits are exceeded, even displeasing.
>
> (Quoted in Kirk, 2014, p. 324)

This approach suggests that there are features that are intrinsic to visual objects that influence our aesthetic responses. And, that these features lie somewhere between the simple and the increasingly complex and this was further elaborated by Daniel Berlyne to include features such as novelty, complexity, surprisingness, uncertainty, and incongruity (Berlyne, 1971).

Semir Zeki's (1998) contribution was to bring to bear on our understanding of aesthetics the neurology of visual perception. He demonstrated and argued that the visual cortex actively extracts information from the external world, discounting much of the information that reaches it, and selecting only what is necessary in order to obtain information that is required to categorize the world such that it can record and make comparisons with stored information. Zeki upheld that the role of the visual cortex is like the manner in which artists respond to the external world, in that some artists aim to represent objects as they really are, emphasizing what is constant and durable, distilling features that are essential and characteristic rather than transient and temporal. For Zeki (1998),

> (T)he general function of art [is] a search for the constant, lasting, essential, and enduring features of objects, surfaces, faces, situations, and so on, which allows us not only to acquire knowledge about the particular object, or face, or condition represented on the canvas but to generalize, based on that, about many other objects and thus acquire knowledge about a wide category of objects or faces.
>
> (p. 76)

There is the sense in which features of objects in the external world are judged to be pleasing, that is, to be beautiful because of their interaction with aspects of neural and cognitive processing within the visual cortex and as such, art evokes the sense of wonder, even of sublimity by these intrinsic features. But this is not only of relevance to art. It could be argued that the fundamental properties that determine whether we judge something to be beautiful have evolved from our interactions with the physical

environment and with other human beings. Chatterjee and Vartanian (2014, 2016) have proposed that aesthetic experiences emerge from the interaction between sensorimotor, emotion-valuation, and meaning knowledge neural systems. So, for example, the brain segregates visual elements such as luminance, colour, and motion as well as higher order objects such as faces, bodies, and landscapes. Specifically, Chatterjee and Vartanian make the explicit point that in their model, aesthetic experience is an emergent mental state comprising aesthetic judgements and aesthetic emotions. The detail of their model is outside of the scope of this chapter.

Coss (2003) makes the further point that there is a role for natural selection on visual pattern recognition and associated physiological arousal underpinning aesthetic perception. For this to work efficiently, there must (a) be specificity of initial pattern recognition, (b) recognition of visual-pattern significance in the appropriate organism–environment context, (c) emotional significance that emerges in this context, and (d) successful expression of appropriate action in dealing with this visual pattern. Furthermore, a taxonomy of aesthetic adaptations has been proposed (Thornhill, 2003):

1. Aesthetic valuation of landscape features
2. Aesthetic valuation of nonhuman animals
3. Aesthetic valuation of acoustic behaviour of nonhuman animals
4. Aesthetic judgements arising from daily or seasonal environmental cues that signal a need to change behaviour
5. Aesthetic valuation of human bodily form
6. Aesthetic valuation of social status cues
7. Aesthetic valuation of social scenarios
8. Aesthetic valuation of skill
9. Aesthetic judgement of food
10. Aesthetic judgement of ideas.

This taxonomy demonstrates that to fully grasp the basic mechanisms underpinning our aesthetic preferences we must widen the scope of our interest. For instance, the nature of aesthetic valuation of habitat affordances, involves features of the habitat that are markers of the physical environment that afford survival as refuge sites or prospect sites. In this scheme, prospect refers to the ability to survey the landscape, and refuge to the ability to hide when in danger. The presence of environmental structures that allow prospect views would have increased the likelihood of spotting resources such as water and food and of recognizing approaching threats such as predators, etc. (Ruso et al., 2003). Landscape features that tend to be perceived and assessed as beautiful include the perception of types of trees such as acacias with broad, moderately layered canopies as the most attractive trees, and of scenes with water that sparkles and ripples whilst reflecting sunlight or moonlight being regarded as beautiful. These features of water as described above are thought to be relevant to the perception of glossy and sparkling surfaces as attractive (Coss, 2003). What the foregoing does is to show how these basic

infrastructures of our perceptual system influence art. Painters are instinctively aware of the importance of these features of the landscape.

The question is how far we can expect that evolutionary aesthetics can identify visual pattern cues that trigger aesthetic pleasure from the perception of social interactions, emblems of social status, etc. And, furthermore whether evolutionary aesthetics can profitably unravel the mechanisms underpinning these aspects of human interaction. Thornhill (2003) makes the case for evaluation of status cues as follows.

> [H]umans seek to possess, control, or be associated with status markers. Markers of social rank are of many types: accents, music, ideology, education, friends, mates, pets, automobiles, homes, cellular telephones, recreation, clothes, etc. I suggest that in general, status markers confer status because they reliably indicate social rank by their rarity, expense, or the difficulty by which they are achieved or obtained. Ascription of aesthetic value occurs with each type of status marker. Beauty here is the perception of cues to increased status.
>
> (p. 29)

In other words, status markers, in this scheme, are visual objects that can be regarded as beautiful, that is, as aesthetically pleasing and the biological underpinning depends on the role of these markers in increasing social rank. This suggests, at least in the first instance, that in seeking to understand how aesthetics may enter the dynamics of clinical encounters, we ought to examine for the presence of identifiable visual patterned cues that are emblematic and that can be perceived and labelled as aesthetically pleasing. However, it may be that these markers are not simple visual cues as described above, but complex visual social markers such as synchronic or reciprocal bodily movements or facial expressions. The role of eye contact as a signifier of attunement is a case in point. I will discuss these matters below.

Aesthetics of the Clinical Encounter

In this chapter, I will discuss the aesthetics of the clinical encounter, first by examining the professional context of clinical consultations. Secondly, I will set out the usual physical setting of clinical encounters with a view to describing their role or otherwise in contributing an aesthetic dimension to clinical consultations. Thirdly, I will focus on Jean-Paul Sartre's distinction between a perfect moment and a privileged moment. I will employ these concepts to further probe the ways in which clinical encounters open up possibilities by allowing something unpredictable but transformative to happen within the clinical situation. In this way, revealing what is human and humane in a potentially sterile social situation. Fourthly, I will explore the patient–doctor relationship and fifthly, the role of language, including words and their meanings, prosody, cadence, and reciprocity in the interchange of words. Essentially dealing with the distinction between

conversation and interrogation. Finally, I will conclude that just as ethics are embedded in clinical encounters, providing a necessary framework to regulate and facilitate clinical interactions because ethics deal with the nature of the good and how to maximize it in clinical encounters, aesthetics too, by necessity, enter clinical encounters by providing the possibility of beauty, a wider value system that goes to the very root of a special kind of pleasure and reward.

Professional Context of Clinical Encounters

The aim of the first clinical encounter with a patient, in medicine, is well established. It is to determine what the diagnosis is, in order to reach a decision about the necessary investigations and management plan. The method too is not in dispute: a thorough history taking followed by physical examination and if it is a psychiatric case, a mental state examination is expected. This method is enshrined by convention and is reinforced by teaching and modelling. What is not explicitly taught is that history taking in a medical context prioritizes an objective account of an individual's problems over the subjective description as narrated by the patient. It is a maxim in medicine that history taking, in particular, the presenting complaint, must or ought to be expressed in the patient's words. This belies the fact that the purpose of the medical history is to reduce the patient's account to what it has in common with other people's account of similar presentations. To put it in another way, the doctor is not interested in the particularities of the patient's account, that is, not what is unique to the patient, rather the interest is what the account has in common with what is the stereotypical presentation of a given medical condition.

If a patient was to present with sudden right-sided lower abdominal pain, the aim of the doctor is to establish that like everyone presenting with acute appendicitis, the abdominal discomfort may spread to the central abdomen, may be associated with nausea and vomiting, and on examination may be associated with tenderness of the abdomen and if severe, with rebound tenderness. The patient's account is steered away from the subjective preoccupation with who was present at the time, where they were standing when they first became aware of the pain and what their spouse or children said, and incidentally which TV programme was being broadcast. The differences in focus and interest between the patient and the doctor has important consequences for whether the encounter is satisfying for either party. At some level, this dissonance is at the root of much that is unsatisfactory about medical consultations. In one mode of storytelling, a factual accounting that strips what is particular to an individual person is valorized and in the other mode, a narrative autobiographical accounting that attempts to situate the problem within the contingencies of a real life, with all of its peculiarities and uniqueness is valued by the patient but dismissed by the clinician within the encounter.

And this is more problematic since the dismissal is taking place at a time of extremis when the contingencies of a real life become salient and important.

To imagine that this same approach, which as I have described above creates dissonance within the clinical encounter in physical medicine, is also the approach within psychiatry. At least in general medicine and surgery, one could argue that the viscera, bones, and skeleton and their diseases can be understood with the barest interest in the particular life of the patient. But in psychiatry, by definition, the abnormal experiences are manifest within the person and not within a discrete organ. Anxiety can only manifest itself within the interests, the concerns and livelihood, the relationships, and the goals and plans of a real life. This means that in any history taking that avoids the particular, that dismisses the actual lived experience, and that constrains the subjective accounting within a sterile framework is likely to be alienating for the patient. But this is the reality of contemporary medical practice.

The emphasis on objectivity, the impulse to devalue what is unique to the patient in preference for what is general, what is shared in common, has problems for how patients experience the encounter. This problem is exponentially aggravated by how language is used within the clinical encounter. In the pursuit of a value-free language, a technical, uniform language and vocabulary is imposed on the interaction. Folk language is translated into technical and more professionally acceptable language: 'butterflies' becomes 'anxiety', 'sadness' becomes 'depression'. Instead of improving communication there is the risk of impoverishing it and the further possibility that mutual understanding and fellow feeling is disrupted.

In summary, the professional context of practice, and its conventions and culture, can and do militate against the real possibility of meaningful satisfaction between two people. It is a wonder that clinical encounters work at all.

Clinical Settings

Clinical encounters occur in clinical settings. The term clinical itself denotes a process that is analytical, cool, dispassionate, and occurring with detachment and precision. It is no surprise then that the architecture of clinical settings aims to promote, if not symbolize, these meanings of the term clinical. Whether in outpatient environments or inpatient contexts, the clinical setting is clean, sterile, often square and painted in cool colours. For example, my own clinic room is square in outline and proportions. Three of the four walls are off white and the fourth is peach. There is one window looking out to the road and covered with ivory-coloured vertical blinds that can be drawn to let in more light. The wooden door has a metallic inset doorknob. One wall has a washstand and sink with mounted soap dispenser and paper dispenser. There is a bright sunflower yellow bin marked for clinical waste only. On my table is a computer and screen and a printer. All the seats are functional in appearance and covered in plastic. The seats are arranged in an L-shape between the doctor and patient but even though this is

designed to facilitate communication, in fact the introduction of a computer and screen interposed between the clinician and patient disrupts the desired effect. The overall effect cannot be described as aesthetically pleasing and I suppose that was never the purpose or intention of the architects and interior designers.

My purpose in describing the physical setting of clinical encounters is to emphasize the point that neither the professional context as described in the previous section, nor the physical setting prioritizes aesthetics. Indeed, it could be argued that the purpose is to project objectivity, precision, and detachment, to the detriment of anything that signals the subjective or the human. It is as if anything that cannot be controlled, risks the intrusion of the chaotic and risky. Of course, much of clinical practice and the design of clinical settings arose in the light of the potentially devastating possibility of microbial infections and the risk to life that infections pose. So, this description is not a critique as such but an analysis of the effects, inadvertent, that result from our current preoccupation with a particular approach to clinical settings.

It is perhaps also important to recognize that the obverse of objective, the subjective, carries with it the notion of being influenced by idiosyncratic personal beliefs or emotions rather than facts. And once we are in the territory of human emotions, there is fear that imprecision and chaos may result. And these are deemed to be undesirable as far as clinical work is concerned.

I am arguing that both the professional context of clinical practice and the physical setting, jointly, stand in the way of how human beings normally communicate with one another. The clinician takes on a well-orchestrated role, one that is taught and mastered, that is projected and rewarded by peers and society. The patient responds to the clinical setting, discovers at the first consultation what is expected and responds to social cues to meet the covert but definite expectations of what is required. The possibility of an aesthetically pleasing outcome is remote and not part of the constellation of possibilities on offer. Yet, we know that both the clinician and the patient have idealized notions of what to expect and that aesthetics contribute to these notions.

In the next section, I will introduce Sartre's notions of 'perfect moment' and 'privileged moment' with a view to using these firstly to explore how idealized notions influence expectations and how the failure to meet these expectations adversely affect the patient–doctor relationship. Secondly, how the possibility of a privileged moment, an unplanned but open moment, that occurs spontaneously between two people and that is accepted as aesthetically pleasing and rewarding, is itself a motivating force within clinical encounters.

Perfect and Privileged Moments

Sartre's (1905–1980) novel *Nausea* was published in 1938 (Sartre, 1938). Flynn (2014) describes it as 'the paradigm of a philosophical novel [which] embodies the tension between philosophy and literature, concept and image, life and art' (p. 137). It is not

merely a philosophical novel but a phenomenological one too, as it places emphasis on descriptions of the world as observed whilst at the same time de-emphasizing the interior reflections of the subject, the psychology of the subject. The novel is the diary of the central character, Antoine Roquentin. Roquentin 'surveys, analyses and records in a detached, phenomenological manner the actions, events and surroundings of his world, as if they were happening to him and not the result of his own actions' (Flynn, 2014, p. 142).

In *Nausea*, Sartre introduces the concepts 'perfect moment' and 'privileged moment'. These are complex concepts, neither of which is defined but are instead illustrated. And often it is never quite clear how they differ and where the overlaps are. Roquentin describes his girlfriend Anny's beliefs and attitudes to perfect moments as follows:

> She always wanted to enjoy 'perfect moments'. If the time was not convenient, she took no more interest in anything, the life went out of her eyes, and she trailed around lazily like a gawky schoolgirl at the awkward age. Or else she would pick a quarrel with me.
>
> (Sartre, 1938, p. 74)

He elaborates further:

> I could feel that the success of the enterprise was in my hands: the moment had an obscure significance which had to be trimmed and perfected; certain gestures had to be made, certain words spoken. [...]
>
> (Sartre, 1938, p. 75)

Perfect moments seem to have about them something that is perfected in imagination, an experience that is contingent on aspects of the immediate environment, but for completion requires the participation of another person or other persons. To be specific, the perfect moment is apprehended in one person's imagination, but it requires the witting or unwitting participation of another person for the moment to come to fruition and to be experienced. But, of course, the ultimate goal is for the perfect moment to be jointly experienced. It requires attunement, and joint purpose and as in the novel, it often fails to materialize, and this can be the source of frustration. You could say that it is an aesthetic of the moment, determined by visual and spatial configurations but also including what is said. It recalls to mind the possibilities of a 'good death' and what that might mean for individuals and families. The social and visual patterning of death scenes is not lost on painters who in their composition evoke the aesthetic of the moment such that a tragic event rises beyond the transient moment to become an aspect of the eternal (see Jacques Louis David's (1748–1825) The Death of Socrates, Arthur William Devis' (1762–1822) The Death of Nelson, 21 October 1805, etc.). It is unclear whether the perfect moment is experienced in retrospect or whether it is lived, treasured, and found to be pleasing in the actual moment.

It is unsurprising that the other illustration of a perfect moment is the birth of a child at the opposite end of the human lifecycle. It is not the actual labour that is treated as aesthetically pleasing, rather it is the moment when the mother has the child to her breast or when the child is presented to the world. The iconography of a birth in Western art is influenced by the myths around the birth of Christ, dominated by Renaissance paintings of the Nativity. But modern paintings such as those by Amanda Greavette, focus on the moment when the mother has the baby in her arms and there's the attuned gaze of one to the other. This perfect moment, too, is independent of the contingencies whether it be a home birth or one in hospital with obvious attachments of drips and monitors, but the focal point is always the intensified mutual gaze.

The risk with enactment of the 'perfect moment' is that the expectation is never or rarely fulfilled. It is possible that the right words to fit the moment do not come to mind and somehow this mars the expected atmosphere.

Now, as for 'privileged moments' the exact difference from perfect moments is unclear yet it is suggestive of the potentiality of something emerging from a particular set of circumstances. In the extract below, Roquentin is reporting what Anny said to him about the distinction that attempts to draw between privileged and perfect moments:

> 'The privileged situations?' The idea I formed of them. They were situations which had a very rare and precious quality, a style if you like. To be a king, for example, struck me as a privileged situation when I was eight years old. Or else to die. You may laugh, but there were so many people drawn at the moment of their death, and there were so many who uttered sublime words at that moment, that I honestly thought ... well, I thought that when you started dying you were transported yourself. Besides, it was enough just to be in the room of a dying person: death being a privileged situation, something emanated from it and communicated itself to everybody who was present. A sort of grandeur.
>
> (Sartre, 1938, p. 176)

It seems as if the distinction between a 'perfect moment' and a 'privileged moment' is that between an imagined ideal and the process of realizing the ideal. There's work involved in the realization of something perfect that flows out of a privileged situation. Indeed, Sartre refers to it as a work of art. This can involve signs that announce the arrival of the privileged situation. Then there are the acts to be performed, the attitudes to be assumed, and the exact words to be uttered. In this sense there are attitudes and words, too, that must be prohibited.

To summarize, perfect moments are idealized conceptions of particular situations that are open to being experienced as exceptional and privileged and ready to be worked on, that is, to be perfected. The question is whether clinical encounters are anticipated as exceptional opportunities for privileged situations that are open to be experienced and perfected in the moment. This will require some kind of visual spatial configuration that can be anticipated and experienced as aesthetically pleasing. The iconography of clinical encounters usually involves two people who are in attunement, facing one another

and looking into one another's eyes with a steadfast and focused gaze. Sometimes the direction of gaze is directed at a joint project, for example, looking at a clinical report or computer screen. The iconography is one of understanding, emotional support and valuation of the patient as human even if vulnerable, worthy of equal treatment even if there is an asymmetry of power, and the patient always has dignity, and the clinician evinces respect for the other (see Luke Fildes' [1843–1927] The Doctor).

Patient–Doctor Relationship

I want now to turn to what it is in the clinical encounter, that is, which acts, attitudes, and words go to the making of the work of art, the aesthetic possibilities of the privileged moment that perfect it, such that both the clinician and patient experience aesthetic pleasure and fulfilment. To fully grasp this privileged situation, the clinical encounter, especially in psychiatry, we need an understanding of the intrinsic nature of the relationship between clinician and patient.

Martin Buber (1878–1965) (1937) in *I and Thou* gave an account of the difference between our encounter with a material object and our encounter with a person. Buber refers to the material world as 'It' and the world of selves as 'You'. For Buber, the material world is lasting, objective, reliable, and sustaining for the self.

> 'It' has density and duration and 'one can recount it with one's eyes open ... it is only *about* (italics in the original) it that you can come to an understanding with others; although it takes a somewhat different form for everyone, it is prepared to be a common object for you; but you cannot encounter others in it. Without it You cannot remain alive, its reliability preserves You'.
>
> (Buber, 1937, p. 82)

Our attitude and disposition towards material objects is distinct from our apprehension and disposition towards persons. And it is this distinction, characterized by the fact that persons have projects of their own, are agents in their own right, and are free by definition that plays a fundamental part in our relationship with persons in the clinical encounter. This is what makes the encounter open and fragile but also risky and potentially fulfilling.

Buber (1937) makes the point 'The world You that appears to you in this way is unreliable, for it appears always new to You, and you cannot take it by its word. It lacks density ... it cannot be surveyed ... it does not stand outside you, it touches you, it touches your ground' (p. 83). So, evidently selves, persons are unpredictable and cannot be grasped in full like an inert material object can. Indeed, Buber makes the further point that persons influence our emotions, that is, persons do not merely stand outside us like a stone might, but they invade our emotional life, touching us. Whilst we depend on the material world for sustenance, as Buber remarks 'whoever lives only with that [It] is not

human' (p. 85). For Buber, the urge towards sociality is matched by the urge towards mutuality. Mutuality encompasses the capacity to reciprocate the regard for us by other selves and as Buber says 'Here I and You confront each other freely in a reciprocity that is not involved in or tainted by any causality' (p. 100). Mutuality is expressly human precisely because it is freely given and received. The freedom to act towards another with a similar regard as one has for oneself and without being duty bound to act as such, because one wants to, is peculiarly human.

Buber goes one step further. He makes the cogent point that persons, selves, enter into the world through other selves:

> The I of the basic word I-It appears as an ego and becomes conscious of itself as a subject (of experience and use). The I of the basic word I-You appears as a person and becomes conscious of itself as subjectivity... Egos appear by setting themselves apart from other egos. Persons appear by entering into a relation to other persons.
>
> (pp. 11–112)

I have been arguing that the clinical encounter is constrained by the demands of professional context and the physical setting. Furthermore, that at its best, the clinical encounter makes possible the emergence of something, perhaps something immanent, that is contingent on action, attitude, and words. The prerequisite of this emergent work of art is the attitude that two people bring into the encounter, the capacity for mutuality, the precious consciousness of the freedom of both parties to experience the world distinctly yet the potential to act jointly for the good of the other.

LANGUAGE IN THE CLINICAL ENCOUNTER

I want now to turn to words, the role of language in the clinical encounter and the place of language in the creation of an aesthetic of the clinical encounter. This is particularly crucial in psychiatry, a discipline that is dependent on language as a tool of both inquiry as well as a therapeutic agent. In *What is Literature?* Sartre (1948/1993) makes an important distinction between the use of words in poetry and prose. For the poet, words are themselves the very artefacts from which art is wrought. For poets, words have a physical aspect to them much in the way that wood or stone is the material that a sculptor works. In short, for the poet, words are objects in their own right and there is a degree to which they please or displease in themselves. Whereas in prose a word 'designates, demonstrates, orders, refuses, interpolates, begs, insults, persuades, [or] insinuates' (p. 11). To emphasize, words, in prose, are not objects in themselves but refer to objects and the question is to whether or not in referring to objects they do so accurately or not. But perhaps even more relevant to psychiatry, Sartre makes the point

If you name the behaviour of an individual, you reveal it to him; he sees himself. And since you are at the same time naming it to all others, he knows that he is *seen* at the moment he *sees* himself. The furtive gesture which he forgot while making it, begins to exist beyond all measure, to exist for everybody; it is integrated into the objective mind; it takes on new dimensions; it is retrieved. After that, how can you expect him to act in the same way?

(p. 13)

This is to say that there is a revelatory aspect to words, to language. The clinical inquiry is designed to reveal, by means of an interchange of words. The words make objective, that is turn what is subjective and private into something that is shared between two people, exposes what is not merely private but also often secret, into something that can exist beyond the inner world of one person, but that has a reality that potentially can exist for everyone.

Even though Sartre is talking about writing, his insights are true for spoken words. It is so true when he says

[W]ords are there like traps to arouse our feelings and to reflect them towards us. Each word is a path of transcendence; it shapes our feelings, names them, and attributes them [...] confers object, perspectives, and a horizon upon them.

(p. 33)

Poetry also enters into the clinical discourse because the experiences that are at the centre of the encounter are at the extreme of human experience and difficult to describe. There is a manner in which these experiences are beyond words such that there is a ready resort to metaphor, to analogical language and even then the patient in extremis feels that language has failed in denoting, exactly, the nature and quality of the experience under inquiry. For example, in writing about his experience of depression William Styron (1990) wrote

Depression is a disorder of mood, so mysteriously painful and elusive in the way it becomes known to the self—to the mediating intellect—*as to verge close to being beyond description* (my italics). It thus remains nearly incomprehensible to those who have not experienced it in its extreme mode.

(p. 7)

The fact that the subjective experience of anomalous feelings or perceptions come close to defying description means that language use in the clinical encounter relies on the attunement of the clinician to the precarious role of words and language. It also means that there is a need for a joint project, a collaboration in the creation of reality and meaning through a shared language between the clinician and the patient. And this conversation ought not to be constrained by the often-impoverished language of questionnaires, proformas, or jargon. There is also the need to be accepting of

approximations, of the futilities of language, the failures of language in this treacherous terrain. This can mean the courage to accept that the experience is outside the scope of language but that it is yet real and valid.

Here is where analogical language helps. Styron, in his case, uses the motif of a telephone exchange to illustrate how it feels for his conscious awareness to be failing:

> That fall, as the disorder gradually took possession of my system, I began to conceive that my mind itself was like one of those outmoded small-town telephone exchanges, being gradually inundated by flood waters. One by one, the normal circuits began to drain, causing some of the functions of the body and nearly all of those of the instinct to slowly disconnect.
>
> (p. 47)

And Kay Redfield Jamison (1995), in *An Unquiet Mind*, writes 'Depression is like an amoeba, altering its shape to take in every corner of my life' (p. 38). There is beauty in this use of language, how wondrous that such descriptive power can be wrought from the most profound depths of anguish, so that our attention, our interest is secured and then intensified. And to imagine that this possibility is present in each clinical encounter, that even given the strictures of the circumstances of a clinical consultation, a precious and rich potential is waiting to be grasped.

And if I might, I want to compare the discourse between doctor and patient to the relationship between the writer and the reader. In fiction, the writer assumes common ground that is shared with the reader. This means that there is no need to explain the adventitious meanings of words, the implicit beliefs and prejudices that shape the possibilities of the novel. As Sartre put it,

> [P]eople of the same period and community, who have lived through the same events, who have raised or avoided the same questions, have the same taste in their mouths; they have the same complicity, and there are the same corpses among them. That is why it is not necessary to write so much; there are key-words.
>
> (Sartre, 1948/1993, p. 51)

This speaks to the common humanity of both doctor and patient, the shared understanding of the fragility of life and the precarious nature of normal experience. This stands at the foundation of the mutuality that Buber describes so well, and it is what makes a privileged situation recognizable and gives a faint outline of how it might be perfected as a work of art, made manifest, between two people. But the beauty of the work is only really perfected if it emerges spontaneously in the moment rather than if it is constructed by artifice or technique. There must be a degree of independence and freedom within the regulated formalities of the clinical encounter for the subtleties of the aesthetic to be provident.

If we think of the patient as the writer and the doctor as the reader, the promise of the clinical encounter becomes plainer and more explicit, namely that the patient is

making an appeal to the doctor to be understood, as writers do to the reader. The patient is appealing to the doctor to collaborate in the production of his work, his life and anguish, and requiring the doctor to recognize the patient as an agent in his own right, to trust the patient and to have confidence in the patient. Usually, in medical ethics, trust and confidence are features of what the patient desires of the doctor. But in this analysis, it is the doctor who must trust the truthfulness of the patient's account, who has to have confidence in the verisimilitude and good faith of the patient. These are aspects of the freedom of both parties and fundamental characteristics of what makes possible an aesthetic of the clinical encounter. Language is central to this endeavour and where, for whatever reason, there is failure in the attunement to the common purpose of language to aid mutuality and understanding, the possibility of any aesthetic of the moment is compromised. As Fiona Shaw (1997) put it,

> The psychiatrists were never interested in the words I chose. Words had only one side to them, as far as they were concerned; story-making was all very well so long as it didn't go too far […] So they found out very little about me, and so did I.
>
> (p. 188)

Mutual discovery of the possibility of an aesthetic moment, something precious and worthwhile, waiting to be grasped despite the improvident climate of the clinic, is facilitated and nourished by language.

Biographical Illusion

Finally, I turn to the conceptual dilemma—the distinction between a lived life and a recounted life, what Sartre in *Nausea* (Sartre, 1938) terms the biographical illusion. This is the idea that a lived life can resemble a recounted life and that for the commonplace to become an adventure, for example, it must be recounted. This is another way of saying that it is through storytelling, by narration, that we give shape and meaning to our lives. And that in living, we also structure each moment as if it were part of a story. But, Sartre's contention is that one needs to choose between living and recounting. I suppose the point is that living is spontaneous and structureless whereas living as if we are recounting, corresponds to some detachment from the immediacy and urgency of living.

In the clinic, patients are, by definition, recounting their lives, giving meaning to aspects of it and in the telling drawing causal connections between disparate elements, telling stories that make sense and with a narrative drive to them. This is not to say that these narratives are untrue. The goal of the accounts are determined by the nature of storytelling rather than the facts alone. The contingencies that are itemized in any story, whether it was a sunny day or a starry night at the start of the event, whether the significant other person was turned towards the narrator or away from them at the time, these

facts that come together to determine the beauty of the account, are chosen, and made salient by the subjectivity of the patient and their freedom as narrators. I want to emphasize this aspect of the clinical encounter so as to make explicit that aesthetic valuation enters into the clinical encounter in more than one way.

Conclusion

I have been drawing attention to the visual and spatial configuration of the clinical encounter as determinants of the aesthetic of the encounter. These configurations are already recognized as potential social cues that may confer evolutionary advantage, in for example, denoting social hierarchy and therefore also having aesthetic value. In this chapter, I have argued that visual social cues may also play a similar role. Eye gaze, focused and joint attention, mimicry, and reciprocal bodily movements may all serve as social cues that stand for aesthetic value that then act to deepen social interaction and understanding. I have argued that the doctor–patient relationship and the use of language are all involved in the making of the art of the encounter. I have concluded by hinting that independent of these is the way in which narrative structures influence the aesthetic of the encounter.

In this chapter, I have explored some of the characteristics of the aesthetic values that influence both the patient and the doctor in their joint enterprise within the clinical encounter by making links with Sartre's notions of privileged moments and perfect moments and Buber's account of the I-Thou relationship. The singular feature of the encounter is the pursuit of humanity in the face of the constraints of the professional context and the physical clinical setting. At a basic level, the drive towards mutuality, the understanding of shared humanity and the place of language make possible the emergence of an aesthetic of the clinical encounter.

References

Adorno, T. (1997). *Aesthetic theory* (translated by R. Hullot-Kentor). Bloomsbury.
Berlyne, D. E. (1971). *Aesthetics and psychobiology*. Appleton-Century-Crofts.
Buber, M. (1937). *I and thou* (translated by W. Kaufmann). Scribners.
Chatterjee, A., & Vartanian, O. (2014). Neuroaesthetics. *Trends in Cognitive Sciences 18*(7), 370–375.
Chatterjee, A., & Vartanian, O. (2016). Neuroscience of aesthetics. *Annals of the New York Academy of Science 1369*, 172–194.
Coss, R. G. (2003). The role of evolved perceptual biases in art and design. In E. Voland & K. Grammer (Eds.), *Evolutionary aesthetics* (pp. 69–130). Springer.
Flynn, T. R. (2014). *Sartre: A philosophical biography*. Cambridge University Press.
Hegel, G. W. F. (1975). *Aesthetics: Lectures on fine art volume 2* (translated by T. M. Knox). Oxford University Press.

Jamison, K. R. (1995). *An unquiet mind. A memoir of moods and madness*. Knopf.
Kant, I. (1790/2000). *Critique of judgment* (translated by P. Guyer & E. Matthews). Cambridge University Press.
Kirk, U. (2014). The modularity of aesthetic processing and perception in the human brain. In A. P. Shimamura & S. E. Palmer (Eds.), *Aesthetic science: Connecting minds, brains, and experience* (pp. 318–336). Oxford University Press.
Ruso, B., Renninger, L., & Atzwanger, K. (2003). Human habitat preferences: A generative territory for evolutionary aesthetics research. In E. Voland & K. Grammer (Eds.), *Evolutionary aesthetics* (pp. 279–294). Springer.
Sartre, J.-P. (1938). *Nausea*. London: Penguin Modern Classics.
Sartre, J.-P. (1948/1993). *What is literature?* (translated by B. Frechtman). Routledge.
Shaw, F. (1997). *Out of me*. London: Penguin.
Styron, W. (1990). *Darkness visible. A memoir of madness*. Cape.
Thornhill, R. (2003). Darwinian aesthetics informs traditional aesthetics. In E. Voland & K. Grammer (Eds.), *Evolutionary aesthetics* (pp. 9–35). Springer.
Zeki, S. (1998). Art and the brain. *Daedalus 127*(2), 71–103.

CHAPTER 48

AN EXPLORATION OF THE AESTHETIC MOMENT IN THE CLINICAL ENCOUNTER USING FREE MUSICAL IMPROVISATION AS A MODEL

ANDREW WEST

INTRODUCTION

I would like to introduce you to a group of musicians. Let us be flies on the wall in the lobby of a university arts building on a weekday evening. Musicians arrive, greet one another as they take out instruments, pull up chairs, and sit down forming a circle. There is a cello, a couple of violins, a viola, and a trumpet. One person sits at the piano, another at an electronic keyboard, and a third sets up a vintage analogue synthesizer, connecting the sockets with short lengths of wire and a piece of fool's gold in the jaws of a crocodile clip. Another pulls from a bag a selection of domestic implements: a cheese-grater, ceramic plate, steel comb, biscuit tin. There is an acoustic double bass and a melodion, cymbals, a singing bowl, and a set of panpipes. The chat fades, attention focuses, and someone starts to play.

The first sound could be a few speculative notes on the piano, or a sustained shimmer from a bowed string. It could be a constipated non-note from the trumpet, or a sudden cataclysmic crash from two cymbals picked up and dropped on the floor. It may be added to incrementally or leapt on by the others like footballers celebrating a goal. Contributions may mimic, join, contrast, or punctuate one another and the volume will wax and wane. After a while, and without any signal, play will come to an end. Whatever the character of the ending, it will be at that moment that the piece is defined, and it will

occur to you that this piece has never been played before and that there is no chance of its ever being repeated. This is Free Musical Improvisation (FMI).

Is there anything that can be learned from this and applied to the interaction between a clinician and their patient? I believe so. 'Aesthetic Moments in Everyday Clinical Practice' was the title of an advanced studies seminar of the Aesthetics in Mental Health Network, hosted in 2018 by the Collaborating Centre for Values-based Practice in Health and Social Care, in Oxford (AiMH Meetings, 2023). This chapter developed out of my presentation at that seminar. Whilst at the time a very experienced child and adolescent psychiatrist and a life-long amateur string player, I was still relatively new to musical improvisation. I have since played regularly with an FMI collective (Oxford Improvisers, 2023), explored some of the academic writing about improvisation, and reflected on the relationship between clinical practice and FMI. What I offer here is an emergent product of that process.

I shall discuss improvisation in music and clinical work, drawing comparisons between the two. My understanding and use of the word 'aesthetic' and the idea of 'aesthetic attitude' will be important to grasp, as they prove to be highly relevant in FMI as well as to pivotal moments in the productive clinical encounter.

I shall then reflect on the idea of 'moment', addressing the relationship between the 'aesthetic moment' and Daniel Stern's 'present moment' (Stern, 2004).

I shall focus on what we may learn from improvisational practice and the conditions that allow for the emergence of fleeting moments in the clinical encounter which occur during clinical treatment but are not an explicit part of it and which derive their power from the fact that they employ aesthetic attitude and are improvisational in nature. These moments, I believe, enhance the clinical relationship by transcending the norms and hierarchies that otherwise tend to dominate it. I shall stress a crucial proviso that applies in both FMI and clinical practice, namely that freedom demands a particularly acute ethical responsibility and is only safe within certain bounds. I do not advocate approaches, in the clinical setting, that lack or cross any of the boundaries of current clinical practice, but I hold that within these boundaries it is possible—indeed desirable—to exercise both freedom and the ethical responsibility that freedom entails. This is an aspect of good clinical practice that already pertains, but I believe may not be as thoroughly understood, taught, or applied as it could be.

I have allowed chance a significant role in writing this chapter, picking up threads and following them according to their salience. This approach may be relatively unfavoured in academic circles but is practically central to improvisation, and therefore represents my commitment to the process that I am describing.

Even so, due to the process of writing for publication, this chapter cannot escape being a carefully constructed artefact, rather than a fleeting utterance in a dialogic interaction. This is a pity because immersion in dialogic interaction is my preferred milieu and is more likely, I think, to yield developmental shifts in both parties.

Clinical material must be drastically altered to protect patients, not only from breaches of confidence, but also from the potential harm of seeing the integrity of their

experience deconstructed according to another person's perspective and agenda. This remains a concern, even when consented to by the patient. Clinical vignettes presented here are therefore fictional; constructed from elements of experience. They do not relate to individual people or events.

Improvisation

To improvise is to respond to unique circumstances, using familiar or unfamiliar elements in novel ways. The improvised is unprecedented. The translated Latin roots of 'improvise' are *not, beforehand,* and *seeing* (Onions, 1966). We improvise out of necessity when, having embarked on a favourite recipe, we discover that a key ingredient is missing from the kitchen. Alternatively, we may deliberately create the necessary conditions for improvisation because we know that it is the best way to do what we want to do.

> I was moving earth in the garden, sieving it for stones and breaking up clods as I did so. Frustrated that the size of sieve made this a slow process and casting around for ideas, I spotted a roll of chicken-wire and stretched it in a wide arch over the sieve. Shovelling earth onto this arch, I was surprised and delighted that its recoil caused larger material to rebound onto the source pile where it could be broken up and re-presented in an iterative fashion, speeding up the work in a way I had not anticipated.

Improvisation in Music

Improvisation has been a part of musical practice across the board, though its explicit role has been almost squeezed out of Western European classical music over the last century or so (Scholes, 1991, 509). Any scope for improvisation on the part of the performer, introduced in the last half of the twentieth century, still tends to be within limits prescribed by the composer (Bailey, 1993, 60 et seq.). Yet however rigid the score, a degree of improvisation remains at the point of performance and in the process of composition itself (Benson, 2003, 25). When not mandated or expected, there is still an element of idiosyncratic variation introduced by the performer. Without interpretation, nuance, and responsiveness to other players, the audience, the acoustics of the space, and the performer's own internal situation, a technically flawless performance can land flat and ineffective.

Conventional Jazz improvisation follows predictable chord progressions, incorporates fragments of melody which will be altered but still recognizable, and is generally of a set duration (Bailey, 1993, 48). Underlying structure is much less evident

in 'Free jazz', but it is in FMI that the constraints on the freedom of the performer are at their most flimsy though, as we shall see, are not absent.

Free Musical Improvisation

Borgo (2002a) succinctly charts the emergence of freely improvised musical styles and suggests that the primary bond that unites these diverse groups is 'a fascination with sonic possibilities and surprising musical occurrences and a desire to improvise, to a significant degree, both the content and the form of the performance' (167).

There may be a perception that 'anything goes', but this would be wrong. Backstrom's view (2013) is that free improvisation is far from free, being suffused with its own conventions and taboos. But of greater relevance to the argument I am building, Kanellopoulos (2011), drawing on Bakhtin and others, argues persuasively that ethical decision-making comes to bear exactly when one is called upon to act in a situation in which clear rules governing choice are absent.

When we think of freedom, we typically focus on what we are freed from without giving much thought to what we will do with this freedom—until we find ourselves having to choose and act. This question is constantly addressed in FMI, but its ethical importance becomes obvious in clinical situations where crucial choices are made in the face of uncertainty.

Free Musical Improvisation does not just cope with uncertainty when it arises, it positively fosters it. Players may at times deliberately reduce their own intentional control over the sound produced. The musician with the synthesizer knows that using the fool's gold, with its uneven surfaces and non-linear electrical properties, is a way of producing an effect, part of which is unpredictability. But lack of control is not embraced lightly; it is not that it does not matter, or that it can be corrected. An important feature of each action taken is that it is irrevocable; redeemed not so much by forgiveness as by the ongoing committed intention of the practitioner. As Kanellopoulos (2007, 113) says, 'there is nothing that can "save" the process from collapsing but the promise that one will keep fighting for the best, even at moments perceived as problematic.' Clinical practice can also, at times, feel like this.

The contemporary classical composer, Thomas Adès, describes placing notes in a context to see what they will do (Service, 2012, 2). Adès might not regard this approach as improvisatory, but it strikes me that it describes a relationship with the notes and an openness to their contribution to the process. This is in effect an unscripted, dialogic approach which has much in common with improvisation.

Somewhat similarly, in composing the book title, *The Improvisation of Musical Dialogue,* Benson (2003) places the words 'musical' and 'dialogue' next to one another. The juxtaposition of these words places them in a new relationship with each other in our thinking. We start to notice ways that music can behave like dialogue, and vice versa.

'Playing music', says Benson, 'is an ability that one gains through a combination of learning essential elements and understanding how they are to be utilized' (2003, 139). In my experience, learning to 'play' child psychiatry is a similar process. It is this accumulated skill and understanding that enables one, under the right circumstances, to improvise relatively safely.

Free Musical Improvisation, therefore, provides a practical analogy for disparate human activities. One of the very experienced members of Oxford Improvisers said to me shortly after I joined the group, that the reason he values FMI so much is 'because it is so like real life' (Philipp Wachsmann, personal communication, 18 March, 2018). Kanellopoulos's (2011, 121) way of putting it is this: 'Improvisation is exactly that mode of musical practice that *demands* actions which are not simply a realization of a specific set of rules. And it is in this sense that it comes close to everyday life.' We all improvise, but we are not all aware of when, or how, we do so. Nor are we aware of the importance of many of the small things we do, both in terms of implication and outcome.

> A new member brings their clarinet to one of the weekly evening meetings of the FMI collective and returns the following week and the week after that. During a pause in this third week they ask, 'Are all your pieces twenty minutes long?'. The seasoned members greet this question with a degree of amusement, reflection, interest, and surprise: 'Are they?' one of them says. Apparently, they had been.

Specified length may be part of the compositional frame of a freely improvised piece, but generally there is no firm expectation. At some point there is silence. It may have been settled into, rather as a cat prepares its bed, or it may be sudden like a toddler dropping onto their bottom on the lawn. What I have noticed in the group I play in, is that there is hardly any speech for a while after playing stops. I have a sense that anything that might have been achieved by talking has already been amply achieved through the music.

To summarize:

- Improvisation is the use of techniques and materials in unique ways, variously informed, and chosen in the fleeting moment.
- Improvisation takes place somewhere in all music, as in all life, though degrees of freedom vary.
- Free Musical Improvisation distils and exemplifies concepts important in the clinical context.
- Freedom from constraint brings a heightened ethical responsibility for choices which must take prevailing circumstances and protagonists into account via highly attentive listening, and with an openness of mind that I am calling aesthetic attitude.

Aesthetic Attitude

> A group of free musical improvisers, by arrangement with the curators, performed in the impressive setting of a museum. Over the course of an hour, they dispersed amongst the displays before gathering again for a fanfare to mark the end. There was visible interest from visitors savouring objects, people, and museum spaces uncharacteristically connected by networks of sound, and one person later said that dead objects had been brought alive. As the applause faded and silence reasserted itself, a member of the public was heard to mutter to their companion, 'I don't know what all the clapping was for. That was bloody awful!'.

The word 'aesthetic' is frequently confused with 'beautiful', but beauty, as we were taught from an early age, is in the eye of the beholder; a judgement arising in the mind of the subject and dependent on personal and social values. 'Aesthetic', when used in the way that I use it in this chapter, describes an approach rather than an object, and has much more to do with exploring experiential or perceptual qualities, than the pursuit of beauty or the laws of taste (Kanellopoulos, 2011, 115).

When I spoke on 'the aesthetic moment' in 2018, I asked my audience to listen, not as they would normally do to a presentation at an academic or clinical seminar, but rather as they might listen to a musical performance. My hope was that my utterances, rather than being taken as declarative statements to be either ingested whole or measured against expectations, might be experienced as contributions to a dialogic or developmental process within which discovery would be possible. It was after the event that I realized that I had effectively asked the audience to adopt an aesthetic attitude.

If we adopt an aesthetic attitude towards an object or experience, our reception of it is independent of utilitarian and motivated value, either personal or instilled, and we experience it 'for its own sake' (Honderich, 2005, 8). We set aside established values and greet experience with open-minded attention to its intrinsic nature.

The area is not without controversy, and a case in point is that of Jerome Stolnitz (1978) and George Dickie (1984), whose difference, when it came to aesthetic attitude, appears to be mainly on the extent to which it is possible for a subject to be 'disinterested' when perceiving an object. In my view, engaged curiosity is a kind of 'interest' that is totally consistent with aesthetic attitude. I can retain a lively curiosity whilst dialling down my critical, utilitarian, and values-based associations.

> A musician draws a serrated edge across the side of a cymbal making a sound that many people would associate with metalwork, perhaps breakage or harm, and describe as unpleasant. Paying attention to the complexity of the sound, we hear a multitude of ringing tones, percussive clicks, and white noise, with oscillations in

pitch and volume, and a long decay after an abrupt starting section. We develop a fresh awareness of qualities that were entirely missed in previous, habitual, socially reinforced, assessments.

In FMI our approach is practice-based, rather than theoretical. Knowledge of the process may be acquired and assimilated at a profound level yet may still not be sufficiently amenable to verbal articulation, and therefore struggle to do itself justice in a verbal milieu. With this proviso, my own description of aesthetic attitude, in both FMI and clinical practice, would include: attending to sensory qualities; welcoming with curiosity the unfolding moment; valuing the process of perception and the diversity of perceived phenomena in themselves; an open mind in relation to meaning including a readiness to question or set aside socially commonplace meaning; and indifference towards utilitarian value as an end in itself. This last point may require clarification. As a musician I may hope to attract an audience but, in the moment of playing, I am indifferent to that outcome. It is a little like counting sheep to combat insomnia; while I am worrying about whether it is working or not, I am not counting sheep, and it is not working either; when I forget the aim, my attitude becomes more like an aesthetic one; I count sheep and drift off to sleep.

The Idea of 'Moment'

A moment can be both a point in time, and a short period of time (Sykes, 1976). The word captures brevity, and yet duration. It both separates and joins what went before and what comes after. It passes and is gone, exactly as it is apprehended.

In physics, 'moment' is the turning power of a force (Sykes, 1976). In 2018 I sketched the following scenario:

> Imagine a pivot and a force. Nothing else, for the time being. We will give the pivot inertia; the capacity to resist the effects of force. The force is intangible and invisible—strictly speaking implausible—and does not directly face the pivot. There is nothing happening. They are of no relevance to one another. This situation pertains until a connection—rigid, for the sake of my argument—is established between the two at which point things immediately begin to make sense; the pivot and force are now in a relationship with one another; the force becomes a *moment* and movement is implied.

The two meanings of 'moment' share a Latin root relating to movement (Onions, 1966); something that moves (time) as well as something that can cause movement (an angular force). So, it is neither irrelevant nor coincidental that this word brings together a passing fragment of time, connection, and a resultant power to alter position, speed, or trajectory. In the therapeutic context, this might be the transformative change that is required, and it can be 'momentous'.

When two people are in relational proximity—like Adès' notes and the words in Benson's title—they are invited to discover what they have to offer one another, not just in transactional terms, but also in relation to meaning. If there is a sufficiently transactional agenda, we are generally unlikely to stray into the realm of meaning, and when the situation is open-ended, we are more likely to clam up in embarrassment or pass the time with platitudes, than to explore what we mean to one another. We need considerable motivation, plus the right transactional setting—maybe therapy—before we allow the necessary connection and the 'moment' to take effect. Psychotherapy is a sort of trojan horse. It appears formulaic, but its formula contains unstructured tracts of time and opportunities for such unforeseen moments.

> I was explaining the idea of the aesthetic moment to a psychologist friend who looked at me uncomprehendingly. I knew them to be an art lover and asked what happened when an artwork really caught their attention. 'I suppose it touches me deeply', they said, 'and possibly changes something in my thinking.' When I asked if anything like this happens in the context of work, their eyes lit up. Nothing more needed to be said, but the change was confirmed when they described, 'that moment that arises in therapy when I know that my skill and effort have connected with something meaningful in my client; a connection that can enable change.'

The aesthetic moment is a moment in time, profoundly appreciated by its participants; a moment in which a connection is made between something deep in the patient and the skill and effort of the clinician, such that a change of direction becomes possible.

The American psychiatrist and psychoanalytic theorist, Daniel Stern, described moments of conscious awareness that last up to around ten seconds (Stern, 2004, 41). Stern called these 'present moments' and was struck by their tendency to be pivotal in the experience of the individual. These are not just *times* of change but, by Stern's own implication, also *instruments* of change, both in therapy and in everyday life (2004, 165 and chapter 13).

Stern was especially interested in present moments that were shared between two people in a process similar to resonance, and more formally called 'intersubjectivity'; when each is aware that they are sharing experience, and each is aware that they are within the awareness of the other (2004, xi et seq.).

Stern developed these ideas whilst working with two ostensibly unconnected groups: dancers and choreographers in an artistic setting, and mothers and babies in a therapeutic one. These groups and settings were linked by the communicative and improvisational nature of interactions that occurred in both.

Stern believed intersubjectivity to be a fundamental human motivation of similar importance to attachment and sex (2004, xvi). The salience of this motivation is evidenced by the variety of occasions we have for gathering together and sharing experience—for example, church, sport, parties, concerts—and our tendency to structure briefer interactions and increase the common ground, using greetings, conversations about weather, humour etc. But manufactured shared experiences are pale imitations of the

spontaneous alignment and sharing that can happen in less orchestrated moments of meeting.

The accounts that Stern's subjects provide of present moments include significant perceptual detail, but they also reveal values and meanings, and it is mainly this that differentiates them from aesthetic moments, though I think the two overlap to a substantial degree. It is important to appreciate that aesthetic moments might, but need not, meet the criteria for a present moment, and vice versa. I focus on the aesthetic moment because I believe that clinical practice would stand to gain from a better understanding of this aesthetic approach.

Do Free Musical Improvisers Recognize 'Aesthetic Moments'?

The literature on FMI describes an approach akin to aesthetic attitude, whilst using different terminology. For example, Kanellopoulos (2007), who uses 'attitude' almost in passing, describes 'improvisation ethic' as an 'intention to enter into dialogue and discovery of sounds and ways of response' (113), and 'improvisatory process' as 'without aspirations beyond itself' (107). To find out what my fellow improvising musicians might make of it, I used a popular business communication platform to open a written conversation with them, using 'Aesthetic Moment' as a topic heading and, when pressed for clarity, defined 'moment' as a 'fleeting period of time' and kept a deliberate vagueness around 'aesthetic'. My aim was to encourage as open a discussion as possible whilst being an active part of it, introducing my thoughts and reading gradually, as they became relevant.

A rich conversation resulted, involving eight participants over two months, and generating over 6,000 words of text. Space does not permit a full description of content. I summarized what I judged to be the most relevant and consistent points (leaving aside, for example, interesting comparisons with visual art) and returned my summary to participants for validation with the writing of this chapter as an explicit purpose. These summary points appear below, in my original wording. My subsequent additions and reflections are in square brackets.

(1) Improvising musicians adopt a readiness to accept what comes along in FMI and work with it. This approach has some parallels with aesthetic attitude.
(2) They attempt to travel with the other musicians, making what Daniel Stern might call relational moves, but there is a limit to this capacity and at times the relationship breaks down—which we have called 'not getting it'.

['Travelling with' does not necessarily take the form of mimicking, supporting, following; it can involve challenge, contrast, silence. There is less consternation towards

divergence in FMI than one generally finds in relation to failed relational moves in social or therapeutic contexts. Divergence in FMI, rather like dissensus in values based practice (Fulford et al., 2012), is regarded as a vitality running through the work, rather than a problem to be solved or diffused. As Charnley (2011) argues, 'dissensus is part of the social reality of collaborative art' and may be 'best served by listening, as long as listening does not always mean agreement' (pp. 50, 52). Although relationships in FMI can break down, divergence must be profound, and probably on several fronts, for it to overcome the cohesive ethos of FMI (Borgo, 2002b).]

> (3) Some moments may be experienced by individuals as 'special' in some way—whether in terms of process or product—but there is general agreement that assessment is subjective, experience is individual and diverse, and people will likely disagree on which moments are special and/or why. This discrepancy is in no way daunting.

[Pras et al. (2017) reached a similar conclusion experimentally.]

> (4) Participation in FMI, either as a player or listener, is generally described as requiring effort, attention, and agility in the moment.

[The role and experience of the listener is discussed by Bertinetto (2012).]

> (5) Music is experienced as having a special relationship with time. The product is fleeting, unless recorded; memories and expectations may be brought to the process, but attention is focused on the passing present, to the almost total exclusion of elsewhere and else-when.
> (6) There is a mystery or magic to the process which appears to defy description, and the moment is a 'lived experience' to use Stern's terminology.
> (7) There is an interesting but relatively unexplored area of fear.

[Fear is frequently cited as a possible explanation of negative reactions to the *avant garde*. A much more positive connotation of fear is provided in the skiing analogy below.]

The idea of an aesthetic moment did not reflect the experience of this group of musicians, I think because aesthetic attitude is effectively at the core of FMI. Rather like fish asked their opinion on water, these improvisers take aesthetic attitude so much for granted that they forget they have adopted it. This contrasts with the clinical setting in which most practice does not, and should not, employ aesthetic attitude, as I shall argue below. If two musicians happen to coincide in their assessment of a given moment and are aware of this, then something more like Stern's 'moment of meeting' has taken place. A powerful subjective sense of convergence is clearly possible, as evidenced by the improvising percussionist Eddie Prévost who said, 'I defy any musician not to rejoice, to be exhilarated, by those moments when you really… something just happens…

some kind of convergence... some kind of confluence of activity creates a moment that you've never had before. Those sublime moments come out of this kind of experience' (Prévost, 2021; my transcription). This sounds like the characteristic ending of the 'aesthetic experience', called 'consummation' by the American philosopher and educational reformer, John Dewey (Petts, 2000, 62). Dewey's idea of 'consummation' includes a feeling of 'harmony' or 'rightness' which evokes aesthetic attitude in that it does not depend simply on the satisfaction of performance criteria or the achievement of goals (Petts, 2000).

Dewey also associated aesthetic experience with a sense of 'movement' which he attributed to the fact that the subject is a living creature (Petts, 2000). Movement became breakneck speed in the context of the conversation summarized above.

One musician wrote, 'there is an aspect of anticipation in the music about to happen in the immediate future. It then materializes as one of many possible outcomes that we cannot entirely predict' (Mark Browne, personal communication, 13 June, 2021), and I responded in a spontaneous outflow:

> I really like this! Music travels through time. We travel with it by embodying the changes as they happen. The fulfilment and frustration of expectation is a big part of the appreciation of it. I remember skiing a steep descent much of which followed a winding track through trees, over bridges. It would have been hair-raising if attention and reaction had not been fully employed keeping up with the twists and bumps. Expectation was just a hair's breadth ahead of actuality and having it fulfilled brought a flash of feeling loved, whilst surprise felt more like being entangled with a worthy adversary. Music can feel like this.

Improvisation in Clinical Practice

Perhaps we are reluctant to publish accounts of frank improvisation in clinical practice, but we know they occur. Celentano, Ausobsky, and Vowden (2014) list an impressive range of techniques used to control bleeding under difficult circumstances and, although the word is not used, improvisation, as defined above, clearly played a part. Martelluci (2015) makes an eloquent case for the importance of improvisation in improving team communication, leadership, and in hands-on surgical practice, pointing out the importance, for example, of simultaneous reflection and action, and the continuous mixing of the expected with the novel. Oxtoby (2012), in a collection of good Samaritan acts, provides an account of clinical improvisation on a commercial flight. Improvisation of a more subtle kind is ubiquitous. The unexpected is always just around the corner, every person and situation is unique, and clinicians and clinical services need to be able to flex and adapt if patients' values are to be incorporated into clinical practice (Sackett et al., 1996; Fulford, 2008). Clinicians need to be trained in the skills of managing freedom: listening, dissensus, and responding creatively in the moment.

Irrespective of the branch of health care under consideration, one way to define treatment success would be for the patient to achieve relative freedom from physical, personal, and social constraints to live a fuller and more relational life. The political philosopher, Hannah Arendt, gave 'action' a specific connotation and considered it an expression of freedom and a communication of who we are which, by definition, takes place in public (Kanellopoulos, 2007, 101–106). The conditions of FMI and therapeutic relationships are similarly public. Both involve shared exploration and emergence; in both, participants demonstrate the existential importance of the process in their communicative act.

Kanellopoulos (2011, 120–121) quotes Prévost describing 'this collaborative art… in which musicians discover who they are and what they might become, not through speculation but through praxis… We hear and are determined to make sense of what is heard.' He might just as well have been speaking for therapy as for music.

When talking about clinical freedom we should acknowledge the importance, not only of specific 'treatments', but also the ways that clinicians and services treat—as in *behave towards*—patients all the rest of the time. I call these, respectively, treatment *on the lines* and *between the lines* (West, 2016, xii). Each of these is important, but considerably more effort goes into training clinicians in specific treatments, than how patients are treated in betweenwhiles. When the surgeon fashioned a chest drain out of a urinary catheter (Oxtoby, 2012), it was treatment *on the lines* that was improvised. A recognized procedure was carried out in a spontaneously novel way. It is useful to keep this distinction in mind, even though it is not a rigid one. Chatting about the dog would be *between* the lines for a surgeon, and *on* them (and possibly questionable practice) for a psychodynamic therapist. There are real dangers of freedom in the wrong place or irresponsibly applied. Nevertheless, I believe we are too far from an informed acceptance of the importance of improvisation, both on and between the lines, in clinical practice.

There is an argument that jazz might serve better than FMI as a model for clinical practice (e.g., Haidet, 2007; Martelluci, 2015). In conventional jazz, form and choice are considerably more rule-bound than in FMI, and the degree to which the players and audience members can adopt an aesthetic attitude to the music is arguably much less. This makes conventional jazz the better analogy for clinical practice, in the main. But by the same token it provides less of a test bed for the affordances and responsibilities of freedom. Conventional jazz might show us how to improvise in a scripted way but would not adequately address what is happening in those moments *between the lines* where a much greater degree of freedom reigns. It is one thing to improvise a circumscribed aspect of a treatment that is otherwise goal-directed and carried out on familiar lines. It is altogether something else to manage the degree of freedom required to work when the process is up for grabs as well as the content.

> A mother asks the family doctor what to do about her son's avoidance of school and temper outbursts. The doctor refers the boy (let us call him Chad) to be assessed for Attention Deficit Hyperactivity Disorder. Chad is brought to the clinic and promptly goes into the toilet and locks the door. The clinician considers the option

of abandoning the appointment but instead passes a note under the door; 'Hi Chad. I'm Mel. Who would you like me to talk to?'. There is silence and then something mumbled. Mel says, 'Sorry. I didn't catch that?' and Chad says, more clearly, 'Can I have a pen?'

Patients' values are finding a voice, and initiatives like joint decision-making and patient-led services abound. We know that each patient is unique in their formation, circumstances, and expression. Yet still we live in a culture of prescription and adherence to treatments for precisely defined conditions set down in guidelines of increasing specificity.

Arguably the medical context is one in which 'methodolatry'—the privileging of methodological concerns over other considerations (Chamberlain, 2000)—holds considerable sway and objective and repeatable measures are held as a sort of gold standard. There is a parallel in the world of music education. Kanellopoulos tells us (2011, 118) that many teachers 'adopt a dismissive and defensive stance towards improvisation ... , for they do not know how to respond to something for which no pre-defined standards of excellence can easily be prescribed, nor an ordered course of development can be designed' and argues for more in the way of experimentation and respect for student voices (Kanellopoulos, 2007, 99).

Stern makes it clear (2004, 131) that two individuals in different states can experience this mismatch sufficiently jointly for it to amount to an intersubjective experience. He hints that the opposite can also apply (2004, 109) when he says that ' ... participation in rituals, artistic performances, spectacles and communal activities ... can all result in a transient (*real or imagined*) intersubjective contact.' (Stern's parentheses; my emphasis).

Given the therapeutic power that Stern attributes to the present moment, and moments of meeting in particular, clinicians might begin to treat these as goals in themselves. I think this would be a mistake. Rather like the manufacture of mass shared experience, it might satisfy in one sense, but would not necessarily be in the interests of individual development. As long as we have sufficient alacrity and can, in real time, appreciate the fact that we are *not* on the same page, a moment can still be turned to good ends.

> A therapist arrives, late and flustered, and collects their patient from the waiting room. Whilst apologising for lateness the therapist lets slip personal information and immediately regrets this. When the patient shows an interest, the therapist, rather than deflecting, admits it and quickly feels reassured by the patient's manner and moving on that doing so has not been a disaster. The therapist later traces a subsequent shift in therapy back to this apparent slip and describes the moment as one of 'connection'; the relationship 'gelling' in a new and constructive way.

The supposed mistake unseated the therapist, but all was not lost. Stern describes the importance of 'sloppiness', provided it occurs within an established framework. Two minds work in a 'hit-and-miss-repair-elaborate' fashion to cocreate and share similar worlds that are lived-through, more than understood. Sloppiness, ' ... has gone from a

big problem in understanding treatment to one of the keys in grasping its enormous creativity' (Stern, 2004, 156–165).

Aesthetic Attitude in Clinical Practice

Accepting the patient—taking them as they are—has something of the aesthetic attitude about it. Non-therapists, and those early in their training, sometimes wonder how it is possible to treat someone if you don't like them. One answer is that, as in FMI, liking or not liking do not feature when one is genuinely attending to the patient (or the music).

The therapist, maintaining composure after slipping up, demonstrated not only improvisation in practice but aesthetic attitude also. In FMI one does not think of things as going wrong, so much as notice what is happening in the moment and decide what next action to commit oneself to.

'Hit-and-miss-repair-elaborate' can take place between an artist and their material or between two or more people. When clinicians take this approach, though, they must be careful to avoid treating their patient as 'material'. The patient must be seen as another subject in an intersubjective process. The medical regulator and the court severely sanctioned the surgeon who signed the livers of his patients, describing it as 'medical arrogance' (Chao-Fong, 2022). If clinicians can avoid getting it wrong by remembering intersubjectivity, this case demonstrates the importance of doing so, even when the patient is unconscious. 'Learning Respect' was how we put this in 2001 (West et al., 2001).

When the therapist perceives and makes sense of nonverbal 'communication by impact' (Casement, 1985, 73) the patient can begin to feel that someone, at least, is able to connect with them. Wilfred Bion's instructions were, 'Discard your memory; discard the future tense of your desire; forget them both, both what you knew and what you want, to leave space for a new idea' (Casement, 1985, 222).

Privileging perception, setting aside knowledge and motivation, learning from the patient, not dwelling on error but turning the moment to therapeutic advantage, improvisation, and values-based practice, all require a degree of aesthetic attitude. And it is the intersubjective, ethical, and process-orientation of this understanding of 'aesthetic' that explains the political, philosophical, and participatory appeal of FMI *and* the relevance of aesthetics to the clinical encounter.

The Aesthetic Moment in Clinical Practice

My clinic room gathered, over the years, an interesting collection of items. Balanced above the door was a very small gorilla that some of my young patients would spot

as they left. The large rock on the windowsill and the cactus on the mantlepiece were recognized by the team as rebellious gestures on my part, and statements on risk. There was a cardboard box under the desk, with 'Andrew's Toys' written on it in felt-tipped pen, containing a jumble of vehicles, figures, animals, shapes, and such-like. This room was like the musician's bag described in the introduction to this chapter—full of kitchen implements and found objects—and it was my patients who chose which things to use and what to do with them. The room and elements of ambiguity were invitations to improvise, though we never called it that.

Each object played its part, over and again, for different people and in different ways; the rock on the windowsill, noticed, contemplated, fingered, and never thrown—a shared drama on risk, responsibility, and choice; the cactus for its prickly defences; unfamiliar construction kits which could be made into elaborate structures to be admired, puzzled over, or ignored, by parents, and persisting or perishing between appointments.

The context was always a referral for something or other; perhaps mysterious physical symptoms, behaviour interpreted as naughtiness, depression, anxiety, or fearful and fear-inducing experiences. These objects were the material *and* the prompt for shared improvised moments and communicative, self-defining action.

> A junior doctor joins a mental health team for a few months as a locum and, on leaving, is given a plastic 'doctor's bag' as a parting gift: a small red plastic case containing non-functioning approximations at a syringe, forceps, thermometer, and stethoscope, in primary colours. A couple of decades later, after travel, neglect, and diverse uses and abuses, it is again fished out from under the desk by—let us say—a nine-year-old called Sam. The doctor is talking with a parent while Sam sorts through the contents of the case, exploring each item. After a while, as the adult conversation continues, Sam crosses the room with the stethoscope and draws the room's attention by placing the bell on the doctor's chest. 'What can you hear?', the doctor asks. 'The sea!', Sam says, making eye contact.

The objects in the room may be, on the face of it, non-functional, but they function by offering ways to connect and communicate. The anthropologist Gregory Bateson, responding to a question from the improvising musician Stephen Nachmanovitch (2019, p. 108), said that beauty is 'recognition of the pattern which connects' and I remember hearing an astronomer, asked on BBC radio about the colours added to images of distant galaxies, saying that we make information beautiful in order to understand it. Many people resort to visual images to improve their understanding. As McCandless's (2009) book title states, 'Information is beautiful'.

These examples each hint at a connection between subject and object that is a step away from the logical or utilitarian. Though interested in connection, we may need to be shifted from our habitual stance into a more perceptual one to grasp it.

At this point I realize what I was missing when I thought of the 'aesthetic moment'. A moment in time is not aesthetic or non-aesthetic. It is not even the moment that is

experienced in a more or less aesthetic way. The phrase only makes sense to me now if I think of the 'moment' from physics; the turning power of a force. The double meaning is crucial.

Moments that a clinician finds pleasurable or special in some way quite possibly pass unnoticed or are experienced differently by the patient. They are quite likely to have been appreciated by the clinician with a value-laden rather than aesthetic attitude; arguably more self-absorbed than patient-centred. On the other hand, there may be a felt satisfaction that arises from good clinical work done. We must be wary of deluding ourselves at these times, and the satisfaction should not be a goal in itself, but if this was the Deweyan 'consummation' referred to above then perhaps it was a marker of good listening at an unstructured moment in an otherwise structured interaction; a moment in which the hierarchy was briefly dissolved along with assumed value sets, and experience could be appreciated with a more perceptual, less judgemental, and less utilitarian interest. If so, then it may be a powerful moment and should be treated with the respect that it deserves.

Conclusion

The service was to move to new premises and the cupboards and high shelves in the clinic room had to be cleared. I pulled down a pile of material amongst which was a large sheet of paper folded in two. The sheet was stuck closed by a mixture of paint and glitter-glue and would have to be thrown away. I found myself remembering an indistinct face and a voice saying, 'You can keep it.' and hoped that, at the time, I had made no promise to do so. I was in dialogue with an object and a mixed-up memory and found some reassurance in the thought that that moment of pause reflected the attention and specialness that had been felt in relation to, not one patient, but each and every one of them.

It occurs to me that the way to honour all the things that must be honoured is to signal with sincerity that this *moment* is special; intersubjectivity is fleeting, and yet leaves each party with a trace and the possibility of further moments of connectedness. But that is just my solution at this moment. It may or may not be of use in the future.

I close with a list of things I have learned from FMI that I believe have something to offer in the context of clinical practice:

- Free Musical Improvisation is not just about music. It epitomizes an ethos of relationship between people, their experience, and action.
- Improvisational listening is a good metaphor for attention that is agile, rapt, open-minded, and ready for anything.
- As well as being ready to detect and avert danger, clinicians need to be skilled in an attitude that welcomes novelty and is undeterred by ambiguity.

- Mindfulness meditation, by emphasizing our relationship with experience in the passing moment, may be a good introduction to aesthetic attitude, particularly for those without access to an experienced group of free musical improvisers.
- Dissensus, the holding in process of difference, and the 'yes, and' mindset—possibly three ways of saying the same thing—are key to cocreation.
- Ethical choice comes into play precisely at those times when freedom reigns. Where there is no freedom, there is no need of ethics.
- In a culture of 'methodolatry', we urgently require training in 'sloppiness'. 'Hit-and-miss-repair-elaborate' teaches us to take responsibility for our contributions in a process that discovers its own form and content as it moves forwards.
- Moments may be experienced as special for a variety of reasons and in different ways. Not all of these indicate intersubjectivity, and not all of them have any particular merit aside from pleasure or satisfaction. But some are opportunities for—and instruments of—change and we need to understand them better.
- Unpredictability is inevitable in life and, therefore, in clinical practice. Improvisation is a necessary part of our response to unpredictability, and we should be developing our familiarity with the improvisational triad: listening, expertise, and agility.

Unstructured moments, responded to with an improvisatory and therapeutic ethic can reach parts hitherto unreached, and can engender change. Like Stern's present moment, these powerful agents of change and the skills required to make them productive as well as safe should be of interest to clinicians and services. We need to be capable of quality work in unstructured situations, as well as when we are working to a script. Aesthetic attitude is worth learning about and practising, and free improvisation might help us to do this.

Dedication

I dedicate this chapter to the Oxford Improvisers collective which practices and demonstrates the hospitality and discipline that I hope I have described.

References

AiMH Meetings. (2023). The collaborating centre for values-based practice in health and social care. Available at: https://valuesbasedpractice.org/what-do-we-do/networks/aesthetics-in-mental-health-network-aimh/aesthetics-in-mental-health-network-aimh-meetings/ [last accessed 6 October 2024].

Backstrom, M. J. (2013). The field of cultural production and the limits of freedom in improvisation. *Critical Studies in Improvisation / Études critiques en improvisation* 9 (1), 1–9. https://doi.org/10.21083/csieci.v9i1.2147

Bailey, D. (1993). *Improvisation: Its nature and practice in music.* Da Capo Press.

Benson, B. E. (2003). *The improvisation of musical dialogue: A phenomenology of music.* Cambridge University Press.

Bertinetto, A. (2012). Improvisational listening? *Proceedings of the European Society for Aesthetics 4*, 83–104. https://proceedings.eurosa.org/4/bertinetto2012.pdf

Borgo, D. (2002a). Negotiating freedom: Values and practices in contemporary improvised music. *Black Music Research Journal 22* (2), 165–188. https://doi.org/10.2307/1519955

Borgo, D. (2002b). Synergy and surrealestate: The orderly disorder of free improvisation. *Pacific Review of Ethnomusicology 10*, 1–24. https://ethnomusicologyreview.ucla.edu/sites/default/files/prevol10.pdf

Casement, P. (1985). *On learning from the patient.* Tavistock.

Celentano, V., Ausobsky, J. R., & Vowden, P. (2014). Surgical management of presacral bleeding. *The Annals of The Royal College of Surgeons of England 96*, 261–265. https://doi.org/10.1308/003588414X13814021679951.

Chamberlain, K. (2000). Methodolatry and qualitative health research. *Journal of Health Psychology 5* (3), 285–296. http://dx.doi.org/10.1177/135910530000500306

Chao-Fong, L. (2022). Liver-branding transplant surgeon struck off medical register. *The Guardian*. 11 January, 2022. Available at: www.theguardian.com/society/2022/jan/11/liver-branding-transplant-surgeon-struck-off-medical-register [last accessed 6 October 2024].

Charnley, K. (2011). Dissensus and the politics of collaborative practice. *Art & the Public Sphere 1* (1), 37–53. https://doi.org/10.1386/APS.1.1.37_1

Dickie, G. (1984). Stolnitz's attitude: Taste and perception. *The Journal of Aesthetics and Art Criticism 43* (2), 195–203. https://doi.org/10.2307/429993

Fulford, K. W. M. (2008). Values-based practice: A new partner to evidence-based practice and a first for psychiatry? *Mens Sana Monographs 6* (1), 10–21. www.ncbi.nlm.nih.gov/pmc/articles/PMC3190543/

Fulford, K. W. M., Peile, E., & Carroll, H. (2012). *Essential values-based practice. Clinical stories linking science with people.* Cambridge University Press.

Haidet, P. (2007). Jazz and the 'art' of medicine: Improvisation and the medical encounter. *Annals of Family Medicine 5* (2), 164–169. https://doi.org/10.1370/afm.624

Honderich, T. (Ed.). (2005). *The Oxford companion to philosophy*, second edition. Oxford University Press.

Kanellopoulos, P. A. (2007). Musical improvisation as action: An Arendtian perspective. *Action, Criticism, and Theory for Musical Education 6* (3), 97–127. http://act.maydaygroup.org/articles/Kanellopoulos6_3.pdf https://eric.ed.gov/?id=EJ804698

Kanellopoulos, P. A. (2011). Freedom and responsibility: The aesthetics of free musical improvisation and its educational implications—A view from Bakhtin. *Philosophy of Music Education Review 19* (2), 113–135. http://dx.doi.org/10.2979/philmusieducrevi.19.2.113

Martelluci, J. (2015). Surgery and jazz: The art of improvisation in the evidence-based medicine era. *Annals of Surgery 261* (3), 440–442. https://doi.org/10.1097/sla.0000000000000782

McCandless, D. (2009). *Information is beautiful.* Collins.

Nachmanovitch, S. (2019). *The art of is. Improvising as a way of life.* New World Library.

Onions, C. T. (Ed.). (1966). *The Oxford dictionary of English etymology.* Oxford University Press.

Oxford Improvisers. (2023). Dan Goren. www.oxfordimprovisers.com/

Oxtoby, K. (2012). Good Samaritan experiences. *British Medical Journal 345*, E8491. https://doi.org/10.1136/bmj.e8491.

Petts, J. (2000). Aesthetic experience and the revelation of value. *The Journal of Aesthetics and Art Criticism 58* (1), 61–71. https://doi.org/10.2307/432350.

Pras, A., Schober, M. F., & Spiro, N. (2017). What about their performance do free jazz improvisers agree upon? A case study. *Frontiers in Psychology 8*, 1–19. https://doi.org/10.3389/fpsyg.2017.00966

Prévost, E. (2021). *Eddie Prévost's Blood*. Film directed by Stewart Morgan. Hajdukino Productions. LondonsScreenArchive. (At 17m 30s). Available at: www.youtube.com/watch?v=03DNA8lTMF4 [last accessed 6 October 2024].

Sackett, D. L., Rosenberg, W. M., Gray, J. A., Haynes, R. B., & Richardson, W. S. (1996). Evidence-based medicine: What it is and what it isn't. *British Medical Journal 312*, 71–72. https://doi.org/10.1136/bmj.312.7023.71.

Scholes, P. A. (1991). *The Oxford companion to music*, tenth edition. Edited by J. O. Ward. Oxford University Press.

Service, T. (2012). *Thomas Adès: Full of noises*. Faber and Faber.

Stern, D. N. (2004). *The present moment in psychotherapy and everyday life*. W. W. Norton & Company.

Stolnitz, J. (1978). The aesthetic attitude in the rise of modern aesthetics. *The Journal of Aesthetics and Art Criticism 36* (4), 409–422. https://doi.org/10.2307/430481.

Sykes, J. B. (Ed.). (1976). *The concise Oxford dictionary*, sixth edition. Oxford University Press.

West, A. (2016). *Being with and saying goodbye: Cultivating therapeutic attitude in professional practice*. Karnac.

West, A., Bulstrode, C., & Hunt, V. (2001). Learning respect. *British Medical Journal 322*, 743. https://doi.org/10.1136/bmj.322.7288.743.

CHAPTER 49

CREATIVE ARTS, AESTHETIC EXPERIENCE, AND THE THERAPEUTIC CONNECTION IN EATING DISORDERS

JACINTA TAN, CAROLYN NAHMAN, KIRAN CHITALE, AND STEPHEN ANDERSON

'This is a series I did quite a while ago. It's called "awakening" and represents me getting better within my confidence and mental health, hiding myself in the first, peeking out in the second and feeling liberated and vibrant in the third'.

(Hannah Ford, artist and illustrator—see Figure 49.1)

Introduction

TREATMENT of mental disorders largely tends to focus on the spoken word, through psychotherapy, or on alteration of brain chemistry, through the use of psychiatric medication. But what are eating disorders, underneath all the behaviours and the words? The diagnostic manual's core definition of eating disorders is they are behaviours aimed at losing weight and/or compensating for nutritional intake, which are driven by a 'fear of fatness' (WHO, 2018). As a result, a large component of treatment tends to be focused on correcting any medical consequences of these behaviours and normalizing weight and physical health, alongside using talking therapies to correct those ostensibly irrational fears (National Institute of Health and Care Excellence, 2017).

FIGURE 49.1 'Awakening.' A series of three images by Hannah Ford. Reproduced with the permission of Hannah Ford.

Patients, however, describe that eating disorders feel like part of themselves (Tan et al., 2003; Vitousek & Manke, 1994). It can be experienced in many different ways. Some feel as if the eating disorder is a personality or evil presence which is always denigrating them and ordering them to lose weight; others feel they are punished by the eating disorder if they do eat. Many people find that even if they do want treatment and to be rid of the disorder, they are unable to do so. This could be an intriguing form of 'weakness of the will' (where someone wants to do something but can't, or alternatively doesn't want to do something but does) or 'internal coercion' (where someone feels that because of the influence of their mental disorder, they find themselves forced to act in a way that they do not wish to), both of which are deeply uncomfortable internal battles against anorexia nervosa which is experienced as a malignant influence (Tan et al., 2003). Eating disorders are therefore experienced in a very powerful way, a way which is poorly captured by the external clinical descriptions of body weights, physical findings and behaviours, but may be better captured by additionally exploring sensory detail, or numbness to it, tacit and embodied components.

The authors of this chapter are all eating disorder psychiatrists. Jacinta, Carolyn, and Kiran are child and adolescent psychiatrists, and Stephen is an adult psychiatrist. They will present a case study of a young woman who unlocked her potential for recovery using art, feature a professional artist who has literally drawn (on) her experience, and describe a therapeutic intervention which Kiran has developed. They will additionally provide some research quotes, artwork, poetry, and photographs which draw out the aesthetic nature of eating disorders. They will reflect on how they and their patients experience the aesthetic phenomena which are part of having an eating disorder. To the authors, bringing aesthetic considerations together with the standard mental health

approach may be deeply illuminating and enriching and could have the potential to improve patient-centredness and quality of care as an example aligned with the proposal of Cribb and Pullin (2022). The authors of our chapter hope that they can convey some of this to inspire others, including other eating disorder clinicians, to develop a richer understanding of the aesthetic aspects of eating disorders.

The Understanding of Eating Disorders

The general framework of the medical model divides people into the well and the unwell; in effect, some critics such as Russell charge, the sane and the mad (Russell, 1995). Within the medical model, patients who have anorexia nervosa are suffering from a mental disorder, and mental disorders require treatment to cure the sufferer of them. Treatments are assessed in medical literature chiefly in terms of efficacy of regaining weight and reducing psychopathology scores, rather than in terms of impact of the disorder or its treatment on patients and their families and whether their lives improve. Many sociologists and feminists feel that in the medical model, mental health professionals are seen as keepers of knowledge and wisdom who have expertise, that is, superior knowledge of mental disorders, classificatory systems, the treatments. Therefore, they are arbiters of the medical judgement of physical and psychological normality and how to regain this (Jewson, 1976; Peters, 1995; Russell, 1995). In the last half century or more, feminists have led the way in reclaiming the patient perspective in the experience and treatment of mental disorders in general and anorexia nervosa in particular (Gilligan, 1982; Orbach, 1976). The feminists have also liberated eating disorders from the arena of the personal problem or disorder, reframing them as a wider societal and cultural issue (Katzman & Lee, 1997). Feminist literature on this subject is, in general, highly critical of, and opposed to, the medical approach to eating disorders. Instead, it prefers to frame the development of eating disorders as arising from the oppressed social role of women. This social role is one of being subjugated by men within society, leading to societal norms by which each individual woman is evaluated by others of both sexes in terms of her outward appearance and beauty, whereas the individual man is evaluated by other criteria such as achievement. This, then, is postulated to result in a preoccupation with weight and shape, which, when coupled with low self-esteem, leads to dieting behaviour and preoccupation with weight loss as an attempt to regain control, and thus to the development of anorexia nervosa (Orbach, 1976).

Other issues which are rooted in gender in society have been postulated by feminists as being relevant to body image. In her influential book, *The Second Sex*, Simone de Beauvoir explored how the female role in society means that the newly sexualized adolescent female body is subject to the scrutiny and judgement of male eyes in order to be approved and affirmed (de Beauvoir, 1949). Orbach, in her seminal book *Fat

is a Feminist Issue, described anorexia nervosa as being a dilemma of the adolescent girl between being ultra-feminine, by fulfilling societal norms of thinness as beauty, yet non-feminine, by denying her fertility and development of womanly curves and accompanying sexuality (Orbach, 1976).

Another major strand is the critique of the male-dominated psychiatric institutions and systems, which, through the use of medical labels and superior wisdom about treatments, further disempower and disenfranchise women who constitute the majority of psychiatric patients (Kendall & Hugman, 2016; O'Connor, 2012; Peters, 1995; Russell, 1995). It should be noted that there is a significant minority of people with eating disorders who are male and some are also non-binary or transgender, and there has been as yet relatively little discourse about the non-female narrative and experience of eating disorders. This may differ from the female because of differences in biology, physical development, social expectations, and societal norms (Brewerton et al., 2022; Dunkley et al., 2020; Hartman-Munick et al., 2021). Furthermore, boys and men can suffer from being the minority gender in eating disorder treatment settings, which are largely designed for girls and women. The creative output in this chapter happens to be from women, but this should not be taken to imply that we authors consider that the aesthetics of eating disorders are the sole province of the female, nor that the male experience is unimportant or similar to the female experience.

The feminist position of the sufferer, as having been disempowered by the medical institutions, is therefore generally hostile to the medical model. This has been taken further by some groups of people who acknowledge they have eating disorders such as anorexia nervosa, but flaunt or celebrate it. These people, called 'pro-ana' (street slang for 'pro-anorexic'), espouse a view that anorexia nervosa is a lifestyle choice rather than a medical or psychiatric disorder, and that people with anorexia nervosa have a right to choose to live their 'anorexic lifestyles' without interference (Roberts Strife & Rickard, 2011). The proponents of this pro-anorexic view feel that the medical view of anorexia nervosa as pathological is erroneous, and therefore those with anorexia nervosa should be allowed to live their lives and do with their bodies as they choose. This is often a choice to live at precariously low weights, accepting significant functional impairment in personal relationships, ability to work or study, and physical health (Beat, 2023). This subculture is reflected in websites which are 'pro-ana' in which fellow sufferers trade advice and support each other to resist treatment, fool their doctors, and maintain their thinness. A typical offering is the statement on one such website that anorexia (nervosa) is their pride and pleasure. Note that due to their subversive nature, these websites are regularly taken down by servers and then pop up again, so they cannot be usefully cited but can be found with an internet search. There has been further validation in the popular media, such as the glorification of the unnaturally thin model silhouette by the media. There is even a popular song from the 1980s which describes 'Anorexic beauty, Feather-weight perfection, Anorexic beauty, Underweight Goddess,' though whether it is glorifying or critiquing the pro-ana view is debatable

because it also says 'The girl of my nightmares, Sultry and corpse-like, The girl of my nightmares' and describes the anorexic woman as 'Erotic and skull-faced' as well as 'Sultry and corpse-like' (Pulp, 1987).

Eating disorders have been viewed as beautiful yet fatal, both hated and loved, enfolding yet cold and numbing—and they have a particular siren song quality to them that people find alluring and difficult to resist.

Curiosity Killed the Control, by Hayley B
It's like an ocean. It seems oh so beautiful.
Intriguing, almost.
At first you approach slowly; you're sceptical about what it could potentially bring.
You can't resist but to just dip your toes in the water.
Initially it's a bit of a shock, but you quickly adjust and it's fine again.
You take baby steps further into the ocean.
The water is up to your knees now—it's a bittersweet feeling.
You know you should stop but, with every step, the temptation intensifies.
It lures you further and, before you know it, you're in waist-deep attempting to ride the waves.
The longer you stay there the more comfortable it gets.
Soon you find yourself standing on your tip-toes.
Waves are hitting your face—you're gulping water.
You're struggling to breathe.
Suddenly you're swept off your feet completely and that inch of control you had is gone;
The ocean is now in control of you.
Finally your whole body is under water.
You feel absolutely shocked. The cold is unbearable.
But, soon you acclimatise and everything starts feeling—almost normal.
You can't feel the cold anymore; you're numb.
You've learnt to trust the ocean and you've got a sense of security—a sense of safety.
You're so used to it now that it's difficult to imagine life back on shore.
If you get out now the bitter air will hit you like a tonne of bricks—it's sure as hell going to be painful.
You can see the surface of the sea but it seems so far out of reach.
Under-water has become your life.
It now feels better in than out.
Your parents are in tears watching their child drown—fade away.
The longer you stay under, the weaker you get, yet, the safety—the security—deepens.
Oh how the tables have turned.
Maybe you should swim to the surface.
If not, soon you will surely die.

It should be remembered that although we have discussed feminist literature, eating disorders can affect anyone and perhaps up to one in four people with an eating disorder are male (Hudson et al., 2007). LGBTQ populations appear to be at increased risk of eating disorder symptoms and behaviours and this is likely to be at least partly related to

society's appearance ideals (Convertino et al., 2021; Gordon et al., 2021). It is interesting to note the change in male body ideal over time in the media, an example of which can be seen in the change in Star Wars toy figures which have become more lean and muscular (Pope et al., 1999).

Body shape ideals have changed over time and across cultures (see Figure 49.2). These societal and contextual aesthetic changes have an impact on eating disorder symptoms and behaviours. For example, Becker et al. (2002) highlighted a significant increase in eating disorder behaviours and qualitative changes in aesthetic ideals in young Fijian women between 1995 and 1998 following the introduction of Western television (Becker et al., 2002). Prior to this, Becker notes that the traditional aesthetic ideals reflected 'a preference for a robust body habitus' with only one previously recorded diagnosis of anorexia nervosa. Changes in body ideal in line with social pressures is beautifully illustrated by Nealie Tan Ngo (Ngo, 2019). An Internet search will produce a number of news and media articles on this topic (Anderson, 2015; Bahadur, 2014; Sarafine, 2020). Social media use is also known to increase negative comparison between one's own body and life and that of others (de Valle et al., 2021; Jiotsa et al., 2021).

FIGURE 49.2 Changing body ideals through the ages. Pen and pencil drawing by Jacinta.

Descriptions of Aesthetic Experiences in Eating Disorders

When asked, people who have eating disorders—particularly anorexia nervosa—and their loved ones can describe the experience of living with the disorder in striking, evocative aesthetic terms. As part of Jacinta Tan's DPhil (doctor of philosophy, that is, PhD) research examining how people with anorexia nervosa made decisions and why, she had long in-depth Socratic conversations with young people aged between thirteen to twenty-five years and some of their parents (Tan, 2006). Highly evocative imagery and conceptualizations of anorexia nervosa which engaged the senses emerged.

'I think if you think of it [anorexia nervosa] as a picture, think of it as when you're ill it's a massive, huge thing whatever you want to think of or a huge, massive piece of paper or a ball and as you get better it deflates. Or gets smaller and then when you're recovered so to speak and discharged from hospital and you feel confident in yourself, it's that self-confidence it's kind of folded up really small and put in a drawer, yeah? And the drawer stays up there so it's always still there, like you've had this illness and it could come back and be really huge. But it's under control, you've got it kind of locked away and under control. Does that make any sense? (Laughs) It's my picture thing because I think in pictures'. Participant 20, main study

INTERVIEWER: Who is your anorexia nervosa?
"It's not anything like you know a lot of people try to envisage it like a kind of minx sitting on your shoulder or something like that; but myself, I do see it as kind of like half of my mind kind of thing, and I can separate it out and see it as a different side of me." (Participant C, pilot study)

INTERVIEWER: Who is your anorexia nervosa then?
"That's the thing, you can't see it, you can't say—but then again I know that I would be really scapegoating it, by saying, oh, it's something totally different; no, it must be a part of me, I don't know, it's difficult to say. It's like, you know, have you seen the film Ghost? You know, like when he uses Whoopi Goldberg's body, and steps into her, it's like it steps into you, it's this really evil thing that steps into you and takes over."

INTERVIEWER: So it looks like you but it's someone else pulling the strings.
"Yeah."

INTERVIEWER: That's creepy.
"Yeah, very creepy." (Participant D, pilot study)

"It's just there's lots of symptoms of anorexia nervosa, and I do know this there are symptoms of it, like you isolate yourself and you, most people get depressed and self-harm or whatever. And it's like, that's what I mean about it changes you. Because I went from a nice, happy, and I used to sing, I'm a singer, and I used to sing loads and then when I got the illness, I couldn't sing. I couldn't sing because I was so unhappy, I couldn't sing and it was like my voice wouldn't let me, I just couldn't do anything that I wanted

to do. No, it wouldn't let me do anything that I wanted to do, it wouldn't let me be happy, so, but now I've started singing again." Participant 13, main study

"It [the anorexia nervosa] just gets smaller. If say I was to draw a diagram of my head, and I'd at a low weight when the anorexia is very strong it's taken up like 99% of my head but there's still a little bit of me where as when I start to get better and put on weight and get well then the real me gets stronger and so it goes down and then I'm like 75%, 50/50 and I'm hoping eventually down to nothing. So there's always the real me still there because, well, if the real me wasn't there then I'd be dead because the real me is what I use to fight against it and to motivate me to want to beat it and get well. I truly believe that if there wasn't any me left, if there was none of me inside of me then I would have let it kill me." Participant 36, main study

THE EMBODIED EXPERIENCE OF EATING DISORDERS

The embodied nature of eating disorders and its drive for thinness, medical demands for weight gain to achieve and maintain 'normal,' 'healthy' weight, shape and fitness all focus attention on physical objectives. In addition, health-care professionals may be, or feel, judged by their patients and colleagues if they are too thin or too fat. They may also feel acutely aware of their own imperfect weight and shape and fitness while working with these patients.

People with eating disorders themselves are acutely aware of their physical bodies, the condition of these bodies, and even the amount of physical space their bodies occupy. This consciousness of body size or shape is not itself unusual in modern society, but the degree of preoccupation with this is one of the typical features of eating disorders. The following research quoted from Jacinta's thesis illustrates the complex relationship, little explored in the research literature, between perceived space occupied and value or self-esteem (Tan, 2006). Physical space, in the world of anorexia nervosa, appears to be something one has to have a right to occupy, the occupation of which also draws notice to oneself in proportion to the volume taken. This is similar to Ashworth's conceptualization of 'mere appearances' as actually crucially important because it is 'the lifeworld', the 'things themselves in their appearing' (Ashworth, 2003).

"I think it, it meant that there was more of me, I didn't like my personality and being fat meant there was more of [own name] and I didn't want that, I wanted to make me as small as possible. So I wanted to lessen myself because I felt like I was too big and too loud and too giddy and rebellious and you know, so I just wanted to shrink really." Participant 17, main study

"I think, you know, sometimes I want to disappear and I think the smaller I could be, you know, people aren't going to notice me because I can just shrink back into my shell." Participant 23, main study

INTERVIEWER: OK and what would it mean to you if you were fat?
"It would be a nightmare. I couldn't be."
INTERVIEWER: Why? I mean you know what someone might say "well what's so bad about being fat?" I mean, yeah, we know the health risks but in a sense it feels like it-?
"Yeah. I think, for me I feel like I'd take up too much space. I think that's one of the things I've been working through while I've been here is just the fact that when I'm big I just feel too obvious and like I'm taking up too much space. And I need to be smaller."
INTERVIEWER: Right so it's almost like so you don't get noticed so much?
"Yeah, maybe. I'm not still, I'm still not clear on what that is about but – I think it's something like that." Participant 22, main study

There was a powerful effect of malnutrition and hunger which was both strongly perceived in people with eating disorders and yet this was simultaneously anaesthetizing from other negative feelings. In addition, new meanings could be created for familiar bodily sensations. For instance, the stomach and gut being empty was variously perceived as pure, beautiful, meritorious and clean; conversely, having food in the gut was experienced as dirty and having disgusting contents in the body.

"I think it's feelings as well. I think it's a feeling, kind of, trying to feel good about yourself and like, well it's not feeling very good about yourself, but it's a lot about feelings, like I think I know I used to feel, I used to like feeling empty, and I used to like feeling that I hadn't eaten for ages and I used to feel quite disgusting when I had, or had something which I didn't want to have or shouldn't have had."

INTERVIEWER: Why did you like feeling empty? What did it feel like was the reason for that?
"Um...it's sort of, felt clean, kind of, like nothing dirty or, inside you that shouldn't be. It felt, and kind of felt, sort of in control, that you choose what you put in there and you've chosen to put nothing in there, because it's pure, it's just you, nothing from outside in there." Participant 31, main study
INTERVIEWER: So it sounds like there's something that feels good about losing weight.
"Yeah, you feel empty."
INTERVIEWER: Oh, how is that a good feeling?
"I don't know you just feel light, you just, you can go to bed and you can just, you just don't feel anything inside you, you just feel, and you feel hungry, but you just, it just feels quite good but at the same time it feels awful but it does feel good at the same time." Participant 29, main study

There are echoes here of asceticism, and indeed medical historians believe that some fasting saints such as St Catherine of Siena actually did have eating disorders (Galassi et al., 2018). St Catherine also described altered gustation (dysgeusia). Dysgeusia is a disorder that distorts the sense of taste. People with this condition describe all foods as tasting sweet, sour, bitter, or metallic. This may arise from a variety of causes, including vitamin B and zinc deficiency. It is commonly seen more recently as a consequence of

loss of smell (anosmia) associated with COVID-19 infections (Cleveland Clinic, 2021). A common and arguably core feature of eating disorders is the 'felt experience' of body shape and fatness, often articulated as 'I *feel* fat' even when a person is emaciated. Indeed, it appears that this single state of feeling fat may capture what a detailed psychopathology questionnaire does (Zhang et al., 2021).

The preoccupation with food and eating/not eating can be an experience which draws out the aesthetics of food in itself. The burgeoning of books about cookery and food and preponderance of pictures of food on social media attest to the aesthetic aspects of, and fascination with, food amongst the general public (Cardwell, 2017; Giousmpasoglou et al., 2020; Ranteallo & Andilolo, 2017). The intense focus as part of the eating disorder on internal sensation and normal physiological functions, for example in the gut, can compound this. With eating disorders, this aesthetic experience can be heightened and gain added meaning.

> 'I went through a phase of doodling pictures of food, which is definitely weird. I guess your brain makes the thing you deny yourself seem the most aesthetically attractive to you-exciting, beautiful, in the way one might view a beautiful woman/man, and feel a sexual attraction- your body turns those urges off and fires up desires for the thing it most vitally needs, and where that would normally be reproduction it becomes food to someone who is in a starved state. I guess food is attractive at some level to everyone as it's still vital, but with a deficiency in anything necessary the balance of what you are attracted to is tipped towards whatever that is'.
>
> (Hannah Ford, artist and illustrator—see Figure 49.3)

It is very common for people who have eating disorders to develop an aesthetic preoccupation with food, with intense pleasure from making food, which they then feed others but deny themselves. They pore over cookbooks, and avidly watch cookery shows. One research participant described long luxurious daydreams of what food she would populate her refrigerator with, even though she knew she would never eat any of it. It appears that where the simple pleasures of eating are forbidden or poisoned, the aesthetic appearances or attractiveness of food become paramount. Many people with eating disorders dream about food. This can include dreaming that they have eaten everything in the fridge and waking in terror that this may be true, to being chased down the street by a giant pizza.

THE IMPACT OF EATING DISORDERS ON CLINICIANS AND THERAPISTS

Health-care professionals who work with people who have eating disorders are often powerfully and emotionally affected by these encounters, in such a way that it is perceived in the body. A common statement heard amongst eating disorder therapists

FIGURE 49.3 Food, by Hannah Ford. Reproduced with the permission of Hannah Ford.

is: 'Every time I see people with anorexia nervosa, I feel so hungry!' In-patient nursing staff can find it extremely stressful providing meals for and meal support to patients with eating disorders (personal experience and Ryu et al., 2022). Feelings of anxiety, frustration, and incompetence may be elicited in working with people who have eating disorders and these can impact on how we treat the individual, for example in increasingly coercive management; avoiding conflict or taking on an overly-nurturing role. These countertransference responses all impact on treatment and need to be reflected upon and managed in supervision (DeLucia-Waack, 1999; Satir et al., 2009; Seah et al., 2017). Elwyn summarizes transference and countertransference, including her own experience of comments made by therapists in highly aesthetic terms, in her response as a patient to recent discussions around the subject of coining a new term, 'terminal anorexia' (Elwyn, 2023).

Symptoms and signs of eating disorders include feeling constantly cold, having cold peripheries and grey marbled mottled skin, and growing fine downy lanugo hair in response (Hediger et al., 2000; Strumìa et al., 2001). To meet and work with people who have eating disorders in an empathic way is to connect with the freezing and starving

souls who survive by being rigid or emotionally inaccessible whilst living in terror as prisoners to the controlling force which is eating disorders. The authors of this chapter find themselves turning instinctively to the creative arts in response and reaction. Through the creative arts and shared images they seek and express and celebrate creativity with themes of growth, warmth, nourishment, and containment, as well as the sheer joy and beauty of nature (see Figures 49.4 and 49.5).

It is part of the cognitive nature of eating disorders that people who have eating disorders can focus excessively and rigidly on minute details. Stephen reflects: 'We can often get caught up in the distress of the here and now and the fear of weight gain, and we need to be able to able to help our patients to see the bigger picture, and not get stuck with them in this. We ourselves can fail to lift our heads and look around us. When I was a medical student, I would get more and more consumed by the right here, right now of studying for exams, and would just go up to Arthur's Seat next to the halls of residence in Edinburgh—when you go high up and look out over Scotland, you just feel small

FIGURE 49.4 Warmth and nourishment. Upper row: Soft and/or warming creations (made by Caz and Jacinta); Lower row: Nourishment and containment—coffee and cake (photographs by Caz, Kiran and Stephen).

FIGURE 49.5 'Lift your head—it's a wonderful world'—photographs by Stephen, Caz, Kiran, and Jacinta at home, near home, and from all over the world.

and insignificant, and realize that there is more to life than just the thing you're getting consumed by'.

Part of any eating disorder treatment is working with the person to regain their life from the grips of the disorder—and to do this they need to be able to see and maintain focus on the bigger picture they see for their life.

Interestingly, in peer discussion, Jacinta, Caz, Kiran, and Stephen often share photos with each other of the wonderful scenery and wonders of nature that they find themselves enjoying (see Figure 49.5).

Despite a wealth of rich evidence of the aesthetic nature and impact of eating disorders, the current evidence base mainly emphasizes weight restoration and/or addressing nutritional deficiencies, and talking therapies (National Institute of Health and Care Excellence, 2017). There is some growing evidence that expressive or creative arts therapies can be effective for eating disorders (Dieterich-Hartwell, 2018; Dunphy et al., 2013; Frisch et al., 2006; Hodge & Simpson, 2016; Kron, 2006). We would go further, and argue that to see aesthetics as limited to the domain of art therapy is to underestimate the centrality and importance of aesthetic experience to eating disorders. Furthermore, awareness of, the understanding and utilization of aesthetic experience may offer access to deep emotional understandings and unlock psychological shifts which mere words fail to do, such as the complexity of the tacit, embodied, or pre-reflective (i.e., not yet come to consciousness). As Kron states of art therapy: 'Conditions treated may be those where the patients physical awareness or verbal communications are limited' (Kron, 2006). We suggest that despite their apparent fluency and articulateness, this describes many patients with eating disorders. There is often a disconnect or contradiction between words uttered and the emotions and core identity and values of the person with the eating disorder (Craigie et al., 2013; Hope et al., 2005; Tan, Hope, & Stewart, 2003).

As such, encountering the aesthetic side of eating disorders, acknowledging broader ways of knowing, coming to understand and employing the language of aesthetics can be empowering (Misluk-Gervase, 2020).

Cribb and Pullin propose that aesthetic considerations should be built into how we deliver health care and be part of our 'normal business' to improve quality (Cribb & Pullin, 2022). Within eating disorders in mental health, we will illustrate this potential with two case studies—one of a psychiatrist's approach incorporating awareness of aesthetic issues and one of a patient's journey in response to a simple initial request to draw her eating disorder.

RESPECT-ME: Development

The following section is written from Kiran's (author KC) first-person perspective:

> Fifteen years ago, I remember how creativity became the saviour. It also was the beginning of the journey of RESPECT-ME, an innovative model of therapeutic interventions that I designed, which is evolving as a mode of engagement in my eating disorders practice (Chitale, work in progress). The composite case study below illustrates this.
>
> *The caterpillar and the butterfly:*
> A twelve-year-old girl was angry with the world. She felt that nobody heard her. She was fed up with all the rules, the lists of foods she had to eat, the ways of life she had to lead, when all she wanted was to be left alone to run by the lotus pond. She was upset with the nurse who had weighed her in the clinic room, and I heard her tell her mother that she did not trust anyone. I saw her teary eyes as she quickly covered her face with her long golden hair. She had just overheard a discussion about an inpatient admission to be considered if there was no progress.
>
> I remember thinking that day that the numbers on the scale and receptors in the brain were not enough. We needed to do something differently. I asked her if she would help me choose some paints for my art. She reluctantly agreed, perhaps as she was not to be marched into the clinic room again. Her eyes lit up when she entered the art room. This was a large room with an old, wooden rustic table in the middle, with chairs all around it. There was a farmer's sink on the side counter and the art therapists had stocked a variety of artists' paints, glitter, beads, buttons, palettes in the cupboards all around. The room opened into a courtyard garden where the neighbour's cat came to play. There was a bench in the garden under an old fig tree and the wisteria popped its bright blue head into the room.
>
> We began to explore the room together and she chose her paints. Neither of us spoke much as we painted our own art. She drew a caterpillar and said that it was her, a 'wounded, ugly caterpillar'. With bruised, blue fingers, a pale face, falling hair and sunken, vacant eyes I could see what she was trying to express.
>
> Every subsequent session was in the art room. She would quickly go to get herself weighed and then walked to the art room with a newfound determination.

She kept her painting safely in her large folder in the art room. We began to share stories over the weeks, and she would talk about her school and the lotus pond. We shared our liking for lotuses. I told her about India and pink lotuses in my pond (see Figure 49.6, Lotus Pond painted by Kiran). We agreed that they signified grace and confidence.

FIGURE 49.6 Lotus Pond, painted by Kiran.

After some months, she came running to me and said that she was going to complete her painting. There was palpable excitement in the art room that day. Her painting was ready. It was a beautiful butterfly flying over a pink lotus pond. She said that she was setting the butterfly free, and it was no longer a caterpillar. I looked at her glowing eyes, they were full of stories. There was colour in cheeks, her fingers looked pink, and she had a bright pink hair band with glittering stones. What a transformation!

Kiran's enlivened case example led to the following discussion in collective peer reflection:

'This case example shows how aesthetic experience may work in action, i.e., during practice. Kiran invites her patient into the art room where the atmosphere appears welcoming, warm and sets the scene for embracing immersion in experience. The process of art making therein enables a shift of mode of mind into "being" in experience, not solely talking "about" it in words. Not only for her patient, but for Kiran too, this appears to enhance her attunement. Rather than this being about the more conventional meaning of aesthetics in relation to art and more distanced appreciation, here it is about connection in immersive experience itself. Kiran senses the needs her patient may have to articulate and express problems in terms other than verbal and the need for her, as the psychiatrist to understand this within a broader epistemology than can be gleaned from verbal medical history taking.

Attuned, Kiran senses what may be needed to connect. It's not solely the art as an end image, although these are important images, it is also that she and her patient work together. Kiran shifts into the same mode of mind. It is not interrogative, it is collaborative, in a shared space and experiential encounter and goes beyond words alone. It enables the patient to access what she perceives that is tacit, pre-reflective, embodied, and for it to be expressed.

Gifted with sensibility in her clinical skill, this example shows how Kiran's awareness of aesthetic issues can be important in understanding the patient's condition and so ultimately contribute to care management. Indeed, without this awareness, much could be missed'.

It was from such starting points that RESPECT-ME was developed. There were further examples of adolescents who were able to utilize creative media to connect with and explore the dilemmas and difficulties of their eating disorders.

The Three Domains in Systemic Practice

I had learnt about the three domains in systemic practice, that is, the general approach child and adolescent psychiatrists adopt which views the patient as a member of a wider system of the family, school, and society as well as the child and family being part of a system with the treating team. These are: the *domain of production*, which involves

immediate treatment, risk assessment, safeguarding; the *domain of explanation* which is to explain the illness and a treatment plan to young people and families, and the third and most important is the *domain of aesthetics*, which is at the heart of it all, the art within the science. I feel this defines us as psychiatrists (Lang et al., 1990).

How could I accept that the feisty, smart, determined young people who we meet, are simply numbers on the scale, or calories on a plate or a measure round the waist? Aided by curiosity and a slight irreverence to concepts, I began to explore narratives to work with patient stories. I met the most courageous young people, but not everyone could articulate their demons, express their sadness, conceptualize their challenges. We needed meaningful encounters. Something more tangible, more engaging, more empowering.

Meaningful Encounters in a Space of Compassion

I tapped into all forms of non-verbal communication and began to use the art therapy room to see young people. The space provided a base for creative expression during individual and group therapy.

It was a sanctuary for those anxious, tired minds who had just had to endure fear in the clinic room for weight monitoring, in addition to all the other worries of the day. The two rooms were adjacent, and I soon discovered that it was a space of compassion for all... patients and professionals. We are all human after all, and the clinic space can be as daunting for staff as it is for our patients.

This is where I saw communication at its best. It embraced components of aesthetic experience. These included a sense of perception, a space for imagination, and a platform for stories to flow without fear. It provided a safe space for creative art, story stems, imaginary play, music, role play, dance moves, and even some easy gardening in the courtyard.

I began to access the toolbox of therapeutic repertoire in an eclectic fashion, tailoring this to the developmental, psychological, physical, contextual needs of young people. As child and adolescent psychiatrists, we have the unique privilege to experience many treatment modalities during our comprehensive training. And then it is also about being creative with what we know and adventurous with what we need to know, balanced with the courage to tap into this cautiously and safely.

I was able to hold on to the systemic trunk of the therapeutic tree which gave me the strength to work within the basic principles of neutrality, circularity, while adding hues to narrative therapy with compassion and creative externalization (see Figure 49.7, Strength).

I could also tap into my training in the MacArthur Story Stem Assessments (Bretherton et al., 1990, 2003), which is an assessment instrument that examines children's ability to cope with conflict-laden situations and narrative work for attachments in children. This helped them express their fears and inner worlds through story stems. They made life-lines with toy figures and memory boards with photos and dried flowers.

FIGURE 49.7 Strength, painted by Kiran.

The 'miracle' question (De Shazer, 1988) afforded a magical space for young people to recreate a life without eating disorders; expressed as starlit forests with fireflies, peacocks and hummingbirds, ice-cream vans and music gigs; challenging climbs on mountains of dreams and seashores with scorching golden sands under bare feet (see Figure 49.8 for an expression of beauty).

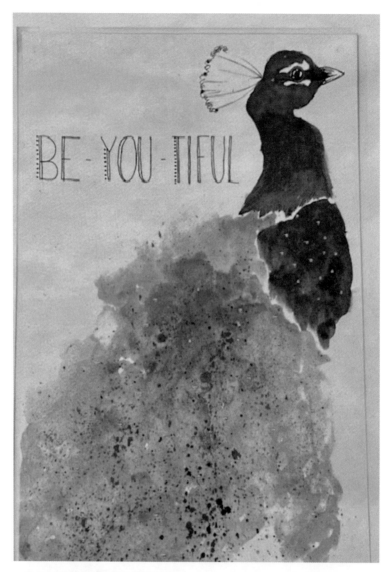

FIGURE 49.8 Be-YOU-Tiful, painted by AP.

I had learnt a new way of working.

Using metaphors such as 'the brain lounge with the sprawling intruder', 'the battleship and helpers', 'the flying carpet of wishes', and 'the shores of compassion', afforded a new way of exploring the inexplorable. The metamorphosis of the caterpillar into a butterfly became a recurring theme (see Figure 49.9, a Butterfly rug made by SL).

I have had the privilege to work with many inspiring and brave young people and the story of a young person battling anorexia from a wheelchair lives tall in my experiential repertoire. Discharged from the paediatric ward once medically stabilized, this person had named their eating disorder, 'the roundabout with no exits'. Over some

FIGURE 49.9 A Butterfly Rug, made by SL. Photographed and reproduced with permission.

months in the colourful space of the art room, this person worked tirelessly on their ambivalence and lack of motivation to change through expressive writing on the principles of Motivational Enhancement Therapy and the five stages of change (Prochaska & DiClemente, 1983), and finally discovered the clear 'exit'.

These encounters fostered the quest for gaining skills in various therapeutic approaches, learning from the stalwarts in eating disorder therapies, including training in Compassion Focused Therapy (Gilbert, 2010, 2015); Cognitive Remediation Therapy (Tchanturia, 2014; Tchanturia & Lock, 2011), Cognitive Behavioural Therapy for eating disorders (CBT-E) (Fairburn, 2008; Fairburn et al., 2003), Multi-Family Therapy (Eisler et al., 2016; Simic & Eisler, 2015) and Group Therapy.

While I was facilitating Multi-Family Therapy, a group of young people who participated with their families, wished to continue with after-school group therapy, as part of follow-up.

This secured the foundations for 'RESPECT-ME', after a focus group of young people identified shared vulnerability factors for their illness. They were able to create a mind-map on the blackboard and of these, a fundamental factor which was common to all was a 'lack of respect' for self. This was also perceived to be a maintaining factor for their eating disorder. I also remembered the caterpillar and the butterfly and its metamorphosis which appeared to be a recurring theme over the years.

Creative art was used as a medium of expression for each theme to communicate difficult feelings and fears about food and weight, emotional processing, self-compassion, self-esteem, and social confidence.

RESPECT-ME

RESPECT-ME is an acronym to represent factors perpetuating the core cognitions of the illness (see Figure 49.10).

Group Structure

A young woman who was previously under my care (now a fully recovered adult, and highly awarded Art graduate) helped me to facilitate the evening groups with an assistant practitioner.[1] She would speak of her own determination to battle her illness and her voice was the strongest in the room as it was the voice of lived experience.

Groups consisted of structured activities including creating food collages, decoupage, role plays, interviewing in pairs or groups, engaging in supervised debates, mind-maps, memory boards, reflective journeys, dance moves with music, lifelines, and psychoeducation. These were facilitated over four sessions per theme. There was also a 'Getting ready for Christmas' group, a challenging time for patients with eating disorders.

Rules and boundaries were set at the outset and feedback was encouraged after each session. Verbal consent was obtained from young people around Young Ambassador co-facilitation (see footnote 1). Each session began and ended with a mindfulness exercise to encourage self-compassion.

The vulnerability factors identified by the focus group were addressed. These have been formulated as RESPECT-ME (see Figure 49.10):

- Resilience building while tackling the 'judgemental' societal expectations about ideal weight, shape, and diets. In pairs, young people explored narratives using curiosity and art with experiential confidence. (See Figure 49.11 for a depiction of body image by JA.)

FIGURE 49.10 RESPECT-ME model.

- Eating choices were shared and the 'past food story' created through making interactive food collages and recipe booklets.
- 'Social media: friend or foe': a debate was facilitated and presented to the local minister of mental health. Topics discussed were school weigh-ins, discrimination based on peri-pubertal weight and anti-obesity campaigns.
- Self-esteem work using dance moves and drama; coping with Stigma; managing Stress of exams, bullying, peer acceptance, family difficulties
- 'Perfecting the art of imperfection'; and Psychoeducation on physical health, neurobiology, effects of starvation, pubertal milestones, hunger cycle.
- Emotional recognition and regulation.
- Compassion for self through Creativity (see Figure 49.12 Self-Compassion—Happy Place in Shoreditch is my safe compassion space by HH).
- Trigger recognition and developing a Toolkit.

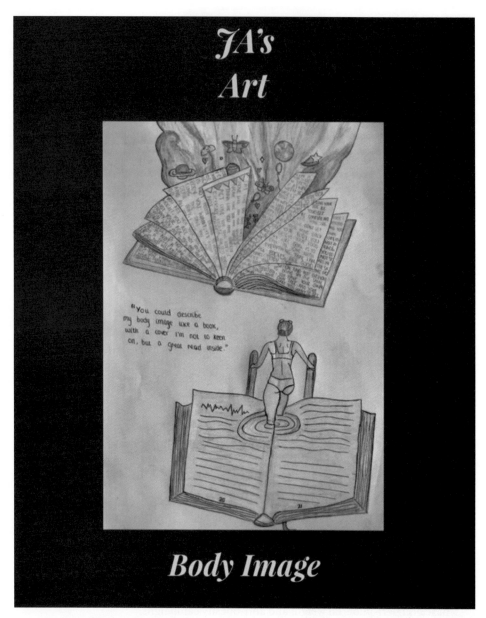

FIGURE 49.11 Body Image, by JA.

- **ME:** Motivation Enhancement Therapy and Mindfulness exercises were practised at the beginning and end of the group

Creativity was used as a medium of expression for each theme to communicate difficult feelings and fears about food and weight, emotional processing, self-compassion,

CREATIVE ARTS, AESTHETIC EXPERIENCE 947

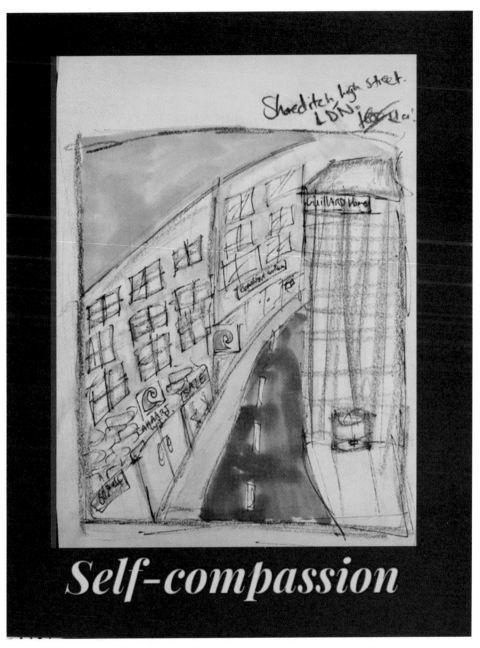

FIGURE 49.12 Happy Place Shoreditch (is my safe compassion space) by HH.

self-esteem, and social confidence. Developing resilience and strength in the face of societal pressures and perceived expectations, fear of being negatively appraised, and stressful life events were addressed through creative arts. Personality traits including anxious avoidance, obsessionality, cognitive inflexibility, perfectionism, attention

deficit, and lack of bigger picture thinking, could also emerge in this process and subsequently be explored further in individual therapy.

Evidence from practice as given in feedback and level of engagement suggests that this model works well.

I-RESPECT-ME (Individualized RESPECT-ME)

The COVID-19 pandemic lockdowns saw the advent and normalization of remote working and remote therapy (Johns et al., 2021; Moreno et al., 2020). Out of necessity RESPECT-ME also began a new journey of individualized remote therapy. I now see young people virtually and we set up remote 'Spaces of compassion' with art medium chosen by young people in their own homes. Following assessment, I offer them a menu of therapeutic options tailored to their treatment goals and we work creatively together to achieve their goals.

There have been some new, contextual additions to the themes including: 'Coping Corona' (see Figure 49.13), 'Recovery ladder', 'Storm shelter', 'Treasure dreams', and the 'Lightbulb moments'. The experience of developing and facilitating Respect-Me is captured in the artwork Radiance (see Figure 49.14).

FIGURE 49.13 Coping Corona, by JA.

FIGURE 49.14 Radiance, by Kiran.

Case Study: Exploring, Expressing, and Understanding the Experience of Anorexia Nervosa Through Art

The following case study is written by Carolyn (author CN) in co-writing with Millie and her mother.

Millie (not her real name) is a fifteen-year-old girl who has struggled with an eating disorder, low mood, and anxiety for a long time. She has always struggled with poor self-confidence, shyness, and social anxiety. At the initial assessment and early days of treatment within Child and Adult Mental Health Services (CAMHS), she found it hard to talk. As she began to express her emotions and thoughts through art, her communication and the connection both with her family and her treatment team progressed. Although Millie was often quiet during sessions, she would bring the art work to the next meeting and was able to describe her thoughts and feelings after the event.

When invited to draw her eating disorder she initially drew a large hand moving a black pawn on a chess board (see Figure 49.15). The hand represented the grasp the eating disorder had over her. She chose the pawn to represent herself, because it is the weakest character on a chess board and easily manipulated. As the piece developed, colour was introduced as a symbolic reference to the conflicting emotions attached to the eating disorder and in response to the voice in her head. Millie also explored the theme of 'under' and 'over' thinking about being 'under control' where she was able to show herself feeling under the control of an invisible puppeteer (see Figure 49.15). Millie

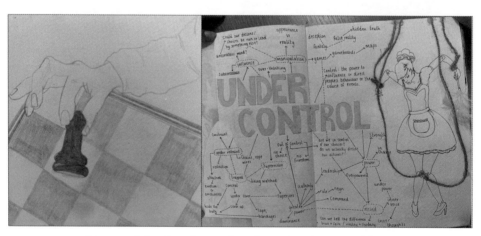

FIGURE 49.15 First pencil drawing of eating disorder and Under Control, by Millie.

FIGURE 49.16 The thoughts in my head, by Millie.

also showed the 'over control'—the desire to control everything in her life and everything around her due to feeling overwhelmed and not in control.
She depicted that despite being quiet and not saying much, there was a huge volume of thoughts going round in her head (see Figure 49.16).

Finally, Millie explored a theme of Alice in Wonderland where everything around her felt surreal and she felt as though she was constantly watched through a looking glass, under scrutiny with no control (see Figure 49.17).

As Millie progressed, although she continues to be overwhelmed and pre-occupied by her thoughts, she was able to talk more, connect more, and verbalize her feelings more with the team. By building relationships with the team, Millie was able to gain confidence to share her artwork. The engagement and connection would not have been possible without the art. This narrative is co-written with Millie and her parents and the artwork shared with her written permission.

Recovery

And finally, a word about recovery. Recovery is rarely spoken about in eating disorder treatment but it is possible. Treatment tends to aim for improved psychopathology

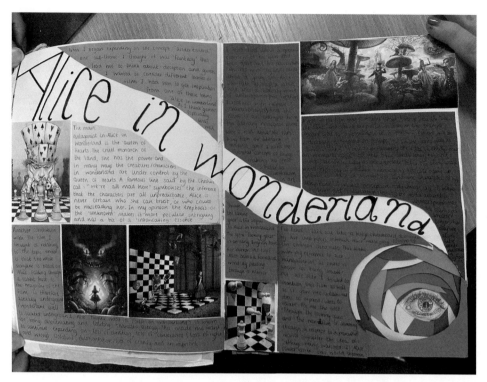

FIGURE 49.17 Everybody is watching you, by Millie.

scores and healthy weights (Kenny & Lewis, 2021). True recovery, however, is not solely about a particular weight or behaviour, but freedom from the tyranny of the eating disorder and freedom to listen to one's body and make untrammelled choices. Eaton found five overarching themes emerged from her research: (1) the eating disorder as a life jacket, (2) drowning: recognizing consequences, (3) treading the surface: contemplating recovery, (4) swimming: the path toward recovery, and (5) reaching recovery: a sense of freedom (Eaton, 2020). This poem, however, describes recovery best:

<p style="text-align:center">Progression, by Hayley B</p>

Somewhere between then and now
The salad turned into pizza
The sweetener became flavoured syrup
The ice cream was made from real dairy
The 'I'm not hungry' became 'let's order dessert'
The leggings turned into jeans
The food stopped tasting of numbers
The routines turned into spontaneity
The black coffees became milky lattes
 The regrets turned into memories
 The colour splashed back into my cheeks
 The fear turned into faith

And the body I spent years destroying
Finally felt like home.

Conclusion

Eating disorders bring with them a range of strong, powerful aesthetic experiences. These may be experienced by people who have eating disorders, their families and even their health-care professionals in various ways which encompass a range of senses. The body and its size, shape, and volume take on a new meaning with eating disorders, and is perceived accordingly. The normal physical sensations of food and eating, usually pleasurable, take on new and ominous meanings as well. In summary, the experience of eating disorders is deeply emotive and profoundly aesthetic, to the extent that expressive media such as art, creative writing, and poetry are often found more meaningful to both express and heal the difficult thoughts and feelings and even chart shifts in understanding that accompany eating disorders.

It is not surprising that the use of creative and expressive media and examination of the felt experience of having an eating disorder shows promise in helping people to express their dilemmas, experiences and to walk along the road to recovery. Indeed, what is surprising is the current relative lack of focus, apart from within art therapy, on the aesthetic experience of eating disorders in the psychiatric, medical, and therapeutic approaches to assessing and treating eating disorders. Appreciating the phenomenological aspects of eating disorders in themselves as discussed in this chapter, that are aesthetic in nature, upholds the importance of acknowledging aesthetic issues in eating disorders. Of note, the International Association of Eating Disorders Professionals Foundation runs an annual multimedia art contest designed to promote a healthy awareness and acceptance of body images, called 'Imagine Me Beyond What You See' (see http://www.iaedp.com/upload/2020_iaedp_Imagine_Me_Beyond_.pdf for past entries and winners). We suggest that more exploration and a deeper understanding of each individual's aesthetic experience of eating disorders, as well as the therapists' aesthetic experience of treating them, is important and needs to be given a greater role than it currently is.

Acknowledgements

All photographs, art, and creations are published and reproduced with the permission of the creators. Special thanks go to Hannah Ford, artist and illustrator (www.hannahfordart.com), 'Millie', Hayley B, JA, AP, HH, and SL for generously sharing and giving permission for the use of their stories, words, creations, and art with us for this chapter. We are also grateful to the research participants whose quotes are included, and all patients and families who inspired this chapter. Ethical Approval for the research was provided by the South East Multi-Centre Research Ethics Committee (MREC) reference 01/1/65. Consent was specifically obtained

for the use of research quotes with a specific 'Consent Form for Future Use of Interview, 28 August 2002' which was signed after participants had read the transcript of their interviews. Participants consented to the following: 'It is intended that quotes or selections from my interview, anonymized according to my wishes, will be available for use in publication, education and lectures. This material will not be used for personal profit or commercial gain.'

NOTE

1. We sought appropriate clearance and an honorary contract accordingly: Disclosure and Barring Service check on behalf of an employee for working with children, www.gov.uk

REFERENCES

Anderson, T. (2015, January 19). How the 'ideal' body shape has changed over the last 100 years. *Cosmopolitan.* www.cosmopolitan.com/uk/body/news/a32749/perfect-body-has-changed-over-100-years/

Ashworth, P. (2003). An approach to phenomenological psychology: the contingencies of the lifeworld. *Journal of Phenomenological Psychology* 34(2), 145–156.

Bahadur, N. (2014, February 13). It's amazing how much the 'perfect body' has changed in 100 years. *The Huffington Post.* www.huffingtonpost.co.uk/entry/perfect-body-change-beauty-ideals_n_4733378

Beat. (2023). *The Dangers of Pro-Ana and Pro-Mia.* www.beateatingdisorders.org.uk/get-information-and-support/about-eating-disorders/dangers-of-pro-ana-and-pro-mia/

Becker, A. E., Burwell, R. A., Herzog, D. B., Hamburg, P., & Gilman, S. E. (2002). Eating behaviours and attitudes following prolonged exposure to television among ethnic Fijian adolescent girls. *British Journal of Psychiatry* 180(6), 509–514. https://doi.org/10.1192/bjp.180.6.509

Bretherton, I., Oppenheim, D., Buchsbaum, H., & Emde, R. N. (1990). The MacArthur story stem battery. *Unpublished Manual.*

Bretherton, I., Oppenheim, D., Emde, R. N., & the MacArthur Narrative Working Group (2003). The MacArthur story stem battery. In R. N. Emde, D. P. Wolf, & D. Oppenheim (Eds.), *Revealing the inner worlds of young children: The MacArthur story stem battery and parent–child narratives* (pp. 381–396). Oxford University Press.

Brewerton, T. D., Suro, G., Gavidia, I., & Perlman, M. M. (2022). Sexual and gender minority individuals report higher rates of lifetime traumas and current PTSD than cisgender heterosexual individuals admitted to residential eating disorder treatment. *Eating and Weight Disorders: Studies on Anorexia, Bulimia and Obesity* 27(2), 813–820. https://doi.org/10.1007/s40519-021-01222-4

Cardwell, S. (2017). Season to taste: television cookery programmes, aesthetics and seasonality. *The Journal of Popular Television* 5(1), 11–29. https://doi.org/10.1386/jptv.5.1.11_1

Cleveland Clinic. (2021). *Dysgeusia.* Cleveland Clinic. https://my.clevelandclinic.org/health/diseases/22047-dysgeusia#symptoms-and-causes

Convertino, A. D., Albright, C. A., & Blashill, A. J. (2021). Eating disorders and related symptomatology in sexual minority men and boys. In J. M. Nagata, T. A. Brown, S. B. Murray, & J. M. Lavender (Eds.), *Eating disorders in boys and men* (pp. 253–264). Springer Nature.

Craigie, J., Hope, T., Tan, J., Stewart, A., & McMillan, J. (2013). Agency, ambivalence and authenticity: the many ways in which anorexia nervosa can affect autonomy. *International Journal of Law in Context 9*(1), 20–36. https://doi.org/10.1017/S1744552312000456%5Cn

Cribb, A., & Pullin, G. (2022). Aesthetics for everyday quality: one way to enrich healthcare improvement debates. *Medical Humanities 48*(4), 480–488. https://doi.org/10.1136/medhum-2021-012330

de Beauvoir, S. (1949). *The second sex*. Gallimard.

De Shazer, S. (1988). *Clues: investigating solutions in brief therapy*. W.W. Norton & Co.

de Valle, M. K., Gallego-García, M., Williamson, P., & Wade, T. D. (2021). Social media, body image, and the question of causation: meta-analyses of experimental and longitudinal evidence. *Body Image 39*, 276–292. https://doi.org/10.1016/j.bodyim.2021.10.001

DeLucia-Waack, J. L. (1999). Supervision for counselors working with eating disorders groups: countertransference issues related to body image, food, and weight. *Journal of Counseling and Development 77*(4), 379–388. https://onlinelibrary.wiley.com/doi/10.1002/j.1556-6676.1999.tb02463.x

Dieterich-Hartwell, R. (2018). Creative arts therapies and clients with eating disorders. *Music Therapy Perspectives 36*(2), 282–283. https://doi.org/10.1093/mtp/miw027

Dunkley, C. R., Svatko, Y., & Brotto, L. A. (2020). Eating disorders and sexual function reviewed: a trans-diagnostic, dimensional perspective. *Current Sexual Health Reports 12*(1), 1–14. https://doi.org/10.1007/s11930-020-00236-w

Dunphy, K., Mullane, S., & Jacobsson, M. (2013). The effectiveness of expressive arts therapies: a review of literature. *Psychotherapy and Counselling Journal of Australia, 2*(1). https://doi.org/10.59158/001c.71004. https://pacja.org.au/section/3408-literature-reviews

Eaton, C. M. (2020). Eating disorder recovery: a metaethnography. *Journal of the American Psychiatric Nurses Association 26*(4), 373–388. https://doi.org/10.1177/1078390319849106journals.sagepub.com/home/jap

Eisler, I., Simic, M., Hodsoll, J., Asen, E., Berelowitz, M., Connan, F., Ellis, G., Hugo, P., Schmidt, U., & Treasure, J. (2016). A pragmatic randomised multi-centre trial of multifamily and single family therapy for adolescent anorexia nervosa. *BMC Psychiatry 16*(1), 1–14.

Elwyn, R. (2023). A lived experience response to the proposed diagnosis of terminal anorexia nervosa: learning from iatrogenic harm, ambivalence and enduring hope. *Journal of Eating Disorders 11*(1), 2. https://doi.org/10.1186/s40337-022-00729-0

Fairburn, C. G. (2008). *Cognitive behavior therapy and eating disorders*. Guilford Press.

Fairburn, C. G., Cooper, Z., & Shafran, R. (2003). Cognitive behaviour therapy for eating disorders: a "transdiagnostic" theory and treatment. *Behaviour Research and Therapy 41*(5), 509–528.

Frisch, M. J., Franko, D. L., & Herzog, D. B. (2006). Arts-based therapies in the treatment of eating disorders. *Eating Disorders 14*(2), 131–142. https://doi.org/10.1080/10640260500403857

Galassi, F. M., Bender, N., Habicht, M. E., Armocida, E., Toscano, F., Menassa, D. A., & Cerri, M. (2018). St. Catherine of Siena (1347–1380 AD): one of the earliest historic cases of altered gustatory perception in anorexia mirabilis. *Neurological Sciences 39*(5), 939–940. https://doi.org/10.1007/s10072-018-3285-6

Gilbert, P. (2010). *Compassion focused therapy: distinctive features*. Routledge.

Gilbert, P., & Irons, C. (2015). Compassion focused therapy. *The beginner's guide to counselling & psychotherapy* edited by Stephen Palmer (pp. 127–139). SAGE. https://doi.org/10.4135/9781473918061

Gilligan, C. (1982). *In a different voice.* Harvard University Press.

Giousmpasoglou, C., Brown, L., & Cooper, J. (2020). The role of the celebrity chef. *International Journal of Hospitality Management 85*, 102358. https://doi.org/10.1016/j.ijhm.2019.102358

Gordon, A. R., Moore, L. B., & Guss, C. (2021). Eating disorders among transgender and gender non-binary people. In J. M. Nagata, T. A. Brown, S. B. Murray, & J. M. Lavender (eds.)., *Eating disorders in boys and men.* Springer, Cham. https://doi.org/10.1007/978-3-030-67127-3_18

Hartman-Munick, S. M., Silverstein, S., Guss, C. E., Lopez, E., Calzo, J. P., & Gordon, A. R. (2021). Eating disorder screening and treatment experiences in transgender and gender diverse young adults. *Eating Behaviors 41*, 101517. https://doi.org/10.1016/j.eatbeh.2021.101517

Hediger, C., Rost, B., & Itin, P. (2000). Cutaneous manifestations in anorexia nervosa. *Schweizerische Medizinische Wochenschrift 130*(16), 565–575.

Hodge, L., & Simpson, S. (2016). Speaking the unspeakable: artistic expression in eating disorder research and schema therapy. *Arts in Psychotherapy 50*, 1–8. https://doi.org/10.1016/j.aip.2016.05.005

Hope, T., Tan, J., Stewart, A., & Fitzpatrick, R. (2005). Anorexia nervosa and the language of authenticity. *The Hastings Center Report 41*(6), 19–29. https://www.muse.jhu.edu/article/458040. https://doi.org/10.1002/j.1552-146x.2011.tb00153.x

Hudson, J. I., Hiripi, E., Pope, H. G., & Kessler, R. C. (2007). The prevalence and correlates of eating disordersin the National Comorbidity Survey Replication. *Biological Psychiatry 61*(3), 348–358. https://doi.org/10.1016/j.biopsych.2006.03.040

Jewson, N. D. (1976). The disappearance of the sick-man from medical cosmology, 1770–1870. *Sociology 10*(2), 225–244.

Jiotsa, B., Naccache, B., Duval, M., Rocher, B., & Grall-Bronnec, M. (2021). Social media use and body image disorders: association between frequency of comparing one's own physical appearance to that of people being followed on social media and body dissatisfaction and drive for thinness. *International Journal of Environmental Research and Public Health 18*(6), 2880. https://doi.org/10.3390/ijerph18062880

Johns, G., Burhouse, A., Tan, J., John, O., Khalil, S., Williams, J., Whistance, B., Ogonovsky, M., & Ahuja, A. (2021). Remote mental health services: a mixed-methods survey and interview study on the use, value, benefits and challenges of a national video consulting service in NHS Wales, UK. *BMJ Open 11*(9), e053014.

Katzman, M. A., & Lee, S. (1997). Beyond body image: the integration of feminist and transcultural theories in the understanding of self-starvation. *International Journal of Eating Disorders 22*(4), 385–394. https://doi.org/10.1002/(SICI)1098-108X(199712)22:4<385::AID-EAT3>3.0.CO;2-I

Kendall, S., & Hugman, R. (2016). Power/knowledge and the ethics of involuntary treatment for anorexia nervosa in context: a social work contribution to the debate. *British Journal of Social Work 46*(3), 686–702. https://doi.org/10.1093/bjsw/bcu134

Kenny, T. E., & Lewis, S. P. (2021). Reconceptualizing recovery: integrating lived experience perspectives into traditional eating disorder recovery frameworks. *Psychiatric Services 72*(8), 966–968. https://doi.org/10.1176/APPI.PS.202000447

Kron, J. (2006). Creative art therapies. *Journal of Complementary Medicine 5*(4), 26–35.

Lang, P., Little, M., & Cronen, V. (1990). The systemic professional: domains of action and the question of neutrality. *Human Systems 1*(1), 34–49.

Misluk-Gervase, E. (2020). The role of art therapy in eating disorder advocacy. *Art Therapy 37*(4), 194–200. https://doi.org/10.1080/07421656.2020.1823783

Moreno, C., Wykes, T., Galderisi, S., Nordentoft, M., Crossley, N., Jones, N., Cannon, M., Correll, C. U., Byrne, L., & Carr, S. (2020). How mental health care should change as a consequence of the COVID-19 pandemic. *Lancet Psychiatry 7*(9), 813–824.

National Institute of Health and Care Excellence. (2017). *NICE Guideline NG69: Eating disorders: recognition and treatment*. London: National Institute of Health and Care Excellence. https://www.nice.org.uk/guidance/ng69. Last updated 16 December 2020.

Ngo, N. T. (2019). What historical ideals of women's shapes teach us about women's self-perception and body decisions today. *AMA Journal of Ethics 21*(10), 879–901. https://doi.org/10.1001/amajethics.2019.879

O'Connor, R. A. (2012). De-medicalizing anorexia: opening a new dialogue. In Carole Counihan and Penny Van Esterik (Eds.), *Food and Culture: A Reader* (pp. 290–297). Routledge. https://doi.org/10.4324/9780203079751

Orbach, S. (1976). *Fat is a feminist issue*. Arrow Books.

Peters, N. (1995). The ascetic anorexic. *Social Analysis: The International Journal of Anthropology 37*, 44–66. Berghahn Books.

Pope, H. G., Olivardia, R., Gruber, A., & Borowiecki, J. (1999). Evolving ideals of male body image as seen through action toys. *International Journal of Eating Disorders 26*(1), 65–72. https://doi.org/10.1002/(SICI)1098-108X(199907)26:1<65::AID-EAT8>3.0.CO;2-D

Prochaska, J. O., & DiClemente, C. C. (1983). Stages and processes of self-change of smoking: toward an integrative model of change. *Journal of Consulting and Clinical Psychology 51*(3), 390.

Pulp. (1987). Anorexic beauty. In *Album: Freaks*. Fire Records. https://www.firerecords.com/product/pulp-freaks-2012/

Ranteallo, I. C., & Andilolo, I. R. (2017). Food representation and media: experiencing culinary tourism through foodgasm and foodporn. In A. Saufi, I. Andilolo, N. Othman, & A. Lew (Eds.), *Balancing development and sustainability in tourism destinations*. Proceedings of the Tourism Outlook Conference 2015 (pp. 117–127). Singapore: Springer. https://doi.org/10.1007/978-981-10-1718-6_13

Roberts Strife, S., & Rickard, K. (2011). The conceptualization of anorexia: the pro-ana perspective. *Journal of Women and Social Work 26*(2), 213–217. https://doi.org/10.1177/0886109911405592

Russell, D. (1995). *Women, madness and medicine*. Blackwell Publishers.

Ryu, H., Hamilton, B., & Tarrant, B. (2022). Early career mental health nurses' emotional experiences in specialist eating disorder units, Victoria, Australia. *International Journal of Mental Health Nursing 31*(1), 230–239. https://doi.org/10.1111/inm.12955

Sarafine, A. (2020, January 29). *Understanding ideal body shapes through history*. PureGym News. www.puregym.com/blog/body-shapes/

Satir, D. A., Thompson-Brenner, H., Boisseau, C. L., & Crisafulli, M. A. (2009). Countertransference reactions to adolescents with eating disorders: relationships to clinician and patient factors. *International Journal of Eating Disorders 42*(6), 511–521. https://doi.org/10.1002/eat.20650

Seah, X. Y., Tham, X. C., Kamaruzaman, N. R., & Yobas, P. (Klainin). (2017). Knowledge, attitudes and challenges of healthcare professionals managing people with eating disorders: a literature review. *Archives of Psychiatric Nursing 31*(1), 125–136. https://doi.org/10.1016/j.apnu.2016.09.002

Simic, M., & Eisler, I. (2015). Multi-family therapy. In Katharine L. Loeb, Daniel Le Grange, and James Lock (Eds.), *Family therapy for adolescent eating and weight disorders: New applications* (pp. 130–158). Routledge.

Strumìa, R., Varotti, E., Manzato, E., & Gualandi, M. (2001). Skin signs in anorexia nervosa. *Dermatology 203*(4), 314–317. https://doi.org/10.1159/000051779

Tan, J. (2006). *Competence and treatment decision-making in anorexia nervosa* [DPhil Thesis]. University of Oxford.

Tan, J., Hope, T., & Stewart, A. (2003). Anorexia nervosa and personal identity: the accounts of patients and their parents. *International Journal of Law and Psychiatry 26*(5), 533–548. https://doi.org/10.1016/S0160-2527(03)00085-2

Tan, J., Hope, T., Stewart, A., & Fitzpatrick, R. (2003). Control and compulsory treatment in anorexia nervosa: the views of patients and parents. *International Journal of Law and Psychiatry 26*(6), 627–645. https://doi.org/10.1016/j.ijlp.2003.09.009

Tchanturia, K. (ed.). (2014). Cognitive remediation therapy (CRT) for eating and weight disorders. Routledge. https://www.routledge.com/Cognitive-Remediation-Therapy-CRT-for-Eating-and-Weight-Disorders/Tchanturia/p/book/9781138794030

Tchanturia, K., & Lock, J. (2011). Cognitive remediation therapy for eating disorders: development, refinement and future directions. *Current Topics in Behavioral Neurosciences.*, *6*, 269–287. https://doi.org/10.1007/7854_2010_90.

Vitousek, K., & Manke, F. (1994). Personality variables and disorders in anorexia nervosa and bulimia nervosa. *Journal of Abnormal Psychology 103*(1), 137–147. https://doi.org/10.1037//0021-843X.103.1.137

WHO. (2018). *ICD-11 for mortality and morbidity statistics: feeding or eating disorders.* https://icd.who.int/browse11/l-m/en#/http%3A%2F%2Fid.who.int%2Ficd%2Fentity%2F1412387537

Zhang, Y. Y., Burns, B. D., & Touyz, S. (2021). Exploring a core psychopathology in disordered eating: the feelings of fat scale. *Journal of Eating Disorders 9*(1), 64. https://doi.org/10.1186/s40337-021-00401-z

CHAPTER 50

THEOLOGICAL AESTHETICS AND CLINICAL CARE

ARIEL DEMPSEY

'Most people live dejectedly in worldly sorrow and joy; they are the ones who sit along the wall and do not join in the dance.'
~Kierkegaard, *Fear and Trembling* (Kierkegaard, 2013, p. 84)

INTRODUCTION

THIS chapter is a personal reflection on aesthetic experience and explores a way in which theological aesthetics can contribute to clinical care. Whilst theological aesthetics[1] warns that aesthetics alone might not cure medicine of what ails it, it also suggests that aesthetic experience has an important contribution to make in creating connections and relationships. By 'aesthetic experience' I refer to an enlivening awareness of sensory perception and imagination leading to deeper reflection (see Fox, this volume).[1] In the image of a dancer, I offer an instance of aesthetic experience bringing together two things often set in opposition to one another; clinical objectivity and compassionate care. The image arises from my experiences of performing dance, leading trauma healing groups, studying the philosophy of Søren Kierkegaard, and observing the ritual of the Catholic Eucharist. I share how this image of a dancer helped a group of medical students reimagine the compassion and objectivity of clinical care, not as a burden of meeting two impossible and competing demands, but as an invitation to join in the dance.

[1] For other definitions of 'aesthetic experience' see Iseminger (2003).

As background, I am a medical doctor from America working on a doctorate in Science and Religion at the University of Oxford. Alongside my studies, I teach Medical Humanities to fifth-year medical students at the Oxford Medical School. One thing that medical students often struggle with is navigating a tension between two conflicting expectations. They are told they must be clinically objective, remain distant, and shut down emotions in order to protect themselves and their patients. But they are also told they must be caring, empathetic, compassionate and engage emotions in order to be good doctors. Bioethicist and MD, Jodi Halpern, describes the conflict as follows: 'There is a long-standing tension in the physician's role. On the one hand, doctors strive for detachment to reliably care for all patients regardless of their personal feelings. Yet patients want genuine empathy from doctors and doctors want to provide it' (Halpern, 2003, p. 670).

Empathy has long been recognized as a key component of physician training. The UK General Medical Council lists empathy as a core value in medical training (GMC, 2020) and the Association of American Medical Colleges likewise considers empathy an essential learning objective in medical school (AAMC, 1999). Sadly, studies suggest that medical students' empathy decreases through the course of clinical training (Andersen et al., 2020; Bellini & Shea, 2005; Chen et al., 2007; Colliver et al., 2010; Howick et al., 2023; Hojat et al., 2004; Neumann et al., 2011; Newton et al., 2008).[2] Many studies track this change but comparatively few explore why such a change occurs. A recent study by Dr Jeremy Howick (Howick et al., 2023) conducted a systematic review of qualitative studies investigating why empathy might decrease during medical school and several important themes emerged. One of which was the presence of a 'hidden curriculum' that taught medical students to adapt to the stresses of medical training through cynicism, desensitization, and emotional distancing. In this hidden curriculum biomedical knowledge was prioritized and presented as though it were in competition with human connection and feelings of the heart. In this chapter, I offer a reflection that I shared with the Oxford medical students; one which they found helpful for opening up a more holistic way to think about clinical practice.

The insight came from an experience I had while leading a trauma healing group in a local church. Through the support of the Rotary International Foundation,[3] I lead trauma healing groups in a church in which refugees and immigrants make up a significant portion of the congregation. I'm certified to lead these groups through the Trauma Healing Institute, which integrates scientific evidence-based psychology in the context of religious faith.[4] Central to this trauma healing programme is a ceremony that facilitates letting go and acceptance. On one occasion there was a participant who could not attend. I felt that it was important for this person to experience this part of the trauma healing programme but did not have anyone to lead the ceremony with me or anyone to join the participant in it. As a solution, I organized a special one-to-one session in which I served as both a leader and participant in the ceremony. I was hesitant because I was not sure what it would be like to lead and participate at the same time. Could I keep the distance necessary to lead the ceremony while also genuinely participating in it?

In order to explain the experience that followed, I need to give some background. For many years I have been performing circus arts—specializing in cyr wheel and aerial silks. One thing I have learned from performing is that there are two errors to

make. One error is focusing so much on technique that the performance looks flat and rehearsed, and the audience cannot connect. The other is to lose yourself so much in the feel of the music, passion of the movement, and energy of the audience that you have sloppy technique and make dangerous mistakes. In 2020, I performed an aerial dance in a TEDxTalk (Dempsey, 2020) I spoke about my experience of living with the uncertainty of a traumatic brain injury and life-threatening diagnosis and embodied the talk through aerial silks. I danced blindfolded through the air, tumbling on large strips of fabric hanging from an eight-metre rig. My mental cues were for both technique and feeling. (Wrap the silks around you; right foot, left, then right again. Check that the right silk is over the left and pinched beneath the inside of your feet. Remember to lock your core and neck to avoid whiplash. Listen to the music, the moment. Let go. Feel the falling, metres through the air blindfolded. Catch, hanging by your ankles.) To take my attention off the technical aspects of properly tied knots and cleanly executed movements would be dangerous, but to lose the feeling would be to lose the purpose of doing the dance at all. In golden moments of performing, such as in this TEDxTalk, I experience a flow between technique and feeling. I keep my mind on abstract technical goals while also being present in the feel of the dance.

This aesthetic experience in dance opened up a way for me to lead and participate in the trauma healing group ceremony. In previous trauma healing groups, I aimed to be kind and compassionate but occasionally found that my mind was overly focused on the technicalities of conducting each session: facilitating the conversation, coordinating the activities, watching the time clock to stay onschedule, shepherding the group etc. In the ceremony with the refugee, as I was a participant and leader, I found that flow that I have felt in golden moments of performing. This aesthetic experience was striking and a vision of how I want to practise medicine—the objective clinical distance brought together with compassionate care. As I led, I could remember the technicalities and also be present in the dance.

This aesthetic experience from the trauma healing group in the church prompted me to reflect more broadly on theological aesthetics and insights it might contribute to medicine. I began this chapter with stories from personal experience and will now move into theological aesthetics through imagery of dance in the philosophy of Søren Kierkegaard and ritual of the Eucharist. I will end the chapter by reflecting on how these ideas apply to clinical practice and how aesthetic engagement could have rich relevance for deeper connectivity, compassion, and humanity in health-care practice today.

I approach the vast field of aesthetic experience from the perspective of theological aesthetics. There are many religious traditions that could make rich contributions to this discussion. Although the scope of this chapter is limited to the Christian tradition, this by no means excludes the valuable contribution of other spiritual/religious traditions (Brown, 2013). By writing this chapter from the perspective of my own spiritual experience I hope to inspire health-care practitioners to speak from experiences of their own spiritual and religious traditions.

THEOLOGICAL AESTHETICS

Theology is the study of God, and as an academic discipline it inquires into religious/spiritual beliefs, practices, and experiences. How might God, faith, and theology relate to human perception, imagination, sensation, beauty, and the arts (Garrett, 2012, p. 1)? Theological aesthetics (theology as it relates to aesthetic experience) encompasses a diversity of themes (Brown, 1990, 2013; Viladesau, 1999, 2014) and is the subject of an extensive body of literature. Distinctions can be drawn between theology that interacts with aesthetic objects, theology that is informed by philosophy of aesthetic theories, theology that reflects on aspects of aesthetic experience such as sensation, imagination, emotion, beauty, and art, and theology that uses aesthetics processes to make theology aesthetic (Viladesau, 1999). As representative examples see (Augustine, 2009; Bychkov & Fodor, 2008; Barth, 1957; Balthasar, 1982; Delattre, 2006; Hart, 2003; Kuyper, 2002; Leeuw, 2006; Lewis & Hooper, 2013; Nichols, 1980; O'Connell, 1978; Rahner, 2021; Thiessen, 2004; Viladesau, 1999; Wolterstorff, 1980). The field of theological aesthetics is vast and complex, yet at least two broad themes emerge. First, theological aesthetics offers a warning about aesthetics. It serves as a reminder that aesthetics can be misused and it alone cannot save humanity from what ails it. Second, theological aesthetics affirms aesthetics, especially as aesthetics can create connection with the world, ourselves, others, and God. Each of these themes will be discussed briefly below.

Warning: Aesthetics Alone Will Not Save

Many voices within theology remind us that what is aesthetic cannot always be equated with what is Godly or good (Barth, 1957, pp. 650–652). Although aesthetics can have moral and spiritual effects, these are situated within nuanced discussions on relationships between nature, grace, and original sin. The patristic fathers warned against the idolatrous allure of beautiful things, and the temptation to worship them (Garrett, 2012, p. 2). An oft-quoted verse from scripture is Jeremiah 17:9, 'The heart is deceitful above all things' (Jeremiah 17:9 *NIV*). St Anthony, a man considered to be a founder of the Christian monastic tradition, renounced the pleasures of the world, and withdrew to the desert, to a live a life of solitude and destitution in sole pursuit of God. *The Life of Saint Anthony* by Athanasius is a gripping narrative chronicling St Anthony's struggles against the temptations of Satan (Athanasius, 1950). When reading this work, one sees that aesthetics not only have the power to draw St Anthony closer to God but are also a favourite tool of the devil. Many in the Medieval church (for example St Bernard of Clairvaux) warned that aesthetic pleasures could distract from love of one's neighbour and love of God, and could be used to deceive oneself and others (Viladesau, 2014, p. 33). The iconoclastic movement of the Reformation which purged Protestant

churches of its religious art is an example of a religious group, that warned aesthetics should be used with caution (Noyes, 2013).

One takeaway from this discussion is that anything, even aesthetics, can be misused. After making an extensive case for the value of aesthetics for improvement in healthcare quality measures, bioethicist Alan Cribb and professor of design and disability Graham Pullin write, 'There is the question of when we should be suspicious of appeals to aesthetics—when it may send us in directions that are potentially damaging' (Cribb & Pullin, 2022, p. 487). Aesthetic values are among a plethora of values in medicine and (as is shown in the philosophy of values-based medicine) values often exist in tension with one another (Fulford, 2004, pp. 55–58; Fulford et al., 2012). In *Aesthetics of the Familiar: Everyday Life and World-Making,* philosopher of aesthetics Yuriko Saito speaks about the power of aesthetics to affect quality of life for '*better or for worse*' (Saito, 2017a, p. 5). Aesthetics might not always make things better (Bishop, 2011; Garden, 2007; Petersen et al., 2008; Saito, 2007, 2017b). They are to be used with careful reflection—as is well known by medical practitioners, sometimes the best attempts at treatment can do as much harm as good.

Affirmation: Aesthetics as a Two-Way Movement Creating Connection

At the same time, Christian tradition also affirms aesthetics. Consider the beauty of St Peter's Basilica or La Sagrada Familia Cathedral; see the great art commissioned by the church, works such as Michelangelo's statue of Madonna Della Pietà or Leonardo Da Vinci's Last Supper; listen to the symphonies of Johann Sebastian Bach or hymns of Charles Wesley, read the poetry of Dante Alighieri or John Milton, hear praises sung of nature's beauty in St. Francis of Assisi or St. Hildegard of Bingen; notice the beauty written into the liturgy, such as in the ritual of the Eucharist.

Central to theological aesthetics is the conviction that there can be a two-way movement between experience of beauty and experience of God (Viladesau, 2014, pp. 30–32). For instance, in the theological aesthetics of Hans Urs Von Balthasar, God is revealed in beauty and beauty is part of what draws us into the mystery of God. There is a downward movement as God's glory is revealed and incarnated in beauty, and an upwards lift as mankind is raised up to partake and participate in that glory. Saito's use of 'aesthetic' extends to includes the ugly and disturbing (Saito, 2022, p. 1), and with similar extensive reach, Balthasar's notion of beauty includes even the suffering of the cross (Balthasar, 1982, p. 124; Viladesau, 2014, p. 35). For Balthasar, aesthetics plays an important role in creating relationships that connect mankind to the good, the true to each other, to the world, and to God (Balthasar, 1982; Viladesau, 1999, pp. 30–35; Chia, 1996).

Theological aesthetics suggests that aesthetics can create connections and relationships. I believe that aesthetic experience can play an important role in creating a deeper connectivity and compassion in medicine too. There is a movement in medical education to cultivate empathy in medical students through literature, arts, reflection, and other sources of aesthetic experience (Batt-Rawden et al., 2013; Bleakley et al., 2006; Bleakley, 2015; Charon et al., 1995; Churchill, 1982; Pera & Pera, 2017; Coote, 2005;

Pellegrino, 1982; Stepien & Baernstein, 2006; Spiro, 1992) and qualitative studies support its effectiveness (Hojat, 2009; Kelm et al., 2014). Medical historian Victoria Bates speaks to the value of aesthetics in architecture for humanizing health-care environments (Bates, 2018). Bioethicist Alan Cribb and professor of design and disability Graham Pullin explain the importance of aesthetic considerations for health-care quality and improvements in prosthetic design (Cribb & Pullin, 2022). Professor of nursing, Kathleen Galvin, draws on aesthetic experience for humanizing perspectives in nursing (Galvin & Todres, 2013).

Perhaps theological aesthetics can also be used as a way of exploring the relevance of aesthetic experience for deeper connectivity and compassion in medicine. The psychiatrist Curt Thompson has drawn links between the relational function of aesthetics in spirituality and interpersonal neurobiology, and offers practical strategies for applying this to practice (Siegel, 2012; Thompson, 2010). Health-care ethicists Kimbell Kornu (Kornu, 2014) and Nathan Carlin (Carlin, 2019) appeal to theological aesthetics to encourage a bioethics rooted in relationship and connectivity instead of disinterested duty or principalism. Despite warnings about limitations of aesthetics, theological aesthetics affirms that aesthetics can contribute towards deepening the humane connectivity that is at the core of clinical care.

In the section which follows, I will explore the relevance of aesthetics for medicine by focusing on a single image from one theologian's work: the Danish philosopher/theologian Søren Kierkegaard (1813–1855) and a particular figure he deploys in *Fear and Trembling*, the image of a dancer (Kierkegaard, 1983, p. 41). I will begin with an exposition of this image and at the end of the chapter will apply it for use in clinical practice.

Kierkegaard's Dancer

There is something ironic about choosing Søren Kierkegaard as a representative of theology and aesthetics because he is a theologian whose work is characterized as pitting aesthetics against religion (i.e., Kierkegaard, 1987). This, however, is a mischaracterization. For Kierkegaard the word 'aesthetics' takes on a provisional and narrow definition as worldly life driven by pleasures of the senses (Pattison, 1991). On the whole, Kierkegaard does not reject what falls under the larger umbrella of aesthetics; he was a founder of existentialism, a philosophy which centralizes experience. His work itself is aesthetic, drawing on beautiful images, indirect communication, and other aesthetic skills to communicate his ideas. His work is an example of aesthetic theology in a deeper sense as well. It is an art crafted to draw his reader into authentic experience and relationship with God, others, and themselves.

Kierkegaard plays with the image of dance in many places in his corpus (Ferreira, 1997; Fiskvik, 2018), and some have even likened Kierkegaard's literary style to a dance (Ewegen, 2010; Hall, 2018; LaMothe, 2004). He references many types of movements in dance such as the twisting body of a trampolinist, oscillation of a tightrope dancer,

complex patterns of a quadrille social dance and grace of a ballet leap. He uses the image of dance to signify a diversity of ideas about life, learning, loneliness, love, loss, self-reflection, social commentary, and even thoughts of death (Fiskvik, 2018, pp. 157–159). A particularly beautiful image used by Kierkegaard is that of the ballet dancer. In *Fear and Trembling,* he depicts the 'knight of faith' as a ballet dancer leaping up towards the infinite and landing again upon the ground of the finite with grace.

Fear and Trembling is a complex text with many movements. It is written under the pseudonymous name of Johannes de Silentio and wrestles with the Biblical narrative of Abraham and Isaac. Abraham is commanded by God to sacrifice his son Isaac but at the last moment, as Abraham raises the knife above Isaac, God provides a ram to be sacrificed in Isaac's place. *Fear and Trembling* considers the psychological turmoil that Abraham, the loving father and moral man, must have wrestled with in the three-day journey up Mount Moriah on his way to make the sacrifice. In trying to understand this paradoxical story, *Fear and Trembling* walks through other ways the story of Abraham could have played out. The difficulties with understanding the story multiply and this opens discussion of three spheres of existence, the 'aesthetic',[5] the ethical, and the religious. The conclusion is that the story of Abraham defies rational understanding—posing an existential challenge to the limits of rational understanding itself (Green, 1997).

Leaps have many meanings in Kierkegaard's corpus. Leaps evoke paradoxes, movements going both up and down (LaMothe, 2004, p. 92). Leaps also transcend dichotomies, going beyond the limitations of the rational and ethical. Faith is itself considered a leap: an existential risk in committing oneself to God, a passion, or a way of life. In *Fear and Trembling* the metaphor of the leap joins with the metaphor of dance. As Joshua Hall points out in *Religious Lightness in Infinite Vortex: Dancing with Kierkegaard* the Latin word for 'to leap', *saltare*, is also the word 'to dance' (Hall, 2018, p. 9).

Much scholarship on Kierkegaard looks upon the leap, i.e., the 'leap of faith'. What is often overlooked is that in Kierkegaard the 'landing of faith' is just as important. In ballet dance and in Kierkegaard the landing is often just as difficult and just as much a part of a dance, as the leap.

Two types of characters in *Fear and Trembling* leap. The first is the 'knight of infinite resignation', who bears the suffering of the sacrifice with dutiful resignation and makes a leap because it is justified by reason and demanded by ethical understanding. The second is Abraham, the 'knight of faith'. Both the knight of infinite resignation and the knight of faith are likened to ballet dancers who leap through the air with perfect posture and the appearance of effortless ease. However, it is the landing back upon the ground that distinguishes the knight of infinite resignation from the knight of faith. This can be seen clearly in the following passage from *Fear and Trembling*:

> It is supposed to be the most difficult feat for a ballet dancer to leap into a specific posture in such a way that he never once strains for the posture but in the very leap assumes the posture ... The knights of [infinite resignation] are ballet dancers and have elevation. They make the upward movement and come down again, and this, too, is not an unhappy diversion and is not unlovely to see. But every time they come

down, they are unable to assume the posture immediately, they waver for a moment, and this wavering shows that they are aliens in the world. It is more or less conspicuous according to their skill, but even the most skillful of these knights cannot hide this wavering. (Kierkegaard, 1983, p. 41)

Kierkegaard describes the knight of infinite resignation leaping towards the infinite but 'wavering' when the weight of their humanity pulls them to the ground of the finite. They are not at home in the finite and ordinary and their landing betrays this. They waver. The ordinary is lost to abstract ideals. By contrast, the knight of faith achieves something even more marvellous than the leap. He lands. The knight of faith is 'able to come down in such a way that instantaneously one seems to stand and walk, to change the leap of life into walking, absolutely to express the sublime in the pedestrian …' (Kierkegaard, 1983, p. 41).

What is the difference between the knight of infinite resignation and the knight of faith then? Both knights leap but only the latter leaps and lands. The knight of faith is recognized not by his grace in the air but his grace upon the ground. He embraces both the sublime and pedestrian, the absurdity of the human condition—one that leaps upwards towards the transcendent and infinite and lands again in the life of the ordinary and finite. It is the landing in everyday life that is the miracle.

Unlike the knight of infinite resignation, the knight of faith is just as much at home in the pedestrian as in the sublime. He can leap towards the infinite yet love the world and its finitude. He trusts in God, not just in spite of the absurdity, but even through it. The absurdity of it all becomes a dance. The knight of faith lands and leaps again, lifts and lowers, ascends and descends, rises and falls. He is dancing.

The text, *Fear and Trembling*, is not just a commentary on the story of Abraham or treatise of philosophical-theology; it is an existential challenge to join in the dance. Kierkegaard invites his reader to join in the dance and make the leap and landing for themselves. The dance is not something simply to be observed but to be participated in.

I began this chapter by reflecting on my experience of caring for those with trauma and my experience of dancing in aerial silks. These experiences come together in the image of a dancer who could be aware of both the technique and feel of the dance. Kierkegaard's philosophy adds flesh and bones to this dancing imagery. We have leapt up into the philosophy of Kierkegaard and will hover a moment longer before landing in practical application in medicine. We leave Kierkegaard's dancer hanging in the air, but will return to them at the end. In order to apply this image of Kierkegaard's dancer to medicine I will first show how it applies to an aesthetic experience of a ritual in the church in which I lead trauma healing groups. The ritual is that of the Catholic Eucharist.

Aesthetic Experience in the Eucharist

Ritual can be considered an aspect of aesthetic experience. and can be a rich source of aesthetic imagination and experience (Saito, 2001, p. 92). One ritual that has been

significant in shaping human experience across eras, locations, and cultures is the Eucharist.

In theological aesthetics, there is a downward movement as God's glory is revealed, incarnated in beauty, and an upwards lift as mankind is raised up to partake and participate in that glory (Balthasar, 1982; Viladesau, 1999, pp. 25–35). I witness this downward and upward movement in the Eucharist as well. In the following section I describe the practice of the Eucharist (Roman Missal, 2010) and what arises in my imagination from it.

To preface, I am not a Catholic, but I attend Mass at the Catholic Church where I lead trauma healing groups. Each week I sit in the pew of the church and each week I watch the ritual of the Eucharist. The Eucharist is a sacrament of the Catholic church, believed to be instituted by Christ at the Last Supper before his crucifixion. During this ritual, Christians share bread and wine which they believe becomes the body and blood of Christ. The priest performs the ritual like a dancer moving through choreography. I watch the host, the circular wafer of bread believed to be the body of Christ, lifted, and lowered. I cannot help but see Kierkegaard's dancer. Leaping and landing.

The Catholic Mass is divided into two parts: the 'Liturgy of the Word' (which consists of readings of scripture, the sermon and prayer) and the 'Liturgy of the Eucharist'. The Liturgy of the Eucharist begins with a call and response. The congregation stands for the Eucharist Prayer. The priest lifts his hands, saying 'Lift up your hearts'. The congregation replies 'We lift them up to the Lord'. After the Eucharist Prayer the congregation replies with the Sanctus, a hymn of praise to God in the highest. The congregation kneels, and those who are able to do so remain kneeling throughout the consecration of the bread and wine. They stand to address God in the prayer 'Our Father' and greet one another with a sign of peace. They sit as the host is broken. They walk down the aisle of the church to the front of the altar to receive the host. Some receive the host standing, others whilst kneeling. They lift and land and I imagine the congregation is dancing.

So too, I imagine, is the priest. He bows with a slight bend in his back as the bread becomes the body of Christ. He stands tall, with arms in full extension, then genuflects (kneels) in adoration. The altar is so tall that only his head is visible above the surface. In an almost rhythmic pattern, the priest bows, genuflects, stands, his arms move from just above the altar to back down, lift to full extension and return to the altar again. He offers prayers with arms apart (a position of *orans*) and joins them together again at the level of his heart.

In the Catholic tradition the consecration is when the bread and wine become the body and blood of Christ. The priest begins the consecration by reciting the words of Christ from the Last Supper. He lifts the host from the paten, a small golden plate which rests on a square cloth called the corporal, and holds the bread slightly above the altar. As a bell rings, he stands tall, lifting the host heavenwards. He hovers there for a moment before gently placing the host back upon the altar, genuflecting in adoration. I imagine, the host is dancing as well. Descending from the infinite, landing gracefully in the finite.

The consecration is followed by the Breaking of the Bread. In this part of the ritual, the circular wafer of the host is broken as Christ's body was broken on the cross. There are various ways in which the priest can perform this. This priest opts to lift the two

semicircles of the broken host into the air and hold them apart so that the congregation can clearly see that it is broken. He lowers the host and crumbles a small bit into the chalice. The two semicircles overlap so that there is a triangular gap in what was once a perfect circle. He lifts the host again, this time lifting the chalice with it (see Figure 50.1).

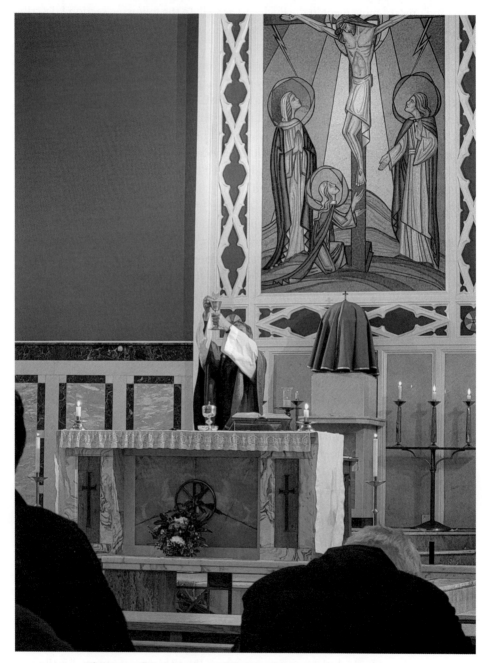

FIGURE 50.1 Elevation of Host. Photograph from author's personal collection.

FIGURE 50.2 Distribution of Holy Communion. Photograph from author's personal collection.

He lowers it, lowers himself in genuflection, and lifts a small piece to his lips, crumbling it in his mouth. He descends down the steps of the altar. Carrying the paten and chalice, he brings the body and blood of Christ down with him to the front of the church. The congregation leaves their seats and comes forward to receive the host. Before each person the priest raises the host and whispers 'the Body of Christ', to which they reply, 'Amen'. The host is lowered onto their hands. It lands on their hands, on their lips, and in their lives (see Figure 50.2).

I said the host 'lands in their lives'. This is what I mean. One day after the Mass I asked the priest, 'What is your favourite part of the Mass?' He said that his favourite part is the Dismissal, when he blesses the congregation and sends them out to be the love of Christ in the world. It is the culmination of Christ descending from the altar into the congregation and into the world, into the particularities of daily lives—a woman working long hours as a nurse at the hospital and trying not to take out stress from home on difficult patients, a father struggling with depression and trying to encourage a daughter disheartened by poor grades, a woman lonely and angry at God for allowing the stroke that left her in a wheelchair, a man grieving the death of his mother and wondering if he was a 'good enough' son, a man with schizophrenia frustrated that no one will believe his visions, a husband feeling like a failure because he can't meet his wife's expectations, a boy missing his family back home in Africa and traumatized from war, a man who hates his job driving a taxi, a mother with cancer undergoing chemo and praying to live long enough to make her son's wedding, a grandmother helping with childcare and tying the child's shoe while answering a phone call about the broken boiler, a young girl sharing her markers with her younger sister even though last time she entirely used up the colour yellow. I was deeply moved when the priest told me that his favourite part of Mass was the Dismissal, when the congregation 'lands' back in their lives and brings the love of

Christ into their everyday existence. Through aesthetic experience of the Eucharist, I became more aware of a sense that the divine may come to land amidst earthly humanity.

In contrast to the seriousness of the Eucharist, the American novelist Annie Dillard offers a more light-hearted description. In a playful scene from *Teaching a Stone to Talk*, she describes the earthly, human realities of attending Mass at her church.

> No one, least of all the organist, could find the opening hymn. Then no one knew it. Then no one could sing anyways. There was no sermon, only announcements ...
>
> ... During communion, the priest handed me a wafer which proved to be stuck to five other wafers. I waited while he tore the clump into rags of wafer, resisting the impulse to help. Directly to my left and all through communion, a woman was banging out the theme from *The Sound of Music* on a piano.
>
> (Dillard, 2017, pp. 25–27)

In Dillard's account, the choir sings off pitch, the Priest tries to distribute the sacred host and body of Christ but five wafers are stuck together in a clump. A theme moving through Dillard's book is: 'Wherever we go, there seems to be only one business at hand—that of finding a workable compromise between the sublimity of our ideas and the absurdity of the fact of us' (Dillard, 2017, p. 37).

The Eucharist is meant to call to mind the larger movements of the Christian story—the downwards and upwards motions of Christ's incarnation, death, resurrection, ascension, and return—and it becomes a spiritual means and symbol of a way in which believers are joined into that story. In this way, everyday lives may be lifted up and transformed.

The lifting of the host is important. Yet, as with Kierkegaard's dancer I am especially interested in the landing. Theologically, incarnation (the Christian belief that God became a human being in the person of Jesus Christ) is an affirmation of our humanity. That faith embraces the finitude of being human. That it is okay to be human, to be 'absurd' (Dillard, 2017, p. 26).[6]

Each week after the Eucharist I go to the fellowship room attached to the main sanctuary and have coffee. I navigate the awkwardness of small talk with strangers, wish I had more coffee, my mind half distracted and uncertain about what the dynamics of the healing group will be that day. Who will come? What stories will they bring? I am trying to make last minute preparations but am interrupted by a member from a past healing group running to me and excited to tell me about an answer to prayer they had been praying for ten years. In the middle of their heartfelt story another person interrupts to ask me questions about the group. I try to coordinate healing group logistics with another person for whom English is a second language. We struggle to understand one another's accents and at the end of the conversation aren't sure if we have communicated what we thought we had. We both smile and nod and let it be. My co-leader spills water across my carefully prepared handouts and notes but it is time to start and I can do nothing about it. The trauma healing group congregates together in a small chapel attached to the fellowship room and I begin to lead the session. We work

through exercises on expressing grief, listening to others, understanding stages of grief, letting go, acceptance and forgiveness. We sit together in a circle and discuss the deepest feelings of human hurt and trauma beyond language, and also the missing flipchart marker, the right number of chairs, the long uncomfortable silences before a question is answered, and running behind schedule. I imagine the knights of faith who can land in the world and treat it and its humanity with love. For they trust in God not just in spite of the 'absurdity' but even through it.

Aesthetic Experience in Medicine

These twisting images from dance, Kierkegaard, and the Eucharist trigger my imagination in relation to clinical practice. As my practice of dance makes me attune to the physical movements of the congregation, priest, and host, so mypractice of the Eucharist makes me open and attune to certain ways of experiencing the world. In the Eucharist something sacred is juxtaposed with something absurd. It is not so different in medicine. As we care for those with health problems, we are invited into sacred places of human suffering and in accepting that invitation we enter into the idiosyncrasies of what humans do. When I speak of the 'absurd' in clinical practice, I do not mean it in the sense of chaotic irrationality. I use it in the way that Kierkegaard speaks of the knight of faith and Dillard speaks of the Eucharist, as the infinite meeting the finite, clinical ideals landing in all of the humanity and idiosyncrasy of each person's everyday life and values. Dillard describes the earthly, human realities of attending Mass. There are earthly, human realities of practising medicine too.

One of the most important tools a physician possesses is questions. If the patient is stable, a clinical encounter often begins with taking a patient history. Patient histories are recorded in medical records for other practitioners to reference and for medico-legal purposes. SOAP is an acronym commonly used as a heuristic for medical documentation and stands for Subjective, Objective, Assessment, and Plan (Podder et al., 2021). 'Subjective' includes the patient history and information from the patient interview. 'Objective' is the physical/mental exam, tests, lab, and imaging results. 'Assessment' is the differential diagnosis. 'Plan' is the plan for treatment and follow-up. A patient history usually begins with a presenting complaint which is the reason why the patient is seeking care, (e.g., hearing voices, feelings of anxiety, panic attacks, etc.) Next the patient is interviewed about the history of present illness. This includes information about onset, presentation, symptoms, change through time, alleviating, exacerbating factors, treatments tried, etc. This is followed by questions about the patient's past medical history, (i.e., questions about past diagnoses, procedures, traumas, surgeries, immunizations, family medical history and otherwise. Then there are questions about medications (both past and present) and allergies. Social history, which bears an especially prominent role in psychiatry, comes next. This includes questions regarding marital status, household, employment, alcohol/tobacco/substance use etc. Finally,

there is a review of systems in which a physician methodologically checklists essential organ systems potential symptoms. Psychiatry is especially challenging in that some patients do not have capacity or insight to answer questions and information is thus gathered indirectly, or through friends, family, and previous health-care documentation. Patient histories also vary for different patient populations, and each physician personalizes their interview style. Despite variation, this general way of structuring a patient history with SOAP is utilized by physicians across many specialties. In some ways, it is like a ritual repeated from room to room and patient to patient. Many hospital systems use electronic medical records which create standardized SOAP templates with questions to ask and tick boxes to check. A young medical student tasked with taking a patient history might run through this auto-populated list of questions verbatim. They drag their computer into the patient room, ready to write down the answers to their questions and check their tick boxes.

The above paragraph lists questions asked in a typical patient history. In *Playing God: Poems About Medicine*, the physician and poet Glenn Colquhoun makes a poem out of the types of answers patients give to such questions (Colquhoun, 2007, pp. 16–17). In the poem, 'A history', readers imagine the question asked and hear the patient's reply. Though fictional, this poem is not untypical of conversations between physicians and their patients with issues of mental health. The poem is a parody of a phenomena experienced by many physicians—the sublimity of our ideas bumping up against the 'absurdity' of us.

A history
The presenting complaint
It was a fine day. I was outside. I thought to myself it was a good day for washing. There are people who say they will do it for me but there are many ways of hanging it out. It was a fine day and I was warm. It was a terrible sound. Like someone had cracked a branch. I knew by the sound of it that it wasn't good. It was a very hot day. I hope someone has got them in. You probably don't mind which way they are hung.

A past medical history
I knew a doctor once which was many years ago. You may have heard of him. You have not. You must have. He was quite famous. He invented a machine. I was the first he tried it on. Do they still use it? I'm not surprised.

No. I have no problems there. I take pills of course but I don't know what they are for. They may be for that. I have read that sometimes you would not know. They could be for that—the pills. It would make sense. What do you think?

No. No. No. No. Oh my goodness no. I have never had that. Not at least that I know of. Should I have known? I am not sure. I could have I suppose. How would I know? I wouldn't have thought so. You have me thinking.

You have had me thinking and now I remember. I have had upsets there yes. In the past. Yes I have had problems. How is that then? I have. Thank you for reminding me.

The medications
I have taken many pills in my time. Yes there have been a lot. I used to take a blue pill. It was small even for a pill. Once for a while I took the blue-tongued mussel. Have you ever heard of that? I don't know why I took it now. I told my doctor I had

been taking it. He said that the less of it I took the better. I don't suppose I should have taken it now. The blue tongued mussel. Could it have done me any harm? . . .

A social history

I have been married. It did not seem long ago. I met him when he was playing rugby and I was going to church. In the end of course he came to church. I had to wait until he could not play any more. He went happily after that. He came to be very strong. He was an elder. He was a winger and an elder. Very fast. I suppose I was faster.

I live on my own now and I do not smoke. My husband used a pipe. Is that better or worse? He said it was better. I was not sure. I drink wine on occasions. I have been told that it is good for me.

You have been very thorough.

Have I told you what you wanted to know?

(Colquhoun, 2007, pp. 16–17)[7]

One can imagine the physician in the conversation above. She is trying to fill in the blank space in the chart for 'presenting complaint' and in a formal, professional tone asks 'What brought you into the office today? What can I help you with?' She receives a verbose answer tangled in a discourse on laundry. Like Dillard's description of the Eucharist at her church, this poem shows how the sublime forms of theories and reasoning land in the particularities of dealing with idiosyncratic individuals. Can we have the faith, and flexibility to embrace both?

Kierkegaard spoke of the knight of faith and knight of infinite resignation. In the philosophy of Kierkegaard, the knight of infinite resignation is good but not the greatest good. It is a stage that some find necessary to pass through in becoming knights of faith (Kierkegaard, 1983, p. 46). Playing on Kierkegaard's phrase, I can imagine the 'physician of infinite resignation' who is willing to sacrifice their emotions and connectivity for the sake of duty. With calm and cool composure, they leap through difficult situations that would leave many in tears. They have seen this scenario a thousand times and can move through it seemingly unaffected. They emotionally disengage to protect themselves and their patients. And this is not a bad thing. Yet, like the knights of infinite resignation, these physicians waver upon the landing. Something is lost in their empathy and ability to connect with others and their work. Recent studies show that this remarkable feat of emotional disengagement contributes to physician burnout and decreased ability to find meaning and satisfaction in work (Halpern, 2003; Thirioux et al., 2016; Lamothe et al., 2014; Yue et al., 2022).

I can also imagine the 'physician of faith' who, like the physician of infinite resignation, makes the leap. They too can deal with the most tender and stressful circumstances with dry eyes and cool calm composure. But they also land. They land in the particularities of patients' lives, this lady and her laundry and blue pills. Some days the leaping and landing is harder than others—especially when hungry, tired, stressed or overworked—but physicians of faith join in the dance, accepting its human absurdity with compassion and grace.

As practitioners we too are part of the 'absurdity'. Can we complete the checklist for the patient history whilst being emotionally attuned. A study on patient–physician communication in the *Journal of the American Medical Association* showed that a physician can run through the checklist and ask all the right questions, but without emotional attunement patients are less likely to disclose information needed for diagnosis and treatment (Suchman et al., 1997). Human minds are structured in such a way that it can sometimes be difficult to attend to analytical tasks and intense emotions at the same time. Cognitive focus on some elements of experience can be an impediment to certain emotions and sometimes emotion can obfuscate clear thinking and clinical judgement (Ekman & Krasner, 2017; Fox et al., 2005; Groopman, 2008; Lajoie et al., 2021; Preisz, 2019; Vohs et al., 2007; Thompson et al., 2019; Zaki & Ochsner, 2012.) Most patients do not want a teary, blubbering doctor. They look for someone they can trust, who cares for them, listens to them, and can try to help and guide them (Osler, 1922).

This is where I find the analogy of a dancer so helpful. It transforms competing goals into dynamic movements. Yes, a focus on clean dance technique can block the feel and experience of the dance. Yes, losing oneself in the feel of the dance can ruin the technique and have dangerous consequences. But this is not always the case, in dance or in medicine. Experienced medical practitioners describe states of flow in which there exists a dynamic movement between leaping and landing, between technique and feeling. Halpern, for instance, makes a compelling case that emotional attunement can make care more efficient and effective (Halpern, 2001, 2003, p. 673). Dr Paul Tournier (Tournier, 1957, 1966) is an inspiring example of such a physician. In *Playing God: Poems About Medicine,* physician Glenn Colquhoun honestly portrays the 'humanness' of being a doctor through poetry (Colquhoun, 2007). Professor of nursing, Kathleen Galvin (also an editor of this *Handbook*), speaks of 'caring for well-being' and 'open-heartedness' in the practice of nursing and grounds this in an aesthetic phenomenology (Galvin & Todres, 2013). Health services researcher Dr Anthony Suchman shows practical opportunities for empathetic engagement during biomedical patient interviews (Suchman et al., 1997). The philosopher of evidence-based medicine, Dr Jeremy Howick, explores empirical research on the value of 'therapeutic empathy' for patient outcomes (Hardman & Howick, 2019; Howick et al., 2018; Howick et al., 2018). Schön's *Reflective Practitioner,* a foundational training text for medical students in the United Kingdom, emphasizes the interconnectedness of thought, feeling, and action (Schön, 2017; GMC, 2018, p. 5). In Kierkegaard it is through reaching towards the infinite that the knight of faith regains the finite. In dance, mastery of technique allows space to improvise and be present in the feeling. In medicine too, technical expertise can free a physician to be truly compassionate. And indeed, studies show that compassion can enhance the techniques of care (Dambha-Miller et al., 2019; Derksen et al., 2013; Di Blasi et al., 2001; Hojat et al., 2011; Howick et al., 2018; Kelley et al., 2014; Little et al., 2001; Steinhausen et al., 2014; Vermeire et al., 2001).

In *Theology and Aesthetics,* Richard Viladesau writes, '… stories and images have the power to shape communities of experience and practice' (Viladesau, 1999, p. 20). In my

experience, I often find medical students imagining clinical objectivity and compassionate care as competing expectations. Striving for both is another burden and impossible demand added to an ever-lengthening list. I believe that this aesthetic image of a dancer could offer a way of shaping imaginative experience of clinical practice. What was once imagined as a burden of conflicting expectations instead becomes an invitation to join in the dance.

I shared this image of a dancer with medical students at one of the Medical Humanities sessions and they told me that it helped them reflect on their experiences of clinical practice in a new way. They realized that the dichotomy between technique and feeling that they thought was unpassable in medicine was a dichotomy that they managed bypass in other areas of their life. In art, music, writing, sports, etc., they too had experienced a flow between technique and feeling and reflecting on their ability to navigate dichotomies in other disciplines gave them hope that they would find a way to do so in medicine too.

Conclusion

The goal of this chapter was to consider an example of aesthetic experience as it lands in clinical practice. I began this chapter by reflecting on a moment in which my experiences of caring for those with trauma came together with my aesthetic experiences in dance. When asked by medical students 'how can we be clinically objective while also being caring and compassionate?', I shared with them the image of a dancer.

Reflection on Kierkegaard's dancer enriched this image through the distinction between leaping into the infinite and landing in the finite and drew attention to the significance of the landing. In the Eucharist, the infinite, sublime, and sacred is embodied in particular human beings with individual lives. Through the example of a patient history, I gestured toward a similar movement in medicine. The leaps toward ideals of caregiving land in the finite world of particular human individuals, embodied in emotions and idiosyncrasies of life. Kierkegaard, the Eucharist, and clinical practice come together to encourage and embrace that landing in all its 'absurdity'.

Whilst the larger field of theological aesthetics warns that aesthetics alone might not cure medicine of what ails it, it also suggests that aesthetic experience has an important contribution to make in creating connections and relationships. In the image of a dancer, I have shown an instance of aesthetic experience bringing together two things often set in opposition to one another; clinical objectivity and compassionate care. I tried to indicate how this image of a dancer could be helpful and invite you, dear reader, to help it land. Aesthetic experience alone might not cure, but used well, can land in clinical practice. At the very least, it helped a group of medical students reimagine the compassion and objectivity, not as a burden of meeting two impossible and competing demands, but as an invitation to join in the dance.

Notes

1. A working definition of theological aesthetics can be found below in the section 'Theological Aesthetics'.
2. Colliver et al., (2010) argues the reported decline of empathy among medical students is exaggerated due to biased interpretation of qualitative empathy studies but still concedes that there could be a decline.
3. Rotary International Foundation: see www.rotary.org/en/about-rotary/rotary-foundation [last accessed 6 October 2024].
4. Trauma Healing Institute: see https://traumahealinginstitute.org/ [last accessed 6 October 2024].
5. As mentioned Kierkegaard sometimes uses the word 'aesthetic' with provisional and narrow definition, referring to a worldly life driven by pleasures of the senses (Pattison, 1991).
6. Kierkegaard speaks of the absurd as faith (Kierkegaard, 1983, pp. 35–38). Dillard speaks of the absurd in terms of the limitedness of our humanity (Dillard, 2017, pp. 25–27). While 'absurd' in Kierkegaard and Dillard are not exactly synonymous, they share resonance in that for Kierkegaard the true mark of faith (the absurd) is the embrace which stretches from the infinite and transcendent to the finite.
7. Poem reproduced here with author's permission (Colquhoun, 2007, pp. 16–17).

References

AAMC (Association of American Medical Colleges). (1999). Learning objectives for medical student education—Guidelines for medical Schools: Report I of the medical school objectives project. *Academic Medicine* 74(1), 13–18.

Andersen, F. A., Johansen, A. S. B., Søndergaard, J., Andersen, C. M., & Assing Hvidt, E. (2020). Revisiting the trajectory of medical students' empathy, and impact of gender, specialty preferences and nationality: A systematic review. *BMC Medical Education* 20(1), 52. https://doi.org/10.1186/s12909-020-1964-5

Athanasius. (1950). *The life of Saint Antony* (R. T. Meyer, Trans., vol. 10). The Newman Press. (Original publication date: 373AD).

Augustine, A. (2009). *The city of god*. Hendrickson Publishers. (Original publication date: 426 AD.)

Balthasar, H. U. v. (1982). *The glory of the Lord: A theological aesthetics* (E. Leiva-Merikakis Trans., *vol. 1. Seeing the form*). Fessio & J. Riches (Eds.). T&T Clark.

Barth, K. (1957). *Church dogmatics II/1* (T. H. L. Parker, W. B. Johston, H. Knight, & J. L. M. Hair, Trans.). G. W. Bromiley & T. F. Torrance (Eds.). T&T Clark. (Original publication date 1932.)

Bates, V. (2018). 'Humanizing' healthcare environments: Architecture, art and design in modern hospitals. *Design for Health* 2(1), 5–19.

Batt-Rawden, S. A., Chisolm, M. S., Anton, B., & Flickinger, T. E. (2013). Teaching empathy to medical students: An updated, systematic review. *Academic Medicine* 88(8), 1171–1177.

Bellini, L. M., & Shea, J. A. (2005). Mood change and empathy decline persist during three years of internal medicine training. *Academic Medicine* 80(2), 164–167.

Bishop, J. P. (2011). *The anticipatory corpse: Medicine, power, and the care of the dying*. University of Notre Dame Press.

Bleakley, A. (2015). *Medical humanities and medical education: How the medical humanities can shape better doctors*. Routledge.

Bleakley, A., Marshall, R., & Brömer, R. (2006). Toward an aesthetic medicine: Developing a core medical humanities undergraduate curriculum. *Journal of Medical Humanities 27*(4), 197–213. https://doi.org/10.1007/s10912-006-9018-5

Brown, F. (1990). *Religious aesthetics: A theological study of making and meaning* (Studies in literature and religion). Macmillan.

Brown, F. B. (2013). *The Oxford handbook of religion and the arts*. Oxford University Press.

Bychkov, O. V., & Fodor, J. (2008). *Theological aesthetics after von Balthasar*. Ashgate Publishing Ltd.

Carlin, N. (2019). *Pastoral aesthetics: A theological perspective on principlist bioethics*. Oxford University Press. https://doi.org/10.1093/oso/9780190270148.001.0001

Charon, R., Banks, J. T., Connelly, J. E., Hawkins, A. H., Hunter, K. M., Jones, A. H., Montello, M., & Poirer, S. (1995). Literature and medicine: Contributions to clinical practice. *Annals of Internal Medicine 122*(8), 599–606. https://doi.org/10.7326/0003-4819-122-8-199504 150-00008

Chen, D., Lew, R., Hershman, W., & Orlander, J. (2007). A cross-sectional measurement of medical student empathy. *Journal of Global Information Management 22*, 1434–1438.

Chia, R. (1996). Theological aesthetics or aesthetic theology? Some reflections on the theology of Hans Urs von Balthasar. *Scottish Journal of Theology 49*(1), 75–95. https://doi.org/10.1017/S0036930600036619

Churchill, L. R. (1982). Why literature and medicine? *Literature and Medicine 1*(1), 35–36. https://doi.org/10.1353/lm.2011.0195

Colliver, J. A., Conlee, M. J., Verhulst, S. J., & Dorsey, J. K. (2010). Reports of the decline of empathy during medical education are greatly exaggerated: A re-examination of the research. *Academic Medicine 85*(4), 588–593.

Colquhoun, G. (2007). *Playing God: Poems about medicine* (rev. ed.). Hammersmith Press.

Coote, B. (2005). Medical humanities: To cure sometimes, to relieve often, to comfort always. *Medical Journal of Australia 182*(8), 430–432.

Cribb, A., & Pullin, G. (2022). Aesthetics for everyday quality: One way to enrich healthcare improvement debates. *Medical Humanities 48*(4), 480–488.

Dambha-Miller, H., Feldman, A. L., Kinmonth, A. L., & Griffin, S. J. (2019). Association between primary care practitioner empathy and risk of cardiovascular events and all-cause mortality among patients with type 2 diabetes: A population-based prospective cohort study. *Annals of Family Medicine 17*(4), 311–318. https://doi.org/10.1370/afm.2421

Delattre, R. A. D. (2006). *Beauty and sensibility in the thought of Jonathan Edwards: An essay in aesthetics and theological ethics*. Wipf & Stock Publishers.

Dempsey, A. (March 2020). Live like you're dying?: Acting in uncertainty. *TED Talk*. Retrieved from: www.ted.com/talks/ariel_dempsey_live_like_you_re_dying_acting_in_uncertainty?language=en

Derksen, F., Bensing, J., & Lagro-Janssen, A. (2013). Effectiveness of empathy in general practice: A systematic review. *British Journal of General Practice 63*(606), e76–84. https://doi.org/10.3399/bjgp13X660814

Di Blasi, Z., Harkness, E., Ernst, E., Georgiou, A., & Kleijnen, J. (2001). Influence of context effects on health outcomes: A systematic review. *Lancet 357*(9258), 757–762. https://doi.org/10.1016/s0140-6736(00)04169-6

Dillard, A. (2017). *Teaching a stone to talk: Expeditions and encounters*. Canongate Books.

Ekman, E., & Krasner, M. (2017). Empathy in medicine: Neuroscience, education and challenges. *Medical Teacher 39*(2), 164–173.

Ewegen, S. M. (2010). Apotheosis of actuality: Kierkegaard's poetic life. *Continental Philosophy Review 43*(4), 509–523. https://doi.org/10.1007/s11007-010-9155-4

Ferreira, M. J. (1997). Faith and the Kierkegaardian leap. In A. Hannay & G. D. Marino (Eds.), *The Cambridge companion to Kierkegaard* (pp. 207–234). Cambridge University Press.

Fiskvik, A. M. (2018). Let no one invite me, for I do not dance: Kierkegaard's attitudes toward dance. In E. Ziolkowski (Ed.), *Kierkegaard, literature, and the arts* (pp. 149–174). Northwestern University Press. https://doi.org/10.2307/j.ctv3znxrg

Fox, M. D., Snyder, A. Z., Vincent, J. L., Corbetta, M., Van, E., David, C., & Raichle, M. E. (2005). The human brain is intrinsically organized into dynamic, anticorrelated functional networks. *Proceedings of the National Academy of Sciences 102*(27), 9673–9678. https://doi.org/10.1073/pnas.0504136102

Fulford, K. W. M. (2004). Ten principles of values-based medicine (VBM). In T. Schramme & J. Thome (Eds.), *Philosophy and psychiatry* (pp. 50–80). De Gruyter.

Fulford, K. W. M., Peile, E., & Carroll, H. (2012). *Essential values-based practice: Clinical stories linking science with people*. Cambridge University Press.

Galvin, K., & Todres, L. (2013). Part III: Developing the capacity to care. In *Caring and wellbeing* (pp. 131–182). Taylor & Francis Group.

Garden, R. (2007). The problem of empathy: Medicine and the humanities. *New Literary History 38*(3), 551–567.

Garrett, S. M. (2012). Theological aesthetics. In G. T. Kurian (Ed.), *The encyclopedia of Christian civilization vol IV* (1st ed., pp. 2344–2346). Blackwell. https://onlinelibrary.wiley.com/doi/epdf/10.1002/9780470670606.wbecc1370?saml_referrer

GMC (General Medical Council). (2018). *The reflective practitioner–Guidance for doctors and medical students the UK conference of postgraduate medical deans, the General Medical Council, and the Medical Schools Council*. Retrieved from: www.gmc-uk.org/-/media/documents/dc11703-pol-w-the-reflective-practitioner-guidance-20210112_pdf-78479611.pdf [last accessed 6 October 2024].

GMC (General Medical Council). (2020). *Our strategy 2021–25*. Retrieved from: www.gmc-uk.org/-/media/gmc-site/about/how-we-work/corporate-strategy/corporate_strategy_document_final_en_04122020.pdf [last accessed 6 October 2024].

Green, R. M. (1997). 'Developing' fear and trembling. In A. Hannay & G. D. Marino (Eds.), *The Cambridge companion to Kierkegaard* (pp. 257–281). Cambridge University Press.

Groopman, J. (2008). *How doctors think* (1st Mariner Books ed.). Houghton Mifflin.

Hall, J. M. (2018). Religious lightness in infinite vortex. *Epoché 23*(1), 125–144.

Halpern, J. (2001). *From detached concern to empathy: Humanizing medical practice*. Oxford University Press.

Halpern, J. (2003). What is clinical empathy? *Journal of General Internal Medicine 18*(8), 670–674. https://doi:10.1046/j.1525-1497.2003.21017.x

Hardman, D., & Howick, J. (2019). The friendly relationship between therapeutic empathy and person-centred care. *European Journal for Person Centered Healthcare 7*(2), 351–357.

Hart, D. (2003). *The beauty of the infinite: The aesthetics of Christian truth*. William B. Eerdmans.

Hojat, M. (2009). Ten approaches for enhancing empathy in health and human services cultures. *Journal of Health and Human Services Administration 31*(4), 412–450.

Hojat, M., Louis, D. Z., Markham, F. W., Wender, R., Rabinowitz, C., & Gonnella, J. S. (2011). Physicians' empathy and clinical outcomes for diabetic patients. *Academic Medicine 86*(3), 359–364. https://doi.org/10.1097/ACM.0b013e3182086fe1

Hojat, M., Mangione, S., Nasca, T. J., Rattner, S., Erdmann, J. B., Gonnella, J. S., & Magee, M. (2004). An empirical study of decline in empathy in medical school. *Medical Education 38*(9), 934–941.

Howick, J., Bizzari, V., & Dambha-Miller, H. (2018). Therapeutic empathy: What it is and what it isn't. *Journal of the Royal Society of Medicine 111*(7), 233–236.

Howick, J., Dudko, M., Feng, S. N., Ahmed, A. A., Alluri, N., Nockels, K., Winter, R., & Holland, R. (2023). Why might medical student empathy change throughout medical school? A systematic review and thematic synthesis of qualitative studies. *BMC Medical Education 23*(1), 270. https://doi.org/10.1186/s12909-023-04165-9

Howick, J., Moscrop, A., Mebius, A., Fanshawe, T. R., Lewith, G., Bishop, F. L., Mistiaen, P., Roberts, N. W., Dieninyte, E., Hu, X., Aveyard, P., & Onakpoya, I. J. (2018). Effects of empathic and positive communication in healthcare consultations: A systematic review and meta-analysis. *Journal of the Royal Society of Medicine 111*(7), 240–252.

Iseminger, G. (2003). Aesthetic experience. In J. Levinson (Ed.), *The Oxford handbook of aesthetics* (pp. 99–116). Oxford University Press.

Kelley, J. M., Kraft-Todd, G., Schapira, L., Kossowsky, J., & Riess, H. (2014). The influence of the patient-clinician relationship on healthcare outcomes: A systematic review and meta-analysis of randomized controlled trials. *PloS One 9*(4), E94207. https://doi.org/10.1371/journal.pone.0094207

Kelm, Z., Womer, J., Walter, J. K., & Feudtner, C. (2014). Interventions to cultivate physician empathy: A systematic review. *BMC Medical Education 14*(1), 219. https://doi.org/10.1186/1472-6920-14-219

Kierkegaard, S. (1983). *Fear and trembling; Repetition* (H. V. Hong & E. H. Hong, Trans.). Princeton University Press. (Original publication date 1843).

Kierkegaard, S. (1987). *Either/or* (E. H. Hong & H. V. Hong, Trans.). Princeton University Press. (Original publication date 1843).

Kierkegaard, S. (2013). *Fear and trembling and the sickness unto death* (W. Lowrie, Trans.). Princeton University Press. (Original publication date 1843, 1849).

Kornu, K. (2014). The beauty of healing: Covenant, eschatology, and Jonathan Edwards' theological aesthetics toward a theology of medicine. *Christian Bioethics 20*(1), 43–58. https://doi.org/10.1093/cb/cbu007

Kuyper, A. (2002). *Lectures on Calvinism*. Eerdmans Publishing Company. (Original publication date 1898.)

Lajoie, S. P., Zheng, J., Li, S., Jarrell, A., & Gube, M. (2021). Examining the interplay of affect and self regulation in the context of clinical reasoning. *Learning And Instruction 72*, 101219. https://doi.org/10.1016/j.learninstruc.2019.101219

LaMothe, K. L. (2004). The poet and the dancer. In *Between dancing and writing: The practice of religious studies* (pp. 85–102). Fordham University Press.

Lamothe, M., Boujut, E., Zenasni, F., & Sultan, S. (2014). To be or not to be empathic: The combined role of empathic concern and perspective taking in understanding burnout in general practice. *BMC Family Practice 15*(1), 15. https://doi.org/10.1186/1471-2296-15-15

Leeuw, G v. d. (2006). *Sacred and profane beauty: The holy in art*. Oxford University Press.

Lewis, C. S., & Hooper, W. (2013). *The weight of glory: And other addresses*. William Collins.

Little, P., Everitt, H., Williamson, I., Warner, G., Moore, M., Gould, C., Ferrier, K., & Payne, S. (2001). Observational study of effect of patient centredness and positive approach on outcomes of general practice consultations. *British Medical Journal* 323(7318), 908–911. https://doi.org/10.1136/bmj.323.7318.908

Neumann, M., Edelhäuser, F., Tauschel, D., Fischer, M. R., Wirtz, M., Woopen, C., Haramati, A., & Scheffer, C. (2011). Empathy decline and its reasons: A systematic review of studies with medical students and residents. *Academic Medicine* 86(8), 996–1009.

Newton, B. W., Barber, L., Clardy, J., Cleveland, E., & O'Sullivan, P. (2008). Is there hardening of the heart during medical school? *Academic Medicine* 83(3), 244–249.

Nichols, A. (1980). *The art of God incarnate: Theology and image in Christian tradition*. Darton, Longman and Todd.

New International Version (NIV) study Bible (2020). Edited by Barker, K. L., Strauss M. L., Brown J. K., Blomberg C. L., Williams, M. Zondervan.

Noyes, J. (2013). *The politics of iconoclasm: Religion, violence and the culture of image-breaking in Christianity and Islam*. I. B Tauris.

O'Connell, R. J. (1978). *Art and the Christian intelligence in St. Augustine*. Blackwell.

Osler, W., Sir. (1922). *Aequanimitas: With other addresses to medical students, nurses and practitioners of medicine*. P. Blakiston.

Pattison, G. (1991). Kierkegaard: Aesthetics and 'the aesthetic'. *British Journal of Aesthetics* 31(2), 140–151.

Pellegrino, E. D. (1982). To look feelingly: The affinities of medicine and literature. *Literature and Medicine 1*, 18.

Pera, C., & Pera, M. (2017). Could the medical humanities be a remedy for the rising disengagement between physician and patient? *MedEdPublish 7*, 179.

Petersen, A., Bleakley, A., Brömer, R., & Marshall, R. (2008). The medical humanities today: Humane health care or tool of governance? *The Journal of Medical Humanities* 29(1), 1–4.

Podder, V., Lew, V., & Ghassemzadeh, S. (2021). SOAP notes. *StatPearls [Internet]*. StatPearls Publishing. Retrieved from: https://www.ncbi.nlm.nih.gov/books/NBK482263

Preisz, A. (2019). Fast and slow thinking; and the problem of conflating clinical reasoning and ethical deliberation in acute decision-making. *Journal of Paediatrics and Child Health* 55(6), 621–624.

Rahner, K. (2021). Art against the horizon of theology and piety. In G. E. Thiessen (Ed.), *Karl Rahner's writings on literature, music and the visual arts* (pp. 159–165). T&T Clark. http://dx.doi.org/10.5040/9780567700568.0018

Roman Missal (2010). Catholic Truth Society. (Original publication date 1474.)

Saito, Y. (2001). Everyday aesthetics. *Philosophy and Literature* 25(1), 87–95. https://doi.org/10.1353/phl.2001.0018

Saito, Y. (2007). Everyday aesthetic qualities and transience. In *Everyday aesthetics* (pp. 149–204). Oxford University Press. https://doi.org/10.1093/acprof:oso/9780199278350.003.0005

Saito, Y. (2017a). *Aesthetics of the familiar*. Oxford University Press.

Saito, Y. (2017b). Consequences of everyday aesthetics. In *Aesthetics of the familiar: Everyday life and world-making* (pp. 141–195). Oxford University Press.

Saito, Y. (2022). Aesthetic values in everyday life: Collaborating with the world through action. *The Journal of Aesthetics and Art Criticism* 81(1), 96–97. https://doi.org/10.1093/jaac/kpac068

Schön, D. (2017). *The reflective practitioner: How professionals think in action*. Routledge.

Siegel, D. (2012). *Pocket guide to interpersonal neurobiology: An integrative handbook of the mind* (1st ed., The Norton series on interpersonal neurobiology). W.W. Norton & Co.

Spiro, H. M. (1992). What is empathy and can it be taught? *Annals of Internal Medicine* 116(10), 843–846. https://doi.org/10.7326/0003-4819-116-10-843

Steinhausen, S., Ommen, O., Thüm, S., Lefering, R., Koehler, T., Neugebauer, E., & Pfaff, H. (2014). Physician empathy and subjective evaluation of medical treatment outcome in trauma surgery patients. *Patient Education and Counseling* 95(1), 53–60. https://doi.org/10.1016/j.pec.2013.12.007

Stepien, K. A., & Baernstein, A. (2006). Educating for empathy: A review. *Journal of General Internal Medicine* 21(5), 524–530.

Suchman, A. L., Markakis, K., Beckman, H. B., & Frankel, R. (1997). A model of empathic communication in the medical interview. *Journal of the American Medical Association* 277(8), 678–682.

Thiessen, G. (2004). *Theological aesthetics: A reader*. SCM Press.

Thirioux, B., Birault, F., & Jaafari, N. (2016). Empathy is a protective factor of burnout in physicians: New neuro-phenomenological hypotheses regarding empathy and sympathy in care relationship. *Frontiers in Psychology* 7(5), 763.

Thompson, C. (2010). *Anatomy of the soul: Surprising connections between neuroscience and spiritual practices that can transform your life and relationships*. Tyndale Momentum.

Thompson, N. M., Uusberg, A., Gross, J. J., & Chakrabarti, B. (2019). Chapter 12: Empathy and emotion regulation: An integrative account. In N. Srinivasan (Ed.), *Emotion and cognition* (vol. 247, pp. 273–304). Academic Press.

Tournier, P. (1957). *The meaning of persons*. SCM Press.

Tournier, P. (1966). *The healing of persons*. Collins.

Trauma Healing Institute. (2020). Retrieved from https://traumahealinginstitute.org/ [last accessed 6 October 2024].

Vermeire, E., Hearnshaw, H., Van Royen, P., & Denekens, J. (2001). Patient adherence to treatment: Three decades of research. A comprehensive review. *Journal of Clinical Pharmacy and Therapeutics* 26(5), 331–342.

Viladesau, R. (1999). *Theological aesthetics: God in imagination, beauty, and art*. Oxford University Press.

Viladesau, R. (2014). Aesthetics and religion. In F. Brown (Ed.), *The Oxford handbook of religion and the arts* (pp. 25–43). Oxford University Press. https://doi.org/10.1093/oxfordhb/9780195176674.013.001

Vohs, K., Baumeister, R., & Loewenstein, G. (2007). *Do emotions help or hurt decision making?: A hedgefoxian perspective*. Russell Sage Foundation.

Wolterstorff, N. (1980). *Art in action: Toward a Christian aesthetic*. Eerdmans.

Yue, Z., Qin, Y., Li, Y., Wang, J., Nicholas, S., Maitland, E., & Liu, C. (2022). Empathy and burnout in medical staff: Mediating role of job satisfaction and job commitment. *BMC Public Health* 22(1), 1033. https://doi.org/10.1186/s12889-022-13405-4

Zaki, J., & Ochsner, K. (2012). The neuroscience of empathy: Progress, pitfalls and promise. *Nature Neuroscience* 15(5), 675–680.

Index

For the benefit of digital users, indexed terms that span two pages (e.g., 52–53) may, on occasion, appear on only one of those pages.

Tables, figures, and boxes are indicated by an italic *t*, *f*, and *b* following the page number.

7000 HUMANS 626, 630–32, 638n.3, 641n.34, 642n.53, 643nn.59,61

Abbuond, J. E. 740
A Beautiful Mind (2001) 522
Abraham, A. 833, 834, 835
Abraham, K. 557
Abramson, P. R.
 Dr. Payne's Electroshock Apparatus (with T. L. Abramson) 674–76, 675*f*
 Fuck Mom/Fuck Dad 679–80
 On the Road with Music and Outrage: The Legacy of Lynching and Child Sexual Abuse 679
Abramson, T. L.
 Dr. Payne's Electroshock Apparatus (with P. R. Abramson) 674–76, 675*f*
 In Case of Shame 666–67, 667*f*
 Portraits of Abiding Despair and Steadfast Determination 677, 678*f*
 Say Her Name 677–79, 679*f*
active agency 156–57, 158–60
Addams, J. 842
addictive disorders
 in film 579–87
 film therapy 536–39
 addiction films 543–45
 love films 540–43, 544–45
 psychotherapy portrayals 539–40
 Orpheus programme 339–40
 values-based practice 12, 13
 see also substance use
Adès, T. 908, 912

adherence to treatment
 atmospheres 308–9
 health-care improvement 781–82
 hospitals, aesthetic experience in 754
Adorno, T. W.
 aesthetic liberation 114, 123, 124–26
 artworks 4, 888–89
 authoritarianism 113, 118, 121–22, 125
 and Benjamin 114, 408
 capitalism 126
 music 122, 125
 obstinacy versus pathology 112–13
 sensible well-being 172–73
adrenaline 847
aerial dance 774–75, 960–61, 966
Aeschylus 74
aesthetic attitude 910–11
 clinical practice 918
 mindfulness 921
aesthetic beings, well-being of 186
 aesthetic agents 189–91, 193–97
 aesthetic objects 187–89, 191–97
 mutual vulnerability 198–99
aesthetic choice 231–33, 237–38, 244
 aesthetic disillusionment 239
 aesthetic footprint 239–40
 coping strategies 240–41
 care 242–44
 ecoanxiety 242
 nihilism 241–42
 cultures of excess 233
 Diderot effect 235
 fascination with the new 233–34
 planned obsolescence 236–37

aesthetic discipline 190, 193–94, 196
aesthetic disillusionment 238–39
aesthetic engagement 130–31, 143–44
 embracing all the senses 134–36
 nature of 131–33
 perceptual participation 133–34
 sense of self 136–38
 totality of nature 138–43
aesthetic footprint 239–40
aesthetic handprint 239
aesthetic moments 910, 912, 913
 clinical practice 918–20
 Free Musical Improvisation 913–15
Aesthetics in Mental Health (AiMH)
 network 13
aesthetic virtue 370–72, 377–78
ageing process
 aesthetization of 276
 bodily aesthetics 648, 653–54, 656, 657–58
 cognitive ageing 139–40
 positive psychiatry 35
social aesthetics 290, 328
see also older people
agency
 active 156–57, 158–60
 everyday aesthetics 156–57, 158–60, 162–63, 165, 276–77, 281, 283
 self, sense of 137, 142–43
 storytelling 493–94
 and values-based practice 394*t*, 395
Aichhorn, A. 565
Aiken, C. 424–25
Akhtar, S. 535–36
Akoto-Bamfo, K. 665
À la folie… pas du tout! (2002) 591
Albanese, C. L. 482n.19
Alcoff, L. 652–53, 654
alcohol use/disorders
 in film 579–84
 film therapy 530, 537
 values-based practice 12, 13
alexithymia 535
Allegranti, B. 864
Allen, P. G. 138
Allen, W. 568
Allendy, R. 565
Allwood, D. 788–89

American Beauty (1999) 45–46, 586
American Psychiatric Association 30
Améry, J. 587–88
analytic therapies
 awareness 389
 sharing 391
Analyze That (2002) 558–59
Analyze This (1999) 539, 558–59
anatomical observation 829
Anaya, R., *Bless me, ultima* 483n.24
Anderson, S. 507, 518, 520–21
animal studies 232
Aniston, J. 649–51
anonymity, *The Strangers Project* 489–90, 502
anorexia nervosa 925
 aesthetic experiences 930–31
 bibliotherapy 451
 case study 950–51, 950*f*–52*f*
 embodied experience 931–33
 everyday clinical work 820*b*
 impact on clinicians and therapists 933–35
 RESPECT-ME 942–43
 self-acceptance, lack of 174
 understanding 926–28, 929
 values-based practice 12–13
anosmia 932–33
Another Round (2020) 583–84
Anthony, St 962–63
anthropocentrism 160–61
anthropology 134
see also visual anthropology
anti-psychiatry 426, 560, 590–91
antisocial personality disorder 560n.13
anxiety
 aesthetics of clinical encounter 894
 bodily aesthetics 647
 dementia 722
 dhat 464
 eating disorders, impact on clinicians and therapists 933–34
 eco-anxiety 242, 243, 855
 environmental aesthetics 191
 film therapy 536
 gardens/gardening 214, 848, 849, 850, 856
 green spaces 139
 higher education 747
 hospitals, aesthetic experience in 758

Moving Pieces Approach 863
psychoanalysis as art of meeting the
 other 711
Anzaldúa, G. 657
 Borderlands/La Frontera 472–73, 475
Apollinaire, *La carpe* 434–35
Appadurai, A. 466
Appleton, J. 846–47
applied social aesthetics 326–27
 as life practice and the art of living 328–33
 Will to Beauty 340–41
 and mental health 338–40
 as natural force and cultural event 333–38
Apted, M. 604–6
Aquinas, St Thomas 718, 728
architecture
 aesthetic disillusionment 238–39
 atmospheres 314–16
 clinical settings 894–95
 everyday aesthetics 248–51, 252–53, 254–59
 self-build 252–53, 252f, 254f, 259–60
 health-care quality improvement 776–77, 785–86
 hospitals 753
 Oculus building 497
 Plato's influence 61–62
 proxemics 175
 regenerative 259–60
 sensible well-being 178–79
 spiral iterative process 822
 touch, sense of 177–79
 vernacular 259, 260–61
Archytas of Tarentum 52
Arendt, H. 494, 916
Ariosto, L. 424–25
 Orlando Furioso 425, 427, 443
Aristotle
 beauty 104
 catharsis 441, 534
 character ethics 370
 clinical care 351–52
 cognitive-rational knowledge 326–27
 happiness 271–72
 and Nietzsche 102
 philosophers as physicians 69
 psychiatric practice 363
 sensible well-being 169, 170

Arnim, A. v. 425
 Der tolle Invalide auf dem Fort Ratonneau 432
Aronofsky, D. 513, 585
art, visual 419–20
 bodily aesthetics 654–57
 dementia 720–22, 725–26
 forgeries, engagement with 665–66
 hospitals 750–52, 755–56, 757t, 763
 moments in 712–13
 psychology of art-viewing 683–86
 Interpretative Phenomenological
 Analysis 686–99
 theological aesthetics 963
 and trauma 661, 680–81
 Abramson and Abramson's *Dr. Payne's Electroshock Apparatus* 674–76, 675f
 engagement 666–69, 667f–68f
 engagement and pedagogy 669–71
 metaphors 671–74, 672f–73f
 narrative 661–66, 662f, 664f
 real-world encounters 676–80, 678f–79f
Artaud, A., *Lettre aux Médecins-Chefs des Asiles de Fous* 434
art-centred aesthetics 265–67
art-house film and anthropology 603–4
artification (creative industry) 154
Art Psychotherapy 447–48
arts versus everyday aesthetics 152, 153–54, 155–56
art therapy 446
 dementia 720–22
 Dewey 85
 eating disorders 936–37, 953
 anorexia nervosa case study 950–51, 950f–52f
 RESPECT-ME 937–48, 941f–48f
 Freud 85
 hospitals 750–51, 757
Asch, T. 601n.4
Asclepius 441
Ashworth, P. 931
Assassin of Youth (1937) 581–82
Association for Poetry Therapy (APT) 447–48
asylum seekers
 creative well-being workshop 736–47
 The Silent University 14–16, 19, 20

Athanasius 962–63
atmospheres 308–9, 321–23
 clinical relevance 311–13
 engaging with the arts 313–21
 narrative 308–9, 316–19
 pervasiveness 310–11
 social aesthetics 290–91, 292
 spatial 308–9, 314–16, 319
 theatrical 319–21
atmospheric turn 179
attachment theory 140–41
attention deficit disorder/attention deficit and hyperactivity disorder (ADD/ADHD) 139, 214
Attention Restoration Theory (ART) 215–16, 845–46
Atwood, M. 647
auditory sense, *see* hearing, sense of
Aue, H. v., *The Poor Heinrich* 441–42
Augustin, E. 422–23
 Raumlicht. Der Fall Evelyne B. 431
Augustine, St 61, 136–37, 143–44, 180–81, 334
Ausobsky, J. R. 915
Austen, J., *Pride and Prejudice* 303
Austin, J. L. 10
authoritarianism, Frankfurt School 113–14, 115, 118–23, 125
autism in film 592
Autoarte 657
autonomy
 bibliotherapy 456
 clinical care 345, 346, 352, 358
 patient 7
awareness, and values-based practice 385*t*, 386, 390*t*, 393, 395–96
awe, sense of 226

babies, *see* infants
Bach, J. S. 101
Bachelard, G. 256
Backstrom, M. J. 908
Bacon, F. 520
Bakhtin, M. 908
Balboni, A. L. 531–32
Ballatt, J. 825
Balthasar, H. U. V. 963
Balzac, H. de 424–25

 Louis Lambert 425–27, 428, 431–32, 434
 Madame Firmiani 454
 Un drame au bord de la mer 453–54
Banerjee, D. 608, 609
Bansal, A. 799, 811–12
Barfly (1987) 583
Barthes, R. 511–12, 516, 525, 725
Basic Instinct (1992) 564
Basic Instinct 2 (1992) 587
Bataille, G. 404
Bate, J. 727
Bates, V. 963–64
Bateson, G. 599, 601–2, 919
Bathing Babies in Three Cultures (1952) 601–2
Batho Pele 13
Baudelaire, C. 401–2, 409–10, 414
Baumard, N. 298, 305–6
Baumgarten, A. G. 326–27, 726, 728
Beach Bum, The (2019) 586
Beard, R. L. 719
Beauchamp, T. 23n.22
Beautiful Mind, A (2001) 522, 590–92
Beauvoir, S. de 648, 649–51, 652, 653, 657–58, 926–27
Becker, A. E. 929
Beethoven, L. v. 101
Beghetto, R. A. 724
Beginners (2010) 540–41
Belle Haleine exhibition 176
Bellow, S. 424–25
Benjamin, W.
 'art of storytelling' 492, 493, 496–97, 500, 504
 atmospheres 31
 dialectical images 401–2, 403–9, 410–12, 413–14
 media technology 113, 114–18
Benn, G. 422–24, 431, 458
 Gehirne 431–32
Benson, B. E. 908–9, 912
Bentall, R. P. 513
bereavement, *see* grief
Béres, L. 493–94
Bergande, W. 712
Bergner, R. 618
Bergqvist, A. 16, 18, 20–21
Bergson, H. 353

Berke, D. 259–60
Berleant, A.
 aesthetic engagement 826–27
 aesthetic experience 802
 aesthetic objects 192
 everyday aesthetics 158
 quality of life 271
 social aesthetics 289–90, 327, 332
 well-being 182
Berlyne, D. 890
Bernard, St 840–41, 962–63
Bernhard, T. 424–25, 587–88
 Frost 434
Bernini, M. 498
Be Tipul (2005–2008) 574n.27
Betterup 136–37
Beuys, J.
 connective practice 622, 639nn.12, 15, 17, 640n.21, 640n.24, 643n.71
 'imaginal thinking' 624–25
 'making sense' 624
 new organs of perception 625
 social sculpture 251, 824
Bhabha, H. 466
Bible 441, 442, 450, 587–88, 962–63
bibliotherapy 423
 defined 448
 development 440–48
 dimensions 448
 dependence on the form of therapy 644–453
 influence of the different diseases 449–51
 job profile of bibliotherapist 456–57
 personality of the sick person 453–55
 provision and communication of the literary text 455–56
 reading during health and illness 449
 film therapy comparison 534
 perspectives 457–58
Bichat, X. 350
Bignold, S. 799
binge eating disorder 30
Bingen, H. v. 441–42
Binswanger, L. 540
biodiversity loss 233, 244
bioethics 345
Bion, W. 918

biophilia 216–17, 844, 850
bipolar disorder
 bibliotherapy 452
 diagnostic criteria 419–20
 electroconvulsive therapy 560
 film 419–20, 592
 literature 419–20
 positive psychiatry 37
birth, as perfect moment 897
Black Swan (2010) 513
Blackwood, B. 601–2, 603
Blanchot, M. 353
Bleakley, A. 788
Blixen 494
Blondel, C. 353
Blondin, B. 475
bodily aesthetics 647–49, 658
 aesthetic beings 193–98, 199n.3
 artistic interventions 654–57
 bodily imaginaries 651–53
 damaging imaginaries 653–54
 dementia 723–24
 depression 282
 disciplinary practices and objectification 649–51, 650f
 eating disorders 926–27, 928–29, 929f
 health-care improvement 783
 re-imagining ourselves 657–58
 see also Moving Pieces Approach
body dysmorphia 653
Boethius 61
 The Consolation of Philosophy 441–42
Bohm, D. 803–4
Böhme, G. 310, 311, 321, 322, 497
Bollas, C. 707
Bonaparte, M. 564–65, 572n.2
Bonaventure, St 61
Booker, C. 300
Booth, W. C. 296
borderline personality disorder 573n.13
Borgo, D. 908
Boston Change Process Study Group (BCPSG) 707, 713
 metapsychology of meeting 710–11
 moments in art and aesthetic response 712–13
 moments of meeting 709–10
 moving along 708–9

Boston Change Process Study Group
(BCPSG) (*cont.*)
 now moments 709
 present moments 708
 vitality affects 707–8
Bower, U. G. 601–3
Bowlby, J. 140–41
Boyle, D. 585, 592n.6
Brady, E. 830–31, 832, 835
Brand, P. Z. 649, 654–55
Brantbjerg, M. H. 868–69, 871
Brecht, B. 120–21, 408, 641–42n.44, 825
Breton, A., *Manifest* 434–35
Breuer, J. 431, 468, 556
Broken Blossoms (1919) 581–82
Broken Embraces (2009) 540–41
Brook, I. 828–29, 830, 832, 835
Brook, J. 142
Brook, L. 685–86
Broyard, A. 804
Bruner, J. 297
Bruno, G. 319
Brunswick, M. 564–65, 572n.2
Bry, I., *Medical Aspects of Literature* 447
Bryan, A. I., *Can There be a Science of Bibliotherapy* 447
Buber, M.
 connected engagement 803–4
 'I-Thou' relationship 331–32, 774, 898–99, 901, 903
 'real' encounter 563–64
Buchli, V. 255–56
Buck-Morss, S. 405–6
Buddhism
 everyday aesthetics 269, 270, 271, 275, 276
 mindfulness 3–4
 social aesthetics 158–59
built environment, *see* architecture
Bukowski, C. 583
bulimia nervosa 174
Bulwer, L. 511
Buñuel, L. 601n.4
Burke, E. 104
Burroughs, W. S., *Naked Lunch* 587
Burton, R., *Anatomy of Melancholy* 442
Butler, J. 518–19
Byrne, P. 509

Cabinet of Dr. Caligari, The (1920) 559–60, 572n.10, 590–92
Cabot, R. 348
Callieri, B. 331
Camillo, G. 639n.10
Campbell, A. 17–18
Campling, P. 825
Camus, A. 101–2
Canappele, P. 531–32
Canetti, E. 789
Canguilhem, G. 346, 347–48, 349, 352
cannabis/marijuana use in film 579–80, 581–82, 586
Canvas (2006) 591
capitalism 118–19, 126–27
Captured by Women (2011) 602, 602n.5, 612–13
cardiac care 758–59
care/caregiving/caregivers
 art engagement 684
 dementia 720, 721, 724, 727
 developmental psychology 707
 ecological awareness 236, 242–43
 end-of-life care 759–60
 everyday aesthetics 205–6, 209–10, 266–67, 827–28
 everyday clinical work 821b
 gardens/gardening 852–53, 857–58
 images 401–2, 410–14
 Baudelaire 409–10
 dialectical 404–9
 importance to understanding 402–3
 positive psychiatry 29, 36–37
 touch, sense of 175
Carefree (1938) 558–59
Care Services Improvement Partnership (CSIP) 10–11
Carey, M. 294, 298–99
Carlin, N. 964
Cartier-Bresson, H. 153–54
Casablanca (1942) 540–41, 566
Caspari, S. 754, 755–56
Catherine, St 932–33
Cavarero, A. 494–95, 503–4
Cavell, S. 729
Caygill, H. 406–7
Celan, P. 587–88

Celentano, V. 915
Céline, L.-F. 422–23
 Voyage au bout de la nuit 430
Centre for Contemporary Art and the Natural
 World (CCANW) 638n.4, 640–41n.30
Cermolacce, M. 510, 511
Cervantes, M. de 424
 Don Quixote 445–46
 El licenciado Vidriero 427
Cézanne, P. 483n.21
Chagnon, N. 601n.4
Chaplin, C. 581–82
character ethics 370
Charnley, K. 913–14
Charon, R. 805
Chatterjee, A. 890–91
Chekhov, A. P. 422–23, 431
 Ward No. 6, 426–27, 431–32, 454
Cheng, F. 476, 481, 482n.12, 483n.21
 Le dit de Tianyi 476
Cherokee Indians 668
Chiarugi, V. 444
children and young people
 aesthetic beings 190
 bibliotherapy 451–52, 455
 bodily aesthetics 647–51, 654
 Dewey on 87, 90, 93
 eating disorders
 aesthetic experiences 930
 case study 950–51, 950f–52f
 RESPECT-ME 937–48
 understanding 66–940
 education 58–60, 87, 93
 film 598–99, 611–13
 art-house film and anthropology 603–4
 Delhi at Eleven 608–9
 Digital Children project 610–11
 filming children for research
 purposes 599
 MacDougall's films 606–8
 Seven Up! television series 604–6
 visual anthropology and ethnographic
 film 599–601
 women filmmakers 601–3
 film therapy 536
 health-care improvement 786–87, 789
 music therapy 750

 natural learned abilities 877–78
 play 707, 851
 psychiatry 925–26, 939–48
 improvisation 909
 sensible well-being 174
 sexual abuse, and art
 engagement 666–67, 667f
 engagement and pedagogy 671
 metaphors 671, 673–74, 673f
 real-world encounters 676–77, 680
 see also infants
Children's Hour, The (1961) 587–88
Childress, J. 23n.22
Chinese aesthetics 266, 269
Chitale, K.
 Lotus Pond 937–38, 938f
 Radiance 949f
 Strength 941f
choirs 749, 751–52, 757, 761–62
Chomsky, N. 98
Christiane F.—Wir Kinder vom Bahnhof Zoo
 (1981) 584
Chronicle of a Summer (1961) 603–4
chronic pain 756–57, 761–62
Cicero
 On Old Age 441
 Plato's *Republic* 64n.2
 Tusculan Disputations 441
cinema, *see* film
cinema therapy, *see* film therapy
Cinema Vérité 603
circular economy 236
City Lights (1931) 581–82
climate change
 environmental aesthetics 830–31
 gardens/gardening 855
 political passivity 127
 see also ecological awareness
clinical practice 771–75
 aesthetic experience in everyday clinical
 work 817–22, 835–37
 connective aesthetics 823
 connective practice approach 824–26b
 design 822–23
 environmental aesthetics 830–33
 everyday aesthetics 827–28
 existing relevant practice and theory 823

clinical practice (*cont.*)
 Goethean observation 828–30
 imagination 833–35
 mindful awareness 835
 philosophy 826–27
 aesthetics of clinical encounter 892–93, 903, 905–7, 920–21
 aesthetic attitude 910–11, 918
 aesthetic moments 911–15, 918–20
 biographical illusion 902–3
 improvisation 907, 915–19
 language 899–902
 musical improvisation 905–6, 907–9, 913–15, 920–21
 patient–doctor relationship 898–99
 perfect and privileged moments 895–98
 professional context 893–94
 settings 894–95
 clinician insight 797–98, 813
 aesthetic experiencing and everyday aesthetics 802–3
 barriers 812
 consultation as aesthetic experience 803–5
 creative enquiry in medical education 805–12
 human dimension 798–801, 801*f*
 epistemological and ethical dimensions 344–48, 349, 351, 352–53, 354–59
 Levinas 355–59
 paradox of 347–50
 and aesthetics gaze 350–51
 psychiatry, *see* psychiatric practice
 quality improvement 776–81, 793, 963–64
 extending improvement scholarship 790–93
 making and revising aesthetic discriminations 781–85
 social dimension 785–89
 theological aesthetics 959, 961, 963–64, 971–75
 see also hospitals
clothing 178, 208
Coaten, R. 723–24
cognitive ageing 139–40
cognitive behavioural skills training (CBST) 30

cognitive behavioural therapy (CBT)
 awareness 389
 for eating disorders (CBT-E) 943
 sharing 391
 understanding 393
Cognitive Remediation Therapy 943
Colbert, S. 685–86
Coleridge, S. T. 234, 317, 621, 639n.10, 641n.35, 713
Colliver, J. A. 976n.2
Colquhoun, G., *Playing God: Poems About Medicine* 972, 974
 'A history' 972–73
Colquhoun, M. 829
comfort 180–81
communication
 aesthetics of clinical encounter
 language 899–902
 settings 894–95
 bibliotherapy 447–48, 455–56
 dependence on the form of therapy 452
 influence of the different diseases 450–51
 job profile of bibliotherapist 456, 457
 clinician insight into practice 800
 health-care improvement 788–89
 patient–physician 974
 social aesthetics 328–31
 The Strangers Project 497
 values-based practice 385*t*, 387, 389–91, 390*t*, 395–96
community gardens/gardening 218, 219, 220–22, 842, 857–58
Compassion Focused Therapy 943
Compassionomics 800
compliance with treatment, *see* adherence to treatment
comportment, professional 787–88, 789
composting 219
computerization 107
confidence, *see* self-confidence
Confucianism
 everyday aesthetics 269–70, 271, 282
 moral virtues 3
 social aesthetics 158–59
connective aesthetics 772, 822, 823, 827, 836
connective distance 621
 guiding images 627
 new organs of perception 625

connective imagination 621, 627, 628–30, 636–37
 'instruments of consciousness' 630
 new organs of perception 625
connective practice 620–21, 636–38
 aspects 623–24
 guiding images 626–27
 instruments of consciousness 630
 making sense 624
 'making social honey' theory of change and 'connective imagination' root methodology 628–30
 modes of thinking 624–25
 organs of perception 625
 connective distance, imaginal thinking, and 'instruments of consciousness' 621
 everyday clinical work 821, 824–26b
 evolution 622
 questions 622–23
 strategies of engagement in 'instruments of consciousness' 630–32, 631f–33f
 commonalities and differences 635
 FRAMETALKS 633–35, 634f
Connolly, K. 195
Conrad, J. 458
consultation as aesthetic experience 803–5
consumerism
 ecological awareness 232
 aesthetic choice 237–38
 Diderot effect 234–35, 236–37
 fascination with the new 233–34, 236–37
 planned obsolescence 235–37
 everyday aesthetics 161–62
conviviality 174–77, 183
Cooper, D. E. 272–73
coping skills 31–32, 37
Corbin, H. 624–25
Cordonnier, C. 724–25
cortisol 845
Coss, R. G. 891
countertransference
 eating disorders 933–34
 film 564–65, 567–68
COVID-19 pandemic
 anosmia 932–33
 art and trauma 677
 connective practice 632

continuing professional development 836
conviviality, need for 175
creative well-being workshop 737
 eating disorders 948, 948f
 gardens/gardening 218, 225, 844, 850
 hospitals, aesthetic experience in 755–56
 Moving Pieces Approach 866
 online health care 787
 sense-based activities 92–93
 stress perception 34
Cranach the Elder, L., *Fountain of Youth* 540
creative enquiry 772, 798, 805–12
creative industry 154
creative well-being workshop 733–36, 746–47
 creative community 736–37
 output 741f–45f
 participants 738f
 sense of place 737–41
creative writing
 clinician insight into practice 805
 hospitals, aesthetic experience in 751–52, 757t
 cardiac care 758–59
 Moving Pieces Approach 872–73, 874
 see also graphotherapy
Cribb, A. 799, 925–26, 963–64
Criminal Hypnotist, The (1909) 572n.8
Cronenberg, D. 513, 587
Crothers, S. M., *A Literary Clinic* 446
cruelty 192
Crying 4 Kafka, *Fuck Mom/Fuck Dad* 679–80
Csikszentmihalyi, M. 91–92, 686, 850
cultural Marxism 120
Cunningham, M., *The Hours* 588–89
curanderas/os 472–73, 482n.18
curation, *see* museum curation
Cure, The (1917) 581–82

Dachau Concentration Camp Memorial, Berlin 661, 663–64, 663f
Dai, S. 476
 Balzac and the little seamstress 476–77
 Le complexe de Di (*Mr Muo's Travelling Couch*) 476, 477–80
Daldry, S. 588–89
Dalsus, S., *Children at Home* 608
Damon 50–51

dance
 aerial 774–75, 960–61, 966
 health-care improvement 789
 hospitals 751–52, 755
 Nietzsche 82
 theological aesthetics 959, 960–61, 964–66, 975
 clinical practice 971, 973–75
 Eucharist 967
 to the stars 405
dance therapy
 dementia 723–24
 hospitals 750
Danckwardt, J. F. 712
Dangerous Method, A (2011) 564–65
Dango, M. 241
Dante Alighieri, *Divine Comedy* 441–42
Darwin, C. 85
DasGupta, S. 800–1, 804
Das Weiße Rauschen (2001) 588, 591
Davis, H. 260
Day, C. 257
daylight 844–45
Dead Poets Society (1989) 529, 587–88
death and dying
 bibliotherapy 451
 end-of-life care 751–52, 759–61
 gardens/gardening 854–55
 perfect and privileged moments 896, 897
 see also grief
de Certeau, M. 248, 252
decision-making, *see* shared decision-making
Deconstructing Harry (1997) 568
de Gaudemar, M. 317
De Jaegher, H. 802–4
de la Croix, A. 805–6
Deleuze, G. 466–67, 512–13, 517, 519
Delfina Foundation 14
delusions
 DSM 510–11
 in film 522, 590–92
 imaginary worlds 302–3
De Maria, W. 131–32
 The New York Earth Room 130–31, 132–33, 144
dementia
 aesthetics of 717–20, 729

 being human 727–29
 dance 723–24
 music 722–23
 photography 724–25
 play 724–25
 poetry 724–25
 understanding dementia 725–27
 visual art 720–22
art engagement 684
 in film 592
 gardens/gardening 214
 hospitals, aesthetic experience in 750, 761–62
 social relationships 220
depression
 aesthetics of clinical encounter
 language 900, 901
 professional context 894
 anorexia nervosa 930–31
 bibliotherapy 441
 bodily aesthetics 647
 and capitalism 127
 dementia 722
 electroconvulsive therapy 560
 everyday aesthetics 3–265, 277–80, 283
 loss and impoverishment 281–82
 film therapy 538
 gardens/gardening 214, 219–20, 848, 850, 856, 857
 hospitals, aesthetic experience in 750
 arts activities in cardiac care 758
 chronic pain 757
 imaginary world-making, deficit in 302–3
 olfactory reference syndrome 174
 placebo effect 666
 positive psychiatry 35–36, 37, 38
 present moments, disturbances in 708
 psychiatric practice 364–65, 366–67, 372–77
de Rougement, D. 540
Derrida, J. 357, 512, 514–15, 517, 520–21, 524
Descartes, R. 169, 170, 326–27
Deshmukh, S. R. 720
design theory 177–78
Deuze, M. 492–93
Devereux, G. 464
Dewey, J.
 aesthetic beings 189

aesthetic experience 88–89, 133, 802–4,
 813, 827–28
aesthetic footprint 239
aesthetic moments 914–15, 920
anti-dualism and continuity 91
art education 87–88, 93
art therapy 85
better-ordered society 88
contemporary philosophers 90–91, 92–93
educational theory 87
everyday aesthetics 84, 158, 265–66, 778–79
everyday awareness 90
expression 89–90
and Freud 85–87, 89–90, 91, 93
gardens/gardening 842
mental health 84–85, 93
positive psychology 91–92
dhat 464
Diab, S. 735–36
diagnostic aesthetics 69–70, 73, 364–65,
 370, 377–78
Diagnostic and Statistical Manual of Mental
 Disorders (DSM)
 delusions 510–11
 non-Western pathologies 464
 psychosis 510–11
Dickens, C. 424–25, 426–27, 431
 A Tale of Two Cities 428, 433
Dickie, G. 910
Diderot effect 234–35, 236–37
Didi-Huberman, G. 410–11
Didion, J. 468
Die Auslöschung (2013) 588
Die Summe meiner einzelnen Teile (2011) 591
dietetics 440–41, 442, 446
dignity 248–49, 254, 259
Dillard, A. 153–54
 Teaching a Stone to Talk 970, 971, 973
Dirac, P. 375–76
Direct Cinema 603
disability
 aesthetic beings 195, 196, 197
 bodily aesthetics 647, 648, 653–55, 656,
 657
 dementia 721
 hidden 808
 limb difference 783–85

disinterestedness
 aesthetic engagement versus 132, 133
 everyday aesthetics 149–50, 152, 157–58
 sensible well-being 181–82
Dissanayake, E. 306
dissocial personality disorder 573n.13
diversity, equity, and inclusion
 health-care improvement 786, 789
 heritage site management 20–21
Dix, O. 671
Dixon-Woods, M. 792
Döblin, A. 422–23
Doddington, C. 92–93
Doman, B. 489–91, 496–97, 499–502, 504
domestic violence 217
Donabedian, A. 777–78
Don Jon (2013) 579–80
Don Juan DeMarco (1995) 539, 564, 572, 591
Dooley, J. 725
Doon School (1999–2008) 606–7
Dooyeweerd, H. 20–21
dopamine 847, 850
Dose, L. 754
Dostoevsky, F. M. 424–25
 The Idiot 426–27
Dowlen, R. 722–23
Down's syndrome 648
Dr. Dippy's Sanitarium (1906) 572n.7
Dream SMP 610–11
Dressed to Kill (1980) 559–60, 590–91
Drew, R. 603
Dr. Mabuse the Gambler (1922) 556–57,
 572n.10
drug use 579–82, 584–87
 see also addictive disorders
Dubourg, E. 298, 305–6
Duchamp, M., *Fountain* 364, 675–76
Duffy, M. 650f, 657
Dufrenne, M. 179, 319
Duran, J. 91
Duras, M., *Détruire dit-elle* 453
Duvall, J. 493–94
dying, *see* death and dying
dynamic therapy 395
dysgeusia 932–33
dystoposthesia (environmental
 sensitivity) 178–79

Earth Forum 629–32, 633*f*, 637, 642n.53, 643n.60
eating disorders 924–26, 953
 aesthetic experience 774
 binge eating disorder 30
 bodily aesthetics 647
 bulimia nervosa 174
 embodied experience 931–33
 film therapy 536
 impact on clinicians and therapists 933–37, 935*f*–36*f*
 recovery 951–53
 RESPECT-ME 944, 945*f*
 development 937–44
 group structure 944–48
 individualized (I-RESPECT-ME) 948
 understanding 926–29
 values-based practice 12–13
 see also anorexia nervosa; overweight
Eaton, C. M. 951–52
Eatough, V. 687–88
Eat Pray Love (2010) 540–41, 542
Eco, U. 317
eco-anxiety 242, 243, 855
ecological awareness 231–33, 244
 broadening of aesthetic evaluation 237
 aesthetic choice 237–38
 aesthetic disillusionment 238–39
 aesthetic footprint 239–40
 coping strategies in the face of aesthetic choices 240–41, 244
 care 242–43
 ecoanxiety 242, 243
 nihilism 241–42, 243
 cultures of excess 233
 Diderot effect 234–35
 fascination with the new 233–34
 planned obsolescence 235–37
 everyday aesthetics 780
Edel, U. 584
Edmonston, P. 802
education
 Dewey 84, 85, 87
 art education 87–88, 93
 and contemporary philosophers 92–93
 medical 812–13
 consultation as aesthetic experience 803
 creative enquiry 805–12
 everyday clinical work 836
 history taking 971–72
 human dimension 798–801, 801*f*
 theological aesthetics 960, 963–64, 974–75
 music 917
 person-centred care 20
 Plato 58–60
 positive psychiatry 38
 psychiatric 363, 377
 aesthetic perception 367–70
 aesthetic virtue 370–72
 films as educational tools 508
 trauma and art 669–71
Egginton, W. 522–23
Ehresman, C. 722
elderly people *see* older people
electrocardiogram (ECG) 820, 830, 834–35*b*
electroconvulsive therapy (ECT)
 Abramson and Abramson's *Dr. Payne's Electroshock Apparatus* 674–76, 675*f*
 in film 559–60, 586
 for schizophrenia 97
Elegy (2008) 540–41
Eliade, Mircea, *Shamanism: archaic techniques of ecstasy* 474
Eliot, T. S. 409, 512, 813
Ellenberger, H. 482–83n.20
Ellis, C. 733
Elsässer, T. 127n.1
Elwyn, R. 933–34
Embassy of the North Sea project 245n.3
emigrants, *see* migrant populations
Emmy of Voigt 565
empathy
 aesthetic beings 189–90
 aesthetic choice 244
 bibliotherapy 455, 456
 clinician insight into practice 800
 De Maria's *The New York Earth Room* 131
 eating disorders 934–35
 eroticism 175–76
 everyday clinical work 818–19, 820, 836
 connective aesthetics 824, 826*b*
 connective practice approach 825

environmental aesthetics 830–31
 everyday aesthetics 828*b*
 Goethean observation 829, 830
 imagination 834
film 520
gardens/gardening 214
health-care improvement 788–89
Husserl 366
medical education 960, 963–64
Moving Pieces Approach 871
nature's effect on 854
person-centred care 20
positive psychiatry 37
psychiatric practice 364, 366–67, 376–77
 and education 371
social aesthetics 331
theatrical atmospheres 320
theological aesthetics 960, 963–64, 973, 974
end-of-life care 751–52, 759–61
endorphins 847, 853
Enduring Love (2004) 591
enfranchisement of natural objects and environments 160
Engel, G. L. 800, 811
Engelhardt, D. v. 448
English Patient, The (1996) 587–88
En thérapie (2021–2022) 574n.27
environmental aesthetics 265
 aesthetic beings 191
 aesthetic choice 240
 climate change 231–32
 everyday aesthetics 778–79
 everyday clinical work 830–33
 sensible well-being 177–80
 see also gardens/gardening
environmental sensitivity 178–79
envy, and theatrical atmospheres 320
epilepsy 598–99
 bibliotherapy 451
epoché 404, 624, 629–30
equity, *see* diversity, equity, and inclusion
Equus (1977) 564
Erasmus von Rotterdam, *The Praise of Folly* 433
Erikson, E. 854
Erlenberger, M. 422–23

eroticism
 film therapy 540–41, 544–45
 Marcuse 124
 Plato 60–61
 influence on Freud 62
 therapists in films 565–68, 570
 touch, sense of 175–76
Esquirol, J. É. 444, 445
ethics
 aesthetic beings 189–90
 aesthetics of clinical encounter 892–93, 901–2, 906, 918, 921
 autonomy-driven 7, 17–18
 care 175, 242–43
 character 370
 clinical care 344–48, 349, 351, 352–53
 Levinas 353, 354–59
 connective practice 623, 636–37, 825
 Dewey 87
 ecological awareness 233, 238, 240, 242–43, 244
 environmental 160
 eudemonistic 172–73
 everyday aesthetics 161, 206, 209–11, 266–67, 271
 health-care improvement 777, 783, 785, 786, 787–88, 790–91, 792–93
 feminist 242–43
 film 564–65, 566
 filming children 85, 599n.2
 filmmakers with lived experience of mental health conditions 509
 Foucault's aesthetics of existence 106
 images of care 403, 411
 improvisation 774, 908, 909, 913
 individual versus social 289
 love affairs between therapists and patients 570
 person-centred care 8
 Plato 50, 51
 reparative reading 491
 The Strangers Project 491, 493, 495, 503
 theological aesthetics 965
 transcultural perspective 464–65
 values-based practice 8, 10, 386
 virtue 69, 370

ethnicity, *see* race and ethnicity
ethnographic film 599–601, 611–13
 art-house film 603–4
 'attention dimension grid' 600*f*
 Delhi at Eleven 608–9
 Digital Children project 610–11
 MacDougall's films 606–8
 Seven Up! television series 604–6
 women filmmakers 601–3
ethnopsychiatry 464–65
etiquette, medical 787
Eucharist 961, 963, 966–71, 968*f*–69*f*, 975
Euripides 74
Evans, R. G. 804
everyday aesthetics 149–51, 152–53, 165
 active agency 158–60
 aesthetic choice 240
 and art-centred aesthetics 265–67
 artefacts 160–62
 attention 499
 bodily attunement 155–58
 clinician insight into practice 802–3
 depression 264–65, 277–80, 283
 loss and impoverishment 281–82
 Dewey 84, 158, 265–66, 778–79
 East Asian 269
 Confucianism 269–70
 Indian Buddhism 269
 Shinto 270
 Zen Buddhism 270
 ecological awareness 232, 234, 240
 everyday clinical work 827–28
 examples 267–68
 happiness 264–65, 271–72, 274, 277, 279–80, 283
 aesthetization of negative aspects of the world 275–76
 enhancement of aesthetic agency 276–77
 enrichment of experience 274–75
 loss and impoverishment 281–82
 phenomenology 272–74
 health-care improvement 771–72, 776–81, 793
 extending improvement scholarship 790–93
 making and revising aesthetic discriminations 781–85
 social dimension 785–89

hidden gems, appreciation of 153–55
hospitals, aesthetic experience in 751
 presence 203–4, 210–11
 care 205–6, 209–10
 ethical and ecological considerations 209–11
 familiarity 206–9, 210–11
 ontology 204–5
 reliability 206–7, 210
 and resilience 248–55, 260–62
 architecture 255–60
 concept 247–48
 sensible well-being 171, 179
 shaping our lives and the world 162–64
evidence-based practice (EBP) 7, 435–36
 and person-centred care 11
 and shared decision-making 10, 18
 shared values 383–84
 and values-based practice 8, 10–12, 384–86, 387–88
evolution
 natural environments 216, 846–47
 rebuilding of environments to suit preferences 753
 stress response 845
evolutionary aesthetics 888–92, 903
 aesthetic footprint 240
 ecological awareness 234, 240
 narrative art 302–3, 304
Ewald, A. 829
Exchange Values: Images of Invisible Lives 630–32, 631*f*–32*f*, 637, 638–39n.9
existence, Foucault's aesthetics of 96–97, 107–8
 beauty and health 103–4, 105, 106–7
 neoclassicism 98, 100, 102–3
Experience Based Co-Design (EBCD) 778, 790–91, 792–93
exposure effect 376
Ey, H. 312
Eye-See (2004) 518

familiarity
 Diderot effect 234–35
 everyday aesthetics 206–9, 210
family
 everyday aesthetics and resilience 248–50, 252–53, 254–56, 259–62

Frankfurt School 119–20
positive psychiatry 29, 36–37
Famin, M. M. 447
Fanon, F. 193–94, 653–54
fascism 113, 115, 117–22, 125–26
Fassin, D. 465
Fatal Attraction (1987) 591
Faulkner, W. 423–25
Fausch, D. 259–60
Fechner, G. T. 889–90
Federn, P. 557
feeding and eating disorders, *see* eating disorders
Feil, N. 723
Feldenkrais, M. 868, 870–71, 874, 877–78
Feldenkrais Method 862, 864, 868, 869–71, 883
feminism
 art and trauma 668–69, 670
 care 175, 242–43
 and Dewey 91
 eating disorders 926–28
 everyday aesthetics 248–49, 778–79
 higher education 747
 Moving Pieces Approach 864, 882, 883
 psychotherapists in films 566
Ferenczi, S. 563–64, 565
Féret, R. 509, 513–17, 520–21, 522, 523–24
Ficino, *de Amore* 61
fiction, *see* literature; storytelling
Fight Club (1999) 591–92
film 419–21
 children's realities 598–99, 611–13
 art-house film and anthropology 603–4
 Delhi at Eleven 608–9
 Digital Children project 610–11
 filming children for research purposes 599
 MacDougall's films 606–8
 Seven Up! television series 604–6
 visual anthropology and ethnographic film 599–601
 women filmmakers 601–3
 hospitals 751–53, 755, 757*t*
 lived experience of filmmakers 507–13, 523–25
 Féret 513–17

literature 508–10
Sen 518–23
mental disorders in 578–79, 592
 delusion, psychosis, and schizophrenia 590–92
 substance use, intoxication, ecstasy, and addiction 579–87
 suicide, self-murder, and voluntary death 587–90
proxemics 175
psychotherapists, psychologists, and psychiatrists in 555–65, 571–72
 love 565–71
see also storytelling
film therapy 529–30, 544–45
 addiction treatment 536–39
 addiction films 543–44
 love films 540–43
 psychotherapy portrayals 539–40
 mechanism of action 534–36
 psychosis 508
 silent film era 530–32, 544–45
 Le mystère des roches de Kador 532–34, 545f–51f
Final Analysis (1994) 564
Finzi Pasca, D. 319–22
Fischer King, The (1991) 591
Fish, D. 807
Fitzgerald, F. S. 424–25
 Tender is the Night 426, 430–31
Flaherty, R. 600–1, 612
flaneur 171
Flight (2012) 542–43
flourishing
 atmospheres 312, 316
 Dewey 84, 85, 89, 93
 and contemporary philosophers 91, 92–93
 everyday aesthetics 271–72
 gardens/gardening, *see* gardens/gardening: and flourishing
 Plato (*eudaimonia*) 49–50
 positive psychiatry 34
 social aesthetics 290, 326, 328–29
 hospitality 291
 touch 290–91

flow states
 clinical practice 974, 975
 dance 960–61
 gardens/gardening 850
Flynn, T. R. 895–96
food
 aesthetics
 active agency sidelined 156
 eating disorders 933
 everyday aesthetics 266–67
 gardens/gardening 857
 hospitals 751–52
 sensible well-being 171–72
 co-naturality 179–80
 conviviality 176–77
 social aesthetics 159
Ford, H.
 'Awakening' 924, 925f
 food aesthetics 933, 934f
forest bathing 214–15
forgeries, engagement with 665–66
Forman, M. 560, 561
Forrest Gump (1994) 540–41
Foucault, M.
 aesthetics of existence 96–97, 107–8
 beauty and health 103–4, 105, 106–7
 neoclassicism 98, 100, 102–3
 classificatory systems in human sciences 126
 clinical care 350–51
 narrative therapy 301
 One Flew Over the Cuckoo's Nest 560
 power 733–34
 psychosis 511, 524
 Histoire de Paul 509, 513, 514–16
 Outside (2013) 519
 sexuality 175–76
found objects 364
Fox, H. 13, 20
fractal patterning 846
'fragile pieces' 252–53, 253f
FRAMETALKS: Making Social Honey 629–35, 634f, 637, 638n.3, 642n.53, 643n.55
Frampton, S. B. 762
Frankfurt School
 aesthetic liberation, resistance to cliché, and happiness 123–26

authoritarianism and experience 118–23, 125
 capitalism 118–19, 126–27
 media technology and historical modes of perception 114–17
 obstinacy versus pathology 111–14
freedom
 aesthetics of clinical encounter 906
 connective practice 620–21, 626, 637
 Foucault 104, 107–8
 Frankfurt School 114, 123–26
 and psychiatry 312
 sensible well-being 182
 values-based practice 394t, 395
Freeman, W. 573n.17
Free Musical Improvisation (FMI) 774, 905–6, 907–9
 aesthetic attitude 910–11, 918
 aesthetic moments 913–15
 as model for clinical practice 916, 918, 920–21
Frenkel-Brunswik, E. 113, 118, 121–22
Freud, S.
 art therapy 85
 bibliotherapy 452
 Dai's *Le complete de Di* 477, 478, 479, 485n.36
 death 854–55
 destructiveness 713–14
 and Dewey 85–87, 89–90, 91, 93
 film and television series 512, 556, 557–58, 564–65, 567, 568, 570–71
 flowers 851–52
 happiness 273–74
 id 98
 Interpretation of Dreams 477
 love 540–41
 and Marcuse 124
 paranoia 591
 Plato's influence 62
 psychoanalysis as art of meeting the other 706–7
 storytelling 468
 sublimation 851–52
 super-ego 119
Freud: the Life of a Dream (1984) 564–65
Freud—The Secret Passion (1962) 564–65

Froerer, P. 604
Fromm, E. 113, 114, 118–21, 216, 339
Fuery, P. 512
Fulton, H. 131–32
Funch, B. S. 685
Fusar-Poli, P. 508, 524

Gabbard, G. 558, 565–66
Gabbard, K. 558, 565–66
Gablik, S. 758, 823–24, 827
Gadamer, H.-G. 172–73, 720
Galen 441
Gallagher, S. 297, 301
Galton, J. M., *On Reading, Recreation and Amusement for the Insane* 445
Galvin, K. 963–64, 974
gambling 537
Gandhi's Children (2011) 606, 607
gardens/gardening 213, 218, 226–27, 772
 beauty 223–25
 everyday aesthetics 779–80
 evidence of mental health benefits 214
 explanations 215–16
 and flourishing 840, 857–58
 Attention Restoration Theory 845–46
 beauty 847
 biophilia 844
 care relationship 852–53
 climate change and eco-anxiety 855
 environmental aesthetics 846–47
 evidence base 856
 flow states 850
 fractals 846
 future orientation 850
 Green Care 856–57
 grief and the cycle of life 854–55
 historical perspective 840–44
 human connection 854
 natural setting 844–45
 play and creativity 851–52
 safe green space 849
 shaping of physical surroundings 852
 simple social relationships 853
 slow time and mindfulness 849–50
 smell 847
 stress, modification of 848
 health-care improvement 786–87

 meaningful active engagement 219–20
 metaphor 222–23
 minimal nature 214–15
 nature deficit 216–17
 social dimension 220–22
 soil 218–19
 unselfing 225–26
Gardner, R. 601n.4
Garrison, J. 92–93
Gatens, M. 652
Geddes, P. 842
Geiger, M. 181–82
Gelo, F. 685–86
Gendlin, E. 618
General Medical Council (GMC) 9–10, 16, 18
Gentileschi, A. 668–69
geometry 51–54
German Library Association 448
German Society for Poetry and Bibliotherapy 448
Gerrard, N. 718–19
gestures, everyday clinical work 820–21
Gibson, J. J. 133
Gilby, T. 718, 727, 728–29
Gilmour, D., *The Film Club* 529
Ginsberg, A. 422–23
Ginsburg, C. 869
Glas, G. 20–21
Glissant, É. 467
global climate crisis, *see* climate change
globalization 463–65, 466, 480–81
 Foucault's aesthetics of existence 107
Godard, J. 514
Goebbels, J. 63–64
Goeltzenleuchter, B. 179
Goethe, J. W. v.
 and Benjamin 412, 414
 connective imagination 628, 642n.51
 'imaginal thinking' 624–25
 influence on Freud 713–14
 new organs of perception 625
 observation 828–30
 The Sorrows of Young Werther 443, 587–88
Gogol, N. V., *Diary of a Madman* 426–27
golden ratio 336, 889–90
Goldwyn, S. 557
Go Naked to the World (1961) 587–88

Good, B. J. 800
Good, M. J. D. 800
Goodman, N. 665–66
Good Will Hunting (1997) 419–20, 539, 561–65, 574n.29
Götze, G. H., *Kranken-Bibliothek* 443
Goulart, D. M. 510
Grafl, F. 534
Grahame-Smith, S., *Pride and Prejudice and Zombies* 303
Grant, A. 736
Gran Torino (2008) 588
graphotherapy 423, 440–41
 bibliotherapy combined with 449
 dependence on the form of therapy 451
 personality of the sick person 453–54
 potential 457
 see also creative writing
gratitude 225
Gray, C. 822
Greavette, A. 897
Greek tragedy 74–76
Green, H., *I Never Promised You a Rose Garden* 450
Greenberg, H. R. 564
Greenblatt, C. 724–25
Green Care 843–44, 856–58
Greene, G. 443–44
Gregor, M. 726
Gregory, J. 787
Gregory, R. 519
Gregory of Nyssa 61
Griaule, M. 601n.4
grief
 eco-anxiety 855
 film therapy 536
 gardens/gardening 855
 theological aesthetics 970–71
Griesinger, W. 424
Griffith, D. W. 572n.8
Groddeck, G. 565
Gross, R. 573n.13
group therapy
 bibliotherapy 452
 eating disorders 943–48
 hospitals 760–61
Guardini, R. 458

Guattari, F. 466
gustatory sense, *see* taste, sense of
Guzmán-García, A. 723
Gypsy (2017) 559–60

Haddon, A. C. 600–1
Haemerling, K. 580
Haghighian, N. S., *Fuel to the Fire* 22n.17
Haidet, P. J. 812
Hakim, B. 259–60
Hall, J. 965
Hall, S. 465–66
hallucinations 519–20, 521, 591–92
Halpern, J. 960, 974
Hamburger, A. 709, 710
hand collage 252, 252f
Handke, P. 587–88
Hands of X: design meets disability exhibition 784–85
Hankir, A. 524
happiness
 everyday aesthetics 264–65, 271–72, 274, 277, 279–80, 283
 aesthetization of negative aspects of the world 275–76
 enhancement of aesthetic agency 276–77
 enrichment of experience 274–75
 loss and impoverishment 281–82
 phenomenology 272–74
 hedonic accounts 271–72, 274
 life-satisfaction accounts 271–72, 274
haptics, *see* touch, sense of
Hara, K. 785–86
Hardman, C. 604
Hare, R. M. 10
harmony 49–64
Harper, K. H. 208
Harris, S. 259–60
Hartley, G. 472
Hartman, G. 666
healers 464–65, 468–69, 474
health care, *see* clinical practice
hearing, sense of
 aesthetic beings 197
 aesthetic engagement 135
 everyday aesthetics 155–56
 gardens/gardening 225

intellectualist coalition 169, 170
social aesthetic values 382
Hearing the Voice 508–9
Hegel, G. W. F.
 aesthetic response 712
 art-centred aesthetics 265–66
 artworks 888–89
 images of care 410–11
 influence on Levinas 354
 neoclassicism 98, 99–100, 101
 The Oldest Systematic Programme of German Idealism 46
 sensible well-being 170, 172–73
Heidegger, M.
 calculative and meditative thinking 624–25
 enframing 635
 everyday aesthetics 204–6, 207
 influence on Levinas 353–54
 questioning 540
 sensible well-being 180
 solicitude 728–29
 Will to Beauty 335
Heider, K. G. 600f
Heimann, P. 567–68
Hein, H. 16–17, 18, 20–21
Heinämaa, S. 640n.26
Henkel, D. 587–88
Heraclitus 75–76
Herder, J. G. 197, 466
heritage site management, participatory turn in 20–21
Herman, J. 849
heroin addiction 579–80, 584–86
Hesley, J. G. 535
Hesley, J. W. 535
Hesse, H. 587–88
 Unterm Rad 424
Hickman, R. 699
Hidden, Ignored, Denied 643n.57
hierarchy of needs 234
Higgins, P. 759, 760–61
High Anxiety (1977) 558–59
Hildegard, St 841
Hill, L., *Retracing the Trace* 668, 668f
Hillman, J. 624–25, 821, 824, 831b
Hippasus of Metapontum 51–52
Hippias 333–34

Hippocrates 787
Hirngespinster (2014) 591
Histoire de Paul (1975) 509, 513–17, 522, 524
history taking
 aesthetics of clinical encounter 893–94
 theological aesthetics 971–74, 975
histrionic personality disorder 366–67
Hitchcock, A. 555–56, 558, 566
Hitler, A. 63–64
Hoffmann, E. T. A. 424–25, 427–28, 587–88
Hoffmannsthal, H. v. 423–24
Hölderlin, F. 412, 413, 414, 444
 The Oldest Systematic Programme of German Idealism 46
Holiday, B. 671, 679
Höller, C. and Roche, F., *Hypothèse de grue* 176
Holt, N. 131–32
Home of the Brave (1949) 574n.29
Homer 76, 99
Homo Faber (1991) 540–41
homosexuality 97
hooks, b. 195, 657
hope
 film therapy 542–44
 hospitals 750, 752–53, 757
 positive psychiatry 31
 values-based practice 390t, 392–93, 395–96
Hopper, E., A Nude 655
Hörbst, V. 466
Horkheimer, M. 113, 114, 115–17, 118–21, 125
horticultural therapy 214, 218, 219, 221, 222–23, 226–27, 843, 856, 857
 see also gardens/gardening
hospitality
 clinical care 344, 347, 356–57, 358
 social aesthetics 290–91, 327, 332
hospitals
 aesthetic experience in 749–56, 756t–57t, 762–63
 arts activities in cardiac care 758–59
 end-of-life care 759–61
 music interventions in chronic pain management 756–57
 song writing project for mental health service users 759
 workplace choirs for well-being 761–62
 corridor photographs 833–34b
 gardens/gardening 843, 853, 856–57

Hourigan, N. 259, 260
Hours, The (2002) 588–90
household chores
　everyday aesthetics 160–61, 248–50, 250f, 256
　　Zen Buddhism 270
　sensible well-being 178–79
House of Fools (2002) 591
Howard, R. 522
Howick, J. 960, 974
How to Change your Mind (2022) 556
Hughes, J. C. 726, 727–28
Hughes, T. 473–75
　Crow 473
　Gaudete 473
　Prometheus on His Crag 473
human-based medicine 339–40
Humanifesto for an Eco-Social Future 633–35
human rights 9–10
Hume, D. 785
humility
　atmospheres 309
　creative enquiry 811–12
　dementia 727
　everyday aesthetics 161–62
　　ageing 276
　　Confucianism 269–70
　　Zen Buddhism 270
　human dimension 218–19, 801
　narrative 800–1
Hunting and Gathering (2007) 540–41
Huo, D. 484n.32
Husserl, E. 141, 347, 350–51, 353–54, 366, 640n.26
Huston, J. 572n.3
Hutto, D. D. 297, 301

I Dreamed of Africa (2000) 587–88
I Hired a Contract Killer (1990) 588
images of care 401–2, 410–14
　Baudelaire 409–10
　dialectical 404–9, 410–12, 413–14
　understanding and the importance of images 402–3
'imaginal thinking' (connective practice) 624–25, 633–35, 637
imaginary world-making 294, 298, 302–6

imagination
　aesthetic engagement 135
　bibliotherapy 455
　clinician insight into practice 798, 807
　eating disorders 940
　everyday aesthetics 154
　everyday clinical work 818–21, 823, 833–35, 836
　　connective practice approach 824, 825, 826b
　　environmental aesthetics 830–33
　　Goethean observation 829, 830
　　mindfulness 835
　health-care improvement 788–89, 790
　perfect moments 896
　The Strangers Project 502–4
　transcultural perspective 464
Imitation Game, The (2014) 97
immigrants, *see* migrant populations
imperfectionist aesthetics 154, 155, 240
improvisation 907
　clinical practice 907, 915–19, 920–21
　music 905–6, 907–10, 913–15, 916, 917, 920–21
　present moments 912
inclusion, *see* diversity, equity, and inclusion
Indian Buddhism 269, 271
Indigenous cultures
　art and trauma 668
　storytelling 468–72, 475
industrialization 98–99, 101
I Never Promised You a Rose Garden (1977) 590–91
infants
　aesthetic beings 199n.2
　developmental psychology 707
　sensible well-being 175, 180
　social aesthetics 328, 335–36
Inside (2021) 507, 518, 521–23
insight
　psychotherapy 395
　and values-based practice 394t, 395
'instruments of consciousness' (connective practice) 621, 630–32, 631f–33f
　commonalities and differences 635
　FRAMETALKS 633–35, 634f
insulin-induced coma 97

intellectualist coalition being 168–73, 181–82
International Association of Eating Disorders Professionals 953
International Federation of Library Associations 447–48
International Network of Women 736–47
International Positive Psychology Association 29–30
Internet 107–8
interpersonal therapy 389
Interpretative Phenomenological Analysis (IPA) 686–99
interpreters, creative well-being workshop 738
Intouchables (2011) 586
Iser, W. 314

Jackson, C. R., *The Lost Weekend* 582
Jackson, D. 786–87
Jacobi, M., *Über die Anlegung und Einrichtung von Irren-Heilanstalten* 445–46
James, H., *The Wings of the Dove* 429
James, W. 29–30, 92, 278–79
Jamison, K. R. 901
Japanese aesthetics
 everyday aesthetics 264, 266, 275–76, 778–79
 earthquake and tsunami (2011) 154, 163
 Shinto 270, 275
 Zen Buddhism 269, 270, 275, 276
 kintsugi (repair by gold) 163
 shakuhachi music 275
 signs of ageing and use 240
 tea ceremony 154, 159–60, 275, 827–28
 Umeda Hospital, Yamaguchi 785–86
 wabi-sabi aesthetic 275–76
Jarmusch, J. 587
Jaspers, K. 278–79, 413, 422–23
Jauss, H. R. 314
Jay, M. 512
Jennings, M. 405–6
John of Climacus, *Ladder of Divine Ascent* 61
Johnson, M. 90–91
Johnson, S., *The History of Rasselas, Prince of Abissinia* 427–28
Joker (2019) 590–91
Jones, A., 'The Acrobat' 749

Journaling for Change 632
Joye, Y. 846
Jung, C. G. 452–53, 565, 642n.51, 854
Jünger, E. 117

Kafka, F. 414, 458
Kahlbaum, K. L. 445–46
Kandinsky, W. 624–25
Kanellopoulos, P. A. 908, 909, 913, 916, 917
Kant, I.
 aesthetic disillusionment 245n.2
 aesthetic experience 364–65
 aesthetic footprint 239
 art 86
 beauty 104
 and Benjamin 406–7, 408
 clinical care 351–52
 criticism of Baumgarten 726
 disinterestedness theory 132, 157, 181–82
 and Husserl 366
 and Marcuse 124
 neoclassicism 100, 101
 scientific and evolutionary aesthetics 889
 self, sense of 136
 sensible well-being 170, 171–72, 181–82
 smell, sense of 135
 three questions of philosophy 72–73
 Will to Beauty 337
Kaplan, R. 215–16, 217
Kaplan, S. 215–16, 217
Kashyap, A., *My Funny Film* 608, 609
Kaufman, J. C. 724
Keats, J. 727, 800–1
Kennedy, Jacqueline 108n.1
Kennedy, John Fitzgerald 108n.1
Kennedy, Joseph P. 108n.1
Kennedy, R. 108n.1, 560
Kepler, J. 65n.10
Kerner, J. 422–23
Kesey, K., *One Flew Over the Cuckoo's Nest* 561
Kessler, F. 532
Kierkegaard, S.
 Sickness unto Death 453
 theological aesthetics 775, 959, 961, 964–66, 975
 clinical practice 971, 973, 974
 Eucharist 967, 970

Killick, J. 724–25
Kilroy, A. 763
kinaesthesia 155–56, 157
Kind of Blue: James Hillman on Melancholia & Depression (1992) 556
Kipphardt, H. 422–23
Kitwood, T. 727
Klages, W. 452
Klee, P. 624–25
Klein, M. 707, 855
Klein, N. 852
Kleist, H. v. 425, 587–88
Klevan, T. 736
Klingemann, E. A. F., *Nachtwachen des Bonaventura* 428
Kluge, A. 111–12, 126
Kohut, H. 137–38
Kollwitz, K. 668–69
Kooning, W. de 725
Kopfstand (1981) 564, 573n.15
Koran 442
Kornu, K. 964
koro 464
Korzybski, A. 740
Kosofsky Sedgwick, E. 491
Kottman, P. A. 494, 495
Kotzebue, A. v. 445–46
Kowaltowski, D. 260
K-Pax (2001) 564, 591
Kracauer, S. 580
Krauss, R. 639n.12
Kristeva, J. 463–64
Kron, J. 936–37
Kunitz, S. 854
Kunst und Therapie 447–48

Lacan, J. 335
Lacis, A. 408
Lagerspetz, M. 686
Lambert, K. 852
land art 130, 141–42, 153–54
Landing Strip for Souls 632, 643nn.56,61
Land Without Bread (1932) 601n.4
Lang, F. 556–57, 572n.10, 601n.4
Langer, S. K. 811
La Place d'un Autre (1993) 516–17
Lapper, A. 656

Lars and the Real Girl (2007) 539, 591
Last Embrace, The (1979) 566
Last Sunset, The (1961) 587–88
Last Tango in Paris (1972) 540–41
Latour, B. 245n.3
law, and shared decision-making 9–10
Lawson, B. 751–52, 753–54
Leacock, R. 603
Leadbetter, G. 474
Lecoq, J. 864, 877–78
Leddy, T. 250–51, 271, 785
Leder, H. 686
Lefebvre, H. 247–48, 250, 252–53, 255–56
Lefève, C. 349
Lehman, R. 800
Leibniz, G. 326–27, 406
Le locataire (1976) 588
Le mystère des roches de Kador (1912) 532–34, 572n.9
L'Enfer (1994) 591
Lenk, S. 532
Lenrow, E. 447
Leonardo da Vinci, *Vitruvian Man* 61–62
Le Patient (2022) 564
Le rêve d'un fumeur d'opium (1908) 580–81
Les invasions barbares (2003) 588
Lessing, D. 435
Let There Be Light (1946) 556
Lévinas, E. 175–76, 344, 353–59
Levinson, D. 113, 118, 121–22
Le voyage dans la lune (1902) 556
Lewin, K. 133
Lewis, C. 218, 221, 225
Lewis, P. J. 493
LGBTQ people 195–96, 197, 928–29
Liberati, E. G. 792
liberty, *see* freedom
libido 114, 118–19, 120, 123, 124
life expectancy 37, 191
Lifton, R. 854–55
Lilliputian hallucination syndrome 423–24
Lincoln, Y. S. 733
Lind, M. 14, 15, 19–20
literature 419–21, 422–24, 435–36
 change in time and space 424–27
 doctor and therapy 429–32
 everyday aesthetics 153, 154

patient and disease 427–29
Plato 58
psychosis 508–10
social relations 432–33
symbolism 433–35
see also bibliotherapy; poetry; storytelling
Literature and Medicine 447–48
Livingston, G. 718–19
Livingston, P. 295
lobotomy 97, 108–9n.2, 559–60
Locke, J. 170
Loewi, H. 565
Long, R. 131–32
'lookism' 164
Loos, A. 257–59
Lorde, A. 648–49, 653, 656
Lost Weekend, The (1945) 542–44, 582–83
Louv, R. 842
love
　in film 591
　　film therapy 540–43, 544–45
　　therapists 565–71
　　Plato 60–61
Love Happens (2009) 540–41, 574n.29
Lovers of the Arctic Circle (1998) 540–41
Lovesick (1983) 559
Lukács, G. 120–21, 125, 408
Lumière brothers 556, 600–1

Mabey, R. 278–79
MacArthur Story Stem Assessments 940
MacDougall, D. 598, 601n.4, 606–8
　'Childhood and Modernity' Project 608–9
　The Wedding Camels 601
MacDougall, J. 601n.4
　The Wedding Camels 601
MacFarlane, A. 601–2, 612–13
Machado de Assis, J. M., *The Alienist* 426–27
Mackintosh, K. 256
Macphail, A. 798–99, 803
Madhukumar, V. 473, 474–75
Magill, L. 760–61
Magritte, R., 'ceci n'est pas une pipe' 696
Mahler, M. S. 565
Maimonides, M. 442
maintenance 236
Maio, G. 788

Mairs, N. 653–54, 657
'making sense' (connective practice) 624, 627, 629
'making social honey' (connective practice) 621, 626, 627–30, 637
　'instruments of consciousness' 630–31, 633–35
'making strange' (connective practice) 627
Malins, J. 822
Mandoki, K. 192, 754
manic depression, *see* bipolar disorder
Mann, T., *Magic Mountain* 443–44
Manolopoulou, Y. 256–57, 259–60
Man with a Movie Camera (1927) 601n.4
Man with the Golden Arm, The (1955) 542–43, 544, 584
Mao Zedong 476, 478
maps, creative well-being workshop 737, 740–46, 741f
Mar Adentro (2004) 588
Marcuse, H. 113–14, 118–21, 123–24
Margolles, T., *Vaporización* 176
marijuana/cannabis use in film 579–80, 581–82, 586
Marijuana—Weed With Roots in Hell (1936) 581–82
Marinetti, F. T. 117
Marmontels, J.-F., *Mémoires d'un père pour servir à l'instruction de ses enfants* 443
Marnie (1964) 558
Marshall, J. 601n.4
Martelluci, J. 915
Martin du Gard, R. 447
　Les Thibaults 453–54
Marx, K. 85–86, 91
Marxism
　Benjamin 408
　cultural 120
　Frankfurt School 118
　Neo-, 120–21
masks, Moving Pieces Approach 873f, 874, 875, 876f–77f
Maslow, A. 92, 234
mastery, *see* personal mastery
mathematics 50, 51–54
Matisse, H. 656
Matrix, The (1999) 107–8, 513

Matthews, J. T. 512
Mattingly, C. 347
Maupassant, G. de, *Le Horla* 428
Maysles, A. 603
McCandless, D. 919
McCormick, A. 726
McCullers, C., *Clock Without Hands* 453, 454
McIntosh, P. 804–5
McKillen, T., *Bless Me Child for I Have Sinned* 673–74, 673f
McLuhan, M. 610
Mead, M. 599, 601–2
Mean Streets (1973) 513
media technology 113, 114–17
medical care, *see* clinical practice
medically unexplained symptoms (MUS), and Moving Pieces Approach 862, 883
 case study 875
 evaluation 882
medical students, *see* education: medical
medicines 781–83, 793
Meeropol, A. 671
melancholia 532
melatonin 844–45
Melchionne, K. 237–38, 241
Méliès, G. 556, 580–81
Melle, T., *The World at My Back* 419–20
Meltzer, D. 707
Memorial to the Murdered Jews of Europe, Munich 661–62, 662f, 664–65
memory
 environmental aesthetics 191
 gardening 214
 Moving Pieces Approach 862, 883
 body as safe container 867
 case study 880–81
 context and background 863
 creating a 'poetic space' 865
 sensations to image making as implicit basis for self-knowledge 871–72, 873
Mendieta, A. 668–69
Menick, J. 572n.4
Menninger, K. 843
 The Human Mind 447
mental delay 536
Merleau-Ponty, M. 133, 141, 169, 349, 649–51
Merzenich, M. 870

Mesmer, F. A. 425
Messas, G. 13
Metropolis (1927) 601n.4
Metz, C. 512
Meyer, C. F.
 Angela Borgia 443
 Der Gewissensfall 454
Meyers, D. 653, 656
migrant populations
 creative well-being workshop 736–47
 The Silent University 14–16, 19, 20
 theological aesthetics 960
 transcultural perspective 463, 464–65, 480–81
 China-born migrants in France 476–80
 postcolonial theoretical framework 467
 trauma 598–99
mild cognitive impairment (MCI) 722
Mill, J. S. 443
Millar, S. 759
Million Dollar Baby (2004) 588
MIND 508–9
mindfulness 3–4
 aesthetic attitude 921
 awareness 389
 eating disorders 944, 946
 everyday clinical work 826b, 835
 environmental aesthetics 832
 gardens/gardening 849–50, 853
 see also presence, aesthetics of
mirroring
 gardening 223
 Moving Pieces Approach 872
Mistry, K. 256
moments 911–12
 aesthetic 910, 912, 913
 clinical practice 918–20
 Free Musical Improvisation 913–15
 perfect 892–93, 895–98, 903
 present 912–13, 921
 privileged 892–93, 895–98, 903
Moniz, A. E. 573n.17
Montesquieu, C. de 442
Montgomery judgement 9–10, 16, 18
mood disorders 29
 see also anxiety; depression

Moore, S. 259–60
moral goodness 63–64
morality
 Buddhism 3
 clinical care 344–45, 349, 352
 Levinas 355
 Dewey 84–85
 ecological awareness 242
 everyday aesthetics 158–59, 160, 163, 206, 266–67
 care 266–67, 268
 Confucianism 269–70
 happiness 271–72
 Shinto 270
 Zen Buddhism 270
 everyday clinical work 827–28
 imagination 834, 835b
 film 530, 581–82
 Foucault 96–97, 104, 106, 108
 individual versus social 289
 Kant 100
 Marcuse 124
 Nietzsche 71–73, 78–79
 participatory turn in museum curation 20–21
 Plato 48, 49–50, 55, 58, 59, 63–64
 positive psychiatry 36–37
 psychiatric practice and education 362–63, 366–68, 370, 371, 377–78
 sensible well-being 168–69, 182
 social aesthetics 158–59
 theological aesthetics 962–63
moral nobility 51
Moral Therapy 841
moral-virtue theory 371
More, A. 782
Moreck, C. 580
Moreno, J. L. 452
Morgan, M. 519
Morin, E. 603–4
Morris, R. J. H. 468
Morris, W. 90
Morrison, T. 656
 The Bluest Eye 648
Most, G. F. 445–46
Motivational Enhancement Therapy 942–43

Moving Pieces Approach (MPA) 772, 862–63, 883
 attention to polarities 874
 body as safe container 867–71
 case studies 875–82, 876f–77f, 879f–80f
 context and background 863–64
 creating a 'poetic space' 864–66
 evaluation and application 882
 sensations to image making as implicit basis for self-knowledge 871–74
Mr. Jones (1993) 419–20, 570
Muhr, C. 422–23
Muir, J. 138–39
Multi-Family Therapy 943–44
multi-sensory perception 168, 171, 173
 co-naturality 177–80
 conviviality 174–77
 sensory reflexivity and self-acceptance 173–74
Münchhausen, H. C. F. v. 445–46
Munchausen syndrome 423–24
Munro Hendry, P. 491
Murdoch, I. 226
Musalek, M. 13, 312–13
museum curation 8–9, 13–14
 expanded field 15, 19–20
 person-centred care 15–21
 The Silent University 14–16, 19, 20
Museum of Modern Art 721–22
 Adorno 122, 125
 aesthetic beings 191–92
 atmospheres 316
 cosmic 52
 dementia 718–19, 722–23
 everyday aesthetics 154
 Hippasus of Metapontum 51–52
 hospitals, aesthetic experience in 749–53, 755, 756t–57t, 763
 cardiac care 758
 chronic pain 756–57
 song writing project for mental health service users 759
 workplace choirs 761–62
 improvisation 905–6, 907–10, 913–15, 916, 917
 aesthetic attitude 910–11
 see also Free Musical Improvisation

Museum of Modern Art (*cont.*)
 Moving Pieces Approach 866
 Nietzsche 78, 81–82
 Philolaus of Croton 51–52
 Plato 50–52, 58, 60, 61–62, 63–64
 suicidality 587–88
 Will to Beauty 339
music therapy
 dementia 722–23
 hospitals 750, 755–56
 chronic pain 756–57
 end-of-life care 759–61
 mental health service users 759
 in literature 441
Musil, R. 423–25
 Der Mann ohne Eigenschaften 429, 430, 435
My Name Was Sabina Spielrein (2002) 556
mythology 75

Nachmanovitch, S. 919
Naked Lunch (1991) 587
Nanook of the North (1922) 600–1
Naranch, L. E. 495
narcissistic personality disorder 366–67
Narkotika—Die Welt der Träume und des Wahnsinn (1924) 581–82
narrative, and sense of self 137, 142–43
Narrative Analysis 685–86
narrative atmospheres 308–9, 316–19
narrative medicine 23n.29
 storytelling 468, 469–70
narrative therapy (NT) 294, 305–6, 392
 author and co-authors 294–98
 authoring-forth and world-making (WM) 294, 298, 302–6
 narratives 298–302
 re-authoring (RA) 294–98, 301–2, 304–5
Nathan, T. 464–65, 466, 478, 485n.36
National Institute for Health and Care Excellence (NICE) 9–10
National Institute for Mental Health in England (NIMHE) 10–11
National Memorial for Peace and Justice, Montgomery, Alabama 664–65, 664f
Native American cultures
 art and trauma 668
 storytelling 468–72, 475

nature 149, 152, 213
 aesthetic engagement 132–33, 138–43
 deficit 216–17, 842
 eating disorders, impact on clinicians and therapists 936f, 936
 everyday clinical work
 environmental aesthetics 830–31, 832–33
 Goethean observation 829
 evidence of mental health benefits 214
 explanations 215–16
 minimal 214–15
 Zen Buddhism 270
 see also environmental aesthetics; gardens/gardening
Naukkarinen, O. 239
Navajo Indians 471–72
 Night Chant/Nightway Chant 468–71, 472, 475
Nebel, E. L. W., *Medizinisches Vademecum für lustige Ärtze und lustige Kranken* 443
Negt, O. 111–12, 126
Nehamas, A. 272–73
Nelson, R. 822
Neo-Marxism 120–21
Neoplatonists 61, 169
Nerval, G. de, *Aurélia ou la rêve et la vie* 434
neuroses
 bibliotherapy 450–51, 452
 literature 422–23, 424
New Eyes for the World 630–32, 637, 642n.53
Newman-Bluestein, D. 723–24
newness, fascination with 233–34, 236–37
Ngo, N. T. 929
Nietzsche, F.
 from 'art before witnesses' to 'the music of forgetting' 80–82
 domains of culture 72–73
 everyday aesthetics 162–63
 existence and the world eternally justified only as aesthetic phenomenon 73–76
 and Foucault's aesthetics of existence 104–7
 gratitude to art 72–73
 health 68
 music 82
 narrative therapy 301–2
 neoclassicism 100, 101–3

physicians
 patients as 77–80
 philosophers as 68–72
 transfiguration 75, 76–77, 78–79, 80, 81, 82
 Will to Beauty 337
 Will to Power 334, 335
 Yalom's *When Nietzsche wept* 431
Nightmare Alley (2021) 559–60
nihilism 241–42, 243
Nin, A. 565
Nishiko, *Repairing Earthquake Project* 163
Nisreyasananda, S. 642n.49
nobility, moral 51
noise pollution 755–56, 756t, 763
Nordenfelt, L. 339
Norinaga, M. 275
Novalis 425, 444
 Heinrich von Ofterdingen 434
novels, *see* literature; storytelling
novelty, fascination with 233–34, 236–37
nudging 235
Nymphomaniac (2013) 579–80

Obama, B. 656–57
Oberarzt Dr. Solm (1955) 573n.19
obesity 174
Oblomov syndrome 423–24
Obsessed (2009) 591
obsolescence, planned 235–37
Odoevskij, V., *Russian Nights* 425–26
Öğüt, A., *The Silent University* 14–16, 19, 20
older people
 art engagement 684
 bodily aesthetics 648, 653–54, 656, 657–58
 hospitals, aesthetic experience in 755–56, 756t–57t
 arts activities in cardiac care 758–59
 end-of-life care 759–61
 music interventions in chronic pain management 756–57
 song writing project for mental health service users 759
 see also ageing process
olfaction, *see* smell, sense of
olfactory reference syndrome 174
Oliver, P. 259
Olmsted, F. L. 841–42

One A.M. (1916) 581–82
One Flew Over the Cuckoo's Nest (1975) 560, 590–91
online health care 787
online therapy 948
Only Lovers Left Alive (2013) 587
On Tam, C. 686, 688
optimism 29, 32–33, 37, 38–39
Orbach, S. 931
Ordinary People (1980) 574n.29, 588
Orpheus programme 339–40
Ortega, M. 657, 658
Osborn, M. 690
Osler, W. 348
Outside (2013) 507, 518–21
over the counter (OTC) medicines 782
overweight
 bibliotherapy 451
 bodily aesthetics 648, 649, 653–54
 obesity 174
ownership, and sense of self 137, 142–43
Oxford School 10
Oxtoby, K. 915
oxytocin 853

Pabst, G. W. 557, 572n.10
pain, chronic 756–57, 761–62
Palestine 248–50, 253–56, 257–59, 260–62
Palos, E. 565
Palos, G. 565
Pappenheim, B. (Anna O.) 468, 706–7
Paracelsus 540, 570, 639n.11
Paradise Now (2004) 588
paranoia 591
Parmenides of Elea 326–27
participatory turn
 heritage site management 20–21
 museums, *see* museum curation
Pasternak, B., *Doctor Zhivago* 426
patient-centred care, *see* person-centred care
Paul, J. 442
 Selina oder über die Unsterblichkeit der Seele 427–28
Paulette (2012) 586
Peabody, F. W. 348, 798–99, 803
Pederick, J. 673
Peeping Tom (1960) 588

Pellegrino, E. D. 344–45, 352
Pellico, S., *My Prisons* 454
Perception (2012–2015) 590–91
Percy, W. 431
 Love in the Ruins 432
perfect moments 892–93, 895–98, 903
performance, Moving Pieces Approach 876–81, 879f–80f
perfumery 171–72, 176, 178–79
Permanent Breakfast 176–77
Perret, L. 532, 572n.9
personality factors in bibliotherapy 453–55
personalized medicine 435–36
 and person-centred care 21–22n.1
personal mastery
 Plato 49
 positive psychiatry 31–32
person-centred care 8–9, 11–12, 14
 clinician insight into practice 799, 800–1, 805–6
 eating disorders 925–26
 everyday aesthetics 777–78, 785, 786, 789, 792
 and evidence-based practice 11
 participatory turn in museum curation 15–21
 and shared decision-making 9–10, 15–18, 20, 21
 values-based practice aligned with 384–86
person-values-centred practice 384–86
perspectivism 78
Petronius 176–77
pheromones 176
Philip II, King of Spain 442
Philolaus of Croton 51–52, 65n.13
Philosophical Cinematherapy 536–39
 addiction films 543–44
 love films 540–43
 psychotherapy portrayals 539–40
photography
 architectural features 256–59
 dementia 724–25
 eating disorders, impact on clinicians and therapists 936, 936f
 everyday aesthetics 153–54
 sensible well-being 171–72
physical activity, and gardening 219–20, 224

Pi (1998) 590–91
Piaget, J. 598, 599
picturesque aesthetics 154, 155
Pinel, P. 425, 444
Piper, A. 198–99
placebo effect 666
planned obsolescence 235–37
Plath, S. 422–23, 587–88
 The Bell Jar 429, 450
Plato 48–49, 63–64
 afterlives 61–62
 beauty, harmony, and the bad life? 62–63
 censorship of the arts 48–49, 63–64, 66n.43
 cognitive-rational knowledge 326–27
 education in beauty 58–59
 eros 60–61
 and Foucault 106
 geometry 51–54
 happiness 272–73
 harmonia 50–51
 kalon 51
 love 540
 microcosm and macrocosm 54–55
 Nietzsche on 69–70
 philosopher-artists 56–58
 proposed censorship of the arts 3
 psychic harmony and a flourishing life 49–50
 sensible well-being 169, 180
 conviviality 176–77
 shape of a life 56
 thumeoides 60
 Will to Beauty 333–34
play
 children 707
 dementia 724–25
 gardens/gardening 851–52
Plessner, H. 711
Pliny the Elder 65n.10
Plotinus 61, 102–3, 272–73
Pochinko masks 873f, 874, 875, 876f–77f
Poe, E. A. 428
 Berenice 454
 The System of Doctor Thaer and Professor Fether 431–32
poetic space, Moving Pieces Approach 864–66, 868

poetry 419–20, 422–23, 424
 Adorno 125–26
 aesthetics of clinical encounter 899, 900
 bibliotherapy
 development 443, 444, 445–46, 447–48
 personality of the sick person 455
 reading during health and illness 449
 cardiac care 758–59
 change in time and space 425–26, 427
 creative well-being workshop 740, 743f–45f
 dementia 724–25
 everyday clinical work 823
 connective practice approach 825
 mindfulness 835
 images of care 401–2, 409–13
 Plato 58
 symbolism 434–35
 transcultural perspective 471, 472–75, 480–81
Poetry Therapy Association 447–48
Poetry Therapy Institute 447–48
Poincaré, H. 375–76
Pollock, F. 114
Poltrum, M. 13
Porges, S. 867
positive organizational behaviour 30–31
positive psychiatry 28, 38–39
 history 29–30
 interventions 30
 and mental or physical illness 37
 nature of 28–29
 outcome measures 33–37
 positive organizational behaviour and psychological capital 30–33
 training 38
positive psychology 30–31, 271
 Dewey 91–92, 93
 history 29–30
Post, S. G. 726
postcolonialism 465–68, 480–81
post-traumatic growth 35
post-traumatic stress disorder (PTSD)
 gardens/gardening 214, 849
 positive psychiatry 30, 35–36
 sexual violence 669
pottery 171–72
Pradines, M. 353

pragmatism 86
precision medicine 435–36
precision psychiatry 38–39
Preminger, O. 584
presence, aesthetics of 203–4, 210–11
 care 205–6, 209–10
 ethical and ecological considerations 209–11
 familiarity 206–9, 210–11
 ontology of the everyday 204–5
 reliability 206–7, 210
present moments 912–13, 921
prevention of health problems 28–29, 37, 38–39
Prévost, E. 914–15, 916
Prince, G. 299
Prince of Tides, The (1991) 539, 540–41, 564, 569–70
prisoners
 art engagement 684
 gardens/gardening 853
Private Worlds (1935) 566
privileged moments 892–93, 895–98, 903
prognostics 70, 73
Proof (2005) 590–91
Propp, V. 300
proprioception
 aesthetic beings 196, 197
 everyday aesthetics 155–56
prospect refuge theory 216
prostheses 783–85, 788, 793, 963–64
Protagoras 58
Proust, M.
 À la recherche du temps perdu 429–30, 431–32
 and Benjamin 414
 everyday aesthetics 153–54
 and Levinas 353, 354
 on writing 443–44
Proust syndrome 174
proxemics 175
Prum, V. A. 668–69, 672–73
 Days Stretch Out 672f
 The Deadeye and the Deep Blue Sea 672f, 673
Pseudo-Dionysius the Areopagite 61

psychiatric education 363, 377
 aesthetic perception 367–70
 aesthetic virtue 370–72
 films as educational tools 508
psychiatric practice 362–63, 377–78
 aesthetic experience 363–67
 aesthetics of clinical encounter
 language 899, 902
 patient–doctor relationship 898
 professional context 894
 aesthetic virtue 370–72
 case example 372–77
 eating disorders 925–26
 RESPECT-ME 939–40
 understanding 927–28
 improvisation 909
 theological aesthetics 971–72
psychiatrists in film 555, 558–61, 564, 566, 568
Psycho (1960) 590–91
psychoanalysis
 as art of meeting the other 706–7, 713–14
 metapsychology of meeting 710–11
 moments in art and aesthetic
 response 712–13
 moments of meeting 709–10
 moving along 708–9
 now moments 709
 present moments 708
 vitality affects 707–8
 bibliotherapy 452
 in film 555–58, 565, 566–68
 film therapy 535–36
 storytelling 469–70
 transcultural perspective 476, 477–81
psychodrama 452
psychodynamic psychology 401
psychodynamic therapies 389, 391
psychologists in film 555, 557–58, 559–60, 561–64
psychopathology 617–19
psychosis 510–12
 art engagement 685–86
 DSM 510–11
 in film 590–91
 filmmakers with lived experience 507–13,
 523–25
 Féret 513–17
 Sen 518–23
 film therapy contraindicated 535–36
 lobotomy 573n.16
 positive psychiatry 36–37
 psychoanalysis as art of meeting the
 other 711
 shamanism 484n.29
 see also schizophrenia
psychotherapists in film 555–58, 561–66, 570,
 571–72
psychotherapy
 aesthetic moment 912
 bibliotherapy 452
 film therapy 529–30, 535–36
 portrayals of psychotherapy 539–40
 spaces 786–87
Public Enemy, The (1931) 581–82
Pullin, G. 925–26, 963–64
pulse, taking a 819–20, 827–28
punishment 192
Puolakka, K. 788–89
Purifoy, N., *White/Colored* 675–76
Pythagoras 65n.10
Pythagoreans 50–52, 53, 65n.16

Q-methodology 685–86
quality improvement, *see under* clinical
 practice: quality improvement
queer communities 195–96, 197, 928–29
Quinn, M., *Complete Marbles* 656

Rabelais, F., *Gargantua et
 Pantagruel* 442, 445–46
race and ethnicity
 aesthetic beings 193–96, 197
 bodily aesthetics 648, 649
 artistic interventions 654–55, 656–57
 bodily imaginaries 652–53
 damaging imaginaries 653–54
 re-imagining ourselves 657
 heritage site management 20–21
racial discrimination/racism
 aesthetic objects 188
 art and trauma 664–65, 664f–, 71–, 678–
 79, 679f
 smell, sense of 176
Radovic, S. 467n.13
Rafael, *Transfigurazione del Signore* 76–77, 82

Ramirez, M. 668–69
Ramsey, J. 469–70, 471
Rank, O. 565
Rapoport, A. 255–56, 259
Rapunzel syndrome 423–24
Ratcliffe, M. 277, 278, 279, 280, 281
Ray (2004) 542–43
Reader, The (2008) 587–88
reading
 in hospitals 752–53, 755
 reparative 491
 see also bibliotherapy
Ready Player One (2018) 107–8
reasonable person model 217
Rechtman, R. 465
recognition, and values-based practice 393, 394t
Redvers, N. 475
Reefer Madness (1936) 581–82
refugees
 creative well-being workshop 736–47
 gardens/gardening 853
 The Silent University 14–16, 19, 20
 theological aesthetics 960, 961
regret 234–35
Reil, J. C. 444–45
reliability 206–7, 210
religiosity
 art engagement 695–96
 bibliotherapy 441, 442, 450
 child sexual abuse 673–74
 Dewey 85
 everyday aesthetics
 Confucianism 269–70
 happiness 271
 Japanese aesthetics 275
 Shinto 270
 Foucault's aesthetics of existence 96–97, 98, 107
 Freud 85
 gardens/gardening 840–41
 hospitals, aesthetic experience in 751–52
 music 760–61
 neoclassicism 98, 101
 Nietzsche 71–73, 75, 78–79
 positive psychiatry 36
 sensible well-being 169–70, 182

 touching 291
 see also spirituality; theological aesthetics
remote health care 787
remote therapy 948
renal dialysis patients 750–51
repair
 ecological awareness 236
 everyday aesthetics 162, 163
Repairing Earthquake Project 163
reparative reading 491
Requiem for a Dream (2000) 513, 542–43, 584, 585–86
resilience
 everyday aesthetics 154, 248–55, 260–62
 architecture 255–60
 concept 247–48
 happiness 271
 gardens/gardening 222–23
 positive psychiatry 28–29, 32, 37, 38–39
Resource Oriented Skills Training 868–69
respect 161
 Confucianism 269–70
RESPECT-ME 944, 945f
 development 937–44
 group structure 944–48
 individualized (I-RESPECT-ME) 948
Rhys, J., *Outside the Machine* 454
Ricoeur, P. 344, 351–53, 358–59, 688
Riegl, A. 114–15
Rikandi, E. 511
Rilke, R. M. 402, 443–44
 Aufzeichnungen des Malte Laurids Brigge 444
 'Death of the Beloved' 484n.33
 Orpheus Sonnets 340–41
ritual
 Confucianism 269–70, 282
 Eucharist 961, 963, 966–71, 968f–69f, 975
 history taking 971–72
 Moving Pieces Approach 868, 875
 music 760–61
 transcultural perspective 464
Ritual Aids for the Impasse 643n.55
Rivera, G. N. 698
Roald, T. 686
Roaring Twenties, The (1939) 581–82
Robinett, J. 482n.18

Robinson, R. E. 686
Roche, F. and Höller, C., *Hypothèse de grue* 176
Rodriguez, R. 652–53, 656–57
Roethke, T. 422–23
Rogers, M. 493–94
Rössler, W. 573n.13
Roth, P., *Portnoy's Complaint* 295, 299–300, 301
Rothschild, B. 862
Rouch, J. 603–4, 611–12
 Chronicle of a Summer 601
 Mad Masters (*Les Maîtres Fous*) 601
Rousseau, J.-J. 354
Royal College of Obstetricians and Gynaecologists 23n.24
ruins, aesthetization of 275–76
Rush, B. 444, 445, 446, 841
Russell, D. 926
Russell, S. 294, 298–99
Ryōkan 270

Sabat, S. R. 728
Sachs, H. 557
Sacks, O. 518–19
Sacks, S. 502–3, 821, 824–25, 827
Sadler, J. Z. 364
sado-masochism 120, 121–22
Safe (2022) 574n.27
safety
 aesthetics of clinical encounter 906
 clinician insight into practice 810, 812
 creative well-being workshop 737, 738–39
 everyday aesthetics 206–7, 208, 209
 gardens/gardening 846–47, 849, 853, 854, 858
 hospitals, aesthetic experience in 752–54, 763
 Moving Pieces Approach 863, 883
 attention to polarities 874
 body as safe container 867–71
 creating a 'poetic space' 864, 865
 performance 878–79
 sensations to image making as implicit basis for self-knowledge 871–72
 play 851
Sainsbury Centre for Mental Health 10–11

St. Matthew Passion 442
Saito, Y.
 attention 499
 care 206, 209
 everyday aesthetics 248–49, 250–51, 253–54, 265, 266–67
 clinical practice 771
 everyday clinical work 827–28
 happiness 274, 276–77
 health-care improvement 777, 778–80
 hospitals, aesthetic experience in 751
 imperfect aesthetics 192, 963
 potentially damaging effects of aesthetics 963
Salmon, C. 668–69
Sanford, N. 113, 118, 121–22
Sartre, J.-P.
 biographical illusion 902
 and Foucault 98
 freedom beings 626
 La chambre 429, 433
 language 899–900, 901
 Nausea 895–96, 897, 902
 perfect and privileged moments 774, 892–93, 895–96, 897, 903
 relation 467
Sartwell, C. 266
Saunders, S., *Slipper and Shoe* 809–10, 809f
savannah hypothesis 216
Saville, J. 520, 522–23, 653, 656, 657–58
Saving Grace (2000) 586
Sayonara (1957) 587–88
Scannell, K. 804
Scarface (1932) 581–82
Scarry, E. 272–73
Scha, R. 251–52
Schelling, F. W. J. 46, 425
Schenk, R. 471
Schilder, P. 870
Schiller, F. 100–1, 124
schizophrenia
 bibliotherapy 450, 452
 diagnosis by smell 176
 DSM-5, 510
 in film 590–92
 filmmakers with lived experience 512
 film therapy 536

hospitals, aesthetic experience in 750
literature 424
 Balzac's *Louis Lambert* 432
 Fitzgerald's *Tender is the Night* 430–31
 Tobino's *Le libere donne di Magliano* 431
lobotomy 573n.19
positive psychiatry 30, 33–34, 37
shamanism 484n.29
The Three Christs (2017) 97
Schlegel, A. W. 74
Schlozman, S. 529–30
Schmid, W. 291
Schmitz, H. 310
Schneider, G. 710
Schneider, I. 558–60, 561, 564
Schneider, J. 719–20
Schneider, K. 424
Schnitzler, A. 587–88
Scholem, G. 405–6
Schön, D. A. 805–6, 822, 974
SchoolScapes (2007) 606, 607
Schopenhauer, H.
 film 590–91
 neoclassicism 98, 101
 and Nietzsche 75, 78
 suffering 273
 Will to Life 334, 335, 336–37
 Yalom's *The Schopenhauer Cure* 431
Schroeder, B. 583
Schubert, F. 63–64
Schubert, G. H. v. 425
Schumacher, E. F. 623
Schwartz, M. 349
scientific aesthetics 888–92
Scorsese, M. 513
Scott-Hoy, K. 733
Scrutton, A. P. 279, 282
Searles, H. 853
Secrets of a Soul (1926) 557–58, 572n.10, 574n.29
Seel, M. 310–12
Segal, H. 707
Segalen, V. 482n.12
Selberg, S. 721–22, 725
Selbin, E. 491, 492–93
self, sense of 136–38, 142–43
self-acceptance and sensory
 reflexivity 173–74, 183

self-awareness 799–800, 811–12
self-confidence
 gardens/gardening 220
 hospitals, aesthetic experience in 758
self-efficacy 31–32
self-esteem
 eating disorders 931, 944, 945–48
 gardens/gardening 214, 220
self-harm 647
self-respect 944
Seligman, M. E. P. 29–30, 32–33
Selznick, D. O. 555–56
Sen, D. 507, 511, 518–24
Seneca 441
senses
 aesthetic engagement 134–36
 bibliotherapy 458
 everyday aesthetics 155–56
 forest bathing 214–15
 gardens/gardening 224–25
 hierarchy 134, 155–56, 170
 hospitals, aesthetic experience in 750–51
 social aesthetic values 382
 see also multi-sensory perception; sensible well-being
sensible well-being 168, 182–83
 intellectualist coalition 168–73
 multi-sensory perception 173–80
 nuances 180–82
sensory reflexivity and self-acceptance 173–74, 183
sensory turn 169
Sentimental Journey 680–81
serotonin 847
Seth, A. 519–20, 521
Seven Up! series (1964–2019) 604–6
sex addiction 579–80
sexuality
 aesthetic beings 196–97
 touch, sense of 175–76
 Will to Beauty 336
sexual violence, and art
 engagement 666–69, 667f–68f
 and pedagogy 671
 metaphors 671, 673–74, 673f
 real-world encounters 676–77, 680
Shakespeare, W. 424, 587–88
 Titus Andronicus 442

shamans 464–65, 473–75, 480–81, 482n.15, 482–83n.20
Shame (2011) 542–43, 579–80
Shapiro, J. 799–800, 811
shared decision-making 8, 14
 and person-centred care 9–10, 21
 participatory turn in museum curation 15–18, 20
 and values-based practice 9, 10–11, 12
Shaw, F. 278–79, 901–2
Shining (1980) 590–91
Shinto 270, 271, 275
Shivhare, R., *My Lovely General Store* 608
Shoesmith, E. K. 721
Shorter, E. 560
Showroom, The 14
Shrink (2009) 573–74n.23, 586
Shrodes, C., *Bibliotherapy. A Theoretical and Clinical-Experimental Study* 447
Shusterman, R. 90–91, 92–93, 175–76
Shutter Island (2010) 591–92
Sibley, F. 368–69, 377–78
Side Effects (2013) 559–60
Sidemen 611
Siebers, T. 647, 654–55, 656
sight, *see* vision, sense of
Sigmund Freud Home Movies (1930–1939) 556, 564–65
Silence of the Lambs, The (1991) 561
Silent University, The 14–16, 19, 20
Silko, L. M., *Ceremony* 469–70
Silvers, A. 654–55
Simmel, G. 115–16
Simmias 65n.13
Simons, T. 611
Singh, A., *Why Not a Girl?* 608–9
Singh, G. 789
singing, *see* music
Single Man, A (2009) 588
Siskind, A. 153–54
skills and virtues 371
Slater, P. 777–78, 783
slavery 672–73
Slavson, S. R. 452
slow time 849
smell, sense of 173
 aesthetic beings 197

aesthetic engagement 134–35
co-naturality 178–79
conviviality 176
everyday aesthetics 155–56
female seduction 176
gardens/gardening 224–25, 847
intellectualist coalition 169–71, 172–73
loss of 932–33
self-acceptance 174
social aesthetic values 382
Smiraglia, C. 685–86
Smith, C. 491
Smith, J. A. 687–88, 690
Snake Pit, The (1948) 558, 564, 573n.15, 590–91
social aesthetics 289–92
 active agency 158–60
 aesthetic beings 191
 atmospheres 308–9, 321–23
 clinical relevance 311–13
 engaging with the arts 313–21
 narrative 316–19
 pervasiveness 310–11
 spatial 314–16, 319
 theatrical 319–21
 etiquette 177
 gardens/gardening 220–22, 853–54
 values-based practice 380–81, 396
 decision-making 384–88
 therapeutic utility and gain from 389–96
 values, scope and reach of 381
 people and items 381–82
 shared and divergent aesthetic values 383–84
 values of various kinds 383
 see also applied social aesthetics
social class 119–20
social discrimination 176
social engagement 35, 37, 38–39
social media
 bodily aesthetics 647–48, 656
 eating disorders 929
 food aesthetics 933
 RESPECT-ME 945
social sculpture 251, 821, 824, 825
Social Sculpture Lab for New Knowledge and an Eco-Social Future 642n.47
social support 28–29, 35–36, 37

socioeconomic status 119–20, 188
Socrates
 death 51–52
 Plato's writings 48, 63–64
 beauty, harmony, and the bad life? 62–63
 education in beauty 58–59
 eros 60–61
 geometry 52–53
 microcosm and macrocosm 54, 55
 philosopher-artists 56–58
 psychic harmony and a flourishing life 49, 64n.4
 unexamined life not worth living 163–64
 Will to Beauty 333–34
Sof Shavua B'Tel Aviv/For My Father (2008) 588
soil 218–19
Soldt, P. 712
Sologub, F., *Light and Shadows* 433
Solomon, A. 280
somaesthetics 92–93, 157, 175–76, 269–70
song writing 759
Sophocles 74
Sōseki, N. 274
spatial atmospheres 308–9, 314–16, 319
spectatorship
 everyday aesthetics 152, 155–57, 158
 hospitals, aesthetic experience in 750–51, 752–53
 Moving Pieces Approach 878–79, 880–81
 Nietzsche 74–75, 76–77, 79, 81, 82
 psychology of art-viewing 683–86
 Interpretative Phenomenological Analysis 686–99
 sensible well-being 171
Spellbound (1945) 558, 566–68, 588
Spero, N. 669
Spider (2002) 513, 590–91
Spiele Leben (2005) 542–43
Spielrein, S. 565
Spieß, C. H., *Biographien der Wahnsinnigen* 443
spirituality
 art engagement 685–86
 everyday aesthetics 248
 happiness 271
 Shinto 270

hospitals, aesthetic experience in 752–53
music 760–61
neoclassicism 101
positive psychiatry 36, 37
sensible well-being 169
touching 291
see also religiosity; theological aesthetics
Spoerri, D., *Tableaux-pièges* 176–77
sports aesthetics 156
Srivastava, R. 782
Stalin, J. 63
Stanghellini, G. 12–13
Starring Sigmund Freud (2012) 556
State of Mind (2017) 97
status markers 892
Steckel, W. 565
Steiner, R. 622, 642n.51
stereotypes 189–90
Stern, D. N. 707–10, 912–13, 914–15, 917–18, 921
stethoscope contemplation 831–32
Stevenson, R. L. 431
 Strange Case of Dr. Jekyll and Mr. Hyde 431–32
Stifter, A., *Die Mappe meines Urgroßvaters* 443
stigma
 art engagement 685–86
 atmospheres 318
 filmmakers with lived experience of mental ill-health 509–10
 film misrepresentations of mental ill-health 509
 limb difference 783
 The Strangers Project 498–99
Stoller, P. 134
Stolnitz, J. 910
Stompe, T. 591–92
Storck, T. 712
Storm, T., *Schweigen* 432
storytelling 419–21
 The Strangers Project 489–504
 transcultural perspective 480–81
 globalization 463–65
 narration as transnational cultural technique 468–72
 Oedipus in China 476–80

storytelling (*cont.*)
 postcolonial theoretical framework 465–68
 writers, shamans, and curanderas 472–76
 see also film; literature
story therapy 392
Strange Fruit 671–72, 679, 680
Strangers Project, The 489–504
Strausz, E. 638n.1
Strawson, G. 301, 302–3
Streisand, B. 569–70
strengths focus 19, 20
stress
 aesthetic beings 191, 192–93
 art engagement 684–85
 environmental aesthetics 191
 gardens/gardening 214, 216, 223–24, 845, 847–48, 856, 858
 green spaces 139
 hospitals, aesthetic experience in 763
 Moving Pieces Approach 862–63
 body as safe container 867, 868–69, 870
 context and background 864
 positive psychiatry 29, 33, 34, 37
 Resource Oriented Skills Training 869
 response 845, 847, 848
stress reduction theory 845
Strode, O. B. 799
stroke rehabilitation 750
Stroud, S. 90–91
Styron, W. 277–78, 900, 901
substance use 579–82, 584–87
 see also addictive disorders
Suchman, A. 974
Suddenly, Last Summer (1959) 573n.19
suicidality
 in film 587–90
 filmmakers with lived experience of psychosis 513, 515, 516, 522
 film therapy 542–44
 in literature 587–88
 olfactory reference syndrome 174
sunlight 844–45
Suzuki, D. T. 270
Swift, J. 424–25
 A Digression Concerning the Original, the Use and Improvement of Madness in a Commonwealth 425, 427–28
Symonds, A. 735
'Sympathy for the Devil' 713–14
symptomatology 69–70
synaesthetics 169, 177
Szeeman, H., *When Attitudes become Form* exhibition 639n.16

T2 Trainspotting (2017) 592n.6
tactile sense, *see* touch, sense of
Talley, H. 648
Tallgren, E., *We are all individuals on this planet* 810–11, 811*f*
Tamboukou, M. 495
Tarnas, R. 639n.10
taste, sense of 173
 aesthetic beings 197
 aesthetic engagement 134
 co-naturality 179–80
 conviviality 176–77
 everyday aesthetics 155–56
 intellectualist coalition 169–71, 172–73
 social aesthetic values 382
Tate, S. 656
Tate Modern, London 14–15
Tausk, V. 565
taxonomy of aesthetic adaptations 891–92
Taylor, P. 653–54, 657
Tedlock, B. 735
teenagers, *see* children and young people
television series
 mental disorders in 590–91, 592n.5
 psychotherapists, psychologists, and psychiatrists in 559–60, 564–65, 570
 visual anthropology 604–6
Temkin, O. 347
Tensta Konsthall museum, Stockholm 14–15, 22n.17
Testament of Dr. Mabuse, The (1932) 590–91
textiles 171–72
theatre 154
theatrical atmospheres 319–21
Thematic Analysis 685–86
theological aesthetics 959–64, 975
 clinical practice 959, 961, 963–64, 971–75
 Eucharist 966–71, 968*f*–69*f*
 Kierkegaard's dancer 959, 961, 964–66, 967

therapeutic horticulture 214, 218, 219, 221, 222–23, 226–27, 843, 856, 857
 see also gardens/gardening
therapeutic relationship
 aesthetics of clinical encounter 892–93, 895, 898–99, 903
 atmospheres 308–9, 316
 bibliotherapy 457
 clinician insight into practice 802–3
 in film 561, 565–71
 film therapy 535, 537–38
 gardens/gardening 857
 psychiatric practice 375
 psychoanalysis as art of meeting the other 709, 711
 shared values 383–84
Thompson, C. 964
Thomson, R. G. 653–54, 656
Thorn Birds, The (1983) 570
Thorne, B. 604–5
Thornhill, R. 891, 892
Three Approaches to Psychotherapy I (1965), *II* (1977), and *III* (1986) 556
Three Christs, The (2017) 97
Three Faces of Eve, The (1957) 574n.29
Tidball, K. 844
Tierney, W. G. 733
Tilley-Lubbs, G. 733–34
Timaeus 54
Time to Change 508–9
Titicut Follies (1967) 509
Tobino, M. 422–23
 Le libere donne di Magliano 429, 431
Todres, L. 618
Tolstoy, L. N., *War and Peace* 426
Tomlinson, A. 685–86
topophilia 179
To Save a Life (2009) 587–88
touch, sense of 173
 aesthetic beings 196–97
 bathing exercise 826*b*
 co-naturality 177–78
 conviviality 174–76
 everyday aesthetics 155–56
 gardening 224
 intellectualist coalition 169–71, 172–73
 narrative atmospheres 317

social aesthetics 290–91, 332
 values 382
Tournier, P. 974
tragedy 74–76, 79, 101–2
training, *see* education
Trainspotting (1996) 584, 585
Trakl, G. 587–88
transactional analysis 389
transcultural perspective 480–81
 globalization 463–65
 narration as transnational cultural technique 468–72
 Oedipus in China 476–80
 postcolonial theoretical frame work 465–68
 writers, shamans, and curanderas 472–76
transference
 eating disorders 933–34
 film 564–65, 570–71
trans people, bodily aesthetics 653
trauma
 and art 661, 680–81
 Dr. Payne's Electroshock Apparatus 674–76, 675*f*
 engagement 666–69, 667*f*–68*f*
 engagement and pedagogy 669–71
 metaphors 671–74, 672*f*–73*f*
 narrative 661–66, 662*f*, 664*f*
 real-world encounters 676–80, 678*f*–79*f*
 clinician insight 797–98
 in film 592
 film therapy cautions 535–36, 537–38
 gardens/gardening 853
 Moving Pieces Approach 862–63, 883
 body as safe container 867, 869
 context and background 863, 864
 creating a 'poetic space' 865
 evaluation 882
 sensations to image making as implicit basis for self-knowledge 873
 Resource Oriented Skills Training 869
 theological aesthetics 960–61, 966
 Eucharist 967, 970–71
 see also post-traumatic stress disorder
Trauma Healing Institute 960
Treatment (2008–2021) 570

trust
 aesthetics of clinical encounter 901–2
 atmospheres 308, 316
 narrative 318
 in clinical practice 345, 352–53, 359, 974
 Levinas 357, 358
 creative well-being workshop 737–38
 eating disorders 937
 film and public trust in psychiatry/
 psychotherapy 564
 film therapy 538, 540
 in God 966, 970–71
 health-care improvement 781, 785–86
 hospitals, aesthetic experience in 754
 cardiac care 758
 nature's effect on 854
 sensible well-being 180
 values-based practice 390t, 392, 395–96
Tsunami and the Cherry Blossoms (2011) 154
Tucknott-Cohen, T. 722
Tuke, W. 841
Turing, A. 97
Turning Point 10–11

ugly laws 199n.3
Ulrich, R. 216, 845
Unbearable Lightness of Being, The
 (1988) 540–41
understanding
 importance of images 402–3
 and values-based practice 393, 394t
United Kingdom
 3 *Keys* programme 19–20
 bibliotherapy 446
 Department of Health 10–11
 film therapy 532
 green space policy 139
 homosexuality, criminalization of 97
 Montgomery judgement 9–10, 16, 18
 participatory turn in heritage site
 management 20–21
 shared decision-making 9–10
 The Silent University 14–16, 19, 20
 visual anthropology 604–6
United States
 art and trauma 664–65, 664f, 668, 675–76,
 678–79, 679f

bibliotherapy 446
Federal Bureau of Narcotics 581–82
film therapy 531, 532
National Park System 138–39
participatory turn in heritage site
 management 20–21
Prohibition 581–82
schizophrenia treatments 108n.1
ugly laws 199n.3
University of the Trees (UOT) 637, 638–
 39nn.4,9, 640–41n.30, 642n.47
Unsaid, The (2001) 564
unselfing 225–27
Up in Smoke (1987) 586
urban environment
 aesthetic engagement 139–40
 green spaces 216–17, 841–42, 848
 public artworks 683–84
 sensible well-being 179
Utermohlen, W. 725

Valery, P. 353
Valley of the Dolls (1967) 588
values-based practice (VBP) 380–81, 396, 963
 decision-making 384–88
 elements 385t
 and evidence-based practice 8, 10–12
 and person-centred care 8, 9, 11–12
 participatory turn in museum
 curation 17
 philosophical resources 12–13
 shared and divergent values 383–84
 and shared decision-making 9, 10–11, 12
 therapeutic utility and gain from 389
 potential 393–96, 394t
 relationship-based mediators 389–
 93, 390t
van der Steen, J. T. 722
van Gogh, V. 207
Van Staden, W. 13
Varga, S. 510
Vartanian, O. 890–91
Veen, M. 805–6
Velázquez, D., 'Las Meninas' 688–98, 689f
Veronika Decides to Die (2009) 564,
 573n.15, 588
Vertov, D. 601n.4, 612

Viladesau, R. 974–75
Vink, A. C. 722
Vinterberg, T. 583–84
virtue, aesthetic 370–72, 377–78
virtue ethics 69, 370
vision, sense of
 aesthetic beings 196–97
 aesthetic engagement 134, 135, 140, 141–42
 everyday aesthetics 155–56
 gardens/gardening 224
 intellectualist coalition 169, 170, 171–72
 scientific and evolutionary aesthetics 890–91, 892
 self-acceptance 174
 social aesthetic values 382
visual agnosia 518
visual anthropology 598–601, 611–13
 art-house film 603–4
 Delhi at Eleven 608–9
 Digital Children project 610–11
 MacDougall's films 606–8
 Seven Up! television series 604–6
 women filmmakers 601–3
vitamin D. 844–45
Vitruvius, *de Architectura* 61–62
Vogt, W. 422–23
Vollgas (2002) 542–43
von Bonsdorff, P. 314
von Weizsäcker, V. 311–12, 352
Vowden, P. 915
vulnerability
 clinical care 344–45, 353
 Levinas 355–56, 358
 everyday aesthetics and resilience 248–49, 261–62
 mutual 198–99
 and nature 217
 sensible well-being 174–75, 197
 The Strangers Project 495

wabi aesthetics 154, 155
Wachowski, L. and L. 513
Wade, C. M., 'The Woman with Juice' 657
Wagner, R. 63–64, 78, 101–2
Walker, K. 669
Walker, R., *Self-Care* 807–9, 808f

Wandsworth Community Engagement Network 22n.18
'warmth work' (connective practice) 623, 641n.42
Warner, M. 740
Warren, S., *Cancer* 443
Ways 266, 270
Weems, C. M., *Kitchen Table* 649
Wellcome Trust 508
Welsch, W. 327, 466
West, R. 443–44
West, T. 474
Westfall, J. 512, 522–23
What About Bob? (1991) 558–59
What's New Pussycat? (1965) 558–59
Whig history 301
Whitbeck, C. 339
White, M. 493–94
White, R. 492
Whittaker, N. 198–99
Wickhoff, F. 114–15
Wiene, R. 572n.10
Wiggins, O. 349
Wilbur Wants to Kill Himself (2002) 588
Wilder, B. 542–43
Will to Beauty 340–41
 and mental health 338–40
 as natural force and cultural event 333–38
Wilson, E. O. 216, 305, 844
Wilson, G. 723
Wilt, J. A. 698
Winckelmann, J. J. 99–100
Windle, G. 722
Winnicott, D. W. 707, 786–87, 804, 851
Wir Kinder vom Bahnhof Zoo (2021) 592n.5
Wiseman, F. 509, 601n.4
Wittgenstein, L. 272, 302
Wojnarowicz, D. 668–69
Wolf, A. 466
Wolff, A. 565
Wolz, B. 535–36
women
 aesthetic beings 193–94, 195–96, 197
 art and trauma 666–69
 bodily aesthetics 647, 648, 654–55, 656, 657
 creative well-being workshop 736–47
 eating disorders 926–27, 929

women (*cont.*)
　ethnographic and autobiographical
　　intentions 735
　everyday aesthetics 248–50
　filmmakers 601–3
　institutionalized sexism 735–36
　as psychotherapists and psychiatrists in
　　film 565–70
　self-assertion 735
　sensible well-being 171–72, 174, 175–76,
　　178–79
Woolf, V. 419–20, 423–25, 587–90
　Mrs Dalloway 428–29, 430
Wordsworth, W. 234, 443
　Intimations of Immortality 443
workplace choirs 761–62
World Health Organization (WHO)
　arts and health report 750
　mental health defined 112, 292, 338–39, 340–41
　migration 463
World Psychiatric Association 30
Wounded Healer, The (2017) 524
Wroblewski, G. 14
Wyrusch, J. 450

Yalom, I. D. 422–23
　The Schopenhauer Cure 431
　When Nietzsche wept 431
Yalom's Cure (2014) 556
Yancy, G. 199
Yellow Man and the Girl, The (1919) 581–82
Young, R. 719, 720
young people, *see* children and young
　people
YouTube 601, 610–12

*ZAKHE, Resources for Cooperative
　　Development* 639n.16
Zeisel, J. 822
Zeki, S. 519–20, 847, 890
Zelig (1983) 568
Zen Buddhism 269, 270, 271, 275,
　276
Žižek, S. 335
Zola, É. 424–25, 426
Zumdick, W. 502–3
Zumthor, P. 314, 315, 316, 319
Zweig, S. 587–88
　Mental Healers 419–20